Fine and Applied Arts Terms Index

Fine and Applied Arts Terms Index

FIRST EDITION

An Alphabetical Guide to Sources of Information
on More Than 45,000 Terms Used by Museums,
Art Galleries, and Auction Galleries in the
English-Speaking World, and by Artists, Artisans,
Designers, and Professionals in Associated Fields,
Including Words and Phrases That Describe Objets d'Art,
Objets de Vertu, Bibelots, Antique Furnishings, Jewelry,
Rugs and Carpets, Paintings, Engravings, Drawings,
Sculptures, As Well As Designs, Styles, Periods,
Influences, Motifs, Ornamentation, Components,
Shapes, Production Techniques, Materials, and
Finishes, the Entries Gathered from Standard
Reference Books and Auction Catalogues, with
Sources and Illustrations Indicated, the Whole
Complemented by a Descriptive Bibliography
of All Materials Indexed

Laurence Urdang
Editor-in-Chief

Frank R. Abate
Managing Editor

Gale Research Company
Book Tower · Detroit, Michigan 48226

Editorial Staff:

Laurence Urdang, *Editor-in-Chief*

Frank R. Abate, *Managing Editor*

Peter M. Gross and Charles F. Ruhe, *Editorial Associates*

James Chotas, Janet T. Cohen, and Nancy Delia, *Editorial Assistants*

Keyboarding, Programming, Data Processing,and Typesetting
by Alexander Typesetting, Inc., Indianapolis, Indiana

Typographic and Systems Design by Laurence Urdang

Library of Congress Cataloging in Publication Data

Urdang, Laurence.
 Fine and applied arts terms index.

 Bibliography: p.
 1. Art–Terminology–Indexes. 2. Decorative arts–
Terminology–Indexes. I. Abate, Frank R. II. Title.
N34.U72 1983 701'.4 83-16532
ISBN 0-8103-1544-0

Contents

Foreword

Slang has long been considered a productive source of new words in English, and there is incontrovertible evidence of the truth of that tenet: *jazz* had its origins (as a word) in a black taboo word meaning 'sexual intercourse.' Various scientific disciplines—chemistry, for instance—yield an enormous number of new words each year; but most such terms have little public exposure, being confined to specialized works. English, perhaps more than any other language (since many of the others simply borrow our terms), coins terms prodigiously in all fields.

One of the most productive fields in which new crops of terms are continually being nurtured is the fine and applied arts. Curiously, English has little panache among dealers and collectors of fine art, bibelots, objets de vertu, objets d'art, etc., and an item can often command a higher price if it is called a *bergère* rather than an "armchair," a *vitrine* rather than a "display case," or if it is described as a *bas relief* or *basso rilievo* rather than the mundane "low relief." Of course, many terms of English do survive: *settle, settee, oil painting, etching, engraving,* etc. But the trend today is toward the cachet of the loanword.

Examples abound; although the practice in the past has yielded many French loanwords, the vastly increased and broadened interest in recent years in the arts of Japan, China, and other oriental cultures has produced terms from more exotic sources. From Japan, for instance, we have imported *mokkogata, sentoku, katakiribori, koro, himatoshi,* and the popular *netsuke.* The auction catalogues reveal an odd mixture of descriptions like, "A Chinese export black lacquer shaped oval tray" alongside others like, "A woven silk tonkotsu with pawlonia kanemono." Interspersed among descriptions of another sale is the term *kraak porselein,* which must surely have an English equivalent; the color usually called *ox-blood* in English is more commonly referred to in the world of applied arts as *sang de boeuf;* the variety of marble known in more traditional Anglicized French as *verde antique* is now called *verdi antico;* but even in English one encounters the unfamiliar (save to the initiate) in terms like *strut clock, lenticle, sedan clock,* and *haines.*

Except for the more traditional *ormolu, cloisonné, cameo, galleried,* etc.—and the self-evident ones—*teardrop-shaped, footed, long case clock, hanging shelf,* etc.—

7

there is little documentation of the terms used by museums, collectors, auction galleries, and dealers. On one occasion, I copied from the descriptive cards at an exhibition in New York's Metropolitan Museum of Art about a score of words to look up when I returned home: none was listed in any general unabridged dictionary, yet many thousands of people were visiting that section regularly, as it was part of a permanent exhibition of ancient Greek and Roman artifacts.

The *Fine and Applied Arts Terms Index* is not a direct response to the need for a dictionary containing definitions of those terms, but it is a start. We have selected terms for inclusion in the *Index* from more than 150 sources; dictionaries and encyclopedias, auction catalogues, periodicals, and other published materials have been culled for words and phrases dealing with every period and style of fine and applied art—paintings, sculpture, carpets, furniture, flatware, jewelry, clocks, barometers—in short, almost every conceivable object that may have yielded to the collector of collectibles and the connoisseur of items and that are usually described in more elevated terms.

In many cases, there are illustrations in the sources, and their presence has been indicated alongside the appropriate bibliographical references in the *Index*. For other particulars about the arrangement of information and the content of the *Index*, please refer to **How To Use This Book** in the pages following.

Care has been taken to reproduce the words exactly as they appear in the sources: hence, if a word has been misspelled in the source, it is shown in the *Index* in that form. As many words are borrowings, and there may be a disagreement about transliteration from the foreign language, the variant spellings have been preserved, without "corrections."

The *Fine and Applied Arts Terms Index* represents the first major attempt at systematic documentation of a field that is extremely productive and imaginative in its coinages and borrowings. Undoubtedly, fruitful sources have been missed and, indeed, certain rather common terms may consequently have been omitted. The editors would be grateful for suggestions concerning improvements, for it is their aim to make the *Index* as useful a work as possible.

Laurence Urdang

Essex, Connecticut
August 1983

How To Use This Book

Following each term in *Fine and Applied Arts Terms Index* is an alphanumeric symbol, or symbols separated by semicolon. These symbols represent the sources from which terms were selected for the *Index*. The Bibliography contains the complete list of the sources with their respective symbols and descriptive information.

Many terms are illustrated in the sources. Whenever a source includes an illustration along with a term, the *Index* indicates this by the symbol ① accompanying the symbol for the source, e.g.,

> **abstract wave pattern,** RTA/40 ①.

Symbols for the sources are frequently followed by a virgule (/), then a number or term in italics. The style is explained as follows:

1. A symbol given alone indicates that the term can be found listed alphabetically in the indicated source, e.g.,

 > **abstract art,** DATT.

 in which **abstract art** is the headword and DATT the source in which it can be found.

2. A symbol followed by a virgule and a number indicates that the term can be found on the given page number or, in some catalogues, under the given lot number, e.g.,

 > **academic printing,** JIWA/*10*.

 in which **academic printing** is a term used on page *10* of JIWA, the source in which it can be found;

 > **acanthus capitals,** C-0279/*451*.

 in which **acanthus capitals** is a term used in the description of lot *451* in C-0279, the catalogue in which it can be found.

9

3. A symbol followed by a word or phrase indicates that the term can be found under that particular headword or section of the source, e.g.,

 Altai rugs, EA/*Pazyryk carpet.*

in which **Altai rugs** is a term used in the entry for *Pazyryk carpet* in EA, the source in which it can be found.

 antiques law, DADA/*Supplement.*

in which **antiques law** is a term in the *Supplement* section of DADA, the source in which it can be found.

The editors have endeavored to represent individual terms as they are found in the sources. Thus, peculiar spellings and typographic details have been maintained as they were found originally. The exceptions to this policy are that many plural forms have been changed to the singular for the *Index,* and that all terms are printed in a roman typeface.

Bibliography

Listed below are all sources from which terms were selected in compiling *Fine and Applied Arts Terms Index*. Sources are given in two separate sections, the first giving bibliographic information for books consulted, the second detailing the catalogues and newsletters that were used. In each section the sources are shown in order by their respective alphanumeric symbols, at left. In the section on books, bibliographic information includes a brief description of the content and organization of the source and, for those which the editors used in a special or selective way, an indication of how terms were chosen and presented in the *Index*. The section on catalogues and newsletters lists, in their respective groups, sources published by Christie, Manson & Woods Inc., Antiques, Inc., and Sotheby Parke Bernet Inc.; here symbols are given along with identifying information on each catalogue or newsletter.

Please note that for books the symbols are abbreviations of the title, sometimes accompanied by an identifying number; for catalogues and newsletters the symbols consist of a letter designating the publisher and a code, assigned by the editors of the *Index*, specifying each individual source.

I. Books

ACD *Antique Collector's Dictionary*, Donald Cowie and Keith Henshaw, 208pp., New York: Gramercy Publishing Co., 1962.

A small book containing about 1600 terms, this source concentrates on the terminology of antiques; it is intended for British and American readers. Entries are brief but are supplemented by numerous illustrations. Many foreign terms common in the field of antiques are presented with an explanation of how they are

used. All headwords have been included in the *Index*. The arrangement is alphabetic.

CEA

The Collectors' Encyclopedia of Antiques, Phoebe Phillips, editor, 704pp., New York: Bonanza Books, 1978.

This work, which is illustrated with more than 1,800 photographs and 200 line drawings, is divided into sixteen categories, each of which contains detailed information for the following fields: Arms and Armour; Bottles and Boxes; Carpets and Rugs; Ceramics; Clocks, Watches and Barometers; Embroidery and Needlework; Furniture; Glass; Jewellery; Metalwork; Musical Instruments; Netsuke and Inro; Pewter; Scientific Instruments; Silver; Toys and Automata. Each section gives introductory and technical information, a history of the subject, a sequence of photographs with descriptive text, information on maintenance, repairs, and forgeries, and a list of major museum collections, complemented by a glossary and bibliography. Artisans' names and their marks are given wherever applicable. Numerous items throughout the text are included in the *Index*.

CHGM

The Collectors Handbook: A Guide to the Marketplace, Wendy Murphy, 64pp., New York: Time-Life Books, 1978.

A guide for the novice collector, this little book has seven chapters: "Auctions," "Flea Markets and Yard Sales," "Dealers and Shows," "Appraisals," "Protecting against Fire and Theft," "Collecting Abroad," "Detecting Fakes." It introduces the reader to the art of collecting, explaining such things as: how to bid at an auction, what to look for when purchasing antiques, where, when, and how items can be bought for the best price. Terms related to collecting are included in the *Index*.

DADA

The Dictionary of Antiques and the Decorative Arts, Louise Ade Boger and H. Batterson Boger, ix + 662pp., New York: Charles Scribner's Sons, 1967.

Containing more than 5,500 entries, this reference book covers glass, furniture, ceramics, and silver, as

well as styles, periods, and artisans. It focuses on the decorative arts in America, Europe, and the Orient from the early Chinese Dynasties to the present. The dictionary is supplemented by line drawings and photographs, ample cross references, a classified list of subjects and terms, and a bibliography organized by subject matter. Besides the small drawings which accompany the text, there are also full-page line drawings and photographs arranged by category; the latter are listed in the Contents. The *Index* includes the majority of headwords; terms taken from the Supplement are labeled accordingly.

DATT

A Dictionary of Art Terms and Techniques, Ralph Mayer, 447pp., New York: Barnes and Noble Books, 1981.

This dictionary is a collection of terms used in painting, sculpture, and related visual arts. More than 3,200 entries are included, with treatment of schools, styles, and periods, as well as technical matters. There are many illustrations, and a bibliography that covers such subjects as art history, color, anatomy, and sculpture. Most headwords were selected for the *Index*. The arrangement is alphabetic.

DSSA

Dictionary of Subjects & Symbols in Art, revised edition, James Hall, xxix + 349pp., New York: Harper & Row, 1979.

This book is about the subject matter of Western art and deals mainly with the historical, mythological, and religious themes that artists have drawn upon for their work. The symbolism of many objects is explained, and characters from classical myth and literature are identified, as well as allegorical figures and Christian saints and martyrs. In most cases, the entries include a description of the attributes used to represent the figures as an aid to identification. Extensive cross references and a supplementary index are included. The arrangement is alphabetic.

EA

The Encyclopedia of Antiques, Ian Cameron, Elizabeth Kingsley-Rowe, editors, 400pp., New York: Greenwich House, 1982.

Written in a condensed style, this encyclopedia of more than 5,000 entries complemented by 1,000 illustrations covers American, European, and Oriental antiques to 1875. It also includes maps of centers of production, a bibliography arranged by subject, and a list of silver and ceramic marks. Most of the headwords and all relevant names and marks of artisans have been included in the *Index*.
Some entries have been taken from the picture captions; such entries are given in the *Index* with the number of the page on which the caption is found. All headwords are arranged in alphabetic order.

EC 1
EC 2

The Encyclopedia of Collectibles, Andrea DiNoto and Betsy Frankel, editors, each 160pp., Alexandria, Virginia: Time-Life Books, 1978.

The two volumes from this series, which is oriented toward the American collector, cover, among other things, the following subjects: Art Glass, Art Pottery, Chinese Export Porcelain, and Clocks. In each case a brief history of the subject is accompanied by numerous color photographs with explanatory captions, a description of where and how these items are most likely to be found, and a useful list of museums and books to consult for further information. Entries for the *Index* have been drawn from the text and the captions in those areas mentioned above.

EG

The Encyclopedia of Glass, Phoebe Phillips, editor, 320pp., New York: Crown Publishers, Inc., 1981.

All aspects of glass are treated in this heavily illustrated work. In Part One, the history of glassmaking from Egyptian and Roman times throughout the centuries up to contemporary international studio glass is explained, with chapters on particular centers of production. In Part Two the techniques of glass production—the manufacture of bottles, flat glass, optical glass, and solar-tinted architectural glass, as well as glass melting, the chemistry of colors, and cold glass

decoration—are all described. An exhaustive reading list, illustrated glossary, list of public and private collections, and index all add to the usefulness of this encyclopedia. Terms referring to particular forms and styles of glass and to manufacturing techniques have been included in the *Index*. Each term is given with its appropriate page number.

FFDAB

Federal Furniture and Decorative Arts at Boscobel, Berry B. Tracy, 165pp., New York: Boscobel Restoration Inc. and Harry N. Abrams, Inc., 1981.

Boscobel, a major historic house museum situated on the Hudson River thirty-five miles north of New York City, is a reconstruction based on an 1806 inventory of the States Dyckman estate. This lavishly illustrated volume, with more than 100 color photographs and many more in black and white, treats in detail furniture, decorative arts, and paintings of the Federal period and includes notes, a bibliography, and an index. Each entry included in the *Index* is given with its appropriate page number.

IDC

An Illustrated Dictionary of Ceramics, George Savage, Harold Newman, 320pp., New York: Van Nostrand Reinhold, 1976.

This book of more than 3,000 entries deals with wares, materials, processes, styles, patterns, and shapes encountered in pottery and ceramics throughout the history of the art form. It is extensively illustrated and includes ample cross references. An additional feature of the book is a list of the principal European ceramic factories and their marks. Most headwords were selected for the *Index*. The arrangement is word-by-word alphabetic order.

IDPF

Illustrated Dictionary of Pottery Form, Robert Fournier, xiii + 256pp., New York: Van Nostrand Reinhold Co., 1981.

This dictionary is intended as a source of inspiration and instruction to the craftsman and, as such, concentrates on handmade forms as opposed to machine-made. In addition to a booklist at the beginning, to

which frequent references are made, there are also more than 800 black and white photographs and drawings. The arrangement is alphabetic.

JIWA

Japonisme: The Japanese Influence on Western Art in the 19th and 20th Centuries, Siegfried Wichmann, 432pp., New York: Harmony Books, 1981.

That Japonisme (which includes the applied as well as fine arts) stimulated the development of modern art and had a particularly enduring effect on the work of the Impressionists, Symbolists, and Expressionists is the thesis of this book. The encounter of European art with Japanese is examined through a comparison of thematic characteristics as well as technical—color, form, line, depth, light, shade—of both traditions, and a series of more than 1,000 illustrations is juxtaposed for the analysis. This study is enhanced by notes, a bibliography, and an index. Terms referring to characteristics, theses, styles, influences, materials, etc. are included in the *Index*.

LAR 82

The Lyle Official Antiques Review, 1982, Margot Rutherford, compiler; Anthony Curtis, editor, 670pp., Voor Hoede Publicaties B.V., 1981.

LAR 83

The Lyle Official Antiques Review, 1983, Margot Rutherford, compiler; Anthony Curtis, editor, 672pp., Voor Hoede Publicaties B.V., 1982.

Published annually, this preeminent reference book on antiques records prices paid for items at more than 150 auction houses in Europe and the United States. It covers a variety of antiques and collectibles: furniture, silver, china, glassware, rugs, jewelry, bric-à-brac, and many others. This price guide to the contemporary market includes descriptions, illustrations, values, and sources of thousands of individual items. For the most part, terms describing a particular type of antique have been chosen for the *Index*, and each of these is illustrated. As all foreign terms are Anglicized, they appear without accents or capitals.

LP

The Language of Painting, John N. Barron, 207pp., Cleveland: The World Publishing Co., 1967.

This dictionary contains more than 1,000 entries focusing on terms used in Western painting, particularly those for materials and techniques, history of painting, and art criticism. Definitions are concise and are supplemented by illustrations; phonetic pronunciations and language identification are provided for foreign terms. All headwords have been included in the *Index*. The arrangement is alphabetic.

MP

Meissen Porcelain, Otto Walcha, 516pp., New York: G.P. Putnam's Sons, 1981.

In this study of Meissenware the author examines his subject in terms of its historical and social background, beginning with a discussion of European porcelain and the development of Meissenware. The descriptive text is accompanied by more than 250 illustrations with notes. Entries for the *Index*, all listed with page numbers, were chosen from the text and notes and from the brief glossary; entries within the plates are listed by plate number and accompanied by the designation "Plates." A chronology of the Meissen porcelain manufactory, a chronological survey of forms and decorations of Meissenware, a list of marks, a bibliography, and an index supplement the text.

NYTBA

The New York Times Book of Antiques, Marvin D. Schwartz and Betsy Wade, 344pp., New York: Quadrangle Books, Inc., 1972.

This comprehensive study defines antiques and describes how to identify and purchase them. It also goes into the history of antiques, details of period, style, and manufacture, and discussion of restorations, reproductions, and fakes and how to discern them. Furniture, textiles, ceramics, pictures, metals, and glass are depicted with more than 260 illustrations to complement the text. Many of the items selected from the text for the *Index* are accompanied by illustrations.

OC

The Oriental Carpet, P.R.J. Ford, 352pp., New York: Harry N. Abrams, Inc., 1981.

Not a history of antique carpets but rather a survey of oriental carpets as seen from within the trade, this work seeks to illustrate carpet types which are today widely available both in the Orient and in the West. As such, it is designed to be both a handbook on rug identification and a practical guide to the more than 600 designs used in the modern oriental carpet. The book is divided into two main parts. In the first, the introduction, there is general discussion of identification, classification, materials, structure, and coloring; other subjects such as value, size, symbolism, and history of carpets are touched upon. In the second part, carpets are classified under four categories of design: Border, Universal, Geometric, and Floral. The book is illustrated with more than 780 plates of very high quality, most in color, and includes several maps of carpet-weaving areas, a select bibliography, an index of illustrations, and a general index. Terms related to all aspects of the oriental carpet are included in the *Index*.

OPGAC

The Official Price Guide to Antiques and Other Collectibles, 3rd edition, Grace McFarland, iv + 450pp., Orlando, Florida: The House of Collectibles, Inc., 1981.

More than 20,000 items and their prices are listed in this guide and are arranged alphabetically by category. Each subject section is preceded by a brief introduction, and the usefulness of the guide is enhanced by a complete index of items and subject categories. Entries from the sections on Art Deco, Art Nouveau, Glassware, and Porcelain and Pottery are included in the *Index*.

RGS

Russian Gold and Silverwork: 17th-19th Century, Alexander von Solodkoff, 238pp., New York: Rizzoli International Publications, Inc., 1981.

Limiting itself to a period from the 17th to the 19th centuries, this illustrated work classifies the objects and explains the forms, techniques, and nomenclature characteristic of the art of the Russian goldsmith. One of

the main goals of the author has been to elucidate in a historical context those qualities of this art which are peculiarly Russian. The history of the Russian goldsmith's art, materials and techniques, marks and marking, centers of gold- and silverwork, important masters, workshops, and firms are all discussed. The text is annotated and complemented by a bibliography, list of masters, illustrations of Russian marks, index of marks and signatures, and general index. Terms characteristic of this craft are included in the *Index*.

RTA

Rings through the Ages, Anne Ward, John Cherry, Charlotte Gere, Barbara Cartlidge, 214pp., New York: Rizzoli International Publications, 1981.

The history of rings—from ancient times up to the present—is described and illustrated in this work with more than 400 photographs. Metal-working, materials, and gem-cutting are all discussed; an index and bibliography are included. As the book is organized chronologically, page numbers are given for all entries chosen for the *Index*.

SDF

A Short Dictionary of Furniture, revised and enlarged edition, John Gloag, 813pp., London: George Allen and Unwin Ltd., 1977.

A standard reference work of more than 2,600 entries and 1,000 illustrations, this dictionary covers British and North American furniture dating from 1100 to 1950. The main part of the work—Dictionary of Names and Terms—lists entries in alphabetic order and discusses the age and derivation of terms as well as identifying relevant neologisms; there are numerous cross references, and most terms are either illustrated on the same page or accompanied by a reference to an illustration elsewhere. There are sections covering the description and the design of furniture, a bibliography of books and periodicals, and a useful outline of the development of and influences on furniture since A.D. 1000. Entries taken from the sections on makers and designers are given with page numbers; all others are listed in normal alphabetic order.

II. Catalogues and Newsletters

Terms drawn from 138 recent auction catalogues and newsletters on fine and applied arts, representative of more than 500 catalogues reviewed, were selected for the *Index*. The two major fine arts auction houses, Christie, Manson & Woods International Inc. and Sotheby Parke Bernet Inc., publish catalogues of their sales as a guide to their customers. Each sale lot is described in detail, often illustrated with a photograph, and, for some of the more important pieces, the provenance is detailed. Estimated price values for each lot are also given.

Also included in this section are three issues of *Kovels on Antiques and Collectibles*, a publication of Antiques, Inc. aimed at dealers and collectors of antiques. These newsletters contain information on prices, popularity, and availability of antiques, books available on the subject, and schedules of antique shows and auctions throughout the U. S.

According to both Sotheby Parke Bernet and Christie's, major metropolitan and university libraries as well as important museums are subscribers to their series of catalogues covering fine and applied arts. Those who wish to consult catalogues referred to in the *Index* should check the holdings of institutional libraries.

In the *Index*, references to the catalogues and newsletters are by the symbols listed below, which are followed by a number designating the specific location of the entry in the source.

Christie's catalogues (codes beginning with C) Information on each catalogue includes code, at left, with title, date, sale number, and name of specific gallery holding the sale. Catalogues of the following Christie's galleries were used:

London: 8 King Street, St. James's, London, SW1Y 6QT
South Kensington: 85 Old Brompton Road, London SW7 3JS
Christie's East: 219 East 67th Street, New York, NY 10021
New York: 502 Park Avenue, New York, NY 10022
Christie's Amsterdam B.V.: Cornelis Schuytstraat 57, 1071 JG
 Amsterdam

C-0103 *Silver*; March 1, 1982; sale number SIL 0103/82; South Kensington.

C-0225 *Art Nouveau/Art Deco*; February 23, 1982; sale number 225; Christie's East.

C-0249 *Furniture, Decorative Objects and Prints*; February 2, 1982; sale number 249; Christie's East.

C-0254 *Continental, English & American Silver*; February 10, 1982; sale number 254; Christie's East.

C-0270 *Continental, English & American Silver*; April 14, 1982; sale number 270; Christie's East.

C-0279 *18th & 19th Century Furniture, Works of Art, Sculpture and Rugs*; May 18, 1982; sale number 279; Christie's East.

C-0282 *Oriental Works of Art*; February 25, 1982; sale number COW 2502; South Kensington.

C-0403 *Scientific Instruments, Weights and Measures, Pens, Domestic and other Machines*; March 4, 1982; sale number MSI 0403/82; South Kensington.

C-0405 *Costume, Accessories, Fans, Textiles and Embroidered Pictures*; May 4, 1982; sale number TOS 0405/81; South Kensington.

C-0406 *Victorian and Early Nineteenth Century Silver and Plate and Collectors Items*; June 4, 1982; sale number SIL 0406/82; South Kensington.

C-0604 *Costume, Furs, Leather and Crocodile Accessories and Textiles*; April 6, 1982; sale number TOS 0604/82; South Kensington.

C-0706 *Silver*; June 7, 1982; sale number SIL 0706; South Kensington.

C-0782 *Oriental Ceramics*; June 7, 1982; sale number COR 0706/82; South Kensington.

C-0803 *Oriental Ceramics*; March 8, 1982; sale number COR 0803/82; South Kensington.

C-0906 *Carpets, Objects of Art and Musical Instruments*; June 9, 1982; sale number FOB 0906/82; South Kensington.

C-0982 *Furniture*; June 9, 1982; sale number FUR 0906/82; South Kensington.

C-1006 *European Ceramics*; June 10, 1982; sale number CEU 1006/82; South Kensington.

C-1082 *Tribal Art and Oriental Works of Art*; June 10,1982; sale number COW 1006/82; South Kensington.

C-1304 *Fans and Accessories, Costume, Linen and Lace*; April 13, 1982; sale number TOS 1304/82; South Kensington.

C-1407 *Furniture*; July 14, 1982; sale number FUR 1407/82; South Kensington.

C-1502 *Silver*; February 15, 1982; sale number SIL 1502/82; South Kensington.

C-1506 *Fine Embroidery, Textiles, Costume and Lace*; June 15, 1982; sale number TOS 1506/82; South Kensington.

C-1582 *Antiquities and European Ceramics*; July 15, 1982; sale number CEU 1506/82; South Kensington.

C-1603 *Fans*; March 16, 1982; sale number TFA 1603; South Kensington.

C-1609 *Scientific Instruments, Cameras and Photographic Equipment*; September 16, 1982; sale number MSI 1609; South Kensington.

C-1702 *Carpets, Objects of Art, Clocks and Barometers*; February 17, 1982; sale number FOB 1702/82; South Kensington.

C-2202
Silver; February 22, 1982; sale number SIL 2202/82; South Kensington.

C-2203
Costume, Linen, Lace, Quilts, Embroidery, Samplers and Textiles; March 22, 1983; sale number TOS 2203; South Kensington.

C-2204
European Ceramics; April 22, 1982; sale number CEU 2204/82; South Kensington.

C-2320
English Furniture; Eastern Rugs and Carpets; March 11, 1982; sale number FERRY 2320-2317; London.

C-2323
Chinese Ceramics and Works of Art; March 15, 1982; sale number CHANGLI 2323; London.

C-2324
Important Art Nouveau, Art Deco and Studio Ceramics; March 16, 1982; sale number GUTRUNE 2324; London.

C-2332
Chess Sets, Objects of Vertu, Russian Works of Art and Fine Miniatures; March 23, 1982; sale number ORESTEIA 2332; London.

C-2357
Important English Furniture; Eastern Rugs and Carpets; April 15, 1982; sale number FELSPAR 2357; London.

C-2360
English Porcelain and Pottery; April 19, 1982; sale number PRUDENCE 2360; London.

C-2364
Fine French Furniture and Objects of Art; April 22, 1982; sale number FERMENT 2364; London.

C-2368
Barometers, Fine Clocks and Important Watches; April 28, 1982; sale number EJECT 2368; London.

C-2370
English Furniture; April 29, 1982; sale number FETE 2370; London.

C-2382 *Pewter and Metalwork; English and Continental Oak Furniture*; May 13, 1982; sale number FETLOCK 2382; London.

C-2388 *Fine English Furniture; Eastern Textiles, Rugs and Carpets*; May 20, 1982; sale number FEND 2388; London.

C-2398 *Victorian and Early 19th Century Silver*; June 2, 1982; sale number SPUR 2398; London.

C-2402 *Furniture*; February 24, 1982; sale number FUR 2402/82; South Kensington.

C-2403 *English Furniture; Eastern Rugs and Carpets*; June 10, 1982; sale number FEY 2403; London.

C-2409 *Art Nouveau and Art Deco*; September 24, 1982; sale number CAN 2409; South Kensington.

C-2414 *Early Chinese Ceramics, Archaic Bronzes, Paintings and Works of Art*; June 17, 1982; sale number CAULDRON 2414; London.

C-2421 *Fine English Furniture*; June 24, 1982; sale number FIACRE 2421; London.

C-2427 *Important Continental Porcelain, Pottery and Italian Maiolica*; June 28, 1982; sale number PANIER 2427; London.

C-2437 *Fine French and Continental Furniture; Important Tapestries*; July 1, 1982; sale number FIBRE 2437; London.

C-2458 *Chinese Ceramics, Bronzes, Works of Art, Hardstones and Snuffbottles*; July 19, 1982; sale number CAROLINE 2458; London.

C-2476 *Modern Sporting Guns and Vintage Firearms*; September 15, 1982; sale number HARKOM 2476; London.

C-2478 *English Furniture; Eastern Rugs and Carpets*; September 23, 1982; sale number FEIF 2478-2479; London.

C-2482 *Carpets, Antiquities, Objects of Art and Sculpture*; February 24, 1982; sale number FOB 2402/82; South Kensington.

C-2486 *Fine Continental Porcelain, Pottery and Italian Maiolica*; October 4, 1982; sale number PEGASUS 2486; London.

C-2487 *English and Foreign Silver and Objects of Vertu*; October 6, 1982; sale number SWIFT 2487; London.

C-2489 *Scientific Instruments, Clocks and Watches*; October 7, 1982; sale number ELFIN 2489; London.

C-2493 *English Porcelain and 19th Century European Ceramics*; October 11, 1982; sale number PANTOMIME 2493; London.

C-2498 *Pewter and Metalwork, English and Continental Furniture*; October 14, 1982; sale number FIERCE 2498; London.

C-2501 *Fine Costume, Embroidery, Samplers, Textiles and Lace*; January 25, 1983; sale number TOS 2501/83; South Kensington.

C-2502 *European Ceramics*; February 25, 1982; sale number CEU 2502/82; South Kensington.

C-2503 *Antique Arms and Armour*; October 20, 1982; sale number HARLEY 2503; London.

C-2510

Fine Victorian and Early 19th Century Silver; November 3, 1982; sale number SYRACUSE 2510; London.

C-2513

Fine Chinese Export Porcelain and Works of Art; November 1, 1982; sale number COCKEREL 2513; London.

C-2520

Fine Musical Instruments and Printed Music; November 5, 1982; sale number ZANZIBAR 2520; London.

C-2522

Important English Furniture; November 18, 1982; sale number FIGURE 2522; London.

C-2546

Fine Continental Furniture; Tapestries; Eastern Rugs and Carpets; December 2, 1982; sale number FILBERT 2546-2547; London.

C-2555

Objects of Art; Highly Important French Furniture; December 9, 1982; sale number FILAMENT 2555; London.

C-2569

Antique Arms; December 15, 1982; sale number HAROLD 2569; London.

C-2608

Scientific Instruments, Domestic and Other Machines; August 26, 1982; sale number MSI 2608; South Kensington.

C-2704

Quilts, Samplers, Embroidered Pictures, Lace Bobbins and Linen; April 27, 1982; sale number TOS 2704; South Kensington.

C-2904

Scientific Instruments, Weights and Other Machines; April 29, 1982; sale number MSI 2904; South Kensington.

C-2910

Art Nouveau and Art Deco; October 29, 1982; sale number CAN 2910; South Kensington.

C-3011
Fine Costume, Embroidery, Samplers and Textiles; November 30, 1982; sale number TOS 3011/82; South Kensington.

C-5005
Important Art Déco & Art Nouveau; October 4, 1980; sale number JEAN 5005; New York.

C-5114
Fine American Furniture, Silver and Decorative Arts; January 23, 1982; sale number SEYMOUR 5114; New York.

C-5116
Important English and Continental Furniture, Clocks and Objects of Art; January 30, 1982; sale number SCARSDALE 5116; New York.

C-5117
Important English and Continental Silver; Objects of Vertu; Russian Works of Art and Watches; February 11, 1982; sale number INMAN 5117; New York.

C-5127
Chinese and Japanese Ceramics and Works of Art; March 23-24, 1982; sale number 5127; New York.

C-5146
Art Nouveau and Art Deco; May 27, 1982; sale number EXPO 5146; New York.

C-5153
Important American Furniture; Silver and Decorative Arts; June 12, 1982; sale number GODDARD 5153; New York.

C-5156
Important Chinese and Japanese Paintings, Ceramics, Hardstone Carvings and Decorative Works of Art; June 23, 24, 28, 1982; sale number 5156; New York.

C-5157
Fine English and Continental Furniture, Clocks and Objects of Art; June 26, 1982; sale number SCOT 5157; New York.

C-5167
Art Nouveau, Art Deco and Moderne; October 9, 1982; sale number DESKEY 5167; New York.

C-5170 *Fine English and Continental Furniture, Clocks and Objects of Art*; October 23, 1982; sale number SKIDMORE 5170; New York.

C-5173 *Highly Important English and Continental Silver and Objects of Vertu*; October 26, 1982; sale number MORGAN 5173; New York.

C-5174 *Fine Judaica, English and Continental Silver, Russian Works of Art, Watches and Objects of Vertu*; October 25-26, 1982; sale number MICHAEL 5174; New York.

C-5181 *Nineteenth Century Furniture and Works of Art*; September 21, 1982; sale number 5181; Christie's East.

C-5189 *Victorian Porcelain, Sculpture, Works of Art, Furniture and Rugs*; October 5, 1982; sale number 5189; Christie's East.

C-5191 *Art Nouveau / Art Deco*; October 8, 1982; sale number 5191; Christie's East.

C-5203 *Continental, English & American Silver*; October 21, 1982; sale number 5203; Christie's East.

C-5220 *The Elizabeth Parke Firestone Collection of Important Gold Boxes and Objects of Vertu*; November 19, 1982; sale number FIRESTONE 5220; New York.

C-5224 *Fine French and Continental Furniture, Clocks, Objects of Art. Tapestries and Sculpture*; November 20, 1982; sale number LEVASSEUR 5224; New York.

C-5234 *The Pan Asian Collection; Parts I and II*; December 1, 1982; sale number PAN ASIAN 5234; New York.

C-5236 *Important Chinese and Japanese Works of Art*; December 2-3-4, 1982; sale number 5236; New York.

C-5239 *Art Nouveau/Art Deco*; December 9, 1982; sale number 5239; Christie's East.

C-5255 *Important Musical Instruments*; January 19, 1983; sale number 5255; Christie's East.

C-5259 *The Estate of Sarah Hunter Kelly: European Furniture, Decorative Objects, Porcelain and Rugs*; January 25, 1983; sale number 5259; Christie's East.

C-5323 *Fine Oriental Rugs and Carpets*; April 26, 1983; sale number 5323; Christie's East.

C-GUST *Art Nouveau and Art Deco*; November 22, 1982; sale number GUSTAVE; London.

C-MARS *Arms and Armour: Clocks and Watches*; September 28, 1982; sale number MARS; Amsterdam.

Kovels on Antiques and Collectibles (codes beginning with K)

Information on *Kovels on Antiques and Collectibles* includes volume, number, and date. In the *Index*, numbers appearing after the source code refer to the page number in the newsletter where the entry can be found.

K-710 *Kovels* Volume 7, Number 10; June 15, 1981.

K-711 *Kovels* Volume 7, Number 11; July 15, 1981.

K-802 *Kovels* Volume 8, Number 2; October 15, 1981.

Sotheby Parke Bernet catalogues (codes beginning with S)

Information on each catalogue includes code, at left, with title, date, sale number, and name of specific gallery holding the sale. Catalogues of the following Sotheby Parke Bernet galleries were used:

New York: 1334 York Avenue, New York NY 10021
Los Angeles: 7760 Beverly Boulevard, Los Angeles, CA 90036

S-286 *Fine 19th and 20th Century Prints*; September 22-23, 1980; sale number 286; Los Angeles.

S-288 *Important Oriental Rugs*; October 20, 1980; sale number 288; Los Angeles.

S-291 *Highly Important Jewelry*; November 10, 1980; sale number 291; Los Angeles.

S-2882 *Decorative Arts*; October 20-22, 1982; sale number 288 vol. II; Los Angeles.

S-3311 *Furniture and Decorative Arts*; March 1-3, 1982; sale number 331, vol. I; Los Angeles.

S-3312 *Oriental Works of Art*; March 4, 1982; sale number 331, vol. II; Los Angeles.

S-4414 *Jewelry, Art Nouveau and Art Deco, English Furniture, Silver & Decorative Works of Art*; September 9-10, 1980; sale number 4414; Chicago (sale held at the Drake Hotel).

S-4436 *English Furniture and Decorations*; October 18, 1980; sale number 4436Y; New York.

S-4461 *Decorative Works of Art, Furniture and Rugs*; November 6, 1980; sale number 4461Y; New York.

S-4507 *Neo-Classical Art Moderne Furniture, Part One*; December 18, 1980; sale number 4507Y; New York.

S-4796 *Oriental Rugs and Carpets*; March 5-6, 1982; sale number 4796Y; New York.

S-4802 *Watches, Clocks, English & Continental Silver and Portrait Miniatures*; February 17-18, 1982; sale number 4802Y; New York.

S-4804 *Victorian International*; February 19-20, 1982; sale number 4804Y; New York.

S-4807 *Pre-Columbian, American Indian, African and Oceanic Art, Egyptian, Classical, Western Asiatic, and later Works of Art*; February 24, 1982; sale number 4807Y; New York.

S-4810 *Fine Chinese Jades, Works of Art and Snuff Bottles*; February 25-26, 1982: sale number 4810Y; New York.

S-4812 *English Furniture, Decorations and Clocks*; February 27, 1982; sale number 4812Y; New York.

S-4823 *French and Continental Furniture, Decorations and Ceramics*; March 20, 1982; sale number 4823Y; New York.

S-4829 *The Gretchen Kroch Kelsch Collection of Japanese Lacquer, Part II*; March 27, 1982; sale number 4829Y; New York.

S-4843 *English Pottery*; April 24, 1982; sale number 4843Y; New York.

S-4847 *Fine Oriental Rugs and Carpets*; May 1,1982; sale number 4847Y; New York.

S-4853 *Important Continental Porcelain, Fine French Furniture, Decorations and Clocks*; April 22, 24, 1982; sale number 4853Y; New York.

S-4881 *Barbara Johnson Whaling Collection: Part II*; September 24, 25, 1982; sale number 4881; New York.

S-4905 *American Furniture and Related Decorative Arts*; June 30-July 1; 1982; sale number 4905Y; New York.

S-4922 *Important Silver*; June 16, 1982; sale number 4922Y; New York.

S-4927 *Antique and Period Jewelry, Watches and Instruments*; October 6, 1982; sale number 4927; New York.

S-4928 *Fine Netsuke, Inro and Lacquer*; October 6, 1982; sale number 4928; New York.

S-4944 *English and Continental Silver*; October 27, 1982; sale number 4944; New York.

S-4947 *Victorian International*; October 29-30, 1982; sale number 4947; New York.

S-4948 *Fine Oriental Rugs and Carpets*; October 30, 1982; sale number 4948; New York.

S-4955 *Important French Furniture, Decorations and Clocks*; November 6, 1982; sale number 4955; New York.

S-4963 *Important Chinese Ceramics, Bronzes and Works of Art: The Collection of Captain S. N. Ferris Luboshez, USN (Ret'd)*; November 18, 1982; sale number 4963; New York.

S-4965 *Fine Chinese Ceramics, Works of Art, Chinese and Japanese Paintings*; November 19, 1982; sale number 4965; New York.

S-4972 *European Works of Art, Armour, Furniture and Tapestries*; December 3-4, 1982; sale number 4972; New York.

S-4973 *Fine Egyptian, Classical, and Near Eastern Antiquities, Islamic Works of Art, and Oriental Miniatures and Manuscripts*; December 2-3, 1982; sale number 4973; New York.

S-4988 *Fine English Furniture, Decorations and Clocks*; October 16, 1982; sale number 4988; New York.

S-4992 *19th Century Porcelain from the Estate of Wilfred Swall, Part I*; December 11, 1982; sale number 4992; New York.

Fine and Applied Arts Terms Index

N.B.: *The policy of the editors has been to list words and phrases as they were found in the sources; hence, peculiarities of spelling and other typographic details have been reproduced exactly as they appeared originally.*

A

AA, EA/*Arras, Sèvres.*

à abattant, EA/*secrétaire en armoire.*

Aalto, Alvar, DADA/*Supplement.*

A. a. M., EA/*aus alten Modell.*

a and r, CEA/*258*①.

Aarne, Victor (workmaster), C-5174/
314①.

Aaron Lestourgeon, C-5117/*56*①.

Aaron's Rod, DATT.

Aaron Willard, EC2/*89.*

AB, CEA/*185*①; EA/*Dorotheenthal.*

abachi, SDF.

abaculus, DATT.

abacus, DSSA; EA; SDF/①.

abacus tripod base, FFDAB/*110.*

Abadeh, OC/*104*①.

Abadeh rug, C-2403/*198.*

Abalone pattern, C-5167/*262*①.

abalone shell, C 5156/*802*, S-3311/
915; S-4881/*88*①, *438*①.

a barbottina, EA.

abattant, C-2402/*269*; DADA.

Abbe, Ernst, CEA/*611*①.

Abbey, Richard, ACD.

Abbotsford furniture, ACD.

Abbotsford period, SDF/①.

Abbotsford style, EA.

abbozzo, DATT.

abbreviated definition, C-5156/*206*①.

ABC art, DATT.

Abdy, William, C-5174/*584.*

Abdy, William II, C-2487/*64.*

a bell, EA/*Sheffield plate.*

Abercromby, Robert, C-2487/*144*;
C-5174/*593.*

Abildgard, N. A., CEA/*316*①.

ABL, CEA/*622*①.

Abney level, C-0403/*198.*

Abraham IV, EA/*Drentwett family.*

abrash, CEA/*83*①, *101.*

abrashed, C-0279/*5*; C-5189/*359*;
C-5323/*43*①.

abrashed powder blue, S-4847/*178.*

abrashes, OC/*131, 244, 266.*

abrasion, S-4905/*59*①, *134*①.

abraum, DATT.

abricotier, DADA.

Abridgments of Specifications for
Patents, C-2904/*24.*

Abruzzo school of silversmiths,
C-5224/*254*①.

Absolon, William, EA.

Absolon Yar^m, EA/*Absolon, William.*

absolute alcohol, DATT.

absorbent ground, LP.

absorbent paper, JIWA/*403*.

abstract, C-0249/*113*; LP.

abstract art, DATT.

abstract border, C-0254/*78*.

abstract chapter, C-5117/*427*①.

abstracted flowers, C-2704/*188*.

abstracted meandering, C-2704/*25*①.

abstract expressionism, DATT; JIWA/*396*; LP.

abstract floral design, NYTBA/*247*①.

abstraction, JIWA/*5, 10, 50*①*, 276*; LP.

abstractionism, JIWA/*267*.

abstraction of nature, JIWA/*6*.

abstract mask, C-5156/*319*.

abstract painting, LP.

abstract pattern, JIWA/*58*.

abstract scroll, C-1082/*106*.

abstract wave pattern, RTA/*40*①.

Abtsbessingen, DADA; EA.

Abtsbessingen faience, EA/*18*①.

Abundance, DSSA.

abura, SDF.

acacia, ACD; DATT; SDF.

acacia faux wood, DADA.

acacia leaf, EA.

acacia wood, DADA.

academic, DATT; LP.

académic artist, NYTBA/*190*.

academician, DATT.

academicism, DATT.

academic painting, JIWA/*10*.

Académie des Beaux-Arts, DATT.

academy, DATT; LP.

academy blue, DATT.

academy board, DATT.

academy figure, DATT.

à cage, RGS/*146*①.

acajou, DADA; DATT.

acanthus, ACD; C-0982/*24*; C-2398/ *21*①; C-2402/*30, 36*; C-5116/ *43*①; CEA/*405*; DADA/①; DATT/①; IDC/①; K-710/*111*; S-4414/*254*①; S-4922/*21*①.

acanthus-and-tie motif, C-5174/*313*①.

acanthus capital, C-0279/*451*.

acanthus-carved, C-0982/*15, 120*; C-2388/*22*.

acanthus carved, S-4436/*101*①.

acanthus-carved cabriole leg, S-4414/ *483*①.

acanthus carved capital, C-0279/ *270*①.

acanthus carved outset toe, S-2882/ *280*①.

acanthus centering shell, S-4414/ *270*①.

acanthus clasp, C-2437/*10*①.

acanthus-decorated scroll grip, S-2882/*1167*①.

acanthus flowerhead, S-4414/*324*①.

acanthus foot, SDF.

acanthus heading, C-2402/*42*.

acanthus leaf, C-1502/*95*; C-2202/ *123*; CEA/*305*①.

acanthus leaf and paw foot, C-5117/ *124*①.

acanthus leaf borders, S-4461/*72*.

acanthus leaf handle, C-2427/*28*①.

acanthus leaf lip, S-4461/*225*.

acanthus-leaf ornament, MP/*172*.

acanthus leaf terminal, S-4804/*44*①.

acanthus motif, EA; MP/*35*.

acanthus mount, S-4461/*11*.

acanthus ornament, SDF/①.

acanthus pattern, C-0254/*76*.

acanthus sabot, C-2437/*75*①; S-2882/*785, 836*.

acanthus-scroll, C-2402/*52, 109*.

acanthus-scrolled, C-0982/*59*; C-2402/*7*.

acanthus wreath, C-5005/*218*①.

acaroid resin, DATT.

accelerated test, DATT.

accelerator, DATT.

accent, C-2704/*118*; JIWA/*81.*

accessories drawer, C-0403/*126.*

accessory, C-1506.

accessory dish, EC2/*29*①.

accollé, S-4922/*23*①, *50*①.

accordian, C-0906/*260.*

accordion pleat, SDF.

accouchement bowl, IDC/①.

accouchement cup, IDC.

accouchement set, IDC.

accretion, C-5236/*379.*

accroides, DATT.

acetabulum, IDC.

acetate, DATT.

acetic ether, DATT.

acetone, DATT; LP.

acetylene, DATT.

acetylene black, DATT.

à chassis, S-4955/*191*①; S-4972/*571.*

Achmad Isphahan, S-4948/*124*①.

achromat, CEA/*612.*

achromatic color, DATT; LP.

achromatic compound microscope, CEA/*611*①.

achromatic telescope, CEA/*602*①.

Achtenhagen, Karl Ludwig August, MP/*198.*

acid bath, DATT.

acid-cut-back, C-5146/*144A.*

acid-cut back vase, C-5191/*387*①.

acid embossing, SDF.

acid engraved, CEA/*444*①.

acid-etched, C-5191/*255*; CEA/ *481*①, *626*①; S-2882/*1253*①, *1264*, *1316*①; S-3311/*896*①.

acid etched, C-2409/*39*; EG/*286*①; S-4905/*163*①.

acid etched border, C-0225/*223.*

acid finished, C-0225/*239.*

acid gilding, IDC.

acid number, DATT.

acid polishing, CEA/*502*; EG/*286.*

acid resist, DATT.

acid-staining, NYTBA/*302.*

acid stamped, C-5239/*124.*

acid value, DATT.

Acier, Michael-Victor, ACD.

Acier, Michel-Victor, EA.

Acier, Michel Victor, MP/*153.*

Ackermann, Rudolph, CEA/*691*①.

acolé, C-5220/*44*①.

acollé, C-2427/*200.*

acollé coats-of-arms, C-5117/*91*①.

acollé crest, C-5117/*145*①.

acolyte, C-0782/*31.*

Acoma, S-4807/*289*①.

à confident, CEA/*380*①.

acorn, C-2398/*68*①; C-5116/*174*①; DADA.

acorn burrs—Northwood, OPGAC/ *180.*

acorn chair, DADA; SDF/①.

acorn clock, EA.

acorn finial, C-0254/*266*; LAR82/ *234*①; S-4414/*331*①; S-4436/*5*①; S-4461/*269*; S-4804/*44*①.

acorn (York) flagon, EA.

acorn flagon, LAR83/*516*①.

acorn knop, CEA/*423*①.

acorn-knopped, CEA/*594.*

acorn-knop spoon, EA.

acorn molding, DADA.

acorn motif, EA.

Acorn pattern, C-0254/*76*; C-0270/ *169*; C-5167/*152*①.

acorn pendant, S-2882/*300.*

acorn shape clock, EC2/*93*①.

acorn-shaped, C-5117/*42.*

acorn spoon, DADA.

acorn-studded, C-0982/*110.*

acorn table lamp, C-5005/*400*①.

acorn thumb-piece, CEA/*586*①.

acorn timepiece, LAR83/*210*①.
acorn-tipped, C-5157/*154*①.
acorn top, SDF/①.
acorn turning, SDF/①.
acoustic jar, IDC.
Acra red, DATT.
acrolith, DATT.
acroterium, DADA.
acrylic, RTA/*146*.
acrylic brush, DATT.
acrylic canvas, DATT.
acrylic color, DATT.
acrylic jewellery, RTA/*174*①.
acrylic resin, DATT; LP; RTA/
　*174*①.
acrylic varnish, DATT.
Acryloid, DATT.
Acteon, C-2427/*254*.
actinic light, DATT.
action painting, DATT/①; JIWA/
　396; LP.
Act of Parliament, CEA/*234*①.
Act of Parliament clock, C-2368/*96*;
　DADA; EA/①; LAR83/*209*①;
　SDF.
actress, OPGAC/*199*.
Acts of the Apostles tapestry, EA.
AD, EA/*Drentwett family*.
Adair, R. F., S-3311/*628*.
Adam, C-5116/*66*; CEA/*321*;
　NYTBA/*17*.
Adam, Charles, C-2487/*107*; CEA/
　*183*①; EA.
Adam, Henri Georges, DADA/
　Supplement.
Adam, Robert, ACD; C-2357/*10*①;
　CEA/*100*①, *303*, *321*; DADA/①;
　EA; SDF/*745*.
Adam and Eve, C-1506/*103*①; IDC/
　①.
Adam and Eve charger, EA.
Ada May, C-2409/*287*.
Adamesque, C-2478/*178*.

Adam pattern, S-2882/*1357*.
Adam period, CEA/*446*①.
Adams, ACD; C-1006/*154*; OPGAC/
　190; EA/*Adams family*.
Adams, Ansel, K-710/*118*.
Adams, Edwin, CEA/*232*①.
Adams, G., CEA/*262*①.
Adams, George, EA/*280*.
Adams, G. Jnr., CEA/*603*①.
Adams, Mark, DADA/*Supplement*.
Adams, Robert, CEA/*36*①.
Adams, Stephen, S-4944/*94*.
Adams, Stephen I, C-2487/*152*.
Adams, William, DADA.
Adams and Adams-Deane revolver,
　ACD.
Adams and Company, DADA/
　Supplement.
Adams & Co, EA/*Adams family*,
　Adams family.
Adams family, EA.
Adams I, Stephen, C-5117/*36*.
Adam style, C-0249/*380*; C-0254/
　*311*①; C-2402/*137*; DADA; EA/
　①; IDC; LAR82/*366*①; LAR83/
　*248*①; SDF.
adapted, C-2421/*44*①; C-5117/*380*①.
adapted frieze, C-2388/*47*.
adapted interior, C-2403/*69*; C-2478/
　12.
additive color, DATT.
additive color mixture, LP.
addorse, C-2458/*229*.
addorsed, LAR83/*346*①; S-4965/
　*67*①.
Adelaide Style, CEA/*364*①.
à deux crayons, DATT.
Adie, C-2904/*204*.
Adie & Son, C-2904/*204*.
Adige, Alto, LAR83/*404*①.
adige-work, S-4972/*447*.
à disposition, C-1506/*1*; C-2704/*80*.
adjustable, C-5157/*56*.

adjustable base, C-5005/*414*ⓘ.
adjustable curve ruler, DATT/ⓘ.
adjustable foot, C-5117/*222*.
adjustable furniture, SDF/ⓘ.
adjustable shelf, C-5005/*358*ⓘ.
adjustable triangle, DATT.
adjustable weight, C-5117/*484*ⓘ.
adjustable writing slope, C-0982/*168*.
adjusted, C-5117/*404*ⓘ.
adjusted extra, C-5117/*433*.
adjustor, C-0906/*265*.
Adlerglas, DADA/ⓘ.
Admiral Ordinance, C-2904/*248*.
adobe, IDC.
Adolph crest, C-5117/*205*ⓘ.
adoption, JIWA/*6*.
Ador, Jean-Pierre, EA.
adorsed, C-5127/*308*ⓘ.
Adriaen Pijnacker factory, NYTBA/*138*ⓘ.
Adrianople red, DATT.
Adriatic oak, SDF/*Austrian oak*.
adsorption, DATT.
adulterant, LP.
advancing and retreating colors, DATT.
adventurine, DADA; EG/*216*.
advertising fan, C-1304/*28*.
adz, DATT/ⓘ.
adze, DATT/ⓘ; SDF.
ae., DATT.
Aegean art, DATT.
Aegean painting, LP.
Aelmis, Jan, EA/ⓘ.
aerial composition, LP.
aerial perspective, DATT; LP/ⓘ.
aerograph, IDC.
aerugo, DATT.
Aesop, IDC/ⓘ.
aesthetic dress, C-1506/*18*.
aesthetic gestalt form, JIWA/*402*.

Aesthetic movement, LAR83/*265*ⓘ; C-2324/*247*; DADA/*Supplement*.
'Aesthetic' movement taste, LAR83/*627*ⓘ.
aesthetic quality, IDPF/*105*.
aesthetics, LP.
aesthetic style, C-2910/*154*.
aes ustum, DATT.
aet., DATT.
Afanassiev, Fedor, C-5117/*358*ⓘ.
afara, SDF.
Affenkapelle, CEA/*176*ⓘ; EA; IDC/ⓘ.
Affenkapelle (Monkey Band), MP/*478*.
Affleck, Thomas, C-2522/*22*ⓘ; DADA; EA; SDF/*767*.
affronté, S-4905/*84*ⓘ.
afgani border, S-2882/*188*.
Afghan, C-2388/*192*; C-2478/*214*.
Afghan Beluchis, OC/*110*.
Afghan Bokhara, DADA.
Afghan carpet, EA; S-4461/*845*.
Afghan design, S-3311/*25*ⓘ.
Afghan embroidered bag, S-4461/*777*.
Afghan Hatchli, S-4461/*755*.
Afghan kilim, C-0906/*20*.
Afghan rug, C-0906/*31*; C-2482/*24*; S-4461/*764*; S-4796/*55*.
Afghan tent band, S-4461/*768*.
Afghan Turcoman rug, S-4461/*787*.
African, IDPF/*55*.
African art, RTA/*156*ⓘ.
African blackwood, DATT.
African cherry, DATT.
African genre scene, C-5167/*200*ⓘ.
African ivory tusk, C-0906/*101*.
African mahogany, DATT; SDF.
African masks, CHGH/*46*.
African rosewood, DATT.
African teak, SDF.
African walnut, DATT; SDF.

African whitewood, DATT; SDF.

African zebrawood, SDF.

afrormosia, SDF.

afshar, DADA; C-0906/*24*; C-2320/ *132*; C-2403/*181*; C-2478/*230*; S-4847/*26, 161.*

Afshar bag, C-0906/*68.*

Afshari, OC/*69*①, *110*①, *207*①.

Afshar rug, C-2357/*152*; C-2482/*25*; S-4461/*770*; S-4796/*122*; S-4847/ *35.*

aftaba, IDC.

aftabeh, IDC/*aftaba.*

after, DATT.

after-chased, C-2202/*10.*

after dinner coffee set, S-4804/*86.*

afterimage, LP.

after-yellowing, DATT.

Agafanov, Vasili, C-5174/*292.*

agalloch wood, DADA.

agalma, DATT.

agalmatolite, DADA; DATT.

agal wood, DADA.

Agam, Yaacov, S-286/*174.*

agata, DADA; EC1/*56, 61*①; OPGAC/*158*; C-0225/*282.*

agate, C-0103/*78*; C-1082/*170*; C-2202/*7*; C-2421/*3*; C-2458/*305*; C-5005/*226*①; C-5127/*314*; C-5156/*395*; DATT; EA; JIWA/ *304*①; LAR82/*60*①; RTA/*21*①; S-4461/*37, 452*; S-4843/*100*①; S-4927/*325*; S-4972/*67*①.

agate earthenware, CEA/*154*①.

agate glass, EG/①.

agate ware, ACD; DADA; EA/①; IDC.

agateware, K-710/*117*; LAR82/ *179*①.

agathe, NYTBA/*286.*

age-crack, IDC.

aged, NYTBA/*6.*

agent, LP.

Ages of Man, DSSA.

Ages of the World, DSSA.

agglutinant, DATT.

aggregate, DATT.

Aghkand, EA.

agitable lamp, EA.

A. Golay-Leresche & Fils, C-5117/ *477*①.

agra, DADA; OC/*124*①, *305*; S-4847/*296*①.

Agra rug, C-2320/*130.*

Agricola, Georgius, EA.

agricultural medallion, C-2398/*21*①.

Ahar, OC/*266, 304*①.

A Health to J-ms, EA/*Jacobite glass.*

Ahrenmuster, MP/*472*①.

Ahrens, LAR82/*34*①.

Ai-Apec, S-4807/*39*①.

aiban, JIWA/*244.*

aiban tate-e, C-5236/*984.*

aiban yoko-e, C-5236/*1216.*

aide-memoire, C-2332/*70.*

aide mémoire, EA.

aigrette, EA; RGS/*70.*

aiguière, IDC.

aiguière handle, IDC.

aikuchi, DADA.

ailanto, DADA.

ailettes, DADA.

aina khaneh, OC/*330.*

Ainsley, C-2489/*13.*

A.I.R., LP.

air, à l', IDC.

air bead, CEA/*503.*

air brush, LP/①.

airbrush, DATT/①.

air bubbles, JIWA/*310*①.

aircraft curve, DATT.

air drain, DATT.

Aird & Thompson, Glasgow, C-2489/ *104.*

air eraser, DATT.

alarm watch, S-4927/*63*①.

alarum, EA/① *alarm*.

Alaterre, J., C-5117/*15*; C-5220/ *39*①.

alb, DADA.

Albania, OC/*321*①.

Albani stone, DATT.

Albany couch, EA/*reading seat*; SDF.

albany pattern, C-0706/*160*; C-0103/ *38*.

Albany slip, DADA/*Supplement*; DATT; EA.

albarelli, EA/① *albarello*.

albarello, ACD; C-2427/*145*①, *210*; C-2486/*178*; C-5156/*446*; CEA/ *132*①; DADA/①; EA/①; IDC/ ①; IDPF/*3*①; LAR82/*137*①; LAR83/*112*①; S-4461/*175*; S-4972/*132*, *392*.

Albarez, Diego, CEA/*25*①.

Alberene stone, DATT.

Alberhill Pottery, Alberhill, California, EC1/*85*.

Albers, Anni, DADA/*Supplement*.

Albers, Josef, S-286/*176*.

Albertine, CEA/*472*①; EC1/*56*.

Albertolli, Giacomo, EA.

Albertolli, Giocondo, DADA.

Albertus, Gundorph, C-GUST/*104*①.

Albisola, EA.

Albrecht, Friedrich August, MP/*137*.

Albrechtsburg Manufactory, MP/*23*.

Albrechtsen, CEA/*316*①.

album, C-2458/*265*; C-5156/①; C-5236/*1333*.

album leaf, C-5156/*441*; C-5236/ *589*①; JIWA/*76*①.

album motif, C-2704/*61*.

album painting, C-2414/*96*①.

album quilt, SDF.

alburnum, SDF.

Alcaraz carpet, EA.

alcarazza, IDC.

alcarraza, IDPF/*3*①.

alchemist, DSSA.

alchemists' sign for tin, EA/ *Plymouth*.

Alchorne, Charles, C-2487/*102*.

alcohol, DATT; LP.

alcohol color, DATT.

alcohol thermometer, C-2368/*2*; C-2489/*40*.

alcora, ACD; DADA; C-2427/*32*; EA.

Alcora ware, IDC.

alcove, SDF/①.

alcove cupoard, DADA.

alder, ACD; SDF.

alder wood, DADA; MP/*36*.

Aldridge, C., C-2487/*83*.

Aldridge, Edward, C-5117/*72*①; C-5174/*552*; EA/*241*.

Aldridge & Green, LAR82/*586*①; S-4944/*285*①.

ale barrel, IDPF/*13*①.

Alechinsky, Pierre, S-286/*1*.

ale glass, DADA; EA/①; S-4972/ *411*.

Alekseiv, N. V., C-5174/*283*.

alembic, CEA/*600*; DATT; IDPF/*4*.

alençon point, DADA.

à l'épi, CEA/*183*①; EA/*Chantilly*.

ale warmer, EA.

Alexander, Julius, CEA/*484*.

Alexandria blue, DATT.

Alexandrian art, DATT.

Alexandrian blue, DATT.

alexandrite, EC1/*56*; RGS/*82*.

Alexeyev, Nicolay Vasilevich, C-5117/ *322*①.

Alexeyev, Nikolay, C-5117/*330*①.

aleyard, DADA.

Algardi, Alessandro, CEA/*623*①.

Alhambra vase, EA; IDC.

almanac, C-5174/*458.*
almanac ware, CEA/*129*①.
almandine (garnet), RTA/*43*①.
almandine, RTA/*140.*
almery, ACD; SDF/*aumbry.*
almirah, EA; SDF.
almond, DSSA; LAR82/*310*①.
almond boss, EG/*40*①.
almond design, EA/*boteh motif.*
almond thumbprint, OPGAC/*199.*
almond wood, DADA.
almoner's cupboard, DADA.
almorrata, EA.
almorratxa, DADA/①; EG/*87*①.
alms bowl, IDC.
alms dish, C-2382/*7;* C-2498/*30;*
 CEA/*584*①; DADA; EA/①;
 IDPF/*4;* LAR82/*251*①; LAR83/
 *222*①; S-4972/*330*①.
aloes wood, DADA.
Aloncle, F. J., CEA/*184*①.
alpaca, SDF.
Alpen, S-4847/*190*①.
alphabet sampler, C-1506/*136;*
 C-2704/*187.*
alpujarra, DADA.
Alpujarra rug, EA.
Alsace, DADA/①.
Altaic Turk type, S-4965/*211*①.
Altai rug, EA/*Pazyryk carpet.*
altar, S-3311/*484*①.
altar clock, C-5157/*32;* CEA/*225*①;
 EA.
altar coffer, C-5236/*561*①; S-4965/
 *66*①.
altar cruet, EA.
altar cup, DADA; IDC.
Altare, DADA; EA.
altar form, LAR82/*224*①.
altar frontal, C-5224/*240*①; S-2882/
 405.
altar garniture, C-2513/*484*①;
 S-4810/*308*①.

altar hanging, LAR83/*648*①.
Altarist style, EA/*Altare.*
altar lamp, IDPF/*142.*
altarpiece, DATT; MP/*77.*
altarstick, C-0249/*292;* C-0279/*208.*
altar table, C-5127/*330*①; C-5156/
 *464*①; C-5236/*559*①; LAR82/
 *401*①.
altar vase, EA; IDPF/*4*①.
altar ware, IDC.
alt-azimuth circle, CEA/*603*①.
Altbrandensteinmuster, IDC; MP/
 472.
Altena, Arjen Pieters, C-5174/*494*①.
Altenberg, C-2427/*197*①.
alteration, C-5117/*288.*
altered, C-0405/*7.*
alter interior, S-4955/*96*①.
alternating, C-5117/*144*①.
alternating boteh, S-2882/*102.*
alternating cartouche, C-5323/*118*①.
alternating flowering boteh, S-2882/
 *139*①.
alternating panels, S-4992/*6*①.
alternative limb, C-0403/*161*①.
Alti Bolagh, OC/*176*①, *185*①.
altimeter, C-2904/*245.*
altissimo marble, DADA.
Alt-Neubrandenstein pattern, MP/
 122.
alto lute, EA/*lute family.*
Alton, J. Snelling, C-2489/*101.*
Altoon, John, S-286/*2.*
alto-rilievo, DADA; DATT.
Altozier, MP/*122.*
Altozierrand, IDC.
alumina hydrate, DATT; LP.
Aluminia, C-2409/*143;* C-2910/*123.*
aluminium, C-0403/*61.*
aluminum, C-5239/*286;* DATT.
aluminum casing, C-2904/*191.*
aluminum leaf, DATT.

aluminum paint, DATT.

aluminum powder, DATT.

Alundum, DATT.

alva bottle, d', IDC.

Always, I., NYTBA/*39*.

Always, James, SDF/*767*.

amalgam, IDC.

amandier wood, DADA.

amaranth, C-0279/*425*①; C-2364/ *46*①; C-5224/*61*①; DATT; LAR82/*284*①; SDF.

amaranth border, C-2437/*47*.

amaranth wood, DADA.

amarillo, SDF.

A-marked porcelain, IDC.

amasette, DATT.

amateur, LP.

Amati, CEA/*551*①.

Amati family, EA.

amatori, IDC/①.

amatory, C-2427/*40*.

amatory jewellery, EA/①.

amatory motif, EA/① *amatory jewellery*.

amatory trophies, IDC.

amatory trophy, C-2364/*23*; C-2486/ *63*.

amatory trophy motif, C-2493/*234*①.

Amatus, C-0906/*255*.

Amazon, OPGAC/*199*①.

Ambassadorial, S-4922/*29A*①.

ambassadorial plate, EA.

amber, C-2458/*18*; C-5005/*243*①; C-5127/*579*①; C-5156/*722*①; C-5191/*263*; C-5236/*716*①; DATT; EA; LP; S-4461/*452*; S-4810/*63*①.

amber-flash, LAR83/*412*①.

amber-flashed base, CEA/*496*①.

Amberg, DADA.

amber gilding, EA/*gilding*.

amber glass, EG/*27*①; LAR83/ *439*①.

ambergris, C-5191/*401*.

amberina, ACD; C-0225/*210*; DADA; EC1/*55*①, *56*; LAR83/ *415*①; OPGAC/*158*; NYTBA/ *302*①.

amber tinted, S-4461/*27*.

ambiance, LP.

ambiguity, LP.

ambiguous space, LP.

amboina wood, DADA.

amboise, DADA.

amboyna, ACD; C-1407/*62*; C-1702/ *141, 175*; C-2478/*15*; C-5005/ *342*①; C-5157/*135*①; C-5239/*279*; CEA/*303, 405*; LAR82/*65*①, *227*①, *292*①; LAR83/*261*①; S-4436/*163*①; S-4804/*855*; SDF.

amboyna cabinet, C-5005/*341*①.

amboyna wood, DADA; S-4972/ *523*①.

amboynawood, LAR83/*371*①.

Ambrose, W. J., London, C-2489/ *240*①.

ambry, DADA; EA/*aumbry*; SDF/ *aumbry*.

ambulante, EA/①.

ambuscade bed, SDF.

Amelung, John Frederick, CEA/*459*; EA; NYTBA/*290*.

Amende, Johann, C-5117/*195*①.

amen glass, DADA/①; CEA/*432*①; EA/①; EG/*142*.

American Arcot Mission Industrial Institute Catpadi, C-1407/*110*.

American Art Ceramic Company, Corona, New York, EC1/*85*.

American art glass, K-711/*124*.

American Art Nouveau, CEA/*404*①; DADA/*Supplement*; LAR83/*286*①; RTA/*139*.

American Baroque, S-4804/*941*.

American baroque style, LAR83/ *351*①.

American black walnut, SDF.

American boxwood, SDF.
American Burmese, EC1/*62*①.
American ceramics, EA.
American cherry, SDF.
American chippendale, S-2882/*273*①; NYTBA/*18*; S-2882/*265*.
American clock, EA.
American cloth, SDF.
American college ring, RTA/*170*①.
American Colonial, DADA/①.
American Colonial style, EA/ *American furniture*, ①.
American Craftsmen's Council, DADA/*Supplement*.
American Directoire, DADA.
American Directoire style, EA/ *American furniture*.
American dwarf oak chest, C-0982/ *41*.
American eagle, CEA/*207*①.
American eagle flask, EA/①.
American eagle pattern, DADA.
American Eastlake, S-4804/*929*①.
American/Edgerton Art Clay Works, Edgerton, Wisconsin, EC1/*85*.
American Empire, DADA; NYTBA/ *72*.
American Empire style, EA/*American furniture*; SDF.
American federal, S-2882/*256, 263*; DADA/①.
American Federal style, EA/*American furniture*, ①; SDF.
American Flint Glass Manufactory, Manheim, Pennsylvania, NYTBA/ *289*.
American Flint Glass Works, CEA/ *459*.
American Flyer, CEA/*696*①.
American furniture, CEA/*389*; EA.
American glass, CEA/*459*; DADA/ ①; EA/①.
American Gothic, S-2882/*665*①.
American jewellery, CEA/*520*.

American lime, SDF.
American organ, DADA/*Supplement*.
American pewter, CEA/*590*.
American Pilgrim decoration, NYTBA/*29*.
American plane, SDF.
American porcelain, CEA/*205*; IDC.
American Porcelain Manufacturing Company, EA.
American pottery, CEA/*165*; IDC.
American Pottery Company, DADA; EA.
American Pottery Company, Jersey City, NYTBA/*154*.
American red gum, SDF.
American red oak, SDF.
American Renaissance, S-2882/*666, 669*①; S-4804/*923*①.
American Renaissance revival, LAR83/*246*①.
American revival, CEA/*489*.
American Rococo, S-2882/*676*①.
American rococo revival, LAR83/ *343*①.
American Saruq, OC/*280*.
American silver, DADA; EA.
American snuff-box, EA.
American Sweetheart, OPGAC/*190*.
American tapestries, DADA, *supplement*.
American turned, S-3311/*200*.
American vermilion, DATT.
American views, IDC.
American Waltham Watch Co., C-5117/*398*①.
American white oak, SDF.
American whitewood, SDF.
Americo-Bohemian, CEA/*470*①.
Ames Manufacturing Company, CEA/*37*.
amethyst, C-2202/*129*; C-5005/*205*①, *237*; C-5146/*90A*①; EG/*80*①;

JIWA/*304*①; S-4414/*8*①; S-4461/
94.

amethystine, S-4461/*12, 490.*

amethystine quartz, DADA.

amethyst quarts, S-4810/*162*①.

amethyst quartz, C-2458/*348;*
C-5127/*43;* C-5156/*432;* RTA/*145.*

Amherst sandstone, DATT.

amice, DADA.

Amici, G. B., CEA/*611*①.

Amida, C-2414/*24*①.

Amlash, S-4461/*450.*

ammeters, C-0403/*199.*

ammonia, DATT.

ammonite scroll, IDC/①.

Amol ware, IDC.

Amore design, NYTBA/*307.*

amorials, S-4414/*263.*

amorini, C-0249/*219;* DADA; EA;
S-3311/*108;* SDF.

amorini mask, C-2510/*90*①.

amorino, C-2398/*18*①; DATT; IDC.

amorous decoration, S-4905/*19*①.

amorous plate, S-4905/*21*①.

amorphous, DATT; LP.

Amour, L', IDC/①.

amphibolite, C-5174/*227.*

Amphitrite Group, MP/*449.*

amphora, ACD; C-5146/*145;*
C-5236/*412, 1571*①; CEA/*415;*
DADA; DATT; EA/①; EG/*40;*
IDC/①; IDPF/*5*①; LAR83/
*443*①; MP/*502;* OPGAC/*344, 16.*

amphora-like vase, MP/*490*①.

amphora pottery, S-3311/*863.*

amphora pottery vase, S-2882/*1283*①.

amphora shape, C-5146/*93*①.

amphora-shaped, C-5005/*227.*

amphorisk, S-4807/*526;* S-4973/*1*①.

ampico action, LAR83/*521*①.

ampmeter, C-2904/*257.*

ampulla, DADA/①; EA; IDC;
IDPF/*5.*

amputation saw, S-4927/*224G*①.

amritsar, DADA; OC/*138*①, *305.*

amstel, DADA; C-1582/*78;* EA/①;
LAR83/*105*①.

amulet, C-2482/*79;* C-5156/*173, 364;*
C-5174/*17;* C-5234/*215.*

amuletic ring, C-5174/*19, 182.*

amul ware, DADA.

amusement machine, LAR82/*34*①.

amyl acetate, DATT.

amyl alcohol, DATT.

A.N.A., DATT.

anabori, CEA/*562, 575.*

anaglyph, DATT.

analogous, LP.

analogous color, LP.

analogy, JIWA/*6.*

analyser, C-0403/*120;* C-2904/*96*①,
*110*①.

Analytical Cubism, LP.

anamorphosis, DATT.

anan, SDF.

Ananaspokal, DADA.

anastatic printing, DATT.

anathema cup, DADA.

Anatolia, OC/*232*①, *238*①.

Anatolian, C-0279/*1;* C-2478/*227;*
C-5189/*400;* C-5323/*72*①; DADA;
S-4847/*30*①, *94*①.

Anatolian animal carpet, EA.

Anatolian carpet, EA.

Anatolian drinking rhyton, IDPF/
*24*①.

Anatolian rug, ACD; C 2482/*34.*

Anatolian Turkoman, OC/*174*①.

Anatolian yastik, LAR82/*548*①;
S-288/*40*①.

anatomical figure, C-5224/*272*①.

Ancely Pere & Fils, S-4947/*109*①.

ancestor pictogram, C-5156/*387.*

ancestor portrait, C-0279/*154;*
C-2323/*171;* C-2458/*267;* C-2513/
35; C-5236/*1806*①.

anchor, C-5157/*34*①; CEA/*267*; DSSA.

anchor and dagger in red, EA/*Bow Porcelain Manufactory.*

anchor escapement, C-5116/*48*; CEA/*231*①; LAR82/*232*①; S-3311/*109*; S-4414/*385*①; S-4812/*16*; S-4988/*412*①.

anchor-shaped, C-5156/*223A.*

ancien, DATT.

ancient, DATT.

Ancient Moon Terrace porcelain, EA/*Ku Yüeh Hsüan style.*

ancona, DATT.

ancone, SDF.

Andaman marblewood, SDF.

Andaman padauk, SDF.

Andaman padouk, SDF/*Andaman padauk.*

andaman redwood, DADA.

Anderson, Elbert, Junior, SDF/*767.*

Anderson, Elbert & Son, SDF/*767.*

Anderson, J., C-2476/*43.*

Anderson, W., C-5117/*447.*

Anderson, William C., DADA/*Supplement.*

andiers, DADA.

andiron, ACD; C-5153/*70*; C-5189/*182*①; C-5239/*262*; CHGH/*59*; DADA/①; NYTBA/*250*①; S-3311/*205*①; S-4461/*11*; S-4507/*12*①; S-4905/*326*; SDF/①.

André, Emile, C-5167/*186*; DADA/*Supplement.*

Andreoli, Giorgio, CEA/*135*①.

Andreoli, Maestro Giorgio, EA.

Andrews, William, CEA/*644*①.

Andries (Andriesz), Guido, EA.

Andries, Jasper, EA/*Andries, Guido.*

Andries Vis, C-5117/*14.*

androecium, S-4810/*379*①.

Andromeda, DSSA.

androsphinx, DATT.

anecdotal painting, LP.

anelace, DADA.

anemometer, C-2904/*192.*

anemone, DSSA.

anephoros, IDC.

aneroid, C-0403/*117*; C-2904/*87, 109, 191*; CEA/*217.*

aneroid barometer, C-0403/*100*; C-0906/*77*; C-2489/*42*; C-2904/*147*; C-MARS/*200*; CEA/*260, 268.*

Angarano, EA.

angel, DSSA.

angel bed, DADA; SDF.

Angell, George, C-5117/*271*①; CEA/*662*①; S-3311/*712.*

Angell, George II, S-4922/*85*①.

Angell, John, EA/*365*①; LAR82/*629*①.

Angell, John Joseph, C-5174/*506.*

Angell, Joseph, C-5117/*211.*

Angell, Joseph & John, C-0270/*139*①.

Angers Tapestry, EA.

Angerstein service, IDC/①.

Angkor Thom style, C-5236/*352*①.

Anglaise case, C-2368/*38*①; C-5117/*392*①.

angle, C-0249/*467*; C-2388/*89.*

angle block, SDF.

angle bracket, C-2388/*57.*

angle chair, EA/*corner chair*; SDF.

angle clasp, C-2437/*4*①.

angled corner, LAR82/*336*①.

angled handle, C-2409/*107*; S-4905/*166.*

angled shoulder, C-5156/*71.*

angled sloping shoulder, C-5156/*4*①.

angle of vision, JIWA/*10, 220*①.

Angles, J., OPGAC/*15.*

Anglesey on the right, C-2704/*27*①.

Angleterre, DADA.

Anglo-American pottery, IDC.

Anglo-American Sheraton, FFDAB/ *25.*

Anglo-Chinese, C-5156/*462.*

Anglo-Indian, C-1407/*110*; C-2421/ *133*①; C-2478/*16*; S-4988/*545*①.

Anglo-Indian style, C-5170/*13.*

Angouleme, C-1006/*214.*

Angoulême, EA.

ANGOULEME, EA/*Angoulême.*

Angoulême sprig, CEA/*185*①; EA/ *barbeau sprig*; IDC/①.

'angoulème sprig' pattern, S-4823/*89.*

Angouleme sprig pattern, LAR82/ *162*①.

Angoumois, DADA.

Angst, LP.

angular, C-0254/*130*; C-2403/*164*; C-5005/*245*; C-5117/*7.*

angular baluster form, C-5146/*56*①.

angular cabriole leg, S-2882/*329, 374, 766*①.

angular capital, SDF/①.

angular handle, C-2204/*58*; C-5117/ *151*①; MP/*486*①; S-4992/*9*①.

angular hook, DADA.

angular knop, CEA/*423*①.

angular liner, DATT.

angular perspective, DATT; LP.

angular setting, RTA/*61*①.

angular strap handle, LAR83/*127*①.

an hua, ACD; EA; IDC/①.

anhua, C-2458/*166*①; C-5236/*506*; S-4965/*239*①.

anhydrous, DATT.

anhydrous alcohol, DATT.

aniline, DATT.

aniline colors, LP.

aniline purple, DATT.

anima, EA/*core, core.*

animal black, DATT.

animal carpet, EA.

animal clock, EA/①.

animal combat group, C-2403/*195.*

animal cup, DADA/①.

animal design, CEA/*666*①.

animal figure, IDC.

animal form, IDPF/*6.*

animal-form leg, NYTBA/*19*①.

animal furniture, SDF.

animal glue, LP.

animal-hair backing, S-3311/*29.*

animal-head dagger (ass-head) (deer-head) (elk-head), S-4965/ *123*①.

animal-head spout, IDPF/*40*①; RTA/*30*①.

animal-hoof foot, S-4414/*246.*

animalier, S-4804.

animalier bronze, C-5156/*760*①; S-4947/①.

Animaliers, les, EA/①.

animal-masked foot, C-5156/*95.*

animal-mask spout, C-2458/*78*①.

animal paw foot, S-2882/*239*①, *663, 667, 837, 1372, 1447*①, *776A*①; S-4414/*214*; S-4905/*411*①.

animal paw sabot, S-2882/*793.*

animal rug, DADA.

animals as motif, C-2414/*50*①.

animal sculpture, MP/*77.*

animal shape, EA/*Monkey Salt.*

animal spout with mask, MP/*486*①.

animal style, EA.

animal triple band border, S-4965/ *115*①.

animal weight, EA/*Baccarat.*

animate design, S-4965/*142*①.

animated lion, S-4948/*119.*

animated scene, CEA/*683*①.

animé, DATT.

anise wood, DADA.

ankh, DATT; S-4973/*109*①.

anklet, C-1082/*23*; C-2458/*1.*

Anlau pattern, C-5146/*90.*

Annaberg, LAR82/*130*①; S-4972/ *138*①.

Annagelb, EA/*Riedel, Joseph.*

Annagrün, CEA/*457*①; EA/*Riedel, Joseph.*

Annamese, C-0782/*111*; C-2323/*18*; C-2458/*40*; C-5156/*89*①.

Annamese taste, C-5236/*1601.*

Annamese ware, IDC.

annatto, DATT.

annealed, CEA/*59*①.

annealing, CEA/*502*; DADA; DATT; EA; EG/*286.*

annealing oven, CEA/*414*; EG/*89.*

Ann Gomm pattern, EA/*209.*

anniversary clock, SDF.

Anno Dommani, C-2704/*13.*

annona pattern, IDC.

annoted, C-5191/*365.*

annual ring, SDF/①.

annular clock, DADA.

annular dial, S-4802/*157.*

annular foot, C-2458/*168*①.

annulated, LAR82/*442*①.

annulated column, SDF.

annulated knop, CEA/*423*①.

annulated ring, EG/*141*①.

annulet, C-2414/*66*①; SDF.

annulus, S-4461/*541.*

Annunciation, C-2704/*35*; DSSA.

Annunciation glass, EG/*107*①.

anobium punctatum, SDF.

Anodio, M., Napoli, C-5181/*72.*

anodized aluminum, S-286/*308.*

anodizing, DATT; SDF.

ansate cross, DATT.

Ansbach, CEA/*138*①; DADA; EA/ ①; LAR82/*130*①; LAR83/*65*①; S-4853/*159*①.

Ansonia Clock Company, EA.

Ansonia Company, CEA/*249*①.

antefix, IDC; S-4807/*515*; S-4973/ *142*①.

Antes, Horst, S-286/*177.*

anthemia, C-5116/*82*; S-4507/*20*①.

anthemion, C-0249/*433*; C-2402/*37, 59*; C-2421/*18*①, *72*; C-5117/ *117*①; C-5189/*275*①; CEA/*541, 678*; DADA/①; DATT/①; IDC; LAR83/*99*①; S-2882/*674*①, *813*①, *813*①, *819*①; S-4414/*424*; S-4436/*113A*①; S-4802/*182*①; S-4922/*2*①; S-4955/*8*; S-4972/ *153*①; SDF.

anthemion and husk chasing, CEA/ *661*①.

anthemion-and-lotus border, C-5114/ *38*①.

anthemion and paw foot, C-5117/ *147*①.

anthemion back, SDF.

anthemion border, C-5114/*50.*

anthemion frieze, S-2882/*840*①.

anthemion handle join, C-5114/*31*①.

anthemion motif, C-2409/*209*; CEA/ *659*①.

anthemion (honeysuckle) motif, EA.

anthemion ornament, C-2398/*1*①.

anthemion plaque, C-2421/*51*①.

anthemion splat, C-5116/*165*①.

anthemium, ACD.

antheniennes, S-3311/*519*①.

anthropomorphic form, LP.

anthropomorphic name, IDPF/*6.*

anti-axial, JIWA/*207.*

Antico base, S-4843/*387*①.

antico rosso, C-0279/*453*①.

antic work, DATT.

Antikzierat, EA.

antimacassar, DADA/*Supplement*; SDF.

Antimone, LAR82/*67*①.

antimony, CEA/*586*①, *594*; EA; EG/*22.*

antimony orange, DATT.

antimony sulfide, DATT.

antimony vermilion, DATT.

antimony white, DATT.

antimony yellow, DATT.

Antiope, DSSA.

antiquarianism, DATT.

antique, ACD; DATT; SDF.

antique bevel, SDF/*Vauxhall bevel.*

antique element, S-3311/*487.*

antique finished, OC/*32.*

'antique finished', OC/*123*①.

antique furniture, DADA.

antique glass, EG/*54.*

antique laid paper, S-286/*497.*

antique lamp finial, C-2437/*20.*

Antique Lily pattern, C-0270/*178.*

antique method, EG/*245.*

antique needlework, S-4461/*628.*

antique profile portrait, MP/*172.*

antiques law, DADA/*Supplement.*

'Antique-struck', C-0706/*69.*

antique-struck 'Hallmarks', C-2202/*20.*

Antique tripod, C-2364/*23.*

antique washed, OC/*304.*

antler handle, C-2202/*67.*

antler-handled, C-1502/*107.*

antlers, C-2398/*91*①.

Antonibon, Giovanni Battista, EA.

Antonibon, Giovanni Battista II, EA/*Antonibon, Giovanni Battista.*

Antonibon, Pasquale, CEA/*172*①.

Antonibon period, LAR83/*121*①.

Antonio, Neri, EA/*Arte Vetraria.*

antoxidant, DATT.

Antwerp, C-2427/*145*①; EA.

Antwerp blue, DATT; LP.

Antwerp lace, DADA.

Antwerp red, DATT.

Antwerp school, DATT.

Antwerp style, EA.

antwerp tapestry, EA/①.

anvil, DATT; DSSA.

Anysley, C-1582/*159.*

aogai, C-5127/*442, 645*; C-5156/*709*①; C-5236/*780*; CEA/*573*①, *574*①, *575*; S-3312/*1064.*

aogai inlay, S-3312/*1052.*

aoi tsuba, DADA.

ao kutani, IDC.

Ao Oribe, EA.

AP, EA/*Aprey, Pennis, Johannes.*

apala, IDPF/*7*①.

ape, DSSA.

aperture, C-0982/*129A*; C-2437/*34*①; C-2458/*45, 190*; C-5005/*386*; C-5146/*148*①; S-4972/*430*①.

apex pediment, C-1407/*132.*

Aphrodite, DSSA.

Apocalypse, DSSA.

Apocalypse Tapestry, EA.

Apollo, DSSA; OPGAC/*200.*

apollo drug jar, LAR83/*123*①.

Apollo mask, C-2421/*8*①.

Apollon de Revoire, EA/*Revere, Paul the Elder.*

Apollo scene, C-5174/*459*①.

apostle, C-0706/*212.*

Apostle figure, MP/*78.*

Apostle finial spoon, C-0103/*57.*

apostle glass, EA.

Apostle jar, IDC.

apostle spoon, ACD; C-5117/*101*①; C-5173/①; CEA/*594*; DADA; EA/①; LAR82/*592*①; LAR83/*579*①; S-4802/*250*①; S-4972/*311*; C-1502/*65*; NYTBA/*219.*

Apostle tankard, IDC.

apothecaries box, C-0906/*199.*

apothecary, C-0403/*57*; C-2904/*292, 297.*

apothecary balance, C-1609/*91.*

apothecary jar, S-4461/*177.*

apothecary's box, C-2403/*13.*

apothecary weight, C-0403/*56.*

apotheosis, DSSA.

apparatus, C-2904/*24, 135.*

apparel, DADA.

appearance, LP.

Appel, Karel, S-286/4.

appertures, C-5127/15.

Appian, Adolphs, S-286/70.

apple, DSSA.

apple blossom twig, OPGAC/180.

apple corer, EA/①.

apple-green, IDC; S-4992/18①.

apple green, C-1506/75; DADA.

apple green (Chinese glaze) colour, EA/①.

apple green jade, C-5127/296.

apple jar, S-4965/178①.

Apple Jelly, CEA/56①.

apple teapot, IDC.

Appleton, Nathanial, C-5117/52.

apple wood, DADA; DATT.

applewood, ACD; C-5116/9; SDF.

application lace, DADA.

application of color, MP/196.

applied, C-0225/217; C-0706/68; C-0982/44; C-5005/235①; C-5116/171①; C-5117/283①; C-5236/842①; IDC; S-4992/32①.

applied and chased, S-4804/19.

applied and chased gadroon rim, S-2882/1176①.

applied art, DATT; JIWA/6.

applied bezel, RTA/82①.

applied Celtic-style, C-0706/69.

applied coiled stringing, S-2882/1332.

applied cresting, SDF.

applied crimped handle, C-5114/141①.

applied decoration, DADA.

applied disc, C-5117/164.

applied facet, SDF.

applied foliage, MP/33.

applied glass vase, C-5005/300①.

applied handle, C-5005/269①; C-5114/33①.

applied leaf decoration, S-4804/12①.

applied mask and ring handle, C-5156/10①.

applied medallion, C-0406/41.

applied midband, C-5114/117①.

applied moulding, CEA/405; SDF.

applied openwork, C-5117/16①.

applied ornament appliqué, EA.

applied pattern, C-1506/174.

applied scroll foot, C-1502/4.

applied scroll handle, LAR83/432①.

applied scrolling, C-5127/43.

applied scrollwork, S-2882/939①, 967.

applied sequin, C-2704/43.

applied shell and scrollwork rim, S-2882/1085①.

applied silver, S-4414/234①.

applied stepped moulding, C-1502/6.

applied turning, SDF.

applied wart, CEA/451.

applied work, DADA/appliqué.

appliqué, C-2437/55①.

applique, C-3011/19.

appliqué, C-5156/302①; C-5239/71①, 106; CEA/287, 292①; DADA; DATT; NYTBA/108①; S-4461/66; S-4507/1①; SDF.

appliqué embroidery, JIWA/288①.

appliqué-work, C-2704/176.

appraisal, CHGH/28.

appuie-main, DATT.

aprey, EA/Aprey; DADA; EA/Aprey.

apricot, S-288/15①.

apricot-ground, S-4905/141①.

apricot gum, DATT.

apricot wood, DADA.

apron, ACD; C-0982/83, 86, 194; C-1407/79A; C-1506/66; C-2402/252; C-5114/378①, 318C; C-5116/171①; C-5127/82; C-5156/465①; CEA/277①, 355①, 405; DADA/①; FFDAB/26; LAR82/276①;

S-4436/*171*①; S-4812/*22*; S-4988/
*403*①; S-4992/*4*①; SDF/①.

apron drawer, S-4812/*72*①.

apron or skirting board, EA.

apsara, S-4965/*89*①.

apse, LAR82/*274*①.

apsidal sideboard, LAR83/*349*①.

apt, DADA; EA.

Apulian, LAR82/*124*①; S-4807/
*499*①.

Apulian ware, DADA; IDC.

aqua, C-5117/*342*①; S-4847/*50*.

aqua fortis, DATT.

aquafortis, EA.

aquamanale, DADA.

aquamanile, EA/①; IDC; IDPF/*7*①.

aquamarine, C-5005/*213*①, *282*①;
C-5117/*357*①; RTA/*124*①; S-291/
*68*①; S-4927/*321*.

aquarelle, DADA; DATT; LP.

Aquarius, DSSA.

a quartieri, EA.

Aquatec, DATT.

aquatic microscope, C-1609/*43*.

aquatint, C-0249/*10*; CHGH/*63*;
DADA; DATT; JIWA/*102*;
NYTBA/*203*; S-286/*20, 27, 400*①,
*408*①, *423*①, *396A*①.

aquatint and drypoint, S-286/*371*①,
*406*①, *424*①, *453*①.

aquatint over heliogravure, S-286/*466*.

à quatre faces, C-2364/*46*①; C-2437/
*62*①, *74*①; C-2555/*45*.

aqueduct, CEA/*527*.

aqueous paint, DATT.

aquila, SDF.

aquilegia cup, RGS/*182*.

A.R., CEA/*173*①.

AR, CEA/*642*①; EA/*Aprey, Arras,
van Rijsselberg, Ary*.

arabesque, ACD; C-0249/*205*;
C-0254/*60A*; C-0982/*189*; C-1407/
59; C-1502/*9*; C-2202/*52*; C-2388/

185; C-2458/*195*①; C-5117/*329*①;
CEA/*209, 625*①; DADA/①;
DATT/①; IDC; JIWA/*52*;
LAR82/*387*①; LP/①; S-3311/*4*;
SDF.

arabesque and flower medallion,
S-4948/*77*.

arabesque (Shah Abbas) carpet, EA.

arabesque cartouche, S-4948/*124*①.

arabesque decoration, C-0279/*430*①.

arabesque design, CEA/*621*①.

arabesque-form, S-3311/*21*.

arabesque-formed, S-4948/*132*①.

arabesque-formed prayer arch,
S-4948/*88*①.

arabesque-like stylization, JIWA/*87*.

arabesque mounted frieze, C-0279/
*431*①.

arabesque ornament, RGS/*17*①.

arabesque pattern, C-0270/*71*①;
CEA/*429*①; EA.

arabesque prayer arch, S-4847/*14*.

arabesque scrolling, C-2421/*56*.

arabesque-shaped handle, C-5117/
*327*①.

arabesque spandrel, S-4414/*546*①.

arabesque tendril, S-4796/*9*.

arabesque vine, S-288/*29*①.

arabesque work, C-0254/*97*.

Arabian, C-5191/*461*.

Arabian chapters, C-5005/*218*①.

arabic, gum, DATT.

Arabic figure, CEA/*258*①.

Arabic hour figure, CEA/*227*①.

Arabic numeral, C-0270/*119*.

Arab seated musician, C-0225/*58*.

Arachne, DSSA.

Arad, OC/*264*.

**A. Radford Pottery, Clarksburg, West
Virginia,** EC1/*85*.

**A. Radford Pottery, Tiffin and
Zanesville, Ohio,** EC1/*85*.

Arak (Mahal) carpet, EA.

Arak rug, DADA.

Aranji, OC/*176*①.

arariba, DATT.

Arazzeria Medici, EA.

arbalest, DADA.

arbor, ACD; C-2502/*111*; CEA/ *221*①, *267*; EA.

arbor group, IDPF/*8*; S-4853/*176*①.

arbour, C-1506/*103*①; C-1603/*44*.

arbour group, EA; IDC/①.

arbre d'amour, IDC.

arbrush, S-2882/*45*; S-3311/*8*.

arbrush border, S-2882/*78*①.

arbrush field, S-2882/*74*, *110*①, *142*, *202*.

arbrush latch hooked mirab, S-2882/ *64*.

arc, CEA/*607*①; S-4461/*81*.

arca, DADA.

arcade, C-5116/*85*①; CEA/*541*.

arcaded, C-0249/*365*; C-0982/*84A*; C-2402/*15*; C-2403/*137*; C-2478/ *191*; DADA; LAR82/*291*①; LAR83/*316*①; S-4436/*186*①; S-4812/*54*①; S-4988/*522*①.

arcaded apron, C-0249/*410*①.

arcaded architectural niche, C-0249/ *434*.

arcaded back, C-2522/*22*①.

arcaded base, C-2403/*133*.

arcaded blind fretwork, C-5116/*69*.

arcaded centre, C-0982/*33*.

arcaded chapter ring, S-4802/*135*①.

arcaded cornice, C-5116/*149*①.

arcaded decoration, IDC.

arcaded frieze, LAR83/*247*①.

arcaded gothic-pattern, C-2403/*49*.

arcaded minute ring, EA.

arcaded mullions, C-5116/*131*①.

arcaded panel, C-0279/*334*①; C-1407/*11*; LAR83/*404*①.

arcaded pattern, C-2493/*6*.

arcaded support, RTA/*48*①.

arcading, EA; SDF.

arc and arbelette outline, C-5224/ *116*①.

arcanist, ACD; DADA; EA; IDC; MP/*502*.

arcanum, CEA/*209*; MP/*502*.

arc-back, SDF/①.

arc-en-arbalette outline, C-2364/*72*.

Arc-En-Ciel Pottery, Zanesville, Ohio, EC1/*85*.

arch, C-0279/*29*; C-5114/*294*①; C-5146/*107C*; S-4972/*430*①.

archaeological, CEA/*517*①.

archaeological jewellery, EA/*Brogden, John*.

archaic, DATT; LP; C-2409/*120*.

archaicism, LP.

archaic jade, C-5156.

Archaic period, DATT.

archaic smile, C-5127/*3*①.

archaic style, S-4461/*154*.

archaistic, C-0782/*69*; C-2458/*69*; C-5156/*173*; DATT; S-4810/*365*①.

archaistic motif, C-5156/*377*.

archaistic vessel, S-3312/*1211*.

Archambo, Peter, C-5173/*36*①.

Archambo, Peter the Elder, EA/①.

Archambo, Peter the Younger, EA/① *Archambo, Peter the Elder.*

arch-back Windsor, EA.

archbishop's cross, DATT.

arch-cittern, CEA/*552*①.

archebanc, DADA/①.

arched, C-0982/*82B*; C-2388/*13*; C-2458/*242*; C-5116/*42*①, *147*①.

arched apron, S-4414/*446*①, *476*, *510*①; S-4812/*125*①.

arched apron drawer, S-4414/*437*①.

arched astragal door, LAR83/*255*①.

arched back, C-2403/*33*①; C-2421/ *17*①.

arched backrest, S-4955/*98*.

arched bevelled plate, S-4414/*383*①.

arched bonnet, S-2882/*814*①;
 S-3311/*488*①.

arched cartouche, S-4922/*12*①.

arched centre, C-2421/*122*①.

arched crest, C-0249/*470*.

arched dial, S-3311/*109*; S-4414/
 *385*①; S-4988/*412*①.

arched frame, C-2704/*181*.

arched glazed, C-2402/*23*.

arched grape, OPGAC/*200*.

arched handle, C-2414/*8*①.

arched hood, C-2357/*26*①; C-2368/
 *6*①; C-5114/*266*①, *318F*①;
 C-5157/*44*.

arched molded cornice, S-4414/*428*①.

arched pediment, C-0279/*428*;
 C-1407/*106*; C-5116/*47*.

arched pigeonhole, C-5153/*109*①.

arched recessed apron drawer,
 S-4414/*462*①.

arched rectangular plate, C-0982/*82*.

arched rib, EG/*119*①.

arched sabre leg, LAR83/*365*①.

arched shoulder, JIWA/*343*①.

arched skirt, C-5114/*266*①.

arched splayed leg, C-2357/*33*①.

arched stone, C-5156/*298*①.

arched stretcher, C-2370/*84*①;
 LAR83/*391*①; SDF/①.

arched top, S-4461/*565*.

arched top mirror, LAR83/*370*①.

arched toprail, C-2357/*10*①; LAR83/
 *268*①.

arched wire, C-0249/*461*.

arched X-stretcher, C-5005/*321*①.

Archer, Andrew, C-2487/*131*;
 C-5117/*94*.

Archers Badger badge, C-0103/*68*.

archer's ring, C-5127/*297*; C-5156/
 319.

Arches laid, S-286/*455*.

Arches paper, S-286/*5*.

Arches wove, S-286/*454*.

arch-headed, C-5116/*34*.

archiac, C-2414/*4*①.

archiepiscopal cross, DATT.

archil, DATT.

arching lappet, S-2882/*1271, 1350*①.

arching open shelf, S-2882/*1444*①.

architectonic, DATT; LP.

architect's desk, S-4972/*647*①.

architect's drawer, C-2388/*70*①.

architects' rendering brush, DATT/①.

architects' scale, DATT.

architect's table, C-5157/*145*①;
 DADA; EA; LAR83/*400*①;
 S-3311/*142*①; SDF/①.

architectural, CEA/*230*①, *529*;
 S-4922/*71*①.

architectural arrangement, MP/*39*.

architectural background, RGS/
 *133*①.

architectural border, S-2882/*232*①.

architectural cartouche, C-5173/*40*①.

architectural case, C-0906/*132*; EA/
 ①; S-4461/*72*.

architectural cornice, S-2882/*408*.

architectural crestrail, S-2882/*674*①.

architectural design, LAR82/*70*①;
 NYTBA/*19*①.

architectural element, IDC/①.

architectural-form, S-2882/*821*①.

architectural form, C-2421/*36*①;
 S-4414/*174*.

architectural fragment, S-4965/*89*①.

architectural frame, C-2546/*115*;
 SDF.

architectural furniture, SDF/①.

architectural ground, C-0279/*270*①.

architectural interior, C-0249/*456*①.

architectural landscape, S-4955/*183*.

architectural mantle, S-2882/*1198*①.

architectural marquetry, S-4955/*203*.

architectural motif, RGS/*92*①;
 S-2882/*980*①; S-4905/*462*①.

architectural niche, C-0279/*231*; C-2522/*138*①.

architectural porcelain, MP/*77*.

architectural pottery, IDC.

architectural roundel, C-5156/*188*①.

architectural scene, S-4905/*175*①.

architectural sculpture, DATT.

architectural support, C-2427/*249*.

architectural tile, NYTBA/*129*.

architectural tracery, C-0279/*73*.

architectural wall clock, S-4461/*487*.

architrave, CEA/*300, 405*; DADA; MP/*110*; SDF/①.

archlute, CEA/*552*①; EA/*lute family*.

arch mount, S-4461/*19*①.

arch pediment, C-5116/*45*①.

arch-shaped border, C-5114/*195*①.

arch top, LAR82/*323*①.

archway, C-5114/*148*①; MP/*77*.

'archway' design, OC/*126*.

arc of ovals, C-5005/*246*①.

arctic fox, C-0604/*136*.

arc welding, DATT.

Ardebil, CEA/*75*; OC/*64*①, *227*①. ·

Ardebil carpet, EA/①; OC/*43*①, *295*.

Ardebil design, C-2388/*185*.

ardebil rug, DADA.

Ardebil shrine, EA.

Ardebil weave, OC/*226*①.

Ardus faience factory, EA.

area, LP.

'Aredebil' carpet, OC/*31*.

arenato, DATT.

Arequipa Pottery, Fairfax, California, EC1/*85*.

Ares, DSSA.

Arfe family: Enrique, Juan, Antonio, EA.

Argand lamp, DADA; EA; S-4461/*499*.

argenta, C-0225/*61*; C-2910/*96*.

argentan, EA/*argentine*; C-1506/*176*.

Argentan point, DADA.

argentella, DADA.

argentine, EA.

argil, ACD; IDC.

argilla, DATT.

Argus, OPGAC/*200*①.

argus pattern, NYTBA/*298*①.

argyle, ACD; C-0103/*114*; C-0254/*33*; C-5117/*56*①; CEA/*656*①; DADA; EA/①; LAR82/*554*①; LAR83/*590*①; S-2882/*903*①, *904*①; S-4802/*289, 371*①.

argyll, C-2487/*135*; IDC/①.

Argy-Rousseau, G., C-5005/*243*①.

Argy-Rousseau, Gabriel, C-5167/*124*; CEA/*488*①.

Argy-Rousseau, Garbriel, C-GUST/*49*.

arhat, IDC.

ariel, DADA/*Supplement*.

Aries, DSSA.

Arikawa, DADA/*Supplement*.

arita, C-5127/*379*; ACD; C-0782/*5, 118*; C-5156/*799*; DADA/*Supplement*; EA/①; LAR82/*138*①; S-3312/*1113*①.

Arita blue, C-0803/*22, 22*.

Arita blue and white vase, C-5127/*378*①.

Arita dish, S-3312/*1114*①.

Arita pattern, NYTBA/*170*.

Arita porcelain, IDC/①.

arita ware, DADA.

A.R. jug, IDC.

ark, ACD; CEA/*322*①; EA; LAR82/*421*①; SDF.

Arkhangelskoë, EA/*Iusupov*.

Ark of the Law, C-5174/*128*①.

arkwright, SDF.

Arlaud, Jacques-Antoine, EA.

Arlaud, Louis-Aimé, EA.

arm, C-5005/*224*①, *356*①; C-5157/
*158*①; CHGH/*25*; S-4461/*73*;
S-4905/*135*①.

armada chest, ACD; SDF.

'Armada' chest, LAR83/*469*①.

Armada chest, EA/①.

Armada dish, C-2202/*20*.

Armada pattern, LAR82/*598*①;
LAR83/*576*①.

armadio, DADA; EA.

Armand & Cie, S-4927/*111*.

armario, DADA.

armature, DATT/①.

armband, C-1506/*17*.

arm-chair, CEA/*307*①.

armchair, C-0982/*5, 36, 94*; C-1407/
5; C-2402/*7*; C-5116/*66*; C-5153/
*96*①; C-5156/*465*①; C-5239/*244*;
S-3311/*105*①; S-4436/*86*①;
S-4804/*832*①; SDF; C-2357/*9*①.

Armenian blue, DATT.

Armenian bole, DATT; EA/
sealing-wax red; IDC.

Armenian dragon rug, EA.

Armenian red, IDC.

Armenian stone, DATT.

'Armenibaff', OC/*283*.

armet, DADA.

Armfelt, Hjalmar (workmaster),
C-5174/*309*①.

armillaire cup, IDC.

armillary sphere, C-5174/*429*①;
DADA/①; EA; RTA/*110*①.

armlet, C-2458/*1*.

armoire, ACD; C-0279/*340*①;
C-5189/*355A*①; CEA/*405*;
DADA; EA/①; LAR82/*424*①;
LAR83/*315*①, *406*①; NYTBA/
37; S-2882/*768*①; S-3311/*405*①;
S-4461/*738*①; S-4804/*888*①;
S-4972/*617*; S-4992/*116*; SDF.

armoire à deux corps, DADA.

armoire d'encoignure, DADA.

armoire door, C-0982/*223*.

AR monogram mark, EA/*Augustus
Rex mark*.

armor, CHGH/*25*.

armorial, C-0782/*42*; C-1006/*171*;
C-1502/*92*; C-2202/*250*; C-5127/
*232*①; C-5236/*1767*; CEA/*643*①;
S-2882/*372*①, *921*①, *1042,
1099*①, *1102, 1107, 1112*①;
S-3311/*481*①; S-4414/*346*①;
S-4461/*512*; S-4804/*116*①;
S-4922/*1*①, *11*①, *14*①, *9B*①;
S-4972/*114*①; C-2427/*34*①, *210*.

armorial china, ACD.

armorial crest, C-0982/*208*.

armorial dish, C-2486/*101*①; S-4843/
*1*①.

armorial escutcheon, EC2/*24*①.

armorial goblet, LAR82/*443*①.

armorial plate, C-0249/*267*; C-2458/
*109*①, *151*①; EC2/*20*①.

armorial porcelain, EA.

armorial style, SDF.

armorial tapestry, DADA.

armorial ware, DADA; IDC/①.

'Armori' rug, OC/*163*.

armory, SDF.

armory show, LP.

armour, ACD; C-MARS/*71*①;
DSSA; LAR82/*38*①.

armour bright, CEA/*541*.

armourer, CEA/*537*.

arm-pad, C-1407/*39*.

arm pad, SDF.

armpad, C-0982/*15, 84*; C-2402/*70*;
DADA.

arm palette, DATT/①.

arm rail, SDF/①.

armrail, C-5114/*397*①.

armrest, C-0982/*61, 96A*; C-5005/
*350*①; C-5239/*268*; S-4461/*675*.

Arms, John Taylor, S-286/*13*.

Armstrong, Robert, C-5117/*245*①.

Armstrong, Robert Williams, LAR82/
*90*①.

arm stump, SDF.
arm-support, C-2388/*10*; C-2403/*26*.
arm support, C-5114/*325*①, *354*①.
arm-thick coil, IDPF/*220*①.
Army & Navy, C-2476/*23*.
army revolver, S-4972/*233*.
Arnaudon's green, DATT.
Arnd, Samuel, C-5117/*361*①.
Arnheim, DADA.
Arnhem, DADA/*Arnheim*.
Arnhold, Johann Samuel, MP/*184*.
Arnold, John, EA.
Arnold & Dent, C-2489/*82*①.
Arnold & Son, EA/*Arnold, John*.
Arnold type, CEA/*255*①.
Arnold-type crossbar, C-2368/*87*.
Arnoux, Leon, CEA/*163*①, *204*①.
à rognon, C-5259/*491*.
arquebus, ACD; C-5156/*777*; DADA.
arqueta, DADA.
arrangement, JIWA/*10*.
arras, ACD; C-5259/*122*①; DADA; SDF; C-2486/①; EA; S-4823/*85*.
Arras lace, DADA.
Arras tapestry, DADA; EA.
arretine ware, DADA/①; DATT; IDC.
arribida red, DATT.
arriccio, DATT.
arris, DATT; EA.
arris edge, SDF.
Arrizabalaga, P., C-2476/*92*.
arrosoir, IDC.
arrow, DSSA.
arrow-back, S-4461/*596*.
arrow back, DADA; LAR82/*304*①; SDF.
arrow-back Windsor, EA.
arrow-form hand, S-4927/*215*①.
arrowhead device, C-0279/*19*①.
arrowhead motif, C-2403/*206*.
arrow-shaped dish, C-2513/*348*.

arrow-shaped stretcher, CEA/*393*①.
Arrowsmith, A. London, S-4881/*36*①.
arrow spindle (in furniture), EA.
arrow stand, C-5156/*781*.
arrow-styled, S-4927/*471*.
"arrow" vase, C-5236/*1588*.
arrow vase, IDC/①.
Arsall, C-5239/*164*.
arsedine, SDF.
arsenic, CEA/*486*①.
arsenic orange, DATT.
arsenic yellow, DATT.
art, LP; OPGAC/*200*.
Art autre, JIWA/*396*.
art brut, l', LP.
art deco, C-5005; S-4414/*34*①; C-0706/*66*; C-1502/*143*; C-2202/*65*; C-2409/*43*; C-5005; IDPF/*39*; RTA/*141*; S-4461/*491*.
Art Deco clip, S-291/*160*①.
Art Deco glass, EG/*274*①.
Art Deco ring, S-291/*72*①.
Art Deco style, C-0706/*126A*; RTA/*159*①.
Art Deco taste, S-2882/*764*①.
Art Deco twin ring, S-291/*146*①.
artefact, JIWA/*8*.
artemesia leaf, C-2458/*344*①.
artemesia leaf mark, S-3312/*1338*①.
artemisia leaf, IDC; S-4843/*23*①.
artemisia leaf mark, S-4905/*5*.
artesonado, DADA/①.
Arte Vetraria, EA.
art glass, C-5005; C-5181/*12*; DADA, *supplement*; NYTBA/*268*①; CEA/*459*; EG/*112*; LAR83/*449*①.
Artgum, DATT.
Arthur Richard, C-5117/*447*.
artichoke finial, C-0103/*103*; C-2398/*37*.
artichoke handle, C-5174/*604*①.
artichoke leaves, C-5005/*388*①.

Ascension, DSSA.

Ascha, Anton, Vienna, C-2503/*152*①.

ascos, CEA/*662*①.

Ascos form, C-2510/*33*.

ascos shaped, LAR83/*576*①.

ash, ACD; C-0249/*321*①, *388*;
C-5005/*330*①; DADA; FFDAB/
33; IDC; LAR82/*297*①; NYTBA/
*35*①; S-4804/*935*; SDF.

Ash, Gilbert, DADA; EA; SDF/*768*.

Ash, John, C-5173/*20*①.

Ash, Joseph II, C-2510/*97*.

Ash, Thomas (I), SDF/*769*.

Ash, Thomas (II), SDF/*769*.

Ash, Thomas and William, SDF/*769*.

Ashbee, Charles Robert, DADA/
Supplement.

Ashbee, C. R., CEA/*653*①.

Ashberry metal, EA.

Ashburton, OPGAC/*201*.

ashburton pattern, NYTBA/*298*①;
C-5114/*146*; CEA/*471*①.

ashbury metal, DADA.

Ashcan School, DATT; LP.

ashes of roses, IDC.

ashes-of-roses glaze, C-5156/*145*.

ash glaze, CEA/*167*①; DATT.

ashi, DADA.

ashikaga, DADA.

Ashikaga period, JIWA/*387*.

Ashley post machine, CEA/*50*.

ash pot, S-4965/*256*①.

ash tray, C-1502/*91*.

ashtray, C-0254/*199*; C-5005/*250*①;
C-5117/*314*①; C-5146/*111*①;
C-5239/*49*; JIWA/*307*①.

Asian lacquerware, JIWA/*8*.

Askew, Richard, EA.

askos, DATT; IDC/①; IDPF/*9*①,
23.

asmalak, OC/*30*.

asmalyk, C-2388/*152*; C-2357/*130*;
S-4847/*42*①, *44*①.

Asmat, S-4807/*444*.

asparagus butter bowl, IDC.

asparagus butter dish, IDC/①.

asparagus dish, S-4461/*111*.

asparagus plate, IDC.

asparagus server, C-5114/*22*.

asparagus shell, IDC/①.

asparagus-tongs, C-5117/*32*; DADA.

asparagus tongs, C-0406/*56*; C-1502/
222; C-2202/*40*; EA/①.

asparagus tureen, IDC.

aspergillum, ACD; DSSA/①.

asphalt, DATT.

asphaltum, DATT; LP.

aspidistra stand, SDF/①.

Assadabad, OC/*98*①.

assay, EA.

assay cup, DADA.

assay-master, C-2487/*132*.

assaymaster, C-5173/*4*①.

assay-master's mark, EA/*deacon's
mark*.

assemblage, DATT/①; JIWA/*50*; LP.

assembled, C-5153/*7*; S-4992/*84*①.

assembled set, S-4905/*80*①.

assertive pattern, JIWA/*44*.

assimilated, JIWA/*8*.

Assisi work, DADA.

Assman, J., C-5174/*399*.

Associated Artists, DADA/
Supplement.

associated tassel, C-2357/*107*.

Assumption, DSSA.

Astbury, S-4843/*111*①.

Astbury, John, CEA/*154*①; DADA;
EA; NYTBA/*149*.

Astbury, John and Thomas, ACD.

Astbury type, NYTBA/*148*①.

Astbury ware, EA; IDC/①.

Astbury-Whieldon figure, IDC/①.

Astbury-Whieldon ware, EA/①.

aster ornament, DADA/①.

aster pattern, EA; IDC/①.

a St Jean du desert, EA/*Clérissy, Joseph*.

Astley-Cooper chair, SDF/①.

Astley Cooper chair, CEA/*361*①.

Aston & Mander, C-2904/*125*.

astragal, ACD; C-1407/*30*; C-2388/*124*①; C-2402/*27*; C-2421/*153*①; C-5153/*171*①; DATT; EA; LAR82/*272*①; S-4988/*522*①; SDF/*bead*.

astragal door, C-0982/*82B*.

astragal end, FFDAB/*56*①.

astragal-end top, C-5114/*370*①.

astragal glazed, C-0982/*98B*.

astragal molding, C-5153/*218*①; DADA.

Astrakahn, C-0604/*119*.

Astrakhan gold, RGS/*139*.

Astrakhantsev, A., C-5203/*111*.

astral lamp, DADA; K-710/*110*.

astro compass, C-2608/*79*.

astrolabe, ACD; CEA/*600, 604*①; EA/①.

astrolabe clock, DADA.

astrological mantel clock, LAR83/*203*①.

astronomical, C-2904/*256*.

astronomical clock, DADA; EA/① *Habrecht, Isaac*.

astronomical dial, EA.

astronomical indication, CEA/*230*①.

Astronomy as motif, C-2364/*52*①.

a sun, EA/*Sondag, Rudolph*.

asymetrically, C-5127/*361*.

asymmetical pattern, JIWA/*19*①.

asymmetric, C-2421/*22*①; S-4948/*128*①.

asymmetrical, OC/*17*.

asymmetrical composition, JIWA/*11*.

asymmetrical folly form, S-4955/*10*.

asymmetrical grouping, JIWA/*87*.

asymmetrical knot, EA/① *Persian knot*.

asymmetrical quartering, OC/*176*①.

asymmetrical stone, RTA/*162*①.

asymmetrical vista, JIWA/*251*.

asymmetry, DATT; IDPF/*5*; RGS/*69*.

AT, EA/*Tanqueray, David*.

at angle, C-5117/*336*.

ataujía, DADA.

a-tectonic, LP.

atef-crown, S-4973/*109*①.

atelier, C-2364/*52*①; C-2493/*31*; DATT; LP.

à thé, C-5259/*527*.

Athene, DSSA.

athénienne, DADA; EA.

atheniennes, S-4853/*332*①.

Atkin, H., C-2476/*20, 36*.

Atkin Bros., C-5203/*151*; S-3311/*710*.

Atkin Bros. of Sheffield, EA/*Law, Thomas*.

Atkin Brothers, C-0406/*46*.

Atkins, G., S-4927/*221A*.

Atkins, Sam., London, C-MARS/*167*.

Atkinson, Thomas, CEA/*645*①.

atlantes, DADA; DATT; IDC; SDF.

atlas, SDF; DSSA.

Atlasmuster, S-4853/*125*①.

atmos clock, C-5167/*205*; LAR83/*201*①.

atmosphere, DATT; JIWA/*50*.

atmospheric color, LP.

atomiser, C-0254/*285*.

atomizer, C-5191/*238*; C-5239/*127*; DATT; LP/①; S-3311/*901*; S-4461/*25*.

atomizer scent bottle, LAR83/*438*①.

ato shonsui, IDC.

atramentum, DATT.

à trois crayons, DATT.

Atropos, DSSA.

attached medallion, S-2882/*195*.
attapulgite, DATT.
attelet, DADA.
attendant figure, S-4965/*194*①.
attenuated, FFDAB/*25*.
attenuated form, LP.
attenuated scroll, C-2555/*58*①.
Atterbury & Company, EA.
Atterbury Duck, CEA/*468*①.
at-the-fire, EG/*286*.
at-the-lamp, EG/*290*.
Attic, LAR82/*90*①.
Attic base, MP/*490*①.
attic bed, FFDAB/*75*.
Attic pedestal, MP/*464*.
Attic psykter, IDPF/*188*①.
attributed to, C-5156/*563*; S-4905/*223*; S-4992/*105*①.
attribution, MP/*65*.
atunded triangular single lotus base, C-5234/*20*①.
aubergine, C-0782/*76*; C-2323/*20*①; C-2403/*195*; C-5127/*73, 25A*; C-5236/*1614*; DADA; IDC; S-4461/*398, 445*; S-4847/*3*①, *33, 189*; S-4905/*6*①.
aubergine body, S-4414/*217*.
aubergine glass, C-5005/*366*.
aubergine rosette-filled guard border, C-5323/*76*①.
Aubert, Ange Joseph, EA/*Auguste, Robert-Joseph*.
Aubert, Francois-Joachim, C-5220/*30*①.
Aubert, Georges, S-286/*471*①.
aubusson, SDF; ACD; C-0249/*310*; C-0405/*193*; CEA/*96, 99*①; NYTBA/*97, 115*; OC/*312*; S-4972/*192*①.
Aubusson carpet, C-0279/*422*; DADA; EA; LAR82/*545*①; S-3311/*80*①; C-0906/*1*.
Aubusson style, S-2882/*765*①.

Aubusson tapestry, C-2364/*37*; C-2437/*36*; DADA; EA/①; S-4436/*81*.
au carquois, EA.
Aucoq, A., C-5203/*122*.
Audebert, Denis, C-5117/*460*.
Audemars Piguet, Geneva, S-4927/*11*.
Audran, Claude, DADA/①.
Audubon, John James, DADA; S-286/*178*.
Audubon pattern, C-0254/*77*; C-0270/*248*.
Aufenwerth, Johann, EA.
Auffenwerth, Johannes, MP/*166*.
auger flame, SDF/①.
Augsburg, C-2486/*138*; CEA/*606*①, *685*; MP/*166*.
Augsburg, instrument-making center, C-5174/*429*①.
Augsburg clock, EA/①.
Augsburg fashion, MP/*466*①.
Augsburg Renaissance, DATT.
Augsburg service, C-2486/*61*①.
Augsburg style, RGS/*22*①.
Augsburg table clock, CEA/*236*①.
Auguste, Henri,, EA.
Auguste, Robert-Joseph, EA.
Augustin, Jean-Baptiste-Jacques, EA.
Augustus Rex, C-2427/*113*①.
Augustus Rex mark, EA.
Augustus Rex monogram, MP/*499*①.
Augustus Rex ware, IDC.
Augustus the Strong, MP/*10*.
Auler, CEA/*137*①.
Auliczec, Dominicus, EA.
aulne wood, DADA.
Aumbrey, LAR82/*425*①.
aumbry, DADA; EA/①; SDF/①.
Aumund, DADA.
au premier coup, DATT; LP.
aural/visual pun, OC/*123*.

aurene, C-0225/*286*; C-5191/*378*; LAR82/*456*①; CEA/*481*①; LAR83/*418*①; OPGAC/*156*; S-4461/*20*①.

aurene glass, C-5239/*296*; DADA, *supplement*.

aureole, DATT/①; DSSA.

aureolin, DATT; LP.

auricular handle, LAR83/*419*①.

auricular motif, EA.

auricular style, SDF.

Aurillac lace, DADA.

auripigmentum, DATT.

Aurora, DSSA.

aurora yellow, DATT.

Auroro, C-5239/*2*.

aurum musivum, DATT.

Ausschuss Porzellan, IDC.

Aust, Gottfried, CEA/*166*①.

Austen, Joseph and Son, C-2498/*48*①.

Austen, Joseph & Son, CEA/*586*①.

Austin, Jesse, EA.

Australian blackwood, SDF.

Australian merino wool, OC/*299*.

Australian walnut, SDF.

Austria, CEA/*451*.

Austrian Art Nouveau, DADA/*Supplement*.

Austrian clock, EA/①.

Austrian engraved beaker, CEA/*588*①.

Austrian oak, SDF.

Austrian porcelain, C-1006/*48*.

Austrian porcelain figure, C-1006/*25*.

Austrian punchmark, C-5167/*158*.

Austrian snuff-box, EA.

Austrian Werkbund, DADA/*Supplement*.

Auteuil studio, JIWA/*14*.

autograph (in bronzes), EA.

autolithography, DATT.

automata, CEA/*685*; EA.

automated, C-5117/*394*①.

automatic, C-2476/*1*.

automatic cashier, C-2904/*1*.

automatic drawing, JIWA/*399*.

automatic weapon, ACD.

automation, LAR82/*40*①.

automation watch, S-4927/*55*.

automatism, DATT; LP.

automaton, S-4802/*142, 148*①.

automaton and musical clock, EA/*Black Forest clock*.

automaton clock (watch), EA.

automaton mantel clock, LAR83/*206*①.

Autoperipatetikos, CEA/*696*①.

Autumn as motif, C-2364/*14*①.

'autumn colours', OC/*339*.

autumn leaf ball table lamp, C-5005/*388*①.

Autumn motif, C-2493/*108*.

Auvergne, DADA.

auzara, C-5156/*825*①.

AV, EA/*van Vianen, Adam*.

avance & retard, CEA/*258*①.

avant-garde, DATT; JIWA/*28*; LP.

avant-garde motif, JIWA/*73*.

Avarice, DSSA.

Avati, Mario, S-286/*180*.

avellan cross, DATT.

Avelli, Francesco Xanto, EA.

aventurine, ACD; C-2458/*426*; C-5127/*434A*; C-5156/*436*; CEA/*60*①, *502*; EA; EC1/*56*; EG/*286*①; LAR82/*223*①; RGS/*204*; SDF.

aventurine glass, EA/①.

aventurine glaze, IDC.

avenue, C-2704/*42*.

Avery, C-2904/*42A*.

Avery balance, LAR82/*305*①.

aviary vase, MP/*129*① *Plates*.

Avignon berries, DATT.

Avisse, Jean, stamp: AVISSE,
C-5224/*80*①.

avodire, DATT.

Avon Pottery, Cincinnati, Ohio, EC1/
85.

Avril, Etienne, DADA.

Awaji pottery inro, CEA/*574*①.

Awaji ware, DADA/①.

awaji-yaki, CEA/*575, 574*①.

Awata kiln, EA/*Kenzan.*

Awata ware, DADA.

A. WEISWEILER, EA/*Weisweiler,
Adam.*

A with D below, EA/*Dextra, Jan
Theunis.*

axe, DSSA.

axe-drop handle, EA/*86*①.

axe-head, C-2458/*1.*

axe head, C-5236/*376*①; C-MARS/
1.

axis, LP/①.

axle, C-2370/*29*①.

axle hub cap, C-5156/*181.*

Axminster, CEA/*75, 96*; DADA.

Axminster carpet, ACD; EA/①.

axonometric projection, DATT.

Axson, William, Jr, EA.

Axson, William, Junior, SDF/*769.*

Aynsely, C-1006/*138.*

Aynsley & Co, LAR82/*97*①.

ayous, DATT.

Ayrshire work, C-1304/*83*; CEA/*275,
294.*

Ayr stone, DATT.

Azerbaijan, OC/*223*①.

Azerbaijan-related style, OC/*193.*

azimuth compass, CEA/*608*①.

azimuth mirror, C-2608/*109.*

azo color, DATT.

aztec mask and trophy, C-5167/*24*①.

Aztec pottery, IDC.

AZU GR Patent, C-2370/*34.*

azulejo, IDC.

azulejos, DADA/①.

azure blue, DATT; LP.

azure cobalt, DATT.

azure ground, JIWA/*92.*

azurine, OPGAC/*345.*

azurite, C-5156/*174*; DATT.

B

B, EA/*Batenin, Sergei, Warsaw faience factory.*

B, script G,, EA/*Bow Porcelain Manufactory.*

Baba Haidar, OC/*260*①.

Babaseqal, OC/*176*①, *210*①.

babool gum, DATT.

babul gum, DATT.

baby block, C-2704/*95.*

baby cage, DADA; EA/*baby-walker;* SDF.

baby-chair, SDF.

baby doll, CEA/*697.*

baby face, OPGAC/*201*①.

baby-feeder, IDC.

baby grand, C-0982/*113.*

baby lace, DADA.

baby rattle, C-0254/*135.*

baby's bonnet, C-1506/*94*; C-3011/*81.*

baby's boot, C-1506/*70.*

baby's cup, S-4461/*290.*

baby's dress, C-1506/*94.*

baby's fork, S-4461/*237.*

baby-walker, EA/①.

Baccanalian putti decoration, C-2510/*120*①.

baccarat, DADA; C-5239/*100*①; CEA/*484, 489*; EA; LAR82/*448*①; LAR83/*414*①, *436*①; NYTBA/*284*; OPGAC/*159*; S-4461/*491.*

Baccarat anemone, CEA/*498*①.

Baccarat butterfly over clematis, CEA/*498*①.

Baccarat close millefiori, CEA/*491*①.

Baccarat dome, K-802/*16.*

Baccarat snake, CEA/*501*①.

Bacchanale, C-0249/*245.*

bacchanale group, S-4461/*517.*

bacchanal figure, S-2882/*1032*①, *1191*①.

Bacchanalian figure, C-0249/*182*; MP/*476*①.

Bacchanalian mask, C-2398/*56.*

Bacchanalian scene, C-0279/*40*①; C-2482/*148.*

Bacchante, DSSA; MP/*131*; S-4804/*563*①.

bacchante jug, IDC.

bacchante masque, C-0279/*379*①.

bacchic mask, C-2364/*17*①, *58*①; C-2437/*32*①; C-5116/*155*①; S-4804/*137*①.

bacchic putti, C-2403/*7.*

Bacchic Revel, CEA/*175*①.

Bacchus, C-2427/*205*①; DSSA.

Bacchus, George, and Sons, EA.

Bacchus, George & Sons, CEA/*489*.

Bacchus group, MP/*476*①.

Bacchus jug, IDC/①.

Bacchus mask, C-1006/*161*.

Bacchus mushroom, CEA/*496*①.

Baccin, Giovan Maria, EA.

Bach, Martin Sr., CEA/*479*①.

Bachelier, Jean-Jacques, EA.

bachelor chest, DADA; EA/①.

bachelor milk jug, C-0706/*21*.

bachelor's chest, C-2421/*68*①;
C-2478/*96*; CEA/*332*①; S-4988/
*445*①; SDF.

bachelor's table, SDF.

bachelor's tea (coffee) service,
C-5203/*149*.

bachelor tea-service, C-0706/*1*.

bacile, IDC.

bacini, DADA/①; IDPF/*10*.

bacino, IDC.

back, C-5239/*247, 279*.

back-action lock, C-2569/*57*.

back board, SDF.

backboard, C-5114/*263*①; C-5239/
253.

backed, C-0225/*410*; C-2403/*194*;
S-4881/*49*①.

Backers, CEA/*550*①.

backgammon board, ACD; C-0906/
116; DADA.

backgammon table, DADA; EA;
LAR83/*394*①; SDF.

backgamon box, C-1082/*179*.

background, C-5156/*286*; DATT;
JIWA/*10*; LP.

background paper, DATT.

background plane, JIWA/*73*.

back-handled, CEA/*650*①.

backing, C-2320/*140*; C-2478/*209*;
NYTBA/*103*①, *111*①.

backlock, C-2476/*2, 40*.

Backman, Jacob, DADA.

back-painting, DATT.

back panel, C-0982/*15*; C-2402/*14*.

back-plate, C-2482/*152*; CEA/*236*①;
EA/①.

back plate, C-0249/*291*; DADA;
S-4972/*236*①.

backplate, C-0279/*207*; C-2320/*61*;
C-2357/*5*①; C-2421/*19*①;
C-2503/*41*; C-5116/*163*①;
C-5146/*113*①; C-5157/*32*; S-3311/
*112*①; S-4802/*14, 25*; S-4905/
*335*①.

backrail, C-2357/*61*①.

back rest, SDF.

backrest, C-5005/*322*①; S-4853/
*421*①; S-4972/*446*; S-4988/*512*①.

backscratcher, C-1082/*152*; DADA.

back screen, EA; SDF/①.

backsight, C-MARS/*127*①.

back-spike, S-4972/*143*①.

backsplash, C-5153/*113*.

back-staff, CEA/*607*①; EA.

back-stamp, IDC.

back stitch, CEA/*277*①, *282*①.

back-stool, SDF/①.

back stool, ACD; C-5114/*324*①; EA.

back stool chair, DADA.

back support, C-2904/*45*.

backsword, C-2569/*11*; C-MARS/*19*;
DADA.

back-to-purity movement, NYTBA/
21.

backward curve, IDPF/*142*.

backwards handle stop, IDPF/*121*①.

bacon cupboard, SDF/①.

bacon dish, DADA.

baconette, SDF/*balconet*.

bacon settle, C-0249/*408*①; C-5157/
*126*①.

Baddeley, William, EA.

Badeganeh, OC/*257*①.

bajixiang, S-3312/*1388*①; S-4965/
*285*①.

Bajode (pagoda figure), MP/*72*.

baked enamel, DATT.

bakelite, C-2910/*194*; C-5239/*99*;
RTA/*144*; S-4881/*158*①.

bakelite case, C-0403/*94*.

baker, IDPF/*11*; C-2904/*96*①.

Baker, F. P., C-2476/*67*.

Baker, John, CEA/*591*①; DADA/
Supplement; S-4881/*356*.

Baker, Richard, CEA/*231*①.

Baker Furniture Inc., DADA/
Supplement.

baker rifle, ACD.

Bakewell, Benjamin, CEA/*462*①.

Bakewell, John P., CEA/*465*①.

**Bakewell, Page & Bakewell,
Pittsburgh,** NYTBA/*293*①.

Bakewell, Pears and Company,
DADA/*Supplement*.

Bakewell, Robert, EA.

Bakewell & Co, CEA/*467*①.

Bakewell & Co., CEA/*462*①.

Bakewell & Co. Glasshouse, EA/①.

Bakewell's Glass Works, DADA/
Supplement.

Bakhara carpet, EA/*Bokhara carpet*.

Bakhmetev family, EA/*Russian glass*.

Bakhshis, DADA.

Bakhskaish, OC/*266*.

Bakhtiari, DADA; OC/*67*①.

Bakhtiari carpet, OC/*147*.

Bakhtiari panel design, OC/*146*①.

Bakhtiari rug, C-0906/*72*; C-2403/
161.

Bakhtiar lozenge-panel, OC/*328*.

Bakhtiar rug, OC/*21*①.

baking dish, IDPF/*11*.

baking-iron, EA.

Bako, S-3312/*1065*.

Bakshaish, C-5189/*379*; S-4847/*208*,
*245*①.

Bakshaish carpet, S-4948/*136*①.

Baktiari, C-5189/*378*①; S-4847/*175*,
195, 207; S-4948/*127*①.

Baktiari carpet, S-3311/*2*; S-4796/
*149*①.

Baku, DADA; S-4843/*277*.

Baku carpet, EA.

Baku Chila, S-4847/*2*.

baku rug, ACD; LAR82/*545*①;
S-4796/*103*.

balalaika, CEA/*552*①.

balance, C-2904/*28*; C-5117/*444*①;
CEA/*267*; DATT; EA; LP/①;
NYTBA/*260*.

balance bridge, CEA/*250*.

balance cock, CEA/*250, 252*①.

balance pan, C-0403/*86*.

balance spring, CEA/*217, 251*①.

balance weight, S-2882/*1347*①.

balance wheel, ACD; C-0249/*307*;
CEA/*267*.

balancing figure, S-4928/*42*①.

balaustre, DATT.

balayeuse, C-2501/*43*.

balconet, SDF.

baldachin, DADA; DATT; IDC;
RGS/*17*①.

baldachin cartouche, RGS/*17*①.

baldaquin, DATT.

Baldini, Baccio, CEA/*622*①.

Baldwin Gardiner, S-4905/*199*①.

bale, C-5174/*427*①.

baleen, S-4881/*63*①.

baleen plaque, C-5114/*196*①.

bale handle, DADA.

Balenciaga, C-0405/*46*.

Balikesir, S-4847/*86*①.

balk, SDF.

Balkan, C-2388/*138*.

ball, C-0906/*115*; C-5127/*73*;
C-5146/*165*①; CEA/*24*①.

Ball, Tompkins and Black, DADA/
Supplement.

Ball, Tompkins & Black, S-4905/ 180①.

Ball, Tompkins & Black, New York, NYTBA/230①.

Ball, William, CEA/200①; EA, .

ballad horn, CEA/554①.

ball-and-arrow, C-5114/322①.

ball-and-bar thumbpiece, EA.

ball and claw, DADA.

ball-and-claw foot, ACD; EA.

ball and claw foot, S-4922/13①.

ball and ring terminal, S-4414/147.

ball and swirl, OPGAC/201.

ball-and-wedge thumbpiece, EA.

ballast ware, EC2/24.

ball base, C-5117/151①.

ball clay, DATT; IDC.

ball clock, EA/①.

ball dress, C-1506/8.

balleen-mounted, S-3311/160①.

ball-encrusted, C-2388/24; C-2478/ 174.

ball-encrusted frame, C-2403/37.

ballerina ring, S-291/63①, 96①, 102①, 114①, 169, 170.

ballet figure, EA.

ball fender, C-5239/263.

ball finial, C-0279/289; C-2437/34①; C-5005/226①; C-5114/267①; C-5117/152①; S-2882/902①; S-4414/282.

ball-finial Greek pattern, C-1407/112.

ball-flower, DADA/①.

ball foot, ACD; C-0254/69; C-1502/ 20; C-5114/230, 321①, 394①; C-5116/1; C-5146/182①; CEA/ 587①; DADA; EA; K-802/22; S-4414/239①, 387①; S-4461/244; SDF.

ball-form watch, S-4927/132①.

ball fringe, SDF.

ball grip, LAR83/56①.

ball-hung, S-4436/50①.

ball-hung border, S-4414/408; S-4812/37①.

Ballin, A., S-286/70.

Ballin, Claude I, EA.

Ballin, Claude II, EA.

ball knop, EA; LAR82/442①.

ball-knopped, CEA/594; LAR82/ 539①.

ball measure, LAR82/534①.

ball mill, DATT/①.

ballock dagger, C-MARS/1; CEA/27.

balloon, C-0982/138.

balloon-back, DADA; EA/①; S-4804/879.

balloon back, C-1407/24; LAR82/ 295①; LAR83/268①, 272①.

balloon-back chair, ACD.

balloon back chair, SDF.

balloon case, C-5181/98①.

balloon clock, CEA/235; DADA; EA; S-3311/112①; SDF.

balloon glass, DADA.

'balloon' mantel clock, LAR83/204①.

balloon seat, C-5114/326①; C-5153/ 153①.

balloon-shaped, C-5116/173①.

balloon shaped, S-4988/469①.

balloon-shaped case, S-3311/112①.

ballot box, IDC.

ball pull, C-0225/374①.

ballroom chair, S-4947/248.

ball-shaped finial, CEA/432①.

ball-shaped foot, C-0782/95.

ball-shaped stopper, EA/stopper.

ball stand, S-4881/443①.

ball terminal, S-2882/1090①.

ball thumbpiece, C-2427/184①.

ball-turned, C-5114/295①.

ball turning, SDF/①.

Bally, J.A., Arc, C-MARS/158.

Balouchi prayer rug, S-3311/27.

Balouchi rug, S-3311/34.

balsa, DATT.

balsam, DATT; LP.

balsamaria, DADA; IDPF/*11*; S-4807/*555*.

balsamarium, S-4807/*547*①; S-4973/ *381*.

balsa wood, S-4881/*197*①.

Balthazar, Paris, C-5189/*294*①.

Baltic amber, S-4810/*68*①.

Baltic silver, RGS/*186*.

Baltimore assay mark, DADA.

Baltimore glass work, EA/*38*①.

Baltimore monument flask, EA/①.

Baltimore pear, OPGAC/*201*.

Baltimore Rose pattern, C-0254/*201*.

Baltimore Rose style, S-4804/*37*.

Baltimore Silversmiths Co., S-3311/ *608*①.

Baluchi carpet, EA.

Baluchi Juval pillow, S-288/*38*①.

baluster, ACD; C-0782/*14*; C-2360/ *70*; C-2388/*13*; C-2398/*8*; C-2402/ *97*; C-2414/*39*①; C-2458/*17*; C-5114/*229, 282*①, *355*①; C-5116/*104*; C-5127/*5*①; C-5153/ *67A*①; C-5156/*11*①; C-5239/*12*; CEA/*426*①, *502, 678*; DADA; EA; EG/*286*①; IDC/①; S-4804/ *130*; SDF/①.

baluster-and-bobbin, SDF.

baluster-and-ring, SDF.

baluster-and-spindle, SDF.

baluster and spindle back, EA.

baluster aubergine vessel, S-4414/*216*.

baluster back, SDF/①.

baluster base, C-5005/*260*①; K-711/ *126*.

baluster beer jug, LAR83/*587*①.

baluster body, C-2437/*16*.

baluster contour, S-4414/*213*①, *219*①.

baluster cross-stretcher, C-0982/*91A*.

baluster feet, C-1502/*180*; C-5114/ *271*①, *337*①; C-5117/*344*.

baluster finial, C-0254/*157*; C-1502/ *85*; C-2202/*44*; C-5117/*56*①, *300*; S-4414/*275, 331*①, *342*①; S-4972/ *311*.

baluster-form, C-5114/*115*.

baluster form, C-0225/*13*; C-5005/ *237*; CEA/*642*①; IDPF/*11*①; S-2882/*288, 316, 403*①, *803, 971*①, *979*①; S-4414/*215*; S-4804/ *116*①; S-4922/*15*①.

baluster-form cup, S-4804/*136*①.

baluster form on pedestal foot, S-4414/*331*①.

baluster-form standard, S-2882/*335*.

baluster goblet, LAR83/*431*①, *431*①.

baluster handle, C-5117/*210*①.

baluster jar, C-2458/*197*①.

baluster jug, IDC.

baluster-knop, CEA/*594*.

baluster knop, C-0254/*165*①; C-5117/*135*①; EA.

baluster leg, C-0982/*21*; C-2402/*5*; C-5116/*119*; CEA/*405*; SDF/①.

baluster measure, CEA/*594*; DADA.

baluster mug, LAR83/*594*①.

baluster pillar, C-5117/*483*①; S-4802/*135*①.

baluster ribbed standard, S-4414/ *227*①.

baluster section, S-2882/*1268, 1396*.

baluster shaft, C-2388/*35*①.

baluster shape, CEA/*151*①, *644*①; LAR82/*156*①.

baluster-shaped, C-5005/*277*; C-5114/*27*①, *228*; CEA/*140*①.

baluster-shaped pedestal, C-5116/*135*.

baluster-shaped splat, C-0249/*460*; C-5116/*107*①.

baluster splat, S-4414/*427*①, *466*①; S-4436/*99*①; S-4812/*74*①; SDF.

baluster standard, S-4414/*225*①, *239*①.

baluster stem, ACD; C-0254/257;
C-2478/181①; C-5114/53①,
113①; C-5116/123; C-5117/99①,
166①, 236①; CEA/640①;
DADA/①; EA; LAR83/63①;
S-2882/1035①; S-4414/267, 460;
S-4436/31; S-4922/5①.

baluster stretcher, C-2320/37;
C-2403/78.

baluster stump, C-0249/408①.

baluster support, C-2357/14①,
C-5114/397①; S-2882/702;
S-4414/445; S-4461/743①.

baluster top, C-5117/53.

baluster-turned, C-5153/76①;
S-2882/631①.

baluster turned, S-2882/700①.

baluster-turned leg, C-5114/378①.

baluster-turned pedestal, C-5114/
398①.

baluster-turned stem, S-2882/695①.

baluster-turned stretcher, C-5116/
127①.

baluster turned stretcher, LAR83/
390①.

baluster-turned support, C-5114/
384①; CEA/402①.

baluster turning, SDF.

baluster vase, C-0225/18; C-1006/6;
C-5127/38①.

baluster vessel, S-4461/93.

baluster wood handle, C-5117/57①.

balustrade, JIWA/71; S-2882/803;
S-4461/545.

balustraded, C-2320/41.

balustraded base, C-5156/191.

balustraded cresting, C-2437/31①.

balustraded side, C-2421/52①.

balustrated tilting top, S-4414/496①.

balustroid, EG/134; LAR83/451①.

balustroid stem, CEA/423①; EA.

Balzac, Edmé Pierre, EA.

Balzac, Jean-Francois, EA/*Balzac,
Edmé Pierre.*

Balzac, Pierre, NYTBA/227①.

Bamberg clock, CEA/237①.

Bamberger Stockuhr, CEA/237①.

bambocciata, DADA.

bamboo, C-0249/354; C-0982/5;
C-1603/28; C-2403/31; C-2414/
96①; C-2458/104, 394; C-5153/
102①; C-5236/884, 1822; CEA/
562; DADA/*Supplement*; FFDAB/
45①; OPGAC/201; S-4810/326;
S-4881/203①.

'bamboo', ACD.

bamboo brush, DATT.

bamboo carving, C-5156/429.

'bamboo' case, LAR83/186①.

bamboo-form, S-2882/679①.

bamboo form, IDPF/12①.

bamboo furniture, SDF/①.

bamboo handle, C-5156/148.

bamboo motif, S-4965/112①.

bamboo node, S-4829/84.

bamboo node foot, C-5156/140.

bamboo pen, DATT.

bamboo section, C-5236/1694.

bamboo sticks, S-4461/179.

bamboo style, CEA/129①.

bamboo-turned, C-5114/292①;
DADA; S-4461/595; S-4812/40,
180①.

bamboo turned, SDF/①.

bamboo turning, EA.

bamboo ware, IDC/①.

banana oil, DATT.

banana-shaped, C-2503/96.

banc, DADA.

bancelle, DADA.

Banchiang excavated ware, C-2458/
1①.

bancone, DADA.

band, C-0225/100A; C-2458/1;
NYTBA/67①; S-4461/326;
S-4922/2①; SDF/①.

band border, S-4905/75.

bandbox, DADA/*Supplement*.
banded, C-5116/*1*; DADA.
banded agate, S-4810/*119*①.
banded apron, C-5114/*373*①.
banded border, C-0254/*163*.
banded composition, JIWA/*59*.
banded creamware (mocha creamware), DADA/*Supplement*.
banded creamware, IDC.
banded decoration, CEA/*166*①.
banded edge, C-5114/*367*①.
banded hedge (haie fleurie), EA/ *décor coréen*.
banded hedge, IDC.
banded leg, S-4812/*100*①.
banded octagonal sconce, S-2882/ *1025*①.
banded spout, IDC.
banded stem, C-0254/*22*.
banded top, C-5114/*372*①.
bandelet, SDF.
banderole, DADA; DATT.
B and fleur-de-lis, EA/*Beauvais tapestry*.
Bandi-Kurdi, OC/*205*.
banding, ACD; C-5114/*315*①, *326*①, *350*①; C-5116/*45*①; LAR82/ *320*①; S-3311/*82*①; S-4461/*28*; S-4507/*44*①; SDF.
banding wheel, DATT.
band of guilloche, C-2398/*56*.
band of mist border, JIWA/*376*.
band of scrolls, C-5117/*159*①.
bandoleer bag, S-4807/*233*①.
bands, C-0706/*223*; C-5239/*42*; S-4992/*4*①.
bands of lobes, S-4922/*19*①.
Bandwurmglas, EG/*90*① *tapeworm glass*.
Bandwurm glass, DADA.
bandy leg, DADA; EA/*cabriole leg*; SDF/① *cabriole leg*.
Bang, Jacob E., DADA/*Supplement*.

Banger, E., London, C-2489/*197*.
bangle, C-5156/*341*; C-5236/*1687*.
bangle-bracelet, S-4414/*38*; S-4927/ *239*.
bangle bracelet, LAR83/*478*①; S-291/*141*.
banister, C-5114/*267*①; DADA; SDF.
banister-back, EA.
banister back, LAR83/*267*①; SDF.
banister-back chair, ACD; DADA/①.
banister-form back, S-2882/*242*.
banjo, C-0906/*276*.
banjo barometer, ACD; C-0249/*276*; C-1702/*266*; C-2368/*3*; C-2388/ *5*①; C-2478/*21*.
banjo clock, ACD; C-5114/*264, 331*; C-5153/*167*; CEA/*243*①; DADA; EA/①; EC2/*91*; FFDAB/*117*①; LAR82/*234*①; S-4905/*355*①.
banjo mandolin, C-5255/*30*.
banjo shape, C-0249/*340*.
banjo-shaped, C-5116/*33*; C-5157/*11*.
banjo wall clock, EC2/*94*①.
banker, DATT; SDF.
banking pin, C-5174/*416*①.
bank in the foreground, C-2704/*27*①.
banko ware, DADA; EA; IDC; K-711/*131*.
banner, C-0279/*171*; C-2498/*85*.
banner paper, DATT.
banner screen, SDF.
banner-stave locker, SDF.
bannister, C-5114/*377*①.
bannister-back, C-5114/*289*; C-5153/ *94*①.
bannister back, C-5114/*383*①.
bannock rack, EA.
banquette, DADA; EA/①; LAR82/ *365*①; LAR83/*357*①; S-3311/ *388*①; S-4972/*481, 591*.
bantam-work, ACD.
bantam work, SDF; EA.

banuyo, SDF.

banyan leaf band, C-5127/*39*①.

banyan leaf pattern, C-5127/*208*.

Baphuon style, C-5156/*209*.

baptismal basin, DADA; EA.

baptismal bason, CEA/*665*.

bar, C-0249/*370*; C-0982/*144*; C-2402/*43*; C-5114/*336*①; CEA/*21*①.

Baradelle, J., CEA/*604*①.

Barancourt, Pierre Michel (Barancourt à Paris), C-5224/*47*.

bar and link, C-2487/*10*.

bar and rail back, C-1407/*49*.

Barat, Philippe, C-2555/*25*①.

barb, S-4881/*313*①.

bar-back, DADA.

bar back, C-0982/*4*; SDF/①.

Barbar, C-2503/*137*; CEA/*27*.

barbarian jewellery, RTA/*16*.

Barbe, John, C-2487/*100*.

barbeau, ACD.

barbeau, cornflower, Angoulême sprig, EA.

barbeaux, DADA; IDC.

barbed, S-3312/*1123*.

Barbedienne, C-0249/*212*; C-5189/*253*①; LAR82/*36*①.

Barbedienne, F., C-5189/*148*.

Barbedienne, Ferdinand, EA.

Barbedienne foundry, C-5191/*126*; C-5224/*252*①.

barbed rim, IDC; S-4965/*151*①.

Barber, J. York, C-2487/*66*.

Barberi, Luigi, C-5189/*342*①.

Barberi, Michelangelo, C-5189/*342*①.

Barberini handle, IDC.

Barberini tapestry, DADA.

Barberini vase, DADA; IDC.

Barberini workshop, EA.

barber pole design, S-288/*24*①.

barberpole guard border, C-5323/*66*①; S-4796/*17*; S-4948/*6*.

barber-pole stripe, C-2320/*148*; C-2357/*155*; DADA.

barberry, OPGAC/*201*①; SDF.

barber's basin, DADA; IDPF/*12*①.

barber's bottle, CEA/*54*①.

barber's-bowl, C-2427/*188*.

barber's bowl, C-5156/*814*.

barber's bowl (basin), (dish), EA/①.

barber's bowl, IDC/①; S-4905/*27*①.

barbers bowl, C-0782/*43*.

barber's chair, DADA; EA; SDF.

barber's clock, EA.

'barber's pole' effect, OC/*22*①.

barber's pole stripes, C-2478/*221*.

'barber's-pole' type, OC/*262*.

Barbezat Baillot, C-5117/*412*①.

Barbin, François, Barbin, Jean-Baptiste, EA.

Barbizon school, DATT; JIWA/*28*; LP.

Barbman, IDPF/*20*.

bar border, C-0279/*10*.

barbotine, ACD; DADA; EC1/*83*; IDC.

bar brooch, LAR83/*481*①.

barbute, DADA.

Barcelona chair, C-5167/*211*; C-GUST/*157*①; DADA/*Supplement*.

Barcheston tapestry, DADA; EA.

Bardery, Louis Armand, C-5191/*133*.

Bardford, William, Leeds, C-2489/*74*.

bardiglio, DATT.

bardiglio marble, C-2364/*3*①.

Bardin, T.M., C-2478/*137*①.

barding needle, EA.

barefaced tenon, SDF/①.

barefaced tongue, SDF/①.

baren, DATT.

bar foot, C-0982/*3*; C-2388/*51A*; DADA; LAR82/*415*①.

bargee teapot, IDC.

bargello, DADA.

bargello work, SDF.

'barge' teapot, LAR83/*157*①.

bargueño, EA/① *vargueño*.

barilla, EA/*soda-glass*; EG/*83*.

bar-in-wood, C-2476/*66*; C-MARS/ *147*.

barite, DATT.

barium sulfate, DATT.

barium yellow, DATT; LP.

Barjid, OC/*208*①.

Barker, E., LAR82/*216*①.

Barker, Ellis, C-0270/*1*.

Barker, John, CEA/*196*①.

Barkley, Samuel, London, C-2489/ *221*.

'bark'-textured gold, RTA/*165*①.

Barlach, Ernst, MP/*202*; S-286/*183*.

barley, OPGAC/*202*.

barley sugar turning, DADA.

barley-sugar twist, EA.

barley sugar twist, CEA/*405*; SDF.

barley-sugar twist design, C-2498/*19*.

barley-sugar-twist leg, CEA/*321*.

barley-sugar twist leg, CEA/*365*①; LAR83/*303*①.

barley-twist arm, S-2882/*336*.

barley-twist support, LAR82/*303*①.

barlink, S-4927/*129*①.

bar lock, S-4972/*272*.

Barlock, C-2904/*6*.

Barlow, Edward, EA.

Barlow ware, IDC.

Barman, Christoffer, S-4944/*148*①.

barm jar, IDPF/*13*.

barm pot, IDC.

Barnard, E., C-2487/*149*①.

Barnard, Edward, EA/*Emes, John*; S-3311/*721*.

Barnard, Edward, Edward Jr., John, William, C-5174/*507*①.

Barnard, Edward I, C-5117/*24*.

Barnard, Edward & Sons, EA.

Barnard, Lucy, NYTBA/*111*①.

Barnes, CEA/*251*①.

Barnes, Zachariah, EA.

Barnes and Bull, CEA/*252*①.

Barn Raising design, C-2704/*68*.

Barnsley, Edward, DADA/ *Supplement*; SDF/*745*.

Barnsley, Ernest Arthur, DADA/ *Supplement*; SDF/*745*.

Barnsley, Sidney, DADA/*Supplement*; SDF/*745*.

bar numeral, S-4927/*1*.

barograph, C-0403/*157*; C-2608/*27*; C-2904/*171*; C-5174/*337*.

Barolac, C-2409/*51*.

barometer, ACD; C-0906/*109*; C-2437/*34*①; C-2904/*43, 87*; C-5116/*33*; C-5157/*11*; C-5189/ *354*; CEA/*260*; DADA/①; EA/ ①; EC2/*99*①; LAR82/*42*①; S-4881/*60*①.

barometer/thermometer, S-4972/*426*.

barometer tube, CEA/*262*①.

barometric tube, C-2368/*6*①.

Baroni, Giovanni, CEA/*172*①.

'baronial' furniture, ACD.

baronial style, SDF.

baron's coronet, C-5117/*54*①.

baroque, ACD; C-2427/*141*①; C-5116/*91*; C-5117/*254*①; C-5157/*28*①; CEA/*529*; DADA/ ①; IDC; LP; RGS/*69*; S-4436/*21*; SDF; C-0279/*60*①; DATT; IDPF/ *228*; RGS/*35*; S-4461/*160*; S-4972.

baroque cartouche, C-2427/*113*①; C-5117/*382*①; CEA/*646*①; RGS/ *17*①.

Baroque coffer, S-3311/*90*.

baroque cultured pearl, S-4927/*290*①.

baroque form, RGS/*157*①.

baroque pearl, C-2324/*236*; C-2409/ *189*; CEA/*518*①; EA/①; RTA/

*149*①; S-291/*115*①; C-5005/
*215*①.
baroque scroll, CEA/*644*①.
baroque scrolling foliage, C-5117/
*255*①.
baroque scrolling foliate mantle,
S-2882/*1099*①.
baroque scrollwork, S-2882/*405*.
baroque shield, S-2882/*1107*.
baroque show medal, RGS/*90*.
baroque style, EA; MP/*9*; S-4804/
*106*①, *834*①.
baroque swag, C-2458/*191*.
baroque wooden-wheeled clock, CEA/
*223*①.
Barovier and Toso, DADA/
Supplement.
bar pattern movement, C-5117/*413*,
*423*①.
Barr, C-2493/*32*.
Barr, Flight & Barr, C-2493/*69*.
Barr, Martin, CEA/*196*①.
Barraban, J., EA/*Berlin tapestry*.
Barraud & Lund, London, C-2489/
222.
Barraud of Cornhill, CEA/*255*①.
Barre, Alfred, EA.
barred forget-me-not, OPGAC/*202*①.
barrel, C-5117/*444*①; C-MARS/
*136*①; CEA/*21*①, *235*, *267*.
barrel (in clock/watch), EA.
barrel, S-4922/*10*①; S-4927/*90*;
S-4972/*155*①, *157*①.
barrel arbor, CEA/*243*①.
barrel-back armchair, S-3311/*117*①.
barrel-back chair, DADA.
barrel band, C-2569/*84*; S-4972/
*262*①, *267*.
barrel beaker, C-5173/*24*①.
barrel chair, EA; SDF/①.
barrel hinge, LAR82/*346*①.
barrelled cover, S-4414/*59*①.
barrelled links, S-4414/*136*.

barrelled watch, S-4414/*147*.
barrel organ, EA; FFDAB/*119*①;
LAR83/*520*①.
barrel shape, IDPF/*13*; S-2882/
*1273*①.
barrel-shaped, C-2513/*278*; C-5127/
21; C-5156/*94*.
barrel shaped, C-5156/*9*①; C-5236/
*467*①, *1587*.
barrel-shaped back, S-2882/*403*①,
790.
barrel-shaped backrail, LAR83/*287*①.
barrel-shaped bead, C-5156/*382*①.
barrel shaped mug, C-0782/*23*.
barrel-shaped seat, DADA/① *garden
seat*.
barrel-shaped teapot, C-2458/*91*.
barrelsmith, C-2503/*96*.
barrel tang, C-2569/*61*①.
Barret, John, C-0906/*257*.
Barrett, Henry, CEA/*55*①.
Barrett, William II, C-2510/*66*.
barrister's wig, C-2203/*210*.
Barritt-Servis Star and Planet Finder,
C-2904/*188*.
Barr: Martin, Martin Junior, George,
EA.
Barrow, Samuel, LAR82/*216*①.
Barrow, William, S-4988/*419*①.
barrs, SDF.
Barry, Cork Fecit, C-2904/*193*.
bar shoe, C-0604/*65*.
bar slide, C-5117/*472*①.
bar splat, C-2320/*16*; C-5170/*59*.
bar stool, LAR83/*355*①.
bar stretcher, C-2382/*170*.
Bar-Tal, Ariel, DADA/*Supplement*.
Bartholomew babies, CEA/*697*.
Barthou, P. F., C-5189/*176*①.
Bartlett, Samuel, LAR82/*601*①.
bartmann jug, IDPF/*13*; DADA.

bartmannkrug, C-2486/*192*; C-2427/
195; CEA/*136*①; EA/*bellarmine*;
IDC.

Bartmannkruger, IDPF/*20*.

Barwise, London, C-2489/*223*.

barwood, DATT.

Barye, Antoine-Louis, EA; S-3311.

Barye, Antoine Louis, C-5189/*130*.

baryta, DATT.

baryta green, DATT.

baryta water, DATT.

baryta white, DATT.

barytes, DATT.

basal rim, CEA/*498*①, *502*; EG/*286*.

basal ring, IDC.

basalt, ACD; C-1006/*94*; C-1603/
120; C-2332/*38*; C-2502/*14*;
DATT; IDC; JIWA/*310*; LAR82/
*186*①.

basalt covered, LAR83/*168*①.

basaltes, IDC; S-4843/*387*①, *432*①;
CEA/*150*.

basaltes ware, DATT.

basalt plaque, C-1006/*2*.

basalt stoneware, MP/*171*.

basalt ware, DADA; DATT.

bas d'armoire, CEA/*405*; DADA.

bas d'armoire (entre-deux), EA.

bas d'armoire, LAR82/*425*①.

base, C-0782/*31*; C-0982/*66*;
C-1082/*32*; C-2402/*125A*; C-2458/
190, *293*①; C-5005/*311*①;
C-5114/*4*, *352*①; C-5153/*2*①;
CEA/*113*①, *241*①; DATT; IDC;
IDPF/*13*; LP; S-4992/*4*①, *6*①;
SDF, .

base apron, LAR83/*257*①.

base kick-up, CEA/*57*①.

base metal, EA; NYTBA/*211*①.

base molding, C-5114/*278*①, *391*①.

bashed pot, IDPF/*18*.

basic round form, JIWA/*179*.

basil, SDF.

basilard, DADA.

basin, C-0279/*400*①; C-2458/*187*;
C-5114/*228*; C-5116/*77*; C-5127/
124; C-5146/*113*①; C-5156/*141*;
C-5236/*496*, *1701*; IDC; IDPF/
*13*①; S-4802/*454*①; S-4905/*103*①,
*117*①.

basin and ewer, SDF.

basinet, DADA.

basin slant, DATT.

basin-stand, EA/①.

basin stand, C-0249/*357*; CEA/
*394*①; DADA/①; FFDAB/*86*①;
S-4812/*132*; SDF/①.

Baskerville, John, EA.

basket, C-0225/*37*; C-0254/*60A*;
C-2388/*25*; C-2398/*22*; C-5114/
*393*①; C-5117/*173*; C-5153/*2*①;
C-5236/*884*; CEA/*502*; DADA/①;
DSSA; EA/①; EG/*286*; IDPF/
*14*①; S-4905/*70*①.

basket chair, EA; SDF/①.

basket dish, IDC.

basket finial, S-2882/*828*.

basket form, S-2882/*342*.

basket-form watch, S-4927/*196*①.

basket-grate, SDF.

basket grate, C-2388/*25*; C-2478/*66*;
C-5116/*34*.

basket hilted, CEA/*22*①.

basket-hilted broad-sword, C-2569/*18*.

basket-hilted broadsword, C-2569/*31*.

basket mount, S-291/*197*①.

basket—Northwood, OPGAC/*180*.

basket-shaped, C-5174/*588*①.

basket stand, C-5127/*277*①; SDF/
①.

basket stitch, DADA.

basket-top, EA.

basket top, CEA/*231*①; LAR82/
*200*①; SDF.

basket vase, IDPF/*14*.

basket ware, IDC/①.

basket-weave, C-5220/*18*①; CEA/
*450*①.
basket weave, C-0254/*239*; OPGAC/
203; SDF.
basketweave, C-2458/*366*①.
basketweave border, S-4461/*137*.
basketweave design, S-4414/*20, 154*;
S-4461/*334*.
basket-weave motif, MP/*122*.
basket weave pattern, C-5156/*333*.
basketweave pattern border, C-0279/
364.
basket-weave side, C-5117/*144*①.
basket-work, CEA/*648*①.
basket work, C-1006/*64*; SDF.
basketwork, C-0225/*165*; C-2427/
*19*①; C-2458/*282*; C-5236/*1769*.
basketwork border, LAR82/*92*①.
Baskin, Leonard, S-286/*16*.
basma, C-5189/*224*①; RGS/*37*.
basma technique, RGS/*133*①.
bason, IDC.
Basque, DADA.
bas-relief, CEA/*534*①; DADA; IDC;
SDF.
bas relief, ACD; C-0225/*103*;
C-0279/*430*①; C-5156/*392*①;
DATT; LAR82/*102*①.
bass, CEA/*549*.
Bassano, LAR82/*137*①.
bass drum, CEA/*554*①.
basset, DADA.
basse-taille, DADA; IDC; RGS/*40*.
bassetaille, DATT.
basse-taille enamel, RGS/*123*①.
basse taille enamel, ACD.
basse-taille enamelling, EA/①.
basse taille enamelling, CEA/*70*.
Basset-Lowke, CEA/*696*①.
Bassett, Francis I, CEA/*591*①.
Bassett, Frederick, CEA/*591*①;
S-4905/*310*.
Bassett, John, CEA/*591*①.

basset table, SDF.
bassinet, SDF.
bass lute, EA/*lute family*.
bassoon, CEA/*549*.
basso-relievo, SDF.
basso-rilievo, DADA; DATT.
basso rilievo, IDC.
basso rilievo istoriato, IDC.
bass-relief, SDF/*bas-relief*.
bass seat, DADA.
bass viol, CEA/*551*①.
basswood, DATT; SDF.
basting-spoon, C-2487/*56*.
basting spoon, C-0254/*4, 127, 218*;
C-0706/*59*; C-1502/*197*; C-5203/
199; DADA.
bat, DATT; DSSA; IDC.
Bataille, Jean Charles, CEA/*631*①.
Bataille, Nicolas, EA.
batavian ware, DADA; EA; IDC.
batch, CEA/*502*; EA; EG/*286*.
batch house, EG/*236*.
bateau, C-5239/*116*.
Bateman, ACD.
Bateman, Hester, C-5117/*57*①; EA;
NYTBA/*221*.
Bateman, P. and A., C-2487/*76*.
Bateman, Peter and William, C-5117/
*31*①.
Bateman, Peter, Ann, and William,
C-5173/*20*①.
Bateman, Peter & Jonathan, S-4944.
Bateman, William, C-0406/*130*.
Bateman, William II, S-3311/*176*.
Bateman family, EA.
Batemen, Hester, CEA/*656*①.
Batenin: Sergei, Peter, Filipp, EA.
Bates, Aaron, C-5117/*94*.
Bates, Kenneth F., DADA/
Supplement.
Batesville marble, DATT.
bat girl, C-2409/*288*.

bath, IDPF/*14*①; SDF/①.
bat handle, C-5156/*162*①.
Bath border, EA/*pie-crust*.
bath chair, SDF/①; EA.
bath fireplace, SDF/①.
bath metal, SDF; EA.
bath metal toy, CEA/*697*.
bath rasp, IDPF/*14*①.
bathroom furniture, SDF.
bath-shaped, IDPF/*14*.
bath stove, SDF/① *bath fireplace*.
batik, C-0405/*197*; DADA.
batiste, FFDAB/*75*.
bat motif, OC/*315*.
baton, CEA/*524*.
baton-shaped, S-4927/*128*①.
baton stripe, C-2388/*183*.
bat-printed, C-1006/*96*.
bat-printing, IDC.
bat printing, ACD; DADA; EA.
bats and clouds, C-0782/*3*.
bats in flight motif, S-4965/*273*①.
battam ware, ACD.
batten, SDF.
batten and button, SDF.
batten-board, SDF.
batten-end, C-5114/*318B*①.
batten end, C-5114/*378*①.
batter bowl, IDPF/*15*①.
batter head, CEA/*554*①, *556*.
batterie de cuisine, CEA/*554*①.
batter-jug, IDC.
batter jug, IDPF/*15*; K-802/*17*.
Battersea, DADA; EA.
Battersea enamel, ACD; S-4988/*415*①.
battery metal, EA/*latten*.
battle-axe, DADA/①.
battle for the breeches, IDC.
battle hammer, S-4972/*239*.
battlement crest, S-4905/*141*①.
battle scene, IDC/①; MP/*66, 121*.

bat-wing shaped, C-2202/*3*.
Baubé, Jean-Baptiste, C-5174/*472*.
bauchkanne, C-2498/*53*; C-2382/*64*①.
baudekin, DADA.
Baudesson, Daniel, CEA/*65*①; EA.
Baudoin, Pierre-Antoine, EA.
Baudouine, Charles A., DADA/*Supplement*.
Bauer, Adam, CEA/*178*①.
Bauer, Matthias, CEA/*138*①.
Bauer Am Taubenschlag, C-2427/*83*①.
Bauerntanzkrug, IDC.
Bauhaus, DADA/*Supplement*; DATT; IDPF/*105*; LP; NYTBA/*6*; RTA/*141*.
Baule, C-1082/*76*.
baulk, SDF/*balk*.
bauluster-form, C-5153/*14*①.
Baumann, Fritz, S-286/*184*①.
Baumgarten Works, Williamsbridge, N.Y., NYTBA/*98*.
Baumhauer: Joseph, Gaspard, Joseph, EA.
Baur, J. W., CEA/*173*①.
Bautte, Geneve, S-4927/*39*.
Bautte Rossel, J. F., & Fils, C-2489/*142*.
Baxter, C-0405/*123*; C-1603/*14*.
Baxter, Thomas, ACD; EA.
Baxter print, ACD.
Bayard, Cailar, C-5203/*75*.
Bayer, J. C. W., CEA/*181*①.
bayes, SDF.
Bayeux lace, DADA.
Bayeux tapestry, DADA.
bay-leaf band, RGS/*123*①.
bayleen, S-2882/*634*①.
Bayley, John, Bridgewater, C-2489/*112*①.
Bayley, Richard, C-5174/*597*①; S-4922/*16*①; S-4944/*403*.

bayonet, ACD; CEA/*27*; S-4972/
*273*①.

bayonet cover, C-0254/*106*.

bayonet fastener, DADA.

bayonet fastening, CEA/*644*①.

bayonet joint, C-0254/*94, 102*;
C-2487/*145*; EA.

bayonet slide, C-MARS/*123*.

Bayon style, C-5156/*208*.

Bayreuth, ACD; C-2427/*142*①, *181*;
CEA/*138*①; DADA; EA/①;
LAR82/*90*①.

Bayreuther, OPGAC/*351*.

Bayreuth Hausmalerei, EA.

Bayreuth ware, IDC.

bays, C-5239/*273*.

Bay State Glass Company, EA.

baywood, ACD; DADA; SDF.

bay wreath, RGS/*35*.

bay-wreath cartouche, RGS/*31*①.

bay-wreathed medallion, RGS/*31*①.

'bazaar goods', OC/*322*.

Bazel, Karel Petrus Cornelis de,
DADA/*Supplement*.

Bazerga, Geb., Rotterdam, C-MARS/
202.

bazil, SDF.

B. C. & Co., C-2904/*270*.

bead, ACD; C-0249/*294*; C-5114/
*326*①; C-5116/*39*; C-5156/*300*①;
C-5236/*779, 1687*; CEA/*541, 579*;
DADA; IDPF/*15*①; S-4461/*452*;
SDF.

bead, beading, CEA/*405*.

bead and butt, SDF/①.

bead and flush, SDF/①.

bead and gadroon, IDC.

bead and leaf sconce, S-4804/*160*①.

bead and mask handle, C-5117/
*198*①.

bead and quirk, SDF.

bead-and-reel, C-2388/*136*; C-2403/
*109*①; C-2421/*15*①, *29*①.

bead and reel, DADA; DATT/①;
SDF.

bead-and-reel border, S-4507/*61*①.

bead and reel border, IDC.

bead-and reel moulding, EA.

bead-and-reel ornament, C-2478/*61*.

bead curtain, SDF.

beaded, C-0406/*17*; C-0982/*16*;
C-1082/*26*; C-2202/*15*; C-2402/
172; C-2403/*90*①; C-5005/*402*①;
C-5114/*44*; C-5153/*22*①; DADA.

beaded acorn medallion, OPGAC/
203.

beaded ball, S-4905/*329*.

beaded band, C-5117/*12*; OPGAC/
204.

beaded base, C-2437/*12*①.

beaded border, C-0254/*24*; C-2388/
*26*①; C-2398/*8*; C-2402/*28*;
C-5114/*13*; C-5117/*58*①; C-5146/
*166*①; IDC; RTA/*68*①; S-2882/
*901, 934*①, *967, 1051, 1077*;
S-4507/*55*①.

beaded brass border, C-5114/*162*.

beaded circular foot, C-5117/*61*①.

beaded column, C-2458/*47*.

beaded cushion knop, CEA/*430*①.

beaded dewdrop, OPGAC/*204*.

beaded drawer, C-5114/*269*①.

beaded edge, C-5114/*364*①; IDC;
S-4965/*69*.

beaded foot, C-5117/*205*①, *228*①.

beaded frame, C-2320/*15*①; C-2403/
*66*①.

beaded frieze, C-0279/*280*.

beaded glass, C-5239/*310*.

beaded grape, OPGAC/*204*.

beaded grape medallion, OPGAC/
204.

beaded knitting, CEA/*274*①.

beaded knop, LAR83/*418*①.

beaded leaf, S-2882/*1214*①.

beaded lip, C-5153/*50*①; S-4461/*496*.

beaded loop, OPGAC/*204*.

beaded molding, LAR83/*254*①.

beaded moulding, CEA/*643*①.

beaded mount, CEA/*515*①.

beaded outer border, RTA/*65*①.

beaded outline, C-1407/*22*.

beaded pattern, C-0254/*76*.

beaded plinth, C-2437/*22*①.

beaded rat-tail, S-4922/*13*①.

beaded rib, C-5117/*73*①.

beaded-rim, C-2402/*58*.

beaded rim, C-5114/*26*①; S-2882/ *948*①; S-4414/*337*; S-4922/*49*①.

beaded rim base, S-4804/*178*①.

beaded scroll handle, C-5117/*203*①; LAR83/*634*①; S-2882/*939*①.

beaded shell, S-4922/*13*①.

beaded shell foot, C-0254/*155*.

beaded spreading base, C-5117/*58*①.

beaded support, C-5117/*61*①.

beaded tulip, OPGAC/*205*.

beaded wire, RTA/*32*①.

bead finial, C-5153/*8*.

bead-foresight, C-MARS/*127*①.

beading, C-1502/*73*; C-5116/*133*①; CEA/*678*; IDC; MP/*35, 172*; RTA/*30*①; S-2882/*671*①; S-3311/ *228*①; S-4461/*213*; S-4804/*135*.

beading frame, CEA/*314*①.

beading tool, RTA/*153*①.

bead-molded footrim, C-5114/*124*.

bead molding, DATT/①.

bead moulding, ACD; EA.

bead pattern, C-5156/*218*.

bead pedestal, C-0225/*165*.

bead pendant, C-5156/*306*①.

Bead & Pod, C-0270/*180*.

bead rim, IDPF/*16*①.

beads and marbles: eye bead, EA.

bead stopper, C-5236/*1735*.

bead support, S-4414/*424*.

bead work, ACD; CEA/*279*①; DADA; SDF.

beadwork, C-0906/*193*; C-1082/*10*; C-3011/*115*; C-5239/*310*; NYTBA/*104*①.

beadwork basket, C-2357/*7*①.

beadwork border, S-2882/*718*①.

beadwork picture, C-0249/*282*.

beadwork rim, S-4461/*172*.

beak, IDC; IDPF/*17*; LAR82/*39*①.

beaked branch, C-2421/*7*①.

beaker, ACD; C-0254/*3, 46, 145A*; C-0706/*143*; C-0782/*142*; C-1502/ *75*; C-2202/*69*; C-5114/*4, 95*①; C-5117/*18, 27*①; C-5153/*40*①; CEA/*629*①; DADA; EA/①; EG/ *27*①; IDC; IDPF/*16*①; LAR83/ *412*①; MP/*32*; NYTBA/*227*; S-4461/*204*; S-4802/*181*; S-4804/ *112*①, *209*; S-4905/*174*; S-4922/ *7*①; S-4972/*412*.

Beaker Folk form, IDPF/*21*.

beaker form, S-4414/*221*①.

beaker splat, S-4436/*105*①; S-4812/ *110*①; S-4988/*457*①.

beaker vase, C-0782/*10, 114*; C-2323/*96*; C-2458/*93*; C-5127/*67*; C-5156/*54*①; C-5236/*499*; LAR82/*93*①.

beak molding, DATT/①.

Beale, Charles, EA/*Beale, Mary*.

Beale, Mary, EA.

beam, C-2904/*28*.

beam balance, C-0403/*36*; C-2489/ *22*; C-2608/*104*.

bean-end, C-1502/*23*.

bean pot, IDPF/*17*①.

bearded man jug, EA/*bellarmine*.

bearded mask, C-0254/*312*①; C-2364/*58*①; C-2403/*113*; C-2427/*195*; C-2437/*18*①.

Beardsley, Aubrey Vincent, DADA/ *Supplement*.

bearer, CEA/*405*; SDF.

bear-form decoration, S-4965/*143*①.

bear-jug, IDC/①.

bear jug, DADA/①; EA; IDPF/
 *17*①.
Bear series, EA/*Austin, Jesse.*
bears of Berne set, C-2332/*21*①.
Bear's Paw, CEA/*287.*
beaten and pierced, C-2324/*258.*
beaten copper, C-2409/*233;* C-5156/
 150.
beaten gold, RTA/*190*①.
beaten metal, EA/*a barbottina.*
beaten shape, IDPF/*18*①.
beating, IDPF/*55*①.
beating-down, OC/*21*①.
beatnik, LP.
Beatty & Sons, Alexander J., EA.
beau bleu, IDC.
Beau Brummel, DADA.
Beau Brummel dressing table,
 LAR82/*391*①.
Beau Brummell table, SDF.
beaucage, IDC.
Beaudin, André, S-286/*432.*
beaufait, ACD.
Beaujolais, DADA.
Beaumont, Jean, C-5167/*216*①.
Beaumont-Adams, CEA/*36*①.
Beaumont Glass Company, CEA/
 *477*①.
beautrellis, C-0225/*165.*
beauty, LP.
Beauvais, ACD; C-5167/*216*①;
 DADA; NYTBA/*97;* S-4972/
 *197*①, *590.*
Beauvais carpet, EA.
Beauvais tapestry, C-2364/*36*①;
 C-5116/*94*①; EA/①; SDF.
Beauvais tapestry upholstery, S-4955/
 *147*①.
Beauverie, C., S-286/*70.*
beaux-arts, LP.
Beaux-Arts, Ecole des, DATT.
Beaux Arts style, NYTBA/*320.*
beaver, C-1506/*47;* DADA.

beaver board, DATT.
beaver-tail forend, C-2476/*46.*
Becerril, Cristobal, CEA/*620*①.
Becerril family: Alonso, Francisco,
 Cristobal, EA.
Bech, Paul, CEA/*315*①.
Becher, Leopold, CEA/*25*①.
Beck, C-2904/*104*①.
Beck, R. & J., London, C-MARS/
 197.
Becker, C-2904/*29.*
Becker, Johann Albrecht, EA.
Becker & Buddingh, C-2904/*218.*
Beckere, P. de, CEA/*537.*
Beckers Sons, C-2904/*30.*
Beckmann, Max, S-286/*185*①.
beckoning Chinaman, the, IDC/①.
Beckwith, London, C-2503/*201*①.
bed, C-5005/*342*①; DADA/①; EA;
 S-4461/*693;* S-4972/*471;* SDF/①.
bed case, SDF.
bed-chair, CEA/*328*①; SDF.
bed console, S-4507/*69*①.
bed cover, CEA/*276*①.
bed end, C-0982/*92.*
bedfordshire lace, DADA.
Bedfordshire Maltese lace, C-2203/
 124.
Bedfordshire Maltese style, C-2704/
 143.
Bedford stone, DATT.
bedhanging, C-1506/*100*①; NYTBA/
 104.
bed joiner, SDF.
bed-lines, SDF.
bedmatt, SDF.
bedpan, IDC.
bedpillar, SDF/① *bedpost.*
bed post, C-0982/*314.*
bedpost, SDF/①.
bedpost clock, SDF.
bedrieger, IDC.

bedroom chair, C-2402/*90*; SDF/①.

bedroom suite, C-2402/*14*; S-4461/*738*①.

bed rug, NYTBA/*110*①.

bed-settee, SDF.

bedside cabinet, S-3311/*118.*

bedside cupboard, C-2478/*136*; C-5181/*173*①; EA/①, ① *night table*; S-4436/*91*; SDF/①.

bedside table, C-5181/*153*; EA/①; S-4972/*625*; SDF.

bedspread, NYTBA/*98*①; SDF.

bedstaff, SDF/①.

bedstead, C-0982/*267*; C-2402/*68*; C-5114/*388*①; C-5153/*156*; DADA; EA; FFDAB/*77*①, *82*①; S-4804/*909*①; SDF/①.

bedstead bolt, SDF.

bedsteads, C-2402/*14.*

bed-steddle, SDF.

bed steps, DADA; EA; LAR83/*355*①; SDF/①.

bedstick, SDF/① *bedstaff.*

bedstock, SDF.

bed table, EA; SDF/①.

bed wagon, SDF.

B. Edwards, Belfast, EA/*Belfast Glass Company.*

bed-warmer, EA/① *warming-pan.*

bedwarmer, S-3311/*200*; S-4461/*617*; S-4905/*322.*

bed-warming pan, C-2498/*25.*

bee, EA/*Jacobite glass.*

bee and brickwork, LAR83/*351*①.

beech, ACD; C-0982/*4, 94*; C-1407/*93*; C-2402/*72*; C-5116/*165*①; FFDAB/*33*; SDF.

beech-framed, C-2402/*210.*

beechwood, C-0249/*367*; C-0403/*88*; C-0982/*18, 85B*; C-1407/*41*; C-2403/*30*; C-2478/*24*; C-5181/*180*①; DADA; LAR82/*79*①, *289*①; S-4461/*678*; S-4804/*910*①; S-4881/*88*①; S-4972/*498.*

beefeater flagon, EA.

Beefeater's Hat shaped cover, CEA/*584*①.

beefwood, LAR82/*329*①.

beehive, EC2/*90*; IDPF/*19*①; CEA/*246*①.

beehive chair, SDF/①.

beehive clock, EA.

beehive form, C-2409/*72.*

beehive headdress, C-5234/*98*①.

beehive honey pot, LAR83/*590*①.

beehive mark, C-0249/*186*; C-2427/*69*①; C-2486/*92*①; C-2493/*305.*

beehive shaft, C-2478/*1.*

beehive-shaped, C-2513/*268.*

beehive turning, C-5114/*240.*

beehive waterpot, S-3312/*1364*①.

Beeldenkast cupboard, LAR82/*336*①.

beer bottle, IDPF/*19.*

beere, SDF.

beer jug, C-0254/*168.*

beer-jug, C-5117/*76*①, *255*①; C-5173/*33*①.

beer wagon, SDF.

Beesley, C-2476/*80.*

bee super, IDPF/*19.*

beeswax, DATT; LP.

Beetham, Mrs Isabella, EA/①.

beetle and poker hand, C-5117/*473*①; S-4802/*132B*; S-4927/*30.*

beetle trap, IDC/①.

beggar's badge, EA/*badge.*

begging bowl, IDC.

Béhagle, Philippe, EA.

Behbehan, OC/*198*①.

Behbehan red, OC/*216.*

Behrens, Peter, DADA/*Supplement.*

beige, LP.

Beijing, C-2323/*152.*

Beijing glass, C-2414/*1*①; C-2458/*279*; C-2513/*79.*

Beilby, S-4972/*416.*

Beilby, Mary, EA/① *Beilby, William.*

Beilby, William, C-5117/*253*①; CEA/*442*①; EA/①.

Beinglas, EA.

Belarmine, C-1006/*61*.

Belcher, Joseph, CEA/*592*①.

Belcher Bros., CEA/*609*①.

Belchier, John, C-2522/*125*①.

Belding, Samuel, CEA/*389*.

Beleek, ACD.

Belfast, CEA/*446*①.

Belfast Glass Company, EA.

Belgian Art Nouveau, DADA/*Supplement.*

Belgian black, DATT.

Belgian Contemporary Arts and Crafts, DADA/*Supplement.*

Belgian marble, DATT.

Belgian marble, black, DADA.

Belgian Symbolism, JIWA/*10*.

Belgian Symbolist, JIWA/*11*.

Belgique marble, S-4972/*625*.

bell, C-1082/*49*; C-2421/*52*①; C-2458/*1*; C-5117/*210*①; C-5156/*183*; C-5157/*34*①; CEA/*230*①, *549*; DSSA; EA/*Roberts, Samuel the Younger*; IDC/①; IDPF/*19*①; MP/*31*; S-4972/*113*①.

Bell, G. H., EA/*37*.

Bell, John, C-1582/*96*; C-2204/*67*.

Bell, Peter, CEA/*167*①.

Bell, Samuel, CEA/*154*①.

Bellamine jug, C-2502/*99*.

bell-and-baluster, SDF/①.

bell and baluster turning, EA.

Bellanger, Joseph, C-5220/*54*①.

bellarmine, ACD; DADA; EA/①; IDC/①; IDPF/*20*①; LAR83/*66*①; C-1582/*149*; CEA/*136*①.

Bellarmine jug, NYTBA/*158*①.

Bellarmino, Cardinal Roberto, CEA/*136*①.

bell beaker, IDPF/*21*①.

bell bowl, CEA/*423*①; LAR82/*442*①; LAR83/*451*①; S-4972/*415*.

bell canopy, CEA/*220*①.

belled, C-2503/*116*.

Belleek, C-0249/*205*; C-1006/*34*; C-1582/*42*; C-2493; CEA/*204*①; DADA; DATT; EA; LAR83/*66*①; OPGAC/*347, 352*; S-4804/*288*①.

Belleek Co., Fermanagh, C-2493/*168*.

Belleek Tridacna ware, C-5189/*23*.

Belleek ware, DADA/*Supplement*; IDC/①; NYTBA/*180*.

Belle Epoque maiden, C-5005/*219*①.

Bellegarde tapestry, EA.

Bellenot, Peug, S-4947/*135*①.

belle peinture, LP.

Belle Époque, La, LP.

Bellevue, DADA; EA.

bell-flower, C-2403/*90*①.

bell flower, C-1407/*78*; DADA.

bellflower, C-0982/*38, 82B*; C-2402/*30*; OPGAC/*205*; SDF/①; CEA/*472*①.

bell-flower chain, C-5157/*162*①.

bellflower husk wreath, C-5114/*332*①.

bell-flower inlaid, S-4414/*457*.

bell-flower motif, EA.

Bellflower pattern, CEA/*469*①.

Bellflower table glass, EG/*274*①.

bell-form, S-2882/*1324*; S-4461/*25, 29*.

bell form, C-1082/*37*; S-2882/*1044*①, *1329*.

bell-form bowl, S-2882/*1086*①.

bell-form finial, S-2882/*1102*.

bell-form sconce, S-2882/*1032*①, *1189*.

Bell Gum, CEA/*56*①.

Belli, Valerio, EA.

Belli, Vincenzo, EA.

bellied tankard, EA.

Beman, Reuben, Jr., DADA.

Ben Akiba, LAR82/*75*①.

Benares, C-1407/*172*; C-5173/*13*①.

bench, C-0249/*463*; C-0982/*205*;
 DADA; S-4461/*637*; S-4507/*20*①;
 S-4972/*479*; SDF.

bench base, C-5114/*380*①.

bench board, SDF.

bench end, SDF.

bench table, EA; SDF.

bench-work, CEA/*528, 541*.

Benckgraff, J., CEA/*175*①.

Benckgraff, Johann, CEA/*176*①; EA.

bend, SDF.

Benda, G.K., C-5191/*235*.

bended-back, EA.

bended-back chair, SDF/①.

bending, CEA/*528*.

bends (in furniture), EA.

Benedict, Julius, C-0906/*325*.

Beneman, Guillaume, DADA/①.

Beneman, Jean Guillaume, ACD.

Beneman (Benneman), Jean
 Guillaume, EA.

Bengal cutch, DATT.

Bengal Tiger pattern, C-2493/*56*;
 LAR83/*178*①.

Bengal tyger pattern, IDC.

Bengtsson, CEA/*315*①.

Benin, C-0405/*125*; C-1082/*49*;
 LAR82/*52*①.

Benin handscreen, C-1603/*105*.

bénitier, IDC/①.

Benitier, C-2427/*170*.

Bénitier, EA.

Benjamin Cheney Jr., EC2/*89*.

Benjamin & James Smith, S-4922/
 *14*①.

Benjamin Laver, S-3311/*763*①.

Benjamin Smith, S-4922/*78*①.

Benjamin Stephenson, C-0706/*17*.

ben Jischai, Moses, C-5174/*42*①.

Bennet, Ward, DADA/*Supplement*.

Bennet pottery, DADA.

Bennett, Edwin, K-710/*119*.

Bennett, Edwin, Pottery Company,
 DADA/*Supplement*.

Bennett, E.& W. Pottery, EA.

Bennett, London, C-2503/*200*.

Bennett, Mansell, London, C-2489/
 *92*①.

Bennett, Peter, C-2487/*56*.

Bennett, Samuel, SDF/*745*.

Bennett, William, C-2487/*113*;
 C-5117/*218*; C-5174/*518*①.

Benney, Gerald, CEA/*663*①.

Bennington, CEA/*205*; DADA/①;
 OPGAC/*350*; S-4461/*165*.

Bennington, Vermont, CEA/*168*①.

Bennington potteries, EA.

Bennington ware, IDC.

Benoni Stephens, C-0406/*45*.

Benood, William, John, EA.

Benson, CEA/*234*①.

Benson, J. W., London, S-4927/*138*.

Benson, William Arthur Smith,
 DADA/*Supplement*.

bent chisel, DATT.

bent gouge, DATT.

Bentley, S-4843/*349*①.

Bentley, Thomas, ACD; EA; K-710/
 117.

bent line, JIWA/*53*.

Benton, Thomas Hart, S-286/*187*①.

bentonite, DATT.

bent spout, C-5127/*17*.

bent wire, S-4881/*227*①.

bent-wood, DADA.

bentwood, ACD; C-0225/*360*;
 C-0403/*7*; C-1407/*65*; C-5127/*345*;
 C-5236/*811*①; C-5239/*255*;
 S-4461/*570*①.

bentwood furniture, EA; K-711/*121*;
 NYTBA/*4*; SDF/①.

benzene, DATT; LP.

benzine, DATT; LP.

benzol, DATT; LP.

benzol black, DATT.

Bérain, Jean, ACD; CEA/*317*①.

Berain: Jean, Jean II, EA.

Bérain, Jean, the Elder, DADA.

Berainesque, C-5189/*112*①.

Bérainesque design, C-2364/*66*①.

Bérain motif, IDC.

berbery, SDF/*barberry*.

berdelik, DADA.

beret, C-3011/*63*.

berettino, DADA; IDC.

Berg, Magnus, EA.

Bergama carpet, EA/①.

Bergama rug, ACD; C-0279/*29*;
C-0906/*36*; C-1702/*5*; C-2403/*178*.

Bergamo, CEA/*80*①; DADA;
S-4847/*40*.

Bergamo Yastik, S-4948/*3*.

Berge, E., C-5191/*129*.

Berge, Henri, C-5005/*253*①.

Bergé, Henry, C-5167/*123*①.

Berger, Christian Gottlieb, MP/*170*.

bergère, ACD; C-1407/*19*.

bergere, C-2370/*26*.

bergerè, C-2421/*62*.

bergere, C-5157/*159*①.

bergère, CEA/*377*①.

bergere, CEA/*405*; LAR83/*278*①,
*289*①; S-2882/*790*.

bergère, S-3311/*516*①.

bergere, S-4414/*468*; S-4461/*629*,
686; S-4812/*181*①; S-4823/*209*.

bergère, S-4853/*423*①; S-4988/
*551*①; SDF/①; C-5114/*342*①;
CEA/*385*①; DADA/①; EA.

bergère à l'oreilles, C-5224/*132*.

bergère d'enfant, C-5224/*187*.

bergere d'enfant, C-5259/*557*①.

bergère en cabriolet, S-4955/*66*①.

bergere en cabriolet, S-4972/*593*.

bergère en confessionnal, EA.

bergere en gondole, C-5259/*467*①.

bergère en gondole, S-4955/*77*①.

bergere lounge suite, LAR83/*359*①.

Bergh, Elis, DADA/*Supplement*.

Bergman, Frank, C-5191/*131*.

Bergman, Johan, S-4944/*146*①.

Bergonzi, C-0906/*282*.

Beringer, CEA/*40*①.

Beringer, David, EA/①.

Berkeley Castle Service, EA.

Berkey and Gay, DADA/*Supplement*.

Berlage, Hendrik Petrus, DADA/
Supplement.

berlin, C-5259/*134*; C-2427/*41*;
C-2486/*64*①; C-2493/*259*; DADA.

Berlin blue, DATT; LP.

Berlin cup, IDC.

Berlin double cross mark, C-2364/*6*.

Berlin Faience factories, EA.

Berlin figure, C-1006/*133*; S-4461/
138.

Berlin iron jewellery, EA/①.

Berlin K.P.M., C-5189/*34*.

Berlin oviform vase, C-1006/*37*.

Berlin plaque, S-4947/*32*①; S-4992/
*99*①.

Berlin porcelain, ACD; C-2364/*6*;
S-3311/*367*①.

Berlin porcelain factory, EA/
Antikzierat, ① *Berlin Faience
factories*.

Berlin porcelain works, MP/*206*.

Berlin school, EA/①.

Berlin tapestry, EA.

Berlin transparency, IDC.

Berlin wool, CEA/*294*.

Berlin wool work, DADA.

Berlin woolwork, C-2704/*10*; CEA
275.

Bernard, Emile, S-286/*463*.

Bernard Palissy, S-4843/*23*①.

Berndorf Electroplate Manufacturing Co., DADA/*Supplement.*

Bernini, Giovanni Lorenzo, DADA.

Bernini-Permoser tradition, MP/*115.*

Bernini tradition, MP/*139.*

bernous, C-1506/*4.*

Berovieri family, EA.

berretino, C-2486/*212*①.

berrettino, CEA/*209*; EA; C-2427/*221*①.

berried, C-5156/*127*①.

berried finial, C-2437/*18*①.

berried foliage, C-2421/*101.*

berry finial, S-2882/*1203.*

berry-pattern, C-2458/*105*①.

berry spoon, C-0254/*118, 282*; C-0406/*14*; C-1502/*168*; C-5203/*201*; DADA; S-4804/*64.*

berry theme, RGS/*34.*

Bertha of Limerick, C-1506/*175.*

Berthe, J., C-5220/*23*①.

Berthevin, Pierre, CEA/*149*①.

Berthon, Paul, S-286/*194*①.

Berthoud, C-5117/*462.*

Berthoud, Ferdinand, CEA/*228*①; EA.

Berthoud, Paris, S-4927/*61, 172.*

Bertoia, Harry, DADA/*Supplement.*

Bertolla, Bartolomeo Antonio, CEA/*225*①.

Bertrand, Joseph Charles Paul, C-2555/*27*①.

beryl, C-5146/*67*①.

besaque, DADA.

Beshir, C-2388/*204*; C-2478/*267*; OC/*104*①, *176*①, *190*①, *192*①.

Beshir carpet, C-2403/*203.*

Beshire rug, DADA.

Beshir rug, ACD.

Besnard, Albert, S-286/*195*①.

Besnier, Nicolas, EA.

Bessarabian, OC/*264*; S-4804/*960.*

Bessarabian carpet, S-3311/*79*①.

Bessarabian carpet fragment, C-0279/*414.*

Bessarabian design, C-0279/*413.*

Bessarabian kilim, C-1702/*39.*

Best, Marmaduke, C-5173/*51.*

Bestelmeier, G. H., CEA/*685.*

Beswick, C-2204/*130*; C-2409/*141.*

betel box, CEA/*62*①.

betrothal jug, IDC.

betrothal ring, RTA/*110*①.

Better Nine, EA/*Britannia Standard.*

Bettisi, Leonardo, EA.

Betts, Thomas, EA.

Betts label, C-0906/*339.*

betty lamp, EA/*cruisie*; S-4905/*345*; DADA/①; SDF.

Beugel, Peter, C-MARS/*15.*

Beunigen, Clemens, C-MARS/*15.*

Beurdeley, Alfred-Emmanuel-Louis, S-4947/*136*①.

Beuren, Paul, C-5173/*52*①.

beurrier, IDC.

beutelflasche, IDPF/*21.*

Beutmuller, Caspar, EA/*269.*

Beutmuller, Caspar II, EA/*244.*

Beutmuller, Hans, EA.

Beutmüller the elder, Caspar, CEA/*626*①.

Bevan, Charles, SDF/*746.*

bevel, S-286/*296*; SDF.

beveled, C-5116/*125*①; FFDAB/*51.*

beveled glass, S-4461/*80, 498.*

beveled glass mat, C-5114/*171*①.

beveled tapered stem, S-2882/*1096*①.

bevel-glazed case, LAR83/*206*①.

bevelled, C-0982/*16, 82B*; C-2478/*59*; C-5153/*154*①; C-5236/*546*; EG/*260*; S-4436/*8*①.

bevelled edge, C-2458/*209*①; C-5127/*145*; C-5156/*484*①.

bevelled plate, C-2402/*79.*

bevelled rectangular plate, C-5116/*132*①.

bevor, C-2503/*75*; C-2569/*55*;
S-4972/*166*①.

Beyer, Johann Christian Wilhelm,
EA.

Beyerlé monogram, EA/*Niderviller.*

Bezalel, C-5174/*89*①.

bezel, ACD; C-0279/*189*; C-2332/*37*;
C-5117/*432*; C-5173/*51*; CEA/*267,
405*; EA; RTA/*18*①; S-291/*172*;
S-4461/*315, 339*; S-4802/*11,
135D*①; SDF.

bezels, S-291/*104*①.

bezel-set, S-4927/*258*.

Beziard, C-5117/*461*.

bezzel, C-1702/*361*.

B.F.B., EA/*Worcester.*

B. F. Perkins & Sons Inc., C-2904/
78.

BGH Ping, EA/*Häuer (Hoyer.*

B. Haas & Co., C-5117/*443*①.

Bhadohi, OC/*305*.

bhuj, C-2503/*1*.

bhumisparsa mudra, S-4810/*279*.

bi, C-5156/*316*①; C-5234/*206*①;
C-5236/*328, 1737*; S-4810/*468*;
S-4965/*139*①.

biacca, DATT.

bianca-sopra-bianca porcelain vase,
JIWA/*92*.

bianchetto, IDC.

Bianchi, Ipswich, C-2489/*38*.

bianchi di Faenza, EA/*fašence
blanche.*

bianco di Faenza, IDC.

bianco sangiovanni, DATT; LP.

bianco sopra azzurro, DADA; IDC.

bianco-sopra-bianco, C-2360/*143*;
CEA/*147*①; S-4843/*26*; S-4905/
*12*①.

bianco sopra bianco, ACD; C-5127/
250; DADA; EA; IDC.

Biarritz, C-2409/*86*.

Biarritz, The, C-2910/*87*.

Biarritz Bizarre, C-2910/*76*.

bibelot, DADA; EA/*objects of vertu*;
S-4461/*280*.

biberon, DADA; IDC; IDPF/*21*.

Bibibaff, OC/*149, 279*.

Bibikabad, C-5189/*377*.

Bibikabad carpet, S-4796/*213*.

Bibik-Abad rug, DADA.

Bibikibad, S-4847/*230*.

bible box, C-0982/*226*; EA/①;
C-0249/*387*; C-1407/*86*; CEA/
*325*①; DADA; NYTBA/*31*; SDF.

Bible paper, DATT.

Bible pillow, C-3011/*114*.

Bible scenes motif, C-5174/*168*.

Biblical tapestry, LAR83/*649*①;
S-4972/*173*①.

bibliothèque, C-0225/*375*.

bibliotheque, C-0249/*454*①; C-5259/
*479A*①.

bibliothèque, DADA; EA.

bibliothèque basse, C-5224/*118*①;
EA.

bibliotheques, C-0279/*453*①.

bice, DATT; LP.

Bickford, Walter, EA/*216*.

Bickley, Benjamin, EA.

bi-colored, C-5005/*219*①.

bicycle, C-0906/*89*.

bicycle lamp, C-0906/*94*.

Bideford, LAR82/*131*①.

Bidermann, Samuel, CEA/*555*①.

bidet, ACD; C-0279/*400*①; EA;
IDC; SDF.

bidet chaise, S-2882/*396*①.

Bidgeneh, OC/*257*①.

bi disc, C-5234/*207*①; C-5236/*336*;
S-4810/*391*.

bidjar, S-4847/*146*; C-5189/*385A*①;
CEA/*91*①; S-4847/*54*.

Bidjar carpet, S-4796/*161*.

Bidjar mat, LAR83/*527*①.

Bidjar rug, S-3311/*10*; S-4461/*780*;
S-4796/*7*.

binding, SDF.

binding hole, C-5236/*1006*①.

Bing, Samuel, CEA/*520*.

Bing, Samuel (Siegfried), DADA/ *Supplement*.

Bing and Grøndahl, DADA/ *Supplement*.

Bing and Grondahl, C-1006/*195*; S-4804/*538*.

Bing & Grondahl, C-0249/*221*; LAR82/*130*①; OPGAC/*352*.

Bing & Grondahl, Copenhagen, JIWA/*343*①.

binjin-ga, C-5236/*947*.

bin label, IDC.

Binns, Charles Fergus, DADA/ *Supplement*.

binocular, C-2904/*64, 102*.

binocular microscope, C-2608/*25*.

binocular periscope, C-0403/*111*.

biomorphic, LP.

biomorphic form, DATT/①.

bi-part thumbpiece, C-5114/*117*①.

Birbeck, W., S-4947/*189*.

birch, ACD; C-5114/*351*①; C-5146/ *143*①; C-5153/*93*①; C-5174/*281*; DADA; DATT; SDF.

birch-bark decoration, RGS/*179*①.

birch-bark quill work, CEA/*288*①.

birch box, C-5114/*257*①.

birch panel, C-5114/*387*①; C-5153/ *133*.

birch veneer, C-5114/*340*①.

birchwood, S-4972/*387*①, *644*.

bird, DSSA.

bird and flowering tree medallion, S-2882/*92*①.

bird and strawberry, OPGAC/*205*.

bird-beaked jug, EA.

bird box, CEA/*549*.

bird-cage, CEA/*394*①; IDC/①; S-3311/*111*①.

bird cage, C-5189/*242*; DADA; IDPF/*21*.

birdcage, C-5114/*250*①, *270*①; C-5116/*42*①, *135*; CEA/*405*; EA/ ①; SDF/①.

bird cage candlestand, LAR83/*380*①.

bird-cage clock, DADA.

bird cage clock, ACD.

birdcage clock, SDF.

birdcage crest, S-4461/*595*.

birdcage frame, CEA/*232*①.

bird-cage support, DADA/①.

bird cage support, C-1407/*158*; S-4436/*106*.

birdcage support, C-5114/*305*①, *398*①; S-3311/*193*; S-4905/*457*①.

birdcage tea table, C-5153/*90*①.

bird-call, IDC.

bird call, ACD.

bird-cup, DADA.

birdeye maple, C-5239/*286*.

bird-feeder, IDC.

bird feeder, IDPF/*21*①.

birdfeeder, S-4963/*85*①.

bird-filled medallion, S-4948/*12*.

bird-form, S-4965/*127*.

bird-form finial, S-2882/*982*①.

bird gnomon, CEA/*606*①.

bird handle, C-1082/*49*.

birdimal, OPGAC/*346*.

bird in flight decoration, S-4965/ *148*①.

bird-in-flight motif, S-4948/*7*①.

bird organ, EA.

bird picture, C-2421/*1*①.

bird rug, S-288/*11*①.

birds, IDC.

birds among plum, C-1082/*88*.

birds and cherries, OPGAC/*180*.

birdsbeak lock, SDF.

birdsbeak moulding, SDF/①.

bird's-eye, C-0982/*140*; S-3311/*203*.

bird's eye, ACD; C-0279/*275*;
C-5114/*278*①; DATT.

bird's-eye maple, C-5167/*167*①;
CEA/*401*①; LAR83/*372*①; SDF.

bird's eye maple, C-2421/*45*; S-4812/
33.

birds eye maple, C-2910/*274*.

birdseye maple, C-1407/*150*; DADA.

bird's-eye view, DATT/①; JIWA/
*291*①.

bird's eye view decoration, C-2522/
*120*①.

bird's head butt, C-2569/*85*①.

birds in a tree, EA/*birds in branches*.

birds in branches, EA.

birds in branchis, IDC.

bird's mask, C-2357/*5*①; C-2437/
*40*①.

birds mask, C-2421/*32*.

bird's mask scroll spout, C-5174/
*504*①.

birds on branches, C-1006/*71*.

bird-spout, IDC.

bird theme, RGS/*34*.

bird tureen, DADA; EA; IDPF/*22*①.

bird vase, LAR83/*127*①.

bird-whistle, IDC/(①).

Birge and Fuller, CEA/*245*①.

Birjand, CEA/*94*.

Birks, Alboine, LAR82/*157*①;
S-4947/*1*①.

Birks, Lawrence, S-4947/*5*.

Birley, Sam, Birmingham, C-2489/
115.

Birmingham enamel, EA.

birthday cup, IDC.

birthday plate, IDC; S-4823/*12*①.

birth of Bacchus, the, IDC/①.

birth-table, IDC.

Bischofschüte, IDC.

biscuit, ACD; C-2458/*16*; C-5156/
*21*①; C-5236/*433*①; CEA/*120*①,
209; DADA; DATT; EA/①; IDC;

LAR83/*151*①; MP/*502*; S-3312/
*1385*①.

biscuit barrel, C-0706/*142, 197*;
C-1502/*88*; C-2409/*106*; C-2910/
160.

biscuit-box, EA.

biscuit box, C-0254/*24, 36*①;
C-0706/*135*; C-2510/*34*; S-4461/
212.

biscuit bust, C-2427/*5*①.

biscuit figure, C-0249/*189*; DADA.

biscuit fired, JIWA/*343*.

biscuit firing, IDC.

biscuit foot, C-2323/*11*①; C-2414/
*36*①; C-5127/*19*.

biscuit group, C-1006/*44, 105*.

biscuit lifter, S-4881/*487*①.

biscuit mold, DATT.

biscuit porcelain, EA; S-2882/*755*.

biscuit porcelain technique, MP/*170*.

biscuit relief, C-2482/*140*.

biscuitware, K-710/*109*.

biscuit warmer, C-0254/*91*.

bisette, DADA.

bishop bowl, DADA; EA; IDC/①;
IDPF/*22*.

Bishopp, Hawley, CEA/*424*①.

Bishops Hat, C-2409/*99*.

bishop's length, DATT.

bishop's purple, IDC.

bishop's ring, RTA/*96*.

Bishop Sumner pattern, IDC/①.

Bisley, CEA/*42*①.

bismuth, ACD; CEA/*586*①, *594*;
EA.

bismuth white, DATT.

bison-head handle, IDC.

bisque, CEA/*684, 697*; DADA;
DATT; EC1/*83*; IDC; K-711/*128*;
LAR83/*148*①; S-4992/*13*①.

bisque fire, DATT.

bistite, EG/*192*.

bistre, DATT; JIWA/*58*; LP; S-286/
*13, 296, 371, 450, 497, 321A,
538B*.
bit, DATT, .
biting, DATT.
bitstone, DATT.
bitsu (holes), JIWA/*183*.
bitters bottle, S-4461/*163*.
bitumen, DATT; LP.
Biugg, Lars, Jonkoping, S-4944/
*148*①.
biwa, S-4928/*162*.
biwa pearl, S-291/*256*①.
Bizarre, C-2409/*61*.
Bizarre bowl, C-2910/*69*.
Bizarre 'Crayon-Ware', C-2910/*84*.
Bizen, C-5156/*789*; C-5236/*854*;
DADA; EA.
Bizen ware, C-5156/*825*①; DATT;
IDC.
BK, EA/*Kornilov factory*.
Blaataarn, EA/*Copenhagen*.
Blaataarn (Blue Tower) factory, EA/
Copenhagen Stoore Kongensgade.
black, EC2/*91*; IDC.
Black, Starr and Frost, CEA/*520*.
Black, Starr and Frost, Ltd., DADA/
Supplement.
black agate, RTA/*159*①.
blackamoor, C-0279/*397*; C-5189/
*346*①; C-5224/*107*①; DADA;
EA/*guéridon*; IDC; LAR83/*67*①.
blackamoor table, C-2402/*211*.
black-and-gold marble, DATT.
black-and-white effect, JIWA/*5, 326*.
black-and-white silhouette style,
JIWA/*262*.
black-banded, C-5127/*698*.
black basalt, C-1006/*156*; K-710/*109*.
black basaltes, DADA, *basalt ware*;
IDC/①.
black basalt or basaltes, EA/①.
black bead, C-1082/*1*.

black bean, SDF.
blackberry, OPGAC/*205*; CEA/
*472*①.
'blackberry-chain', OC/*266*.
black bottle, CEA/*70*.
black-boy gum, DATT.
black chalk, DATT.
black Chantilly lace, C-1506/*153*.
black cherry, DATT; SDF.
black ebony, DATT.
blacked Damascus, C-2476/*36*.
black Egyptian, IDC; ACD.
black enamel seam, S-4414/*31*①.
blackened, C-2904/*108*; S-4972/*147*.
blackened base, C-0403/*183*.
blackened hide, C-1082/*21*.
blacket box, C-0982/*92A*.
black-figure, LAR83/*65*①; S-4807/
*495*①.
black-figured pottery, DATT/①.
black-figure style, IDC.
black figure ware, DADA.
Black Forest clock, CEA/*238*①; EA.
black glass, C-1506/*149*①; DADA.
black-glaze, S-4807/*503*①.
black glaze, MP/*51*.
black glazed earthenware, IDC.
black-glazed porcelain, MP/*38*.
black-glazed tyg, IDPF/*242*①.
black-glazed ware, ACD.
black gold ware, DADA.
black ground, C-1082/*116*.
black Honan stoneware, IDPF/*25*.
Blacking, CEA/*56*①.
blacking bottle, DADA.
black iron oxide, DATT.
black-jack, CEA/*49*; EA.
black jack, DADA.
black japan, DATT.
black japanned, S-3311/*570*.
Black Koryo ware, EA.

Blaublümchenmuster, EA; IDC.

Blaue Reiter, der, DATT; LP/①.

blaue Teutsche Bluhme (blue German flower), MP/*131*.

Blaue Vier, DATT.

Blauwerk, IDC.

blazon, CEA/*374*①.

bleached, JIWA/*324*.

Blease & Seddon, C-2357/*95*①.

bleau nuagé, IDC.

bleed, DATT.

bleeding, IDC; LP.

bleeding-bowl, DADA/①; EA/①; IDC/①.

bleeding bowl, CEA/*647*①; IDPF/*22*; LAR83/*542*①, *598*①.

bleeding-dish, EA/*bleeding-bowl*.

bleeding heart, C-0225/*236*; OPGAC/*206*①.

Bleiweiss, C-5189/*172*①.

blender, DATT; LP/① *brushes*.

blending, DATT.

Blenheim Palace service, IDC.

Blenko Glass Company, DADA/*Supplement*.

bleu agate, IDC.

bleu camaieu, RGS/*105*.

bleu-celeste, LAR82/*128*①, *174*①.

bleu celesté, C-0249/*239*.

bleu celeste, C-0279/*225*.

bleu céleste, CEA/*184*①; EA; IDC.

bleu celeste, S-4802/*150*①.

bleu-celeste border, S-3311/*361*①.

bleu-celeste-ground, LAR83/*142*①.

bleu-céleste ground, S-4804/*291*.

bleu celeste ground, C-2502/*176*; S-2882/*823*①.

bleu céleste ground, S-4823/*91*.

bleu-de-roi, CEA/*202*①; DADA; LAR82/*174*①.

bleu de roi, EA; IDC.

bleu de sèvres, IDC.

bleu de vincennes, IDC.

bleu-du-roi, C-5189/*36*; S-4804/*300*①; S-4853/*26*①.

bleu du roi, S-4992/*13*①.

bleu-du-roi ground, S-4804/*293*①.

bleu fouetté, IDC.

bleu lapis, C-2486/*5*①; CEA/*183*①; IDC.

Bleu Nevers, CEA/*145*①.

bleu nouveau, C-2546/*14*①; IDC; LAR82/*175*①.

bleu nouveau ground, C-2364/*5*.

bleu persan, CEA/*145*①, *151*①, *209*; EA/*bleus de Nevers*; IDC/①; DADA.

bleu royal, IDC; MP/*174*.

bleus de Nevers, EA.

bleu soufflé, IDC.

bleu soufflé vase, S-3312/*1376*①.

bleu turc, EA; IDC.

bleu turquin, C-5181/*190*; IDC; S-3311/*295*①.

bleu turquin marble, S-4972/*654*; S-4955/*54A*①; DADA.

Blick, C-2904/*16*.

Blickensderfer No 5 typewriter, C-0403/*1*.

Blin, Peter, CEA/*389*.

blind basket ware, IDC.

blind blocking, JIWA/*217*①.

blind-carved quartrefoil, C-5116/*171*①.

blind caster, EA.

blind Chinese fret, LAR83/*283*①.

blind drawer, S-2882/*261*.

blind Earl pattern, EA; C-2493/*59*; IDC/①.

blind-earl's pattern, DADA.

blindfolding, DSSA.

blind frame, SDF.

blind-fret, C-2402/*1*, *62*, *69*.

blind fret, C-0982/*49*; LAR82/*323*①; SDF.

blind fret acanthus panel, C-1407/37.

blind fret-carved, S-4812/154①, 162①.

blind fret-carved frieze, S-4414/439①.

blind fret-carved hexagonal support, S-4414/478①.

blind fret-carved sloping support, S-4414/500①.

blind fret-carved square chamfered leg, S-4414/500①.

blind fret frieze, C-5157/134①.

blind fretwork, C-2388/57; C-2403/99; C-2421/104; C-2478/194.

blind-fronted, SDF.

blind man's watch, EA.

blind printing, DATT.

blind sleeve, CEA/644①.

blindstamp, C 0225/384; C-0249/118; C-5191/331; C-5239/188; S-286/2, 3, 5; S-2882/1400, 1401; S-3311/822; S-4881/44①.

blind tooling, DADA.

blind tracery, SDF/①.

blinking-eye clock, EA.

Blinking eye clock, CEA/247①.

Blissett, Isaac, London, C-2503/208①.

Bliss & Nye, New Bedford, Mass., S-4881/323①.

blister, DATT.

blister glaze, DATT.

blob, ACD; CEA/466①.

block, C-2388/14; C-5114/309①; IDC/① mould.

block action, S-4972/165①.

block and baluster turned, LAR83/375①.

block and fan, OPGAC/206①.

block and ring, S-4905/417①.

block-and-turned H-shaped stretcher, C-5116/107①.

block-and-turned leg, C-5114/397①.

block and turned leg, C-0249/347.

blockboard, SDF.

block book, DATT/①.

block column, C-0982/70.

block-cutting, IDC.

blocked, S-4461/587.

blocked corner pillar, C-2368/40①.

blocked leg, C-0249/365; LAR82/304①.

blocked line, S-291/227①.

blocked stretcher, CEA/393①.

blocked tapering octagonal leg, C-5116/93①.

block foot, ACD; C-0982/2, 7; C-2357/94①; C-2402/18; C-5116/61, 74.

block-front, C-5153/188①, 198①; DADA/①.

block front, CEA/405; EA/①; LAR82/322①; SDF.

blockfront, NYTBA/52①; S-4461/587.

block front chest, CEA/395①.

block-front elevation, CEA/315①.

block handle, IDPF/22①.

block-in, LP.

blocking, CEA/541; NYTBA/56.

block leg, C-0982/5.

block optic, OPGAC/191.

block-out stencil method, DATT.

block print, DATT.

block-printed, C-1506/110①.

block-printed cotton, NYTBA/88①.

block scraper, DATT.

block support, S-3311/278①.

block-tin ware, DADA.

block toe, S-4414/450①, 510①; S-4436/100①; S-4812/125①.

block-turned, C-0249/363.

Blohm, Johan Henrik, CEA/635①.

Blois enamel, EA.

blonde, C-5236/560①.

Blondeau, EA.

Blonde de Caën, DADA.

blonde de fil, DADA.

blonde lace, DADA.

blonde mahogany, C-5239/60.

blonde mate, DADA.

blonde tortoiseshell, C-1603/74; C-2487/10.

blonde wood, S-4461/200.

blond painting, DATT.

blond tortoiseshell, C-1304/15.

blood, DSSA.

blood porringer, EA/bleeding-bowl.

blood-red, C-2403/187.

bloodstone, C-5117/410①; C-5220/27①; CEA/64①; DADA.

bloodstone (heliotrope), RGS/123①.

bloodstone, S-4927/325.

bloodstone agate, C-5234/300.

bloodwood, DADA.

bloom, CEA/541; DATT; LP.

blooming, CEA/517①.

Bloor, Robert, CEA/187; EA.

Bloor, Robert & Co., C-2493/90①.

Bloor, William, CEA/205.

Bloor Derby, C-1006/180; C-1582/132; CEA/187; LAR82/117①; LAR83/89①; EA/Bloor, Robert.

Bloor Derby porcelain, S-3311/349.

blossom and tendril medallion, S-4948/42①.

blossom finial, C-5127/289①.

blotter, C-0254/40; C-0906/96; C-5239/62; S-4461/57.

blotter corner, S-4414/237; S-4461/89.

blotter end, C-5005/381; C-5146/157; C-5239/321.

Blount, Godfrey, DADA/Supplement.

blow and blow process, EG/253.

blower, EA; SDF.

Blowers, John, S-4905/230.

blowhole, CEA/541; EA.

blowing, EG/287①; NYTBA/268.

blowing-tube, EA.

blown, C-5239/322①.

blown fruit, CEA/489.

blown-glass, C-5116/157①.

blown glass, K-711/123; LAR82/430①; S-4461/135.

blown glass bottle, S-2882/706.

blown-molded, C-5114/148①; DADA.

blown-mould pattern (geometric), (arched), (baroque), EG/182.

blown oil, DATT.

blown ring, C-5114/120.

blown three mold, DADA.

blown-three-mold glass, NYTBA/293①.

blown-three-mould, CEA/459; EA; EG/184.

blow-pipe, CEA/414; EG/77, 287①.

blow spout, IDPF/65.

blow-up, LP.

blowup, DATT.

blue, IDC.

blue Alexandria, K-710/118.

blue and white, C-1006/159; C-5156/84①; C-5236/426①; S-4905/33①.

'blue and white', ACD.

blue and white Ch'ing, DADA.

blue and white kraak porselein, C-0782/9.

blue and white Ming, DADA.

blue and white plate, S-4823/86.

blue-and-white porcelain, IDC.

blue and white porcelain, C-2458/69①.

blue-and-white pottery, IDC.

blue-and-white transfer-printed ware, EA.

blue ash, DATT.

bluebell, C-0405/160.

blue bice, DATT.

blue black, DATT.

blue Bristol finger bowl, CEA/442①.

blue clay, IDC.

blued, CEA/26①; S-4972/153①.

blue-dash, LAR82/*145*①; S-4843/ *13*①.

blue dash charger, ACD; IDPF/*22*.

blue-dash charger, DADA; EA; IDC/ ①.

blue dash pattern, NYTBA/*142*①.

blued finish, C-2569/*67*①.

blue dip ground, S-4843/*493*.

blue dragon pattern, IDC.

blued steel, C-5117/*395*①; S-291/*8*; S-4802/*5*.

blued steel hand, S-4927/*9*.

blue faience, RTA/*26*①.

Blue Fitzhugh, S-4905/*100*.

blue frit, C-1582/*8*; C-2482/*79*; DATT.

blue glass, C-0706/*18*.

blue glass liner, C-0706/*18*; C-2202/ *16*.

blue grey, C-2403/*215*.

blue ground, C-5127/*44*.

blueing, CEA/*44*.

blue-jasper, C-2502/*84*.

blue jasper, S-3311/*413*①.

blue jasper cameo, CEA/*513*①.

blue john, C-2421/*3*①; CEA/*336*①; DADA; EA/①; SDF.

bluejohn, C-2332/*40*.

Blue-John, C-2357/*1*①; C-2478/*8*.

blue lacquer, C-5156/*224*①.

blue lacquered, C-2402/*240*.

blue lake, DATT.

blue lily pattern, IDC.

blue-line, C-2486/*94*.

Blue Lynn, CEA/*441*①.

blue malachite, DATT.

Blue Midwestern, K-711/*123*.

blue model, MP/*70*.

blue pigment, DATT.

blue-resist printed cotton, NYTBA/ *85*①.

Blue Rider, DATT.

Blue Rider, The, LP/①.

Blue Rock pattern, C-2493/*33*.

Blue Rose, DATT.

blue-scale, C-2493/*27*.

blue scale, IDC.

Blue Staffordshire, NYTBA/*152*.

blue stone, C-1082/*168*.

blue swordmark, MP/*166*.

Blue Trellis border, EC2/*24*①.

blue underglaze painting, MP/*35*.

blue verditer, DATT.

blue ware, MP/*104*.

blue wave mark, C-0249/*155*.

blue-white ware, JIWA/*348*.

Blumen, IDC.

Blumenau, Lili, DADA/*Supplement*.

blunderbuss, ACD; C-2503/*116*; CEA/*29*①; DADA; S-4972/*217*.

blunderbuss-pistol, C-2569/*92*①.

blunger, DATT.

Blunt, T. & T., London, C-2489/*33*.

blunt arrow turning, SDF.

blunt-ended cone, RTA/*171*①.

B. Luppens & Cie., S-3311/*573*①.

blush, DATT.

BM, EA/*Magnus, Johann Bernard*.

B. MOLITOR, EA/*Molitor, Bernard*.

board, C-5236/*1804*①; DATT; S-4881/*44*①; SDF.

board and batten, SDF.

board chest, C-5114/*259*.

boarded bedstead, SDF.

boarded chest, SDF/①.

boarded construction, SDF.

boarded end, C-0249/*405*.

board-ended stool, SDF.

boarding pike, C-MARS/*54*.

Boardman, Thomas D. and Sherman, C-5153/*64*①.

boardroom table, C-1407/*33*.

board top, C-0249/*407*①.

boar's head, C-2414/*17*①.

boar spear, C-2503/*20*; C-2569/
*100*①.

boar's tooth, S-4928/*99*①.

boar's tusk, C-1082/*24*; S-4881/
*501*①; S-4928/*100*①.

boasting, SDF.

boat, IDPF/*22*①.

boat bed, DADA; EA/①.

boat-shape, C-2458/*235*.

boat shape, S-4414/*298*; S-4922/*56*①.

boat-shaped, C-0706/*110*; C-1502/
122; C-2398/*68*①; C-5117/*52*,
*333*①; CEA/*447*①, *654*①.

boatshaped, IDPF/*241*.

boat-shaped cartouche, C-1502/*21*.

boat-shaped mount, S-4414/*8*①.

boat-shaped vase, LAR83/*443*①.

boat-shell guard, C-2569/*44*①.

boatshell guard, C-2503/*12*;
C-MARS/*41*①.

bob, CEA/*229*①, *267*; EC2/*96*①.

bobbin, C-0982/*44*, *69*; C-2704/*121*.

bobbin back, LAR82/*313*①.

bobbin banded, C-0982/*12*.

bobbin-bordered, C-0982/*56*.

bobbin bottle, EG/*47*.

bobbin chair, SDF.

bobbin-framed, C-0982/*71*.

bobbin furniture, SDF.

bobbing doll, EC2/*100*①.

bobbing head, S-4988/*436*①.

bobbin knop, CEA/*423*①.

bobbin lace, C-1506/*173*①; DADA;
NYTBA/*91*①.

bobbin leg, C-1407/*43*.

bobbin net, DADA.

bobbin-turned, C-0249/*411*; C-1407/
121; C-2402/*113*; C-2478/*84*;
C-2498/*115*.

bobbin-turned angle, C-2388/*108*.

bobbin turned stretcher, LAR83/
*286*①.

bobbin-turned support, S-2882/*691*.

bobbin turned support, LAR83/
*372*①.

bobbin-turning, CEA/*326*①.

bobbin turning, EA/①; SDF/①.

bobeche, C-5114/*134*; C-5239/*304*.

bobèche, CEA/*401*①.

bobeche, CEA/*675*①.

bobêche, DADA.

bobeche, FFDAB/*112*.

bobêche, IDC.

bobeche, S-4436/*76*①.

bobêche, S-4461/*5*.

bobeche, S-4804/*130*.

bobèche, S-4988/*433*①.

bobéchon, DADA.

bocage, ACD; C-5189/*106*; DADA/
①; EA/①; IDC/①; S-4843/
*198*①.

boccale, IDC.

boccaro, ACD; DADA; EA; IDPF/
200.

Boccaro ware, IDC.

Boch, S-4461/*45*.

Boch, William, CEA/*207*①.

Boche Fréres, C-5239/*46*.

Boch Frères, C-2910/*136*.

Boch Fréres, C-5191/*59*.

Boch Keramis, OPGAC/*346*.

bock, IDPF/*226*.

bockbuechsflinte, C-2476/*4*.

Bocour blue, DATT.

Bocour green, DATT.

Boda factory, EG/*226*.

Bodeker, J., EA/*conical pendulum*.

Boden, EA/①.

bodger, SDF.

bodhidharma, IDC.

Bodhisattva, C-5156/*165*; S-4810/
*263*①.

bodice, C-1506/*8*, *43*.

bodied linseed oil, DATT.

bodkin, C-2332/*78*; C-2487/*20*①; S-4881/*295*①.

bodkin case, C-0406/*84*; EA/①.

Bodley, C-1582/*139*.

Bodorf ware, IDC.

body, C-0225/*332*①; C-2458/*1*; C-5005/*207*①, *265*; C-5114/*27*①; C-5239/*9*; CEA/*209*; DATT; IDC; S-4905/*142*①.

body band, C-2202/*15*, *146*, *234*.

body bands, C-2202/*2*.

body color, DATT; LP.

bodycolor, C-2409/*148*.

body colour, RTA/*119*①.

bodying-in, SDF.

body stain, DATT.

Bochm, LAR82/*46*①; OPGAC/*350*.

Boehm, Edward Marshall, DADA/*Supplement*; OPGAC/*350*.

Boehm birds, IDC.

Boehme, Charles Louis, CEA/*676*①.

Boehmer, CEA/*513*.

Boehm Studios, Trenton, New Jersey, OPGAC/*350*.

Boelen, Henricus I, C-5153/*44*①.

Boelen, Henricus II, CEA/*671*①.

Boelen, Jacob, CEA/*667*①; EA.

Bogaert, Johannes, EA.

Bogaert, Thomas, EA.

bogatyr, C-5174/*241*.

boggle, DADA; IDPF/*24*.

Bogh, CEA/*190*①.

Bogle, John, EA.

bog oak, ACD; SDF.

bog wood, DADA.

bog yew, SDF.

Bohemian, C-5117/*386*①; C-5189/*32*; C-MARS/*135*①; CEA/*416*①, *686*①; LP; OPGAC/*159*; S-3311/*387*①; S-4461/*75*; S-4992/*1*①.

Bohemian earth, DATT.

Bohemian glass, ACD; CEA/*451*; DADA; EG/*101*, *288*; NYTBA/*275*.

Bohemian porcelain, IDC.

Bohemian wood, MP/*28*.

Bohi, C-5236/*1835*.

Bohme, Carl, EA/*Karl Wilhelm*.

Bohnad, OC/*220*.

Bohne, Ernst, K-710/*119*.

boiled oil, DATT; LP.

Bointaburet, G., C-2510/*18*.

Bointaburet à Paris, C-2486/*148*①.

bois chair, C-5146/*121*①.

bois citronnier, C-2555/*68A*①.

bois clair, C-2403/*47*; C-5005/*342*①; C-5224/*24*; S-4461/*659*.

bois de bout, S-4955/*177*, *186*①.

bois de citron, C-5259/*556*①.

bois durci, EA; SDF; C-0906/*144*.

bois satiné, C-2364/*51*①; C-2437/*72*.

bois satiné border, S-4853/*540*①.

Boissier, CEA/*145*①.

bois simulé, C-2458/*140*①; C-2486/*60*①; IDC.

bois violet, C-2555/*58*①.

Boit, Charles, EA.

boite a portrait, CEA/*70*.

boite églantine, C-0225/*163*.

Boizot, Louis Simon, EA.

Bojesen, Kay, DADA/*Supplement*.

bokhara, SDF; C-2478/*235*; CEA/*94*; DADA.

Bokhara carpet, C-2482/*2*; EA/*Turkoman carpet*.

Bokhara design, C-0906/*16*.

Bokhara rug, ACD; OC/*25*①.

Bokhara Susani, LAR82/*546*①.

Bokhara Susanni panel, LAR83/*529*①.

bolar earth, MP/*502*.

Boldaji, OC/*147*①.

bold cut, C-5156/*324*①.

boldly cast, C-5127/*343*①.
boldly potted, C-5156/*87*①.
boldly scrolling, C-2421/*38*.
bold relief, C-5114/*318D*①.
bold resin, DATT.
bole, DATT; LP.
bolection, ACD; C-5157/*120*; DADA.
bolection frieze, C-0279/*427*①;
 C-5116/*110*.
bolection moulding, SDF.
bolero, C-0405/*49*; C-0604/*31*;
 C-2203/*2*.
Boleschka, Charles, CEA/*523*①.
Boleyn Cup, EA.
Bologna (Emilia), EA/①.
Bologna, Giovanni, C-5224/*273*①;
 EA.
Bologna chalk, DATT.
Bologna stone, DATT.
Bologna-Susini group, C-5224/*280*.
Bologne, J. de, C-5189/*146*.
Bologneser Hund, MP/*112*.
bolshoy naryad, RGS/*52*.
bolster, C-2403/*79*; C-5005/*331*①;
 C-5114/*285*①; SDF.
bolster arm, SDF/①.
bolt, CEA/*541*.
bolt-and-shutter maintaining power,
 C-2489/*95*①, *107*①.
bolt and shutter maintaining power,
 ACD.
boltel, SDF.
bolter arm, C-5167/*217*①.
bolting ark, SDF.
bolting cloth, DATT.
Bolton, John, C-2360/*88*①.
Bolton, Robert, Wigan, C-2503/*81*.
Bolton Abbey, C-2704/*37*.
bolt-safe, C-2476/*7*.
bolus ground, LP.
bombard, DADA.
Bombay blackwood, SDF.

Bombay furniture, DADA.
bombé, ACD; C-0249/*229*; C-2368/
 1; C-2458/*237*①; C-5116/*170*①;
 C-5117/*332*.
bombe, C-5127/*200*.
bombé, CEA/*317*①; EA; IDC.
bombe, LAR82/*109*①.
bombé, S-4414/*154*; SDF; C-0249/
 330; CEA/*395*①; DADA/①.
bombe bureau, LAR83/*250*①.
bombé casket, S-4461/*367*.
bombé chest, C-0270/*40*①.
bombe chest, C-2388/*62*①.
bombé commode, C-2421/*115*①.
bombe commode, LAR83/*307*①.
bombé cuff, S-4414/*38*.
bombé fluted, C-0254/*112*.
bombé form, C-2398/*3*; S-2882/*936*.
bombè form, S-4988/*432*①.
bombé oval body, S-4922/*6*①.
bombe shape, LAR82/*287*①;
 LAR83/*178*①.
bombé side, C-5157/*175*①; RGS/
 *17*①; S-2882/*991*; S-3312/*1279*①.
bomb lance shoulder gun, S-4881/
 *303*①.
bomb-shaped, C-2409/*197*.
bombylios, IDC.
bon bon dish, LAR83/*456*①.
bonbon dish, C-0103/*42*; C-0406/*43*;
 C-0706/*24, 128*; C-1502/*4*;
 S-4461/*290*; S-4804/*95*.
bonboniere, S-4804/*217*.
bonbonnière, ACD; C-2487/*5*; CEA/
 *67*①, *540*①; DADA; EA/
 sweetmeat box; IDC.
bonbonniere, LAR83/*242*①.
bonbonnière, RGS/*146*①.
Bond, London, C-2503/*121*.
Bond, Philip, London, C-2503/*172*.
Bond, William, Dublin, C-2487/*74*.
bond paper, DATT.

bone, C-1082/*8*; C-5117/*81*; LAR82/ *292*①; S-4922/*24*①; S-4972/*483*①.

Bone, Henry, EA.

Bone, Sir Muirhead, S-286/*200*.

bone-ash, CEA/*190*①; IDC.

bone ash, DATT; EA.

bone bead, C-5156/*377*.

bone black, DATT; LP.

bone brown, DATT.

bone-china, CEA/*201*①; IDC.

bone china, ACD; DADA; DATT; EA; K-710/*109*; LAR82/*160*①; NYTBA/*180*①.

boned bodice, C-1506/*51*.

bone edge, IDPF/*24*.

bone folder, DATT.

bone glass, DADA.

bone-inlaid, S-2882/*293*.

bone inlay, S-2882/*711*①.

bone lace, C-2704/*122*; DADA.

boneless technique, C-5156/*605*①.

bone overlay, C-1082/*176*.

bone white, DATT.

bonheur-du-jour, ACD; CEA/*314*①, *405*; SDF.

bonheur du jour, C-0279/*415*.

bonheur du jour,, C-2320/*50*.

bonheur du jour, C-2357/*65*①; C-2403/*65*; C-2421/*51*①; CEA/ *364*①; DADA; EA; LAR83/ *396*①; S-2882/*771*①; S-4853/ *462*①; S-4988/*477*①.

Bonn, C-2910/*155*.

Bonnard, Pierre, S-286/*201*①.

Bonnemain, Pierre, S-4955/*194*①.

bonnet (clock), FFDAB/*110*.

bonnet, S-3311/*108*.

bonnet doll, CEA/*697*.

bonnet finial, S-4461/*72*.

bonnetiere, C-5181/*199*.

bonnetière, DADA.

bonnet scroll, SDF.

bonnet-scroll pediment, EA.

bonnet-top, S-4905/*452*①.

bonnet top, C-5170/*33*①; CEA/ *392*①, *405*; DADA/①; LAR83/ *256*①; SDF.

Bonnin, Gousse, CEA/*206*①.

Bonnin and Morris, CEA/*205*; EA.

Bonn porcelain, CEA/*249*①.

Bonsach, Baard Gandolphi, EA.

Bonsack, A., C-2904/*195*.

bonsai bowl, IDPF/*24*①.

Bonte, C-GUST/*125*.

Bontemps, Georges, CEA/*484*, *487*①; EA.

booge, CEA/*594*; EA.

booged bowl shape, CEA/*583*①.

book, C-2458/*294*.

book box, C-0906/*144*.

bookcase, ACD; C-0249/*341*; C-0982/*25*; C-1407/*111*; C-2388/ *134*; C-2402/*26*; C-5114/*333*①; C-5153/*87*; C-5239/*243*; DADA; SDF/①.

bookcase table, SDF.

book cover, C-5156/*218*; C-5174/ *1*①; S-4972/*205*.

book-end, C-5005/*361*.

book end, C-5146/*159*①.

bookend, C-0225/*34*; C-5167/*18*①; C-5239/*13*.

Booker, William and John, C-2421/ *36*①.

book jacket, JIWA/*84*.

bookmarker, CEA/*279*①.

Bookmark pattern, C-5191/*489*.

book matched, SDF.

book of hours, DATT.

book ornamentation, JIWA/*84*.

bookplate, C-5157/*167*①.

book press, C-0254/*173*①.

book rack, C-5146/*157*.

book-rest, DADA.

book rest, ACD; SDF.

book shaped panel, C-1082/*184*.

bookshelf, S-4461/*666*①; SDF.

bookspine, C-2437/*28*①.

book stand, S-3311/*511*①.

bookstand, C-2478/*18*; SDF/①.

book table, C-0982/*81*.

book trough, C-0982/*310*.

boosting, SDF/*boasting*.

boot, IDPF/*24*①.

boot button eye, C-2202/*161*.

boot glass, S-4972/*411*.

Booth, Edward, EA.

Booth, Enoch, EA.

boot-heel, EA.

Booths blue and white, C-2502/*122*.

Booths tureen, S-4461/*396*.

böotischen Koroplasten, MP/*115*.

bootjack, CHGH/*61*.

bootjack foot, S-4905/*418*①.

boot-rack, SDF.

boot rack, C-0279/*289*.

boot-shaped, IDPF/*124*.

booze bottle, EA.

Borchalu, OC/*93*①.

Borchalu Kazaks, OC/*283*.

bordalou, C-2204/*123*.

bordeaux, DADA, ; EA.

bordeaux ground, C-0279/*422*.

border, C-2202/*28*; C-2320/*132*; C-2402/*20*; C-2478/*209*; C-5116/*132*①; C-5153/*10*①; C-5189/*360*; IDC; S-4804/*966A*①; SDF.

bordering, SDF.

bordering wax, DATT.

Bordier, C-5117/*461*.

Bordier à Paris, C-5181/*96*①.

Bordjalou Kazak, C-5323/*105*①.

bore, C-2476/*2*, *15*①; CEA/*44*, *549*; S-4972/*159*①.

Boreas, DSSA.

Borelly, (Boselli, Bosselly), Jacques, EA.

Boreman, Zachariah, ACD; EA.

Borg, Anders Nielsen, Trondheim, C-2487/*41*①.

Borghese urn, EA.

bori, DADA.

Borm, A., EA/*270*①.

Borman, Johan Balthazar, EA.

borne, DADA.

Borneo cedar, SDF.

Börner, Emil Paul, MP/*203*.

Bornholm clock, CEA/*242*①.

borogove vase, IDC/①.

Borough,(Burrough) John, EA.

Borujird, OC/*61*①.

Bos, Cornelis, EA.

boscage, IDC.

boscages tapestry, EA.

Boscobel oak box, EA/①.

"Boscobel Oak" Plate, S-4843/*24*.

Boselli,(Boselly) Jacques, EA.

boshi, C-5236/*1828*.

boskie, IDC.

boss, C-2323/*132*; C-2388/*63*; C-2409/*1*; C-2421/*20*①; C-2437/*55*①; C-2458/*146*①, *214*; C-5116/*169*①; C-5117/*322*①; C-5127/*114*①; C-5156/*314*; C-5236/*336*; CEA/*113*①, *390*①, *623*①; DADA; DATT; EG/*23*①; IDC; IDPF/*24*①, *85*; RTA/*18*①, *39*①; S-2882/*666*, *985*, *989*; S-4972/*330*①; SDF; C-2476/*26*①.

Boss, Thomas, London, C-2503/*112*.

boss brooch, C-0103/*86*.

Bosse, Abraham, CEA/*374*①; DADA.

bossed horn, S-4965/*120*①.

bossed terminal, S-4804/*8*.

bossierer, MP/*502*; EA; IDC.

Bossierer's mark, C-2486/*162*①.

Bosson, C-5117/*471*①.

boss up, EA.

Boston and Sandwich Glass Co., OPGAC/*170*.

Boston and Sandwich Glass Company, NYTBA/*294*①.

Boston and Sandwich Glass Works, CEA/*464*①; DADA/*Supplement*.

Boston Cup, S-4843/*266*①.

boston rocker, SDF/①; CEA/*697*; EA/①.

Boston rocking chair, DADA/①.

Boston & Sandwich Glass Co., CEA/*489*.

Boston & Sandwich Glass Company, CEA/*54*①; EA; EC1/*68*.

Boston Silver Glass Company, EC1/*68*.

Boston's Revere Pottery, EC1/*82*①.

botanical, C-5189/*18*.

botanical design, C-2513/*385*①.

botanical dish, LAR83/*77*①.

botanical flower, EA.

botanical ware, IDC.

Botanic Microscope, The, C-2904/*165*.

Botany Bay gum, DATT.

Botany-bay wood, SDF.

boîte, DATT; IDC.

boîte à ballon, CEA/*64*①.

boîte à fard, IDC.

boîte à farine, DADA.

boîte à gaufre, DADA.

boîte à mouche, IDC.

boîte à mouches, EA/*patch-box*.

boîte à portrait, EA/*portrait box*.

Boîte à rouge, EA/*rouge box*.

boîte à sel, DADA.

boîte en or, RGS/*158*.

boteh, C-2320/*125, 134*; C-2357/*106*; C-5323/*101, 127*; CEA/*83*①, *91*①, *101*; S-288/*8*①; S-2882/*83, 173, 215*①; S-4414/*539*; S-4796/*14*; S-4804/*966*; S-4847/*2*.

'boteh', OC/*52*.

boteh and vine border, S-4948/*23*.

Boteh design, OC/*15*①.

boteh field, S-2882/*130*.

boteh motif, C-2478/*204*; EA; OC/*65*①; S-4796/*60*①.

boîtes ou tabatières, CEA/*61*.

botijo, IDC.

Bott, Thomas John, EA.

bottega, DATT.

Bottengruber, Ignaz, EA; MP/*166*.

Böttger, C-2486/*130*①; CEA/*130*.

Böttger, J. F., CEA/*169*.

Böttger, Johann Friedrich, ACD; CEA/*172*①; DADA; EA; MP/*10*.

Böttger Bayreuth, S-4853/*229*①.

böttger handle, IDC/①.

Böttger-lustre, C-2427/*94, 112*①.

Böttger lustre, EA.

Böttgerlustre, C-2486/*126*.

Böttger period, MP/*30*.

Böttger porzellan, IDC/①.

Böttgerporzellan, EA.

Böttger red stoneware, IDC/①.

Böttger's stoneware, MP/*35*.

Bottger Steineug, LAR82/*151*①.

Böttger stoneware, MP/*502*.

Böttger-type, S-4853/*240*①.

bottle, C-2458/*73*①; C-5236/*450*; CEA/*49*; IDC; IDPF/*25*①; NYTBA/*316*①.

bottle box, C-5114/*256*①.

bottle brick, IDPF/*34*.

bottle cap, C-0254/*182*.

bottle-carrier, C-2478/*88*①.

bottle carrier, C-2403/*15*①.

bottle case, EA; SDF.

bottle clock, C-0249/*355*.

bottle coaster, C-5170/*25*①.

bottle cooper, SDF.

bottle drawer, C-5114/*317*①; C-5116/*85*①; C-5157/*81*①; C-5170/*77*.

bottle-end glazing, SDF.

bottle form, C-5156/*824*①.

bottle glass, DADA; EA.

bottle-gourd form, JIWA/*324.*

bottle holder, C-5117/*279*①.

bottle-horn, S-4963/*8*①.

bottle-jack, EA.

bottle kiln, IDC/①.

bottle label, EA; IDC.

bottle opener, C-0254/*76, 257;* S-4804/*35.*

bottle rack, LAR83/*352*①.

bottle ring, S-4461/*16.*

bottles, C-0254/*141.*

bottle-shaped pot, JIWA/*324*①.

bottle-stand, IDC.

bottle support, S-4461/*38.*

bottle turning, EA; SDF.

bottle-vase, EG/*161*①.

bottle vase, C-0279/*146*①; C-2458/ *77*①, *201;* C-5236/*498;* IDC; IDPF/*27*①.

bottom, IDPF/*27.*

bottom deckle edge, S-286/*240.*

bottom drawer, CEA/*225*①.

boubache, C-5191/*477.*

bouchard, DATT.

Bouchard, Giovanni, EA/*129*①.

boucharde, DATT.

Bouchardon, Edmé, EA/*cris de Paris.*

Boucher, François, CEA/*189*①; DADA; EA.

Boucher, style, IDC.

Boucheron, C-5167/*166;* CEA/*520.*

Boucher scene, NYTBA/*170.*

Boudet, S-4947/*153*①.

boudeuse, DADA.

Boudin, Leonard, S-4955/*183.*

Boudin, Léonard, S-4955/*193*①.

boudior shade, C-5239/*314.*

boudiour lamp, C-0225/*247*①.

boudoir bonnet, C-1304/*185.*

boudoir bottle, C-2458/*361.*

boudoir chair, C-5191/*322;* C-GUST/ *145*①.

boudoir clock, LAR83/*188*①.

boudoir grand piano, LAR83/*520*①.

boudoir suite, LAR83/*358*①.

Bouffioulx, DADA.

bouge, CEA/*594;* EA/*booge.*

bougeoir, DADA; IDC.

Bough, S-4843/*375*①.

bough-pot, C-2427/*177;* IDC.

bough pot, C-2493/*140;* C-2513/*151;* LAR82/*114*①; LAR83/*71*①; S-4905/*120*①.

bougie box, DADA; EA/①.

bougie d'accrocher, C-2364/*6.*

Bougival white, DATT.

Bouilhet, Henri, C-2510/*19*①.

bouilloire, DADA.

bouillon bowl, S-4905/*75.*

bouillon cup, IDC/①.

Bouillon pot, CEA/*137*①.

bouillon spoon, C-5114/*16;* S-4804/ *28*①, *35*①.

bouillotte, C-5114/*239, 241;* C-5224/ *26;* C-5259/*488*①; DADA; C-0279/*224;* S-4461/*10.*

bouillotte lamp, C-5259/*294;* DADA/ ①; S-2882/*401*①.

bouillotte table, EA.

Boulard, Jean-Baptiste, S-4955/*98.*

Boulard, Jean-Baptiste, stamp: J B BOULARD, C-5224/*101.*

boulder, C-1082/*158;* C-5156/*81*①.

boule bonheur du jour, S-3311/*425*①.

boulle, CEA/*226*①, *264*①; DATT; LAR82/*70*①, *218*①; S-2882/ *800*①; S-4804/*765*①; SDF; C-0249/*246, 344;* C-1407/*79A;* C-1702/*93.*

Boulle, André-Charles, CEA/*375*①.

Boulle, André Charles, CEA/*226*①; DADA/①; NYTBA/*34.*

Boulle base, S-2882/*523*①.

bowed crest, S-4461/*605*.
bowed crest rail, C-0279/*265*.
bowed cushion seat, C-0249/*435*.
bowed door, C-1407/*17*.
bowed drawer, C-0249/*453*①;
C-2364/*70*①; C-5114/*341*①.
bowed end, C-2409/*141*; S-3311/
*187*①.
bowed ribbon, C-0279/*347*.
bowed side, C-5116/*4*; S-2882/*943*①.
bowed slope front, C-5170/*175*①.
bowed stretcher, C-5116/*80*.
bowed upholstered seat, C-2403/*93*①.
Bowen, John, EA.
bow-end, LAR82/*417*①.
bow-ended, C-2320/*37*; C-5116/
*133*①.
bow-ended base, C-2364/*23*; C-2437/
*24*①.
bow-ended top, C-2437/*70*①.
bowenite, C-0282/*147*; C-1082/*163*;
C-2458/*405*; C-5117/*356*①;
S-4810/*471*①.
bowenite panel, LAR82/*355*①.
Bowen style, IDC/①.
Bowes, Sir Jerome, EA.
Bowes Cup, EA.
Bow figure, C-2502/*24*.
bow-form, S-4461/*208*.
bow-front, C-5114/*272*①, *317*①;
DADA/①; S-2882/*289*; S-4461/
598; S-4905/*461*①.
bow front, ACD; EA; SDF/①.
bowfront, C-0982/*42*, *270*; C-1407/
83; C-2402/*35*, *50*; S-4414/*416*①.
bow front case, S-4461/*80*.
bowfront chest, C-0982/*78*.
bow-fronted, C-5005/*330*①; LAR82/
*270*①; S-2882/*351*; S-3311/*126*;
S-4414/*456*①; S-4436/*125*①;
S-4812/*100*①; S-4972/*491*;
S-4988/*447*①.
bowfronted, C-2388/*53*; C-2403/*87*;
C-2421/*109*①; C-2478/*108*.

bow-fronted door, C-0279/*457*.
bow-fronted frieze drawer, S-4414/
*474*①.
bow fronted seat, S-2882/*266*.
Bow group, C-2360/*112*①.
Bowie, James, CEA/*43*①.
Bowie knife, CEA/*37*.
bow in case, C-0906/*288*.
bowing, IDPF/*120*.
bowknot, DADA.
bowl, C-0225/*9*; C-0254/*26*; C-0782/
21; C-5005/*225*①, *402*①; C-5114/
7A; C-5117/*101*①, *245*①; C-5153/
*44*①.
bowl (on spoon), C-5203/*133*.
bowl, CEA/*631*①; DADA; DSSA;
EC2/*31*①; IDC; IDPF/*27*①;
S-4804/*62*①; S-4881/*158*①;
S-4922/*2*①; S-4972/*411*.
bowl and cover, S-4905/*40*①.
bowler hat, C-0405/*57*.
bowl fixture, C-2489/*125*.
bowl form, C-1082/*103*.
bowl sanctuary, IDPF/*31*①.
bowl stand, IDPF/*31*①; SDF.
Bow porcelain, NYTBA/*176*.
Bow Porcelain Manufactory, EA/①.
bow ring, RTA/*69*①.
bow stretcher, S-2882/*334*.
bow-tie device, C-5323/*71*①.
bow top, SDF.
Bowyer, William, CEA/*230*①.
box, C-5114/*102*, *248*①; C-5156/
744; C-5239/*43*; CEA/*61*; DADA;
IDC/①.
box and cover, C-2458/*149*; C-5117/
*152*①.
box bedstead, EA; SDF/①.
box border, S-4847/*33*.
box-case clock, EA.
box chair, EA; SDF.
boxed heart, SDF.
boxed octagon, C-0279/*4*.

box end, SDF.

box-form hand camera, C-1609/*177*.

box-form roll-film camera, C-1609/*142*.

box frame, C-0279/*40*①.

box geometrical stringing, C-5116/*101*.

box hinge, C-5117/*396*①; CEA/*638*①; S-4802/*8*①; S-4927/*96*.

boxing figure, IDC/①.

box iron, SDF/①.

boxlock, C-2476/*46*.

box-lock belt pistol, C-2569/*64*.

box-lock pocket pistol, C-2569/*65*, *81*①.

box moulded base, C-0279/*275*.

box-on-box clock, EA/*Massachusetts shelf clock*.

box ottoman, SDF.

box pleat, SDF.

box pleated, C-1506/*19*.

box seat, C-0982/*18*.

box-seat base, C-2402/*16*.

box section, RTA/*186*①.

box settle, EA; SDF.

box sextant, LAR83/*461*①.

box-shaped pendant, S-291/*180*①.

box stool, C-1407/*170*; SDF.

box stretcher, C-5114/*296*①, *378*①; C-5153/*83*; DADA; EA; S-3311/*91*; S-4414/*425*①, *494*; S-4436/*113*.

box toilet glass, SDF.

boxwood, ACD; C-1407/*26*; C-2388/*29*; C-2402/*50, 110*; C-5116/*3*; C-5127/*516*; C-5156/*684*①; C-5236/*696*; C-5255/*9*; CEA/*303*; DADA; DATT; LAR82/*317*①; S-4928/*81*①; S-4972/*93*①; SDF.

box-wood comb, JIWA/*195*.

boxwood line, C-0982/*1, 143*; C-2357/*60*①; C-2402/*8*.

boxwood recorder, C-0906/*274*.

boxwood stringing, C-5116/*10*; CEA/*348*①; LAR82/*42*①.

Boy at the Window Pattern, C-2360/*11*.

Boyce, Geradus, C-0270/*217*.

Boyd, Parks, CEA/*590*.

Boyfriend, The, C-0405/*138*.

boy in a tree, IDC.

Boyle, John, CEA/*204*①.

Boyton, Charles, C-2409/*173*; C-2910/*202*.

bozetta, CEA/*159*①.

bozetto, S-4972/*82*①.

bozzetto, DATT; S-4972/*104*①.

B & R, EA/*Brunswick*.

BR, incised, EA/*Bourg-la-Reine faience and porcelain factory*.

Brabant lace, C-1506/*166*.

Brac, MP/*31*.

brace, SDF.

brace-back, S-4905/*383*①.

brace back, LAR82/*311*①.

brace-back chair, DADA.

brace back chair, SDF.

braced-back, EA.

bracelet, C-1082/*9*; C-2458/*1*; C-5005/*211*; SDF.

bracelet ring, RTA/*148*①.

bracelet/ring, RTA/*168*①.

bracelet watch, S-4927/*17*①.

braces, C-5114/*292*①.

Brachard, Alexandre, CEA/*185*①.

bracing, NYTBA/*21*①.

Brack, IDC.

bracket, C-0279/*269*①; C-0982/*41*; C-2202/*14*; C-2402/*256*; C-5114/*390*①; C-5181/*59*; DADA; IDC; K-710/*111*; SDF/①.

bracket base, DADA.

bracket clock, ACD; C-1702/*324*; C-2364/*31*①; C-5157/*33*①; C-MARS/*222*; CEA/*222*①, *267*; DADA; EA/①; LAR82/*200*①;

Brandt Junior, C-2904/*1.*

brandy-bowl, C-2487/*37*; C-5117/ *20*①, *189*①; C-5174/*479*①.

brandy bowl, C-0254/*42*; EA; LAR83/*540*①; S-4802/*258*①.

brandy flask, LAR83/*577*①.

brandy-saucepan, C-2487/*104*; C-5174/*502.*

brandy saucepan, C-0103/*89*; C-0706/*63*; C-5117/*57*①; LAR83/ *546*①; S-4802/*461.*

brandy snuffer, DADA.

brandy warmer, C-0406/*63*; DADA/ ①; S-3311/*670*①.

Brangwyn, Frank, C-2409/*90*①; DADA/*Supplement*; S-286/*63.*

Branham Barumware, LAR82/*99*①.

Branksome China, C-2409/*108.*

Brannam Ware, C-2409/*123.*

Braque, Georges, S-286/*432, 202A*①.

bras de lumière, ACD.

Brasenhauer, Ditlev, C-5173/*53*①.

brasero, IDC.

Brasher, Ephraim, C-5203/*325A.*

Brasher doubloon, K-710/*118.*

Brasher gold doubloon, K-710/*118.*

brass, ACD; C-1082/*97*; C-2402/*4*; C-5116/*25*; C-5153/*66*①; C-5156/ *173*; C-5239/*20, 167*; CEA/*527, 547*; DADA/*Supplement*; DATT; EA; S-3311/*460*①; S-4436/*25*; S-4461/*70*; S-4972/*142*①, *248*①.

brass andirons, C-5114/*229.*

brass ball foot, C-5114/*330*①.

brass banding, C-5116/*163*①.

brass bezel, CEA/*224*①.

brass-bound, C-2421/*65*①; C-2478/ *69*①; C-5116/*57*; C-5157/*97*①; FFDAB/*51*; S-4414/*414*①; S-4436/*4*①; S-4461/*505.*

brassbound, C-2332/*1*; C-5116/*26.*

brass-bound case, C-5116/*70.*

brass candlestick, S-3311/*259*①.

brass cased weight, CEA/*239*①.

brass claw-and-ball foot, C-5116/*6.*

brass dial, CEA/*261*①.

brass drawer pull, CEA/*303.*

brasses, ACD; DADA; FFDAB/*94.*

brass fitting, C-0403/*126.*

brass-fluted, S-4955/*133*①.

brass foot, C-5116/*129*①.

brass fret side, LAR83/*180*①.

brass group, C-1082/*2.*

brass hand, CEA/*221*①.

brass horn, C-0906/*351.*

brass-inlaid, C-2421/*59*; C-5116/ *64*①.

brass level, C-MARS/*192.*

brass line, C-5116/*153*①.

brass-mounted, C-0982/*6*; C-2402/*24.*

brass-nailed, C-5116/*112.*

brass nailhead, C-2403/*51.*

brass pan, CEA/*25*①.

brass paw caster, S-4414/*455.*

brass paw foot, C-5114/*370*①.

brass plate, CEA/*605*①.

brass rail, C-1407/*73.*

brass roller, FFDAB/*55.*

brass rosette, C-2478/*181*①.

brass rubbing, DATT.

brass sand, DATT.

brass shim, DATT.

brass silvered, C-1082/*23.*

brass-studded, S-4972/*475*①.

brass superstructure, S-2882/*277*①.

brass toe, C-0982/*31.*

brass wheel, CEA/*218.*

brass wire, S-4988/*429*①.

brasswork, SDF.

bratina, DADA; EA; RGS/*17*①, *37.*

Bratmann, Demmer R., C-5189/ *172*①.

Bratmann, E., C-5189/*172*①.

brattishing, SDF.

Braun, CEA/*635*①.

Braunsdorf, Július Eduard, MP/*196.*

Braunsdorf underglaze, MP/*498*①.

Brauwers, Joseph, DADA/
Supplement.

bravura, DATT; LP.

Bray, F. J., C-2493/*204*.

brayer, DATT/①.

brayette, DADA; S-4972/*151*①.

brazen serpent, DSSA.

brazier, C-0906/*191*; DADA; DSSA;
EA/①; IDPF/*32*; NYTBA/*253*①,
258; S-4461/*447*; S-4802/*256*.

brazier bowl, C-5117/*17*①.

braziletto, SDF.

Brazilian beetle, CEA/*523*①.

Brazilian mahogany, SDF.

Brazilian rosewood, DATT; SDF.

Brazilian tulip wood, SDF.

Brazilian walnut, DATT.

Brazil wax, DATT.

brazilwood, DADA; SDF.

Brazilwood lake, DATT.

brazing, DATT.

bread, DSSA.

bread and butter dish, S-4804/*66*.

bread and cheese cupboard, DADA.

bread-basket, C-5117/*142*①.

bread basket, C-0225/*91*; S-4802/
296.

breadbasket, MP/*169*.

bread bin, IDPF/*33*①.

bread crock, IDPF/*33*①.

bread dish, S-4804/*54*; S-4922/*75*①.

bread necklace, C-2482/*95*.

bread pan, IDPF/*33*①.

bread plate, C-5174/*39*.

bread tray, C-0254/*3, 193*; C-5114/
*212*①; S-3311/*655*; S-4461/*291*.

bread trough, DADA; SDF.

break, SDF.

break-arch, EA.

break-arch case, C-2489/*71*.

breakfast can, IDC.

breakfast dish, C-0706/*171*.

breakfast fork, C-0254/*248*; C-0270/
*200*①.

breakfast knife, C-0254/*248*; C-0270/
*200*①.

breakfast service, EA/①; IDC;
S-4461/*104*.

breakfast table, ACD; C-0249/*401*;
C-0982/*277*; C-1407/*91*; C-2388/
60; C-2402/*9*; C-2478/*133*;
C-2522/*110*①; C-5116/*82*;
C-5157/*78*; CEA/*337*①; DADA;
EA; S-4804/*857*①; SDF/①.

break-front, CEA/*348*①; DADA.

break front, SDF/*broken front*.

breakfront, ACD; C-0249/*342*;
C-0982/*19, 33, 151*; C-2402/*26*;
C-2478/*200*; C-5116/*74*; C-5157/
*88*①, *165*①; CEA/*405*; EA;
FFDAB/*102*①; LAR82/*331*①;
LAR83/*348*①; S-4436/*156*①;
S-4461/*669*①; S-4812/*185*①;
S-4972/*432*.

break-front bookcase, DADA.

breakfront bookcase, C-2388/*136*;
C-2403/*142*; LAR83/*249*①;
S-3311/*243*①.

breakfront cornice, C-0249/*479*①;
C-5170/*108*①.

breakfront display cabinet, LAR83/
*321*①.

breakfronted outline, S-4955/*60*;
S-4972/*478*①.

breakfront form, S-2882/*800*①;
S-3311/*221*①; S-4414/*510*①.

breakfront library bookcase, C-2357/
*73*①; C-2421/*146*①.

breakfront pedimencct, LAR83/
*315*①.

break-front secretary bookcase,
DADA.

breakfront side cabinet, C-0982/*76*.

breakfront top, C-2403/*132*.

breakfront wardrobe, C-1407/*37*.

breast, DSSA.

breast bowl, IDC/①.
breast drawer, SDF/①.
breast-plate, C-MARS/*80*; CEA/ *20*①.
breast plate, S-4972/*238*.
breastplate, C-2332/*267*; C-2503/*41*.
breastplate (Torah), C-5174/*145*①.
breastplate, LAR82/*39*①.
breath motivation, CEA/*697*.
breccholito marble, C-2555/*74*①.
breccia, DADA; DATT; S-4807/*452*; C-0279/*376*; C-2437/*58*.
breccia marble, C-2364/*48*①; C-2403/*92*; C-2421/*114*①; C-5259/*642*.
brèche, DADA.
breche d'Alep, S-4461/*681*; S-4804/ *779*①.
breche d'alep marble, C-5189/*308*①.
breche violette, LAR82/*405*①.
brèche violette marble, C-2364/*69*①.
brêche violette marble, C-2546/*60*.
Brede hedgehog, IDC.
Brede pottery, EA.
breech, CEA/*23*①.
breeches, C-1506/*27*.
breech-loading, C-MARS/*125*.
breech-loading pistol, S-4972/*165*①.
breech-loading repeating flintlock pistol, CEA/*24*①.
Breed, Mary, NYTBA/*98*①.
Breguet, C-2368/*128*; CEA/*255*①.
Breguet, Abraham-Louis, EA/①.
Breguet, Louis Antoine, EA/*Breguet, Abraham-Louis*.
Breguet, Paris, S-4927/*49*.
Breguet à Paris, EA/*Breguet, Abraham-Louis*.
Breguet et Fils, C-5117/*463*; CEA/ *258*①; EA/*Breguet, Abraham-Louis*.
Breguet hand, CEA/*258*①.
Breguet lever, CEA/*258*①.

Breguet overcoil, EA.
breloque, EA; IDC.
Bremen blue, DATT.
Bremen green, DATT.
Brent, Moses, C-2487/*127*; C-2503/ *200*; C-5117/*33*; C-5174/*530*; S-4944/*48A*①.
Brescian, C-0279/*136*.
Brescian marble, C-5189/*168*①.
Breslau, CEA/*454*①.
Breslau Hausmalerei, EA.
Bressans consort, CEA/*553*①.
Bresse, DADA.
Bressler, H. G. von, MP/*166*.
Bretagne, DADA.
Breting, Ulysse, C-5174/*402*.
Breton, DADA/①; LAR82/*338*①.
Breton, Jean François, CEA/*65*①.
Breton bed, DADA.
Breton hat, C-3011/*64*.
Breuer, Marcel, C-5191/*326*①; DADA/*Supplement*.
Breuer, Peter, C-5191/*145*.
Brevete, F. R., C-2493/*246*.
Brevette, C-5191/*239*.
Brevoort, John, CEA/*670*①; EA/*53*.
Brewer, John, C-2493/*87*; CEA/ *193*①; EA.
Brewer, Robert, EA.
brewing vat, IDPF/*34*.
Brewood, Benjamin, S-4944/*367*.
Brewster, CEA/*390*①.
Brewster, Elder William, CEA/*390*①.
Brewster and Ingrahams, CEA/*246*①.
Brewster chair, DADA/①; EA/①; SDF/①.
Brewster form, S-4843/*569*①.
Brewster teapot, IDC.
Brewster-type chair, CHGH/*56*.
Brianchon, Maurice, S-286/*432*.
Briançon lustreware, IDC.
Brian Corcoran, C-2904/*34*.

briar, S-4881/*160*.

Briati, Guiseppe, EA.

bric à brac, DADA.

Brich, William Russell, EA.

Brichard, E., C-5117/*183*①; C-5220/ *24*①, *44*①.

brick, EA/*Delftward*; IDC; IDPF/ *34*①; MP/*28*; S-4461/*100*.

brick-form, S-3311/*109*.

brick liner, DATT.

brick-red, C-2403/*184*.

brick red, S-4948/*1*①.

brick relief, IDPF/*34*.

brickwork, C-0982/*211*; C-5203/*271*.

bridal bowl, IDC.

bridal cup, EA.

bridal vase, C-5189/*6A*; IDC.

bride, DADA.

bride bouclée, DADA.

bride epinglée, DADA.

bride picotée, DADA.

Bride's Bottle, EG/*269*①.

brides ornées, DADA.

bride tortillée, DADA.

bridge, CEA/*257*①, *267*, *556*; DATT; S-4802/*37*①; S-4927/*36*①.

Bridge, John, C-2510/*98*①; C-5117/ *29*; S-3311/*727*①; S-4922/*24*①.

bridge, the, LP.

bridge-cock, C-2368/*28*; C-MARS/ *155*.

bridge cock movement, C-5117/*461*.

bridgecock movement, C-5117/*480*①.

bridge cock verge, C-2368/*51*.

bridge floor lamp, C-5005/*375*.

bridge handle, IDPF/*34*①.

bridge lamp, LAR83/*487*①.

Bridgens, Richard, C-2478/*125*①.

bridge pattern movement, C-5117/ *426*①.

bridge spout, IDC.

bridle, C-5156/*262*①; CEA/*44*; DSSA/①.

bridle gauntlet, C-MARS/*99*①.

Brierley Crystal, CEA/*481*①.

Brierley glasshouse, EA/*Brierly Hill*.

Brigden, Zachariah, CEA/*673*①.

Briggle, van, Pottery Company, DADA/*Supplement*.

Briggs, John, DADA/*Supplement*.

bright, DATT; LP/① *brushes*.

Bright, Henry, C-5189/*198*.

bright-cut, C-0103/*4*; C-0706/*3*; C-1502/*12*; C-2202/*6*; C-2487/*110*; C-5117/*32*; C-5153/*8*; DADA; S-2882/*933*; S-4804/*4*, *29*; S-4905/ *222*.

bright cut, C-5153/*20*; CEA/*678*; S-4461/*314*.

bright-cut arch, S-2882/*1076*.

bright-cut border, S-2882/*1104*.

bright-cut decoration, S-4905/*178*.

bright-cut engraved, S-4414/*330*, *333*.

bright-cut engraving, CEA/*618*; EA.

bright-cut oval reserve, S-2882/ *1156*①.

bright-cut pointed stem, C-5117/*15*.

bright-cut terminal, S-2882/*1160*.

bright-cut wrigglework border, S-2882/*1126*①.

Brighton Pavilion taste, C-2478/*132*.

Brighton Pavillion style, S-4988/ *547*①.

Brille à Paris, C-5224/*51*.

brilliant, C-5117/*437*①, *480*①; CEA/ *459*, *524*.

brilliant-cut, CEA/*510*; RTA/*94*.

brilliant cut, EA; LAR82/*432*①; LAR83/*450*①.

brilliant-cut diamond, S-4927/*120*.

brilliant-cutting, SDF.

brilliante-mounted, C-5224/*51*.

brilliantly enamelled, S-4905/*115*①.

Brilliant Period, DADA/*Supplement*; NYTBA/*307*.

brilliant scarlet, DATT.

brilliant set bezel, C-5117/*480*①.

brilliant yellow, DATT.

brim, C-0225/*85*; C-5239/*137*.

brin, EA.

Brind, Walter, C-2487/*93*①; CEA/ *654*①; S-4944/*287*.

brindille, à la, IDC.

brine pan, IDPF/*35*.

brinjal bowl, C-2513/*286*; DADA; EA; IDC.

Brinner, John, SDF/*769*.

briolette, CEA/*524*; EA.

briolette-cut diamond, RGS/*199*①.

briolette emerald drop, S-291/*224*①.

Brion, Pierre-Gaston, C-2555/*41*①.

Briot, François, C-2510/*44*; CEA/ *588*①.

Briot, Francois, EA.

Briot, François, NYTBA/*242*.

briqueté ground, IDC/①.

brisé, C-1603/*1*.

brise fan, C-0405/*123*.

brisé fan, C-1304/*16*; EA.

Brislington, NYTBA/*143*①.

bristle, LP/*brushes*.

bristle brush, DATT.

Bristol, CEA/*145*①, *200*①; DADA/ ①; LAR82/*96*①; OPGAC/*160*; S-4461/*161*; S-4843/*16*.

BRISTOL, BRISTOLL, EA/*Lund, Benjamin*.

Bristol blue glass, EG/*139*.

bristol board, LP.

Bristol-board, JIWA/*229*.

Bristol board, DATT.

Bristol Brass Wire Company, EA.

Bristol colander-bowl, IDPF/*57*①.

Bristol delft, LAR83/*71*①.

Bristol delftware, EA/①; IDC.

Bristol flower-painting, CEA/*201*①.

Bristol glass, ACD; C-2332/*19*①; C-5116/*36*; EA/①; NYTBA/*281*.

Bristol glaze, DATT.

Bristol measure, EA.

Bristol penny toy, CEA/*697*.

Bristol porcelain, ACD; EA/①; S-3311/*346*.

Bristol pottery, ACD.

Britain, William, CEA/*694*①.

Britannia, C-5114/*112*.

Britannia figure finial, C-2510/*65*①.

Britannia mark, NYTBA/*213*①.

britannia metal, DATT; ACD; CEA/ *586*①, *594*; DADA; EA; NYTBA/ *245*; SDF.

Britannia standard, ACD; DADA; CEA/*678*; EA.

British gum, DATT.

British metalwork, CEA/*529*.

British pewter, CEA/*581*.

British pigment standard, DATT.

British Series, C-2503/*29*①.

Brittany, DADA.

Britzin, Ivan, C-2332/*148*.

BRK, EA/*Kornilov factory*.

B R Mo, EA/*Mô, Christophe, Jean*.

Brno arm chair, C-5167/*192*①.

broad-angle view, JIWA/*227*.

broad border, C-2704/*48*.

broadcloth, SDF.

broad flute, C-0406/*46*; C-5114/*92*①.

broad glass, DADA; EA.

Broadhead Collection, C-2370/*62*.

broad leg, C-0279/*267*①.

broadloom, DADA/*Supplement*.

broad loop handle, LAR83/*443*①.

broadly fluted, C-5117/*126*①.

broad manner, DATT.

broad oviform, C-0782/*47*.

broad oviform jar, C-0782/*15*.

broad-rimmed charger, CEA/*597*①.

broad-rimmed pewter ware, EA.
broadsheet technique, CEA/*484*; EG/
162.
broadside, S-4881/*36*①.
broad strap handle, LAR83/*160*①.
Broad Street Glass House, EA/
Bowes, Sir Jerome.
broad stretcher, C-5005/*330*①.
broadsword, C-MARS/*15*; CEA/*27*;
DADA.
broad waisted, C-1082/*89*.
Broadwood, CEA/*550*①.
brocade, ACD; C-0279/*303*①;.
C-2203/*25*; C-5156/*282*①;
C-5157/*69, 125*①; DADA;
NYTBA/*86*; SDF.
brocade box, C-5127/*23*.
brocaded, OC/*16*.
brocaded damask, DADA.
brocaded satin, NYTBA/*87*①.
brocaded stand, C-5156/*70*.
brocaded velvet, NYTBA/*86*①.
brocaded ware, IDC.
brocade-inset, C-2402/*66*.
brocadella, SDF/*brocatelle*.
brocade-pattern, C-2323/*76*.
brocade pattern, EA; IDC/①;
LAR83/*134*①.
brocade patterns, C-5236/*558*①.
brocade roundel, C-2458/*113*①.
brocade silk, C-5156/*262*①.
brocade-upholstered, C-2402/*14*.
brocado, SDF/*brocade*.
brocà glaces, EG/*289*①.
Brocard, Joseph, CEA/*487*①;
DADA/*Supplement*.
brocatelle, C-5181/*136*; DADA; SDF.
brocatelle d'Espagne, S-4461/*699*.
brocatelle d'Espagne marble, S-4955/
79, 141.
Brockbank, Atkins & Moore, London,
C-2489/*241*①.
Brockhurst, Gerald, S-286/*205*①.

Brocot escapement, S-3311/*414*①,
*552*①.
Brocot movement, LAR82/*230*①.
Brocot's escapement, C-MARS/*224*.
Brocot suspension, EA.
brocs a glaces, CEA/*503*.
broderie, CEA/*146*①.
broderie Anglaise, C-1506/*75*;
C-2203/*28*; C-3011/*81*; DADA;
CEA/*275*.
broderie de Nancy, DADA.
Brogden, John, EA.
Broggi, F., C-0270/*59*.
Brogniart, NYTBA/*172*.
broken arch, DADA; EA/*break-arch*.
broken arched cresting, S-4436/*87*①.
broken arch pediment, C-0279/*327*;
C-5116/*138*.
broken border, OC/*294*.
broken cabriole, SDF.
broken color, DATT; LP.
broken column, OPGAC/*206*;
S-4461/*72*.
Broken Dishes, C-2704/*48A*.
broken front, ACD; CEA/*405*; SDF/
①.
broken glaze texture, JIWA/*162*.
broken handle (in pewter), EA.
broken pediment, ACD; C-2388/
*126*①; CEA/*533*①; DADA/①;
LAR83/*254*①, *406*①; SDF.
broken scrolled, C-2421/*31*①.
broken scrolled cresting, C-2421/
*29*①.
broken scrolled pediment, LAR83/
*261*①.
broken swan's neck cresting, S-4436/
*172*①.
broken swirl, DADA.
broken triangular cresting, S-4436/
*183*①.
broken triangular pediment, C-2421/
*149*①; S-4436/*101*①.

Bromley, William, CEA/*208*①.

Brongniart, Alexandre, EA.

bronze, ACD; C-2458/*212, 234*①;
C-5005/*311*①, *382*①; C-5116/
*169*①; C-5127/*145*; C-5156/*80*①;
C-5239/*50*; CEA/*529*; DADA/①;
DATT.

Bronze-Age, IDPF/*7*.

bronze bell, MP/*205*.

bronze blue, DATT.

bronze cast, JIWA/*11*.

bronze circular mirror, C-1082/*106*.

bronze color marquise diamond,
S-291/*250*①.

bronzed border, C-2437/*20*.

bronze disease, DATT.

bronzed metal, C-1082/*97*.

bronze doré, DADA; DATT; EA/
ormolu.

bronzed pottery, IDC.

bronze Etruscan ware, IDC.

bronze figure, C-1082/*81*; C-5005/
*344*①; CEA/*226*①; S-4804/*550*①.

bronze-form, C-5156/*114*①.

bronze form, IDPF/*35*①.

bronze gilding, EA/*ormolu*.

bronze group, C-5117/*343*①.

bronze leaf, DATT.

bronze mirror, C-5156/*182*; S-4965/
*150*①.

bronze-mounted, C-5116/*43*①;
S-2882/*502A*①.

bronze mounting, C-5005/*258*.

bronze patination, EA.

bronze plaquette, CEA/*171*①.

bronze powder, DATT.

bronzes, C-1082/*37*.

bronzes, Chinese, DADA/①.

bronze stand, C-1082/*94*.

bronze vase, C-5005/*383*.

bronze wedding jug, JIWA/*106*.

bronzing, DATT.

bronzing liquid, DATT.

Bronzino, Angiolo, EA.

bronzo antico, IDC.

brooch, C-0706/*48*; C-5005/*202*①;
C-5146/*71*①; CEA/*514*①, *579*;
EA; S-4927/*225*.

brooch/pendant, C-5005/*210*①.

brooch-pin, S-4414/*71*.

Brooklyn Flint Glass Works, DADA/
Supplement.

Brooks, Hervey, EA.

Brooks, John, EA.

Brooks, Thomas, DADA/*Supplement*.

Brookshaw, George, EA.

broom, S-4461/*643*.

Broom Corn pattern, C-0270/*248*.

Brosamer, Hans, EA.

Broseley blue dragon, IDC.

Broseley Willow, CEA/*163*①.

Broseley willow pattern, CEA/*160*①.

Bros. Kornilov, C-5117/*330*①.

broth bowl, EA; IDC.

Brough, Thomas, C-0406/*109*.

Broussa rugs, ACD.

Brouwer, Hugo, EA/*Brouwer, Justus*.

Brouwer, Justus, EA.

Brouwer, Middle Lane (mark), EC1/
*84*①.

Brouwer, Theophilus, EC1/*77*①.

Brouwer, William Coenraad, DADA/
Supplement.

Brown, Ford Madox, DADA/
Supplement.

Brown, George W., CEA/*694*①.

Brown, J., C-2522/*4*①.

Brown, J. C., CEA/*244*①.

Brown, Jonathan Clark, EA.

Brown, J. S., CEA/*696*①.

Brown, Samuel, C-5174/*416*①.

Brown, Westhead, Moore & Co,
C-1006/*62*.

Brown Bess, CEA/*30*①, *44*.

Brown Bess musket, ACD.

brown china, IDC.

brown coat, DATT.

'Brown Cornflower' pattern, C-2910/
150.

brown ebony, SDF.

browned, S-4972/164①, 267.

brown edge, IDC.

Brownfield, JIWA/351.

brown glaze, MP/51.

brown glazed, C-1006/33.

brown-glazed ware, NYTBA/155.

browning, CEA/44; C-2904/214.

Browning, John, C-2904/207, 230,
236.

brown lampblack, DATT.

brown mouth and iron foot, EA.

brown oak, SDF.

brown ochre, DATT.

brown patina, S-4804/550①.

brown pigment, DATT.

brown pink, DATT.

brown sauce, DATT.

brownstone, DATT.

brown stoneware, IDC.

brown ware, C-5236/1590; EA/
Rockingham ware.

bruciaprofumo, IDC.

Brücke, die, DATT.

Brucke, Die, LP.

Bruges school, DATT.

Bruges tapestry, EA.

Brugger, Emanuel, CEA/223①.

Bruguier, Charles Abraham, C-5174/
451①; EA.

Bruhl, Count, CEA/63①.

Brühl pattern, IDC.

Brühlsches Allerlei-Dessin, IDC.

Brühlsches Allerlei (Brühl's various)
relief decoration, MP/484.

Bruhot, Louis, NYTBA/78①.

bruise, C-5114/7; C-5127/35.

bruising, DATT.

brûle-parfum, C-0279/454①; C-5189/
319; IDC.

brûle-parfum, S-3311/412①.

brûle parfum, C-2364/7.

brule parfum, C-5005/292①.

brûle parfum, C-5224/28; DADA/①;
S-4853/337①.

Brûlé parfum, C-5146/127①.

brummagem, DADA.

brun de Rouen, IDC.

Brunet, Geneva, S-4927/31.

Brunetto, Thomaz, EA.

brunkessi, DADA.

Brunstrom, John A., CEA/590.

Brunswick, DADA; EA.

Brunswick blue, DATT.

Brunswick green, DATT.

brush, C-0706/48; C-5236/810, 1429;
C-5239/106; DATT/①; JIWA/25;
S-4461/56.

brush, acrylic, DATT.

brush, bristle, DATT.

brush, hair, DATT.

brush, quill, DATT.

brush, red sable, DATT.

brush and mirror set, C-1502/97.

brush and pen, JIWA/22①.

brush box, C-5236/808.

brush cleaners, DATT/①.

brushed aluminum, C-5239/286.

brushed color, NYTBA/150.

brushes, LP/①.

brush exercise, JIWA/164.

Brush Guild, New York City, New
York, EC1/85.

brush-holder, C-2458/156.

brush holder, C-2458/116①.

brushholder, C-5156/115①.

brushing, C-2402/107.

brushing-slide, C-2357/68①.

brushing slide, C-0982/23, 58;
C-1407/54; CEA/332①; S-4414/

442ⓘ; S-4436/148ⓘ; S-4812/124;
S-4988/465ⓘ; SDF/ⓘ.

brush jar, DADA/ⓘ.

brush mark, NYTBA/143ⓘ.

brushpoint, S-286/475, 476.

brush-pot, C-2458/64; CEA/123ⓘ;
IDC.

brush pot, S-4905/38ⓘ.

brushpot, C-5156/112ⓘ; C-5236/
454ⓘ; LAR82/140ⓘ; S-3312/
1179.

brush-rest, EA; IDC/ⓘ; S-4810/
495ⓘ.

brush rest, IDPF/35ⓘ; S-4905/9ⓘ.

brush technique, JIWA/77, 380.

brush-washer, C-2458/178; IDC/ⓘ.

brush washer, C-5127/290; C-5156/
426; DATT/ⓘ.

brushwasher, C-0782/101; C-1082/
162; C-5236/1617; LP/ⓘ; S-3312/
1220ⓘ; S-4810/373ⓘ.

brushwork, C-5156/625Aⓘ; EC2/
32ⓘ; JIWA/44ⓘ; LP.

Brussa, C-0279/22.

Brussa carpet, EA.

Brussels applique, C-1506/170.

Brussels appliqué, DADA.

Brussels carpet, ACD; DADA; EA/
moquette carpet.

Brussels lace, C-1506/8; C-1603/75;
C-2203/6, 40, 135A; DADA;
NYTBA/91ⓘ.

Brussels style genre tapestry, S-4804/
953.

Brussels tapestry, DADA; EA/ⓘ;
LAR83/648ⓘ.

Brustolon, Andrea, EA/ⓘ.

Bruyucco, V., C-5191/149.

Bry, Thierry de, CEA/625ⓘ.

Bryce, McKee & Company, EA.

Bryce Brothers, DADA/*Supplement*;
NYTBA/310.

Bryenne, C-5191/235.

bryony leaf decoration (in ceramics),
EA.

bryony-leaf ground, IDC/ⓘ.

B.S., C-0405/17.

BS, EA/*Seuter, Bartholomäus.*

BS above BS, EA/*Smith, Benjamin
the Elder.*

B & S Glass Co. Sandwich, EA/
*Boston & Sandwich Glass
Company.*

B-shaped handle, IDC.

bubble, CHGH/61; DSSA; EG/286;
OPGAC/191; S-4461/99.

bubble bowl, EA.

bubble cup, IDPF/36ⓘ.

bubble design, C-0225/280.

'Bubbles' design, LAR83/170ⓘ.

bubble sextant, C-0403/122.

bubbletrap, C-5239/144.

bubbling, C-5156/85ⓘ.

bubby-pot, IDC.

bubinga, DATT.

bucaro, EA/*boccaro.*

búcaro, IDC.

buccaro, DADA/ⓘ; EA/*boccaro.*

buccaro ware, DADA; IDPF/36ⓘ.

bucchero stemmed, C-2482/111.

bucchero ware, DADA; DATT; IDC.

Buchanan, Thos., C-MARS/150.

Bucharo ware, C-5236/1587.

Buchwald, Johann, CEA/139ⓘ; EA.

Buck, Adam, C-2493/138.

buckelurnen, IDPF/36, 52ⓘ.

bucket, C-0254/170; C-2402/181;
C-2403/38; C-2421/82; DSSA;
IDPF/36; S-4965/176ⓘ.

bucket bench, SDF.

bucket bowl, CEA/423ⓘ; LAR82/
441ⓘ.

bucket-shaped, C-0254/152.

bucket-shaped cup, MP/486ⓘ.

bucket weight, C-2904/33.

buckeye, DATT.

Buckinghamshire lace, DADA.
buckle, C-0706/*92, 231*; C-5117/*92*①; EA; OPGAC/*207*①.
buckle-back, EA.
buckle back chair, SDF/①.
buckled, JIWA/*324*.
buckler, C-2503/*34*; DADA.
buckling, DATT.
buckram, S-4881/*364*①; SDF.
buckram slipcase, C-5156/*441*.
buckthorn berry, DATT.
buckthorn lake, DATT.
buckwheat celadon, IDC.
bucranea, C-0249/*163, 235*; C-5181/*24*.
bucranium, IDC.
'Bucureşti', OC/*265*①.
Budai, C-2458/*60*; C-5127/*109*①.
bud-and-wedge thumbpiece, EA.
budded ivy, OPGAC/*207*.
budd finial, C-0406/*47*.
buddha, DADA.
Buddha's-hand citron, IDC/①.
Buddhist figure, S-4965/*99*①.
Buddhistic emblem, C-0782/*9*; C-0803/*23, 23*.
buddhistic lion, C-5156/*85*①; C-2323/*31*①; C-2458/*66*; C-5127/*111*.
Buddhistic lion motif, C-0279/*154*.
Buddhistic symbol, C-5127/*47*.
Buddhist lion, IDC.
buddhist lion handle, LAR83/*74*①.
Buddhist motif, S-4965/*113*①.
Buddhist screen art, JIWA/*156*.
Buddhist shrine, S-4965/*100*①.
budding foliage surround, C-5117/*271*①.
bud finial, C-0254/*143*①; C-5114/*55*①, *58*①; C-5117/*16*①, *133*①; S-4414/*281*; S-4461/*295*; S-4922/*58*①.
bud holder, C-5239/*323*.

bud-molded standard, S-2882/*1320*①.
bud neck, C-0225/*229*①, *331*①.
bud-shape, C-2458/*35*.
bud-shaped, C-5239/*322*①.
bud-shaped finial, C-2414/*28*①, *39*①.
bud thumbpiece, EA.
bud vase, C-0225/*4*; C-5239/*19*; IDPF/*36*①.
Buen Retiro, ACD; DADA; EA/①.
buff, C-0249/*308*; C-0782/*120*; C-5146/*26*①; C-5236/*351*①.
buffalo comb, K-802/*15*.
buffalo horn, C-2398/*4*①; CEA/*562*; S-4810/*83*①.
buffalo pottery, S-4881/*323*①; C-5191/*1*; NYTBA/*155*.
Buffalo Pottery, Buffalo, New York, EC1/*85*.
buffet, C-2498/*141*; CEA/*323*①; DADA; EA/①; LAR83/*312*①; S-4972/*611*; SDF/①.
Buffet, Bernard, S-286/*211, 432*.
buffet à deux corps, DADA; S-3311/*402*①.
buffet à glissants, DADA.
Buffet a Paris, C-0906/*329*.
buffet bas, DADA.
buffet-crédence, DADA/①.
buffet stool, SDF.
buffet-vaisselier, DADA/①; S-3311/*403*①.
buff ground, C-2414/*84*.
buff pottery, C-2414/*28*①; C-2458/*7*; C-5127/*1*; C-5156/*1*①; LAR82/*107*①.
buff stoneware, C-2414/*30*①.
buffware, S-4807/*487*.
buffware flask, C-2482/*80*.
bugaku, S-4928/*165*①.
Bugatti, Carlo, C-GUST/*136*①.
Bugatti stand, LAR83/*354*①.
Buggin bowls, EA.

bugle bead, C-0405/*7*; C-3011/*31*; EA/*beads and marbles.*

buhl, ACD; DATT; SDF/*boulle*; DADA; LAR82/*223*①.

Buhl work, EA/*Boulle work.*

Buhot, Felix, S-286/*70, 212*①.

buie, IDC/*buire.*

building, DSSA; IDPF/*36*①.

building board, DATT.

built-in furniture, SDF/① *fitted furniture.*

built-in mechanism, CEA/*314*①.

buire, IDC.

buis wood, DADA.

Bukhara carpet, EA/*Bokhara carpet.*

bulb, C-5127/*208*; EA; SDF/①.

bulb-and-ring turning, EA/*bow-back Windsor.*

bulb bowl, C-2458/*132*; C-5156/*50*; C-5236/*482*①, *1595*; CEA/*116*①; DADA; IDPF/*38.*

bulb-jar, IDC.

bulbous, C-0225/*4*; C-0982/*72*; C-2402/*17*; C-5156/*54*①; C-5239/ *10*; DADA; SDF.

bulbous body, S-2882/*1395*①.

bulbous centrepiece, CEA/*531*①.

bulbous circular form, S-4414/*295*①.

bulbous column, C-0982/*135.*

bulbous contour, S-4414/*194*①.

bulbous cup and cover leg, LAR83/ *377*①.

bulbous foot, C-0225/*241*; C-0249/ *468.*

bulbous form, C-5156/*848*①; S-2882/ *938*①; S-4922/*27*①.

bulbous gadrooned body, LAR83/ *176*①.

bulbous jug, EG/*45.*

bulbous knop, C-5127/*62.*

bulbous lip, C-5156/*134*①.

bulbous lower section, S-2882/ *1240*①.

bulbous measure, CEA/*589*①.

bulbous mouth, S-2882/*1349.*

bulbous oval form, S-4414/*278*①, *317*; S-4922/*77*①.

bulbous ring-turned tapering leg, S-2882/*675*①.

bulbous-shaped leg, LAR83/*366*①.

bulbous side, S-4414/*338.*

bulbous stem, S-4461/*133.*

bulbous support, S-4414/*453*①.

bulbous tavern measure, EA.

bulbous-turned, C-5114/*399*①.

bulbous-turned leg, C-0249/*468.*

bulbous-turned stem, C-5157/*82.*

bulbous vase, C-2324/*6.*

bulbous vessel, S-4414/*200.*

bulb-pot, C-2427/*176*①.

bulb-shaped lip, C-5156/*66.*

bulb spout, C-2513/*138*①.

bulb tray, IDC.

bulb-vase, IDC.

Bulgarian copy, OC/*99.*

bulging spherical contour, S-4414/ *198*①.

Bulkley & Herter, C-5189/*262*①.

bull, DSSA.

Bull, Edmund, CEA/*251*①.

bull-baiting group, IDC.

bullen-nail, SDF.

bullet, CEA/*35.*

bullet diamond, S-291/*60, 151*①, *253*①.

bullet-form, S-2882/*1007*①; S-3311/ *675.*

bullet mold, C-2503/*208*①.

bullet mould, C-2569/*67*①; CEA/ *26*①.

bulletproof breast-plate, CEA/*37.*

bullet shade, C-5239/*154.*

bullet shape, C-0225/*260*; C-5239/ *263*; CEA/*647*①.

bullet-shaped, C-2487/*108*①;
 C-2510/*113*; C-5117/*207*; LAR83/
 *624*①, *640*①.
bullet shaped, C-0706/*82*.
bullet tea-pot, CEA/*647*①.
bullet teapot, EA/①.
bullion, SDF.
bull nose, SDF.
Bullock, George, C-2421/*51*①;
 C-2478/*125*①.
bullock-form, S-4965/*165*①.
bull point, DATT.
bull's-eye, CEA/*466*①.
bull's eye, DADA; EA; EG/*243*;
 OPGAC/*207*①; SDF/*bullion*.
bullseye, C-2904/*110*①.
bull's eye lamp, DADA.
bull's eye mirror, DADA.
bull's eye with diamond point,
 OPGAC/*207*.
bull's eye with fleur-de-lis, OPGAC/
 208.
bull's head mark, C-MARS/*15*.
Bull's Head watermark, S-286/*396A*.
bulrushes, C-5116/*155*①.
Bulverdi, OC/*217*.
Bumbutsu, S-3312/*962*①.
bumping glass, EA/①.
bun, C-0706/*238*.
bun cover, EA.
bun finial, C-0254/*251*; IDC.
bun foot, ACD; C-0706/*57, 193*;
 C-0982/*12, 56*; C-1407/*35*;
 C-1502/*24*; C-2398/*23*; C-2402/*12*;
 C-2409/*196*; C-5116/*91, 106*;
 CEA/*329*①, *365*①; DADA; EA;
 IDC; K-710/*111*; S-2882/*245, 247,
 385*①, *709*; S-4414/*416*①, *476*;
 S-4436/*47A*①; S-4804/*22*①; SDF/
 ①.
bungay mug, IDC.
bunghole, IDPF/*38*.
bunjin-ga or symbolic landscape,
 JIWA/*278*.

bunk, SDF.
bun-lid flagon, CEA/*597*①.
Bunney, London, C-2503/*192*.
bun pepper, C-0706/*239*.
bun pepperette, C-0103/*111*.
bun support, S-2882/*918, 1179*①.
Bunte Deutsche Blume (colored
 German flower), MP/*474*.
Buntline Special, CEA/*42*①.
Bunzlau, C-2427/*198*①; C-2486/
 *189*①; DADA.
buona notte, IDC.
buon fresco, DATT; LP.
Büottger porcelain, MP/*502*.
Buquoy, Georg Franz Longueval,
 Count von, EA.
Burano lace, DADA.
Burch, Cornelius Van Der, CEA/
 *667*①.
Burdess, Adam, CEA/*254*①.
bureau, ACD; C-0249/*345*; C-0982/
 79, 196; C-2402/*116*; C-2403/*72*;
 C-5116/*121*①; DADA; EA;
 FFDAB/*94*①; K-802/*15*; S-4436/
 *47A*①; S-4972/*435*①; SDF/①.
bureau-a-cylindre, CEA/*405*.
bureau a cylindre, C-0279/*372*①.
bureau à cylindre, C-2364/*77*①.
bureau a cylindre, C-2437/*70*①.
bureau à cylindre, C-5181/*203*①;
 CEA/*381*①; DADA/①; EA/
 roll-top desk; S-4972/*637*①.
bureau à dos d'ane, DADA.
bureau à pente, DADA.
bureau base, C-2421/*46*①.
bureau bedstead, EA; SDF.
bureau bookcase, C-5116/*29*①;
 C-5157/*168*①; DADA; EA;
 LAR83/*254*①; S-3311/*115*①;
 SDF/①.
bureau-cabinet, C-2478/*199*①;
 C-2498/*108*.

Burma pattern, C-5259/*82*.

burmese, DADA; CEA/*472*①, *474*①; EC1/*56*; OPGAC/*161*.

Burmese dome, K-802/*16*.

Burmese fairy lamp, LAR83/*484*①.

Burmese glass, ACD; EC1/*62*①.

Burmese ivory, C-1082/*152*.

Burmese pattern, NYTBA/*300*①.

Burmese sandalwood, SDF.

Burmese sapphire, RTA/*190*①.

Burnand, Eugene, S-286/*70*.

Burnand, Richard, Newcastle-upon-Tyne, C-2503/*156*.

Burne-Jones, Sir Edward, DADA/*Supplement*.

burner, C-0706/*106*; C-5114/*35*①; C-5236/*444*①; C-5239/*92*; S-4461/*185, 499*.

Burnham, Benjamin, EA.

burning-on, EA.

burnished, C-5156/*9*①; EG/*289*①; IDC.

burnisher, DATT/①.

burnishing, EA.

Burnside's patent carbine, C-2503/*104*.

burn stamp, S-4955/*195*.

burnt, C-5127/*37*.

burnt carmine, DATT.

burnt green earth, DATT; LP.

burnt gypsum, DATT.

burnt-in, IDC.

burnt jade, C-5156/*173*.

burnt ochre, DATT.

burnt-oil varnish, DATT.

burnt orange, C-2403/*189*.

burnt serpentine, S-4810/*109*①.

burnt sienna, DATT; LP.

burnt umber, DATT; LP.

burr, ACD; C-2402/*212*; C-5116/*134*①; DATT; EA; S-4436/*54*①; SDF.

burr-elm, C-2478/*96*; LAR82/*408*①.

burr elm, C-5116/*129*①; C-5157/*92*①.

burr-maple, C-2403/*91*①.

burr maple, C-5157/*128*.

Burrough,(Borough) John, EA.

Burrough, John, SDF/*746*.

Burrows, Alice and George, EA/*107*① cream jug.

burr-satin birch, LAR83/*48*①.

burr-walnut, C-0982/*28*; C-2388/*65*; C-2402/*9*; C-2403/*89*; CEA/*331*①.

burr walnut, C-0982/*18*; C-5116/*21*①; S-4812/*63*①.

burrwood, C-0249/*330*.

burr-yew, C-2421/*116*①; C-2478/*11*; LAR82/*218*①.

burr yew, C-5116/*12*①; C-5157/*150*①.

Bursa type, OC/*135*①.

burse, DADA.

Burslem, C-5189/*1*.

burst-off penny green work, CEA/*70, 56*①.

Burt, Benjamin, CEA/*675*①.

Burt, John, CEA/*671*①.

Burt family: John, Benjamin, Samuel, William, EA/①.

Burton, H., LAR82/*50*①.

Burton, James H., CEA/*37*.

Burton, John, CEA/*483*①; DADA/*Supplement*.

Burton, William and Joseph, DADA/*Supplement*.

Burujird rug, DADA.

Burwash, William, C-2510/*79*; S-4922/*35*①.

Busch, Christian Daniel, EA; MP/*164*.

Busch, Christoph, MP/*442*①.

Busch, Ernst von dem, MP/*166*.

bush, DSSA.

Bushberry, OPGAC/*345*.

bushel measure, C-0403/*78*①.

bushhammer, DATT/①.

bussa, IDPF/*38*.

bust, C-0225/*121*①; C-0279/*112*①; C-5156/*195*; C-5239/*50*; DATT; IDC; S-4461/*249*; S-4843/*305*; S-4992/*13*①.

Bustelli, Franz Anton, ACD; C-2486/*90*①; CEA/*177*①; EA/①.

Bustelli figure, IDC/①.

bust figure, S-4881/*158*①.

bustle, C-1506/*67*.

bust-length, C-5153/*61*①.

bust peg, DATT.

buta motif, EA/*boteh motif*.

butchers' block, CEA/*322*①.

Buteaux, Abraham, C-5117/*292*①.

Butes, C-2476/*96*.

butler, SDF.

Butler, London, C-2489/*41*.

Butler Buggen bowl, CEA/*444*①.

butler's desk, C-0279/*313*; EA; SDF/①.

butler's secretary, S-3311/*141*①.

butler's sideboard, DADA; EA; SDF.

butler's table, DADA.

butler's tray, ACD; C-5114/*247*; C-5236/*1640*; EA/①; FFDAB/*72*①; SDF.

butt, CEA/*24*①; S-4972/*155*①, *162*①, *272*.

Buttall, Sarah, C-5174/*544*①.

butt beaker, IDPF/*60*①.

butt cap, CEA/*29*①.

butted, C-2503/*58*.

butt-end, S-4972/*164*①.

Buttenmann, DADA.

butter boat, C-1006/*81*.

butter-cooler, IDC/①.

butter crock, CEA/*167*①; IDPF/*38*, *64*.

buttercup, S-4972/*138*①.

butter-dish, CEA/*191*①; IDC.

butter dish, DADA; EA/①; IDPF/*38*①; S-4461/*179*.

butter dish holder, C-1502/*81*.

Butterfield, C-2904/*155*.

Butterfield, Michael, CEA/*606*①; EA.

Butterfield, Paris, C-2489/*20*①.

butterfield dial, CEA/*606*①.

Butterfiled dial, C-2608/*128*.

butterflies among flowers, C-0782/*7*.

butterfly, CEA/*495*①; DATT; DSSA; EA/*Jacobite glass*.

butterfly and berry, OPGAC/*180*.

butterfly cut-out, C-5174/*354*①.

butterfly frame, C-2403/*43*.

butterfly head, C-2513/*162*①.

butterfly hinge, SDF.

butterfly lustre, K-710/*109*.

butterfly motif, RTA/*151*①.

butterfly pattern, JIWA/*92*①.

butterfly pin, S-291/*255*.

butterfly plate (in furniture), LAR83/*329*①.

butterfly stopper, LAR83/*76*①.

butterfly table, ACD; CEA/*362*①, *391*①, *405*; DADA/①; EA; LAR82/*392*①; LAR83/*372*①; S-3311/*187*①; SDF/①.

butterfly weight, CEA/*490*.

butterfly wing picture, C-2409/*155*.

butter-knife, C-5117/*80*.

butter knife, C-0254/*87*; C-1502/*136*; EA; S-4804/*65*; S-4905/*167*; S-4922/*34*①.

butter mold, CHGH/*56*.

butternut, DATT.

butter patty, S-4461/*279*.

butter pick, C-0254/*310*.

butterpick, K-711/*130*.

butter piggin, LAR83/*435*①.

butter plate, C-0254/*175*, *193*.

butter-pot, IDC.

butterscotch glass, C-5146/*174*.

butter-shell, C-5117/*23*①.

butter shell, C-5153/*43*①; LAR82/*586*①; LAR83/*575*①.

butter-spoon, IDC/①.

butter spreader, C-5114/*16*; S-4804/*28, 35*①; S-4905/*160*.

butter stamp, IDPF/*39*①.

butter-tub, IDC.

butter tub, S-4905/*66*.

buttess shaped, C-5239/*265*.

butt hinge, SDF.

but tip, C-0254/*65*.

butt join, DATT.

butt joint, SDF.

butt mask, CEA/*29*①.

button, C-5156/*314*; CEA/*426*①, *540*①; EA/①; IDC; IDPF/*39*①; NYTBA/*258*; S-291/*33*①; S-4972/*155*①.

button-and-chip carved, C-1407/*150*.

button base, IDPF/*39*.

button boot, C-0604/*48*.

buttoned, C-0982/*84*; C-2402/*72*.

buttoned back, LAR83/*277*①.

buttoned leather, C-5116/*76*.

buttoned squab cushion, C-2403/*29*①.

button finial, C-5114/*10*①; S-4905/*194, 202*①; S-4944/*70*①.

button foot, S-4461/*749*.

button hole, C-1506/*24*.

buttonhole stitch, CEA/*276*①; DADA.

button hook, C-0254/*140*; C-0706/*5, 64, 210*; C-1502/*56*; C-5203/*226*.

buttoning, C-1506/*1*; SDF.

button lac, DATT.

button pearl, S-4927/*240*.

button point, CEA/*541*.

button repeat, S-4802/*17*.

button set, C-5117/*439*①.

button stick, K-710/*110*.

button trigger, C-2569/*84*.

button-upholstered, LAR82/*362*①; LAR83/*281*①; S-4507/*69*①.

buttonwood, SDF.

butt-plate, C-2476/*1, 38*.

butt plate, S-4972/*262*①.

buttress, C-0279/*73*; EA/*Abbotsford style*; S-4972/*328*①; SDF/①.

buttressed, C-0225/*83*; C-5239/*285*.

buttressed handle, C-0225/*6*.

butt trap, CEA/*38*①.

Butty, Francis, CEA/*653*①; S-4922/*36*①, *51*①.

butyl lactate, DATT.

Butzek, B., C-5191/*195*①.

Bux, (Buchs, Bochs) Johann Baptist, EA.

Buxbaum, Meir, Aberle, C-5174/*13*①.

B.V.R.B, EA/*van Risenburgh, Bernard*.

B.V.R.B., CEA/*377*①; EA/*van Risenburgh, Bernard*.

Bye-lo, K-711/*128*.

Byerley, Thomas, EA.

byka, IDPF/*126*.

bypass ring, S-291/*66*①.

Byrdcliffe Pottery, Woodstock, New York, EC1/*85*.

Byrne, Gustavius, C-5174/*516*.

Byrne, James, S-4905/*222*.

byrnie, DADA.

Byzantine, DADA/①; DATT.

Byzantine art, LP.

C

C, EA/*Sèvres*.

C, S, or Sx, SALOPIAN,, EA/ *Caughley*.

cabaret, C-5189/6; DADA; EA; LAR82/182①.

cabaret-service, CEA/184①.

cabaret service, IDC.

cabaret set, ACD; LAR83/166①.

cabaset, LAR82/38①.

cabasset, DADA.

cabbage-leaf jug, IDC.

cabbage-leaf-molded, C-2493/46①.

cabbage pattern, CEA/160①.

cabbage rose, OPGAC/208.

cabbage stalk, CEA/452①, 625①.

cabbage ware, IDC/①.

cabinet, ACD; C-5116/56, 89; C-5156/483①; C-5157/61; C-5239/243; CEA/308①; DADA/ ①; NYTBA/37; S-4461/585①; S-4972/456, 464; SDF.

cabinet back, C-0982/83B.

cabinet bud vase, C-0225/324.

cabinet cherry, SDF.

cabinet cup, LAR83/161①.

cabinet cups and saucers, IDC.

cabinet doors, S-4461/502.

cabinete-secrétaire de cylindre, DADA.

cabinet-maker, ACD; SDF.

cabinetmaker, CHGH/58; DADA; NYTBA/6.

cabinet-maker's tree, SDF.

cabinet of curiosity, CHGH/36.

cabinet on chest, C-5170/127①.

cabinet-on-stand, C-2478/146①.

cabinet organ, C-5255/44①.

cabinet piano, SDF/①.

cabinet pianoforte, C-2520/52.

cabinet picture, DATT; LP.

cabinet plate, C-0249/227; C-0279/ 234; C-5189/27; S-4804/287①; S-4992/62①.

cabinet table, SDF.

cabinet vase, C-0225/321; C-5005/ 364①; C-5239/168; S-4461/42.

cabin trunk, SDF.

Cabistan, CEA/83①.

cabistan rug, DADA.

cable, OPGAC/208; S-4905/129①.

cable border, C-2704/66.

cabled border, RTA/78①, 78①.

cable molding, S-2882/353A.

cable moulding, EA; SDF.

cable-pattern work, RTA/*50.*

cable stitched, C-5236/*553.*

cabling, SDF/①.

cabochon, ACD; C-0225/*334;*
C-0254/*61*①; C-1407/*78;* C-2357/
*8*①, *83*①; C-2402/*30;* C-5005/
*235*①; C-5117/*306, 307;* C-5167/
*156*①; CEA/*524;* DADA; DATT;
RGS/*68;* S-288/*11*①; S-291/*35*①;
S-4414/*278A;* SDF/①.

cabochon amethyst, RTA/*35*①.

cabochon angle, C-2364/*63*①.

cabochon border, C-0982/*82A.*

cabochon carnelian, RTA/*36*①.

cabochon-carved, S-4812/*88*①, *89*①.

cabochon carved cabriole legs,
S-4414/*481*①.

cabochon cat's eye, S-291/*222*①.

cabochon coral, S-291/*74*①.

cabochon cresting, C-2421/*25*①.

cabochon-cut amethyst quartz, RTA/
*167*①.

cabochon-cut sapphire, C-5005/*214*①.

cabochon-cutting, RTA/*104*①.

cabochon emerald, S-291/*111*①;
S-4414/*114*①.

cabochon foot, C-2403/*27;* C-2478/
32.

cabochon garnet, LAR83/*454*①;
RTA/*162*①.

cabochon glass, S-291/*136.*

cabochon jade, S-291/*125, 130, 164,
237*①, *238*①, *262.*

cabochon jewel, C-0225/*50.*

cabochon moonstone push-piece,
RGS/*123*①.

cabochon motif, EA/*in furniture.*

cabochon-mounted heading, C-1407/*3.*

cabochon ruby, RGS/*199*①; S-291/
*63*①, *142;* S-4414/*30, 40.*

cabochons, C-5117/*315*①; C-5239/
323; S-3311/*854.*

cabochon sapphire, RTA/*61*①, *63*①;
S-291/*240*①.

cabochon-shaped, S-4461/*280.*

cabochon star sapphire, S-291/*189.*

caboose lantern, K-711/*130.*

Cabrier, C., London, C-2489/*184*①.

Cabrier of London, EA/*99.*

Cabril Chavanne & Compey, Vienna,
C-2489/*230.*

cabriole, ACD; C-0982/*15, 84B;*
C-5239/*256;* CEA/*405;* S-2882/
279; S-4436/*86*①.

cabriole base, C-2357/*47*①; C-2388/
28.

cabriole bracket, SDF/①.

cabriole chair, FFDAB/*33*①; SDF.

cabriole corner, SDF/①.

cabriole leg, C-0982/*80;* C-1407/*8,
41;* C-2402/*7, 22;* C-2478/*32;*
C-5114/*26*①, *270*①; C-5116/*31,
52;* C-5153/*88;* C-5156/*462;*
C-5259/*533;* CEA/*307*①; DADA/
①; EA; LAR83/*357*①; S-2882/
*260*①, *276, 774, 1447*①, *357A;*
S-4414/*226*①, *426*①, *427*①,
*429*①, *448*①, *466*①, *509*①;
S-4812/*67*①; SDF/①.

cabriole period, SDF.

cabriole sofa, C-5114/*385*①.

cabriole stand, CEA/*312*①.

cabriolet, CEA/*405;* DADA.

cabriolet fan, EA/①.

cabriole tripod base, C-2357/*28*①.

CAC, OPGAC/*347.*

cachemire, EA.

Cachemire decoration, IDC.

cache-pot, C-2513/*201;* S-4853/*44*①,
*221*①.

cache pot, C-0249/*208;* S-4461/*44,
492;* S-4804/*285*①.

cachepot, C-5189/*205;* C-5191/*206;*
DADA; EA/*Chantilly;* IDC/①;
LAR82/*115*①.

Cache-pot, S-4843/*317*①.

cachet, DATT.

cachou, DATT.

cachou box, C-0706/*90*; C-1502/*22*.

Cactus pattern, C-0254/*79*; C-0270/*99*.

Cadaval toilet set, EA.

caddies, C-5116/*21*①.

caddinet, EA/*cadenas*; SDF.

caddy, C-0249/*297*; IDC; IDPF/*39*①; S-4905/*71*①; SDF.

caddy set, CEA/*650*①; S-4922/*584*①.

caddy-spoon, C-2487/*44*; IDC.

caddy spoon, C-0254/*147*; C-0706/*47*; C-1502/*19*; C-5203/*161*; DADA; EA/①; LAR82/*591*①; LAR83/*581*①.

caddy-top, C-MARS/*245*; S-3311/*107*①.

caddy top, C-0279/*226*; C-2489/*92*①; C-5116/*27, 50*①; C-5157/*33*①.

cadeceus, MP/*499*①.

cadenas, EA; SDF.

cadmium-barium pigment, LP.

cadmium green, DATT.

cadmium orange, LP.

cadmium pigment, LP.

cadmium red, DATT; LP.

cadmium yellow, DATT; LP.

cadogan, IDC/①; EA/*Rockingham Works*.

cadogan teapot, ACD; DADA/①; IDPF/*40*; EA.

caduceus, C-2357/*82*①; C-5117/*13*①; DSSA/①.

caduceus mark, C-2427/*129*①; EA/*Meissen porcelain factory*.

cadus, IDPF/*5, 40*.

caelatura, DADA.

Caen, DADA.

Caen stone, DATT.

Caernarvonshire on the left, C-2704/*27*①.

caeruleum, DATT.

Caesar, Julius, jug, IDC.

caesura, JIWA/*89*.

Cafaggiolo, EA/*alla porcellana*; S-4972/*398*.

Cafaggiolo maiolica centre, EA.

Cafe, John, S-4922/*57*①.

Cafe, William, C-5173/*31*①; C-5174/*555*.

cafe-au-lait, C-0803/*50, 50*.

café au lait, IDC.

café au lait glaze, EA.

cafe-au-lait ground, C-0782/*201*; C-0803/*50, 50*.

cafe-au-lait set, C-2202/*203*.

Caffaggiolo, ACD; CEA/*134*①; DADA.

CAFFIERI, EA/*Caffiéri, Jacques*.

Caffieri, Jacques, DADA.

Caffiéri: Jacques, Philippe, EA.

C & AG, EA/*Giuliano, Carlo*.

cage, C-0225/*328*①; S-4881/*498*①.

cage form case, S-4955/*35*①.

cage sleeve, S-4881/*320*①.

cage-work (in silver), EA.

cage work, C-0706/*127*.

cagework, C-5220/*27*①; CEA/*70*.

cage-work box, EA.

cagework foliage, C-5117/*13*①.

Cahusac, C-0906/*354*.

caille pattern, EA.

cailloutages, DADA; IDC.

caillouté, C-2486/*12*; DADA; EA; IDC.

cailloute, S-4947/*165*.

caillouté pattern, C-2493/*253*.

cailloux du rhin, RTA/*113*.

Cain, Auguste-Nicolas, EA.

Cains, Thomas, CEA/*462*①.

Cairean cedarwood, C-2402/*15*.

Cairene carpet, EA/*Turkish Court Manufactory*.

cairngorm, C-5220/*11*①; EA.

Cairo carpet, EA.

caisse à fleurs, IDC.

caitya, C-5156/225①.

cake-basket, C-2398/35; C-5117/163; C-5173/30①; C-5174/505.

cake basket, C-0254/22, 156; C-0706/26; C-1502/9; C-5117/220; LAR83/535①; S-4802/408①; S-4905/161.

cake basket clock, LAR83/203①.

cake cutter, S-4804/1.

cake dish, C-5236/880①; S-4461/ 109; S-4905/162.

cake fork, C-0254/190.

cake knife, C-0270/169; C-0706/233; S-4461/209.

cake platter, S-4804/25.

cake-server, C-5114/48①.

cake-slice, EA.

cake slice, S-4804/28, 35.

cake stand, C-0103/39; C-0254/200; C-0706/65.

cake-tong, EA.

calabash, JIWA/324①.

calabash form, IDPF/41①.

calabash ladle, IDPF/41①.

calamanco, SDF.

calamander base, C-5005/340①.

Calamander center table, C-5116/ 153①.

Calamander ebony, DATT.

calamander wood, ACD; C-2332/1; SDF.

calamanderwood, C-2388/33; C-2403/ 95①; C-2478/130; C-2522/72①; LAR83/339①, 390①.

calambac wood, DADA.

Calamelli, Virgilio, EA.

Calamelli, Virgiliotto, EA.

calamus, DADA.

calash, C-2501/7.

calcareous flux, MP/17.

calcedonio, EA/①.

calcified, C-5127/299; C-5156/298①; S-3312/1206.

calcimine, DATT.

calcine, DATT; IDC.

calcined bone, CEA/187.

calcined magnesite, DATT.

calcite, C-5191/388; K-710/118; S-4461/43.

calcium carbonate, LP.

calculating rule, C-2904/261.

Caldas da Rainha, EA.

Calder, Alexander, S-286/212A①.

Calder, William, S-4905/316.

Calderwood, Robert, LAR82/607①.

Caldwell, James, CEA/159①; EA.

Caldwell, J. E., LAR82/210①.

Caldwell, J. E., and Company, DADA/Supplement.

Caldwell, J. E. & Co., C-0270/221; S-4927/77.

Cale, C-2904/184.

Caledonian brown, DATT.

Caledonian white, DATT.

calendar, EA/①; EC2/99①; S-4802/ 135B①.

calendar aperture, C-5157/34①; S-4988/407①.

calendar chronograph, C-MARS/ 157①; LAR83/213①.

calendar clock, ACD; CEA/248①.

calendar frame, C-0225/309; C-5191/ 472; C-5239/91, 317.

calendar movement, C-2364/76①.

calendar watch, S-4802/58①; S-4927/ 54.

calendering, DATT.

Calenian style, C-2482/112.

calfskin glue, DATT.

caliatour wood, DADA.

caliber, S-4972/218①, 259①.

calibrated, C-2476/14①; S-3311/213; S-4927/122.

calibre, CEA/38①, 44.

calibré-cut, RTA/*113*①; S-4414/*1*; S-4927/*141*①.

calibre-cut emeralds, S-291/*87*①.

calibre-cut rubies, S-291/*78*①.

calibre-cut synthetic sapphires, S-291/*207*①.

calibre emerald, S-291/*111*①, *243*.

calibre ruby, S-291/*195*①.

calibre sapphire, S-291/*145*①.

calico, C 2403/*27*; DADA; SDF.

calico patchwork, NYTBA/*107*①.

California asphalt, DATT.

California Faience, Berkeley, California, EC1/*85*.

caligraphy, S-4461/*447*.

caliper, CEA/*414*.

calipers, DATT/①.

caliver, DADA.

calix, IDPF/*41*.

calking, DATT.

Callaghan, London, C-2489/*42*.

Callard, Isaac, C-5117/*257*; EA/*172*.

Callegari, (Caligari) Filippo Antonio, EA.

Callen, Anson W., CEA/*522*①.

calligraphic, C-5156/*59*①; C-5157/*166*①; DATT; LP.

calligraphic border, C-2403/*167*.

calligraphic meander, C-2323/*25*①.

calligraphic slip, CEA/*166*①.

calligraphic spray, S-4965/*224*①.

calligraphy, C-0249/*215*; C-5127/*168*; DATT; JIWA/*9*.

calling card case, S-4461/*219*.

Callot, Jacques, CEA/*148*①, *193*①; EA.

callot figure, DADA; ACD; EA; IDC/①; MP/*37*.

calm, DATT.

calpis, IDC.

Caltagirone, C-2427/*211*①; C-2486/*209*①; EA.

Calvary cross, DATT.

calyx, C-5117/*124*①; C-5173/*18*①; EA; S-2882/*921*①, *978*; S-4905/*192*①.

calyx-and-leaf ornament, EA/*Armenian dragon rug*.

camaïeu, CEA/*148*①; DATT.

camaïeu, en, IDC.

camaïeu rose, RGS/*145*①.

camagon wood, DADA.

camaïeu, LP.

camaieu, MP/*474*, *502*; S-3311/*373*; S-4804/*472*①; S-4823/*77*; S-4853/*29*①, *32*①, *121*①, *212*①; S-4905/*26*①.

camail, C-2503/*55*; DADA.

Cambi, A., C-5189/*175*①.

camblet, SDF/*camlet*.

Cambodian horn, C-2332/*29*.

Cambria clay, IDC.

cambrian, ACD.

cambrian pottery, DADA.

Cambrian Pottery Works, EA/①.

Cambrian ware, IDC.

Cambria Rock, CEA/*160*①.

Cambridge, OPGAC/*162*.

Cambridge Art Pottery, Cambridge, Ohio, EC1/*85*.

Cambridge Glass, Cambridge, Ohio, OPGAC/*162*.

Camden Town Group, LP.

came, DATT; SDF.

camel, DSSA; IDC/①.

camel-back, DADA/①.

camel back, CEA/*393*①, *405*; LAR82/*365*①.

camel back chair, SDF.

camel blanket, S-3311/*29*.

camel-coloured ground, OC/*28*.

camel hair, C-5189/*388*; DATT; LP/*brushes*; OC/*16*.

camellia branch, C-2414/*102*①.

camellia-leaf green, IDC.

camel's hair field, S-4847/*64*.

camel-shaped back, LAR83/275①.

camel teapot, IDC/①.

cameo, C-1702/88; C-5117/361①; CEA/502, 524; DADA; EA/①; EC1/56; IDC/①; RTA/16; S-2882/513; S-3311/899①; S-4461/41, 97, 260.

cameo, glass, EA.

cameo back, ACD.

cameo carving, CEA/450①.

cameo-cut glass, EG/206.

cameo cutting, CEA/487①.

cameo deposé, C-5191/259.

cameo-glass, EC1/66①.

cameo glass, ACD; C-2409/23; C-5239/151; DADA; LAR82/432①; LAR83/422①; NYTBA/268; S-3311/899①, 908①.

cameo glass bottle, LAR83/413①.

cameo incrustation, DADA; EA/sulphides; CEA/450①.

cameo mark, C-2409/24.

cameo paper, S-4881/187①.

cameo relief, CEA/417①; EG/28①.

cameos, C-5116/147①; S-4414/53.

cameo sard, RTA/70①.

cameo-set jewellery, RTA/112①.

cameo-shaped, LAR82/304①.

cameo signature, C-5005/238; C-5146/91①; C-GUST/69①.

cameo technique, JIWA/304; RTA/35①.

cameo vase, C-0225/205; LAR83/442①.

camera lucida, C-1609/122; C-2608/50; DATT; LP/①; LAR83/467①.

camera obscura, C-1609/183①; DATT; LP/①.

Camerini of Turin, CEA/224①.

Cameron, A., C-2489/153.

Cameron, David Young, S-286/24.

Cameroon, C-1082/3.

camicia, EA.

camiknickers, C-0604/53; C-1304/179.

camisole, C-2203/65.

camlet, SDF.

camomile and garland weight, LAR83/437①.

Camota, Halifax, C-2489/35.

camp, LP.

campagna urn, C-5259/202.

campagne, DADA.

campaign bed, C-5189/357; LAR83/346①; S-4461/717.

campaign chair, EA/72; LAR83/278①.

campaign chest, S-3311/249①; S-4461/742①.

campaign furniture, EA/①; SDF/①.

campana, C-2493/126; IDC; LAR82/462①; S-4905/169.

campana-form, S-2882/1418①; S-3311/387①, 585; S-4804/212A①; S-4992/77①.

campana form, LAR83/468①; S-4802/327①; S-4804/144①; S-4905/173.

campana shape, LAR83/644①; S-2882/1035①, 1036①; S-4414/265①, 310①.

campana-shaped, C-0103/122; C-0254/82, 212; C-0706/217; C-2202/27, 29; C-2398/6; C-2510/64①; C-5117/162, 297①; C-5189/100; LAR82/154①; S-4802/274; S-4922/57①; S-4992/1①.

campana-shaped body, LAR83/89①.

campana-shaped sconce, S-2882/1027①; S-4414/254①, 256①, 272①.

campana-urn, S-4461/492.

campana vase, LAR82/96①.

Campani, Giuseppe, CEA/602①.

Campanian, S-4807/499①.

campanini, DADA.

campan marble, DADA; DATT.

candy mold, IDPF/*42, 60*①.

cane, ACD; C-1082/*19*; C-2402/*21, 90*; C-5114/*173*; C-5239/*256*; CEA/*60*①, *502*; DADA/ *Supplement*; EG/*61*; FFDAB/ *38*①; LAR82/*448*①; NYTBA/ *32*①; OPGAC/*208*; S-4881/①.

cane and sword handle, IDPF/*42*.

cane-back, CEA/*327*①.

cane back, C-2370/*29*①.

cane bottom, C-0249/*446*.

cane chair-maker, SDF.

cane-colored ware, DADA.

cane-coloured stoneware, EA.

cane-covered, C-2409/*109*.

caned, C-0279/*352*; C-0982/*92, 207*; C-2403/*25*; C-5239/*243*; DADA; S-4436/*139*①.

caned back, C-1407/*1*; LAR82/ *296*①; S-2882/*241*①, *243*①.

caned bergere, C-5116/*95*.

caned chairback settee, C-5116/ *130*①.

cane design, S-4948/*12*.

cane design spandrel, C-5323/*17*①.

caned panel, C-5156/*485*①.

caned seat, C-2357/*11*①; C-2388/*40*; C-2421/*58*; C-5116/*95*.

caned seats, C-0982/*216*.

caned wings, C-0249/*446*.

cane-handle, C-2427/*57*①; IDC/①.

cane handle, C-5236/*798*; IDPF/ *42*①; MP/*34, 468*①.

cane panel back, C-1407/*5*.

cane pattern, C-0279/*15*.

canephora, DADA/①.

cane rocker, C-0225/*360*.

cane seat, C-5116/*64*①.

canestrella, IDC.

canette, IDC.

cane-ware, IDC.

cane ware, IDPF/*12*; K-710/*109*.

caneware, EA/*cane-coloured stoneware*; LAR82/*188*①; LAR83/ *169*①; S-4843/*368*①.

cane-work, EA/①.

canework, SDF.

cangiante lustre, IDC.

caning, SDF/①.

canister, C-5146/*169*①; C-5236/*884*; DADA; IDC; IDPF/*42*; S-4461/ *280, 486*.

canister base, C-5191/*492*①.

canister case, SDF.

canister clock, EA.

cann, C-5114/*91*①; C-5153/*34*①, *50*①; CEA/*673*①; DADA; EA; LAR82/*601*①; LAR83/*594*①.

Çannakkale, OC/*240*①.

canned seat, C-1407/*1*.

cannelle wood, DADA.

Canner, Christopher, CEA/*643*①.

cannetille, EA; LAR83/*481*①.

cannibal crown, CEA/*54*①.

Canning Jewel, EA.

cannister, C-5236/*1701*.

cannon, C-MARS/*140*; DSSA.

cannon-ball pattern, IDC/①.

cannonball pattern, LAR83/*122*①.

cannon barrel, C-2569/*73*; S-4972/ *222*①.

cannon spout, IDC.

cannula, DADA.

Cano, Joseph, Madrid, C-2503/*148*①.

canoe shape, S-2882/*1239*①.

canoe-shaped, LAR83/*422*①.

can opener, S-4461/*220*.

canopic jar, EA/①; IDPF/*42*; LAR82/*33*①; IDC.

Canopic vase, IDC/①.

canopied, C-5189/*290*①.

canopied drop, S-4812/*17*.

canopy, ACD; C-1407/*63*; C-2357/ *74*①; C-2402/*55*; C-2403/*4*; C-5116/*41, 105*; C-5153/*115*①;

DADA; LAR83/*324*①; S-4436/
*18*①; SDF.

canopy bed, C-5116/*105*; C-5189/
346.

canopy cresting, C-2437/*40*①.

canopy frame, FFDAB/*75.*

Canova, Antonio, C-5224/*251*①.

cans, C-1006/*45.*

cant, SDF.

Cantagalli, C-5189/*112*①; LAR82/
*137*①.

Cantagalli, Ulysse, CEA/*135*①.

Cantagalli lustred maiolica, S-4804/
516.

Cantagalli ware, IDC.

cántaro, DADA; EA.

cantaros, IDPF/*42.*

canted, C-0279/*197*; C-2402/*47*;
C-2486/*4*①; C-5114/*329*①, *337*①,
*344*①; C-5116/*10*; C-5156/*406*;
CEA/*405*; DADA; LAR82/*286*①;
S-4436/*54*①; S-4461/*620*; S-4988/
*510*①; SDF.

canted angle, C-0982/*22, 211*;
C-1407/*40*; C-2402/*8.*

canted back, S-3311/*945*①.

canted corner, C-0279/*447*; C-1502/
221; C-2388/*108*; C-5114/*151,
177*①; C-5116/*7*; C-5153/*162*①;
CEA/*355*①; IDC; LAR82/*134*①;
LAR83/*310*①; S-2882/*695*①,
*698*①; S-4414/*495*①; S-4812/
*102*①.

canted form, LAR83/*410*①.

canted front corner, C-5116/*122*①.

canted pilaster, CEA/*311*①.

canted pilaster strip, C-5116/*122*①.

canted rectangular form, LAR83/
*426*①; S-4414/*509*①.

canted square shape, S-4965/*246*①.

canted top, C-0982/*95B.*

canteen, ACD; C-0706/*193*; C-2202/
59; EA; SDF.

canterbury, ACD; C-2478/*70*;
C-5114/*251*; C-5116/*51*; CEA/
*359*①; LAR82/*294*①; LAR83/
*266*①; S-3311/*128, 245*; C-2402/
207; C-2403/*42*; DADA/①; EA;
SDF/①.

cantharus, DATT; IDC.

Cantigalli part, C-2502/*113.*

cantilevered, C-5127/*33.*

cantilevered cupboard, C-5167/*194*①.

càntir, DADA.

cántir (cántarro), EG/*86*①.

cantle, C-5156/*262*①.

Canton, ACD; DADA; EC2/*20*;
LAR83/*74*①; S-4461/*131.*

Canton enamel, C-2458/*257*①;
C-5156/*150*; DATT; EA; LAR82/
*100*①; S-4810/*234*①.

Cantonese, C-0782/*6.*

Canton famille rose bowl, S-3312/
*1395*①.

cantonnière, DADA.

Canton porcelain, IDC.

Canton ware, DADA/*Supplement*;
EC2/*20.*

canvas, C-5005/*349*①; C-5236/
*1801*①; DATT; LP; SDF.

canvas board, DATT; LP.

canvas carrier, DATT.

canvas pin, DATT/①; LP.

canvas separator clip, LP.

canvas size, LP.

canvas size, French, DATT.

canvas size, landscape, DATT.

canvas size, portrait, DATT.

canvas-stretching pliers, LP/①.

canvas tack, DATT.

canvas webbing, NYTBA/*39.*

cap, C-5146/*92B*①; CEA/*278*①;
SDF.

capacity mug, IDC.

capanna, IDC.

caparison, C-5127/*645*; C-5234/*118.*

caparisoned, S-4965/*106*①.

cap back, C-1506/*167.*

capback, C-2501/*59.*

cap cover, IDC.

cape, C-3011/*3.*

cape boxwood, SDF.

Cape Cod Glass Works, EA; EC1/*68.*

Cape plate, EA.

capital, ACD; C-0279/*268*; C-0982/
85; C-1502/*95*; C-5005/*224*①,
*348*①; C-5114/*352*①, *377*①;
C-5116/*48*; C-5157/*88*①; C-5167/
218; S-3311/*293*①; S-4507/*14*①;
S-4804/*7*①; S-4972/*342*; SDF.

capital base, S-4507/*66*①.

cap nozzle, S-4972/*264.*

Capo-di-Monte, ACD; C-0249/*181,
268*; S-4461/*105.*

Capo di Monte, C-5189/*37*; DADA.

Capodimonte, C-2427/*30*①; CEA/
*171*①; EA; LAR82/*102*①;
LAR83/*75*①.

Capo di Monte porcelain, S-2882/
*737*①.

'capo-di-monte' vase, S-4804/*348*①.

caposcuola, DATT.

Cappagh brown, DATT.

capped, C-5117/*129*; C-5173/*54*①;
S-4905/*176*①, *184*①.

capped bracket handle, C-0254/*131.*

capped finial, S-4965/*116*①.

capped paw feet, C-2202/*215.*

capped paw support, S-4922/*27*①.

capped scroll feet, C-0103/*2.*

capped spout, C-5114/*227.*

Cappiello, Leonetto, S-286/*433B.*

capping moulding, SDF.

capriccio, DATT/①.

capriccio landscape, RGS/*146*①.

Capricorn, DSSA.

Capri-decorated, S-4843/*401*①.

capstain, C-0103/*37.*

capstan, C-0706/*206*; C-2364/*27.*

capstan form, LAR83/*599*①; S-4436/
*20*①.

capstan salt, CEA/*640*①; EA/*spool
salt.*

capstan-shaped, C-5174/*53*①.

capstan table, ACD.

capsule makers, C-2904/*288.*

Capt, Henry, C-5174/*381*①.

Captain, CEA/*436*①.

captain glass, DADA; EA/*master
glass.*

captain's armchair, S-4812/*87*①.

captain's cabin instruments, S-4881/
*57*①.

captain's chair, C-1407/*93*; DADA/
Supplement; SDF/①.

capuchine, IDPF/*43.*

capucine, DADA; LAR82/*206*①;
CEA/*228*①.

capucine clock, C-2489/*54*; LAR83/
*186*①.

caput mortuum, DATT; LP.

'capuzin' brown, EA/*Kapuzinerbraun.*

caqueteuse, EA/*caquetoire*; NYTBA/
28; SDF.

caqueteuse chair, LAR83/*286*①.

caquetoire, ACD; CEA/*373*①, *405*;
DADA; EA/①; SDF/*caqueteuse.*

Carabagh carpet, EA.

carafe, C-0706/*127*; C-2409/*43*;
DADA; IDPF/*43*①; S-4804/*157.*

carafes, C-0249/*210.*

carafe with stopper, C-0706/*127.*

Caramanian pattern, IDC/①.

caramel, C-2357/*120.*

caramel glass, C-2910/*237*; DADA/
Supplement.

carapace, C-5156/*314.*

carara ware, NYTBA/*181.*

carat, S-4927/*246.*

carbine, C-2476/*10*; DADA.

carbine-pistol, C-2476/*14*①.

carbine pistol, CEA/*28*①.

carbiole leg, C-2357/9①.

carbon bisulfide, DATT.

carbon black, DATT.

carbon pencil, DATT.

carbon pigment, DATT.

carbon tetrachloride, DATT.

carborundum, S-286/333①; DATT.

carboy, LAR82/431①.

carbuncle, CEA/524; EA; LAR82/500①.

carcase, ACD.

carcase (carcass), C-2555/64①.

carcase, SDF.

carcase work, SDF.

carcel, DADA/Supplement.

Carcher, Jan and Nicholaus, EA.

carchesion, IDC.

Carchi, S-4807/98.

card, C-5156/887.

card- and games-table, C-2403/91①.

card and note case, C-0706/3.

card and writing table, C-5157/156①.

cardboard, LP.

card case, C-0254/215, 234; C-0706/219; C-1082/148; C-1502/49; EA; LAR83/554①; NYTBA/238①; S-3311/714①.

card-cut, ACD; DADA/①; SDF.

card-cut ornament (on furniture), EA.

Carder, Frederic, OPGAC/178.

Carder, Frederick, C-5239/296; CEA/440①, 459, 480①, 481①; DADA/Supplement.

Cardew, Michael, DADA/Supplement.

card holder, S-4804/42, 223①.

cardinal bird, OPGAC/209.

cardinal's hat, ACD; C-5173/3①; DADA.

cardinal's hat (Pewter dish), EA.

cardinal's hat form, C-2427/251①.

Cardinaux à Paris, CEA/185①.

card-rack, IDC.

card rack, SDF/letter rack.

card-table, ACD; CEA/397①.

card table, C-0982/67; C-1407/12; C-2402/12; C-2478/104; C-5114/271①, 315①; C-5116/104; C-5153/162①; C-5156/462; DADA; EA/①; LAR83/360①; SDF/①.

cardtable, C-5153/116①.

card tray, DADA/①.

caricature, DATT/①; JIWA/35①, 69; LP.

carinated, C-2482/105; IDPF/113①.

carinated body, S-4973/26①.

carination, IDPF/43①.

Carl Bamberg, C-2904/213.

Carlin, M., CEA/371①.

Carlin, Martin, ACD; C-2555/49①; C-5189/294①; DADA; EA/①; S-4955/192①.

carl magnus hutschenreuter, S-4804/460①.

Carl Magnus Hutschenreuther, S-3311/384①.

Carlton House, LAR82/419①; S-4988/485①.

Carlton House desk, DADA.

Carlton House desk or table, EA.

Carlton House table, ACD; SDF/Carlton table; C-2357/92①.

Carlton table, SDF.

Carlton Ware, C-2409/82.

Carltonware, C-2502/173.

Carl Zeiss, C-2904/140.

Carl Zeiss, Jnr., C-2904/50.

car mascot, C-2910/246; C-5239/129①; LAR82/76①.

carmine, DATT; LP.

Carnaby, John, C-5117/262①.

carnation, C-2704/65; DATT; DSSA; CEA/199①.

carnation corner, S-4843/61①.

carnauba wax, DATT; LP.

carnelian, C-2458/*250*; C-5117/
 *342*①, *362*①; C-5127/*162*①, *317*;
 C-5156/*433*; C-5236/*1765*; JIWA/
 310; RTA/*18*①; S-3312/*1051*①.
carnelian agate, S-4414/*155*.
carnelian ring, C-5146/*72*①.
Carnes, John, CEA/*591*①.
carnet de bal, DADA; EA/①.
carnival glass, DADA/*Supplement*;
 OPGAC/*180*; CEA/*480*①.
carnival glass bowl, CHGH/*54*.
carnival ring, RTA/*111*①.
Carolean, CEA/*644*①; DADA;
 LAR82/*300*①; SDF.
Carolean chair, DADA.
Carolean plate, CEA/*640*①.
Carolean style, C-0982/*222*; C-2402/
 257; EA.
Carolingian, LP.
Carolingian art, DATT/①.
Carolingian period, NYTBA/*32*.
Carolsfeld, Julius Schnorr von, MP/
 190.
Caron, Pierre-Augustin
 (Beaumarchais), C-5174/*410*①.
Caron, Pierre Augustin, EA.
carotte, CEA/*63*①.
Carpeaux, Jean-Baptiste, C-5224/
 *318*①.
carpenter, ACD; MP/*82*; SDF.
carpenter's pencil, DATT.
Carpenter & Westley, C-2904/*106*.
carpet, ACD; C-2478; C-5236/*555*;
 S-4804/*975*; SDF.
carpet-ball, IDC.
carpet-bowl, IDC.
carpet bowl, DADA; IDPF/*43*①.
carpet folk-art, OC/*258*.
carpet-ground, LAR82/*451*①.
carpet ground, CEA/*491*①, *502*;
 EG/*287*.
carpet-lined tread, C-2403/*60*.
carp-form, S-4810/*429*①.

carquois, à la, DADA; IDC.
Carr, Alwyn, C-2510/*24*①; CEA/
 *663*①.
carrack porcelain, IDC; EA.
carrara, S-4436/*182*; C-2357/*34*①;
 LAR82/*327*①.
Carrara marble, C-0279/*229*; C-2357/
 *36*①; C-2364/*16*①; C-2437/*45*;
 DADA; DATT.
Carrara porcelain, IDC.
Carrara ware, ACD; S-4843/*302*①.
Carré, Jean, CEA/*420*①; EA.
carreau, CEA/*405*.
carreau, le, CEA/*368*①.
carreau de revêtement, IDC.
Carrere, Ouillon, LAR83/*42*①.
carriage, C-5117/*445*①; CEA/*256*①.
carriage clock, C-1702/*300*; C-5117/
 *390*①; CEA/*229*①; DADA; EA/
 ①; EC2/*96*①; LAR82/*206*①;
 LAR83/*186*①; RGS/*179*①;
 S-4461/*79*, *498*; S-4802/*150*①;
 S-4927/*74*; C-2368/*30*.
carriage lamp, C-0906/*94*.
carriage-warmer, EA/*foot-warmer*.
Carrickmacross, C-1506/*162*.
Carrickmacross lace, C-1603/*118*;
 C-2203/*132*; DADA.
Carrickmacross quipure, C-2203/*276*.
Carriera, Rosalba, EA.
Carrier-Belleuse, A., C-5191/*184*.
Carrier-Belleuse, Albert, EA/①.
Carrier-Belleuse, Albert-Ernest,
 C-5189/*149*.
Carriès, Jean, JIWA/*349*.
carrillon watch, S-4927/*186*.
Carrington and Co., C-2510/*25*.
Carron Company, EA.
carrying box, C-5127/*155*.
carrying-handle, C-2388/*48*①;
 C-2421/*54*; C-2522/*137*①.
carrying handle, C-0279/*329*;
 C-2364/*20*①; CEA/*228*①.

carte-de-visite, DATT.

carte-de-visite wet-plate camera, C-1609/*222.*

cartel, DADA; IDC.

cartel clock, C-0249/*198*; C-0279/ *459*; C-2364/*32*①; C-5259/*281*; C-MARS/*225*; EA/①; LAR82/ *228*①; LAR83/*209*①; S-4927/*86*; SDF; C-2437/*30.*

Carter, G. A., C-2510/*121*①.

Carter, John, C-2487/*155*①; C-5117/ *238*; C-5173/*27*①; CEA/*654*①.

Carter, Richard, C-5117/*68*①; CEA/ *656*①.

Carter, Tho., LAR82/*212*①.

Carter Stabler and Adams, C-2910/ *112.*

Cartier, C-2368/*29*; C-2489/*61*; C-5005/*235*①; C-5167/*144*; CEA/ *520*; OPGAC/*13.*

Cartier, Inc., DADA/*Supplement.*

Cartier, T., C-5181/*67.*

Cartier, Thomas, C-5189/*131.*

Cartier Inc., C-0270/*61.*

cartilaginous style, EA/*Dutch grotesque style.*

cartisane, DADA.

Cartlidge, Charles, CEA/*205.*

cartoccio, DATT.

cartonier, C-5189/*244.*

cartonnier, C-5259/*523*; CEA/*380*①; EA; LAR83/*347*①.

carton pierre, CEA/*364*①; C-2421/ *26*①.

cartoon, DADA; DATT/①; EA; EG/*287*; JIWA/*211*①; LP; S-4881/*532*; S-4972/*182.*

cartouche, ACD; C-1502/*91*; C-2202/ *52*; C-2402/*61*; C-2421/*12*①; C-2458/*74*①; C-5114/*15*①; C-5116/*23*; C-5127/*84*; C-5153/ *21*①; C-5156/*114*①, *471*①; CEA/ *90*①, *226*①, *305*①, *612*; DADA; DATT/①; EA; IDC/①; LP/①; MP/*133*; OC/*47*①; RGS/*8*①;

RTA/*23*①; S-2882/*374*, *612*①, *675*①, *776A*①; S-4414/*407*①, *422*; S-4436/*8*①; S-4802/*10*①; SDF.

cartouche and shell cresting, C-0982/ *77.*

cartouche back, C-0249/*437.*

cartouche border, C-0225/*215A*; OC/ *42*①.

cartouche dial, EA.

cartouche form, RGS/*31*①; S-4804/ *103*①.

cartouche frame, RGS/*17*①.

cartouche-like openwork composition, S-291/*240*①.

cartouche pattern, OC/*46.*

cartouche shape, LAR83/*475*①; S-4922/*23*①.

cartouche-shaped, C-5117/*381*; C-5157/*106*①.

cartouche-shaped back, C-0249/*460.*

cartouche-shaped case, C-2437/*31*①.

cartouche-shaped handle, S-2882/ *996*①.

cartouche-shaped Table Mirror, S-2882/*1021*①.

cartridge-magazine, C-2476/*78.*

cartridge paper, DATT.

cartridge pleat, SDF.

carved, C-1603/*96*; C-2357/*12*①; C-2414/*42*①; C-5116/*56*; C-5127/ *163A*; OC/*313*; S-4461/*514*, *517*; S-4992/*2*①.

carved and pierced bone, C-1082/*146.*

carved brush feet, S-4905/*477*①.

carved columnar leg, NYTBA/*23.*

carved corner, C-2704/*11.*

carved edge, C-0982/*101*; S-4461/ *594.*

carved emerald, S-291/*141*; S-4927/ *284*①.

carved fan, S-4461/*593*①.

carved figure, JIWA/*9.*

carved form, IDPF/*43.*

carved husk, C-0249/*271.*

carved ivory, EA/*Berg, Magnus*; S-4947/*78A*①.
carved jade, C-5156/*299*①.
carved lacquer, CEA/*571.*
carved mahogany barometer, CEA/ *262*①.
carved pattern, C-5114/*324*①.
carved pediment, CEA/*241*①.
carved relief, S-4461/*61.*
carved relief decoration, RTA/*16.*
carved shell, C-5116/*81.*
carved skirt, C-0279/*266.*
carved steel, RGS/*157.*
carved wainscot, CEA/*322*①.
carved ware, IDC.
carver, DATT; LAR82/*295*①; LAR83/*276*①; MP/*33*; SDF/①; CEA/*390*①.
Carver, Governor John, CEA/*390*①.
carver chair, LAR83/*289*①; SDF/①; ACD; DADA/①; EA.
carver's piece, C-2546/*91*①.
carver's tree, SDF.
carver's wood, SDF.
carving, C-2458, *307*; C-5114/*271*①; C-5156/*194, 374*①; CEA/*562*; DADA; DATT.
carving fork, C-5117/*123.*
carving (German) fork, EA.
carving knife, C-5117/*123.*
carvings, S-4461/*75.*
carving set, C-0254/*21, 201*; C-0270/ *104*; C-1502/*107*; C-5114/*16*; S-4461/*75*; S-4804/*28, 35*; S-4905/ *160.*
carving-table, CEA/*340*①.
carving tool, MP/*116.*
Cary, C-2904/*105.*
Cary, G. & J., C-2478/*24.*
Cary, London, C-2489/*34.*
caryatid, ACD; C-0225/*89*; C-0249/ *455*①; C-0279/*323*; C-2202/*205*; C-2398/*90*; C-2402/*127A*; C-2482/

142; CEA/*384*①; DADA; DATT/ ①; EA; IDC; S-4461/*489*; S-4507/*61*①; S-4802/*366*①.
caryatid candelabrum, MP/*106.*
caryatid candlestick, S-4944/*223*①.
caryatides, SDF/①.
caryatid handle, IDC; LAR83/*86*①.
caryatid stem, C-5117/*246*①.
caryatid support, C-0406/*55*; LAR82/ *373*①.
caryatid terminal, S-3311/*692*①.
Cary's, C-2357/*89*①.
Casali, Antonio, EA.
Casali's green, DATT.
Casanova, A, S-286/*70.*
Casanova, François, EA/*Beauvais tapestry.*
Casa Pirota, EA/*Casali, Antonio.*
Casares, J., C-0405/*147.*
Casarrelli, Fra, C-5189/*354.*
Casas Grandes, S-4807/*285*①.
Casbard, Geoffrey, C-2476/*32*①.
cascade, SDF.
case, C-0982/*18*; C-2202/*144*; C-2402/*3*; C-5005/*380*; C-5114/ *278*①, *335*①, *362*①; C-5117/ *419*①; C-5156/*701*①; C-5239/*43, 108*; CEA/*261*①; S-286/*396A*; S-4461/*23, 316*; SDF.
case bottle, DADA; EA.
case clock, C-5114/*266*①; C-5153/ *111*①.
cased, CEA/*456*①, *481*①, *492*①.
cased glass, EA/*cameo glass*; EC1/ *56, 67*①; EG/*287*①; JIWA/*86*①, *305*①.
cased or flashed or overlay glass, ACD.
case furniture, C-2370/*62*; SDF/①.
case gilt, C-2458/*234.*
case glass, DADA.
case-hardened, C-2503/*191.*
case hinge, CEA/*255*①.

casein, DATT; LP.

casein color, DATT.

case maker, SDF.

casemaker's mark, C-5117/*484*①.

casement cloth, SDF.

case-mould, IDC.

case on case clock, CEA/*243*①.

case piece, NYTBA/*39*.

cash, C-2458/*235*; C-2513/*278*; C-5156/*181*; C-5236/*468*①; IDC.

cashed border, LAR82/*629*①.

cash emblem, C-2458/*190*.

cashepot, S-4461/*483*.

cashew lake, DATT.

cash ground, C-5127/*138*.

cash handle, C-5127/*121*①.

cash medallion, S-3312/*1290*; S-4905/*119*①.

cashmere, C-1304/*239*.

cash outlet, C-5127/*248*①.

cash pattern, C-5156/*64*①; DADA.

cash symbol, S-4928/*67*①.

casing, C-2904/*27*; C-5114/*3A*; C-5146/*87D*①; DADA; OPGAC/*163*.

cask, IDPF/*43*.

casket, C-0254/*69*; C-0279/*98*; C-0406/*123*; C-2364/*52*①; C-2398/*11*①; C-5117/*326*①; C-5173/*48*①; CEA/*540*①; EA/①; IDC; IDPF/*44*; JIWA/*136*; LAR83/*404*①; S-4804/*230A*①; S-4972/*71*①, *337*①; SDF.

casket-shaped, C-1502/*180*.

casque, DADA.

casque ewer, IDC.

cassapanca, DADA/①; EA:

cassaponca, C-0279/*336*.

Cassatt, Mary, S-286/*231*①.

Cassé, André-Louis, C-5220/*43*①.

cassel, ACD; DADA; EA.

Cassel earth, DATT; LP.

Cassel green, DATT.

Cassel yellow, DATT.

casserole, EA; IDPF/*44*①.

casserole spoon, S-4804/*35*.

Cassina, C-GUST/*156*①.

Cassini, J. D., CEA/*602*①.

cassiterite, CEA/*580*.

Cassius, Andreas, CEA/*148*①.

cassolet, C-2482/*153*; SDF.

cassolette, C-0249/*235*; C-5116/*43*①; C-5170/*27*①; C-5259/*285*①; DADA; EA/①; IDC/①; IDPF/*45*; LAR82/*56*①; S-4843/*349*①; SDF/*cassolet*.

cassone, ACD; CEA/*305*①; DADA/①; EA/①; LAR82/*420*①; LAR83/*405*①, *405*①; S-2882/*837*, *776A*①; S-4461/*159*; S-4972/*447*; SDF; C-0279/*323*; NYTBA/*24*①.

cassone form, C-5146/*105B*①.

cassone painting, DATT/①.

cast, C-0254/*20*, *123*①; C-1082/*9*, *23*; C-2202/*86*; C-2458/*1*; C-5114/*15*①; C-5127/*433A*; C-5146/*30*①; C-5153/*2*①, *14*①, *39*①; DATT; IDC; LP.

cast and carved from a model, C-2409/*284*.

cast applied, C-5114/*27*①, *30*①, *35*①.

cast applied foliate rim, C-5153/*2*①.

cast bud finial, C-5114/*96*①.

cast crest handle, C-5117/*115*①.

castelated pediment, C-1702/*251*.

Castel Durante, ACD; DADA; EA; LAR82/*102*①.

Castellani, Fortunato Pio, CEA/*517*①.

Castellani: Fortunato Pio, Alessandro, Augusto, EA/①.

castellated, SDF.

castellated edge, EG/*140*①.

castellated gallery, C-5174/*175*①.

Castelli, ACD; C-2427/*205*①; C-2486/*222*①, *232*①; CEA/*136*①;

DADA; EA/①; LAR82/*102*①, *137*①.

caster, ACD; C-0254/*34, 161*; C-0279/*272*①; C-2487/*76*; C-5114/*25*①, *104*①, *281, 344*①, *350*①; C-5116/*51*; C-5153/*7*; CEA/*644*①; DADA/*Supplement*, ①; EA/①; FFDAB/*26*; IDC; IDPF/*45*; LAR83/*555*①; S-3311/ *128, 658, 792*①; S-4436/*10*①; S-4461/*569, 636*; S-4988/*507*①; SDF/*castors*.

caster cover, S-4905/*215*.

caster-oil spoon, LAR83/*579*①.

cast feet, C-5114/*41*.

cast flat handle, C-5117/*19*.

cast foliage rim, C-5114/*14*.

cast foliate finial, C-5114/*29*①.

cast handle, C-5114/*36*①.

cast hollow, C-5236/*348*①.

casting, CEA/*528, 580, 678*; DATT; IDC.

casting fault, S-3311/*301*.

casting on, CEA/*541*.

casting plaster, DATT.

casting seam, CHGH/*59*.

casting stone, DATT.

cast-iron, C-2388/*25*; C-2904/*23*; C-5114/*186*①; S-4461/*654*; S-4804/*943*①.

cast iron, ACD; C-5116/*34*; CEA/ *404*①; NYTBA/*250*①; S-4905/ *323*; SDF.

cast-iron figure, S-4965/*98*①.

cast iron furniture, DADA/ *Supplement*.

cast iron furniture and decoration, SDF/①.

cast iron supply pipe, CEA/*537*.

cast-iron toy, CHGH/*50*①.

castle, C-1006/*159*; C-2704/*33*.

Castle, Wendell, DADA/*Supplement*.

cast lead mount, C-5116/*172*①.

cast leaf furl, C-5114/*13*.

cast leaf-shaped bowl, C-0254/*124*①.

Castleford, DADA.

Castleford-type wares, DADA/ *Supplement*.

Castleford ware, IDC/①.

cast mask, C-5114/*35*①.

cast-off, C-2476/*18*.

cast-on, C-2476/*51*.

castor, ACD; C-0279/*437*; C-0982/ *46*; C-2402/*258*; C-5117/*29, 292*①; C-5189/*200*; SDF.

castored feet, LAR82/*307*①.

castor oil, DATT.

castor set, LAR82/*583*①.

castor ware, DADA; IDC.

cast scroll, C-5114/*2*①.

cast shadow, DATT/①; LP.

cast shell, C-5114/*110*.

cast spoon, C-0706/*37*.

cast ware, IDPF/*71*①.

cast-zinc, S-2882/*640*①.

casuarina wood, CEA/*264*①.

Caswell, Zeruah H. G., NYTBA/*113*.

cat, ACD; DADA; SDF/①.

Catabond, DATT.

Catalan pottery, EA/*20*① *albarello*.

catalogue, C-2904/*22*; C-5156/*460*.

Catalon, LAR82/*336*①.

catalyst, DATT.

catapult gun, C-2503/*78*.

catchpole, DADA.

catechu, DATT.

catenary curve, DATT.

cathedral, S-4461/*200, 19*①.

cathedral back, SDF.

cathedral clock, EA/①.

cathedral glass, SDF.

Catherine Halliwell, C-2704/*185*.

Catherine wheel pattern, EA/*Queen Charlotte, whorl*; IDC/①.

catheter, C-2904/*286*.

cats, IDC.

cat's eye, C-2458/*391.*

cat's-eye chrysoberyl, RTA/*130*①.

cat's-eye damar, DATT.

cat's gold, DATT.

cattail molded, C-0225/*122.*

cat-tail motif, C-5146/*106*①.

cattails, S-4461/*203.*

Catteau, Charles, C-5191/*62.*

Cattle, R., C-2487/*66.*

Cattle, Robert and Barber, J., C-0406/*28.*

Caucasian, C-0279/*24*①; C-0906/*54;* C-2478/*213;* C-5117/*313*①; C-5189/*389;* CEA/*81*①; S-4461/ *58;* S-4972/*154*①.

Caucasian carpet, C-0906/*60;* EA.

Caucasian design, OC/*14.*

Caucasian dragon carpet, OC/*328.*

Caucasian rug, DADA; OC/*15*①.

Caucasian runner, S-3311/*71*①.

Caucasian/Sileh rug, LAR83/*527*①.

Caucasian style, OC/*14.*

Caucasian-style border, OC/*132.*

Caucasion rug, C-2482/*5.*

caudebec, C-0225/*174.*

caudle-cup, C-5117/*90;* C-5173/*54*①; C-5174/*560;* EA/①; IDC.

caudle cup, ACD; CEA/*666*①, *668*①; DADA; IDPF/*45;* LAR82/ *583*①; S-3311/*803*①; S-4992/ *84*①; S-4843/*247*①.

caudle-flask, IDC.

caudle-pot, IDC.

caudle-urn, IDC.

Cauer, Emil, C-5191/*144.*

Caughley, ACD; C-2493/*31;* CEA/ *195*①, *199*①; DADA; EA/① *caster;* LAR82/*103*①; LAR83/ *75*①.

caul, SDF.

cauldon, C-5259/*93.*

cauldron, ACD; C-0103/*2;* C-0706/ *19;* C-2202/*16;* C-2498/*11;* DSSA; LAR82/*49*①, *189*①.

cauldron salt, LAR83/*600*①.

cauldron salt cellar, C-0706/*10;* C-1502/*11.*

cauliflower moulded, C-1006/*150.*

cauliflower ware, EA; IDC/①; S-4843/*126*①.

caulking, DATT; EA.

causeuse, ACD; DADA/①; EA/*love seat;* SDF.

Caussy, Paul, EA.

cauteria, DATT.

cavalier, C-0103/*85.*

cavalier projection, DATT.

Cavallo's Worcester, IDC.

cavalry carbine, C-2503/*98;* C-2569/ *56;* C-MARS/*123.*

cavalry pistol, C-MARS/*130.*

cavalry sword, CEA/*28*①; S-4972/ *247.*

cave painting, LP.

cavetto, C-0249/*267;* C-2498/*143;* DADA; DATT; IDC; LAR82/ *317*①; S-3311/*228*①; S-4823/*1*①; S-4905/*10*①; S-4972/*126*①, *389*①; S-4988/*443*①; SDF/①.

cavetto cornice, C-2403/*148*①; C-2421/*127*①; LAR82/*484*①; LAR83/*300*①.

cavetto frieze, C-2357/*48*①.

cavetto frieze drawer, LAR83/*259*①.

cavetto moulding, EA.

caviar bowl, C-5174/*220.*

cavityless casting, DATT.

cavo-rilievo, DADA; DATT.

Cawdell, William, C-5117/*106*①.

caxton chair, SDF/①; EA.

cayenne pepper spoon, C-0706/*235.*

CB, CEA/*69*①, *176*①.

C. Baker, C-2904/*45, 103, 147.*

C. Bard & Son, S-4905/*181*①.

C. Baredt fec, EA/*Baerdt, Claess Fransen.*

CBD monogram, EA/*Coalport.*

C. B. Upjohn Pottery, Zanesville, Ohio, EC1/*85.*

C. C. *Hunger, EA/*Meissen porcelain factory.*

C-couronné poinçoin, C-5224/*52*①.

CC Pesaro, EA/*Casali, Antonio.*

C. CRESSENT, EA/*Cressent, Charles.*

C. C. SAUNIER, EA/*Saunier, Claude Charles.*

Cd, EA/*Limoges, Coalport, Drentwett family.*

CDale, Coalport, or Coalbrookdale, EA/*Coalport.*

C. D. *Busch, EA/*Meissen porcelain factory.*

cedar, ACD; DADA; SDF.

cedar, oil of, DATT.

cedar-lined, C-2421/*119*; C-2478/*147*①.

ceiler, SDF.

ceiling mount, C-5239/*156.*.

ceiling ornament, IDC/①.

ceiling rod, C-5146/*170*①.

celadon, ACD; C-2323/*8*; C-2458/*21*; C-5127/*16, 25*; C-5156/*40*①; C-5236/*331*①; C-5323/*55*; CEA/*111*; DADA; DATT; EA; EC2/*23*①; IDC; LAR83/*43*①; MP/*502*; S-288/*14*①, *26*①; S-4461/*130*; C-2414/*83*①; C-5236/*444*①; S-4461/*161.*

celadon green, DATT.

celadon ground, C-0782/*7*; C-5127/*87*; C-5156/*130*; S-4414/*219*①.

celadon jade, C-1082/*159*; C-5234/*61.*

celadon kiln, EA/*Shang-yü.*

celadon porcelain, S-4414/*404.*

celadon vase, S-4461/*192.*

celadon ware, JIWA/*344.*

cele, SDF.

celebe, IDC.

celery dish, C-0254/*249*; C-0279/*157.*

celery glass, EA/①.

celery handle, S-4944/*209*①.

celery vase, CEA/*470*①.

celeste, S-4461/*324.*

céleste, S-4853/*27*①.

Celeste, C-2427/*6*①.

celeste blue, C-5239/*297.*

celestial, C-2478/*137*①.

celestial blue, DATT.

celestial globe, C-0403/*224*; C-5116/*31.*

celestial globe clock, EA.

celestial globe stand, DADA.

celestial gore, CEA/*603*①.

Celite, DATT.

cell, S-4905/*34*①.

cell and Y-pattern, C-2458/*136.*

cellar, SDF.

cellaret, ACD; CEA/*345*①; EA/①; S-4436/*120*①; S-4972/*556*①; SDF.

cellaret drawer, S-4414/*446*①, *456*①, *510*①; S-4436/*151A*①; S-4812/*125*①.

cellaret sideboard, EA; SDF.

cellarette, C-2320/*78*; C-2388/*43*; C-2402/*147*; C-2478/*101*①; C-5116/*70*; C-5157/*148*; DADA/①; FFDAB/*26, 67*①; LAR82/*427*①; LAR83/*354*①; S-3311/*239*①.

cellarette drawer, C-0982/*33, 118A*; C-2403/*151.*

cell diaper border, S-4414/*349*①; S-4905/*16*①.

cellerette, C-1407/*109.*

cell glazing, ACD.

cell ground, IDC.

Cellini, Benvenuto, DADA; EA.

Cellini pattern, C-5117/*280*①; LAR82/*598*①; LAR83/*538*①.

Cellini salt, EA.

Cellinni pattern, C-0406/*25.*

cell-mosaic, ACD/*cell glazing.*

cello, C-0906/*292*; EA/*violin family.*

cello bow, C-0906/*357.*

cellophane tape, DATT.

Cellosolve, DATT.

cell-pattern, C-2323/*62*①; C-2458/*257*①; C-5116/*157*①; C-5236/*385.*

cell pattern, C-0782/*188*; C-2427/*114*; C-5127/*209.*

cell-pattern border, C-2486/*75.*

celluloid, CEA/*684*; SDF; DATT.

cellulose acetate, DATT.

cellulose cement, DATT.

cellulose nitrate, DATT.

Celotex, DATT.

celour, ACD.

Celtic cross, DATT.

Celtic design, C-5146/*62.*

Celtic-inspired, C-5167/*142*①.

Celtic ornament, C-5174/*516.*

Celtic-style, C-0706/*68.*

Celtic style strapwork, C-2704/*96.*

celure, SDF.

cembra wood, CEA/*684.*

cement, DATT; C-2904/*199.*

cement stucco, JIWA/*339*①.

cemetery design, OC/*202.*

C enclosing L, EA/*Clayton, David.*

censer, ACD; C-0782/*126*; C-2414/*93*①; C-2458/*236*; C-5127/*200*; C-5236/*400*①; DADA/①; DSSA/①; EA; IDC; K-711/*125*; LAR82/*132*①, *588*①; S-4810/*287*①, *293*①, *297*①, *299*①.

censor's seal, C-5236/*1030*①.

centaur, DSSA.

center, C-5005/*218*①; S-4922/*4*①.

center-bowl, S-4804/*293*①.

center bowl, S-4947/*12*①; S-4992/*30*①.

centerfold, C-5156/*934*①; C-5236/*942*; S-286/*276.*

centering, C-5116/*124.*

centering shell, S-4414/*269*①.

center of vision, LP.

centerpice/epergne, S-4804/*154*①.

centerpiece, C-0249/*224*; C-0254/*90*①; C-5114/*238*①; LAR83/*556*①; S-4461/*559*; S-4922/*80*①, *85*①.

centerpiece bowl, C-0225/*46, 173*①; C-5239/*45*; S-4804/*6, 55*①.

centerpiece flower arranger, S-4804/*80.*

centerpiece plateau, S-4804/*115.*

center-seconds chronometer, LAR83/*213*①.

center shell finial, LAR83/*254*①.

center-swinging pendulum, C-MARS/*236.*

center table, C-0249/*353*; C-2478/*113*; C-5114/*318*①, *379*①; C-5116/*166*①; C-5153/*131*①; DADA; S-4436/*153*①; S-4461/*719*①; S-4804/*802*; S-4972/*490*; S-4992/*21*①.

center wheel, C-5117/*412*①.

centimeter, LP.

central, C-0782/*61.*

Central American pottery, IDC.

central axis, JIWA/*251.*

central block, C-5116/*169*①.

central boss, C-1082/*106.*

central burner, S-4922/*25*①.

central floral finial, C-0254/*72.*

central floral medallion, S-4461/*121.*

central frieze, C-5114/*360*①.

central hub, CEA/*495*①.

centralizing motif, JIWA/*207.*

central knob, C-5157/*155*①.

central leaf, C-5116/*68*①.

central loop, C-0254/*141*; C-2458/ *220*.

central medallion, C-2704/*65*; EC2/ *28*①; RGS/*22*①; RTA/*34*①; S-4461/*6*.

central motif, S-286/*1*.

central motif with peripheral projection, RTA/*43*①.

Central Persian, C-2478/*255*.

Central Persian rug, C-2403/*168*.

central perspective, JIWA/*10*.

central piercing, S-2882/*736*.

central piled, S-4948/*20*①.

central pod, C-0270/*103*①.

central reserve, LAR83/*87*①.

central ridge, S-4972/*142*①, *274A*.

central roundel, LAR83/*117*①.

central shaft, C-5114/*253*.

central shield, S-4461/*344*.

central slit, JIWA/*183*.

central stretcher, C-5239/*241*.

central support, S-4461/*8*.

central tablet, C-1407/*147*.

central theme, JIWA/*75*.

central urn-form standard, S-2882/ *669*①.

central-vision, C-2476/*18, 60*.

central visual ray, DATT.

central wave-pattern, C-5116/*90*.

centre book table, C-0982/*35*.

centre-motif, OC/*335*.

centre-piece, ACD.

centre piece, C-0406/*64*.

centrepiece, C-2398/*54*①; C-5005/ *231*①, *234*①; CEA/*446*①; IDC/ ①.

centrepiece table lamp, C-5005/ *402*①.

centres, C-2437/*36*.

centre-seconds hand, EA.

centre table, C-2388/*93*①; C-2402/ *30, 38*; C-2421/*120*①; C-5005/ *348*①; EA.

centre well, CEA/*448*①.

centre wheel, EA.

centrifugal casting, DATT; RTA/ *190*①.

centura tableware, DADA/ *Supplement*.

century, C-5153/*101*.

century guild, DADA/*Supplement*.

Century pattern, S-4804/*52*.

century vase, DADA/*Supplement*.

cera colla, DATT.

ceramic, ACD; C-5117/*362*①; JIWA/*8*; S-4461/*510*; S-4972/*396*.

Ceramic Art Company, DADA/ *Supplement*; NYTBA/*180*; OPGAC/*347*.

ceramic artist, JIWA/*349*①.

ceramic color, DATT.

Ceramic decoration, EA/ *Blaublümchenmuster*.

ceramics, C-5127; C-5236/*861*; DATT.

ceramic ware, IDC.

Céramique siliceuse, IDC.

Cerbara, Niccolo, C-5117/*361*①.

Cerberus, DSSA.

cereal spoon, C-0254/*190, 248*.

çerek, OC/*30*.

ceremonial camel trapping, OC/*30*.

ceremonial dance paddle, S-4807/ *445*①.

ceremonial lance, C-2421/*6*①.

ceremonial plaque, C-5117/*191*.

ceremonial pose, JIWA/*10*.

ceremonial saddle caparison, C-5156/ *262*①.

Ceres, DSSA.

ceresin, DATT.

cerisier wood, DADA.

cerography, DATT.

cerquate, IDC/①.

certificate, C-5117/*469*①.

certosina, DADA; EA.

cerulean blue, DATT; LP; S-4804/*3*.
ceruse, DATT.
cervide, C-0225/*169*.
cestrum, DATT.
Ceylon, C-MARS/*42*.
Ceylonese, C-0982/*207*.
Ceylon lacquer, DATT.
Cezanne, Paul, S-286/*452*.
CF, EA/*Fox, Charles*.
C. F. Hancock and Company,
 C-5117/*21*.
C. F. Herold, EA/*Meissen porcelain
 factory*.
CFM, EA/*Meyer, Christoffel Jansz*.
C-form handle, S-2882/*1261, 1424*①.
Chacan, IDC.
Chad Jli, C-2388/*158*.
chad pot, IDPF/*45*.
chaff-cutter, C-2368/*36*①.
Chaffer, Richard, CEA/*200*①.
Chaffers, Richard, ACD; EA/①.
Chaffers, William, ACD.
chaffing dish, C-0406/*57*.
chafing-dish, C-1502/*82*; EA.
chafing dish, ACD; C-5005/*228*①;
 CEA/*672*①; DADA; IDPF/*45*①.
Chagall, Marc, S-286/*233*①.
Chahal Shotur, OC/*149*①.
Chahine, Edgar, S-286/*247A*①.
Chaillot, la Savonnerie de, EA/
 Savonnerie carpets.
chain, C-0279/*227*; C-0706/*179, 210*;
 C-5005/*220*①; C-5114/*258*;
 C-5156/*388*①; C-5157/*8*; CEA/
 235; DADA; DSSA; OPGAC/*209*.
chain and drop, C-5116/*38*.
chain border, IDC.
chain decoration, EG/*190*; S-4461/
 38.
chained, C-5117/*55*①.
chained strap, C-MARS/*80*.
chain handle, C-0254/*52, 68, 234*;
 CEA/*417*①.

chain-handled jug, EG/*156*.
chain link, C-5127/*308*①.
chain mail, DADA.
chain-pattern, C-2458/*137*.
chain pattern, C-2427/*237*①.
chain stitch, C-1506/*69*; DADA; OC/
 *19*①.
chain suspension, C-5156/*780A*.
chain trailing, EG/*73*①.
chain with star, OPGAC/*209*.
chair, C-5114/*319*; CEA/*276*①, *490,
 502*; DADA/①.
chair (in glass), EA.
chair, SDF/①.
chair back, SDF/①.
chair-back form, CEA/*585*①.
chair-back settee, DADA; SDF/①.
chairback settee, C-0279/*299*.
chair back settle, EA/*chair-table*.
chair-back thumbpiece, EA.
chair bed, SDF.
chair bedstead, SDF.
Chair Bottom, NYTBA/*307*.
chair bracket, SDF/①.
chair cover, C-5156/*475*.
chaire, C-5156/*785*; C-5236/*858*①;
 CEA/*405*.
chair frame, S-3311/*126*.
chair knob, CHGH/*60*①.
chair-maker, SDF.
chairmaker, DADA.
chair rail, DADA; SDF.
chair-table, ACD; EA/①; SDF/①.
chair table, DADA/①.
chaise, C-0279/*366*①; CEA/*405*;
 EA; S-4461/*695*.
chaise à accoudoir, DADA.
chaise à Bec de Corbin, DADA.
chaise à bureau, DADA.
chaise à Capucine, DADA.
chaise à commode, S-3311/*397*①.
chaise à la capucine, EA.

chaise a l'Anglaise, C-0249/*424*.

chaise à l'Anglaise, C-5224/*182*; C-5259/*546*①.

chaise à la reine, S-4853/*441*; S-4955/*98*①.

chaise à poudreuse, DADA.

chaise à sel, DADA.

chaise à vertugadin, DADA.

chaise de femme, DADA.

chaise en cabriolet, S-2882/*359*①; S-4955/*124*①.

chaise encoignure, DADA.

chaise longue, ACD; C-0982/*285*; C-2402/*72*; DADA; EA; LAR83/ *342*①; S-2882/*767*; S-4461/*678*; S-4804/*938*; SDF.

chaise lounge, C-2324/*254*①.

chaise or coach clock (or watch), EA/*coach clock*.

chaise percée, DADA.

ch'ai ware, IDC.

Ch'ai ware, EA.

Chakesh, OC/*176*①, *187*①.

chakra, C-5234/*2*①.

chalcedony, C-2332/*49*; C-2458/*304*; C-5117/*317*①, *357*①; C-5127/*306*; CEA/*64*①; EA; JIWA/*310*; RTA/ *30*①; S-291/*151*①; S-4810/*117*①; S-4927/*77*.

chalcedony beads, C-2482/*95*.

Chalfont, Jones, C-2489/*117*.

chalice, ACD; C-0225/*101A*; C-0270/ *73*; C-2202/*146*; C-2498/*35*; C-5114/*117*①; CEA/*620*①; DADA/①; DSSA; EA; EG/*73*; IDPF/*46*; LAR83/*582*①; NYTBA/*211*①; S-4802/*266*①; S-4804/*153*①; S-4905/*315*; S-4972/*309*①.

chalice border, S-4796/*104*①.

chalice-shaped, C-5173/*13*①.

chalice veil, C-2704/*30*.

chalk, DATT; JIWA/*16*①; LP; MP/ *15*.

chalk engraving, IDC.

chalking, DATT.

chalk manner, DATT.

chalk roll, DATT.

chalkware, EA/①; LAR82/*103*①.

Challinor, Taylor and Company, CEA/*469*①; DADA/*Supplement*.

Challinor Taylor & Co., CEA/*478*①.

challis veil, C-3011/*145*.

chalons, SDF.

chamber, C-0706/*16*; C-2202/*44*.

chamber barrel organ, CEA/*549*.

chamber-candlestick, C-2487/*65*; C-5117/*289*; C-5173/*3*①; DADA.

chamber candlestick, C-0103/*212*; C-0706/*17*; EA/①; IDC/①; LAR83/*558*①; S-3311/*791*①.

chamber chair, SDF.

chamber clock, EA/①.

chamber horse, ACD; EA; SDF.

Chamberlain, Robert, ACD; CEA/ *196*①; EA.

Chamberlain, Thomas, C-2498/*51*; CEA/*252*①.

Chamberlain's, S-4461/*458*.

Chamberlain's key, C-2332/*45*①.

Chamberlain's Worcester, C-2493/*31*; C-2502/*1*; LAR82/*194*①; LAR83/ *174*①; S-4947/*11*.

Chamberlains Worcester, S-4461/*101*.

Chamberlain Worcester, EA/ *Worcester*.

chamber organ, EA.

chamber-pot, IDC.

chamber pot, IDPF/*46*.

chamberpot, NYTBA/*245*.

Chambers, Sir William, ACD; C-2522/*6*①; DADA; SDF/*746*.

chamber stick, C-0270/*19*; S-4804/*10*.

chamberstick, C-0279/*203*; C-5114/ *239*; C-5117/*7*, *112*①; C-5174/ *493*; C-5259/*213*; EA/*chamber candlestick*; LAR82/*55*①; LAR83/ *558*①; S-4804/*103*①.

Chamber Stick, IDPF/*41*①.
chamber sticks, C-0254/*39*.
chambersticks, C-5114/*53*①; S-4905/*342*.
chamber table, FFDAB/*88*①; SDF.
Chambre Claire, C-2904/*79*.
chambrelan, IDC.
Chambrette à Lunéville, EA/*Lunéville faience factory*.
chameleon, DSSA.
chamfer, ACD; C-5156/*307*①; CEA/*405*; SDF/①.
chamfered, C-0982/*46, 81C*; C-2320/*44*①; C-2402/*62, 145A*; C-5114/*268*①; C-5116/*137*①; C-5157/*30*; CEA/*353*①; DADA; S-3311/*89*; S-4436/*99*①; S-4972/*437*.
chamfered angle, C-0249/*440*; C-0279/*340*①; C-2357/*56*①; C-2388/*106*; C-2421/*45*; C-5005/*358*①; C-5116/*47, 103*.
chamfered base, S-4804/*305*.
chamfered corner, C-2458/*124*①; IDC; S-2882/*1435*; S-4507/*87*①.
chamfered fluted angle, C-2437/*32*①.
chamfered leg, C-1407/*86A*; LAR83/*387*①; S-2882/*302*; S-4414/*425*①, *439*①, *465*①.
chamfered molded leg, S-4414/*430*①, *497*①.
chamfered post, C-5114/*388*①.
chamfered rectangular form, LAR83/*427*①.
chamfered section, RTA/*62*①.
chamfered square leg, LAR83/*363*①.
chamfered taper leg, LAR82/*303*①.
chamfered top, LAR83/*182*①.
chamfer-top case, EA.
chamfron, CEA/*20*①.
chamfron or chanfron, ACD.
chamlet, SDF/*camlet*.
chamois, C-2324/*102*; DATT.
chamois leather, C-1506/*31*.
chamois skin, LP.

champagne, C-0225/*167*; C-5239/*109, 143*; DADA.
champagne bucket, C-0270/*7*.
champagne flute, RGS/*106*①.
champagne glass, CEA/*431*①; DADA; S-4461/*120*; S-4972/*413*.
champagne jug, LAR82/*445*①.
champfered, C-5127/*53*①.
Champion, Richard, ACD; CEA/*200*①; EA.
champleve, C-1082/*105*; C-5117/*327*①, *465*①; C-5127/*357*.
champlevé, DATT; IDC.
champleve, LAR83/*154*①, *483*①.
champlevé, RGS/*40*; RTA/*13*; S-4802/*12*.
champléve, S-4804/*3*.
champlevé, S-4804/*682*; S-4927/*40*.
champleve, S-4972/*51*.
Champlevé, S-4461/*77*①.
champlevé enamel, DADA.
champleve enamel, LAR83/*187*①.
champlevé enamel, RGS/*67*①, *124*①; S-291/*135*; S-4802/*136*①; ACD.
champlevé enamel clock garniture, S-3311/*552*①.
champlevé enameling, S-291/*136*.
champlevé enamelled, C-5117/*318*①.
champleve enamelled, C-5117/*340*.
champlevé enamelled, C-5117/*476*①.
champlevé enamelling, EA.
champlevé mounted, S-4992/*25*①.
Chancay, S-4807/*57*.
Chance, W. and R. L., EA/*Chance Bros. Glass House*.
Chance Bros. Glass House, EA.
chandelier, ACD; C-2364/*12*①; C-2421/*7*①; C-5005/*277*; C-5116/*41*; C-5153/*81*①; C-5239/*153*; CEA/*346*①, *446*①, *531*①; DADA; EA; EG/*78*①; IDC/①; OPGAC/*210*; S-3311/*527*①; S-4436/*28*; S-4812/*17*; SDF/①.

chandelle, C-0249/*415*; C-0279/*214*; C-2555/*63*①.

Chandlee, DADA.

Chandlee, G., C-5153/*79*①.

Chandler, London, C-2489/*93*①.

C-handles, C-5114/*10*①.

chanelled foot, S-4965/*288*①.

chanfron, DADA.

Chang bowl, LAR82/*120*①.

Ch'ang-ch'ing, EA/*Yü-yao*.

ch'ang ch'un, CEA/*124*①.

changeable silk, SDF.

changeant, C-2203/*18*.

Chang family, EA.

Ch'ang-sha, EA.

Changsha, C-2323/*7*; C-2458/*19*.

Changsha glazed, LAR83/*162*①.

Changsha type, S-4965/*187*①.

Chan Karabagh prayer rug, S-4796/*24*①, *51*.

channel, SDF.

Channel Islands, C-0982/*193*.

Channel Islands measure, CEA/*586*①.

channelled band, C-2555/*59*①.

channelled neck, S-4992/*45*①.

channel-set, S-4414/*1*, *7*; S-4927/*348*①.

Channon, John, CEA/*336*①.

cha-no-yu, IDC.

chanterelles, EA/*hurdy-gurdy*.

chantilly, S-4853/*1*①; ACD; C-2493/*127*; CEA/*169*; DADA/①; EA/①; LAR83/*102*①; NYTBA/*170*.

Chantilly lace, C-1506/*151*; C-1603/*119*; DADA.

Chantilly pattern, C-0254/*201*, *315*; C-5153/*7*.

Chantilly spray, IDC/①.

Chantilly sprig, CEA/*199*①; EA; IDC/①.

Chantilly style, S-4823/*88*.

Chantler, Thomas, CEA/*234*①.

chantourné, DADA/①.

chape, C-2503/*29*①; C-2569/*1*.

chapeau de gendarme, C-2403/*27*; C-5259/*534*; S-4972/*594*.

chapeau de gendarme back, C-5181/*180*①.

chapeau de gendarme toprail, S-4955/*113*①.

chape cast, C-2458/*211*.

Chapelle, Jacques, CEA/*147*①; EA.

Chapin, Aaron, CEA/*400*①; DADA; EA; SDF/*770*.

Chapin, Eliphalet, EA.

chaplet, SDF.

Chaplet, Ernest, DADA/*Supplement*.

Chaplin, B. E., C-2476/*21*.

chapnet, EA.

chapter, C-5146/*67A*; C-5167/*145*; S-291/*152*.

chaptering, C-1702/*257*.

chapter-ring, C-2368/*62*.

chapter ring, ACD; C-0249/*297*; C-0279/*327*; C-5116/*48*; CEA/*221*①, *251*①, *267*; EA; S-2882/*252*①; S-3311/*107*①, *109*, *488*①; S-4414/*388*①; S-4802/*13*, *40*①, *75*; S-4905/*358*①; S-4988/*407*①; SDF.

Chapuis, Claude, stamp: CHAPUIS, C-5224/*105*.

chara, RGS/*38*, *84*.

character border, C-2388/*202*.

characteristic gul, S-2882/*163*.

characterization, JIWA/*69*.

character-mark, IDC.

char aina, C-2503/*32*.

charamde, C-0225/*190*.

Charchangi, OC/*176*①.

charcoal, C-5146/*76*; DATT; JIWA/*139*①, *270*; LP.

charcoal black, DATT.

charcoal glass, S-4461/*99*.

charcoal gray, DATT.

charcoal paper, DATT.

Charder, C-5239/*161*.

char dish, IDPF/*46*.

charge, CEA/*28*①, *541*.

charge mark, EA.

charger, ACD; C-0225/*42*; C-2427/
 *222*①; C-5156/*847*; C-5236/*515*①;
 DADA; EA/①; IDC; IDPF/*46*;
 LAR82/*113*①; LAR83/*73*①;
 NYTBA/*139*①; S-4436/*34*;
 S-4804/*277*; S-4905/*7*①, *33*①.

chariot, DSSA.

Charity, DSSA.

charka, C-2332/*121*; C-5117/*298*①;
 DADA; EA; RGS/*17*①, *34, 38,
 185*.

Charle, George, London, C-2489/*174*.

Charles, A., EA/①.

Charles, R.A., EA/*Charles, A.*.

Charles, Richard, DADA/*Supplement*.

Charles I, S-4812/*58*.

Charles I period, CEA/*584*①.

Charles I style, C-0249/*365*.

Charles II, C-0982/*69*; C-1407/*125*;
 C-2478/*146*①; C-5116/*40*;
 C-5117/*269*①; S-4812/*1*①;
 S-4922/*20*①, *72*①.

Charles II chair, DADA.

Charles II period, C-2498/*63*;
 C-5173/*51*; CEA/*584*①.

Charles II style, NYTBA/*32*①.

Charles X, C-2364/*2*; DADA; EA/
 Sèvres; LAR82/*412*①; S-4853/
 330; S-4972/*600*①.

Charles X Aubusson carpet, S-288/
 *26*①.

Charles X period, C-MARS/*210*;
 S-4947/*240*①.

Charles & George Fox, C-0406/*35*.

Charles Reily & George Storer,
 C-0406/*82*.

Charles Stuart Harris & Son,
 S-3311/*706*.

Charles-Symphorien, EA/*Jacques,
 Symphorien*.

Charlier, Jacques, EA.

Charlton House, C-2402/*178*.

Charlton house style, C-2402/*87*.

charm, S-4927/*387*.

charme wood, DADA.

Charol, D., C-5191/*161*.

Charon, DSSA.

charouk, C-2403/*195*.

Charpentier, Alexandre, DADA/
 Supplement.

char-pot, IDC.

char pot, EA.

charpoy, SDF.

charred, S-4881/*297*①.

charred accents, S-3311/*507*①.

Charrière, S-4927/*224D*①.

Charters, Cann & Dunn, S-4905/*182*.

chart glass, S-4881/*54*①.

chart pads, S-4881/*55*①.

chartreuse, C-5005/*244*①; C-5146/
 *99*①, *89D*①; S-4905/*35*①.

charts, S-4881.

Charvet, Claude, C-5174/*487*①.

chase, C-2458/*99*①, *321*; C-5191/*57*.

chased, C-0254/*169*; C-0270/*44*①;
 C-2202/*16*; C-2398/*1*①; C-2409/
 175; C-2421/*4*①; C-5005/*235*①;
 C-5114/*6, 22*; C-5116/*43*①;
 C-5127/*225*①; C-5153/*15*①, *16*①;
 C-5156/*106*①; IDC; S-4802/*6*;
 S-4804/*7*①; S-4922/*10*①.

chased and engraved relief, RGS/*51*.

chased and mercurial-gilt brass,
 CEA/*303*.

chased and pierced, LAR83/*539*①.

chased and repoussé, C-0254/*126*①.

chased blade, C-5114/*75*.

chased capital and base, C-2403/
 *150*①.

chased cast foliage, C-5114/*14*.

chased decoration, LAR82/*206*①; RGS/*83.*

chased dial, C-2320/*3*①; C-2437/*20.*

chased domed foot, C-2437/*15*①.

chased floral panel, C-0254/*19.*

chased floral swag, C-5114/*44.*

chased foliate nozzle, C-2437/*14*①.

chased fur, C-2202/*161.*

chased gadrooning, RGS/*31*①.

chased gold, C-5005/*216*①.

chased handle, C-0254/*67.*

chased inner rim, S-4414/*257*①.

chased iron, JIWA/*95*①.

chased ornamental border, C-5114/*36*①.

chased ornamentation, RGS/*138.*

chased patera, CEA/*659*①; S-4922/*23*①.

chased petal, C-5156/*245*①.

chased plumage, S-4922/*76*①.

chased rocaille design, RGS/*31*①.

chased scroll design, S-4461/*76*①.

chased scroll enframement, C-5114/*39*①.

chased silver mount, S-4461/*363.*

chased stand, C-5114/*43*①.

chased stylized wave, S-2882/*938*①.

chased terminal, S-4414/*245*①.

chased with basketweave, C-0270/*116*①.

chased work, JIWA/*182*①.

chasing, CEA/*524, 528, 678*; DADA; DATT; EA; NYTBA/*216*; RTA/*12*①; SDF.

chasing punch, CEA/*618.*

châsse, DADA.

chasse, DATT; S-4972/*51.*

chassis, DATT.

Chastenet of Limoges, EA/*114*① *decimal dial.*

Chastity, DSSA.

chasuble, C-0405/*196*; C-1304/*224*; DADA/①; DSSA; NYTBA/*103*①.

châtaignier wood, DADA.

chatalaine clip, C-0706/*95.*

Château de Saint-Gobain, CEA/*484.*

Château de Vincennes, NYTBA/*170*①.

chatelaine, ACD; C-0406/*100*; C-2202/*86.*

châtelaine, CEA/*68*①, *513, 516*①.

chatelaine, EA/①; IDC/①; LAR82/*237*①; S-4802/*135*①, *135*①; S-4927/*192*①.

chatelaine hook, LAR82/*64*①.

chatônes, DADA.

chatoyant, DATT.

Chatsworth Toilet Service, EA.

chatter mark, DATT.

chaudor, S-3311/*28, 28.*

Chaudor carpet, EA.

Chaudron & Rasch, C-5153/*25*①.

chauffe-assiette, DADA.

chauffe-nourriture, IDC.

chauffe-plat, DADA.

chauffeuse, C-5259/*472*①; DADA/①; S-2882/*362*①; S-4972/*601*①.

Chauncey Jerome, EC2/*90.*

chausses, DADA.

Chauvel, Ch., S-286/*70.*

Chavaux, CEA/*227*①.

Chavin, S-4807/*1.*

ch'a wan, IDPF/*27.*

chawan, C-0782/*163*; C-5156/*790*; C-5236/*834A*①.

Chawner, Henry, C-0270/*158*; C-2487/*111*; CEA/*658*①; EA/ *Emes, John.*

Chawner, Mary, C-2510/*101*①.

Chawner, T., C-2487/*43.*

Chawner, Thomas and William, C-5117/*63.*

Chawner, William II, C-2487/*43*; C-5117/*33.*

chay, DATT.

Chayé, Germain, C-5220/*44*①.

ch'a-yeh mo, IDC.

C.H.C., MP/*500*① *Churfürstliche Hof Conditorey* = *Eletoral Court Pantry*.

cheating, OC/*18*.

checked cottons, C-2704/*48A*.

checked wool, C-1506/*1*.

checker, ACD/*chequer*; C-5153/*110*①; CEA/*697*.

checkerboard, OPGAC/*210*.

checker board design, C-5146/*72*①.

checkerboard ground, IDC.

checkerboard reserve, S-4948/*39A*.

checker-board surface, S-3311/*130*.

checkered, C-5005/*339*①; S-4972/*163*①.

checkered diamond, DADA.

checkered stringing, C-5114/*344*①.

checker inlay, C-5114/*307*①.

checking, DATT.

cheek, SDF.

cheek-piece, C-2569/*59*①.

cheek piece, CEA/*26*①; S-4965/*127*; S-4972/*155*①, *272*.

cheekpiece, C-2476/*2*; C-MARS/*126*①.

cheese-coaster, C-2478/*19*.

cheese coaster, C-0906/*84*; C-2403/*16*; DADA.

cheese-dish, C-5117/*132*①; IDC.

cheese dish, C-0254/*10*; C-0706/*178*.

cheese dish/cover, IDPF/*46*①.

cheese-hard, IDC.

cheese-knife, C-5117/*41*; C-5174/*296*.

cheese knife, C-0254/*185*; C-1502/*108*; C-5114/*75A*; S-4804/*35*; S-4905/*160*.

cheese-mould, IDC/①.

cheese press, IDPF/*47*①.

cheese-scoop, C-5117/*33*.

cheese scoop, C-0254/*310*; C-0270/*169*; EA/①; S-4461/*179*; S-4922/*34*①.

cheese server, C-0254/*211*; C-5117/*38*.

cheese slice, S-4804/*81*①.

cheese strainer, IDPF/*47*①.

cheese wagon, SDF.

cheese wringer, IDPF/*47*①.

chef-d'oeuvre, LP.

chef d'oeuvre, DATT.

cheffonier, SDF.

Chekian, C-5236/*482*①, *1595*.

Chekiang, C-5236/*467*①; CEA/*113*①, *117*①.

Chelaberd, OC/*208*①.

Chelabi, OC/*208*①.

Chelabi Kazaks, OC/*210*.

Chelabred rug, S-3311/*61*①.

Chelebard Karabagh, C-5323/*42*.

Chelsea, ACD; C-2360/*73*; C-2493; CEA/*61*, *155*①, *188*①; DADA; EA/①; LAR82/*103*①; LAR83/*76*①; MP/*133*.

Chelsea and Dedham, DADA/*Supplement*.

Chelsea Bird pattern, S-4461/*6*.

'Chelsea' carpet, OC/*306*.

Chelsea carpet, OC/*80*①.

Chelsea-Derby, ACD; EA/*Derby*.

Chelsea Derby, C-1006/*206*.

Chelsea-Derby period, CEA/*187*.

Chelsea Keramic Art Works, EC1/*74*①.

Chelsea Keramic Art Works (mark), EC1/*84*①.

Chelsea Keramic Art Works, Chelsea, Massachusetts, EC1/*85*.

Chelsea Pottery, C-0225/*3*.

Chelsea toy, IDC.

chemche güls, S-3311/*35*.

chemical, C-2904/*131*.

chemical balance, C-2608/*104*.

chemical glass-ware, CEA/*600*.

chemical lace, C-0604/*60*.

chemical washing, OC/*32*.

chemigraphy, DATT.

chemise, C-1506/96; C-2203/63.

chemon design, C-2482/116.

chen, IDPF/122.

chenet, C-0249/285; C-0279/219;
C-5189/255; C-5259/354; DADA;
EA; S-3311/411①; S-4461/545,
561, 631, 658; S-4804/678, 684①;
SDF.

Cheney, Elisha, CEA/38①.

chêng, EA.

Cheng Ho, EA.

chenghua, S-4810/32.

Ch'êng Hua, DADA.

Chêng-hua, CEA/111.

Ch'eng-hua, CEA/119①.

Ch'êng-hua, CEA/120①.

Ch'êng Hua, EA.

Chenghua, C-2323/159; C-2458/104;
C-5127/64; C-5156/143; S-4965/
243, 284①.

Chenghua character mark, LAR83/
92①.

Chenghua mark, C-2323/54.

Cheng Sui, C-2414/105.

Chêng-tê, CEA/111.

Cheng-tê, CEA/120①.

Chêng Tê, DADA.

Cheng Tê, EA.

Chêng T'ung, DADA.

chenille, C-0249/176; C-0405/164;
C-1603/16; C-2704/23; C-3011/
130; CEA/294; DADA; SDF.

chenille Axminster, EA.

Chen Ji, C-2414/96①.

Chen Ming Yuan (Hecun), S-4965/
306①.

Ch'ên-tzŭ-shan, EA.

chequer, ACD; CEA/489, 491①,
502; SDF.

chequer-board design, C-0103/108.

chequerboard (checkerboard)
paperweight design, EG/287.

chequered, C-2402/8.

chequered boxwood line, C-0982/74.

chequered design, C-0405/102.

chequered diamond design, CEA/
461①.

chequered grip, S-4972/272.

chequered line, C-2403/12; C-2421/
44①.

chequered lined, C-0906/169.

chequered pattern, JIWA/71.

chequer-pattern, C-5116/79①.

chequer pattern, LAR83/171①.

chequer-pattern border, C-0249/449.

chequer-pattern horsehair, C-2421/
23①.

Cheret, Jules, S-286/433C.

chern, RGS/90.

cheroot, C-2202/144.

cheroot box, LAR82/562①.

cheroot case, C-0706/154; C-1502/
76; C-5156/456.

cheroot holder, LAR83/522①.

cherry, ACD; CEA/562; DSSA;
FFDAB/31, 42; S-4461/726①.

Cherry Basket, C-2704/75.

cherry blossom, OPGAC/192.

cherry gum, DATT.

cherry wood, DADA.

cherrywood, C-5114/252①; C-5153/
90①; DATT; LAR82/214①;
S-2882/343; S-3311/182; S-4461/
579; S-4905/370①; SDF.

Chertsey tile, IDC.

cherub, C-1006/93; C-2202/26;
C-2486/152①; DADA; DATT;
DSSA; S-3311/412①.

cherub finial, S-2882/1346①.

cherubim motif, C-5174/128①.

cherub mask, CEA/644①.

cherubs mask, C-0406/14.

cherub spoon, EA.

chê shih, DATT.

Cheshire, C-0249/389①.

chess, IDPF/47①.

chessboard, C-5157/116.

chessboard ground, IDC.

chessmen, IDC/①.

chess pawn, C-0706/231.

chess set, C-1082/150.

chess table, S-4461/743①; SDF.

chessylite, DATT.

chest, C-0982/26; C-1407/9; DADA;
DSSA; IDPF/48①; S-4461/23,
487; S-4972/454; SDF/①.

chest-bench, DADA.

chest close-nailed, C-2402/17.

Chester, C-0406/10; S-4461/260.

Chesterfield, C-1407/36; SDF/①.

Chesterfield, Earl of, CEA/189①.

Chesterfield brown ware, EA.

Chesterfield Vase, CEA/189①.

Chesterman, Charles, C-5117/71①.

chest microscope, C-1609/29.

chestnut, ACD; C-0249/409;
LAR82/425①.

chestnut basket, IDC/①.

chestnut bottle, DADA.

chestnut brown, DATT.

chestnut red, S-288/17①.

chestnut-roaster, EA.

chestnut roaster, CEA/531①; IDPF/
49.

chestnut-server, EA/chestnut-urn.

chestnut-urn, EA.

chestnut urn, C-2478/5.

chestnut wood, DADA; SDF.

chestnut wood, French, DADA.

chest of drawers, C-5114/252①;
C-5116/109①; DADA/①; S-4436/
90; S-4972/457; SDF/①.

chest of drawers on a stand, DADA.

chest-on-chest, C-2403/147; C-5116/
122①; DADA; EA/tallboy; SDF.

chest on chest, C-5157/119①;
C-5170/120①; S-4436/125A①;
S-4988/465①.

chest-on-frame, DADA; S-4905/378.

chest on frame, NYTBA/31①.

chest-on-stand, C-0982/266; C-2403/
121①; NYTBA/29①.

chest on stand, C-5116/120; LAR83/
302①; S-4436/167①.

chest-over-drawer, C-5114/318A①.

chest-upon-chest, CEA/333①.

Cheuret, Albert, C-5005/369①;
C-5167/187.

cheval, ACD; C-0982/85A; C-2402/
111, 141A; C-2421/47; C-2498/85;
S-4436/10①.

cheval dressing glass, SDF/①.

cheval fire screen, DADA/①.

cheval firescreen, C-2357/32①.

cheval glass, CEA/363①; EA/①;
S-4461/731.

Chevalier, CEA/611①.

Chevalier & Cochet, C-5174/421.

Chevaliernche, C-5239/109.

Chevallier, Jean-Baptiste, C-5174/
445.

Chevallier, Jean-Mathieu and
Charles, C-2555/58①.

cheval mirror, C-0982/64; C-1407/
80; DADA; LAR83/492①.

cheval screen, EA.

cheval screen libraire, SDF.

cheveret, ACD; DADA; EA/①
bonheur du jour; LAR82/419①;
LAR83/399①; SDF.

Chevigny, Claude, stamp: C
CHEVIGNY, C-5224/198①.

chevrette, IDC; IDPF/49.

chevron, C-0279/10; C-2388/188;
C-2458/38; C-2482/99; C-5116/61;
C-5153/191①; CEA/113①;
S-4461/18; S-4507/19①; SDF.

chevron banded, LAR82/277①.

chevronbanded, LAR83/300①.

chevron border, IDC.

chevron-pattern, C-0249/*283*; C-2323/*132*; C-2421/*77*①; C-5116/*21*①.

chevron pattern, C-0279/*373*; C-2414/*66*①.

chevron-pattern line, C-5116/*140*①.

chevron-pattern line border, C-5116/*48*.

chez Clerissy a Moustiers, EA/ *Clérissy, Pierre.*

chia, DADA; EA.

Chia-ching, CEA/*111, 121*①.

Chia Ch'ing, C-0782/*61*; DADA.

Chia Ching, DADA; EA.

Chia-Ch'ing Period, S-288/*15*①.

Chia Ching period, LAR82/*106*①.

chia li, CEA/*124*①.

chiang t'ai, IDC.

Chi-an ware, EA.

chiao, EA/*chüeh.*

Chiao-t'an, CEA/*118*①; EA.

chiao-tou, ACD.

Chia-pi-ts'un, EA.

chiaroscuro, DADA; DATT; IDC; LP.

chiaroscuro areas, JIWA/*49*.

chiaroscuro woodcut, DATT/①.

chibukli, OC/*64*.

Chicago Gas Appliance, K-711/*129*.

Chicago Terra Cotta Works, Chicago, Illinois, EC1/*85*.

Chicaneau, Pierre, CEA/*169, 182*①; MP/*15*.

Chicaneau family, EA.

chic anglais, DATT.

Chichaksu, OC/*140*①.

Chichester, Hart, C-2489/*119*.

Chi Chi, S-4847/*102*; S-4948/*29*①.

Chichi, CEA/*83*①; DADA.

Chi-Chi border, S-4796/*73*①.

Chi Chi border, S-4948/*29*①.

chichi carpet, EA.

'chi-chi' design, C-5323/*69*①.

Chi Chi rug, S-4847/*7*.

Chichi rug, ACD.

Chi-chou ware, EA.

chi chou yao, DADA.

chicken brick, IDPF/*49*①.

chicken finial, CEA/*467*①.

'chicken head' ewer, LAR83/*80*①.

chicken-head spout, EA/①.

chicken skin, C-1304/*23*; EA; IDC.

chickenskin leaf, C-1603/*3*.

chicken spout, IDPF/*87*①.

chicken ware, IDC/①.

chief's blanket, S-4807/*269*①.

chien, EA; CEA/*111*.

Chiengsen style, C-5156/*253*①.

chien lung, C-5259/*29*.

Ch'ien Lung, C-0782/*150*; DADA.

Ch'ien Lung, EA.

Ch'ien-lung period, JIWA/*315*①, *343*.

Chien ware, ACD; EA.

Chien Wên, DADA.

Chien yao, IDC; C-5156/*41*; DADA.

Chien-yao ware, JIWA/*348*.

chiffon, C-3011/*1*.

chiffonier, C-0982/*150, 282*; C-1407/*104*; C-2403/*123*; CEA/*361*①; EA; LAR83/*297*①, *304*①; SDF/①; ACD.

chiffonière, ACD.

chiffoniere, S-4461/*551, 676*.

chiffonnier, C-2478/*125*①; DADA/①; EA/①; S-4972/*632*.

chiffonnière, DADA.

chiffre, RGS/*135*.

chifonie, EA/*hurdy-gurdy.*

chih, C-5236/*386*①; DADA; EA.

chih-ch'ui p'ing, IDC.

ch'ih lung, IDC.

chi-hung, IDC.

chi hung, DADA.

Chi'ien Lung, C-0782/*19*.

Chikusen, DADA/*Supplement.*

Chila rug, C-0279/*33*.

childrens' armchairs, C-2402/*105*.

child's chair, C-0225/*367*; DADA; S-3311/*265*; S-4461/*591*; SDF/①.

child's convertable highchair, C-0982/*109*.

child's cradle, C-5157/*44*.

child's flatware set, C-0254/*239*.

child's fork, C-0254/*218*; C-5114/*67*.

child's knife and fork set, S-4804/*1*.

child's mug, C-5114/*107*; C-5203/*343*①; S-3311/*621*①.

child's presentation set, S-4804/*91*①.

childs rocking chair, C-0906/*138*.

child's set, C-0254/*287*①; C-5203/*265*.

child's side chair, C-0279/*342*.

child's tea service, S-4905/*61*①.

child's violin, C-0906/*268*.

ch'i-lin, DADA; IDC.

Ch'i-lin, EA.

chill, DATT; SDF.

chills, IDPF/*50*①.

chilong, C-2458/*233*; C-5127/*303*; C-5156/*148*.

chilong dragon, C-2458/*64*.

chime, CEA/*223*①.

chimera, C-2437/*42*①; C-5189/*348*①; DADA; LAR83/*489*①; S-288/*28*①, *32*①; S-4810/*583*①; SDF.

chimera mask, C-2437/*75*①.

chimerical figures, SDF.

chime/silent, C-5189/*198*.

chimney, MP/*31*.

chimney-board, ACD.

chimney-crane, EA, .

chimney crane, CEA/*532*①; SDF.

chimney frame, SDF.

chimney furniture, SDF/①.

chimney garniture, NYTBA/*142*①.

chimney glass, DADA; EA; FFDAB/*115*①; SDF.

chimney neck, C-2324/*69*.

chimney piece, S-3311/*134*①; S-4436/*182*.

chimneypiece, MP/*65*; SDF/①.

chimney-piece ornament, IDC.

chimney pot, IDPF/*50*①.

chimney shaped, K-802/*16*.

Chimu, S-4807/*51*.

Chimú pottery, IDC.

china, DADA; EA/*red porcelain*; IDC; CEA/*561*.

china cabinet, DADA/①; SDF/*china case*.

china case, SDF.

china-clay, CEA/*110, 209*.

china clay, MP/*27, 158, 502*; DADA; DATT; IDC; LP.

china glaze, CEA/*166*①; IDC.

China Maker, CEA/*195*①.

Chinaman teapot, IDC/①.

china-marking crayon, DATT.

china painting, DATT.

china paper, S-286/*272, 463*.

china shelf, SDF.

china-stone, CEA/*110, 209*.

china stone, EA; MP/*502*.

China-stone, IDC.

China stone, DADA; DATT.

china table, DADA; SDF/①.

China Trade, C-2487/*27*.

China Trade picture, C-5156/①.

China-Trade Porcelain, DADA/*Supplement*.

China tree wood, DADA.

China wood oil, DATT.

Ch'in Dynasty, ACD.

chiné, C-2501/*11*.

chine appliqué, S-286/*22, 25, 38*①, *272*.

Chine collé, S-286/*96*.

chine ground, C-2324/*7*.

Chinesco, S-4807/*153*.

Chinese, ACD.

Chinese animal figures, DADA.

Chinese Aubusson, OC/*309*①.

Chinese 'Aubusson', OC/*308*①, *313*①.

Chinese blue, DATT; LP.

Chinese blue and white, C-0782/*63*.

Chinese blue and white porcelain, S-4965/*239*①.

Chinese bronze, C-1082/*83*.

Chinese carpet, C-2482/*17*; EA.

Chinese celadon, EA.

Chinese ceramic decoration, EA/ *Mazarin blue.*

Chinese ceramic form, EA/ *pear-shaped bottle.*

Chinese ceramics, CEA/*111*; EA/ *kylin,*

Chinese ceramic shape, EA/*pilgrim flask.*

Chinese Chippendale, CEA/*405*; DADA/①, LAR83/*362*①; SDF/ ①.

Chinese Chippendale style, C-2402/ *144A*; EA/①.

Chinese clock, EA/①.

Chinese cloisonné enamel, EA/①.

Chinese cloisonne plates, C-1082/*115.*

Chinese counter, CEA/*694*①.

Chinese design, OC/*11.*

Chinese duplex watch, EA/*Chinese watch.*

Chinese dynasties, DADA.

Chinese embroidery, DADA.

Chinese export, C-0782/*91*; C-1082/ *179*; C-2320/*96*①; C-5114/*97*; C-5116/*150*①; C-5157/*116*①; S-4436/*165*; S-4461/*122*; S-4812/ *43.*

Chinese export porcelain, DADA; EA/①; EC2/*20*; IDC/①; DADA/ *Supplement.*

Chinese export ware, EC2/*32*①.

Chinese felt rug, OC/*341*①.

Chinese figure subject, RGS/*52*①.

Chinese floral, OC/*340*①.

Chinese four season flowers, DADA.

chinese frame, C-5156/*285*①.

Chinese fret, C-5170/*130*①.

Chinese fretwork, C-5116/*94*①.

Chinese Fu Dog rug, S-4461/*811.*

Chinese furniture, DADA/①.

Chinese glass, DADA; EA.

Chinese gods, DADA.

Chinese Gothic, CEA/*335*①.

Chinese green, DATT.

Chinese hand-tufted carpet, DADA.

Chinese Hanging, EA/*Béhagle, Philippe.*

Chinese Han period, IDPF/*62*①.

Chinese huai style, JIWA/*75.*

Chinese imari, DADA; IDC; C-0782/ *18*; EA; S-4905/*30*①.

Chinese influence, RGS/*88.*

Chinese ink, DATT.

Chinese insect wax, DATT.

Chinese ivory, C-2458; EA.

Chinese ivory groups, C-1082/*138.*

Chinese jade, EA/①.

Chinese lacquer, DADA; DATT; EA/ ①.

Chinese-Lowestoft, CEA/*194*①.

Chinese Lowestoft, DADA; IDC.

Chinese manner, JIWA/*207.*

Chinese-market clock, EA/①.

Chinese mirror, EA.

Chinese mount, S-291/*237*①.

Chinese Oriental rug, DADA.

Chinese paintings, JIWA/*8.*

Chinese paling, C-2478/*91.*

Chinese 'Peking', OC/*308*①, *313*①.

Chinese pillar rug, S-4461/*782.*

Chinese porcelain, EA.

Chinese railing, DADA/①; SDF/①.

Chinese red, DATT; S-4414/*210*①.

Chinese reign-mark, IDC/①.

Chinese rug, C-0906/*55.*

Chinese seal-mark, IDC.

Chinese soft paste, DADA.

Chinese style, C-2402/*14.*

Chinese symbols and emblems, DADA/①.

Chinese taste, C-5156/*156;* DADA; NYTBA/*49*①; SDF/①.

Chinese theme, MP/*33.*

Chinese triad, IDC/①.

Chinese vermilion, DATT; LP.

Chinese ware, EC2/*20*①.

Chinese watch, EA/①.

Chinese white, DATT; LP.

Chinese white-line print, JIWA/*71.*

Chinese willow pattern, C-2704/*155.*

Chinese yellow, DATT.

Chine sur commande, IDC.

Chine volant, S-286/*196, 320, 320A.*

Ch'ing, DADA.

Ch'ing dynasty, IDC; JIWA/*306.*

Ch'ing dynasty, CEA/*111;* EA/①.

Ch'ing Ho Hsien, DADA.

ch'ing lung, IDC.

ch'ing-pai, IDC.

Ch'ing-p'ai, CEA/*117*①.

Ch'ing-Pai, CEA/*111.*

Ch'ing-pai porcelain, JIWA/*344*①.

Ching-pai ware, EA/①.

Ching T'ai, DADA.

ching-tê Chên, IDC.

Ching-tê-chên, ACD.

Ching-tê-chên,, CEA/*111.*

Ching tê Chên, DADA.

Ching-tê-chñ kilns, EA.

chinkin-bori, CEA/*562, 572*①, *575.*

chinkinbori, DADA.

chinoiserie, ACD; C-0249/*208;* C-0982/*88B;* C-1407/*100;* C-1603/*43;* C-2402/*4, 240;* C-2421/*77*①; C-5173/*30*①; CEA/*209;* DADA/①; DATT; EA/*Erfurt,* ①; IDC/

①; JIWA/*6, 8;* LAR83/*77*①; LP; MP/*470*①; S-2882/*236, 278*①, *348*①, *379, 772A;* S-3311/*107*①; S-4414/*368, 465*①; S-4436/*95*①; S-4461/*170;* S-4812/*16;* S-4853/*128*①; S-4922/*53*①; SDF; C-5116/*46*①; CEA/*63*①, *329*①.

chinoiserie decoration, LAR82/*127*①; S-2882/*707*①.

chinoiserie design, C-0604/*36;* C-2357/*26*①.

chinoiserie figure, C-1603/*44;* C-2421/*46*①; C-2437/*3*①; C-2704/*3;* S-4843/*29*①; C-0279/*226.*

chinoiserie furniture, C-2421/*53.*

chinoiserie lacquer, S-4955/*183.*

chinoiserie motif, EG/*110.*

Chinoiserie painting, CEA/*449*①.

chinoiserie pavilion, C-2388/*9.*

Chinoiserie style, C-2202/*130.*

chinoiserie sun, S-4922/*58A*①.

chinoiserie tapestry, S-4972/*195*①.

Chin tsun, CEA/*113*①.

chintz, C-1506/*88;* DADA; SDF.

chintz band, C-2704/*117.*

Chintz pattern, S-4853/*125*①.

chio, DADA/①.

Chiodo family, EA.

chip, C-5117/*324.*

chiparus, LAR83/*32*①; LAR82/*46*①.

Chiparus, Demetre, C-5191/*122*①.

Chiparus, D.H., C-2910/*303.*

chipboard, DATT.

chip-carved, C-0249/*365;* C-5114/*318D*①.

chip-carved border, C-1407/*86.*

chip-carving, ACD; C-0279/*328.*

chip carving, DADA; EA; SDF/①.

chipped, S-4461/*95.*

chipped ice finish, C-0225/*277.*

Chippendale, C-0982/*49;* C-5114/*256*①; CEA/*321;* FFDAB/*51;*

LAR82/20①, *214*①; S-3311/*193*; S-4905/*439*①.

Chippendale, Haig & Co., C-2478/ *164*; EA/*Chippendale, Thomas the Elder.*

Chippendale, Thomas, ACD; C-2357/ *83*①; C-5116/*158*①; CEA/*321*; DADA; NYTBA/*48*; SDF/*747, 747.*

Chippendale, Thomas, Jr., DADA.

Chippendale, Thomas the Elder, EA.

Chippendale, Thomas the Younger, EA.

Chippendale and Haig, CEA/*321*.

'Chippendale' border, S-4414/*319*①.

Chippendale border, EA/*pie-crust*; S-4414/*341*; S-4461/*366*.

Chippendale Director style, C-2421/ *37*①.

Chippendale form, JIWA/*376*.

Chippendale Revival, C-2402/*133*.

Chippendale style, C-1407/*8*; C-2402/*7*; C-2478/*58*; C-5153/*88*; DADA/①; EA/①; LAR83/*248*①; SDF/①.

chipping, LAR83/*397*①.

chips, C-2458/*225*; C-5114/*143*; S-4992/*1*①.

chi-rho, DATT/①.

chi-rho monogram, DSSA/①.

Chiron, DSSA.

chisel, DATT/①.

chisel brush, DATT.

chiseled, FFDAB/*122*①.

chiselled border, C-2332/*292*.

chiselled steel, CEA/*23*①; EA; RTA/*129*①.

chiselling, CEA/*528*.

chitarrone, EA/*lute.*

chiton, S-4973/*132, 143*①.

chitsu, C-5236/*1333*.

chitterone, C-5255/*39*①.

chiu, DADA.

Ch'iung-lai, EA.

Chiu-yen, CEA/*113*①; EA.

chiwara, S-4807/*366*①.

chlamys, S-4973/*131*.

chlorite, C-5156/*212*①.

chloromelonite, C-2458/*342*①.

Chobash, OC/*176*①.

chocolate and olive green, C-2704/ *166*.

chocolate brown, S-4847/*342*; S-4992/*78*①.

chocolate-cup, IDC.

chocolate cup, CEA/*184*①; MP/*49*.

chocolate-pot, EA; IDC.

chocolate pot, ACD; C-0225/*39*; C-0406/*62*; CEA/*645*①; DADA; LAR82/*574*①; LAR83/*559*①; S-4802/*228*①.

chocolate set, C-0225/*39*; IDPF/*50*.

chocolate-stand, IDC/①.

Chodor, OC/*176*①.

Chodor carpet, EA; LAR82/*544*①.

Chodor engsi, S-4948/*71*①.

Chodor enssi, OC/*109*①.

Chodowiecki, Daniel, EA.

choice uncirculated, K-710/*118*.

choir-screen, CEA/*527*.

choir stall, SDF.

Choisy, S-4843/*230*①.

choisy and creil, C-5259/*124*.

Choisy-le-Roi, S-4843/*330*①; CEA/ *484*.

Choisy-le-Roi glasshouse, EA/ *Bontemps, Georges.*

choker, C-5005/*220*①.

choker-length, S-4414/*4*.

choker-necklace, S-4927/*232*.

Chollomando, CEA/*129*①.

chondrin, DATT.

chondrometer, C-0403/*97*; C-2904/ *34*.

chondzoresk indigo medallion, S-2882/*41*.

chonin, CEA/*568*①.

Choo Dynasty, C-5156/*311.*

chop, S-286/*473.*

chop dish, C-5203/*121.*

chopin, CEA/*594*; DADA; EA.

chopine, IDC.

chopnet, EA.

chopnut, EA/*chopnet.*

chopped strand mat, DATT.

chopper, C-5114/*207*①.

chopper-lump barrel, C-2476/*1.*

chopping board, C-5114/*207*①.

chou dynasty. ACD; CEA/*113*①; EA/①.

choufleur, CEA/*496*①.

Chou period, JIWA/*315.*

Chou tou, IDPF/*148.*

choval, CEA/*101*; OC/*30.*

Chow, Fong, DADA/*Supplement.*

Chow Dynasty, C-5156/*309.*

Choy, Katherine Pao Yu, DADA/ *Supplement*

Chrétien, J., CEA/*554*①.

Chretien Koerber a Ingelfingen, CEA/*26*①.

chrismatory, CEA/*579, 594*; EA/①; DADA.

Christ, Rudolf, CEA/*166*①.

Christallerie du Creutro, EA/ *Baccarat.*

christening can, LAR83/*594*①.

christening cup, EA/①; LAR83/ *571*①.

christening goblet, EA; IDC.

Christening knife and fork, C-1502/ *65.*

christening mug, C-0706/*61*; LAR83/ *594*①; C-0103/*48*; C-1502/*204*; C-2202/*27.*

Christening of the Prince of Wales, C-0405/*195.*

Christening robe, C-1506/*21.*

christening set, C-5117/*200*; LAR82/ *583*①.

christening spoon, C-0706/*130*; EA; C-1502/*64.*

Christian, S-4972/*1*①.

Christian, Philip, CEA/*200*①; EA.

Christian II, EA/*Drentwett family.*

Christmas fork, C-5203/*139.*

Christmas nativity art, DADA.

Christmas plate, S-4804/*542.*

Christmas spoon, C-0254/*92.*

Christofle, C-5167/*168.*

Christofle, Paul, C-2510/*19*①.

Christofle & Co., C-2510/*19*①.

Christofle Silver, Inc., DADA/ *Supplement.*

Christogram, DATT.

chroma, DATT; LP.

chromatic color, DATT; LP.

chromatic drum, CEA/*549.*

chromaticity, DATT.

chrome, C-5005/*353*; C-5146/*111*①; C-5239/*97.*

chromed, C-5005/*347.*

chrome dye, OC/*32.*

chrome-green, IDC.

chrome green, DATT.

chrome ochre, DATT.

chrome orange, DATT, .

chrome pigment, LP.

chrome-plated, C-5239/*113.*

chrome plated, C-0225/*82.*

chrome-railed, C-0982/*109.*

chrome red, DATT, .

chrome yellow, DATT.

chromium, EG/*257.*

chromium oxide green, DATT; MP/ *184.*

chromium oxide green opaque, LP.

chromium oxide green transparent, LP.

chromium plated, C-2324/*213.*

chromium plating, SDF.

chromo, DATT.

chromolithograph, C-0249/79; CEA/
693①; DATT.

chromolithographic, C-1603/14.

chromolithographic card, C-0405/123.

chronograph, C-5117/431①; S-4802/
14, 16, 20.

chronograph train, S-4802/20, 37①.

chronograph wristwatch, S-4802/67A;
S-4927/29.

chronometer, C-2904/262; CEA/
255①; EA/①; LAR82/208①;
S-4802/30①, 52.

chronometer carriage clock, LAR83/
186①.

Chronometre Lusina, S-4927/120.

chronometro gondolo, S-4927/165①.

chronoscope, EA.

chrysanthemum, C-0782/43; DADA.

chrysanthemum as motif, C-2458/47.

chrysanthemum bowl, C-5156/138.

chrysanthemum design, MP/472①.

chrysanthemum dish, C-5156/157①.

Chrysanthemummuster, IDC.

Chrysanthemum pattern, C-0254/218;
C-5114/21①; S-4804/83①.

chrysanthemum vase, DADA/①.

chryselephantine, C-5167/36①;
DATT.

chrysoberyl, RGS/82.

chrysoberyls, RTA/113① chrysolite.

chrysocolla, DATT.

chrysography, DATT.

chrysoprase, C-2910/228; EA/Berlin
school; JIWA/180.

chuang, C-5234/301.

chuban, C-5236/947, 1335①.

chūban, JIWA/244.

chuban tate-e, C-5236/965.

chuban yoko-e, C-5236/975, 1333.

ch'ü chou, DADA.

Ch'u-chou ware, EA.

Ch'u Chou yao, IDC.

Chuchu, C-2476/13.

chueh, DADA.

chüeh, EA/in jade, ①.

chueh, IDPF/51①, 133.

Chüeh, ACD.

chufti knot, EA/jufti knot.

ch'ui ch'ing, IDC.

chü-lü hsien, DADA.

Chu-lu Hsien, IDC.

chum, RGS/84.

Chün, CEA/111.

Chün-Chou, CEA/116①.

chung, EA.

Ch'ung Chêng, DADA.

Chung Kuei, C-2458/357①.

Ch'ün-shan kiln, EA.

chun ware, S-4461/539.

Chün ware, ACD; EA/①.

chün yao, DADA; IDC/①.

chun-yao-type, C-0782/211.

Chupícuaro, S-4807/139, 143.

chu-posts, DADA.

church, C-2704/21①.

church embroidery, CEA/282①.

church fan, EA.

Church Gresley pattern, IDC.

Churchill, E. J., C-2476/18.

Church Needlework, C-0405/169.

church plate, EA/American silver.

Churchwarden pipe, CEA/533①.

Church Works, EA/Palmer,
Humphrey.

churn, C-0906/95; CEA/166①;
IDPF/51①; K-802/17.

Churriguera, José, EA/
Churrigueresque style.

Churrigueresque, DADA; SDF.

Churrigueresque style, EA/①.

chute, C-0279/426①, 450①; C-5189/
290①; C-5259/620①; S-3311/
425①; S-4955/68①.

chytra, IDPF/51.

ciborium, DADA; EA/①; LAR82/
250①.
cicada blade, S-4965/114①.
cicelè, C-5189/50①.
Cicely L. Chamberlayne, C-0405/160.
cider glass, EA/①.
cider-jug, IDC.
cider jug, IDPF/51①.
cider pitcher, EA.
Cien, Fernand, C-5189/180.
cigar-box, C-2398/75.
cigar box, C-1082/174; C-5146/66;
EA.
cigar-box detective camera, ·C-1609/
263.
cigar-case, C-5173/11①.
cigar case, C-0406/6; C-5117/319①.
cigar clip, S-4461/369.
cigar cutter, C-0406/99.
cigarette box, C-0254/38, 61①;
C-0706/39, 71; C-1502/31, 91;
C-2409/22; C-5146/65①.
cigarette-case, C-5117/349①.
cigarette case, C-1082/96; C-1502/
91; C-5005/213①; LAR83/559①.
cigarette container, S-3311/155.
cigarette cover, C-0254/199.
cigarette holder, C-0254/45; C-5005/
402①; C-5239/104; S-4881/165①.
cigarette support, C-0249/265.
cigarette urn, S-4461/291.
cigar holder, C-5153/11①; LAR83/
522①; S-4881/165①.
cigar stand, C-5153/11①.
cigar store figure, C-5114/188①.
cigogne, EA/décor Coréen.
cimaise, EA.
cimarre, EA/cimaise.
ciment fondu, DATT.
Cincinnati Art Pottery, Cincinnati,
Ohio, EC1/85.
Cincinnati Limoges, EC1/72①.
cinerary urn, IDC; IDPF/52①.

cinnabar, C-2458/284; C-5117/325①;
C-5127/1; C-5174/236①; C-5236/
367①; DATT; LAR82/63①, 67①;
LP.
cinnabar lacquer, DADA.
cinnabar pigment, C-5156/8.
cinq bouquet, IDC.
cinquecento, DADA; DATT; LP; EA.
cinquedea, DADA; S-4972/152①.
cinquefoil, C-2323/66; C-2357/2①;
C-2458/280①; DADA/①; DATT;
IDC; SDF.
cinquefoil flower, RTA/83①.
cinquefoil plinth, C-5234/83①.
cintimani, C-5234/19①.
cipher, IDC; S-4905/66.
Ciphers and Codes, C-2904/25.
cipolin, DATT.
cipollino, DATT.
Cipriani, B., LAR82/56①.
Cipriani, Giovanni Baptista, DADA.
Cipriani, Giovanni Battista, EA/①;
SDF/747.
circa, S-4922/11①.
Circassian, LAR82/63①.
circassian rug, DADA.
circassian walnut, DADA; SDF.
Circe, DSSA.
circle, C-2458/229.
circle and square border, IDC.
circle bow brooch, S-291/87①.
circle brooch, S-291/162①.
circle cutter, DATT.
circlet, S-4972/51.
circlet band, C-5156/116①.
circlet ground, C-5156/119①.
circlette, S-4972/99, 239.
circular, C-0406/30; C-0982/241;
C-5157/107①.
circular aperture, S-4414/363.
circular base, C-0982/308; C-1082/
149; C-2398/4①; C-5114/283①.
circular basin, C-0782/3.

circular border, NYTBA/*141*①.

circular bowl, C-1006/*79*.

circular bowl (in spoons), C-2510/*20*①.

circular bowl, C-5114/*20*.

circular corona cast, C-2357/*6*①.

circular-cut diamond, C-5005/*216*①.

circular dish, C-0782/*9, 18*; C-1082/*118*; C-2458/*419*.

circular dished base, S-4436/*35*.

circular dished top, C-5116/*146*①.

circular domed foot, S-2882/*701*.

circular drum top, LAR83/*389*①.

circular expanding foot, S-2882/*1356*①.

circular faceting, MP/*464*①.

circular fan, C-1603/*68*.

circular field, RTA/*26*①.

circular flute, CEA/*447*①.

circular fluted base, C-0254/*143*①.

circular fluted foot, C-0254/*102*; C-5117/*130*①.

circular foot, C-0254/*7, 301*①; C-0270/*59*; C-5114/*10*①, *36*①; CEA/*640*①; S-3311/*621*①; S-4414/*202*①, *223*①.

circular footed base, S-4461/*85*.

circular footrim, C-5114/*35*①.

circular form, S-2882/*932*①; S-4922/*2*①.

circular furnace, MP/*181*.

circular inner lid, C-5153/*5*①.

circular leg, S-4955/*151*.

circular lotus mound, C-5234/*192*①.

circular medallion, S-4507/*92*①.

circular mirror, C-2458/*213*.

circular molded aperture, S-4414/*529*①.

circular molded foot, C-5153/*3*①.

circular mount, C-0225/*358*; S-291/*161*①.

circular movement, CEA/*251*①.

circular pedestal, C-0249/*394*.

circular pedestal foot, C-0225/*262*.

circular plaque, S-2882/*249*①; S-4922/*23*①.

circular plate, C-0225/*1*.

circular radiating panel, C-5170/*205*①.

circular reflector, S-4436/*25*.

circular reserve, S-2882/*943*①.

circular rim foot, C-5117/*8*.

circular saucer-dish, C-2486/*9*.

circular shield, C-2398/*1*①.

circular spiraling prunt, S-2882/*1268*.

circular spreading foot, C-0270/*291*; C-5117/*49, 76*①.

circular stage, C-0403/*125*.

circular stamp, C-5005/*247*.

circular stand, C-5114/*43*①; S-4414/*285*①; S-4436/*160*①.

circular stepped base, S-2882/*698*①.

circular support, C-0249/*430*.

circular tapering body, C-5157/*7*.

circular telescopic close-up, JIWA/*227*①.

circular tilt-top, C-1407/*2*.

circular tureen, C-1006/*157*.

circular turned handle, S-2882/*618*①.

circular wall plate, S-4414/*241*①.

circular-window view, JIWA/*224*①.

circumcision beaker, C-5174/*104*①.

circumcision knife, C-5174/*31*①.

circumferencial, C-2904/*70*.

circumferentor, CEA/*604*①.

cire-perdue, EA/*lost-wax process*.

cire perdue, CEA/*481*①.

cire perdue (lost-wax), DADA/*Supplement*.

cire perdue, DATT; C-5191/*155*.

cire perdue (lost-wax) process, RTA/*23*①.

ciselé, C-2427/*26*①, *34*①; C-2486/*4*①; IDC.

ciselé velvet, DADA.

cissing, DATT.

clasped-book vinaigrette, RTA/*128*①.

'clasped-hands' ring, RTA/*107*①.

Class B 2lb, C-2904/*31*.

classeur, DADA.

classic, C-5127/*6*①; C-5156/*50*.

Classic Acrycolor, DATT.

classical, C-5116/*147*①; CEA/*529*; DATT; IDC.

classical abstraction, DATT.

Classical Art, LP.

classical bust, C-5174/*452*①.

classical drapery, S-4461/*46*.

classical dress, C-2704/*183*.

classical emblem, RGS/*35*.

Classical era, FFDAB/*51*.

classical ewer decoration, C-5170/*192*①.

classical female, C-2364/*26*①.

classical figure, C-2502/*84*; C-5116/*38*; C-5173/*63*①.

Classical form, C-5114/*359*①.

classical frieze, S-4461/*94*.

classical garden carpet, OC/*144*.

classical god, C-5224/*49*①.

classical ground, C-2427/*231*.

classical handle, IDC.

classical intaglio, RTA/*63*①, *66*①.

classical lapidary, RTA/*55*.

classical line, S-4972/*39*①.

Classical maiden reserve, S-2882/*678*①.

classical medallion, C-0249/*296*.

classical modelling, JIWA/*10*.

classical motif, JIWA/*398*.

classical pediment, C-2402/*8*.

Classical period, DATT.

classical portrait medallion, C-2421/*3*①.

classical relief, RGS/*90*.

classical revival, EA/*neo-classical style*.

classical scene, C-5117/*382*①; C-5174/*432*①.

classical scene motif, C-2493/*229*.

classical shape, C-5239/*103*.

classical style, SDF.

classical-style bust, MP/*490*①.

classical taste, C-0706/*111*.

classical temple beside a lake, a lady in Regency, C-2704/*183*.

Classical theme, MP/*170*.

classical urn-form standard, S-4414/*224*.

classic Canton, EC2/*22*①.

classicism, DATT; MP/*167*.

Classic pattern, CEA/*472*①.

Classic Period, CEA/*489*.

classic revival, DADA/①.

Clauce, Isaac Jacques, MP/*174*.

Clauce, Isaak Jakob, EA.

Claude Lorrain glass, DATT.

Clavel, H., C-5117/*179*.

clavichord, ACD; CEA/*547, 548*; DADA; EA; LAR83/*520*①; SDF.

claw, EG/*46*①; FFDAB/*57*.

claw and ball, C-0982/*101*; CEA/*339*①; S-4436/*49*①.

claw-and-ball, C-5153/*39*①.

claw and ball foot, C-1502/*60*; DADA; IDC; S-4414/*427*①, *467*, *483*①; S-4812/*68*①.

claw-and-ball foot, ACD; C-1407/*7*; C-2402/*7*; C-5116/*135*; S-4414/*337*; SDF/①.

claw-and-ball support, S-2882/*967*, *1006*①.

claw-beaker, EG/*40*①.

claw beaker, CEA/*418*①.

claw foot, C-0254/*24*; C-2357/*31*①; C-2364/*21*①; CEA/*309*①; EA.

clawfoot, K-710/*118*.

claw-set, RTA/*56*.

claw setting, RTA/*48*①.

claw support, S-2882/*1053*; S-4804/
 19.

claw table, EA; SDF/①.

clay, C-5236/*842*①; CEA/*110*;
 DATT; IDC.

Clay, Charles, DADA.

Clay, Henry, ACD; EA.

clay body, DATT.

claymore, CEA/*27*; DADA.

claymore hilt, S-4972/*254*①.

clay pipe, S-4881/*158*①.

clay-size, IDC.

clay slab, MP/*17*.

clay's ware, SDF; DADA.

Clayton, David, EA.

Clay ware technique, EA/*papier
 mâché*.

cleaning of paintings, LP.

cleaning-rod, C-2476/*14*①.

cleaning rod, CEA/*26*①.

cleaning stock, S-4972/*163*①.

clear, C-5239/*117*.

clear diagonal band, OPGAC/*210*.

clear glass, C-0706/*110*; C-2414/*2*①.

clear glaze, JIWA/*85*①.

clear ribbon, OPGAC/*210*.

clear soup spoon, C-0254/*248*.

cleat, C-5114/*259, 379*①, *401*①,
 *318A*①; C-5153/*131*①.

cleavage, DATT; LP.

Cleffius, Lambert, EA.

Cleffius, Willem, CEA/*141*①.

clefs à peigne, CEA/*538*①.

clef-shaped, S-4414/*2*①.

cleft-hoof foot, C-1407/*71*.

clemantis, OPGAC/*210*.

clematis, EG/*171*①, *246*①; LAR82/
 *448*①.

Clematite pattern, C-5167/*185A*.

Clemens Oskamp, S-4905/*174*.

Clement, William, EA.

Clement Augustus service, EA.

Clementi, CEA/*550*①.

Clementi & Co., C-5170/*107*①.

Clements, Robert, CEA/*231*①.

clenched fist handle, S-4881/*91*①.

Cleopatra headdress, C-0604/*282*.

Cleopatra vase, C-2421/*3*.

clepsydra, C-1702/*286*; EA.

clerical metal, S-4461/*500*.

clerical script calligraphy, C-5127/
 208.

Clerici, Felice, EA.

Clérissy, CEA/*148*①.

Clérissy, Joseph, EA.

Clérissy: Pierre, Antoine, Pierre II,
 EA.

Clerrenwell, William Grace, LAR82/
 *233*①.

Clewell Metal Art, Canton, Ohio,
 EC1/*85*.

Clewes, J. & R., NYTBA/*152*①.

CLEWS, EA/*Clews, James and
 Ralph*.

Clews, James and Ralph, EA.

Cleyn, Francis, EA.

clibanus, IDPF/*52*.

Clichy, CEA/*484, 489*; DADA/①;
 EA/①; LAR82/*25*①, *449*①;
 NYTBA/*286*.

Clichy flat floral bouquet, CEA/
 *499*①.

Clichy garland, CEA/*495*①.

clichy rose, CEA/*502*; EG/*246*①,
 287.

Clichy swirl, CEA/*497*①.

click piece, C-5157/*32*.

Cliff, Clarice, C-2409/*61*; C-2910/*68*;
 C-5167/*71*; LAR82/*108*①.

cliff-form base, S-4461/*497*.

Clifton, John Sr., C-5117/*263*①.

Clifton Art Pottery, Newark, New
 Jersey, EC1/*85*.

Clignacourt, CEA/*186*①.

clignancourt, ACD; DADA.

clinometer, C-2904/*72, 74, 195.*
Clio, DSSA.
clip, C-0406/*99*; C-2202/*86*; S-4927/
*370*①.
clipped scroll handle, LAR82/*444*①.
cloak, DSSA.
clobbered, LAR83/*141*①; S-4905/
*67*①.
clobbered decoration, ACD.
clobbering, EA; IDC/①.
cloche, C-0405/*138*; C-0604/*299*;
C-3011/*75.*
clock, ACD; C-5157/*34*①; CEA/
218; DADA/①; DSSA; EC2/
*94*①; IDC; IDPF/*52*①; SDF/①.
clock bracket, SDF.
clock-case, CEA/*628*①; IDC/①.
clock case, C-0249/*179*; CEA/*185*①;
EA/①.
clock-case maker, SDF.
clock dial, EA.
'clock-face', OC/*245.*
clock face, IDPF/*52*①.
clock garniture, C-0225/*147*①;
C-0249/*193*; C-0279/*189*; LAR83/
*192*①; S-4804/*421*①.
clock group, C-1006/*122.*
clock hood, C-2402/*221.*
clock lamp, EA.
clock/luminaire, C-5167/*202.*
Clockmakers' Company, CEA/*252*①.
Clockmakers' Company of London,
EA.
clockmaker's sector, C-MARS/*194.*
clock-watch, CEA/*252*①; EA/①.
clockwatch, K-710/*118*; S-4802/
*135C*①; S-4927/*110.*
clockwork, C-5189/*71*①; CEA/*697.*
clockwork driven, CEA/*555*①.
Clodion, C-2364/*28*①; C-5189/*147.*
Clodion, (Michel) Claude, EA.
Clodion, Claude-Michel, DADA.

cloison, DATT; EA/*Canton enamels*;
RGS/*62*①; RTA/*18*①.
cloisonne, C-0782/*210*; C-1082/*80.*
cloisonné, C-5117/*323.*
cloisonne, C-5127/*219*; CEA/*487*①.
cloisonné, CEA/*519*①; DATT; EG/
*210*①; IDC; K-710/*112.*
cloisonne, LAR83/*218*①.
cloisonné, RGS/*34, 40*; RTA/*13*;
S-2882/*775*①; S-4461/*163, 402*;
S-4802/*145*①.
cloisonné black ground, C-1082/*93.*
cloisonné effect, C-5156/*147*①.
cloisonne enamel, ACD; C-2458/*68.*
cloisonne enamel, C-5127; C-5156/
150.
cloisonné enamel, RGS/*62*①;
DADA.
cloisonné enamelled, C-5117/*330*①.
cloisonné enamelling, EA/①.
cloisonne yellow ground, C-1082/*174.*
cloisonnisme, JIWA/*53, 164*; LP.
cloisonniste (heavy outline) style,
JIWA/*264.*
cloissoné enamel, C-5005/*214*①.
close-back, OC/*32.*
close chair, EA.
close-covered grounds, OC/*225.*
close-cropped pile, OC/*108.*
close cupboard, EA; SDF.
closed and open pans, C-2904/*29.*
closed back, CEA/*510.*
closed composition, LP.
closed exhibition, LP.
closed form, LP.
closed fretwork, C-5157/*86.*
closed gold mount, RGS/*194.*
closed helmet, S-4972/*166*①.
closed knot, EA/*Turkish knot,
Turkish knot.*
closed-over, IDPF/*215.*
closed ring, IDPF/*124.*
closed robe, C-1506/*39*①.

close helmet, C-2569/*55*; C-MARS/
*104*①; CEA/*20*①.

close millefiorispaced
millefiorimushroom, EG/*248*.

close-nailed, C-0982/*6*.

close-nailed curvilinear, C-1407/*63*.

close nailing, EA.

close pattern, JIWA/*112*①.

close-plated, C-1502/*217*.

close-plating, EA.

close spiral pattern, CEA/*432*①.

close-stool, DADA.

close stool, EA; SDF.

close stool chair, SDF/①.

close stool or close chair, ACD.

close-up, JIWA/*87*, *130*①.

close-up image, JIWA/*39*.

close-up view, JIWA/*87*①.

close web design, S-4461/*49*.

closing-ring, EA/*door-furniture*.

closure, LP/①.

clothes brush, C-0254/*111*, *140*;
C-0706/*5*, *33*; S-4461/*375*.

clothes chest, SDF/①.

clothes horse, EA/*towel horse*; SDF/
①.

clothes-press, C-2402/*18*.

clothes press, C-0982/*210*; C-1407/
17; C-2388/*88*; C-2403/*88*;
C-2478/*193*; C-5116/*171*①; EA/
①; LAR83/*314*①; S-4812/*149*;
SDF/①.

clothespress, DADA/①.

Clotho, DSSA.

clou, au, IDC.

cloud, C-5156/*47*①.

cloud and thunder fret, IDC.

cloud-band, C-2388/*185*; DADA;
OC/*79*.

cloudband, C-2403/*195*; CEA/*79*①;
S-4847/*157*①.

cloud-band border, OC/*43*①.

cloud band device, C-5189/*399*.

cloudband-filled medallion, S-4948/*4*.

cloud band Karabagh, C-5323/*91*.

'cloud-band' Kazak, OC/*210*①.

cloudband Kazak rug, S-4948/*4*;
S-4796/*72*①.

cloudband medallion, S-4948/*9*①.

cloud-band motif, OC/*42*, *83*.

cloud band or pattern, EA.

cloud-collar, OC/*312*.

cloud collar, C-0279/*151*①; C-2323/
*47*①.

cloud collar pattern, C-5127/*39*①.

clouded, S-4461/*168*.

clouded ware, IDC.

cloud-form, S-4928/*76*①.

cloud form apron, LAR83/*286*①.

'cloud-head' pattern, OC/*80*①.

cloud-like collar, C-2414/*49*①.

cloud pattern, S-4928/*14*①.

cloud-scroll, C-2427/*78*.

cloud scroll, C-2458/*38*; C-5236/
*330*①.

cloud scroll base, C-0782/*102*.

cloud scroll grounds, C-1082/*115*.

cloudy apple, C-5236/*332*①.

cloudy crystal, JIWA/*310*.

Clouet, Jean, EA.

Cloume Oven, IDPF/*169*.

clous d'or, EA.

cloute, C-1603/*73*.

clouté d'or, DADA.

clove, DATT.

cloven foot, C-0249/*445*; C-0279/
347; C-5116/*156*①; EA/*hoof, hoof
foot*; SDF.

cloven hoof foot, C-0279/*441*;
C-5259/*544*; DADA.

cloven hoove, C-0249/*235*.

clover border, C-0254/*131*.

clover inset, S-4461/*323*.

clover-leaf, FFDAB/*52*.

clover leaf, C-2704/*155*.

clover-shaped, C-5114/*284*①, *400*①; S-4927/*484*.

cloves, oil of, LP.

Clowes, William, ACD.

CLR in oval, EA/*Le Roux, Charles.*

Cluatt, James, C-5117/*105*①.

club, DSSA.

club armchair, C-2402/*128*.

club chair, S-3311/*945*①; SDF/①.

club divan, SDF.

club fender, C-1407/*66*; SDF.

club foot, ACD; DADA; SDF.

club foot or Dutch foot, EA.

club form, S-2882/*1238*.

club leg, C-2320/*41*; C-2388/*7, 52*; C-2402/*54*; C-2403/*56*; C-2421/*69*; C-2498/*71*.

club shape, S-2882/*1243*.

club-shaped, C-2409/*59*; C-GUST/*73*.

club support, LAR82/*351*①.

Cluny enamel ware, IDC.

Cluny guipure, DADA.

Cluny style, S-2882/*356*.

cluster, S-4461/*550*; S-4922/*1*①.

cluster-column, C-2202/*154*; C-2487/*91*.

cluster column, C-0982/*95B*.

cluster-column leg, C-5116/*86*.

cluster column leg, S-4414/*459*.

cluster columns candlestick, LAR83/*551*①.

cluster design, S-291/*106*①; S-4414/*61*①.

clustered colonnette, C-5116/*148*①.

clustered column, C-5114/*345*①; CEA/*405*; EA; SDF.

clustered column leg, SDF.

cluster leg, DADA.

cluster mount, S-4414/*135*①.

cluster ring, S-291/*69*①, *119, 171*.

cluster vase, IDPF/*53*.

clutch bag, C-2203/*92*.

Clutha vase, LAR82/*458*①.

cluthra, C-5191/*397*.

Cluthra vase, C-0225/*280*.

Clyde, CEA/*248*①.

cmmpote, NYTBA/*296*①.

coach clock (or watch), EA/①.

coach clockwatch, S-4927/*184*①.

coach horn, EA/*post horn.*

coaching carbine, C-2503/*99*.

coaching clock, EA/① *Act of Parliament.*

coaching glass, DADA; EA.

coaching inn clock, SDF.

coaching lamp, S-2882/*325*.

coaching table, C-2388/*33*; LAR83/*367*①.

coach lamp, LAR82/*504*①.

coach panel, LAR82/*79*①.

coach-pot, IDC.

coach varnish, DATT; LP.

coach watch, DADA; SDF.

coadestone, LAR82/*645*①.

Coade stone, SDF.

coal box, C-0982/*165*; C-2409/*235*; SDF/①.

Coalbrookdale, C-1582/*60*; DADA, *supplement*; LAR83/*207*①.

Coalbrookdale Company, EA.

Coalbrookdale ware, IDC.

Coalbrookedale, C-2502/*142*.

coal firing, MP/*186*.

coal helmet, LAR83/*226*①.

coal plate, CEA/*534*①.

Coalport, ACD; C-0279/*234*; C-1006/*185*; C-1582/*62*; C-2360/*1*; C-5189/*19*; CEA/*196*①, *199*①; DADA; EA/① *Coalbrookdale*; FFDAB/*129*①; LAR82/*108*①; LAR83/*82*①; NYTBA/*180*.

Coalport Felt Spar Porcelain in Garland, EA/*Coalport.*

Coalport or Coalbrookdale Porcelain, EA/*Coalport.*

Coalport porcelain, FFDAB/*128*①.

coal scuttle, S-4436/*23*; SDF/①.

coal skuttle, C-0706/*58*.

coal-tar color, DATT.

coal-tar pigment, LP.

coal-tar solvent, DATT.

coal-vase, EA/*coal-scuttle*.

coarse muslin, C-2704/*171*.

coarse peasant weave, OC/*11*.

coarseware, IDPF/*34*.

coaster, ACD; C-0706/*55*; C-5239/*107*; DADA; S-4461/*205*; S-4802/*171*; SDF.

coastguard pistol, C-2503/*162*.

coat, C-1506/*19*.

coated paper, DATT.

Coates, Wells Wintemute, SDF/*748*.

coat-of-arms, C-0254/*146A*; C-2398/*9*①; C-5116/*110*; C-5153/*40*①; C-5236/*1769*; S-2882/*635*①, *637*①; S-4804/*150*①.

coat of arms, C-0782/*42, 61, 188*; S-3311/*285*①; S-4905/*136*①.

coat-of-mail, DADA.

coat pistol, C-2569/*68*.

cobalt, C-5156/*97*①; EC2/*23*.

cobalt black, DATT.

cobalt-blue, CEA/*417*①; EA; S-4843/*88*①; S-4905/*85*①; S-4992/*63*①.

cobalt blue, C-5005/*310*; DATT; IDC; LP.

cobalt-blue cane, CEA/*501*①.

cobalt blue glass, ACD.

cobalt drier, DATT; LP.

cobalt green, DATT.

cobalt ore, MP/*41*.

cobalt ultramarine, DATT.

cobalt violet, DATT; LP.

cobalt yellow, DATT; LP.

Cobb, John, ACD; C-2357/*10*①, *57*①; C-2522/*16*①, *132*①;

C-5116/*170*①; CEA/*341*①; DADA; EA; SDF/*748*.

cobbler and wife, IDC/①.

cobbler's bench, NYTBA/*40*.

Cobb's table, SDF/①.

cob-iron, SDF.

cobiron, DADA/①; ACD.

Cobridge, CEA/*163*①.

Coburg-pattern (on silver), C-5174/*515*.

Coburg pattern, C-5117/*119*①.

Cochin, Charles-Nicholas, the Younger, DADA.

Cochin, Charles-Nicolas, EA.

cochineal, DATT; OC/*290*; S-288/*2*①.

cochineal-based, OC/*25, 322*.

cock, C-5117/*456*; CEA/*23*①, *44, 267, 405*; DSSA; EA; S-4802/*132B*; S-4927/*35*; S-4972/*220*.

cockade fan, C-1603/*113*; LAR83/*232*①.

cock and hen teapot, IDC/①.

cock and peony, IDC.

cockatoo, C-0405/*192*.

cockatrice, SDF.

cockbead, C-5114/*272*①.

cock-beaded, C-5153/*174*①; CEA/*332*①.

cockbeaded, C-5153/*110*①; S-4905/*370*①.

cockbeaded decoration, C-0225/*363*.

cock-beaded drawer, C-5114/*349*①.

cockbeaded drawer, C-5114/*251*; S-4461/*600*.

cockbeaded frieze, S-4905/*391*①.

cock-beading, ACD.

cock beading, EA; SDF.

cockbeading, DADA.

cockbead molding, S-2882/*317*.

cocked-bead, CEA/*405*.

cocked bead, SDF.

cocked hat lamp, IDPF/*142*①.

cockerel, C-2357/*99*①; C-2398/*7*.

cockerel finial, C-5224/*43*.

Cockerell, Sydney, DADA/ *Supplement*.

cock-fighting chair, CEA/*334*①; EA; LAR83/*279*①; SDF.

cockfighting chair, DADA.

cocking, DATT.

cocking-indicator pin, C-2476/*4, 91*.

cocking-lever, S-4972/*155*①.

cock-jaw, C-2569/*76*.

cockle-pot, IDC.

cockle-shell pattern, CEA/*589*①.

cock-metal, EA/*Billies and Charlies*.

cockpen, C-2478/*91*.

cock pheasant and hen decoration, C-5170/*166*①.

Cockpit Hill, EA/①.

Cocks & Bettridge, C-0270/*153*.

'cock's-comb' motif, OC/*259*.

cockshead, SDF.

cockspur, IDC.

cocktail dress, C-0604/*18*.

cocktail fork, S-4804/*28*.

cocktail goblet, C-5167/*118*.

cocktail service, C-5005/*235*①.

cocktail shaker, C-0254/*8, 184*; C-0706/*196*; C-1502/*113*; C-2910/ *97*; C-5173/*1*.

cock tureen, IDC.

cocobola, DATT.

cocobolo, DATT.

Coco de Mer, C-2482/*137*.

coconut-cup, C-5173/*58*①.

coconut cup, C-5174/*211*①; CEA/ *629*①; DADA/①; EA/①; LAR83/*570*①.

coconut shell, RGS/*37*.

coconut-shell cup, RGS/*31*①.

cocotte, IDPF/*53*.

cocquilla nut, C-0906/*121*.

Cocteau, Jean, S-286/*432*.

cocuswood, C-5255/*5*; SDF.

cod, SDF.

Codd's patent bottle, CEA/*70*.

coefficient of expansion, DATT.

coelanaglyphic, DADA.

coelanaglyphic sculpture, DATT.

coelin, DATT.

coeruleum, DATT.

coffee-biggin, C-2487/*133*; C-5117/*6*.

coffee biggin, S-4802/*356*.

coffee-can, CEA/*194*①; IDC.

coffee can, C-0706/*216*; C-5189/*26*; IDPF/*41*.

coffee-cup, IDC.

coffee cup, C-0782/*21, 160*; S-4461/ *101*.

coffee grinder, C-0254/*171*①.

coffee jug, LAR83/*565*①.

coffee-maker, IDC/①.

coffee percolator server, C-5239/*99*.

coffee-pot, ACD; C-2398/*24*①, *40*; C-5005/*229*; C-5114/*2*①; CEA/ *645*①; IDC.

coffee pot, C-1502/*134*; CEA/*579*①; DADA; LAR83/*563*①; S-3311/ *711*①, *778*①; S-4905/*151*①; S-4922/*52*①; S-4992/*84*①.

coffeepot, C-5114/*112*; C-5153/*1*①; EC2/*22*①, *23*; IDPF/*54*①.

coffee-room table, SDF.

coffee-service, IDC.

coffee service, C-0254/*19, 105*; C-5153/*1*①; S-4905/*76*①.

coffee spoon, C-0706/*77*; C-1502/*12*.

coffee table, C-5005/*337*①; C-5239/ *266*; NYTBA/*40*; S-4507/*8*①; SDF.

coffee table book, SDF.

coffee-urn, C-5174/*467*①; CEA/ *630*①; IDC/①.

coffee-warmer, IDC/①.

coffeewood, DATT.

coffer, ACD; C-0279/*319*; C-0982/
84A; C-1407/*10*; C-2402/*158*;
C-2478/*162*; C-5116/*27, 84*; CEA/
*305*①; DADA; DSSA; LAR82/
*420*①; LAR83/*402*①; SDF.
coffer bach, ACD.
coffered, C-0982/*84A*; C-1407/*17*;
C-2402/*147*; C-2437/*68*①;
C-2478/*10*; C-2546/*73*①.
coffered frieze, LAR82/*334*①.
coffered lid, C-2320/*6*; C-2370/*49*;
C-5116/*8*.
coffered panel, DADA; SDF.
coffered shape, CEA/*62*①.
coffered top, C-5116/*4*.
cofferer, SDF.
coffer form, C-2357/*82*①.
coffering, SDF.
coffer maker's chair, SDF.
coffin, DSSA; MP/*31*.
coffin clock, EA; SDF.
coffin-end, C-5114/*80*①; S-3311/*622*.
coffin-end spoon, DADA; EA/①.
coffin-fiddle handle, C-5114/*65*.
coffin handle, K-802/*14*.
coffin-handle spoon, EA/*coffin-end
spoon*.
coffin jewel, RTA/*98*①.
coffin stool, LAR83/*356*①; SDF.
coffre, C-0249/*231*; C-2364/*20*;
C-5189/*110*; DADA.
coffre-fort, C-2364/*60*①.
coffret, CEA/*62*①.
cogging, DATT.
coggle, IDC.
Cogniet, Jean Louis Gericault-Leon,
S-286/*272*.
Cogswell, Henry, C-5203/*356*.
Cogswell, John, DADA; EA.
Cogswell & Harrison, C-2476/*47, 58*.
Cohiy, T., C-5189/*172*①.
Cohler, K., C-5189/*172*①.
Cohr, S-4461/*209*.

coiffeuse, C-5005/*356*①; C-5189/
*313*①; C-5224/*167*①; C-5259/
*561*①; DADA/①.
Coignet, Michel, EA.
coiled, C-5127/*308*①.
coiled basket, S-4807/*306*①.
coiled dolphin stem, LAR83/*599*①.
coiled handle, C-0225/*37*.
coiled pot, IDPF/*35*①.
coiled pottery, IDPF/*54*①.
coiled rope foot, S-4810/*245*①.
coil foot, IDPF/*102*①.
coil gong, S-3311/*435, 552*①.
coiling, IDC; IDPF/*55*①.
coiling chain, CEA/*510*.
coiling leafing vine, C-2704/*96*.
coil knob, IDPF/*139*①.
coil method, DATT.
coils, C-2904/*132*.
coil spring, DADA/*Supplement*.
coin, ACD; EA; MP/*204*; S-4928/
*73*①; SDF; EA/*American silver*.
coin border, IDC.
coin box, C-0254/*81*①; C-5174/*88*.
coin cabinet, EA/*medal cabinet*,
medal cabinet; SDF.
coin dot, OPGAC/*181*.
coin-feed, C-2904/*24*.
coin glass, ACD; DADA; EA.
coin glass pattern, CEA/*473*①.
coin goblet, CEA/*424*①, *441*①.
coin ground, IDC.
coin inset, C-0706/*126A*.
coin-pattern, C-5224/*66*.
coin pendant, C-0706/*179*.
coins, DSSA.
coin silver, DADA; EA.
coin spot shade, LAR83/*483*①.
coin tankard, EA.
coin weight, EA.
Coke, John, CEA/*194*①.

Coker, Ebenezer, C-5117/*236*①; C-5174/*546*.

colander, IDPF/*57*①.

colander bowl, IDC.

Cola style, C-5234/*166*.

Colbert, EA/*Aubusson tapestry*.

Colbert, Jean Baptiste, MP/*12*.

Colclough, Matthew, CEA/*202*①.

colcothar, DATT.

cold carving, CEA/*50*.

cold chisel, DATT.

cold color, DADA.

cold colour, C-2427/*147*①; IDC.

cold cut, DATT.

cold-decorated, S-4823/*48*.

cold gilding, C-5234/*66*①; EA/ *gilding*; EG/*270*.

cold glass, EG/*265*.

cold-hammering, EA/*forging*.

colditz clay, MP/*28*.

cold meat fork, S-4804/*35*①.

cold paint, S-4823/*1*①.

cold-painted, C-5167/*24*; LAR82/ *46*①; LAR83/*36*①, *163*①; S-2882/*1410*①, *1411*①; S-3311/ *830*①.

cold painted, C-0225/*102*; C-5146/ *29*①; C-5239/*64*.

cold painting, EA.

cold-pressed linseed oil, LP.

cold-pressed oil, DATT.

cold-pressed paper, DATT.

cold printing, IDC.

cold-rubber mold, DATT.

Coldwell, George, CEA/*590*.

cold-working, EA.

Cole, James Ferguson, EA.

Cole, Maker, London, C-2489/*31*.

Cole, Sir Henry, DADA/*Supplement*.

Cole, Thomas, EA.

Cole, Thos., C-2489/*55*.

Colebrookdale, ACD.

Colenbrander, Theodorus A. C., DADA/*Supplement*.

colichemarde, C-2503/*23*; DADA.

colichemarde blade, C-2569/*13*.

Colima, S-4807/*173, 175*①.

colimaçon, à, IDC.

Colindian, C-2476/*63*.

Colinet, CJR, OPGAC/*13*.

Colinet, Cl. J.R., LAR83/*41*①.

Collaert, Hans, EA.

collage, DADA/*Supplement*; DATT/ ①; JIWA/*210, 383*①; LP; S-286/ *254*①.

collagraph, DATT.

collapsing stem, C-5170/*6*.

collar, C-0254/*152*; C-0906/*285*; C-2202/*73*; C-2388/*15*; C-2421/ *3*①; C-2458/*61*①, *99*①; C-5114/ *316*①; C-5117/*30*①, *161*①; C-5156/*83*①; C-5236/*558*①; CEA/*428*①, *541*; IDC; RTA/ *85*①; S-4905/*203*①; S-4922/*8*①; S-4972/*237*①; SDF.

collared lip, C-5114/*148*①.

collared urn, IDPF/*58*①.

collar knop, EA/*merese*.

Collas, Achille, EA/*Barbedienne, Ferdinand*.

collé, LP.

collection, JIWA/*9*.

collection number, C-5167/*13*.

collection piece, MP/*37*.

collections cabinet, C-5116/*147*①.

collection stamp, RGS/*165*.

collector, LP.

collectors' cabinet, CEA/*304*.

collector's seal, C-5156/*512*; C-5236/ *970*①.

college cup, EA/①.

college ring, RTA/*142*.

collet, C-0403/*247*; C-2332/*87*①, *326*; C-2487/*18*①; C-5174/*184*①; RTA/*64*①.

collet-set, S-4414/*32, 36*①; S-4927/
*77, 328*①.

collet set, S-291/*88.*

collet-set round diamond, S-4414/*57,
60.*

collet-set single-cut diamond, S-4414/
*48*①.

Colley, C-2489/*221.*

collie, SDF.

collier, ACD; S-4843/*185*①.

Collier, Nicolas, C-5117/*15.*

Collier, W., CEA/*606*①.

Collier revolver, ACD.

Collier Toby jug, LAR83/*144*①.

Collin & Cie, S-4927/*224A.*

Collingwod, Peter, DADA/
Supplement.

Collins, James, EA.

Collis, Charles, C-2409/*132.*

Collis, George Richmond, EA.

colloid hard soldering, RTA/*12.*

Collot, E., C-5189/*105.*

collotype, S-286/*29.*

Colnick, Cyril, C-5191/*291.*

Cologne, DADA.

Cologne, School of, DATT.

cologne bottle, EA; LAR83/*438*①.

Cologne earth, DATT; LP.

Cologne spirits, DATT.

Cologne stoneware, EA/*①.*

Cologne ware, IDC.

Colomby, Abraham, C-2368/*181*①;
S-4927/*199.*

colonette, C-0279/*327*; C-2324/*247*;
C-5117/*394*①; C-5153/*111*①,
*168*①; C-5157/*32*; C-5174/*157*①.

Colonial, C-0279/*277*; C-2202/*69*;
C-5114/*273*①; C-5153/*4*①.

Colonial Georgian style, SDF.

Colonial revival style, C-5153/*3*①.

colonial spirits, DATT.

Colonial style, DADA.

colonnaded, C-0249/*456*①; C-2320/
41.

colonnaded pergola, C-2437/*3*①.

Colonna Eugène, DADA/*Supplement.*

colonnette, C-2320/*45*; C-5116/*49*①,
*50*①; C-5157/*150*①; C-5224/*14*①;
S-3311/*204*①; S-4461/*550, 627*;
SDF.

colonnette-back, SDF.

colophon, C-5127/*175*; C-5156/
*600*①.

colophony, DATT.

color, C-5156/*913*; C-5236/*564*;
DATT; LP/*①.*

(F) color, S-291/*76, 95*①.

(D) color, S-291/*99*①.

(F) color, S-291/*200.*

(D) color, S-291/*218.*

(E) color, S-291/*234*①.

Colorado Yule Statuary, DATT.

color chart, DATT.

color chemist, MP/*63, 122.*

color chord, LP.

color circle, DATT/*①.*

color comparison, DATT.

color crayon, JIWA/*63.*

color development, MP/*157.*

colored cement, DATT.

colored looping, DADA.

colored pencil, DATT.

colored photographic reproduction,
C-2409/*149.*

colored print, DATT,

colored resin, DATT.

colored sculpture, DATT.

colored silhouette style, JIWA/*264*①.

colored stoneware, JIWA/*99*①.

color effect, DATT.

color fatigue, LP.

color field painting, LP.

colorimeter, DATT.

colorimetry, DATT.

coloring power, DATT.

colorist, DATT.

colorless flux, MP/*70.*

colorless glass, S-4905/*307*①.

color lithography, DATT; NYTBA/ *205.*

color modulation, LP.

color notation, DATT.

color oxide, DATT.

color patch, JIWA/*205.*

color print, DATT.

color properties, DATT.

color run, C-5323/*2.*

color scattering, LP.

color scheme, DATT; EC2/*20*①.

color sketch, DATT.

color stability, DATT.

color study and theory, LP.

color system, LP.

color temperature, LP.

color triangle, DATT.

color-twist, LAR83/*453*①.

color varIant proof, S-286/*538A.*

color wheel, DATT; LP/①.

colossal, DATT.

colour, IDC; JIWA/*6, 10*; LP.

colour combing, SDF.

colour double overlay, CEA/*495*①.

coloured arabesque, JIWA/*39.*

coloured body, IDC.

coloured enamel, C-0782/*20.*

coloured glass, EG/*284.*

coloured glaze, IDC.

coloured gold, CEA/*524.*

coloured lustre ware, IDC.

coloured Shonsui, IDC.

coloured silk, C-2704/*15.*

coloured slip, IDC.

coloured wool, C-2704/*14.*

colour ground, CEA/*502.*

colourless glass, JIWA/*112*①, *329*①.

colour-plan, OC/*252.*

colour-print, JIWA/*8.*

colour twist, EA.

colour woodcut, JIWA/*8, 29*①.

Colston, Richard, C-2368/*69*①.

Colt, DADA; S-4972/*233, 259*①.

Colt, Samuel, CEA/*37.*

Colt musket, C-2503/*102.*

Colt Navy, CEA/*34.*

Colt Paterson revolver, CEA/*39*①.

Colt revolver, ACD.

Colt single-action revolver, CEA/ *42*①.

Colt Walker revolver, CEA/*40*①.

Columbia, S-4461/*358.*

Columbia flask, EA/①.

Columbian Art Pottery, DADA/ *Supplement.*

Columbian-coin, OPGAC/*210.*

Columbian spirits, DATT.

columbine, DSSA.

columbine cup, EA.

column, C-2402/*12*; C-5114/*125*①; DSSA; S-4972/*452*; SDF/①.

column-and-vase stem, C-5116/*52.*

column angle, C-2403/*150*①.

columnar, S-4992/*80*①.

columnar band, RGS/*31*①.

columnar border, S-4972/*441*①.

columnar-form leg, S-3311/*91.*

columnar handle, IDC.

columnar lamp, C-0249/*272.*

columnar pedestal, C-0249/*260.*

columnar pilaster, C-0249/*453*①; C-1407/*17.*

columnar shaft, C-5114/*300*①, *305*①.

columnar splat, C-0249/*424.*

columnar standard, C-5114/*127*; S-4461/*599.*

columnar stem, C-5114/*133*①; S-4414/*435*①; S-4461/*52.*

columnar stile, C-0279/*448*①.

columnar support, LAR83/*375*①;
S-2882/*306*①.

column candlestick, IDC.

column clock, EA.

column end-standard, C-1407/*87*.

column-form stile, S-2882/*786*.

column krater, S-4807/*496*①;
S-4973/*131*①.

column Ladik carpet, EA.

columnn, C-5153/*67*①.

column of calligraphy, C-2414/*98*①.

column shaft, C-5116/*37*①.

column support, C-0982/*46*.

column-turned post, C-5114/*383*①.

comb, C-0706/*5, 41*; C-2458/*32*;
C-2503/*61*; C-5156/*754*; CEA/*76*;
DADA; DSSA/①; S-4927/*242*.

comb-back, S-4905/*383*①.

comb back, S-4812/*135*.

comb-back chair, LAR83/*291*①.

comb back chair, SDF/①.

comb-back Windsor, EA/①.

comb-back Windsor chair, DADA/①.

comb base, EA/*Nabeshima ware*.

comb border, S-2882/*164*.

comb-cut, S-4436/*63*①.

comb design, IDC.

comb device, C-0279/*23*.

combed, C-2323/*4*; C-2414/*72*;
C-5156/*96*; C-5236/*474*①, *843*①;
S-4965/*220*.

combed decoration, ACD; DATT;
IDC.

combed slip decoration, EA/*101*①.

combed ware, DADA.

combed-wave pattern, S-4928/*172*①.

combed wave-pattern, C-2323/*25*①.

combed well, C-5156/*46*①.

comb holder, S-4461/*56*.

combination of scrolls, NYTBA/*44*①.

combination weapon, CEA/*25*①.

combine. LP.

combing, EG/*287*; SDF.

comb motif, S-4948/*35*①.

comb-motif, C-2478/*228*.

comb piece, SDF.

comb skirt, S-2882/*86, 107*.

comemoratives, DADA/*Supplement*.

comfit, CEA/*435*①.

comfit box, EA/*sweetmeat box*;
RGS/*140*①.

comfit-box, IDC.

comfit glass, EA.

comfit-holder, IDC/①.

comic figure, C-0405/*125*.

comma feet, C-5236/*430*①.

comma form, JIWA/*53*.

command fan, JIWA/*166*.

commas, C-5236/*846*.

comma-shaped, C-5156/*340*.

commedia dell'arte, DADA; EA;
CEA/*170*①.

commedia dell'arte characters,, EA/
Ansbach.

Commedia dell'Arte figures, IDC/①.

commemorative, CEA/*443*①.

commemorative beaker, C-5203/
*348*①.

commemorative coin, MP/*38*.

commemorative figure, C-5189/*60*①.

commemorative jug, IDC.

commemorative medal, C-5117/*359*①.

commemorative ring, RTA/*97, 110*①.

commemorative sword, CEA/*35*.

commemorative vase, NYTBA/*179*①.

commemorative ware, IDC.

commendation mark, IDC.

commerce table, EA; SDF.

commercial artist, DATT.

Committee of Safety musket, CEA/
*38*①.

commode, ACD; C-0982/*7, 42, 94*;
C-1407/*68*; C-2357/*74*①; C-2364/
*45*①; C-2402/*120*; C-2478/*75*;
C-5005/*330*①; C-5114/*341*①;

C-5116/*170*①; CEA/*311*①, *347*①, *405*; DADA/①; EA/①; FFDAB/ *79*①; LAR82/*328*①; LAR83/ *296*①, *305*①; S-4436/*121*①; S-4461/*553*①; S-4804/*771*①; S-4972/*502*; S-4988/*528*①; S-4992/*111*①; SDF/①.

commode à encoignures, EA/①.

commode à l'anglaise, EA; C-5224/ *125*①.

commode à la régence, EA/①.

commode armchair, C-0982/*132*.

commode à vantaux, EA.

commode à vautaux, C-5259/*597*①.

commode chest, LAR83/*306*①.

commode clothes press, SDF.

commode-desserte, DADA; EA/①.

commode drawer, C-2403/*63*.

commode dressing chest, SDF.

commode dressing table, DADA/①.

commode en console, EA.

Commode en demilune, EA/*347*①.

commode en tombeau, EA/*commode à la régence.*

commode front, SDF.

commode secretary, DADA.

commode table, SDF.

common pose, JIWA/*16*.

Commonwealth, C-2382/*33*①; DADA.

Commonwealth oak, LAR83/*403*①.

Commonwealth or Puritan style, EA.

Commonwealth style, EA/*andirons.*

Commonwealth tankard, EA.

common white, EA/*salt-glaze ware.*

communion, DSSA.

Communion chalice, MP/*492*①.

communion cup, C-2498/*57*; DADA; C-0706/*40*.

communion set, S-4905/*180*①.

compact, C-0406/*115*; C-0706/*4*; C-1502/*43*, *93*; C-5117/*372*①.

compactness, S-4928/*21*①.

compactum, C-0982/*243*.

Compagnie des Cristalleries de Baccarat, CEA/*489*.

Compagnie des Cristalleries de Saint Louis, CEA/*489*.

Compagnie des Indes, NYTBA/*166*.

Compagnie des Indes ware, IDC.

compaña-shaped, C-5224/*20*.

Companie-des-Indes, LAR83/*98*①.

companion chair, SDF/①.

companion figure, EA/*dummy-board figure.*

companion piece, IDC.

Compant, D., C-5220/*26*①.

company porcelain, DADA.

compartment, C-5153/*171*①.

compartment border, OC/*47*①.

compartmented, S-288/*5*①.

compartmented candelabra field, S-2882/*67*, *193*.

compartmented gul, S-2882/*61*.

compartmented interior, C-0906/*129*; S-4905/*330*.

compass, C-2904/*43*; C-5114/*312*①; C-5153/*79*①; DATT; DSSA; NYTBA/*260*.

compass card, C-2904/*163*.

compass cutter, DATT.

compass design, C-5116/*20*.

compass front, SDF.

Compassion, C-2704/*185*.

compass-medallion, C-2403/*64*①; C-2478/*89*①.

compass medallion, C-2388/*103*.

compass microscope, CEA/*610*①.

compass needle, C-2904/*213*.

compass point, C-2458/*115*①.

compass seat, EA; SDF.

compass star, C-5157/*160*①.

compass stretcher, S-4988/*409*①.

compass table, SDF.

Compendiario, C-2486/*231*①.

compendiario dish, IDC.

compendiario style, EA/*Castelli.*

Compendiaro, C-2427/*230*①.

compensating planimeter, DATT.

compensation, EA.

compensation balance, C-5117/*393*①.

compensation curb, C-2489/*232*; C-5117/*458*①.

compensation pendulum, CEA/*249*①.

complementary color, DATT; LP.

complementary guard border, S-4847/*124.*

complementary juxtaposition, JIWA/*42.*

complete set, C-5156/*999*①.

complex brocade border, LAR83/*145*①.

complicated work, EA.

Complin, George, EA.

compo, SDF.

components drawer in base, C-2904/*32.*

comport, C-0406/*46*; C-0706/*102*; C-1006/*5*; C-5239/*18, 94*; DADA; EA; IDC; IDPF/*58*; LAR83/*152*①, *608*①.

comport base, C-0103/*165.*

composite, C-1006/*41*; LAR82/*434*①.

composite button, NYTBA/*318.*

composite canteen, LAR83/*580*①.

composite clarinet, C-0906/*374.*

composite format, JIWA/*5, 224.*

composite order, SDF.

composite part tea service, C-0782/*140.*

composite pigment, DATT.

composite pot, IDPF/*58*①.

composite rhidso, C-2478/*208.*

composite service, IDC.

composite set, C-0403/*58.*

composite stem, CEA/*423*①; EG/*134*①.

composite suite, LAR83/*579*①.

composite white, DATT.

composition, C-0103/*126*; C-0982/*203*; C-2402/*191*; C-2409/*50*; C-2458/*374*; JIWA/*6*; LP; S-4461/*62*; SDF.

compositional, JIWA/*6.*

compositional element, JIWA/*72*①.

compositional formula, JIWA/*20.*

compositional method, JIWA/*44.*

compositional order, JIWA/*10.*

compositional scheme, JIWA/*24.*

compositional unit, JIWA/*24.*

composition bookend, S-4461/*4.*

composition carving, S-4461/*183.*

composition frame, C-0982/*62.*

composition handle, C-0706/*53.*

composition leaf, DATT.

composition-mounted, S-4461/*61.*

composition originale, C-5239/*198.*

composition plinth, C-0225/*125*①.

composition scroll moulding, C-0982/*150.*

compote, C-0225/*165*; C-0270/*2, 21*; C-5005/*248*①; C-5114/*11*; C-5153/*10*①; C-5167/*150*; C-5203/*243*; EG/*182*①; IDPF/*58*; LAR82/*438*①; LAR83/*423*①, *575*①; S-3311/*931*①; S-4804/*8*; S-4905/*307*①.

compotier, FFDAB/*128.*

compôtier, IDC.

compotier, IDPF/*58.*

compounded order, SDF.

compounder, MP/*20, 41.*

compound microscope, CEA/*611*①.

compress, C-2458/*40, 178.*

compressed, C-0254/*304*; C-0782/*216*; C-2202/*231*; C-5127/*5*①; C-5236/*497.*

compressed baluster body, C-5156/*125*①.

compressed baluster form, LAR83/*92*①.

compressed body, C-2458/*58.*

compressed circular, C-0406/*23*; C-0706/*1*.

compressed circular bowl, C-0782/*44*.

compressed circular form, S-2882/ *916*①, *983*.

compressed conical shape, LAR83/ *448*①.

compressed form, IDPF/*60*.

compressed funnel shape, S-2882/ *1242*.

compressed globular, C-5114/*26*①.

compressed inverted pear form, S-4414/*271*①.

compressed ovoid form, S-2882/ *1292*①.

compressed spherical form, LAR82/ *452*①.

compressed spherical teapot, C-1502/ *2*.

compter, SDF.

comptoire, SDF/*compter*.

Comptoise clock, LAR82/*218*①.

comtoise clock, C-2489/*109*; C-MARS/*235*; EA.

Comtoise movement, CEA/*228*①.

Comyns, William, C-0406/*9*; C-0706/ *49*.

Comyns, William & Sons, LAR82/ *591*①.

con basso relievo istoriato, C-2486/ *20*①; C-2493/*252*.

concave, C-2402/*4*; C-5127/*31*; FFDAB/*65*.

concave angle, C-5005/*279*.

concave centre, C-2403/*46*.

concave corner, S-4853/*386*①.

concave curve, JIWA/*20*.

concave cutting, EG/*36*.

concave fluted stretcher, C-2357/ *35*①.

concave frieze, C-5116/*166*①.

concave front, C-0279/*314*①; C-5153/*173*①.

concave-fronted, C-2403/*85*; C-2421/ *46*①.

concave-fronted drawer, C-2357/ *100*①.

concave fronted drawer, S-4414/ *383*①.

concave-fronted seat, C-2388/*18*.

concave graduated tier, S-4414/*178*①.

concave interior, C-2458/*140*①.

concave molding, LAR83/*196*①.

concave panel, RTA/*81*①.

concave platform base, C-0982/*85*.

concave relief, DATT.

concave shelf, C-2403/*124*.

concave-sided, C-2388/*38*; C-2403/ *109*①.

concave-sided top, C-2403/*47, 124*.

concave side panel, C-0982/*1*.

concave splat, S-4965/*76*①.

concave top, C-2357/*26*①.

concave vertical splat, S-2882/*370*①.

concave-walled, IDPF/*74*①.

concealed erotic scene, S-4927/*174*①.

conceit, IDC.

concentrated composition, JIWA/*89*.

concentric, C-2403/*158*; C-2904/*192*; C-5127/*45*; CEA/*489, 502*; EG/ *287*.

concentric band, C-1506/*111*; C-2704/*82*.

concentric circle, C-2458/*1*; C-5116/ *168*①.

concentric dial, C-2437/*32*①.

concentric diamond pattern, C-5114/ *278*①.

concentric garland, EG/*156*①.

concentric hand, CEA/*224*①.

concentric lobed roundel, C-2357/ *75*①.

concentric medallion, C-2388/*152*.

concentric poled medallion, C-5323/ *29*.

concentric rib, C-5127/*5*①.

concentric roundel, C-2421/49①.

concentric torsade, EG/246①.

concept of space, JIWA/10.

conceptual color, DATT.

conceptual image, JIWA/284.

conceptual jewellery, RTA/167①.

conceptual painting, LP.

concert grand piano, C-5189/324①.

concertina, C-0906/258; CEA/392①, 553①.

concertina action, C-2403/105①; C-2498/102; C-5224/129; CEA/343①; S-4414/483①; S-4812/71①.

concertina action games table, S-4988/459①.

concertina album, C-5236/1525.

concertina construction, EA.

concertina movement, DADA.

concertina side, SDF/①.

concertina tier, C-2388/36.

concertina whatnot, LAR83/328①.

conch shell, C-1006/118; S-4927/379.

conch shell foot, C-2398/34①; C-5117/23①.

Concord, DSSA.

Concord pattern, C-0270/269.

concours, DATT; LP.

concrete, DATT.

condenser, C-0403/120; C-2904/121, 198①.

condiment bottle, C-1502/151.

condiment dish, S-4461/285; S-4905/28.

condiment fork, C-0254/79; S-4461/246.

condiment garniture, S-3311/653.

condiment holder, S-4804/147①.

condiment jar, C-0254/9.

condiment ladle, C-0254/77.

condiment ledge, IDC.

condiment set, C-0706/46; LAR83/557①.

condiment spoon, C-0254/79; C-0706/46; S-4944/61.

condiment stand, C-0254/83.

condiment urn, C-5173/34①.

condition, C-5156/913.

Condliffe, James, EA/314.

cone, CEA/316①; IDC; IDPF/34; SDF.

cone, ceramic, DATT.

cone-beaker, CEA/418①; EG/43①, 128.

cone beaker, ACD.

coned cresting, C-2421/15①.

cone device, EA/boteh motif.

cone finial, C-2357/14①; C-2382/54①; C-2421/9①; C-2437/21①.

cone-form, S-4461/427.

cone of vision, DATT; LP/①.

cones, C-5146/59.

cone-shaped, C-2364/6; C-2409/106; C-GUST/2.

Coney, John, CEA/666①, 667①, 671①; EA/①.

coney cape, C-0405/35.

coney coat, C-0405/35.

coney hood, C-0405/35.

confectionary mold, IDPF/60①.

confessional, CEA/405; DADA.

confidante, ACD; EA; SDF.

confident, CEA/405.

confidente, DADA.

confinement set, IDPF/60.

confiturier, IDC.

confluent color, DATT.

conforming, C-5116/57; S-4972/634.

conforming base, S-4461/382.

conforming border, C-0279/325; C-5116/118.

conforming case, C-5114/341①, 371①.

conforming crystal section, S-4414/94①.

conforming foot, S-4804/54.

conforming frame, S-4414/*37.*

conforming frieze, C-5116/*81*;
C-5157/*171*①.

conformingly-shaped, S-4905/*475*①.

conformingly shaped, S-4905/*401.*

conformingly-shaped frieze, S-4905/
*446*①.

conforming plate, C-5116/*124.*

conforming skirt, C-5114/*337*①.

conforming tool, S-4905/*326.*

conforming undertier, C-2478/*145.*

confronted, S-4965/*121*①.

confronted dragon, C-2414/*13*①.

confronted wyvern, RTA/*69*①.

Confucius, DADA.

cong, C-5156/*308*; C-5234/*209*①,
*219*①.

congé, SDF.

conglomerate, C-5236/*360.*

Congreve, William, EA.

Congreve clock, EA/*ball clock.*

conical, C-0782/*17, 81*; C-2458/*22*①,
*36*①; C-5005/*247*; C-5153/*1*①;
C-5239/*89*; S-4972/*142*①, *414.*

conical and ball finial, S-2882/*1030.*

conical base, S-4461/*547.*

conical body, C-5127/*30*①.

conical border, C-2414/*63*①.

conical bowl, C-0782/*8*; C-2414/
*92*①; C-5156/*40*①; C-5236/*429*;
S-4414/*237.*

conical cup, C-0225/*158.*

conical finial, C-5114/*266*①.

conical foot, C-2414/*3*①, *12*①;
C-5153/*11*①.

conical kick, EA/*balustroid stem.*

conical lid, IDPF/*123.*

conical pendulum, EA.

conical shade, C-0225/*342*; C-5005/
*313*①; C-5146/*149A*①.

conical shape, S-2882/*1299.*

conical shape with inverted neck,
S-2882/*1253*①.

conical shoulder, C-2414/*83*①.

conical spire stopper, EA/*stopper.*

conical steeple, C-5174/*175*①.

conical stem, C-5156/*77*; IDPF/*40*①.

conical top, S-4905/*329.*

conicle, C-2202/*44, 58.*

conjoined, C-5005/*305*①; C-5117/
*181*①.

conjoined bracket, S-3312/*1184*①.

conjoined circle, S-3311/*705.*

conjoined demi-oval, S-2882/*1026*①.

conjoined foliate oval, S-2882/*1180.*

conjoined Hawthorne design, S-2882/
*1079*①.

conjoined medallion, S-2882/*196*①.

conjoined shellwork support, S-2882/
*921*①.

conjoined spiral, RTA/*40*①.

conjoined wirework loop, S-2882/
*966*①.

conjuring cup, IDC/①.

Connecticut chest, DADA/①; EA/
①; SDF.

Connecticut shelf clock, EA.

Connelly, Henry, CEA/*389*; EA;
SDF/*770.*

Conner, Jerome, K-710/*115.*

Conning, James, S-3311/*620*①.

Connor, John H., S-4905/*190.*

conoidal, IDC.

Conrad, CEA/*45.*

Conrade family: Domenico, Baptiste,
Augustin, EA.

consecration ring, RTA/*58.*

conservation, DATT.

conservation of painting, LP.

conserve cup, IDC.

consistency, DATT.

console, ACD; JIWA/*321*①; MP/*77*;
S-3311/*273*①; S-4804/*819*①;
SDF/①.

console-bracket, CEA/*315*①.

console cabinet, S-4436/*125*①.

console chiffonier, SDF/①.

console desserte, C-0279/*393*;
C-2437/*73*①; S-4823/*239*①;
S-4972/*634*.

console or clap table, EA/①.

console side table, C-0982/*85*.

console table, ACD; C-0249/*432*;
C-0279/*268*; C-1407/*18, 124*;
C-2357/*50*①; C-2402/*191*;
C-2403/*92*; C-2478/*111*; C-5127/
322; CEA/*405*; DADA; LAR83/
*364*①; S-4804/*818*①; S-4972/*497*;
S-4988/*495*①; SDF/①.

constable glass, DADA.

Constancy, DSSA.

constant second, S-4802/*58*①.

constant white, DATT.

constitution clock, DADA.

constitution mirror, DADA; EA.

constricted neck, C-2482/*81*.

construction, DATT.

construction paper, DATT.

Constructivism, DATT; LP; RTA/
141.

constructivist furniture, JIWA/*321*.

consular case, C-2489/*213*①; EA.

Consulat, FFDAB/*24*.

Contador, C-2498/*160*.

contained shadow, DATT.

container, C-0906/*118*; JIWA/*136*.

Conté, LP.

Conté crayon, DATT.

contemporary, C-5153/*38*①; C-5157/
95; LP.

contemporary gross-point, C-5116/
*164*①.

contemporary needlework, C-5116/
*160*①, *167*①.

contemporary style, SDF.

content, DATT; JIWA/*23*; LP.

Contex cash counter, C-2904/*5*.

continental, S-4436/*51*; C-0706/*3*;
C-1502/*113*; C-5116/*163*①;
C-5117/*177*①; C-5173/①;

C-5174/*20*; LAR82/*65*①, *124*①;
S-4992/*3*①.

Continental Baroque, S-3311/*467*①.

Continental carpet, S-3311/*78*①.

Continental furniture, CEA/*304*.

Continental jewellery, CEA/*513*.

continental metal work, CEA/*537*.

Continental mid 18th century taste,
C-0406/*55*.

Continental Neo-Classic, C-5116/
*29*①.

Continental neoclassical, S-2882/
*395*①; S-3311/*523*①.

Continental pattern, C-5167/*154*①.

Continental pewter, CEA/*581*.

Continental porcelain, C-0782/*33*;
C-1006/*17*; CEA/*169*.

Continental pottery, CEA/*130*;
C-2409/*109*.

Continental rococo, S-2882/*394*①;
S-3311/*500*①.

continental silver, DADA; C-5117.

continents, the four (or five), IDC.

continuing striated feather device,
S-2882/*1324*.

continuous armchair, S-4905/*361*①.

continuous frieze, S-4804/*300A*①;
S-4947/*16*①; S-4992/*8*①.

continuous husk, S-2882/*1149*①.

continuous line, JIWA/*16*.

continuous meander, C-2323/*72*①.

continuous scene, S-4905/*112*.

contour, DATT; JIWA/*87*; LP;
S-3311/*434*①; SDF/①.

contour drawing, DATT/①.

contour-framing, IDC.

contour ring, S-291/*100*①.

contracted neck, IDC.

contract-quality, OC/*32*.

contraposto, C-0279/*66*①.

contrapposto, C-2427/*82*①; DATT/
①; LP/①; S-3311/*284*.

contrapuntal, LP.

contrast, JIWA/*19, 71*; LP/①.

contre-partie, LAR82/*418*①.

contrepartie, CEA/*375*①, *405*.

contre partie marquetry, C-2364/ *70*①.

contre-partie work, EA/*Boulle (buhl.*

contrived "heap and pile" effect, S-3312/*1352*①.

control mark, C-5117/*177*①, *190*①; C-5173/*64*①; S-4972/*162*①, *271*.

Contumacia, DSSA.

conundrum, C-1603/*6*①.

conventional pose, JIWA/*16*.

conventions, JIWA/*16*.

conversation chair, DADA; SDF.

conversation pattern, IDC.

conversation piece, DATT/①.

conversation settee, LAR83/*345*①.

conversion (in clocks and watches), EA.

convex, C-5005/*357*①; C-5153/*112*; S-4972/*63*①.

convex angle, C-2546/*90*①.

convex form, IDPF/*199*.

convex frame, C-5157/*36*.

convex frieze, CEA/*329*①.

convex frieze drawer, C-2388/*131*①; C-2403/*152*①; LAR83/*338*①.

convex loaf center, S-4965/*240*①.

convex mirror, C-2368/*1*; C-5114/ *376*; CEA/*401*①; FFDAB/*109*.

convex moulding, CEA/*231*①.

convex octagonal panel, C-0249/ *480*①.

convex panel, C-0279/*427*①.

convex panelled apron, C-5114/ *285*①.

convex plate, C-2403/*37*.

convex wall mirror, DADA/①.

convoluted, SDF.

convoluted border, OC/*292*.

convoluted knob, IDPF/*140*①.

convolvuli, S-2882/*1219, 1219*.

convolvulus, C-2546/*91*①.

Conway Stewart, C-0403/*13*.

Cook, Thomas, S-4922/*65*①.

Cooke, Dr Henry, CEA/*159*①.

Cooke, Thomas, II, C-5203/*210*①; S-3311/*794*.

Cooke, T. & Sons, York, C-2489/*103*.

cooked oil-resin varnish, LP.

cooking bell, IDPF/*169*.

cooking pot, IDPF/*60*①.

Cook Pottery, Trenton, New Jersey, EC1/*85*.

cooks, Bow, IDC/①.

Cookworthy, William, ACD; CEA/ *110, 187, 200*①; EA.

cool color, DATT; LP.

cooler, IDPF/*61*①.

coolie, C-0405/*156*.

Coope, Rotterdam, C-MARS/*161*.

cooper, C-5005/*385*; SDF.

Cooper, Alexander, EA.

Cooper, Francis, DADA/*Supplement*.

Cooper, Hans, DADA/*Supplement*.

Cooper, John Paul, DADA/ *Supplement*.

Cooper, Robert, CEA/*643*①.

Cooper, Samuel, EA/①.

Cooper, Susie, C-2409/*62*.

coopered joint, SDF.

coopered pail, S-4414/*414*①.

coopering, SDF.

Cooper's patent revolver, C-2503/*186*.

Coors laboratory porcelain, CEA/*205*.

copaiba balsam, DATT; LP.

copaïba wood, DADA.

copal, DATT; LP.

cope, DADA; DSSA.

cope chest, SDF.

copeland, ACD; C-2493/*152*; C-2502/*71*; C-5189/*22*①; CEA/ *202*①; DADA; LAR82/*177*①; LAR83/*85*①.

Copeland, Joseph, CEA/*590*.

Copeland, William Taylor, EA.

Copeland and Garrett, C-1006/*104*, *215*; C-5259/*89*; LAR82/*110*①.

Copeland factory, NYTBA/*181*.

Copeland & Garrett, C-2493/*167*; CEA/*204*①.

Copeland late Spode, EA/*Copeland, William Taylor*.

Copeland Stone China, EA/*Copeland, William Taylor, mark:*.

COPELAND with crown, EA/*Copeland, William Taylor*.

COPELAND with crown and garlands, EA/*Copeland, William Taylor*.

Copenhagen, ACD; C-0249/*260*; DADA.

Copenhagen blue fluted service, IDC.

Copenhagen figures, IDC/①.

Copenhagen pattern, IDC.

Copenhagen plate, C-2486/*97*.

Copenhagen school, JIWA/*146*.

Copenhagen Stoore Kongensgade factory, EA/①.

Coper, Hans, LAR82/*111*①; LAR83/*85*①.

Copernican armillary sphere, CEA/*603*①.

coperta, CEA/*141*①, *209*; EA; IDC.

copied seal, C-5156/*649*.

Copier, Andries Dirk, DADA/*Supplement*.

Copier, Serica, C-5239/*144*.

Copland, Henry, DADA; EA; SDF/*748*.

Copley, John Singleton, EA.

copolymer, DATT.

coppa amatoria, IDC.

copper, C-0225/*85*; C-0403/*54*; C-5005/*236*; C-5239/*89, 241*; CEA/*527*; DATT; EG/*257*; S-4436/*25*; S-4461/*82*.

copper beech branch, C-2704/*31*.

copper blank, EA.

copper blue, DATT.

copper bound, IDC.

copper engraver, MP/*50*.

copper engraving, JIWA/*24*.

copper foil, C-5167/*198*①.

copper glaze, C-2502/*44*.

copper-green, IDC.

copper kettle, C-0906/*158*.

copper lustre, C-2427/*173*; IDC.

copper oxide, EC2/*23*.

copper pan, C-2904/*41*.

copper panel, C-5156/*757*①.

copperplate, CHGH/*63*.

copperplate engraving, DATT.

copper-plate printing, NYTBA/*87*①.

copper-red decoration, EA.

copper resist, IDC.

copper rim, C-5156/*46*①.

copper-smelting plant, EG/*21*.

coppery-bronze, C-1082/*109*.

coppery bronze, C-5156/*217*.

Coptic art, DATT.

copy, DATT; JIWA/*10*; LP.

copying camera, C-1609/*233*.

copying press, DATT/①.

coqueret, C-5117/*479*①; C-5174/*414*; EA.

coquetière, IDC/①.

coquillage, ACD; DADA; EA; SDF/①.

coquilla nut, LAR83/*606*①.

coquille board, DATT.

coquille d'oeuf, C-5146/*67*①; C-5191/*204*; C-5239/*115*.

corail, DATT.

corail wood, DADA.

coral, C-1006/*38*; C-2403/*193*; C-2458/*250*; C-5127/*645*; C-5156/*245*①; C-5236/*326*; CEA/*562*; DSSA; EC1/*56*; RGS/*80*; S-3312/*1244*; S-4810/*104*①; S-4843/*162*①; S-4927/*305*①; S-4972/*221*.

coral beads, C-1506/*149*①.

coral cabochon, S-4414/*12*.

coralene, EC1/*56*; OPGAC/*163*;
S-4414/*232*.

coral-glazed, C-2323/*114*.

coraline point, DADA.

coral-red, IDC.

coral wood, DADA.

coramandel, C-5127/*335*.

corbel, ACD; DADA; S-4972/*3*①;
SDF.

corbel figure, S-4972/*344*①.

corbelled, S-4436/*7*①; S-4988/*405*①.

corbelled foot, S-2882/*311*①.

Corbet, Charles Louis, C-5224/*315*①.

Corbisier, Pierre-Francois-Joseph,
C-2555/*38*①.

cord, CEA/*502*; EC2/*89*.

cord and tassel, OPGAC/*210*.

cordate, DATT.

corded, C-5173/*31*①; S-3311/*621*①.

corded border, C-5117/*29, 294*①;
LAR83/*544*①; S-2882/*1164*.

corded handle, S-2882/*1191*①.

corded quilting, CEA/*276*①.

corded rib, C-2510/*8*①.

corded rim, S-3311/*618*.

corded wirework, S-2882/*912*.

cordia, SDF.

cordial cup, S-4461/*219*; S-4804/*207*.

cordial glass, ACD; CEA/*429*①;
DADA.

cordial service, S-4461/*110*.

Cordie, Guillaume, S-4955/*176*①.

Cordier, C., C-5174/*490*①; C-5220/
*56*①.

Cordier, Charles Henri Joseph,
C-5189/*169*①.

cording, S-2882/*1027*①.

cord-like whipping, OC/*22*.

cordonnet, DADA.

cordonnier, SDF/*cordwainer*.

Cordova, OPGAC/*211*.

cordovan, SDF/*cordwain*.

cord repeat, S-4927/*80*.

cords (striae), EG/*287*.

cordwain, SDF.

cordwainer, SDF.

core, CEA/*415, 541*; DATT; EA;
IDPF/*206*①; SDF.

coréen, IDC.

core-formed, EG/*23*①; S-4807/*526*.

core winding, CEA/*50*.

Corinithian column, S-4461/*80*.

corinthian, C-5116/*48*; C-2398/*28*;
C-2478/*178*; C-5116/*163*①.

Corinthian capital, C-2437/*27*①;
CEA/*323*①; S-4804/*201*.

Corinthian column, C-0103/*163*;
C-0254/*294*; C-2202/*102*; C-2388/
24; C-2402/*24*; C-5173/*2*; EA;
LAR82/*209*①.

Corinthian column candlestick,
C-0103/*150*.

Corinthian column support, S-2882/
*1034*①.

Corinthianesque, C-5224/*54*①.

Corinthian leg, C-0254/*64*.

Corinthian order, SDF.

Corinthian pilaster, C-0982/*1*.

cork, SDF; CEA/*427*①, *446*①.

cork black, DATT.

Cork Glass Co., EG/*149*.

Cork Glass Company, EA/①.

corking, EA/*caulking*.

cork screw, C-0406/*119*; S-4804/*35*.

corkscrew, C-5153/*152*①; C-5239/
113; S-4972/*416*.

corkscrew air twist, CEA/*433*①.

corkscrew finial, C-5153/*197*①.

corkscrew pattern, CEA/*432*①.

corkscrew-shaped link, S-4414/*65*.

corkscrew thumbpiece, EA.

cormandel, CEA/*405*.

cormier wood, DADA.

cormolu, C-1702/*318*.

cormorant, C-2414/*103*①.

cormorant fisherman, IDC.

corn, DSSA.

Corn and Beans, CEA/*287*.

Cornation, C-0706/*214*.

corne, à la, DADA; IDC.

cornel, SDF.

cornelian, C-2332/*39*; RGS/*80, 199*①.

Cornelius, Christian, DADA/ *Supplement*.

corner, IDC.

corner armchair, C-2402/*39*; S-4812/ *95*①.

corner armoire, S-4955/*198*①.

corner banding, C-5116/*2*.

corner block, FFDAB/*42*①; SDF.

corner cabinet, C-5239/*283*; DADA; S-4436/*189*①; S-4461/*584*①; SDF.

corner chair, ACD; C-0982/*71*; C-5114/*397*①; CEA/*394*①; DADA/①; EA/①; LAR83/*288*①; S-4905/*464*①; SDF.

corner cupboard, ACD; C-0982/*22*; CEA/*379*①; DADA; EA/①; LAR83/*310*①; S-3311/*526*①; S-4436/*186*①; SDF/①.

corner flange, C-5156/*80*①.

corner mount, C-2368/*110*①; C-5220/*30*①; S-4955/*196*①.

corner ottoman, SDF.

corner piece, S-4972/*396*.

corner post, SDF/①.

corner reeded, S-4461/*550*.

corner settee, C-5224/*202*①.

corner shelf, SDF.

corner stile, SDF.

corner stool, SDF.

corner stringing, C-5116/*3*.

corner table, DADA.

corner-turn, OC/*211*.

cornett, CEA/*547, 556*.

cornetti, C-5255/*24*.

corne verte, C-2364/*30*①; C-2546/ *40*.

cornflower, DADA; IDC.

cornflower decoration, CEA/*477*①.

corn flowers, C-1006/*214*.

cornflower sprig, EA.

Cornhill, Barraud, London, C-2489/ *69*.

corn-husk pattern, CEA/*207*①.

cornice, ACD; C-0982/*22, 66, 142*; C-1407/*16*; C-2388/*24*; C-2402/*23, 256*; C-2409/*239*; C-5114/*278*①; C-5116/*48*; C-5153/*97*; C-5189/ *262*①; CEA/*405*; DADA; FFDAB/*77*; LAR82/*208*①, *272*①; LAR83/*314*①; S-2882/*292, 300, 358*①, *1443*①; S-4436/*93*①; S-4461/*199, 583*; SDF/①.

cornice mirror, FFDAB/*109*.

corniche, C-2489/*45*.

corniche-shaped, C-2546/*42*.

Corning, New York, CEA/*478*①.

Corning Flint Glass Works, DADA/ *Supplement*.

Corning Glass Works, CEA/*478*①; DADA/*Supplement*; NYTBA/*308*.

Cornish stone, DATT; IDC.

Cornman, Philip, CEA/*659*①.

Cornock, Edward, CEA/*63*①; S-4944/*391*①.

cornopean, C-5255/*26*①.

corn pitcher, IDC.

cornucopia, C-2398/*12*①; C-2437/ *38*①; CEA/*56*①; DADA; DSSA; EA; IDC; IDPF/*62*; NYTBA/*72*; SDF; S-4843/*316*①.

cornucopia border, S-4804/*121*①.

cornucopia branch, C-2421/*5*①.

cornucopiae, C-1506/*54*①.

cornucopia flask, EA.

cornucopia form, C-2493/*124*.

cornucopia leg, DADA.

cornucopia pattern, IDC; LAR82/ 439①.

cornucopia-shaped, C-1006/*143*.

cornucopia sofa, SDF.

cornucopia support, S-4507/*60*①.

cornucopia vase, LAR82/*162*①.

Cornwall stone, DATT.

coromandal, C-2202/*60*.

coromandel, ACD; C-0906/*80*; C-2202/*214*; C-2421/*128*①; C-5157/*166*①; LAR82/*66*①; LAR83/*48*①; S-4972/*436*; DATT.

coromandel lacquer, DADA; EA/ *Bantam work*.

coromandel screen, C-2522/*118*①; C-5156/*442*①.

coromandel wood, SDF.

coromandelwood, LAR83/*629*①.

corona, ACD; C-2364/*12*①; C-2421/ *7*①; C-2437/*21*①; C-2478/*9*; DADA; LAR83/*63*①; S-2882/*342*; S-4955/*19*; S-4972/*429*; SDF; C-2904/*3*.

'Corona' pattern, C-2910/*144*.

Corona Pottery, Corona, New York, EC1/*85*.

coronation jeton, RGS/*31*①.

coronation ring, RTA/*96, 128*①.

coronel, C-2503/*18*.

coronet, C-0982/*222*; C-2202/*38*; C-2398/*6, 29*; C-2427/*205*①; C-5117/*17*①; S-4905/*72*; S-4922/ *10*①.

coronet and bird's head knop, S-4804/*150*①.

coroneted cypher, RGS/*105*①.

coronet finial, C-5117/*320*.

coronet knop, C-5174/*141*①.

coroplast, DATT.

Corot, Jean-Baptiste-Camille, S-286/ *70*.

corporal case, DADA.

corporation piece, DATT.

Corrado family, EA.

correction chairs, C-2402/*89*.

correction-collar, C-2904/*198*①.

correction collar objective, C-0403/ *206*.

correction white, DATT.

Correr service, EA.

corridor stool, SDF/①.

corrosion, DATT.

corrugated foot, CEA/*427*①.

Corry, Henry, C-5117/*247*.

corselet, DADA.

corset, C-1506/*59*.

corset back, SDF.

Cory, John, C-5173/*46*①.

Cory, Thomas, C-5117/*100*.

Cosandier fr. & Co., C-2368/*123*.

Cosens, James, CEA/*29*①.

Cosmati, DATT.

Cosmati work, DADA.

cosmetic, C-5236/*812*.

cosmetic box, C-2513/*266*; C-5236/ *396*①, *861*; CEA/*572*①.

cosmetic jar, C-5127/*25A*; S-4804/*14*.

cosmetic palette, S-4973/*89*①.

cosmetic pot, IDPF/*62*①.

cosmetic vase, C-5236/*1583*.

cosmological mirror, C-2458/*214*; C-2513/*92*.

cosmorama, DATT.

Cossack, RGS/*86*.

Cossack dress set: shashka, kindjal, leather belt, cross-belt, straps, C-5174/*213*①.

coster, DADA; SDF.

Coster, Salomon, CEA/*226*①; EA.

costrel, CEA/*594*; DADA; EA/ *pilgrim bottle*; IDC; IDPF/*62*①.

costruzione legittima, DATT.

costume, C-1506.

costume print, NYTBA/*103*①.

costumer, C-5239/*251*.

Cosway, Richard, EA/①.

cosy corner, SDF/①.
cot, SDF/①.
Coteau, Jean, EA.
Coteau, Joseph, C-5220/22①.
Cotes, Samuel, EA/①.
cot quilt, C-2704/47A.
cotralls, SDF.
cotswold chair, SDF.
Cotswold School, DADA/Supplement.
cottage, CEA/239①; IDC/①;
 OPGAC/211.
cottage Bristol, IDC.
cottage china, EA; IDC.
cottage clock, EA.
cottage diner, CEA/331①.
cottage earthenware or porcelain, EA.
cottage furniture, DADA/Supplement.
cottage model, IDPF/235①.
Cottage of Content, C-2704/25①.
cottage piano, SDF/①.
Cottage Queen Anne, NYTBA/77.
cottage style, SDF/①.
cottage weave, SDF.
cott bedstead, FFDAB/75.
Cotterill, Edmund, EA.
cotter pin, CEA/541.
Cottey, Abel, EA.
Cottin, J., C-5174/491①; C-5220/
 55①.
cotton, C-5156/440; LP; OC/16.
cotton canvas, DATT.
cotton printing, DADA/Supplement.
cotton reel band, C-2704/55.
cotton reel block, C-2704/55.
cotton runners and mats, C-2704/145.
cotton-stalk painter, EA.
cotton twist, EG/287.
cotton-warped, OC/15, 17①.
cottonwork, C-5117/379.
cottrell, EA/chimney-crane.
cotyliscos, IDC.
Couba, CEA/81①.

couch, ACD; CEA/358①; DADA;
 DATT; EA; SDF/①.
couchant, CEA/644①.
couch bed, SDF/①.
couch bedstead, SDF/① couch bed.
couched, C-2409/243.
couched stitch, CEA/291①.
couching, CEA/282①, 294; DADA;
 SDF.
Coulon, Gaspard, Balthazar, stamp:
 COULON, C-5224/181①.
Coultry Pottery, Cincinnati, Ohio,
 EC1/85.
Council of Industrial Design, DADA/
 Supplement.
counter, ACD.
counter and counter-board, SDF.
counterarch, C-5167/219A①.
counter-balance ball, C-5146/172①.
counter-balance ball terminal, S-4414/
 240.
counter-balance floor lamp, C-5146/
 172①.
counter-balance lamp, C-5167/293①.
counter-balance sphere terminal,
 S-4414/249.
counter-balance table lamp, S-2882/
 1334①.
counter-balance terminal, S-4414/233.
counterbalancing, JIWA/53.
counter box, CEA/70; EA.
counter-diagonal, JIWA/218①.
counter-enamelling, RGS/61.
counterguard, CEA/21①.
counterpane, DADA; SDF.
counterpoint, SDF/counterpane.
counterpoised lever, C-2489/138.
counter-posed design, C-2478/272.
counterposed design, C-2403/155.
counterproof, DATT.
Counter-Reformation, MP/10.
countersink, SDF.
countersunk, S-4965/261①.

counter table, DADA.

counterweight, C-5005/*415*.

counterweight desk lamp, C-5005/*389*.

counter-well, C-2320/*42*①; C-2403/*56*; C-2478/*112*①.

counter well, C-2388/*54*.

counterwell, C-2522/*41*①.

counting-house bookcase, SDF.

country carving, NYTBA/*37*.

country Chippendale, SDF/①.

country furniture, NYTBA/*35*①.

country of origin mark, IDC.

country Queen Anne, NYTBA/*39*.

country turned furniture, SDF.

count wheel, CEA/*220*①, *267*; EA/*striking mechanism*.

countwheel, C 2489/*65*; S-3311/*204*①, *461*.

countwheel strike, C-2364/*26*①; C-MARS/*211*.

coup, IDPF/*63*.

coupe, C-5146/*90*; DADA; IDC; IDPF/*63*①; LAR82/*559*①.

coupled column, SDF.

coupled-rangefinder roll-film, C-1609/*188*.

Couratin, Paris, C-MARS/*184*①.

courbaril wood, DADA.

couronné, DADA.

Courrade family, EA.

course protractor, S-4881/*56*①.

coursing cup, S-4944/*273*①.

court art, JIWA/*9*.

Courtauld, Augustin, EA.

Courtauld, Augustine, CEA/*646*①.

Courtauld, Louisa, EA/*Courtauld, Samuel*.

Courtauld, Samuel, CEA/*653*①; EA.

Courtauld, Samuel II, EA/*Courtauld, Samuel*.

court beauty motif, C-2493/*256*.

court cabinet, SDF.

court carpet, EA/*animal carpet*.

court cupboard, ACD; C-0279/*328*; C-5157/*62*; CEA/*323*①; DADA; EA/①; LAR82/*334*①; LAR83/*312*①; NYTBA/*29*; S-4972/*455*; SDF/①.

court doll, CHGH/*50*①.

Courtenay, Hercules, EA.

court fan, C-5156/*458*①.

courting chair, DADA; SDF.

courting mirror, DADA/①.

court lady figure, S-4965/*209*①.

Court Manufactories, OC/*12*.

Courtois, Nicolas-Simon, S-4955/*74*①.

court painter, MP/*122*.

courtship and marriage, IDC.

Court suit, C-2203/*57*.

couse, C-2503/*21*①.

Cousin, Jean, DATT.

Cousinet, Ambroise-Nicolas, EA.

Cousinet, Henry-Nicolas, EA.

Coustou, LAR82/*52*①.

couter, DADA.

couvert, EA.

couverte, IDC.

couvre-feu, EA/*curfew*.

cove, C-5153/*97*; SDF.

cove cornice, C-5114/*276*.

coved, C-5114/*243*①; C-5116/*5*; C-5157/*153*①.

coved cornice, C-5116/*1*, *6*; S-2882/*264*.

coved oval fluted back, C-5116/*165*①.

coved padded back, C-5116/*99*①.

coved top rail, C-5116/*64*①.

cove molding, C-5114/*266*①, *394*①.

Coventry, Earl of, pattern, IDC.

cover, C-1506/*164*①; C-5005/*225*①; IDC; NYTBA/*107*.

coverdish, IDC.

covered, S-4905/*175*①.

covered beaker, RGS/*17*①, *22*①;
S-4802/*191*①.

covered box, C-5005/*238*.

covered chalice, C-5005/*226*①.

covered creamer, S-4905/*179*①.

covered cup, CEA/*624*①; S-4922/
*58*①.

covered entree dish, S-3311/*587*①.

covered pitcher, C-5114/*29*①.

covered saucepan, C-5117/*171*.

covered sugar, C-5005/*222*①;
C-5114/*46*①.

covered sugar bowl, EC2/*29*①.

covered urn, NYTBA/*161*①; S-4436/
*5*①.

covered vase, C-5005/*267*; S-4992/
*3*①.

covered vegetable dish, CEA/*664*①.

covered vessel, C-2414.

covered water pitcher, S-4905/*196*①.

cover fillet, SDF.

covering power, DATT.

coverlet, C-2704/*49A*; NYTBA/*93*①,
107; SDF.

coverlid, SDF/*coverlet*.

cow, DSSA.

Cowan, OPGAC/*346*.

Cowan Pottery, Cleveland and Rocky
River, Ohio, EC1/*85*.

cow-cream, C-2204/*73*.

cow-creamer, DADA.

cow creamer, C-2202/*30*; EA/①;
IDC; IDPF/*63*①.

cowerie shell, C-0270/*154*.

cow hair, OC/*16*.

cowhorn-and-spur stretcher, EA.

cow-horn stretcher, CEA/*345*①.

Cowles, George, EA/*Courtauld,
Samuel*.

Cowley, George, London, C-2489/
149.

cowl neckline, C-0604/*222*.

Cowperthwaite, John K., SDF/*770*.

cowries, C-1082/*7*.

cowrie shell, C-1082/*19*.

cow's tail, EA/*Black Forest clock*.

cow's tail pendulum, EA/①.

cow tail pendulum, CEA/*223*①.

Cox, Frederick J., C-2904/*135*.

Cox, Henry, New Bedford, S-4881/
*143*①.

Cox, James, EA/①.

Cox, William, CEA/*656*①.

Coypel, Charles-Antoine, EA.

Coypel, Noël, EA.

Cozzi, C-2486/*25*.

Cozzi, Geminiano, CEA/*171*①; EA.

Cozzi factory, EA/*Baccin, Giovan
Maria*.

Cozzi porcelain, IDC/①.

C.P., LP.

C-P and ducal coronet, EA/*Paris
porcelain*.

C. Plath, C-2904/*258*.

C-poinçon, EA/*crowned C*.

CR, EA/*Crespin, Paul, Rendsburg*.

crab, DSSA.

crab and vine scroll border, S-2882/
165.

crab-claw marking, IDC.

'crab' design, OC/*331*.

crab device, C-5189/*385A*①; C-5323/
*16*①.

crab-rosette border, C-2388/*143*;
C-2478/*265*.

crab's claw crackle, DADA.

crab star, S-3311/*50*.

crabstock, EA/①; IDC; S-4905/
*13*①.

crabstock handle, IDPF/*63*, *118*①;
LAR83/*157*①.

crabstock spout, LAR82/*178*①;
S-4843/*121*①.

crabstock spout and handle, LAR83/
*172*①.

crabstock ware, DADA.

crab-tooth, LAR82/*239*①.

crabwood, SDF.

Crace, Frederick, EA/*Crace & Son.*

Crace, John G., EA/*Crace & Son.*

Crace & Son, EA.

crack, DATT.

cracked, C-5236/*342*; CEA/*490*; S-4992/*7*①.

cracked-ice, S-4905/*8*①.

cracked ice, C-2458/*88.*

"cracked ice" border, S-3312/*1383*①.

cracked-ice ground, IDC; S-4843/*37*①.

cracked ice ground, EA.

cracked-ice-pattern, C-2323/*49, 86.*

cracked ice pattern, C-0782/*47.*

cracked off, CEA/*414.*

crackIng, C-0249/*40.*

cracking off, CEA/*502*; EG/*287.*

crackle, ACD; C-5127/*12*; DADA; DATT; IDC/①; S-3312/*1360*①.

crackle, cracquelure, EA.

crackled, C-2323/*113*; C-2458/*9*; C-5146/*144B*; C-5239/*18.*

crackled glass, C-2910/*54.*

crackled glaze, C-5156/*68.*

crackle finish glaze, C-0225/*69*①.

crackle glass, DADA/*Supplement*; K-711/*130.*

crackle glaze, C-2458/*178.*

crackle-glazed, EC1/*74*①.

crackleware, EC1/*83.*

crackling, EG/*73*; JIWA/*304*①.

cracks in painting, LP/①.

cradle, C-1407/*42*; C-5114/*318F*①; DADA/①; DATT; EA; IDC/①; IDPF/*63*①; S-4905/*327*①; S-4927/*220E*; SDF/①.

cradling, DATT; LP.

Cradock, J., C-2510/*96.*

Cradock, Joseph, C-5117/*23*①; S-4944/*288*①.

craft, DATT; JIWA/*13.*

Craft Centre of Great Britain, DADA/*Supplement.*

craft guild, MP/*23.*

Craftsman, NYTBA/*81.*

craftsmanship, JIWA/*8*; LP.

craftsman's ring, RTA/*95.*

craftsmen, JIWA/*8.*

Craftsmen, the, IDC.

Craig, Major Isaac, CEA/*55*①.

Crailsheim, C-2486/*188*①; LAR82/*130*①.

Crailsheim faience factory, EA.

cramoisi sky, C-2437/*2*①.

cramp-ring, RTA/*58.*

cranberry-coloured, CEA/*474*①.

cranberry glass, K-710/*118*; LAR83/*443*①.

Cranberry pattern, NYTBA/*312.*

cranberry server, S-4804/*28*①.

Crandall, C. M., CEA/*692*①.

Crandall, Jesse, CEA/*692*①.

crane, C-2414/*98*①; DSSA; SDF.

Crane, Walter, DADA/*Supplement.*

cranequin, C-2569/*110*①; C-MARS/*106*; CEA/*21*①.

cranes in flight frieze, S-4965/*245*①.

crane's-neck bottle, EA.

Cranier, CEA/*227*①.

crank key, S-4927/*216*①.

crape-myrtle, DADA.

craquelle, EC1/*56, 59*①.

craquelure, C-2323/*8*; DATT; IDC; JIWA/*348*; LP.

crater, DATT; IDC; MP/*490*①, *502.*

crater-shaped, CEA/*659*①.

cravat, C-1506/*21.*

cravat holder, SDF/①.

Craven Art Pottery, EC1/*78*①.

Craven Art Pottery, East Liverpool, Ohio, EC1/*85.*

crawl, DATT.

crawling, LP.

crayfish salt, IDC.

crayon, DATT; JIWA/25.

crayon manner, DATT.

crayon sauce, DATT.

crazed, C-2493/16; C-5239/3; CEA/697.

crazing, CEA/189①, 209; DADA; DATT; EA; EC1/83; IDC; MP/502.

crazy paving design, C-0604/267.

crazy work, C-2704/56.

Creak, C-2489/202.

cream, C-0982/206.

cream-boat, C-5117/66; IDC/①.

creamboat, LAR83/603①.

cream-colored, S-4843/129①.

cream-colored earthenware, DADA.

cream crackle, S-4461/118.

creamer, C-0254/199; C-5005/222①; C-5114/8, 145①; C-5153/1①, 3①, 14①; C-5203/94; IDC; IDPF/63①; S-4804/23; S-4905/173.

creamers, S-4461/225.

cream ewer, LAR83/576①.

cream glazed, C-5156/33①.

cream-ground carpet, OC/25.

cream-jug, C-0254/311①; C-2398/24①; C-2427/70①; C-5114/2①; C-5117/78①, 87①; C-5153/21①; C-5173/38①; IDC.

cream jug, ACD; C-0706/224; C-1502/17, 54A; C-2458/112; DADA; EA/①; LAR82/581①; LAR83/567①; S-3311/637①.

cream-ladle, C-2510/43.

cream ladle, S-4804/1, 195①; S-4905/167.

cream onyx, C-2910/222.

cream-pail, C-2487/141①; C-2510/43; C-5117/71①; DADA; IDC/①.

cream pail, LAR83/567①.

cream painted, S-3311/393①.

cream pan, IDPF/64.

cream pitcher, C-0225/16; C-5114/56.

cream pot, CEA/662①.

cream satin ground, C-2704/45.

cream soup spoon, C-0254/248; S-4804/64.

creamware, ACD; IDC; K-710/117; LAR82/99①; LAR83/73①, 121①; NYTBA/149①; S-4905/152; C-1006/157; C-1582/104.

creamy white, C-0782/211.

creased, C-5236/942.

crease wear, C-5323/18.

creasing, C-0249/40.

creative, LP.

crèche, CEA/685; LP.

crèche art, DADA.

crèche figure, C-5224/243①; S-4972/278①.

credence, ACD.

crédence, DADA/①.

credence, EA/①; S-4972/478①; SDF.

credence cupboard, S-3311/468①.

credence table, C-0982/121; DADA; SDF.

credenza, C-0249/470; DADA/①; EA/①; LAR82/289①; LAR83/313①.

credenzina, DADA.

creeper, ACD; DADA; EA; SDF.

creepie, SDF.

creese, DADA.

creil, DADA; EA/Creil.

Creil et Montreau, C-2910/137.

Cremnitz white, DATT; LP.

crenate lip, CEA/591①.

crenelated, IDC; S-4461/541.

crenelated border, IDC.

crenelated rim, S-4804/107.

crenellated, S-4972/500.

crenellated base, C-5167/27①.

crenellated border, C-2493/160.

crenellated pediment, C-5116/*148*①.
crenellated stripe, C-2403/*185.*
crenellation, DATT.
crenolated, C-0225/*293.*
crepe de chine, C-0604/*72.*
crescent, C-2458/*229;* C-5156/*363;*
	S-4461/*301;* C-1582/*30.*
crescent brooch, LAR83/*478*①,
	*481*①.
crescentic form, S-4807/*9.*
crescent moon, C-2414/*102*①.
crescent pin, S-291/*168.*
crescent-punched, C-2323/*136.*
crescent-shaped, C-2458/*209*①;
	C-2478/*119.*
crescent-shaped blade, C-MARS/*71.*
Crespel, Sebastian, James, C-5174/
	*553*①.
Crespell, Sebastian and James,
	C-5117/*237.*
Crespell, Sebastian II, C-2510/*104.*
Crespin, Paul, CEA/*650*①; EA.
crespina, C-2486/*231*①; IDC/①;
	LAR82/*183*①; S-4972/*134*①.
cress-dish, IDC.
Cressener cup, CEA/*638*①.
Cressent, Charles, C-5224/*55*①;
	DADA; EA; NYTBA/*16*①;
	S-4955/*198*①.
cresset, ACD; DADA; EA; IDPF/
	64; SDF.
cresset spit dog, LAR83/*469*①.
Cresson, Jean-Baptiste, C-2555/*38*①.
Cresson, Louis, C-2364/*44*①.
Cresson, Louis, stamp: L.
	CRESSON, C-5224/*112*①.
crest, C-0254/*16;* C-0706/*4;* C-0782/
	188; C-2398/*2, 6;* C-5114/*364*①,
	*390*①; C-5116/*90, 118;* C-5117/*5;*
	C-5153/*10*①; C-5156/*739*①;
	CEA/*21*①; EA; EC2/*25*①;
	S-4922/*26*①, *38*①, *56*①.
crested, LAR82/*194*①; S-2882/*913.*
crested arch, S-2882/*681*①.

crested disc, S-3311/*728*①.
crested mask jug, LAR83/*90*①.
crested scrollwork cartouche, S-2882/
	1082.
cresting, ACD; C-0982/*37, 53;*
	C-1407/*1;* C-2357/*23*①; C-2364/
	*10*①; C-2402/*46, 60;* C-2478/*59;*
	C-5117/*293*①; C-5157/*38;* DADA;
	S-2882/*249*①, *311*①, *708*①, *357B;*
	S-3311/*107*①; S-4436/*7*①;
	S-4812/*23;* S-4972/*433*①; S-4988/
	*406*①; SDF/①.
cresting in furniture, EA.
cresting-rail, C-0982/*75.*
cresting rail, C-2402/*7.*
crest or cresting, EA.
crest-rail, CEA/*328*①, *328*①; EA/
	yoke-rail; SDF.
crest rail, C-5114/*277, 289;* C-5189/
	*265*①; DADA; FFDAB/*29, 37;*
	LAR82/*302*①; LAR83/*272*①.
crestrail, S-2882/*665*①, *671*①.
crest-rail tablet, FFDAB/*31*①.
Creswick, J. and N., C-2510/*46.*
Creswick, T. & J., S-4944/*210.*
Creswick, T. J. and N., Sheffield,
	C-2487/*63.*
creta laevis, DATT.
Cretan, IDPF/*55.*
Cretan painting, LP.
cretonne, DADA; SDF.
Creussen, LAR82/*129*①.
crevé, DATT.
crewel, CEA/*277*①; LAR82/*544*①;
	NYTBA/*104;* S-2882/*287*①; SDF.
crewel stitch, DADA.
crewel-work, ACD; NYTBA/*98*①.
crewel work, CEA/*293*①; SDF.
crewelwork, C-1506/*99;* C-3011/*110;*
	DADA/①; S-3311/*270.*
cri, CEA/*594;* EA.
Criaerd, André, C-2555/*61*①.
Criaerd, Mathieu, EA.

Criard, Antoine Matthieu, S-4955/ 202①.

crib, SDF/① *cradle.*

cribbage board, C-5114/*197*①; S-3311/*161*①; S-4461/*371.*

cribbage board and peg box, S-4881/ *167*①.

cribbled, DATT.

criblé, DADA; DATT.

C. Richard, S-4905/*192*①.

Crichton, London, C-MARS/*196.*

Crichton Bros., C-5203/*146A*; S-3311/*701, 703*①.

Crichton Brothers, C-5173.

crich ware, ACD; IDC.

cricket, EA; SDF.

cricket box, LAR82/*142*①.

cricket-cage, IDC/①.

cricket cage, S-4810/*407*①; S-4853/ *405*①.

cricket stool, DADA.

cricket table, C-2382/*98*; DADA; EA; SDF.

cri de l'étain, EA/*cri.*

cries of London, DADA.

cries of Paris, DADA.

Crimean war, C-2704/*60.*

crimped, C-0225/*18*; C-2332/*73*; S-4881/*87*①.

crimped border, C-5117/*192*; C-5174/ *151.*

crimped drip plate, S-4905/*346*①.

crimped-edge, C-5191/*416.*

crimped edge, C-5114/*155*; NYTBA/ *124.*

crimped neck, C-5239/*172.*

crimped semi-circular pediment, C-5114/*236.*

crimped strap handle, C-5114/*124.*

crimped wave rim, C-1502/*104.*

crimper, S-4881.

crimping, CEA/*490*; DADA; EA.

crimson, C-5005/*282*①; DATT; LP; S-3311/*42*①.

crimson lake, DATT.

crinet, DADA.

crinoline, C-2501/*35.*

crinoline figure, IDC/①.

crinoline group, C-5189/*65*①; DADA; EA; LAR83/*135*①; MP/ *115, 478*①.

crinoline rocking chair, SDF.

crinoline stretcher, C-1407/*115*; LAR83/*285*①; S-4812/*192*①.

CR in script, EA/*Crespin, Paul.*

criosphinx, DATT.

Cripps, William, CEA/*650*①, *653*①; EA; S-4944/*357.*

cris de Londres, IDC.

cris de Paris, EA; IDC/①.

cris de Vienne, IDC.

criseby, DADA.

crisp carving, NYTBA/*42.*

crisply, C-5127/*97*①.

crisply carved, C-5116/*161*①.

crisp paint, LP.

crisp relief, C-5156/*301*①.

crisselling, JIWA/*307*①.

cristal dichroïde, EA/*Baccarat.*

cristal jade, JIWA/*307.*

cristallai, EA/*Venetian glass.*

Cristallerie de St Louis, EA.

cristallo, ACD; CEA/*413*①; EA; EG/*61*①.

cristallo-ceramic, EA/*sulphides.*

cristallo-céramie, CEA/*487*①.

cristallo ceramie, EA.

cristal supérieur, EG/*288.*

Cristie-Miller service, IDC.

Cristofori, Bartolommeo, EA.

critic, LP.

crizzelling, DADA.

crizzled glass, EA/①.

crizzling, CEA/*424*①, *502.*

crizzling (crisselling), EG/*287*.

C.R. jug, IDC.

crochet, C-2203/*69*; DADA; SDF/ *crocket*.

crocidolite, C-2332/*42*; C-5117/ *357*①.

crock, EA; IDC; IDPF/*64*①; K-802/*17*.

crockery, IDC; IDPF/*65*①.

crocket, DADA/①; SDF.

crocketted arch, S-4972/*70*.

crocketted gable, S-4972/*401*.

crock handle, IDC.

crock lug handle, IDPF/*155*①.

crock pie, IDPF/*44, 65*.

crocks, C-5114/*154*.

crocodile, C-0103/*56*; C-0706/*215*.

crocodile handbag, LAR82/*36*①.

crocus, C-0225/*20*.

crocus martis, DATT.

crocus martius, DATT.

crocus-pot, IDC.

Croesus, OPGAC/*211*①.

croft, ACD; DADA; EA; SDF.

Croissant, Pierre, CEA/*64*①.

Crolius, DADA.

Crolius, William, CEA/*165*; EA.

Cromwell chair, SDF.

Cromwellian, CEA/*325*①; DADA; LAR82/*39*①; S-4812/*135*.

Cromwellian chair, DADA; EA; SDF/①.

Cromwellian clock, EA/*lantern clock*; SDF.

Cromwell pattern, S-4804/*52*.

Cronus, DSSA.

crook, DSSA/①.

crook handle, S-4881/*211*①.

croquet chair, SDF.

croquet hoop design, CEA/*441*①.

croquis, DATT; LP.

Cros, Henri, DADA/*Supplement*.

Crosby, Samuel T., C-0270/*240*.

cross, C-2486/*76*①; C-2904/*129*; C-5117/*196, 342*①; DATT/①; DSSA.

cross ancrée, DATT.

cross-back, FFDAB/*34*①.

crossback, FFDAB/*46*.

cross-banded, C-5114/*334*①; DADA; S-2882/*307*; S-4414/*430*①, *432*①; S-4436/*104*①; S-4812/*72*①.

crossbanded, C-0982/*39, 83*; C-2320/ *39*①; C-2388/*51*; C-2402/*50, 156*; C-2489/*114*①; C-5116/*4, 10*; S-3311/*97*; S-4461/*666*①; S-4905/ *480*①; S-4972/*494*.

cross-banded and featherbanded hinged sloping front, S-4414/*447*①.

cross-banded border, FFDAB/*27*; LAR82/*325*①.

cross banded cuff, S-4905/*416*.

crossbanded drawer, C-0249/*358*; C-2364/*45*①; C-5116/*109*①.

cross-banded rectangular top, S-4414/ *524*①.

cross-banded shaped rectangular top, S-2882/*267*.

cross-banded top, S-2882/*282*.

crossbanded top, C-5116/*56*.

cross-banding, ACD; CEA/*333*①; EA; S-4414/*445*.

cross banding, SDF.

crossbanding, C-5116/*50*①; FFDAB/ *56*; LAR83/*300*①.

cross-bar, OC/*23*; S-4414/*443*①.

cross bar, C-5114/*184*①; SDF.

crossbar, LAR82/*312*①; S-4928/ *44*①.

crossbeaded, C-0279/*420*.

cross-beat escapement, EA.

cross-bolt, C-2476/*55*.

cross botonée, DATT.

cross bourdonée, DATT.

crossbow, C-2503/*83*①; C-2569/
*110*①; C-MARS/*1, 106*; CEA/
*21*①; DADA/①.

cross-bracing, CEA/*331*①.

cross clechée, DATT.

cross-crosslet, DATT.

Crosse, Richard, C-5117/*101*①; EA.

crossed base, C-5156/*758*①; C-5236/
846.

crossed baton, S-3311/*350*.

crossed linear decoration, LAR83/
*146*①.

crossed members, NYTBA/*24*①.

crossed sword mark, C-0249/*154*.

cross filled rhomboid, S-2882/*137*.

cross fitché, DATT.

cross fleuretté, DATT.

cross fleuronée, DATT.

cross fleury, DATT.

cross flory, DATT.

cross-form, S-3311/*9*.

cross formée, DATT.

cross formy, DATT.

cross fourchée, DATT.

cross-grained moulding, SDF.

cross gringolée, DATT.

cross-guard, DADA.

cross-hatch, C-5114/*139*①.

crosshatch beading, C-5156/*320*.

cross-hatched, C-1082/*4*.

crosshatched, RTA/*85*①.

cross hatch ground, IDC.

cross-hatching, C-5114/*89*①; DATT;
EA; EG/*35*①.

crosshatching, LP.

cross-hatch pattern, LAR82/*439*①.

cross-legged, C-2414/*24*①.

Crossley, R., C-2487/*147*.

Crossley, Richard, EA/*43*①.

cross moline, DATT.

cross of Iona, DATT.

cross of St. Andrews, S-288/*1*①.

crossover design, S-4414/*104*.

crossover ring, S-291/*193*①.

cross patch, C-2704/*112*.

cross pattée, DATT.

cross patty, DATT.

cross pommée, DATT.

cross rail, C-5116/*64*①; SDF/*cross
bar, slat*.

crossrail, C-0249/*412*; DADA.

cross recercelée, DATT.

cross-section, CHGH/*64*.

cross section, DATT/①; S-4972/
*141*①.

cross-sectioned specimen of a cable,
C-2904/*257*.

cross-section paper, DATT.

cross-staff, C-2904/*126*; EA.

cross stitch, CEA/*274*①, *279*①;
SDF.

cross-stitch, C-2522/*1*①; DADA.

cross-stitch carpet, DADA.

cross stitch embroidery, C-2203/*2*.

cross stretcher, C-1407/*28*; DADA.

cross-stretcher, C-0982/*3*; C-2364/
*42*①; C-2388/*29*; C-2402/*5*.

cross stretcher base, LAR83/*352*①.

cross stretcher support, LAR83/
*408*①.

cross-strut, C-2904/*258*.

cross watch, EA.

crotch-grained, C-5157/*174*①.

crotch mahogany, DADA.

crotch veneer, CEA/*392*①.

Crouch, C-2904/*206*.

Crouch, J., C-2487/*115*①.

Crouch, John I, S-3311/*770*①.

Crouch, John II, C-5174/*520*.

crouching dragon, C-2414/*10*①.

crouching posture, JIWA/*36*.

crouch ware, ACD/*crich*; DADA.

crouchware, EA.

Crouch ware, IDC.

crow, DSSA.

crowing Paduan cock, MP/468①.

crown, C-0706/123; C-5117/432; CEA/497①; DSSA; C-2476/70.

crown back, SDF/①.

crown-derby, DADA.

Crown Derby, IDC; NYTBA/180①.

Crown Dresden, IDC.

Crown Ducal, C-2409/124; C-2910/152.

crowned anchor, EA/Derby.

crowned arms, C-2486/101①.

crowned C, EA.

Crowned C, The, S-4955/23 tax mark.

crowned cypher, RGS/31①.

crowned device, RTA/132①.

crowned harp, CEA/637.

crowned medallion, C-2486/191①.

crowned rose, C-1506/106①.

crowned X, CEA/593①.

crown-form, C-5181/21.

crown form, S-4461/197.

crown glass, DADA; EA; SDF.

crown handle, C-5153/64①.

crown hollow blown, EG/156①.

crown Milano, EC1/56; C-5191/277; CEA/472①; LAR83/112①; NYTBA/302.

crown motif, C-5174/45.

Crown of Thorns, CEA/287.

crown rose-cut diamond, S-4414/81; S-4927/105①.

crown rug, S-4847/253①.

crown technique, CEA/484.

crown top, C-5173/20①.

Crown Tuscanware, OPGAC/162.

crown weight, CEA/502; EG/288.

crown wheel, ACD; EA.

crow quill, DATT.

crow's foot, OPGAC/211①.

crozier, C-5224/241①; DADA; DSSA/①; EA.

crozier-back, DADA.

crucible, DATT; DSSA/①; IDPF/65①.

crucifix, C-2498/17; C-5203/110A; DSSA; MP/31.

crucifix clock, EA/①.

crucifix figure, S-4972/10①.

crucifixion, DSSA.

cruciform, C-0279/20①; C-2388/153; C-2458/113①; C-2493/8①; CEA/257①, 441①, 502; DATT; EG/288; S-4507/66①; S-4847/10, 47.

cruciform design, S-4847/34①; S-4948/53.

cruciform lozenge, C-2403/159; C-2478/219.

cruciform medallion, C-2403/163.

cruciform pattern, C-2414/50①.

cruciform rest, C-5117/199①.

cruciform stretcher, DADA.

cruciform watch, S-4927/220①.

cruet, C-0254/141; C-0706/162; C-2202/70; CEA/579, 594; DADA; IDC; IDPF/65①; K-710/118; LAR82/122①, 582①; LAR83/568①.

cruet bottle, C-5114/120.

cruet-frame, C-2487/64; C-5117/242①, 279①.

cruet frame, EA/①; LAR83/568①; S-3311/784①; S-4802/427①; S-4922/84①; S-3311/653.

cruet set, S-4802/324; S-4905/171①; S-4944/62①.

cruet-stand, IDC/①.

cruet stand, C-0254/141; C-1502/93; DADA/①; EA/① cruet frame; LAR83/568①; S-4853/11①.

cruisie, EA.

crumber, C-5114/75; C-5203/29; S-4461/179.

crumb knife, S-4804/35.

crumb scoop, C-0103/*144*; C-1502/*69*.

crumb tray, S-4804/*147A*①.

Crump, Francis, C-2487/*96*①; C-5203/*194*; S-4922/*53*①.

Crunden, John, ACD; DADA; EA; SDF/*749*.

cruse, IDPF/*66*.

crushed egg shell, C-5146/*67*①.

crushed relief, DATT.

crushed velvet, C-0405/*81*; C-0604/*98*.

crusher, MP/*87*.

crushing mill, MP/*191*.

crusie, SDF/①.

crust, C-5236/*341*.

crustae, DADA.

crutch, C-2364/*52*①; DSSA.

Crutched Friars, CEA/*420*①.

Crutched Friars Glass House, EA.

Crutchfield, William, S-286/*22*.

crutch piece, C-2489/*97*①.

crux ansata, DATT.

crux commissa, DATT.

crux decussata, DATT.

cruxifiction scene, C-1506/*118*①.

cruxiform, S-4461/*21*.

crux immissa, DATT.

Cruyck, G. L., CEA/*141*①.

cruzie lamp, DADA.

Crylla, DATT.

cryolite, DATT.

cryptocrystalline chalcedony, S-4810/*347*.

crystal, C-5005/*213*①; C-5236/*849*; C-5239/*137*; CEA/*513*; OPGAC/*212*; S-4802/*37*①.

crystal, full, half lead, CEA/*502*.

crystal glass, DADA; EG/*285*.

Crystalleries St.-Louis, NYTBA/*286*.

crystalline, C-0225/*77*.

crystalline glaze, DATT; EC1/*83*; MP/*502*.

crystalloceramic, LAR82/*449*①.

Crystallo-Ceramic, CEA/*450*①.

crystallo ceramie, ACD.

crystallo-ceramie process, EG/*150*①.

Crystal Palace, CEA/*501*①.

crystal regulator, CEA/*229*①, *249*①.

crystal vase, S-291/*151*①.

crystal watch, EA.

crystal wedding, OPGAC/*212*.

c-scroll, SDF; C-2414/*7*①; C-2458/*232, 309*; C-2478/*175*; C-5116/*117*; C-5153/*16*①; C-5156/*311*; DADA.

C-scroll (in silver), EA.

C-scroll, IDC; S-3311/*216*①; S-4414/*467*①; S-4436/*52*①.

C-scroll arm, S-4414/*245*①.

C-scroll brackets, C-5116/*137*①.

C-scroll cartouche, C-0249/*459*.

c-scroll carved crestrail, S-2882/*677*①.

C-scroll-carved tripod cabriole leg, S-4414/*467*①.

C-scrolled, C-0982/*32, 53*.

C-scrolled back, C-1407/*90*.

C-scrolled border, C-2402/*30*.

C-scrolled handle, LAR83/*158*①.

C-scrolled support, C-5116/*94*①.

C-scroll handle, C-5114/*96*①; S-2882/*933, 1079*①, *1195*①, *1301*; S-4804/*143*①.

C-scroll spandrel, S-4414/*388*①.

C-shape, C-2458/*14*①.

C-shaped handle, IDC.

C-shaped support, C-5116/*161*①.

C. Smith & Son, CEA/*534*①; S-4988/*409*①.

C. Stevens & Son, C-2904/*32*.

C.T, CEA/*178*①, *178*①.

CT, EA/*Mosbach*.

C. Tinelly à Aix, EA/*148*.

CTP (color trial proof), S-286/*472A*.

Cuban mahogany, SDF.

Cuban sabicu, SDF.

cube, DSSA.

cube and bun foot, CEA/308①.

cube marquetry, LAR83/50①;
S-4972/542.

cube parquetry, C-0279/450①;
S-4955/75①.

cube-pattern, C-2320/99; C-2546/54.

cube pattern, C-0279/373, 380.

cube-patterned casing, C-0403/27.

cube-shaped, C-5174/267①.

cube table, SDF.

cubic zirconia, RTA/146.

Cubism, DATT/①; JIWA/399; LP;
RTA/141.

cubist, C-5146/53①.

cubist work, NYTBA/184.

cubitiere, DADA.

Cucci, Domenico, EA.

cuckoo clock, CEA/239①; EA;
EC2/97①; SDF; EA/Black Forest
clock.

cucumber green glaze, IDC.

cucumber server, C-0254/293;
C-0270/104.

cucumber slicer, EA/①.

cudbear, DATT.

cuenca, CEA/130; DADA; IDC;
EA/Alcaraz carpet.

Cuenca carpet, EA.

cuenca technique, EA/①.

Cuenca tile, C-2427/175.

cuerda seca, CEA/130; DADA; EA/
①; IDC.

cues, C-0906/115.

Cuevas, Jose Luis, S-286/249.

cuff box, C-5181/1.

cuffed, C-5174/136①.

cufflink, C-5114/82; S-4927/255.

cuff-link, C-5117/360①.

cuffs, C-5114/317①, 373①; C-5153/
116①; S-4905/480①.

Cuff-type microscope, C-1609/70.

Cufic script, EA.

cuirass, C-2503/40; C-MARS/104①;
DADA; DSSA.

cuirassier, S-4972/166①.

cuisse, DADA.

cul-de-lampe, CEA/376①.

culet, RTA/170①.

cullet, CEA/502; EA; EG/236, 286.

Culpeper, C-2904/247①.

Culpeper, Edmund, CEA/610①.

Culpeper type, C-2904/277.

Culpeper-type compound microscope,
CEA/610①.

Culpeper-type microscope, C-1609/76.

cultured Biwa pearl, S-291/94①.

cultured pearl, C-5117/424①;
S-4414/7.

Cumberland, Duke of, IDC.

Cumberland-action drop-leaf, LAR83/
373①.

cumdach, DADA.

cumfitt box, CEA/61.

Cumming, Alexander, ACD; C-2368/
97①.

Cummings, Thomas Sier, EA.

Cunningham and Cogans, S-4881/
305①.

cup, C-0254/43; C-0782/117;
C-2414/30①; C-2458/130;
C-5114/37①; C-5153/42①;
DSSA; IDC; IDPF/66①.

cup-and-baluster leg, C-2388/79.

cup and cover, DADA/①; SDF.

cup-and-cover baluster, C-5157/62.

cup-and-cover motif, EA.

cup and saucer, S-4905.

cup-board, CEA/323①.

cupboard, ACD; C-0249/331;
C-0982/23; C-5114/297①;
C-5153/87; C-5239/283; CEA/
308①; DADA; S-4905/481①;
S-4972/568①; SDF/①.

cupboard chest, C-0982/68.

cupboard door, C-0249/*456*①;
C-0982/*126A*; C-2357/*36*①;
C-2403/*96*; C-5116/*56*; C-5153/
*103*①; S-4461/*735*.

cupboard stool, SDF.

cup bowl, CEA/*423*①.

cupel, EA/*cupellation*.

cupellation, EA.

cup-hilt, C-MARS/*22*.

cup hilt, S-4972/*251*.

cup-hilt rapier, C-2569/*25*.

cupid, C-2704/*111*; CEA/*135*①;
DATT; C-2398/*11*①; CEA/*227*①;
DSSA.

Cupid and Venus, OPGAC/*212*.

cupid angle, C-2555/*64*①.

Cupid motif, C-2493/*234*①.

cupid's-bow, S-3311/*144*.

cupid's bow, DADA; EA; SDF.

cupid's bow crestrail, S-4461/*586*.

cupola, C-2498/*14*; C-5117/*342*①;
C-5174/*155*①; CEA/*541*.

cupola form, S-2882/*331*.

cupola shape, C-5146/*170*①.

cupped lower body, C-5114/*25*①.

cupped mouth, C-5127/*132*; C-5156/
*108*①; C-5236/*372*①.

cupped top, EA; SDF.

cupping-bowl, IDC.

cupping-dish, EA/*bleeding-bowl*.

cupping or bleeding bowl, NYTBA/
217.

cup plate, CEA/*465*①; DADA; EA;
IDPF/*68*; K-711/*123*; NYTBA/
294.

cuprite, C-5156/*340*; S-3312/*1281*①.

cup salt, EA.

cup-shaped mouth, S-4965/*172*①.

cup shaped rim, C-5127/*15*.

cup-shaped terminal, RTA/*22*①.

cup stand, C-2458/*283*①; DADA;
IDC; IDPF/*68*.

cup-warmer, IDC/①.

curate, SDF.

curb, SDF.

curb link, C-5117/*407*①; S-4927/*387*.

curb link chain, C-5117/*396*①.

curcuma, DATT.

cure, DATT.

curfew, ACD; CEA/*530*①; EA/①;
IDC; IDPF/*68*①; SDF.

curio, DADA.

curio cabinet, DADA; NYTBA/*78*①.

curiole stretcher, LAR82/*316*①.

curl, CEA/*405*; SDF.

curled leaf, C-2458/*415*.

curled maple, FFDAB/*30, 47*①.

curl ground, IDC.

curl-hook, C-2403/*206*.

curl-hooked, C-2403/*203*; C-2478/
267.

curl-hooked border, C-2357/*132*.

curlicue, OC/*54*.

curling motif, OC/*210*.

curly, C-5114/*339*①; C-5153/*185*①.

curly ash, C-5116/*17*.

curly grain, SDF.

curly maple, C-5153/*91*; DADA;
S-3311/*192*①; S-4461/*575*①;
S-4905/*349, 426*①.

curly walnut, C-5114/*379*①.

Curragh, DADA.

currant washer, IDPF/*69*①.

curricle, SDF/①.

curricule, EA.

Currier and Ives, CHGH/*36*;
OPGAC/*212*.

Currier & Ives, NYTBA/*206*.

Curry, Jean Steuart, S-286/*252*①.

cursive, DATT.

cursive geometric motif, C-1082/*30*.

curtain, C-1506/*101*; DATT;
OPGAC/*212*; SDF.

curtain and valance, C-5174/*9*.

curtain border, C-5146/*175*①.

curtain cornice, SDF.

curtain-holder, EA/①; SDF.

curtain holder, DADA.

curtain piece, SDF.

curtain rail, LAR83/*350*①; SDF/ *curtain rods.*

curtain rod, SDF.

curtain tape, SDF.

Curtis, Lemuel, C-5153/*176*①; EA.

curule, ACD; C-5114/*254*①; C-5189/ *261*; DADA/①; FFDAB/*39*.

curule armchair, C-5116/*98*①.

curule chair, EA.

curule-formed, FFDAB/*29*①.

curule frame (in furniture), EA.

curule support, FFDAB/*26*.

curve, DATT.

curved back, C-2370/*29*①.

curved-back thumb-rest, CEA/*203*①.

curved foliage spout, C-5117/*130*①.

curved groove, JIWA/*132*.

curved handle, C-5117/*202*①; IDPF/ *119*①.

curved lattice back, LAR83/*273*①.

curved lip, C-2398/*90*.

curved profile, MP/*464*①.

curved stem, C-5117/*83*①.

curved support, C-2437/*22*①.

curved toprail, C-2421/*14*①.

curvetto, C-0982/*85*.

curvetto cornice, C-0982/*84B*.

Curvex, S-4927/*3*.

curvex wristwatch, S-4802/*63*①.

curvilinear, C-0982/*15*; C-2324/*265*; OC/*11*①.

curvilinear back, C-0982/*107*.

curvilinear design, OC/*11*; SDF.

curvilinear filigree pattern, RTA/ *65*①.

curving baluster form, S-2882/*1291*①.

cushion, C-5116/*64*①; DADA; SDF.

cushion border, C-5170/*96*①.

cushion cover, C-2704/*14*.

cushion-cut, C-5005/*205*①; RTA/*94*, *165*①; S-291/*1*, *21*①.

cushion-cut diamond, S-291/*103*①.

cushion-cut emerald, S-291/*173*①.

cushion-cut ruby, S-291/*78*①, *150*①.

cushion-cut sapphire, S-291/*170*.

cushioned, C-0982/*59*; C-5156/*405*.

cushioned edge, C-5156/*486*①.

cushion foot, C-5146/*89C*①.

cushion frame, C-2388/*125*; C-2421/ *46*①; C-2498/*78*; S-3311/*183*.

cushion frieze, C-2364/*42*①; DADA; SDF.

cushion glass, C-1407/*79*.

cushion knop, CEA/*427*①; LAR82/ *454*①; LAR83/*451*①.

cushion molded frame, S-2882/*286*①.

cushion-moulded, C-5116/*166*①.

cushion ruby, S-291/*92*①, *178*①, *195*①, *239*①.

cushion sapphire, S-291/*114*①.

cushion seat, C-0249/*367*; C-2403/ *24*; C-5005/*331*①, *332*①; C-5116/ *137*①.

cushion shape, CEA/*69*①.

cushion-shaped, S-4927/*134*①.

cushion-shaped emerald, S-4414/ *122*①.

cushion-shaped ruby, S-4414/*139*.

cusp, CEA/*502*; DADA/①; DATT; EA/*Abbotsford style*; EG/*288 stem knop*; SDF.

cusp-back, EA; SDF/①.

cusped, C-2402/*70*, *154*; C-2403/*197*; C-2478/*238*; C-5153/*178*①, *201*①; C-5157/*46*.

cusped border, C-5114/*1*, *52*①.

cusped corner, C-5153/*85*, *187*①.

cusped medallion, C-2388/*166*; C-2403/*180*.

cusped setting, RTA/*76*①.

cuspidor, EA; IDC; S-4461/*112*; SDF.

cuspidore, SDF/*cuspidor*.

cusps, C-0982/*124A*.

custard bowl, C-0249/*269*.

custard cup, C-0254/*210*; C-5236/*1770*; IDPF/*69*.

custard-cup, C-2427/*25*; CEA/*183*①; IDC/①.

custard cup and domed cover, C-2458/*142*.

custard glass, DADA/*Supplement*; OPGAC/*185*.

Custode, Pierre, EA.

custodia, CEA/*620*①; EA.

cut, C-5236/*842*①; CEA/*415, 459*; DATT.

cut and voided velvet, NYTBA/*87*①.

cut-away, IDPF/*133*.

cutaway coat, C-2501/*2*.

cut-away demonstration model, C-MARS/*142*.

cut-ball foot, S-2882/*378*.

cut base, C-5114/*120*.

cut bird pattern, NYTBA/*39*.

cut block lug handle, IDPF/*155*①.

cut-brass, C-2421/*51*①.

cut-brass panel, C-2403/*150*①.

cut-card, S-4802/*299*.

cut-card decoration, CEA/*678*.

cut card mark, C-0254/*94*.

cut-card ornament, CEA/*641*①.

cut-card work, C-5174/*598*①; DADA; DATT; EA/①; S-4802/*457*①.

cutch, DATT.

cut-corner, S-4927/*437*.

cut corner, C-0406/*96*; C-2398/*26*; S-4507/*38*①.

cut crystal, C-0279/*157*; C-5239/*137*; EG/*118*.

cut down, C-5239/*133*.

cut face, IDPF/*71*①.

cut facet, IDPF/*71*①.

cut faceted side, C-5114/*121*.

cut feet teapot, CEA/*156*①.

cut foot, IDPF/*57*①.

cut-glass, C-0982/*46*; C-1502/*93*; C-2398/*30*①; C-2421/*4*①; C-5116/*36*; C-5117/*311*①; LAR82/*432*①; S-3311/*263*; S-4436/*63*①; S-4804/*128*①; S-4922/*29*①; S-4972/*429*; S-4988/*428*.

cut glass, C-0254/*111*; C-5114/*120*; DADA; EA; EC1/*56*; LAR83/*415*①; OPGAC/*186*; S-2882/*844*①.

cut glass, American, DADA/*Supplement*.

cut-glass bowl, S-4804/*105*.

cut-glass prism, S-4414/*424*.

Cuthbert and Tulley, CEA/*611*①.

cutlass, CEA/*44*; DADA.

cutlass bayonet, CEA/*36*①.

cutlasse, C-2503/*9*.

cutler's mark, C-2332/*44*.

cutlery, S-4905/*330*.

cutlery-box, C-2478/*28*.

cutlery canteen, LAR83/*578*①.

cutlery handle/box, IDPF/*69*①.

cutlery urn, C-0906/*169*; CEA/*362*①; LAR82/*71*①.

cut log, OPGAC/*213*.

cut-off object, JIWA/*6, 239*.

cut-off technique, JIWA/*243*①.

cutout, NYTBA/*196*①.

cut-out, S-4905/*327*①.

cut-out (ausgeschnitten) border, MP/*492*.

cut-out iron, LAR83/*661*①.

cut-out rim, IDC.

cut-out sheet, C-5236/*392*①.

cut-paper, C-1603/*141*.

cut rim, IDPF/*69*①.

cut-sided bowl, IDPF/*70*①.

cut sliced fruit painter, EA.

cuts of gemstones, RTA/*95*①.

cut steel, EA/①.

cut steel jewellery, EA.

cut swirl, C-0254/*271*.

cutter, DATT; LP/① *brushes*.

cutting, C-0225/*316*; EG/*265*; IDPF/ *71*①.

cutting out, MP/*36*.

cutting technique, JIWA/*201*.

cuttlebone, LP.

cuttlefish ink, DATT.

Cutts, John, ACD.

cutty stool, SDF.

cut-velvet, C-0604/*292*.

cut velvet, C-0279/*409*①; C-5156/ *475*.

cut-work, SDF.

cutwork, C-2203/*41*, *106*; DADA.

cutwork and drawn threadwork, C-2704/*154*.

cuvete, S-4802/*2*①.

cuvette, C-5117/*395*①; LAR83/ *214*①; S-291/*2*, *118*①, *263*; S-4802/*1*; S-4927/*41*①.

cuvette à fleurs, IDC.

Cuvilliés, François de, DADA.

CV, EA/*Kloster-Veilsdorf*.

cyan, DATT.

cyanine blue, DATT; LP.

cyathus, IDC.

Cycladic, DATT/①.

cycloidal cheek, C-2489/*84*①; S-4927/*87*①.

Cyfflé, Paul-Louis, EA.

CYFFLE A LUNEVILLE, EA/*Cyfflé, Paul-Louis*.

CYFFLE/A LUNEVILLE, EA/ *Lunéville faience factory*.

cylinder, C-2437/*70*①; CEA/*36*①, *484*; IDPF/*73*①; S-4972/*259*①.

cylinder bureau, C-2403/*134*; C-2421/*113*①; CEA/*356*①; LAR83/*250*①.

cylinder cabinet, S-4812/*195*①.

cylinder desk, C-5189/*272*①; DADA.

cylinder door, S-2882/*322*.

cylinder escapement, C-5117/*392*①; EA/*horizontal escapement*.

cylinder fall, SDF/①.

cylinder front desk, LAR83/*331*①.

cylinder jar, LAR82/*32*①.

cylinder knop, CEA/*423*①.

cylinder movement, S-4802/*12*; S-4927/*31*, *39*.

cylinder pin, S-4972/*234*.

cylinder seal, S-4807/*485*.

cylinder top, C-5116/*29*①; C-5153/ *174*①.

cylinder-top desk, C-2402/*29*; EA.

cylinder top desk, S-4972/*547*①.

cylinder-topped, CEA/*351*①.

cylinder top writing desk, LAR83/ *253*①.

cylinder watch, C-5117/*447*, *471*①; C-5174/*370*; LAR82/*238*①; LAR83/*213*①.

cylindrical, C-0225/*9*; C-1006/*94*; C-5153/*4*①, *12*①; C-5239/*38*, *289*; S-4804/*9*.

cylindrical base, C-5116/*38*.

cylindrical basin, C-5127/*49*.

cylindrical body, S-4922/*8*①.

cylindrical bowl, C-5114/*147*.

cylindrical box, C-0782/*88*.

cylindrical castor, CEA/*668*①.

cylindrical decoration, S-4414/*148*①.

cylindrical feet, C-0279/*458*.

cylindrical foot, C-5114/*31*①.

cylindrical form, S-4414/*177*①; S-4461/*12*.

cylindrical glass stick, CEA/*490*.

cylindrical leg, C-2414/*7*①, *9*①; C-5114/*399*①.

cylindrical mug, C-1006/*77*; C-5127/ *229*①.

cylindrical neck, C-1082/*92*; C-2414/ *45*①; C-2458/*39*, *164*①, *170*;

C-5114/*29*①; C-5127/*5*①;
C-5153/*5*①; S-4414/*196*①, *201*①,
*205*①, *232*; S-4461/*15*.
cylindrical pedestal, S-4992/*1*①.
cylindrical plinth base, S-2882/*1029*.
cylindrical section, S-4461/*20*①.
cylindrical sided, C-5156/*2*①.
cylindrical spout, C-2414/*46*①;
C-5156/*27*.
cylindrical standard, S-4414/*184*①,
*228*①.
cylindrical stem, C-5127/*24*①.
cylindrical teapot, C-0782/*2*; C-2458/
91.
cylindrical tumbler, LAR83/*441*①.
cylix, DATT; IDC.
cyma, DATT/①; IDC.
cyma-curve, S-4461/*707*.
cyma curve, DADA.
cymaise, DADA/①; EA/*cimaise*.
cyma recta, ACD; EA; SDF.
cyma recta pediment, LAR83/*325*①.
cyma reversa, ACD; EA; SDF.

cymarre, EA/*cimaise*.
cyma scroll, FFDAB/*84*.
Cymric, C-2409/*172*; C-5167/*142*①.
Cymric pattern, LAR83/*547*①.
cypher, C-2510/*101*①; C-5117/
*156*①, *293*①; C-5153/*37*①;
C-5173/*36*①; S-286/*277*; S-3311/
*784*①; S-4922/*12*①.
cypress, ACD; DADA; SDF.
cypress tree cartouche, S-4948/*131*①.
Cyprian green earth, DATT.
Cypriot, C-1582/*4*; IDPF/*55*.
cypriote, C-5146/*151*①.
'Cyprus chest', LAR83/*404*①.
Cyprus style, S-4461/*466*.
Cyprus umber, DATT.
cyst, LAR82/*442*①.
cytise wood, DADA.
Czar's Bell motif, C-5174/*268*.
Czechoslovak contemporary glass,
DADA/*Supplement*.

D

D, CEA/*141*①.
dabber, DATT/①.
Dabir Kashan rug, S-4796/*174*.
dab painting, J1WA/*88*.
dacha motif, C-5174/*258*①.
Dacian, OC/*264*.
da Costa, Antonio Firmo, C-5117/*172*.
Dada, DATT; LP.
dado, DADA.
Daedalus, DSSA.
Daffinger, Moritz Michael, EA.
daffodil, EA/*Jacobite glass*.
daffodil lamp, LAR83/*486*①.
daffodil table lamp, C-5005/*412*①.
dag, DADA.
Dage, L., C-GUST/*8*.
Dagestan (Daghestan) carpet, EA.
Dagestan rug, S-3311/*69*①.
dagger, C-5117/*313*①; CEA/*21*①; DADA; DSSA; RGS/*134*; S-4972/*230, 243*①.
dagger handle, C-5156/*435*.
dagger pin, S-291/*135*.
dagger striper, DATT.
Daghestan, CEA/*83*①; OC/*194*①, *210*①; S-4847/*25, 165, 171*.

Daghestan prayer rug, S-4461/*812*; S-4796/*32*①.
Daghestan rug, DADA/①; LAR82/*547*①; S-4461/*794*; S-4796/*27, 68*.
dagobert chair, DADA.
Dagoty porcelain, NYTBA/*172*.
dagswain, SDF.
daguerreotype camera, C-1609/*281*.
daguerreotype sliding box camera, C-1609/*166*.
dahlia, OPGAC/*213*.
Dahlskog, Ewald, DADA/*Supplement*.
Dahlstrom, Sven, S-4944/*147*①.
Daikoku, C-1082/*122*.
daimyō nanako, DADA.
dais, C-5156/*193*①; SDF/①.
dai seppa, DADA.
dai-shō, DADA.
daisho, S-3312/*1064*.
dai-shō-no-soroimono, DADA.
daisho stand, S-3312/*1064*.
daisy and button, OPGAC/*214*①.
daisy and button with cross bars, OPGAC/*213*①.
daisy-head meander, C-2458/*64*.
daisy-in-hexagon, DADA.
Dakon, C-2409/*255*.

Dakota, OPGAC/*215*.

Dalen, Lieven van, CEA/*142*①.

Dali, OC/*173*①.

Dali, Salvador, S-286/*253*①.

Dallas Pottery, Cincinnati, Ohio, EC1/*85*.

dalles de verre, EG/*54*.

Dallwitzer Nagel, IDC.

dalmatic, DADA/①; DSSA.

Dalou, Jules, EA/①.

Dalpayrat, Adrien-Pierre, DADA/ *Supplement*.

D'Alva bottle, IDPF/*73*.

damaged, S-4972/*248*①.

damar, DATT.

damascene, C-0225/*303, 333*; C-5156/*413*①; DATT; LAR82/ *515*①; CEA/*96*.

damascened, C-5236/*332*①; EG; S-4802/*1, 4*①; S-4972/*159*①; C-5117/*399*①.

damascene shade, S-4414/*233*; C-5005/*401*①.

damascening, ACD; C-5005/*236*; CEA/*540*①, *541*; DADA; EA; SDF.

damascus, S-4972/*160*①; IDPF/ *225*①.

damascus barrel, S-4972/*162*①.

Damascus carpet, EA.

Damascus pattern, C-2569/*53*①.

damascus steel, S-4972/*252*①.

Damascus-twist, C-2503/*213*①.

Damascus ware, EA; IDC.

damask, C-0279/*299*; C-1407/*135*; C-2203/*77*; C-2388/*21*; C-2704/ *116*; C-5157/*42*; DADA; NYTBA/ *86*; SDF.

damask'd, IDC.

damaskeening, SDF/*damascening*.

damask runners, C-2704/*140*.

Damaskus tile, S-4461/*445*.

damassin, SDF/*damask*.

Damcan, C-5156/*221*.

Dameral, EA.

dammar, LP.

Dammouse, Albert Lous, DADA/ *Supplement*.

Damo, S-4810/*283*①.

Danaë, DSSA.

Danby, D., London, C-2489/*170*.

dance crest, S-4807/*424*①.

dance mask, C-5236/*1745*.

Dancer, J. B., C-2904/*123*①, *187*.

Dancer, J. B., Manchester, C-2489/ *129*.

.dance staff, C-1082/*4*.

dancette, SDF.

dancing Bala Krishna, C-1082/*109*.

Dancing Hours, the, IDC/①.

dancing jack (pantin), CEA/*697*.

Dancing Lesson, the, IDC.

dancing maenad, RGS/*106*①.

dan day chair, SDF.

dandelion, DSSA.

Dane, Thomas, CEA/*672*①.

Danecraft, C-5239/*98*.

Danese, Bernardino, C-5224/*282*①.

Danforth, Thomas, CEA/*590*.

Danforth, Thomas, II, S-4905/*318*.

Danfrie, P., CEA/*604*①.

d'Angoulême, Duc, CEA/*185*①.

Daniel, ACD.

Daniel, Joseph and Daniel, EA.

Daniel, Thomas, C-2487/*76*.

Daniel Holy, Parker & Co., C-2510/ *4*.

Daniell, Jabez, C-2487/*94*.

Daniell, Thomas, C-2487/*154*.

Daniel Mylius, EA/*158*.

Daniel Piers, S-3311/*780*.

Daniel's, C-1006/*84*.

Daniel Smith and Robert Sharp, C-0706/*246*.

Daniel's Real Ironstone, C-2493/*155*.

Daniel van Pilcom, EA/*148.*

Danish Contemporary Arts and Crafts, DADA/*Supplement.*

Danish knife, C-0270/*169.*

Danish modern furniture, DADA/*Supplement.*

Danish Rococo, S-3311/*502*①.

Danish style, S-4461/*281.*

Dannecker, Johannes Heinrich von, MP/*190.*

Dannhäuser, Leopold, EA.

Dannhöfer, Johann Philipp, MP/*166.*

Dannhöfer, Joseph Philip, EA.

Dannhöfer, Joseph Phillip, CEA/*138*①.

Dannhoffer, C-2486/*135*①.

Danse Macabre, DSSA.

Danske chest, SDF.

Danske pot, EA.

Dantesca, NYTBA/*25.*

Dantesca chair, DADA.

Dante-style, LAR82/*314*①.

Danube school, DATT.

Danzig chest, EA; SDF/*Danske chest.*

Daoguang, C-2458/*117*①, *155;* C-5127/*120;* C-5156/*168*①; LAR83/*86*①.

Daoguang period, LAR82/*111*①.

Daoist emblem, C-5156/*117*①.

Daoist Immortal, C-2458/*159;* LAR82/*48*①.

Dao Ji, C-2414/*98*①.

Darby and Joan chair, SDF.

D'Ardenne de Tizac, H., C-2458/*294.*

Dargent, Claude, EA/*351*①.

D'Argental, C-5005/*238;* C-GUST/*55.*

D'Argenthal, C-5191/*250.*

Darjezine, OC/*284*①.

dark and light, LP.

dark horn, S-4928/*15*①.

dark mustard, C-1506/*129.*

dark outline, JIWA/*36.*

Darley, Matthew, EA.

Darly, Mathias, ACD; DADA; SDF/*749.*

darn, DADA.

darned netting, DADA.

darnex, SDF.

darning, C-1506/*121*①.

Darricarrère, Roger, DADA/*Supplement.*

dart, C-2202/*57.*

dart-beaded border, C-1407/*57.*

Darte, C-2493/*249.*

darting gun, S-4881/*310*①.

dart-motif, C-2357/*132.*

dart pattern band, C-5127/*228*①.

Darty porcelain, NYTBA/*172.*

daruma, S-4810/*320*①; C-1082/*122.*

Daruma tumbler figure, CEA/*689*①.

Darwall, John, CEA/*654*①.

Darwin, Erasmus, service, IDC.

da Savino, Guido, EA.

dash border, C-5114/*213*①; IDC.

dash motif, C-2360/*130*①.

da Silva, Antonio Gomes, C-5174/*38.*

date, DSSA; OC/*31.*

date aperture, C-5157/*35*①.

dated, S-4905.

date flask, LAR83/*426*①.

date indicator, CEA/*251*①.

date-letter, DADA; IDC.

date letter, C-2486/*6*①; C-2487/*37.*

date letter (in ceramics), EA.

date letter (in gold and silver), EA.

date-mark, IDC.

date mark, NYTBA/*213*①.

date panel, S-288/*2*①; S-4461/*321.*

Dattel, Heinrich, EA.

Daubigny, C. F., S-286/*70.*

Daulatabad, OC/*141*①.

Daum, C-2409/*28;* C-2910/*44;* C-5005; C-5239/*163;* JIWA/*92;*

K-710/*118*; LAR82/*432*①;
LAR83/*422*①; OPGAC/*156*.

Daum, Nancy, C-5181/*12*.

Daum brothers, JIWA/*10*; CEA/
*488*①.

Daumenglas, EA/*349*①.

Daum Frères, DADA, *supplement*.

Daum glass vase, C-2324/*146*①.

Daumier, Honoré, S-286/*24*.

Daum Nancy, OPGAC/*15, 156*;
S-3311/*896*①.

Daunian buffware, C-1582/*21*.

Dauphiné, DADA.

Dautel à Paris, C-5224/*50*.

davenport, C-5189/*277*; DADA/①;
SDF/①.

Davenport (1), ACD.

Davenport (2), ACD.

Davenport, C-0982/*9, 46*; C-1006/*4*;
C-2502/*70*; CEA/*158*①, *357*①;
DADA; LAR82/*340*①; LAR83/
*86*①, *317*①; S-4843/*150*①.

Davenport, Isaac, C-2487/*131*.

Davenport, John, EA/①.

davenport bed, SDF.

Davenport desk, LAR83/*317*①.

DAVENPORT LONGPORT, EA/
Davenport, John.

davenport style desk, K-802/*15*.

davenport table, SDF.

Daventry, Nicholas, C-MARS/*181*.

D'Avesn, C-2324/*108*.

D'Avesn, P., C-5191/*242*.

DAVID, EA/*Roentgen, David*.

David, E., C-5167/*163*.

David, Jacques Louis, DADA.

David, John, C-5153/*34*①; CEA/
*675*①; S-4905/*178*.

David King, S-4922/*70*①.

Davidson & Company, EA.

David White Co., C-2904/*47*.

Davies, John Derby, C-2904/*190*.

Davies, Robert, CEA/*533*①.

Davis, Alexander Jackson, DADA/
Supplement.

Davis, Edward, S-4905/*224*.

Davis, John, CEA/*607*①.

Davis, Stuart, S-286/*259*①.

Davis, William, CEA/*187*.

Davis Collamore & Co. Ltd., C-5189/
216.

Davis & Flight period, CEA/*187*.

Davis's quadrant, EA/*back-staff*.

**Davydov, Jakov Alexejevitsh
(assaymaster),** C-5174/*60*①.

Davy's gray, DATT.

Daws, R, C-2370/*34*.

Dawson, Nelson, CEA/*519*①.

Dawson & Sons, C-2904/*134*.

Day, Daniel, SDF/*749*.

Day, Lewis Foreman, DADA/
Supplement.

Day, Robin, SDF/*749*.

Dayak, C-1082/*8*.

Da Ya Studio, C-5156/*469*.

day-bed, ACD; CEA/*306*①, *325*①;
EA/①; SDF/①.

day bed, DADA/①; LAR83/*344*①;
S-4507/*78*①; S-4812/*66*①;
S-4853/*422*①; S-4972/*493*.

daybed, C-0279/*295*①; C-2403/*79*;
C-5239/*249, 265*; S-4804/*899*①.

400-day clock, EC2/*96*①.

day dress, C-3011/*15*.

daylight fluorescent color, DATT.

day-or-night telescope, C-2608/*77*.

**Dayton Porcelain Works, Dayton,
Ohio,** EC1/*85*.

8-day wall clock, CEA/*238*①.

DB, EA/*Worchester*.

DC, EA/*Clayton, David*.

DCF in oval, EA/*Fueter*.

deacon's mark, EA.

dead-beat, S-3311/*445*.

dead-beat escapement, C-5116/*47*;
EA.

dead beat escapement, CEA/*236*①.

deadbeat escapement, C-2489/*76*①.

dead-beat pinwheel, C-2364/*52*①.

dead coloring, DATT.

dead-end, OC/*276*.

dead-leaf, C-2486/*140*①.

dead-leaf brown, IDC.

dead leaf brown, EA.

de-air, DATT.

deal, ACD; CEA/*405*; DADA; SDF.

dealer, LP.

dealer's mark, IDC.

Dean, William, NYTBA/*300*.

Death, DSSA.

death mask, DATT; S-4807/*212*①.

death's-head ring, RTA/*108*①.

death-watch beetle, SDF.

Debain, S-3311/*653*.

Debaufre, Jam, S-4927/*35*.

Debaufre, Peter and Jacob, EA.

de Bauve, Matthieu, stamp: BAUVE, C-5224/*63*.

Debay, A., C-1582/*41*.

de Bettignies, Maximilien-Joseph and Henri, EA.

Debrie, Henry-Nicolas, S-4944/*191*.

Debrie, Jean, C-5174/*485*.

decadence, DATT.

decadent art, DATT.

decadent period, DATT.

decade ring, RTA/*57, 81*①.

decafoil, C-5156/*221*.

decagonal, C-0403/*172*; C-1702/*156*.

decal, CEA/*697*; DATT.

decalcomania, DATT/①; IDC.

de Caluwe, Jacobus, EA/*de Caluwe, Jacobus*.

Decamps, LAR82/*40*①.

decanter, ACD; C-0279/*159*; C-0706/*112*; C-5114/*121*; C-5239/*100*①; CEA/*424*①; DADA; EG/*152*①;

LAR82/*436*①; NYTBA/*281*; S-3311/*639*; S-4436/*63*①.

decanter bottle, IDC.

decanter box, C-0906/*96*.

decanter caddy, C-2403/*11*.

decanter coaster, LAR83/*562*①.

decanter label, LAR83/*645*①.

decanter set, C-5239/*100*①.

decanter stand, C-0706/*161*; C-1502/*96*; C-5117/*3*①; C-5203/*7*①; DADA; S-4812/*164*; SDF.

decanter trolley, S-4944/*221*①.

Deceit, DSSA.

deception bed, DADA.

deception table, EA; SDF/①.

deceptive bowl, CEA/*436*①.

deceptive glass, LAR83/*452*①.

décharge, C-2427/*3*.

dechelbecher, CEA/*502*.

decimal dial, EA/①.

Deck, Theodore, C-2910/*124*; DADA/*Supplement*; JIWA/*8*.

Deck, Théodore, JIWA/*93*①.

deck box, C-5117/*404*①.

deck chair, SDF.

Deckelbecher, C-2427/*131*①.

deckelpokal, C-2486/*139*; CEA/*502*; EA.

deckle, S-286/*262*.

deckled edge, S-286/*3, 19, 22, 374, 515, 522*.

deckle edge, S-286/*112, 155, 528B*.

deck watch, C-2489/*135*; C-5117/*404*①; EA.

décolleté, C-2332/*229*①.

decolourizing (in glass), EA.

decolourizing, EG/*256*.

de Comans, Marc, EA.

décor à cinq bouquets, IDC.

décor à guirlandes, EA; IDC.

décor à la corne, IDC.

décor à la fleur de pomme de terre, IDC/①.

décor à rubans, IDC.

decorated, C-0982/*86B*; S-4905/ *192*①; S-4922/*1*①; S-4992/*6*①.

decorated tile, MP/*213*.

decorated wall paper, S-4988/*423*①.

decoration, IDC; LP; S-4992/*9*①.

decorative, JIWA/*8*.

decorative art, DATT.

Decorative Art Society, DADA/ *Supplement*.

decorative comb, JIWA/*188*.

decorative detail, NYTBA/*21*①.

decorative ewer, LAR83/*576*①.

decorative lamp, K-711/*126*.

decorative marking, JIWA/*95*.

decorative painting, C-5156/*271*①.

decorative panel, C-5156/*273*①; JIWA/*173*.

decorative paper, C-5156/*878*.

decorative pattern, C-5114/*235*①.

decorative platter, NYTBA/*258*①.

decorative ring, RTA/*60*①.

decorative roof, RTA/*48*①.

decorative sampler, C-1506/*124*.

decorative scrolling, RTA/*40*①.

decorative scrolls, S-4461/*22*.

decorative spoon, C-0706/*137*.

decorative tendril, RTA/*33*①.

decorative title page, JIWA/*126*①.

decorative vocabulary, C-2478/*178*.

décor aux cinq bouquets, EA.

décor Berain, EA/*style Berain*.

décor bois, DADA; EA/①; IDC.

décor carquois, IDC.

Decorchemont, C-5005/*254*①.

Decorchemont, F., C-5005/*247*.

Décorchemont, François Emile, DADA/*Supplement*.

décor coréen, EA; IDC.

Decoro, C-2910/*159*.

décor persan, EA/*bleus de Nevers*, *bleus de Nevers*.

décor ronda, EA/*décor aux cinq bouquets*.

décor sur émail cru, IDC.

décor sur émail cuit, IDC.

découpage, DADA/*Supplement*; DATT.

Decourchemont, OPGAC/*156*.

Dedham (mark), EC1/*84*①.

Dedham pottery, DADA/*Supplement*; LAR83/*64*①; C-0225/*1*; CEA/ *165*; EC1/*74*①.

Dedham Pottery, Dedham, Massachusetts, EC1/*85*.

dedicatory inscription, C-5156/*309*.

De Dissel (The Thistle), CEA/*141*①.

De Distel, DADA/*Supplement*.

Deeley's 1884 Patent ejector, C-2476/*51*.

deep, LP.

Deep Blue Staffordshire, NYTBA/ *152*①.

deep border, C-2704/*24*.

deep-bowl, C-2427/*250*.

deep bowl, C-2427/*159*①; C-2486/ *211*.

deep brick border, C-2704/*111*.

deep color, DATT.

deep fawn, C-2704/*7*.

deep flared, C-1082/*86*.

deep leaf, C-5153/*196*①.

deeply etched, C-5005/*275*①.

deep needlepoint, C-1506/*178*.

deep oval form on pedestal foot, S-4414/*331*①.

deep plate, C-0782/*112*.

deep relief, DATT.

deep ribbed, LAR83/*430*①.

deep writing drawer, C-0982/*57*.

deer and pine tree, OPGAC/*215*.

Deerfield Society of Blue and White Needlework, CEA/*293*①.

deer skin, C-5156/*695*①.

deer teapot, C-0225/*59*.

deesis, DATT.

Defer, Jean Nicolas, NYTBA/*238*①.

de Fernex, Jean-Baptiste, EA.

deferrization, MP/*502*.

de Feure, S-4461/*98*.

De Feure, Georges, S-286/*31*.

definition, C-5156/*49*①.

deflocculate, DATT.

de Franoz, C., C-5191/*160*.

degame, DATT.

degenerated, S-4948/*193*①.

DeGland, Bm., Geneva, C-2489/*160*.

degradation, C-2414/*36*①; C-2458/*9*.

degraded, C-5127/*5*①, *18*; C-5156/ *11*①, *29*.

degraded color, DATT.

degraded glaze, C-2323/*5*; C-2458/ *12*.

De Grave, C-2904/*38*.

de Gravesande, Charles, S-286/*70*.

degree scale, S-4927/*220A*①.

De Grieksche A, CEA/*140*①.

Degué, C-5239/*153*.

Deguignes, S-286/*260*.

de Herrera, Juan, EA/*Herrera style*.

'Deh Kurd', OC/*149*.

Dehn, Adolph, S-286/*26*.

Dehua, C-2323/*97*; C-2458/*167*; C-5236/*534*.

Dehua blanc de Chine, C-5156/*65*.

deinos, IDC/①.

deisis, DATT.

déjà vu, LP.

déjeuner, CEA/*184*①; EA/*cabaret*.

déjeuner service, IDC.

Dekelmann, A., Munich, C-2493/*299*.

de King, Mathew, London, C-2489/ *120*.

de Koningh, Gilles and Hendrik, EA.

de Koo, Pieter, C-5174/*437*.

del., DATT.

Delabrierre, EA/*26*①.

Delabrierre, Paul Edouard, C-5189/ *132*.

de Labroue, E., LAR82/*228*①.

Delafons, Jno., London, C-2489/*165*.

Delafons, Pierre François, CEA/ *65*①.

Delafosse, Jean-Charles, DADA.

Delaherche, Auguste, DADA/ *Supplement*.

Delaitre, Louis, C-2364/*63*①; C-2555/*67*①.

Delamarre, Joseph, C-5174/*492*①.

de Lamerie, Paul, EA/①; C-5117/ *256*①; C-5173.

Delanois, L., S-4955/*168*①.

Delanois, Louis, C-2555/*35*①; CEA/ *379*①; DADA; EA.

Delany, H., CEA/*30*①.

Delany, Henry, London, C-2503/ *202*①.

Delapchiez, Eugene, C-5191/*126*.

Delapierre, Michel II, EA.

Delaplaine, Joshua, SDF/*770*.

de la Planche, François, EA.

de la Planche, Raphael, C-2546/ *138*①.

Delaporte, Antoine-Nicolas, C-2555/ *33*①.

Delatour, Alexandre and Edouard, EA.

Delatte, C-5005/*240*; C-5191/*244*.

Delatte, Andre, C-GUST/*57*.

Delaunay, Nicolas, EA/*de Launay, Nicolas*.

Delaunay, Sonia, S-286/*27*.

Delaune, Étienne, EA.

Delaville, L., C-5189/*203*.

Delaware, OPGAC/*215*①.

Delcomyn Kjøbenhavn, CEA/*26*①.

Delecia, C-2409/*104*.

Delffter Guth, MP/*17*.

Delffter Stein und Rund Bäckerey, Dresden, MP/*162*.

delft, CEA/*151*①; DATT; LAR82/
*96*①.

Delft (England), ACD.

Delft (Holland), ACD.

Delft, C-0225/*46*; C-0249/*187*;
C-2360/*130*①; C-2427/*147*①;
C-2904/*29*; CEA/*140*①; DADA/
①; IDPF/*21*; MP/*15*; S-4843/*16*.

Delft dorée, IDC.

Delft factory, EA/*Heart, The.*

Delft faience, MP/*166*.

Delft faience works, MP/*50*.

Delftfield Pottery, EA.

delft noir, EA.

Delft noire, IDC.

delft rack, LAR82/*347*①.

Delft squat, C-1502/*7*.

delftware, DADA; DATT; IDC;
NYTBA/*137*; S-4843/*3*①; CEA/
110.

Delhi rug, DADA.

delicately potted, C-5156/*48*①.

delicate spray, C-2704/*29*.

Delion, Pierre, C-5220/*55*①.

De Lisle, CEA/*257*①.

Delisle, Jacques-André, C-5220/*51*①.

della Riviera, Jacopo, EA/*Barberini
workshop.*

della robbia, OPGAC/*345*; DADA/
①; C-2409/*132*; LAR83/*88*①.

Della Robbia, Luca and Andrea, EA.

Della Robbia pottery, IDC.

Della Robbia ware, IDC/①.

Dellebarre, L. F., CEA/*611*①.

Dellicourt, Etienne, C-5189/*358*①.

Delmester, John, C-5117/*242*①.

DELORME, EA/*Delorme, Adrien.*

Delorme, Adrien, EA.

Delorme, Jean-Louis-Faizelot, EA.

Delorme, Philibert, CEA/*372*①.

'Delphos' dress, LAR83/*231*①.

Delunesy, Nicholas Pierre, C-2555/
*26*①.

Delure, C-2904/*268*.

Delvaux, Paul, S-286/*261*①, *432*①.

Delys, LAR82/*174*①.

de Lysle, Anthony, EA.

de Maecht, Philip, C-2546/*138*①;
C-5224/*217*①.

de Maecht, Philippe, EA.

de Mailly, Charles Jacques, EA.

de Malliée, Pierre-Nicolas (Maillie),
C-5220/*50*①.

demantoid, C-5005/*213*①; S-4927/
324.

demantoid garnet, S-291/*124*①.

Demay, Jean-Baptiste-Bernard,
stamp: DEMAY RUE-DE-CLERY,
C-5224/*117*①.

Demay, (de May) Stephen, EA.

de Melter, Jean, EA.

Demeter, DSSA.

Demetrius, Daniel, EA.

demi-commode, EA.

demi-compass, C-0249/*455*①.

demi-fan, C-5157/*105*①.

demi-fan panel, C-5224/*186*.

demi-figure, C-2398/*11*①.

demi-florette, C-5236/*1778*.

demiflowerhead, S-4823/*11*; S-4905/
*7*①.

Demigot, Victor, EA.

demi-grand feu, IDC.

demi grand feu, DADA.

demi-griffon, C-2398/*1*①.

de Milde, Ary, EA.

demi lion rampant, S-4905/*141*①.

Demilt, A., S-4905/*167*.

demilunar, C-5236/*1566*.

demi-lune, C-2324/*69*; C-2402/*264*;
C-5114/*341*①; C-5153/*199*①;
LAR82/*328*①; LAR83/*348*①;
S-3311/*546*①; S-4436/*104*①;
S-4812/*158*; S-4988/*479*①.

demilune, C-5156/*462*; DADA.

demi-lune door, C-5170/*210*①.

Denver China and Pottery Company, DADA/*Supplement.*

Denzilon, John, CEA/*658*①.

de Pannemaker, Pieter (Pierre), EA.

deployant, S-4927/*482.*

deployant clasp, S-4927/*14.*

De Porcelyne Fles, CEA/*140*①.

Deposé, C-2409/*14.*

Deposition, DSSA.

depressed form, IDPF/*74*①.

depression glass, EG/*206*; K-710/*112*; OPGAC/*190.*

Deptford Pottery, EA/*Ball, William.*

depth, JIWA/*6, 10, 10, 50, 63*; LP.

depthing tool, C-MARS/*195.*

Derain, André, S-286/*432.*

Derbend, C-2546/*152*; C-5189/*402*①; OC/*195*①, *210.*

Derbend rug, C-1702/*6*; CEA/*89*①; DADA; S-4461/*789*; S-4796/*92.*

Derby, ACD; C-1006/*70*; C-1582/*55*; C-2493; CEA/*448*①; DADA/①; S-4461/*503.*

Derby blue, EA; IDC.

Derby ceramics, EA/①.

Derby figure, LAR82/*25*①.

Derby folding chair, SDF.

Derby porcelain, NYTBA/*176*; S-3311/*348*①.

Derby red, DATT.

Derbyshire, C-5157/*16*; CEA/*155*①; S-4436/*15*①; S-4988/*416*①.

Derbyshire chair, ACD; C-0982/*44*; DADA/①; SDF.

Derbyshire spar, DADA; SDF; CEA/*336*①.

Derby Silver Company, NYTBA/*234*①.

De Re Metallica, EA.

Derenne, C-5191/*178*①.

Deringer, DADA; S-4972/*232.*

Deringer, Henry, Jr, CEA/*40*①.

Deringer pistol, CEA/*40*①.

dernier cri, le, LP.

Deruelle, Pierre, CEA/*186*①.

Deruta, ACD; C-2427/*222*①; C-2486/*241*①; CEA/*134*①; DADA; S-4972/*126*①.

Deruta Maiolica, EA/①.

Descamps, G., CEA/*685.*

Descent from the Cross, DSSA.

Deschamps, S-4947/*278.*

desco da parto, DATT.

Descomps, Joe, C-5191/*151*①.

deshilado, DADA.

design, C-5153/*47*①; DATT; EC2/*98*①; JIWA/*7*; LP; OC/*10*; S-4922/*82*①.

Design and Industries Association, DADA/*Supplement.*

design border, C-5323/*9*①.

designer, JIWA/*9.*

designer-craftsman, DADA/*Supplement.*

designers' colors, DATT.

desk, ACD; C-5114/*363*①; C-5153/*87*; C-5239/*248, 273*; DADA; SDF.

desk-and-bookcase, NYTBA/*58*①.

desk and bookcase, SDF.

desk box, EA.

desk chair, EA/*corner chair.*

desk clock, C-0225/*366*; C-0706/*209*; C-2409/*211*; C-5005/*380*; S-4802/*153*; SDF.

desk ends, C-5239/*91.*

Deskey, OPGAC/*13.*

Deskey, Donald, C-5167/*226.*

desk folder, LAR83/*660*①.

desk implements, S-4905/*332.*

desk lamp, C-5146/*141*①.

desk lamp base, C-0225/*311.*

desk-on-frame, DADA; S-3311/*192*①.

desk organizer, C-5239/*248.*

desk or hand seal, EA/*seal.*

desk seal, EA/*seal*; LAR82/*550*①;
LAR83/*532*①.

desk-seal, C-2487/*18*①.

desk set, C-0254/*40*; C-1502/*87*;
C-2493/*167*; C-5005/*381*; C-5167/
*262*①; IDC.

desk set: folder, blotter, pen-holder,
letter opener, C-5174/*314*①.

desk-stand, C-2427/*204*.

desk stopper, C 0225/*180*.

desk tray, C-0254/*278*.

Desmalter, Jacob, DADA.

Desny, C-5167/*206*.

Desoches, CEA/*176*①; EA.

Despair, DSSA.

Després, OPGAC/*156*.

Despres, Jean, C-5167/*175*①.

Desprez, NYTBA/*284*; S-4947/*16*①.

Desprez, father and son, EA.

dessert, IDC.

dessert compote, C-0254/*205, 275*①.

dessert dish, C-5174/*500*.

desserte, C-5146/*134*①; C-5181/
*204*①; DADA.

dessert flatware, S-4922/*1*①.

dessert flatware service, S-4804/
*195*①.

dessert-fork, C-2398/*14*; C-5117/*43,
123*.

dessert fork, C-1502/*26*; C-5114/
*21*①; S-4804/*65*; S-4905/*170*;
S-4922/*1*①.

dessert glass, ACD.

dessert-knife, C-5117/*206*.

dessert knife, C-0254/*288*①; C-5114/
16; DADA; S-4804/*65*; S-4922/
*1*①, *38*①.

dessert plate, S-4461/*2*.

dessert-service, C-1006/*46, 84, 216*;
C-5117/*206*; IDC.

dessert service, C-5189/*18*; EA/①.

dessert-spoon, C-2398/*14*.

dessert spoon, C-0270/*200*①;
C-1502/*26*; C-5114/*16*; C-5117/*43*;
C-5153/*27*①; DADA; S-4905/*170*;
S-4922/*1*①.

dessert-stand, C-2398/*30*①.

dessert stand, C-0254/*88*; LAR83/
*556*①, *575*①.

dessert ware, C-1006/*213*.

Dessinateur du Cabinet, EA/①
Meissonier, Juste-Aurèle.

dessus de cheminée, DATT.

dessus de porte, DATT.

De Stijl, DADA/*Supplement*; DATT.

detachable, C-0706/*16*; C-5117/*208*.

detachable base, C-5117/*149*①.

detachable coil, CEA/*554*①.

detachable collar, C-2398/*5*; C-5174/
*531*①.

detachable cover, C-0406/*100*.

detachable finial, C-5174/*504*①.

detachable nozzle, C-0706/*166*;
C-2398/*2*; C-5117/*236*①.

detachable rim, S-4922/*31*①.

detached column, C-2370/*66*;
C-2421/*36*①.

detached viewpoint, JIWA/*71*.

detail, C-5114/*186*①; JIWA/*6*; LP;
S-4992/*11*①.

detector lock, CEA/*531*①.

detent, CEA/*267*.

detent escapement, EA/*escapement*.

detent pipe, C-2368/*91*①.

detonator, S-4972/*265*.

Detouche, Henri, S-286/*29*.

de Troy, Jean-François, EA.

deu-darn, SDF/*deu-ddarn*.

deu-ddarn, SDF.

Deutsch, J., EA/*114*①.

Deutsche Blume (German flower)
decoration, MP/*103*.

deutsche Blumen, C-2427/*58*①; EA;
CEA/*209*; MP/*502*; DADA/①;
IDC/①.

deutsche Manier blumen, C-2427/ *100.*

Deutsche Prazisions-Uhrenfabrik Glasshutte, S-4927/*122.*

Deutscher Werkbund, DADA/ *Supplement.*

Deutsche Werkstatten, C-2409/*237.*

Deutsche Werkstätten, DADA/ *Supplement.*

Deveranne, M., CEA/*517*①.

De Vez, C-2409/*24.*

device (in silver), EA.

device, S-4461/*21*; S-4992/*6*①.

Devil, DSSA.

devil's work, DADA; IDC.

Devisenkinder, MP/*155.*

Devlin, Stuart, CEA/*663*①.

Devon, C-0249/*408*①; C-2704/*167.*

Devonshire, C-5167/*243*①.

Devonshire, Thomas, S-3311/*779.*

Devonshire clay, DATT.

Devonshire lace, DADA.

de Vos, Josse, EA.

devotional chair, SDF.

de Vriese, Paul Vredeman, NYTBA/ *26*①.

dew, DSSA.

dew and raindrop, OPGAC/*216.*

dewdrop, DADA.

Dewey, OPGAC/*216.*

De Witt & Co., John, SDF/*770.*

dexter, S-4802/*490*①.

Dextra, Jan Theunis, EA.

dextrin, DATT; LP.

dey fret border, S-2882/*111.*

D. G., mullet, EA/*Govaers, Daniel.*

DH, EA/*Dresden, Hennell.*

dhal, C-2503/*33.*

dharani, C-5156/*772.*

dhoti, C-5234/*4*①.

dhurrie, C-2478/*262*; S-4847/*238.*

dhyana, S-4810/*279.*

dhyanamudra, S-4810/*375*①.

dhyanasana, S-4810/*265*①.

dhyanasana Buddhistic position, C-2458/*53*①.

diablerie, DATT.

diabolo, IDPF/*74*①.

diacetone alcohol, DATT.

diadem, CEA/*514*①; EA; RGS/*80, 199*①.

diaglyph, DATT.

diagonal, C-1506/*94.*

diagonal band, C-5117/*334.*

diagonal banding, C-5114/*243*①.

diagonal barometer, CEA/*262*①.

diagonal cane motif, S-4948/*5*①.

diagonal composition, JIWA/*5, 44, 218.*

diagonal line, C-2458/*2.*

diagonally set, C-2704/*56.*

diagonal principle, JIWA/*6.*

diagonal reeding, S-2882/*1070*①.

diagonal rows, C-2357/*102.*

diagonal scale, CEA/*612, 612.*

diagonal stretcher, CEA/*309*①.

dial, C-2904/*155*; C-5116/*47*; C-5153/*79*①; C-5157/*33*①; S-4461/*126*; S-4812/*26*; S-4992/ *16*①.

dial clock, EA.

dial surround, S-4414/*126, 153*①.

diamante, C-2203/*74*; C-3011/*31.*

diameter, C-5153/*6.*

diametrical bridge, CEA/*606*①.

diamond, C-5005/*207*①, *215*①.

diamond-and-dot, S-4905/*134*①.

diamond-and-hook, OC/*214.*

diamond bangle, S-291/*59.*

diamond-bar-form, S-3311/*9.*

diamond beading, IDC.

diamond black, DATT.

diamond cluster earclip, S-291/*83*①.

diamond-cut, S-2882/636①; S-4436/66.

diamond-cut base, LAR82/451①.

diamond-cut paste, RGS/133①.

diamond cutting, CEA/448①.

diamond daisy, DADA.

Diamond Daisy design, NYTBA/307.

diamond diapering, CEA/463①.

diamond endstone, C-2368/40①.

diamond etching, MP/166.

diamond grid, C-5146/140.

diamond ground, IDC.

diamond lock, C-5114/252①.

diamond lozenge, RTA/40①.

diamond medallion field, S-2882/70.

diamond mould, CEA/503.

diamond ornament, SDF.

diamond pane, C-5153/87.

diamond panel, C-5114/394①.

diamond pattern, CEA/291①; DADA; S-4461/361; S-4972/168①.

diamond-patterned border, C-5114/195①.

diamond patterning, C-0279/196①.

diamond-pavé, S-4414/121.

diamond point, CEA/419①, 444①; DADA/①; EG/213; OPGAC/216①.

diamond-pointed knop, CEA/594.

diamond-point engraving (in glass), EA.

diamond-point engraving (on porcelain), EA.

diamond point engraving, DADA; EG/73.

diamond-point spoon, DADA; EA.

diamond-quilted, S-4947/86①.

diamond quilted, C-2704/109; OPGAC/216.

diamond-set, C-5117/391①.

diamond-set bow, S-4414/57.

diamond-set decoration, S-4414/57.

diamond-set link, S-4414/37.

diamond-shaped, S-288/26①.

diamond shaped, C-2402/79.

diamond shaped group, C-2704/77.

diamond-shaped panel, RTA/84①.

diamond spray, C-5005/217①.

diamond sunburst, OPGAC/217.

diamond surround, RGS/145①.

diamond thumbprint, OPGAC/217①.

Diana, DSSA.

diaper, ACD; C-0225/294; DADA; DATT/①; IDC; S-4905/63; SDF.

diaper and scalework, S-2882/1188①.

diaper and strap-work border, S-2882/1078①.

diaper border, S-2882/1073①; S-4905/6①, 10①, 55.

diaper diamond medallion field, S-2882/222.

diapered, CEA/84①.

diapered background, C-5114/39①.

diapered medallion, C-5323/6.

diaper medallion field, S-2882/119.

diaper motif, S-4414/337, 346①.

diaper-pattern, C-2478/40; C-5116/157①.

diaper pattern, C-2203/20; C-2323/88①; C-5117/380①; C-5127/82; C-5236/498; CEA/282①; RTA/77①.

diaper pattern border, S-4461/426.

diaper pattern ground, C-5156/117①.

diaper work, CEA/649①.

diaperwork, S-4905/148①.

diaphragm pump, MP/191.

diatomaceous earth, DATT.

diatreta, EG/35①.

diatretaril, EG/33.

Diatretta, C-0225/328①.

Dicas, C-2904/261.

dice beaker, LAR83/412①.

dice bowl, C-5156/86①.

dice pattern, IDC/①; S-4843/618①; LAR82/188①.

dice tumbler, LAR83/441①.
DiChirico, Giordio, S-286/247C①.
dichroic, C-5146/169①.
dichroic green, C-5005/304①.
dichroism, DATT.
Dickensian figure, C-2502/174.
Dickens jug, C-2324/5.
Dickens' Ware, EC1/83①.
Dickson, Charles, S-4944/376①.
dicky pot, IDPF/13.
die, C-5114/327①, 334①; EA;
 S-4461/621.
die, dice, DSSA.
Diebenkorn, Richard, S-286/262①.
die board, DATT.
Die Brücke, JIWA/51.
die-cut overlay, S-286/309.
Diehl, Edith, DADA/Supplement.
die-maker, CEA/590.
die-nut, C-0403/193.
Dieppe, C-2904/20.
Dieppe ivory, C-5189/125①.
Dier, Ed, OPGAC/345.
die-rolled, C-5114/241; C-5153/10①,
 25①.
die rolled, C-5203/262①.
die-rolled beaded border, C-5114/44.
die-rolled border, C-5114/31①.
die-stamp, RGS/165.
die-stamping, EA.
diet, EA.
Dietrich, Christian Wilhelm Ernst,
 EA.
Dietrich, Johan, C-5117/298①.
diffraction, DATT.
diffraction color, DATT.
diffuse, JIWA/23.
diffuse reflection, LP.
diffusion, LP.
digestive chair, SDF.
Dighton, Isaac, CEA/644①.
digital dial, C-5174/379①.

digital openface watch, S-4802/31①.
dignitary figure, S-4965/193①.
di Guardiagrele, Nicola, C-5224/
 254①.
Dihl and Guérard, CEA/185①.
Dijsselhof, Gerrit Willem, DADA/
 Supplement.
dilettante, LP.
Dillwyn, Lewis Weston, EA.
Dillwyn, L. W., CEA/202①.
DILLWYN SWANSEA, EA/
 Cambrian Pottery Works.
diluent, DATT; LP.
Di Mario, Laurenzo, S-4927/64.
dimetric projection, DATT.
diminishing glass, DATT.
dimity, DADA; FFDAB/78①; SDF.
dimple, C-2409/1.
dimpled, C-0225/5; C-2458/135;
 C-5191/275; C-5239/15.
dimpled form, C-2324/120.
dimpled ground, C-2513/149①.
dimpled neck, LAR83/443①.
dimpled oviform, C-5146/89A①.
dimple glass decanter, C-1502/14.
Dinah Deaves, C-2704/7.
dinanderie, C-2382/7; C-5239/115;
 CEA/529, 541; DADA; C-5167/
 140; NYTBA/258.
Dinanderie brass, EA.
Dinant, NYTBA/258.
ding, C-2414/7①; C-5236/1718;
 S-4963/18①; C-5236/436①.
ding dish, C-5156/46①.
ding form, S-4810/441①.
Dingler's green, DATT.
Dinglinger, Johann Melchior, EA.
ding-shaped, C-5236/1680.
dingyao, C-5156/44①.
Ding Yao, C-5236/435①.
Dingyao, C-5236/1587.
Dingyao deep dish, C-5127/31.

Dingyao dish, K-711/*125*; S-3312/
*1312*①.

ding yao type, C-2323/*6*.

Ding Yao vessel, C-2414/*61*①.

Dingyao ware, S-4965/*215*①.

dingzhou, C-5236/*365*①.

dining-chair, C-2388/*7*.

dining chair, C-0982/*24*; C-1407/*1*;
C-5116/*113*①; S-4436/*99*①;
S-4461/*593*①; S-4812/*110*①.

diningroom pedestal, LAR83/*353*①.

dining room urn, C-5157/*67*①.

dining suite, C-0982/*30*; C-5239/*244*.

dining table, C-0982/*8*; C-5114/
*310*①; C-5153/*114*①; DADA/①;
S-4461/*594*.

dining tray, DADA.

dinner bell, C-5153/*4*①, *12*①,
C-5239/*113*; S-4804/*133*①.

dinner fork, C-5114/*16*; C-5153/*7*;
S-4804/*28*①, *35*①.

dinner-knife, C-5117/*41*.

dinner knife, C-5114/*16*; C-5153/*7*;
S-4804/*28*, *35*①.

dinner-plate, C-2398/*74*; C-5117/*77*,
*285*①.

dinner plate, C-1006/*55*; S-3311/
*734*①; S-4461/*2*.

dinner-service, C-1006/*41*, *168*;
C-2502/*7*; IDC.

dinner service, JIWA/*121*①; S-4461/
386.

dinner wagon, SDF.

dinos, IDC.

Dionysus, DSSA.

diorama, DATT; S-4881/*193*①.

Dior bottle, S-4461/*25*.

diota, IDC.

dip, CEA/*462*①; S-4843/*359*①.

dip-decorated ware, IDC.

dip jasper, IDC.

dip mold, LAR82/*432*①.

dipped, IDC.

dipped enamel, EA.

dipped seat, SDF/① *dropped seat*.

dipped top rail, S-4414/*512*①.

dipped upholstered seat, S-4414/
*451*①.

dip pen, S-4461/*374*.

dipper, DATT.

dipper cup, DATT.

diptych, C-5156/*931*①; C-5236/
*980*①; DADA; DATT; S-4972/*70*.

diptych dial, CEA/*606*①; EA/
sundial; LAR83/*461*①.

diptych leaf, S-4972/*69*①.

diptych sundial, C-2904/*166*.

Dipylon style, IDC.

direct carving, DATT.

direction, LP.

directional, C-5114/*185*①.

direct metal sculpture, DATT.

Directoire, C-2364/*18*①; C-2437/
*22*①; C-5191/*421*; CEA/*363*①;
DADA/①; LAR83/*37*①; S-3311/
419, *420*①; S-4853/*337*①, *482*①.

Directoire furniture, NYTBA/*64*.

Directoire style, EA; IDC.

Directoire style clock, CEA/*224*①.

direct painting, DATT.

dirk, C-2569/*7*; C-MARS/*3*; CEA/
27; DADA.

dirty turquoise, EA.

Disbrowe, Nicholas, ACD; DADA;
EA; SDF/*770*.

disc, C-1082/*4*; C-2458/*298*; C-2482/
95; S-4436/*37*①.

disc-end spoon, EA.

disc finial, S-4414/*206*①.

disc foot, DADA.

disc-form, S-4905/*168*①.

discharge, C-5117/*258*.

discharge mark, EA.

dischbank, SDF.

discobolos, C-1702/*86*.

discolored, S-3311/*350*.

disc-set striker, C-2476/46.
disc-shape, C-2458/345①.
discus, C-2482/112.
discus body, LAR82/142①.
disegno, DATT.
disengaged columns, C-0249/480①.
disguised numeral mark, IDC/①.
dish, C-0225/1; C-0254/121; C-1006/
39; C-2398/34①; C-2513/146;
C-5114/239; C-5117/359①; CEA/
620①; EA/bleeding-bowl; IDC;
IDPF/75①; S-4972/331①.
dish base, C-2437/19; S-4461/547.
dish clock, CEA/237①.
dish-cover, C-2398/37.
dish cover, C-0706/121; C-5174/
540①; DADA.
dish-cross, C-5117/61①, 222.
dish cross, C-5174/544①; DADA;
EA/①; LAR82/612①; S-4461/
208; S-4802/392①.
dished, C-0249/372; C-0982/308;
DADA; S-4436/37①; S-4881/
485①; S-4972/523①.
dished base, C-5114/114①, 241;
S-2882/704; S-4414/229①.
dished base with carrying handle,
S-2882/704.
dished brim, C-5153/32①.
dished center, C-5114/10①.
dished circular base, S-4414/224.
dished circular foot, C-5114/113①.
dished circular rim, S-2882/1378①.
dished corner, ACD.
dished dial, EA.
dished drip pan, S-4853/377①.
dished plaque, RGS/83.
dished rectangular base, C-0279/203.
dished rectangular form, C-0249/284.
dished rectangular top, C-0982/80.
dished seat, EA; SDF.
dished snap top, LAR83/383①.
dished top, C-5116/59; S-4988/547①.

dished tray, C-5116/53.
dishevelled bird, IDC.
dish holder, C-0406/64; C-1502/81.
dishing, SDF.
dishlight, C-2478/26.
dish-ring, EA.
dish ring, CEA/672①; DADA;
LAR82/586①; LAR83/572①;
S-3311/772①; S-4802/445.
dish-shaped reservoir, C-2421/7①.
dish-strainer, EA/① mazarine.
dish-top, ACD.
disk, C-5114/163.
disk finial, C-5114/8, 48①, 112, 229.
disk stopper, C-5114/121; S-4436/
63①.
dislocation of space, JIWA/164.
dismal hound, IDC.
dismounted, C-1603/47.
dispensary, SDF.
dispersion, DATT.
display-cabinet, C-2478/178.
display cabinet, C-0982/19, 82B;
C-1407/16; C-2402/85; C-5189/
282①; LAR83/320①.
displayed, C-2478/3.
displayed eagle, C-2364/27; C-2403/
4; C-2421/37①; LAR83/206①.
displayed eagle cresting, C-2403/37.
displayed phoenix, C-5116/125①.
display stand, C-2458/275①.
display-table, JIWA/323.
display table, C-5236/1656.
disposable dining table, CEA/353①.
disposable palette, DATT/①.
disposition, C-3011/108.
dissecting, C-2904/120.
dissolved, CEA/113①.
dissonance, LP.
distaff, DSSA/①.
distemper, DADA; DATT; LP.
distillation, DATT.

distorted form, IDPF/76①.
distortion, DATT; LP/①.
distressed, C-5117/420, 460; CEA/405; SDF.
dital harp, C-5255/37.
divan, ACD; CEA/405; DADA; S-4507/1①; SDF.
divan easy chair, SDF/①.
Divernois, Jean-Henri, C-5174/410①.
divided beveled plate, C-5116/118.
divided dish, IDPF/77①.
divided double-flap top, LAR83/383①.
divided drawer, C-1304/233.
divided plate, C-2357/23①; C-5116/155①; S-4972/427.
divided shank, RTA/194①.
dividers, C-2904/71; C-5114/302①; DATT; DSSA.
dividing brass, DATT.
divine tortoise, IDC.
division, C-2402/207; C-5239/323.
divisionism, DATT; LP.
division plate, CEA/218.
Dixon, Arthur Stansfield, DADA/Supplement.
Dixon, James, EA; S-4944/210.
Dixon, James, and Sons Ltd., DADA/Supplement.
Dixon, Nicholas, EA.
Dixon, Samuel, C-2421/1①.
Djed-pillar, S-4807/452.
Djijim, DADA.
Djoushegan carpet, EA/Joshagan carpets.
djuft, CEA/101.
djufti knot, CEA/101; EA/jufti knot.
Djushaghan rug, DADA.
D & J Welby, C-0406/4.
DM, EA/Männlich.
D & M Birmingham, C-0706/3.
D.M.C., CEA/68①.
Dobbie McInnes Ltd., S-4927/220B.

dobbin, DADA.
Dobrich, C-1006/48.
Doccia, ACD; CEA/169, 170①; DADA; LAR82/117①; LAR83/103①.
Doccia Alla Sassonia, C-2427/29.
Doccia porcelain factory, EA/①.
Dockwra's Copper Company, EA.
doctor, DATT.
doctor blade, DATT.
doctor's lady, DADA.
doctor's watch, C-MARS/163.
Doctor Syntax, IDC/①.
Doctor Syntax series, EA/Clews, James and Ralph.
documentary dated, LAR82/137①.
documentary piece, NYTBA/260.
documentary specimen, IDC/①.
document box, C-2364/20①; C-5114/209①.
document chest, S-4905/328.
document drawer, C-5114/304①; C-5153/174①.
documents cabinet, CEA/323①.
dod, IDC.
Dodd, C-0906/359.
dod handle, IDPF/78.
Dodson, C-1006/216.
dog, CEA/29①; DSSA; IDC.
dog collar, C-2555/10①.
dog finial, NYTBA/140①.
dog grate, SDF.
dog irons, SDF.
dognose, S-4905/228①; S-4922/42①.
dog-nosed top, C-5117/94.
dognose end, S-4922/43①.
dognose spoon, S-4905/229.
dog-nose spoon, EA/wavy-end spoon.
dognose terminal, S-2882/1095①.
dog of Fo, EA; IDC; DADA.
Dogon, C-1082/1.
dog orchestra, IDC/①.

dogs chasing stags, C-1506/*101*.

dog tooth, DADA.

dog-tooth decoration, S-4965/*121*①.

dog tooth ornament, SDF.

dog-tooth-pattern, C-2323/*130*.

dog-whistle, C-2493/*103*.

dogwood, C-0225/*73*; SDF.

dogwood table lamp, C-5005/*409*①.

Döhlen pottery works, MP/*182*.

Doirat, E., C-2555/*47*①.

Dokhtar-e-Ghazi Beluch, OC/*140*①.

Dolbeare, John and Edmund, CEA/
 *591*①.

dole cupboard, ACD; DADA; EA/①;
 LAR82/*337*①; SDF.

doll, ACD; CEA/*690*①; IDPF/*78*①.

Dolland, C-2904/*221*.

dollar pattern, IDC.

doll house, DADA.

Dollond, C-2904/*58*①.

Dollond, John, CEA/*602*①.

Dollond, Peter, CEA/*602*①.

doll's chair, S-4905/*326*.

doll's-head, C-2476/*64*.

doll's head, C-2476/*2*.

dolls' house, ACD; CEA/*304*.

doll's house pattern, IDC.

Dolmetsch, Carl Frederick, DADA/
 Supplement.

doloire, C-2503/*19*.

dolomite, DATT; EG/*236*.

dolomitic limestone, DATT.

dolphin, C-2402/*174*; CEA/*232*①;
 DADA/①; DSSA.

dolphin and mask, CEA/*671*①.

dolphin and putto stem, S-4804/
 *124*①.

dolphin arm-support, CEA/*306*①.

dolphin cresting, C-5116/*34*.

dolphin finial, CEA/*677*①.

dolphin foot, ACD; SDF/①.

dolphin-form foot, S-4507/*60*①.

dolphin-form sauce boat, S-4804/
 *132*①.

dolphin handle, C-2360/*166*①;
 C-2364/*67*①; C-2382/*52*①;
 LAR82/*50*①.

dolphin head handle, C-0782/*74*.

dolphin hinge, SDF.

dolphin jug, IDC.

dolphin mask, SDF.

dolphin ring handle, C-0254/*162*.

dolphin's mask, C-5174/*124*①.

'dolphin' support, LAR83/*317*①.

dolphin support, C-0254/*20, 59*①.

dolphin table, S-3311/*517*①.

Domaige, Etienne Henry, C-5191/
 141.

DOMANEK, EA/*Domanek, Anton
 Matthias*.

Domanek, Anton Matthias, EA.

dombari, IDC.

dome, C-5127/*73*; EA/*hood*; SDF.

dome bed, EA; SDF/①.

dome center, C-0225/*348*.

dome cover, IDC.

domed, C-0982/*23*; C-2202/*74*;
 C-2458/*7*; C-5127/*7*①; S-4905/*28*.

domed and folded foot, LAR83/
 *431*①.

domed back leg, C-5127/*347*.

domed base, C-2437/*11*.

domed canopy, C-2421/*9*①.

domed chest, S-4461/*23*.

domed circular foot, C-0254/*72,
 291*①; C-5114/*39*①; C-5153/*18*①;
 S-2882/*1035*①; S-4414/*236*①.

domed cistern cover, S-4414/*384*.

domed cover, C-0254/*16, 251*;
 C-0270/*142A*①; C-0406/*28*;
 C-0782/*4, 119*; C-2414/*28*①;
 C-5114/*25*①, *29*①, *84*①, *89*①;
 C-5117/*116*①, *265*①; C-5156/*27*;
 CEA/*645*①; RGS/*31*①; S-4414/
 *234*①, *275, 328*①; S-4922/*12*①.

domed font, C-5114/*130*.

domed foot, C-0254/*54, 212*; C-2458/
*164*①; C-5117/*21*; C-5146/*164*①;
CEA/*423*①; EG/*288*①; S-4461/
234; S-4804/*78*①; S-4922/*10*①.

domed hexagonal foot, C-0254/*74*.

domed hood, LAR83/*195*①.

domed-lid, CEA/*585*①.

domed lid, C-2382/*135*; C-2421/*54*;
C-2437/*18*①; C-5114/*8, 40*①,
*48*①, *96*①; C-5153/*41*①; S-4414/
*386*①; S-4461/*223*.

domed mount, S-4414/*141*.

domed oval base, S-4804/*230*①.

domed oval form, S-4414/*336*①.

domed ovoid foot, C-5153/*1*①.

domed pedestal foot, C-0254/*297*.

domed pediment, LAR83/*254*①.

domed platform, C-5146/*182*①.

domed rim foot, S-4804/*145*①;
S-4922/*11*①.

domed shade, C-5005/*257*①; S-4461/
495.

domed shaped, C-0270/*26*①.

domed spreading foot, S-4804/*7*①.

domed square base, S-2882/*695*①.

domed straight gadroon base, S-4922/
*19*①.

domed-top, EA.

domed top, C-5114/*128*①; C-5116/
*42*①; C-5153/*3*①; IDPF/*4*;
S-4414/*387*①; SDF.

domed-top box, C-5114/*217*①.

dome of Florence cathedral, EA/
Medici porcelain.

dome ring, S-291/*112*.

dome shade, C-0225/*338*.

dome-shaped, RTA/*30*①.

dome-shaped foot, NYTBA/*296*.

dome-shaped lid, NYTBA/*218*.

dome-shaped pierced link, S-4414/
*163*①.

domestic clock, EA.

domestic scene, C-5224/*16*①.

domestic stand, IDPF/*217*①.

domical ceiling cap, S-4414/*238*.

domical cover, S-2882/*1203*.

domical foot, NYTBA/*277*①.

domical shade, S-3311/*935*; S-4414/
*220*①, *224, 253*①.

dominance, LP.

dominant color, DATT.

dominant medallion, OC/*330*.

Dominick & Haff, C-0270/*171, 205*.

Dominion, C-2476/*40*.

Dominique, C-5005/*352*①; C-5167/
*200*①.

domino paper, DADA.

dominos, S-4881/*70*①.

Donaldson, J., CEA/*189*①.

Donaldson, John, ACD; EA.

Donatello, OPGAC/*345*.

Doncaster cup, C-5117/*68*①.

done bronze, C-0225/*137*.

Donisthorp, Geo., Birmingham,
C-2489/*169*.

donkey-bag, OC/*204*.

Donnaing, S-4461/*45*.

Donner, Johann, MP/*442*①.

donor, DSSA.

Don Pino, EA/*Bettisi, Leonardo*.

Don Pottery, ACD; DADA.

Don Qixote, DSSA.

door, C-2402/*19*; S-4972/*35*.

door divider, C-0279/*275*.

door frame, MP/*77*.

door-furniture, IDC.

door furniture, EA; SDF.

door handle, C-0906/*163*.

door knocker, C-0906/*139*.

door-stop, CEA/*534*①.

door-stop (in glass), EA.

Do Pî, EA/*Bettisi, Leonardo*.

Doppelfrieskrug, EA; IDC.

doppelwandglas, DADA.

dopskal, DADA.

dorcer, SDF.

Dordrecht, C-5117/*18.*

doré, C-5191/*121*①; C-5239/*52*①; FFDAB/*121.*

dore, LAR82/*210*①.

Doré, C-0225/*103.*

doreur, C-2555/*41*①.

Dorez, Barthélémy, CEA/*147*①.

Dorflinger, Christian, CEA/*467*①, *471*①, *478*①; DADA/*Supplement.*

Dorflinger, William, NYTBA/*308.*

Dorflinger Glass Company, CEA/*478*①.

Dorflinger & Sons, Inc., CEA/*480*①.

Doric, C-5116/*50*①; CEA/*248*①.

doric and pansy, OPGAC/*192.*

doric column, C-0225/*82*; C-5116/*78*①; C-5157/*35*①.

Doric order, SDF/①.

dormant, SDF.

Dorn, Marion, C-GUST/*131*①.

Doroksch carpet, S-4796/*262*①.

Dorotheenthal, DADA; EA.

dorsal, SDF.

D'Orsay, C-5239/*120.*

Döşemealti, OC/*117*①.

Döşemealti origin, OC/*117.*

Dosemealti rug, OC/*25*①.

dossal, DADA; DATT.

dossier, DADA.

dot, C-2458/*226*; S-4461/*315*; S-4905/*75.*

dotaku, EA/*Japanese metal-work.*

dot and stalk ground, IDC.

dot and stroke, JIWA/*53.*

Dot block, C-2704/*109.*

dot border, S-4461/*301.*

dote, SDF.

dot mark, C-2427/*87.*

dot molded, C-0225/*345.*

dot-pattern, C-2323/*49*; C-5224/*180*①.

dot pattern, C-5114/*126*①.

"dot period", MP/*502.*

Dot period, S-4853/*174*①; MP/*484.*

dot system, JIWA/*54.*

dotted coping, OC/*289.*

dotted detail, C-2704/*95.*

dotted manner, DATT.

dotted print, DATT.

dottle spoon, S-4881/*164.*

Dou, J. P., CEA/*604*①.

douai, DADA; EA.

double action pedal harp, C-5255/*38*①.

double-action percussion revolver, C-2569/*66.*

double arched crest, C-5116/*173*①.

double-arched pediment, C-5170/*210*①.

double-arm, C-5114/*238*①.

double-armed, C-5239/*90.*

double-armed cross, RTA/*72*①.

double back, SDF.

double bag, C-2478/*219.*

double baluster, C-5116/*41.*

double bar, C-0279/*291.*

double-barrelled, CEA/*36*①.

double basket top, EA.

double-bass, EA/*violin family.*

double bead molding, C-5114/*266*①.

double beaker, EA/①.

double bed, C-5005/*354*①.

double-bellied coffee-pot, CEA/*674*①.

double border, C-2704/*49A.*

double-boteh border, S-4796/*148.*

double bottle, IDC.

double-bottom case, EA.

double boxes, IDPF/*32*①.

double brass, C-5116/*46*①.

double breakfront, LAR83/*248*①.

double cabinet, SDF.

double case, CEA/*254*①.

double-c back, SDF; EA.

double chair, SDF.

double C handle, CEA/592①.

double chest, DADA; EA/*tallboy*; SDF.

double circle, C-5127/99①; C-5156/98①.

double circular, C-2458/422.

double cloth, SDF.

double convex, IDPF/147①.

double cotton, C-2704/175.

double cover, C-5174/588①.

double cross banding, S-4507/64①.

double cruciform coiffure, C-1082/31.

double cup, CEA/626①; DADA/①; EA; IDC.

double-curved handle, EA.

double curved handle, CEA/585①.

double curve motif, CEA/288①.

double decker, EA/①.

double-dialled calendar key, C-2489/150.

double disc shape, C-2458/423.

double-dome cover, CEA/592①.

double-domed, C-2421/148①; LAR83/320①.

double domed, SDF/①.

double-domed cornice, C-2403/89.

double domed cornice, LAR83/254①.

double-domed foot, C-5114/240.

double donkey bag, OC/30.

double dragon border, S-4948/14.

double drop, C-5114/79①.

double-eagle finial, RGS/31①.

double E design, C-5189/405.

double-edged, S-4972/148.

double eight-pointed star, RTA/170①.

double elliptical foot, C-2513/128①.

double ended, C-0706/215; C-1502/59.

double-ended dog, SDF.

double ended drum, CEA/549.

double-end tool, DATT.

double-entente, C-1603/22.

double-entwined outside spiral, CEA/435①.

double face jug, C-2324/13①.

double-flap top, C-5116/72.

double flower head, C-2704/54.

double fringe, OC/23.

double-fronted, CEA/350①.

double-fu motif, S-4965/276①.

double gate-leg table, C-5116/72.

double gate leg table, SDF/①.

double-gourd, C-2458/44.

double gourd, C-0225/79A; C-0782/113; C-5156/101.

double gourd bottle, C-0782/80.

double gourd ewer, C-5127/17.

double gourd form, C-5005/278①; C-5239/135.

double-gourd shape, S-2882/1300①; S-4810/75①.

double-gourd shaped, C-5146/156A.

double-gourd snuff bottle, S-4810/25①.

double-gourd vase, C-2458/155①; IDPF/80①.

double gourd vase, EA; IDC; LAR82/70①.

double half-round pendant, S-4905/415①.

double-handed sword, S-4972/241.

double-headed eagle, C-5174/134①.

double-hinged, C-2478/112①.

double image, C-1603/22; DATT/①.

double imagery, LP.

double inkwell, C-0225/145.

Double Jug, The (De Dobbelde Schenckan), Delft factory, EA.

double knop stem, S-2882/978.

double-line, C-5236/504.

double-line border, S-4414/351①.

double line border, C-2458/31①.

double-line framework, S-3311/356.

double lip, C-1006/*41*.

double-lipped, CEA/*648*①; S-4922/ *56*①.

double-lipped punch ladle, S-4804/*94*.

double-lipped sauce-boat, IDC.

double-lipped sauce boat, C-2502/*180*.

double-lipped sauceboat, S-4802/*206*.

double lobed apron, FFDAB/*92*.

double loop, S-4414/*303*①.

double loop handle, C-5236/*428*①.

double lotus, C-5127/*9*.

double lotus base, C-5156/*220*①.

double moon flask, C-2458/*164*①.

double-necked pot, IDPF/*81*①.

double-niche, S-3311/*46*.

double ogee, IDC; K-711/*130*.

double-ogee bowl, S-4972/*415*.

double ogee bowl, CEA/*423*①; LAR82/*438*①; LAR83/*451*①.

double ogee form, LAR83/*179*①.

double open twist, SDF.

double outlined carving, C-5156/ *305*①.

double oval, S-291/*212*①.

double-overlay, C-5146/*87D*①; EG/ *210*.

double overlay, C-0225/*230*; C-5005/ *240*; C-GUST/*63*①; CEA/*438*①, *495*①; LAR82/*450*①; LAR83/ *423*①.

double-page, JIWA/*108*.

double page, S-4881/*186*①.

double peacock pedestal, C-5234/*5*①.

double pear-shaped prabha, C-5234/ *56*①.

double pedestal, C-0249/*374*, *403*; C-0279/*288*.

double photograph frame, C-5005/ *386*.

double plain, SDF.

double prayer Kazak, C-5323/*65*①.

double prayer rug, C-2320/*119*; C-2403/*179*.

double reed, CEA/*553*①.

double ribs, C-5127/*6*①.

double rope, C-2402/*89*.

double rope twist, SDF/*double twist*.

double salt, NYTBA/*227*①; S-4853/ *184*①.

double-scroll, S-4922/*13*①.

double scroll, CEA/*533*①; IDC; S-4922/*18*①.

double-scroll handle, S-2882/*1182*①.

double scroll handle, C-5114/*90*①; C-5117/*58*①, *227*; DADA; S-2882/ *1062*①; S-4461/*225*.

double scroll ring finial, S-2882/ *1167*①.

double seating, IDPF/*231*.

double serpent handle, S-2882/*817*.

double sextant, LAR83/*460*①.

double shell-guard, C-2569/*43*①.

double shell motif, S-4461/*543*.

double-sided, C-1603/*152*; C-2421/ *145*①.

double-sided oil, C-0249/*137*.

double sided patchwork, C-2704/*81*.

double-sided relief, S-4972/*348*①.

double sloping grate firing, MP/*191*.

double spear, OPGAC/*217*.

double-spiral thumb-piece, CEA/ *666*①.

double spoon, DADA.

double-spotted, S-3312/*1333*①.

double-spouted, C-2513/*359*; IDPF/ *215*.

double stand, JIWA/*315*.

double star motif, CEA/*445*①.

double-stepped, CEA/*398*①.

double stopping, CEA/*556*.

double-straightlines, S-4414/*103*.

double striking alarm clock, LAR83/ *189*①.

double stroke, JIWA/*88*.

double sunk, C-5117/*415*.

double sunk dial, S-4802/*33*①.

double-swell fiddle pattern, C-5114/
64.

double tea-caddy, IDC.

double teapot, IDC/①.

doublet objective, CEA/602①.

double tombstone crest, LAR83/
47①.

doublet pattern, DADA.

double trencher, LAR82/175①.

double twist, SDF.

double twisted, S-4461/310.

double vase, IDC.

double violin case, C-0906/365.

double virgule, C-5174/410①.

double volute thumbpiece, EA.

double-wall, IDC.

double-walled, CEA/416①; EC2/
30①.

double-walled glass, EG/119①.

double-walled insert, CEA/455①.

double-walled medallion, CEA/454①.

double-walled openwork, MP/36.

double weave, OC/22, 182①.

double-wefted, OC/15.

double wefted, OC/19①.

double well inkstand, LAR83/584①.

double-width damask, NYTBA/108.

double-Y stretcher, C-2522/131①.

doublure, S-4973/261①.

doucai, LAR82/140①; C-2458/189;
C-5156/167①; C-5236/1624;
LAR83/78①, 92①.

Doucai Yanyan, LAR82/117①.

doughbox, C-0279/317.

dough-grate, EA/baking-iron,
baking-iron.

Doughty, Susan Dorothy, DADA/
Supplement.

doughty birds, IDC/①.

Douglas, Jon, C-2910/105.

Doulton, ACD; LAR82/118①.

Doulton Lambeth, C-1006/33;
C-2502/45; LAR83/95①; EA/
Doulton.

Doulton Pottery, EA.

dounswept acanthus, S-4905/431①.

douters, EA.

douzième, CEA/264①.

dove, DSSA.

dovecote, DADA/Supplement; EG/
45.

dovetail, C-5114/303①; CHGH/
60①; DADA.

dovetail detent, C-2489/128.

dovetailed, S-4881/276①.

dovetailed case, C-5114/262①,
375①.

dovetailed furrow, CEA/540①.

dovetailed joint, NYTBA/19①; SDF.

dove-tailing, CEA/367①.

dovetailing, ACD; CEA/300, 405.

dovetail-mounted, C-2476/5.

Dowager Empress Dynasty, C-5156/
434①.

Dowager Empress period, C-5127/
352.

dowel, ACD; CEA/405; DADA;
SDF.

dowel legs, C-0249/386.

dowel pin, CEA/541.

dowels, CHGH/58.

dower chest, C-0279/285①; DADA;
EA/① dower; LAR82/422①;
LAR83/402①; NYTBA/31①;
SDF.

Dowicide, DATT.

dowled joint, NYTBA/19①.

down-curved, C-0982/65.

down-curved arm-support, C-2403/32;
C-2421/23①.

down-curved foot, C-2402/20.

down-curved leg, C-0982/31; C-1407/
2; C-2402/9.

down-curved support, S-4955/136.

downcurved tapering leg, C-5116/*82*.

downcurving, C-5116/*136*; S-4972/*518*①.

downcurving arm, C-5157/*59*.

down-curving leg, C-5116/*83*.

down-curving support, C-5116/*66*.

Downes, John, C-5117/*90*.

down hearth, EA.

Downing, Andrew Jackson, SDF/*770*.

down lining, C-1506/*22*.

downscrolled, S-2882/*316*.

downscrolled foot, S-2882/*261, 281, 691*.

downscrolled leg, C-0279/*343*.

down-scrolling, S-3311/*111*①.

down-stroke action, C-2904/*6*.

downswept, S-3311/*202A*.

downswept leg, S-4436/*134*①; S-4812/*170*①; S-4988/*409*①.

downswept quadruple leg, S-4414/*435*①.

downswept tripod leg, S-4414/*445*.

down-turned handle, S-2882/*1012*.

downturned handle, K-802/*14*.

down-turned pointer, C-2904/*71*.

down-turned rim, S-2882/*953*.

dozar, CEA/*101*; OC/*30*.

D. Philby, C-2904/*133*.

drab, C-2704/*117*.

drab body, IDC.

drab-ware, EA/*297*①.

Drabware, C-1006/*103*.

drafting, DATT.

drafting machine, DATT/①.

drafting paper, DATT.

drafting tape, DATT.

draftsman, DATT.

draftsmanship, LP.

drageoire, EA/*sweetmeat box*; LAR82/*183*①.

dragging, DATT.

dragging stroke, DATT.

dragon, DADA; DSSA; IDC/①; OC/*79*; SDF.

dragon and phoenix border, EA/*Alcaraz carpet*.

'dragon and phoenix' design, OC/*191*.

dragon as motif, C-2458/*39*.

Dragon Bead, S-4843/*258*①.

dragon bottle, S-3312/*1349*①.

dragon carpet, CEA/*84*①; OC/*328*①.

dragon cup, S-4965/*81*.

dragon dish, C-5156/*144*.

dragon finial, C-2458/*129*.

dragon-flies, C-2704/*157*.

dragonfly lamp, C-5167/*296*①.

dragonfly lamp shade, C-5005/*390*①.

dragonfly table lamp, C-5005/*399*①.

dragon handle, C-2458/*152*; C-5156/*261*①.

dragon-headed fish, C-2414/*18*①.

dragon-headed S-scroll, C-2458/*213*.

dragon-head foot, C-2402/*28*.

dragon head handle, LAR83/*33*①.

dragon head handle, LAR83/*33*①.

dragon-head roundel, C-2458/*38*.

'dragon'-hook motif, OC/*246*.

Dragon King, S-4843/*258*①.

dragon lustre, IDC; K-710/*109*.

dragon-mask loop, C-2414/*6*①.

dragon motif, JIWA/*5, 336*.

dragon pot, JIWA/*339*①.

dragon rug, C-5236/*554*; S-4965/*107*①.

dragon's blood, DATT; EA; SDF.

dragon-scroll, S-4810/*409*①.

dragon service, IDC.

dragon Soumac, S-4948/*30*①.

dragon spout, C-5156/*261*①; MP/*464*①.

dragon Sumak carpet, S-3311/*67*①.

dragoon sabre, CEA/*43*①; C-2503/*9*.

drainer, IDC; IDPF/*81*①.

Drais, Pierre-François, EA.

drake foot, DADA.

dralon, C-0982/*84*; C-1407/*43*; LAR82/*366*①.

dram cup, DADA; EA.

dram-glass, ACD.

dram glass, DADA.

drap d'or, DADA.

draped figure, C-2398/*17*.

draped form, IDPF/*82*.

draped lotus base, C-5234/*12*①.

draped swag, IDC.

draped tray, C-0249/*443*.

draperie mouillée, DATT.

drapery, MP/*136*; OPGAC/*217*①; S-4461/*28*; S-4922/*48*①.

drapery-carved, FFDAB/*29*①.

drapery glass, C-5146/*161A*.

drapery mantle, S-2882/*1167*①.

drapery mantling, C-5117/*76*①, *148*①.

drapery panel, FFDAB/*34*.

drapery pendant, C-2398/*30*①.

drapery swag, C-0225/*350*; C-2370/*96*; C-2421/*17*①; C-2478/*42*①; S-2882/*1225*①; S-3311/*535*①.

draping, CEA/*166*①.

draught chair, SDF.

draught screen, C-0982/*89B*; EA.

draughtsman, DATT.

draughtsman's curves, C-2904/*48*.

draughtsmanship, LP.

drawback mark, EA; S-4802/*398*①.

drawer, C-0254/*171*①; C-0982/*14*; C-2203/*66*; C-2402/*8*; C-5153/*110*①; C-5239/*241*; SDF.

drawer lip, S-4905/*414*①.

drawer runner, SDF.

drawing, C-2421/*2*①; DATT; JIWA/*13*; LP; OC/*295*.

drawing board, DATT.

drawing box, SDF.

drawing curve, DATT.

drawing down, CEA/*541*.

drawing instrument, C-2489/*12*; C-2904/*48*; C-MARS/*193*.

drawing master, MP/*126*.

drawing-out, CEA/*528*.

drawing out, CEA/*541*.

drawing paper, DATT.

drawing pen, DATT.

drawing pin, DATT.

drawingroom chair, LAR83/*268*①.

drawing-room chair, SDF.

drawing-room furniture, SDF/①.

drawingroom suite, LAR83/*358*①.

drawing table, DATT/①; SDF.

drawing-table, CEA/*339*①.

drawing wire, CEA/*510*.

draw-leaf, C-2388/*121*①.

draw leaf, S-4972/*487*①.

draw-leaf table, CEA/*323*①; EA/①; LAR83/*376*①.

drawn, C-5127/*87*; C-5156/*60*①; S-4972/*417*.

drawn stem, DADA.

drawn stem glass, EG/*288*.

drawn threadwork, C-2704/*137, 171*.

drawn trumpet shape, LAR83/*451*①.

drawn work, CEA/*294*.

drawnwork, DADA.

draw-out, C-5157/*145*①; DATT.

draw-plate, RTA/*12*.

drawplate, EA.

draw slip, SDF.

drawstring, C-1506/*44*.

draw-table, CEA/*322*①.

draw table, ACD; SDF.

draw-top table, DADA/①.

dredger, C-2487/*103*; DADA; EA; IDPF/*45*; LAR82/*571*①.

Dreicer & Co., OPGAC/*13*.

Drentwett family, EA.

Drerup, Karl, DADA/*Supplement*.

Dresden, ACD; C-1582/*33*; C-2409/*128*; C-5189/*26*; CEA/*451*;

DADA; EA; K-802/*21*; LAR82/ *122*①; MP/*10*; S-4461/*140*; S-4804/*493*①; S-4947/*170*.

Dresden Art Academy, MP/*188*.

Dresden china, IDC.

Dresden Kunstgewerbeakademie, MP/*203*.

Dresden liner, DATT.

Dresden Palace, C-0782/*9*.

Dresden porcelain, S-2882/*740*①; S-3311/*369*①.

Dresden Romantic school, MP/*182*.

Dresden School of Arts and Crafts, MP/*208*.

Dresden style, MP/*77*.

dress, C-1506/*5*; DATT.

dressed, C-5236/*1591*.

dresser, ACD; C-0982/*70*; C-1407/ *34*; CEA/*405*; DADA/①; JIWA/ *321*; LAR83/*324*①; S-4436/*171*①; SDF/①.

Dresser, Christopher, C-2409/*136*; DADA/*Supplement*; LAR82/*458*①.

dresser base, C-0249/*413*①; C-5157/ *104*.

dresser-board, SDF/① *dresser*.

dresser ornament, S-4461/*105*.

dresser set, C-5239/*127*; LAR83/ *628*①; S-4461/*16*.

dresser stand, S-4461/*39*.

dressing, CEA/*541*.

dressing box, ACD; C-5116/*4*; EA; SDF.

dressing case, C-0706/*5, 209*; C-1082/*167*; C-2202/*60*; LAR83/ *629*①.

dressing casket, S-4812/*1*①.

dressing chair, SDF.

dressing chest, C-0982/*146*; C-1407/ *119*; SDF/①.

dressing chest of drawers, S-4905/ *370*①.

dressing commode, SDF/①.

dressing glass, C-5005/*356*①; C-5146/*161*①; C-5153/*85*; C-5157/*20*①, *29*①; S-4905/*349*; SDF.

dressing-glass, EA/*toilet mirror*.

dressing mirror, C-0279/*277*; DADA; EA/*toilet mirror*.

dressing stand, S-4804/*862*①; SDF.

dressing stool, SDF/①.

dressing-table, C-2478/*142*.

dressing table, ACD; C-0982/*250*; C-1407/*156*; C-2402/*14, 156*; C-5114/*263*①, *393*①; C-5116/*77, 168*①; C-5153/*105*; DADA; S-4436/*109*①; S-4461/*649*①; S-4812/*72*①; S-4972/*494*; SDF/ ①.

dressing table box, S-4461/*40*.

dressing table clock, C-2409/*224*.

dressing table mirror, C-5005/*367*①.

dressing-table set, C-2409/*176*.

dressing table set, C-0706/*5, 41*; C-1502/*165*.

dressing table stand, C-0249/*234*.

dressoir, DADA.

dress sword, C-2569/*8*.

dress watch, C-2489/*138*.

Drew, John, CEA/*29*①.

dribble, C-5156/*74*①; C-5236/*414*.

dribbling, C-5156/*64*①.

dried, C-0405/*128*.

drier, DATT; LP; SDF.

drift, CEA/*528*.

drifting, CEA/*541*.

drilled for electricity, C-0706/*166*.

drilled hole, C-5127/*96*①.

drill hole, C-5156/*249*①.

drilling, CEA/*528*.

drillingsbecher, IDPF/*105*①; IDC.

Dring & Fage, C-2904/*83*.

drinking flask, S-3311/*170*.

drinking glass, ACD.

drinking group, C-2493/*293*①.

drinking-horn, C-2398/4①; C-5173/58①; EA/①.

drinking horn, DADA.

drinking jug, IDPF/82.

drinking-table, C-2478/119.

drinking table, DADA; SDF.

drinking water pot, IDPF/82.

drip-catcher, CEA/588①.

drip dish, C-5153/67①.

drip glaze, C-0225/15.

drip painting, JIWA/406.

drip pan, C-0279/209; C-2202/58; C-2421/4①; C-5116/37①; S-3311/228①; S-4804/53.

drip-pan, C-2357/6①; C-2409/123; EA/greasepan; IDC; S-4922/37①, 80①.

drip rim, C-5191/412①.

Dritchlery Co., Manchester, C-2489/37.

Drochel, C-1506/174.

drollery, DATT.

drop, C-0279/194; C-5116/41; C-5157/8; C-5173/33①; DADA; S-4461/499; S-4812/14; SDF/①.

drop acorn finial, S-4414/243.

drop black, DATT.

drop border, S-4414/225①.

drop chain, C-0249/277.

drop dial, CEA/239①.

drop dial clock, EA.

drop-dial wall clock, LAR83/210①.

drop-down barrel-assembly, C-2476/13.

drop ear-ring, CEA/520.

drop finial, S-4414/238; S-4881/498①.

drop-front, C-5005/340①; DADA.

drop front, SDF.

drop-front secretary drawer, C-5116/149①.

drop-handle, ACD; C-2382/54①.

drop handle, C-0982/123A; DADA/①; LAR83/251①; SDF.

drop-hung, S-4988/440①.

drop hung canopy, S-4436/66.

drop-in, C-0249/446; C-5005/332①.

drop-in seat, ACD; C-0982/30, 97B; C-1407/8; C-2320/16, 46; C-2370/34; C-2388/14; C-2402/7; C-2478/37; C-5116/63①; C-5157/66①; LAR83/269①; S-2882/250①; S-3311/275; S-4436/127; S-4988/447①.

drop knop, CEA/423①.

drop leaf, C-5114/269①; S-4461/606.

drop-leaf, C-1407/105; C-5153/200①; CEA/389; DADA; FFDAB/57①; S-3311/93; S-4972/522①.

drop leaf dining table, C-0982/95A.

drop-leaf pedestal table, LAR83/369①.

drop leaf table, SDF.

drop-leaf table, ACD; C-5153/120; FFDAB/51; S-4436/117.

drop loop handle, LAR83/296①.

drop octagon, EC2/98①.

drop ornament, SDF/①.

dropout, DATT.

drop-over lid, IDPF/15.

dropped bottom, EA.

dropped seat, ACD; DADA; SDF/①.

drop pendant, C-0249/274.

drop pigment, DATT.

drop prism, C-0249/277.

drop ring, C-5117/3①.

drop ring and whistle terminal, S-2882/1186.

drop ring handle, C-0254/35, 152; C-5117/21, 156①; S-2882/901, 910, 1170.

drop-ring handle, C-5117/262①; C-5173/17①.

drop-shaped, C-5156/349①.

drop-shaped aquamarine, S-291/
202①.

droschel, DADA.

Drouot, Edouard, C-5189/157①.

drugget, SDF.

drug-jar, C-2427/236①; CEA/133①.

drug jar, IDC; S-4972/399.

drug-pot, CEA/133①.

drug pot, IDPF/82①.

druid, C-0225/168.

drum, C-1006/156; C-1502/61;
C-2458/240; C-2513/112A;
C-5114/358①; C-5116/146①;
C-5189/184①; C-MARS/221;
IDC/①; IDPF/82①; S-4992/28①.

drum case, C-0249/245; C-0279/191;
LAR82/230①.

drum clock, EA/①; S-4461/342①;
SDF/①.

drum form, S-4928/167①.

drum-form case, S-3311/413①.

drum-head clock, EA.

drum seat, NYTBA/67①.

drum-shape, C-2458/391; S-4507/
77①.

drum shape, S-2882/1119①.

drum-shaped, C-2910/80.

drum shaped, C-5127/114①.

drumshaped, CEA/257①.

drum-shaped case, C-2437/26;
S-4972/432.

drum table, ACD; C-1407/92;
C-2388/122①; C-2421/96①;
C-2478/161; CEA/347①; DADA;
FFDAB/102; S-4436/134①;
S-4461/698; S-4988/514①; SDF/
①.

drum top, CEA/307①.

drum-top table, LAR83/378①;
S-2882/261.

drum watch, EA/①.

drunkard, CEA/432①.

drunkard's chair, SDF.

drunken figure motif, C-5174/504①.

drunken parson jug, IDC.

Drury, Dru, C-5174/545.

Drury, John, CEA/232①.

Dr Wall, C-1006/73.

dry blue, IDC.

dry body, IDC.

dry-brush painting, DATT.

dry color, DATT.

dry-drug jar, IDC/①.

dry drug jar, S-4823/39.

dry edge, IDC.

dry-edge figure, EA.

dryfoot, DATT.

drying hole, S-286/503.

drying oil, DATT; LP.

drying rate, LP.

drying time, DATT.

dry lacquer, C-5127/41.

dry Meissen flower, MP/121.

dry mounted, S-286/364A.

dry mounting, DATT.

dry-mounting tissue, DATT.

dry mustard-jar, IDC/①.

dry painting, DATT.

dry pigment, LP.

drypoint, C-0225/377; C-5191/331;
C-5239/188; DATT; S-286/34, 63,
64, 82, 89, 200, 255, 256, 278①,
279①, 304, 370①, 383①, 247B①;
S-3311/808①.

drypoint and aquatint, S-286/231①.

drypoint and roulette, S-286/465.

dry rot, DATT.

dry sink, EA.

"D" sectioned shaft, S-3312/1286.

D-shape, C-1407/178; C-2458/228①.

D-shaped, C-2403/59; C-2409/86;
C-5114/327①; C-5239/281①;
FFDAB/54; S-2882/362A①.

D-shaped end, S-2882/691.

D-shaped handle, IDC.

DT, EA/Tanqueray, David.

dual end, C-2402/*171*.
dual pictorial unit, JIWA/*140*.
dual weight marking, C-2904/*33*.
Dubief, Paris, C-2489/*245*.
Dublin, CEA/*446*①.
Dublin Delft, S-4843/*62*①.
Dublin delftware, EA/①; IDC.
Dublin pattern, C-0254/*188, 252*;
 S-4461/*208*.
Dublin tapestry works, DADA.
Du Bois, C-2368/*163*.
Dubois, CEA/*227*①; LAR82/*226*①;
 EA/① *Dubois, Jacques*.
Dubois, Abraham, EA/①; C-5153/
 *28*①.
Dubois, Adrien, C-5224/*52*①.
Dubois, Francois, S-4955/*26*①.
Dubois, Gilles, EA.
Dubois, Gilles and Robert, CEA/
 *183*①.
Dubois, Jacques, ACD; EA/①;
 S-4955/*183*.
Dubois, Paris, S-4927/*56*①.
Dubois, Paul, C-5189/*151*①.
duBois, René, DADA; EA.
Dubois, Robert, EA.
du Bois, Tunis, EA/*99*.
Dubois, Tunis D., NYTBA/*219*①.
Duboule, Jean Baptiste, EA/*96*①.
Dubreuil, Toussaint, C-5224/*217*①.
Dubrovin, Nikolai (assaymaster),
 C-5174/*223*.
Dubucand, Alfred, C-5189/*133*①.
Dubuffet, Jean, S-286/*264*①.
Duc, C-5189/*111*.
ducal coronet, RTA/*132*①.
Du Cerceau, CEA/*371*①.
du Cerceau, Jacques Androuet,
 DADA.
Ducerceau, Jacques Androuet, CEA/
 *372*①.
du Cerceau, Jacques-Androuet the
 Elder, EA/①.

Duchamp, Marcel, S-286/*266*.
Duché, Andrew, CEA/*205*.
Duché, Anthony, CEA/*165, 205*.
Duché, James, CEA/*165*.
Duché family: Antoine, James,
 Andrew, EA.
Duchêne, Louis, S-4927/*80*.
duchess bed, SDF.
Duchess brise, LAR82/*363*①.
duchesse, ACD; C-0982/*250*;
 DADA/①; EA/①; SDF; C-0249/
 446.
duchesse brisée, DADA; EA/①;
 S-4955/*175*①.
Duchesse Brisee, C-0249/*447*.
duchesse lace, DADA.
duck-bill joint, SDF.
duck-egg body, IDC.
duck foot, DADA; S-4881/*504*①.
duck-footed, C-5156/*173*.
duck's head terminal, CEA/*645*①.
duck's nest, SDF/①.
duck tureen, IDC.
Duco, DATT; LP.
Ducoin, CEA/*145*①.
Ducrollay, Jean, CEA/*66*①; EA.
Ducrollay, Jean-Charles, C-5220/
 *50*①.
ductile, DATT; EG/*61*.
ductility, EA.
ductus, JIWA/*402*.
duding box, C-5236/*1726*.
duding type, C-5236/*1580*; C-5127/
 112.
Duding type vase, C-2458/*58*.
Dudley, Countess of, service, IDC.
Dudley vase, IDC.
Dudley Watch Co., C-5117/*397*①.
duecento, DATT.
duelling pistol, ACD; C-2503/*166*;
 CEA/*26*①, *44*; DADA; S-4972/
 *163*①.
duelling rapier, C-2569/*28*.

Duesberry, William, MP/*161*.

Duesbury, William, ACD; CEA/*187*; EA.

Duesbury & Co., C-2360/*84*①.

duet-stand, C-2320/*33*.

duet stand, S-3311/*230*.

Duffner & Kimberly, K-711/*129*.

Dufrene, C-2324/*189*.

Dufrêne, Maurice, C-5005/*348*①.

Dufrène, Maurice, C-5167/*216*①.

Dufy, Raoul, S-286/*267*.

dughi rose, OC/*25, 266*.

Dugourc, J.-D., C-2555/*14*①.

dug-out chest, SDF/①.

Duguay, (Duguet) Jacques, EA.

du Halde, Jean Baptiste, EA.

Duhamel, C-2364/*52*①.

Duhamel, Francois, S-4955/*26*①.

Duhamel, Pierre, CEA/*257*①.

Duke of Rockingham pottery, NYTBA/*155*.

Duke of Villeroy, NYTBA/*170*.

dulcimer, EA; SDF.

dulongmuster, IDC/①.

Dulong pattern, MP/*123*.

dumb, C-MARS/*184*①.

dumbbell border, S-4905/*93*①.

dumbbell head, C-5191/*291*.

dumb-waiter, C-2403/*70*; C-2421/*53*①; CEA/*349*①; DADA.

dumb waiter, ACD; C-0982/*157*; EA/①; LAR82/*350*①; LAR83/*328*①; S-4461/*687*; SDF/①.

dumbwaiter, FFDAB/*67*①; S-4436/*88*; S-4988/*464*①.

Dumee, Nicholas, S-4922/*36*①, *51*①.

Dummer, Jeremiah, CEA/*665*; EA/①.

Dummer, Phineas, CEA/*466*①.

dummy board, C-5114/*183*; SDF.

dummy-board figure, EA/①.

dummy drawer, C-2388/*62*①.

dummy pendulum, CEA/*233*①.

dummy stand, C-2498/*86*.

dummy ware, IDC.

du Mons, J., EA/*Beauvais tapestry*.

Dumont, François, EA/①.

Dumont blue, DATT.

Dunand, Jean, C-5005/*337*①; C-5167/*170*; C-5239/*115*.

Duncan Miller Glass Co., CEA/*472*①.

Dunhill, Alfred, S-4927/*406*.

Dunlap, DADA.

Dunlap, Samuel, II, EA/①.

Dunlop, Andr., London, C-2489/*180*①.

Dunlop, Conr., London, C-2489/*198*.

Dunlop, Sybil, LAR82/*591*①.

dunt, DATT.

Dunville stone, DATT.

duodecimal time, EA/*114*①.

Duofold Junior, C-0403/*14*.

duo-in-unio balance spring, C-5117/*454*①.

Du Paquier, C-2427/*76*①; LAR82/*163*①; LAR83/*165*①; S-4853/*110*①.

Du Paquier, Claude, ACD.

du Paquier, Claudius Innocentius, EA/①.

Du Paquier period, EA/*251*①.

Duplessis, Claude-Thomas, EA.

Duplessis, Jean-Claude-Thomas, EA.

Duplessis vase, IDC/①.

duplex escapement, EA/*escapement*.

duplex platform, C-2368/*39*①.

duplex watch, C-2489/*149*; C-MARS/*165*; LAR82/*239*①: LAR83/*213*①.

Dupont, Pierre, CEA/*96*; EA.

Dupré, Pierre, S-4955/*146*.

Duquesnoy, François, C-5224/*296*①.

duramen, SDF.

Durand, C-5167/*234*; C-5191/*398*; C-5239/*292*; CEA/*685*; OPGAC/*163*.

Durand, Antoine-Sébastien, EA.

Durand, Bon, S-4955/*85*①.

Durand, Victor, DADA/*Supplement*.

Durand, Victor, Jr., OPGAC/*163*.

Durand iridescent glass, S-3311/*919*①.

Durantino, (Fontana) Guido, EA.

Durant Kilns, Bedford Village, New York, EC1/*85*.

Durbin, Leslie, CEA/*663*①; DADA/*Supplement*.

Durgin Co., C-0270/*245*.

Durham, C-2704/*85*.

Durham quilt, C-2704/*48*.

Durham style, C-2704/*58*.

Durlach, DADA; EA.

Dürr, Christoph, CEA/*589*①.

Dusautoy, Jean-Pierre, stamp: JB DUSAUTOY, C-5224/*166*.

Dussanssois, Jacques, NYTBA/*240*①.

Düsseldorf school, DATT; JIWA/*146*.

dust board, CEA/*405*; EA; SDF.

dust box, DATT.

dust cap, C-5117/*447*; EA; S-4927/*85*①.

dust cover, S-4927/*207*①.

dusting, IDC.

dusting brush, DATT.

dusty malachite, C-5156/*174*.

dusty pink, C-2403/*204*.

Dutalis, Joseph Germaine, C-5174/*467*①.

Dutch, C-2421/*130*①.

Dutch and Flemish glass, DADA/①.

Dutch Art Nouveau, DADA/*Supplement*; JIWA/*9*.

Dutch baroque, S-2882/*370*①; C-5116/*121*①; S-4461/*735*.

Dutch candlestick, CEA/*588*①.

Dutch Caravaggism, DATT.

Dutch chair, DADA; EA.

Dutch chairs, SDF.

dutch chocolate pot, S-4804/*111*①.

Dutch clock, EA/①.

Dutch Colonial, DADA/①.

Dutch Colonial style, C-2546/*105*①; EA.

Dutch-Delft, C-2502/*86*.

Dutch Delft, C-1006/*10*; LAR83/*87*①; S-3311/*355*①.

Dutch Delft blue and white, C-1006/*8*.

Dutch delftware, IDC.

Dutch doll, CEA/*697*.

Dutch East India Company, C-2458/*192*.

Dutch fashion, CEA/*346*①.

Dutch foot, DADA; SDF.

Dutch furniture, DADA; EA/①.

Dutch genre painting, NYTBA/*97*.

Dutch glass, EA/①.

Dutch gold, EA; SDF.

Dutch grotesque, EA/①.

Dutch jugs, IDC.

Dutch maiolica, IDC.

Dutch metal, DATT; EA.

Dutch mordant, DATT.

Dutch oven, CEA/*153*①; EA; IDC/①.

Dutch Palace, MP/*76*.

Dutch pink, DATT.

Dutch-process white lead, DATT.

Dutch Rococo, S-3311/*488*①.

Dutch seventeenth century design, C-0906/*155*.

Dutch stove, IDC.

Dutch striking, EA/*striking systems*.

Dutch ware, IDC.

Dutch watch, EA.

Dutch white, DATT; LP.

Dutton, William, CEA/*233*①;
S-4927/*207*①.

duty-dodging, EA.

duty mark, EA; NYTBA/*213.*

Duval, Frederic, LAR82/*237*①.

Duval, Louis, CEA/*514*①.

Duvivier, ACD.

Duvivier, Claude, EA/*231.*

Duvivier, Fidèle, EA.

Duvivier, Henri-Joseph, EA.

DV, CEA/*183*①; EA/*Mennecy
faience and soft-paste porcelain
factory.*

DV MO, EA/*Mô, Christophe, Jean.*

dwarf, C-0982/*13, 63*; C-2202/*96*;
C-2402/*34.*

dwarf ale, CEA/*436*①; EA.

dwarf bookcase, C-0982/*82A*;
C-2402/*3, 23*; C-2403/*103*;
C-2421/*44*①; C-2478/*132*; SDF.

dwarf-cabinet, C-2320/*72*①.

dwarf cabinet, C-2388/*98*; C-2403/*96.*

dwarf candlestick, C-0706/*91.*

dwarf chest, C-1407/*54.*

dwarf column form, LAR83/*550*①.

dwarf cupboard, C-2388/*64.*

dwarf figure, S-4965/*203*①.

dwarf side cabinet, C-0982/*1.*

dwarf-tall clock, EA.

Dwight, John, ACD; CEA/*110, 150*;
DADA; EA/①.

Dwight, Timothy, CEA/*666*①.

Dwight of Fulham, CEA/*138*①;
IDPF/*20.*

Dwight ware, IDC/①.

dwt, EA/*pennyweight*; S-291/*83*;
S-4414/*3*; S-4927/*463.*

Dyck, Peter van, CEA/*668*①.

dye, LP.

Dyer & Son, C-2368/*147.*

dyer's stencil, JIWA/*196.*

dyes, DATT.

dyestuff, DATT; OC/*18, 23.*

dynamic, LP.

dynamic symmetry, DATT.

Dynastic Period, S-4807/*450.*

Dynasty III, LAR82/*32*①.

Dynasty XVIII, LAR82/*32*①.

Dyottville Glass Works, EA.

Dyrnak, C-2320/*150*; S-4847/*98.*

E

E, or Eckernförde, EA/*Eckernförde*.
ea boxes, C-5116/*3*.
eagle, CEA/*590*; DADA; DSSA.
eagle bracket, EA/①; SDF/①.
eagle-carved, C-5114/*359*①.
eagle console table, DADA.
eagle finial, RGS/*17*①, *31*①.
eagle-headed scroll, CEA/*317*①.
eagle-inlaid, S-4905/*444*①.
'Eagle' Kazak, OC/*208*①.
'Eagle Kazak' rug, OC/*328*.
Eagle Kazak rug, S-4796/*44*.
eagle mask, C-2388/*15*; C-5173/*40*①.
eagle mirror, SDF.
eagle motif, NYTBA/*161*①.
eagle pediment, LAR82/*223*①.
eagle's foot, C-2398/*12*①.
eagle's head terminal, C-5117/*83*①.
eagle's mask, C-2421/*30*①.
eagle spout, IDC/①.
eagle stem, C-2478/*3*.
eagle table, EA/*128*①; SDF/① *eagle bracket*.
eaglewood, DADA.
Eames, Charles, C-5167/*223*; DADA/ *Supplement*.

Eames, Rebecca, C-5117/*24*; C-5203/ *182*.
ear, CEA/*583*①; IDC.
earclip, S-291/*45*①.
ear-dish, CEA/*594*.
ear-drop, C-2458/*325*.
eared, C-0249/*346*; C-0982/*1*;
 C-2364/*62*①; C-2388/*12*①;
 C-2403/*5*; C-2409/*244*; C-2421/
 *29*①; C-2498/*103*; C-5116/*56*;
 CEA/*345*①; LAR82/*288*①.
eared and concave cross-banded,
 C-1407/*18*.
eared bowed, C-2402/*118*.
eared cup, EA/*porringer*.
eared dish, EA/*porringer*.
eared frame, C-2421/*33*①.
eared mask, S-4965/*117*①.
eared plinth base, C-2403/*111*.
eared rectangular top, C-0249/*448*①;
 C-0982/*19*; LAR83/*307*①.
ear handle, C-5127/*17*, *261*①.
earlike stop, IDPF/*121*①.
Earl of Leicester, C-2704/*36*.
earl's coronet, C-5117/*26*.
earl's coronet and crest, C-5173/
 *39*①.

earl's coronet finial, C-5117/*44*①.

early ceramic, C-2458.

early Edo period, C-5156/*777*.

early George III, S-4922/*13*①.

Early Georgian, DADA/① *Queen Anne.*

early Georgian architectural wall mirror, DADA/①.

early Georgian style, DADA; SDF.

early glass, C-5156/*343*①.

early Kang Hsi, C-0782/*8.*

Early Kangxi, C-5156/*141.*

early Meissen ware, MP/*32.*

early metalwork, C-2458/*209*①.

early/mid Qing Dynasty, C-2458/*233.*

Early Shu period, JIWA/*88.*

early style, C-5156/*339.*

Early Tang Dynasty, C-5156/*17*①, *177*①.

early 18th Century, C-2403/*114.*

early Victorian, C-0406/*125*; C-2478/ *32.*

Earnshaw, Thomas, C-5117/*484*①; CEA/*255*①; EA.

Earnshaw balance, C-2489/*125.*

Earnshaw spring detent, C-2489/*125.*

Earnshaw's spring-detent escapement, C-MARS/*203.*

ear-ring, CEA/*514*①.

earring, C-5236/*395*①; EA.

ears, SDF.

ear-shaped handle, CEA/*201*①.

ears of corn, C-2402/*195.*

earth color, DATT; LP.

earthenware, ACD; C-5146/*45*; CEA/*151*①; DADA; DATT; IDC; IDPF/*33*①; JIWA/*85*①; LAR82/ *504*①; S-4461/*405.*

earthenware factory, EA/*Cockpit Hill.*

earthenware sculpture, C-5167/*92*①.

earthenware vase, S-2882/*757*①.

earth spirit figure (mythical beast), S-4965/*206*①.

earthworm tracks, IDC.

ear trumpet, C-2608/*155.*

ease-and-comfort, SDF.

easel, C-5005/*367*①; DATT/①; LP/ ①.

easel back, S-4927/*124*①.

easel desk clock, C-2489/*147A.*

easel mirror, C-2522/*159*; S-3311/ *418.*

easel painting, DATT; LP.

easel stand, C-5005/*386.*

easel top, C-2388/*28.*

East, Edward, ACD; CEA/*251*①; DADA; EA/①; S-4927/*220*①.

East, John, C-5117/*261*①.

East African copal, DATT.

East Anglican, C-5117/*264*①.

easter egg, C-5117/*348.*

Eastern ethnic jewellery, RTA/*193*①.

Eastern Jin Dynasty, S-4965/*186*①.

eastern loom, DADA.

Eastern textiles, C-2478.

Eastern Turkestan rug, S-4461/*779.*

Eastern Zhou Dynasty, C-5156/*335*, *381*①.

East Greek, C-1582/*12.*

East India flowers, EA/*indianische Blumen.*

East Indian rosewood, DATT.

East India porcelain, DADA.

Eastlake, C-5189/*256*①; LAR83/ *351*①.

Eastlake, Charles Lock, DADA/ *Supplement*; EA.

Eastlake, Charles Locke, SDF/*749.*

Eastlake style, EA; NYTBA/*77*; SDF/①.

East Liverpool Pottery Company, DADA/*Supplement.*

Easts, The, SDF/*776.*

East Turkestan, OC/*108.*

Eastwood, EA/*Baddeley, William*; S-4843/*375*①.

easy chair, ACD; C-5114/*323*①; C-5153/*208*①; DADA; EA; FFDAB/*29*; SDF/①.

Eaton, Elizabeth, C-5117/*32*.

Eaton, William, EA/*50*.

Eaton Hall chair, ACD; SDF.

eau de cologne bottle, C-0270/*273*.

eau de Javelle, DATT.

eau de Labarraque, DATT.

eau-de-nil, C-0405/*172*; C-2203/*36*; LAR83/*231*①; S-288/*3*①.

eave, C-2421/*52*①.

eaved base, C-2498/*82*.

Eavestaff, C-5005/*347*.

ebauche, C-5117/*427*①; C-5174/*401*.

ébauche, CEA/*250*; DATT; EA.

ebene de macassar, S-4804/*799*①.

ebéné macassar, C-5146/*120*①, *133*①; C-5167/*194*①.

Ebenezer Coker, S-3311/*774*①.

Ebénier des Alpes, DADA.

ébéniste, CEA/*378*①.

ebeniste, CEA/*405*.

ébéniste, DADA.

ébéniste, EA/*Riesener, Jean-Henri*; SDF.

ébéniste ordinaire, EA/*Riesener, Jean-Henri*.

ébénisterie, C-2364/*45*; C-2555.

ebénisterie, DADA.

Eberlein, Johann Friedrich, EA/①; MP/*109*.

ebonise, ACD.

ebonised, C-0982/*76, 82B*; C-1502/*77*; C-2402/*157*; C-5005/*346*.

ebonised line, C-1407/*25*; C-2388/*53*.

ebonised wood, C-0706/*1*; C-2409/*270*①.

ebonised wood frame, C-5005/*339*①.

ebonist, SDF.

ebonize, DADA; SDF.

ebonized, C-0982/*1*; C-5116/*45*①, *54*; FFDAB/*55*; LAR83/*180*①; S-2882/*670*; S-4414/*408*.

ebonized and reeded border, LAR83/*367*①.

ebonized band, C-0982/*42*.

ebonized base, S-2882/*795*①.

ebonized block foot, S-2882/*782*.

ebonized furniture, JIWA/*377*①.

ebonized wood, LAR83/*56*①; S-3311/*461*.

ebonized wood handle, RGS/*106*①.

ebony, C-2402/*102, 115*; C-2437/*64*; C-2458/*400*; C-5005/*229*; C-5114/*173*; C-5116/*50*①; C-5157/*150*①; C-5239/*100*①; CEA/*225*①, *303, 562*; DADA; DATT; FFDAB/*43*; RTA/*196*①; S-4436/*14*; SDF.

ebony-bodied, C-0403/*34*.

ebony veneer, CEA/*373*①.

F. Brandt, C-5005/*336*①.

EBS, K-710/*119*.

Ebsworths, The, SDF/*776*.

Ecalle, A., LAR82/*239*①.

écarté, C-2332/*1*.

eccentric, C-5127/*241*; C-5236/*465*①.

eccentric brown, C-5127/*347A*.

eccentric pattern, C-5156/*155*.

ecclesiastical, CEA/*579*.

ecclesiastical plate, C-5173/*58*①.

echinus, DADA; EA; IDC; SDF/①.

echinus foot, S-4973/*123*①.

echinus moulding, ACD.

echinus mouth, S-4973/*124*①.

echoppe, DATT.

Eckernförde, DADA.

Eckernförde faience factory, EA.

Eckfourd, John, LAR82/*574*①.

Eckhardt Edris, DADA/*Supplement*.

Eckmann, Otto, DADA/*Supplement*.

Eckstein, Johan Niclas, CEA/*317*①.

eclecticism, DATT; LP.

eclipse, K-710/*118*.

ecliptic, C-2489/17①.

ecliptic ring, C-5174/429①.

Ecole de Nancy, C-5167/186; CEA/ 484.

écorché, DATT/①; LP/①.

écorché figure, C-5224/265①.

Ecosse, Jean-March-Antoine, C-5220/20①.

ecran à coulisse, DADA.

ecran à eclisse, DADA.

ecran à eventail, DADA/①.

écran de feu, C-5224/56.

écritoire, IDC.

ecru, C-0279/303①; LP.

ectype, DATT.

écuelle, ACD.

ecuelle, C-0254/48; C-2427/30①, 74; C-5236/492; CEA/594, 631①.

écuelle, CEA/647①.

ecuelle, DADA.

écuelle, IDC.

ecuelle, IDPF/83.

écuelle, RGS/31①.

ecuelle, S-2882/996①.

écuelle, S-4853/29①.

ecuelle, S-4922/65①; S-4944/178.

éculle, C-2486/65①.

écureuil, EA.

ED, EA/Drentwett family.

Edad Media XVI, XVII, XIX, C-2704/165.

Edelzinn, EA.

edge, C-0225/325; C-5114/277; IDC; LP.

edged, C-1603/88; C-2421/29①; C-5116/83.

edged ecru linen, C-0405/63.

edged hook, S-4972/143①.

edged reticulation, S-2882/712A①.

edged weapon, C-2503/①.

edged with butter yellow, C-2704/61.

edge lift-top, C-5114/294①.

edge-related composition, JIWA/ 405①.

Edgerton Pottery, Edgerton, Wisconsin, EC1/85.

edging, C-5114/339①; EG/102①; SDF.

edging strip, JIWA/134①.

Edinburgh, C-2904/204.

Edinburgh & Leith Flint Glass Works, EA/Scottish glass.

Edinburgh & Leith Glass Company, EA/Scottish glass.

Edinburgh microscope, C-2608/84.

Edington, J. Charles, S-4944/271①.

Edington, J. Chas, C-0706/82.

editeur, C-5181/68①.

edition, C-5167/19.

Edkins, Michael, CEA/442①; EA.

Edmands & Co., EA.

Edmonds, B., C-5153/75①.

Edmonds, Ino., C-MARS/169.

edo, DADA; C-5127/446; CEA/575.

Edo artists, S-4928/41.

Edo period, C-0782/120; IDC; JIWA/18①, 352; LAR82/38①; C-5156/696①; C-5236/846; CEA/ 575.

Edo style, C-5127/359①.

Edouard Bouty, C-2904/61①.

Edouart, Augustin,, EA/①.

Educational Sciences, C-2904/25.

Edwardian, C-0982/10; C-1407/55; C-1502/19; C-1506/53; C-2402/38; CEA/683; DADA/Supplement; LAR82/63①; NYTBA/304; S-3311/704; S-4461/560①.

Edwardian Albany pattern, C-2202/5.

Edwardian period, S-4927/289①.

Edwardian walnut chair, C-0982/61.

Edwards, Benjamin, EA/Belfast Glass Company.

Edwards, family: John, John Allen, Samuel, Thomas, Joseph, EA.

Edwards, James, C-0406/15.

Edwards, John, C-5153/*42*①; CEA/ *668*①; S-4905/*229*.

Edwards, Joseph Jr., C-5153/*36*①.

Edward Smith, C-0406/*79*; S-3311/ *715*①.

Edward VII pattern, S-4804/*31*.

Edward VII period, C-5174/*498*①.

Edwin Bennett Pottery, Baltimore, Maryland, EC1/*85*.

EE, EA/*Mennicken family*.

eel's blood crackle, IDC.

eel-skin yellow, IDC.

eel tureen, IDC.

Eenhoorn, Lambertus van, C-2486/ *167*①.

Eenhoorn, Samuel van, CEA/*140*①.

Eenhoorn, Wouter van, CEA/*141*①.

effigy, C-5191/*7*; CEA/*537*.

effigy jar, S-4807/*88*①.

effigy jug, CEA/*167*①.

effigy pot, IDPF/*83*.

efflorescence, DATT; LP.

Eger, CEA/*455*①.

Egermann, F., EA/*49*①.

Egermann, Friedrich, CEA/*59*①, *455*①; EA/①.

Egerton, Matthew (I), SDF/*771*.

Egerton, Matthew (II), SDF/*771*.

Egerton, Matthew Jr., CEA/*398*①.

egg, DSSA; IDC; IDPF/*83*①.

Egg, Durs, London, C-2503/*209*①.

egg, use in painting, DATT.

egg and acanthus leaf border, C-0254/*59*①.

egg-and-anchor border, IDC.

egg-and-dart, C-2320/*100*①; C-2388/ *63*; C-2421/*32*; C-5116/*132*①; S-4804/*76*.

egg and dart, C-0254/*131*; C-1502/ *51*; C-2202/*73*; DADA; DATT/①; S-4436/*11*①.

egg-and-dart and egg-and-tongue, ACD.

egg-and-dart border, IDC.

egg and dart border, C-0254/*88*; C-5117/*30*①, *130*①.

egg and dart decoration, C-1502/*9*.

egg-and-dart molding, S-2882/*798*①.

egg and dart molding, LAR83/*249*①.

egg-and-dart moulding, EA.

egg-and-dart ornament, C-2478/*111*.

egg and dart pattern, S-4988/*495*①.

egg and dart rim, S-4414/*265*①.

egg and dart short stem, S-4922/*8*①.

egg-and-spinach glaze, IDC.

egg and spinach-glaze, C-2458/*127*.

egg and spinach glaze, DADA.

egg-and-tongue, SDF/①.

egg and tongue, DADA.

egg-and-tongue border, IDC.

egg and tongue border, C-5117/*217*.

egg-and-tongue moulding, EA/ *egg-and-dart*.

egg-beater, IDC/①.

egg boiler, EA/①.

egg border, IDC.

egg coddler, LAR83/*590*①; S-4802/ *345*.

egg cruet, C-0706/*126*; C-1502/*104*; EA/① *egg frame*; LAR83/*568*①.

egg-cup, C-5117/*26*; IDC.

egg cup, C-0706/*130*; C-1006/*41*; C-5174/*256*①; C-5203/*353*.

eggcup, EC2/*23*.

egg cup frame, DADA.

egg-cup stand, IDC/①.

egg-drainer, IDC.

Eggebrecht's factory, MP/*67*.

egg frame, EA/①.

egg in sand, OPGAC/*217*.

egg knop, CEA/*423*①.

egg-poacher, IDC/①.

egg-ring, IDC.

egg-separator, IDC.

egg shape, S-4972/*309A*.

egg-shaped, C-1006/*182*; C-5157/
*133*①.

egg-shaped bottle, CEA/*56*①.

egg-shaped opal, S-291/*48*①.

egg-shell, S-4965/*297*①.

egg shell, C-5127/*260*①.

eggshell, DADA; EA; IDC; LAR83/
*149*①.

eggshell bowl, C-2458/*137*; C-2513/
*228*①.

eggshell finish, DATT.

eggshell glaze, IDC.

eggshell jade, C-5234/*250*①.

egg-shell porcelain, ACD.

eggshell porcelain, C-2324/*77.*

egg shell porcelain vase, C-5005/*315.*

egg-spoon, EA.

egg spoon, C-0254/*176*; C-0706/*77.*

egg-stand, C-2486/*23*; IDC.

egg stand, C-1006/*211.*

egg tempera, DATT.

egg warmer, C-0254/*3.*

egg yoke, LP.

eggyolk-yellow, C-5236/*1625.*

eggyolk yellow, C-5127/*100.*

eglomisé, C-5114/*171*①.

églomisé, C-5114/*276*; C-5153/*87,
161A*①; CEA/*389.*

eglomisé, CEA/*400*①; DADA.

églomisé, FFDAB/*111.*

eglomise, S-4905/*355*①.

eglomisé banjo clock, S-3311/*210*①.

eglomisé mat, C-5114/*176*①.

eglomisé panel, C-5114/*264*; S-2882/
*683*①, *684*, *685*①.

églomisé portrait, S-2882/*658*①.

Egnatian ware, IDC.

egouttoir, DADA.

Egypt, CEA/*689*①.

Egyptian, C-0225/*332*①; CEA/*415,
509*; OPGAC/*218.*

Egyptian art, DATT.

Egyptian black, ACD; EA; IDC.

Egyptian blue, DATT; IDC; LP.

Egyptian brown, DATT.

Egyptian Canopic jar, IDPF/*106.*

Egyptian carpet, EA.

Egyptian cross, DATT.

Egyptian detail, CEA/*360*①; DADA/
①.

Egyptianesque motif, S-2882/*1370*①.

Egyptian faience, IDC.

Egyptian green, DATT.

Egyptian head decoration, C-2555/
*13*①.

Egyptian 'Kashan', OC/*299*①.

Egyptian mask, C-2357/*6*①; S-4922/
*26*①.

Egyptian monopodia angle, C-2403/
96; C-2478/*174.*

Egyptian motif, CEA/*384*①.

Egyptian painting, LP.

Egyptian paste, DATT; IDPF/*62,
200.*

Egyptian pillar, C-5117/*460*;
C-MARS/*175.*

Egyptian pottery, IDC.

Egyptian revival, C-5114/*35*①.

Egyptian revival taste, C-5117/*202*①.

Egyptian service, IDC/①.

Egyptian soul house, IDPF/*108.*

Egyptian style, C-GUST/*2*; RTA/
*20*①; SDF/①.

Egyptian style pillar, CEA/*251*①.

Egyptian taste, C-2489/*102.*

Egyptian ware, IDC.

Egypto, OPGAC/*345.*

Ehder, Johann Gottlieb, MP/*118.*

E. Hide & Co., C-0405/*84.*

E. Howard Watch Co., C-5117/*402.*

Ehrenreich, Johan Ludwig Eberhard,
EA.

Ehrenreich, Johann, CEA/*149*①.

Ehrenring, RTA/*142.*

Ehret, George D., CEA/*189*①.

Ehrhardt, W., C-5117/453①.

Eichhörnchendekor, IDC.

eidograph, C-2608/24; C-2904/254, 260.

eigelstein, DADA.

Eigesteiner pottery, NYTBA/156①.

Eight, The, DATT; LP.

eight Buddhist emblems, the, IDC.

eight-day clock, S-4927/73.

eight-day watch, C-5117/444①.

Eighteen Lehan, C-2458/415.

eighteen Lohan, DADA/① Lohan.

Eighteen Lohan, the, IDC.

18th Century Taste, C-2487/148.

eight-foil bezel, RTA/49①.

eight happy omens, DADA.

eight horses Mu Wang, the, IDC/①.

Eight Horses of Muwang, C-2458/393.

Eight Immortals, the, IDC/①.

eight-pointed rosette, OC/332.

eight-point star, C-2704/170.

eight precious objects, DADA.

eight precious things, C-5156/437.

Eight Precious Things, the, IDC.

eight-sided pedestal stem, CEA/428①.

eight Taoist immortals, DADA.

eight trigrams, DADA/①.

Eight Trigrams, the, IDC.

E.I.G. pistol, C-2503/160.

E II, CEA/184①.

Einbrenner, MP/84.

Eiraku ware, DADA.

Eisch, Erwin, DADA/Supplement.

Eisenporzellan, IDC.

eisenrot, C-2486/67.

eisenrot (iron red), EG/161.

eisenrot, IDC; C-2427/143①.

Eisenrotmalerei, EA/red monochrome, red monochrome.

Eisho ga, S-3312/961①.

Eisolt, August Friedrich Ferdinand, C-5174/148①.

Ejagham, C-1082/4.

ejector, C-2476/4.

ejector candlestick, C-1702/100.

ejector gun, C-2476/15①.

Ekaterineburg Hardstone Factory, C-5174/256①.

Ekman, Johan, DADA/Supplement.

Ekoi, C-1082/4.

elaborately pierced applique motif, C-2704/63.

élan vital, LP.

El Armarna, C-0225/332①.

elbow chair, C-1407/139; DADA; EA/①; LAR82/298①; LAR83/280①; SDF.

elbow dish, IDPF/85.

elbow gauntlet, LAR82/39①.

elbows, SDF.

elder wood, DADA.

Election cup, S-4843/65.

electioneering decanter, LAR83/420①.

electioneering ware, IDC.

election jug, LAR83/82①.

electoral arms, MP/133.

Electoral Court service, S-4853/126①.

elector glass, DADA.

Elector's crown, C-2332/46①.

electric blue, C-2704/57.

electric illuminator, C-2904/29.

electrified, C-5153/81①.

electro-damascene design, C-5146/126①.

electro-gilding, EA.

electrolier, SDF.

electroplate, NYTBA/215.

electro-plated, C-0103/24; C-0706/32.

electroplated, C-2202/62; LAR82/120①.

electroplated copper, LAR83/592①.

electro-plating, EA/①.
electroplating, CEA/477①; DADA/
 Supplement; DATT.
electro-static, C-2904/138.
electro-static machine, C-2904/280①.
electrotype, LAR82/585①.
electrotype copy, C-2510/7①.
electrotyping, EA.
electrum, DATT; EA.
electuary-pot, IDC.
elegant surface, MP/10.
elem, C-0279/20①; C-5189/406;
 S-3311/30; S-4847/10.
element, C-5114/305①; DSSA;
 JIWA/23.
Elements, the Four, IDC.
elemi, DATT.
elem panel, S-4796/121①.
elephant, C-0225/67; DSSA.
elephant and flowerhead caryatid,
 C-5234/33.
elephant caryatid, C-5234/51①.
elephant clock, EA.
elephant-head, C-2402/101.
elephant head, C-0270/28.
elephant-head foot, C-2458/252.
elephant head handle, C-1082/90.
elephant ivory, CEA/562.
elephant's ear, DATT.
elephant's foot, EA/gul foot.
elephant's head and ring handle,
 LAR83/138①.
elephant stand, C-0906/83.
elephant standard, C-0249/274.
elephant's tooth, LAR83/606①.
elephant teapot, IDC.
elephant tusk, S-4881/229①.
Elers, DADA.
Elers, David and John, ACD.
Elers, John Philip and David, EA/①.
Elers redware, IDC/①.
elescopic candlestick, C-5174/461.

Eleusinian marble, DATT.
E. LEVASSEUR, EA/Levasseur,
 Etienne.
elevated-rib, C-2476/4.
elevation, DATT.
elevator, IDC.
Eley, Charles, C-5117/38.
Eley, W., C-2487/45.
Eley, William I, C-5117/33.
Eley & Fearn, C-0706/8; S-4922/
 33①; S-4944/162.
Elfe, Thomas, DADA; EA; SDF/771.
Elfe, Thomas, Junior, SDF/771.
Elgin, George, CEA/40①.
Elgin cutlass pistol, CEA/40①.
Elgin National Watch Co., C-5117/
 396①.
Elgin vase, LAR82/189①; EA/
 Northwood, John I.
Elhafen, Ignaz, C-5224/248①.
Eliaers, A., C-5189/262①.
Elijah cup, C-5174/102①.
Elizabethan, CEA/389; DADA/①;
 LAR82/271①; NYTBA/73;
 S-4972/471.
Elizabethan furniture, EA.
Elizabethan revival, LAR83/287①.
Elizabethan style, C-2478/125①;
 SDF.
Elizabethan ware, IDC.
Elizabeth I, C-5117/106①.
Elkington, C-0406/38.
Elkington, Frederick, C-2510/30;
 CEA/662①.
Elkington, George Richards, DADA/
 Supplement; EA/①.
Elkington & Co., EA; LAR82/585①;
 S-3311/697.
Elkington and Company, DADA/
 Supplement.
Ellaume, Jean-Charles, stamp: J C
 ELLAUME, C-5224/186.
ell-handle, S-4881/204①.

Ellicott, S-4927/*216*①.

Ellicott, John, CEA/*232*①; EA/①.

Ellicott, John the Elder, EA/① *Ellicott, John.*

Ellicotts, The, SDF/*776*.

Elliott, Charles, SDF/*750*.

Elliott, John, CEA/*396*①; DADA.

Elliott, W., C-2510/*75*.

Elliott Bros., C-2904/*170, 234*.

Elliott Family, The, SDF/*750*.

ellipse, C-5114/*93*①, *315*①.

ellipse guide, DATT.

ellipsograph, LAR83/*465*①.

elliptical, C-0982/*121*; C-1407/*12, 25*; C-2402/*54*; C-5005/*262*①; C-5117/*347*; C-5127/*273*; C-5153/ *47*①; CEA/*675*①.

elliptical form, C-2402/*21*.

elliptical procedure, JIWA/*390*.

elliptical pull, S-4965/*71*.

elliptic corner, FFDAB/*54*①.

Ellis, John, CEA/*389*.

Ellis, William, CEA/*166*①.

Ellore, OC/*305*.

Elluru, OC/*305*.

Ellwangen, EA/*Utzmemmingen.*

elm, C-0982/*7, 81C*; C-1407/*93, 138*; C-2402/*219*; C-5116/*119*; C-5157/ *125*①; C-5239/*256A*; SDF.

Elme, C-2409/*11*.

elmwood, C-0249/*317*; C-5116/ *168*①; DADA; S-3311/*250*; S-4436/*137*①; S-4812/*192*①; S-4972/*461*①; S-4988/*546*①.

elongated, C-5117/*202*①; S-4847/*41*; S-4905/*227*①.

elongated neck, C-5203/*101A*.

elongated octagonal, C-5114/*213*①.

elongated ovoid shape, S-2882/*1257*.

elongated shape, S-4972/*137*①.

eloping bride, IDC.

Elsner green, DATT.

Elsten, John, CEA/*647*①.

Elston, John, C-5117/*99*①.

Elton, C-2409/*110*.

émail, IDC.

émail cloisonné, JIWA/*86*①.

émail closionné, JIWA/*9*.

émail en plein, RGS/*50*.

émail en résille sur verre, EA.

émail en ronde bosse (encrusted enamel), RGS/*50*.

émail ombrant, IDC.

Email Ombrant, DADA/*Supplement.*

émail sur bisque (or biscuit), IDC.

emaki art, JIWA/*221 horizontal scroll painting.*

Emanuel, Harry, CEA/*518*①.

E. MAYER, EA/*Mayer, Franz Ferdinand.*

embattled, SDF.

embattled border, IDC.

embelished, S-4461/*653*.

embellishment, LP.

ember tongs, SDF.

ember-tongs, EA/*smokers' tongs.*

emblamatic, C-2502/*2*.

emblazoned, S-4928/*36*①.

emblem, C-1603/*138*; C-5127/*59*; JIWA/*5, 75*.

emblematic device, RTA/*14*.

emblematic significance, JIWA/*75*.

embossed, C-0225/*100A*; C-0706/ *109*; C-2202/*31*; C-2421/*1*; IDPF/ *24*①; JIWA/*123*①; LAR82/*71*①; S-286/*308, 309*; S-3311/*653*; S-4436/*38*①; S-4461/*13, 29*; S-4804/*14*; S-4881/*30*①; S-4905/ *175*①; S-4922/*11*①, *11*①, *13*①; S-4972/*151*①, *168*①.

embossed and chased, S-4804/*70*①.

embossed border, S-4461/*281*.

embossed label, C-5114/*227*.

Embossed Vine Leaf, S-4843/*297*.

embosser, MP/*502*.

embossing, CEA/540①, 618, 678;
DADA; DATT; IDPF/85;
NYTBA/216; SDF.

embossing technique, JIWA/278.

embouchure, CEA/549.

embrittlement, DATT.

embroidered, C-1603/74; OC/16;
S-4461/513.

embroidered bolster, C-5236/368.

embroidered panel, CEA/281①.

embroidered picture, NYTBA/84①.

embroidered rug, DADA.

embroidered screen, LAR83/334①.

embroidery, CEA/273; DADA;
S-4461/66; SDF.

embroidery, late Victorian and
Edwardian, DADA/Supplement.

embroidery design, NYTBA/91.

embroidery on silk, C-5156/437①.

embroidery panel, S-4948/31A.

embryo shell thumbpiece, EA.

embu, DATT.

embuya, DATT.

Emens, Jan, EA.

Emens, William, CEA/136①.

emerald chromium oxide, DATT.

emerald-cut, S-4414/7.

emerald-cut aquamarine, S-291/260.

emerald-cut diamond, S-291/46, 57①;
S-4414/49①.

emerald-cut emerald, S-291/72①,
73①, 177①, 181①, 192; S-4414/
76①.

emerald green, DATT; LP.

emerald leaf, S-4414/94①.

Emeralite, K-711/129.

emeraude green, DATT.

Emerson's patent (1780), EA/brass.

emery, DATT.

Emery, Josiah, EA.

Emery, Josiah, London, C-MARS/
172.

Emes, John, C-0706/18; C-2487/112;
C-5117/36, 42, 149①; EA.

Emes, Rebecca, EA/Emes, John;
S-3311/721; S-4944/311①.

Emmanuel, EA/Drentwett family.

emotion, LP.

empathy, DATT; LP.

emphasis, LP.

empire, ACD; CEA/405; C-5114/56;
C-5117/175①; CEA/172①, 516①;
DADA/①; FFDAB/24; NYTBA/
8; S-4461/554; S-4804/899①;
S-4905/411①.

Empire low-boy, CEA/384①.

Empire period, CEA/304.

Empire shelf clock, CEA/244①.

Empire stenciled, S-3311/215①.

'Empire' style, RGS/35.

Empire style, C-2402/165; EA/①
Emes, John; IDC/①; RGS/80,
170①, 184; S-2882/783①, 787①;
S-4804/825①; SDF.

Empoli, DADA/Supplement.

Empress Elizabeth of Russia service,
IDC.

empty space, JIWA/89.

empyrematic, DATT.

emulsion, DATT; LP.

emulsion ground, DATT.

enamel, ACD; C-0254/40; C-0782/
42; C-1082/87; C-2398/7; C-2458/
254; C-5156/70; CEA/209, 540①,
620①; DADA; DATT; EC2/20①;
IDC; LP; RGS/39; S-4461/379;
SDF.

enamel blank, EA.

enamel color, MP/40, 502.

enamel colour, IDC.

enamel dial, C-2904/259; C-5117/
398①; S-4461/301.

enameled, EC2/95①; S-4992/3①.

enameled glass, EC1/56; NYTBA/
272①; S-4804/672①.

enameled gold mount, S-291/240①.

enameler, MP/*34.*

enamel famille, C-1082/*95.*

enamel firing, IDC.

enamel glaze, EC1/*83.*

enameling on metal, MP/*39.*

enamelled, C-1502/*128;* C-5005/ *204*①, *206*①, *220*①; C-5127/*46;* C-5156/*805*①; CEA/*415.*

enamelled bezel, C-2368/*129.*

enamelled case, CEA/*250.*

enamelled mount, C-0706/*118.*

enamelled porcelain, C-5156.

enamelled signature, C-5005/*261*①.

enamelling, EG/*38*①; JIWA/*12;* RTA/*13.*

enamellist, CEA/*509.*

enamel miniature, RGS/*145*①.

enamel on biscuit, IDC/①.

enamel-on-copper, C-5146/*119;* C-5189/*234.*

enamel on copper, C-0225/*101B.*

enamel on sterling, C-0225/*101.*

enamel paper, DATT.

enamel plaque, CEA/*262*①; RGS/ *116*①.

enamels, C-5117.

enamel spandrel, RGS/*124*①.

enamel style, RGS/*40*①.

enamel white, DATT.

E.N.A.P.I., DADA/*Supplement.*

en arbalette, S-4955/*156.*

en arballette, S-4972/*528.*

e-nashiji, S-4928/*141*①.

en bateau, CEA/*385*①.

en bois de bout, C-5259/*483*①.

en cabochon, RGS/*40*①.

en cabriolet, CEA/*380*①.

en cage, C-5220/*13*①.

en camaïeu, EA/*Chantilly, Nyon.*

en camaieu, C-2427/*54.*

en camaïeu, EA.

en camaieu rose, C-2486/*7*①.

encarpa, SDF.

encarpus, SDF/*encarpa.*

encased overlay, CEA/*502;* EG/*288.*

encaustic, ACD; DATT/①; K-710/ *109;* LAR83/*169*①.

encaustic decoration, IDC.

encaustic painting, DADA; DATT/①; LP.

en chiffonniere, S-4823/*198;* S-4972/ *541.*

encircling, EC2/*28*①.

enclosed area, JIWA/*206*①.

enclosed stepped medallion, S-2882/ *76.*

enclosed top, C-5005/*351*①.

enclosing shelf, C-5157/*61.*

encoigneur, EA/① *corner cupboard.*

encoignure, ACD; C-0279/*369*①, *457*①; C-2364/*48*①; C-5224/ *181*①; C-5259/*641;* CEA/*379*①, *405;* DADA/①; LAR82/*331*①; LAR83/*310*①; S-4804/*773*①; S-4823/*194;* SDF.

encoignure à deux corps, DADA.

encrier, C-2437/*17*①; C-2546/*2;* IDC; LAR82/*52*①; LAR83/*489*①.

encrustation, C-2427/*197*①; C-2458/ *210*①; C-5127/*161;* C-5156/*4*①; C-5236/*1718.*

encrusted, C-2493/*256;* IDC/①; S-4972/*285A.*

encrusted enamel, RGS/*51.*

encrusted ware, IDC.

en cuvette, EA.

Encyclopedia of Needlework, C-0405/ *169.*

end-cut, C-2364/*69*①; C-5116/*101.*

end-cut kingwood, C-5224/*200*①.

end drawer, C-1407/*153.*

Ende, Wm., C-5189/*117.*

Endell, August, DADA/*Supplement.*

Enderlein, Caspar, NYTBA/*242.*

en deshabille, C-0103/*118.*

end-frieze, OC/*218*①.

end grain, SDF.

Endicott & Co., New York, S-4881/19①.

endive, DADA.

endive marquetry, EA/①; SDF.

endive pattern, DADA.

endive scroll, SDF.

'endless knot', OC/80①.

endless knots decoration, S-4965/262.

end-of-day glass, DADA/Supplement; EG/289①.

end-of-day mixture, EG/27.

endova, RGS/67.

endpaper, C-0249/125; JIWA/201; S-4881/41①.

end plate, C-0906/263.

endpost, C-5153/115①.

end-section, C-2421/139①.

end standard, C-1407/20; LAR83/392①.

end-standard, C-0982/3, 45; C-1407/168; C-2402/20, 111.

endstone, C-2368/91①; C-2489/195; C-5117/456; S-4802/22; S-4927/88.

end-stone, EA.

end-web, CEA/76.

end well, C-5116/15①.

enema, C-2904/294.

en face, JIWA/20; LP.

Enfants Boucher, les, IDC/①.

Enfield, CEA/34.

Enfield Pottery, Laverock, Pennsylvania, EC1/85.

Enfield Small Arms Factory, CEA/27.

enfilade, DADA.

en flambeau, C-0279/226, 426①; C-5116/37①; C-5157/33①.

en fleur de solanée, CEA/133①.

engagé, LP.

engageante, C-3011/97.

engaged, DATT; NYTBA/56; S-4988/413①.

engaged pilaster, C-5224/148.

engagement pad, C-5239/321.

enghalskrug, C-2427/192; CEA/138①; DADA; EA; IDC/①.

Enghalskrüge, EA/Erfurt.

Enghien tapestry, DADA; EA.

engine-turned, C-0706/4, 28; C-1502/91; C-2202/1; C-2487/15; C-5117/14; S-291/8; S-4802/1, 30①; S-4804/12①; S-4843/372①; S-4922/23①.

engine turned, C-1502/59, 199; S-4461/346①.

engine-turned base, S-2882/1172.

engine-turned bolt, C-2476/5.

engine-turned border, C-0249/293.

engine-turned case, LAR83/214①; S-4461/335①.

engine turned case, C-5117/413; S-291/118①.

engine turned cover, C-2202/18.

engine-turned decoration, IDC.

engine turned decoration, DADA.

engine-turned dial, S-4461/324.

engine-turned foot rim, S-2882/1165①.

engine turned linear pattern, S-291/129①.

engine-turned surface, C-0254/37.

engine-turning, C-5116/43①; EA.

engine turning, CEA/70, 524, 540①.

Englehart, George, EA.

Englehart, John Cox Dillman, EA.

English, C-2421/7; C-2476/56.

English Aesthetic Movement, CEA/404①.

English Art Nouveau, RTA/139.

English Axminster carpet, S-288/4①.

English baluster jug, IDPF/11①.

English baluster measure, EA.

English baroque, S-2882/312.

English Bone China, S-3311/*351*①.

English carpet, EA.

English ceramic, EA/①.

English ceramic figure, NYTBA/ *151*①.

English china, IDC.

English Chippendale, NYTBA/*18*.

English clock, EA.

English contemporary arts and crafts, DADA/*Supplement*.

English decorated style, DADA.

English Delft, S-4905/*154*①.

English delftware, EA; IDC; NYTBA/*139*①.

English dial, EA/*dial clock*.

English dresser, EA/① *dresser*.

English embroidered carpet, EA/ *English needlework carpets*.

English Empire, NYTBA/*70*; SDF.

English furniture, CEA/*321*; EA.

English glass, CEA/*424*①; EA.

English glass making centre, EA/ *Stourbridge*.

English gold and silver, EA/①.

English Gothic jewellery, CEA/*513*.

English green, DATT; LP.

English Ironstone, C-1006/*24*.

English jewellery, CEA/*513*.

English king pattern, C-5114/*19*.

English lacquer, SDF.

English maiolica, EA.

English mark, NYTBA/*213*①.

English needlework carpet, EA.

English Neo-classical, RTA/*123*①.

English Oak, SDF.

English Palladian, CEA/*313*①.

English pewter, EA/*fine pewter*; C-2910/*198*.

English pink, DATT.

English point, DADA.

English porcelain, C-1006/*19*; CEA/ *187*; DADA.

English porcelain miniature, C-0782/ *29*.

English pottery, CEA/*150*.

English provincial, C-5117/*96*①.

English red, DATT; LP.

English Regency, NYTBA/*68*.

English Renaissance, SDF.

English Sheraton, FFDAB/*24*.

English silver, C-5173; CEA/*619*, *637*; DADA.

English snuff-box, EA.

English soft paste, DADA.

English sycamore, DATT.

English symbol, CEA/*590*.

English tapestries, EA.

English Tower lock, S-4972/*260*.

English vermilion, DATT.

English walnut, SDF.

English watch, EA.

English white, DATT.

English wine glass, EA/①.

engobe, DADA; DATT; IDC; IDPF/ *224*.

en gondole, CEA/*385*①.

engrailed, C-2458/*215*; C-2513/*91*; IDC.

engraved, C-0706/*4*; C-2476/*11*①; C-5116/*25*; C-5117/*5*, *51*; C-5156/ *1068*; CEA/*540*①; S-286/*308*①; S-4922/*1*①.

engraved basketwork decoration, RGS/*179*①.

engraved blades, S-4905/*167*.

engraved brass chapter ring, S-2882/ *249*①.

engraved-brass dial, EC2/*90*①.

engraved chapter ring, S-2882/*301*①.

engraved Chinese mount, S-291/ *238*①.

engraved circle, JIWA/*118*①.

engraved cock, C-5117/*453*①.

engraved copper-plate, CEA/*187*.

engraved decoration, IDC/①.

engraved designs, IDC.

engraved floral decoration, RTA/ 69①.

engraved glass, CEA/305①; DADA/ ①; EA/①; EC1/56.

engraved glass vase, C-5005/303.

engraved initials, C-5153/1①.

engraved openwork mount, S-291/ 51①.

engraved pendant, JIWA/194.

engraved scrimshaw, S-2882/597, 598.

engraved scrolling, RGS/31①.

engraved wood, C-0279/403; C-5116/ 33; C-5157/20①.

engraving, C-0249/8; C-5236/1642; CEA/444①, 524, 528, 618, 678; DADA; DATT; EA; EG/265; NYTBA/198; RTA/12①; S-286/ 54; S-4461/61; S-4881/114①; SDF.

engrêlure, DADA.

en grisaille, C-2458/191; EA; RGS/ 151①; S-4461/101.

en grissaille, C-0782/56.

engsi, OC/153; S-4796/77; C-5189/ 405.

enile rug, DADA.

Enjilas, OC/96①.

enlargement diagonal, LP/①.

enlarging, DATT.

enlongated pear-shaped, C-5153/3①.

ENOCH WOOD, EA/Wood Enoch.

Enoch Wood & Sons, EA/Wood Enoch.

ENOCH WOOD & SONS BURSLEM., EA/wood Enoch.

en pavé, S-291/31①, 147.

en pente veneered, CEA/378①.

en plein, C-5117/319①, 370①; C-5174/235; CEA/64①.

en plein air, LP.

en plein enamel, ACD; RGS/145①.

en plein enamelling, CEA/70; EA.

en plein enamel painting, RGS/49①.

en rapport, LP.

enrichment, SDF.

en ronde bosse, S-291/240①.

enseigne, EA.

Ensell, Edward, CEA/462①.

ensemble, LP.

Ensi, S-288/7①.

enssi, OC/154①.

'enssi', OC/143①, 153①.

en suite, C-2357/2①; C-2421/17; C-2458/150; C-2910/274; C-5127/ 244; C-5156/703①; C-5236/345①; FFDAB/84; LAR83/424①; S-291/ 10.

ensuite, C-0982/207; C-5127/269.

entablature, C-5189/358A; DADA; EA; SDF.

en taille d'epargne, DATT.

entasis, SDF.

en tombeau, CEA/376①.

entre-deux, EA/bas d'armoire.

entrée dish, C-0254/3.

entree dish, C-0706/114; C-1502/82; C-2487/151.

entrée dish, DADA; EA.

entree dish, LAR83/572①; S-4804/ 20; S-4922/4①, 29A①.

entree-dish, C-2398/44; C-5117/141.

entree-dish and cover, C-5117/115①.

entree dish base, C-0706/126.

entre-fenêtre, C-2437/2; EA/① French tapestry.

entrelac, C-0225/70, 199①; C-0982/ 230; C-2324/116; C-2364/39; C-2437/57①; C-2478/50; C-5189/ 337①; C-5259/514; DADA; DATT.

entrelac-and-rosette, C-2421/36①.

entrelac-and-rosette ornament, C-2555/64①.

en tremblant, RGS/179①; S-291/ 81①, 117①; S-4927/236①.

entwined branchform handle, S-2882/ 922①.

entwined design, C-0225/281.

entwined dragon motif, C-5234/254.

entwined dragons, C-0982/208.

entwined garland, CEA/495①.

entwined palmette, RTA/42①.

entwined ribbon and garland, C-2458/151①.

entwined ribbon decoration, C-2555/53①.

entwined serpent, C-2398/30①.

entwined serpent handle, C-2546/14①.

entwined snake handle, C-2510/41①.

entwined strap handle, C-0782/23; S-4905/105①.

envelope card table, LAR83/360①.

envelope form, IDPF/85①.

envelope table, CEA/326①; DADA.

envelope top, SDF.

environment, DATT.

Envy, DSSA.

E & O, CEA/694①.

Eocean, OPGAC/345.

Eocean mug, OPGAC/345.

E-Oribe ware, EA/oribe ware.

Epargnie, EA.

épater le bourgeois, LP.

epaulette, C-1506/42①.

epaulette-cut diamond, S-291/253①.

epaulière, DADA.

E.P.B.M., EA/Britannia metal.

epergne, ACD; C-0270/18; C-5153/2①, 48; C-5173/39①; CEA/653①, 654①; DADA/①.

épergne, EA/①; IDC/①.

epergne, IDPF/86; LAR82/462①; LAR83/104①, 556①; S-4461/275①; S-4802/430①; SDF.

epergne basket, S-4802/385.

epergne stand, S-3311/598.

Ephraim pot, EA/tankard.

epichysis, IDC.

epigon, DATT.

epigone, DATT.

epigraphy, DATT.

Epines, C-5191/226.

epinetron, IDC/①.

epine-vinette wood, DADA.

episcopal ring, EA; RTA/58, 71①.

E.P.N.S., EA.

eponge, boîte à, DADA.

epoxy resin, DATT.

épreuve d'artiste, S-286/19, 229, 230.

épreuve d'artiste, S-286/35.

equation clock, DADA; EA.

equation of time clock, LAR83/195①.

equatorial dial, CEA/606①.

equatorial ring dial, CEA/606①.

Equestrian, S-4843/18①.

equestrian figure, C-1006/48; C-2204/170; LAR83/157①.

equestrian group, C-5224/290①; S-4804/585.

equestrian model, C-2487/57.

equestrian statue, MP/96, 496.

equilibrium, DATT.

equinoctial dial, C-2489/20①.

equinoctial ring dial, LAR83/464①.

ER, CEA/639①.

erable wood, DADA.

Erard, CEA/550①.

Erard, Pierre, EA/Érard, Sébastien.

erased, S-4922/45①.

Erato, DSSA.

erecting eyepiece, C-0403/193.

erect spout, C-5156/800.

erfurt, C-2486/187①; DADA; EA; LAR82/130①.

erhabene Blumen, C-2486/74①; EA/Gotzkowsky pattern.

Eris, DSSA.

Erivan, C-2478/236, 252.

ermine, C-0604/135B; C-1603/108; C-3011/29; DSSA.

ermined, C-1506/*111*.

ermine ground, IDC.

Ernst, Max, S-286/*268*①.

eroded, C-5156/*3*①.

Eros, DSSA.

eroti, C-5173/*53*①.

erotica, JIWA/*68*.

erratic hair panel, C-2332/*305*.

Ersari, S-4847/*182*.

Ersari Beshir, C-5323/*54*①; S-4948/
*48, 70*①.

Ersari Beshir carpet, S-4796/*3*.

Ersari Beshir mosque rug, S-4796/*48*.

Ersari Beshir torba, S-4796/*148*.

Ersari carpet, EA/①.

Ersari engsi, S-4796/*121*①.

Ersari Juval, S-4847/*8*.

Ersari rug, S-4461/*836*.

Ersari Turkoman, C-5323/*50*①.

Ertel & Sohn, C-2904/*211*.

E. R. Watts & Son, C-2904/*75*.

escabeau, DADA.

escallop, SDF/①.

escallop shell, C-1502/*146*.

escapement, ACD; C-5157/*34*①;
CEA/*223*①, *267, 697*; EA;
S-3311/*110*①, *445*.

escape wheel, C-5117/*484*①.

escapewheel, C-2368/*91*①.

escargot fork, S-4461/*263*.

eschel, DATT.

Escher, Maurits Cornelis, S-286/
*105*①.

escritoire, ACD; C-0982/*54*; CEA/
*344*①; DADA; LAR82/*276*①;
LAR83/*336*①; SDF/①.

escritoire-vitrine, LAR82/*344*①.

escritorio, CEA/*307*①.

escudelle ab orelle, IDPF/*86*①.

escudelles ab orelles, DADA.

escudié, DADA.

escutcheon, ACD; C-0249/*234*;
C-0982/*167*; C-1407/*171*; C-1603/
9; C-2402/*219*; C-2487/*84*;
C-5114/*252*①, *274*; C-5117/*65*;
C-5153/*128*①, *137*①; C-MARS/
121; CEA/*315*①, *405, 527*;
DADA; IDC; LAR83/*251*①;
RGS/*92*①; S-2882/*348*①; S-4461/
487; S-4823/*184*; S-4881/*276*①;
S-4972/*435*①; SDF/①.

escutcheon-plate, EA.

Esfahan, S-288/*29*①.

Esherick, Wharton, DADA/
Supplement.

espagnolette, ACD; C-5189/*352*;
DADA/①; EA.

espagnolette mask, C-2364/*32*①;
C-2437/*60*①; C-5116/*48*.

espagnolette plaque, C-2364/*74*①.

esparto, DATT.

espetera, DADA.

Esphahan carpet, S-3311/*40*①.

Esphahan rug, S-3311/*21*.

esquisse, DATT.

essence, DATT.

essence, l', LP.

essence vase, DADA.

essential oil, DATT; LP.

Esser, Max, MP/*494*.

Essex, William, EA/①.

Essex elbow chair, LAR83/*291*①.

estagnié, DADA.

estate bureau cabinet, LAR82/*280*①.

estate cabinet, C-2388/*133*①.

ester, DATT.

Ester, Etienne, S-4927/*54*.

ester gum, DATT.

Estève, CEA/*145*①.

Esteve, Maurice, S-286/*30*.

Esther, OPGAC/*218*.

esthetics, LP.

estoc, DADA.

Estève, Maurice, S-286/*432*.

excelsior, OPGAC/*218*①.
excelsoir pattern, NYTBA/*298*①.
excise mark, IDC.
excluding flounce, C-2704/*86*.
executioner's sword, C-MARS/*45*.
execution in wood, MP/*116*.
exercising chair, DADA.
Exeter, CEA/*96*.
Exeter carpet, EA.
exhibition, LP.
Exon, EA/*Exeter carpet*.
Exotic, MP/*480*①.
exotic bird, C-2704/*5*; C-5224/*111*;
 IDC.
exoticism, JIWA/*8*.
exotic wood, NYTBA/*33*①.
expanding cylindrical contour,
 S-4414/*235*①.
expanding dining-table, C-2403/*151A*.
expansion shank, S-291/*49*①, *207*①.
experimental bowl, C-5191/*4*.
exploded view, DATT.
export, S-4812/*42*.
export bowl, S-3312/*1390*.
export china, IDC.
export vessel, C-2458/*47*.
exportware, S-3312/*1393*.
exposed balance, C-5117/*444*①;
 S-4802/*133*①.
exposed skirt, S-4905/*393*①.
expression, LP.
expressionism, DATT; JIWA/*51*; LP.
Expressionist, JIWA/*6*, *10*, *36*.
Expressionist movement, MP/*204*;
 RTA/*156*①.
extempore, LP.

extender, DATT; LP.
extending dining table, C-0982/*242*;
 C-1407/*81A*.
extending table, SDF.
extension dining table, C-5005/*321*①.
extension grip, CEA/*26*①.
extension table, EA.
exterior, C-0782/*8*; C-5239/*42*;
 JIWA/*6*.
external count wheel, S-3311/*415*①.
extinguisher, C-2487/*65*; C-5117/*7*;
 C-5203/*190*①; EA; S-4802/*330*;
 S-4944/*28*①.
extra grade, C-5117/*419*①.
extra leaf, C-0982/*31*, *34*.
extra-wide dozar size, OC/*207*.
extruded form, IDPF/*87*.
ex-voto, DATT.
eye, C-5114/*60*; DSSA; SDF.
eye-bath, IDC.
Eye Form, CEA/*483*①.
eyelet, S-4972/*166*①.
eyelet guard, S-4881/*201*①.
eye level, LP.
eye-motif, OC/*54*.
eyepiece, C-2904/*47*.
eye pull, LP.
eye roundel, C-5156/*361*①.
Eyes of Horus, S-4807/*452*.
Ezineh, OC/*133*①, *240*①.
Ébéniste, ACD.
École de Paris, L', LP.
École des Beaux-Arts, JIWA/*182*.
École des Beaux-Arts, L', LP.
Érard, Sébastien, EA.

F

F, CEA/*176*①; EA/*Fürstenberg porcelain factory*.

FA, MP/*94*.

fabeltiere, IDC; MP/*52*① *Plates*.

Fabeltiere decoration, EA.

Fabergé, C-5117/*305*①; C-5174/*257*①; CEA/*516*①.

Faberge, LAR82/*74*①.

Fabergé, Carl, C-5117/*354*.

Fabergé, Carl Gustavovich, DADA.

Fabergé jewel, CHGH/*46*.

fable decoration, IDC/①.

Fable plate, S-4843/*312*①.

fables, Aesop's, IDC.

Fabriano paper, S-286/*374*.

fabric, DATT; NYTBA/*86*; SDF.

fabricfold, C-5191/*494*①.

fabrique, C-5167/*273*①; CEA/*165*.

fabulous animal, IDC.

fabulous hybrid, SDF/①.

facade, S-4905/*376, 456*①.

face, C-2458/*84*①; C-2478/*217*; C-2513/*339*; C-5005/*218*①, *380*.

facecloth, C-0604/*87*; C-2501/*96*.

face-filled, S-4948/*133*.

face-jug, IDC/①.

face-pot, IDC/①.

face pot, IDPF/*88*①.

face screen, S-3312/*1403*; SDF/①.

facet, C-2458/*225*; C-5153/*8*; EG/*37*①.

facet-cut, CEA/*437*①; LAR82/*441*①.

facet-cut steel, EA/① *cut steel*.

facet-cutting, CEA/*509, 510*; RTA/*94*.

faceted, C-0225/*101A*; C-0982/*46*; C-2402/*15*; C-2421/*30*①; C-5117/*366*①; C-5156/*809*; C-5236/*328*; S-4461/*12*; S-4905/*184*①; S-4922/*71*①.

faceted, square-shaped panel, S-4414/*81*.

faceted amethyst, RTA/*150*①.

faceted aquamarine, RGS/*199*①.

faceted arching backsplash, S-2882/*1280*①.

faceted baluster form, S-4461/*247*.

faceted baluster stem, C-5174/*98*①; LAR83/*367*①.

faceted bead, S-2882/*342*.

faceted blade, C-5156/*311*.

faceted case, S-4461/*318*.

faceted column, C-5005/*224*①.

259

faceted crystal rondelle, S-4414/*80*.
faceted Cubism, LP.
faceted cylindrical bottle, S-2882/ *1218*.
faceted cylindrical form, S-2882/*1226*.
faceted dish, S-2882/*784*.
faceted drop, C-2357/*6*①; C-2546/ *35*①.
faceted element, C-5114/*240*.
faceted form, IDPF/*89*.
faceted goblet, LAR83/*428*①.
faceted gold bar, S-4461/*321*.
faceted hexagonal shape, LAR83/ *646*①.
faceted leg, C-0982/*100A*.
faceted marble base, S-2882/*1429*.
faceted obelisk, C-2437/*16*.
faceted pistol handle, S-2882/*1105*.
faceted side, C-5114/*130*; S-2882/ *1364*; S-4461/*28*.
faceted spout, S-4414/*261*; S-4461/ *393*.
faceted S-scroll handle, S-4414/*322*.
faceted steel, EA.
faceted steel mount, CEA/*516*①.
faceted stem, CEA/*423*①; EA.
faceted stopper, C-5114/*120*.
faceted stud border, C-2357/*24*①.
faceted swan-neck spout, S-2882/*905*.
faceted swelling grip, C-2569/*42*①.
faceted tall cylindrical neck, S-2882/ *1339*①.
faceted ware, IDC.
faceting, CEA/*446*①; NYTBA/ *283*①; S-4461/*21*.
facet stemmed, LAR83/*431*①, *450*①.
facetted, C-2409/*111*; S-4972/*404*①, *411*.
facetted stem, C-5116/*36*.
Fachralo, C-2388/*149A*; S-4847/*61*①.
Fachralo Kazak, C-5323/*18*, *43*①.
Fachralo Kazak prayer rug, S-4796/ *83*①.

Fachralo Kazak rug, S-4796/*124*.
Fachralo medallion, C-5323/*18*; S-4796/*124*.
facia, SDF/*fascia*.
facing, SDF.
facing to dexter, C-5174/*209*.
Facio, CEA/*250*.
Facio, Nicholas, EA.
façon de Venise, EA/*Altare, almorrata*, ①; EG/*74*①; CEA/ *415*; NYTBA/*273*.
facsimile, C-5156/*918*; C-5236/*1527*; JIWA/*16*①; LP.
facsimile signature, C-2409/*67, 173*.
factory-mark, IDC.
factory mark, MP/*54*.
faded, C-5236/*938*.
faded mahogany, C-5157/*93*; C-5170/ *113*.
faded rosewood, C-2403/*108*.
Fade Ometer, DATT.
fading of colors, DATT.
faïence, DADA; S-4823/*42*.
faïence anglaise, IDC.
faïence á niellure, IDC.
faïence blanche, EA/*Paris porcelain*.
faïence d'Oiron, IDC.
faïence fine, DADA; IDC/①.
faïence fine d'Angleterre, IDC.
faïence hollandaise, IDC.
faïence parlante, DADA; IDC.
faïence patriotique, IDC.
faïence plate, S-286/*425*①, *426*①, *427*①, *428*①.
faenza, LAR82/*137*①; S-4972/*128*①; ACD; C-2427/*230*①; DADA/①; EA/①; NYTBA/*131*①.
faenza basket, LAR83/*112*①.
Faenza school, CEA/*130*.
fagoting, DADA.
Fahlstrom, Anders, CEA/*149*①.
Fahrner, Theodore, C-2910/*215*.
fa-hua, IDC.

fa hua, CEA/*111, 120*①; EA/*san ts'ai stoneware.*

fahua, C-5127/*25A*; C-5156/*64*①.

Fahua guan, S-3312/*1329*①.

fahua pottery, C-2458/*60.*

Fahua style, C-5236/*1632.*

Fahua type, C-5236/*502, 1594.*

faience, ACD; C-0249/*206*; C-2502/ *87*; CEA/*110, 137*①, *151*①; DATT; EA; EC1/*83*; IDC; IDPF/ *15*; JIWA/*112*①; LAR83/*67*①, *102*①; MP/*502.*

faïence, S-2882/*725, 727*①, *728*①, *763*①.

faience, S-4804/*289*; S-4972/*429A*①; C-1582/*118.*

faience fine, CEA/*183*①; NYTBA/ *148.*

faience fountain, C-5146/*113*①.

faience japonnée, CEA/*147*①.

faience jar, S-4414/*398.*

Faience Manufacturing Company, CEA/*205.*

Faience Manufacturing Company, Greenpoint, New York, EC1/*85.*

faience parlante, CEA/*209.*

Faience Pottery, Zanesville, Ohio, EC1/*85.*

faint, C-5127/*7*①.

Fairfax pattern, S-4461/*532.*

Fair Hebe jug, IDC/①.

fairing, EA/*140*①; IDC/①.

fairy lamp, LAR83/*482*①.

fairyland lustre, IDC/①; K-710/*109, 117*; LAR82/*186*①; LAR83/ *167*①.

Fairy pyramid, K-802/*16.*

Faith, DSSA.

fake, CHGH/*31*; IDC; LP.

faking, SDF.

fa-lang, IDC.

falchion, CEA/*22*①; DADA.

falciform, DATT.

falcon, DSSA.

Falconet, Étienne-Maurice, C-5224/ *267.*

Falconet, Etienne-Maurice, EA.

Falconet, Pierre, S-4955/*118*①.

falcon holding a sceptre, C-1506/ *106*①.

Falcon Works, CEA/*450*①.

falding, SDF.

faldistorio, C-2498/*64*; LAR82/ *374*①.

faldistorium, DADA.

faldstool, DADA/①; EA; SDF.

Falize, Alexis, CEA/*519*①; JIWA/*12.*

fall, SDF.

fall-flap, C-2388/*131*①; C-2421/ *107*①; C-2437/*67*; CEA/*313*①; LAR82/*293*①.

fall flap, LAR83/*250*①.

fall-flap top, C-2403/*139.*

fall-front, C-2409/*238*; CEA/*325*①, *395*①, *658*①; DADA; LAR83/ *400*①; S-2882/*783*①; S-4436/ *93*①; S-4461/*580*①; S-4972/*483*①.

fall front, C-2402/*269*; EA/*drop front*; K-802/*15*; S-2882/*278*①, *308*①, *1438*①.

fall-front bureau, LAR83/*253*①.

fall-front desk, S-4461/*707.*

fall front desk, S-2882/*1447*①.

fall-front opening, S-2882/*786.*

fall-front secretaire, S-4823/*168.*

fall-front secretary, C-0249/*455*①; S-4905/*411*①.

fall-front wood case, S-4804/*147A*①.

Falline, OPGAC/*345.*

falling table, SDF.

fall-leaf table, EA/*drop-leaf table.*

fall panel front, C-1407/*52.*

fall writing flap, C-0982/*54.*

false biting, DATT.

false body, DATT.

false drawer, C-2421/73①; C-2478/161.

false flute, IDC.

false gadroon, C-5127/123; C-5156/127①; C-5236/1657①; IDC.

false grid, C-1702/279.

false-gridiron pendulum, C-MARS/209.

false knot, EA/jufti knot.

false muzzle, S-4972/268.

false outline, IDPF/58①.

false-pendulum, C-MARS/161.

false pendulum, LAR83/212①.

false topaz, DADA.

falsification, DATT.

FA (Frederick Augustus) mark, MP/499①.

Fame, DSSA.

Famechon, Pierre-Antoine, C-5117/176.

Fame figure, S-4955/43①.

famille, C-5127/121①; IDC.

famille jaune, ACD; C-2323/116; C-2458/200; CEA/122①, 209; DADA; IDC.

famille-noire, S-4461/520.

famille noire, ACD; C-0279/147①; C-0782/227; C-2323/120①; C-5127/137①; CEA/122①, 209; DADA; IDC; JIWA/342; LAR82/138①; LAR83/79①, 100①.

famille-rose, S-4810/31①.

famille rose, ACD; C-0782/2; C-2323/72①; C-2458/112, 134①; C-5156/70; CEA/111, 123①, 209; DADA; EA/①; EC2/23; IDC; LAR82/94①; LAR83/100①.

famille-rose enamel, S-4414/381.

famille rose manner, LAR83/74①.

famille rose style, LAR83/69①.

famille verte, ACD; C-0279/151①; C-0782/30; C-2323/62①; C-2458/67, 122; C-5127, 81; CEA/122①, 209; DADA; EA/①; IDC; IDPF/239; LAR82/126①; LAR83/101①; S-4804/729①.

famille verte taste, C-5127/387.

family service, EC2/29①.

fan, C-1082/184; C-2402/175; C-5114/336①, 346①; C-5153/170①; C-5236/589①; DADA/①; JIWA/162; LP/① brushes; SDF.

fan and rose carving, LAR83/407①.

fan-back, C-5114/291①, 319, 381①; EA/①; S-3311/201①; S-4461/596.

fan back, ACD; C-5189/331①.

fan-back chair, DADA/①.

fan back chair, SDF.

fan bearer, MP/60.

fan-box, C-1603/72.

fan brush, DATT/①.

fan-carved, C-5114/308①, 374①.

fan carved drawer, LAR83/329①.

fances, C-2427/81.

Fanciullacci, G. B., C-2486/24①.

fan corner, LAR83/332①.

fan cut, CEA/445①.

fancy-back spoon, EA.

fancy baguette, S-4414/104.

fancy chair, DADA; EA; FFDAB/18.

fancy-cut diamond, S-291/188①.

fancy cut sapphire, S-291/7.

fancy dress, C-1506/28.

fancy link, C-5117/406①.

fancy-shaped, S-4927/331①.

Fanelli, Francisco, C-5224/281①.

fan-end salt, CEA/463①.

Faneuil pattern, C-0270/248.

fan-fluting, CEA/655①.

fan-form, S-4927/214.

fan format, JIWA/166.

fang ding, C-2458/236; S-4810/287①.

fang hu, C-2513/311①.

fang i, EA.

fanglei, S-4963/15①.

Fangstossgruppe, MP/*476*①.

fang yu, C-2414/*4*①.

fan-hung, IDC.

fan-inlaid lunette, C-5114/*343*①.

Fanin-Latour, Henri, S-286/*25*.

fan leaf, C-1603/*47*; JIWA/*6, 13, 23*①, *67*①.

fan medallion, S-4436/*113A*①.

fan motif, DADA; NYTBA/*307*; S-4955/*175*.

fan mount, S-4461/*411*.

fanned decoration, S-4414/*67*①.

fan painting, C-2323/*168*; C-2414/*103*①.

fan-pattern, C-5157/*137*①.

fan pendant, C-5114/*252*①.

fans, C-0279/*157*; C-0982/*74*; C-5005/*246*①; C-5114/*391*①; JIWA/*14*; S-4461/*18*.

fan screen, JIWA/*166*.

fan-shape, C-2458/*398*.

fan shape, C-0225/*159*.

fan-shaped, S-4461/*25*.

fan shaped, C 5127/*63*; C-5236/*812*.

fan-shaped panel, S-4414/*359*.

fan-shaped table, CEA/*371*①.

fan spandrel, C-2403/*69*; SDF/①.

fan-tail, OC/*255*.

fantasie headdress, C-0604/*284*.

fantasie Vögel, IDC/①.

Fantasque, C-2409/*76*; C-2910/*91*.

Fantasque Bizarre, C-2910/*92*.

Fantasque pattern, LAR83/*81*①.

fantastic animal motif, S-4965/*250*①.

fantastic art, LP.

fantasy box, CEA/*68*①, *70*; EA.

fantasy ring, RTA/*123*①.

Fantin-Latour, Henri, S-286/*463*.

fan vase, C-5239/*306*.

Faraghan carpet, S-3311/*3*.

Faraghan rug, S-288/*18*①.

Faraghan silk rug, S-288/*3*①.

Far Eastern dry brush style, JIWA/*59*.

Far Eastern symbol, JIWA/*10*.

Farini, A., C-2910/*125*.

Farmacia Orsini Colonna drug-jar, IDC.

Farmborough, William, EA/*Burrough, (Borough*; SDF/*750*.

Farmer, Edward, C-5236/*345*①.

Farmer, Wm., Co., S-4927/*108*.

farmhouse, CEA/*242*①.

farmhouse clock, EA.

farmhouse furniture, SDF.

Farnell, John, S-4944/*387*①.

Farre, Paris, S-4927/*86*.

Farrell, Edward, C-2510/*61*①; C-5174/*504*①; CEA/*661*①; S-3311/*732*①.

Farren, Thomas, C-2487/*106*.

Farsi, OC/*40*.

farsibaff, CEA/*101*.

Farsibaff carpet, EA/*meshed carpets*.

Fars province, OC/*104*.

farthingale chair, ACD; DADA; EA; SDF/①.

Farukh, OC/*176*①.

fasces, C-2555/*41*①; DADA; DSSA/①.

fascia, SDF.

fašence blanche, EA.

fašence fine, EA.

fašence japonnée, EA.

fašence parlante, EA.

fašence patriotique, EA/*fašence parlante*.

fašence patronymique, EA/*fašence parlante*.

fašence populaire, EA/*fašence parlante*.

Fashion, CEA/*248*①.

fashion accessory, JIWA/*165*.

fashion plate, NYTBA/*204*①.

fast, OC/*25*.

fast color, DATT.

fastener, CHGH/*58*.

fastening hole, S-4972/*108*①.

fastening strap, S-4972/*162*①.

fast synthetic dye, OC/*23*.

fat, DATT.

fat-bellied stock, CEA/*38*①.

Fates, DSSA.

Father Time, DSSA.

Father Time figure, C-5224/*55*①.

Fathpur rug, DADA.

Fatimid ware, IDC.

fat-over-lean, LP.

Fatshan Chun, EA/*Kwang-tung (Canton*.

Fatshan Chün, IDC.

Fatto in Palermo, EA/*Palermo maiolica*.

Fattorini, Pietro, Stefano, Jacopo, EA.

fatty acid, DATT.

Faubourg Saint-Denis, DADA; EA/*Paris porcelain*.

Faubourg Saint-Lazare, DADA.

Faubourg St. Antoine, DADA.

Faubourg St. Germain, DADA.

Faubourg St. Marceau, DADA.

faucet, C-5127/*109*①.

fauchard, DADA.

Fauchier, Joseph, NYTBA/*145*①.

Fauchier, Joseph I, CEA/*147*①.

Fauchier, Joseph II, CEA/*147*①.

fauld, CEA/*20*①.

fauldersteuil, DADA.

Faulk, Jacob, CEA/*166*①.

Faulkner, E., London, C-2489/*73*①.

Faulkner, Kate, DADA/*Supplement*.

fauns' mask, C-2398/*94*.

Fauquez, Jean-Baptiste-Joseph, EA.

Fauquez faiencerie, CEA/*147*①.

Fauré, Camille, C-5167/*171*.

fauteuil, ACD; C-0982/*15*; C-2364/*33*; C-5005/*333*①; C-5189/*316*; CEA/*374*①, *405*; DADA/①; EA; S-4461/*677*; S-4507/*33*①; S-4804/*777*①, *785*①, *786*①; S-4972/*599*①; SDF.

fauteuil à canné, C-5224/*102*.

fauteuil à coiffer, C-5224/*178*①.

fauteuil à la reine, EA.

fauteuil a la reine, S-4804/*787*①; S-4823/*200*①.

fauteuil a oreilles, S-4823/*220*①.

fauteuil à oreilles, S-4853/*421*①.

fauteuil de bureau, C-5146/*120*①; C-5181/*193*; C-5224/*172*.

fauteuil d'enfant, C-5224/*150*; C-5259/*554*.

fauteuil en cabriolet, C-5224/*57*; C-5259/*466*; EA; LAR83/*282*①; S-3311/*392*①.

fauteuil en confessional, EA/*bergère en confessional*.

fauteuil en confessionnal, EA/*bergère en confessionnal*.

fauteuil en cul de four, EA/*chaise en cul de four, chaise*.

fauteuils a la reine, S-2882/*360*①, *765*①.

fauteuils à la reine, S-4955/*64*①.

fauteuils en cabriolet, S-2882/*789*①; S-3311/*393*①.

Fauves, les, DATT.

Fauvism, LP.

faux, C-5259/*623*①; S-4812/*45*; S-4972/*437*.

faux bamboo, C-5191/*97*.

faux bamboo leg, S-3311/*253*.

faux bambou, S-4905/*16*①.

faux bois, S-4965/*293*①.

faux bois bowl, S-3312/*1399*.

faux brocatelle, C-5181/*132*.

Favier, CEA/*145*①.

Favre-Bulle, Frédéric-Louis, EA.

favrile, C-5146/*145A*; DADA; C-2910/*46*; CEA/*479*①; LAR82/*27*①, *456*①.

favrile fabrique, C-5146/*179*①; C-5167/*280*.

favrile glass, C-0225/*333*; C-5005/*379*①; K-711/*126*; S-2882/*1331*, *1332*; S-4414/*233*; NYTBA/*304*①.

Favrile glass beetle, CEA/*523*①.

Favrille, OPGAC/*176*.

Fawcett, Peter, C-2458.

Fawdery, William, C-5117/*92*①; C-5173/*41*.

fawn brown, DATT.

fawn field, C-0906/*6*.

fawn linen table, C-2704/*178*.

Fayd'herbe, Lucas, CEA/*159*①.

Fayence, IDC.

Fayence-Porzellan, IDC.

Fayral, C-5191/*166*; LAR82/*46*①; OPGAC/*13*.

Fazackerley colour, EA/①.

Fazackerl(e)y flower, IDC/①.

F. Barbedienne, S-3311/*317*.

F. Barker & Son, C-2904/*87*.

F.B.B., EA/*Worchester*.

FC, CEA/*640*①.

Fearn, W., C-2487/*45, 147*.

Fearn, William, C-5117/*33*.

feather, DSSA.

feather band, C-1407/*187*.

feather-banded, C-0279/*306*; C-5116/*81*; C-5157/*176*①; S-4414/*432*①; S-4436/*175*①.

featherbanded, LAR82/*278*①.

feather-banded top, C-5116/*109*①.

feather banding, ACD; DADA; EA/*herring-bone, herring-bone banding*; SDF.

feather bed, SDF.

feather brooch, CEA/*521*①.

feather decoration, C-GUST/*39*; IDC.

feather design, C-5239/*336*.

feather device, C-5323/*26*; S-2882/*1371*; S-4414/*236*①, *250*①.

feathered, C-0225/*198*①; S-4905/*58*①.

feathered crown, C-2704/*100*.

feather-edge, EA.

feather edge, DADA; SDF.

feather-edge border, S-2882/*945*, *1110, 1114*; S-3311/*717*.

feather-edged, C-0706/*225*; IDC/①.

feather edged, C-0103/*72*; C-1502/*103*.

feather-edged serrated rim, S-4414/*353*①.

feathered scrollwork, S-4414/*245*①.

feathered slip decoration, EA/*combed slip decoration*.

feathered surface, C-0225/*295*.

feathered ware, DADA.

feather inlay, C-0982/*83*.

feather mahogany, CEA/*303*.

feather mosaic, C-5156/*757*①.

feather motif medallion, S-4948/*13*①.

feather pattern, C-0279/*373*; IDC.

feather patterning, JIWA/*109*.

feather scroll, S-4802/*10*①.

feather stitch, C-2203/*69*; DADA.

Featherweight, C-2904/*16*.

featherwork, S-4928/*29*①.

feathery chain, C-2513/*385*①.

feathery leaf, C-2403/*211*.

fecit, DATT; LP.

Fecit, Manly, C-2489/*177*①.

Fécondité, la, IDC/①; CEA/*153*①.

Fedelmayer, Joh. Melch, S-4944/*156*.

Federal, C-5153/*103*①; CEA/*389*; FFDAB/*62*; LAR82/*320*①; LAR83/*198*①; S-3311/*205*①; S-4461/*575*①; S-4905/*329*.

Federal carved, S-3311/*202A*.

Federal furniture, NYTBA/*66*.

Federal Glass Co., OPGAC/*196*.

Federal ladle, C-5114/79①.

federal style, DADA; S-4414/457; SDF.

Federal sugar bowl, C-5114/84①.

Federal tea and coffee service, C-5114/85①.

Federer, Joh. Michael, S-4944/156.

fede ring, RTA/59.

Federoff, George, DADA/Supplement.

Federviehmalerei, MP/174.

Federvieh-Spezialisten, MP/174.

feeder, EG/253.

feeder flask, S-4973/16①.

feeding bottle, IDC/①.

feeding cup, DADA; EA/spaut cup; IDC/①; IDPF/89.

feeding pot, IDC/①.

feeding spoon, IDC/①.

feeling, LP.

feet, IDPF/24.

feicui, C-5127/295.

feicui jade, C-2323/184.

feicui table screen, C-5236/330①.

Feilner, Simon, C-2486/80①; CEA/176①.

Feilner, (Feylner) Simon, EA.

Feilt, Gaspard, S-4955/87①.

feine Figuren, MP/103.

Feine Figuren und Landschaften, MP/68.

Fei-Ts'ui jade, DADA.

feldspar, CEA/111; DADA; DATT; EC2/22; EG/236; MP/502; IDC/feldspathic rock.

feldspar glaze, JIWA/344.

Feldspar porcelain, IDC.

feldspathic glaze, C-2414/25; CEA/209; DADA; IDC.

Feldthus, Isack Andersen, CEA/636①.

Feline, Edward, C-2487/105①; C-5117/287①.

Fell, Thomas, EA.

Felletin tapestries, DADA.

Felletin tapestry, EA.

FELL NEWCASTLE, EA/Fell, Thomas.

Felsing, Conrad, Berlin, C-5189/338①.

felspar, C-2502/73.

felt, C-1506/46; CEA/556; LAR82/36①; OC/15.

felt-lined top, C-2478/110.

felt rug, OC/33.

felt-tip pens and markers, DATT.

female bust capital, C-0279/439.

female figure, C-2398/54①.

female mask, C-2388/18; C-5116/162①.

female mask capital, C-0279/434.

fence, C-2476/1; DATT.

fence pattern, IDC.

'Fence' pattern, S-4414/349①.

Fence Pattern, C-2493/31.

fender, ACD; C-1702/91; C-2478/68; C-5116/34; C-5153/77; DADA; EA/fend-iron; S-4461/561; S-4905/325①; SDF/①.

fender curb, SDF.

fender stool, C-0906/145; C-1407/174; SDF.

fend-iron, EA/fender.

fenestrated steeple, C-5174/53①.

fenestration, DADA.

fêng-huang, IDC.

feng huang, OC/80①, 167; S-4810/302①.

Fêng-Huang, DADA/①.

Feng mark, S-4965/308.

feng shen yu t'aio, CEA/122①.

Fennell, Richard, SDF/776.

Fên Ting, DADA.

fên Ting yao, IDC.

Fenton, NYTBA/310.

Fenton, Christopher Webber, CEA/168①, 206①; EA.

Fenton, Jonathan, CEA/*165*.

fên-ts'ai, IDC.

Fenwick, George, C-5117/*32*.

Feraghan rug, ACD; C-0906/*67*; C-1702/*61*; C-2482/*39*; DADA.

Ferahan, OC/*92*①, *93*①.

Ferahan carpet, EA.

'Ferahan design', OC/*86*.

Ferahan Heratis, OC/*104*.

Ferahanization, OC/*104*.

Ferahan pattern, EA/*herati pattern*.

Fereghan, CEA/*92*①; S-3312/*1307*①; S-4796/*1*①.

Fereghan carpet, EA.

Fereghan corridor carpet, C-0279/*32*.

Fereghan rug, S-4461/*797*.

Ferella, OPGAC/*345*.

feretory, DADA.

Ferguson, James, EA.

Feridan, OC/*147*①.

fermier general, CEA/*70*.

Fernández, Juan, EA.

Fern and Feather pattern, CEA/*478*①.

fern-ash, IDC.

fern border, C-1006/*126*.

Ferner, F. J., EA.

fern frond leg, C-5114/*254*①.

fern mirror, C-5167/*269*①.

fern pot, IDC/①.

fern pottery, IDC.

Feron, London, S-4927/*33*①.

Ferrahan carpet, EA/*Ferahan carpets*.

Ferrara tapestry, DADA; EA.

Ferretti, Antonio, EA.

ferric chloride, DATT.

Ferrière, François, EA.

Ferris, Richard, C-5117/*38*.

Ferrite, DATT.

ferronerie, IDC.

ferronnerie, CEA/*209*; DADA; EA.

Ferrox, DATT.

ferruginous, IDC.

ferruginous glaze, S-4972/*394*.

ferrule, C-0103/*94*; FFDAB/*53*①; S-4881/*158*①, *201*①.

Ferville-Suan, Charles George, C-5191/*138*①.

festival plate, C-5174/*146*①.

Festonenmuster, IDC.

festoon, ACD; C-0249/*201*; C-1407/*71*; C-5114/*339*①; C-5116/*174*①; C-5127/*258*; C-5153/*200A*①; DADA; DATT/①; EA; EG/*22*; IDC; OPGAC/*219*; S-2882/*925*; S-291/*165A*; S-4414/*242*; S-4461/*258*; S-4802/*182*①; S-4804/*40*, *135*; SDF.

festoon border, C-0254/*245*.

festooned, C-5116/*58*, *105*; C-5157/*8*.

festooned cresting, C-0982/*62*.

festooned drapery, C-0249/*425*.

festooned lockplate, C-5170/*179*①.

festooned urn, C-0279/*214*.

festoon necklet, LAR82/*499*①.

Festoon Service, MP/*448*.

festoons of husks, C-2398/*28*.

fete, C-2402/*20*.

fête champêtre, C-1603/*57*; S-4905/*20*①.

féte galante, C-1407/*71*.

fetes gallantes, C-2402/*127A*.

fetters, DSSA/①.

fettle, DATT.

fettling, CEA/*541*; IDC.

feu de moufle, IDC.

feuille de chou, IDC.

feuille-de-choux, C-2360/*200*; C-2427/*22*; C-2486/*15*.

feuille de choux tapestry, LAR82/*646*①.

feuilles de choux, C-5189/*208*.

Feure, Georges de, DADA/*Supplement*.

Feyen-Perrin, S-286/*70*.

FF, EA/① *Fulda faience factory.*

FH in monogram, EA/*Flörsheim.*

fiat glass, DADA; EA/*Jacobite glass.*

fiber, NYTBA/*86.*

fiberboard, DATT.

fiber glass, DATT.

fibre, OC/*27.*

fibula, C-2482/*110*; S-4973/*169.*

fibulae fragment, C-2482/*92.*

Fichtelgebirgsglas, CEA/*502.*

fictile, IDC.

Fictoor, Louwijs, EA.

fiddle, C-2202/*236.*

fiddle, thread and shell pattern,
C-5117/*29*; S-4804/*133*①.

Fiddle and Shell pattern, C-0254/*119.*

fiddle and thread, C-1502/*26*;
C-5117/*15*; DADA.

fiddle and thread pattern, C-0254/
122.

fiddle and thread pattern (on silver),
C-5174/*514*; C-5203/*118.*

Fiddle and Thread pattern, S-4905/
172.

fiddle-back, C-2320/*70*; C-2403/*153*;
EA; LAR82/*290*①.

fiddle back, DADA.

fiddleback, C-2388/*28*; C-2478/*10.*

fiddle-back bookcase, C-2522/*179*①.

fiddle back chair, SDF/①.

fiddleback figure, SDF.

fiddleback handle, C-5114/*80*①.

fiddle back sycamore, SDF.

fiddleboard, SDF.

fiddle brace back, SDF.

fiddle handle, C-5114/*65*; C-5153/*19.*

fiddle handle, fin, K-802/*14.*

fiddle handle, no fin, K-802/*14.*

fiddlehead, SDF.

fiddle mottle, SDF.

fiddle-pattern, C-5117/*32, 199A*①.

fiddle pattern, C-0103/*4*; C-0706/
130; C-1502/*28*; C-2202/*41*;
C-5114/*64*; C-5153/*9*; DADA;
EA/①; LAR83/*580*①; C-2487/*44*;
S-3311/*632*; S-4414/*300*; S-4804/
82.

Fiddle pattern flatware, C-5114/*77.*

fiddle rack, SDF.

fiddler jug, IDC.

fiddle shaped handle, FFDAB/*125.*

fiddle-shaped table, DADA.

fiddle-thread handle, C-5114/*61.*

fiddle-thread knife, C-5114/*65.*

fiddle-thread pattern, C-5114/*67*;
C-5153/*29.*

Fiddle Thread pattern, S-2882/*963,
969*; S-4905/*170.*

fiddle thread shell pattern, LAR82/
*592*①; S-2882/*993.*

Fidelity, DSSA.

Fiechthorn, Johann Andreas, CEA/
*138*①.

Fiedler, J. G., C-2555/*68*①.

Fieffé, Pierre, C-5224/*48*①.

Fiegler, C-2489/*148.*

field, C-2458/*217*; C-5156/*360*;
CEA/*101*; FFDAB/*79*; OC/*170*①;
S-4804/*966A*①; S-4948/*100.*

Field, Alexander, C-2487/*72*①; EA/
*107*① *cream jug.*

Field, John, EA.

Field, Robert, EA.

field bed, DADA/①; FFDAB/*75*;
SDF/①.

field camera, C-1609/*149.*

fielded, C-0982/*22, 66*; C-2388/*116*;
C-2402/*18, 19*; C-2421/*49*①;
C-2478/*170*; C-2498/*100*; C-5116/
*103, 147*①; C-5224/*90*①.

fielded cupboard door, C-5116/*27.*

fielded door, C-1407/*53*; C-2402/*8*;
LAR83/*255*①.

fielded frieze drawer, C-0249/*439.*

fielded panel, C-0249/*385, 406, 477*; C-0279/*270*①; C-5114/*394*①; C-5116/*115*; CEA/*405*; DADA; SDF/①.

fielded panel cupboard, S-2882/*324*.

fielded paneled drawer, S-2882/*245*.

fielded paneled side, S-2882/*350*.

fielded panel front, S-2882/*347*.

field glasses, C-2904/*167*.

field metal, EA/*champlevé enamelling*.

field of vision, JIWA/*10*; LP.

fiestaware, K-710/*112*.

15th century style, C-5127/*162*①.

15th century taste, C-5156/*128*①.

fifteenth century taste, C-5156/*163*①.

fig, DSSA.

Figg, J. W., CEA/*662*①.

fig milk, DATT.

fig-shaped, S-4944/*414*①.

fig-shaped bowl, C-5117/*321*; C-5174/*270*①; S-2882/*1098*①.

fig-tree juice, DATT.

figuline, DADA.

figulines rustiques, IDC/①.

figural, C-0225/*34*; C-5127/*118*; C-5239/*13*; K-710/*113*; OPGAC/*345*; S-4507/*6*①; S-4810/*557*①; S-4905/*333*.

figural andiron, LAR83/*225*①.

figural box, CEA/*65*①.

figural candelabra, S-2882/*811*①, *824*①; S-4947/*106*①.

figural candlestick, S-3311/*357*.

figural centerpiece, S-4804/*128*①.

figural clock, S-4804/*235*①.

figural cresting, S-2882/*286*①.

figural crowned terminal, S-2882/*1042*.

figural desk garniture, S-3311/*830*.

figural finial, C-0254/*91*; C-5203/*116*.

figural footed dish, S-4804/*124*①.

figural form, S-4461/*14*.

figural group, C-0225/*111*; C-5191/*50*; LAR83/*45*①; S-4461/*63*.

figural handle, C-0254/*113*.

figural handled, C-0254/*62*.

figural jug, NYTBA/*151*①.

figural lamp, C-0225/*126*; S-2882/*529*.

figural loop handle, S-4804/*137*①.

figural mantel clock, S-4947/*105*①.

figural marquetry, C-5170/*34*①.

figural mask, C-0249/*351*.

figural mount, S-4461/*85*.

figural panel, C-0225/*368*; C-0254/*39*; C-5116/*160*①.

figural panel foot, S-4804/*143*①.

figural pedestal, C-0279/*397*.

figural pilaster, S-2882/*776A*①.

figural relief plaque, C-0225/*143*①.

figural rondel, S-2882/*392*.

figural sculpture, C-0225/*105*.

figural spoon, S-4804/*110*.

figural wager cup, S-4804/*136*①.

figurative, LP.

figurative style, JIWA/*177*①.

figure, C-0406/*124*; C-0782/*229*; C-5146/*77*①; DATT; IDC; SDF.

figure candlestick, IDC.

figure composition, JIWA/*27*.

figured, C-0982/*30, 46*; C-5236/*549*; S-4905/*392*①.

figured flask, CEA/*56*①.

figured mould, CEA/*50*.

figured wood, C-5156/*489*.

figure-eight clock, LAR83/*211*①.

figure eight wall clock, C-5114/*357*.

figure finial, C-1502/*153*; C-2398/*24*①; C-5117/*14*.

figure-ground, LP/①.

figure group, CEA/*159*①; IDC.

figure handle, C-2510/*61*①.

figurehead handle, S-4461/*38*.

figure jug, IDC.

figure-of-eight base, C-2904/*23*.
figure-of-eight garland, IDC.
figure of elephant, S-4965/*106*①.
figure of Maitreya, C-2414/*24*①.
figure of Mercury, C-2398/*12*①.
figure painting, JIWA/*27*; LP.
figure pot, IDPF/*125*①.
figure representation, JIWA/*44*.
figures symbolic of Beauty, Industry, and Justice, C-5174/*507*①.
figurestone, DADA.
figure tapestry, EA/*Beauvais tapestry*.
figurine, DATT; IDC; MP/*32*; S-4461/*483*.
filagree, C-5239/*309*.
filati smalti, RTA/*127*①.
filbert, LP/① *brushes*.
filbert brush, DATT.
file, bronze, S-4965/*142*①.
filed rib, C-2476/*1*.
file mark, CHGH/*59*.
filet brodé à reprisés, DADA.
filet guipure, DADA.
filet lace, C-1506/*177*①.
filigree, C-0103/*86*; C-0225/*335*; C-0254/*215, 60A*; C-0270/*40*①; C-0706/*150, 221*; C-5005/*386*; CEA/*502, 513, 624*①; DADA; DATT; EA/①.
filigree (lace) (muslin), EG/*288*.
filigree, JIWA/*87*; RGS/*67*; RTA/*12*①, *104*①; S-2882/*809*; S-4436/*61*; S-4461/*385*; S-4802/*439*; SDF.
filigree cane, CEA/*490*.
filigreed, C-5005/*390*①.
filigree decoration, LAR83/*191*①.
filigree enamel, RGS/*50*.
filigree glass, DADA; EA.
filigree metal, CEA/*684*.
filigree motif, RTA/*30*①.
filigree overlay, C-0225/*337*.
filigree paper decoration, DADA.
filigree setting, C-5117/*319*①.

filigree shade, C-0225/*99*.
filigree wire, RTA/*36*①.
filigree work, C-0270/*86*; SDF/*filigree*.
filing, CEA/*528*.
filing-cabinet, CEA/*323*①.
filing cabinet, SDF/①.
filled medallion, S-2882/*57*.
filler, DATT; LP; SDF.
filler rod, DATT.
fillet, C-2357/*22*①; C-2364/*55*①; C-5114/*264, 331, 356*①; C-5156/*390*①; DADA; DATT; EA; RGS/*31*①; RTA/*56*; S-4955/*142*①; SDF/① *band*.
filling, DADA; SDF.
film, DATT.
film color, LP.
film-former, DATT.
film integrity, DATT.
film-stencil method, DATT.
film-thickness gauge, DATT.
filoselle, CEA/*294*.
filter, C-2904/*61*①; IDC/①; IDPF/*89*①.
filtered light, LP.
filter press, DATT; MP/*191, 502*.
final state, S-286/*272*.
Finchett, Arnold, EA/*368*①.
fin de siècle, DATT; LP.
fin de siècle mood, JIWA/*73*.
Findlay, John and Hugh, EA/*23*①.
fine, C-5153/*42*①; C-5157/*177*①; S-4905/*52*①.
fine art, DATT; JIWA/*6*.
fine-blown, EG/*118*.
fine crazing, S-4965/*183*①.
fine cut, OPGAC/*219*.
fine cut and panel, OPGAC/*219*.
fine granulation, RTA/*19*①.
fine impression, S-286/*14*.
fine laid paper, S-286/*322*.

finely polished, C-5156/*355*①.

finely potted, C-5156/*71*.

finely turned, S-4905/*151*①.

fine manner, DATT.

fine modeling, MP/*38*.

fineness of stitch, OC/*30*.

fineness of weave, OC/*11*.

fine patina, C-2458/*222*.

fine pewter, EA.

fine rib, OPGAC/*219*.

fine silver, DADA.

fine stoneware, IDC.

fin-form feet, S-4804/*132*①.

finger bowl, C-5236/*817*①; DADA; EA; LAR83/*415*①; S-3311/*612*; S-4461/*484*.

finger carved, LAR83/*343*①.

finger citrus handle, C-2323/*96*.

finger foot, C-5156/*775*.

finger glass, DADA.

finger grip, SDF.

finger-hole, SDF.

fingerhole, S-4905/*339*①.

finger lamp, K-710/*118*.

finger-mould, SDF.

finger painting, DATT.

finger-plate, EA.

finger-ring, CEA/*527*.

finger ring, C-5236/*1738*.

finger-ring watch, RTA/*125*①.

finger-vase, IDC/①.

finger vase, ACD; DADA; EA; IDPF/*89*.

finial, ACD; C-0254/*19*; C-0782/*74*; C-1006/*103*; C-2202/*12*; C-2409/*72*; C-2458/*24*①; C-2555/*16*①; C-5116/*42*①; C-5117/*198*①; C-5127/*35*, *43*; C-5153/*1*①; CEA/*220*①, *251*①; DADA; DATT; EA; EC2/*29*①; EG/*73*; IDC; IDPF/*89*; S-2882/*331*; S-4414/*220*①, *224*, *253*①; S-4922/*10*①; SDF/①.

finial handle, S-4414/*308*①.

finialled, C-0982/*37*; C-2402/*111*.

Finiguerra, Maso, CEA/*622*①.

finish, C-1082/*22*; C-2476/*3*; C-5239/*104*; CEA/*70*; DATT; EG/*250*; LP.

finished cotton, C-2704/*58*.

finished hand, C-5117/*424*①.

finishing trowel, DATT/①.

Finney family, CEA/*263*①.

Finnish contemporary arts and crafts, DADA/*Supplement*.

finocchio, C-2427/*251*①.

fioleri, EA/*Berovieri family, Venetian glass*.

fior di persica marble, DADA.

fioret, C-5191/*224*.

fir, S-4881/*488*①.

fire, DSSA.

fire arm, C-MARS/*115*①.

firearm, C-2503/①.

fire-back, ACD; CEA/*530*①.

fireback, C-0249/*300*; C-2388/*25*; C-5116/*34*; DADA/①; EA/①; NYTBA/*252*; S-4905/*323*; SDF.

firebox, S-4905/*324*.

firebrick, DATT.

fire bucket, C-5114/*242*.

fire-clay, IDC.

fireclay, DATT.

fireclay body, JIWA/*353*①.

fire clock, EA.

fire-crack, IDC/①.

fire crack, RTA/*114*①.

fire-dog, ACD; CEA/*530*①.

fire dog, DADA; SDF.

firedog, EA/①; S-2882/*339*; SDF/① *andirons*.

fired overglaze painting, MP/*498*①.

fire-fork, ACD; EA.

fire fork, SDF.

fire furniture, S-4461/*643*.

fire gilding, DATT; EA/*gilding*.

fire-gilding, CEA/455①; EA/*gilding.*
fire-grate, DADA.
fire grate, C-0906/97; S-4905/324.
firegrate, C-0906/167.
fire-guard, EA.
fire guard, SDF.
firehouse Windsor, EA; SDF.
fire-iron, ACD; EA/144①.
fire iron, SDF/①.
firelock, DADA.
fireman's coin, LAR83/583①.
fire marble, DATT.
fire-mark, C-2427/172.
fire mark, DADA; EA.
fire opal, S-4927/340.
fire pan, ACD; DADA; SDF.
fireplace, C-5181/128.
fireplace furniture, EA.
fireplace garniture, S-4905/326.
fireplace grate, C-5170/18①.
fireplace stand, C-5239/240.
fireplace surround, S-4955/99.
fireplate, EA/*fireback.*
fire-plate, ACD/*fire-back*; DADA.
'fire polish', ACD.
fire-polished, C-5191/267①; C-5239/
172; EG/28; LAR83/445①;
S-2882/1229①, 1235①, 1246.
fire polished, C-0225/258; C-2324/
172; C-GUST/70①; S-4414/206①.
fire-polishing, CEA/502.
fire polishing, EG/288.
fire pot, IDPF/90.
fire red, DATT.
fire-screen, C-2704/15; CEA/379①.
fire screen, ACD; C-1082/186;
C-5153/135①; DADA; EA/*screen*;
S-3311/503①; S-4972/603; SDF.
firescreen, C-0249/423; C-0982/82C;
C-1407/38; C-2402/40, 244;
C-2421/47; C-2498/85; C-5189/
318; S-4804/790①.
fire scroll, C-2458/119①.

fire speckled, C-5127/24①.
fire-speckling, IDC.
fire tools, DADA.
fire vase, SDF.
firework shower, C-5156/161.
firey, C-0225/246①.
firing, C-2458/36; C-5127/34;
C-5156/51①; DATT; EC1/83;
EC2/23; IDC; IDPF/90.
firing crack, C-2493/15; C-5146/51;
C-5236/497.
firing experiment, MP/18.
firing flaw, C-2493/214①.
firing foot, CEA/436①.
firing-glass, ACD.
firing glass, DADA; EA/*bumping
glass, bumping glasses.*
firing hole, S-4843/473①.
firing-pin, C-2476/14①.
firing process, MP/112.
firing-ring, IDC.
firm's mark, C-5005/214①.
firm's mark and numbering, C-5005/
222①.
first day's vase, IDC/①.
first edition, C-5156/962; CHGH/36;
S-4881/42①.
first ground, CEA/477①.
fir wood, DADA.
Fischer & Mieg, C-2493/261.
fish, DSSA; IDC.
fish bowl, C-5156/164①; C-5236/
1786①.
fishbowl, C-0279/147①; C-5127/
140①; C-5239/260; IDPF/90.
fish dish, C-1006/41; IDPF/90.
Fisher, Alexander, DADA/
Supplement.
Fisher, John, SDF/771.
Fisherman, the, IDC/①.
'Fisherman' pattern, S-4414/356①.
'fisherman's ring', RTA/96.

fish fork, C-0254/*248*; C-5114/*16*;
S-4804/*4, 28, 35.*
fish form, IDPF/*91*Ⓘ.
fish glue, DATT.
fish-head hammer, C-2503/*213*Ⓘ.
'fish-in-the-pond' design, OC/*84.*
fish knife, C-0254/*248*; C-0706/*34*;
C-1502/*67*; C-5114/*16*; EA;
S-4804/*1, 35.*
fish knife and fork, C-0706/*53.*
Fishley family, EA.
fish mold, S-4843/*89*Ⓘ.
fish platter, C-0254/*26*; C-5114/*34*Ⓘ.
fish rhyton, S-4973/*63*Ⓘ.
fish roe crackle, DADA.
fish-roe glaze, IDC.
fish-roe ground, IDC; S-4965/*223*Ⓘ.
fishroe ground, C-2569/*102*Ⓘ.
fish-roe yellow, IDC.
fishscale, OPGAC/*219.*
fish-scale carving, FFDAB/*35.*
fish-scale ground, IDC.
fishscale-molded, S-2882/*1423*Ⓘ.
fishscale panel, S-4507/*62*Ⓘ.
fish-scale pattern, CEA/*196*Ⓘ, *418*Ⓘ.
fishscale pattern ground, C-5127/*47.*
fish-server, DADA.
fish server, EA; LAR82/*591*Ⓘ;
S-4804/*4.*
fish set, C-0254/*310.*
fishskin-covered, C-2503/*13.*
fish-slice, C-5117/*32, 194A*Ⓘ;
C-5174/*530*; DADA/Ⓘ.
fish slice, C-0254/*47*; C-1502/*70,
100*; C-5114/*24, 32*Ⓘ; EA/Ⓘ;
S-4804/*5*; S-4922/*34*Ⓘ.
fish slice and fork, C-0706/*190.*
fish slice blade, C-5114/*24.*
fish tail, DADA.
fishtail, EA.
fish-tail butt, C-2503/*203*Ⓘ; C-2569/
60Ⓘ.
Fish Tail ewer, S-4843/*424*Ⓘ.

fishtail tool, DATT.
fishtail train, C-0604/*3.*
fish-trowel, IDC/Ⓘ.
fissure, DATT.
fit, DATT.
fitch, DATT/Ⓘ; LP/Ⓘ *brushes.*
fitment, C-2487/*152*; SDF.
Fitoorsz, Louwijs, EA/*Fictoor,
Louwijs.*
fitted, C-0706/*5*; C-2402/*50, 269*;
C-5116/*2*; S-4955/*14*Ⓘ.
fitted beaker, C-5117/*190*Ⓘ.
fitted bodice, C-3011/*7.*
fitted box, C-2458/*11*Ⓘ.
fitted case, C-1502/*70*; C-2458/
165Ⓘ; S-4992/*17*Ⓘ.
fitted double interior, RGS/*151*Ⓘ.
fitted drawer, C-2421/*67.*
fitted frieze drawer, C-2421/*76*Ⓘ.
fitted furniture, SDF/Ⓘ.
fitted interior, C-0249/*417*; C-0279/
425Ⓘ; C-1407/*187*; C-2388/*65*;
C-5114/*304*Ⓘ; C-5116/*4, 20*;
NYTBA/*58*Ⓘ; S-4972/*511*Ⓘ.
fitted plush box, C-1082/*165.*
fitted stand, S-4461/*195.*
fitted well, C-5157/*145*Ⓘ.
fitted wood stand, C-0782/*40.*
fitting, C-2458/*210*Ⓘ; C-2904/*280*Ⓘ;
C-5114/*258*; C-5117/*305*Ⓘ;
C-5156/*483*Ⓘ; C-5236/*537*Ⓘ;
S-4461/*158*; S-4965/*131*Ⓘ.
fittings-up, SDF/*fitment.*
Fitzhugh, S-4905/*96*Ⓘ.
Fitzhugh border, EA.
Fitzhugh pattern, C-0803/*109, 109*;
C-2513/*314*Ⓘ; C-5127/*258*; EC2/
23Ⓘ; IDC/Ⓘ; LAR82/*106*Ⓘ;
NYTBA/*167*Ⓘ; S-4905/*103*Ⓘ.
Fitzroy, Robert, CEA/*263*Ⓘ.
Fitzroy barometer, CEA/*260, 263*Ⓘ.
5-arm balance, C-2489/*187.*
Five Blessings, the, IDC.

flaring lip, S-4414/*189*①, *190, 194*①, *339*①; S-4461/*18*.

flaring neck, C-5127/*18*; IDPF/*108*①; S-2882/*1234*①, *1249*①; S-4461/*439*.

flaring ovoid form, S-4461/*508*.

flaring ruffled rim, S-4414/*251*①.

flaring seat, S-4461/*630*.

flaring side, C-5114/*7A, 239*.

flaring skirt, S-4461/*36*.

flaring vessel, S-2882/*1216*①.

flash, C-5236/*856*①.

flashed, CEA/*495*①.

flashed (flashing), EG/*288*.

flashed, OPGAC/*159*.

flashed glass, ACD; DADA/*Supplement*; EC1/*56*; JIWA/*312*①; S-4436/*18*①.

flash gilt, C-0279/*180*①.

flash-guard, C-2569/*60*①.

flashing, DADA; DATT.

flask, C-0254/*105A*; C-0906/*89*; C-1006/*61*; C-2569/*67*①; C-5114/*3A, 148*①; CEA/*49, 452*①, *541*; DADA/①; DSSA; IDC/①; IDPF/*94*①; NYTBA/*316*; S-4804/*2*; S-4972/*408*.

flask-shaped vase, JIWA/*335*.

flat, C-2402/*110*; CEA/*694*①; DATT; LP, ① *brushes*; S-4972/*140*①.

flat back, C-2458/*198*.

flatback, IDC.

flat-back figure, EA/①.

flat base, CEA/*415*.

flat bottom, JIWA/*112*①.

flat-bottomed, IDPF/*11*.

flat bouquet, CEA/*502*; EG/*288*.

flat-bouquet weight, LAR83/*437*①.

flat cap cover, CEA/*644*①.

flat carving, DADA.

flat-cashed, S-4944/*216*.

flat-chased, C-5117/*85*①; C-5174/*520*; LAR83/*595*①; S-4802/*310*①.

flat chased, S-4804/*95*.

flat-chasing, EA.

flat chasing, CEA/*618*.

flat collar, EG/*290*①.

flat color, DATT.

flat cover, C-2458/*24*①; S-4922/*22*①.

flat-cut topaz, RTA/*124*①.

flat dished foot, C-5114/*237*①.

flat end, C-5156/*2*①.

flat-ended shaft, C-5156/*174*.

flat-faced, IDPF/*26*.

flat faceted, C-0279/*159*.

flat finial, S-4922/*14*①.

flat flared rim, LAR83/*449*①.

flat foot, CEA/*423*①.

flat glass, EG/*243*.

flat hammering, EA.

flat-iron, EA.

flat knop, S-4414/*323*.

flat leaf design, CEA/*445*①.

flat-lidded, CEA/*584*①.

flat lug, IDPF/*155*①.

Flatman, Thomas, EA.

flat parallels, JIWA/*175*.

flat point, DADA.

flat relief, RTA/*45*①.

flat-shaped cover, C-5117/*148*①.

flat sketching pencil, DATT.

flat stacking weight, C-2904/*31*.

flat stitch, C-5127/*352*.

flat stopper, S-4461/*26*.

flat strap handle, C-5114/*224*①.

flat stretcher, CEA/*308*①.

flat surface, JIWA/*10*.

flatten, C-2458/*342*①.

flattened, C-2458/*316*; C-5117/*106*①.

flattened baluster, LAR83/*74*①.

flattened bead, C-5156/*361*①.

flattened bulbous body, S-4414/*211*①.

flattened circular body, C-5156/37①; LAR83/587①; S-4414/250①.

flattened circular boss, S-2882/1284.

flattened circular foot, S-4414/184①.

flattened circular shape, S-2882/1202①.

flattened curb links, S-4414/84.

flattened decoration, EG/43①.

flattened flaring handle, S-4414/185①.

flattened form, IDPF/95.

flattened globular form, S-4461/21.

flattened globular pommel, C-2569/38①.

flattened head, C-1082/4.

flattened heart form, S-4414/196①.

flattened outward-flaring lip, S-4414/195

flattened oviform body, C-5005/366.

flattened ovoid form, S-2882/1259①.

flattened pear shape, C-2409/27.

flattened pear-shaped, C-0782/90.

flattened sawtooth, OPGAC/220.

flattened shell, NYTBA/38.

flattened spherical base, S-4414/201①, 205①.

flattened spherical shape, C-5005/241.

Flatters & Garnett Ltd., C-2904/86.

flat-top, EA/on long-case clocks; S-4905/425①.

flat topped cover, C-5117/221①.

flatware, C-2202/59; C-5153/7; CEA/677①, 678; DATT; EA; IDC; IDPF/96; S-3311/606; S-4804/1; S-4905/160.

flatware service, C-0254/21; C-0406/54; C-5114/16; C-5167/152①; S-4461/459; S-4804/28①.

flat wash, JIWA/42.

flat weave, OC/16.

flatweave, C-5189/384.

flat weight, C-2904/39.

flat-woven, NYTBA/115; S-3311/29.

flatwoven, S-4796/19.

flatwoven carpet, S-4804/966A①.

flat-woven selvedge, OC/22.

flauged spout, IDC.

flavine lake, DATT.

flaw, C-5127/289①.

flax, DATT.

flax-blue, C-2427/40.

Flaxman, John, ACD; DADA; EA/①.

FL crowned, EA/Fleming, William.

flea motif, EA/boteh motif.

Flechtmuster, IDC.

fleck, C-1506/6; C-5005/276.

flecked, C-1082/22; C-2458/318①; C-5005/250①; C-5156/51①; EG/84.

flecked flambé, C-5156/161.

flecking, C-5127/311①; C-5236/329; S-4810/29①.

fleece, DSSA; OC/16.

Fleming, Baron Erik, DADA/Supplement.

Fleming, Joseph Adam, SDF/772.

Fleming, William, C-2487/106; EA/①.

Flemish, C-0405/158; C-1407/13; C-2382/133; C-2478/125①.

Flemish baroque, C-5157/26.

Flemish chair, DADA/①.

Flemish chalice, CEA/588①.

Flemish furniture, DADA.

Flemish glass, DADA.

Flemish pattern, C-0254/227.

Flemish scroll, DADA.

Flemish style, C-2546/94①; C-2704/147; C-5181/56.

Flemish tapestry, DADA.

Flemish ware, IDC.

Flemish white, DATT.

Flemming's stone, MP/502.

flesh, EC2/22.

flesh color, DATT.

flesh ochre, DATT.

flesh pink, S-288/1①.

flesh tone, S-4905/21①.

Fletcher, Thomas, CEA/677①.

Fletcher and Gardiner, CEA/677①.

fleur-de-lis, C-5114/40①; CEA/
137①, 171①; DADA; S-2882/
1335.

fleur de lis, C-0604/206.

fleur-de-lis and chain border,
NYTBA/96①.

fleur-de-lis border, C-0225/355.

fleur-de-lis corner, S-2882/785.

fleur-de-lys, C-0405/2, 172; DSSA;
SDF.

fleur de lys, EG/164①.

fleur-de-lys border, C-2478/244.

fleur-de-lys handle, RGS/61①.

fleur de peche marble, S-4947/137①.

fleur de pecher, C-5181/131.

fleur de pêcher, DADA.

fleur-de-roi, CEA/186①.

fleur de solanée, EA/potato flower,
potato flower.

fleurette, C-0225/160; C-5239/164.

fleurette branch, C-0225/173①.

Fleurier watch, EA/Chinese watch.

fleuri marble, DADA.

fleurs-de-lis, RTA/69①; S-4853/22①.

fleurs-de-lys, C-2382/7.

fleurs des Indes, EA/indianische
Blumen, indianische Blumen; IDC;
MP/502.

fleurs fines, EA/deutsche Blumen;
IDC.

fleur volante, DADA.

Fleusier watch, EA/Chinese watch.

flexible brick link strap, S-291/153①.

flexible mount of tubular design,
S-4414/40.

flexible pierced link, S-291/47①.

flexible rubber mould, RTA/142①.

flexibly-mounted, S-4414/49①.

flexibly-mounted pendant, S-4414/
61①.

flick, S-4927/84A.

Fliegender Fuchs (flying fox) pattern,
MP/472①.

fliegender Hund, IDC.

Fliegender Hund painted decoration,
MP/486.

fliegender Kinder, EA.

Flight, Barr & Barr, C-1582/137;
C-2493/70; EA/Worcester;
LAR83/175①.

Flight, Barr & Barr period, CEA/
196①.

Flight, Benjamin, C-5170/176①.

Flight, Joseph & John, CEA/196①.

Flight, Thomas, John, Joseph, EA.

Flight & Barr, EA/Worcester,
Worchester.

Flight & Robson, CEA/555①.

flint, CEA/70, 459; DATT; IDC.

flint clamp, S-4972/266.

flint enamel, DADA/Supplement.

flint enamel glaze, CEA/168①;
NYTBA/154①.

flint enamel ware, EA; IDC.

flint-glass, EA.

flint glass, CEA/59①, 502; DADA;
EG/287; NYTBA/277①.

flint glass-ware, CEA/55①.

flintlock, ACD; C-1702/104; C-2569/
70; C-MARS/121; CEA/23①, 44;
DADA; S-4972/159①, 161①, 261.

flintlock duelling pistol, C-2569/82①.

flintlock hand mortar, C-2569/62①.

flintlock musket, C-2569/61①.

flint-lock rifle, C-5156/778.

flintlock rifle, S-4972/260.

flintporslin, DADA; EA; IDC.

flint-poslin, CEA/209.

flintware, IDC.

flip, DADA.

flip-top, S-4461/733①; S-4804/799①.

flip top, C-5239/*287*.

flirt, EA/*striking mechanism*.

flirt action, S-3311/*413*①.

flirting eye, CEA/*697*.

flitch, DATT; SDF.

flitch-cut-board, C-5157/*174*①.

float, DATT.

float glass, SDF.

floating figure, JIWA/*39*.

floating panel, C-3011/*13*.

floating picture plane, JIWA/*71*.

floating signature, DATT.

floating space, JIWA/*10*.

floating-turtle mystery clock, LAR83/*202*①.

flock, SDF.

flocking, DATT.

flock paper, DADA.

Flohbein, IDC.

flong, DATT.

floor candelabrum, C-5146/*160*①.

floor clock, EA.

floor lamp, C-5236/*1638*.

floor lamp base, C-5146/*177*.

floorplate, C-2476/*5*.

Flora, DSSA.

flora and fauna motif, EC2/*23*①.

Flora Danica, ACD; S-3311/*366*①.

flora Danica service, IDC/①; EA.

floral, OC/*11*; OPGAC/*192*.

floral all-over design, OC/*324*.

floral and scroll decoration, C-0254/*239*.

floral and scroll motif, S-2882/*753*.

floral band, C-5114/*59*①; C-5117/*46*①; C-5153/*24*①.

floral bloom, C-0706/*123*.

floral boteh design, OC/*72*.

floral bouquet, CEA/*489*.

floral brocade, C-2704/*166*.

floral carpet, EA.

floral cartouche, S-2882/*777*.

floral-chased, C-0706/*3, 3, 46*.

floral chased, C-1502/*36*.

floral chinoiserie, S-4414/*504*.

floral clasp, S-291/*258*.

floral collar, C-2414/*24*①.

floral crown, RTA/*148*①.

floral design, EC2/*90*①; S-4461/*305*.

floral finial, C-0254/*25*; C-5117/*212*; S-4461/*254*.

floral garland, S-288/*26*①.

floral guard border, C-0279/*4*; S-4948/*12*.

floral head, C-0254/*55*.

Floral Herat carpet, OC/*324*①.

floral knop, S-4414/*354*①; S-4804/*141*①.

floral lattice, S-4948/*15*①.

floral marquetry, C-0249/*472*; C-0982/*76*; C-2555/*52*①; CEA/*330*①; LAR83/*198*①.

floral matrix, C-2403/*159*.

floral meander, C-2323/*30*①, *39*①; C-2414/*90*①; C-2458/*33*; IDC.

floral medallion, C-0782/*66*; OC/*270*①.

floral medallion-plain design, OC/*310*①.

floral motif, C-2414/*49*①; C-2458/*31*①.

floral mounting, S-291/*164*.

floral ornament, C-5117/*291*①.

floral panel, C-1082/*163*; RTA/*80*①.

floral-pierced, C-1502/*23*.

floral relief, EC2/*26*①; RGS/*17*①, *88*.

floral reserve, C-2458/*109*①.

floral rim, C-0254/*22*.

floral roundel, C-0782/*4*.

floral scroll band, C-5117/*46*①.

floral scroll frieze, S-4965/*223*①.

floral spray, S-4905/*43*①; S-4955/*213*.

floralspray stem, C-5174/*61*①.

floral sprig border, S-4843/26.
floral-stamped, C-2202/62.
floral-stamped ferrule, C-1502/72.
floral swag, C-1502/9; C-2458/137;
IDC/①; S-4804/25.
floral tapestry panel, S-3311/87.
floral terminal, S-4461/386.
floral vignette, S-4965/229①.
Floramuster, IDC.
Flora of Denmark, EA/Flora Danica
service.
Flora Paine, C-2704/6.
floreated, SDF.
Florence, DADA.
Florence Cathedral, CEA/169.
Florence zinc oxide, DATT.
Florentia, C-5191/383.
Florentine, LAR82/64①; LAR83/
34①.
Florentine brown, DATT.
florentined, S-291/27.
Florentine frame, C-0982/59.
Florentine gypsy mount, S-291/244①.
Florentine ii-poppy, OPGAC/193.
Florentine intarsia, CEA/515①.
Florentine lake, DATT.
Florentine mosaic work, SDF.
Florentine motif, K-711/127.
Florentine Pottery, Chillicothe, Ohio,
EC1/85.
florentine stitch, C-2704/32; SDF.
Florentine tapestry, EA.
floret, C-5236/852; S-4414/214;
S-4804/30①, 116①.
floret form, S-4965/264①.
florette, C-0279/453①; C-1006/82;
C-5156/257; IDC; S-3311/4;
S-4461/212.
florette border, IDC; S-2882/139A.
florette column, S-288/28①.
florette foot, S-4414/356①.
florette guard, S-2882/108, 164.

florette handle, C-5236/1583.
florette spandrel, S-2882/109①.
Florianware, LAR82/158①; LAR83/
139①.
floriated, CEA/157①; DATT.
'floribunda' style, OC/199.
Florida porcelain, DADA.
floriform, C-0225/295; C-5191/88;
S-2882/1323①; S-4461/5, 50,
86①, 489, 507.
floriform knop, S-4804/231①.
floriform neck, S-2882/1291①.
floriform nozzle, C-5005/233①.
floriform rim, C-2409/78.
floriform shade, S-4414/241①.
floriform socket, S-4414/252①.
floriform stem, S-4461/181.
floriform vase, C-0225/319; C-5005/
286①; LAR82/456①; S-2882/
1351①.
Flörsheim, DADA; EA.
flounce, C-1506/5, 8; C-2202/58;
C-2704/58; C-3011/106; NYTBA/
91①.
flour Ting, IDC.
flow blue, EA.
flower (modelled in porcelain), EA.
flower, IDC/①.
Flower, Joseph, EA.
flower and star motif, S-2882/619①.
flower and stem border, S-4948/1①.
flower-and-vine pattern, C-5114/
125①.
flower arranger, S-4461/250.
flower-basket pattern, IDC.
flower bowl, C-0225/5; C-5127/113.
flower box, DADA.
flower-box, SDF.
flower bracelet, S-291/81①.
flower brick, IDPF/96①.
flower-brick, C-2427/189; IDC/①.
flower brooch, S-4414/39①.
flower capped, C-2202/57.

flower-dish, IDC.

flowered and wave pattern, C-5156/ 59①.

flowered glass, DADA/①.

flower festoon, RGS/123①.

flower-festooned, S-4905/50①.

flower figuration, JIWA/194①.

flower flagon, C-0225/10.

flower foot, IDPF/181①.

flower form, C-5146/89D①.

flower-formed medallion, S-4414/ 546①.

flower-form finial, S-4804/147①.

flower frog, C-0225/318①.

flower garland, MP/33.

flower grate, S-4804/80.

flower head, C-0782/8, 86.

flowerhead, C-0982/38; C-2421/39①; S-4436/8①.

flower-head, C-2458/40, 150; C-5116/ 35.

flowerhead and vine scroll border, S-2882/177.

flower head border, S-288/38①.

flowerhead border, C-2421/151①; S-2882/116; S-4414/539.

flowerhead cresting, C-2437/41A; C-2555/35①.

flowerheaded, C-2402/9.

flowerhead festoons, C-2402/21.

flowerhead finial, LAR83/117①; S-4414/260.

flowerhead foot, S-4414/271①.

flowerhead guard, S-2882/43.

flower heading, C-2402/51.

flowerhead lozenge, C-2403/178.

flowerhead motif, S-4948/10①.

flowerhead nimbus, C-5234/192①.

flowerhead primary border, S-3311/ 46.

flowerhead skirt, S-2882/193.

flower holder, C-5189/40①; IDPF/ 97①; S-4881/319①.

flowering, CEA/155①.

flowering fan palmette, S-4948/141.

flowering leaf medallion, S-2882/121.

flowering prunus, C-0706/137; C-2421/130①.

flowering tree, C-2704/113①.

flowering urn, S-2882/48.

flower lattice-work, OC/252.

flower medallion, OPGAC/220.

flower-pot, C-2427/140①; C-2493/ 89; C-2704/152; IDC/①.

flower pot, S-4905/116①.

flowerpot, IDPF/98①.

Flowerpot factory, The, Rotterdam, EA/① Aelmis, Jan.

flower ring, S-291/54①.

flower shaped, C-5156/445.

flower-shaped claw, RTA/60①.

Flowers of the Four Seasons motif, S-4965/302①.

flower spray, C-0782/19.

flowerspray, C-5117/196; S-4414/ 289①, 305.

flower-spray, C-2458/45; C-2502/83; OC/290.

flowerspray finial, S-2882/1197①.

flower-stalk motif, OC/42.

flower stand, SDF/①.

flower-swag, C-2437/28①.

flower table, EA/stand; SDF/① flower stand.

flower theme, RGS/34.

flower vase, C-0706/202; C-5236/ 441①.

flow glaze, JIWA/349①.

flowing right-to-left emaki style, JIWA/157.

flown blue, IDC.

fluidity, DATT.

fluid lamp, C-5114/113①.

fluke, C-2503/15; C-MARS/69①.

fluorescence, DATT.

fluorescent paint, DATT.

fluorite, DATT; S-3312/*1240*.

fluorspar, C-5157/*16*; DATT; LAR83/*102*①.

flush, C-5146/*123*①; SDF.

flush bead, SDF.

flush beading, DADA.

flush brass pull, S-4461/*502*.

flush cover, C-2487/*108*①; C-5117/*207*.

flute, C-0906/*280*; C-2398/*37*; CEA/*502, 549*; DADA; EA.

flute (in glass), EA/①.

flute, IDPF/*99*①; OPGAC/*220*; S-2882/*1024*①.

flûte à bec, EA/*recorder, recorder*.

flute cutting, CEA/*445*①.

fluted, C-0225/*64*; C-0782/*13, 30, 66*; C-0982/*17*; C-1407/*3*; C-1502/*149*; C-2402/*4*; C-2458/*37*; C-5116/*37*①, *69*; C-5259/*508*; CEA/*644*①; S-2882/*980*①; S-4972/*248*①.

fluted, textured crescent mount, S-291/*261*.

fluted and ball foot, C-5117/*279*①.

fluted and pad foot, C-1502/*54A*.

fluted angle, C-0249/*448*①; C-2364/*72*; C-2388/*46*①.

fluted ball support, S-2882/*1122*①.

fluted baluster finial, C-5117/*240*①.

fluted baluster mug, LAR83/*594*①.

fluted band, C-0254/*36A*; C-5117/*127*①, *140*.

fluted banding, S-4414/*148*①.

fluted bar, C-2402/*40*.

fluted body, C-2382/*51*①; C-5117/*16*①, *212*.

fluted border, C-0254/*73*; S-4461/*532*; S-4922/*49*①.

fluted bracket foot, C-5117/*225*①.

fluted branch, C-0254/*72*.

fluted calyx, CEA/*643*①.

fluted campana-form sconce, S-3311/*766*①.

fluted candle socket, S-4461/*363*.

fluted canted corner, S-4436/*97*①.

fluted chamfered angle, C-5116/*116*.

fluted circular leg, C-0279/*334*①.

fluted column, C-1502/*95*; C-5114/*346*①; LAR82/*228*①; S-2882/*708*①, *815*; S-4461/*72, 382*.

fluted columnar angle, C-0249/*439*.

fluted columnar base, C-0279/*198*①.

fluted columnar shaft, C-5114/*241*.

fluted column drawer, C-5114/*363*①.

fluted column stem, LAR83/*484*①.

fluted column support, C-0254/*88*.

fluted coral, S-4414/*121*.

fluted corbel, S-4507/*55*①.

fluted corinthian column, S-4414/*344*①.

fluted cornice, C-2388/*134*.

fluted cylindrical leg, CEA/*314*①.

fluted die, FFDAB/*58*.

fluted domed cover, C-5117/*115*①.

fluted edge, C-5114/*386*①.

flute de pan, IDPF/*99*.

fluted exterior, C-2414/*2*①.

fluted foot, LAR82/*327*①.

fluted frame, LAR83/*270*①.

fluted gadrooned shoulder, C-0254/*143*①.

fluted ground, IDC.

fluted jar, C-2323/*5*.

fluted knop, C-5117/*144*①.

fluted leg, C-0249/*424*; C-0279/*437*; S-2882/*789*①.

fluted melon form, S-4804/*100*.

fluted neck, S-4414/*339*①.

fluted panel, C-5117/*67*①.

fluted panel support, S-2882/*1149*①.

fluted pedestal base, C-0279/*167*①.

fluted pendant, C-5114/*356*①.

fluted pyriform body, C-5114/*2*①.

fluted quarter column, C-5114/*392*①; C-5153/*181*①.

fluted rail, C-5116/*165*①.

fluted rim, S-4414/*351*①.

fluted scroll foot, S-4804/*78*①.

fluted seat-rail, C-2388/*10*.

fluted serpentine column, S-2882/*508*①.

fluted shaft, C-2388/*28*; C-2403/*50*.

fluted shell bowl, C-5114/*19*.

fluted shield form, S-4804/*173*.

fluted side, C-5117/*263*①.

fluted sphere, C-2421/*5*①.

fluted spout, C-0254/*64*.

fluted standard, C-0249/*163*; S-4461/*594*.

fluted stem, C-0254/*12*; C-0279/*412*①; C-5117/*99*①; S-4436/*35*; S-4461/*9*.

fluted stile, C-0249/*351*.

fluted sunburst ground, C-5117/*202*①.

fluted support, S-4461/*382*.

fluted swept rail, C-5116/*99*①.

fluted tablet, FFDAB/*37*①.

fluted tapered cylindrical form, S-2882/*988*①.

fluted tapering leg, C-0249/*370*; C-2320/*15*①; C-2388/*97*; S-2882/*362*①, *362A*①.

fluted tapering shaft, C-5114/*255*①.

fluted turned, C-2402/*21*.

fluted vase shape, S-2882/*905*.

Flute Lesson, the, IDC.

flutes, C-5116/*171*①.

flutina, C-0906/*320*.

fluting, ACD; C-0254/*61*①; C-2398/*52*①; C-2458/*29*; C-5116/*16*①, *158*①; CEA/*678*; DADA; DATT/①; EA; EG/*288*①; FFDAB/*27*; IDC; IDPF/*99*①; S-4972/*67*①; SDF.

flux, CEA/*110*; DATT; EA; EG/*288*; IDC; MP/*502*; RTA/*11*.

fluxed and run rim, C-2324/*54*.

fluxing ingredient, DATT.

FLV, EA/*Fauquez, Jean-Baptiste-Joseph*.

fly, CEA/*267*; DSSA; EA/*striking mechanism*.

flyback date, C-5117/*455*①.

fly bracket, CEA/*356*①; SDF.

fly chair, EA; SDF.

fly foot, SDF.

flying angle bracket, C-5170/*207*①.

flying double scroll handle, S-2882/*1100*①.

flying finial, SDF/①.

flying fox and squirrel, IDC/①.

flying gallop, IDC.

flying geese motif, C-2704/*105*.

flying phoenix, C-2458/*283*.

flying scroll, S-2882/*915*.

flying scroll handle, C-1502/*157*; S-4944/*379*①.

flying strap handle, S-4802/*352*.

flying stretcher, C-2478/*114*①.

fly leaf, SDF.

fly leg, FFDAB/*51*.

fly rail, SDF.

flywheel, C-2904/*267*.

fly whisk handle, C-5156/*428*; C-5236/*339*.

F.M., CEA/*68*①.

F. Mayer, EA/*Mayer, Franz Ferdinant*.

FM or Metzsch, over Bayreuth, EA/*Bayreuth Hausmalerei*.

foamed plastic, DATT.

fob, C-5117/*396*①; EA.

fob brooch, C-2368/*184*①.

fob-chain, EA.

fob-loop, S-4414/*31*①.

fob seal, EA/*seal, seal*; LAR82/*550*①; S-4802/*148*①; S-4944/*51*①.

fob-watch, S-4927/*145*.

fob watch, C-2489/*157*; LAR82/*237*①, *498*①; LAR83/*217*①.

fob watch and chain, C-1502/*139*.

focus, LP.

Fodeschi, H. A., Willenhall, C-2489/
150.

Foehr, C-0270/*73.*

Fogelberg, Andrew, C-2487/*72*①;
C-5117/*233*①; C-5173/*22*;
C-5174/*535*; EA.

Fogelburg, Andrew, CEA/*659*①.

foil, DATT/①; EG/*287.*

fois bois rosewood, FFDAB/*47*①.

fold, C-0249/*35*; C-1603/*22*; C-5236/
*1028*①; S-4461/*653*; S-4881.

folded conical foot, CEA/*423*①.

folded foot, EA; EG/*58*①; LAR82/
*439*①; S-4972/*415.*

folded form, IDPF/*99*①.

folded rim, C-5005/*285*; C-5114/*150.*

folder, C-2458/*286.*

folding, C-0706/*64*; C-0982/*11, 17.*

folding chair, C-0249/*380.*

Folding Corona portable typewriter,
C-0403/*2.*

folding fan, JIWA/*165.*

folding frame, C-0249/*380.*

folding friction leaf, CEA/*609*①.

folding furniture, SDF/①.

folding-leaf, C-2476/*87*①.

folding leg, C-0403/*125.*

folding microscope, C-1609/*5.*

folding plate camera, C-1609/*136.*

folding roll-film camera, C-1609/*132.*

folding screen, JIWA/*5, 6, 154.*

folding spoon, DADA/①; S-4972/
312.

folding stand, C-2904/*116.*

folding strut camera, C-1609/*131.*

folding table, S-4972/*468*①.

folding top, C-2403/*45*; C-5114/
*337*①; C-5116/*104.*

folding travel clock, S-4927/*72*①.

folding trigger, C-2476/*13*; C-2569/
79; CEA/*39*①.

foldover, C-2402/*104.*

fold-over dressing-table, CEA/*350*①.

fold-over swivel top, LAR83/*362*①.

fold-over top, C-0982/*27*; C-5114/
*389*①.

foldover top, C-1407/*12*; C-2402/*12*;
C-5114/*366*①.

foliage, C-2398/*2*; C-2402/*155*;
C-2458/*32, 41.*

foliage and hoof foot, C-2487/*29*①.

foliage and paterae foot, C-5117/
*134*①.

foliage and paw foot, C-5117/*8.*

foliage and paw support, C-5117/
*148*①.

foliage and reeded ring handle,
C-5117/*116*①.

foliage and reed handle, C-5117/
*128*①.

foliage and ribbon festoon, C-5117/
*58*①.

foliage and rosette border, RGS/
*151*①.

foliage and scroll foot, C-5117/*9.*

foliage and shell border, C-5117/
*17*①.

foliage and shell foot, C-5117/*4.*

foliage baluster seal top, C-5117/
*106*①.

foliage border, C-2398/*9*①.

foliage butt, C-5174/*545.*

foliage capped, C-5117/*68*①, *281.*

foliage capped double scroll handle,
C-5117/*66.*

foliage capped hook, C-5117/*112*①.

foliage centering shell, S-4414/*290*①,
*308*①.

foliage festoon, C-5117/*47*①.

foliage finial, C-5117/*211.*

foliage foot, C-5114/*59*①; C-5117/
*130*①.

foliage handle, C-2398/*5.*

foliage ornament, RGS/*31*①, *51.*

foliage reed and tie handle, C-5117/
*136*①.

foliage scroll, C-5156/*163*①.

foliage socket, C-2398/*18*①.

foliar, C-0405/*82*.

foliate, C-0782/*50*; C-2402/*5, 20*; C-2458/*252*; C-5116/*37*①; C-5153/*2*①, *17*①; FFDAB/*54*; IDC; S-3311/*110*①.

foliate and diaper pierced bowl, S-2882/*1137*.

foliate and scalework cartouche, C-5117/*90*.

foliate and scroll foot, C-1502/*54*.

foliate and tongue motif, S-2882/*1101*①.

foliate ball foot, S-4461/*15*.

foliate band, C-5114/*41, 153*; S-4461/*77*①.

foliate base, EG/*112*①.

foliate blade, C-0254/*5*.

foliate border, C-0254/*17*; CEA/*642*①; S-4461/*76*①.

foliate boss, S-2882/*1182*①.

foliate bracket foot, S-4414/*304*①.

foliate calyx, C-5117/*129*.

foliate candlearm, C-5114/*238*①.

foliate capital, C-0279/*450*①.

foliate capped, C-0254/*35*.

foliate capped spout, C-0254/*136*①.

foliate cartouche, C-0254/*23*①, *89*; C-0706/*243*; IDC.

foliate center, C-0254/*18*.

foliate-chased, C-1502/*71, 95*; S-4804/*3*.

foliate chase sabot, S-4461/*624*.

foliate clasp, C-2357/*47*①.

foliate cluster, S-4414/*85*①.

foliate cresting, C-0279/*445*.

foliated, C-5156/*59*①; DATT; SDF.

foliate decoration, S-4414/*21*①, *53*; S-4804/*13*①.

foliated engraving, CEA/*513*.

foliate design, C-0254/*114*; S-4414/*60*; S-4948/*118*①.

foliated lappet, C-5156/*169*.

foliate engraving, CEA/*510*.

foliate festoon, S-4414/*298*.

foliate finial, C-5114/*43*①.

foliate foot, C-0254/*16, 123*①; C-2364/*22*①; C-2403/*59*; S-4461/*16*.

foliate footrim, C-5114/*43*①, *46*①.

foliate frame, C-2421/*64*①.

foliate frieze, RGS/*31*①.

foliate garland, S-4992/*39*①.

foliate handle, C-2364/*63*①; C-5114/*40*①; LAR83/*72*①; S-4461/*254*; S-4804/*86*.

foliate heading, C-2402/*7*.

foliate initial, S-4414/*307*.

foliate leg, S-4461/*82*.

foliate mantle, S-2882/*1042, 1151*①; S-4414/*263*.

foliate marquetry, S-2882/*290*①, *368*.

foliate molded, LAR83/*328*①.

foliate monogram, S-3311/*635*①; S-4414/*307, 317*.

foliate motif, S-4414/*543*①; S-4948/*119*; S-4955/*128*①.

foliate-moulded, C-0982/*39*.

foliate mount, S-4414/*206*①.

foliate ornament, EA; RTA/*75*①.

foliate oval, C-2403/*102*.

foliate paw foot, C-0254/*83*; C-5116/*27*; S-4804/*100*.

foliate piercing, C-5114/*232*①.

foliate plaque, S-2882/*813*①.

foliate-repoussé, C-5157/*32*.

foliate rim, C-0782/*27*; C-5114/*40*①.

foliate ring, C-5114/*27*①.

foliate ring finial, S-2882/*908*①.

foliate ring handle, C-0254/*32*; C-5153/*17*①.

foliate sabot, C-0249/*444*.

foliate scroll, C-0249/*477*; C-5114/*38*①; C-5116/*49*①, *121*①;

S-2882/*385*①; S-4414/*256*①, *284,*
*290*①; S-4436/*75*①; S-4804/*9.*

foliate scroll border, C-0254/*18*;
S-4461/*158.*

foliate scroll mount, S-4461/*16.*

foliate scroll spout, C-0254/*25.*

foliate scroll surface, S-4414/*266.*

foliate scrollwork, S-2882/*785A*①.

foliate shell, C-0254/*100*①, *270.*

foliate shell base, C-0254/*57.*

foliate shell handle, C-0254/*16.*

foliate shell rim, C-0254/*36B.*

foliate spandrel, S-2882/*65, 190.*

foliate spout, C-0254/*263*; C-5114/
*43*①.

foliate spray, S-4414/*25*①.

foliate sprig, S-4414/*115.*

foliate standard, C-5114/*238*①.

foliate strapwork, S-2882/*357B*;
S-4802/*191*①.

foliate support, S-2882/*818*①.

foliate surround, S-2882/*918.*

foliate swag, C-1502/*46.*

foliate-tailed, S-4965/*67*①.

foliate toe (in furniture), S-4955/
*80*①.

foliate vine, S-2882/*622*①.

foliate vine border, S-2882/*623*①.

folio, C-2409/*160*; C-5156/*598.*

folio stand, LAR83/*353*①.

foliot, ACD; CEA/*230*①, *267*; EA.

foliot clock, EA/*Black Forest clock.*

folium, DATT.

folk art, DATT; NYTBA/*73.*

folkfiddle, C-5255/*83.*

folk picture, NYTBA/*104.*

folk-tale embroidery, CEA/*285*①.

folk weave, SDF.

Follot, Paul, C-5167/*198*①.

folly pattern, IDC.

Folon, Jean-Michel, S-286/*32.*

Folwell, John, DADA; SDF/*772.*

Fon, C-1082/*2.*

fond, DADA.

fond arlequin, IDC.

fond bois, IDC/①.

fond chant, DADA.

fond de neige, DADA.

fond ecaille, DADA.

fond écaille, EA.

fond écaillé, IDC.

fondelló, EA.

fondeur, C-5181/*77*; C-5189/*168*①.

fondeur-ciseleur, EA.

fondi d'oro, DADA; EA.

fond laqué, IDC.

fond pointille, C-2486/*8.*

fondporzellan, EA/*ground colour,*
ground colours; IDC.

fond simple, DADA.

fond taillandier, IDC.

fond truité, IDC.

font, C-5114/*113*①, *127*; DSSA;
S-4436/*38*①; S-4461/*366, 381.*

Fontaine, Pierre-François-Léonard,
EA.

Fontainebleau, ACD.

Fontainebleau, School of, LP.

Fontainebleau cup, IDC.

Fontainebleau pattern, C-0254/*246.*

Fontainebleau school, DATT.

Fontainebleau tapestry, DADA.

Fontainebleau workshop, EA.

Fontana, Guido, EA/*Durantino,*
Guido.

Fontana, Orazio, EA.

Fontana workshop style, IDC.

fontange-shaped, C-1603/*140.*

font cup, C-0103/*187.*

Fontenay, Belin de, CEA/*96.*

Fontenay, Mr de, CEA/*486*①.

font-shaped, C-5173/*58*①.

font-shaped cup, EA.

food bowl, C-2414/*13*①; C-5236/*1861*.

food-carrier, IDC/①.

food cupboard, DADA.

food hutch, SDF.

food pail, NYTBA/*240*①.

food-warmer, CEA/*158*①; IDC/①.

food warmer, C-0782/*60*; IDPF/*100*①.

foot, C-2370/*8*; C-5005/*226*①; C-5146/*54*①; DADA; DATT; EG/*289*; IDC; IDPF/*101*①; S-4922/*2*①; S-4992/*47*①; SDF/①.

foot-bath, IDC/①.

foot-board, S-4853/*422*①.

footboard, C-5239/*249*; SDF.

foot bowl, LAR83/*416*①.

foot cloth, SDF.

foot-detent escapement, C-2368/*83*.

footed, C-0225/*52*; CEA/*499*①.

footed baluster form, C-0225/*15*.

footed base, C-5114/*223*①.

footed bowl, C-5114/*42, 44*; C-5146/*92*①; C-5153/*45*①; LAR82/*136*①, *433*①; S-4461/*109, 480*; S-4804/*58*; S-4823/*109*①.

footed cage mount, C-0225/*242*.

footed compote, C-5114/*31*①; S-4804/*47*.

footed cream-jug, C-0254/*109*.

footed cup, C-5114/*45*①; S-4804/*16*①.

footed dahlia, CEA/*498*①.

footed dish, C-0254/*235*.

footed inkwell, C-0225/*89*.

footed ring base, C-5114/*221*①.

footed salt, C-0254/*15*.

footed salver, C-5114/*52*①; CEA/*643*①.

footed stand, C-5114/*15*①; S-4461/*523*; S-4905/*90*①.

footed urn, S-4461/*102*.

footed vase, C-0225/*63*; C-5114/*149*①.

footmaker, CEA/*414*.

footman, DADA; EA; LAR83/*222*①; SDF.

foot post, CEA/*398*①.

footpost, S-4905/*377*①.

footrail, DADA.

foot rasp, IDPF/*102*.

foot-rest, C-2370/*29*①; C-2437/*41*①.

footrest, C-5116/*76*; C-5157/*64*.

foot rim, C-2427/*68*; CEA/*587*①; IDC; LAR82/*90*①.

footrim, C-5114/*8*; C-5127/*20*; C-5153/*23*①; S-4905/*28, 120*①; S-4972/*139*①.

foot-ring, EA; IDC.

foot ring, IDPF/*102*①.

footring, C-2458/*179*; C-5114/*7A*; C-5127/*99*①; C-5156/*58*①; C-5236/*424*①.

foot-scraper, IDC/①.

footstool, C-0279/*290*; C-0982/*12*; C-2478/*32*; C-5170/*99*; DADA; SDF.

foot-warmer, EA; IDC/①.

foot warmer, C-2498/*24*; S-4881/*129*①; SDF.

Forain, Jean-Louis, S-286/*88*.

Forain, Jean Louis, S-286/*268A*.

Forbes, John W., C-5153/*47*①.

Forbes, William, C-5153/*10*①; S-4905/*173*.

Forbes, William G., CEA/*676*①.

Forbidden Fruit, The, C-2704/*186*.

forbidden stitch, C-5156/*475*.

forcer, SDF.

Ford, W., C-2476/*39*.

Fordsmand, CEA/*255*①.

Ford & Tupper, S-4905/*186*①.

forearm sheath, C-2458/*1*.

forecorner, S-3311/*488A*①; S-4955/*186*①.

fore-edge painting, DATT.
fore-end, S-4972/*230.*
foreground, C-5156/*278;* DATT;
　JIWA/*6, 32;* LP; S-4922/*53*①.
foreground object, JIWA/*10, 21.*
forehearth, EG/*236.*
foreign figure, S-4965/*212*①.
foreign flower, OC/*314.*
foreign groom figure, S-4965/*211*①.
foreign metal ware, C-0706.
foreign silver, C-2487/①.
foreshortening, DATT/①; JIWA/*69,
218;* LP/①.
forest chair, SDF/①.
forest glass, EG/*288;* CEA/*452*①.
Forestier, Etienne, C-2555/*64*①.
forest marble, DATT.
forestock, C-2476/*10.*
Foretay, Alfred, C-5191/*176.*
forge, DSSA.
forged, S-4972/*141*①.
forged brass, EC2/*89.*
forgery, CHGH/*31;* DATT; IDC;
LP.
forget-me-not, EA/*Jacobite glass.*
forget-me-not pattern, IDC.
forging, CEA/*528, 541.*
fork, C-5114/*18;* DADA/①.
forked handle, IDC.
forked-leaf, S-4847/*332*①.
forked loop handle, S-4414/*336*①.
forked rectangular handle, S-4414/
327.
forked scroll thumbpiece, S-4922/
*11*①.
forked tendril, S-4948/*38*①.
forked tendril motif, S-4948/*121.*
forked thumbpiece, S-4922/*20*①.
forked vine and flowerhead border,
S-4948/*88*①.
fork scroll meander border, S-2882/
100.

form, ACD; DADA; DATT; IDC;
JIWA/*6, 76;* LP; SDF.
formal, LP.
formal band, S-3312/*1354.*
formal border, C-0254/*225;* LAR82/
*173*①; S-3312/*1342*①; S-4461/*388.*
formaldehyde, LP.
formalin, LP; DATT.
formalism, CEA/*538*①; DATT; LP.
formal pattern, C-5156/*446.*
formal-pattern band, C-5236/*1694.*
formal pattern ground, C-5156/*102.*
formal portraiture, JIWA/*10.*
formal rhythm, JIWA/*10.*
formal scroll, C-2458/*80*①.
formal scrolling foliage, S-4461/*313.*
formal zoomorphic design, C-5234/
259.
form and function, CEA/*663*①.
format, JIWA/*6, 6;* LP.
form box, EA/*fantasy box.*
forme, DADA.
Formey, Jean, C-5220/*45*①.
formica, C-0403/*61;* DATT.
forms, JIWA/*10.*
formula, C-2904/*135.*
form watch, EA/①.
Forster, Thomas, EA.
forte, C-2569/*37*①; C-MARS/*12.*
forte-piano, CEA/*548.*
fortification marble, DATT.
Fortin à Paris, C-5224/*11*①.
Fortitude, DSSA.
Fortling, Jacob, CEA/*149*①.
Fort Pitt Glass Works, DADA/
Supplement.
Fortune, DSSA.
Fortune ('t Fortuyn), EA.
Fortune factory, EA/*Hofdyck,
Dammas.*
Fortune Teller, the, IDC/①.
forward-scrolling arm, C-5114/*383*①.

fossilized limestone, C-5224/*148*.

fossilized marble, C-5224/*116*①.

fossil limestone, LAR83/*221*①.

fossil marble, C-2357/*78*①.

fossil pattern, IDC.

fossil resin, DATT.

Fostat carpet, EA.

Fostat ware, IDC.

Foster, Edward, EA.

Foster Pinxt, EA/*Foster, Edward*.

Fostoria Glass Company, CEA/ *473*①.

Fothergill, John, C-5174/*540*①; EA/ ① *Boulton, Matthew*.

Fouache, J. B., C-5220/*26*①.

Foucher, Blaise, EA.

Foujita, Tsouguharu, S-286/*34*.

Foulard, JIWA/*20*①.

foul biting, DATT.

Foullet, Antoine, C-2364/*52*①.

Foullet, Pierre Antoine, C-2364/*52*①.

founder, CEA/*541*.

Founder's cup, C-5173/*58*①.

founders stamp, C-2409/*279*.

founding, EA.

found object, DATT/①; LP.

foundry mark, C-0225/*117*; C-5005/ *344*①; S-2882/*528, 529, 530, 1414*; S-3311/*317*; S-4461/*69*.

foundry sand, DATT.

foundry seal, C-5146/*31*①.

fountain, DSSA; IDC; S-4972/*6*①.

Fountain, William, C-2487/*79, 133*; EA; S-4944/*325*.

fountain brush, DATT.

fountain figure, IDC/①.

fountain pen, C-0403/*16*.

Fountain Screen, CEA/*531*①.

Fouquay, Nicolas, EA.

Fouquet, C-5005/*215*①.

Four Ages of Man, the, IDC.

four-armed medallion, S-4948/*52*①.

four-barrelled, C-2476/*12*.

four-board top, C-5114/*309*①.

four case, S-4829/*69*①.

four-case inro, C-1082/*153*; CEA/ *573*①; LAR83/*458*①.

four-chair-back settee, S-4988/*550*.

four character mark, C-5127/*50*.

four character-mark, IDC/ *character-mark*.

four-character mark, C-2458/*68*; IDC.

four-claw dragon motif, S-4965/*234*.

four color gold, S-4802/*56*.

four-color gold, C-5220/*43*①.

four-colour, EA.

four-columned shaft, C-5146/*112*①.

four-column inscription, C-2414/*15*①

Four Continents, the, IDC/①.

four-cornered base, C-2403/*58*.

four cup, C-0706/*126*.

Fourdinois, H., LAR82/*289*①.

Fourdinois, Henri, DADA/ *Supplement*.

Four Elements, DSSA.

Four Elements,the, IDC/①.

four-fold, S-4972/*436*.

four-fold scrap screen, C-2402/*271*.

four leaf screen, C-5127/*334*.

four Minton, C-2502/*2*.

Four Monarchs, the, IDC.

Fournier, George Friedrich, C-5174/ *37*.

Fournier, Louis, EA.

four-part leaf shape, C-2704/*49*.

four-piece suite, C-0982/*36*.

four plated, C-0906/*280*.

fourpost bedstead, SDF.

four-poster, CEA/*350*①; DADA.

four poster, FFDAB/*75*; K-710/*111*.

fourposter, SDF/*fourpost bedstead*.

four-poster bed, C-5157/*73*.

four-poster bedstead, LAR82/*270*①.

four poster bedstead, S-4461/*581.*

Four Quadrants, the, IDC.

four-screw mounting, C-2904/*44.*

Four Seasons, CEA/*485*①; DSSA.

Four Seasons, the, IDC/①.

four-section bracelet, S-291/*214*①.

four-sided circle, JIWA/*182*①.

four-sided pedestal stem, CEA/*428*①.

four-sided rod, CEA/*609*①.

foursquare, C-5127/*8*①; C-5236/
*1562*①.

four stand bullseye, C-0403/*193.*

Four Supernatural Creatures, the,
IDC.

Four Temperaments, DSSA.

Foval, CEA/*477*①.

**F over PR over Milon (Rubati,
Pasquale),** EA.

fowling-piece, C-2503/*149*①; C-2569/
*102*①.

fowling piece, CEA/*23*①; S-4972/
270.

Fox, Charles, C-0406/*25*; EA;
S-4922/*73*①.

Fox, Charles I, C-2487/*67.*

Fox, Charles II, S-3311/*722*①.

Fox, Charles Thomas, EA/*Fox,
Charles.*

Fox, George, C-2510/*43*; C-5117/
*280*①; LAR82/*598*①.

fox-brown, C-2357/*130*; C-2403/*206.*

foxed, C-5156/*553.*

fox-head, IDC.

fox-head cup, EA/*stirrup-cup,
stirrup-cup.*

foxing, C-0249/*23, 33*; DATT;
S-286/*44, 46, 63*; S-2882/*1402.*

fox mark, S-286/*65.*

foxmark, C-2324/*292.*

foxtail-link, S-4414/*90*①.

FR, EA/*Rato, Rochat, Frères.*

Frabel, Hans, CEA/*483*①.

**Frackelton Pottery, Milwaukee,
Wisconsin,** EC1/*85.*

fractional rendering, DATT.

fractur, DADA/①; DATT/①.

fractura, NYTBA/*195*①.

fracture, S-4972/*272.*

fractured, C-5146/*170*①; S-4972/
*144*①.

fractured glass, C-5005/*398*①.

fragment, C-0249/*175*; C-1506/*92*;
C-2458/*223*; C-5156/*176, 194,
343*①.

fragmentary vista, JIWA/*255.*

Fragonard, Jean-Honoré, EA.

Fragonard cup, IDC.

frailero, DADA.

fraktur, DATT/①.

frame, C-2320/*153*; C-2476/*14*①;
C-5114/*179*①; C-5116/*40*; CEA/
*623*①; IDPF/*103*①; JIWA/*10*;
S-4972/*386*①; SDF.

framea, DADA.

frame and rack adjustment, C-0403/
173.

framed, C-1006/*19*; C-5156/*264*;
C-5239/*189*; CEA/*317*①; S-4972/
*4*①.

framed and glazed, C-2704/*5.*

frame size, DATT; LP.

frame support, C-5153/*196*①.

framework, C-5239/*10*; S-4972/*99.*

framing function, JIWA/*10.*

Frampton, George James, DADA/
Supplement.

Franc, F. C., C-2364/*72.*

France, Edward, C-2522/*21*①; EA.

France, Robert, C-2522/*21*①.

France, William, C-2522/*21*①.

Franceuil, Dupin de, CEA/*380*①.

Franche-Comté, DADA.

Francini, Thomas de, CEA/*685.*

Francis, Sam, S-286/*269*①.

Francis Gardner Porcelain Factory, EA.

Francis I pattern, S-2882/927①, 928①.

Francis Ist pattern, C-0270/209.

Franck, Kaj, DADA/Supplement.

Franco-Flemish, S-4461/546.

Franco Flemish, S-4955/96①.

Franco-Flemish tapestry, C-2546/134.

François-Honoré-Georges, EA/ Jacob-Desmalter.

François I, DADA.

François Ier style, EA/①.

François vase, IDC/①.

Frankart Inc, K-711/129.

Frankel, Paul, C-5191/304.

Frankelite Company, K-711/129.

Frankenthal, ACD; C-2427/34①; C-2486/57①, 87①; CEA/178①; DADA; LAR82/126①; LAR83/ 101①; S-4853/127①.

Frankenthal manufactory, MP/162.

Frankenthal porcelain, S-3311/371①.

Frankenthal Porcelain factory, EA/ ①.

Frankfort black, DATT.

Frankfurt, C-2486/199①; CEA/451; EA/①; LAR82/127①.

Frankfurt-on-Main, DADA/①.

Frankl, Paul T., DADA/Supplement.

Franklin fly whisk, DADA.

Franklin Richmond, S-4905/191.

Franklin stove, C-5153/78①.

Frank Mayr, EA/Mayer, Franz Ferdinant.

Frankoma, K-710/118; OPGAC/353.

Franquelin-Descrano, C-5167/199.

Fratelli Toso, DADA/Supplement.

fraternity ring, RTA/142.

Fraud, DSSA.

Frauenkopf, C-2427/113①, 133①.

Frauensbildgen (Female portrait), MP/486.

Fray, M., C-5203/130.

Frechen, DADA.

Frederick Augustus II, MP/94.

free adaptation, JIWA/73①.

free-blown, EA/36①; EG/184.

free blown, CEA/470①.

freeblown, LAR82/434①.

free-blown glass, DADA; EG/26①.

free calligraphic engraving, S-4881/ 329①.

free composition, MP/38.

freedom box, CEA/70; DADA; EA/ ①; LAR83/545①.

freedom casket, LAR83/544①.

free-form, C-0225/296.

free-form shape, DATT/①.

free-form vase, S-3311/930.

freehand drawing, DATT.

Freeman, Philip, C-2487/142①.

Freemason box, EA.

free piece, MP/72.

free-representational painting, MP/ 105.

free-sprung, C-2489/234.

free sprung, C-5117/454①, 484①.

free standing, SDF.

free-standing column, EC2/90; S-3311/215①.

free-standing square upright, S-4414/ 383①.

freestone, DATT.

free style, C-5156/104.

Freiberg, DADA.

Freiburg, NYTBA/211①.

freize drawer, S-4414/453①.

Frémiet, Emmanuel, EA.

Fremin, Jean, C-5220/52①.

French Art Nouveau, DADA/ Supplement.

French Art Pottery, LAR83/103①.

French barbotine, EC1/72①.

French Baroque, S-2882/522①.

French berry, DATT.

French biscuit group, C-1006/*18.*

French blue, DATT; LP; MP/*174.*

French bracket foot, DADA; LAR83/*249*①.

French cannon, LAR82/*53*①.

French carpet, DADA; EA.

French castor, C-2402/*68.*

French ceramic decoration, EA/*bleu turc.*

French ceramics, EA/*bleu céleste.*

French chair, EA; SDF/①.

French chalk, DATT; IDC; LP.

French clock, EA/①.

French commode, SDF.

French contemporary arts and crafts, DADA/*Supplement.*

French corner chair, SDF/①.

French court furniture, NYTBA/*62.*

French curve, DATT/①.

French-cut, S-291/*29*①, *29*①.

French-cut calibre emerald, S-291/*73*①.

French-cut diamond, S-291/*80*①; S-4414/*11*①.

French Directoire, FFDAB/*24.*

french doors, S-3311/*439A.*

French drawing paper, MP/*73.*

French dresser (dressoir), EA/*dresser.*

French embossing, SDF.

French Empire influence, RGS/*90.*

French Empire period, C-MARS/*227*①.

French Empire style, CEA/*366.*

French fashion, CEA/*697.*

French foot, C-0279/*276*①; C-5114/*252*①; C-5153/*87, 109*①; CEA/*355*①, *405*; EA; FFDAB/*26*; SDF/①.

French foot and drapery, FFDAB/*92.*

French fork, EA.

French furniture, CEA/*366.*

French genre tapestry, S-4804/*950*①.

French glass, CEA/*484*; EA/①.

French gold and silver, EA.

French Gothic, NYTBA/*21*①.

French horn, EA/*182.*

French knot, CEA/*282*①.

French lacquer, SDF.

French lamp, EA/*Sinumbra lamp.*

French neck mount, C-2486/*118.*

French neo-Renaissance, RTA/*128*①.

French onion, CEA/*250.*

French perfectionism, CEA/*510.*

French pewter, S-4414/*278A.*

French plating, EA.

French polish, DADA; DATT; EA; SDF.

French polishing, CEA/*300.*

French porcelain, C-2502/*66*; DADA.

French-process zinc oxide, DATT.

French provincial, S-2882/*389*①, *420*①; C-0982/*79*; C-2402/*100A*; DADA/①; LAR82/*346*①.

French provincial style, EA.

French purple, DATT.

French relief-cast dish, CEA/*588*①.

French Renaissance spirit, NYTBA/*132.*

French Restoration period, C-MARS/*223*①.

French revival, CEA/*489.*

French sand, DATT.

French scroll foot, SDF.

French Second Empire period, C-MARS/*217.*

French snuff-box, EA/①.

French sprig, CEA/*199*①.

French stool, SDF/①.

French-style design, OC/*313.*

French-style rose, OC/*331.*

French stylistic influence, RGS/*184.*

French tapestry, EA/①.

French taste, C-2421/*115*①.

French taste, the, C-2478/*94*①.

French ultramarine, DATT; LP.

French Veronese green, DATT.

French walnut, SDF.

French watch, EA/①.

French white, DATT.

French whorl foot, DADA.

frêne wood, DADA.

frères Collin à Königsberg, EA/ *Königsberg.*

Frères Esquivillon, C-MARS/*152.*

Fresard, Oscar, C-5174/*380*①.

fresco, DADA; DATT/①; LP.

fresco liner, DATT.

fresco secco, DATT; LP.

fresh colors, C-5157/*29*①.

fresh impression, S-286/*533.*

fresh water pearl, C-5005/*220*(①).

freshwater pearl, S-4927/*399.*

Fres Melly & Ruegger, S-4927/*43.*

fresquera, DADA.

fret, C-0982/*211*; CEA/*405*; DADA; DATT/①; EA/*key pattern.*

fret (in clock), EA.

fret (in stringed musical instrument), EA.

fret, FFDAB/*102*; IDC; SDF/①.

fret border, C-0270/*9.*

fret bracket, C-5116/*93*①.

fret broken, C-1407/*70.*

fret-carved, C-0982/*13*; C-2402/*233.*

fret carved, S-4436/*100*①.

fret carved hood, LAR83/*199*①.

fret-inlaid, S-4972/*551*①.

fret pattern, EA/*key pattern.*

fret rail, S-4507/*53*①.

fretted, C-5146/*107C*; CEA/*552*①; EA.

fretted square factory mark, CEA/*196*①.

fret work, C-2368/*77*①.

fretwork, ACD; C-1082/*9*; C-2357/*90*①; C-2388/*88*; C-5114/*254*①;

C-5116/*131*①; C-5127/*350*; C-5153/*182*①; DADA; DATT; EA; LAR82/*273*①; SDF.

fret-work border, OC/*316.*

fretwork cloison pattern, S-4461/*402.*

fretworked, C-5236/*335B.*

fretwork foot, S-4461/*171.*

fret-work frieze, LAR83/*389*①.

fretwork gallery, C-2357/*47*①.

fretwork mirror, DADA/①.

F.R.F., CEA/*172*①.

friar's chair, DADA.

friction drum, CEA/*549.*

Friedlander, Johnny, S-286/*35.*

Friedman, Eduard, Vienna, C-5167/ *158.*

Friendly Society emblem, EA/*153.*

Friendly Society pole-head, EA/①.

friendship quilt, CEA/*277*①.

Friesen Service, MP/*104.*

friesian, DADA; C-5114/*248*①.

Friesian carving, EA.

Friesian stoelklok, LAR82/*234*(①).

Friesian teapot, EA.

Friesland, C-0254/*170.*

Friesland clock, EA/*Dutch clock.*

Friesland stoelklok, C-MARS/*231.*

Friess, Joachim, CEA/*627*①.

frieze, ACD; C-0254/*120*①; C-2388/ *26*①; C-2398/*95*①; C-2402/*4, 5, 21*; C-2421/*36*①; C-5114/*340*①, *363*①; C-5116/*38*; C-5156/*193*①, *464*①; CEA/*300, 316*①; DADA; EA; FFDAB/*100*①; IDPF/*34*; JIWA/*210*①; LAR83/*312*①; S-2882/*310, 668*①, *1303*①, *1442*①; S-4992/*5*①; SDF.

frieze aperture, C-0982/*35.*

frieze drawer, C-0249/*326*; C-0279/ *274*; C-0982/*11, 17, 38*; C-1407/*4*; C-2409/*240*; C-5116/*51, 85*①; S-2882/*256, 267, 659, 780*①; S-4414/*392, 425*①, *430*①, *446*①, *448*①, *463*①; S-4436/*47A*①;

S-4461/*592*; S-4812/*79*①; S-4988/
*450*①.

frieze panel, LAR83/*406*①.

frieze pattern, C-5114/*127*.

frieze rail, LAR83/*403*①; SDF.

frigate, CEA/*443*①.

frigate in full sail, C-2704/*19*.

frigger, ACD; EG/*289*①.

Frijtom, Frederick van, NYTBA/
*137*①.

frill, C-1506/*34*.

frilled hem, C-1506/*83*; C-2324/*309*.

frilled rim, C-2409/*107*.

frilling, DATT.

frill vase, IDC/①.

fringe, DADA; JIWA/*289*①;
NYTBA/*86*; OC/*16, 18*; S-3311/
28; S-4881/*202*①; SDF.

Frisard, Jacob, EA.

Frisbee, William, S-4922/*48*①.

frisket, DATT.

frisket paper, LP.

frit, ACD; C-2458/*40*; C-2482/*85*;
CEA/*170*①, *209*; DADA; DATT;
EA; IDC; MP/*502*.

frit chip, C-2323/*17*.

fritillary, EA/*Jacobite glass*.

frit porcelain, IDC.

Fritsche, Georg, EA.

fritted, C-2323/*20*①; C-2414/*57*①;
C-5127/*55*; C-5156/*87*①.

fritting, C-5127/*258*; C-5236/*517*.

frit ushabit, C-1582/*6*.

frit ushabti, C-2482/*100*.

Fritz, Barthold, CEA/*550*①.

Fritzsche, Georg, MP/*72*.

frizzen, CEA/*23*①, *44*.

frock coat, C-1506/*25*①.

Frodsham, Charles, C-2489/*97*①;
C-5117/*454*①.

Frodsham, H., Liverpool, C-2489/*44*.

frog, C-0906/*359*; DSSA.

frog mug, ACD; DADA; EA; IDC.

frog nozzle, C-2364/*9*①.

Frog service, EA; IDC.

Fröhlich, IDC/①.

Fröhlich and Schmiedel, IDC.

fromager, IDC.

Fromanteel, C-2489/*248*①.

Fromanteel, Ahasuerus, DADA.

Fromanteel family, EA.

Fromanteels, The, ACD; SDF/*776*.

Froment-Meurice, Emile, CEA/
*518*①.

Froment-Meurice, F. D., CEA/*518*①.

Froment-Meurice, François-Desiré,
EA.

Fromery, Alexander, EA.

Fromery workshop, C-5220/*23*①.

frond, C-5157/*108*.

front, S-4972/*528*.

frontal, DADA.

frontal depiction, DATT.

frontally, JIWA/*23*.

frontal projection, JIWA/*176*.

front and reverse, MP/*59*.

front columns, C-0982/*85*.

front cover winding, C-5117/*443*①.

Frontenac pattern, C-0254/*211*.

Frontier, CEA/*42*①.

frontispiece, C-0249/*33*; JIWA/*265*;
S-286/*15, 389*; S-4881/*41*①; SDF.

fronton, SDF.

frontoon, SDF/*fronton*.

front post, C-5114/*383*①.

front rail, C-5114/*342*①.

front seat, C-5114/*336*①.

frontsight, C-2476/*14*①.

frosted, C-0706/*31*; C-5005/*251*①,
*334*①; C-5239/*117*.

frosted and clear, C-5239/*119*.

frosted box, S-4414/*183*.

frosted glass, C-0225/*159*; C-1502/
182; C-2409/*4*; C-5005/*212*①;
C-5191/*224*; C-5239/*77*; DADA/

Supplement; EC1/*56*; LAR82/
*432*①; LAR83/*439*①; OPGAC/
220; S-2882/*1202*①, *1207*①;
S-3311/*879*; S-4461/*29*; S-4804/
*686*①; SDF.

frosted glass liner, C-5117/*149*①.

frosted leaf, OPGAC/*220*.

frosted lion, OPGAC/*220*.

frosted ribbon, OPGAC/*221*.

frosted stem, C-0225/*158*.

frosted stork, OPGAC/*221*.

frosted surface, NYTBA/*302*.

frosting, C-2414/*1*①.

frosting (in silver), EA.

frosting, EG/*73*.

Frothingham, Benjamin, DADA; EA.

frottage, DATT/①; JIWA/*49*; LP.

frottis, DATT.

frozen Charlotte, CEA/*697*.

F.& R.P., EA/*Pratt, Felix.*

F&R PRATT FENTON, EA/*Pratt, Felix.*

fruit, DSSA.

fruit and nut set, C-1502/*71*.

fruit basket, S-4461/*390*.

Fruit Basket block, C-2704/*88*.

fruit bowl, C 0254/*202*, C-0706/*117*;
C-1502/*200*; C-5203/*122*; CEA/
*447*①; EC2/*22*①; LAR82/*433*①;
S-4804/*19*.

fruit cluster, S-4414/*262*.

fruit-cluster foot, S-4922/*12*①.

fruit compote, C-0254/*244*.

fruit fork, C-0254/*80*.

fruit-fork, C-5117/*312*①.

fruit form, JIWA/*356*.

fruit-form, C-5174/*61*①.

fruit-form jar, S-4905/*89*①.

fruiting, S-4965/*241*①.

fruiting peach branch, C-2414/*98*①.

fruiting swag, S-4812/*5*①.

fruiting vine, C-1006/*75*; C-2403/*67*;
C-2458/*277*.

fruiting-vine, C-2402/*140*.

fruit knife, C-0706/*64*; C-5114/*21*①;
S-4804/*28, 35*.

fruitknife, C-0254/*65*.

fruit-knife, C-5117/*312*①.

fruit meander, C-2323/*31*①.

fruit plate, S-3311/*366*①.

fruit service, C-0254/*5*.

fruit set, C-0406/*39*.

fruit-set, C-2910/*76*.

fruit stand, C-0706/*31*; IDPF/*104*①.

fruit-stand, C-2510/*121B*①.

fruit wood, CEA/*562*.

fruitwood, C-2478/*93*; C-5116/*4*,
*65*①; DADA; DATT; LAR83/
*59*①; S-2882/*354*; S-4461/*634*;
S-4972/*430*①; S-4992/*104*①.

fruitwood carving, RTA/*118*①.

fruitwood cricket table, C-1407/*122*.

fruttiera, IDC.

Fry, T. C., Glass Company, DADA/
Supplement.

Frye, Thomas, ACD; CEA/*190*①;
EA.

frying pan, IDPF/*104*①.

F.S., CEA/*68*①.

F. Smith & Hartmann, S-4905/*219*.

fs with flourishes, EA/
*Saint-Amand-les-Eaux faience
factory.*

FT, EA/*Siegburg.*

FT (F. Trac), EA/*Knütgen.*

fu, ACD; CEA/*118*①; DADA; IDC.

fubako, C-1082/*182*.

fuchi, C-5236/*1826*; DADA.

fuchsine, DATT.

fuddling-cup, ACD; IDC/①.

fuddling cup, DADA/①; EA/①;
IDPF/*105*①; LAR82/*145*①;
LAR83/*119*①.

fuddling glass, DADA.

fudebako, C-5156/*743*①; C-5236/
808.

fu dog, S-4804/*662*①; MP/*112*.

fu-dog mount, S-4461/*189*.

fuel canister, C-5005/*399*①; C-5146/*168*①.

Fueter, Daniel Christian, EA/①.

Füger, Friedrich Heinrich, EA.

fugitive, LP.

fugitive color, DATT; NYTBA/*85*.

fugitive synthetic dye, OC/*23*.

fu-hsing, DADA.

Fuji, C-1082/*96*.

Fujian, C-2458/*79*.

Fujian vase, LAR82/*156*①.

Fujien, C-5156/*66*.

Fuji Masanobu and kakihan, CEA/*569*①.

Fujiwara, DADA.

Fujiwara period, EA.

Fukagawa, LAR82/*138*①; LAR83/*103*①.

fukashi, C-5236/*1828*.

fukien, C-5127/*110, 79*; CEA/*111*; DADA.

Fukien octagonal beaker, C-0803/*20, 20*.

Fukien ware, IDC.

Fuld, Alexander, C-5174/*244*.

Fulda, ACD; CEA/*139*①; DADA/①; S-4853/*154*①.

Fulda factory, MP/*165*.

Fulda faience factory, EA/①.

Fulham, ACD; C-1582/*27*; CEA/*96*; DADA.

Fulham carpet, EA.

Fulham carpet manufactory, EA.

Fulham period, LAR83/*88*①.

Fulham stoneware, IDC.

Fulham tapestry, DADA.

fu lion, DADA; S-4810/*269*①.

full-cut diamond, S-291/*212*①.

full cut diamond, S-291/*186*①.

fuller, C-2569/*40*①; C-5117/*313*①; C-5174/*212*; C-MARS/*34*①; CEA/*22*①; S-4972/*154*①, *248*①.

Fuller, Crispin, C-2487/*134*.

Fuller, G., C-2476/*81*.

Fuller, Loïe, CEA/*185*①.

fullered, C-2503/*3*.

fullered blade, C-2569/*10*.

fuller's earth, DATT; LP.

Fuller White, S-4905/*242*①; S-4922/*17*①.

full-formed, IDPF/*60*①.

full gallery, S-4436/*12*①.

full kilim skirt, C-5323/*2*.

full length, DATT; S-4972/*215*.

full mold casting, DATT.

full-plate movement, S-4927/*97*.

full plate movement, C-5117/*452*①.

full relief, S-4972/*12*①.

full sheet, S-286/*213, 214*.

full-sized mold, NYTBA/*293*①.

full stock, C-2569/*82*①, *103*①, *108*①.

fully adjusted movement, C-5117/*427*①.

fully marked, C-5117/*30*①, *99*①, *242*①.

fully ridged construction, OC/*187*①.

Fulper, C-5191/*4*; K-710/*118*; K-711/*129*; OPGAC/*346*.

Fulper Pottery, EC1/*86*①.

Fulper Pottery, Flemington, New Jersey, EC1/*85*.

fu medallion, S-4810/*294*①.

fumed oak, DADA; SDF.

fumeuse, DADA.

fumigation, DATT.

Funck, Dr. Willy, MP/*201*.

Funcke, Johann Georg, MP/*40*.

Functionalism, IDPF/*105*; RTA/*144*.

functional painting, MP/*105*.

functional porcelain, MP/*77*.

function and form, IDPF/*105*.

G

G, CEA/*177*①, *190*①.

G (Gehwerk), CEA/*236*①.

G, EA/*Francis Gardner Porcelain Factory.*

G., EA/*Berlin Faience factories.*

G, or Gera, EA/*Gera porcelain factory.*

gabardine, C-3011/*40.*

Gäbel, Johann Jacob, MP/*40.*

gaberdine, C-3011/*53.*

gabled, C-1702/*156.*

gabled lid, C-1702/*155.*

gabled links, S-4414/*58*①.

gable figure, LAR82/*87*①.

gable medallion, C-2388/*149A.*

Gabonese painted, C-2332/*12.*

Gaboon ebony, DATT.

gabri ware, DADA; EA; IDC.

gada, C-5234/*9, 62*①.

G. Adams, S-4922/*34*①.

gadget (in glassmaking), EG/*289.*

gadroon, C-2478/*61*; C-5117/*293*①; C-5156/*76*①; CEA/*406*; DADA; DATT; EA; IDC/①.

gadroon and shell border, C-0254/*212.*

gadroon border, S-2882/*1194*; S-4414/*262.*

gadrooned, C-0982/*119*; C-2364/*75*①; C-2398/*6*; C-2402/*67*; C-5117/*199B*①; C-5127/*59*; C-5153/*39*①; C-5236/*330*①; CEA/*643*①; LAR82/*439*①; S-4436/*7*①.

gadrooned and pierced, C-1502/*8.*

gadrooned apron, C-2403/*149.*

gadrooned arms, C-5116/*165*①.

gadrooned bands, C-5117/*99*①.

gadrooned base, C-0254/*28*; CEA/*418*①; EG/*124*①; S-4436/*31.*

gadrooned border, C-0254/*16, 26, 35*; C-0982/*35*; C-2402/*55*; C-5117/*54*①; CEA/*337*①; LAR83/*386*①; S-2882/*788*①.

gadrooned bowl, S-2882/*817.*

gadrooned carved molded plinth, S-4414/*502*①.

gadrooned circular top, S-2882/*667.*

gadrooned decoration, S-4461/*457.*

gadrooned dished circular foot, S-4414/*244*①.

gadrooned edge, C-5153/*32*①; LAR83/*221*①.

gadrooned foliage and shell border, C-5117/*148*①.

gadrooned foot, C-2403/*137*; C-5114/*122*; LAR83/*563*①; S-2882/*348*①.

gadrooned midband, C-5114/*36*①.

gadrooned prabha, C-5234/*28*①.

gadrooned rim, C-1502/*54A*.

gadrooned scroll, S-4922/*14*①.

gadrooned wire, RTA/*42*①.

gadrooning, ACD; C-5116/*106*; CEA/*209, 502, 678*; EA; EG/*289*; S-2882/*325, 801*; S-4414/*239*①; S-4804/*53*; SDF/①.

gadroon inner rim, S-4414/*258*.

gadroon rim, S-2882/*929, 1054, 1059, 1083*; S-4414/*254*①, *258, 290*①; S-4922/*87*①.

Gaea, DSSA.

gaffen, EA.

gaffer, CEA/*414, 502*; EG/*289*.

gaffle, C-2503/*79*.

Gagart, LP.

Gageliano, C-0906/*297*.

Gahn's blue, DATT.

Gaillard, Eugène, DADA/*Supplement*.

Gailliard, Lucien, CEA/*519*①.

gaine, DATT.

Gaines, John, EA.

Gains, John, CEA/*394*①.

Gainsborough chair, SDF/①.

Gainsford, R., C-0406/*23, 91*.

Gaki ware, IDC.

galante, C-2458/*268*.

galanterie, RGS/*115*.

Galanterien, EA.

Galanteriewaren, IDC.

galantes, C-2402/*20*.

Galatea, DSSA.

Galatian, William W., SDF/*772*.

galbé outline, C-2555/*59*①.

Gale, William Jr. & Company, C-5153/*8*.

Gale & Moseley, C-5153/*19*.

galena, CEA/*209*; IDC.

Galileo, CEA/*601*.

galipot, DATT.

Gallatin, Albert, CEA/*461*①.

Galle, C-2324/*172*; LAR82/*210*①.

Gallé, C-2910/*30*; C-5239/*166A*; OPGAC/*16, 163*; S-2882/*1229*①; S-3311/*899*①; S-4461/*41*.

Gallé, Émile, C-2409/*25*.

Gallé, Emile, C-5005/*278*①; CEA/*484, 487*①; DADA, *supplement*; JIWA/*10, 92*①; OPGAC/*163*.

Galle glass, LAR82/*22*①.

galleon, C-2427/*94*.

galleon terminal, C-0254/*67*.

galleried, C-2364/*55*①; C-2402/*232*; C-5236/*1566*; LAR82/*226*①; S-4436/*9*; S-4461/*186*; S-4812/*140*; S-4992/*84*①.

galleried border, S-4461/*390*.

galleried cornice top, LAR83/*350*①.

galleried oval shelf, S-2882/*362B*.

galleried platform shelf, C-2478/*147*①.

galleried rail, CEA/*675*①.

galleried rectangular top, S-4414/*459*.

galleried rim, C-5146/*89*; IDC/①.

galleried shelf, S-4461/*627*.

galleried table, SDF.

galleried top, CEA/*340*①; S-4414/*487, 498, 533*; S-4812/*133*①.

galleried tray, S-4414/*418*.

galleried undertier, C-0249/*429*; C-0279/*359, 424*①.

gallery, C-0254/*141*; C-0982/*28, 46*; C-2402/*83*; C-2403/*99*; C-2478/*18*; C-5005/*320*①; C-5114/*250*①, *360*①; C-5153/*11*①; DADA/①; EA; IDPF/*111*; LAR82/*326*①; LP; S-3311/*111*①; SDF.

gallery clock, LAR82/*236*①.

gallery tone, DATT.

gallery top, C-0279/*415*; C-1407/*160*; LAR83/*263*①; S-4461/*666*①.

gallery tray, C-0254/*1*; C-2202/*114*; FFDAB/*63*.

Gallet, Nancy, C-5181/*201*①.

Gallet, Roger, C-5191/*225*.

galley, C-2427/*94*.

galleypot, EA.

galley tile, IDC.

gallipot, ACD; DADA; DATT; EA; IDC; IDPF/*111*.

gall nut, DATT.

Gallon, C-2904/*37*.

galloon, SDF.

gallooning-length, C-5174/*9*.

Gallo-Roman, LAR83/*35*①.

gallstone, DATT.

Gallyon, C-2476/*65*.

gallyware, IDPF/*111*.

Galusha, Elijah, DADA/*Supplement*.

galvanized metal, DATT.

galvanometer, C-2608/*113*; C-2904/*127, 171*.

gama Ishime, DADA.

gambier, DATT.

Gambier-Parry spirit fresco, DATT.

gamboge, DATT; EA/*brass*; LP.

game cupboard, SDF.

game piece, CEA/*416*①.

game-pie dish, IDC.

game pie dish, S-4843/*380*①.

game plate, S-4947/*189*.

game-rib, C-2476/*15*①.

game rifle, C-2503/*151*.

games board, C-5116/*126*①.

games compendium, C-2332/*1*.

games table, C-2402/*4*; C-2478/*93*; CEA/*307*①; EA; LAR82/*20*①; LAR83/*392*①; S-4461/*563*①; S-4804/*769*①; SDF/①.

game table, S-4507/*87*①.

game terrine, IDC.

gaming motif, EA/*Austrian snuff-box*.

gaming set, IDC/①.

gaming stick, C-1082/*121*.

gaming table, DADA.

gammadion, DATT/①.

Gandharan, C-5156/*193*①.

ganosis, DATT.

Ganthony, Rich., London, C-2489/*200*.

Ganymede, DSSA.

Gao Kegong, C-2458/*263*.

Gao Ke-kong style, C-5156/*612*①.

GAR, EA/*Guillibaud, Jean-Baptiste*.

garance, DATT; LP.

garbrand, MP/*502, 459 full firing*.

García Juan José, DADA/*Supplement*.

garde du vin, EA/*cellaret, cellaret*; SDF/①.

garde-manger, DADA.

garden armchair, S-4988/*497*①.

garden carpet, EA/①; OC/*144*.

garden chair, C-2402/*92A*; S-3311/*577*①.

garden design, OC/*67, 106*.

Gardener, Benjamin, DADA/*Supplement*.

Gardener & Co., C-2368/*16*.

garden furniture, C-0279/*269A*; SDF/①.

garden machine, SDF/①.

garden mask, S-3311/*233*.

Garden of Eden, DSSA.

garden ornament, C-0782/*17*.

garden pedestal dial, CEA/*605*①.

garden rug, DADA.

garden seat, C-5127/*121*①; C-5156/*64*①; C-5236/*467*①, *1632*; DADA/①; IDC/①; S-3312/*1401*; S-4905/*119*①; S-4963/*91*①.

garden settee, C-5114/*254*①.

garden suite, S-4804/*942*①.

garden table, S-3311/*577*①.

garden tapestry, S-4972/*176.*
garden theme, NYTBA/*112.*
garderobe, DADA.
Gardet, Georges, C-5189/*135.*
Gardiner, Baldwin, C-5153/*21*①.
Gardner, C-2493/*235*; EA/*Francis Gardner Porcelain Factory.*
Gardner, Ann, NYTBA/*104*①.
Gardner, Francis, ACD; EA.
Gardner, Frantz and Alexander, EA/ *Gardner, Francis.*
Gardner, Frantz Frantsevich, EA/ *Gardner, Francis.*
Gardner Factory, C-5174/*207.*
Gardner figures, IDC/①.
Garfagnana marble, rosso, DADA.
Garfield drape, OPGAC/*221.*
gargoyle spout, IDC.
G. Argy–Rousseau, OPGAC/*156.*
garland, C-5114/*96*①, *339*①; EG/ *246*①; FFDAB/*94.*
garlands and swags of blossoms, S-2882/*232*①.
garlands of foliage, S-2882/*234*①.
garland surround, S-4812/*1*①.
garlic bud mouth, S-4461/*437.*
garlic lobe, C-2458/*58.*
garlic-mouth, IDC.
garlic mouth, C-5236/*1608*; S-4965/ *294*①.
garlic neck, C-1082/*90*; C-2323/*64*; C-2458/*52*; LAR83/*88*①, *172*①.
garlic rim, C-2513/*85*①.
garlic-shaped mouth, S-3312/*1354.*
garlic vase, IDPF/*112*①.
garnet, C-5005/*213*①; C-5117/*317*①, *352*①; C-5156/*216*; LAR82/ *496*①; S-4927/*312.*
garnet bead, S-4414/*80.*
garnet lac, DATT.
garnet paper, DATT.
garneture, C-0782/*114.*

Garnier, François, stamp: F GARNIER, C-5224/*61*①.
Garnier, P., S-4955/*110.*
Garnier, Paul, C-2368/*36*①.
Garnier, Pierre, DADA; S-4955/ *161*①.
garnish, ACD; CEA/*594*; EA.
garniture, C-1702/*278*; C-2409/*118*; C-2513/*367*①; C-5127/*107*; C-5189/*195*①; LAR82/*135*①; LAR83/*70*①; S-4804/*295*①, *301*①; S-4992/*14*①.
garniture de cheminée, ACD; EA; IDC.
garniture de cheminee, LAR82/ *184*①; LAR83/*193*①.
garniture de table, IDC.
garniture de toilette, IDC.
garniture set, C-0225/*362.*
Garon, Peter, S-4988/*407*①.
Garrard, Robert, C-2487/*65*; C-5117/ *285*①; CEA/*662*①.
Garrard, Robert the Elder, EA.
Garrard, Robert the Younger, EA/ *Garrard & Co..*
Garrard & Co., EA.
Garrett, Thomas, EA.
Garter, C-2437/*68*①.
Garthorne, Francis, EA/①.
Garthorne, George, CEA/*642*①; EA.
garudas, S-4461/*470.*
garzone, DATT.
Gas, C-2904/*199.*
gas black, DATT.
Gascogne, DADA.
gaselier, SDF/①.
Gashgai, S-4847/*15*①, *39, 136.*
Gashgai bag, S-4847/*73.*
Gashgai gelim, S-3311/*8.*
Gashgai rug, S-3311/*22*①; S-4461/ *813*; S-4796/*8, 13.*
Gaskin, Arthur, C-2910/*206*; CEA/ *519*①.

gasolier, SDF/① *gaselier.*

Gasparo, CEA/*551*①.

gate, C-2489/*84*①; C-5167/*196*; CEA/*527*; DATT.

Gate, Simon, C-GUST/*24*; DADA/ *Supplement.*

gate action, C-1407/*96.*

gate and screen, CEA/*532*①.

gatelag table, NYTBA/*33*①.

gate-leg, ACD; CEA/*389, 391*①; S-4972/*522*①.

gateleg, C-0249/*398*; C-0982/*96B*; C-1407/*44*; C-2402/*97*; C-2478/ *100*; C-5239/*265*; LAR82/*382*①.

gateleg dining-table, C-2403/*136.*

gate-leg frame, C-0249/*411.*

gateleg frame, C-2403/*74.*

gate-leg table, CEA/*329*①; DADA/ ①; EA; S-4436/*116*①, *118*①; S-4461/*708*①; SDF/①.

gateleg table, C-0982/*69, 303*; C-2382/*99*; C-2402/*224*; FFDAB/ *26*; LAR83/*374*①.

Gates, John Monteith, DADA/ *Supplement.*

Gates, William, DADA; EA; SDF/ *750.*

gather, ACD; CEA/*414, 502*; DATT; EA; EG/*289*; NYTBA/*290.*

gathered sleeve, C-3011/*8.*

gaude yellow, DATT.

Gaudez, Adrien-Etienne, C-5189/ *153*①.

Gaudi, Antonio y Cornet, DADA/ *Supplement.*

Gaudin, LAR82/*243*①.

Gaudreau, Antoine-Robert, DADA.

Gaudreau, (Gradreaux) Antoine Robert, EA.

Gaudron, Antoine, C-5224/*53 Gaudron à Paris.*

Gaudy, Seb., C-2489/*159.*

gaudy Dutch, DADA; EA/①.

Gaudy ware, IDC.

gaudy Welsh, EA.

gauffrage, DATT.

gauffrage border, S-3312/*972*①.

gauge, C-MARS/*191*; DATT.

Gauger's slide-rule, CEA/*609*①.

gauntlet, C-MARS/*104*①; S-4972/ *151*①.

gauntlet sword, C-MARS/*17.*

Gauron, Nicolas-François, EA.

Gauron, N. J., CEA/*186*①.

Gautier, Andrew, DADA; SDF/*772.*

Gautrait, L., C-5005/*216*①.

gauze, C-0405/*214*; JIWA/*169*①.

gauze fan, C-1603/*77.*

gavel, C-5117/*1.*

Gayday, C-2409/*98.*

'Gay-day' design, C-2910/*85.*

Gazebo, the, IDC.

Gazelle Bowl, CEA/*482*①.

GB, CEA/*428*①; EA/*Guillibaud, Jean-Baptiste.*

GBA, EA/*Le Nove.*

gbathia ware flask, C-2482/*111.*

G. BENEMAN, EA/*Beneman (Benneman.*

G. B. Giobbio & Co., C-2368/*13.*

G B N, CEA/*696*①.

G. Boyce, S-4905/*173.*

G C & CO, CEA/*696*①.

GCD, EA/*Drentwett family.*

G Delaney, C-1006/*19.*

GDK and HDK, EA/*de Koningh, Gilles and Hendrik.*

ge, S-4963/*3*①; S-4965/*155*①; EA/ *Mennicken family.*

gear, C-5114/*358*①; EC2/*89.*

gearbox, C-2569/*110*①.

gear train, C-2904/*254.*

Gebbeh, OC/*215*①.

Gebrochener Stab, MP/*472*①.

Gebrochener Stab relief decoration, MP/*152*① *Plates.*

Geburtsschein, DADA.

Gechter, Jean-François-Théodore, EA.

Gechu, CEA/566①.

Ged, Dougal, C-5117/85①.

Geddes, Norman Bel, C-5191/323.

Geflochtenes Körbchen (small woven basket), MP/486.

Gegner (opposing figures), MP/480.

Gegnern, MP/114.

Gehlin, Hugo, DADA/Supplement.

Geiger, Leonard, CEA/42①.

Geisler, C-2904/129.

Geithner, Peter, MP/442①.

gel, LP.

gelatin, DATT; LP.

Gelb, Matthias I, C-5174/429①.

Gelb, Melchior I, C-5174/429①.

gel-coat, DATT.

Gelim rug, LAR82/549①.

gelim skirt, S-2882/200.

Gellert green, DATT.

gel medium, DATT.

gem cameo, LAR82/458①.

gemel bottle, DADA.

gem-engraver, CEA/509.

gem-engraving, CEA/513; RTA/55.

Gemini, DSSA.

Gemini, Thomas, EA.

Gemma Frisius, EA.

gemological report, S-4927/302.

gems, S-4461/323.

gem-set, C-1502/199; C-5117/363①.

gem set, C-1082/87.

gemset, C-2487/3.

gem-set quatrefoil, RTA/98①.

gem-set ring, RTA/91①.

gem-set shaped, C-0103/86.

gem stone, C-1082/87.

gemstone, C-2398/12①; EG/26①; S-4461/230.

gemuschelten (shell-like) cup, MP/488①.

Gendje, CEA/82①; S-4847/11.

Gendje carpet, EA.

Gendje long rug, S-3311/63.

generator, C-2904/138.

Geneva enamel, C-5117/483①; EA.

Gengenbach, Joseph, C-5224/75 Canabas; EA/Canabas.

Gengha, CEA/82①.

Genghis rug, DADA.

genius, LP.

Genje, OC/65①.

Genje-type piece, OC/152.

Genoa lace, DADA.

Genoa Maiolica, EA.

Genoese velvet, DADA.

genouillière, DADA.

genre, DADA; DSSA; JIWA/14; LP.

genre figure, S-4461/409.

genre painting, DATT.

genre representation, MP/49.

genre scene, C-0279/448①; C-5156/638①; S-4948/44.

Genroku style, C-5156/866①.

Genroku taste, C-5156/908①.

Gen Shonsui, IDC.

Gent, Frank E., C-2904/163.

gentians, C-5005/279.

Gentile family: Bernardino, Carmine, Giacomo, Bernardino II, EA.

Gentilshomme verrier, CEA/484.

gentleman's chest, S-4905/430①.

gentleman's coat, C-1506/78.

gentleman's dressing gown, C-1506/29①.

gentleman's dressing mirror, S-3311/122.

gentleman's dressing stand, SDF.

gentleman's dress set, C-5117/360①; S-4927/255.

gentleman's repository, SDF.

Gentleness, DSSA.

Gentry, Denis, S-4955/*187*①.

Genu, Marie Joseph Gabriel, C-5117/*175*①.

Geo. C. Flint Co., CEA/*404*①.

geometric, C-0225/*5*; C-5239/*10*; LP; OC/*11*.

geometric abstraction, DATT.

geometric abstractionism, LP.

geometrical element, NYTBA/*59*.

geometric all-over design, OC/*170*.

geometrically-glazed, C-2403/*138*.

geometrically-panelled drawer, C-0249/*399*①.

geometrically pierced strap, S-4414/*47*①.

geometrical meander, JIWA/*136*.

geometrical ornamentation, JIWA/*201*.

geometric band, C-5156/*452*; S-4461/*404*.

geometric block, C-0249/*385*.

geometric border, C-0225/*38*; S-2882/*625*①; S-4461/*412*.

geometric boxwood stringing, C-5116/*1*.

geometric cluster ring, S-291/*56*①.

geometric design, C-0225/*23*①; C-0782/*118, 220*; C-2458/*310*; C-5005/*249*①.

geometric device, S-4461/*35*.

geometric elem, S-4948/*57*①.

geometric floral meander, S-2882/*79*①.

geometric floral motif, C-5117/*316*.

geometric flower, OC/*203*; S-2882/*638*①.

geometric foliate pattern, C-5117/*313*①.

geometric-form, S-3311/*28*.

geometric guard border, C-0279/*31*①.

geometric handle, CEA/*668*①.

geometric line, C-2402/*15*.

geometric meander border, S-2882/*53*①, *63*.

geometric meander border pattern, OC/*249*.

geometric medallion, S-2882/*146*.

geometric motif, C-5117/*301*; C-5127/*146*①; S-2882/*104, 1050*; S-291/*137*.

geometric mount, S-291/*142*.

geometric panel, C-5146/*54*①.

geometric paneled, LAR82/*324*①.

geometric pattern, C-2414/*85*①; C-2458/*107*①; C-5114/*246*; C-5117/*13*①.

Geometric period, DATT/①.

geometric quadripartite base, LAR83/*382*①.

geometric ribbed, C-0225/*345*.

geometric shade, C-0225/*358*.

geometric spandrel, S-2882/*41, 195*.

Geometric style, IDC.

George, Jean, EA.

George I, C-1502/*20, 219*; C-2421/*31*①; C-5116/*21*①; CEA/*321*; S-4436/*7*①; S-4461/*628*; S-4812/*62*①; S-4922/*18*①.

George I style, C-1407/*34*; S-3311/*270*.

George II, C-1502/*86*; C-2421/*29*①; C-2478/*61*; C-5116/*35*; CEA/*321*; S-4436/*8*①; S-4812/*3*; S-4922/*16*①.

George II period, C-5173/*33*①.

George II Scottish style, C-5117/*207*.

George II style, S-4804/*26*.

George III, C-1407/*2*; C-1502/*19*; C-2202/*7*; C-2402/*35*; C-2478/*7*; C-5116/*2*; C-5153/*85*; LAR82/*24*①, *42*①, *65*①; S-3311/*120*①; S-4436/*9*; S-4804/*190*①; S-4812/*9, 15*.

George III style, C-0982/*22*; C-2402/*18*; C-5157/*103*①; S-2882/*712*①; S-4804/*867*①.

George IV, C-0270/*142A*①; C-0706/
15, 221; C-1407/*143*; C-1502/*151*;
C-2398/*42*①; C-2403/*4*; C-2478/
*125*①; C-5116/*106*; C-5117/*23*①,
211; C-5153/*48*; S-4922/*23*①.

George IV period, C-2487/*43*;
LAR83/*535*①.

George V, S-4804/*175*①.

George Ashford and Co., Sheffield,
C-2487/*150*.

George Grainger, Royal China Works
Worcester, EA/*Grainger, Lee &
Co.*.

George Manson & Co., C-2904/*135*.

Georgian, C-0249/*386*; C-0906/*177*;
C-2357/*26*①; C-2368/*6*①;
C-2403/*6*; C-5116/*4, 111*; CEA/
321; LAR82/*67*①; NYTBA/*45*①;
S-2882/*276, 283*; S-4436/*3*;
S-4461/*383*; SDF.

Georgian bouquet brooch, S-291/
*117*①.

Georgian cross, S-4796/*127*.

Georgian crosses, S-4948/*47*.

Georgian marquetry, S-2882/*290*①.

Georgian Period, DADA.

Georgian provincial, S-2882/*323*.

Georgian silver, CHGH/*30*.

Georgian stripe, CEA/*89*①.

Georgian style, EA; S-2882/*246*.

Georgia White, DATT.

Georovan, OC/*266*.

Geo. Wilson & Co., C-2904/*250*.

Gera, C-2486/*119*; DADA; MP/*164*.

gerandole, SDF/① *girandole*.

geranium lake, DATT.

geranium red, DATT.

Gera porcelain factory, EA.

Gerardus Boyce, S-4905/*184*①.

gerbe, EA/*décor coréen*.

Gerlach, Gerhard, DADA/
Supplement.

Germain, Francis Thomas, NYTBA/
210.

Germain, François-Thomas, EA.

Germain, François Thomas, C-5220/
*46*①; CEA/*632*①.

Germain, Nicolas, EA.

Germain, Pierre II, Le Romain, EA.

Germain, Thomas, C-5220/*46*①; EA.

Germain ceramics, EA.

German, C-0982/*15*.

German and Bohemian glass, EA/①.

German Art Nouveau, DADA/
Supplement.

German-Austrian Empire, NYTBA/
*70*①.

German beer mug, JIWA/*321*.

German black, DATT.

German clock, EA.

German contemporary arts and crafts,
DADA/*Supplement*.

German cross, DATT.

German flowers, DADA; EA/*deutsche
Blumen*.

German fork, EA/*carving fork*.

German glass, CEA/*451*; DADA/①.

German gold and silver, EA/①.

German half-post, EA.

Germanic style, CEA/*537*.

German neoclassical, S-2882/*365*①.

German oak sofa, C-0982/*2*.

German porcelain, C-1006/*37A*;
C-2486; DADA/①.

German porcelain figure, C-1006/*65*.

German rococo, S-2882/*385*①;
S-3311/*488A*①.

German-silver, C-0403/*195*.

German silver, DADA; EA/*argentine*,
① *argentine*.

German snuff-box, EA/①.

German stoneware, DADA.

German style, RGS/*31*①.

German-style romanticism, RGS/*35*.

German tapestry, EA.

German watches, EA/①.

Germany, CEA/*451*.

Gilbert, Stephen, C-5173/*22*;
C-5174/*535*.

Gilbert, W & T, EA/*309*.

Gilbert & Wright, C-2904/*238*.

Gilbody, Samuel, CEA/*192*①, *200*①.

gild, EC2/*32*①.

gilded, C-1006/*7*; C-5116/*165*①;
CEA/*163*①, *442*①; DATT; EG/
*87*①.

Gilded Age, NYTBA/*300*.

gilded lace ornament, MP/*166*.

gilded leather, DADA.

gilded pewter, FFDAB/*122*①.

gilder's cushion, DATT.

gilder's knife, DATT.

gilder's mark, C-2486/*109*①; IDC.

gilder's tip, DATT.

gilder's wax, DATT.

gilding, ACD; C-2458/*145*①;
C-5117/*122*, *393*①; C-5127/*150*;
C-5156/*35*①; CEA/*44*, *209*, *222*①,
*540*①, *678*; DADA; DATT; EA;
EC1/*83*; EG/*38*①, *289*①; IDC;
LP; MP/*502*; S-2882/*716*①;
S-3312/*1279*; S-4905/*6*①, *17*①;
SDF.

Giles, James, ACD; C-2360/*88*①;
C-2421/*9*①; C-2493/*31*; CEA/
*442*①; EA/①.

gilim (ghilim) carpet, EA.

Gilkes, S-3311/*108*.

gill, DADA; CEA/*27*.

Gill, Danl., Rye, C-2489/*122*.

Gill and Half-Gill, C-2904/*37*.

Gilleo, D., C-5167/*140*.

Gillinder, James, and Sons, DADA/
Supplement.

Gillinder & Bennet, CEA/*489*.

Gillinder & Co., CEA/*472*①.

Gillinder millefiori, CEA/*489*.

Gillinder & Sons, CEA/*489*.

Gillinder & Sons, Philadelphia, EA/
*24*①.

Gillingham, George, EA/*330*①.

Gillingham, James, DADA; EA;
SDF/*772*.

Gillion, Paris, C-5181/*95*①.

gill measure, S-4905/*317*.

Gill of London, CEA/*31*①.

Gillot, Claude, DADA.

Gillow, Robert, ACD; DADA.

Gillow Firm, The, SDF/*750*.

Gillow's, EA.

Gillows, C-2403/*44*; C-2421/*94*①.

Gillows, Lancaster, CEA/*358*①.

Gilpin, Thomas, C-2487/*158*①.

Gilsonite, DATT.

gilt, C-0225/*79A*; C-0782/*5*; C-2402/
198; C-5116/*27*; C-5117/*149*①,
*454*①; C-5127/*101*①, *101*①;
C-5153/*32*①; CEA/*35*; DATT, ;
LP; S-4436/*33*; S-4992/*1*①.

gilt-aluminum, C-0225/*84*.

gilt border, S-4461/*2*.

gilt borders, C-1006/*132*.

gilt bowl, C-0254/*268*; S-4461/*373*.

gilt-brass, C-5116/*27*; C-5157/*107*①.

gilt-brass flute, CEA/*336*①.

gilt-brass foot, FFDAB/*41*①.

gilt bronze, C-1082/*100*; C-5156/*172*;
EA/*ormolu*; LAR83/*191*①.

gilt-bronze, C-5005/*330*①, *369*①;
C-5157/*178*①; EA/*ormolu*; IDC;
S-4507/*17*①; S-4804/*241*; S-4992/
*9*①.

gilt-bronze and ivory, S-2882/*1417*①.

gilt-bronze banding, S-2882/*800*.

gilt-bronze collar, S-2882/*410*①.

gilt bronze furniture, S-4955/*192*①.

gilt-bronze mount, CEA/*303*; S-2882/
*771*①.

gilt-bronze-mounted, S-3311/*221*①.

gilt-bronze putti, S-2882/*836*.

gilt button, EA.

gilt cell, C-5156/*434*①.

gilt chain, C-1506/*54*①.

gilt clover border, C-0225/*43*.

gimbal ring, C-2368/*84.*

gimbal style, LAR82/*45*①.

gimbal suspension, C-2368/*18.*

gimmal, ACD.

gimmal ring, RTA/*98*①.

gimmel, ACD.

gimmel flash, EA.

gimmel flask, EG/*265*①; IDC.

gimmick, LP/①.

gimp, DADA.

Gimson, Ernest, SDF/*751.*

Gimson, Ernest William, DADA/ *Supplement.*

gin bottle, IDC.

Gindri, LAR82/*137*①.

gingerbread kitchen clock, EC2/*92*①.

ginger inclusion, C-2458/*362.*

ginger-jar, IDC.

ginger jar, C-5153/*5*①; C-5191/ *408*①; DADA; EA; IDPF/*113*①; LAR83/*591*①; S-3312/*1344*①; S-4461/*424*; S-4905/*92*①, *121*①.

ginger skin, C-2458/*417.*

gingham, C-2704/*73, 48A*; SDF.

gin glass, DADA.

gin measure, IDPF/*158.*

Ginori, Carlo, CEA/*170*①.

Ginori family, EA/① *Doccia porcelain factory.*

giobu, ACD.

Giorgio workshop, C-2486/*248.*

giornata, DATT.

Giotteschi, DATT.

Giovanni Maria, EA/*Zoan Maria.*

giraffe piano, SDF.

girandole, ACD; C-0982/*62*; C-1407/ *149*; C-2320/*31*; C-2357/*24*①; C-2478/*58*; C-5114/*238*①, *376*; C-5116/*124*; C-5157/*110*; C-5170/ *119*①; C-5189/*271*①; CEA/*502*; DADA; EA/①; IDC; LAR82/ *513*①; S-2882/*710*①; S-3311/

*228*①, *450*①; S-4436/*67*; S-4461/ *544*; S-4988/*403*①; SDF/①.

girandole candlestick, SDF.

girandole clock, C-5153/*176*①; EA/ ①.

girandole form, CEA/*401*①.

girandole glass, FFDAB/*112*①.

girandole mirror, DADA/①.

Girard, Alexander, DADA/ *Supplement.*

Giraud, Nicolas, Bulloz, S-4927/*85*①.

girder, IDC.

girdle, DSSA; RTA/*94*; S-3311/*747*; S-4804/*23*; S-4905/*143*①, *180*①; S-4944/*77.*

girdled link, LAR83/*455*①.

gireh, CEA/*101*; OC/*30.*

giretto, IDC.

Girl at Well pattern, EA/*321.*

Girl-in-a-Swing factory, CEA/*189*①.

girl-in-a-swing family, EA/①.

Girl-in-a-swing ware, IDC/①.

girondole, C-5259/*305.*

Giroust, Philippe, C-2364/*27.*

Giroux, Alphonse-Gustave, S-4947/ *134*①.

gisant, DATT.

gisarme, DADA.

Gitterwerk, C-2427/*76*①.

Giuliano, Carlo, CEA/*518*①; EA/①; S-4927/*371.*

Giuliano, Federico and Fernando, EA/*Giuliano, Carlo.*

Giuratti, M., C-2503/*158.*

G. JACOB, EA/*Jacob, Georges.*

Gjorvik glasshouse, EA/*Scandinavian glass.*

GK, CEA/*141*①.

glacé, SDF.

gladstone bag, C-2203/*96.*

Gladstone style, C-0103/*56.*

glair, DATT.

glaive, DADA.

glance, DATT.

Glanzgold, MP/*184.*

gläserwärmer, IDC.

Glasgow, C-2904/*69, 81.*

Glasgow delft, EA.

Glasgow delftware, IDC.

Glasgow School, DADA/*Supplement.*

Glasgow style, C-2409/*238.*

glass, ACD; C-5005/*202*①, *241*; C-5153/*39*①; C-5236/*779*; CEA/ *414*; DADA/①; JIWA/*9*; S-4992/ *3*①; SDF.

glass baluster, EG/*134*① simple, *(inverted.*

glass bead, C-0225/*340.*

glass block, C-2409/*167.*

glass-blower, CEA/*414.*

glass blowing, CEA/*50.*

glass border, C-2388/*173.*

glass bowl, C-5005/*298.*

glass cane, DADA.

glass-ceramics, DADA/*Supplement.*

glass chair, SDF.

glass chandelier, C-5005/*258.*

glass colored print, DATT.

glass-cooler, RGS/*170*①.

glass crystal, JIWA/*302*①.

glass dome, S-4461/*199.*

glass egg, CEA/*456*①.

Glass Excise Acts, EA.

glass fibre, EG/*282.*

glass figure, S-4965/*87*①.

glass finishing, JIWA/*327.*

glass-fronted, C-0403/*177.*

glass-fronted cupboard, JIWA/*321.*

glass gilding, SDF.

glass holder, C-1502/*127.*

glass-house, CEA/*414.*

glasshouse, EA/① American glass.

Glass House Company, The, NYTBA/*288.*

Glasshouse of Ste-Anne, EA/ *Baccarat.*

glassine paper, DATT.

glass jewel, C-5167/*257*①.

glass-legged stool, C-2904/*280*①.

glass liner, C-0706/*102*; C-5117/ *58*①; S-4804/*134, 147A*①.

Glassmakers' Guild constitution, EA/ *Altare.*

glass makers' soap, EA/*decolourizing (in glass.*

glass metal, CEA/*414.*

glass overlay, LAR83/*444*①.

glass painting, DATT.

glasspainting, EG/*77.*

glass peg, CEA/*491*①.

glass picture, C-2522/*51*①.

glass scent, C-2202/*86.*

glass scent bottle, C-0270/*87.*

glass seal, EA/*seal.*

Glass Sellers' Company, DADA.

glass shade, C-5005/*311*①; CEA/ *229*①; S-4461/*86*①.

glass ship, CEA/*449*①.

glass sickness, S-4810/*245*①.

glass-thread figurine, CEA/*485*①.

glass tile, C-0225/*305*; C-5191/*491*①.

glassware, C-2904/*131*; JIWA/*302.*

glass window, C-2324/*252.*

glassy surface, NYTBA/*123.*

Glastonbury chair, ACD; C-2402/ *254*; DADA/①; EA/①; SDF/①.

glattbrand, MP/*502.*

Glätte, MP/*59.*

Glaucus group, MP/*476*①.

glaze, ACD; C-2323/*10*①; C-2402/ *85*; C-2414/*43*①; C-2458/*59*; C-5239/*12*; CEA/*110*; DADA; DATT; EC1/*83*; EC2/*23*; IDC; LP.

glaze coating, EC2/*23.*

glazed, C-0249/*74*; C-0782/*13, 76*; C-2704/*2*; C-5116/*46*①; C-5127/*2*;

C-5153/*87*; C-5156/*32, 264*; EG/
50; FFDAB/*129*; S-2882/*471*①;
S-4461/*45*; S-4992/*4*①.

glazed brown calf, C-5116/*112*.

glazed chintz, SDF.

glazed compass, C-2357/*89*①.

glazed dial, C-2364/*28*①.

glazed ding, C-5127/*43*.

glazed door, C-0982/*1, 19*; C-5116/
*49*①; S-2882/*278*①; S-4414/*522*①.

glazed fabric, NYTBA/*90*.

glazed fritt, IDPF/*3*.

glazed Gothic tracery door, LAR83/
*249*①.

glazed hair, S-4927/*264*.

glazed mahogany, C-0403/*61*.

glazed panel, C-2402/*26*.

glazed porcelain, MP/*170*.

glazed redware, LAR83/*64*①.

glazed rolled gold paper frame,
C-2704/*44*.

glazed stoneware, JIWA/*86*①.

glazed top, C-2403/*125*.

glazed tracery door, LAR83/*249*①.

glazed ware, S-4965/*156*①.

glazier, MP/*20*.

glazing, IDC; LP/*brushes*.

glazing bar, C-0279/*353*; CEA/
*348*①; EG/*245*; SDF.

glazing bead, SDF.

Glen, James, C-5174/*562*.

Glendale, OPGAC/*346*.

globe, C-2357/*89*①; C-2403/*34*;
C-5181/*11*; DSSA.

globe clock, C-0279/*190*; EA.

globe cup, DADA; EA.

globe-form, C-5181/*96*①.

globe inkstand, EA.

globe stand, DADA.

globe watch, EA/①.

globular, C-0782/*2, 13*; C-1082/*88*;
C-2202/*152*; C-2458/*2, 40*;

C-5114/*29*①; C-5117/*7*; C-5127/
43; CEA/*113*①.

globular body, C-2414/*54*①; C-5117/
*55*①, *325*①; S-2882/*1367*①;
S-4461/*222*.

globular bowl, C-2414/*14*①.

globular dish, C-2414/*1*①.

globular footed, CEA/*591*①.

globular form, C-5114/*10*①; LAR83/
*448*①; S-4461/*18*.

globular high shouldered form,
S-2882/*1369*①.

globular jar, C-5156/*20*; LAR82/
*142*①.

globular lamp, C-2458/*168*①.

globular shape, S-4461/*13*.

globular teapot, C-1006/*149*.

globular teapot and cover, C-2458/
129.

globular urn, K-711/*131*.

globular vase, C-2458/*160*①.

globular volume, IDPF/*117*.

glockencanne, LAR83/*517*①.

glory, DATT.

glory-hole, CEA/*502*.

glory hole, EG/*288*.

gloss, C-2458/*427*; DATT.

Gloss, Isaak Jakob, EA/*Clauce,
Isaak Jakob*.

glossy, C-1082/*29*.

glost, DATT.

glost fire, DATT.

glost firing, IDC.

glost-kiln, CEA/*209*.

glost kiln, MP/*502*.

Gloucester, Duke of, service, IDC/
①.

glove box, C-0406/*10*; S-4881/*172*①.

glover, MP/*82*.

glove stretcher, C-0254/*140*.

glue, DATT; LP.

glue block, FFDAB/*32*①.

glue-cutout method, DATT.

gluepot, C-5146/*157.*

glutin, DATT.

Gluttony, DSSA.

glycerin, DATT; LP.

Glynne, Richard, CEA/*610*①.

glyphic art, DATT.

glyptic art, DATT.

G.M.B., EA/*Baccin, Giovan Maria.*

G M C, CEA/*696*①.

G. M. & C. J. Mason, EA/①
Mason, George Miles.

Gmelin's blue, DATT.

gnarl, SDF.

gnathia-ware, S-4807/*499*①.

gnomen, C-2482/*247.*

gnomon, C-2489/*20*①; C-2608/*128*;
C-2904/*268*; CEA/*612*; EA/
sundial; S-4802/*166.*

gnostic gem, RTA/*61*①.

go, CEA/*575*; DADA.

Goanese, LAR83/*265*①; S-4461/*516.*

goat, DSSA.

goat-and-bee jug, EA/①.

goat and bee jug, DADA/①; IDC/
①; IDPF/*113.*

goat hair, OC/*16.*

goats, IDC/①.

goat's hoof supports, S-4802/*174*①.

Gobelin, SDF.

Gobelin family, MP/*12.*

Gobelins, ACD; CEA/*96*; DADA;
EA/①; NYTBA/*97.*

Gobelins tapestry, LAR83/*649*①.

Gobelin stitch, DADA; SDF.

Gobelin tapestry, MP/*122.*

Gobels, Jan, Amsterdam, C-MARS/
245.

goblet, C-0254/*54*; C-0706/*55*;
C-1502/*213*; C-5005/*235*①;
C-5114/*37*①; C-5117/*13*①, *31*①;
CEA/*418*①, *502*; DADA; DSSA;
IDC; IDPF/*113*①; JIWA/*306*;
LAR83/*428*①, *582*①; S-3311/*610.*

goblet drum, IDPF/*83.*

go-cart, EA/*baby-walker,* ①.

Godattes, D. M. N., Saint Malo,
C-2489/*23.*

Godbehere, Samuel, C-5117/*52*;
S-4944/*335*①.

Godbehere, Wigin, Bult and Fox,
CEA/*650*①.

Godbehere & Wigan, LAR82/*593*①.

goddard, EA/*tankard.*

Goddard, John, C-5153/*199*①; SDF/
772.

Goddard, John, I, DADA.

Goddard, John I, EA.

Goddard, John, II, DADA.

goddard foot, EA; SDF.

Goddard-Townsend, CEA/*395*①.

godendag, DADA.

Goderonnierte saucer, MP/*486.*

godet, ACD; CEA/*203*①; IDC/①;
IDPF/*115.*

god figure, MP/*116.*

Godfrey, Benjamin, CEA/*653*①.

Godolphin arms, C-1506/*111.*

godron, IDC.

godroon, DADA.

Godtling, Jeremias Theunison, EA.

Godwin, Edward William, DADA/
Supplement; SDF/*751.*

Goebel, C-5239/*49.*

Goebel, William, C-2910/*98, 134.*

Goff, Thomas, CEA/*532*①.

goffer, DATT.

goffering iron, EA/①.

Gogarjin, OC/*90*①.

Goggingen, C-2427/*186.*

Göggingen, DADA; EA.

goglet, IDC; IDPF/*115.*

going barrel, CEA/*254*①, *267*; EA/
barrel.

going-barrel movement, C-2489/*86*①.

going-cart, ACD; EA/*baby-walker.*

going train, CEA/220①.

göl, OC/76, 76①, 174①.

Gol, José Maria, DADA/Supplement.

Golay, S-4927/192①.

Golay Leresche, A. & Fils, S-4927/114.

gold, C-5005/204①; CEA/255①; EC2/20①; S-4922/23①.

'gold Afghans', OC/260.

gold Albert, C-2489/142.

gold anchor period, EA/Chelsea.

gold aurene, K-802/22.

gold ballpoint, C-0403/18.

gold beading, S-4414/41①.

gold cap, S-4414/121.

gold capped bridge, C-5117/402.

Goldchinesen, IDC.

gold Chinese style, EA.

Golden Age, DSSA.

Golden Age of pewter, CEA/579.

golden calf, DSSA.

golden fleece, DSSA.

golden mean, DATT/①; LP/①.

golden ochre, DATT.

golden pottery, IDC.

golden rose, EA/papal rose.

golden section, DATT; LP.

golden-yellow, C-2403/211.

gold filigree hands, S-291/118①.

gold filled, C-5117/402.

goldfinch, DSSA.

goldfish border, S-4847/19.

gold foil, C-0225/44; EG/117①; S-3312/1046①.

gold fundame ground, S-3312/1049①.

gold-glass, CEA/416①.

gold ground, EA.

gold-headed cane, CEA/520.

gold inclusion, C-5005/302①.

gold-inset eye, S-2882/622①.

gold jewel, C-5005/382①.

gold lacquer, CEA/303, 571.

gold-lacquered brass, CEA/303.

gold leaf, DATT; EG/270, 289①; LP.

gold lorgnette, S-4414/23①.

gold lustre, C-0225/294.

gold lustre ware, IDC.

gold mesh chain, CEA/515①.

gold-mounted, C-5005/208①.

gold net, C-1603/74.

gold nugget, S-4927/252.

gold paint, DATT.

gold plate, CEA/678.

gold powder, DATT.

gold resist, IDC.

gold rope, S-4414/82①.

Goldrubinglas, CEA/453①.

gold sandwich glass, EA/Zwischengolggläser.

gold-scattered paper, C-5156/903①.

Goldscheider, C-2409/255; C-2910/140, 169; C-5239/22①; C-GUST/17①; LAR82/131①; LAR83/106①.

Goldscheider foundry, C-5167/23.

Goldscheider pottery, S-3311/864.

gold sheet, C-2458/225.

gold sheet damascening, C-2513/94.

gold size, DATT; SDF.

goldsmith, CEA/509; JIWA/12, 92.

Goldsmiths and Silversmiths, C-2409/216.

Goldsmiths and Silversmiths Co., C-2487/148.

Goldsmiths' Company, CEA/642①; EA.

Goldsmiths & Silversmiths Co, C-0706/2, 57.

Goldsmiths & Silversmiths Co., S-4944/233.

gold star glass, EA/aventurine glass.

goldstone, C-2458/411.

gold thread, DADA; OC/16.

gold tissue, C-1506/111.

gold-tooled, S-3311/*148*; S-4507/
*70*①.
gold tooling, CEA/*612*.
gold train, C-5117/*442*.
goldweight, S-4807/*408*.
gold worker, MP/*38*.
gol farang, OC/*314*.
gol farang design, OC/*203*.
Golfe-Juan, LAR82/*127*①.
golfer and caddy pattern, IDC.
Golgotha, CEA/*287*.
Goliath, C-0706/*25*.
gol-i-bolbol, OC/*120*.
Gol-i-Hinnai, CEA/*101, 101*①.
göls, OC/*175*.
Gombron ware, ACD.
Gombroon ware, EA; IDC/①.
Gomm, Ann, plate, IDC/①.
gomoku-zōgan, DADA.
Gondelach, Franz, DADA; EA.
gondola-back chair, DADA/①.
gondola bed, EA/*boat bed*.
gondola chair, LAR82/*311*①; SDF.
gondola form, LAR83/*346*①.
gondola prow, CEA/*539*①.
gondola-shape, DADA.
gondola-shaped, C-5189/*357*.
gondole, EA/*barrel chair*.
'Gone with the Wind' lamp, LAR83/
*482*①.
gong, C-1082/*103*; C-1702/*278*;
C-2489/*245*; C-5156/*770*①; CEA/
235.
gongbell toy, CEA/*697*.
gonome nanako, DADA.
Gonon, Honoré, EA.
Goodale, Daniel, NYTBA/*161*①.
Goodden, R. Y., DADA/*Supplement*.
Goode, Charles, London, C-2489/*173*.
good impression, S-286/*247B*.
Goodison, Benjamin, DADA; EA;
SDF/*751*.

Goodman & Co. Patent, C-5174/*461*.
Goodwin, Andrew, C-5117/*88*①.
Goodwin, James, C-0406/*80*.
Goodwin, William F., CEA/*696*①.
goose-neck pediment, EA; SDF.
gooseneck spout, C-0254/*266*.
Gopiganj, OC/*305*.
Göppingen, DADA.
Gordian knot, DSSA.
Gordon, Adam, CEA/*234*①.
Gordon, John, C-5170/*180*①.
Gordon and Taitt, C-2478/*178*.
Goret, Abbeville, C-MARS/*183*①.
Goret, L., Paris, C-MARS/*211*.
Gorevan carpet, S-4461/*852*; S-4796/
153, 160.
Gorevan rug, DADA.
gorge, SDF.
gorge case, C-2368/*31*; LAR82/
*209*①; LAR83/*186*①; S-4802/
*150*①.
gorge de pigeon, CEA/*486*①; EG/
*169*①; LAR83/*439*①.
gorgelet, IDC; IDPF/*115*.
gorget, C-MARS/*92*; DADA.
gorget-plate, C-2503/*75*; C-2569/*55*.
gorget plate, S-4972/*166*①.
gorge type case, LAR83/*188*①.
gorgon foot, C-0225/*299*.
Gorgons, DSSA.
Gorgon's mask, LAR82/*90*①.
Gorham, C-0225/*99*; LAR83/*589*①;
S-4461/*26, 220*.
Gorham & Co, S-4905/*165*①.
Gorham Co., C-0270/*168*; OPGAC/
15; S-3311/*606*.
Gorham Corporation, DADA/
Supplement.
Gorham Foundry, C-5191/*192*.
Gorham Manufacturing Company,
C-5153/*1*①, 7.
Gorham silver, NYTBA/*230*.
Gosling, Richard, C-2487/*103*.

Gospel book, DATT.

Goss, LAR83/*107*①.

gossamer, C-2324/*298*.

Gosselin, Amiens, C-MARS/*144*.

goss model, C-1006/*60*.

Gostelowe, Jonathan, DADA; EA; SDF/*772*.

gotch, IDPF/*115*.

Gotha, DADA; EA.

Gothic, ACD; C-2402/*100*; C-5114/ *137*①; C-5116/*131*①; C-5153/ *126*①; CEA/*529, 624*①; DADA/ ①; DATT; IDPF/*8*; LAR82/ *214*①; NYTBA/*21*; S-4804/*901*①; S-4972/*69*①, *140*①.

Gothic, English, DADA/①.

Gothic, French, DADA/①.

Gothic, German, DADA.

Gothic, Italian, DADA.

Gothic, Spanish, DADA.

gothic-arcaded frieze, C-2388/*123*.

gothic arcading, S-4436/*52*①.

gothic arch, CEA/*498*①; S-4812/ *190*①; C-5114/*346*①; DADA; EC2/*90*.

Gothic arched panel, C-0254/*312*①.

Gothic arch form, CEA/*322*①.

gothic blind fret, S-4436/*49*①.

Gothic Bohemia, CEA/*451*.

Gothic buttress bracket, CEA/*345*①.

Gothic Chippendale, SDF/①.

Gothic clock, EA/*chamber clock, chamber clock*.

gothic column engaged borders, S-4436/*52*①.

Gothic floral style, EA.

Gothic foliage, IDC.

gothic fretwork, C-2478/*99*①.

Gothic furniture, SDF/①.

Gothick, C-0249/*321*①.

'gothick' ediface, S-4414/*367*.

Gothick taste, SDF/① *Gothic taste*.

Gothic lettering, RTA/*55*①.

Gothic painting, LP.

gothic-pattern, C-2388/*14*; C-2403/ *141*; C-2421/*18*①.

Gothic pattern baluster splat, LAR83/*269*①.

gothic point, C-1603/*120*.

Gothic revival, C-5153/*165*; EA; SDF.

Gothic Revival, English, DADA/ *Supplement*.

Gothic revival style, NYTBA/*22*①.

Gothic Ruin, CEA/*163*①.

Gothic script, C-2486/*214*①; NYTBA/*258*.

gothic shape, C-1603/*122*.

Gothic style, EA; IDC; RGS/*82*.

Gothic taste, C-2398/*92*; C-2510/ *58*①; DADA/①; SDF/①.

gothic tracery, C-2403/*33*①; C-5114/ *312*①; S-2882/*665*①.

Gothic wall clock, CEA/*220*①.

Gothik decoration, S-2882/*314*①.

Gothisches Dessin, MP/*486 Gothic design*.

Gotō period, JIWA/*181*.

Goto School fitting, C-5236/*1825*.

Gotō-yūjo school, JIWA/*182*.

Gotszkowsky erhabene Blumen, C-2493/*75*.

Gottlieb Christian, EA/*Drentwett family*.

Gotzkowski, J. E., CEA/*177*①.

Gotzkowsky erhabene Blumen, IDC/ ①.

Gotzkowsky pattern, EA; MP/*123*.

gouache, C-2421/*2*①; C-5156/*265*①; C-5239/*198*; DADA; DATT; EA; JIWA/*66*①; LP; RTA/*119*①; S-286/*393, 471*; S-4881/*377*.

Gouda Pottery, C-2409/*111*.

Gouers á Paris, EA/*Govaers, Daniel*.

gouge, DATT.

gouge carving, EA.

gouged-work decoration, NYTBA/
　25①.
gouge work, SDF.
Goujon, J., EA/*176*①.
Gould, Abel, C-5170/*34*①.
Gould, Christopher, SDF/*776*.
Gould, John, S-286/*42*.
Gouldsmith, Richard, SDF/*773*.
Goupy, Marcel, DADA/*Supplement*.
gourd, C-0225/*292, 321*; C-0254/*199*;
　C-1082/*10*; DSSA.
gourd and lobed shaped, LAR83/
　*128*①.
gourd body, LAR82/*142*①.
gourd cup, CEA/*638*①; EA.
gourd form, CEA/*493*①.
gourd-form base, S-2882/*1316*①.
Gourdin, Jean, S-4955/*163*①.
gourd jar, C-5127/*18*.
gourd pull, C-5156/*432*.
gourd shape, IDPF/*115*①.
gourd-shaped bottle, CEA/*141*①.
gourd-shaped spout, C-5156/*811*①.
goût grec, MP/*151*.
Gouthière, Pierre, C-2555/*26*①;
　DADA; EA/①; S-4955/*14*①,
　*192*①.
gout stool, ACD; C-5116/*76*;
　C-5157/*64*; EA; LAR82/*374*①;
　SDF/① *gouty stool*.
gouty chair, SDF.
gouty stool, DADA; SDF/①.
Gouyn, Charles, CEA/*187*.
Govaers, Daniel, EA.
Govares (Gouers), Daniel, C-5220/
　*56*①.
Governor Winthrop desk, DADA;
　NYTBA/*58*①.
Goya y Lucientes, Francisco José de,
　EA.
gozame ishime, DADA.
Graal, C-5191/*247*.
graal glass, DADA/*Supplement*.

Graal (Ariel) technique, EG/*226*.
grace-cup, IDC.
grace cup, CEA/*667*①; EA/①.
grace plate, IDC.
Graces, DSSA.
gradated colors, NYTBA/*300*.
gradation, DATT; JIWA/*262*; LP.
gradation in the glaze, NYTBA/*165*.
Grade, Louis, S-4947/*256*.
graded ink painting, JIWA/*159*.
graded pearls, RTA/*118*①.
gradin, DADA.
Gradl, Professor, CEA/*178*①.
graduated, C-2402/*35*; C-5005/*340*①.
graduated arc, C-5153/*80*①.
graduated bell, C-2489/*117*.
graduated depictions, C-5114/*196*①.
graduated drawer, C-0982/*26, 57*;
　C-1407/*9*; C-5114/*252*①; C-5116/
　108; C-5153/*185*①; K-802/*15*;
　S-4414/*438*①; S-4461/*587*.
graduated fringe, S-4414/*6*.
graduated long drawer, C-2388/*46*①.
graduated long drawers, C-5116/*120*.
graduated ring-turned neck, S-4414/
　279.
graduated shelf, S-4461/*666*①.
graduated sphere, C-0225/*347*.
graduated tier, C-2388/*56*; S-4414/
　199.
Graduate pattern, C-5167/*270*;
　C-5191/*469*.
graduating, C-2409/*246*①.
graduating canopy top, C-1407/*42*.
graduating dessert basket, S-4944/
　*245*①.
Graeco-Egyptian style, CEA/*659*①.
Graeco-Roman, DATT.
graffiato, DADA; IDC.
graffito, DATT; LP.
Grafton, London, S-4927/*51*.
Graham, C-2489/*221*.

Graham, Geo., London, C-2489/
107①, 183①.

Graham, George, ACD; CEA/254①;
DADA; EA; SDF/776.

Graham Pottery, Brooklyn, New
York, EC1/85.

grain, C-1407/114; CHGH/57;
DATT.

grain alcohol, DATT.

grained, C-2364/33; C-2388/77;
C-5157/79①.

Grainger, C-5189/12.

Grainger, Lee & Co., EA/①.

Grainger, Thomas, ACD; EA/
Grainger, Lee & Co..

Grainger & Co., C-2493/205.

GRAINGER LEE & CO.
WORCESTER, EA/Grainger, Lee
& Co..

Grainger's Worcester, LAR83/175①.

graining, ACD; C-5114/268①;
DADA; DATT; EA; NYTBA/32;
S-4461/486; SDF.

grain lac, DATT.

grain-of-rice, ACD.

grain of rice decoration, EA/
Gombroon ware.

grain of rice pattern, CEA/95.

grain-painted, K-710/111; S-4905/
476①.

grain painted ground, S-4905/376.

grain sack, C-2482/49.

grains d'orge, DADA.

grainy body, JIWA/355①.

grammalogue, JIWA/53.

Grammar, DSSA.

gramophone, SDF.

Gramophone & Typewritter Ltd., The,
C-2904/10.

granary jar, IDC; IDPF/115.

granary urn, DADA.

grande sonnerie, CEA/258①; EA/
striking systems; K-710/118;
LAR82/206①; S-4927/79①.

grande sonnerie carriage clock,
LAR83/186①.

grandfather chair, LAR83/283①;
SDF.

grandfather clock, ACD; C-1006/179;
EA/long-case clock, long-case
clock; EC2/89; LAR82/216①;
SDF.

grandfather's clock, DADA.

grand feu, CEA/147①, 148①;
DADA; EA; IDC.

Grand Feu Art Pottery, Los Angeles,
California, EC1/85.

grand feu color, MP/502.

grand feu colour, EA/
high-temperature.

gran-disegno, LP.

Grandjean, H., S-4927/205.

grandmother chair, LAR83/280①.

grandmother clock, ACD; C-1702/
262; EA/dwarf-tall clock; EC2/89;
SDF.

grandmother's clock, C-0225/363;
DADA.

Grandmother's Flower Garden, CEA/
292①.

Grandmother's flower garden design,
C-2704/71.

'grandmother's weave', OC/279.

grand piano, CEA/548; SDF/①.

grand piano-forte, C-1407/108.

grand plat ménage, IDC/①.

Grand Rapids Furniture, DADA/
Supplement.

grandsire clock, SDF.

grand sonnerie striking, ACD.

granite, C-0249/316; C-5146/130①;
DATT; S-4461/4; S-4972/625.

granite and antler mounted, LAR83/
586①.

granite plinth, C-5005/311①.

granite ware, DADA/Supplement;
EA; IDC.

Granja de San Ildefonso, La, EA/①.

granular surface, JIWA/*310*.

granulated, RGS/*140*①.

granulated gilt ground, RGS/*61*①.

granulated ground, RGS/*92*①.

granulated ornament, EA/*Bonsach, Baard Gandolphi*.

granulation, CEA/*524*; EA; RTA/ *13*①; S-291/*154*.

grape, DSSA.

grape and cable, OPGAC/*181*.

grape and festoon, OPGAC/*221*.

grape and Gothic arch, OPGAC/*182*.

grape and leaf meander, C-2458/*220*.

grape band, OPGAC/*221*.

grape black, DATT.

grape cluster finial, C-5005/*225*①.

grape cup, IDPF/*116*.

grapefruit spoon, C-0254/*233, 248*; C-5114/*16*; S-4804/*82*.

grape leaf pattern, C-0225/*307*.

grapen, IDPF/*116*.

grape pattern, CEA/*207*①.

grape-scissor, C-5117/*121*①.

grape scissor, C-0103/*216*; C-0706/ *73*; C-1502/*71*; EA/①; LAR83/ *581*①; S-3311/*661*; S-4944/*182*.

grape shear, C-0254/*113*; C-5114/*22*; S-4461/*288*; S-4804/*195*①.

grapevine border, C-0254/*18, 25*.

grapevine decoration, S-4804/*27*①.

grapevine device, CEA/*399*①.

grapevine rim, S-4944/*125*.

grape with thumbprint, OPGAC/*222*.

graphic art, JIWA/*14*.

graphic artist, JIWA/*9*.

graphic arts, DATT.

graphic granite, DATT.

graphics, DATT.

graphic technique, JIWA/*11, 61*.

graphic work, NYTBA/*208*.

graphite, DATT.

graphite composition, S-286/*309*.

graphite paper, DATT.

graphite pencil, JIWA/*53*.

graphometer, C-2489/*18*; C-2608/ *119*; CEA/*604*①; S-4802/*161*①.

graph paper, S-286/*170*.

Grass, H., C-5174/*90*①.

Grasset, Eugène, DADA/*Supplement*.

grasshopper, OPGAC/*222*.

grasshopper brush stroke, JIWA/*89*.

grasshopper escapement, EA.

Grassi, Anton, EA.

grasswork, C-2493/*246*; IDC.

grasswork base, C-2486/*150*.

grassy path, C-2704/*2*.

Gratchev, C-5174/*239*①.

Gratchev, Bros., C-5117/*312*①.

grate, ACD; SDF/①.

grater, DATT.

graticulation, DATT.

Gravant, François, EA.

Gravant, Louis François, CEA/*183*①.

graver, DATT/①; EA.

Graves, Samuel, CEA/*591*①.

grave-slab, IDC.

graveyard carpet, EA.

graviata, C-2458/*156*; LAR82/*111*①.

graviata ground, C-2513/*182*.

gravicembalo col piano e forte, EA/ *pianoforte*.

gravity clock, EA.

gravure, DATT.

gravy boat, C-5114/*3*; C-5127/*255*①.

gravy-boat, C-2204/*1*; EA/*sauce-boat, sauce-boat*.

gravy ladle, C-5114/*76*; S-4804/*81*①.

gravy spoon, S-4922/*34*①.

gravy-spoon, C-2398/*14*; C-5117/*34, 270*①.

gravy warmer, EA/*argyle, argyle*.

Gray, George, C-5117/*224*①; S-4944/*42*.

gray agate, C-5117/*387*①; S-4810/*122*①.

gray and black serpentine, S-4810/*112*①.

gray and white marble, C-5157/*171*①.

gray-green, S-288/*9*①.

gray-green glaze, EC2/*23*①.

gray pottery, C-5156/*6*.

gray schist, C-5234/*186*.

Gray's Pottery, C-2409/*63*.

gray-veined, S-3311/*215*①, *455*.

Gray & Vulliamy, C-2368/*74*①.

grayware, S-4807/*15*.

Graz, G. Jenko, C-GUST/*102*①.

grease-blue, EG/*187*.

grease crayon, DATT.

greased wad, CEA/*35*.

grease pan, S-4972/*332*①.

greasepan, EA.

grease pencil, DATT.

grease-spot pattern, IDC.

Greatbach, Daniel, CEA/*168*①.

Greatbatch, S-4843/*140*①.

Greatbatch, (Greatbach) William, EA/①.

Great Cascade, MP/*447*.

great chair, SDF.

Greater Silla Period, C-5156/*235*.

greave, CEA/*20*①, *44*; DADA.

Grecian chair, DADA/①.

Grecian couch, DADA/①.

Grecian furniture, DADA; SDF.

Grecian purple, DATT.

Grecian sofa, DADA; FFDAB/*39*①.

Grecian squab, SDF.

Grecian style, C-3011/*10*.

Greco-Roman, DATT.

Greco-Roman motif, NYTBA/*34*.

Greek, CEA/*509*.

Greek A, The, EA/*De Grieksche A.*

Greek art, DATT.

Greek A The, CEA/*142*①.

Greek Corinthian, IDPF/*9*①.

Greek cross, DATT; RTA/*45*①.

Greek curve border, IDC.

'Greek cut', RGS/*68*.

Greek foot, IDPF/*101*.

Greek form, IDPF/*116*.

Greek fret, CEA/*307*①; DADA; DATT; EA/*key pattern, key pattern*; FFDAB/*125*; SDF.

Greek fret border, IDC.

Greek inscriptions, C-1506/*117*.

Greek key, C-5114/*41*; DATT; S-4436/*100*①; S-4461/*28*; S-4905/*107*①; SDF; C-1502/*183*.

Greek key border, C-5114/*38*①.

Greek key decoration, CEA/*337*①.

Greek key pattern, C-0279/*413*.

Greek key-patterned, S-4905/*118*①.

Greek lace, DADA.

Greek meander band, C-5127/*265*.

Greek numerals, C-2513/*89A*①.

Greek painting, LP.

Greek pitch, DATT.

Greek pottery, DATT.

Greek revival, DADA; SDF/①; C-5153/*167*; CEA/*316*①.

Greek Revival taste, S-4804/*4*.

Greek scroll, C-5156/*107*.

Greek taste, MP/*151*.

Greek vase, IDC.

Greek wave pattern, IDC.

green, CEA/*70*, *417*①; IDC.

Green, Guy, EA/①.

Green, H., C-2487/*83*.

Green, Henry, C-5174/*587*.

Green, Richard, C-5117/*93*.

Green, Romney, SDF/*751*.

Green, Wm., Apenrade, C-MARS/*222*.

green and purple ware, EA.

Greenaway, Henry, CEA/*655*①.

green bice, DATT.
green bowenite, C-1082/*171*.
green card dial, C-2904/*143*.
green Chün ware, EA.
Greene, Henry, CEA/*644*①.
Greene, Richard, C-5173/*42*①.
green earth, DATT; LP.
green ebony, SDF.
Greener-style, C-2476/*55*.
Greene's patent Rifle, C-2503/*106*.
green glass, C-1006/*139*; C-1082/
155; DADA.
green-glazed, CEA/*111*.
green glazed ware, IDC/①.
green-ground, LAR83/*155*①.
green jade, C-5127/*208*.
green jadeite, S-4810/*168*①.
green jasper, S-4955/*192*①.
green Kutani, IDC.
green marble, C-5005/*336*①; DATT.
Green Meadow service, C-2493/*12*①.
Greenough, N. C., C-5174/*404*.
green pigments, DATT.
greenpoint, DADA/*Supplement*.
Greenpoint Glass Works, CEA/
*471*①.
green rouge, DATT.
green smalt, DATT.
green-stained, C-2202/*54*.
green-stained ivory, C-5116/*110*.
greenstone, DATT.
green tourmaline, RTA/*162*①.
green verditer, DATT.
Green & Ward, London, C-2503/
*30*①.
green ware, IDC.
greenware, DATT; EC1/*83*.
green Watteau service, EA.
Greenway, Henry, C-5117/*228*①;
CEA/*641*①; S-4944/*340*.
green wineglass, CEA/*423*①.
Greenwood, Frans, EA.

Greenwood, Franz, CEA/*444*①.
Grégoire, Jean-Louis, C-5189/*160*①.
Gregorian calendar, CEA/*606*①.
Gregorian reflecting telescope,
C-1609/*101*; CEA/*602*①.
Gregory, Andrew, S-4944/*406*①.
Gregory, Mary, CEA/*54*①; DADA/
Supplement; NYTBA/*312*;
OPGAC/*170*.
Greiner family, EA; MP/*164*.
Greiner trefoil, EA/*Limbach*.
Gremigni, L., C-5181/*85*.
grenade, EA/*décor coréen*.
Grenadier's helmet, C-MARS/*95*.
grenadilla, C-5255/*7*; DATT.
grenadilla, South American, DATT.
Grendey, Giles, C-2478/*171*①;
C-2522/*181*①; C-5170/*188*①;
DADA; EA.
Grenoble wood, SDF.
Grenzhausen, DADA.
grès, DADA; EA/*stoneware*; IDC.
Grés, OPGAC/*156*.
gresaille, SDF.
grès d'Angleterre, IDC.
grès de Beauvais, IDC.
grès de Flandre, DADA.
grès de Flandres, EA/*Rhineland
stoneware*; IDC.
grès de Savignies, IDC.
Gresley, C., C-2493/*171*.
Grevenich, N., C-2555/*63*①.
Grévin, A., C-5191/*140*.
greybeard, DADA/①; EA/
bellarmine; IDC; IDPF/*116*.
greybeard jug, EA/*bellarmine*.
Greybeards, IDPF/*20*.
grey marble, C-2403/*142*.
grey mica background, JIWA/*67*①.
grey oriental pearl, RTA/*152*①.
grey ware, EA.
greywood, SDF.

Gribelin, Simon, CEA/*63*①; EA.

Gricci, Giuseppe, CEA/*171*①.

Gricci, Giuseppe (José), EA.

Grice, William, CEA/*30*①.

grid, JIWA/*206*.

gridiron, DSSA/①.

gridiron pendulum, CEA/*227*①, *240*①; EA/*compensation*.

gridiron system, CEA/*228*①.

Griebel, Strasbourg, S-4927/*38*①.

Griffen, Smith and Hill, DADA/ *Supplement*.

griffin, C-5173/*66*①; DSSA; IDC; SDF/①.

Griffin, London, C-2503/*214*①.

griffin figures, S-4804/*137*①.

Griffin & Howe, C-2476/*5*.

griffin monopodia, C-5116/*169*①.

griffin termes, S-4804/*105*.

griffon, DADA; EA/① *animal clock*.

griffon mask, C-2437/*38*①.

Griffon pattern, LAR82/*443*①.

grill, C-0706/*69*; C-5117/*25*①.

grille, C-2402/*223*; C-2403/*150*①; C-5157/*34*①; JIWA/*71, 206*①; SDF.

grille door, C-1407/*179*; C-2402/*197*.

grille motif, JIWA/*233*①.

grille pattern, JIWA/*6*.

Grilley, Henry, Samuel, and Silas, EA.

grill work, S-4436/*154*①.

grillwork, S-2882/*358*①; S-4812/ *185*①.

grinder, C-0254/*171*①.

grinding, EG/*89*; IDC.

grinding of paints, DATT.

grinding technique, JIWA/*327*.

griotte, DATT.

griotte d'Italie marble, DADA.

griotte marble, C-2364/*10*①.

griotte St. Rémy marble, DADA.

grip, C-5114/*61, 231*; CEA/*22*①; IDPF/*120*; S-4972/*163*①, *218*①.

grip handle, C-5117/*272*①; S-4972/ *248*①.

grisaille, ACD; C-0249/*234*; C-2458/ *143*; C-5127/*232*①; CEA/*406*; DADA; DATT; LAR83/*242*①; LP; MP/*502*; RGS/*39, 145*①; S-2882/*413*; S-4810/*310*①; S-4812/*104*; S-4972/*38*①; SDF; CEA/*357*①.

grisaille, en, IDC.

grisaille cup, C-5236/*1600*.

grisaille-edged, S-4905/*12*①.

grisaille roundel, C-2403/*29*①.

Grisailles, NYTBA/*236*.

gris d'Angleterre, IDC.

grit, C-5127/*53*①.

grivennik, RGS/*84*.

G. R. jug, IDC.

Gröden carver, CEA/*684*.

grog, DATT; IDC.

grog lifter, DADA.

grog table, SDF.

Grollier de Servière, Nicolas, EA.

Gromaire, Marcel, S-286/*46*.

Groneberg, A.E., C-5153/*20*.

Gronquist, Johan, C-5117/*167*.

Gronsveldt-Diepenbroil, Count van, CEA/*181*①.

groove, C-2458/*3*; OC/*180*; SDF.

grooved, C-5005/*320*①; C-5127/*75*; C-5236/*542*.

grooved feet, C-5005/*322*①.

grooved loop handle, C-2360/*131*①.

grooved top, C-5127/*350*.

groove rifling, S-4972/*272*.

Gropius, Walter Adolf George, DADA/*Supplement*.

Gropper, William, S-286/*47*.

gros, C-2704/*24*.

gros-bleu, C-2493/*50*.

gros bleu, C-2546/*16*; DADA; EA; IDC.

grosgrain, C-0604/*227*.

Grosjean & Woodward, C-5153/*14*①.

gros-point, C-2402/*62, 142*; C-2704/*11*.

gros point, C-2437/*37*; C-2498/*85*; CEA/*274*①; DADA; LAR82/*306*①; S-4972/*469*; SDF.

gros point de Venise, DADA; LAR83/*233*①.

gros point needlework, C-2421/*47*.

grosse indianische Bluhmen, MP/*131*.

gross needlepoint, C-5189/*265*①.

Grosz, George, S-286/*274*①.

Groszbreitenbach, DADA.

Groszbreitenbach porcelain factory, EA.

Grotell, Maija, DADA/*Supplement*.

groteschi, CEA/*209*.

grotesco, CEA/*135*①; DATT.

grotesque, C-5116/*121*①; CEA/*134*①; DADA/①; DATT; EA; IDC/①; LAR83/*127*①; S-3311/*303*①; SDF.

grotesque beast, C-0706/*216*.

grotesque bird, C-0706/*161*.

grotesque border, C-2437/*3*①.

grotesque mask, C-0279/*218*.

grotesque mask and shell foot, C-5174/*504*①.

grotesque mask feet, S-4804/*101*①.

grotesque mask handle, S-4461/*102*.

grotesque mask thumbpiece, C-2398/*93*①.

grotesque Punches, IDC.

grotesque vase, MP/*120*.

Groth, Albret, EA.

grottesche, C-2437/*68*①.

grotteschi, C-2486/*217*①.

grotto, IDC/①.

grotto candlestick group, LAR83/*68*①.

grotto group, MP/*478*①.

Grotto hall armchair, C-5116/*139*①.

grotto vase, MP/*36*.

ground, C-0782/*5, 25*; C-2202/*27*; C-2458/*1*; C-5005/*218*①; C-5116/*24, 50*①; C-5220/*46*①; CEA/*415, 502*; DADA; DATT; EG/*289*; IDC; LP/①; S-4992/*4*①.

ground cartouche, S-4461/*420*.

ground color, MP/*141*.

ground colour, EA/*bleu céleste*.

ground dish, C-2427/*251*①.

ground font, CEA/*464*①.

ground gold, EA/*ormolu*.

ground-hog kiln, CEA/*167*①.

ground-laying, IDC.

ground line, LP/①.

ground mat, C-5127/*353*.

ground of flowers, C-0782/*11*.

ground plane, LP/①.

ground-shade, OC/*189*.

group, C-2458/*303*; C-5156/*90*①; DATT; IDC; S-4992/*2*①.

group exhibition, LP.

Group II sword, C-2503/*29*①.

Group of Lawyers, MP/*115*.

grouse, C-1603/*121*.

grout, DATT.

Grove, Rich., London, C-2489/*167*.

growing shape, EA/*crane's-neck bottle*.

Grubbe plates, IDC.

Gruber, OPGAC/*14*.

Gruber, Jacques, C-5005/*321*①; DADA/*Supplement*.

Grudchos & Eggers, S-4881/*307*①.

Grue, Aurelio, C-2486/*232*①.

Grue, Carlo Antonio, C-2486/*234*①; CEA/*136*①; EA.

Grueby, CEA/*165*; EC1/*84*①; OPGAC/*346*.

Grueby, William H., DADA/*Supplement*.

Grueby-Faience Company, EC1/75①.

Grueby Faïence Company, DADA/
Supplement.

Grueby Pottery, Boston,
Massachusetts, EC1/85.

Grue family: Francesco, Francesco
Antonio, Anastasio, Aurello,
Liberio (Liborio), Saverio, EA.

Gruen, C-5167/145.

Gruen Watch Co., C-5117/438①.

Grue workshop, C-2486/222①,
237①.

Grundy, William, S-4922/54①;
S-4944/368①.

Grust, Theodor, MP/199.

gryphon, SDF/① griffin.

gryphons, C-1506/54①.

gryphon's claw, C-5174/432①.

gryphon's egg, EA/ostrich-egg cup.

GS, EA/345.

G. Santi Fils, C-2904/215.

gu, C-2414/10①; C-5127/107;
S-4965/114①.

guadamací, DADA.

guaiac wood, DADA.

guan, C-5156/76①; C-5236/1774①.

Guandi, C-2458/133; S-4810/278.

guang, S-4963/12①.

Guangdong, C-5236/1620.

Guangming, S-4965/308.

Guangxu, C-2323/59; C-2458/118①,
160①, 205; C-5156/171; LAR82/
132①; LAR83/109①.

guan shape, S-4963/86①.

Guanyao, C-5156/75①.

Guanyao dish, K-711/125.

Guanyao tradition, C-2323/113.

guanyin, C-5127/148; C-5259/43;
C-2458/242; S-4810/255①.

Guanyin Buddhistic figure, C-2458/
53①.

guanyin group, C-5127/96①; S-4461/
429.

Guanyin groups, S-4461/538.

guarantee mark, C-5174/594.

guarantee of authenticity, CHGH/7.

guard, -288/20①; C-2569/42①;
CEA/22①; OC/42, 264; S-288/
3①.

guard (in fan), SEA.

guard border, C-5323/9①.

guard borders, S-3311/9; S-4414/536.

guard box, C-2368/84.

guard chain, C-5117/471①; LAR83/
455①.

guardian, S-4965/102①.

guardian figure, S-3312/1069①.

guard-ring, RTA/96.

guard ring, S-4414/7.

guard room table, DADA.

guardstick, C-1603/1.

guard stripe, C-0906/75; EA.

Guarneri family, EA.

Guarnerio, Pietro, C-5189/177.

Guarra wove paper, S-286/396A.

Guarro paper, S-286/343, 344.

gubbio, CEA/135①; DADA; ACD;
EA.

Gubbio lustre, CEA/164①; IDC.

Gubbio style, C-1006/10.

Gübelin, C-5117/470①.

guelder-rose vase, IDC.

guelder rose vase, DADA.

guendje rug, DADA.

Guenin Brodeur, C-0405/203.

Guentbach, Daniel, NYTBA/154①.

Guerhard porcelain, NYTBA/172.

gueridon, C-0249/426.

guéridon, C-2364/53①.

gueridon, C-5005/320①; C-5259/480.

guéridon, CEA/375①; DADA; EA.

gueridon, LAR82/400①; LAR83/
378①.

guéridon, LP.

gueridon, S-2882/787①, *839*①;
 S-3311/*535*①; S-4804/*778.*

guéridon, S-4853/*417*; S-4972/*654*①;
 SDF; IDC.

Guéridon, also Guéridon table, ACD.

guéridon-table, SDF/*guéridon.*

guéridon table, EA.

Guerin, Eloi, CEA/*631*①.

Guérin, Jean-Urbain, EA.

guérite, DADA/①.

guernsey, DADA.

Guerpal, A., C-5191/*128.*

Guerrero, S-4807/*187*①.

gueuse, DADA.

gu-form, S-4810/*308*①.

gu form, C-5156/*54*①; LAR83/
 *118*①.

gui, C-2414/*6*①, *13*①; C-5156/
 *450*①; C-5236/*336A*; S-4965/
 *115*①.

gui bi, C-5236/*1684.*

guide, printmaker's, DATT.

guideline, C-5236/*377*①.

**Guidobono, Gian Antonio (Giovanni),
 Bartolommeo, Domenico,** EA.

guienne, DADA.

Guignet's green, DATT; LP.

guild, CEA/*579.*

Guild and School of Handicraft,
 DADA/*Supplement.*

guild cup, EA/①.

guild flagon, EA.

Guild of Handicrafts, C-2409/*196.*

Guild of Handicrafts Ltd., LAR83/
 *581*①.

Guild of Saint Luke, EA.

guild system, CEA/*619.*

Guillaume, Albert, S-286/*276*①.

Guillaume, Martin, CEA/*632*①.

Guillaumin, S-286/*452.*

Guillibaud, Jean-Baptiste, EA.

guillochage, RGS/*40.*

guilloche, ACD; C-0249/*301*①, *353*;
 C-0982/*64.*

guilloché, C-2332/*63*; C-2357/*35*①.

guilloche, C-2398/*6*; C-2402/*261*;
 C-2409/*226.*

guilloché, C-2437/*70*①.

guilloche, C-2910/*234*; C-5005/
 *207*①; C-5116/*105*; C-5181/*177*;
 C-5259/*553*; CEA/*466*①; DADA/
 ①; DATT/①.

guilloché, EA/*guilloche.*

guilloche, EA/①.

guilloché, RGS/*40.*

guilloche, S-3311/*677*; S-4972/*519*;
 S-4988/*430*①; SDF/①.

guilloche band, S-2882/*1027*①.

guilloche border, IDC; S-2882/*986.*

guilloche decoration, LAR82/*52*①.

guilloché enamel, C-2368/*129*;
 C-5117/*330*①; RGS/*62*; S-291/
 *156*①.

guilloché frieze, C-2357/*1*①.

guilloché inlaid frieze, C-0279/*441.*

Guimard, Hector, DADA/
 Supplement; NYTBA/*78.*

Guinand, C. L., C-5117/*434*①.

Guinand, P. L., CEA/*602*①.

guinea hole, EA/*money dish*; S-3311/
 271.

guinea pit, SDF.

guinea scale, C-0403/*88.*

guinea token, C-1702/*96.*

guinea well, S-2882/*305.*

guipure, DADA.

guipure de Flandre, DADA.

Guiramand, Paul, S-286/*432.*

guirlandes, IDC.

guitar, CEA/*552*①, *552*①; EA/①.

guitar, Altamira, CEA/*552*①.

guitar, Vihuela, CEA/*552*①.

guitarra latina, (gittern), EA/*guitar.*

gui vessel, C-2458/*241*①.

gyobu nashiji, S-4829/*70*①; S-4928/
*140*①.
Gyoki ware, IDC.
Gyoko, LAR83/*43*①.

gypsum, DATT; LP.
gypsum plaster, DATT.

H

Haagae clock, C-2489/*84*①.

Haar, Jacob, CEA/*478*①.

Haarlem blue, DATT.

Haarlem school, DATT.

Habaku style, C-5156/*864*①.

habaner ware, DADA; ACD; EA; IDC.

Habermeier, Konrad, DADA/*Supplement*.

Habermel, Erasmus, EA.

habillé, RTA/*109*①.

habitat button, EA.

haboko picture, JIWA/*387*.

Habrecht, Isaac, EA/①.

Hache, J. F., NYTBA/*42*①.

Hachiroemon Kutani, IDC.

hachure, DATT.

Hacilar pottery, IDC/①.

hackbut, C-MARS/*127*①.

hacked cylinder, IDPF/*143*①.

Hackefors, C-2910/*100*.

Hackett, Simon, CEA/*252*①.

Hackle, William, CEA/*674*①.

hack-saw frame, CEA/*539*①.

Hackwood, William, EA; S-4843/*461*①.

Haddock, Bath, C-2489/*68*.

Haddock, Lincoln & Foss, S-4905/*168*①.

Haddou, Newcastle, C-2503/*183*.

Hades, DSSA.

hadith, OC/*136, 156*.

Hadley, Henry, London, C-2503/*206*①.

Hadley chest, C-5114/*401*①; DADA/①; EA/①.

Hadley type, NYTBA/*31*①.

Hadley ware, IDC.

haematite, C-2482/*88*.

Haffner-ware, C-2427/*191*.

Hafner, DADA; EA.

hafner-ware, NYTBA/*135*.

hafner ware, DATT; ACD; IDC/①.

Hafnerware, CEA/*136*①; EA.

haft, C-5156/*387*.

Haft Bolah, OC/*139*.

Haft Bolah Beluch, OC/*140*①.

'haft [seven] mihrab', OC/*140*.

Hagae, C-MARS/*166*.

Hagae, Pieter Visbagh, C-2489/*84*①.

Hagenauer, LAR83/*42*①.

Hagi-Yaki, DADA.

Hague, DADA.

Hague, The, ACD; DADA.

Haguenau, DADA.

Hahn, K., CEA/69①.

Hahn, Karl, C-5174/322①.

Haida, CEA/451.

Haida glass, JIWA/118①.

Haig, Thomas, CEA/343①; DADA; EA/Chippendale, Thomas the Elder; SDF/751.

Haile, Thomas Samuel, DADA/Supplement.

haines, C-1702/148.

Haines, Ephraim, CEA/389; EA.

Hains, Adam, DADA.

hair, DSSA.

hair brush, C-0254/140, 242; C-0706/5, 33.

hairbrush, C-1502/7.

hair clip brooch, S-291/145①.

haircloth, FFDAB/33.

hair crack, C-5127/33; S-4853/49①; S-4905/50①.

hair crystal, S-4810/144①.

hair-embroidery, RTA/124①.

hair-grip, JIWA/188.

hair jewellery, EA.

hairline, C-5239/3.

hairline crack, C-5117/374①; C-5127/48①.

hair mounted, CEA/521①.

hair ornament, C-5156/351①; C-5236/392①.

hair picture, S-4461/378.

hairpin, C-5236/1811; JIWA/188.

hair-pipe, S-4807/236.

hair-slide, C-2910/210.

hair spring, EA.

hairspring, C-5117/453①; CEA/217, 252①.

hairspring with overcoil, C-5117/455①.

hair tidy, C-1502/57.

hair trigger, S-4972/272.

hairwork, C-2203/189; C-2704/6; C-3011/138; S-4928/9①.

hairy claw foot, S-2882/726①.

hairy-hoof foot, C-2364/40①.

hairy paw foot, C-5114/52①; S-4436/101①.

hairy-paw foot, C-2403/112; NYTBA/58.

hairy paw support, S-4804/3.

hairy-paw support, C-2357/31①.

hai shou, IDC.

Haji(ki) ware, IDC.

Hajiyalil, S-4847/253①; S-4948/77.

hake, ACD/pothanger.

hakeme, EA/Punch 'ŏng ware; IDC.

Hakhong-ri, CEA/129①.

hako, S-4928/148①.

hako netsuke, C-1082/137.

hakozan cake dish, C-5127/383.

halation, EG/48; LP/①.

halberd, C-2503/16; C-MARS/59; DADA; DSSA; S-4972/144①.

halberd blade, C-5127/145.

halberd cap, C-5156/174.

halb-Fayence, EA; IDC.

Halcyon Art Pottery, Halcyon, California, EC1/85.

Hald, Edward, C-2409/15; DADA/Supplement.

Halden, C-2904/164.

haldu, SDF.

Hale, Nathan, EA/227①.

Hale, Owen, C-5189/22①.

Hales, Stephen, EA.

Haley, John, London, C-2489/195.

half armour, S-4972/151①.

half-baluster, NYTBA/34.

half-blind dovetail, SDF.

half-bound, C-5156/441.

half bun feet, S-4922/71①.

Half-Bushel, C-2904/37.

half-chalk ground, DATT.

half clock, EA/*Massachusetts shelf clock, Massachusetts shelf clock.*

half cock, CEA/*31*①.

half-crown coin, C-2904/*1.*

half door, C-0225/*375.*

half flowerhead, C-5127/*86*①.

Half-Gallon, C-2904/*37.*

half-headed bedstead, SDF.

half-hunter watch, EA.

half hunter watch, LAR83/*217*①.

half-hunting case, S-4802/*40*①.

half hunting cased, LAR83/*216*①.

half length, DATT.

half-length, C-5156/*282*①; C-5236/*1024*①.

half-length portrait, C-5156/*912.*

half-model, S-4881/*144*①.

half-moon diamond, S-291/*228*①.

half octagon, S-4972/*269*①.

half-octagon, C-0249/*365.*

half-palmette, IDC.

half-patera, C-5157/*45.*

half-pearl, S-4414/*156.*

Halfpenny, W. and J., DADA.

half-pike, DADA.

Half Pint, C-2904/*37.*

half pint mug, C-0706/*164.*

half plate movement, C-5117/*434.*

half-plate movement, S-4927/*102.*

half quarter, CEA/*254*①.

half-quarter repeater, EA.

half quarter repeating duplex watch, S-4802/*18.*

half relief, S-4972/*77*①.

half-relief, DADA; DATT.

half-ring pattern, C-5156/*159.*

half rosette, C-2402/*195.*

half round, S-4972/*269*①.

half-round, S-4905/*369*①.

half-round stile, NYTBA/*47.*

half-ship model, S-3311/*180.*

half-stock, C-2569/*57, 59*①.

half-tester, EA.

half-tester bed, K-710/*111.*

half-tester bedstead, SDF.

half tint, LP.

half-title, S-4881/*41*①.

half tone, LP.

halftone, DATT.

half-tone engraving, JIWA/*198*①.

half-tone screen, JIWA/*53.*

half uncial, DATT.

hali, DADA.

Halifax, John of Bransley, EA/*40*①.

Hall, CEA/*233*①.

Hall, Ann, C-2704/*8.*

Hall, John, DADA/*Supplement*; SDF/*773.*

Hall, John H., CEA/*37.*

Hall, John Hancock, CEA/*39*①.

Hall, Peter, SDF/*773.*

Hall, Peter Adolph, EA.

Hall, Thomas, EC2/*91.*

hallah cover, C-5174/*8.*

hallah plate with knife, C-5174/*40*①.

hall and parlor cupboard, DADA/①.

hall armchair, C-5157/*167*①.

Hallbach, CEA/*692*①.

hall bench, EA/*hall seat.*

Hall breech-loading rifle, CEA/*39*①.

Hall Bros., C-2904/*49.*

hall chair, ACD; C-0249/*322*; C-2403/*46*; DADA/①; EA/①; SDF/①.

hallchair, S-4988/*546*①.

hall clock, EA.

hall cupboard, SDF.

Halleicher, Johann Oth, EA/*25*①.

Hallet, James, Junior, SDF/*773.*

Hallet (Hallet), William, EA.

Hallett, William, DADA; SDF/*752.*

Hallifax, John, CEA/*261*①.

Hall-in-the-Tyrol, EA.

hall lantern, S-4461/*541*.

hall-mark, ACD; CEA/*590, 619*.

hallmark, C-0254/*107*; C-0706/*69*; C-0906/*379*; C-2458/*140*; C-5005/ *229*; C-5117/*429*①; DATT; EA; S-3311/*626*.

hall-mark, English provinces, DADA.

hall-mark, glass, DADA.

hall-mark, Irish, DADA.

hall-mark, London, DADA/①.

hall-mark, Scottish, DADA.

hallmarked, C-5117/*449*; C-5173/ *58*①.

hallmarking, EA.

hallmarking system, EA/*Russian gold and silver*.

Halloren glass, EA.

hall porter's chair, C-2498/*68*.

hall seat, EA/① *bench*; SDF.

hall settee, DADA.

Hall's rifle, C-2503/*147*.

hall stand, C-2402/*79*.

hall (hat) stand, EA.

hall stand, SDF.

Hallsworth, Henry, CEA/*656*①.

hall table book, SDF.

Halm Art Pottery, Sandy Hill, New York, EC1/*85*.

halo, DATT; DSSA.

Halsy, James, CEA/*605*①.

halter-neck, C-3011/*18*.

Halvd, Edward, C-5191/*247*.

halved compass-medallion, C-2403/ *148*①.

Halvei Bidjar Kelei carpet, S-4796/ *215*.

halvei bidjar rug, S-4948/*84*①.

halving, SDF/①.

Hamada, Shoji, DADA/*Supplement*.

Hamada, Shōji, JIWA/*352*.

Hamadan, C-0906/*8*; C-2320/*152*; C-2388/*190*; C-2478/*246*; OC/ *64*①; S-4847/*206*.

Hamadan carpet, EA.

Hamadan long rug, S-3311/*7*①.

Hamadan rug, ACD; C-0906/*6*; C-1702/*3*; DADA; S-4461/*757*.

Hamadan runner, C-2482/*3*; S-3311/ *23*①; S-4461/*765*.

Hamadan Town, OC/*320*①.

Hamanda, Shōji, JIWA/*18*.

Hamburg Faience factory, EA.

Hamer, I. H., CEA/*66*①.

Hamilton, C-0270/*118*; OPGAC/ *222*①; S-4804/*5*.

Hamilton, John, C-5174/*568*; CEA/ *650*①.

Hamilton, William, CEA/*56*①.

Hamilton and Inches, Edinburgh, C-2487/*60*.

Hamilton & Co, C-0706/*129*.

Hamilton & Inches, C-0406/*33*.

Hamilton with leaf, OPGAC/*222*.

Hamlet, William, EA.

Hamlin, Samuel, CEA/*592*①.

hammer, C-2476/*2*; DSSA.

Hammer, Marius, LAR82/*248*①.

hammer arbor, CEA/*223*①.

hammered, C-0254/*279*; C-0982/*228*; C-2202/*166*; C-5239/*104*; DADA; MP/*35*.

hammered band, C-5146/*122*①.

hammered brass, S-2882/*1439*①.

hammered copper, C-2409/*235*.

hammered flute, LAR83/*452*①.

hammered ornamentation, CEA/ *583*①.

hammered silver, C-0706/*5*; S-4461/ *225*.

hammered surface, C-5114/*228*; S-3311/*663*.

hammered texture, C-5167/*287*①.

hammer finish, C-5174/*33*.

hammer-head thumbpiece, EA.

hammering, CEA/*528*.

hammering brass sheet, NYTBA/*258*.

hammering mark, NYTBA/*216*.

hammerless, C-2476/*1*.

hammerman, CEA/*541*.

hammer-marked surface, C-5114/*30*①.

hammer pivot, C-5117/*412*①, *424*①.

Hammersley, C-2204/*116*.

Hammersley, Thomas, S-4905/*225*①.

Hammersly, Thomas, CEA/*665*①.

hammock, SDF.

hammock chair, SDF/*hammock*.

Hammond, London, C-2489/*12*.

Hammond No. 12 typewriter, C-0403/*7*.

Hamond, Edmund, CEA/*640*①.

ham pan, IDPF/*116, 197*①.

Hampden Watch Co., S-4927/*102*.

Hampshire, OPGAC/*346*.

Hampshire Pottery, DADA/*Supplement*.

Hampshire Pottery, Keene, New Hampshire, EC1/*85*.

Hampsphire, C-5239/*1*.

Hampston, J., C-5174/*526*①.

Hampston and Prince, C-5117/*53*.

Hampton Court pattern, C-0254/*213*.

han, DADA; S-4461/*154*.

hanakago-de, IDC.

hanap, ACD; DADA/①; EA; IDC.

hanau, C-2486/*201*①; ACD; C-2427/*183*; DADA; LAR82/*130*①.

Hanau faience factory, EA.

Han Chinese pot, IDPF/*35*①.

Hancock, Joseph, EA.

Hancock, Robert, CEA/*191*①, *195*①; EA.

Hancock engraving, IDC/①.

hand, DSSA; OPGAC/*222*.

hand-and-a-half sword, C-2569/*12*.

hand and a half sword, CEA/*20*①.

hand-and-cup vase, ACD.

hand and cup vase, IDC.

hand-and-stand camera, C-1609/*139*①.

hand basin, C-0982/*129A*.

hand-bell, EA/*table bell*.

hand bell, LAR82/*50*①.

handbell, C-0906/*296*.

hand block printing, DADA.

hand-blown, CEA/*502*.

hand-blown glass, DADA.

hand-candlestick, IDC.

hand carved, C-0982/*207*.

hand-chased, C-5114/*6*.

hand-coil, C-5191/*3*.

hand-colored, NYTBA/*200*; S-2882/*644A*.

hand colored, S-286/*368B*.

hand-colored engraving, S-286/*65*.

hand-colored engraving and aquatint, S-286/*178*.

hand colored etching, S-286/*260, 380*.

hand-colored lithograph, S-286/*42*.

hand coloring, C-0249/*27*; DATT.

hand-coloured, C-1603/*7*.

handcooler, ACD; CEA/*502*.

hand-crafted, C-5005/*234*①.

hand-crank, C-2904/*280*①.

hand-cranked cine camera, C-1609/*147*.

hand-detachable lock, C-2476/*33*.

Handel, C-5167/*244*①; C-5191/*423*; C-5239/*293*; K-711/*127*.

Handel, Philip J., DADA/*Supplement*.

Handel vase, IDC/①.

hand-finishing, CEA/*510*.

hand-forged, CHGH/*58*.

hand-grips, C-5114/*318F*①.

hand illustration, DATT.

handkerchief table, DADA.

handle, C-0254/*242*; C-0782/*25, 94*; C-0982/*271*; C-1082/*152*; CEA/*57*①, *76, 527*; IDC; IDPF/*116*①; OC/*138*; S-4461/*17*; SDF.

'handle', OC/*182*.

handle and back plate, DADA/①.

handle-back, EA; SDF/①.

handled dish, IDC.

handled vase, C-5005/*246*①.

handle grip, C-5114/*38*①.

handle sockets, S-4905/*214*①.

handle stop, IDPF/*121*①.

handle-tag, IDC.

handling, LP.

hand-loom weaving, DADA/ *Supplement.*

hand-made, CEA/*510, 683.*

hand mirror, C-0254/*140*; C-0706/*41*; C-1502/*138*; C-5203/*147*; C-5239/ *106*; S-4461/*56.*

hand-modelled, C-2324/*75.*

hand-mounting iron, DATT.

hand of Buddha citron, IDC.

hand of Fatima, OC/*111.*

hand of Fatima motif, C-5174/*14.*

hand of Levi motif, C-5174/*4.*

hand-painted, EC2/*89*①.

hand pointer, C-0254/*52.*

hand press, CEA/*465*①.

hand-pressed, CEA/*502.*

hand pressed, EG/*289*①.

hand-raised, CEA/*618.*

hand raised, LAR83/*593*①.

handrest, DADA; DATT.

hands, C-5117/*396*①.

hands (on clock), EA.

hand-screen, DADA.

hand screen, CEA/*278*①.

handscreen, C-0405/*125*; C-1603/*6*①.

hand scroll, C-2414/*99*①; C-2458/ *268.*

handscroll, C-5156/*347*①; C-5236/ *579*①.

hand sewing machine, C-2904/*23.*

hand-spun, OC/*33.*

handtooled, NYTBA/*268.*

hand-tufted carpet, DADA.

hand vise, DATT/①.

hand-warmer, IDC/①.

hand warmer, IDPF/*122*①.

hand-wiped, DATT.

handwriting, OC/*16.*

Han dynasty, CEA/*113*①; IDC; LAR82/*132*①; LAR83/*476*①; ACD; C-2323/*130*; C-2414/*15*①, *25*; C-2458/*3, 212*; C-5127/*5*①; C-5156/*2*①, *175*; C-5236/*381, 1562*①; S-3312/*1301*①.

Hanet, Paul, C-5117/*257.*

Han figure, S-4963/①.

Hangchou, CEA/*111.*

Hang-chou ware, EA/①.

hanger, C-5191/*423*; S-4972/*251, 285A.*

hanger chain, C-0225/*38.*

hanging, SDF.

hanging cabinet, C-5224/*165.*

hanging chiffonier, SDF.

hanging clock, EA/①; SDF.

hanging console, S-4955/*78*①.

hanging corner cabinet, C-0279/*358*; S-4812/*139.*

hanging corner cupboard, C-1407/*40*; C-2478/*108*; C-5116/*103*; DADA.

hanging cupboard, C-0982/*66*; JIWA/ *319*; LAR83/*316*①; SDF.

hanging flower basket, C-0225/*38.*

hanging lantern, C-5157/*21*①; C-5170/*13*; S-4436/*18*①.

hanging light, C-5181/*100.*

hanging loop, CEA/*255*①.

hanging medallion, S-4948/*8.*

hanging scroll, C-2414/*97*①; C-2458/ *263*; C-5156/*437*①; C-5236/*565*①; JIWA/*9, 10, 24, 36*①, *95*; S-4461/ *414.*

hanging shade, C-5146/*166*①; S-4461/*97.*

hanging shelf, C-2403/*41*; C-5146/ *107D*; DADA; JIWA/*319*; S-3311/

*121*①; S-4461/*672*; S-4988/ *475A*①; SDF/①.

hanging stand, C-5156/*758*①.

hanging wall cabinet, DADA/①.

hanging wall clock, C-5157/*31*.

haniwa, EA; C-5236/*842*①.

haniwa figures, IDC.

Hankar, Paul, DADA/*Supplement.*

Hannam, T., C-2487/*115*①.

Hannam, Thomas, C-5117/*238*; C-5174/*520*; S-3311/*770*①.

Hannau, C-1582/*43*.

Hannong, Charles François, CEA/ *148*①.

Hannong, Joseph, C-2486/*182*.

Hannong, Joseph Adam, CEA/*149*①.

Hannong, Paul, CEA/*148*①, *178*①.

Hannong, Pierre-Antoine, EA/*Paris porcelain.*

Hannong family: Paul-Antoine, Charles-François-Paul, Joseph-Adam, EA.

Hannong's faience factory, Hagenau, MP/*68*.

Hannoversch Munden, C-2427/*194*①.

Hannya mask, S-4829/*88*①.

Hanoverian, C-0254/*148*; C-1502/ *153*; C-5117/*64, 200*.

Hanoverian glass, DADA.

Hanoverian pattern, C-0103/*27*; C-0706/*13*; C-2202/*221*; C-2487/ *51*; DADA; EA/①; LAR83/ *579*①; S-2882/*1103*; S-4802/*391*; S-4922/*41*①.

Hanoverian period, C-5174/*562*.

Hanover pattern, C-0254/*274*.

Han pottery, IDC.

Hansa yellow, DATT; LP.

Hanseatic bowl, EA.

Hanseatic Tankard, EA.

Hansel in the Cellar, DADA.

Hansen, Johannes, DADA/ *Supplement.*

Hansje in den Kelder, DADA.

Hans Sloane plate, EA/①.

Han style, C-5156/*5*; C-5236/*1561*.

Han taste, C-5156/*172, 457*①.

Hanukah lamp, C-5174/*112*①.

Hanukkah lamp, EA/①.

Han ware, S-4963/①.

hao, S-4965/*305*①.

happening, DATT.

happing, SDF.

Harache, Pierre, CEA/*642*①; EA.

harbour scenes, IDC.

hard and soft ground, C-0249/*32*.

hardanger, CEA/*294*.

hardboard, DATT.

hard edge, LP.

hard-edge painting, DATT.

hardening-on, IDC.

hardening on, DATT.

Harder, Charles, DADA/*Supplement.*

hard-fired, IDC; MP/*17*.

hard-fired porcelain, JIWA/*130*.

hard firing, MP/*28*.

Hardman, Iliffe & Co., EA.

Hardman, John the Younger, EA/ *Hardman, Iliffe & Co..*

Hardman Powell, John, EA/ *Hardman, Iliffe & Co..*

hard metal, EA/*Britannia metal.*

Hardoy chair, DADA/*Supplement.*

hard-paste, CEA/*110, 130*; EA.

hard paste, DADA; DATT.

hard-paste porcelain, CEA/*63*①, *169, 209*; DATT; IDC; MP/*502*.

hard seats, C-0982/*53*.

hard-setting plaster, IDPF/*162*.

hard solder, DATT.

hard-soldered, CEA/*664*①.

hard soldering, RTA/*10*.

hardstone, C-1082; C-2458/*298, 374*; C-5117/*367*①; C-5127/*318*; C-5156; CEA/*513*; EA; K-711/

125; LAR82/*64*①, *439*①; LAR83/
*456*①; S-4461/*230*; S-4810/*237*①;
S-4928/*142*①, *146*①; C-0906/*119*.

hard stone box, C-2202/*86*.

hardware, NYTBA/*40*.

hard-wearing, OC/*29*.

hardwood, C-1082/*167*; C-2458/*302*;
C-2546/*30*; C-5127/*321, 348*;
C-5236/*330*①, *538*; DADA;
DATT; LAR82/*60*①; SDF.

hardwood peg, CHGH/*58*.

hare, DSSA.

harebell, C-0405/*160*; S-4461/*397*.

hare plate, IDC/①.

hare's fur, C-5156/*41*; DADA;
DATT; IDC/①.

"Hare's Fur", C-5236/*438*.

hare's fur glaze, EA; JIWA/*348*.

harewood, ACD; C-0982/*82B*;
C-2357/*57*①; C-2388/*30*; C-2421/
*98*①; C-5116/*13*①; CEA/*303,
351*①, *406*; DADA; DATT;
LAR82/*359*①; LAR83/*49*①;
S-4436/*56*①; S-4804/*868*①;
S-4988/*536*①; SDF.

harewood ground, S-4955/*199*①.

Hargreaves, J., LAR82/*237*①.

hariawase, IDPF/*206*.

haricot, DADA.

hari ishime, DADA.

Harker Pottery Company, DADA/
Supplement.

Harland, Thomas, DADA; EA.

harlequin, C-0254/*292*①; CEA/
*170*①, *174*①; DADA; S-4988/
*539*①; SDF/①; C-2427/*82*①;
IDC/①.

harlequin china, DADA.

harlequin color, S-291/*62*①.

Harlequin Davenport, LAR83/*317*①.

Harlequin Derbyshire, LAR82/*296*①.

harlequin games table, C-2555/*53*①.

harlequin glaze, IDC.

harlequin ground, IDC.

harlequin pattern, LAR82/*130*①.

harlequin Pembroke, DADA.

harlequin ring, RTA/*97*.

harlequin set, C-0982/*93A*; IDC;
C-0982/*86*; C-2498/*71*.

harlequin table, EA; SDF/①.

Harman & Lambert, EA/*Lambert &
Rawlings*.

Harmer, James, C-5117/*214*.

harmonica, SDF.

harmonichord, SDF.

harmonic series, CEA/*556*.

harmonious proportion, MP/*36*.

harmonium, DADA/*Supplement*;
SDF/①.

harmony, LP.

harness fitting, C-2414/*18*①.

harness furniture, EA.

harp, C-0906/*271*; CEA/*548*; DSSA;
EA.

harp-back chair, SDF.

Harper, J., C-2476/*41, 98*.

Harper, Robert, S-4944/*256*①.

Harpers Ferry Armory, CEA/*37*.

Harpers Ferry model, S-4972/*269*①.

Harpers Ferry rifle, CEA/*39*①.

harp-form support, S-2882/*1344,
1381, 1386*①.

harpguitar, CEA/*552*①.

harp handle, S-4804/*100*.

harp lamp, C-0225/*335*.

harp-lute, C-2520/*48*.

harp-lyre, EA/*harpo-lyre*.

harpoon ship-log, S-4881/*62*①.

harp pendulum, LAR83/*209*①.

harp-shaped, C-5173/*64*①; S-4905/
169.

harp-shaped handle, S-2882/*1099*①,
*1161*①; S-3311/*637*①; S-4922/
*10*①.

harp-shaped support, S-4414/*239*①.

harpsichord, ACD; CEA/*547*;
DADA/①; SDF/①.

harpsichord family, EA/①.

harp stand, C-0225/*335*.

harp table lamp, C-5005/*414*①.

harpy, DSSA; RGS/*61*①; SDF.

harquebus, DADA.

harrateen, SDF/*harratine*.

harratine, SDF.

Harrington, Sarah, EA.

Harris, Baker, EA/*174*.

Harris, Charles Stuart, C-0406/*1, 21*;
C-0706/*213*; LAR82/*557*①.

Harris, John, C-2904/*197*; C-5203/
195.

Harrison, Anthony, C-2357/*27*①.

Harrison, John, ACD; C-5117/*458*①;
EA.

Harrison red, DATT; LP.

Harrison's maintaining power,
C-2489/*97*①.

Harrow, John, CEA/*467*①.

harshang, OC/*329*.

'Harshang' design, OC/*328*①.

Hart, George O. 'Pop', S-286/*49*.

Hartl, Hans, C-2409/*237*.

Hartl, Johann Paul Rupert, EA.

Hartley Greens & Co., EA/*Leeds,
Leeds*.

Hartmann, Georg, EA.

Hartmann, Ludwig, Vienna, S-4881/
*159*①.

Hartsoeker, Nicklaas, CEA/*610*①.

Haruj design, S-2882/*180*.

Harvard chair, DADA; EA.

Harvard pattern, LAR82/*456*①;
NYTBA/*307*; S-4461/*13*.

Harvard table lamp, C-5005/*397*①.

harvest, DSSA.

harvest dish, IDPF/*122*①.

harvester, EA/*haystack*.

harvest jug, CEA/*154*①; EA/①;
IDC/①; IDPF/*122*.

harvest table, LAR83/*372*①.

harvest trophy symbol, C-5181/*175*.

hasami, DADA/*Supplement*; C-0782/
165.

hashira-e, C-5236/*992, 1339*; JIWA/
170.

hashira-kake, JIWA/*170*.

hash-spoon, EA/*serving spoon*.

hashtguli, OC/*63*.

hashtguli boteh, OC/*70*.

hashtguli design, OC/*222*.

Hashtrud, OC/*87*①.

Hasius, Jacob, Amsterdam,
C-MARS/*188*.

Haslam, John, C-2493/*92*.

Haslem, John, EA.

hasp, LAR82/*422*①.

Hassam, Childe, S-286/*277*①.

hassock, SDF.

hastener, EA.

haster, EA; SDF.

Hastings, Warren, service, IDC/①.

hat, DSSA.

hat-and-coat stand, C-1407/*142*.

hat badge, EA/*badge, enseigne*.

hatch, C-2427/*208*①.

hatch border, C-5156/*2*①.

hatched, CEA/*31*①; IDC; S-288/
*25*①.

hatched decoration, C-2493/*175*①.

hatched ground, C-5156/*62*①; RTA/
*75*①.

hatched pattern, C-2458/*123*;
C-5236/*1588*.

hatchet, DSSA.

Hatchett's brown, DATT.

hatching, DATT; EA; JIWA/*53*; LP/
①; RGS/*182*.

Hatchli, C-2388/*140*.

Hatchlie (Hatchlu) (Katchlie) rug,
EA/①.

hatchlu, OC/*155*.

hatchment, DADA/①.

hatch pattern, C-5127/*87*; C-5156/
*122*①.

hatchwork, C-2427/*199*①; S-4905/
*11*①, *75*.

Hately, Albert, C-5117/*388*①.

Hathor style, C-1582/*10*.

hat ornament, C-5156/*373*①;
C-5236/*1738*.

hat pin, C-2203/*4*; C-5005/*206*①.

hatpin, C-5239/*115*; JIWA/*195*.

hat-shaped teapot, S-4965/*307*①.

hat stand, C-5236/*1631*; S-4461/*419*;
SDF/*hall stand*, ①.

Hatton, James, C-2489/*131*.

hauberk, DADA.

Hauer, B. G., C-2486/*109*①.

Häuer (Hoyer), Bonaventura Gottlieb,
EA.

Haüer, J. G., EA/*Meissen porcelain
factory*.

Häufebecher, DADA.

Haugenauer, F., C-5191/*188*.

Haugenauer, Karl, C-5239/*116*.

Haupt, Georg, CEA/*317*①.

Haupt, George, EA.

Häusler, V., CEA/*241*①.

Hausmaler, ACD; CEA/*137*①,
*172*①; EA; IDC; MP/*54*.

hausmalerei, DADA; C-2427/*140*①;
CEA/*138*①; EA; IDC; LAR83/
*130*①; MP/*165*.

haute-lisse loom, EA/*high-warp loom*.

Hautin and Boulanger, S-4843/*330*①.

haut-relief, DADA.

Havana wood, SDF.

Havanna wood, SDF/*Havana wood*.

Havdala candlestick, C-5174/*74*①.

Havdala plate, C-5174/*41*.

Haviland, OPGAC/*356*.

Haviland Co., OPGAC/*353*.

Haviland factory, K-802/*21*.

Haviland Limoges, S-4461/*2*.

Hawaiian, CEA/*293*①.

H. A. Weller Art Pottery, Zanesville,
Ohio, EC1/*85*.

Hawes, C-2904/*285*.

Hawes, London, C-2489/*39*.

hawk, DATT.

hawk beak, IDC.

Hawken, Jacob and Samuel, CEA/
*42*①.

Hawken plains rifle, CEA/*42*①.

Hawkes, LAR82/*433*①; S-4461/*18*.

Hawkes, Moseley & Co., London,
C-2503/*198*①.

Hawkes, T. G., and Company,
DADA/*Supplement*.

Hawkes Moseley & Co., London,
C-2503/*164*.

Hawkes type, C-0249/*164*.

Hawkins, C-2493/*175*①.

hawk's beak spout, DADA.

hawksbill, EA.

Hawksworth Eyre & Co., C-GUST/
*99*①.

hawthorn, DADA.

hawthorn ginger jar, EA/*ginger jar,
ginger jar*.

Hawthorn jar, C-5127/*61*.

hawthorn pattern, IDC.

hawthorn vase, IDC.

hawthorn wood, DADA.

Hayashi, Y., Nikko, C-5167/*188*.

hayfork, C-2427/*36*.

Hayler, Wm., Chatham, C-MARS/
174.

Hayne, J., C-2487/*147*; C-2510/*65*①.

Hayne, Jonathan, C-5117/*216*;
S-4944/*273*①.

haystack, EA/*harvester*.

haystack-shaped, CEA/*586*①.

Hayter, Thomas, C-5117/*46*①.

Hazeldene, LAR82/*158*①.

Hazeldene pattern, C-2910/*119*.

Hazel Glass Co., OPGAC/*193*.

Hazledene Moonlit Blue pattern,
C-2910/*151*①.

Hazledene pattern, C-5191/*84*.

HB, EA/*Bateman, Hester, Brouwer, Justus, Herrebøe.*

HC above IE, EA/*Emes, John.*

H. C. Fry Glass Co., CEA/*477*①.

head, C-5114/*278*①; C-5156/*194*; C-5236/*842*①; C-5239/*249*; S-4972/*2*①; SDF.

head adornment, JIWA/*188.*

headboard, C-5114/*388*①; K-710/*111*; S-3311/*417*; SDF.

head calligraphy, JIWA/*384*①.

headdress, C-1082/*45*; C-3011/*66*; S-4807/*366*①.

headed, C-5116/*63*①, *145*①.

heading, C-0982/*30*; C-2402/*30*; SDF.

head of Buddha, C-2414/*23.*

headpiece, S-286/*474, 477.*

headpost, S-4905/*377*①.

headrest, C-1407/*110*; C-5239/*249*; IDPF/*122*①; S-4965/*185*①.

head-shaped whistle, S-4963/*80*①.

head vase, IDC.

Heal, John Christopher, SDF/*752.*

Heal, Sir Ambrose, DADA/*Supplement*; SDF/*752.*

Heal's, LAR82/*309*①.

Heals, Tottenham Court Road, C-0982/*125.*

heaped and piled, CEA/*119*①.

"heaped and piled" effect, S-3312/*1350*①.

heaped and piled effect, EA/*Hsüan Tê.*

heaped and piled technique, S-4965/*239*①.

heaped and piling, C-5156/*86*①.

heart, DSSA.

Heart, The, EA/*'t Hart.*

heart and initial device, RTA/*107*①.

heart and love-knot motif, EA/*22*①.

heart-back, EA/①.

heart-back chair, SDF.

heart case, ACD.

hearth, SDF.

hearth furniture, EA.

hearth rug, DADA; SDF.

heart-lozenge, C-2403/*158.*

heart pattern, EA.

heart shape, RTA/*181*①.

heart-shaped, C-1006/*92*; C-5005/*402*①; S-4905/*327*①.

heart-shaped chair back, DADA/①.

heart-shaped motif, C-2555/*46*①.

heart-shaped panel, C-2486/*187*①.

heart-shaped terminal, CEA/*191*①, *645*①.

heart with thumbprint, OPGAC/*222.*

heart-wood, SDF.

heartwood, DATT.

Heath, CEA/*192*①.

Heath, John, C-5153/*39*①; EA.

Heath, Thomas, CEA/*604*①; EA.

Heath & Co., C-2904/*91.*

Heath & Wing, CEA/*604*①.

heating, CEA/*528*; C-2904/*199.*

Heaton, Clement J., DADA/*Supplement.*

Heaton, Maurice, DADA/*Supplement.*

heaume, DADA.

heavily potted, C-5156/*107*; IDC.

heavy gauge metal, CEA/*642*①.

heavy shell and ring top, C-5117/*249.*

heavy spar, DATT.

heavy steel, C-1082/*6.*

heavy wove, S-286/*91.*

Héban, C-2364/*52*①.

hebatlu, OC/*263.*

hebatlu design, OC/*264, 118.*

hebatlu medallions, OC/*219.*

Hebe, DSSA.

Hebert, Pierre Eugène, C-5189/*162*①.

Hebrew granite, DATT.

Hebrew oil lamp, C-1702/*107.*

Hector, DSSA.

heddle, EA.

hedgehog, DSSA.

hedgehog crocus-pot, IDC/①.

Hedingham, ACD.

Hedwig glasses, EA.

heel, DATT.

heel and toe plate, C-2476/*22*①.

heelball, DATT.

heel plate, S-4972/*272*.

Heemskerk type, CEA/*588*①.

Heerfurth, Christian, MP/*175*.

Heesen, Willem, DADA/*Supplement.*

hefengdi, C-2458/*346*①.

hehbehlik, DADA.

Heian, DADA; EA.

Heianjō, JIWA/*182*.

Heian Period, C-5236/*844*①.

heighten, DATT.

Heike-gani, CEA/*570*①.

Heiler, S-288/*24*①.

Heimerdinger, C-5203/*96*.

heine saw, S-4927/*224D*①.

Heinrich, C-2910/*146*.

Heinrichsen of Nuremberg, CEA/*694*①.

Heinrichsen (Nuremberg) scale, CEA/*697*.

Heinrici, Johann Martin, EA/①; MP/*141*.

Heintze, Gottfried, C-5117/*193*.

Heintze, Johann Georg, EA; MP/*63*.

Heintzelman, Arthur, S-286/*63*.

Heinz Art, C-5239/*103*.

Heinzelman border, EA.

heiroglyphs, C-2482/*76*.

Heisey, NYTBA/*312*; OPGAC/*165*.

Helchis (Helkis) (Helchs), Jacobus, EA.

Hele, Peter, EA.

Helena Wolfsohn, C-2493/*253*.

Helena Wolfsohn porcelain, S-3311/*370*①.

Helen of Troy, DSSA.

helical balance spring, C-5117/*484*①.

helical hairspring, S-4802/*30*①; S-4927/*89*.

helical spring, C-2368/*40*①, *84*; C-MARS/*203*; EA/*30*.

helicon, C-5255/*28*.

helio, C-2904/*262*.

heliograph, C-2608/*68*; JIWA/*112*①.

heliogravure, C-2324/*287*; S-286/*464*.

Helios, DSSA.

heliotrope, CEA/*64*①; DADA.

heliotrope pendant, S-291/*240*①.

helix, IDC.

Hell, DSSA.

Helladic, DATT.

Hellenic art, DATT.

Hellenic painting, LP.

Hellenistic, C-2482/*107*.

Hellenistic Art, LP.

Hellenistic period, DATT.

Helleu, Paul-Cesar, S-286/*278*①.

Hellot, Jean, CEA/*184*①; EA.

Helly, Richd., London, C-MARS/*153*.

helm, C-2503/*60*; DADA.

helmet, C-2398/*91*①; CHGH/*54*; DADA; DSSA; S-4972/*167*①.

helmet ewer, EA/①.

helmet finial, C-0254/*120*①.

helmet form, S-2882/*1143*.

helmet-form creamer, DADA.

helmet-form ewer, DADA.

helmetlike hump oven, IDPF/*169*①.

helmet mask, C-1082/*3*; S-4807/*379*①.

helmet pitcher, IDC.

helmet shape, S-2882/*976*①, *1158*.

helmet-shape, EA/① *cream jug.*

helmet-shaped, C-5005/*277*; C-5117/*78*①; C-5146/*183*①; C-5156/

FFDAB/*26*; LAR82/*69*①, *274*①; LAR83/*246*①.

Hepplewhite, George, ACD; CEA/ *355*①; DADA/①; EA; SDF/*752*.

Hepplewhite design, C-0982/*88A*.

Hepplewhite pattern, C-0254/*218*.

Hepplewhite style, C-0982/*32*; DADA; EA/①; SDF.

Hera, DSSA.

heraldic, S-3311/*108*.

heraldic animal, C-2357/*7*①.

heraldic chairs, SDF/①.

heraldic crest, JIWA/*13, 75*.

heraldic crest decoration, C-0225/*311*.

heraldic dating, SDF.

heraldic design, JIWA/*300*①.

heraldic device (badge), RTA/*54*.

heraldic device, RTA/*69*①.

heraldic engraving, EA.

heraldic pattern, CEA/*280*; C-0254/*247*.

Heraldic shield, RTA/*57*.

heraldic shields, C-5005/*397*①.

heraldic signet-ring, RTA/*96*.

heraldic style, JIWA/*185*①.

heraldic ware, IDC.

Herat, S-288/*29*①.

Herat Beluch, OC/*110, 140*.

Herat border, DADA.

Herat carpet, EA.

Herat floral style, OC/*328*.

herati, C-2388/*197*; S-288/*27*①; S-2882/*58*; S-4796/*23*; S-4847/*4*; CEA/*101, 101*①.

Herati border, OC/*42, 42*①.

Herati design, OC/*15*①.

herati field, S-2882/*71, 139A*.

Herati leaf, CEA/*91*①.

Herati motif, DADA.

herati pattern, C-2320/*135*; C-2357/*135, 145, 161*; C-2403/*163*; C-2478/*255*; EA; S-3311/*3*; OC/*74*①.

herati repeat pattern border, S-4948/*130*①.

herati spandrel, S-2882/*158*.

Herat rug, DADA.

Herbaria, MP/*121*.

Herbert, S. & Co., LAR82/*612*①.

Herbig, B., S-4947/*27*.

Herculaneum (1), ACD.

Herculaneum (2), ACD.

Herculaneum, DADA; S-4843/*359*①.

Herculaneum Pottery, EA.

Herculaneum ware, IDC.

Herculanium, SDF/①.

Hercules, C-2427/*229*①; DSSA.

Hereke, C-5323/*115*①; OC/*134*①, *303*①; S-4847/*192*.

Hereke carpet, EA/①.

Hereke mat, S-4796/*186*.

Hereke rug, ACD; C-1702/*52*.

Herek rug, DADA.

Herend, C-5189/*33*; DADA.

Herez rug, DADA.

Herfurth, Rötger, C-5174/*126*① *Rudiger*.

Héricourt, Antoine, C-2555/*48*①.

Heriz, C-2388/*209*; C-5181/*54*; C-5189/*385*; CEA/*93*①; OC/*266*①; S-288/*13*①.

Heriz-area style, OC/*206*.

Heriz carpet, EA/①; OC/*228*; S-4461/*843*; S-4796/*150, 270*①.

Heriz rug, C-2403/*155*; S-4461/*785*.

Heriz silk carpet, S-3311/*41*①.

Herkomer, Hubert von, DADA/ *Supplement*.

herm, C-2437/*3*①; C-2498/*146*①; DATT; DSSA.

herma, DATT; IDC.

Herman, Anton, CEA/*300*①.

Hermes, DSSA.

hermetic, LP.

Hermodact, R., C-2204/*119*.

herm stem, C-2437/*15*①.

Herne, Lewis, CEA/653①.

heroic, DATT; LP.

heroic attitude, MP/449.

Herold, Christian Friedrich, CEA/63①; EA; MP/66.

Herold, J. G., CEA/169.

Herold, Johann Gregor, CEA/173①.

Herold (Höroldt), Johann Gregorius, EA.

Heron, Robert & Sons, LAR82/189①.

Herreboe, DADA/①.

Herrebøe, EA.

HERREBÖE FABRIQUE, EA/Herrebøe.

Herrengrund cup, EA.

Herrera, Juan de, DADA.

Herrera style, EA/①.

Herrfurt, Rödger, EA.

herring-bone, EA.

herringbone, ACD; IDC; OPGAC/223; S-4972/562①; SDF.

herringbone band, C-2320/60; C-2357/30①; C-2388/51; C-2403/89; C-2421/143①; C-2478/96; C-2522/60①; LAR83/303①.

herringbone banding, DADA; S-4461/487.

herring-bone border, CEA/330①.

herringbone border, S-4905/36①.

herring-bone form, CEA/330①.

herringbone glass, S-4461/25.

herringbone inlaid cross-banded molded rectangular top, S-4414/514①.

herringbone inlay, C-5189/284①.

herringbone-molded, C-2493/20.

herringbone molded, LAR82/194①.

herringbone-pattern, S-4414/56①.

herringbone pattern, C-2409/22; C-2421/155; C-2498/106; C-5005/352①.

herring-bone stitch, CEA/285①.

herringbone stitch, DADA.

herringbone stringing, LAR83/251①.

Hertwig & Co., C-5239/23①.

Hertz, P., C-5203/133.

Hervé, Francis, SDF/752.

Herzfeld, Booms, C-5189/172①.

Hesperian-ware, LAR82/158①.

Hessen, Paris, S-4927/46.

hessian, C-2320/153; C-5153/70; SDF.

Hessian cup, IDC.

Hester Bateman, S-4922/15①, 52①.

Hestor Bateman, C-0706/81.

hêtre wood, DADA.

Hetzel, Johann Christian, C-5174/64①.

Heubach, Gerbruder, C-5239/25.

Heuglin, Johann Erhard II, EA/①.

Heurtaut, Nicolas, CEA/379①.

Heurtaut, Nicolas, stamp: N HEURTAUT, C-5224/144①.

Hewett, Martin, C-5117/104①.

Hewitt, John, SDF/773.

hexafoil, C-0782/141; C-2202/180; C-2414/51①; C-2458/159, 316; C-5117/244①, 374①; IDC; LAR82/125①; LAR83/154①; S-2882/1079①; S-4905/46①.

hexafoil base, C-5117/244①.

hexafoil cartouche, S-4461/309.

hexafoil pedestal, C-0103/39.

hexafoil rim, C-2414/68①.

hexafoil-shaped, C-1502/107.

hexafoil stand, C-0782/56.

hexagon, C-2403/173; C-2704/77.

hexagonal, C-0103/36; C-0782/180; C-5116/57; C-5153/13①; C-5156/51①, 471①; C-5173/59①; C-5239/119.

hexagonal base, C-5117/251①; C-5127/109①.

hexagonal body, C-2458/98①.

hexagonal capital, C-2403/62①.

hexagonal-cut diamond, S-291/*80*①.

hexagonal dish, C-5127/*74.*

hexagonal filigree box, S-2882/*1030.*

hexagonal flaring section, S-4461/*33.*

hexagonal form, LAR82/*250*①; S-4461/*269.*

hexagonal handle, C-5153/*8.*

hexagonal jardiniere, S-4414/*414*①.

hexagonal knop, CEA/*594.*

hexagonal latchhook medallion, S-4948/*1*①.

hexagonally cut, IDPF/*69*①.

hexagonal medallion, C-2388/*146*; S-2882/*202.*

hexagonal nozzle, C-5117/*251*①.

hexagonal pagoda-style lantern, C-1082/*99.*

hexagonal panel, C-0225/*339.*

hexagonal seal-top terminal, S-2882/*1098*①.

hexagonal section, S-4461/*30, 361.*

hexagonal shaft, C-2388/*93*①.

hexagonal-shaped, S-4414/*34*①.

hexagonal stem, C-2510/*58*①; C-5114/*147*; C-5117/*101*①, *193*; LAR83/*583*①.

hexagonal support, C-2403/*146*①.

hexagonal table clock, EA.

hexagonal teapot stand, C-2458/*134.*

hexagonal waisted, C-0782/*96.*

hexagon arranged in medallions, C-2704/*49A.*

hexagram mark, EA/① *Nymphenburg.*

hexalobate, S-4972/*309*①.

hexalobate dish, LAR83/*241*①.

hexalobed body, LAR83/*218*①, *427*①.

Heylin, London, C-2503/*174.*

Heylyn, Edward, CEA/*190*①.

Heyne, Johann Christopher, CEA/ *590.*

Heynemann, Christian Adolf, MP/ *174.*

Heywood, A., C-5117/*448.*

hezzanith, C-2904/*91.*

HF, EA/*Holitsch.*

H-form stretcher, DADA.

HH, EA/*Knütgen.*

H. Hughes & Son Ltd., C-2904/*46, 89.*

H. Hughes & Sons, C-2904/*252.*

H. Hughes & Sons Ltd., C-2904/*52, 62.*

Hiardo-type, C-0803/*113, 113.*

hibachi, C-5127/*377*; DADA; EA/ *Japanese metal-work*; S-4461/*417.*

Hiccolier, C., C-2493/*233*①.

Hickes, Richard, EA/*Hyckes, R.*

hickory, DADA; NYTBA/*36*; SDF.

Hicks, J., C-2904/*72, 167.*

Hida artists, S-4928/*94*①.

Hida Takayama, CEA/*575.*

hidden compartment, S-4927/*95*①.

hide, C-1082/*5*; C-1407/*126.*

hide glue, DATT; LP.

hide membrane, C-1082/*20.*

hide thong, C-1082/*47.*

hiding power, DATT.

Hielckerf, Adied, S-4927/*190*①.

hieracosphinx, DATT.

hieroglyphs, S-4843/*387*①.

Higgins, Francis, C-2510/*21, 43*; C-5117/*204*; S-3311/*717*; S-4944/ *246.*

Higgin's vegetable glue, DATT.

high, LP.

high-back, FFDAB/*29.*

high-backed chairs, NYTBA/*21.*

high-boy, CEA/*333*①, *391*①.

high boy, EA/①.

highboy, ACD; CEA/*406*; DADA/ ①; LAR82/*324*①; S-4461/*582*①, *602*; SDF.

highboy base, S-3311/*184*①.

high chair, S-4972/*531*①; SDF.

highchair, NYTBA/*32*①.

high chair tray, C-0254/*287*①.

highchair tray, S-4804/*91*①.

high chest, C-5153/*137*①; NYTBA/ *34*①.

high chest of drawers, DADA.

high color cushion diamond, S-291/ *243*.

high coup, IDPF/*63*.

high daddy, SDF.

highdaddy, DADA.

high double lotus base, C-5234/*81*①.

Highfield, S-3311/*109*.

high-fire color, NYTBA/*145*.

high-fired, CEA/*111*.

high-fired glaze, EC1/*83*.

high-fired porcelain, LAR83/*151*①.

high glaze, C-0225/*35*; C-5005/ *344*①; EC1/*83*.

high gloss, C-5239/*1*.

high handle, C-0225/*7*.

highlight, DATT; JIWA/*77*①; LP/①.

highlighted, S-4972/*610*.

highlight halftone, DATT.

highly jeweled, S-4802/*4*①.

high neck, C-1506/*34*.

high post, FFDAB/*77*.

high-post bed, SDF/①.

high-relief, DADA; IDPF/*34*.

high relief, C-0406/*124*; C-1082/*72*; C-2402/*68*; C-2502/*175*; C-5005/ *239*; C-5156/*318*; EG/*105 Hochschnitt, 287*; IDC; S-2882/ *1200*①, *1206*①, *1273*①; S-3311/ *164*; S-4414/*179*; S-4461/*500*; S-4972/*92*①.

high relief chinoiserie figure, S-2882/ *286*①.

high relief technique, EG/*101*.

High Renaissance revival, MP/*190*.

high-shouldered, IDPF/*5*①.

high-shouldered globular vase, S-2882/*1325*.

high-shouldered ovoid form, S-2882/ *1361*①.

high-shouldered ovoid section, S-2882/*1205*①.

high shouldered ovoid vase, S-2882/ *1340*.

High Standard, EA/*Britannia Standard, Britannia Standard*.

high table, C-5236/*542*.

high temperature color, DADA.

high-temperature colour, EA; IDC.

high-temperature-fired ware, MP/*17*.

high-temperature kiln, MP/*28*.

high-temperature stoneware, JIWA/ *352*.

high twist, OC/*243*.

high Victorian, CEA/*662*①.

high walled, C-0225/*145*.

high-warp loom, EA/*Arras tapestry*.

high water, CEA/*230*①.

Higo school, LAR83/*661*①.

hiko-né-bori technique, JIWA/*179*①.

Hilderson, John, ACD.

Hill, Joachim, C-5153/*217*①.

Hill, Jockey, C-2493/*89*.

Hill, John, EA.

Hillan, Christian, S-3311/*793*①.

Hill case, C-0906/*355*.

hill-censer, IDPF/*123*①.

hill censer, IDC.

Hillebrand, Friedrich, EA.

Hilliard, Lawrence, EA/①.

Hilliard, Nicholas, EA/①.

Hilliard & Thomason, C-0406/*67*.

hilling, SDF.

hill jar, CEA/*114*①; DADA; EA/①; IDC/①; IDPF/*123*①.

Hilpert, Andreas, CEA/*684, 694*①.

hilt, C-1082/*5*; C-5117/*313*①; CEA/ *22*①, *44*; DADA; S-4972/*152*①, *248*①.

himation, S-4973/*143*①.

himation-clad, S-4807/*502*.

himatoshi, C-0282/*76*.

Himeji, EA.

himotoshi, CEA/*575*; S-3312/*1077, 1082*①; S-4928/*2*①.

Hinard, Louis, EA/*Beauvais tapestry*.

Hindeloopen folk art, CEA/*310*①.

hindquarters, S-3311/*488A*①.

hind's foot, CEA/*594*.

Hine, Margaret, DADA/*Supplement*.

Hineno, LAR82/*38*①.

hinge, C-5153/*39A*①; CEA/*527*; DADA/①; EA/*door-furniture*; SDF.

hinged, C-0982/*28, 84A*; C-2402/*15*; C-5117/*132*①; C-5239/*265*; S-4461/*242*.

hinged base, C-2398/*67*.

hinged-bayonet lid, S-4804/*2*.

hinged box, C-5236/*1699*.

hinged-bridge, C-5191/*494*①.

hinged closure, S-4414/*156*.

hinged cover, C-0254/*24*; C-0270/*40*①; C-1082/*96*; C-2398/*11*①; C-2458/*179*; C-5114/*13, 356*①.

hinged cupboard, C-5156/*486*①.

hinged domed lid, C-5114/*217*①; S-4414/*434*①.

hinged door, C-1082/*181*.

hinged drawer, C-0279/*321*.

hinged flap, C-2403/*15*①.

hinged fly bracket, CEA/*351*①.

hinged frame, C-0254/*70*.

hinged frieze drawer, S-2882/*270*①.

hinged front, C-5114/*335*①, *350*①.

hinged lid, C-0279/*98*; C-5114/*108, 224*①, *340*①; S-4461/*230*.

hinged-lidded, C-5116/*3*.

hinged midsection, C-0254/*44*.

hinged mount, S-291/*59*.

hinged raised cover, C-5117/*139*①, *175*①.

hinged rectangular lid, C-0982/*86A*.

hinged-screw lid, S-4804/*2*.

hinged stand, C-0225/*96*.

hinged stool, C-0982/*179*.

hinged surface, C-0249/*348*.

hinged top, C-0249/*359*; C-5114/*334*①; C-5116/*21*①, *150*①.

hinged writing flap, C-5114/*333*①.

Hingelberg, F., C-0270/*101*①.

hinge-lidded box, C-5116/*17*.

hinge pin, C-5114/*43*①.

hinge plate, C-5156/*437*.

hinoki wood, JIWA/*165*.

hiogi, JIWA/*165*.

Hiolin, Louis Auguste, C-5189/*154*①.

hip, EA/*knee*, *Peridon, Hendrick Janzon*.

hip bath, SDF.

hip dome, SDF.

hip mask, C-1082/*52*.

hipped, C-5116/*172*①; S-4972/*521*①; S-4988/*532*①.

hipped leg, EA; LAR83/*373*①; SDF.

hipped molded cabriole leg, S-2882/*366*①.

hipped reeded downswept quadruped leg, S-4414/*453*①.

hippocampus, DSSA.

hippogriff, DSSA.

hippo tricycle, LAR83/*659*①.

Hirado, C-5156/*807*①; C-5236/*831*; CEA/*565, 575*.

Hirado (Hizen), EA.

Hirado, S-3312/*1115*.

Hirado porcelain, LAR83/*458*①; S-3312/*1098*①.

Hirado-type, C-0782/*209*.

hirado ware, DADA; IDC.

hira-makie, CEA/*562, 575*; DADA.

hiramakie, C-1082/*181*; C-5127/*441*; C-5156/*699*; C-5170/*179*①; C-5236/*779, 811*; LAR83/*459*①, *583*①; S-3312/*1038*①, *1061*①.

hocked animal leg, DADA/①.

hocked-leg, CEA/306①.

Höckel, Jacob Melchior, EA.

hock glass, DADA; EG/117①.

Hocking Glass Co., OPGAC/191.

hock leg, SDF.

Hockney, David, S-286/280①.

Hodder, George, C-5117/84.

Hodges, C-2503/78.

Hododa, LAR83/115①.

Hododa Kinkozan, LAR83/97①.

hoe, DSSA.

Hofdrachen decoration, MP/470①.

Hofdyck, Dammas, EA.

Hoffler, Johann, C-5174/104①.

Hoffman, Esaij Carl, C-5174/176①.

Hoffman, Irwin D., S-286/189.

Hoffman, Josef, C-2409/233.

Hoffman, Joseph, C-5167/209A;
C-5239/255.

Hoffmann, Josef, C-5167/162①;
JIWA/378; K-711/121.

Hoffmeier, CEA/219.

Hoffmeister of Vienna, EA.

Hofkellerei glass, EA.

Hofmann, C-2904/228.

Hofmann, Josef, DADA/Supplement;
NYTBA/262①.

Hofnagel, Peter, CEA/149①.

hog, DSSA.

Hogarth, William, EA.

Hogarth capital, SDF/①.

Hogarth chair, DADA; SDF.

Hogarth glass, DADA; EA.

Hogarth's dog, IDC.

Hogarth's line, DATT/①.

hogen, CEA/575.

hogged, S-4965/145①.

'hog's-back' diamond, RTA/94.

Hogstedt, Carl Gustaf, S-4944/148①.

Hohman, Eustachius, C-5174/110①.

Hohner Carman II, C-0906/251.

Ho-ho and Erh-hsien, IDC/①.

ho-ho bird, C-0982/171; C-2402/198;
IDC.

Ho Ho Erh Hsien, EA.

Hohokam pottery, IDC.

höhr, DADA.

hokkai, C-1082/189.

Hokkei School, C-5156/853①.

Hokusai School, C-5156/893.

Holbein, Hans the Younger, EA.

Holbein border, S-4796/56①;
S-4847/89; S-4948/35①.

Holbein carpet, EA.

holcion, IDC.

holdall, CEA/153①.

hold-back, EA/curtain-holder, ①
curtain-holder.

hold-down, DATT/①.

holder, C-0225/100; C-0906/143;
C-5239/90, 322①; S-4461/17.

holding, C-5114/239.

Holdship, Richard, EA.

Holdship, Richard and Josiah, ACD.

Holics, C-2486/186①.

HOLICS HOLITSCH, EA/Holitsch.

holiday, OPGAC/193.

Holitsch, DADA; EA.

HOLITSH, EA/Holitsch.

holland, SDF; MP/15.

Holland, H. A., C-2510/20①.

Holland, Henry, ACD; DADA; EA;
SDF/753.

Holland, H. & Son, LAR82/592①.

Holland, Thomas II, C-2510/82.

Holland and Sons, C-5170/133①.

holland-circle, CEA/604①.

Holland & Holland, C-2476/2.

Holland & Holland style, C-2476/92.

Holländische porselein, IDC.

Holland paper, S-286/120①, 123①.

Holland rose-cut diamond, S-291/
140①.

hollie-point, C-2704/*18*①.

hollie point, C-2203/*139*.

hollie-work, DADA.

Hollins, C-2502/*69*.

Hollins, Samuel, ACD; DADA; EA; S-4843/*356*①.

Hollming, August Frederik, C-5117/ *360*①.

Hollock, Thomas, S-4988/*414*①.

hollow, C-2458/*377*.

holloware, EG/*289*①; FFDAB/*125*; IDPF/*123*.

hollow-blown, CEA/*485*①.

hollow-casting, EA.

hollow chamfer, SDF.

hollow core, C-1082/*55*.

hollow-cut, C-5114/*166*.

hollowed, CEA/*502*; EG/*289*.

hollowed out, S-4972/*10*①.

hollow foot, CEA/*418*①.

hollow front, FFDAB/*62*.

hollow knop, CEA/*424*①.

hollow-moulded, C-2482/*106*.

hollow pottery tube, IDPF/*34*.

hollow relief, DADA.

hollow seat, SDF/① *dropped seat*.

hollow stem, CEA/*424*①; EA; EG/ *73*.

hollow stemmed drinking glass, ACD.

hollow tile, C-5236/*1565*①.

hollow-ware, CEA/*460*①, *579*, *594*, *677*①; EA.

hollow ware, ACD; DADA; DATT; IDC.

hollowware, S-4905/*316*.

hollow-ware brass, CEA/*303*.

hollowware piece, NYTBA/*229*.

holly, ACD; CEA/*303*; DATT; OPGAC/*224*; S-4881/*356*; SDF.

holly cross, DATT.

holly cuff, FFDAB/*57*.

holly green, DATT.

holly inlay, FFDAB/*57*.

hollypoint, C-1506/*94*.

holly wood, DADA.

hollywood case, C-5117/*355*; C-5174/ *316*.

holm, SDF.

Holmden, London, C-2489/*70*.

Holmes, William, S-4944/*359*.

Holmgaard Glass Works, DADA/ *Supplement*.

holmos, IDC.

Holmström, August, C-5174/*319 workmaster*.

holographed plastic, S-286/*174*①, *175*.

holster pistol, C-2503/*173*; C-2569/ *69*; C-MARS/*133*, *135*①; CEA/ *23*①.

Holy Sepulchre, C-5174/*21*.

holy-water bucket, EA.

holy water font, C-0279/*87*①.

holy-water holder, IDPF/*123*.

holy-water sprinkler, DADA/①.

holy-water stoup, EA/①.

holy water stoup, C-0254/*58*.

holy-wood, DADA.

Holzschnitt Blumen, C-2427/*76*①; C-2486/*92*①.

Holzschnittblumen, IDC.

Home Arts and Industries Association, DADA/*Supplement*.

Home Blickensderfer typewriter, C-0403/*10B*.

homeopathic medicine set, C-0403/ *256*.

Homer, DSSA.

Homeric vase, IDC.

Homer Laughlin China Co., OPGAC/ *355*.

hominid elephant, C-5234/*105*①.

homogeneous construction, JIWA/ *25*①.

Honan, CEA/*111*, *113*①.

honan celadon, DADA.

honan temmoku, DADA.

Honan ware, CEA/116①; IDC.

Honduras mahogany, SDF.

Honduras rosewood, DATT.

hone, DATT.

Hone, Nathaniel and Horace, EA.

Honesdale Decorating Company, CEA/459, 479①.

honesty design, C-2324/210.

honesty leaf, C-2409/197.

Honey, W. B., CEA/192①.

Honeybourne, Richard, EA/Brierley Hill.

honeycomb, CEA/462①; DSSA; OPGAC/224.

honeycomb band, C-2493/206①.

honeycomb cutting, C-0249/219.

honeycomb design, LAR82/547①.

honeycomb facet, S-2882/1308.

honeycomb ground, IDC.

honeycomb hammered surface, S-2882/938①.

honey-comb molded, LAR82/442①.

honeycomb-moulded, EG/139①.

honeycomb moulded, CEA/441①.

honeycomb-patterned, S-4804/700①.

honeycomb patterned, C-0225/276.

honeycomb weave, SDF.

honey gilding, EA/gilding, gilding.

honey-gold, IDC.

honey-jar, IDC.

honey jar, C-0254/9; IDPF/123①.

honeymoon pot, IDPF/124.

honey-pot, CEA/658①, 658①; EA/①.

honey pot, DADA.

honeypot, C-2409/72.

honey-pot with stand, C-5117/149①.

honeysuckle, C-2421/147①; DADA; C-2704/29.

honeysuckle back, SDF.

honeysuckle border, IDC.

honeysuckle leaf corona, S-2882/805.

honeysuckle motif, EA/anthemion motif.

honeysuckle ornament, DATT; SDF.

hong, IDC/①.

Hong-chou celadon, JIWA/344.

Hong Kong reproduction, NYTBA/166.

hong mu, S-4965/66①.

Hongmu, S-4810/317①.

Hongxian, C-2458/164; C-2513/201; C-5127/106; LAR82/125①.

Honiton lace, C-1506/155; C-2203/136; DADA.

Hon Shonsui, IDC.

hon-zōgan, DADA.

honzogan, S-4928/118①.

honzukuri, C-5236/1825.

ho-o, C-0782/12; S-3312/1116①, 1143①.

hood, ACD; C-2388/17; C-5116/48; C-5157/35①; CEA/241①; DADA.

hood (in long-case clock), EA.

hood (clock), FFDAB/110.

hood, S-3311/204①; S-4812/16; S-4972/430; S-4988/413①; SDF/dome.

hooded, DADA/①.

hooded clock, EA.

Hooded Halifax, IDPF/50.

hooded lantern clock, CEA/232①.

hooded top, SDF.

hood in furniture, EA.

hoof, EA.

hoof and branch support, C-0254/91.

hoof foot, C-0254/109, 464; C-0982/266; C-1407/159; C-1502/11; C-2437/55①; C-5114/10①, 26①; C-5116/161①; C-5117/89, 227; C-5157/113①; C-5259/529; CEA/329①; DADA; S-4414/317; S-4507/17①; S-4922/32①, 62①; S-4988/499①; SDF/①.

hoof-foot, ACD.

hoof-shaped spoon, CEA/640①.

hoof support, S-2882/1069, 1082, 1100①; S-3311/704; S-4922/26①.

hook, ACD/pothanger; C-5156/769①; C-5181/104.

hookah, DADA; EA/narghile, narghile.

hookah (hooka), IDC/①.

hookah base, S-4461/449.

hookah bottle, LAR83/413①.

Hooke, Robert, CEA/261①; EA.

hooked, C-2388/140; C-2403/172; S-3311/30.

hooked arch, C-2320/119.

hooked-diamond motif, OC/198, 212.

hooked finial, C-2320/119.

hooked lozenge border, C-2388/148.

hooked medallion, C-2388/143; S-2882/60.

hooked-medallion motif, OC/213①.

hooked octagon, S-2882/112, 184①.

hooked rhombic, S-3311/46.

hooked rug, C-2482/11; DADA; NYTBA/111①; SDF.

hooked scroll motif, S-4965/129①.

hooked tab handle, S-4965/115①.

hooked-vine, C-2357/131.

hooked vine, C-2403/158.

Hooker's green, DATT; LP.

hook handle, C-5117/333①; C-5174/234.

hook harp, CEA/551①.

hooks, C-5239/251.

hook support, C-5116/65①.

Hoolart, G. H., EA.

hoop, CEA/346①.

hoop-back, ACD; C-0982/154; DADA/①; SDF.

hoop back, C-0279/273, 339①; LAR82/310①.

hooped and staved decoration, C-2487/105①.

hooped back, CEA/348①.

hooped top rail, C-5116/119.

hoop handle, C-2409/106.

hoop rail, C-0249/388.

Hooton & Jones, C-2476/54.

hooved foot, C-5116/43①.

Hope, DSSA.

Hope, Thomas, ACD; C-2478/174; CEA/303, 360①; DADA; EA; SDF/753.

Hopei, CEA/111.

Hope in Death, C-2704/21①.

Hope service, IDC.

Hôpital de la Trinité, DADA.

Hôpital de la Trinité workshop, EA.

Hoppe, Johann Andreas, MP/55.

hopper, C-5146/107D.

Hoppesteyn, Jacob Wemmerson and Rochus, EA.

Hoppesteyn, Rochus, CEA/142①.

Hoppestyn, Jacob, CEA/142①.

hop-trellis pattern, IDC/①.

Horace Vernet green, DATT.

Horae, DSSA.

Horaku, C-5236/862①.

Horan, CEA/570①.

horary branch, C-2458/217.

Horary quadrant, CEA/612.

Horchhaimer, Nikolaus, EA.

Horenbout, (Hornebolt), (Hornebond): Gerard, Lucas, (Luke), Suzanne, (Susanna), EA.

horizon, C-2904/249; LP.

horizon line, DATT.

horizontal band design, C-0225/5.

horizontal billet bar, CEA/530①.

horizontal collar, C-2458/216.

horizontal escapement, EA.

horizontal fluted band, C-5117/164.

horizontal furrow, C-2414/6①.

horizontal handle, IDPF/34.

horizontal leading, S-4414/*230*①, *231*.

horizontal loom, EA/*low-warp loom*.

horizontally lobed, C-5236/*1588*.

horizontal palm pattern, S-4461/*197*.

horizontal reeding, S-4414/*291*.

horizontal ribbed design, C-0225/*87*.

horizontal ridge, S-3312/*1342*①.

horizontal stringing, S-4414/*231*.

horloge de cheminée, EA.

horloge de parquet, EA/*régulateur*.

Horloger du Roy, CEA/*227*①.

horn, C-0254/*166*; C-2910/*210*; C-5117/*459*①; C-5127/*579*①; C-5156/*653*; C-5236/*706*; DSSA; EA/①; IDPF/*124*①; RGS/*37*; S-4461/*369*; S-4972/*249*.

Horn, Johann Christoph, EA.

horn beakers, C-0406/*129*.

hornbeam, SDF.

horn-beam wood, DADA.

hornbill (heting), C-2458/*397*.

hornbill ivory, CEA/*562*.

hornbills, C-5236/*1736*.

horn boxes, S-4461/*516*.

horn brisé fan, C-1603/*95*.

Hornby, Richd., Liverpool, C-2489/*126*.

horn case, EA.

horn chair, S-4804/*937*①.

horn covered box, C-2368/*183*①.

horned head-dress, CEA/*594*.

horned head-dress knop, EA.

Hornemann, Christian, EA.

Horner, Charles, C-2910/*213*.

horn form, S-4804/*230*①.

horn furniture, DADA/*Supplement*.

horn handled, C-0254/*62*.

Hornick, Erasmus, EA.

horn netsuke, C-1082/*139*.

horn nut, C-2569/*110*①.

horn of plenty, C-5114/*143*; EA/*cornucopia*; OPGAC/*224*①.

Horn of Plenty comet pattern, CEA/*469*①.

horns, C-1082/*24*; SDF.

horn snuff box, LAR83/*607*①.

horn tips, C-0270/*33*.

horn trumpet, C-1082/*14*.

horn weights, S-4802/*130*.

Höroldt, Johann Gregorius, EA; MP/*41*.

horology, CEA/*218*; EA.

Horowitz, Felix, C-5174/*48*.

Hörrer, Leopold, CEA/*241*①.

horror vacui, RTA/*28*.

hors concours, DATT; LP.

hors d'œuvre dish, IDC.

hors d'oeuvre dish, S-4461/*210*.

hors-d'oeuvre fork, C-1502/*66*.

hors d'oeuvres dish, C-5203/*270*①.

hors d'oeuvre set, C-0706/*190*.

hors d'oeuvres fork, C-0254/*201*; C-0270/*104, 169, 248*.

hors d'oeuvres server. C-0254/*290*.

hors-d'oeuvres set, C-0782/*42*.

horse, DADA; DSSA; IDC/①; SDF.

horseback, C-2204/*162*.

horse blanket, C-2546/*183*; S-3311/*39*; S-4948/*94*①.

horse bone, CEA/*562*.

horse-brass, CEA/*535*①; EA.

horse brass, ACD.

horsechair, ACD.

horse chestnut, C-0225/*1*.

horse chestnut design, C-0405/*106*.

horse dressing glass, DADA; SDF/① *cheval dressing glass*.

horse figure, EA.

horse finial, C-2398/*56*.

horse fire screen, DADA; SDF.

horse firescreen, FFDAB/*119*①.

horse fitting, C-2323/*129*.

horse-form, S-4810/*507*①.

horse glass, EA/*cheval glass*.

horsehair, C-2203/*210*; DADA; LAR82/*83*①; SDF.

horsehair-upholstered, C-2403/*66*①.

horse harness, C-1082/*107*.

'horse-hoof' knop, LAR83/*518*①.

horse-hoof knop, CEA/*594*.

Horseman, Stephen, SDF/*777*.

horseman's axe, C-2503/*15*.

horseman's hammer, CEA/*22*①.

horse screen, EA/*cheval screen*.

horseshoe, C-5157/*46*; OPGAC/*225*.

horseshoe-back, C-5156/*465*①; DADA.

horseshoe back, ACD; S-4965/*76*①.

horseshoe base, C-0403/*156*.

horseshoe dining table, SDF/①.

horseshoe drop-in seat, C-5116/*71*.

horseshoe-shaped, C-5116/*172*①; C-5157/*71*.

horseshoe shaped back, S-2882/*334*.

horse shoe shaped furniture, EA/ *kidney shaped furniture*.

horseshoe-shaped furniture, EA.

horseshoe-shaped toprail, LAR83/ *284*①.

horseshoe stretcher, S-3311/*250*.

horseshoe table, SDF/①.

Horsnail, George, LAR82/*222*①.

Horta, Victor, DADA/*Supplement*.

horticultural panel, C-5116/*160*①.

horticultural trophy, IDC.

Horton, W., C-2476/*57*.

Horton's, H. B., K-710/*119*.

hoseki zogan, EA/*zogan*.

Hösel, Erich, MP/*197*.

Hosenestel, Sabina, EA.

Hoskins, John, EA.

hosoban, C-5236/*947, 960*.

hoso-e, JIWA/*244*.

hospital floor lamp, C-5146/*163*.

Hoss, J., S-4947/*129*①.

Hossein Kermani, S-288/*31*①.

host drawer, C-5117/*342*①.

hotcake turner, S-4881/*486*①.

Hotchkiss and Schreuder, C-5153/*9*.

Ho-tei, IDC.

Hotei, DADA.

hot glass, CEA/*50*.

hot-glass sculpture, CEA/*483*①.

hot-milk jug, C-2398/*24*①; C-2427/ *102*①; C-5117/*169*; C-5174/*471*①.

hot milk jug, DADA; LAR83/*587*①.

hot-plate, C-5117/*160*.

hot-plate and stand, C-5117/*111*①.

hot-pressed paper, DATT.

hot printing, IDC.

hot table, DATT.

hotteur, IDC/①.

hot-water bottle, IDPF/*124*①.

hot-water compartment, C-5117/ *132*①.

hot water dish, S-4905/*78*.

hot-water jug, C-5117/*139*①, *229*①.

hot water jug, C-0254/*27*; DADA; LAR83/*588*①; S-3311/*746*①; S-4802/*425*①; S-4922/*25*①.

hot water kettle, S-4804/*205*.

hot water kettle-on-lampstand, S-4804/*178*①.

hot water kettle-on-stand, S-4804/ *70*①.

hot-water plate, IDC.

hot water plate, EA.

hot water pot, C-5005/*385*.

hot-water stand, C-2398/*83*①.

hot water stand, EA/*hot water plate*.

hot-water stand cover, C-5117/*6*.

hot-water urn, NYTBA/*226*①.

hot water urn, C-5157/*18*; S-3311/ *123*.

hot water vegetable dish, DADA.

Houbras, C. A., S-286/*433H*.

Houdon, C-5181/70①.

Houdon, Jean-Antoine, C-5224/ 317①; EA.

Hough, Samuel, C-5153/38①.

Hougham, Charles, EA/107① cream jug.

Hougham, Solomon, C-2487/116; C-2510/76.

Houghen, Solomon, C-5174/525①.

Houle, D. & C., LAR82/632①.

Houle, John, C-2510/80.

hound-handled, IDPF/124①.

hound-handled pitcher, DADA.

hound-handle pitcher, IDC.

hound sejant mark, EA.

hour-glass, DSSA; EA/sand-glass, sand-glass; SDF.

hourglass, S-3311/784①.

Hour Glass, C-2704/70.

hour-glass feet, S-4922/66①.

hour-glass form, C-5146/89C①; S-4922/66①.

hourglass form, C-0225/101A.

hour-glass ground, IDC.

hour-glass pattern, C-5117/123.

hour-glass pattern (on silver), C-5174/521①.

Hourglass pattern, C-0254/201; S-2882/1173.

hour-glass salt, EA.

hour-glass seat, EA; SDF/①.

hour-glass shape, C-5117/155①.

hourglass-shape, C-5191/13.

hourglass shape, S-4944/379①.

hour-glass shaped drum, CEA/549.

hour repeating clock, LAR83/190①.

hour striking, C-5157/33①.

hour teeth, CEA/607①.

house altar figure, C-5236/349①.

house board, C-1082/30.

housed, C-5191/261.

house flag of Richard Green & Co., C-2704/19.

household shrine, C-5156/782①.

house longhorn beetle, SDF.

house mark, EA.

House of Art, The, N.Y., C-2409/ 152.

house shrine, C-5236/851.

'house' teapot, LAR83/157①.

house urn, IDC.

housing, C-5005/213①; CEA/29①.

houx wood, DADA.

Howard, C-5191/154.

Howard, E. & Co., S-4927/98.

Howard, Edward, EA; EC2/91.

Howard & Co., C-0270/207①; S-3311/607.

Howden, Francis, C-5117/59.

Howe, Admiral, jug, IDC.

Howell, C-2904/154.

Hoyer, C-0906/360.

Höyer, Cornelius, EA.

Hoyss, Leopold, CEA/237①.

H.P. and PALMER, EA/Palmer, Humphrey.

H-pattern, C-2513/139①.

hruchi-bukuro, C-1082/139.

H. Salisbury & Co., S-4905/166.

H-shaped, C-0982/199.

H-shaped stretcher, EA.

hsiang, DADA.

Hsiang Yao kiln, C-5127/31.

Hsiang-yin, EA.

Hsiao-pai-shih, EA.

hsien, DADA; EA.

Hsing ware, IDC.

Hsin-yang, EA.

Hsiu-nei-ssu, CEA/118①.

Hsiu-nei-ssu ware, EA.

Hsi Wang Mu, DADA.

H-stretcher, C-5114/291①; C-5153/ 207①; S-4414/444①, 451①, 500①; S-4436/92; S-4812/83, 98①; S-4988/488①.

H stretcher, S-4414/*441*.
hsuan, IDPF/*167*.
Hsuan tê, CEA/*119*①.
Hsüan Tê, DADA; EA.
Hsuan-te period, JIWA/*343*.
Hsü Ching, EA.
HT, EA/*Tudor & Leader*.
HT & Co, EA/*Tudor & Leader*.
HT over TL, EA/*Tudor & Leader*.
hu, C-2458/*65, 212*; C-5127/*6*①;
 C-5156/*107*; DADA; EA/①; IDC;
 IDPF/*12.5*; S-4965/*118*①.
Hu, Han Dynasty, S-3312/*1285*①.
Huai-nan shih, EA/*Shou-chou ware*.
Huai style, EA.
Huai type, S-4965/*141*①.
Huai Valley, C-2458/*227*.
"Huai Valley" style, C-5236/*1685*.
Huali, C-2323/*155*.
hua marks, C-2323/*45*.
huan, EA; S-4963/*6*①.
huang huali, S-4965/*67*①.
Huanghuali, C-0279/*152*①; C-5156/
 *476*①; C-5236/*542, 1699*.
Huang Meiyin, S-4810/*57*①.
Huang-shan-shan, EA.
Huang-yen, EA/*Yü-yao*.
Huari, S-4807/*82*①.
hua shih, IDC.
Huating school, C-5156/*623*①.
Huaud family: Pierre the Elder,
 Pierre, Jean-Pierre, Aimé, Frères
 Huaud, EA.
Hubbard, Elbert, DADA/*Supplement*;
 K-710/*115*; NYTBA/*81*.
hubble bubble, DADA.
Huber, OPGAC/*225*.
Huber, Patriz, DADA/*Supplement*.
Hubert, David, London, C-2489/
 *249*①.
Hubertusburg, EA.
Hubertusburg castle stoneware
 factory, MP/*182*.

Hubertus group, MP/*117*.
huche, DADA/①.
Hudibras, IDC/①.
Hudson River school, DATT; LP.
hue, DATT; LP.
Huet, Christopher, DADA.
Huet, J-B, EA/*Beauvais tapestry*.
Huet, Jean-Baptiste, DADA.
hu form, LAR83/*160*①.
Hugenot cape commode, LAR82/
 *329*①.
Hugo, Häring, C-GUST/*38*①.
Huguenin, CEA/*693*①.
Huguenin, G.A., C-5174/*377*.
Huguenin, Jules, C-5174/*374*.
Huguenot silver, EA.
Huguenot style, S-4944/*234*.
hui ch'ing, IDC.
hui hui ch'ing, IDC.
Hull, DADA.
Hull, John, EA.
Hull, Pridgion, C-MARS/*244*.
Hulme, John, CEA/*205*.
Hultberg, Paul, DADA/*Supplement*.
human form, IDPF/*125*①.
human legs, C-5259/*552*.
human motifs, S-4948/*18*①.
humidor, C-0225/*80*; C-5005/*384*;
 C-5167/*206*; C-5239/*104*; S-4461/
 173.
humidor-cabinet, C-0279/*417*.
Humility, DSSA.
Hummel, OPGAC/*357*.
hummingbird, OPGAC/*225*.
humpback, C-2478/*51*.
humpen, EG/*92*①; IDPF/*126, 226*;
 LAR82/*429*①; LAR83/*171*①;
 NYTBA/*275*①; CEA/*451*;
 DADA; EA.
Humphrey, Richard, CEA/*674*①.
Humphreys, Jane, C-2704/*27*①.
Humphry, Ozias, EA.

Hundertwasser, Friedensreich, S-286/ *284.*

hundred antiques, DADA.

Hundred Antiques, the, IDC.

Hundred Antiques motif, S-4965/ *278*①.

Hundred Boys at Play motif, S-4965/ *284*①.

Hundred Butterflies, EC2/*31*①.

hung, IDC.

Hungarian green, DATT.

Hungarian stitch, SDF.

Hungarian work, DADA.

Hungary, CEA/*561.*

Hungary blue, DATT.

Hung Chih, DADA.

Hung-chou ware, EA.

Hunger, Christoph Conrad, EA.

Hunger, Conrad Christophe, MP/*45.*

Hung Hsi, DADA.

Hungmu, C-5236/*556*①.

hung with drops, C-2421/*7*①.

Hung Wu, DADA.

Hunt, John S., C-0406/*138*; C-0706/ *168*; C-5117/*221*①; EA/*95*①.

Hunt, Philip, SDF/*753.*

Hunt, William Holman, DADA/ *Supplement.*

hunt carpet, S-4948/*169A.*

Hunter, Dard, K-710/*115.*

Hunter, George II, S-3311/*719.*

Hunter, John, C-0906/*376.*

Hunter, William, CEA/*650*①.

huntercase, C-0270/*119.*

hunter-cased, LAR83/*212*①.

hunter cased, C-5117/*395*①.

hunter case movement, C-5117/*403.*

hunter's table, DADA.

hunter watch, EA.

hunting board, DADA; EA; SDF.

hunting-case, K-710/*118.*

hunting case, S-291/*104*①, *148*①; S-4802/*4*①.

hunting cased, LAR82/*237*①.

hunting case pocket watch, S-291/ *263.*

hunting case watch, S-4461/*301*; S-4802/*3*; S-4927/*47*①.

hunting chair, DADA; EA; SDF.

hunting design, OC/*161.*

hunting frieze, S-4965/*153*①.

hunting group, C-0249/*186.*

hunting horn, CEA/*549*; EA.

hunting horn mark, EA/*Caughley.*

hunting knife, C-MARS/*2*; MP/*34.*

hunting punchbowl, C-2513/*157*①.

hunting rug, DADA; OC/*161.*

hunting scene, C-2704/*184*; C-5170/ *34*①; EA; MP/*63.*

hunting sword, C-2569/*10*; C-MARS/ *11*; CEA/*25*①.

hunting table, SDF.

hunting tapestry, S-4972/*201*①.

hunting tapestry panel, S-3311/*85*①.

Huntley, Marchioness of, service, IDC.

Hunt & Roskell, EA; LAR82/*445*①; S-4927/*204.*

hunt sideboard, DADA/①.

huntsmen, C-2204/*162.*

hunt table, C-2498/*123*; S-4436/ *111*①; C-2403/*139.*

Hunzinger, G., NYTBA/*76*①.

Hunzinger, George, CEA/*404*①.

Huozhou kiln, S-4965/*217*①.

hu p'i, DADA.

Hurd, Jacob, C-5153/*39A*①; CEA/ *672*①.

Hurdals Verk, EA/*Scandinavian glass.*

Hurd: Jacob, Nathaniel, Benjamin, EA/①.

hurdy-gurdy, EA/①; LAR83/*510*①.

hurdy gurdy, C-5255/*36.*

hurdy-gurdy monkey organ, LAR83/*521*①.

Hurley, E.T., OPGAC/*344, 345.*

hurricane glass, DADA.

hurricane lamp, C-5203/*14*; DADA.

hurricane shade, C-0279/*210*; S-3311/*596*①.

Hurter, Joh., Schaffhausen, C-MARS/*178.*

hu shaped, C-5127/*293.*

husk, C-2357/*44*①; S-4843/*29*①.

husk border, IDC.

husk festoon, C-2398/*2*; C-2487/*122*; C-5174/*539*①; DADA/①.

husk ornament, EA.

husk pattern, C-1502/*108.*

husk rim, C-2202/*180.*

husks, SDF/①.

husk service, IDC/①.

husk swag, C-2421/*95*①.

Husseinabad, OC/*94*①.

Hussey Ltd, C-2476/*56.*

hutch, ACD; CEA/*322*①; DADA; EA; LAR82/*338*①; SDF.

Hutchins, E. W., New York, C-5189/*262*①.

Hutchinson, W., London, C-2503/*181.*

hutch press, SDF.

hutch-table, C-5114/*380*①.

hutch table, LAR83/*373*①; SDF.

Hutschenreuter, Carl Magnus, S-4992/*67*①.

Hutschenreuther, C-2493/*306*; C-5189/*38*; C-5191/*50.*

Hutton, John, DADA/*Supplement.*

hut urn, IDPF/*36.*

Hu type, JIWA/*314.*

Huygens, Christian, EA.

HW, CEA/*638*①.

H. Wilkinson & Co., S-3311/*588.*

hyacinth border, IDC.

hyacinth glass, EG/*144*①.

hyalith, CEA/*50*①; LAR83/*429*①; CEA/*455*①.

hyalith glass, EA/①.

Hyam Hyams, C-0406/*113.*

Hyams, Hyam, S-4944/*78.*

Hyatt, John, C-5117/*244*①.

Hyckes (Hickes): Richard, Francis, EA.

Hyde & Goodrich, S-3311/*621*①.

hydrangeas, C-0405/*48.*

hydrated lime, DATT.

hydraulic, DATT.

Hydraulic Machinery, C-2904/*199.*

hydria, DATT; IDC/①; IDPF/*126*; S-4807/*499*①; S-4973/*339*①.

hydrocérame, IDC.

hydrofluoric acid, IDC.

hydrofuge, DATT.

hydrographer's, C-2904/*61*①.

hydrolysis, DATT.

hydromel, DATT.

hydrometer, C-0403/*93, 106*; C-2608/*48*; C-2904/*82, 261.*

hydrophile, DATT.

hydrophobe, DATT.

hydroscopicity, LP.

hydrostatic balance, EA.

hygrometer, C-2368/*1*; C-2489/*32.*

hyllynge, SDF/*hilling.*

hylotrupes bajulus, SDF.

Hyman, J., York, C-2489/*188.*

hymn, C-2704/*187.*

Hyplar, DATT.

I

i, EA, *Ilmenau*; DADA.

IA, CEA/*639*①.

Iangel pattern, EA.

Iaogai, S-3312/*1173*.

I B, CEA/*153*①.

IB, EA/*Bottengruber, Ignaz, van den Bogaert, Jan.*

ibeji, S-4807/*417*.

Ibibio, C-1082/*66*.

I.B. LELARGE, EA/*Lelarge.*

Ibo, C-1082/*33*.

ibrik, EA.

ibriq, C-2357/*117*; C-2546/*145*.

ibzi, C-5174/*216*① cabins.

IC, CEA/*638*①, *639*①.

Icart, Louis, S-2882/*1398*①.

Icarus, DSSA.

ICD, EA/*Drentwett family.*

ice blue, C-2403/*210*.

ice box, K-802/*22*.

ice-bucket, C-2204/*9*.

ice bucket, C-0254/*9*; C-0706/*169*.

ice bucket (pail), EA/*wine cooler.*

icebucket, IDPF/*126*.

ice-chipped, C-5191/*420*.

ice-cream cup, IDC.

ice cream fork, C-0270/*169*; C-5114/*21*①; C-5153/*7*; S-4804/*28, 35.*

ice cream parlor chair, S-4804/*890*①.

ice cream server, S-4804/*4, 81*①.

ice cream spoon, C-5114/*16*; S-4804/*4.*

ice-cream spoon, C-0706/*160*.

iced tea, C-5239/*298*.

iced tea spoon, C-0270/*104*; S-4804/*35.*

iced teaspoon, C-0254/*201*.

iced-tea spoon, S-4461/*391*; S-4804/*28.*

ice finish, C-0225/*223*.

ice-glass, ACD; CEA/*418*①.

ice glass, DADA.

ice glass (crackle glass), DADA/*Supplement.*

ice glass, EA; EG/*73, 289*①; JIWA/*327*①; LAR83/*419*①.

ice-green, C-2403/*183*.

Icenser, S-3312/*1126*.

ice-pail, CEA/*186*①; IDC.

ice pail, C-2493/*143*①.

ice pale, C-1006/*216*.

ice-spade, C-5117/*33, 122.*

ice spade, S-4804/*195*①.

ice spoon, S-4804/*195*Ⓛ.

ice tongs, S-4804/*35*.

ice water pitcher, DADA/*Supplement*.

Ichilong, S-3312/*1360*.

ichirin zashi, IDC.

icicle-carved, S-4988/*408*Ⓛ.

icicle glass, C-0225/*348*.

icicle prisms, S-3311/*463*.

ICizhou jar, S-3312/*1312*.

Icoarse ware, S-3312/*1312*.

icon, C-5117/*342*Ⓛ; C-5174/*320*Ⓛ; C-5189/Ⓛ; C-5236/*369*Ⓛ; DATT/Ⓛ; LP; S-3311/*337*; S-4461/*183, 540*.

iconographic, JIWA/*11*.

iconographic ring, RTA/*53, 80*Ⓛ.

iconographic significance, JIWA/*88*.

iconography, C-5156/*310*Ⓛ; DATT/Ⓛ; JIWA/*6, 14*; LP; RTA/*16*; S-4972/*71*Ⓛ.

iconostasis, DATT.

icon-painting, RGS/*52*.

ICoromandel screen, S-3312/*1265*.

I.D., CEA/*631*Ⓛ.

ideal art, LP.

Idealism, LP.

idées reçues, OC/*136*.

IDehua figure, S-3312/*1378*.

identified work, MP/*62*.

idigbo, SDF.

idiom, DATT; LP.

idle-back, SDF.

ido, IDPF/*126*.

Ido tea bowl, EA.

Idoux, Claude, DADA/*Supplement*.

Ido ware, JIWA/*348*.

I. DUBOIS, EA/*Dubois, René*.

idyllic motif, MP/*131*.

IE, EA/*Emens, Jan, 345*.

I/F, CEA/*176*Ⓛ.

Ife style, C-1082/*42*.

Ifloriform, S-3312/*1237*.

IFukan, S-3312/*1131*.

if wood, DADA.

IG, CEA/*640*Ⓛ.

Iga, C-5236/*859*Ⓛ; JIWA/*348*Ⓛ.

IGandharan stone carving, S-3312/*1247*.

IGashgai, S-4847/*13*.

igel, DADA; EA.

IGeyao type cup, S-3312/*1360*.

Ignavia, DSSA.

igneous rock, DATT.

Ignorance, DSSA.

Igrotto, S-3312/*1206*.

I.H., CEA/*640*Ⓛ.

IH, EA/*Helchis*.

IH above RS, EA/*Hull, John*.

Ihiramakie, S-3312/*1173*.

IH over RR crowned, EA/*Hunt & Roskell*.

IHS, DSSA/Ⓛ.

I-Hsing, CEA/*123*Ⓛ.

I Hsing, CEA/*111*.

I-Hsing ware, S-4965/*305*Ⓛ.

IIW, EA/*Wurth, Ignaz Joseph*.

I. Jacobs Bristol, EA/*Jacobs, Isaac*.

ikakeji technique, JIWA/*150*Ⓛ.

ikat, C-2320/*128*; C-2478/*204*; C-2403/*194*; S-4847/*114*.

ikat chapan, C-2320/*126, 124*.

ikat panel, C-2320/*125*.

ikat strip, C-2357/*105*.

ikebana, C-5236/*884*.

ikon, CHGH/*46*.

Ikonnikov, S. M., C-5174/*278*.

Ilbery, C-2368/*210*Ⓛ.

Ilbery, Jamˢ., London, C-2489/*192*.

Ilbery, William, EA/*91 Chinese watch*.

Il Calotto, EA/*Callot, Jacques, Callot, Jacques*.

illuminated, C-5005/*360*Ⓛ.

illuminated manuscript, DADA/Ⓛ.

illuminated paper, DADA.

illuminating, JIWA/*23*.

illumination, DATT/①.

illuminator, C-2904/*198*①.

illusion, JIWA/*10*; LP.

illusionism, DATT; LP.

illusionistic device, C-2555/*22*①.

illusion of depth, JIWA/*10*; MP/*65*.

illustration, C-5236/*951*; DATT; LP.

illustration board, DATT; LP.

illustrative, LP.

illustrator, JIWA/*61*.

Ilmenau, DADA; EA; MP/*164*.

ilmenite, DATT.

IM, EA/*Mennicken family*.

image, C-5236/*811*①; IDC.

Image, Selwyn, DADA/*Supplement*.

image pattern, IDC/①.

imagery, JIWA/*75*.

image toy, IDC.

imagiers, DATT.

imaginary character, C-2704/*119*.

imagines à vestir, DATT.

imari, C-5127/*253*①; C-5259/*36*;
CEA/*209*; IDC; C-0782/*12*;
C-2458/*126*; C-5156/*803*; C-5236/
821; CEA/*193*①; DADA; EA/①;
LAR82/*134*①; S-4905/*28*.

Imaria pattern, EA/*brocade pattern*.

Imari palette, C-2486/*93*①.

Imari pattern, EA/*brocade pattern*.

Imari plate, S-4461/*422*.

Imari ware, ACD.

imbecile sleeve, C-0604/*89*; C-2501/
125.

Imbert, C-2364/*32*①.

imbrauderers' chair, SDF.

imbrex, IDC.

imbricated, DADA; IDC.

imbricated nef pendant, RTA/*107*①.

imbricated ornament, SDF.

imbricated pattern, C-5173/*58*①.

imbrication, DATT/①; LP/①.

imbuya, DATT; SDF.

Imhof, Hieronimus, CEA/*628*①.

Iminiature garniture, S-3312/*1397*.

imitating cinnabar, C-2458/*405*.

imitating ivory, C-2458/*374*.

imitating realgar, C-2458/*408*.

Imitationen, MP/*59*.

imitation porcelain, NYTBA/*169*①.

imitation signet-ring, RTA/*80*①.

imitation stone, DATT.

imitation vermilion, DATT.

imitative, JIWA/*10*.

imitative realism, JIWA/*10, 275*.

imitative technique, JIWA/*58*.

immediacy, LP.

immortal, EA; C-2458/*125*①; IDC.

I Mo-tzu, CEA/*123*①.

I move with the times, C-2904/*17*.

impacted, C-5236/*353*.

impaling, C-2487/*69*.

impasto, CEA/*133*①, *209*; DATT;
EA; IDC; LAR82/*121*①; LP.

impasto blue, IDC.

impasto red, IDC.

impasto technique, JIWA/*132*①.

impasto texture, JIWA/*59*①.

imperfection, S-4992/*17*①.

imperial, C-5127/*99*①; C-5239/*241*.

imperial armorial, S-4802/*72*①.

Imperial Boosey and Hawkes,
C-0906/*278*.

Imperial Bushel, C-2904/*37*.

imperial dining table, SDF.

Imperial Dragon medallion, S-288/
*15*①.

Imperial eagle, C-5174/*246*.

Imperial Eagle decoration, RGS/
*79*①.

imperial five-toe dragon spandrel,
S-2882/*111*.

Imperial Glass, NYTBA/*310*.

Imperial Glass Company, DADA/
Supplement.

Imperial Glass Company, Bellview,
Ohio, OPGAC/*165.*

imperial green, DATT.

Imperial Hardstone Workshops,
C-5117/*347.*

Imperial porcelain factory, Moscow,
EA/*185*①.

Imperial Porcelain Factory, Saint
Petersburg, EA.

Imperial Queen pattern, S-4804/*36.*

imperial ware, DADA; EA/*Ch'ai
ware.*

Imperial XXV, C-2476/*34.*

imperial yellow, C-5156/*106*①;
DADA; IDC; EA/①.

implement, C-5114/*191.*

implied centre-point, OC/*329.*

import mark, C-0406/*83*; C-2202/*36*;
C-5005/*226*①.

imposition, JIWA/*6.*

impost, SDF.

impressed, C-2458/*170*; C-5005/
*202*①; IDC; S-4992/*7*①.

impressed factory mark, S-3311/*871.*

impressed horse, EA/*Fürstenberg
porcelain factory.*

impressed mark, C-0225/*269*;
C-1006/*151*; C-2409/*64*; C-2502/
84; C-5114/*116.*

impressed seal mark, C-5156/*137.*

impression, C-0225/*410*; C-0249/*18*;
C-5156/*913*; C-5236/*935*; S-286/
73, 231.

impression before letters, S-286/*234,
236, 238, 337.*

Impressionism, DATT; LP.

Impressionist, JIWA/*6.*

impressionist artist, JIWA/*9.*

impressionistic, C-0225/*32*①.

Impressionist pottery, JIWA/*14.*

impression of reality, MP/*111.*

imprimatur, C-0249/*33.*

imprimatura, DATT; LP.

imprinted, C-0225/*412*; S-4972/
*169*①.

improvisation, LP.

Imulti-knopped stem, S-3312/*1256.*

I.N., CEA/*69*①.

Inaba, LAR83/*220*①.

Inaba saku, CEA/*561*①.

Inca pottery, IDC.

Ince, William, SDF/*753.*

Ince, William and Mayhew, John,
DADA; EA.

Ince (William) and Mayhew (John),
ACD.

Ince and Mayhew, C-2357/*56*①.

incense boat, DADA; EA.

incense box, DADA.

incense-burner, C-0782/*225*; IDC.

incense burner, C-5127/*51*; C-5156/
*43, 95, 449*①; C-5191/*375*;
C-5234/*120*①; C-5236/*375*①;
CEA/*624*①; EA; EC2/*33*①;
IDPF/*126*①; LAR82/*51*①;
S-4965/*223*①.

incense burner and cover, C-2458/
244.

incense burning accessories, DADA/
①.

incense-holder, JIWA/*102.*

incense holder, C-5173/*13*①.

incised, C-0225/*3, 75*; C-0249/*345*;
C-0782/*229*; C-1082/*64*; C-2458/
*1*①; C-5127/*100*; C-5153/*36*①;
C-5156/*9*①; IDC; S-286/*308*;
S-4972/*168*①; S-4992/*3*①, *13*①.

incised brass blade, C-1082/*83.*

incised decoration, ACD; EA.

incised design, C-5146/*54*①.

incised enamel, RGS/*40.*

incised frieze, S-2882/*807*①.

incised lacquer, SDF.

incised line, C-2704/*132.*

incised ornament, SDF.

incised paterae, C-5114/*375*①.

incised pattern, S-4461/*521*; S-4843/*94*①.

incised planet symbol, EA/*Bow Porcelain Manufactory.*

incised reeded rim, S-2882/*986.*

incised relief, DATT.

incised ring, C-5114/*112.*

incised signature, C-2409/*62.*

incised stem, EA; EG/*139*①.

incised twist, CEA/*434*①.

incised-twist stem, CEA/*423*①.

incised veining, C-5005/*210*①.

incising, DADA.

inclined plane, CEA/*608*①.

inclined plane clock, EA/①.

inclinometer, C-2904/*175.*

inclusion, C-2324/*135*; C-2458/*305*; C-5127/*297*; C-5236/*330*①; JIWA/*92*①, *304*①.

incrusting, C-5005/*236.*

incunabula, DATT.

incurvate, C-5259/*544.*

incurvate stile, S-4905/*466*①.

in-curved, S-3311/*412*①.

incurved, C-5117/*148*①; C-5157/*18*; C-5173/*18*①.

incurved angle, C-2398/*70*①; S-4922/*4*①.

incurved grip, S-3311/*653.*

incurved mouth, S-4965/*178*①.

incurved neck, S-2882/*932*①, *937*①, *974*①, *1070*①; S-4905/*176*①; S-4922/*24*①.

incurved rim, LAR83/*535*①.

incurved side, RTA/*64*①; S-2882/*1059, 1165*①; S-4802/*386*①.

incurved square, C-5116/*28.*

incurved triangular base, C-5116/*106.*

incurving, C-5127/*330*①.

incurving foot, C-5156/*495*①.

incurving handle, CEA/*659*①.

incurving lip, C-5156/*74*①, *160.*

incurving scroll handle, C-1502/*30.*

incuse, C-5174/*65.*

incused, S-4802/*137*①.

indentation, C-2403/*202.*

indented, C-2403/*200.*

indented angle, S-4802/*386*①.

indented corner, C-2458/*352*; IDC.

indented form, IDPF/*127*①.

indented oviform, C-5167/*137*①.

indented rim, C-5127/*250.*

independent decorator, IDC.

independent jump seconds hand, C-2489/*236*①.

independent seconds, S-4802/*42*①.

index, CEA/*612.*

India back chair, SDF.

India embroidery, DADA.

India flowers, EA/*indianische Blumen.*

'India' goods, ACD.

india ink, JIWA/*66*①; S-286/*393*; DATT; LP.

india ink drawing, JIWA/*9.*

india ink technique, JIWA/*162.*

Indian, CEA/*312*①, *509*; DADA.

Indiana, Robert, S-286/*50.*

Indiana Glass Co., OPGAC/*193.*

Indiana limestone, DATT.

Indiana Tumbler and Goblet Co., CEA/*478*①.

Indian 'Aubusson', OC/*312.*

Indian beadwork, C-2704/*120.*

Indian blue, DATT.

Indian bone knife, C-1082/*128.*

Indian brass spoon, C-1082/*110.*

Indian bronze figure, C-1082/*110.*

indian bust, CEA/*313*①.

Indian chair, SDF.

Indian chintz, C-1506/*107.*

Indian design, NYTBA/*87*①.

Indian flowers, DADA.

'Indian' goods, ACD/*'India'.*

Indian goods, SDF.

Indian Hangings, EA/*163*①.

Indian Hatchet, CEA/*287*.

Indian Heriz, OC/*242*①.

indianische Blumen, C-2427/*94*; EA/
①; MP/*62*; CEA/*209*; IDC/①;
CEA/*173*①; MP/*502*.

indianische Blumendekore, MP/*472*.

Indian jail carpet, EA.

Indian lake, DATT.

Indian laurel, SDF.

Indian madder, DATT.

Indian mask, SDF.

Indian pattern, S-2882/*1360*.

Indian pedestal, C-0706/*128*.

Indian purple, DATT.

Indian red, DATT; LP.

Indian rosewood, C-0982/*156*; SDF.

Indian rug, C-0906/*56*.

Indian shaped, C-2202/*142*.

Indian silver greywood, SDF.

Indian sporting pattern, IDC/①.

Indian squail, CEA/*694*①.

Indian teakwood, C-2402/*101*.

Indian Tree motif, NYTBA/*87*①.

Indian tree pattern, IDC.

Indian water buffalo, LAR82/*37*①.

Indian yellow, DATT; LP.

India Oriental rug, DADA.

India paper, DATT.

India pattern blunderbuss, C-2503/
120.

India plant, CEA/*174*①.

India rubber, DATT.

indicator disc, CEA/*251*①.

indicator hand, CEA/*264*①.

indiennes, DADA.

indigo, C-2357/*135*; C-2403/*187*;
DATT; LAR82/*549*①; LP; OC/
*26*①; S-288/*11*①.

indigo-blue, S-4847/*39*.

indigo border, C-2357/*154*.

indigo field, S-3311/*2*.

indigo thread, C-2704/*4*.

Indiscreet Harlequin, the, IDC/①.

individualistic formal approach,
JIWA/*27*.

individual posture, JIWA/*16*.

Indo-Chelsea carpet, S-4948/*179*①.

Indo-Chinese, C-2704/*160*.

Indo Esfahan, S-288/*37*①.

Indo-Isfahan carpet, EA.

Indo-Isfahans, OC/*82*.

Indo-Isphahan, S-4847/*261*①.

Indo-Isphahan carpet, S-4948/*192*①.

Indo-Mir, OC/*57, 57*①.

Indonesian, C-MARS/*128*.

Indonesian knife, C-1082/*113*.

Indo-Persian, C-2489/*17*①.

Indo-Persian design, OC/*278*.

Indo-Persian Mogul carpet, EA.

Indo-Portuguese, C-5156/*453*.

Indo Sarouk rug, C-0279/*6*.

Indo-Savonnerie carpet, S-4461/*847*.

Indo-Tabriz, S-4948/*170A*①.

industrial art, JIWA/*149*.

I. NEALE HANLEY, EA/*Neale &
Co.*.

inert pigment, DATT.

infilled, S-3312/*1135*①; S-4965/
*244*①.

infilled ground, EA/*Afghan carpet*.

in-filling, OC/*238*.

in-fill pattern, OC/*123*.

infusorial earth, DATT.

inglaze decoration, IDC.

ingle-bench, SDF.

ingle-nook, SDF/①.

Inglis, Robert, EA/*369*①.

Ingoldstadt, CEA/*624*①.

ingot-shape, C-2458/*326*.

Ingraham, Elias, EC2/*92*①.

ingrain, DADA.

ingrain carpet, EA.

inhalator, IDC/①.

inhalor, C-2904/*295*.

inherent vice, DATT.

initial, C-2398/*17*; C-5117/*146*; NYTBA/*213*; S-4922/*4*①.

initialled, S-4843/*3*①; S-4905/*50*①.

initial ring, RTA/*94*.

ink, C-5153/*63*①, *177*①; C-5236/*564*; DATT.

ink bottle, C-1502/*60*; CEA/*56*①.

ink box, C-5236/*443*①.

ink-cake, C-2513/*73*.

ink-dab painting, JIWA/*88*.

ink drawing, S-286/*170*①.

ink-horn, C-0403/*33*.

inkhorn and pen, DSSA.

ink on paper, C-5156/*278*.

ink on silk, JIWA/*85*①.

ink painting, JIWA/*380*.

ink-pot, C-2437/*17*①.

ink pot, C-0254/*174*①.

inkpot, C-2398/*32*; EA/*inkwell*.

ink-screen, DADA/① *screen*.

ink sketch, C-5156/*279*.

ink-slab, IDC/①.

ink slab, C-5236/*810*.

ink stamp, S-286/*69*.

ink-stand, C-2427/*86*①; CEA/*183*①.

ink stand, C-1502/*60*; C-5127/*109*①; S-4461/*244*; SDF.

inkstand, C-0706/*57*; C-2398/*32*; C-5117/*208*; C-5173/*14*; C-5239/*91*; CEA/*647*①; DADA; EA; LAR83/*584*①; NYTBA/*245*; S-4804/*10*, *103*①; S-4881/*464*①.

inkstandish, IDC.

ink-stone, C-2513/*49*.

inkstone, S-4810/*253*①.

ink-stone box, DADA.

ink wash, JIWA/*58*.

inkwell, C-0254/*40*; C-0982/*46*; C-1006/*44*; C-5174/*228*①; C-5239/*62*; EA; IDPF/*128*①;

S-3311/*262*①; S-4804/*103*①; S-4922/*29*①.

inlaid, C-0225/*341*; C-1082/*144*; C-2402/*8*; C-2458/*221*①; C-5005/*316*①; C-5114/*351*①; C-5116/*16*①, *33*; C-5153/*87*; C-5156/*183*, *387*; C-5239/*115*; S-4436/*14*; S-4461/*22*; S-4804/*833*①.

inlaid base molding, C-5114/*243*①.

inlaid beading and stringing, S-2882/*669*①.

inlaid boulle, S-3311/*434*①.

inlaid box, C-5114/*246*.

inlaid coil bead, EA/*beads and marbles*.

inlaid decoration, C-0249/*346*; IDC.

inlaid filigree, C-5234/*31*①.

inlaid fitted drawer, C-0249/*449*.

inlaid fluting, C-5116/*13*①.

inlaid frame, C-5114/*350*①.

inlaid frieze, S-2882/*774*, *813*①.

inlaid frieze drawer, S-2882/*262*.

inlaid lacquer, CEA/*571*.

inlaid metal shape, CEA/*517*①.

inlaid sans traverse, C-2364/*69*①.

inlaid star, C-5114/*391*①.

inlaid stringing, LAR82/*281*①; LAR83/*329*①.

inlaid swags, C-5114/*333*①.

inlaid ware, EA/*zogan*.

inlaid with boxwood lines, C-0982/*19*.

inlay (furniture), ACD.

inlay, C-2388/*88*; C-5114/*274*, *366*①; C-5127/*161*; CEA/*224*①, *300*, *366*; DADA; DATT/①; IDPF/*232*; SDF.

inlaying, EA; RTA/*24*①.

Inman, Evodias, C-5117/*102*①.

Inman, Henry, EA.

in memoriam picture, DADA.

inner case, C-5117/*460*.

inner frame, JIWA/*21*.

Innes, Robert, S-4922/*62*①.

Inness, George, NYTBA/*304*.

Innocence, DSSA.

innovators and developers, LP.

inn sign, CEA/*533*①; EA/*sign*.

in-painting, S-286/*529, 530*.

inpainting, DATT; LP; S-286/*433E*.

in pretence, C-2487/*73*.

in profile, JIWA/*162*.

in relief, C-5127/*25A*.

inro, C-1082/*136*; C-5127/*628*;
C-5156/*700*; C-5236/*779*; CEA/
561.

inrō, DADA/①.

inro, EA; IDC; LAR83/*458*①.

inrobako, S-4829/*95*①.

inro watch, EA.

inscribed, C-2458/*116*①; C-5005/
203; C-5239/*50*.

inscribed signature, C-5005/*210*①.

inscription, C-1603/*62*; C-2414/*6*①;
C-2458/*168*; C-5153/*63*①; OC/*31*;
S-4922/*2*①.

inscription band, RGS/*17*①.

inscription cartouche, S-4796/*208*①.

inscription panel, S-2882/*154*①.

inscription rug, S-4948/*80*.

inscriptions, IDC.

inscriptions on furniture, DADA/
Supplement.

in-scrolled leg, C-2478/*144*①.

in-scrolled support, C-2421/*103*①;
C-2437/*48*①.

insect, IDC.

insect motif, S-4965/*151*①.

insect wax, DATT.

insert, C-5239/*336*; LP/①.

insertion, C-1506/*66*.

inset, C-0225/*101A*; C-2402/*10*;
C-5116/*134*①, *163*①; C-5239/*256*;
FFDAB/*79*.

inset cabochon jade clasp, S-291/
*110*①.

inset-leather, C-0279/*423*; C-5157/
*107*①, *135*①.

inset-leather top, C-5116/*61*.

inset panel seat, C-0982/*44*.

inset-rounded corner, C-5114/*386*①.

inset rounded corner, C-5114/*366*①.

inside-painted, C-1082/*155*; C-2458/
*356*①.

insigna, C-0706/*123*.

insignia of Orders, RGS/*80*.

insikush, S-4796/*22*; S-4847/*10*.

insikush motif, S-4847/*38*①, *47*.

in situ, DATT; LP.

INSOLT, K-802/*14*.

inspiration, LP.

inspissated oil, DATT.

In St Petersburg/Of the Brothers
Kornilov, EA/*Kornilov factory*.

instrument for the salon, CEA/*600*.

instrument maker, NYTBA/*260*.

instrument of the Passion, DSSA.

insufflation, IDC.

insulating board, DATT.

insulating ring, C-5153/*3*①.

intaglio, ACD; C-0225/*312*; C-2332/
38; C-5116/*147*①; C-5127/*311*①,
*432*①; C-5239/*327*; CEA/*209*,
*395*①, *502*, *524*; DADA; DATT;
EA.

intaglio (Tiefschnitt), EG/*105*.

intaglio, EG/*289*①; IDC; MP/*502*;
S-286/*39, 41*; S-3311/*896*①;
S-4843/*528*①.

intaglio-carved, C-5005/*362*①;
S-2882/*1390*.

intaglio carved, S-4414/*207*①.

intaglio carving, JIWA/*304*.

intaglio-cut glass, S-4804/*673*①.

intaglio portrait-head, RTA/*127*①.

intaglio print, DATT.

intaglio-rilevato, DADA.

intaglio rilevato, DATT.

intaglio stamp, RTA/*11*①.

invalid feeding bowl, LAR83/*541*①.

invalid's chair, C-2370/*29*①; C-2498/*67*.

invalid's mechanical chair, CEA/*349*①.

invar-rod pendulum, C-2489/*103*.

invenit et fecit, CEA/*261*①.

inventory mark, C-0782/*9*; S-4955/*87*; S-4972/*588*.

inversely-arched crest, C-5114/*395*①.

inverse negative pattern, JIWA/*183*.

inverted baluster form, LAR83/*555*①.

inverted baluster neck, C-2324/*6*.

inverted baluster stem, LAR83/*451*①.

inverted base, C-0225/*100*.

inverted bell-form, S-2882/*1271*.

inverted bell form, S-4414/*275, 345*; S-4972/*429*.

inverted bell top, LAR83/*180*①.

inverted bell-top case, EA; S-4414/*388*①.

inverted bell top case, C-2368/*68*①; S-4988/*412*①.

inverted cone shape, C-5146/*118*①.

inverted cup plate, CEA/*464*①.

inverted fern, OPGAC/*225*.

inverted frieze, C-2388/*97*.

inverted microscope, CEA/*611*①.

inverted mushroom foot, C-5167/*274*①.

inverted pear form, S-2882/*1232*; S-4414/*266, 343*①; S-4804/*27*①.

inverted pear-shape, LAR83/*576*①; S-2882/*1009*.

inverted pear shape, S-2882/*1196*①; S-4414/*281*.

inverted pear-shaped, C-0706/*122*.

inverted pyriform, IDC.

inverted pyriform vessel, S-4414/*204*①.

inverted rim, C-2414/*41*①; LAR83/*423*①; S-4804/*51*; S-4992/*1*①.

inverted serpentine top, LAR83/*309*①.

inverted shading, JIWA/*16*.

inverted shell splat, C-5170/*188*①.

inverted stem, CEA/*423*①.

inverted tapering circular, C-5114/*221*①.

inverted teardrop shape, S-2882/*1393*①.

inverted thumbprint pattern, NYTBA/*302*①.

inverted top form foot, S-2882/*660*.

inverted trumpet form, C-2910/*2*.

inverted trumpet shape, LAR83/*74*①.

invest, DATT.

investment, DATT.

investment camicia waste mould, EA.

investment casting, RTA/*141*.

Invicta, S-4927/*170*.

in Vienna taste, S-4947/*175*.

invisible chair, SDF.

invitational exhibition, LP.

inward-scrolled foot, S-2882/*669*①.

Io, DSSA.

iodine number, DATT.

iodine scarlet, DATT.

iodine value, DATT.

Iole, DSSA.

Ionian ware, IDC.

Ionic, C-2402/*55*.

ionic capital, C-0249/*351*; C-0982/*60*; C-2478/*178*; S-4992/*23*①.

Ionic column, C-2398/*1*①.

Ionic column candlestick, LAR83/*550*①.

ionic naiskos, S-4973/*132*.

ionic order, SDF.

Ionic wall clock, LAR82/*236*①.

IOushak, S-4847/*292*.

IP, EA/*Pennis, Johannes, Pieterson, Jan*.

IP above EW, EA/*Wakelin, Edward*.

IPD, EA/*Drentwett family.*

Iphigenia, DSSA.

Ipocket thermometer, C-2489/*27.*

IR, EA/*273*①.

Iralian Fars, LAR82/*252*①.

Iranian faience box, IDPF/*148.*

Irian pattern, S-2882/*1312*①.

iridesced, C-5127/*5*①; C-5236/*1716*①.

iridescence, C-2458/*12;* DADA; DATT; EG/*27*①.

iridescent, C-5005/*393*①; C-5146/*89;* C-5239/*19, 133;* NYTBA/*304;* S-4461/*43.*

iridescent coat, CEA/*417*①.

iridescent colour, JIWA/*106.*

iridescent enamel, RTA/*138.*

iridescent glass, C-GUST/*44;* DADA/*Supplement;* S-3311.

iridescent glaze, EC1/*83.*

iridescent lustre, IDC, *stained lustre.*

iridescent spinach glaze, C-5156/*2*①.

iridized, C-0225/*331*①.

IR in an oval, EA/*Richardson, Joseph.*

iris, DSSA, .

iris and herringbone, OPGAC/*194.*

iris glaze, S-3311/*869*①.

iris green, DATT.

Irish, C-2421/*35*①, *131.*

Irish baluster measure, EA.

Irish carpet, EA.

Irish Chain, C-2704/*74.*

Irish Chippendale, C-2402/*61;* DADA; SDF.

Irish cross, DATT.

Irish cut glass, CEA/*446*①.

Irish Delft, S-4843/*64*①.

Irish delftware, IDC.

Irish embroidery, DADA.

Irish glass, EA/①; EG/*143*①; NYTBA/*282*①.

Irish goblet, C-5117/*51.*

Irish gold and silver, EA.

Irish linen sheet, C-2704/*138.*

Irish measure, EA.

Irish point, DADA.

Irish Provincial, LAR83/*563*①.

Irish rose point, DADA.

Irish School, C-2332/*87.*

Irish spirit measure, CEA/*586*①.

Irish stitch, DADA.

Irish table-spoon, C-5174/*561*①.

Irish tablespoon, C-5117/*65.*

Irish yew, SDF.

Iris pattern, C-0254/*310.*

Irminger, Johann Jacob, MP/*33.*

iroe, S-4928/*150*①.

iroe takazogan, C-1082/*83, 119.*

iroe togidashi, C-5156/*741*①.

iroko, SDF.

iron, C-1082/*92;* CEA/*527, 684;* DATT; EG/*257;* JIWA/*178*①; S-4972/*140*①.

Iron Age, DSSA; IDPF/*23*①.

iron black, DATT.

iron blade, C-1082/*28.*

iron blue, DATT.

iron-bound, C-0249/*362.*

iron bound, C-0982/*92A.*

iron brown, DATT.

iron-brown spot, EA/①.

iron clock, EA.

iron grill, S-288/*25*①.

ironing board, SDF.

iron lock, C-2402/*159.*

iron mechanical, FFDAB/*55.*

iron pigment, DATT.

iron-red, C-0782/*5;* C-1006/*51;* C-2323/*118;* IDC; S-288/*9*①; S-3311/*350;* S-4804/*282.*

iron red, C-5127/*26;* DADA.

iron-red decoration, EA.

iron-rust, C-5236/*1576.*

iron rust bottle, S-3312/*1371.*

iron rust glaze, IDC.
irons, DATT; S-4436/27①.
iron slip, C-5156/792①.
iron-splashed, C-5236/439①.
iron-spot, C-2458/44.
iron spot, C-5236/431①; MP/472.
ironstone, C-0249/208; C-1006/11; C-2502/47; IDPF/39; LAR82/97①.
ironstone china, CEA/150; DADA, supplement; EA; IDC; ACD.
ironwood, CEA/562.
iron yellow, DATT.
IR or JR, EA/Roettiers, Jacques.
irregular, C-5127/385.
irregular border, S-4414/229①.
irregular curl, C-0906/293.
irregular curve, DATT.
irregularity, IDPF/9①.
irregular junction, IDPF/149①.
irregularly shaped oval, RTA/162①.
irregularly sized piece, C-2704/50.
irregular sequence, JIWA/205.
irridescent plastic, C-0403/29.
Isaac, DSSA.
Isaac Brokaw, EC2/90①.
isabella, DATT.
Isabelle Campan, DADA.
Isabey, Jean-Baptiste, EA/①.
IS above W, EA/Wurth, Ignaz Joseph.
Isaiah, DSSA.
Iscreen, S-3312/1173.
I: Sellars & C. Price Hydrographers, CEA/608①.
Iserlohn, S-4972/335.
Iserlohn box, EA.
Ise-Yamada artist, S-4928/80.
Isfahan, C-2320/120; C-2388/142; C-5236/1712; OC/275①, 277①.
Isfahan carpet, EA/①.

Isfahan rug, C-2357/136; C-2388/186; C-2403/159.
ISH, EA/Mortimer & Hunt.
I-shaped handle, MP/486①.
ISH crowned, EA/Hunt & Roskell.
ishime, DADA; S-4928/164①.
ishime shakudo ground, S-4928/112①.
ishizuri technique, JIWA/6.
isinglass, DATT.
Islamic, C-5114/29①; CEA/131①, 487①, 604①; S-4461/169.
Islamic glass, DADA/①; EA/①.
Islamic grain measure, IDPF/158①.
Islamic influence, C-5167/156①; MP/470①.
Islamic painting, LP.
Islamic pottery, C-0782/152; EA; IDC.
Islamic style, C-5153/13①.
Isle of Man table, SDF.
islimis, OC/79.
'islimis', OC/276.
isnic style, C-2324/9.
Isnik, CEA/135①.
Isnik pottery, EA/Berlin Faience factories; IDC/①; EA/①.
Isnik style, C-2323/95; C-2409/93.
isocephaly, DATT.
isochronism, EA; S-4802/93; S-4927/24.
isolating varnish, DATT.
isomeric color, DATT.
isomers, DATT.
isometric projection, DATT.
isosceles triangle, C-5117/351.
Ispahan, C-0906/33; CEA/84①, 90①; DADA; LAR82/546①.
Ispahan carpet, ACD; EA/Isfahan carpet.
Ispahan Morris, C-1506/115①.
Ispahan rug, LAR83/526①.
Isphahan, S-4948/113.

Isphahan carpet, S-4461/*846*.

Isphahan hunt rug, S-4796/*165*①.

Isphahan rug, S-4796/*175*①.

Israeli, C-5174/*15*①.

Istemcup, S-3312/*1256*.

istoriato, ACD; CEA/*130, 134*①, *209*; DADA; EA; IDC/①; LAR82/*183*①.

istoriato dish, C-2427/*254*.

istoriato painting, EA/*Casa Pirota*.

istoriato ware, NYTBA/*132*①.

Istrian marble, DATT.

isu, CEA/*575*.

Itakamakie, S-3312/*1173*.

Italian Baroque, S-2882/*776A*①; S-3311/*470*①.

Italian blue, DATT.

Italian Burmese, CEA/*474*①.

Italian ceramic, EA/①.

Italian clock, EA/①.

Italian comedy, S-4905/*10*①.

"Italian Comedy" Charger, S-4843/*55*①.

Italian Comedy figure, CEA/*174*①; IDC.

Italian comedy subject, DADA.

Italian contemporary arts and crafts, DADA/*Supplement*.

Italian contemporary ceramics, DADA/*Supplement*.

Italian earth, DATT.

Italian giltwood, C-0982/*60*.

Italian gold and silver, EA.

Italian High Baroque, MP/*95*.

Italianizer, DATT.

Italian lace, DADA.

Italian Maggiolini style, C-0982/*38*.

Italian maiolica, EA/*Angarano, Italo-Moresque ware*.

Italian maiolica decoration, EA/*alla porcellana*.

Italian maiolica dish, C-1006/*10*.

Italian majolica, DADA.

Italian market, C-2493/*252*.

Italian modern furniture, DADA/*Supplement*.

Italian neoclassical, S-2882/*356, 367*①, *375*①, *417*; S-4436/*46*; S-3311/*520*①.

Italian ochre, DATT.

Italian pink, DATT.

Italian quilting, SDF.

Italian Renaissance, LAR83/*313*①; S-2882/*521*①.

Italian rococo, S-2882/*373*①; S-3311/*499*①.

Italian Rococo style, S-2882/*799*.

Italian tapestry, EA.

Italiante, C-2357/①.

Italian walnut, SDF.

Italian white-glazed, C-1006/*190*.

italic, DATT.

Italo-Moresque ware, EA.

itame hada, C-5236/*1827*.

Itazza, S-3312/*1145*.

ITD, EA/*Dextra, Jan Theunis*.

Ithaca Calendar Clock Co., K-710/*119*.

Itobacco leaf, S-3312/*1397*.

itō sukashi, DADA.

Itsekiri, C-1082/*70*.

ittobori, CEA/*562, 575*.

Iusupov, Prince Nicolai Borisovich, EA.

Ivanov, Adrian, C-5174/*259*①.

Ivan Shagin, C-5117/*295*; S-3311/*674*.

Ives, CEA/*696*①.

Ives, Chauncey, CEA/*244*①.

Ives, Joseph, CEA/*244*①; EA; EC2/*91*.

I. Vickers, EA/*Vickers, John*.

IVL, EA/*van der Laarn, Jan*.

ivorene, C-5239/*64*.

ivories, C-1082; JIWA/*8*.

J

J. A. Bauer Pottery, Los Angeles, California, EC1/85.

Jabberwocky pattern, C-2493/25①; IDC/①.

Jabez Daniell, S-3311/784①.

Jablonc, CEA/451.

jabot, C-1304/238.

jacaranda, DATT; SDF.

jacaranda wood, DADA.

jacarandawood, LAR83/343①.

jacaranta brown, DATT.

jack, CEA/556; DADA; EA.

Jack, George, DADA/Supplement.

Jackeman, Jos., London, C-2489/201①.

jacket, C-1506/61.

jacket mount, S-291/201①.

jackfield, DADA; ACD.

Jackfield and Whieldon, S-4843.

Jackfield ware, EA/①; IDC/①.

jack-in-the-box, CEA/697.

Jack-in-the-cellar, EA.

jack-in-the-pulpit vase, S-3311/921①; C-5239/344①.

jacks, CEA/697.

Jackson, C-5173/58①.

Jackson, Joseph, C-5174/528; LAR82/586①.

Jackson, Orlando, CEA/655①.

Jackson, Walter, C-5117/136①.

jackstraws, CEA/697.

Jacob, DSSA.

Jacob, George, NYTBA/60①.

Jacob, Georges, ACD; CEA/379①; DADA; EA/①; S-4955/69①.

Jacob-Desmalter, EA.

Jacob-Desmalter et Cie., CEA/382①.

JACOB D. R. MESLEE, EA/Jacob, Georges.

Jacobean, C-0982/68; C-1407/44; CEA/323①, 529; DADA/①; S-4461/568; SDF.

Jacobean, late, DADA/①.

Jacobean design, C-5167/219A①.

Jacobean furniture, EA/①.

Jacobean style, C-0982/21; C-2402/5.

Jacob Frères, CEA/382①.

JACOB FRERES RUE MESLE, EA/Jacob, Georges.

Jacobite, CEA/432①; LAR82/179①.

Jacobite emblem, EA/Jacobite glass.

Jacobite glass, ACD; DADA; EA/①.

Jacobite pottery, ACD.
Jacobite ware, IDC.
Jacobite wine glass, CEA/430①.
Jacob Philipp, EA/*Drentwett family*.
Jacobs, Bristol, NYTBA/*281*.
Jacobs, Isaac, EA.
Jacobs, John, C-2487/*163*.
Jacobs, Lazarus, EA.
Jacobsen, Arne, DADA/*Supplement*.
Jacob's ladder, OPGAC/*225*.
Jacob's ladder design, C-2704/*90*.
Jacob's ladder foliage, EA/*Jacobite glass*.
Jacob's staff, EA/*cross-staff, cross-staff*.
Jacobus de Steur Fecit Leyden, C-2904/*281*①.
Jacobus Helchs fecit, EA/*Helchis*.
Jacobus kannetje, IDC.
Jacot, Henri, C-2368/*33*①.
Jacot dual stem-wind, C-2489/*236*①.
Jacottet, C. F., C-5117/*413*.
Jacot tool, C-0403/*121*.
Jacquard, DADA/*Supplement*.
jacquard coverlet, LAR82/*544*①.
Jacqueline, IDC.
jacquemart, C-2368/*142*; C-5117/*468*①; EA/*jack*; LAR82/*241*①.
Jacquemart, Jules, S-286/*70*.
Jacquemart watch, C-MARS/*186*①.
Jacques, Symphorien, EA.
Jacquet-Droz, Henri-Louis, EA.
Jacquet-Droz, Pierre, EA.
jade, C-1082/*83, 157*; C-2458/*307*; C-5146/*66*; C-5156/*81*①; DATT; S-4461/*394*.
jade, Chinese, DADA/①.
jade glass, EG/*200*.
jade green, S-288/*23*①.
jadeite, DADA; JIWA/*304*①; S-291/*211*①, *244*①; S-3312/*1219*①; S-4810/*167*①; S-4965/*106*①.
jadeite pendant, S-291/*143*.

jade mounted, C-2458/*275*①.
jade pendant, S-291/*191*①.
jadite, S-4461/*375*.
Jaeger, C-2489/*204*.
Jaeger-Le Coultre, C-5167/*205*.
Jagd, C-2486/*64*①.
Jagddeckel, MP/*476*.
Jagd service, IDC.
jagging wheel, LAR83/*462*①.
J-A H, EA/*Frankenthal*.
Jahn, Louis H., CEA/*204*①.
J.A. Hoyt, S-4905/*167*.
Jaipur, OC/*305*.
Jaipur style, C-2368/*208*①.
jakobakanne jug, IDPF/*129*①.
Jalisco, S-4807/*167*①.
jallar, OC/*30*.
Jallot, Léon and Maurice, C-5167/*213*①.
jalousie, DADA.
Jaloux, le, IDC/①.
Jamaica ebony, SDF.
Jamaican mahogany, SDF.
jamb, DADA.
jambeau, DADA.
jambiya, C-2569/*1*; DADA.
James, Edward, DADA.
James Dixon & Sons, C-0406/*24*; C-5203/*166*.
James I, C-5117/*103*①.
James I flagon, CEA/*597*①.
James II, C-5117/*294*①.
James II period, C-5173/*50*.
James II style, C-0249/*351*.
James Kent Ltd., C-2910/*108*.
James Powell & Sons, EA/*Whitefriars Glassworks*.
Jamnitzer, H., CEA/*626*①.
Jamnitzer, Wenzel, CEA/*625*①.
Jamnitzer, Wenzel, Abraham, Hans, EA.
jam-pot, IDC.

jam pot, C-5127/*384*; IDPF/*129*①.

jam spoon, C-0254/*76, 190*; C-0270/*166*; C-5174/*272*.

Jan Bernadis Vrythoff Shage, S-4972/*438*.

Jangalarik, OC/*142*①, *176*①.

Janle, C-5191/*174*.

Janna, S-4944/*101*.

Jans (Jansens), Jan, Jean, EA.

Jan Steen flagon, EA.

Jan Steen jug, EA.

janus, S-4807/*453*; DSSA.

Janus figure, IDC.

janus head, C-1082/*50*.

Janvier, Antide, EA.

japan, DATT; EA/① *European lacquer*; IDC; SDF; CEA/*561*.

japan color, LP.

Japan earth, DATT.

Japanese, LAR83/*220*①.

Japanese applied art, JIWA/*10*.

Japanese Arita pattern, C-2458/*192*①.

Japanese brushes and ink, JIWA/*58*.

Japanese brush style, JIWA/*59*.

Japanese celadon, EA.

Japanese clock, EA/①.

Japanese cloisonne, C-1082/*84*.

Japanese contemporary pottery, DADA/*Supplement*.

Japanese crackled celadon, C-0782/*13*.

Japanese design, JIWA/*8*.

Japanese ebony, C-1082/*184*.

Japanese embroidery, DADA.

Japanese enamel, JIWA/*12*.

Japanese Export, NYTBA/*166*.

Japanese fan, DADA/①.

Japanese fret border, IDC.

Japanese gold lacquer, C-5156/*56*.

Japanese iconography, JIWA/*87*.

Japanese imitation Shonsui, IDC.

Japanese Kaga-type, C-0782/*74*.

Japanese knife, C-1082/*83*.

japanese lacquer, DADA; C-2555/*74*①; CEA/*63*①; DATT; EA/①.

Japanese metal-work, EA/①.

Japanese Nanga painting, C-5156/*637*①.

Japanese netsuke, JIWA/*9*.

Japanese oak, SDF.

Japanese Palace, MP/*77*.

Japanese period, DADA.

Japanese porcelain, C-5156/*803*; EA.

Japanese pottery, EA.

Japanese pottery centre, EA/*Seto*.

Japanese Satsuma type, C-0782/*44*.

Japanese screen, S-4965/*57*①.

Japanese Service, MP/*448*.

Japanese silver, C-5156/*145*.

Japanese spirit, NYTBA/*170*.

Japanese sword, DADA.

Japanese sword-guard, EA/①.

Japanese sword guard, JIWA/*12*.

Japanese sword mount, DADA/①.

Japanese taste, C-2493/*176*.

Japanese tea ware, JIWA/*5*.

Japanese time measurement, EA/①.

Japanese ware, JIWA/*355*.

Japanese watch, EA.

Japanese wood-block print, DADA.

Japanese woodcut, JIWA/*8*.

Japanese woodcut technique, JIWA/*142*①.

Japan fan pattern, IDC.

japanische figuren, MP/*131*; EA.

Japanism, DADA/*Supplement*; DATT.

Japan nacré, S-286/*254*.

japanned, C-0982/*165*; C-2478/*5*; C-2904/*45*; C-5116/*46*①; LAR83/*198*①, *300*①; S-4436/*93*①; CEA/*303*; S-2882/*278*①, *286*①, *348*①, *707*①; S-4804/*876*①.

Japanned box, C-5153/*84*; S-4414/
406.

japanned frame, C-2421/*1*①.

japanned metal ware, EA.

japanned stand, C-0403/*176.*

Japanned vitrine cabinet, S-4414/
*465*①.

japanned ware, IDC.

japanning (metal), ACD.

japanning (wood), ACD.

japanning, DADA; S-3311/*110*①;
SDF.

Japan paper, JIWA/*46*①; S-286/*24,
31, 88, 130.*

Japan pattern, EA; IDC; S-3311/*350.*

Japan wax, DATT.

Japonaiserie, CEA/*662*①; IDC.

Japon ancien, S-286/*346, 347, 388.*

Japonism, DATT.

Japonisme, JIWA/*5, 6.*

Japon nacré, S-286/*16.*

Japy factory, EA/①.

Japy Freres, LAR82/*206*①.

Japy Frères et Cie, C-5189/*191*①.

Jaquet Droz, P., CEA/*222*①.

Jaquet-Droz, Pierre, CEA/*685.*

jar, C-0782/*47, 201*; C-2414/*25*;
C-2458/*1*①; C-5114/*150*; CEA/*49,
449*①; DSSA; IDC; IDPF/*131*①;
S-4905/*38*①; S-4972/*125*①.

jar and cover, C-2458/*194*①.

jardinière, ACD.

jardiniere, C-0249/*208*; C-1502/*57*;
C-2402/*21.*

jardinière, C-2458/*52.*

jardiniere, C-2910/*133*; C-5005/
*283*①; C-5127/*71*①, *77.*

jardinière, C-5156/*51*①.

jardiniére, DADA/①.

jardinière, EA/①; IDC/①.

jardiniere, IDPF/*131*; K-711/*125*;
LAR82/*189*①; S-2882/*840*①.

jardinière, S-4507/*48*①; S-4804/*707*;
SDF/①; CEA/*172*①.

jardinieres, C-0279/*149*; C-0782/*86.*

jardiniere stand, LAR83/*353*①.

jarlet, C-0782/*27*; C-2323/*5*; C-2458/
26; C-5236/*861*; S-3312/*1128*;
S-4461/*482*; S-4965/*304*①.

jarrah, SDF.

jarretiere bracelet, LAR82/*499*①.

Jarry, Jacques, EA.

Jarves, Deming, EA; NYTBA/*294.*

Jarves, Demming, CEA/*465*①.

Jarvis, John Wesley, EA.

jasmin cup, IDC.

Jason, DSSA.

Jaspée ware, IDC.

jasper, C-1006/*13*; C-2458/*342*①;
C-5117/*357*①; CEA/*502*; DADA;
DATT; EA; EG/*290*; IDC/①;
JIWA/*310*; K-710/*109*; LAR82/
*65*①; LAR83/*167*①; S-4810/
*118*①; S-4843/*555*①; S-4992/
*57*①; C-2360/*201*; CEA/*150.*

jasper cameo, C-2332/*38*; CEA/*513*;
FFDAB/*131*①.

jasper copy, C-2502/*150.*

jasper-dip, LAR82/*186*①.

jasper dip, K-710/*109.*

jasper-ground, LAR82/*448*①.

jasper jug, C-1006/*154.*

jasper plaque, C-2502/*15.*

jasper-ware, RTA/*114*①.

jasper ware, DADA; DATT; EA/①.

jasperware, C-5116/*38*; C-5157/*8*;
C-5259/*76*; FFDAB/*16*①.

Jasper ware, ACD; IDPF/*200*; MP/
171.

jaspis porzellan, IDC.

jatte à glace, IDC.

jatte à punch, IDC.

jaune brillant, DATT.

jaune jonquille, CEA/*184*①; DADA;
EA; IDC; S-4992/*14*①.

Javanese style, C-2910/*142*.

Javelle water, DATT.

jaw, CEA/*25*①.

jay, EA/*Jacobite glass*.

JBCO, EA/*Odiot,
Jean-Baptiste-Claude*.

J. B. Jones & Co., S-3311/*629*.

J. B. Owens Pottery, Zanesville,
Ohio, EC1/*85*.

J. CANABAS, EA/
Canabas,(Gengenbach.

J. D. and heart device, EA/*Ducrollay,
Jean*.

JE, EA/*Emes, John*.

Jeannest, Pierre Emile, EA.

Jeannette Glass Co., OPGAC/*190*.

Jean Poulard Prad & Company,
CEA/*172*①.

J.E. Caldwell & Co., S-4905/*159*.

Jekyll, Thomas, DADA/*Supplement*.

Jelliff, John, DADA/*Supplement*.

Jellinge-style decoration, RTA/*46*①.

jelly glas, DADA.

jelly glass, EA.

jelly mold, IDPF/*131*①; S-4461/*163*.

jelly mould, C-2502/*135*; CEA/
*535*①; IDC/①.

Jenkins, John, SDF/*754*.

Jenkins, Paul, S-286/*51, 432*.

Jenkins & Jenkins, S-4905/*176*①.

Jennens, J. C. & Son, LAR82/
*214*①.

Jennens and Bettridge, EA.

Jennings, Walter, K-710/*115*.

Jenny Lind bottle, EA.

Jensen, OPGAC/*12*.

Jensen, Georg, C-0270/*99*; C-5005/
223; C-5167/*150*; C-5203/*142*①;
C-5239/*106*; DADA/*Supplement*.

Jensen, Gerreit, ACD; DADA; EA;
SDF/*754*.

Jensen style, C-0254/*200*.

J.E. OEBEN, EA/*Riesener,
Jean-Henri*.

jequitiba, DATT; SDF.

Jeremiah, DSSA.

jerkin, LAR83/*229*①.

Jerome, Chauncey, CEA/*245*①; EA.

jersey, C-0604/*18*; DADA.

Jersey City Porcelain and
Earthenware Company, CEA/*205*.

Jersey City Pottery Company,
DADA/*Supplement*.

Jersey cream jugs, C-2202/*19*.

Jersey Glass Company, EA.

Jersey type, CEA/*586*①.

Jersy Porcelain and Earthenware
Company, DADA.

Jerusalem cross, DATT.

Jervis Pottery, Oyster Bay, New
York, EC1/*85*.

Jessop, G., C-2493/*171*.

jester, DSSA; MP/*60*.

jester's cap, MP/*468*①.

jesters' mask, C-5117/*246*①.

jester's mask decoration, C-2555/
*18*①.

Jesuit china, ACD.

Jesuit porcelain, EA/①.

Jesuit ware, C-2458/*134*①; DADA/
①; IDC/①.

jet, C-1506/*12*; CEA/*522*①, *562*;
DATT; EA.

jet enamel, EA/*Worcester*.

jet-enamelled, IDC.

jet stud, S-2882/*834*.

jeu de l'écharpe, IDC.

Jever faience factory, EA.

jewel, C-0225/*101A*; C-2704/*36*;
C-5117/*434*; C-5146/*160*①; CEA/
*540*①; DSSA.

jewel casket, C-0406/*11*; C-5146/
*105B*①; C-5239/*98*; LAR82/*67*①;
RGS/*67*①.

jewel coffre, C-0249/*232*; C-0279/ *233*.

jewel drawer, SDF.

jeweled, S-4461/*70*; S-4992/*30*①.

jeweling, S-4804/*298*①.

jewell cabinet, CEA/*341*①.

jewelled, C-5005/*399*①; C-5117/ *315*①; C-5236/*1623*.

jewelled decoration, DADA.

jewelled decoration (in ceramics), EA.

jewelled decoration, IDC/①.

jewelled hammer pivot, C-5117/ *437*①.

jewelled pallets, C-5116/*47*.

Jewelled Porcelain, CEA/*184*①.

jewelled train, C-5117/*484*①.

jewelled vase, S-4947/*21*①.

jewellers' cement, RTA/*182*①.

Jeweller's Rouge, CEA/*445*①.

jewellery, CEA/*509*; IDC/①; JIWA/ *14*.

jewellery design, JIWA/*92*.

jewel-like effect, JIWA/*304*.

jewelling, C-2486/*156*.

jewelling (in watchmaking), EA.

7-jewel movement, C-5117/*396*①.

jewel movement, S-4461/*308*.

jewel point, DATT.

jewelry box, S-4461/*502*; S-4804/ *120*①, *122*①.

jewelry (jewel) casket, LAR83/*544*①.

jewelry stand, S-4461/*40*.

jewel terminal, S-4414/*244*①.

Jewett two-door sedan, LAR83/ *659*①.

Jewish ceremonial box, RGS/*31*①.

Jew's porcelain, ACD.

J.F.L., EA/*Leleu, Jean-François*.

J. F. LELEU, EA/*Leleu, Jean-François*.

J-F OEBEN, EA/*Oeben, Jean-François*.

J.G., C-2704/*118*.

J.G. and mullet, EA/*George, Jean*.

J.H., C-0405/*18*.

J.H. RIESENER, EA/*Riesener, Jean-Henri*.

jia form, S-4810/*439*①.

Jiajing, C-5127/*54*; C-5156/*78*①, *105*①; S-3312/*1335*①.

Jiajing period, S-4965/*241*①.

Jiang Bo-fu (Shiying), S-4965/*305*①.

Jianyao type bowl, C-5127/*20*.

Jiaqing, C-2458/*116*①, *161*.

jib-crook, EA/*chimney-crane*; SDF.

ji chi mu, S-4965/*74*.

jigger, IDC; S-4461/*219*.

jima year, C-2458/*76*①.

jimigaki, DADA.

Jin Dynasty, S-3312/*1316*①; S-4965/ *228*①.

jingdezhen, C-5127/*115*.

jingle, CEA/*549*; S-4963/*14*①.

Jizhou, C-5127/*19*; S-4965/*229*①.

jizuri seal, C-5156/*1056*; C-5236/ *1429*.

J. J. Kändler, EA/*Meissen porcelain factory*.

J L, CEA/*152*①.

J.L.F. DELORME, EA/*Delorme, Jean-Louis-Faizelot*.

JLO, EA/*Outrebon, Jean-Louis-Diendonné*.

J.M.E., EA.

JME, CEA/*371*①.

J. Mo, EA/*Mô, Christophe, Jean*.

J. NADAL. LAINE., EA/*Nadal, Jean Réné*.

JNR, EA/*Roettiers, Jacques-Nicolas*.

Joan L, EA/*Lutma, Joannes the Younger*.

Job, DSSA.

jobbing blacksmith, CEA/*532*①.

jockey cap caddy spoon, LAR83/ *581*①.

jockey's scale, LAR82/*305*①.

joey glass, DADA.

Jogan, DADA.

Johann Christoph, EA/*Drentwett family.*

Johanneum, IDC/①.

Johanneum mark, C-5156/*114*①; EA.

John, W. D., C-2493/*1.*

John Broadwood and Sons, C-1407/*108.*

John Brown Model Sharps carbine, CEA/*41*①.

John Goddard foot, SDF.

John Hardman & Co., EA/*Hardman, Iliffe & Co..*

John Kilner & Sons, CEA/*55*①.

John Manton & Son, London, C-2503/*211*①.

Johns, Jasper, S-286/*288*①.

Johnson, C-2489/*143.*

Johnson, Garret, EA/*Jensen, Gerreit.*

Johnson, Garrett, SDF/*754.*

Johnson, Glover, CEA/*646*①.

Johnson, Joseph, C-5174/*406*①.

Johnson, Matthew, CEA/*467*①.

Johnson, Samuel, EA.

Johnson, Thomas, ACD; DADA; EA/①; S-4988/*433*①; SDF/*754.*

Johnson, William, C-5170/*31*①.

Johnston, Alexander, S-4944/*296*①, *366.*

Johnston, Thomas, CEA/*392*①; DADA.

John the Baptist, DSSA.

John the Baptist motif, C-5174/*455*①.

John Winter & Co., C-2487/*122*; S-3311/*766*①.

join, C-5114/*94*①; S-286/*95, 269*①.

joined, C-5005/*330*①; CHGH/*58*; DADA; S-4905/*417*①; SDF.

joined chair, C-0249/*385*; SDF/①.

joined chest, C-0249/*407*①; SDF.

joined chest of drawers, C-0249/*399*①.

joined construction, SDF/①.

joined dresser, LAR83/*327*①.

joined furniture, EA/①.

joined lappet, C-1506/*173*①; C-2501/*59.*

joined node, C-5127/*41.*

joiner, ACD; DADA; SDF.

Joiner of London, CEA/*31*①.

joinery, SDF.

joinery technique, CEA/*300.*

joint, C-5117/*139*①; CEA/*406*; S-4905/*217*①.

jointed, S-4905/*361*①.

joint-pin, C-2476/*65.*

joint stool, C-0982/*312*; C-2382/*71*; C-2402/*5*; CEA/*390*①; DADA/①; EA/①; LAR83/*357*①; S-3311/*95*①; SDF/①.

Jokar, OC/*94*①.

Jokwe, C-1082/*6, 32.*

Joliffe, EA.

jolly, IDC.

jolly-boat, C-5117/*3*①.

Jomon period, IDPF/*148*; C-5236/*842*①.

jomon ware, DATT; IDC.

Jonah, DSSA.

Jones, C-2904/*23.*

Jones, A. E., C-0706/*218.*

Jones, Cha., London, C-2489/*164.*

Jones, George, C-1006/*44*; S-4947/*189.*

Jones, George Greenhill, C-2487/*104*; LAR82/*581*①; S-4944/*396.*

Jones, Henry, ACD; C-2489/*94A*①; EA.

Jones, Inigo, ACD; DADA; EA/*Axminster carpet*; SDF/*754.*

Jones, John, & Co., CEA/*31*①.

Jones, Owen, DADA/*Supplement.*

Jones, Robert II, C-2487/*73.*

Jones, W., EA/270①.

Jones, William, DADA; SDF/754.

Jones, W. & S., C-MARS/194.

Jonge Morisenshooft, Het, CEA/ 142①.

jonquil, OPGAC/345.

J.O. pinxit, EA/① Osterspey, Jakob.

Jordaens, Jakob, EA.

Jorel, A., OPGAC/13.

J or John Rose & Co., EA/Coalport.

jorum, IDC.

Josan, C-2388/147; C-2546/156.

Josan rug, LAR82/547①.

Josan Sarouk, C-5323/29, 139.

Josan Sarouk mat, S-4461/823.

Joseph, DSSA, .

Joseph jug, DADA.

Joseph Stevens & Co. Ltd., C-2904/ 194.

Joshagan, C-5189/395; S-4847/330①.

Joshagan (Jushaghan) carpet, EA.

Joshaghan, CEA/93①; S-4847/205.

Joshaghan carpet, S-3311/14①.

Joshaghan rug, DADA.

Joshaqan, OC/14①, 83, 265.

Joshua Heath blue and white, C-2502/115.

joss holder, C-5236/1795①.

joss stick holder, C-2323/14; C-5127/ 23; C-5236/1793①.

joss-stick holder, C-0782/102; C-2513/370; IDC; S-4905/86①.

Joubert, François, EA.

Joubert, Gilles, C-2555/64①; DADA; EA/①.

Joubert l'aîné, EA/Joubert, Gilles.

Joubert & Petit, C-5005/358①.

Jouet, Simon, C-5117/251①.

Jouette, Jean Joachim, C-5117/ 186①.

jour, DADA.

jour, à, IDC.

Jourdain, William, S-4972/430①.

journal, S-4881/①.

journeyman, DATT.

Jover & Son, London, C-2503/155.

Joyce, R., C-2409/64.

Joye, Mont, C-5239/158.

joyned, CEA/406; SDF/joined.

joyned stool, SDF/① joint stool.

Jozan, OC/288①.

J.P., EA/Petit, Jacob.

J. P. Cutts & Sons, C-2904/176.

J. Poncione Colombo & Co., C-2368/ 17.

J.P. Robinson & Son, CEA/466①.

J.R., EA/Ridgway, John, William.

J R, C-2704/26.

J.REMMEY/MANHATTAN WELLS/NEW YORK, EA/ Remmey, John.

J. Rogers & Son, EA/Rogers, John, George.

JS, CEA/137①.

J. Sang Inv:et:Fec:, EA/Sang, Jacob.

J. & S. Ritchie & Co., C-0405/5.

J. Swift & Son, C-2904/114.

Ju, CEA/111, 116①.

juan ts'ai, EA.

Juan-ts'ai, IDC.

jubako, C-5236/806①; LAR82/63①.

Jucht, Johann Christoph, MP/166.

Jüchtzer, Christian Gottfried, MP/ 171.

Judaica, C-5174/1195①.

Judas hair, DATT.

Judas Iscariot, DSSA.

Judge of Hell, IDC/①.

judor, OC/67.

'judor' pattern, OC/67①.

jue, C-2414/11①; C-2458/146①; C-5236/380; S-4965/114A①.

jufti knot, EA; OC/20, 21①, 102.

K

K, EA/*Königsberg, Kelsterbach.*

kaapsche schotel, CEA/*209*; EA/ *Cape plates.*

Kaapsche schotels, EA/*Cape plate.*

Kaba-Karaman, DADA.

Kabaseqar, OC/*210*①.

Kabistan, DADA.

Kabistan rug, ACD.

Kabuto, LAR82/*38*①.

kabuto gane, DADA.

Kabutrahang, OC/*285*①.

kabuzuchi, DADA.

kachina doll, S-4807/*257*①.

kacho-e, C-5156/*923.*

Kaendler, J.J., CEA/*169.*

Kaendler, Johann Joachim, MP/*52.*

kaeri, C-5236/*1828.*

kaeri asashi boshi, C-5236/*1825.*

kaeri fukashi boshi, C-5236/*1827.*

kaeri-tsuyoshi, C-5236/*1833.*

Kaffeemaschine, IDC.

Kaga baluster vase, C-0803/*25, 25.*

kagami, S-4829/*29*①.

kagami-buta, CEA/*565.*

kagamibuta, C-5236/*730*; CEA/*575*; S-3312/*1054*①; S-4829/*29*①; S-4928/*111*①.

Kaga shaped, C-0782/*26.*

Käge, Wilhelm, C-2409/*94.*

kagi, CEA/*561.*

kago-ami, DADA.

Kaibutsu, CEA/*566*①.

Kaimuri Ferahan, OC/*340*①.

Kairaku-en ware, DADA.

Kaiseri, C-2388/*171*; C-2403/*167*; C-2478/*243.*

Kaiserteller, DADA; EA.

kaishebe, DADA/*Supplement.*

Kajikawa and hogen Haruaki, CEA/ *574*①.

Kajikawa saku, CEA/*561*①, *574*①.

Kakaberu, OC/*63*①.

Kakaberu Kurdish rug, OC/*120.*

kakemono, C-5156/*852*①; C-5236/ *1531*; DADA/①; JIWA/*9, 133.*

kakemono-e, C-5236/*952.*

kaki, C-5236/*878*①.

Kakieman, C-2204/*153.*

kakiemon, ACD; C-5236/*814*; CEA/ *63*①; DADA/①; C-1582/*53*; C-2360/*73*; C-2427/*113*①;

C-5156/805①; CEA/169, 209;
LAR82/139①; LAR83/98①.
Kakiemon, Sakaida, EA.
Kakiemon bowl, S-3312/1116①.
kakiemon dish, C-5127/365.
Kakiemon palette, C-2486/102①;
S-4905/7①.
Kakiemon porcelain, IDC/①.
kakiemon style, S-4461/139; C-0803/
147, 147; C-5236/1857; EA/①;
IDC/①; LAR82/103①; LAR83/
69①.
kakiemon taste, C-5156/806①.
kakihan, CEA/575; LAR83/459①;
S-3312/1078①; S-4928/45①, 72①.
kakuban, C-5156/892; C-5236/1062,
1411.
Kala-i-Zal rug, OC/25①.
kalamet, SDF.
Kalandrin, J. F., C-5174/481.
Kalardasht, OC/236①.
kalasa, C-5234/19①, 84①; S-4810/
278A①.
kalathos, IDC.
kalgan jasper, C-5174/227.
kali, DADA.
kalian, IDC.
kalpis, IDC.
kalsomine, DATT.
kaltmalerei, CEA/502.
Kalt-Maletei, EA/cold painting.
Kaltykov, Ivan, C-5117/310.
Kam, Gerri, CEA/141①.
Kamakura, C-5236/845; DADA; EA.
Kamakura period, JIWA/157;
LAR82/79①; C-5156/765①.
Kamakura style, C-5156/768①.
Kamares style, IDC.
kamashimo zashi, DADA.
kamassi, SDF.
kambun design, JIWA/215.
Kamenický Senov, CEA/451.
Kameyama, EA.

Kam: Gerrit, Pieter, David, EA.
kamigata-e, C-5156/922.
kamigatame, C-5236/948.
Kamigata School, C-5156/903①.
Kampen, C-2487/37.
kamptulicon, SDF.
Kamukura period, JIWA/16.
kanagai, CEA/573①, 575.
kanaki, IDPF/136.
kanamono, DADA.
Kandler, Charles, CEA/649①; EA/
Kandler, Charles Frederick.
Kandler, Charles Frederick, EA.
Kandler, Charles I, S-4922/77①.
Kandler, Frederick, C-2487/101;
C-5174/605; S-4922/63①.
Kändler, J. J., C-2486/150.
Kändler, Johann Friedrich, EA.
Kändler, Johann Joachim, ACD; EA.
Kändler figure, IDC.
Kaneie school, JIWA/182.
kane stone, DATT.
kang, IDC/①.
kangaroo sofa, SDF/①.
k'ang furniture, DADA.
K'ang Hsi, DADA; EA/①.
K'ang-hsi, CEA/122①.
Kang Hsi, C-0782/4.
K'ang Hsi Bowl, S-4843/280①.
K'ang-hsi period, JIWA/315.
K'ang Hsi period, EA/clair de lune.
Kang Hsi period, S-4853/47①.
kang ji, S-4965/67①.
Kang table, C-5156/494; C-5236/549,
1648.
Kangxi, C-0279/147①; C-2323/44①;
C-2458/202; C-5127/62; C-5156/
68; C-5236/493; LAR82/106①,
140①; LAR83/101①; S-3312/
1337.
Kangxi Doucai, LAR83/80①.
Kangxi Dynasty, C-2458/84①.

Kangxi style, C-5236/*832*①.
Kanō, DADA.
Kano school, C-5236/*932*①.
Kanō school, JIWA/*133*.
Kano School, C-5156/*899*.
Kansu Province, CEA/*113*①.
kantharos, DATT; IDC/①; IDPF/
136; S-4807/*505*①.
kanzashi, C-5127/*623*①; JIWA/*190*.
kaolin, ACD; CEA/*110, 184*①, *209*;
DADA; DATT; EC2/*22*; IDC; LP;
MP/*502*.
kaolin clay-barbotine enamel
technique, JIWA/*130*①.
kaolin or china clay, EA.
Kapell, Heinrich, CEA/*23*①.
kapsel clay, MP/*28*.
Kapuzinerbraun, EA/*dead leaf
brown*; IDC.
Karabagh, C-2388/*197*; C-2403/*176*;
C-5189/*365*; C-5323/*12*①, *43*①;
DADA; S-288/*8*①; S-4847/*174,
297*.
Karabagh long rug, S-3311/*70*①.
Karabagh mat, S-4461/*789*.
Karabagh prayer rug, S-4461/*775*;
S-4796/*60*①.
Karabagh rug, S-4796/*59*.
Karabagh runner, S-4796/*101*;
S-4948/*26*.
Karabah carpet, EA.
Karachopt Kazak rug, S-4796/*40*.
kara dagh, DADA.
Karadja runner, S-3311/*11*.
Karagashli, C-5323/*5*.
Karagashli carpet, EA.
Karagashli rug, S-288/*2*①; S-4796/*2*;
S-4948/*42*①.
kara-geuz rug, DADA.
Karaja, OC/*197*①, *226*①.
Karaja rug, ACD; S-4461/*805*.
Karaja runner, S-4461/*757*; S-4796/
104.

kara-kane, DADA.
karako, C-0782/*1*.
Karasz, Mariska, DADA/*Supplement*.
Karatchoph Kazak rug, S-3311/*68*①.
Karatsu, C-5156/*787*; C-5236/*853*;
DADA; IDC.
karatsu-type, C-5156/*828*①.
Karatsu ware, EA; JIWA/*348*①.
karaya, DATT.
kara-zuri, JIWA/*278*.
Karcher, Jan and Nicholaus, EA/
Carcher.
Karcher: Jan, Nicholaus, EA.
karchesion, IDC.
Karelian, C-5174/*281*.
karhula-iittala, DADA/*Supplement*.
Karlsbad, CEA/*455*①.
Karner, Th., C-5189/*44*.
Karpinsky, Michail M., C-5174/*41
assaymaster*.
Karrusel, CEA/*255*①.
karrusel watch, C-2489/*238*①; EA/
tourbillon.
karyobinga, CEA/*566*①.
kas, C-0279/*341*①; CEA/*398*①;
DADA/①; EA/①; LAR82/*339*①;
SDF.
kåsa, RGS/*84*.
kasa, S-4972/*387*①.
Kasak carpet, EA/*Kazak carpet*.
kasane, DADA.
Kasaoka, DADA/*Supplement*.
Kashan, C-0906/*23*; C-2320/*138*;
C-2388/*144, 187*; C-2478/*238*;
C-5156/*443*; C-5189/*399*; C-5236/
1592; DADA; OC/*124*①, *295,
296*①.
Kashan carpet, C-2403/*202*; EA/①.
Kashan medallion, OC/*299*①.
Kashan rug, ACD; C-0279/*26*①;
LAR82/*546*①; LAR83/*529*①;
S-4796/*171*①.
Kashan style, OC/*299*①.

Kashan tile, EA.

Kashān ware, IDC.

Kashgar, DADA.

kashi, DADA.

kashira, C-5236/*1826*; DADA.

kashkul, C-5236/*1742*.

Kashmar, OC/*292*①.

kashmir, C-1702/*109*; DADA; OC/
*124*①, *137*, *137*①, *305*①.

Kashmir embroidery, S-4796/*98*.

kasse, EA/*kas*; SDF/*kas*.

Kassel, CEA/*451*; EA/*Cassel*.

Kassler yellow, DATT.

Kastrup, DADA; EA/*Copenhagen*.

Kastrup faience, CEA/*149*①.

Kastrup Glass Works, DADA/
Supplement.

Kasuba, Aleksandra, DADA/
Supplement.

Kasvin, C-5323/*149*①.

Kasvin rug, S-4461/*752*.

katabori, CEA/*562*, *575*.

katagami, JIWA/*199*.

katagumi, JIWA/*9*.

kata-kiri-bori, DADA.

katakiribori, C-0282/*51*, *121*.

katana, C-5236/*1825*; DADA/①.

katar, C-5156/*448*; C-5234/*304*.

katár, DADA.

Katchina doll, CEA/*697*.

Katchlie Bokhara, DADA.

katechu, DATT.

Kato, Hajme, DADA/*Supplement*.

Katz, Alex, S-286/*291*.

Katzhutte figure, C-2910/*100*.

Kauba, Carl, C-5189/*136*.

Kauffman, Angelica, ACD.

Kauffmann, Angelica, DADA; EA;
SDF/*755*.

Kaufmann, Angelica, C-5189/*28*.

Kaufmann, Edgar Jr., DADA/
Supplement.

kauri, DATT.

Kava bowl, LAR82/*84*①.

Kavak, OC/*132*①.

Kawai, Kanjiro, DADA/*Supplement*.

Kay, Peter, London, C-2489/*118*①.

Kaye, Margaret, DADA/*Supplement*.

Kayin rug, DADA.

Kayseri, OC/*127*①, *302*①.

Kayseri Anatolian rug, LAR83/*528*①.

Kayseri prayer rug, C-2482/*32*.

Kayserzinn, C-5005/*222*①; C-5167/
*159*①; K-710/*118*; OPGAC/*15*.

Kazak, C-0906/*25*; C-2320/*140*;
C-2388/*149A*; C-5189/*374*; CEA/
*88*①, *89*①; DADA; NYTBA/
*114*①.

Kazak carpet, EA/①.

Kazakh rug, LAR82/*549*①.

Kazak rug, ACD; LAR82/*545*①;
OC/*17*①; S-3311/*50*; S-4461/*769*;
S-4796/*14*, *131*①.

Kazan, OC/*187*①.

Kazvin carpet, S-4796/*155*, *214*.

KB, EA/*Künersberg*.

K.D. furniture, SDF.

Kean, Michael, CEA/*187*, *193*①;
EA.

Keatt, William, C-5173/*44*①.

Keay, Robert, C-2510/*67*.

Kebori, DADA.

Keçimuslu, OC/*131*①.

keel-arch, C-2478/*222*.

keeled angle, C-2388/*112*; C-2522/
*163*①.

Keene cement, DATT.

Keene Glass Works, CEA/*463*①;
EA.

Keene's cement, DATT.

keeping room, SDF.

keep-within-compass plate, IDC/①.

Keiser, Aelbrecht, EA/*Keyser,
Aelbrecht*.

Keith, John James, S-3311/*718*.

Keith, Thomas, C-2904/*151*.

Kejebe, S-3311/*28*.

kelebe, DATT; IDC.

Kelei, S-4804/*965*; S-4847/*209, 283*.

Kelety, A., OPGAC/*13*.

kelim, CEA/*77, 101*.

kelim (kilim) carpet, EA/①.

Kell, Harry, C-2476/*32*①.

kelleghi, CEA/*101*.

kelleguis, OC/*262*.

kelleh, C-2357/*154*; C-2388/*196*; C-2403/*201, 207*.

Keller, G., C-5203/*128*; S-4944/*170*.

Keller and Guerin, C-GUST/*10*.

kelleyeh, CEA/*101*.

kelleyi, CEA/*91*①; OC/*30*.

kelleyi format, OC/*63, 87*.

Kellinghusen, DADA; EA.

Kellogg, NYTBA/*206*.

kelly, CEA/*697*.

Kelly, Ellsworth, S-286/*292*①.

Kelly, John, C-5170/*176*①.

Kelsall, J., LAR82/*121*①.

Kelso, John, SDF/*773*.

Kelsterbach, ACD; DADA; EA.

Kelsterbach works, MP/*164*.

Kemereh, OC/*97*①.

Kemp, Guillaume, S-4955/*189*①.

Kempe, Samuel, MP/*43*.

Kempkin, Robert, CEA/*645*①.

Kempthorne pattern, IDC.

ken, DADA.

kenareh, CEA/*101*.

kende, EA/*narghile*.

kendi, C-0782/*13*; C-2323/*33*; C-2513/*138*①; IDC/①; IDPF/*136*; S-3312/*1334*①; S-4461/*524*.

kendi and stopper, C-5156/*811*①.

kensui, IDPF/*137*.

Kent, Ohio, CEA/*463*①.

Kent, Rockwell, S-286/*52*.

Kent, William, ACD; CEA/*334*①; DADA/①; EA/①; NYTBA/*46*①; SDF/*755*.

Kentbury Patent, C-2904/*287*.

Kentian, C-2403/*111*.

Kentian style, C-2403/*27*.

Kenton & Company, SDF/*755*.

Kenton Hills Porcelains, Erlanger, Kentucky, EC1/*85*.

Kentshire, S-4461/*216*.

Kent style, SDF/①.

Kentucky rifle, C-2503/*105*; CEA/*38*①; DADA.

Kent ware, IDC.

Kenzan, EA/①; IDPF/*14*.

Kenzan, Ogata, DADA.

Kepse, C-2320/*146*.

Kepse gul, C-2357/*132*; C-2403/*206*.

Kepsi gul, S-4796/*61*; S-4948/*57*①.

Keramis, Weiner, C-5191/*56*.

Kerbschnitt, IDC.

kerchief, C-1506/*171*; CEA/*277*①.

Kermais, Gres, C-GUST.

Kerman, C-5189/*364*; OC/*58*①, *292*①, *293*①.

Kerman Armori, OC/*163*①.

Kerman carpet, EA; S-3311/*4*.

Kerman corridor carpet, C-0279/*21*①.

Kerman mat, LAR83/*526*①.

Kerman medallion, OC/*293*①.

Kerman rug, S-288/*31*①.

Kermanshah, DADA.

Kerman/Yezd design tradition, OC/*103*.

kermes, DATT.

kermesse, DADA.

kernel black, DATT.

kernos, IDPF/*137*①.

kerosene, DATT.

Kersehir, C-2546/*184*.

kersey, SDF.

Kersting, Georg Friedrich, MP/*182*.

Kertch ware, IDC.

Keshir rug, ACD.

kesi, C-2414/*106*①; C-5236/*1739*; LAR83/*228*①.

Kesi panel, S-3312/*1197*①.

keskul, IDPF/*137*.

Ke Song ben, C-2458/*428*.

Ketland & Co., Birmingham, C-2503/ *128*.

kettle, C-5153/*1*①, *14*①; CEA/*549*; IDC.

kettle-base, CEA/*406*.

kettle base, SDF/*kettle front*.

kettled-boiled oil, DATT.

kettle front, SDF.

kettle lamp, S-4905/*345*.

kettle-on-lampstand, S-4804/*43*.

kettle-on-stand, S-4461/*206*.

kettle-shape, DADA/①.

kettle-shaped, NYTBA/*58*.

kettle stand, C-5116/*69*; DADA; EA/①; S-4922/*60*①.

kettle-tilter, EA; SDF.

Kettner, F., C-2476/*4*.

kewblas, DADA/*Supplement*.

Kew Blas, NYTBA/*306*.

kewpie, CEA/*697*.

key, CEA/*224*①, *252*①, *538*①, *554*①; DATT; DSSA.

key (of clock or watch), EA.

key, LP.

key, stretcher, LP.

key block, DATT.

key border, OC/*249*; S-4461/*523*.

key compartment, C-5117/*375*①.

key escutcheon, C-2368/*67*①; C-5005/*330*①; S-2882/*363*①.

key-fret, IDC; S-4810/*41*①.

key fret, EA/*key pattern*; S-2882/*48*.

keyfret, S-3312/*1351*①.

keyfret band, S-3312/*1334*①; S-4810/*247*①.

key-fret border, C-5323/*134*①.

keyfret border, S-3312/*1334*①.

key-fret design, C-5323/*23*.

key fret pattern, C-5236/*1561*.

keyhole, C-5156/*395*; S-4972/*435*①.

keyhole escutcheon, C-5114/*347*①, *360*①; FFDAB/*62*; S-4955/*86*①.

keyhole handle, CEA/*668*①.

keyhole pattern, DADA/①.

keyhole-pierced handle, C-5114/*10*①.

keyhole plate (in furniture), LAR82/ *330*①.

keyholes, NYTBA/*67*①.

keyhole surround, C-5116/*7*.

keyhole-type, C-5153/*49*①.

keyhole-type handle, C-5153/*35*.

keyless, C-5117/*400*①.

keyless bugle, CEA/*549*.

keyless lever deck watch, C-2368/*82*.

keyless lever minute repeating chronograph, S-291/*105*①.

keyless lever watch, C-5174/*353*①; C-MARS/*154*.

keyless mechanism, EA.

keyless watch, LAR83/*215*①.

keyless work, CEA/*250*.

Keyll, Johann, CEA/*453*①.

key-pattern, C-2323/*73*①; C-2388/ *165*; C-2403/*37*, *157*; C-2421/*3*①; C-2437/*47*; C-2458/*72*①; C-5156/ *90*①; C-5236/*449*①.

key pattern, C-0782/*93*; C-2487/*120*; C-5153/*14*①; DADA; EA; S-2882/ *948*①; SDF.

key-pattern border, C-2414/*81*; C-5117/*350*.

key pattern border, S-2882/*947*, *1165*①.

key pattern bracket support, S-2882/ *1078*①.

key-pattern foot, C-2478/*124*①.

key plate, C-0279/*379*①; DATT; SDF.

key-scroll, C-5236/*542*.

key scroll, C-5127/*43*.

Keyser (Keyzer), Aelbrecht, EA.

key set, C-5117/*400*①.

key-shaped, C-0706/*48*.

keystone, DATT.

key wind, C-0254/*180*.

key wind and set, C-5117/*411*①.

keywork, C-0906/*261, 278*.

KG, EA/*Lunéville faience factory*.

K & G LUNEVILLE, EA/*Lunéville faience factory*.

KH, EA/*Kellinghusen*.

khaki, C-2324/*33*; C-2704/*95*.

khaki gold, OC/*25*.

khaki-green, C-5005/*291*.

khali, CEA/*101*.

Khamariah, OC/*305, 312*①.

Khamseh, OC/*257*①.

Khamseh Confederacy, S-4948/*43*.

Khan, Qazi, OC/*31*①.

khanda, DADA.

khanjar, C-2503/*5*①.

kharak, CEA/*101*.

khatchli, CEA/*101*.

khatchlie rug, EA/*hatchlie rug*.

khattvanga, C-5234/*21*①.

K.H.C., EA/*Meissen porcelain factory*.

K.H.C.W., EA/*Meissen porcelain factory*.

Khelebnikov, Ivan, C-0270/*111*.

Khilim, DADA.

Khiva Bokhara, DADA.

KHK, EA/*Meissen porcelain factory*.

Khlebnikov, C-5117/*307*.

Khlebnikov, Ivan, C-5117/*304*①; C-5174/*215, 253*①, *268*.

Khmer, C-2323/*21*①; C-2458/*42*; C-5156/*207*; C-5236/*351*①; LAR83/*647*①.

Khonjoresk, OC/*210*①.

Khorassan, C-2546/*150*; C-5189/*391*; CEA/*94*; DADA; S-4804/*975*; S-4847/*194*.

Khorassan carpet, S-4461/*858*.

Khorassan inscription carpet, S-4948/*182*①.

Khorassan rug, S-4461/*830*.

khoromnye, RGS/*84*.

Khorramabad, OC/*216*①.

khotan, C-5259/*381*; C-2478/*232*; C-2546/*167*; DADA; OC/*128*①; S-4847/*357*.

Khotan carpet, S-3311/*56*①.

Khotan runner, S-3311/*48*①.

khourjeen, OC/*30*.

Kian, CEA/*111, 117*①.

Kian fu, CEA/*117*①.

Kiangnan Ting, IDC.

Kiangnan Ting ware, DADA.

Kiangsi, CEA/*117*①.

Kian Temmoku, DADA.

Kian ware, EA/*Chi-an ware, Chi-an ware*.

kiathos, DATT.

kick, ACD; CEA/*502*; EA; EG/*290*①.

kick-in base, CEA/*452*①; IDC.

Kickow, Johan Ulrik, C-2487/*38*①.

kick-plate, SDF.

kick terminal, IDC.

kick-up, CEA/*57*①.

kick-up or push-up, CEA/*70*.

kickwheel, DATT/①.

kid, C-1304/*186*; C-1506/*59*.

Kidderminster carpet, DADA; EA; SDF.

Kidderminster rug, ACD.

kiddish cup, C-1502/*223*.

Kiddush cup, C-5174/*89*①.

kidney, DATT.

kidney dial, EA.

kidney form, LAR83/607①.

kidney shape, S-4414/284, 298.

kidney-shaped, C-0982/122; C-2493/
56; LAR82/327①; S-4972/585①;
S-4988/505①.

kidney shaped furniture, EA/①.

kidney table, ACD; DADA; SDF/①
horseshoe table.

Kiel, DADA.

Kiel faience factory, EA.

Kierstede, Cornelius, CEA/671①;
NYTBA/217①.

Kierstede (Kierstead), Cornelius, EA/
①.

kieselguhr, DATT.

kiku knop, S-3312/1106①.

kikumon, IDC.

kiku-no-go-mon, DADA.

kilij, C-2503/2; DADA.

kilim, C-0906/15; C-2388/137;
C-2478/212; OC/16, 18①;
S-4796/34; C-2403/158, 200.

kilim carpet, C-2482/33.

kilim panel, S-4796/15A.

kilim skirt, C-0279/31①.

kilim strip, C-2320/137; C-2403/178,
207.

kilim work, OC/213.

killed plaster, DATT.

Killybegs, CEA/75.

kiln, DATT; EC1/83; EC2/23; IDC;
IDPF/137①; C-2904/199.

kiln-dried wood, DATT.

Kilner Brothers Ltd., CEA/55①.

Kilner Jar, CEA/55①.

kiln furniture, IDC.

kiln grit, S-4965/167①.

kiln house, MP/42.

kiln master, MP/20.

kilnmaster, MP/43.

kiln-site, CEA/112①.

kiln touch, C-5236/448.

kiln waster, IDC.

kilt, C-0604/33.

Kimball, C-5191/397.

kimekomi, JIWA/278.

kimono, C-1304/213; CEA/561.

kimono box, C-5236/809①.

kimono still-life, JIWA/19①, 20.

kimono tray, DADA.

Kinable, C-2364/25①.

Kinai school, LAR83/661①.

kinchaku, CEA/561.

Kinder a la Raphael series, LAR82/
149①.

kinderbuste, C-2493/285.

kindjal, DADA.

kinesthetic, LP.

kinetic, LP.

kinetic art, DATT.

kinetic object, S-286/95.

King, B., CEA/607①.

King, David, C-5117/254①.

King, Jessie M., C-2409/201.

King, Jessie Marion, DADA/
Supplement.

King, John, C-5203/209①.

Kingdom, William, S-4922/58①.

King Ferdinand IV, CEA/172①.

kingfisher glaze, IDC.

King Gothic tea tray, LAR83/660①.

kingin-zuri, JIWA/278.

kingin-zuri technique, JIWA/210①.

King John's Cup, EA.

King of Prussia, IDC/①.

King of Prussia plate, S-4843/25.

king's blue, DATT.

king's crown, OPGAC/226.

king's-pattern (in silver), C-5174/503.

king's pattern, DADA; C-0254/227;
C-2487/43; EA/①.

Kings pattern, C-0103/201; C-0706/
29; C-1502/98; C-2202/165;

C-5114/*110*; S-2882/*1087*; S-4804/
15.

Kingston tureen, C-5173.

King's vase model, C-2522/*6*①.

King's yellow, DATT.

Kingtechen, EA.

Kingtechen Imperial kilns, EA/
Ching-tê-chñ kilns.

"King Tut" pattern, C-5167/*234*.

King William, C-2704/*133*.

kingwood, ACD; C-0982/*19*; C-1407/
61; C-2364/*47*①; C-2402/*127A*;
C-5116/*168*①; CEA/*406*; DADA;
DATT; LAR82/*69*①, *205*①;
LAR83/*295*①; NYTBA/*41*①;
S-2882/*791*; S-3311/*439*①;
S-4461/*624*; S-4804/*713*; S-4972/
*528*①; S-4992/*106*①; SDF.

kinji, CEA/*574*①, *575*; S-4829/*30*①;
S-4928/*139*①, *147*①.

Kinji ground, S-3312/*1038*①.

Kinkozan, LAR83/*115*①.

Kinkozan earthenware, LAR82/
*142*①.

Kinkozan Satsuma bowl, S-3312/
*1119*①.

kin-makie, DADA.

kinran-de, DADA.

kinrande, IDC.

kinrande chawan, EA.

kinuta, EA; IDPF/*138*; C-5236/
*444*①.

kinuta seiji, IDC.

Kip, Richard, Junior, SDF/*774*.

Kipling, W., London, C-2489/*177*①.

Kipling, Wm., CEA/*338*①.

Kipp, Karl, K-710/*115*.

Kirchner, J. G., CEA/*174*①.

Kirchner, Johann Gottlieb, EA; MP/
72.

kiri, CEA/*565*①, *575*.

kiribame, DADA.

kiribame-zōgan, DADA.

kirigane, C-5156/*710*①; C-5236/*779*;
CEA/*575*; LAR83/*459*①; S-3312/
*1056, 1057, 1061*①.

kirikane, S-4928/*136*①, *144*①.

kirimon, IDC.

kirin, IDC.

kirin finial, C-5127/*202*; C-5236/
1707.

kiri-wood, C-5127/*699*.

Kirk, Samuel, CEA/*677*①.

Kirk, Samuel, and Son, Inc., DADA/
Supplement.

Kirkpatrick, Cornwall, CEA/*168*①.

Kirk Repousse style, S-4804/*38*①.

Kirk style, S-2882/*942*①.

kirman, DADA; C-2388/*167*;
C-2478/*259*; CEA/*90*①; S-288/
*19*①; S 4804/*962*.

Kirman carpet, EA; S-4461/*856*.

Kirman Celadon ware, EA.

Kirman pictorial mat, LAR83/*528*①.

Kirman rug, ACD; C-0906/*40*.

Kirman runner, S-4461/*834*.

Kirsch, Steyr, C-MARS/*145*.

Kirsehir, C-2320/*119*; C-2403/*179*.

Kirshehir, S-4847/*178*.

Kirshehir rug, S-4796/*129*.

Kir-Shehr, DADA.

kis carpet, EA.

kiseru, C-0282/*122*.

kiseru-zutsu, C-0282/*121, 122*;
C-5236/*796*①.

kiseruzutsu, C-5156/*699*.

Ki Seto, EA/*Seto*.

'kishti', OC/*147*.

kis khilim, DADA.

Kiss, Paul, C-5191/*314*.

**Kiss Art Pottery, Sag Harbor, New
York,** EC1/*85*.

kit, C-2904/*92*; EA.

kit cat, DATT.

kit-cat frame, DADA.

Kit Cat glass, EA.

kitchen cabinet, SDF.

kitchen clock, CEA/248①; EC2/
99①.

kitchen dresser, NYTBA/36.

kitchen pepper, EA/①.

kite-shaped, S-4927/480.

kite-shaped diamond, S-291/28①;
S-4414/99①.

kithera, S-4807/496①.

kitsch, DATT; LP.

Kittel, Georg, MP/442①.

Kittel, Johann Georg, MP/35.

Kittell, Johann, MP/442①.

kiwame seal, C-5236/1030①.

kiyōmizu ware, DADA.

Kiyomizu ware, C-5156/793①;
C-5236/834.

Kizan earthenware, LAR82/138①.

Kizil Ayak, C-2388/183; OC/142①,
173①, 176①.

Kizil Ayak Juval, C-2482/45.

Klar, F., C-5189/137.

kleine indianische Bluhmen, MP/131.

Kleinplastik, EA.

Klenizer, Moulins, C-MARS/235.

Kley, J., CEA/608①.

Kley, Louis, C-5191/165.

Klimt, Gustav, DADA/Supplement.

Klingenstedt, Karl Gustav, EA.

Klinger, J. G., CEA/174①.

Klinger, Johann Gottfried, EA.

Klinger, Max, S-286/295.

Klingert, Gustav, C-5117/320;
C-5174/265.

Klint, Kaare, DADA/Supplement.

Klipfel, Karl Jacob Christian, EA.

klismos, EA; SDF/①.

Klismos chair, C-5116/154①.

klismos design, NYTBA/68.

Kloot, Cornelius van der, CEA/
141①.

klosterarbeit panel, S-4461/548.

Klostermuhle, CEA/451.

Kloster-Veilsdorf, ACD; C-2486/
83①; DADA; EA.

Kloster Veilsdorf, MP/164.

Kloz, C-0906/378.

Knabe, S-4507/15①.

Knapp, Stephan, DADA/Supplement.

knarl, SDF.

knarled, C-2364/14①.

kneading table, DADA.

kneading trough, EA; LAR83/382①;
SDF/①.

knee, ACD; C-0249/344; C-5114/
370①; CEA/312①; NYTBA/54;
SDF/①.

knee, hip, or shoulder (in furniture),
EA.

knee bowl, IDPF/138.

knee-hole, EA.

kneehole, C-0249/326; C-0982/14,
126A; C-1407/27; C-2402/10, 53;
C-2478/120; C-5116/92; S-4436/
109①; SDF/①.

knee-hole cupboard, S-2882/270①.

kneehole cupboard, C-5116/131①.

knee-hole desk, CEA/335①, 394①.

kneehole desk, C-0249/374; C-2320/
48①; C-2421/76①; C-5116/114;
C-5153/198①; LAR83/330①.

knee-hole dressing table, S-2882/
294①.

kneehole dressing table, C-5116/
159①; S-4988/489①.

knee-hole dressing/writing table,
S-2882/270①.

knee-hole table, ACD.

kneehole writing table, C-1407/4;
DADA.

Kneeland, Samuel, DADA.

kneeler, SDF.

kneeling board, SDF.

kneeling chair, EA/prie-dieu chair, ①
prie-dieu chair; SDF.

kneeling horse, C-2414/19①.

Knibb, CEA/*219*.

Knibb, John, EA.

Knibb, Joseph, DADA; EA/①.

Knibb, Joseph, London, C-2489/*95*①.

Knibbs, The, ACD; SDF/*777*.

knicker-bockers, C-0405/*31*.

knickers, C-2203/*8*.

knife, C-0254/*62*; C-1082/*6*; C-5156/*427*; DADA; DSSA; LP/①; S-4972/*242*.

knife and fork handle, IDC/①.

knife-blade, C-5153/*73*①.

knife box, ACD; C-5114/*249*; C-5157/*22*; CEA/*397*①; DADA; S-3311/*124*.

knife box or case, EA.

knife-case, SDF/①.

knife case, ACD/*knife box*.

knife-file, DATT.

knife handle, S-4972/*74*.

knife-pared, C-5236/*1563*①.

knife pistol, C-2503/*157*.

knife-pleat, SDF.

knife-rest, IDC.

knife rest, C-1502/*66*; EA.

knife shaped foot, S-3312/*1281*①.

knife-tray, C-5117/*155*①.

knife tray, EA.

knife-urn, SDF.

knife urn, C-5170/*16*①; DADA; S-2882/*331*; S-4436/*62*.

Knight, Benj., C-2357/*26*①.

Knight, George, C-2510/*85*.

Knight, Laura, LAR82/*108*①.

Knight, Thomas, LAR82/*215*①.

knight in armour, C-2398/*91*①.

knitted, C-1506/*97*.

knitted glass, EG/*77*.

knitting basket, S-4881/*317*①.

knitting chair, SDF.

knob, C-2402/*138*; C-2458/*230*; IDPF/*138*①; S-3311/*229*①; S-4881/*87*①; S-4922/*83*①; SDF.

knobbed attachment, RTA/*48*①.

knob foot, C-1407/*46*; C-2402/*134A*.

knob handle, C-0249/*208*, *456*①; DADA.

knock down furniture, SDF.

knole sofa, SDF/①.

Knoller, Johann Georg, CEA/*138*①.

knop, ACD; C-0254/*28*; C-1082/*103*; C-2458/*77*①; C-5114/*127*, *161*; C-5117/*68*①, *117*①; CEA/*342*①, *502*, *643*①; DADA; DATT; EA/①; EG/*286*; IDC; K-711/*130*; S-4414/*236*①; S-4804/*3*; S-4853/*39*①; S-4905/*13*①; S-4922/*30*①; S-4992/*54*①; SDF.

knop-and-cusp, SDF.

knop finial, C-0254/*268*; C-0279/*97*①; C-2437/*17*①; C-2458/*107*①; C-5156/*27*; S-2882/*978*, *996*①, *1062*①; S-4414/*260*, *269*①.

knopped, C-0906/*110*; C-5127/*129*; S-4922/*5*①.

knopped and frosted stopper, S-4414/*183*.

knopped baton, S-4804/*127*①.

knopped central section, S-4414/*226*①.

knopped circular base, S-2882/*1234*①.

knopped cover, C-5114/*161*.

knopped cylindrical stem, S-2882/*1084*.

knopped faceted stem, S-2882/*1025*①.

knopped finial, LAR82/*441*①.

knopped foot, C-2414/*93*①.

knopped insert, S-4461/*529*.

knopped neck, S-4414/*202*①.

knopped shaft, S-4461/*159*.

knopped standard, C-0249/*277*; S-2882/*1277*, *1327*①, *1380*①; S-4414/*247*.

knopped stem, LAR83/451①;
S-2882/1030; S-4802/262①;
S-4804/234①; S-4905/348.

knop stem, EG/63①; S-4414/254①.

knot, DSSA; EA/rose.

knot-count, OC/22.

'knot of destiny', OC/80①.

knots/in2, OC/11①.

knots/m2, OC/11①.

knotted lace, DADA.

knotted-pile carpet, OC/35①.

knotted-pile rug, OC/16, 34.

Knotter, Johannes, CEA/140①.

Knowles, Edwin M., K-710/119.

Knowles, Taylor and Knowles, CEA/
205.

Knowles, Taylor and Knowles
Company, DADA/Supplement.

Knowles, Taylor, Knowles, K-710/
119.

Knowles, Taylor & Knowles, East
Liverpool, Ohio, NYTBA/162.

Knox, Archibald, C-2409/197;
C-2910/198; C-5167/142①;
C-GUST/89; LAR82/231①.

knuckle, CEA/394①; IDPF/32①;
SDF.

knuckle arm, DADA; EA; LAR83/
286①; SDF.

knuckle bow, CEA/28①.

knuckle-guard, C-2569/40①;
C-MARS/30; CEA/40①.

knuckle joint, SDF.

knuckle terminal, S-4905/383①.

'Knufic' border, OC/46①.

knulled foot, SDF.

knulling, ACD; DADA.

knurled, C-2487/124.

knurled border, C-0254/319.

knurled handle, C-5117/233①.

knurled inset, C-0254/319.

knurl foot, EA/scroll foot; SDF/①.

knurling, DADA; EA.

Knütgen, Anno, EA.

knysna boxwood, SDF.

ko, IDPF/127.

koa, DATT.

kobako, C-5156/746; S-4829/97①;
S-4928/162.

koban, JIWA/244.

koban tate-e, C-5236/951.

Kobenhaven, C-1006/197.

Kober, Thomas, C-5174/103.

Kobi, C-1082/1.

kobisha, IDPF/137.

Kochi ware, IDC.

Kocks, Adriaen, CEA/141①.

Kocks, Adriaen, Adrianus, EA.

Kocks, Pieter Adriaenson, CEA/
142①; EA/Kocks, Adriaen.

kodansu, C-5156/751①; S-4829/
96①; S-4928/172①.

kodōgu, DADA.

Koechlin, Hartman, Mullhouse,
C-2498/60.

Koehler, Florence, CEA/523①.

koenig horn, C-5255/27①.

Koepping, Karl, DADA/Supplement.

kogai, DADA.

kōgai (sword pin), JIWA/183.

kōgai (hairpin), JIWA/190.

kogo, C-5156/749①; IDC; S-4461/
411; S-4829/99①; S-4928/163①.

kohiki, EA/Punch 'ŏng ware.

Koh Ker style, C-5156/210①.

Köhler, David, EA; MP/39.

kohl-jar, C-1582/18.

kohl tube, IDPF/62①.

Kohn & Kohn, C-5239/256B.

Ko-Imari dish, S-3312/1108①.

kojiri, DADA.

ko-katana, DADA.

kokko, SDF.

kokoshnik, C-5174/270①.

kokoshnik head ornament, RGS/ *179*①.

kokoshnik mark, RGS/*168*.

Kokusai, CEA/*570*①.

Ko-Kutani, EA/*Kutani*.

Ko Kutani, IDC.

Ko-Kutani style, C-0782/*158*; LAR82/*142*①.

Kolbe, Johann, C-2487/*32*.

Koler, Georg, C-5174/*109*①.

kolinsky, C-0604/*125*; DATT.

Kolle, C-5189/*87*.

Kollin, Erik (workmaster), C-5174/ *327*.

Kollwitz, Kathe, S-286/*299*①.

Kolmegaard, C-2409/*42*.

Kolodkin, Nemirov, C-5117/*320*.

Kolyai Kurds, OC/*120*.

Kolyai shirshekeri, OC/*170*①.

kolza, LAR82/*88*①; LAR83/*63*①.

Komai, C-1082/*96*; LAR83/*468*①.

Komai style, C-5156/*840*.

Komai taste, C-5156/*841*.

kommodenschrank, LAR83/*315*①.

komori, IDC.

Konagkend, S-4847/*185*.

Konagkend rug, S-288/*25*①; S-4796/ *54, 73*①.

Konia (Konya) carpet, EA.

Konieh, CEA/*80*①; DADA.

Konieh rugs, ACD.

Königliche Hof-Conditorei, EA/ *Meissen porcelain factory*; IDC/ *Königliche Hof-Konditorei*.

Königliche Hof-Konditorei, IDC.

Königliche Porzellan Fabrik or Manufaktur, EA/*Meissen porcelain factory*.

Königliche Porzellan Manufaktur, EA/① *Meissen porcelain factory*; MP/*147*.

Königsberg, DADA.

Königsberg faience factory, EA.

Kononov, Ivan, C-5117/*296*.

Konor, C-2476/*47*.

Konya, OC/*131*①.

Konya Keçimuslu, OC/*131*①.

Konya Kilim, C-5323/*53*.

Konya prayer kilim, S-4796/*109*.

Konya rug, S-4796/*5*.

Konya Saph kilim, S-4948/*36*①.

Korai, DADA.

Koransha, C-5236/*894*①.

Kordofan gum, DATT.

Korean, C-2458/*222*; IDPF/*55*.

Korean celadon, EA/①.

Korean dynasty, DADA.

Korean Ido style, EA/*Mokubei, Aoki*.

Korean Koryu bowl, IDPF/*31*①.

Korean pottery, C-2458/*58*; EA.

Korean tyger pattern, IDC.

Korean ware, CEA/*127*; DADA; IDC; JIWA/*344*.

Kōrin-nami, JIWA/*134*.

Kōrin-style, JIWA/*194*.

Korin style, C-5236/*810*①.

Kōrin wave, JIWA/*134*.

kork, OC/*299*.

Kork-Kashan, OC/*299*.

Kork-Qum, OC/*299*.

Kornilov factory, EA.

koro, C-0782/*45*; C-5127/*388*; C-5236/*838*①; DADA; IDC; LAR82/*56*①, *173*①; LAR83/ *97*①; S-3312/*1105, 1142*①.

koro and cover, C-5156/*846*①.

koroplastae, IDC.

koruna, RGS/*124*.

Koryai dynasty, IDC/*Koryŏ dynasty*.

Koryō, CEA/*128*①.

Koryo, S-4461/*476*.

Koryŏ dynasty, IDC.

Koryo Dynasty, C-2458/*48*; C-5127/ *16, 153*①; C-5156/*40*①; C-5236/ *348*①, *428*①, *1725*.

Koryo Period, EA/*Koryo.*

Koryŏ pi-saek, IDC.

Koryu dynasty, IDC/*Koryŏ dynasty;* S-3312/*1322*①.

Ko-Satsuma, LAR83/*153*①.

Kosen Kyoto, LAR83/*220*①.

Ko-Seto, EA/*Seto.*

Ko Shonsui, IDC.

Koshu school, C-5236/*1831.*

Kosirev, Alexei (warden), C-5174/*231.*

Ko sometsuke, IDC.

Kossman, Eberwein, CEA/*626*①.

Ko'ssu, DADA.

Kost, Pieter, C-0270/*83.*

kosta, DADA/*Supplement;* EA/ *Scandinavian glass.*

kotchak, C-2320/*148;* C-2388/*172, 199;* C-2478/*235.*

Kothgasser, Anton, CEA/*455*①; EA; LAR82/*455*①.

kotobuki, CEA/*575.*

kotyle, IDC.

kotyliskos, IDC.

Kouba Shirvan, CEA/*107*①.

Koudani Beluch, OC/*139*①.

Koula carpet, EA/*Kula carpet.*

Koultuk, DADA.

kovchik, RGS/*70*①, *83.*

kovsch, EA/①.

kovsh, C-2332/*97;* C-5117/*315*①, *333*①; C-5174/*237*①; CEA/*636*①; DADA; RGS/*34;* S-2882/*1012.*

kovshik, RGS/*88.*

kovsh shape, S-2882/*1395*①.

Ko ware, ACD; EA.

koyame-de, CEA/*129*①.

ko yao, DADA/①; IDC.

Koyetsu (Koetsu), Honami, EA.

Kozlowsky, Franciscus, C-5117/*15.*

kozuka, C-5156/*696*①; DADA.

kozuka (secondary blade), JIWA/*183.*

K.P.F., MP/*499 Königliche Porzellan Fabrique.*

KPF, EA/*Meissen porcelain factory.*

K.P.M., C-5189/*34.*

K.P.M. (Königliche Porzellan Manufactur), MP/*499*①.

KPM, EA/*Meissen porcelain factory.*

KR, EA/*Ripp, Johann Caspar.*

Kraak, C-5156/*102;* C-5236/*481*①; CEA/*111.*

k'raak porcelain, EA/*Carrack, Carrack porcelain.*

kraak porselein, C-0803/*112, 112;* IDC.

'kraak porselein', LAR83/*136*①.

Kraak porselein, C-2458/*73*①; C-2323/*34, 36*①.

kraak porselein charger, C-5127/*56.*

Kraer, Jacob, S-4944/*159*①.

Kraslinikov, Nikifor (assaymaster), C-5174/*105*①.

krater, ACD; DATT; EA/①; IDC/ ①; IDPF/*140*①.

Krater vase, LAR82/*186*①.

Kratina, LAR82/*46*①.

Kratzenberg, Johann David, MP/*36.*

Kraun, Nicolaus, C-2382/*51*①.

krautstrunk, CEA/*452*①; DADA; EA/①.

Kreibitz, CEA/*451.*

Krejci, Luba, DADA/*Supplement.*

Kremlin scene, C-5174/*260.*

Kremlin Silver, EA.

Kremnitz white, DATT.

Krems white, DATT.

Kretschmar ware, IDC/①.

Kreussen, CEA/*137*①; DADA; EA/ ①.

Kreuzen, S-4972/*139*①.

Krider, Peter L., C-5153/*6.*

Kriegvasen, IDC.

kris, C-5234/*156*①; C-5236/*1742;* DADA.

Kunstakademie, MP/*203.*
Kunst foundry, C-5167/*4*①.
kurawanka, IDC.
Kurd, C-5189/*360*; S-4847/*191.*
Kurdish, C-2320/*134*; C-2388/*148*; C-2478/*222*; CEA/*91*①; OC/*112*①.
Kurdish finish, OC/*25*①.
Kurdish rug, ACD; C-0906/*58*; LAR83/*528*①; S-3311/*12.*
Kurdistan, DADA.
Kurdistan carpet, EA/*Bijar and Sehna carpets.*
Kurd Kazak rug, S-4461/*779, 828.*
Kurd Lenkoran rug, S-4796/*111.*
Kurd rug, S-4461/*773.*
Kurd runner, S-4461/*810.*
Kurfursten Humpen, CEA/*452*①.
Kurfürstenhumpen, DADA; EA/①.
Kurfurstenhumpen, LAR83/*412*①.
kurikata, DADA.
Kuro-Oribe, EA/*Oribe ware.*
ku-shaped, C-0782/*153.*
kushi (comb), JIWA/*190.*
kusitakade, IDC.
Kussner, Amalia, C-5174/*453.*
Kutahia ware, EA/① *Isnik.*
Kütahya ware, IDC.
Kutani, C-0782/*220*; C-5156/*797*; C-5236/*812, 860, 1858*; EA/①; JIWA/*92*①; LAR83/*119*①, *584*①; S-4461/*405.*
Kutani bottle, S-3312/*1106*①.
Kutani plate, S-3312/*1102*①.
Kutani porcelain, ACD; IDC.
Kutani style, LAR82/*142*①.
Kutani vase, S-3312/*1104*①.
Kutani ware, DADA/①.
Kuthaya, C-5236/*1743.*

Kuttrolf, EA/①.
Ku-vase, C-1006/*67.*
Ku Yüeh Hsuan, CEA/*124*①.
Ku Yüeh Hsüan, DADA.
Ku Yüeh Hsüan style, EA/①.
kuy yüeh hsüan, IDC.
Kuzmichev, Antip, C-5117/*336*; C-5174/*233, 240*①.
kwaart, CEA/*137*①, *209*; EA; IDC.
kwaiken, DADA.
Kwang-tung stoneware, EA.
Kwangtung yao, DADA.
Kwanju, CEA/*129*①.
kyanthion, IDPF/*141.*
kyathos, IDC/①; IDPF/*141.*
Kyeryong-san, CEA/*129*①.
Kyko, C-2904/*13.*
kylin, C-2493/*155*; DADA; EA/①; IDC; S-4810/*385*①.
kylin knop, S-4843/*104*①.
kylin pattern, IDC/①.
Kylin tureen, S-4905/*82*①.
kylix, DATT; EA; IDC/①; IDPF/*141*①; K-710/*109*; S-4807/*506*①; S-4973/*334*①; LAR82/*90*①.
Kylix motif, S-4461/*593*①.
kylix-on-stand, S-4853/*117*①.
Kylix Potpourri, S-4843/*409*①.
Kyogen mask, S-4928/*82*①.
Kyoto, ACD; C-0782/*11, 192.*
Kyōto, DADA/①.
Kyoto, EA; K-710/*112.*
Kyoto artists, S-4928/*14.*
Kyoto ware, IDC.
Kyo-yaki, C-0782/*117*; EA.
Kyoyaki, C-5236/*834A*①.
Kyo-yaki bowl, C-0803/*91, 91.*

L

L, EA/*Sèvres.*
labarum, DATT.
Labbez, C-2904/*240.*
label, C-5156/*469;* IDC.
label decanter, CEA/*438*①.
labelled, C-0906/*362.*
labelled Amati, C-0906/*345.*
labelled decanter, DADA.
labelled furniture, DADA.
labelled Stradivarius, C-0906/*308.*
label watch, C-5005/*218*①.
Labino, Dominick, CEA/*483*①.
Laboureur, Jean-Emile, S-286/*54.*
labradorite, C-2332/*37.*
Labron, Birmingham, C-2503/*199.*
laburnum, ACD; C-2324/*173;*
 C-5005/*420*①; SDF.
laburnum wood, DADA.
labyrinth, CEA/*483*①; DSSA/①;
 SDF.
lac, DATT; EA/*Chinese lacquer.*
lac-burgauté, DADA.
lac burgaute, C-2458/*355;* C-5236/
 *364*①.
lac burgauté, IDC.
Lac Burgaute, C-2357/*77*①; LAR83/
 *337*①.

lac burgauté technique, EA/*175*①.
lacca, EA.
lacca contraffatta, EA.
Lacca Povera, LAR82/*399*①.
lace, C-1506/*3;* DADA; NYTBA/
 *91*①.
lace-backed, C-0103/*67.*
lace bowl, IDC.
lace box, EA; SDF.
lace choker, CEA/*520.*
lace-decorated linen, C-2704/*145.*
laced-sacking, CEA/*391*①.
lace edge, OPGAC/*194.*
lace-edged, C-2704/*140.*
lace glass, ACD; DADA/①.
lacelike decoration, MP/*50.*
lacemaker's lamp, LAR83/*486*①.
lace mount, C-1603/*56.*
lace picture, S-4461/*548.*
laces, SDF.
lacet, DADA.
lacewood, DATT; SDF.
lacework, DADA; EA.
lacework ground, IDC.
lacework porcelain, IDC.
La Chaux-de-Fonds, EA.

399

Lachenal, C-0906/*258*.

Lachesis, DSSA.

la China, DADA.

lacis, C-2203/*101*; C-2704/*147*; DADA.

La Compagnie des Cristalleries de Baccarat, EA/*Baccarat*.

La Coste, Peter, London, C-2489/*91*①.

la courtille, DADA; CEA/*186*①; EA/*Paris porcelain*.

Lacqai, C-2478/*221*.

lacquer, ACD; C-2458/*24, 216*; C-5127/*9*; C-5236/*377*①; C-5239/*110*; CEA/*561*; DADA; DATT; IDC; LP; S-4436/*165*; S-4461/*431*; SDF.

lacquer, Oriental, DATT.

lacquer box, C-1082/*130*.

lacquer cases, C-0249/*215*.

lacquer colour, CEA/*209*.

lacquer cupboard, JIWA/*84*.

lacquer decoration, IDC.

lacquered, C-1082/*138*; C-1603/*61*; C-5005/*337*①; S-4804/*275*.

lacquered barometer, CEA/*261*①.

lacquered brass, C-5005/*374*①.

lacquered Easter egg, C-5174/*208*.

lacquered ornamental comb, JIWA/*194*.

lacquered panel, C-5005/*339*①.

lacquered screen, C-5005/*338*①.

lacquered wood panel, C-5005/*346*.

lacquered zinc, C-5167/*162*①.

lacquer gilding, EA/*gilding*; IDC.

lacquering, RGS/*88*.

lacquer inro, CEA/*572*①.

lacquer painting, RGS/*49*①.

lacquer solvent, DATT.

lacquer tables, S-4461/*703*.

lacquer-work, SDF.

lacquer worker, MP/*34*.

Lacroix, Roger, EA/ *Vandercruse-Lacroix, Roger*.

Lacroix, Roger Vandercruse, DADA.

lactic acid, OC/*25*.

lacuna, DATT.

lacunae (pl.), LP.

lacy glass, EA; NYTBA/*294*①.

lacy-pressed, C-5114/*137*①.

lacy pressed glass, CEA/*465*①; DADA.

La Dame au Parasol as motif, C-2458/*192*①.

ladder, DSSA.

ladder-back, ACD; DADA.

ladder back, C-0279/*342*; LAR83/*268*①; S-4436/*114*; S-4461/*660*.

ladderback, LAR82/*296*①.

ladder-back chair, CEA/*334*①.

ladder back chair, SDF/①.

ladder-back or slat-back, EA.

laddered straps, S-4414/*29*.

Ladd & Oertling, C-2904/*28*.

Ladick prayer rug, C-1702/*50*.

Ladies' Amusement, the, IDC.

ladies chair, C-0982/*278*.

ladies' chairs, SDF/①.

ladies' easy chair, SDF/①.

Ladies Furniture, CEA/*361*①.

ladies-in-waiting, C-2704/*10*.

ladies' watches, EA.

ladies writing desk, C-5005/*352*①.

ladik, DADA; CEA/*79*①; OC/*131*①.

Ladik carpet, EA/①.

Ladik rug, ACD.

ladle, C-0706/*190*; C-2414/*27*①; C-5114/*17, 33*①; C-5153/*19*; C-5173/*34*①; C-5236/*399*①; DADA/①; DSSA; IDC; IDPF/*142*①; S-4922/*34*①.

L'Adolescenza di Verginia, C-0405/*178*.

Ladomus, Lewis, C-5203/*356*.

lady-and-squirrel pattern, IDC.

lady-in-a-pavilion pattern, IDC.

Ladyman, John, C-5117/*94*; S-4922/*42*①.

lady's cabinet, FFDAB/*103*①; SDF.

lady's chair, C-1407/*39*; C-2402/*154*; S-4804/*922*①.

lady's coat, C-1506/*41*.

lady's companion, SDF.

lady's desk, NYTBA/*64*.

lady's needle case, EC2/*26*①.

lady's purse frame, S-4804/*57*.

lady's watch, C-5117/*398*①.

lady's work box, C-5170/*157*.

lady's work table, SDF.

lady's writing desk, C-5114/*347*①.

Lady with the Unicorn tapestries, EA.

La Farge, John, DADA/*Supplement*.

La "Fécondité" dish, S-4843/*23*①.

Lafosse, Charles de, DADA.

Lafrensen (Lavrience), Niclas the Younger, EA.

lag and feather pattern, IDC/①.

Lagenet, Antoine, C-5117/*185*①.

lagynos, DATT; IDC/①.

Lahore, OC/*138*①, *305*, *308*①.

Lahore design, S-3311/*42*①.

Lahore rug, DADA.

laid Japanese paper, S-286/*368A*.

laid paper, DATT; S-286/*13, 18, 57, 246, 275, 279*.

laid stitch, C-5127/*351*; C-5156/*453*.

l'ainé, C-2364/*32*①.

L'Aîné, Gavelle, Paris, C-MARS/*227*①.

laitance, DATT.

Laithwait, John, C-5117/*457*①.

la-jian paper, C-5156/*547*①.

Lajoue, Jacques de, DADA.

lajvardina ware, EA; IDC.

Lakabi ware, IDC.

lakaina, IDC.

lake, DATT; LP.

lake base, DATT.

lakeland landscape, C-2421/*81*①.

Lakharbi göl, OC/*196*①.

Lakharbi Uzbek, OC/*196*.

Lalique, C-2409/*9*; C-2910/*10*; K-710/*116*; LAR82/*77*①; LAR83/*416*①; NYTBA/*311*①; OPGAC/*353*; S-2882/*1200*; S-3311/*879*.

Lalique, R., C-5005/*201*.

Lalique, Rene, C-5239/*117*.

Lalique, René, CEA/*60*①, *488*①, *519*①; DADA/*Supplement*; JIWA/*92*.

Lalique, Réné, K-710/*116*.

Lalique, Rene, OPGAC/*167*.

Lalique glass, DADA.

Lalique jewelry, C-5005.

Lalique molded glass clock, S-3311/*880*.

lalitasana, S-4810/*270*①.

Lamaist deity, C-2458/*248*.

lamb, DSSA.

Lambayeque, S-4807/*55*.

Lamberan, OC/*226*①.

Lambert, C-2904/*10*.

Lambert, Francis, EA/*Lambert & Rawlings*.

Lambert & Rawlings, EA.

lambeth, ACD; DADA; C-1582/*53*; CEA/*151*①; LAR82/*121*①; NYTBA/*143*①.

Lambeth delft, LAR83/*119*①.

Lambeth delftware, EA/①; IDC/①.

Lambeth Pottery, IDPF/*185*.

Lambeth School of Art, C-2510/*121*①.

Lambeth stoneware, IDC.

Lambeth workshop, EA/*Benood, William, John*.

lamb flagon, EA.

lambrequin, ACD; C-0279/*361*; C-2427/*3*; C-2437/*3*①; C-5114/*268*①; C-5117/*292*①; C-5259/*572*①; CEA/*146*①, *182*①, *209*;

DADA; EA; IDC/①; S-2882/*841*; S-4972/*533*①; SDF; MP/*502*.

lambrequin edges, C-2320/*1*.

lambrequin fringe, C-5116/*146*①.

lambrequin shaped, C-5127/*86*①.

LAMB VAN EENHOORN, EA/*van Eenhoorn, Lambert*.

lame, C-2503/*48*.

lamé, C-3011/*9*.

lamellé, DADA.

Lamerie, Paul, DADA.

Lamerie, Paul de, ACD; CEA/*616*①, *646*①; NYTBA/*220*①.

laminated, C-5114/*279*①; S-3311/*216*①.

laminated glass, EG/*233*.

laminated materials, SDF.

laminated rosewood, S-4947/*115*①.

laminated wood, NYTBA/*73*.

laminating, CEA/*477*①.

lamination, DATT.

laminboard, SDF.

Laminit, Jonas, C-5174/*429*①.

laminwood, SDF/*laminboard*.

La Moda, C-2704/*165*.

La Moncloa, DADA.

Lamour, Jean, CEA/*537*.

lamp, C-0225/*31, 238*①; C-0706/*170*; C-0906/*160*; C-2402/*13*; C-2458/*185*; C-5117/*205*①; C-5156/*166*; DADA/①; DSSA; IDC/①; IDPF/*142*①; SDF.

lamp-base, C-2403/*1*.

lamp base, C-5239/*49*; IDPF/*143*①.

lamp black, LP.

lampblack, DATT.

lamp-blown glass, EA.

Lampe Berger, C-5005/*292*①.

lampe Bouillotte, C-2437/*19*.

lamp filler, IDPF/*143*.

lamp-holder shade, IDPF/*150*①.

lamp pot, C-5236/*1566*.

Lamprecht, George, CEA/*186*①.

lamps, C-5114/*239*.

lamp shade, C-2409/*31*; SDF.

lampshades, C-0706/*199*.

lamp shield, C-0225/*326*.

lamp stand, C-5005/*228*①, *385*.

lampstand, S-4905/*158*; S-4922/*71*①.

lamp standard, C-1407/*123*; C-2402/*57*; SDF.

lamp table, C-2403/*47*.

lampwork, CEA/*490*; EG/*246, 290*①.

lampworked, EG/*80*①.

Lancashire, C-0249/*389*①.

Lancashire box, CEA/*70*.

Lancashire chair, ACD; SDF.

Lancaster, C., C-2476/*50*.

Lancaster, Charles, London, C-2503/*94*.

Lancaster Glass Works, EA.

lance, C-MARS/*54*; DADA; DSSA.

lancehead, S-4796/*11*.

lancehead palmette, S-4414/*542*; S-4847/*142*; S-4948/*171*①.

lance-rest, C-2503/*54*.

lancet, DADA; DSSA; S-4927/*222*①.

lancet-back, EA.

lancet back, SDF/①.

lancet case, LAR83/*629*①.

lancet clock, DADA; EA.

lancet clock case, SDF/①.

lancet frieze, LAR83/*256*①.

lancet leaf, OC/*83*.

lancet-leaf motif, OC/*78*.

lancewood, DATT.

Lancon, S-286/*70*.

Landacre, Paul, S-286/*55*.

Landall and Gordon, SDF/*756*.

Landberg, Nils, DADA/*Supplement*.

landiers, DADA.

land plaster, DATT.

landscape, DATT; DSSA; IDPF/*145*①; LP; S-288/*36*①.

landscape border, JIWA/*44*.

landscape dial, EA.

landscape marble, DATT.

landscape medallion, S-2882/*117.*

landscape painting, S-4461/*414.*

landscape (lay) panel, EA.

landscape panel, SDF.

landscape plaque, NYTBA/*140*①.

landscape spandrel, S-2882/*248*①.

landscape tile, C-0225/*66.*

landscape vase, LAR83/*444*①.

Landsknecht, C-2503/*26.*

Lane, Arthur, CEA/*131*①.

Lane, N., S-4988/*411*①.

Lane Delph pottery, EA/*Pratt, Felix.*

Lange, C-2489/*216.*

Lange, Adolph, C-5174/*398.*

Lange, R., LAR82/*46*①.

Lange, R. W., C-5167/*36*①.

lange Leisjes, EA/*long Elizas.*

lange liezen, C-2458/*99*①.

Lange Lijzen, IDC.

lange Lyzen, EA/*long Elizas.*

Langford, London, C-2503/*24.*

Lang & Hussey, C-2476/*24.*

Langlands, Dorothy, S-4944/*313.*

Langlands, John, S-4944/*327*①.

Langley, Batty, CEA/*334*①; EA; NYTBA/*46*①; SDF/*756.*

Langley, Batty and Thomas, ACD.

Langley, Charles, C-5117/*451*①.

Langlois, Marcoult, C-5174/*491*①.

Langlois, Peter, ACD; EA/①.

langri, OC/*21*①.

langri knot, OC/*308.*

'langri' weaving, OC/*125.*

langsettle, SDF/①.

langue de bœoeuf, DADA.

Languedoc, DADA.

Languedoc marble, DATT.

Langworthy, Lawrence, CEA/*590.*

lang yao, DADA; EA/*ox-blood glaze*; IDC.

langyao, C-5156/*68, 129.*

Langyao bottle, S-3312/*1362*①.

Lang yao glaze, EA.

Lang-yao ware, JIWA/*352.*

Lannuier, Charles-Honoré, CEA/*403*①; NYTBA/*72.*

Lannuier, Charles Honoré, CEA/*389*; DADA; EA.

Lansing, Jacob Gerritse II, CEA/*674*①.

lantaka, C-MARS/*128*; S-4972/*240.*

lantern, C-0249/*315*; C-0279/*455*; C-5114/*235*①; C-5167/*277*①; DADA/①; DSSA; IDC/①; IDPF/*143*; SDF.

lantern clock, ACD; C-0249/*242*; C-2368/*41*①; CEA/*224*①; DADA; EA/①; LAR82/*222*①; LAR83/*200*①; SDF/①.

lantern frame, CEA/*532*①.

lantern pinion, EA/*pinion.*

lantern stand, C-2513/*87A.*

l'Antico, NYTBA/*255*; C-5224/*270*①.

lanyard swivel, C-2503/*162.*

Lanz, J. W., C-2486/*88*①.

Lanze, Johann Wilhelm, EA.

Laocoön, DSSA.

Lao Tzŭ, IDC.

Lapauté, Jean Andre, C-2364/*52*①.

lap desk, LAR82/*65*①; S-4812/*33.*

lapdesk, C-0249/*286*; C-0279/*164*; C-5189/*244.*

lap dovetail, SDF.

lapel-brooch, S-4414/*94*①.

lapel watch, S-4461/*315*; S-4802/*11*; S-4927/*125.*

lapidary, CEA/*451, 509*; MP/*30.*

lapidary-polished, IDC.

lapidary polished edge, S-4843/*522*①.

Lapie, Jean (Lapie le Jeune), S-4955/*201*①.

Lapique, Charles, S-286/*432.*

lapis, C-2421/*3*; C-2427/*26*①;
LAR82/*185*①.

lapis-lazuli, C-5117/*348.*

lapis lazuli, C-2332/*55*①; C-5156/
*424*①; C-5189/*344*①; DATT; EA;
IDC; JIWA/*313*①; LAR83/*610*①;
LP; RTA/*18*①; S-3312/*1270*①.

lapis lazuli cylinder, S-4414/*65.*

lapis lazuli dial, S-4414/*63.*

Laporte, E., C-5181/*71*①.

La Poupée modèle, CEA/*691*①.

lapped brim, C-0225/*290.*

lappet, C-2414/*85*①; C-2458/*46*①;
C-2478/*112*①; C-5116/*145*①;
C-5127/*25A*; C-5259/*641*; S-2882/
*1212*①.

lappet border, C-0249/*184*; S-4414/
381; S-4461/*235*; S-4810/*299*①.

lappet-carved, S-4436/*106.*

lappet design, C-5236/*827*①.

lappet device, S-2882/*1334*①.

lappeted, C-2403/*107*; C-2421/*69.*

lappeted club leg, C-2388/*82.*

lappet handle, C-5117/*324.*

lappet motif, C-5156/*382*①.

lappet of Brussels lace, C-1506/
*156*①.

lappet outline, S-3312/*1135*①.

lappet pattern, IDC.

lappet-pattern band, C-5127/*407*①.

lappett border, S-4461/*442.*

lappetted, C-1407/*85*; C-2402/*45.*

lapping, EA.

laqabi, EA.

l a quality, C-5117/*446*①.

laquée burgautée, porcelaine, IDC.

larch, ACD; SDF.

larch wood, DADA.

Larder, Charles Edward, S-4927/*155.*

Lardin, André-Antoine, C-2364/*50*①;
S-4955/*68*①.

lard stone, DATT.

large pattern motif, JIWA/*206.*

large-ring transitional, C-2476/*14*①.

large-scale lithograph, JIWA/*39.*

Laristan rug, DADA.

Larkobi, C-2320/*137.*

larnaca, IDPF/*145*①.

larnax, IDPF/*145*①.

La Rochelle, DADA; EA.

La Rochelle, with date, EA/*La
Rochelle.*

Larpent and Jurgensen, CEA/*259*①.

Larsen, Jack Lenor, DADA/
Supplement.

Larsen, Linnart, CEA/*315*①.

L'Art Nouveau, CEA/*520*; SDF.

Lasalle, Philippe de, NYTBA/*60*①.

La Sa scenic, C-0225/*4.*

Las Bocas, S-4807/*136.*

laser chased, S-4804/*190*①.

La Seynie, DADA.

lashings, C-1082/*20.*

lasso, C-2357/*77*①.

lass paste, S-4843/*514.*

La Stele stamp, C-5167/*23.*

Last Supper, DSSA.

Lasurstein blue, MP/*187.*

latch, C-0279/*97*①.

latch-hook, CEA/*84*①; S-3311/*9.*

latch hook, DADA; OC/*109, 212.*

latchhook, S-4796/*4*①, *17*; S-4847/
*3*①.

latchhook design, C-5189/*382.*

latchhook-framed reserves, S-4948/
*7*①.

latch hooks, S-288/*1*①.

late Baroque period, JIWA/*8.*

late Biedermeier, C-0982/*65.*

late Ch'ien Lung, C-0782/*23.*

late Chinese, C-1082/*93.*

Late Federal, C-5153/*211*①.

late George III, C-5157/*2.*

late Georgian, C-0982/*4*; CEA/*321.*

Late Georgian period, SDF.

late Gothic period, MP/*492*①.

Late Heian Period, C-5156/*772*.

late impression, C-5156/*1013*.

Late Jacobean, SDF.

late Japanese, C-0782/*75*.

late Kutani, C-0782/*139*.

late Meissen, C-1006/*14*.

late Ming, C-0782/*9, 206*; C-2458/*165*①.

late Ming dynasty, C-2458/*70*; C-5156/*64*①.

late Ming/early Qing Dynasty, C-2458/*53*①.

Late Mon Dvaravati, C-5156/*230*①.

laten, CEA/*541*; SDF/*latten*.

La Tène II Seriesa, C-2503/*29*①.

late new kingdom, S-4807/*470*①.

late period, S-4807/*471*.

Late Qianlong, C-5156/*170*.

later-added, C-0982/*56*; C-2402/*35*.

lateral flower garlands, MP/*492*①.

lateral mask, MP/*464*①.

later bun feet, C-5116/*109*①.

later edition, C-5156/*1036*.

late Regency, CEA/*321*.

late Renaissance style tapestry, S-4804/*954*①.

later-fitted, C-2403/*148*①.

Laterndluhr, CEA/*240*①.

later stand, C-2402/*8*.

later wood, S-3311/*264*.

late Satsuma, C-0782/*185*.

latesino, EA.

Late Southern Song Dynasty, C-5156/*42*.

Late Stuart, C-2489/*19*①.

late Stuart style, C-5157/*25*.

late surimono art, JIWA/*114*.

late Victorian, C-0406/*126*; C-0982/*8*.

late Wanli dynasty, C-2458/*73*①.

latex, DATT; LP.

Latham, Jno., S-4927/*209*.

lath back, SDF/①.

lathe, C-0403/*247*; EG/*100*; IDC; SDF.

Latimer cross, C-2357/*2*①.

Latin cross, C-2704/*9*; DATT.

Latin motto terminal, C-0254/*261*.

Latin signature, C-5173/*18*①.

Latona Bizarre, C-2910/*71*.

latten, ACD; CEA/*529, 531*①, *541*; DADA; EA, *altar cruet*; LAR83/*514*①; SDF; S-4972/*311*.

Latten spoon, S-4972/*313*.

lattice, C-2403/*175*; OPGAC/*226*.

lattice back, C-5116/*86*; SDF/①.

lattice-back chair, DADA.

lattice border, IDC.

latticed, C-2402/*60*; C-5005/*331*①.

latticed back, C-2402/*59*.

latticed cresting, C-1407/*72*.

lattice-decorated, C-0982/*147*.

lattice design, C-2388/*139*; C-2403/*160*.

lattice grille, LAR82/*426*①.

lattice ground, S-4804/*134*.

lattice inlay, CEA/*317*①.

lattice-work, ACD; DADA; OC/*170*①, *205*; RGS/*123*①, *140*①, *145*①; S-4461/*52*; S-4847/*12*.

lattice work, C-2704/*96*; RGS/*31*①; S-4972/*308*①; SDF.

latticework, C-1006/*26*; C-5117/*17*①; CEA/*311*①; LAR82/*316*①; S-2882/*955*①, *1306*①.

latticework border, S-4461/*121*.

latticework door, NYTBA/*50*①.

lattice work mount, S-291/*112*.

lattice-work pendant, OC/*240*.

latticinio, CEA/*502*; DADA; EA; EC1/*56, 64*①.

latticinio decoration, CEA/*480*①.

latticinio glass, CEA/*50*①.

latticinio or latticino, ACD.

latticinio separation, CEA/*489*.

latticinio swirl, CEA/*501*①.

latticino, EA/*latticinio*.

latticino (latticinio), EG/*290*①.

latticino glass, NYTBA/*266*①.

lattimo, EA; EG/*61*①.

Latvian style, NYTBA/*227*.

Latz, Jean-Pierre, C-2555/*52*①; S-4955/*187*①.

Laubengruppe, IDC.

laub und bandelwerk, C-5189/*206*; CEA/*502*; DADA.

Laub- und Bandelwerk, IDC/①.

Laub-und-Bandelwerk, C-2427/*76*①, *94*; EA/① *ollio pot*; EG/*290*.

Laub und Bandelwerk, CEA/*173*①.

Laubund-Bandelwerk, C-2486/*64*①.

Lauche, EA.

Lauche fecit Dresden, EA/*Lauche*.

laughing boy, C-5224/*45*①.

'laughing colours', OC/*200*.

Laughlin, Homer, China Company, DADA/*Supplement*.

Laughlin, John, S-4922/*61*①.

Launay, Nicolas de, EA/*Delaunay, Nicolas*.

Laureate pattern, C-0270/*170*.

laurel, DATT; DSSA; SDF.

laurel border, IDC; S-2882/*982*①.

laurel branch foot, C-5174/*336*①.

laurel cartouche, C-0706/*123*.

laurel-festooned, CEA/*655*①.

laurel foliage, C-5117/*59*.

laurel-leaf border, C-2332/*143*①.

laurel leaf-carved, S-4507/*73*①.

laurel-leaf tip, C-5117/*305*①.

laurel-swag, C-2421/*3*①.

laurel swag, C-5117/*283*①; S-2882/*787A*①.

laurel swags, C-0406/*1*; S-4804/*115*.

laurel wood, SDF.

laurel wreath, C-2398/*56*; S-4881/*65*①.

laurel wreath border, C-0254/*145*; C-2357/*84*①.

laurel wreath cartouche, C-5117/*75*①.

Laurence, Sturgis, OPGAC/*344*.

Laurence Vitrearius, EA.

Laurent, G.H., C-5191/*124*.

lauret, C-2202/*52*.

laurier, C-0225/*177*.

laurier aromatique wood, DADA.

Lauweriks, Johannes L. M., DADA/*Supplement*.

lavabo, C-2498/*31*①; C-5174/*25*①; DADA/①; EA; IDC; NYTBA/*145*.

La Vacquerie, CEA/*131*①.

lava glass, EC1/*56*.

lavaliere, S-291/*257*.

Lavar, S-4847/*330*①.

Lavar Kerman carpet, S-3311/*16*①.

Lavar Kirman Millefleurs rug, S-4796/*184*.

Lavar Kirman pictorial rug, S-4948/*83*①.

Lavar Kirman prayer rug, S-4796/*47*, *100*.

lavastone, LAR83/*532*①.

Lavater, John (Johann Caspar), EA.

lava ware, EA/*scroddled ware*; IDC.

lavender, C-2704/*96*.

lavender, oil of, DATT; LP.

lavender-jar, IDC.

lavender ware, IDC.

laver, EA/*lavabo*; IDC; LAR82/*56*①; NYTBA/*254*①; SDF.

Laver, Benjamin, C-5117/*283*①.

Laver-Kermans, OC/*137*.

lavher, DADA.

Law, Atkin & Oxley, EA/*Law, Thomas*.

Law, Thomas, John, EA.

lawn, C-2501/*56*; DATT.

Lawrence frame, DADA/①.
Lawrence Jones, S-4922/43①.
Lawrence & Mayo, C-2904/175.
Lawrence patent, C-2503/103.
lay, CEA/594; EA.
Lay, Johann Jakob, EA.
layered bowl, IDPF/212①.
layette, DADA.
lay figure, DATT/①; LP.
lay-in, LP.
lay-men, CEA/594.
lay panel, SDF.
Lazarin, Lazaro, C-MARS/135①.
Lazarus, DSSA.
lazuline blue, DATT.
lazulite, IDC.
lazy-back, SDF.
lazy stitch, CEA/289①.
lazy susan, C-0270/10; EA; C-0982/308.
lazy Susan table, SDF.
lazy tong, CEA/697.
LB, EA/Limbach.
L-bar lock, C-5236/811①.
LC, EA/Cleffius, Lambert.
LC above SC, EA/Courtauld, Samuel.
L. Casella, C-2904/245.
LC in lozenge, EA/Courtauld, Samuel.
L. DELANOIS, EA/Delanois, Louis.
lea, EA/lay.
Leach, Bernard, DADA/Supplement; JIWA/351; LAR82/143①.
Leach, David, C-2910/79; DADA/Supplement.
Leach, Janet, C-2910/128.
Leach, John, EA/111①.
leaching, EA.
Leacock, John, S-4905/218.
lead, C-5116/172①; CEA/424①; DATT; S-4972/112①, 311.

lead, white, DATT.
lead alloy, S-3311/233.
lead content crystal, CEA/459.
lead crystal, EG/288; JIWA/307①.
leaded glass, C-0225/326; C-2409/231; C-5005/373; C-5146/165①; C-5167/244①; C-5239/307; K-711/126; S-4461/495.
leaded glass screen, C-5167/257①.
leaded glass shade, LAR82/446①.
leaded glass window, C-5167/266A①.
lead frame, C-0249/158.
lead glass, DADA; EG/80①; LAR83/428①; NYTBA/277.
lead-glaze, CEA/110; EA.
lead glaze, DADA; IDC.
lead-glazed, NYTBA/123①.
lead-glazed sgraffiato earthenware, EA/Bologna (Emilia.
leading edge, S-4881/487①.
leadless glaze, IDC.
lead oxide, CEA/414; EG/288.
lead pencil, DATT.
lead poisoning, LP.
lead white, LP.
leaf, C-1603/74, 90; DATT.
leaf (in fan), EA.
leaf (in furniture), EA.
leaf, S-4972/70; SDF/①.
leafage, C-5114/2①, 13, 393①; S-4905/141①.
leaf and blossom border, S-2882/222A.
leaf and dart, OPGAC/226①.
leaf-and-pod decoration, C-5005/233①.
leaf and scroll, S-4955/178①.
leaf and wine glass border, S-2882/164.
leaf-border, IDC.
leaf border, C-5114/38①; S-4461/509.
leaf bowl, C-0254/292①.

leaf bracket, FFDAB/*51*.

leaf-capped, C-2202/*27*; S-4922/*58*①.

leaf capped, C-0254/*42, 128*; C-1502/*51*; C-2202/*183*.

leaf-capped handle, S-4414/*342*①.

leaf-capped scroll handle, LAR83/*587*①.

leaf-carved, C-2402/*114*; S-4955/*206*.

leaf-carved knee, C-5114/*393*①.

leaf-carved pierced cross-bar, S-4414/*497*①.

leaf carved splat, S-2882/*266*.

leaf cast, S-4955/*203*.

leaf-chiselled fence, C-2476/*66*.

leaf design, C-5114/*20*.

leaf-dish, C-2493/*48*; IDC.

leaf dish, C-0254/*200*; IDPF/*146*①.

leaf escutcheon, C-5114/*49*.

leaf form, C-0249/*263*.

leaf-form feet, S-4461/*265*.

leaf-green, C-5127/*5*①.

leaf green, DATT.

leaf molded, C-5189/*20*.

leaf motif, S-2882/*636*①.

leaf-moulded, C-2360/*111*①.

leaf panel, C-0982/*40*.

leaf-pattern, C-5116/*91*.

leaf ring lid, LAR83/*454*①.

leaf scroll field, S-2882/*175*.

leaf scroll foot, SDF.

leaf-shape, C-2458/*122*; EC2/*29*①.

leaf-shaped, C-1006/*74*; C-5156/*223A*.

leaf-shaped border, C-1006/*56*.

leaf-shaped pelta motif, RTA/*39*①.

leaf-shaped tray, RGS/*31*①.

leaf shelter, C-1082/*21*.

leaf spray, C-2414/*86*①.

leaf spray crest, C-0279/*448*①.

leaf terminal, C-2427/*30*①.

leaf-tip, C-5116/*105*; C-5157/*9*; S-4436/*8*①; S-4922/*7*①.

leaf tip, C-5116/*37*①.

leaf-tip banding, C-5116/*43*①.

leaf tip banding, C-0279/*196*①.

leaf-tip border, S-2882/*961*①; S-4922/*26*①.

leaf tip border, C-0254/*107*.

leaf-tip decoration, S-4804/*75*; S-4944/*37*①.

leaf-tip feet, C-0249/*198*.

leafy palmettes spandrel, S-2882/*157*①.

leafy scroll, S-4461/*544*.

leafy swags, C-2704/*42*.

lean, DATT; LP.

leaping viewpoint, JIWA/*243*①.

Lear, C-5181/*14*.

leather, ACD; C-0706/*5*; C-3011/*13*; C-5116/*27*; C-5239/*246*; S-4461/*23*; S-4972/*475*①.

leather bounded, C-0906/*144*.

leather-cloth, C-2904/*19*.

leather covered hammer, CEA/*548*.

leather-faced, CEA/*343*①.

leather form, IDPF/*146*①.

leather friction pad, C-2904/*280*①.

leather furniture, SDF.

leather glove, C-1506/*70*.

leather grip, C-5117/*153*①.

leather-hard, CEA/*209*; DATT; IDC.

leather-lined, C-0982/*9, 28*.

leather-lined easel, C-2478/*116*①; C-5116/*133*①.

leather-lined top, C-1407/*4, 92*; C-2403/*86*.

leather-mounted, S-4905/*330*.

leather panel, C-0982/*6*.

leather pouch, C-5156/*739*①.

leather pouch form, S-4965/*184*①.

leaves, C-0982/*30, 101*; C-2402/*1*; C-5114/*274*; C-5116/*123*; C-5236/*637*①; C-5239/*244*.

Lebas, Jean-Baptiste, C-2555/*31*.

Lebeau, Joris Johannes Cristiaan, DADA/*Supplement*.

Lebeda, Anton Vineaz, CEA/*26*①.

lebes, IDC; IDPF/*147*.

lebes gamykos, IDC/①.

LeBolt & Co., S-4927/*245*.

Le Brun, Charles, ACD.

Lebrun, Charles, DADA; EA.

Lebyodkin, Ivan (assaymaster), C-5174/*218*①.

Le Chevalier, J., C-5167/*209*①.

lechtschaffen, MP/*105*.

lecithin, DATT.

Le Clerc, Jerome, EA/*341*①.

Lecomte, S-4947/*24*.

Le Corbusier, C-GUST/*156*①.

LeCorbusier, S-286/*248*.

Le Corbusier (pseudonym for Jeanneret-Gris, Charles Edouard), DADA/*Supplement*.

Lecornet, C-5181/*80*.

LeCoultre, S-4927/*116*.

Lecoultre, Marius, C-5117/*439*①.

Lecreux, Nicolas, CEA/*186*①; EA.

Le Croissy, C-1582/*91*.

lectern, C-5117/*199*①; CEA/*368*①, *530*①; DADA; LAR83/*354*①; S-4461/*572*; S-4972/*41*①; SDF/①.

lectern table, LAR83/*353*①.

lectren, C-2498/*89*.

lecythus, DATT.

ledge, IDC.

ledge back, C-2388/*108*; C-2402/*131A*.

ledger paper, DATT.

Ledru, C-2409/*205*.

Ledsam, Vale and Wheeler, C-5117/*369*.

Leech, W., C-2476/*61*.

leech-jar, IDC/①.

Leeds, ACD; CEA/*139*①; DADA; EA; LAR83/*121*①; S-4461/*170*; S-4905/*152*.

Leeds Bishop, IDPF/*50*.

Leeds creamware, LAR82/*144*①.

Leeds pottery, NYTBA/*150*①; EA/*Leeds*; S-4843/*128*①.

Leeds ware, IDC.

Leek Embroidery Society, DADA/*Supplement*.

leek green, DATT.

Leerdam, DADA/*Supplement*.

Leerdam glassworks, EG/*127*①.

Leeuwenhoek, Anton van, CEA/*610*①.

Le Fagauys, Pierre, C-5191/*198*.

Lefébvre, Fran7is, DADA.

Lefebvre (le Fèvre, Lefèvre), Jean, EA.

Lefebvre (le Fèvre, Lefèvre), Pierre, EA.

Lefevre, Louis-Michel, S-4955/*102*①.

Lefèvre, Louis-Michel, stamp: J M LEFEVRE, C-5224/*178*①.

Le Fils, Yver, Angouleme, C-MARS/*180*.

le Flamand, Pierre, EA/*Burghley Nef*.

left- and right-hand pattern, CEA/*330*①.

Leftè, EA/*49*①.

left-hand dagger, C-2569/*32, 99*①.

left hand dagger, S-4972/*285A*.

Lefton china, K-711/*124*.

leg, C-0982/*15, 84B*; C-2458/*3*; C-2513/*95*①; C-5114/*347*①; C-5239/*240*; SDF.

Legaré, Gilles, CEA/*514*①.

Légaré, Gilles, EA.

le Gaugner, Louis Constantin, EA.

leg-cup, IDC.

legend, S-4881/*65*①.

legendary figure, C-2513/*73*.

legendary netsuke, S-4928/*50*①.

le genre pittoresque, EA/①
Meissonier, Juste-Aurèle.

Leger, Fernand, S-286/*300A*①.

legitimate construction, DATT.

leg-of-mutton case, C-2476/*21.*

leg o'mutton sleeve, C-3011/*12.*

Legrand, Deésiré Toussaint, C-5174/
493.

Legrand, Edy, C-5005/*349*①.

Legrand, Louis, S-286/*303*①.

le Gras, C-5191/*251*; C-GUST/*54.*

Legras, C-2409/*45*; C-2910/*49*;
OPGAC/*168*; S-4461/*93.*

leg rest, EA; SDF/①.

Legros, Alphonse, S-286/*82.*

Le Gry, Jean-Louis François, stamp:
L F Le GRY, C-5224/*89*①.

legs carved as animals' legs, C-5224/
*209*①.

leg table, C-5114/*261.*

Lehan, C-2458/*289*①.

Lehman, Benjamin, EA.

Lehman, Caspar, CEA/*451.*

Lehmann, Caspar, EA/①.

Lehmann, C. F., CEA/*315*①.

lehr (annealing), (enameling), EG/
270.

lei, ACD; DADA; EA; IDPF/*131,
147.*

leiberkuhn, C-2904/*198*①.

Leighton, Thomas, CEA/*471*①.

Leighton, William, EA/*lime glass.*

Leihamer, Abraham, CEA/*139*①.

Leipzig yellow, DATT.

Leithner, Joseph, EA.

Leithner blue, DATT.

Leithner's blue, EA/*Leithner, Joseph.*

Leitz, E., C-2904/*98.*

lei-wên, IDC.

leiwen, C-2414/*3*①; C-2458/*213*;
S-4810/*44*①.

lei wen fret, S-2882/*94*①.

leiwen ground, S-3312/*1260*①;
S-4810/*287*①.

lekane, IDC.

lekanis, IDC/①; S-4973/*342*①.

lekanos, IDPF/*147.*

lekythoi, S-4807/*495*①.

lekythos, C-2482/*78*; DATT; IDC/
①; IDPF/*147*①; S-4807/*495*①;
S-4973/*326*①; LAR83/*65*①.

Lelarge, Jean-Baptiste, C-5224/*132*;
EA; S-4955/*168A*①.

Lelee, Leopold, S-286/*4331.*

Leleu, C-5005/*357*①.

Leleu, Jean-François, EA/①.

Leleu, Jean François, DADA.

Leleu, Jules, C-5167/*217*①; DADA/
Supplement.

Leleu, M. J. F., ACD.

Lely family, EA/*van der Lely.*

Lemaire, A., C-5189/*195*①.

Lemanceau, C-2409/*115*; C-5191/*69.*

Lemberg control mark, C-5174/*50.*

Le Mercier, S-4881/*20*①.

Lemire, EA/*Sauvage,
Charles-Gabriel, Sauvage,
Charles-Gabriel.*

LEMIRE PERE, EA/*Sauvage,
Charles-Gabriel.*

Lemnian ruddle, DATT.

Lemon, William, CEA/*399*①.

Lemonade Seller, EA/*cris de Paris.*

lemon-box, IDC.

Lemonnier, EA.

lemon strainer, LAR83/*590*①;
S-4922/*67*①.

lemon wood, DADA.

lemonwood, DATT.

lemon-yellow, IDC.

lemon yellow, DATT; LP.

Lenhendrick, Louis-Joseph, EA.

Lenkoran rug, S-4461/*808.*

Lennoxlove, C-2478/*91.*

Le Noir, Etienne, Paris, C-MARS/
230.
Le Noir, Jean Baptiste Augustin,
C-5224/52①.
Le Normand, Albert, DADA/
Supplement.
Le Nove, C-2427/31, 224①; CEA/
171①; EA; LAR83/121①.
Lenox, C-5239/41; K-802/22;
NYTBA/180; OPGAC/357;
S-4992/64①.
Lenox Boehm, OPGAC/353.
Lenox Company, DADA/Supplement.
Lenox liners, C-0254/175.
Lens: Bernard, Bernard II, Bernard
III, Andrew Benjamin, Peter Paul,
EA.
lenticle, ACD; C-1702/331; C-5116/
49①; C-5170/34①; C-MARS/245.
lenticular, IDPF/147①.
lenticular form, S-4829/90①.
lentoid, S-4807/529.
lentoid flask, S-4973/20①.
Lenzkirch, C-5189/71①.
Leo, DSSA.
Léonard, Agathon, CEA/185①.
Leonard, Reed and Barton, S-4905/
315.
Leoni, Leone, C-5224/284①.
leonine phallus, S-4973/167①.
leopard, DSSA.
leopard skin ground, C-0225/50.
leopard skin rug, LAR82/36①.
leopard wood, SDF.
Lepage, Bastien, S-286/70.
Lepanto marble, DATT.
lepaste, IDC.
Lepaute, J. A., CEA/227①.
Le Pautre, Jean, DADA.
LePautre, Jean-Andre, C-5174/410①.
Lepere, Auguste, S-286/304A.
L'epine, C-5117/480①.
Lepine, Horloger du Roi, S-4927/200.

Lépine, Jean-Antoine, EA.
L'Epine, Paris, S-4927/42①.
lepine calibre, C-5117/411①, 476①.
Lepine-calibre, C-2368/125, 128.
Lepine-calibre movement, C-2489/
139.
Lepine calibre movement, C-2368/
168①.
Lepine principle, CEA/250.
Lequoi, EA/Soqui.
Leriche, Durand, S-4927/103.
LeRoux, Bartholomew, CEA/668①.
Le Roux, Bartholomew II, S-4905/
226.
LeRoux, Bartholomew II, C-5153/
37①.
Le Roux, Charles, EA.
Leroux, Gaston Veuvenot, C-5189/
167①.
Leroux, John, S-4927/34.
Le Roy, C-5117/393①.
Le Roy, Cie., Paris, C-MARS/159.
Leroy, J. B., C-2904/53.
LeRoy, Julien, EA.
Leroy, Paris, C-2489/207①.
Le Roy, Pierre (Pr. Le Roy à
Paris), C-5224/48①.
LeRoy, Pierre, EA.
Leroy & Fils, CEA/228①; S-4927/
112.
Le Sage, Augustin, C-5117/229①.
Le Sage, John, S-4922/76①.
Le Sage, John Hugh, C-5117/249.
les Animaliers, NYTBA/256.
Leschaudel, A., C-5174/485; C-5220/
40①.
Leschaudel, Antoine, C-5174/445.
Leschot, Jean-Frédéric, CEA/685;
EA.
Les Clematites pattern, C-5146/
107①.
les Fenosa, Apel, S-286/432.

Les Frères Esquivillon et
 DeChoudens, C-5174/*413*①.
Lesghi, S-4847/*24*①.
Lesghi cross, S-4796/*78*.
Lesghi design, C-2478/*256*.
Lesghi medallion, C-5189/*363*.
Lesghi rug, S-4796/*78*.
lesghi star, S-2882/*88*.
Lesieur, Paris, C-2489/*233*.
Lesieur à Paris, C-5224/*1*.
Leslie, Charles, C-5117/*87*①.
Lessell Art Ware, Parkersburg, West
 Virginia, EC1/*85*.
Lessore, Emile, CEA/*164*①, *204*①;
 EA; S-4843/*312*①.
Lessore ware, IDC/①.
Lesueur, S-4927/*224G*①.
Lesum, DADA; EA.
let-down pigment, DATT.
Lethaby, William Richard, DADA/
 Supplement; SDF/*756*.
letter, NYTBA/*213*.
letter balance, C-0403/*86*.
letter box, S-4461/*411*.
letterclip, C-5146/*157*.
letter D, C, EA/*American silver*.
letter file, C-0279/*182*.
letter holders, S-4905/*332*.
letterholes, SDF.
lettering, LP/① *brushes*.
lettering brush, DATT/①.
lettering pen, DATT/①.
lettering quill, DATT.
letter in reverse, C-2513/*89A*①.
letter knife, LAR83/*586*①.
letter of provenance, C-2324/*46*.
letter opener, C-0254/*40*, *201*;
 C-5203/*226*; S-4461/*209*.
letterpress, DATT.
letter rack, C-0225/*308*; C-5005/*381*;
 C-5239/*92*; DADA/①; SDF.
letter snuff-box, IDC.

letterwood, DATT; SDF.
Leuteritz, Ernst August, MP/*492*①.
Levallois, Louis, CEA/*178*①.
Levant, les Différentes Nations du,
 IDC.
Levantine, C-0279/*421*①; C-5157/
 138; C-5174/*58*.
Levasseur, A, C-5181/*64*①.
Le Vasseur, Etienne, DADA.
Levasseur, Etienne, EA.
Levasseur, Étienne, stamp: E
 LEVASSEUR, C-5224/*118*①.
Levavasseur: Jacques-Nicolas,
 Marie-Thomas-Philémon, EA.
leve, C-0225/*376A*.
leveling, DATT.
levelling screw, C-2904/*74*.
lever, S-4461/*305*.
lever-action, CEA/*41*①.
lever activated, S-4972/*165*①.
lever escapement, CEA/*254*①, *267*;
 EA/*escapement*; S-4927/*34*.
lever movement, C-5174/*333*①;
 S-4802/*8*①, *24*.
lever platform, LAR83/*187*①.
Le Verre Francais, C-2910/*18*;
 C-GUST/*53*; LAR83/*482*①.
Le Verre Francaise, C-5191/*252*.
lever set, C-5117/*395*①, *436*①.
lever watch, C-5117/*395*①, *416*①;
 LAR82/*237*①; LAR83/*212*①.
Leviathan, DSSA.
levigation, DATT; IDC.
levigator, DATT/①.
Levit, Balthazar, C-5117/*16*①.
levkovo, RGS/*166*.
Levok titre, RGS/*166*.
Lewis, George, CEA/*644*①.
Lewis, Harvey, CEA/*677*①.
Lewis, Martin, S-286/*305*①.
ley, DADA; EA/*lay, lay*.
Ley, Timothy, C-5117/*265*①.
Leyden blue, DATT.

Leyden jars, C-2904/*131*.

Leyniers: Urban, Daniel, EA.

Leyrer, Guss G., Munchen, C-5167/*7*.

leys jar, CEA/*120*①; IDPF/*147*.

ley vase, EA/①.

LF.T., CEA/*68*①.

L.H., C-2704/*141*.

Lhasa, OC/*315*①.

L'Hermittes, Leon, S-286/*56*.

li, ACD; DADA; EA; IDC; S-4963/*21*①.

Liao Dynasty, C-2414/*44*①; C-5156/*37*①; S-3312/*1311*①; S-4965/*93, 183*①.

Liao period, IDPF/*146*①.

Liao ware, S-4965/*183*①.

Lias, John and Henry, C-5203/*180A*.

Lias, John, Henry and Charles, C-5117/*210*①.

lia tza, EA.

libation cup, C-2458/*146*①, *276*; IDC; LAR83/*457*①; S-3312/*1259, 1261*①; S-4810/*327*①; S-4965/*292*①.

libation vessel, C-2414/*11*①.

Libbey, NYTBA/*308*; OPGAC/*168*.

Libbey Glass Company, DADA/*Supplement*; EC1/*68*.

Libbey Glass Works, CEA/*463*①.

Liberty, DSSA.

Liberty and Co., C-2910/*193*.

Liberty and Company, C-5167/*142*①.

Liberty and Matrimony, IDC/①.

liberty bell, OPGAC/*226*.

Liberty Bell pattern, CEA/*472*①.

Liberty & Co., C-2409/*197*; C-5239/*112*.

Liberty seated quarter, K-710/*118*.

Libra, DSSA.

library armchair, C-1407/*19*; C-2388/*15*; C-2403/*26*; C-2421/*23*①;

C-2478/*36*; C-5116/*94*①; C-5157/*161*①; S-4812/*154*①.

library bookcase, C-2403/*154*.

library cabinet, C-5116/*138*.

library case, EA; SDF/①.

library chair, ACD; SDF.

library desk, C-0279/*275*.

library drum table, C-5157/*82*.

library firescreen, SDF/① *library screen*.

library ladder, C-5114/*258*.

library open, S-3311/*105*①.

library paste, DATT.

library press bedstead, SDF.

library screen, EA; SDF/①.

library set, IDC.

library step chair, LAR83/*285*①.

library steps, ACD; C-2403/*51*; DADA/①; EA; SDF/①.

library stool, SDF.

library table, ACD; C-0249/*394*; C-0982/*102, 120*; C-2357/*69*①; C-2478/*170*; C-5116/*129*①; C-5239/*241*; DADA; EA/①; FFDAB/*104*①; SDF/①.

library wheelbarrow, SDF.

library writing table, S-3311/*150*①.

lichee design, OC/*52*.

Lichtenstein, Roy, S-286/*307A*①.

lid, IDC; IDPF/*148*①; MP/*51*; S-4905/*456*①; S-4972/*163*①.

lidded, C-0982/*9*.

lidded compartment, C-5116/*2, 11*.

lidded interior, C-2388/*70*①.

lidded well, C-5157/*157*①.

lid gate, CEA/*541*.

lids, S-4461/*23*.

lid seating, IDPF/*149*①.

lie, OC/*27*.

lieberkuhn, C-2904/*206*.

Lieberkuhn, Christian, S-4944/*152*①.

Lieberkuhns, C-2904/*110*①.

Liebermann, Ferdinand, C-GUST/*15*.

Liebes, Dorothy, DADA/*Supplement*.
Liechti, Andreas, CEA/*220*①.
Liechti Erhard, CEA/*220*①.
Liege, LAR82/*307*①; LAR83/*62*①.
Liegeois, LAR83/*406*①.
Liège proof, C-MARS/*122*.
Liegois, C-2437/*39*.
lien, C-5156/*173*.
Lieutaud, C-2364/*52*①.
lièvre, C-0225/*172*.
life cast, DATT.
life drawing, DATT.
life mask, DATT.
life mask bust, S-4881/*351*①.
life mount, K-711/*124*.
life-size, DATT.
lift-handle, IDC.
lifting, C-0249/*364*; DATT; LP.
lifting cover, C-0279/*400*①.
lifting-handle, C-5116/*21*①; C-5157/*15*.
lifting latch, S-2882/*617*①.
lifting lid, C-2904/*298*.
lifting piece, CEA/*267*.
lifting screen, C-0249/*423*; C-5116/*61*.
lifting top, C-2403/*63*.
lift-off superstructure, C-2522/*171*①.
lift-out tray, C-2357/*8*①.
lift-top, S-4461/*635*①.
lift top, C-0279/*285*①; S-4461/*563*①.
lift-top box, LAR82/*66*①.
lift top chest, C-5114/*259*.
lift-up toplever, C-2476/*85*①.
Liger, Isaac, CEA/*648*①.
light, DATT; JIWA/*6, 63*; LP/①.
light and shade, JIWA/*10*.
light and shade effect, MP/*62*.
light and shadow, LP.
light base, C-0225/*333*.
light brushwork, JIWA/*25*.
light cavalry sabre, CEA/*43*①.

Light Dragoon pattern pistol, C-2503/*176*.
lighted, CEA/*225*①.
lighter, C-0225/*139*; C-5239/*110*.
lightfastness, DATT.
light fixture, S-4461/*81*.
Lightfoot, Peter, CEA/*218, 267*.
lighthouse, C-1502/*209*.
lighthouse caster, LAR83/*555*①.
lighthouse clock, DADA; EA.
lighthouse coffee pot, DADA.
lighthouse shape, EC2/*22*①.
lighthouse sugar caster, C-0103/*199*.
lighting device, S-4905/*345*.
3-light lily table lamp, C-5005/*404*①.
lightly moulded, C-0782/*4*.
light-medium-deep, LP.
Lightner and Kilbourne, CEA/*590*.
lightness, DATT.
lightning, DSSA.
lightning pattern, OC/*261*.
light-on-pedestal, S-4507/*44*①.
light red, DATT; LP.
light relief, JIWA/*92*.
lights, C-0249/*271*.
light socket, C-5005/*400*①.
light stain, S-286/*359A, 369C*.
light-stained, S-2882/*1400*.
light stained, S-286/*299, 307*.
lightweight, C-2476/*18*.
lignum vitae, ACD; C-2478/*88*①; C-5114/*273*①; C-5157/*7*; DATT; S-4436/*2*; SDF.
lignum vitae handle, C-0403/*39*.
Ligurian ware, CEA/*135*①.
Like, The, C-2904/*24*.
Like Composition, C-2904/*199*.
lilac, C-1506/*131*.
lilac band, C-2704/*49*.
lilac cotton, C-2704/*49*.
lilac dip, S-4843/*497*.
lilac dip ground, S-4843/*488*.

lilac ground, EA.

Lilihan, DADA; OC/96①.

'Lilihan design', OC/283.

Lille, CEA/146①; DADA.

Lille lace, DADA.

Lille porcelain, ACD.

Lille tapestry, C-2546/142①; DADA; EA.

Lillihan rug, S-4461/753.

lily, DSSA.

lily blossom finial, C-5174/518①.

lily border, IDC.

lily chandelier, C-5167/286①.

lily form, CEA/501①.

lily-form shades, S-4414/252①.

lily of the valley, OPGAC/227.

lily-pad, CEA/466①; DADA/①.

lily-pad decoration, EA/①.

lily-pad form, EG/187.

lily-pad pitcher, EG/187.

lily pad rigaree, CEA/461①.

lily pattern, IDC; C-0254/293.

Lily tray, S-4843/261①.

lily vase, C-2409/53.

lima wood, SDF.

limbach, C-5259/133; C-1006/65; C-2486/81①; DADA; EA; MP/164.

Limbach, Hermann, MP/492①.

Limbach porcelain, ACD.

Limberts, C-5191/299; C-5239/244.

limb-type microscope, C-1609/7.

lime, ACD; C-5146/103; CEA/414; DATT; LP; SDF.

lime blue, DATT.

limed oak, C-1407/124; SDF.

lime glass, DADA/Supplement; EA.

limehouse, ACD; EA.

limeproof pigment, DATT.

lime putty, DATT.

Limerick, DADA.

Limerick lace, C-1304/98.

lime-soda glass, EA/soda-lime glass.

limestone, C-2458/291; C-2482/82; C-2546/117①; C-5156/184, 206①; DATT; EG/236; LAR82/645①; LAR83/647①; S-4810/106①; S-4972/1①.

limewash painting, DATT.

limewater, DATT.

lime whitening, EA/pickled finish, pickled finish.

lime wood, DADA.

limewood, C-5157/25; C-5224/229①; CEA/684; S-4507/6①.

limited edition, C-0706/55; DATT.

limited palette, DATT.

Limnell, Axel Johan, C-5117/382①.

limner, DATT.

limning, EA; LP.

limoges, C-0249/190; C-1006/132; C-2409/97; C-5181/34; CEA/184①; DADA; EA; K-802/21; S-4461/492, 519.

Limoges China Company, K-802/21.

Limoges enamel, ACD; DATT.

Limoges factory, MP/160.

Limoges porcelain, ACD.

Limoges porcelain plate, S-3311/360①.

Limousin, DADA; LAR83/44①.

Limousin, Léonard, EA.

Linarol, CEA/551①.

Lincoln, F. W. Jnr., CEA/608①.

Lincoln drape, OPGAC/227.

Lincoln Hat, C-0405/216.

Lincoln imp, C-1006/60; C-1502/185.

lincoln rocker, SDF.

Linden, Esaias Zu, C-5173/67①.

Linden, Esaias zur, CEA/627①.

linden wood, DADA.

lindenwood, S-4972/19①.

Lindner, Richard, S-286/312.

Lindner figures, IDC.

Lindstrand, Vicke, C-2409/*29*; DADA/*Supplement.*

70-line, OC/*33.*

line, C-2402/*85*; IDPF/*5*; JIWA/*6, 63*; LP/①.

line and dot, JIWA/*52.*

line and dot technique, JIWA/*5.*

linear, C-5239/*115*; DATT/①; JIWA/*39*; LP.

linear border, S-4461/*463.*

linear design, S-291/*127.*

linear link, S-4414/*94*①.

linear links, S-4414/*48*①.

linear outline, JIWA/*44.*

linear pattern, NYTBA/*112.*

linear perspective, DATT/①; LP/①.

linear quinacridone, DATT.

linear relief, S-4965/*114A*①.

linear ring, C-2324/*18.*

linear structure, JIWA/*219.*

lined, C-5005/*354*①; S-4972/*47*①.

line drawing, DATT.

line-engraving, DADA.

line engraving, C-0249/*11*; DATT.

line-inlaid, C-5114/*249, 274, 334*①.

line-inlaid edge, C-5114/*314*①.

line inlaid oval, C-5114/*371*①.

line inlay, C-5114/*350*①; LAR82/*351*①.

Linell, John, DADA.

linen, C-0225/*410*; C-0249/*123*; C-3011/*76*; C-5116/*65*①; DATT; LP; SDF.

linen-backed, S-2882/*1408, 1408.*

linen backed, S-286/*276, 367, 364A, 433G, 433O.*

linen backing, C-2357/*102.*

linen cupboard, SDF.

linen embroidery, CEA/*282*①.

linen-fold, DADA/①; NYTBA/*21.*

linenfold, C-1407/*85A*; C-2402/*19*; C-5191/*489*; DATT/①.

linen fold carving, LAR82/*420*①.

linen-fold chest, CEA/*322*①.

linenfold chest, LAR83/*402*①.

linen-fold decoration, CEA/*322*①.

linen-fold neck, LAR82/*265*①.

linen-fold panel, C-0249/*478*①.

linenfold panel, SDF/①.

linen-fold panelling, CEA/*368*①.

linenfold panelling, EA/①.

linenfold pattern, ACD.

linenfold table lamp, C-5005/*417*①.

linen jacket, C-2704/*140.*

linen panel, C-2403/*177.*

linen portfolio box, S-286/*176.*

linen-press, ACD.

linen press, DADA; LAR83/*315*①; S-4972/*558*①; SDF.

linenprint, S-4972/*169*①.

linen smoother, EA.

linen table runner, C-2704/*150.*

linen top sheet, C-2704/*141.*

line numeral, S-4927/*21*①.

line of beauty, DATT.

line of sight, LP.

line of vision, DATT.

line quality, LP.

liner, C-0225/*100A*; C-0254/*53, 152*; C-0706/*18*; C-1006/*44*; C-1407/*79A*; C-2202/*73*; C-2458/*200*; C-5005/*384*; C-5117/*30*①, *124*①; EG/*290*①; IDC; LP/*brushes*; S-4802/*290*; S-4843/*380*①.

line rim, LAR83/*77*①.

liners and stripers, DATT/①.

liner's wheel, DATT.

lines scored, JIWA/*49.*

ling-chih, IDC.

ling chih, C-1082/*159*; DADA.

lingere, LAR83/*314*①.

linghzhi, C-2323/*70, 78.*

ling lung, ACD; DADA.

ling-lung yao, IDC/①.

lingzhi, C-2458/*147*①; C-5156/*90*①; LAR82/*125*①; S-4810/*321*①.

lingzhi fronds, S-3312/*1335*①.

lingzhi fungus, S-4810/*368*①.

lingzhi spray, C-2458/*82*.

lining, DATT; SDF.

lining sheet, C-5236/*397*①.

lining up, SDF.

Lin-ju, CEA/*111*.

link, C-5146/*155*.

Link (Linck), Franz Conrad, EA.

link border, IDC.

Linke, F., S-4947/*160*①; S-4992/*106*①.

linked, C-5117/*297*①.

linked boteh stripe, C-2403/*190*.

linked chain, C-1082/*7*.

linked crab border, S-4414/*540*①; S-4948/*4*.

linked flowerhead border, S-4948/*129*①.

linked lozenge, C-2403/*178*.

linked quadruple chain suspension, C-2437/*21*①.

Linnell, John, ACD; C-2522/*20*①; EA; SDF/*757*.

Linnell, William, SDF/*757*.

Linnell, William and John, C-2421/*52*①.

Linnell, Willim, DADA.

Linning, Johan Christian, CEA/*318*①.

Linnit, John, C-2510/*58*①.

linocut, DATT.

linoleum, SDF.

linoleum cut, DATT; S-286/*151*①, *393*①, *395*①, *396*①, *397*①, *398*①, *401*①, *404*.

linoxyn, DATT.

linseed oil, DATT; LP.

linsey wolsey, SDF.

linstock, C-MARS/*43*.

lintel, S-3311/*134*①.

Linthorpe, LAR82/*97*①.

Linthorpe Pottery, C-2409/*107*.

Linwood, Matthew, EA.

Linzeler, Robert, C-0270/*88*.

lion, DSSA.

lion (in Chinese ceramics), EA/*shih tzŭ*.

Lion, CEA/*472*①.

Lion, Florentine, IDC.

lion, impressed, EA/*Cassel*.

lion and grapevine border, C-2458/*219*.

lion-and-ring handle, DADA.

lion cub finial, C-2458/*182*.

Lionels, CEA/*696*①.

lion feet, RGS/*70*①.

lion finial, S-4804/*122*①.

lion foot, MP/*488*①.

Lion-Goldschmidt, C-2458/*295*.

lion-head handle, LAR83/*396*①.

lionhead knop, EG/*79*①.

lion mahogany, SDF/①.

lion-mask, C-2402/*142A*.

lion mask, C-0782/*225*; C-2478/*171*①; DADA; EA.

lion mask and ring handle, LAR83/*590*①.

lion-mask carrying-handle, C-0982/*81*.

lion mask furniture, DADA.

lion-mask handle, C-2458/*65*; EA.

lion mask handle, C-1407/*145*.

lion-mask knob, FFDAB/*56*.

lion monopodium, DADA/①; SDF.

Lion of Buddha, IDC.

Lion of Fo, IDC/①.

lion passant, C-5117/*252*①; CEA/*637*; NYTBA/*213*; RTA/*77*①; S-4944/*131*①.

lion-paw feet, S-4804/*57*.

lion-paw foot, CEA/*305*①.

lion period, SDF/① *lion mahogany*.

lion-prunt beaker, CEA/*417*①.

lion rampant, CEA/*487*①; RTA/ *69*①.

lion sejant knop, CEA/*594*; EA.

lion sejant spoon, DADA.

lion's head, RGS/*105*①.

lion skin rug, LAR82/*36*①.

lion's mask, ACD.

lions' mask, C-2398/*70*①.

lion's mask, tail and paw foot, C-5117/*87*①.

lion's mask and paw, IDC.

lion's mask and paw foot, C-5117/ *78*①.

lions of Judah motif, C-5174/*8*.

lion's paw feet, C-5116/*102*.

lion's paw foot, C-2398/*11*①; C-5153/*47*①; EA.

lion support, C-0270/*28*.

Liotard, Jean-Etienne Le Turc, EA.

lip, C-5114/*4*; C-5127/*99*①; CEA/ *113*①; IDC; IDPF/*151*①.

lipless jug, IDPF/*134*①.

lip moulding, SDF.

lipoid, DATT.

lipophile, DATT.

lipped, C-5236/*558*①.

lipped dish, C-5156/*70*.

lipped drawer, SDF.

lipped openings, S-4461/*519*.

lipping, SDF.

lips, C-5236/*328*; S-4922/*56*①.

Lipscombe, C-1006/*177*.

lip-spout, IDC.

lipstick-holder, C-5117/*354*.

lip work, SDF.

Liqueur, C-5167/*175*①.

liqueur cup, C-0706/*96*.

liqueur cups, C-0706/*195*.

liqueur glass, C-0706/*127*.

liqueur set, C-0706/*143*; LAR83/ *425*①.

liquid drier, DATT.

liquid gold, EA/*gilding*.

liquid silicate, DATT.

Liquitex, DATT; LP.

liquor case, SDF.

lisart candlestick, IDC.

lis de repos, S-4972/*645*.

liseuse, C-5189/*293*①; DADA.

Li Shizo, C-2414/*97*①.

lishui stripe, S-3312/*1204*①.

lishui type, S-4963/*83*①.

Li-shui ware, EA.

Li-shu script, C-5156/*632*①.

listel, SDF.

lit à barreaux, DADA.

lit à colonnes, DADA.

lit à couronne, DADA.

lit à la dauphine, EA.

lit à la duchesse, DADA; EA.

lit à l'anglaise, EA.

lit à la polonaise, EA; DADA.

lit à la turque, EA/*lit de repos*; DADA/①.

lit à l'impériale, DADA.

lit bateau, C-5259/*577*.

lit batteau, C-5189/*323*①.

lit clos, DADA; LAR82/*338*①.

lit d'alcove, C-5224/*85*; C-5259/*565*.

lit d'ange, DADA.

lit d'Anglais, DADA.

lit demi-clos, DADA.

lit de repos, DADA; EA/① *day-bed*.

lit en bateau, DADA/①; EA/*boat bed, boat bed*.

lit en tombeau, DADA.

literal, LP.

literary, DATT; LP.

literary theme, MP/*490*①.

lith, DATT.

litharge, DATT.

Litherland & Whiteside, Liverpool, C-2489/*224*.

litho, DATT.

lithocérame, IDC.
lithochalk, JIWA/*68.*
lithochromy, DATT.
litho crayon, DATT.
lithograph, C-0225/*406*; C-5146/
*79*①; JIWA/*38*①; K-711/*122*;
S-286/*2, 3.*
lithograph and collotype, S-286/*312.*
lithograph and silkscreen, S-286/
*294*①, *509*①.
lithographic, C-1603/*73.*
lithographic crayon, DATT.
lithographic decoration, IDC.
lithographic etch, DATT.
lithographic points, DATT.
lithographic poster, S-286/*74.*
lithographic print, C-0225/*393.*
lithograph ink, DATT.
lithographs, S-2882/*1408*①.
lithograph stone, DATT.
lithography, ACD; DADA; DATT.
lithol red, DATT.
Lithopanies, MP/*502.*
lithophane, DADA; EA; IDC/①;
K-802/*16*; S-2882/*749*①.
lithoplane, ACD.
lithopone, DATT; LP.
litho-press, DATT/①.
litho varnish, DATT.
lithyalin, EA/①; LAR83/*415*①;
CEA/*455*①.
Lithyalin box, CEA/*457*①.
lithyaline, CEA/*50*①.
Li T'ieh-kuai, IDC.
lit mi-clos, DADA.
litmus, DATT.
lits jumeaux, DADA.
Littler, William, ACD; CEA/*194*①;
EA/①.
Littler's blue, EA/①; IDC.
Littler-Wedgwood blue ware, IDC.

Little Stonemason, EA/*de Fernex,
Jean-Baptiste.*
Littleton, Harvey K., CEA/*483*①;
DADA/*Supplement.*
Little Wizard bellows vacuum cleaner,
C-0403/*8.*
liturgical diskos, RGS/*17*①.
Liu Hai, C-2458/*253.*
Liuhai, C-2458/*243*; S-4810/*318*①.
Liu-li-ch'ang, EA/*Ku-i.*
live box, C-0403/*161*①.
Livemont, Privat, S-286/*433J*①.
liver, C-0249/*461*; C-0279/*389*;
C-5156/*67.*
livering, DATT; LP.
Livermore, John, CEA/*152*①.
liver of sulfur, DATT.
Liverpool, ACD; C-2493/*132*;
C-2904/*88*; CEA/*152*①, *200*①;
DADA.
Liverpool coffee cup, C-1006/*23.*
Liverpool Delft, C-1006/*30.*
Liverpool delftware, EA/①; IDC.
Liverpool jug, EA; NYTBA/*150.*
Liverpool porcelain, EA/①.
liver red, S-288/*7*①.
livery beds, SDF.
livery board, SDF.
livery cupboard, ACD; C-0982/*90B*;
C-1407/*53*; DADA/①; EA; SDF.
livery-pot, CEA/*639*①.
livery pot, EA/①.
livery table, SDF.
livre flacon, IDC.
lixui, C-5156/*36*; C-5236/*1586.*
lizard, DSSA.
lizard-skin glaze, IDC.
L-latch, C-5156/*756*①.
LN & JL foundry, C-5167/*26.*
loaded, DATT.
loaded brush, JIWA/*59.*
loading, EA.

loading action, CEA/*24*①.

loading lever, CEA/*39*①.

lobate scrollwork, S-4802/*204*①.

lobate style, EA.

lobby chest, ACD; CEA/*332*①; DADA; EA; SDF.

lobe, C-2458/*40*; IDPF/*152*①; S-2882/*989*.

lobed, C-0782/*35, 91*; C-2204/*88*; C-5005/*330*①; C-5114/*133*①; C-5117/*19*; C-5127/*266*①; C-5156/*66*; IDC; S-3312/*1123*; S-4992/*48*①.

lobed and fluted circular form, S-2882/*1068*.

lobed and fluted domed foot, S-4804/*127*①.

lobed and shaped border, LAR83/*155*①.

lobed angle, C-2555/*46*①.

lobed baluster form, S-4461/*247*.

lobed baluster stems, S-4414/*256*①.

lobed body, LAR83/*623*①; S-4461/*26*.

lobed border, LAR83/*631*①; S-4804/*11*①.

lobed bowl, C-5114/*9*.

lobed campana-shaped sconce, S-2882/*914*.

lobed centre, C-2403/*131*.

lobed circular base, S-2882/*1319*①.

lobed circular foot, C-5114/*45*①.

lobed circular form, S-2882/*1051*.

lobed crest rail, C-0225/*376A*.

lobed cup, IDPF/*66*.

lobed cylindrical form, S-4461/*14*.

lobed decoration, C-5114/*135*.

lobed dish, LAR83/*608*①.

lobed domed, C-2202/*135*.

lobed domed bases, S-2882/*1306*①.

lobed everted border, S-2882/*1154*.

lobed finial, S-2882/*916*①, *1035*①.

lobed fluted side, C-0270/*59*.

lobed foot, S-4802/*222*①.

lobed globular spire, S-4461/*77*①.

lobed handle, C-2409/*241*.

lobed hemispherical form, S-4905/*189*①.

lobed hexagonal foot, C-5114/*233*①.

lobed inverted pear form, S-4414/*260*.

lobed lower body, S-4414/*269*①, *310*①, *336*①.

lobed lugs, S-4802/*76*.

lobed medallion, S-4414/*542*.

lobed molded border, S-4461/*278*.

lobed neck, C-0225/*37*.

lobed neck and base, S-4804/*300A*①.

lobed oval base, S-4804/*13*①.

lobed oval form, S-2882/*927*①, *972*①, *1018*.

lobed ovoid shape, S-2882/*1307*.

lobed ovoid vessel, S-2882/*1391*.

lobed panel, S-2882/*981*①.

lobed panel support, S-2882/*1085*①.

lobed pear shape, S-2882/*1041*.

lobed rim, C-2323/*32*①; S-4414/*348*①.

lobed rondel, S-4804/*229*①.

lobed shell-form handle, S-2882/*992*.

lobed shell support, S-2882/*1194*.

lobed side, C-0254/*74*; C-5117/*20*①; S-4414/*234*①.

lobed silver shape, LAR83/*161*①.

lobed swan-neck spout, S-2882/*1190, 1196*①.

lobed trefoil rim, C-5005/*287*①.

lobed trumpet neck, C-5156/*154*.

lobed wine jar, C-5156/*148*.

lobel, S-286/*433S*.

lobes, C-0103/*187*; C-2414/*54*①.

lobing, ACD; S-4461/*24*; SDF.

lobing devices, S-4461/*36*.

lobing rim, S-4461/*201*.

Lobmeyr, DADA/*Supplement*.

Lobmeyr, Louis, CEA/*451*.

Lobmeyr, Ludwig, CEA/*456*①.

lobster cutter, S-4461/*209.*

lobster set, S-4944/*250.*

lobster-tailed helmet, C-MARS/*94.*

lobster tail helmet, LAR82/*39*①.

local color, DATT; LP.

lochaber axe, DADA.

Lochée, John Charles, S-4843/*467*①.

lock, CEA/*527*; EC2/*26*①; S-4972/ *155*①; SDF.

Lock, Matthias, ACD; DADA; EA/ ①; SDF/*757.*

Lock & Co., C-0405/*57.*

Locke, Joseph, CEA/*472*①, *478*①; OPGAC/*158.*

Locke, Joseph C., DADA/ *Supplement.*

Locke Art, CEA/*478*①.

Locke & Co Worcester, C-1006/*20.*

locker, SDF.

lockers, C-0249/*408*①.

lock escutcheon, C-5114/*351*①; CEA/*303.*

locket, C-0279/*46*; C-2503/*10*; C-5005/*219*①; C-5117/*396*①.

locket on chain, OPGAC/*227.*

locking-plate, EA/*striking mechanism.*

locking plate striking, ACD.

locking screw, C-5173/*13*①.

locking stile, SDF.

locking-stiles, C-2402/*128A.*

lock mechanism, C-0982/*198.*

lock of hair panel, C-2332/*372.*

lock-plate, EA/*lock*; LAR82/*290*①.

lockplate, C-2357/*77*①; C-2388/*117*; C-2403/*112*; C-2421/*115*①; C-2476/*1*; CEA/*23*①.

lock-plates, C-5116/*133*①.

lock plates, C-5236/*537*①.

lock rail, CEA/*541*; SDF.

locks, ACD.

locksmithery, CEA/*528.*

lock-stitch, C-0403/*6*; C-2904/*17.*

Loc Maria, DADA.

locomotive clock, CEA/*246*①.

Locre, J. B., CEA/*186*①.

locust, SDF.

locust vase, LAR83/*442*①.

locust wood, DADA.

Lodi maiolica, EA.

Loehnig, Johan Georg, MP/*174.*

loess, C-5156/*305*①.

Loetz, C-2324/*117*; C-2409/*20*①; C-2910/*3*; C-5167/*119*; LAR83/ *447*①; NYTBA/*304*; OPGAC/*169.*

Loetz glass, C-GUST/*13.*

loft, LP.

Lofthouse, Seth, S-4944/*302*①.

Loftus, C-2904/*226.*

log, S-4881/①.

logbook, S-4881/*44*①.

log cabin, C-2704/*51, 94.*

log drum, CEA/*549.*

Loggan, David, EA.

loggerhead, CEA/*594.*

log-glass, SDF.

log sand glass, S-4881/*57*①.

log stop, C-5114/*229.*

log support, S-4461/*545.*

logwood, DADA; DATT; SDF.

lohan, C-0782/*199*; IDC/①; S-4810/ *319*①; DADA/①.

Lohse, Gottfried, MP/*442*①.

lointains, DATT.

Loir, Alexis III, EA/①.

lokao, DATT.

lokapala, C-5156/*13*①.

Lokele knife, C-1082/*6.*

lolling, FFDAB/*42*①.

lolling chair, C-5153/*207*①; FFDAB/ *29*①; LAR83/*287*①.

Lombardian style, S-4804/*265*①.

lombardic lettering, RTA/*54*①, *63*①.

London, J. Winter, C-2489/*36.*

London Armourers' Company,
C-2503/*46.*

London Company, CEA/*459.*

London-decorated, C-2493/*9*①.

London Delft, S-4905/*153*①.

London Delft Polychrome plate,
S-4843/*53*①.

London delftware, IDC; LAR83/
*123*①.

London fashion carving, NYTBA/
*52*①.

London Gunmakers' Company, CEA/
27.

London hallmark, C-5173/*59*①.

London Manby Violin Co. Ltd.,
C-0906/*347.*

London slipware, IDC.

London white, DATT.

longarm, CEA/*26*①.

long brush, C-0225/*97.*

Longcase, C-2357/*26*①.

long-case clock, ACD; CEA/*222*①;
EA; S-4812/*2*①; S-4988/*407*①.

long case clock, C-5146/*106*①;
CEA/*338*①; DADA; S-4812/*16*;
SDF/①.

longcase clock, C-0279/*327*; C-5116/
48; C-5157/*30*; C-MARS/*239*①;
LAR82/*212*①; LAR83/*194*①;
S-3311/*107*①, *488*①.

longcase regulator, C-5116/*47.*

long drawer, C-2388/*46*①; C-5114/
*303*①.

Long Eliza pattern, IDC/①.

long Elizas, EA; ACD.

long fowler, CEA/*38*①.

'long-haired', OC/*214.*

Longines, C-5117/*432.*

longitudinal form, C-5146/*72*①.

long kharak, OC/*30, 296.*

Long Knight, IDPF/*50.*

long-life symbol, C-2458/*195*①;
C-2513/*305*①.

long-necked bottle, NYTBA/*128.*

long-oil varnish, DATT.

long paint, LP.

Longqing, C-2458/*181.*

Longquan, C-2323/*28*; C-2458/*184*;
C-5127/*35*; C-5156/*53*; C-5236/
*433*①, *1593*; K-711/*125.*

Longquan vase, C-2458/*24*①.

long rug, C-5189/*389*; S-4948/*24.*

long sampler, C-1506/*118*①.

long-stemmed, NYTBA/*273.*

long stitch, C-3011/*133*; C-5156/*475.*

long sweeping line, JIWA/*383.*

long table, C-5156/*467*①.

long tassel, C-2704/*179.*

Longton Hall, ACD; C-2493/*129*;
DADA; EA/①; LAR82/*145*①;
LAR83/*124*①.

Longworth, Maria, CEA/*168*①.

Longwy, C-5239/*45*; NYTBA/*184*①;
OPGAC/*346.*

Longwy enamel ware, IDC.

Lonhuda Pottery, DADA/*Supplement.*

Lonhuda Pottery, Steubenville, Ohio,
EC1/*85.*

looking-glass, DADA; SDF/①.

looking glass, FFDAB/*111*①.

looking-glass clock, CEA/*244*①; EA.

loom, C-2704/*120*; DSSA; OC/*22.*

loom, Eastern, DADA.

loom-drawing, OC/*58.*

loom drawing, OC/*13*①.

Looms, Lloyd, C-5191/*319.*

loom weight, IDPF/*152*①.

loop, C-2458/*40.*

loop and dart, OPGAC/*227*①.

loop and lug handle, C-2458/*49.*

loop-back, DADA/①.

loop back, SDF.

loop-back Windsor, EA.

loop bar, S-2882/*1075.*

loop border, S-4461/*26.*

loop-decorated, CEA/*467*①.

loop decorated glass, CEA/55①.

looped bar, S-2882/1147.

looped decoration, S-4414/103.

looped edge, CEA/435①.

looped flask, EG/265①.

looped joint, RTA/32①.

looped link, S-4414/148①.

looped pile, OC/16.

looped stalk, C-2414/80.

looped stitch, NYTBA/110①.

looped tab, C-5127/145.

looped weaving, OC/292.

loop finial, C-2458/111①.

loop for suspension, C-1082/38.

loop handle, C-0254/25, 99; C-0270/
 244; C-2202/3; C-2414/13①;
 C-2458/129; C-5117/55①, 284①;
 C-5127/123; C-5146/47; LAR82/
 161①; S-2882/1061; S-4414/370;
 S-4436/35; SDF.

loop lug, S-3312/1282①.

loops, NYTBA/111①.

loop splat, LAR82/310①.

loop stitch, DADA.

Loos, Adolf, DADA/Supplement.

loosdrecht, DADA; C-2486/15;
 LAR83/104①.

loose, LP/①; S-4881/41①.

Loose, Pieter, CEA/309①.

loose cover, SDF.

loose cushion, C-0982/207; C-1407/7.

loose-cushioned, S-4972/467①.

loose design, C-5156/104.

loose domed lid, C-5114/103①.

loose leaf, C-5156/455.

loose lid, C-5114/102.

loosely painted, C-0782/38.

looser brushwork, JIWA/44.

loose ring, C-5156/432; C-5236/
 332①.

loose-ring, C-2458/216.

loose ring handle, C-1082/163;
 C-5156/154.

loose-ring handle, C-2323/178;
 DADA; S-4810/88①.

loose seat, C-0982/24; SDF.

loo table, ACD; C-0982/286; CEA/
 406; EA; LAR83/365①, 367①;
 SDF/①.

lopburi, C-5156/207.

Lopburi style, C-5236/351①.

loper, ACD; CEA/326①, 406;
 DADA; EA; SDF.

loper drawer, S-4436/183①.

Lord Leigh, The, C-0405/17.

'Lorelei Vase', C-2910/158.

Lorenzl, C-2910/300; C-5191/120;
 LAR83/32①.

Lorenzoni, Michele, CEA/24①.

Lorenz Penzel, C-0906/272.

lorgnette, C-0254/216; C-2608/159;
 S-4804/220; S-4927/218①.

lorgnette case, S-4461/365.

lorimer, CEA/541.

loriner, CEA/541.

Lori Pambak, S-4847/145; S-4948/
 49①.

Lori Pambak Kazak rug, S-4796/4①,
 134.

Lori Pambaks, OC/109.

Lorraine, DADA.

Lorraine design, NYTBA/307.

Lorraine glass maker, EA.

Lorraine lace, DADA.

Losanti, Cincinnati, Ohio, EC1/85.

Losanti ware, DADA/Supplement.

Loschhorn (Leschhorn), Johann
 Jacob, C-5174/125①.

lost-and-found contours, LP/①.

lost pattern casting, DATT.

lost-wax casting, RTA/141①.

lost-wax method, EA/Barye,
 Antoine-Louis.

lost wax piece, CEA/481①.

lost-wax process, DATT; EA.

lost wax process, CEA/528.

Lot, DSSA; EA.

Lotharinga stone, DATT.

Lotto carpet, EA.

'Lotto' carpets, OC/*189*.

'Lotto' rug, OC/*188*①.

lotus, C-2414/*81*; DADA.

lotus base, C-0782/*116*; C-5156/*177*①; S-4461/*474*.

lotus border, IDC.

lotus bowl, C-1082/*86*; C-5236/*433*①; S-4905/*41*①.

lotus bud, C-2458/*306*.

lotus-bud border, IDC.

lotus bud finial, C-5156/*36*.

lotus character, C-2458/*146*.

lotus cup, C-5156/*806*①; S-4965/*180*①.

lotus cups, C-5127/*73*.

lotus feet, C-5259/*575*.

lotus florette, C-5234/*2*①.

lotus-head, C-5127/*143*①.

lotushead, C-5127/*37*.

lotus-leaf, C-2458/*299*.

lotus-leaf collar, C-2403/*109*①.

lotus meander, C-2458/*77*①.

lotus medallion field, S-2882/*111*.

lotus motif, EA.

lotus nimbus, C-5234/*44*①.

lotus ornament, SDF.

lotus-petal neck, C-5156/*261*①.

lotus pod bowl, EA/*lia tza, lia tza*.

lotus roundel, C-2458/*46*①.

lotus saucer, C-2458/*121*.

lotus scroll, S-4810/*297*①.

lotus-shaped spoon, C-1082/*109*.

lotus spray, C-2414/*61*①.

lotus sprays, C-0782/*116*.

lotus table lamp, C-5005/*396*①.

lotus teapot, S-4905/*39*①.

lotus ware, DADA/*Supplement*.

lotusware, NYTBA/*181*.

Lotus ware, CEA/*205*; IDC.

Lotz, Witwe, CEA/*451*.

loubak, IDC.

Louchet Foundry seal, C-5189/*176*①.

Loudon, John Claudius, SDF/*757*.

Louis, Jean-Jacob, EA.

Louis, J. J., CEA/*181*①.

Louis XII, DADA.

Louis XIII, DADA; S-4972/*470*①, *488*①.

Louis XIII style, CEA/*366*; EA.

Louis XIV, DADA/①; S-4922/*3*①; S-4972/*451*①, *621*.

Louis XIV, style of, ACD.

Louis XIV pattern, S-4804/*67*.

Louis XIV style, CEA/*366*; EA.

Louis XIV style clock, CEA/*222*①.

Louis XV, C-5117/*15*; DADA/①; S-4922/*4*①; S-4972/*580*.

Louis XV, style of, ACD.

Louis XV design, C-0982/*15*.

Louis XV period, NYTBA/*18*①.

Louis XV style, C-2364/*36*①; C-2402/*127A*; CEA/*366*; EA; S-2882/*766*①; S-4992/*106*①.

Louis XV-style, S-4804/*703*.

Louis XV style clock, CEA/*224*①.

Louis XV transitional style, S-2882/*802*①.

Louis XVI, C-2357/*5*①; C-2364/*3*①, *55*①; C-5117/*176, 179, 380*①; CEA/*227*①, *633*①; DADA/①; S-4972/*588*①, *444A*.

Louis XVI, style of, ACD.

Louis XVI design, C-5156/*106*①.

Louis XVI service, IDC.

Louis XVI style, C-0982/*19*; C-1407/*5*; C-2402/*21*; C-2478/*4, 131*①; CEA/*366*; EA/①; RGS/*123*①; S-2882/*767*.

Louis XVI-style, S-4804/*750*①.

Louis XVI taste, S-4804/*160*①.

Louis XVII, DADA.

Louis XVIII, EA/*Sèvres*.

Louis Black, S-3311/778①.

Louis Cannes style, C-0706/220.

Louis Casella and Co., C-5174/337.

Louis C. Tiffany Furnaces, Inc.,
C-5167/267①.

Louis Philippe, DADA; LAR82/
224①; S-4436/59.

Louis Philippe period, C-5189/
355A①.

Louis Philippe style, EA.

Louis-Philippe style, IDC.

Louis-Phillippe, C-1407/134.

Louis Quinze style, IDC; RGS/
123①.

Louis Seize, CEA/182①.

Louis Seize style, IDC.

Louis style, SDF.

lounge, DADA; SDF/①.

lounge chair, LAR83/279①; S-4461/
569; SDF/①.

lounging chair, SDF/① lounge chair.

Lourdet, Simon, CEA/96; EA.

Lourens Eichelar, S-3311/488①.

loutrophoros, DATT; IDC/①.

Louvain school, DATT.

Louvet, H., C-5174/492①; C-5220/
53①.

Louvre, DADA.

Louvre tapestry workshop, EA.

Louvre workshop, EA.

Louwelsa, EC1/73①; OPGAC/346.

Louwelsa pattern, C-0225/20.

love, DSSA.

Love Bird Touch, CEA/593①.

love brooch, EA/① amatory
jewellery.

love ring, RTA/64①, 97.

love seat, C-5005/332①; DADA;
EA/causeuse; SDF.

love-seat, ACD.

loving cup, ACD; C-0225/320;
C-5191/74; CEA/155①, 438①;

DADA; IDPF/152①; LAR83/
571①.

loving-cup, EA; IDC/①.

Low, James, CEA/30①.

low altar table, C-5170/162①.

Low Art Tile Company, CEA/165.

Low Art Tile Works, DADA/
Supplement.

Low Art Tile Works, Chelsea,
Massachusetts, EC1/85.

low-back, DADA.

low back chair, SDF/①.

low-back Windsor, EA.

low-bellied, IDPF/27①.

low bowl, C-5239/1, 94; S-4461/42.

lowboy, ACD; C-0982/43, 83;
C-1407/120; CEA/333①, 406;
DADA/①; LAR83/329①; SDF.

low-boy, CEA/391①; EA.

low chair, C-2388/40.

low chest, NYTBA/37.

low color, DATT.

low coup, IDPF/63.

low daddy, SDF.

Lowdin's Bristol, EA/Bristol
porcelain, ① Bristol porcelain;
IDC.

Lowdin's glasshouse, EA/Bristol
porcelain.

low dish, S-4461/481.

Lowenfinck, Adam Friedrich von,
CEA/138①.

Löwenfinck, Adam Friedrich von,
MP/68.

Löwenfinck style, IDC/①.

Lowenstark & Sons, CEA/236①.

Lowenthal, C-5174/39.

lower body, S-4905/193.

Lowestoft, ACD; C-1006/77;
C-2360/47①; C-2493/31; CEA/
187, 194①; DADA/①; LAR82/
145①; LAR83/124①.

Lowestoft, Allen, EA/Lowestoft
porcelain factory.

Lowestoft porcelain factory, EA/①.

Lowestoft ware, NYTBA/*166*.

low filigree, C-0225/*358*.

low gallery, C-0982/*261*.

low hair crack, C-5127/*228*①.

low-karat gold, S-4927/*325*.

low key, DATT.

low ledge back, C-0982/*30*.

Lowndes, Jonathan, London, C-2489/*94*①.

Lownes, Joseph, C-5153/*24*①; S-4905/*189*①, *201*.

low post bed, DADA; SDF/①.

low post bedstead, FFDAB/*75*.

low relief, C-0782/*14*; C-1082/*66*; C-5005/*351*①; C-5156/*299*①; DATT; IDC; RTA/*30*①; S-4414/*190*; SDF.

low-relief, DADA.

low table, C-1082/*188*; C-5156/*477*①; S-3311/*92*; S-4853/*413*; S-4955/*107*.

low-temperature colour, EA/*enamel*.

low-warp loom, EA.

low-warp loom MDR, EA/*Aubusson tapestry*.

Loyang, CEA/*113*①.

lozenge, C-0254/*143*①; C-0982/*22*; C-1407/*10*; C-2357/*44*①, *51*①, *131*; C-5005/*236*; C-5157/*169*①; C-5259/*600*①; CEA/*57*①; IDC; OC/*42*; S-3311/*507*①; S-4922/*7*①; S-4972/*500*; SDF.

lozenge-and-mask decoration, C-2522/*4*①.

lozenge border, C-0249/*300*.

lozenge carving, LAR82/*423*①.

lozenge-checkered inlaid, C-5114/*347*①.

lozenge-coffered, C-2320/*87*.

lozenge-cut, RTA/*94*.

lozenge design, S-2882/*781*; S-4955/*184*①.

lozenge device, S-4414/*199*.

lozenge form, S-2882/*836*.

lozenge form knop, S-2882/*700*①.

lozenge hand, S-4802/*67*①.

lozenge mark, C-2323/*66*.

lozenge motif, EA; S-4414/*182, 359*.

lozenge panel, C-2458/*56*①.

lozenge pattern, C-0249/*432*.

lozenge-pattern ground, RGS/*133*①.

lozenge pot, IDPF/*152*.

lozenge section, LAR82/*173*①; S-4461/*94*; S-4804/*140*.

lozenge-shape, EC2/*23*①, *32*.

lozenge-shaped, C-5005/*217*①; C-5156/*421*①; CEA/*316*①; S-4905/*102*①.

lozenge-shaped body, S-4843/*129*①.

lozenge-shaped diamond, S-4414/*49*①.

lozenge-shaped diamond pendant, RGS/*199*①.

lozenge-shaped drop, CEA/*446*①.

LPK, EA/*van der Ceel*.

Lpkan, EA/*van der Ceel*.

LS, CEA/*137*①.

L. Schuch & Nache, C-5191/*203*.

L-scroll motifs, C-5236/*1684*.

L-shaped, C-5127/*347*; C-5156/*262*①; C-5239/*283*.

L-shaped leg, CEA/*343*①.

L.S.X, CEA/*186*①.

lu, CEA/*118*①; DADA.

Luba, C-1082/*31*.

Luc, A., S-4947/*22*①.

Lucas, Robert, C-2487/*108*①.

Lucchese patterns, DADA.

Luce, Jean, C-5239/*42*.

luce di sotto, DATT.

lucerne, S-4972/*150*.

lucida, C-0403/*197*.

Lucifer, DSSA.

Lucite, DATT; LP.

Lück, Johann Friedrich, CEA/*178*①; EA/①.

Lück, Karl Gottlieb, CEA/*178*①; EA.

Lücke, Johann Christoph Ludwig, MP/*74*.

Lucknow, C-5173/*13*①.

Ludlow bottle, DADA; EA.

Ludwig Moser & Shone, C-GUST/ *18*.

Ludwig Moser & Söhne, S-4461/*94*.

ludwigsburg, C-5259/*141*; ACD; C-1006/*210*; C-2427/*44*①; C-2486/*58, 72*①; CEA/*181*①; DADA; EA/①; LAR82/*146*①; LAR83/*124*①; S-4853/*151*.

Ludwigsburg manufactory, MP/*163*.

Lufft, C-2904/*60*.

lug, CEA/*220*①, *251*①; IDC; IDPF/*152*①; S-4927/*12*①; S-4972/*241*.

lug chair, SDF.

lug feet, S-4414/*182*.

luggage stand, C-0249/*371*.

lug handle, C-0254/*48, 95*; C-2409/*7*; C-2414/*37*①; C-5127/*126*; IDPF/ *64, 155*①; S-4414/*217, 218*①; S-4965/*220*.

lugs, C-5239/*39*.

lug support, SDF.

Lu-hsing, DADA.

Luis, CEA/*620*①.

Luke, DSSA.

Lukin, William, C-5174/*603*.

Lukutine Factory, C-5174/*208*.

Lullin, Paul, S-4927/*40*.

lumachelle, DATT.

lumbang oil, DATT.

lumbayao, DATT.

lumetto, IDC.

luminaire, C-0225/*178*①; C-5146/ *54*①; C-5167/*209*①; C-5239/*124*.

luminism, DATT.

luminist, LP.

luminous, DATT; LP.

luminous paint, DATT.

Luna, DSSA.

lunar work, EA.

luncheon fork, C-5114/*16*; S-4804/ *28*①, *35*①.

luncheon knife, C-5114/*21*①; S-4804/*28, 35*①.

lunch fork, C-5153/*7*.

Lund, Benjamin, CEA/*187, 195*①; EA/①.

Lunda chief's coiffure, C-1082/*32*.

Lundberg, Teodor, C-2910/*309*.

Lundin, Ingeborg, DADA/ *Supplement*.

Lund's Bristol, IDC.

lunette, ACD; C-0982/*98A*; C-1407/ *83A*; C-2402/*5*; C-2403/*33*①; C-2437/*75*①; C-2478/*141*; C-5157/*45*; CEA/*541*; DADA; DATT; LAR83/*360*①; SDF.

lunette back, SDF.

lunette border, C-2402/*16*.

lunette shape, C-5224/*226*①.

lunette-shaped, C-2437/*34*①; LAR82/*500*①.

lunette window, LAR82/*446*①.

Luneville, C-2502/*83*.

Lunéville, DADA.

Lunéville faience factory, EA.

lung, DADA/①; IDC.

Lung Ch'ing, DADA.

Lung Ch'ing, CEA/*121*①.

Lungch'nan, CEA/*128*①.

Lung-ch'üan, CEA/*111*.

Lung-Ch'üan, DADA.

Lung Ch'uan, CEA/*117*①.

Lung-ch'üan ware, EA/①.

Lung-Ch'üan ware, ACD.

Lung-ch'üan yao, IDC.

Lung-ch'üan yao stoneware, JIWA/ *345*①.

Lunois, Alexandre, S-286/*31*.

Lupiac, A. P., S-286/*433K*.

Luplau, A. C., CEA/*176*①.

Luplau, Anton Carl, EA.

Lupton, C., LAR82/*220*①.

Lurçat, Jean, DADA/*Supplement*.

Luri, OC/*104*.

Luri rug, OC/*25*①.

Luri-type, OC/*216*.

Luri-type design, OC/*221*.

Lurs, OC/*109*.

Lust, DSSA.

luster, DADA; DATT; FFDAB/
 *121*①; JIWA/*210*; S-4461/*499*;
 S-4905/*341*.

luster color, MP/*40*; NYTBA/*129*.

luster decoration, DADA.

lustered, S-4992/*27*①.

luster glaze, EC1/*83*; JIWA/*307*①.

luster vase, S-4461/*140*.

lusterware, DATT; NYTBA/*129*.

lustration vase, IDC.

lustre, ACD; C-1006/*12*; C-2486/
 *102*①; C-5181/*5*; C-5259/*5*; EA;
 EG/*36*; IDC/①; SDF.

lustred, EG/*117*①; S-4972/*126*①.

lustre decoration, CEA/*209*; EA/①.

lustre drop, LAR83/*442*①.

lustre glass, C-0225/*284*.

lustre heart, C-0225/*299*.

lustre mark, EA.

lustre of Deruta, CEA/*164*①.

lustre vase, C-0225/*283*, *79B*;
 LAR82/*99*①; LAR83/*126*①.

lustreware, CEA/*132*①; S-4843;
 S-4972/*389*①.

lustring, SDF.

lustrous, C-2458/*27*①; EC2/*23*.

lustrous glaze, IDC.

Lusuerg, Jacobus, Rome, C-2489/
 *30*①.

lute, C-2427/*141*①; CEA/*552*①;
 DATT; DSSA.

luted join, C-5156/*75*①.

lute family, EA.

lute-form watch, S-4927/*201*.

luteolin, DATT.

lutestring, SDF/*lustring*.

luting, C-5127/*36*; CEA/*210*; EA;
 IDC.

Lutma, Joannes the Elder, EA.

Lutma, Joannes the Younger, EA.

lutrophorous, IDPF/*156*.

Lutschism, DATT.

Lutwyche, John, EA/*322*; S-4922/
 *58A*①.

Lutyens, Sir Edward, C-5167/*219A*①.

Lutz, OPGAC/*170*.

Lutz, Nicholas, CEA/*480*①; DADA/
 Supplement; EA/*Boston &
 Sandwich Glass Company*;
 OPGAC/*170*.

luxuriantly, C-2704/*2*.

Luxus, C-0906/*253*.

LVE, EA/*van Eenhoorn, Lambert*.

LVF, EA/*Victorson, Victor*.

LW, EA/*Knütgen*.

Lyapunov, Yakov, C-5174/*233
 assaymaster*.

Lyapunov, Yakov (assaymaster),
 C-5174/*311*①.

Lycett, Edward, CEA/*205*.

Lycett Manufacturing Company, New
 York, NYTBA/*176*①.

lyctus brunneus, SDF.

lyctus linearis, SDF/*lyctus brunneus*.

Lydia Steel, C-2704/*190*.

Ly Dynasty, C-2323/*18*.

lye, DATT.

Lyman, Fenton and Company,
 DADA/*Supplement*.

Lyman and Fenton, CEA/*205*.

Lyman Fenton & Co., NYTBA/
 *154*①.

lynch pin, C-2414/*17*①.

Lynn factory, CEA/*441*①.

Lynn glass, EA.

Lyon & Co., Joseph, CEA/*696*①.
Lyon faience, EA.
Lyonnais, DADA.
Lyons, CEA/*145*①; DADA.
lyre, C-2437/*14*①; DSSA.
lyre-back, ACD; EA; FFDAB/*29*.
lyre-back chair, DADA; SDF.
lyre clock, C-0249/*241*; EA/①;
 LAR82/*223*①; SDF.
lyre-form, DADA; S-4461/*198*.
lyre-form clock, S-3311/*461*.
lyre-form medallion, S-4507/*81*①.
lyre-form sofa, DADA/①.
lyre frame, LAR83/*493*①.
lyre-guitar, EA/①.

lyre motif, S-3311/*215*①.
lyre-shaped, C-0249/*293*; C-2421/
 *119*①; C-2478/*44*; EC2/*94*①.
lyre-shaped end support, CEA/*362*①.
lyre-shaped inset, LAR83/*352*①.
lyre-shaped motif, RTA/*40*①.
lyre-shaped splat, C-5116/*158*①.
lyre-shaped trestle, C-2370/*84*①.
lyre splat, FFDAB/*27*①, *43*①.
lyre-splat back, C-1407/*138*.
lyre upright, LAR82/*294*①.
lyrical, LP.
Lyrical Abstraction, JIWA/*403*.
lyriform, S-4436/*165*.

M

M, EA/*Mayer, Franz Ferdinand, Minton, Thomas.*
Maastricht, S-4972/*52*①.
macabre, C-5127/*540.*
macana, LAR82/*87*①.
Macao ivory, C-2332/*9.*
macaroni agate, C-2458/*389*; S-4810/*142*①.
macassar, DADA.
macassar ebony, C-5005/*356*①; NYTBA/*80*①; SDF; DATT.
maccasar, C-5239/*100*①.
macchia, DATT.
MacDonald, Frances, DADA/*Supplement.*
MacDonald, Margaret, DADA/*Supplement.*
Macdonald, Margaret and Frances, C-GUST/*92*; CEA/*536*①.
mace, C-2503/*32*; DADA/①; SDF.
Macé, Jean, DADA.
Macedoine vases, LAR82/*457*①.
Macedonian, OC/*264.*
mace-head, DATT/①.
mace head, LAR83/*590*①.
Macé Jean, S-4955/*96*①.
Ma-chang pottery, IDC.

maché (mash), CEA/*697.*
ma-chia-Kang, EA/*Shou-chou ware.*
machiciolated, LAR82/*275*①.
machine chairs, SDF.
machine-made, C-0405/*161.*
machine made, C-0906/*16.*
machine-made head, CHGH/*58.*
machine-made tapestry, C-2704/*37.*
machine net, C-1506/*170.*
ma-chün, DADA.
Ma Chün, IDC.
Macintyre, LAR82/*158*①.
Mackintosh, Charles Rennie, C-GUST/*93*; DADA/*Supplement*; SDF/*758.*
Mackintosh Service, EA/①.
Mackmurdo, Arthur H., SDF/*758.*
Mackmurdo, Arthur Heygate, DADA/*Supplement.*
MacLeary, Bonnie, C-5191/*152*①.
macled, DADA.
macramé, DADA.
Macy Harpoon, S-4881/*311*①.
Madame de Maintenon, CEA/*386*①.
madder, S-288/*20*①; S-3311/*3.*
madder brown, DATT.

madder field, LAR82/549①.

madder lake, DATT; LP.

madder medallion, S-288/2①; S-2882/43.

madder-oriented shade, OC/283.

madder-red, OC/148①.

madder red, OC/92.

madder root, OC/25.

made for export, C-5156/456.

Madeira, LAR82/436①.

Madeira work, C-2203/119; C-2704/147; DADA.

made-up, C-5127/352.

made up, C-0405/6.

made-up scene, NYTBA/154.

madia, DADA.

Madonna, DSSA.

Madonna and child motif, C-5174/455①.

Madonna group, MP/496①.

Madras muslin, SDF.

Madreperla lustre, IDC.

Madrid carpet, EA.

Madrid Federal Glass Co., OPGAC/194.

Madrid-lock, C-2503/148①.

Madrid lock, CEA/25①.

Madrid royal tapestry factory, DADA.

madrone, S-4507/3①.

Madroux, Auguste, C-2510/19①.

Madura edition, C-0225/40.

Maelzel, C-0906/260.

maenad, DSSA; S-4807/502.

mae-pyŏng, CEA/128①.

mae-pyŏng, IDC.

maestà, DATT/①.

Maestro Benedetto, EA.

Maestro Giorgio, EA/Andreoli, Maestro Giorgio.

Magasin anglais, RGS/115.

magazine, C-2476/10; CEA/24①.

magazine-follower, C-2476/14①.

magazine rack, C-5191/158.

magazine stand, C-0982/81; EA/Canterbury.

Magdalen cup, EA.

Magdeburg, DADA.

Magen David, DATT.

magenta, C-2403/179; C-2704/13; DATT; LP; S-288/1①.

Maggiolini style, C-2546/127①.

magic lantern, LAR83/463①.

magic realism, DATT/①; LP.

magilp, DATT.

magma, LP.

Magna, DATT; LP.

magnesia white, DATT.

magnesite, DATT.

magnesium carbonate, DATT.

magnesium oxychloride cement, DATT.

magnet and grape frosted leaf, OPGAC/227①.

magnetic black iron oxide, DATT.

magnetic compass, EA/①.

magnetic plate, CEA/664①.

magnifying glass, S-4461/375; S-4804/10.

magnifying lens, CEA/610①.

magnifying lense, C-5146/118①.

magnum, C-2476/5; CEA/492①, 502; EG/290.

Magnus, Johann Bernard, EA.

Magny, Alexis, EA.

magot, EA; IDC.

magots, EA/Chantilly.

magot teapot, IDC/①.

Maguin, Fontainebleau, C-MARS/185.

Mahal, C-2320/159, 163; C-2478/237; C-5189/381; OC/99①, 267.

Mahal carpet, C-2357/161; C-2403/210; EA; S-3311/20; S-4461/844; S-4796/154.

Mahal design, S-3311/74①.

Mahallat, OC/99①.

mahal rug, DADA.

Mahavallat medallion, OC/290①.

mahi, OC/52, 84, 256.

mahlstick, DATT/①; LP/①.

mahogany, ACD; C-0982/8; C-1407/
6; C-2402/3; C-5114/179①;
C-5116/2; C-5153/85; CEA/303;
DADA; DATT; FFDAB/31①;
JIWA/323①; LAR82/20①;
S-4436/9; S-4992/105①; SDF.

mahogany frame, C-2704/47.

mahogany-framed, C-0982/260.

mahogany lake, DATT.

mahogany stain, DATT.

mahogany veneered frame, C-5114/
206A.

maiden, C-0225/71.

maidenhead, CEA/594.

maidenhead spoon, DADA; EA.

maiden's leg, IDC; IDPF/156.

maiden's mask, C-0254/126①.

Maidstone, C-0906/302.

maie, DADA/①.

Maié, Jean, C-2546/58①.

Maigelein, ACD; EA/①; EG/90.

mail, CEA/44; DADA.

Mailfert, André, NYTBA/6.

mail guard's watch, EA.

Maillol, Aristide, S-286/315①.

mail shirt, C-2503/31; C-MARS/78;
S-4972/140①.

Main, John, C-5117/85①.

main border, OC/42.

main carpet, S-3311/25①; S-4948/
69①.

mainfere, DADA.

main gauche, DADA.

mainspring, C-2476/12; C-5117/
446①; CEA/25①, 251①; EA/
spring; S-4972/155①.

maintaining power, EA.

Maintenon, Mme de, CEA/281①.

maiolica, ACD; C-2486, 164①;
CEA/110, 133①, 151①; DATT;
EA; IDC; S-4972/128①; C-1582/
31; C-2204/119; C-2427/220①.

Maiolica vase, C-0249/258; C-0279/
79①.

Maison de l'Art Nouveau, DADA/
Supplement.

maître banc, DADA.

maître-ébéniste, C-2364/77①.

maître ebéniste, DADA.

Majbrowiez, L., C-5203/112.

majesty, DATT.

majolica, ACD; C-1006/62; DADA,
supplement; DATT.

majolica (English earthenware), EA.

majolica, IDC/①; IDPF/60;
LAR82/137①; LAR83/98①;
NYTBA/131①; S-4461/117, 157,
175; S-4992/4①; C-1006/153.

majolica ware, MP/190.

Majorelle, CEA/386①; LAR82/
292①; S-3311/940①.

Majorelle, L., OPGAC/15.

Majorelle, Louis, C-5005/320①;
DADA/Supplement; NYTBA/78.

Majorelle,Louis, C-5167/183.

major hooked guls, S-288/38①.

Major Hutchinson's Improved,
C-2904/143.

makatlik, DADA.

Makazu, C-5236/895①.

Makemeid, Mary, NYTBA/222①.

makemono, C-5236/1530.

Makepeace, Robert, CEA/656①.

Makepeace, Robert and Thomas,
C-5117/282①.

Makepeace II, Robert, C-5117/54①.

maker's carton, C-2904/7.

maker's mark, C-2332/125; C-2398/
45; C-2487/22; C-5173/4①;
C-5236/898①; EA/Russian gold
and silver; S-4972/141①; DADA.

makers mark, C-0406/*107.*
makie-shi, CEA/*562, 571, 575.*
makimono, C-5156/*885*; DADA/①;
S-3312/*1167.*
makkum, DADA; C-2486/*174*①.
makore, DATT.
makoré, SDF.
Makri carpet, EA/*Megri carpets.*
makri rug, DADA; ACD.
Malabar figure, IDC/①.
malachite, C-1082/*165*; C-2409/*51*;
C-2458/*210, 349*; C-5127/*161*;
C-5156/*260*①; C-5189/*344*①;
DATT; EA; IDC; LAR82/*208*①;
LAR83/*456*①; LP; S-2882/*667,
781, 820*①; S-4853/*375*①; S-4955/
*160*①; S-4972/*587*①.
malachite encrustation, C-2414/*16*①.
Malaga, DADA; EA.
Malay damar, DATT.
Malayer, C-5323/*33, 77, 129*①;
CEA/*88*①.
Malayer carpet, EA/*Meleyer carpets*;
S-4847/*342.*
Malayer rug, S-4461/*818*; S-4796/
187, 199.
Malayir, C-2320/*135*; C-2388/*150*;
C-2546/*183.*
Malbone, Edward Greene, EA.
Malby & Son, S-4988/*402*①.
male hook figure, C-1082/*19.*
male key, S-4802/*13*; S-4927/*31.*
male mask, C-5116/*145*①.
malerisch, DATT; LP.
Malfrey pot, LAR82/*186*①.
Malignity, DSSA.
maline, DADA.
malines, S-4972/*28*①.
Maling, C-0225/*52.*
Malkin, Samuel, EA.
Mallard, Prudent, DADA/*Supplement.*
malleability, EA.
malleable, DATT.

mallet, DATT/①.
Mallet, Mr., CEA/*536*①.
mallet-form manju, S-3312/*1029.*
mallet-shape, CEA/*117*①.
mallet shape, IDPF/*156*①; LAR82/
*436*①.
mallet-shaped, C-1006/*8.*
mallet vase, C-5156/*118*①; C-5236/
461; IDC/①.
malling jug, IDC; ACD; EA.
Maloof, Sam, DADA/*Supplement.*
Maltese, C-2402/*255.*
Maltese clock, CEA/*242*①; EA.
Maltese cross, C-5236/*1780*①;
DATT.
Maltese cross block, C-2704/*118.*
Maltese Cross stopwork, CEA/*255*①.
Maltese lace, C-1506/*175*; DADA.
Maltzof, Jacob, EA/*Russian glass.*
Maltzof, Thomas, EA/*Russian glass.*
Mambrino's helmet, IDC.
mameluke hilt, CEA/*43*①.
Mamluk, LAR82/*252*①; S-4807/*561.*
Mamluk, Mameluk, Cairo or
Damascus carpet, EA/①.
mammiform, IDPF/*157.*
mammy bench (chair), EA.
mammy's bench, SDF.
mammy's rocker, SDF/*mammy's
bench.*
mamori katana, DADA.
Manabi, S-4807/*93.*
manacles, DSSA.
mananito, C-5156/*825*①.
Manara, Baldassare, EA.
Manardi workshop, EA.
Manchester, S-4847/*240.*
Manchester Kashan, C-5323/*152*①.
Manchester Kashan carpet, S-4948/
*178*①.
manchette, DADA/①.
manchon, CEA/*484.*

Manchu period, JIWA/*339*.

mandala, C-0782/*212*; DATT; JIWA/*294*; LP; OC/*272*①.

mandara, DATT.

mandarin, C-5236/*1631*; DADA; EC2/*24*①.

mandarin decoration, IDC.

Mandarin palette, S-4905/*19*①.

Mandarin pattern, LAR82/*504*①.

Mandarin plate, EC2/*31*①.

mandarin porcelain, EA; IDC.

mandarin's chair, LAR82/*310*①.

mandarin service, IDC.

mandarin square, EC2/*26*①.

mandarin style, IDC; C-5127/*265*.

Manding, C-1082/*5, 7*.

mandola, EA/*lute family*.

mandolin, C-0906/*260, 320*; CEA/*552*①.

mandoline, EA/①; LAR83/*510*①.

mandoline watch, EA.

mandora, C-5255/*35*; CEA/*552*①, *556*; EA/*lute, lute family*.

mandore, EA/*lute, lute family*.

mandorla, C-5156/*185*; DATT; DSSA; S-3312/*1195*.

Manessier, Alfred, S-286/*432*.

Manet, Edouard, S-286/*57, 316*.

Manfredi peacock-feather decoration, IDC/①.

manganese, C-2427/*203*; C-2486/*11*; EG/*134, 257*; IDC; S-4843/*29*①, *75*①; S-4905/*88*①; S-4972/*62*①.

manganese black, DATT.

manganese blue, DATT; LP.

manganese brown, DATT.

manganese green, DATT.

manganese panel, C-2502/*91*.

manganese-sponged ground, S-4823/*4*.

manganese sponging, C-2427/*189*.

manganese violet, DATT; LP.

Mangy, Thomas, LAR82/*584*①.

Manhattan, OPGAC/*228*.

Manheim Glass House, EA/①.

Manheim gold, ACD.

Manicus, Frederick, EA.

Manierblumen, IDC.

manière criblée, DATT.

manifestation, DATT.

manifesto, DATT.

manikin, DATT; LP/①.

Manila copal, DATT.

Manila elemi, DATT.

man-in-the-moon moonstone, S-4927/*261*①.

maniple, C-0405/*180*; DADA.

Manises, CEA/*131*①; EA.

Manises ware, IDC.

manjak, DATT.

Manjoy, George, EA/*235*.

manju, C-0282/*76*; C-5127/*451*; C-5156/*655*; C-5236/*782*; CEA/*562, 575*; LAR82/*530*①; S-3312/*1040*①; S-4928/*63*①; S-3312/*1057*.

manju netsuke, C-1082/*138*; CEA/*573*①.

Manjusri, C-2323/*135*.

Mann, Michael and Conrad, EA/*casket*.

Mann, Thomas, C-5117/*252*①.

Mann, W., C-2487/*62*; C-2510/*41*①.

mannerism, LP; DATT.

mannerist, RTA/*92*.

Mannerist frame, C-5189/*276*.

mannerist style, EA; C-2482/*132*.

Mannheim gold, EA.

Manning and Bowman, C-5239/*99*.

Männlich, Daniel the Elder, EA.

Mannlich, Jakob, Heinrich, C-5174/*429*①.

Mannlicher Schoenauer, C-2476/*7*.

manqué, LP.

Mansell, Sir Robert, CEA/*420*①; EA.

Mansfield, Christopher, C-5117/*192*.

Mansheng, S-4965/*307*①.

Mansion House dwarfs, IDC/①.

mansonia, SDF.

Mansuetude, DSSA.

manteau d'armes, C-2503/*44.*

mantel, C-0279/*456*①; SDF.

mantel clock, C-1702/*292, 318;*
C-2409/*170;* CEA/*229*①; EA;
LAR82/*223*①; LAR83/*201*①;
SDF.

mantel garniture, S-4947/*229.*

mantel mirror, C-0982/*147;* SDF.

mantelpiece, C-5157/*88*①; C-5170/
*108*①.

mantelshelf garniture, IDC.

mantel timepiece, C-0906/*102.*

mantel tree, SDF.

Manticha, LAR82/*42*①.

manticore, DSSA.

mantilla back, C-5167/*225*①.

mantle, S-4461/*560*①; S-4802/*332*①;
S-4881/*467*①.

mantle clock, S-4461/*72;* S-4804/
*221*①; S-4992/*16*①.

Mantle Lamp Co, K-711/*129.*

mantling, C-2487/*115*①; C-5174/
*591*①; CEA/*63*①; EA; IDC;
S-4922/*50*①.

Manton, CEA/*27.*

Manton, Joseph, ACD; CEA/*31*①.

Mantou Xin, S-4965/*240*①.

Mantua and Kent Glasshouses, EA.

Mantua tapestries, DADA.

manufactured, OC/*12.*

Manufacture Nationale, Sèvres,
JIWA/*324.*

Manufacture Nationale de Sevres,
JIWA/*9.*

**Manufacture Nationale des Tapis et
Meubles façon de Perse dits
Savonnerie,** CEA/*98*①.

manufacturer, C-0906/*287.*

Manufacture Royale d'Aubusson,
CEA/*99*①.

Manufacture Royale des Glaces,
DADA.

**Manufacture Royale des Grandes
Glaces,** EA/*de Nehou,
Louis-Lucas.*

**Manufacture Royale des Meubles de
la Couronne,** DADA.

**MANUF^re^/de M^or^ le Duc/
d'Angouleme,** EA/*Paris porcelain.*

manuscript catalogue, C-5116/*147*①.

manuscript illumination, NYTBA/
*195*①.

Manvers, Earl, service, IDC.

Manwaring, Arthur, EA/*260.*

Manwaring, Robert, ACD; DADA;
EA; SDF/*758.*

manx table, SDF.

Maori, C-1082/*25.*

map, S-4881/*33*①.

Mapico pigment, DATT.

maple, ACD; C-0982/*140;* C-5005/
353; C-5239/*279;* DADA; DATT;
S-4436/*154*①; SDF.

maple brace, FFDAB/*38.*

maple die board, DATT.

maple frame, C-2704/*183.*

maple leaf, OPGAC/*183, 228*①.

maple silkwood, SDF.

maplewood, C-2403/*103.*

Mappin, E. and J., C-2487/*59.*

Mappin & Webb, C-0406/*32;*
C-0706/*98, 233.*

Mappin & Webb Bros., S-3311/*698.*

maquette, C-5167/*5, 76*①; DATT;
IDC; LP; RTA/*182*①.

Maracaibo balsam, DATT.

Marans, DADA.

marbelized clay, K-711/*131.*

marble, C-0982/*82A;* C-5127/*9;*
C-5153/*163*①; C-5156/*188*①;
DATT; IDPF/*157;* S-4461/*16;*
S-4972/*2*①.

marble back, C-0279/*152*①.

marble base, S-4461/*5.*

marble clock, EA/①.

marble cornice, C-5005/*358*①.

marbled, C-2458/*18*; C-5236/*1718*.

marbled board, C-0249/*33*.

marbled glass, EG/*54, 110*; LAR82/*440*①.

marbled paper, C-2388/*133*.

marbled pattern, CEA/*453*①.

marbled pottery, MP/*171*.

marbled slip decoration, EA/*combed slip decoration*.

marble dust, DATT.

marbled ware, DADA; IDC.

marble fault, C-2546/*85*①.

marble glass, DADA/*Supplement*.

Marblehead (mark), EC1/*84*①.

Marblehead Pottery, Marblehead, Massachusetts, EC1/*85*.

marbleized, S-4972/*102*①.

marbleized bisquit, C-5127/*261*①.

marbleized wood base, S-4461/*517*.

marble landscape panel, C-0279/*152*①.

marble pedestal, C-5116/*39*.

marble plinth, C-5116/*28*.

marble relief, S-3311/*292*.

marble slab, DADA.

marble socle, S-4804/*245*①.

marble striation, LAR82/*438*①.

marble table, SDF.

marble top, C-2357/*34*①; C-5116/*35*; CEA/*311*①.

marble tops, ACD; C-0982/*85*.

marble white, LP.

marbling, ACD; DADA; DATT.

marbling (in Chinese ceramics), EA.

marbling (in furniture), EA.

marbling, SDF.

marblized gold, C-5114/*214*①.

marcasite, C-1502/*143*; C-2910/*230*; EA; RTA/*117*①.

marc black, DATT.

marcella, C-2704/*115*.

marcella cloth, SDF.

marcella whitework, C-1304/*149*.

marchand mercier, CEA/*65*①.

Marchigian, C-2486/*212*①.

Marcion, CEA/*385*①.

Marcks, Gerhard, MP/*203*.

marcolini, C-5259/*131*; C-2486/*58*; LAR82/*149*①.

Marcolini, Count Camillo, EA.

Marcolini era, MP/*141*.

Marcolini period, EA/*Marcolini, Count Camillo*.

Marconiphone, LAR83/*462*①.

Marcotte, Leon, S-4947/*120*①.

Marcus & Co., C-5005/*217*①.

Marden, Brice, S-286/*317*.

margaritai bead, EA/*beads and marbles*.

Margetts, G., C-2489/*131*.

Margetts' side winding mechanism, C-5174/*407*①.

margin, C-0225/*403*; C-5114/*174*①; S-4881/*190*①.

marginal remarques, S-286/*1*.

margins, C-0249/*2*; C-5236/*938*.

marguerite, C-0225/*162*; S-2882/*1213*.

marguerites, C-0254/*237*.

Maria Theresa, Empress, CEA/*186*①.

maribou, C-0604/*19*.

Marie Antoinette, CEA/*227*①.

Marie Antoinette pattern, C-0270/*178*; S-4804/*76*.

Marieberg, ACD; CEA/*149*①; DADA/①; EA.

Marieburg, C-2427/*179*①.

Marie-Joseph-Gabriel Genu, S-4922/*2*①.

marigold, DSSA.

marina setting, C-0225/*138*.

marine, DATT; LP.

marine barometer, CEA/*263*①.

marine chronometer, CEA/*255*①; LAR83/*464*①; S-4927/*91*①.

marine clock, CEA/*246*①.

marine column barometer, C-MARS/ *201*.

Marine Corps officer's sabre, CEA/ *43*①.

marine glass vase, C-2324/*109*.

marine ivory, CEA/*562*.

marine ivory manju, S-4829/*26*①.

mariner's dry-card compass, CEA/ *608*①.

Marini, Marino, S-286/*318*.

Marinite, DATT.

Marinot, OPGAC/*156*.

Marinot, Maurice, CEA/*488*①; DADA/*Supplement*; LAR82/*440*①; NYTBA/*310*①.

mark, C-5181/*37*; DSSA; MP/*502*.

marked, C-5239/*91*.

Markham, Markwich, C-2368/*208*①.

Markham Pottery, Ann Arbor, Michigan, EC1/*85*.

Markham Pottery, National City, California, EC1/*85*.

markings, C-5127/*7*①.

marking system, CEA/*619*.

Mark Lane, C-2904/*34*.

mark of origin, NYTBA/*214*①.

Mark Paillet, S-4922/*41*①.

marks, DADA/①.

marks (in ceramics), EA.

marks, IDC.

marks rubbed, C-5117/*185*①; S-3311/*721*.

Markwick, Markham, London, C-2489/*189*.

Markwick Markham Borrell, C-5117/ *473*①.

marl, IDC.

Marlboro' bedstead, SDF.

Marlboro' leg, SDF.

Marlboro Street Factory, DADA/ *Supplement*.

marlborough, C-5157/*125*①; C-5153/ *126*①.

marlborough leg, C-0249/*360*; C-0279/*284*; C-5116/*62*; C-5157/ *39*; C-5114/*290*; C-5170/*40*; DADA; EA.

Marley, LAR82/*52*①.

marli, DADA; IDC.

marly (marli), IDC.

marmite, IDPF/*157*①.

marmolite, DATT.

marmot, C-0604/*137*.

Maroger medium, DATT.

maroon, C-5117/*379*.

maroquin, SDF.

Marot, Daniel, ACD; C-2357/*29*①; C-2498/*77*; C-2546/*92*; DADA; EA/①; SDF/*758*.

marouflage, DATT; LP.

Marquand, Frederick, C-5203/*356*.

Marquand, Isaac, CEA/*520*.

Marquand and Company, DADA/ *Supplement*.

Marquand and Paulding, CEA/*520*.

marqueterie, LAR83/*92*① *Royal Doulton and Rix*; SDF/*marquetry*.

marqueterie de verre, C-5005/*300*①; EG/*172*①.

marquetrie-de-verre, C-0225/*267*①.

marquetry, ACD; C-0982/*1, 9*; C-1407/*46*; C-2357/*57*①; C-2388/ *62*①; C-5116/*13*①, *49*①; CEA/ *231*①, *300, 311*①, *366, 406*; DADA; DATT/①; EA; LAR82/ *216*①; S-2882/*1443*①; S-3311/ *458*①; S-4436/*55*; S-4804/*768*①; S-4992/*104*①; SDF.

marquetry and penwork, S-2882/ *783*①.

marquetry-inlaid, C-2402/*11*.

marquetry inlay, S-2882/*417*.

marquetry panel, S-2882/*766*①.

marquetry pierced, C-2402/*66.*

marquetry signature, C-2409/*246*①; C-5005/*316*①.

marquetry-sur-verre, C-5191/*269*; C-5239/*179*①.

marquise, ACD; C-5259/*538*; CEA/ *524*; DADA; EA/*love seat, love seat*; S-291/*3*; S-4955/*76*①, *180*①.

marquise cabochon opal, S-291/*85*①.

marquise chair, SDF.

marquise-cut, S-4927/*151*①.

marquise diamond, S-291/*100*①.

marquise diamonds, S-291/*139*, *176*①, *206*①.

marquises, C-0249/*435.*

marquise shape, RTA/*114*①.

marquise-shaped, LAR82/*107*①; S-291/*16*; S-4414/*39*①.

marquise-shaped diamond, S-291/ *67*①, *75*①, *80*①; S-4414/*43.*

marquise-shaped jade panel, S-4414/ *60.*

marquise tanzanite, S-291/*133.*

marquisette, OPGAC/*228.*

marriage box, CEA/*62*①.

marriage casket, C-0406/*83*; EA; LAR83/*545*①; S-4804/*117.*

marriage chaplet, CEA/*666*①.

marriage chest, CEA/*324*①.

marriage cup, C-0254/*43*; EA/ *Berovieri family.*

marriage fan, EA.

marriage glass, EG/*95*①.

marriage panel, S-4972/*405*①.

Marriage pattern, LAR83/*72*①.

marriage plate, CEA/*584*①; EA/①; IDC/①; S-4823/*13*①.

marriage ring, RTA/*47*①.

marriage scene, C-2486/*152*①.

marronnier wood, DADA.

marrow-scoop, C-5117/*62, 94.*

marrow scoop, C-1502/*226*; C-5114/ *76*; DADA.

marrow scoop (spoon), EA/①.

marrow scoop, S-4905/*226*①.

marrow-spoon, C-5117/*94.*

marrow spoon (scoop), C-5174/*566.*

marrow tureen, IDC.

Mars, DSSA.

Marseille, C-2486/*184.*

Marseille faience factory, EA/①.

Marseillemuster, EA; IDC.

Marseille pattern, MP/*123.*

Marseilles, C-2427/*176*①; CEA/ *147*①; DADA; LAR82/*146*①.

Marseilles work, C-1506/*49.*

Marsh, Anthony, LAR82/*244*①.

Marsh, William, ACD; EA.

Marshall, James and William, S-3311/*711*①.

Marshall, John, CEA/*610*①.

Marshall and Sons, C-2510/*32.*

marshall's hat, C-MARS/*96.*

Marshall & Snelgrove, C-0405/*215.*

marshall trophy, C-2502/*121.*

Marshall-type compound microscope, CEA/*610*①.

Mars pigment, DATT; LP.

Marston Cup, EA.

Martabani ware, IDC.

Martebani type, C-2513/*256*①.

martelé, C-0225/*90.*

martele, C-2324/*190.*

martelé, C-5005/*236.*

martele, C-5114/*32*①.

martelé, C-5146/*61*①; C-5191/*87*; C-5239/*104.*

martele, C-GUST/*82.*

martelé, EG/*172*①.

Martele style, S-2882/*1306*①.

martelé working, C-5146/*108.*

marten, C-0604/*115A.*

Martha Gunn, EA.

Martha Washington chair, DADA/①; EA/①.

Martha Washington mirror, DADA.

Martha Washington pattern, DADA.

Martha Washington sewing (work) table, EA.

Martha Washington table, DADA/①.

Marti, L. et Cie., C-5181/98①.

Martial, A. P., S-286/70.

martial trophy, C-1006/94; IDC.

Martie, Samuel, C-5189/193①.

Martin, Edith Park, DADA/ Supplement.

Martin, Guillaume: Etienne, Julien, Robert, EA.

Martin, H., C-2493/204.

Martin, Hall & Co., S-4944/212.

Martin, Johannes, EA/33.

Martin, John, S-286/58; SDF/777.

Martin, Luan, Toledo, C-MARS/ 39①.

Martin and Son, C-5117/205①.

Martin Bros., C-2409/69.

Martin Brothers, C-2910/126; DADA/Supplement.

Martin-Guillaume Biennais, S-4922/ 1①.

Martin Hall & Co, C-0406/136; C-0706/89.

Martin Hall & Co., S-3311/704.

martini cup, C-5203/283.

martini goblets, C-0254/178.

Martini Henry rifle, CEA/36①, 44.

Martinot, CEA/226①.

Martinot, Balthazar, S-4955/17①.

Martin & Runyon, CEA/696①.

Martinware, IDC/①; JIWA/336①.

Martinware (Martin Brothers), LAR83/127①.

maru-bori, DADA.

Maru-bori style, JIWA/185.

Maruki, LAR83/45①.

marver, CEA/414; EA; EG/22①.

Mary, Queen of Scots receiving a cardinal, C-2704/10.

Mary Ann Ashby, C-2704/28.

Mary Ann Newberry, C-2704/186.

Mary Chapman, C-2704/12.

Mary Chawner, C-0706/229.

Mary Clapham, C-2704/20.

Mary Gregory, C-5181/1.

Mary Gregory glass, ACD; EA; EC1/55①, 56; EG/184①.

Mary Huggett, C-2704/16.

Maryland pattern, C-0254/201.

Mary Poltich, C-2704/5.

Mary Stones, C-2704/13.

März, C-5189/75.

marzacotto, IDC.

Masanobu, CEA/572①.

Masayuki and kakihan, CEA/568①.

mascaron, DADA; DATT; EA; SDF.

Masche, Adolf David, C-5117/303①.

mascherone, DATT.

mascotte, OPGAC/228.

Mashad carpet, EA/Meshed carpets.

Ma Sha Xuan, C-2458/364①.

Mashhas rug, LAR82/546①.

Mashiko, DADA/Supplement.

mask, C-2202/74; C-2398/11①; C-2402/68; C-2486/192; C-5156/ 24; C-5236/847; DSSA; IDC; IDPF/157①; SDF.

mask and paw foot, C-5117/175①.

mask and ring handle, LAR83/80①.

mask and trophy plaque, C-2364/ 74①.

mask apron, C-5117/205①.

maskaroon, SDF/mascaron.

mask finial, C-0254/43, 155; LAR83/ 287①.

mask foot, C-2398/4①.

mask-form feet, S-4843/68①.

mask-form handle, S-4804/16①.

mask handle, C-0249/258; LAR83/ 131①, 175①.

masking tape, DATT; LP.

mask-jug, C-2360/*24*; C-2493/*46*①; LAR82/*144*①.

mask jug (mask mug), IDC/①.

mask mug, IDC/①.

masks, C-0254/*126*①; C-0982/*63*.

mask terminal, S-4804/*113*.

Mason, ACD; C-0249/*208*; S-4881/ *312*①.

Mason, John, DADA/*Supplement*.

Mason, Miles, CEA/*163*①, *203*①; EA/①.

Mason, Thomas, C-5117/*252*①.

Mason, William, CEA/*163*①; EA.

Mason: George Miles, Charles James, EA/①.

Masonic, C-2513/*175*①; C-5114/ *148*①; C-5236/*805*①; LAR82/ *166*①; S-4905/*335*①.

Masonic emblem, C-0706/*118*.

Masonic figures, IDC.

masonic flask, EA/①.

Masonic Master's chair, C-2357/ *16*①.

Masonic medals, S-4843/*304*①.

masonic symbol, C-5117/*397*①; S-4905/*335*①.

Masonic ware, IDC.

masonic watch, C-5117/*397*①.

masonic wheel barometer, C-2368/*13*.

mason ironstone, DADA.

Masonite, DATT; LP.

Mason Jar, CEA/*55*①.

masonry, C-0249/*456*①.

masonry plinth, RTA/*30*①.

Masons, C-2502/*47*.

Mason's ironstone, C-5189/*13*.

Mason's Ironstone china, IDC.

MASONS PATENT IRONSTONE CHINA, EA/① *Mason, George Miles*.

masque lantern, LAR82/*503*①.

mass, DATT; LP.

Massachusetts design, S-4461/*605*.

Massachusetts pottery, CEA/*165*①.

Massachusetts shelf clock, EA/①.

Massanetta Art Pottery, Harrisonburg, Virginia, EC1/*85*.

mass color, DATT.

Massé, Jean-Baptiste, EA.

Massé, Jean Baptiste, C-5220/*56*①.

massed lard, IDC.

massicot, DATT; LP.

massier, DATT.

Massier, Clement, C-2409/*130*; C-2910/*131*; C-5167/*67*; C-5239/ *19*.

Massier, Delphin, C-GUST/*5*①.

massive shaft, C-2421/*132*.

masso bastardo, IDC.

Masson, Andre, S-286/*60*.

Masson, André, S-286/*432*.

Masson, Nicolas-Richard, S-4944/ *187*①.

mass tone, DATT.

master, DATT.

master cup, EA/*masterpiece*.

master glass, EA.

Master of the Rocks dish, S-4965/ *288*①.

masterpiece, CEA/*619*; DATT; EA; LP.

master potter, MP/*19*.

masters, JIWA/*16*.

master salt, EA/*salt*.

mastic, DATT; LP.

mastos, IDC/①.

Masulipatam rug, DADA.

mat, C-2546/*174*; C-5005/*297*①; C-5127/*166*; C-5156/*279*; DADA; DATT; IDC; LP; S-286/*260*; S-4461/*817*; SDF.

matador suit, C-0604/*20*.

Mata Kuching damar, DATT.

mat board, DATT.

matchbox, C-0254/*103*; C-1502/*91*; EA/①.

matchbox cover, C-0254/*278*;
C-1502/*22, 91.*
matchbox covers, C-0254/*109.*
match box holders, C-0254/*235.*
matched, SDF.
matched set, S-4881/*233*①.
Matchett, Johannes (John), S-4927/
*210*①.
match holder, C-5173/*15*; C-5239/*93*;
CEA/*468*①.
matchholder, C-0225/*307.*
matching, C-0982/*61, 278*; C-5117/
*147*①; S-4922/*38*①.
matching stopper, C-2458/*347.*
matchlock, ACD; CEA/*28*①, *44*;
DADA.
matchlock gun, C-MARS/*120.*
matchlock musket, C-2569/*60*①.
match safe, C-0254/*226*; C-5146/*157*;
S-4804/*223*①; S-4881/*160.*
match striker, S-4843/*329*①.
matchstriker, C-2409/*192.*
mat cutter, DATT/①.
maté cup, C-5174/*478*①.
mater, EA/*32*①.
material-lined, C-2403/*82.*
materials, JIWA/*6.*
maternal pose, JIWA/*27.*
maternity dress, C-1506/*15.*
mat finish, RTA/*187*①.
mat gilding, DATT.
mat glaze, DATT; EC1/*83.*
mat-gold finish, RTA/*170*①.
Mathew Boulton, C-0706/*211.*
Mathildenhöhe, DADA/*Supplement.*
Mathsson, Karl Bruno, DADA/
Supplement.
matière, LP.
Matisse, Henri, S-286/*432, 320A*①.
Matisse, Pierre, S-286/*320*①.
mat knife, DATT/①.
mat-markings, IDC.

mat medium, DATT.
mat openings, C-0249/*6.*
mat polymer medium, DATT.
maître-ébéniste, CEA/*314*①.
maître ébéniste, EA/*Riesener,
Jean-Henri.*
maître-ébénistes, EA/*J.M.E..*
matrix, C-0249/*300*; C-2324/*224*;
C-5156/*304*①; DATT; EA.
matrix carving, C-2458/*253.*
mats, C-2704/*140.*
mat shimmer, MP/*171.*
mat-stained, S-286/*63.*
mat staining, C-0249/*90.*
mat-su-no-ke, EC1/*60*①.
matt, ACD; C-1082/*96*; C-5239/*6.*
matt (mat), IDC.
matt, S-4461/*319*; SDF/*mat.*
Matta, Roberto Sebastian Antonio,
S-286/*61.*
matt-brillant, IDC.
matt center, S-3311/*110*①.
matte, C-0225/*13*; LP.
matted, C-0225/*414*; C-0406/*127*;
C-2202/*27*; C-2437/*63*①; C-5116/
48; C-5156/*10*①; C-5236/*1642*;
DADA; S-4922/*10*①; SDF.
matted brass, C-5116/*50*①.
matted center, C-5157/*34*①.
matted centre, C-1702/*257.*
matted chair, SDF.
matted copper, C-5127/*362.*
matted dial, S-3311/*109.*
matted dial centre, CEA/*233*①.
matted ground, C-0254/*52*; C-0270/
166; C-2398/*19*①; C-5114/*14*;
C-5156/*184*; RGS/*17*①; S-2882/
*1062*①; S-4414/*302*①; S-4804/*46*;
S-4905/*176*①; S-4922/*2*①, *11*①.
matted rondel, CEA/*641*①.
matte finish, C-5153/*14*①.
matte ground, C-5156/*378*①.
matter, DATT.

matte straw, S-4461/*384*.

matt gilt ground, RGS/*62*①, *151*①.

matt glass, JIWA/*330*.

matt glaze, S-2882/*1391*.

matt gold dial, S-4461/*328*.

Matthäi, Johann, Gottlieb, MP/*171*.

Matthew, DSSA.

Matthew Boulton, C-2357/*1*①;
C-5117/*35*①.

Matthews, Heber, DADA/
Supplement.

Matthew West, S-3311/*758*.

matting, C-5117/*366*①; CEA/*678*.

matting (in silver), EA/①.

matting, SDF.

matting wheel, DATT.

Matt Morgan Art Pottery, Cincinnati,
Ohio, EC1/*85*.

mattoir, DATT.

mattress, SDF.

maturation, DATT.

mat varnish, DATT.

Mauchline box, CEA/*70*.

Mauksch, Johannes Karl, MP/*175*.

maulstick, DATT.

Maundy, William, CEA/*640*①.

Maurer, L., S-286/*251*.

Mauri, OC/*176*①, *180*①.

Mauri Shakh, OC/*183*①.

Mauri weave, OC/*182*①.

Mausch/Paris, OPGAC/*15*.

Mauser, C-2476/*5*.

Mauter, Conrad, stamp: C MAUTER,
C-5224/*196*①.

mauve, C-0405/*47*, *216*; C-1506/*20*;
C-5005/*407*①; DATT; LP.

mauve ground, C-1006/*42*.

mauvish brown, OC/*139*.

Max, G., S-4947/*172*.

Maxim, OPGAC/*15*.

Maximiliansschale, EA.

Maximinenstrasse, DADA.

Max von Boehn, C-2704/*165*.

Maxwell triangle, DATT.

May, John, London, C-2489/*113*.

Mayan blue, DATT.

Mayan pottery, IDC.

mayblossom, IDC.

May day, IDC/①.

Mayer, Elijah, DADA; S-4843/*430*.

Mayer, Franz Ferdinand, EA.

Mayer, Franz Ferdinant, EA.

Mayer, Jean-Ghislain-Joseph, EA.

Mayer P, EA/*Mayer, Franz
Ferdinant*.

Mayeux, Louis-Francois, stamp: L
MAYEUX, C-5224/*98*①.

mayfair-open rose, OPGAC/*195*.

Mayhew, John, DADA; SDF/*758*

Mayhew, Thomas, ACD.

Maynard carbine, S-4972/*274*.

Maynard's Patent magazine, C-2503/
107.

Mayodan, Jean, C-5167/*70*.

Mayr, Jacob, C-2368/*209*.

Mayr, Jacobus, EA/*172*.

mazarin, S-4922/*74*①; S-4802/*351*.

Mazarin blue, EA.

mazarine, ACD; C-2398/*86*①;
C-5127/*237*①; EA/①; DADA.

mazarine-blue, CEA/*189*①.

mazarine blue, EA; DADA; IDC.

mazarlik carpet, EA/*graveyard
carpets*.

maze-gane, DADA.

mazer, ACD; CEA/*638*①; DADA/
①; EA; SDF.

mazer wood, SDF.

mazerwood, DADA.

maze-work, S-4948/*184*①.

maze-work field, S-4965/*108*①.

Mazzoleni, CEA/*601*.

M.:.B, EA/*Ball, William*.

M. & B., CEA/*204*①.

MB, EA/*Marieberg.*

M. Berge, C-2904/*254.*

mber gilding, EA.

mbira, C-1082/*4.*

M. Bouraine, C-5005/*360*①.

mbulu ngulu, S-4807/*437*①.

M. CARLIN, EA/*Carlin, Martin.*

McAshley, C-5191/*296.*

McBeth-Evans Glass Co., OPGAC/ *190.*

McBey, James, S-286/*63, 321A*①.

McCabe, James, CEA/*256*①.

McCobb, Paul, DADA/*Supplement.*

McDonald, Philip, NYTBA/*307.*

McGregor, D., Glasgow, S-4927/ *220A*①.

McGuilp, DATT.

McIntire, Samuel, CEA/*399*①; DADA; SDF/*774.*

McIntyre, Samuel, EA; NYTBA/*66.*

McKay, Cunningham & Co, C-0406/ *36.*

McKay, John, C-5174/*503.*

McKearin, George, NYTBA/*268.*

McKee Brothers, CEA/*469*①.

McLean, John, C-2421/*78*①; CEA/ *358*①.

McMullin, John, CEA/*676*①.

McPherson, W. J., LAR82/*447*①.

M.E., EA/*J.M.E., J.M.E..*

Mead, Dr. Henry, CEA/*205.*

Mead, J. O., DADA/*Supplement.*

mead cup, S-4944/*312.*

Meade, Thomas, C-0706/*99.*

mead glass, EA; LAR83/*450*①.

meadow-green, IDC.

Meadow pattern, C-0254/*247.*

meander, C-5156/*84*①; C-5236/ *449*①; DATT; S-4905/*48*①.

meander-and-star border, IDC.

meander-and-swastika border, IDC.

meander border, IDC; OC/*48*①.

meandering border, C-2704/*33.*

meandering flowering vines, C-2704/ *115.*

meandering foliage, C-2414/*50*①.

meandering honesty blossoms, S-4414/*185*①.

meander ornament, EA/*key pattern, key pattern.*

meander or scroll border, OC/*42*①.

meander (Greek key) pattern, RTA/ *27*①.

meander primary border, S-3311/*3.*

mease mug, IDPF/*164.*

measure, C-2498/*48*①; EA; IDPF/ *158*①, *185*; NYTBA/*260.*

measures, DADA; S-4436/*24*①.

measuring cup, C-0254/*199.*

measuring glass and scale, C-2403/ *13.*

meat-dish, C-1006/*101*; C-2398/*10, 42*①; C-5117/*114*①.

meat dish, C-0254/*107*; C-0782/*57*; C-5117/*11*; DADA; EA; IDPF/ *158*; LAR83/*574*①; S-4802/*207*; S-4922/*36*①.

meat-dish cover, C-2398/*84*; C-5117/ *140.*

meat dish cover, LAR83/*572*①.

meat draining dish, C-1006/*213.*

meat fork, S-4804/*35*①.

meat knife, S-4461/*237.*

meat platter, C-0254/*4*; S-4804/ *151*①.

meat-skewer, C-2487/*84*; C-5117/ *118, 249*; C-5174/*583.*

meat skewer, C-0254/*129*; C-1502/ *174*; S-4905/*222*; S-4944/*40.*

meat tray, C-0254/*27.*

MEB, EA/*Edkins, Michael.*

Mechanical, FFDAB/*51.*

mechanical bank, DADA.

mechanical bell, C-0225/*142.*

mechanical drawing, DATT.

mechanically driven washing drums, MP/*191*.

mechanically-produced, CEA/*683*.

mechanical stage, C-2904/*104*①.

mechanical table, S-4955/*187*①.

mechanical tracing apparatus, NYTBA/*196*.

Mechanico-Mathematical, C-2904/*197*.

mechanism, S-4972/*338*.

mechlin, DADA.

Mechlin lace, C-1506/*176*.

Mecklenburg-Strelitz service, IDC.

médaillier, DADA; EA/*medal cabinet*.

medaillonbecher, CEA/*455*①.

medakhyl, S-288/*11*①.

medal, C-5153/*6*; DADA; RGS/*89*.

medal and coin cabinet, DADA.

medal cabinet, EA; NYTBA/*47*①; SDF.

medallic portrait-head, RTA/*125*①.

medallion, ACD; C-2320/*132*; C-5005/*250*①; C-5117/*386*①; C-5156/*37*①; CEA/*82*①; DADA/①; EA; IDC/①; MP/*32, 204*; OC/*11, 42*; S-4804/*966A*①; S-4922/*48*①; SDF.

medallion/all-over design, OC/*274*.

medallion-and-corner effect, OC/*88*.

medallion and gable, S-2882/*89*.

medallion-and-islimi style, OC/*292*.

medallion carpet, EA.

medallion fan, EA.

medallion handle, C-0254/*263*.

medallion head, C-5114/*38*①.

medallion panel, SDF.

Medallion pattern, C-0254/*77*; S-4804/*1*.

medallion-plain, OC/*110, 292*.

medallion-plain designs, OC/*238*.

medallion-Ushak carpet, EA.

'medallion-with-pendants' design, OC/*217*.

medal portrait, RGS/*133*①.

medal's cabinet, C-0279/*424*①.

Medea, DSSA.

mediaeval, CEA/*509*.

Mediaeval cruet, CEA/*582*①.

Mediaeval metalwork, CEA/*529*.

mediaeval seat furniture, SDF/①.

medial band, S-4414/*217*.

medial shelf, C-5114/*335*①.

medial stretcher, FFDAB/*41*.

median drawer, S-2882/*264, 326*.

median ridge, C-5127/*145*.

medical instrument, S-4927/*222*①.

medical machine, C-2904/*287*.

medical spoon, IDC/①.

Medici, C-2486/*99*.

Medici, flask of, CEA/*170*①.

Medici, Grand Duke Francesco I, de', CEA/*169*.

Medici furniture, NYTBA/*4*.

Medici manufactory, EA.

medicine box, JIWA/*8*.

medicine chest, S-4461/*542*; SDF.

medicine spoon, EA/①; IDPF/*213*①.

medicine vial, CEA/*54*①.

Medici porcelain, DADA; EA; IDC/①; NYTBA/*169*.

Medici tapestry works, DADA.

Medici vase, IDC.

Medieval, C-5156/*443*.

medieval art, DATT.

medieval intaglio, RTA/*63*①.

medieval Islamic metalwork, C-5156/*128*①.

medieval onyx, RTA/*69*①.

Medieval painting, LP.

medieval prototype, NYTBA/*146*.

medieval revival, LAR83/*223*①.

Mekeren, Jan van, CEA/*308*①.

mekugi-ana, C-5236/*1825, 1833*.

mekugiana, C-5236/*1835*.

Melancholy, DSSA.

mélange campan, DADA.

Melas, C-5189/*398*; OC/*134*①.

Melas carpet, EA/①.

Melas rugs, ACD.

Melayer carpet, EA.

Melbourne Creamware, S-4843/ *132*①.

Melchior, Johann Peter, EA.

Melchior, J. P., CEA/*178*①.

Melchoir, Johann Peter, C-2486/ *87*①.

Meles rug, DADA.

mélèze wood, DADA.

Mellor, T., S-4947/*186*.

mellow, OC/*26*.

Melly, Etne., Geneva, C-2489/*228*.

melon bead, C-2482/*79*.

melon bulb, EA/*bulb, bulb*; SDF/①.

melon carving set, S-4804/*195*①.

melon cup, EA.

melon-fluted, C-0103/*63*; C-0706/*119*.

melon fluted, C-0254/*23*①.

melon-fluted form, S-4922/*73*①.

melon fluting, C-5203/*180A*.

melon foot, DADA.

melon forks, C-0270/*269*.

melon-form, S-3311/*247*.

melon-form foot, C-5167/*217*①.

melon knop, LAR82/*539*①.

melon-lobed form, S-2882/*1079*①, *1190*.

melon lobed form, S-2882/*1195*①, *1197*①.

melon pattern, LAR83/*573*①.

melon reeded, C-0254/*266*.

melon-reeded feet, C-5114/*318D*①.

melon shape, C-0225/*10*.

melon-shaped, C-5117/*158, 205*①; LAR83/*622*①; S-4965/*221*.

melon support, DADA.

melon ware, IDC.

Melpomene, DSSA.

melting batch, EG/*83*.

melting end, EG/*236*.

melting point, CEA/*580*.

Melville, David, CEA/*592*①.

Melville, R., CEA/*605*①.

memento mori, DATT/①; LP.

memento mori motif, EA/*Birmingham enamel*.

memento-mori ring, RTA/*98*①, *108*①.

memento mori watch, EA.

memorial brooch, EA/*brooch*.

memorial portrait, C 5236/*1131*.

memorial ring, S-4927/*272*.

memorial tablet, MP/*110*.

memorial urn, S-4944/*53*①.

memoriam picture, DADA.

memory ring, RTA/*108*①.

mempo, LAR82/*38*①, *50*①.

ménager, DADA.

menagerie group, IDC.

Menai Bridge, C-2704/*27*①.

menat, S-4973/*117*.

Mendelsham chair, ACD.

mending tape, DATT.

Mendlesham chair, DADA; EA; LAR82/*316*①; SDF/①.

Mene, Pierre-Jules, EA/①.

Mène, Pierre Jules, C-5189/*138*①.

Mennecy, ACD; C-2427/*1*①; C-5189/*97*; CEA/*147*①, *169*, *183*①; DADA; LAR82/*127*①; LAR83/*105*①.

Mennecy faience and soft-paste porcelain factory, EA.

Mennecy pottery, NYTBA/*170*.

Menner, C-5203/*96*.

Mennicken family, EA.

menorah, C-5174/*40*①; DSSA.

mentonnière, DADA.

Menu, Nicolas, S-4927/*36*①.

menu-holder, C-2493/*270*; IDC.

menu holder, C-0706/*91*; C-1502/*46*.

menuiserie, C-2364/*33*; DADA.

menuisier, ACD; C-5259/*638*①;
CEA/*379*①, *406*; DADA; EA/
J.M.E..

menuisier-ébéniste, EA/*J.M.E.*.

menuisier-sculpteur, C-2555/*41*①.

menuki, C-5236/*1830*; DADA/①.

menu-stand, IDC.

meranti, SDF.

mercerized cotton, OC/*16*.

merchant's mark, EA; RTA/*68*①,
*78*①.

Mercier, André, Liège, C-2503/*184*.

Mercier, P., EA/*Berlin tapestry*.

mercuric gilding, IDC.

mercury, S-4972/*415*; DSSA.

mercury bath, C-0403/*223*.

mercury-filled tube, EC2/*96*①.

mercury gilding, EA/*gilding*.

mercury glass, EC1/*56*.

mercury glass salt, CEA/*471*①.

mercury pattern, CEA/*432*①.

mercury pendulum, C-0249/*197*.

mercury-pendulum clock, S-4947/*235*.

mercury thermometer, C-2489/*34*.

mercury twist, EA; EG/*141*①.

mercury yellow, DATT.

Mercy, DSSA.

Mère, Clement, C-5005/*350*①.

merese, CEA/*503*; DADA; EG/
*290*①.

merese knop, EA.

Meriden Britannia Company, DADA/
Supplement.

meridian ring, C-5174/*429*①.

méridienne, DADA; EA.

meridienne, LAR82/*362*①; S-4804/
*905*①.

merisier wood, DADA.

Meriton, Samuel II, C-2487/*156*.

Meriton, Thomas, C-5117/*48*.

Meriton II, Samuel, C-5117/*60*.

Merlin's Mechanical Museum, CEA/
685.

mermaid finial, S-4804/*111*①.

mermaid handle, S-4804/*124*①.

mermaid spout, C-0103/*103*.

mermaid thumbpiece, LAR83/*612*①.

Merrimac Pottery, Newburyport,
Massachusetts, EC1/*85*.

Merriman and Dunbar, CEA/*243*①.

Merry-Go-Round bowl, CEA/*482*①.

Merry Man, S-4843/*6*①.

Merry Man plate, EA/①.

merry man plates, IDC/①.

'merrythought' jug, EG/*43*①.

Merryweather & Sons, Holloway,
London, C-0982/*30*.

merry widow mounting, S-291/*154*.

Mershon's patent regulator, C-5174/
363.

Mershon's patent watch, S-4927/*98*.

Merton Abbey, NYTBA/*98*.

Meryon, Charles, S-286/*322*①.

merz, LP.

mesail, DADA.

Meschach Godwin, S-3311/*792*①.

Mesch (Mes) family, EA.

mesh, S-3311/*120*①; S-4927/*365*①.

Meshad carpet, C-1702/*13*; C-2482/
14.

mesh bag, C-0405/*102*.

mesh band, S-4461/*300*.

Meshed, C-2320/*155*; C-5189/*368*①;
CEA/*94*; OC/*31*①, *290*①, *290*①,
*294*①.

Meshed Beluch, OC/*193*①.

Meshed carpet, EA; S-4796/*159*.

Meshed medallion, OC/*290*①.

meshed rug, ACD; S-3311/*17*①;
DADA.

Mesheriki, OC/*99*①.

Mesheriki copy, OC/*99*.

Mesheriki style, OC/*99*.

Meshkin, OC/*225*.

Meshkin nabati, OC/*229*①.

mesh necklace, S-4414/*19*①.

mesh petal, S-291/*81*①.

mesh purse, S-4804/*79*.

mesh strap, C-5117/*399*①; S-4414/
150.

Meslée, Jacob D. R., EA/*119*.

mess chair, SDF.

messenger's ring, RTA/*86*①.

metal, C-5127/*455*; C-5153/*76*①;
CEA/*503, 562*; DADA; EG/*83*.

metal banding, C-2704/*122*.

metal bound, C-5236/*1641*.

metal-cased ammunition, CEA/*40*①.

metal cased Stockuhr, CEA/*237*①.

metal casing, C-2904/*1*.

metal collar, CEA/*358*①.

metal design, NYTBA/*169*①.

Metalen Pot, De, CEA/*141*①.

metal form, IDPF/*160*.

metal furniture, SDF/①.

metal imprint, S-286/*284*.

metal-key instrument, C-1082/*4*.

metal leaf, DATT.

metallic, C-0405/*56*; C-5156/*41*.

metallic glaze, C-5156/*70*.

metallic gold, C-5005/*351*①.

metallic lustre, IDC.

metallic oxide, CEA/*156*①, *452*①;
IDC.

metallic silver inclusion, C-5005/
*287*①.

metallic thread, C-5323/*115*①;
S-3311/*503*①.

metallic thread field, S-2882/*157*①.

metal liner, C-2402/*21*.

metallizing, DATT; SDF.

metallurgist, MP/*39, 44*.

metal mount, JIWA/*317*①; SDF.

metal-mounted, C-2458/*179*.

Metal Pot, The (De Metalen Pot),
EA.

metal riza, S-2882/*544*.

metal-spinning, EA.

metal spraying, DATT.

metal thread, C-2403/*195*; C-2478/
226; OC/*339*.

metal thread rug, C-2546/*170*;
C-5236/*553*.

metal work, S-4461/*5*.

metalwork, CEA/*299*.

metal-work, SDF/*metal mount*.

metamerism, DATT.

metamorphic library armchair,
S-4988/*467*.

metamorphic rock, DATT.

metamorphic settee, C-2320/*27*①.

metaphor, LP.

metaphysical painting, LP.

metapolymorphic painting, LP/①.

metate, S-4807/*123*.

Meteorological Office fan
anemometer, C-0403/*116*.

meteri, OC/*262*.

methacrylate resin, DATT.

methanol, DATT.

method, JIWA/*6*.

methyl acetone, DATT.

methyl alcohol, DATT; LP.

methylated spirit, DATT.

methyl cellulose, DATT.

methyl ethyl ketone, DATT.

methyl silicate, DATT.

métier, DATT; LP; MP/*74*.

metope, DADA.

metre, C-2904/*132*.

metric measurement, LP.

metronome, C-0906/*260*.

'Metropolis Shape', C-2910/*108*.

metropolitan slipware, EA; IDC.

Metsch, Johann Friedrich, CEA/ *138*①.

Mettayer, Lewis, C-2487/*130*.

Mettlach, C-1582/*35*; K-711/*130*; LAR83/*136*①; S-4804/*508*.

Mettlach pewter, C-2502/*92*.

Mettlach pottery, LAR82/*155*①.

Mettlach stein, S-2882/*422*①.

Mettlach stoneware, C-2493/*236*.

Mettlach vase, S-2882/*500*①.

Metzsch, Johann Friedrich, EA; MP/ *166*.

meuble d'appui, C-2364/*59*; C-2546/ *57*; CEA/*406*; LAR82/*287*①; C-2437/*63*①.

meubles a hauteur d'appui, LAR83/ *262*①.

meubles parlants, DADA/*Supplement*.

Meure, Peter, EA/*Archambo, Peter the Elder*.

Mewburn, Barrak, CEA/*657*①.

Mewburn, John, C-5117/*28*①.

Mexican maiolica, IDC.

Mexican onyx, DATT.

Meydam, Floris, DADA/*Supplement*.

Meyer, Andreas, CEA/*627*①.

Meyer, Christoffel Jansz, EA.

Meyer, F. E., C-2486/*157*①.

Meyer, Friedrich and Wilhelm, CEA/ *177*①.

Meyer, Friedrich Elias, EA; MP/*135*.

Meyer, Jeremiah, EA.

Meyer, Wilhelm Christian, EA.

Meyes, S-4947/*119*①.

Meylan, C. H., C-5117/*441*①.

Meylan, C.H., S-4927/*161*.

mezuzah, C-5174/*15*①.

mezza-maiolica, IDC; ACD.

mezza maiolica, EA.

mezza majolica, DADA.

mezzara, C-2501/*92*.

mezzo fresco, DATT.

mezzopoint, S-286/*523*.

mezzo punto, DADA.

mezzo-relievo, SDF.

mezzo-rilievo, DADA; DATT.

mezzotint, C-0249/*116*; C-5114/ *176*①; CHGH/*63*; DADA; DATT; NYTBA/*202*①; S-286/*58, 59, 180, 377*.

Miami Pottery, Dayton, Ohio, EC1/ *85*.

mica, C-1506/*149*①; C-5191/*301*; C-5236/*1337*①; C-5239/*89*; DATT; EG/*192*; S-3311/*916*.

mica ground, C-5156/*1041*; S-4461/ *431*.

Mically, Ster., Malta, C-2489/*161*.

mica paper, C-2323/*168*.

mica print (shomen-zuri), JIWA/*260*.

Micarta, DATT.

Michael, DSSA.

Michel, Claude (Clodion), EA.

Michel, Frédéric, stamp: F MICHEL, C-5224/*113*①.

Michel, George, MP/*442*①.

Michelsen, A., C-5203/*139*; S-4944/ *106*①.

Michigan, OPGAC/*229*.

Michoacán, S-4807/*137*①.

Mickey Mouse terminal, LAR83/ *578*①.

microcrystalline wax, DATT.

microdot viewer, C-1609/*123*.

micrometer, C-2904/*78*; CEA/*612*.

micrometer eyepiece, C-0403/*119*.

micrometer microscope, CEA/*603*①.

micrometer regulator, C-5117/*421*①; S-4802/*15, 66*.

micrometer-screw, CEA/*605*①.

micro-mosaic, C-0279/*456*①; C-2332/*48*; C-5189/*342*①; S-4804/ *760*①, *762*①.

microphotograph, C-0403/*182*; C-2904/*187*.

microscope, C-2608/*21*; C-2904/*45*; C-MARS/*198*.

microscope lamp, LAR82/*502*①.

microtome, C-2608/*59*; C-2904/*289*.

microtome blade, C-0403/*191*.

microtone, CEA/*556*.

Midas, DSSA.

Midavaine, Louis, C-5167/*207*.

mid-band, C-5114/*56*; C-5153/*14*①.

midband, C-5153/*25*①.

Middle Ages, CEA/*683*; JIWA/*8*.

middle distance, DATT; LP.

Middle Eastern, C-1502/*24*.

Middle Eastern alabaster group, C-1082/*156*.

Middle Eastern brass, C-1082/*107*.

Middle Eastern tase, C-2513/*403*①.

Middle Edo period, JIWA/*16*①.

middle ground, JIWA/*10*.

middle kingdom, S-4807/*460*.

Middle Lane Pottery, East Hampton and Westhampton, New York, EC1/*85*.

middle period, DADA/*Supplement*.

mid-Georgian, C-2421/*47*; C-2403/*15*①, *105*①; C-2478/*10*.

Midlands, C-1506/*175*.

mid-molding, C-5114/*25*①, *297*①.

midnight blue, S-4847/*2*.

Midnight Modern Conversation, IDC/①.

midrib, C-5114/*79*①, *355*①.

midrim, C-5114/*131*.

mie grimace, JIWA/*6, 69*.

Miers, John, EA/①.

Mi family style, C-2458/*263*.

Migeon, Pierre, II, DADA/①.

Migeon, Pierre II, S-4955/*177*.

Migeon Pierre II, EA.

Mignon, C-2904/*15*.

mignonette, DADA.

Mignot, Daniel, EA.

Miguelet, CEA/*25*①.

mihrab, C-2320/*141*; C-2357/*119, 164*; C-2478/*208*; C-5236/*1712*; C-5323/*72*①, *95*①; CEA/*78*①, *101*; EA; OC/*42, 126*①; S-2882/*78*①; S-3311/*27*; S-4796/*9, 60*①, *183*①; S-4847/*14, 30*①.

mihrab lamp, OC/*186*.

mihrab-shaped form, OC/*143*.

Mikawachi, ACD.

Miklos, Gustave, C-5005/*344*①.

Milanese, C-1506/*21*.

Milan lace, DADA.

Milan Maiolica, EA.

Milas carpet, EA/*Melas carpets*.

milchglas, LAR83/*419*①; EA.

Milch glass, DADA.

Milde, Arij de, stoneware, IDC.

Milde, Ary de, CEA/*142*①.

mildew, DATT.

Mildner, CEA/*455*①.

Mildner, Johann Jacob, EA/①.

Mildner glass, DADA/①; EG/*106*.

mild steel, DATT.

Miles, EA/*Solon, Marc-Louis*.

Miles Mason, EA/*Mason, Miles*.

milieu, LP.

military chest, C-1407/*88*; LAR83/*295*①.

military drum, CEA/*549*.

military secretaire chest, LAR83/*294*①.

military sword, CEA/*32*①.

military trophy, C-2364/*25*①; C-2421/*6*; S-4927/*38*①.

milk and water glass, EA/*Beinglas*.

milk bench, DADA.

milk glass, C-0225/*171*; C-0906/*175*; CEA/*456*①, *468*①; DADA.

milk glass (milk-white glass), DADA/*Supplement*.

milk glass, EG/*155*; LAR82/*506*①; OPGAC/*197*.

Milking group, the, IDC/①.

Milking scene, the, IDC.

milk-jug, IDC.

milk jug, C-0706/*1*; C-0782/*24, 117*; C-1502/*41*; EA/*cream jug*; LAR83/*567*①; S-3311/*613*; S-4992/*17*①, *84*①.

milkjug, C-2458/*134*①; C-5117/*7*.

milk ladle, IDPF/*160*①.

milkmaid cup, DADA.

Milkmaids, the, IDC/①.

milk of lime, DATT.

milk pan, IDPF/*160*.

milk-skimmer, IDC.

milk tea ewer, C-5156/*150*.

milk-white glass, DADA/*Supplement*.

milky glass, JIWA/*303*①.

Millais, Sir John Everett, DADA/ *Supplement*.

milled, C-2421/*4*①; C-2478/*2*; C-2493/*151*.

milled border, C-2357/*41*.

milled disc, CEA/*254*①.

milled ring, EG/*290*①.

milled tapering foot, C-2437/*25*.

milled-thread and chain, CEA/*419*①.

millefiore, NYTBA/*284*①; OPGAC/ *171*.

millefiori, ACD; CEA/*50*①, *416*①, *489, 503*; DADA; EA/①; EC1/*56, 64*①; LAR82/*25*①; S-4807/*548*.

mille-fiori, EA/*Baccarat*.

millefiori cane, CEA/*490*.

millefiori rod, EG/*20*.

millefiori stopper, CEA/*492*①.

millefleur, C-0279/*150*①.

millefleur pattern, S-3312/*1120*①.

mille fleurs, S-4972/*171*①.

millefleurs, DADA.

mille fleurs effect, OC/*294*.

millefleurs pattern, IDC.

mille-fleurs tapestry, EA.

Miller, Benedickh, C-2489/*96*①.

Miller, Edward, & Co., K-711/*129*.

Miller, Fredrick A., DADA/ *Supplement*.

Miller, Herman, C-5167/*223*.

Miller, J., CEA/*603*①.

Miller, J., London, C-2489/*191*.

Miller, William, CEA/*187, 195*①.

Millersburg Glass Company, CEA/ *480*①.

Milles, Ruth, C-5189/*174*①.

millieu de table, C-GUST/*22*.

milling, C-5236/*381*.

Millot, Pierre, C-2555/*28*.

mill-pattern, C-2388/*154*.

mill-pattern stripe, C-2478/*231*.

Mills, Dorothy, S-3311/*782*.

Mills, Nathaniel, C-0406/*75, 111*; C-0706/*220*; C-5203/*173*①; CEA/ *69*①; EA; S-3311/*714*①.

mill-spun, OC/*32*.

mill-spun yarn, OC/*33*.

Mills 'Test your Strength' punch-ball machine, C-0403/*12A*.

millstone, DSSA/①.

Millville flower, CEA/*489*.

Millville inkwell, CEA/*501*①.

Millville pink rose, CEA/*499*①.

Millville ship, CEA/*501*①.

Milori blue, DATT.

Milton Shield, EA/*Morel-Ladeuil, Léonard*.

Milykov, Petr, C-5174/*216*.

Mimbres, S-4807/*283*①.

mimetic trace, JIWA/*33*.

mimpei ware, DADA.

M Imp^le/de Sèvres, EA/*Sèvres*.

Minai, C-5156/*443*.

minai ware, EA; IDC.

Mina Khani, CEA/*101, 101*①; OC/ *83, 330*①.

Mina Khani design, OC/*193*①, *329*①.

mina khani field, S-2882/*122*①.

minakhani field, S-2882/50①.

Mina Khani motif, DADA.

minature, C-5116/28.

minaudiere, C-1304/58; C-2203/223.

Minaux, André, S-286/432.

minbar, OC/142.

mine cut, C-5127/159.

mine-cut diamond, C-5005/207①.

mineral blue, DATT.

mineral deposit, MP/15.

mineral gray, DATT.

mineral green, DATT.

mineral lake, DATT.

mineral oil, DATT.

mineral painting, DATT.

mineral pigment, DATT.

mineral spirits, DATT; LP.

mineral turbith, DATT.

mineral violet, DATT.

mineral white, DATT.

mineral yellow, DATT.

Miners, the, IDC/①.

miner's dial, C-2608/51.

Minerva, DSSA; OPGAC/229.

Mines Royal, EA/latten.

minette, DATT.

Ming, C-0782/27; CEA/111, 571; DADA/①; EC2/22; S-4461/437.

Ming blue and white ware, S-4965/239①.

ming-ch'i, EA/①.

Ming design, C-5156/488.

Ming dynasty, EA; IDC; LAR82/48①, 156①; ACD; C-2323/12; C-2414/106; C-2458/50; C-5236/347①; S-4461/130.

mingei, C-5127/448; DADA/Supplement; C-5156/767①; C-5236/1751.

mingei ware, IDPF/161.

Ming fa-hua, EA.

Ming monochrome, S-4965/252①.

Ming paper, C-5127/174.

Ming polychrome, S-4965/255①.

Ming porcelain, MP/129.

Ming style, C-5127/167.

Ming style jar, S-3312/1350①.

ming tree, OPGAC/345.

miniature, C-0706/91; C-1603/4, 37; C-2458/26; C-5114/391①; C-5117/297①; C-5153/61①; C-5156/179①, 844①; C-5203/71; CEA/276①, 503; DADA; DATT/①; IDC; IDPF/239; JIWA/12; LP; S-4881/290①; S-4905/350①; S-4944/121; S-4972/435①; CEA/521①.

miniature cabinet, C-1082/181; C-5224/14①.

miniature carriage, CHGH/51①.

miniature-carving, RTA/95.

miniature clock, EA; S-4461/342①.

miniature frame, C-0406/86.

miniature furniture, SDF.

miniature ivory carving, RTA/122①.

miniature lacquer painting, RGS/88.

miniature lamp, K-802/16.

miniature mug, C-5114/49.

miniature painter, MP/50, 122.

miniature painting or limning, EA/①.

miniature pistol, C-2503/208①.

miniature portrait, C-5114/164.

miniature silver, EA.

miniature snuff bottle, S-4810/53①.

miniature swirl cane, CEA/495①.

miniature tall case clock, DADA.

miniature tankard, RGS/22①.

miniature teabowl and saucer, C-2458/128.

miniature telescope, C-2487/18①.

miniature vase, C-1082/87; C-5146/156①.

miniature weight, EA/Baccarat.

Mini Daisy, K-802/22.

Mini Khani pattern, C-5189/395.

minimal art, DATT; LP.

Mining, C-2904/*199.*

mining aneroid, C-2904/*248.*

'minipiano pianette', LAR83/*520*①.

minium, DATT; LP.

Minko School, C-5156/*691*①.

mino, DADA/*Supplement*; C-5236/ *855*①, *1833.*

Minoan, DATT/①.

Minoan painting, LP.

minogame, IDC/①; S-4928/*66*①.

minor art, NYTBA/*189*①.

minor arts, DATT.

minor border, S-4948/*69*①.

Minos, DSSA.

Minotaur, DSSA.

Minton, ACD; C-1006/*106*; C-1582/ *26*; C-2910/*132*; C-5189/*4*; CEA/ *163*①; DADA; IDPF/*8*①; LAR82/*109*①, *157*①; LAR83/ *138*①; NYTBA/*179*①; S-4992/ *4*①.

Minton, Herbert, CEA/*204*①; EA/ ①.

Minton, Thomas, CEA/*203*①; EA.

Minton and Co, Stoke-on-Trent, JIWA/*343*①.

Minton Majolica, S-4843/*316*①.

Minton ring handle, CEA/*203*①.

Mintons, C-1006/*22*; S-4461/*2.*

Minuet, the, IDC.

minute hand, C-2368/*42*; CEA/*250, 251*①; EA.

minutely checked ground, C-2704/*76.*

minutely crazed, C-5127/*76.*

minute repeater, C-0270/*119*; EA; S-291/*104*①.

minute repeating, K-710/*118.*

minute repeating chronograph, S-291/ *104*①.

minute repeating watch, C-5117/ *412*①, *424*①; S-4802/*15.*

minute rim frit, C-5127/*257*①.

Miotti family, EA/*Miotti Glasshouse.*

Miotti Glasshouse, EA.

miquelet-lock, C-2503/*149*①; S-4972/ *162*①.

Miquelet lock, ACD; S-4972/*263.*

miquelet-lock fowling-piece, C-2569/ *56A.*

Miquelet lock rifle, S-4972/*159*①.

mirab, C-5156/*477*①; S-288/*12*①; S-2882/*210*①, *214*①.

Miracle clay, DATT.

Miranda, C-2204/*66.*

Mir carpet, EA.

mir-i-boteh, OC/*52.*

Mir Iskusstva, DATT.

Mir iskusstva (World of Art) movement, RGS/*36.*

Miro, Joan, S-286/*324*①.

mirror, ACD; C-0279/*454*①; C-5116/*90*; C-5146/*161*①; CEA/ *276*①, *305*①, *610*①; DADA; DSSA; S-3311/*185*①; S-4972/*427*; SDF/①.

mirror-backed paste, RTA/*123*①.

mirror-black, EA.

mirror black, C-5127/*128*; DADA.

mirror-black glaze, IDC/①.

mirror black vase, S-3312/*1373*①.

mirror border, C-0279/*354.*

mirror clock, EA.

mirror cresting, S-4461/*544.*

mirror door, C-0982/*13.*

mirrored, C-2421/*30*①; C-5239/*97, 288*①.

mirrored border, S-4414/*423.*

mirrored box, C-5156/*415.*

mirrored door, C-5116/*131*①.

mirrored frieze, S-4414/*480.*

mirrored plateau, S-4461/*509.*

mirrored well, C-0249/*456*①.

mirror-figured, C-2364/*63*①.

mirror image, C-2458/*131*; JIWA/ *284.*

mirror image, in, C-2513/*391*①.

mirror knob, DADA.

mirror painting, C-5116/*117*; C-5156/*281*①; C-5170/*159*①; EG/*215*①.

mirror-panelled back, C-2403/*145*.

mirror-panelled door, C-2403/*65*.

mirror picture, C-2320/*2*①; C-2388/*1*; C-5116/*117*.

mirror plate, C-0249/*329*; C-5114/*299*①.

mirror-plateau, C-2398/*47*; C-2510/*42*.

mirror plateau, C-0254/*13*; C-5153/*47*①.

mirror-shaped, C-2493/*45*①.

mirror spandrels, C-2320/*62*.

mirror stand, C-5127/*443*①.

mirror veneer, C-2364/*77*①.

mirrow-shaped, IDC.

Mir Serabend, OC/*56*①.

Mir Serabend carpet, OC/*45*①.

Mir Serabend Kelei carpet, S-4796/*156*.

Mir Serebend rug, DADA.

Mir style, OC/*57*.

Mirzapur, OC/*305*.

Mirzapur rug, DADA.

misericord, DADA/①; SDF/①.

miséricorde, DADA.

misfired, C-5127/*33*.

mishen, RGS/*83, 85*.

mishima, C-5127/*16*; DATT; IDC; CEA/*129*①; DADA.

mishima style, C-5127/*388*.

mishima taste, C-5236/*1572*.

mishima technique, S-3312/*1322*①.

Mishin-Malayir, OC/*259*①.

Mishkin rug, S-4461/*796*.

misrepresented article, CHGH/*31*.

missal box, LAR82/*64*①.

miss america, OPGAC/*195*.

Miss Duncan, C-0405/*212*.

missile club, LAR82/*83*①.

Mission, C-5239/*241*.

mission chair, DADA.

mission furniture, DADA/*Supplement*; SDF.

mission oak, C-5191/*286*.

Mission style, C-0225/*338*.

Misti (Ferdinand Mifliz), S-286/*433M*.

mistletoe, DSSA.

Mitchell, John, EA.

Mitchell, Mary, LAR82/*120*①.

Mitchell and Mott, CEA/*243*①.

Mitchellsone, James, C-5117/*260*.

miter, DADA.

miter-shaped, IDPF/*22*.

Mitin, Alexander (assaymaster), C-5174/*219*①.

mitokoromono, DADA.

mitre, CEA/*406*; DSSA; SDF/①.

mitre corner, EG/*291*①.

mitre cut, CEA/*503*; EG/*291*①.

mitred top, C-5116/*10*.

mitre shape, LAR83/*480*①.

Mitridato, C-2427/*248*.

Mitsuhiro, CEA/*568*①.

mitsusashi, IDC.

mittel, IDC.

mitten, RTA/*20*①.

mitten gauntlet, C-2503/*50*.

mittens, C-1506/*85*.

Mittis green, DATT.

Mittler's green, DATT.

Mittnacht, Hieronymus, C-5174/*172*①.

MIW, EA/*Flörsheim*.

mixed air, EG/*141*①.

mixed and colour twist stem, CEA/*423*①.

mixed media, S-286/*257*.

mixed technique, DATT; JIWA/*120*①; LP.

mixed twist, LAR83/450①.

Mixed white, DATT.

mixing-bowl, C-2403/11.

mixing bowl, DATT; IDPF/14, 161.

mixing machine, MP/191.

mixing table, C-5170/125①; SDF.

mixing varnish, DATT.

Mixtec, S-4807/223.

mixture, EA/batch.

mizpah brooch, C-1502/93.

mizuire, S-4928/166.

mizusashi, C-5236/835①, 859①, 855①.

M. Mason, EA/Mason, Miles.

MM in rectangle, EA/① Myers, Myer.

mobile, DATT/①; S-4881/197①.

mobility, DATT; JIWA/10.

mocha, S-4847/53①; CEA/164①.

mocha creamware, DADA/ Supplement.

mocha stone, CEA/70.

mocha ware, EA/①; IDC/①; C-5114/159.

Mocha-ware mug, C-2204/43.

Mochica, S-4807/8①.

Mochica pottery, IDC.

Mô: Christophe, Jean (Jean-Baptiste), EA.

mock Arabic, IDC.

mock bamboo, CEA/351①.

mock Chinese numeral, EA/Caughley.

mock Chinese seal, C-2502/16.

mock Chinese seal mark, C-1006/ 208.

mock drawers, S-4461/610.

Mockery of Age, the, IDC/①.

mock gold, DATT.

mock handle, FFDAB/104.

mock lion handle, C-0225/289.

mock mark, C-2493/228.

mock Meissen mark, C-1006/73.

mock presentation piece, NYTBA/ 172.

mode à l'antique, RGS/80.

model, C-1082/130; C-5117/177①; C-5157/3; C-5239/50; IDC; LP; S-4965/186①; S-4972/259①; S-4992/13①.

model boat, C-0279/39①; C-1082/21.

modeled, S-4992/4①.

Model Engineering Co. Ltd., C-2904/ 13.

model furniture, IDPF/108①.

modeling, DATT; LP/①.

modeling board, DATT.

modeling clay, DATT.

modeling paste, DATT.

modeling stand, DATT/①.

modeling tool, DATT/①.

modeling wax, DATT.

modelled, C-0782/14; C-1006/34; C-5117/293①; C-5127/3①; S-4972/386①.

modelled affronté, S-4905/85①.

modeller's mark, IDC.

modelling, IDC; JIWA/10.

modello, DATT.

model number, S-4992/7①.

model stand, DATT.

model town, IDPF/236.

moderator lamp, SDF.

modern, C-0406/6; LP.

Modern Arms Co., C-2476/95.

modern art, JIWA/7.

modern coil lug handle, IDPF/155①.

modernism, JIWA/10, 10.

Modernist, C-2409/277; LAR83/ 486①.

modernistic, DADA/Supplement; LP.

Modernist period, C-GUST/131①.

modern Meissen, MP/202.

modern movement, SDF.

modern period, CEA/252①.

modern-style, CEA/663①.

molded edge, S-3311/*269*.
molded-edge skirt, C-5114/*320*①, *378*①.
molded foot, C-5114/*91*①; C-5117/ *267*①; S-4922/*16*①, *9A*①.
molded footrim, C-5114/*159*.
molded footring, C-5114/*208*①.
molded form, IDPF/*162*①.
molded frame, C-5114/*357*.
molded girdle, C-0254/*144*①; S-2882/*1050, 1133*①; S-4414/*275, 345*; S-4802/*455*; S-4922/*15*①.
molded handle join, C-5114/*106*.
molded lead figure, S-4965/*146*①.
molded leg, S-4436/*9*.
molded lip, C-0225/*100*; C-5114/*8*; S-4461/*522*.
molded outset leg, S-2882/*266*.
molded pad feet, S-4414/*478*①.
molded paper, S-286/*203A*.
molded pattern, S-4461/*18*.
molded pediment, LAR83/*248*①.
molded reeded border, C-5117/*48*.
molded rib, C-0254/*143*①; C-5117/ *74, 139*①, *199B*①.
molded rim, C-5114/*41*; S-2882/ *1150*①; S-4414/*328*①; S-4922/*9*①.
molded rim and girdle, S-2882/ *1101*①.
molded rim foot, S-4804/*32*①.
molded Rococo base, S-3311/*381*①.
molded seat, C-5114/*380*①.
molded shield, S-4922/*15*①.
molded signature, C-5146/*92B*①.
molded skirt, C-5114/*394*①.
molded stretcher, S-2882/*313*.
molded swirl, S-4461/*398*.
molded top, C-5114/*262*①.
molded vase and cover, C-5156/ *816*①.
molded voluted frame, S-4414/*490*①.
molded waist, S-4414/*275*; S-4922/ *19*①.

molded ware, DADA/*Supplement*.
molded woven body, LAR83/*176*①.
Moldenhauer, Kirschner, C-5191/*118*.
molder, MP/*20*.
molding, C-5114/*296*①; C-5153/ *22*①; DADA; DATT; MP/*77*; NYTBA/*293*.
mold maker, MP/*53*.
mold mark, CHGH/*54*①.
mold number, MP/*468*.
mold seam, CHGH/*61*.
mole, C-2203/*54*; CEA/*27*.
mole-grey, C-2403/*213*.
molina rosa marble, DADA.
moline, C-5117/*199*①.
molinet, C-2382/*37*; CEA/*645*①; EA/*stirring rod, stirring rod*.
Molitor, Bernard, EA.
Möllendorf service, IDC.
Möller, Andreas, EA.
mollusk shell, S-4881/*195*①.
molten glass, CEA/*414*; EG/*287*.
Momma, Jacob, EA.
Momoyama, DADA.
Momoyama period, EA; IDC; JIWA/ *205*; C-5156/*756*①; C-5236/*811*①, *847*.
Momoyama taste, C-5127/*385*.
mon, C-1082/*182*; C-5127/*360*①; C-5156/*759*①; CEA/*575*; IDC; JIWA/*6*; S-3312/*1061*①; S-4461/ *467*.
monart glass, DADA/*Supplement*.
monastic chair, EA; SDF/①.
monastral blue, LP; DATT.
Monastral green, DATT.
monatsbecher, DADA.
Moncrieff, John, DADA/*Supplement*.
Moncrieff's Glass Works, EA.
Mon Dvaravati Period, C-5156/ *206*①.
money blade, S-4807/*86*.
money-box, IDC/①.

money box, CEA/535①; IDPF/ 162①.

money box mount, C-0406/87.

money dish, EA.

money-pattern, C-5224/31.

money pattern, SDF.

money well, S-4972/562①; S-4988/ 446①.

mon genre, JIWA/227.

Mongolia, CEA/561.

Mongolian, C-2458/351.

Mongol or Yüan Dynasty, ACD.

Monington & Weston, London, C-0982/113; C-5167/210.

monkey band, DADA; IDC; CEA/ 176①.

monkey band figure, C-1006/66.

Monkey Salt, EA.

monkey teapot, IDC.

monkey vase, S-3312/1135①.

Monkhouse, Jon., London, C-2489/ 90.

Monkhouse, Thomas, London, C-2489/87①.

monk's bench, C-2402/16; EA/ chair-table.

monk's bench (chair), EA.

monks' bench, ACD.

monk's cap ewer, EA; S-4965/252①.

monk's-cap jug, IDC/①.

monk's chair, DADA.

monk's head, CEA/594.

monk's seat, SDF.

monk's table, DADA.

monnaie du pape, C-5191/208.

Monnier, Henry, S-286/433N.

Monnier, Nicolet, CEA/258①.

monochord, C-5255/32; LAR83/ 510①.

monochromatic, EC2/20①.

monochrome, C-2458/165①; DATT; IDC; LP; S-4905/79①.

monochrome background, JIWA/23.

monochrome painting, EA.

monochrome print, JIWA/56.

monochrome prints, JIWA/6.

monochromes, C-5127.

monocular, C-2904/167.

monocular body, C-MARS/197.

monocular microscope, C-0403/155.

monogram, C-0249/477; C-0706/5; C-2398/10; C-5005/219①; C-5153/23①; C-5173/52①; CHGH/59; IDC; JIWA/87; S-4461/56; S-4853/240①; S-4905/ 161; S-4922/10①; S-4972/325①.

monogram mark, C-2486/166①.

monogrammed, C-5239/104.

Monolite yellow, DATT.

monolith, DATT.

monopodia, C-0249/433; C-5116/ 43①, 156①; C-5157/18; C-5259/ 550; S-3311/228①, 412①.

monopodia support, C-2364/62①; C-5189/339①.

monopodium, ACD.

monopodium (in furniture), EA.

monopodium, SDF/①.

monopteros pattern, IDC/①.

monotone, LP.

monotone enamel coating, RGS/51.

monotype, DATT.

monoxylon, SDF.

Monro, Death of, IDC/①.

Monroe, C. F. Co., LAR82/457①.

mons, S-4461/508; S-4905/5.

Mons. Martin as Sadhusan, C-0405/ 190.

Monson, C.J., S-4905/178.

monster, DSSA.

monster mask, S-4965/73①.

monstrance, ACD; DADA; DSSA/ ①; EA/Bogaert, Johannes, ①; LAR83/227①.

monstrance clock, EA.

montage, C-1603/*34*; DATT; JIWA/ *357*; LP.

Montagu, Lady Mary Wortley, service, IDC/①.

montant, SDF.

montan wax, DATT.

Montauban, EA.

montée à cage, RGS/*152*.

monteith, ACD; C-5117/*21*; C-5173/ *49*①; CEA/*151*①, *642*①; EA/①; IDC/①; IDPF/*163*; C-2202/*246*; CEA/*199*①; DADA/①.

Monteith bowl, LAR82/*141*①; LAR83/*416*①; S-2882/*926*①; S-3311/*795*①; S-4944/*242*①.

Montelupo, C-2427/*248*; C-2486/ *208*①, *229*①; EA/*alla porcellana*, ①.

Montereau, DADA.

Montgolfier back, EA.

Montgolfier paper, S-286/*478*.

Montgomery touch, C-5114/*111*.

month-going clock, C-2489/*124*①.

month going clock, LAR83/*199*①.

Monthier blue, DATT.

month mark, EA.

month plate, IDC.

month ring, C-2368/*79*①.

Months, the, IDC.

montieth, C-2398/*20*.

Montigny, Philippe-Claude, DADA; S-4955/*162A*①.

Montpellier, CEA/*145*①, *145*①.

Montpellier faience, EA.

Montpellier green, DATT.

Montpellier yellow, DATT.

montre à souscription, EA/ *subscription*.

montre à tact, EA.

monture à cage, RGS/*185*.

monumental, DATT; LP; S-4992/*4*①.

monumental animal mask, MP/*202*.

monumental art, MP/*139*.

monumental clock, EA/*169*①.

monumental sculpture, MP/*90*.

monument candlestick, CEA/*643*①.

Monzani and Co., C-0906/*379*.

Mooar, John, C-5153/*9*.

mood, LP.

Moody Salt, EA.

Mooleyser, Willem, EA.

moon, DSSA; IDC; SDF.

Moon (in porcelain), EA.

moon and star, OPGAC/*229*.

moon dial, S-3311/*109*.

moon flask, C-2458/*117*①; C-5127/ *404*①.

moonflask, LAR82/*107*①; S-4965/ *294*①.

moonlight lustre, C-2493/*137*; EA; IDC/①.

Moonlit Hazledene pattern, C-5191/ *86*.

moon phase, C-5117/*426*①; K-710/ *118*; S-4927/*29*.

moonphase, CEA/*220*①.

'moon shawl' design, LAR83/*232*①.

moonstone, C-2332/*148*; C-2458/*351*; C-2910/*228*; C-5005/*213*①; C-5117/*391*①; IDC; JIWA/*310*; LAR82/*497*①; RTA/*162*①.

moonstone demantoid, S-291/*124*①.

'moonstone' glaze, C-2910/*168*.

moon-style hand, S-4927/*10*①.

moon style hand, S-4802/*17*.

moorcroft, C-2324/*14*①; C-2910/*74*; C-5239/*39*; LAR82/*158*①; LAR83/*139*①.

Moorcroft, William, C-5191/*70*.

Moorcroft Macintyre Florian Ware, C-2910/*114*.

Moorcroft pottery, C-5191; C-2409/ *65*.

Moore, Bernard, C-2409/*139*; C-2910/*163*; DADA/*Supplement*.

Moore, Edward C., C-5203/*262*①.

Moore, Fred, LAR82/*119*①.

Moore, Henry, DADA/*Supplement*; S-286/*359A*①.

Moore, James, ACD; CEA/*334*①; DADA; SDF/*759*.

Moore, James the Elder, EA.

Moore, J. C., NYTBA/*230*①.

Moore, John Chandler, C-5153/*18*①.

Moore, Thomas II, C-5174/*560*.

Moore, William, CEA/*400*①.

Moorfields, CEA/*96*.

Moorfields carpet, ACD; EA.

Moorish, S-4461/*77*①.

'Moorish', LAR83/*335*①.

Moorish arch, C-GUST/*136*①.

Moorish corner, SDF.

Moorish crackle glass, C-5191/*403*.

Moorish form, C-5146/*107B*①.

Moorish influence, C-5239/*104*.

Moorish style, SDF.

moorish taste, S-4804/*244*.

m.o.p., OPGAC/*175*.

mop, DATT.

moquette, C-2403/*35*; SDF.

moquette carpet, EA.

moquette-upholstered, C-2402/*128*.

Moran & Hastings Manufacturing Co, K-711/*129*.

Morani, S., OPGAC/*14*.

Moravia, CEA/*451*.

Moravian, CEA/*166*①.

morbidezza, DATT.

Morbier, S-3311/*460*①.

Morbier clock, EA/*Comtoise clock*; LAR83/*209*①.

Mordan, Sampson, LAR82/*598*①.

mordant, DATT; LP.

mordant gilding, DATT.

Moreau, L., S-4992/*17*①.

Moreau, Louis, C-2364/*60*①; S-4955/*131*①, *185*①.

Moreau, Mathurin, C-5189/*161*①; C-5191/*156*.

Moreau-Gobard, C-2458/*295*.

moreen, FFDAB/*31*; SDF.

Morel-Ladeuil, Léonard, EA.

morelle salt, DATT.

Mores, Jacob, CEA/*626*①.

More Simple Embroidery, C-0405/*169*.

moresque, SDF; DADA.

moresque ornament, EA.

moresques, IDC.

Moresque style, RTA/*98*①.

Morey and Ober, S-4905/*316*.

Morgan, de, ware, IDC.

Morgan, William de, DADA/*Supplement*.

Morgan and Sanders, SDF/*759*.

Morin, L., S-4947/*14*①.

Morin, Marseilles, C-2489/*163*.

morinda, DATT.

morion, C-MARS/*96*; DADA; S-4972/*245A*①.

Morison, George, LAR82/*200*①.

Morison, James, C-2487/*157*.

Morisot, Berthe, S-286/*64*.

Morisset, James, London, C-2503/*30*①.

Moriyama, C-5239/*20*.

Morney, George and William, OPGAC/*357*.

morning dress, C-1506/*1*.

Morning Glory pattern, CEA/*471*①.

morning-star, DADA.

morning star, C-2398/*91*①.

moroccan, C-0279/*442*①.

morocco, C-5156/*441*.

morocco-bound, C-2458/*265*.

morocco leather, C-5116/*158*①; SDF.

Morpheus, DSSA.

Morrill, Benjamin, EA.

Morris, George Anthony, CEA/
206①.

Morris, Henry, C-2493/8①; EA.

Morris, Joshua, C-2522/3①.

Morris, Marshall, Faulkner and Co.,
DADA/Supplement.

Morris, Marshall, Faulkner & Co,
EA/Morris, William.

Morris, May, DADA/Supplement.

Morris, Talwin, DADA/Supplement.

Morris, William, CEA/100①, 334①;
DADA/Supplement; EA; NYTBA/
4; SDF/759.

morris chair, EA; DADA/
Supplement; LAR83/280①;
NYTBA/77; SDF.

Morris & Co., EA/Morris, William.

Morris design, NYTBA/77.

Morris firm furniture, DADA/
Supplement.

Morris firm tapestries, DADA/
Supplement.

Morrison, John, S-4922/60①.

Morris's Patent, C-5174/430.

morse, DADA; S-4972/162①.

morse ivory, S-4972/255①.

Morson, Richard, C-0706/17.

mortar, ACD; C-0279/93; C-2482/
117; C-2904/297; DATT; EA;
IDC; IDPF/163①; LAR82/50①;
LP; NYTBA/211; S-3311/303①;
S-4436/36; S-4972/325①.

mortar and pestle, C-0279/99; DATT.

mortarboard, DATT.

mortarium, IDC; IDPF/163①.

mortice, CEA/406; SDF/①.

mortice and tenon, CEA/300.

Mortimer, CEA/27.

Mortimer, John, EA/Baily, Edward
Hodges.

Mortimer & Hunt, EA.

mortise, NYTBA/19①; SDF/①
mortice.

mortise-and-tenon, SDF/①.

mortise and tenon, ACD; C-5156/
493; DADA.

mortised, FFDAB/75.

mortise lock, ACD; SDF.

Mortlake, DADA; LAR82/159①.

Mortlake tapestry, LAR82/646①;
SDF.

Mortlake tapestry works, DADA;
EA/Acts of the Apostles tapestry,
①.

Morton, Richard & Co., LAR82/
577①.

mortuary chair, SDF.

mortuary sword, CEA/28①.

mortuary type hilt, C-2569/11.

mortuary wares, EA/ming-ch'i.

Moryn, Pieter en Jan, Amsterdam,
C-MARS/246.

mosaic, C-2332/48; C-2704/49A;
C-5005/390①; C-5117/367①;
CEA/415, 515①; DADA/①;
DATT/①; EG/26①; LP; S-2882/
667; CEA/292①.

mosaic bead, EA/beads and marbles.

mosaic book cover, C-0282/158.

mosaic bowl, CEA/416①.

mosaic glass, ACD.

mosaic gold, DATT.

mosaic ground, C-5005/399①.

mosaic painting, CEA/71.

mosaic-style, JIWA/205.

mosaic-work, SDF.

mosaic work, RTA/127①.

Mosaik, CEA/177①.

Mosaik pattern, IDC.

Mosaik, EA.

Mosan brass, EA/Dinanderie.

Mosbach, DADA; EA.

Moscha ware, CEA/164①.

Moscow cloisonné enamel, RGS/62.

Moscow style, RGS/85.

Moser, C-2910/19; C-5005/239;
C-5239/137; CEA/451.

Moser (Glass), OPGAC/*353.*

Moser, George Michael, EA.

Moser, Kolo, JIWA/*378.*

Moser, Koloman, C-2910/*33*;
DADA/*Supplement*; K-711/*121.*

Moses, C-0405/*164*; DSSA.

mosiac tesserae, C-5005/*402*①.

mosque, S-4847/*14.*

mosque lamp, DADA; JIWA/*302*;
NYTBA/*129*①.

mosque lantern, S-288/*32*①.

moss agata, EC1/*56.*

moss-agate, CEA/*53*①; RTA/*123*①.

moss agate, LAR83/*447*①.

moss-green, C-5146/*90A*①.

moss green, DATT.

moss pottery, IDC.

mossul, OC/*30.*

mosul, CEA/*101*; DADA.

Mosul Kurd, DADA.

Mosul rug, C-0906/*19*; C-1702/*4.*

Mosul runner, C-2482/*44.*

Mote Skimmer, S-4922/*58A*①.

mote-skimmer, EA/① *strainer-spoon.*

mote-skimmer or spoon, EA/*strainer
spoon.*

mote spoon, C-2202/*220*; DADA;
EA/① *strainer-spoon.*

mote-spoon, C-0706/*8.*

mother and child pattern, IDC/①.

mother and daughter boteh motif,
S-4948/*43.*

mother mold, DATT.

mother-of-pearl, ACD; C-0706/*64*;
C-1502/*40*; C-2402/*15*; C-5005/
*338*①; C-5117/*81*; C-5157/*116*①;
CEA/*204*①, *473*①, *521*①; DADA;
EA; EC1/*56*; S-4461/*174*; S-4804/
52; S-4922/*58A*①; S-4972/*155*①;
SDF.

mother of pearl, C-2458/*283*;
C-5236/*731.*

mother-of-pearl glass, DADA.

mother-of-pearl glaze, IDC.

mother-of-pearl inlay, C-1082/*134*;
CEA/*552*①.

Mother of Pearl pattern, NYTBA/
*300*①.

moth painter, EA.

motif, C-1082/*5*; C-1603/*109*;
C-5005/*359*①; C-5114/*216*①,
*318A*①; C-5153/*78*①; C-5156/
*46*①; DATT; LP; S-4461/*28, 34,
66*; SDF.

motion, LP.

motion work, CEA/*267*; EA.

motivation, LP.

motive, SDF/*motif.*

motivic composition, JIWA/*53.*

Motley, Richard, S-3311/*107*①.

moton, DADA.

motor, C-2476/*77.*

motoring suit, C-3011/*77.*

mottahedeh, C-5259/*109.*

motted marble, C-5181/*164.*

mottle, C-2458/*18.*

mottled, C-0403/*28*; C-1082/*154*;
C-2414/*43*①; C-5005/*267, 398*①;
C-5127/*19*; C-5156/*43*; FFDAB/
*71*①; S-4461/*57, 100*; SDF.

mottled flambé glaze, S-4461/*439.*

mottled glass, S-4461/*44.*

mottled jade, C-5236/*328.*

mottled rectangular base, S-4853/
*73*①.

mottled russet glaze, LAR83/*129*①.

motto, C-0782/*61*; C-5117/*49*;
S-4905/*73*; S-4922/*26*①.

motto and crest, C-5117/*28*①.

mottoe, C-5117/*213*①.

Moud, OC/*292*①.

moulage, DATT.

mould, CEA/*580*; EG/*23*①; IDC.

mould blowing, EG/*36.*

mould-blown, C-5005/*280*①; CEA/
50.

mould-blown glass, EA.

mould-blown shape, CEA/418①.

mould-cast glass, EA.

moulded, C-0103/36; C-1006/113; C-2398/10; C-2402/5; C-5005/209; C-5116/21①; C-5157/106①; CEA/415, 629①; SDF/①.

moulded baluster, CEA/533①.

moulded bands, C-0782/23.

moulded base, C-0249/312; C-2388/134; C-5116/120.

moulded block feet, C-5116/158①.

moulded body band, C-1502/15.

moulded body bands, C-1502/30.

moulded border, C-1006/23; C-2388/51; C-2398/72; C-2437/48①; C-5116/90.

moulded bracket foot, C-5116/114.

moulded cavetto cornice, C-2421/142①.

moulded chamfer, SDF.

moulded circular top, C-0982/8.

moulded edge, C-2388/86.

moulded frame, C-0249/419; C-0279/404①; C-1407/5; C-2364/33.

moulded glass, CEA/503.

moulded inverted rim, C-5117/297①.

moulded leaf border, C-2204/82.

moulded pedestal, EA.

moulded pedestal stem, ACD; CEA/423①.

moulded plinth, C-5157/127.

moulded rectangular top, C-5157/104.

moulded rib, CEA/644①.

moulded square base, CEA/447①.

moulded stoneware, CEA/165.

moulded top, C-2421/76①.

moulder, CEA/541.

moulding, ACD; C-2402/46; CEA/210; DATT; IDC; SDF/①.

moulding table, SDF.

mould mark, EA.

mould-pressed, CEA/416①.

moulin, DADA.

moulinet, C-MARS/110.

Moulinié Freres & Co., S-4927/136.

Moulton, Edward S., C-5153/35.

Moulton, Joseph M, EA/53.

Moulton, Joseph M., CEA/670①.

mound, CEA/587①.

mound base, C-2427/1①; C-2486/2.

Mounier, Peter, S-4927/207①.

mount, ACD; C-0225/31; C-0279/100, 428; C-0706/5; C-0982/63; C-2203/40; C-2402/4, 34; C-5153/168①; CEA/406; DADA/①; EA.

mount (in fan), EA/leaf (in fan.

mount, IDC; S-4461/16, 105; S-4804/79; S-4972/51; S-4992/23①; SDF.

mountain blue, DATT.

mountain green, DATT.

mountainous landscape, C-1506/134; C-2414/104①; C-2421/112①; C-2704/183; C-5224/119①.

mountain soap, DATT.

mounted, C-2409/147; C-2421/3①; C-2486/156; C-5116/27, 38; C-5156/278; C-5236/580①; S-4881/50①; S-4922/11①; S-4972/249; S-4992/8①.

mounted box, C-5117/363①.

mounted glass, EG/291①.

mounted lipstick, C-0706/4.

mounted on black glass, C-2704/34.

mounted on card, JIWA/22①.

Mount Vernon Glass Works, CEA/463①; EA.

Mount Washington Glass Company, Massachusetts, NYTBA/294①.

Mount Washington Glass Company, New Bedford, Massachusetts, NYTBA/300①.

Mount Washington Glass Works, EA.

mourning fan, EA.

mourning jewellery, EA/①.

mourning jug, DADA; IDC.

mourning-ring, RTA/*82*①, *97*.

moustache cup, IDC/①.

Moustiers, ACD; DADA; EA/①.

Moustiers plate, S-4823/*74*.

Moustiers style, C-2427/*177*.

Moustiers-type, S-4823/*77*.

moutardier, IDC.

mouth, IDC.

mouth blower, DATT.

mouth-blown, CEA/*50*.

mouthpiece, CEA/*556*.

mouth wire, EA.

mouvementé mount, C-2555/*58*①.

mouvementés, JIWA/*36*.

movable pointer, CEA/*263*①.

Movado, S-4927/*118*.

movement, ACD; CEA/*254*①; EC2/
89; JIWA/*6*; LP/①.

movement striking on a gong,
C-0906/*141*.

moving bookstand, SDF.

moving library, SDF.

moving sideboard, SDF.

moving slide, CEA/*609*①.

moyen-âge, DATT.

Moyen Age, LP.

Moynat, Jean, CEA/*53*①.

Mozambique ebony, DATT.

Mozart vase, MP/*199*.

M.P.F., MP/*499*① *Meissner
Porzellan Fabrique*.

MPM (Meissner Porzellan
Manufaktur), EA/*Meissen porcelain
factory*.

Mr. Abbott as Romeo, C-0405/*199*.

MRDA, CEA/*99*①; EA/*Aubusson
tapestry*.

Mr. Keen as Richard II, C-0405/*190*.

MS, CEA/*138*①.

M.S.E., C-2904/*289*.

MT, EA/*Mosbach*.

Mt. Washington, CEA/*489*.

Mt. Washington Glass Company,
DADA/*Supplement*.

Mt. Washington Glass Works, CEA/
489; EC1/*68*.

Mt. Washington Glass Works, New
Bedford, Massachusetts, OPGAC/
161.

Mucha, Alphonse, S-286/*362*①.

mucilage, DATT.

Muçur carpet, EA/*Mudjur carpets*.

mudéjar, DADA/①.

mudéjar style, EA.

Mudge, Thomas, CEA/*233*①; EA;
S-4927/*207*①.

Mudge & Dutton, CEA/*254*①.

mudhead, S-4807/*258*.

Mudjar prayer rug, S-4796/*35*.

Mudjar rugs, ACD.

Mudjur carpet, EA.

Mudjur rug, CEA/*79*①.

mudra Buddhistic position, C-2458/
*53*①.

Mueck-Cary Co., C-0270/*220*.

Mueller Freres, OPGAC/*156*.

Mueller Fres., S-4461/*115*.

Muers, Aert van, CEA/*629*①.

muff bag, C-1304/*7*.

muff-chain, C-2332/*139*.

muffin, IDC.

'muffin' cover, LAR83/*516*①.

muffin cover, EA.

muffin-dish, C-2493/*69*; IDC.

muffin dish, C-5203/*11*.

muffineer, DADA; EA; LAR83/
*555*①; SDF.

muffin lidded flagon, CEA/*584*①.

muffle, DATT; IDC.

muffle color, DADA.

muffle colour, EA.

muffle furnace, DATT.

muffle-kiln, CEA/*142*①, *210*.

muffle kiln, DATT; EA; EG/*269*,
291; MP/*40*.

mufflekiln, MP/*502*.

mug, C-0254/*24*; C-2458/*152*;
C-5114/*115*; CEA/*164*①; DADA;
IDC; IDPF/*164*①; LAR83/*594*①;
S-4804/*422*①.

Mughal, C-5236/*339*.

Mughal carpet, EA/*Mogul carpets*.

Mughal taste, C-5156/*412*①.

mugs, C-5117/*93*; S-4922/*59*①.

Muhammed b. as-Saffar, CEA/*604*①.

Mühlenbecher, DADA.

Mujur carpet, EA/*Mudjur carpets*.

mukade, DADA; EA/*Japanese
sword-guards*.

Mukhin, Alex, C-5174/*278*.

mukozuki, IDPF/*165*.

mulberry, LAR82/*289*①; SDF.

mulberry or olive spoon, EA/*strainer
spoon*.

mulberry paper, C-5156/*282*①;
C-5181/*42*.

mulberry spoon, EA/①
strainer-spoon.

mulberry wood, DADA.

mule chest, C-2402/*166*; DADA/①;
EA; LAR82/*423*①; LAR83/
*403*①; SDF.

mull, C-5117/*1*; CEA/*71*; DADA;
EA/*Scottish snuff mull*; FFDAB/
*79*①.

mullahs, OC/*126*.

muller, DATT/①; LP; C-5167/*125*;
C-5239/*149*①.

Müller, Friedrich, CEA/*684*.

Müller, Gottfried, EA.

Müller, H., C-5189/*173*①.

Muller, J. G., CEA/*177*①.

Müller, John, CEA/*601*.

Müller, Karl, DADA/*Supplement*.

Müller, N., C-5191/*162*.

Muller, Richard, S-286/*368*.

Muller frères, C-5005/*255*①;
C-2409/*16*; C-5191/*238*.

Muller Fréres, C-5239/*154*.

Muller Freres, C-GUST/*19*.

Muller Frères, OPGAC/*15*.

Muller Freres, S-3311/*908*①.

Müller service, IDC.

mullet, C-5173/*49*①; S-4922/*20*①.

Mullin, C-2904/*78*.

mullion, C-0249/*458*①; C-0279/*306*;
C-5116/*89*; C-5170/*117*.

mullioned, S-4461/*583*; S-4905/*375*.

multi-baulster, C-2421/*7*①.

multi-coloured, C-2421/*12*①.

multi-hoop ring (memorias), RTA/
*108*①.

multiliner tool, DATT/①.

multi-piece carriage clock, C-2489/*52*.

multiple baluster stem, C-5116/*146*①.

multiple band, RTA/*107*①.

multiple border, C-2403/*179*.

multiple braid, RTA/*42*①.

multiple faceting, RTA/*90*.

multiple graver, DATT.

multiple key-pattern, C-2388/*192*.

multiple pot, IDPF/*165*①.

multiple-reeded edge, CEA/*584*①.

multiple ring, RTA/*38*①.

multiple scroll handle, S-4414/*302*①,
338.

multiple spout, IDPF/*214*①.

multiple stroke, JIWA/*383*①.

multiple-tint tool, DATT.

multipurpose ground, DATT.

multi-stand, JIWA/*323*.

multi-stand cupboard, JIWA/*321*.

mummmy cone, IDC.

mummy, DATT; LP.

mummy-bead, C-2482/*91*.

mummy bead, C-2482/*79*.

mummy mask, S-4807/*470*①.

Munakata, Shiko, S-286/*368A*①.

Munch, Edvard, S-286/*370*①.

Münchener Vereinigte Werkstätten für Kunst in Handwerk, DADA/*Supplement*.

Münch-Khe, Willy, MP/*203*.

Münden, DADA.

Munden, EA.

Munich lake, DATT.

Munich School, DADA/*Supplement*; JIWA/*162*.

Munich tapestries, DADA.

Munich tapestry, EA.

munjeet, DATT.

Munn & Cobb, CEA/*696*①.

Muns, John, C-5117/*66*; C-5174/*551*.

Munsell Color System, LP.

Munsell system, DATT.

Munster Iron Works, CEA/*586*①.

munt, C-5181/*114*.

muntin, ACD; DADA.

muntin(g), EA.

muntin, SDF.

munting, SDF/*muntin*.

Muntz's metal, EA/*patent metal, patent metal*.

mural, CEA/*233*①; DATT.

mural clock, CEA/*234*①; SDF.

mural design, MP/*213*.

mural painting, LP.

mura-nashiji, S-3312/*1050*①; S-4928/*151*①.

mura nashiji, CEA/*573*①, *575*; S-4829/*31*①.

mura-nashiji ground, S-3312/*1043*①.

murano, DADA; ACD.

Murano glass, EA/*Venetian glass*; EG/*80*; DADA/*Supplement*.

murderer's house, IDPF/*37, 165*.

Murdock & Cassel, CEA/*463*①.

murex purple, DATT.

murier wood, DADA.

muromachi, DADA.

Muromachi period, EA; IDC; JIWA/*128*.

Murray, James, S-4927/*89*.

Murray, James, London, C-2489/*127*.

Murray, Joyce, LAR82/*208*①.

Murray, Keith, C-2409/*67*; C-2910/*73, 153*.

Murray, William Staite, DADA/*Supplement*.

murrey, DATT.

murrhine, ACD; EG/*61*.

murrhine ware, IDC.

murrine, ACD/*murrhine*.

Murrle Bennett & Co, C-GUST/*127*.

Musashi, DADA.

muscadier wood, DADA.

Muscheln, IDC/①.

muse, C-2437/*63*①.

Muse as motif, C-2364/*21*①.

Musenbergen, MP/*116*.

Musenkinder, MP/*134*.

Muses, DSSA.

Muses Modeller, IDC/①.

museum marking system, CHGH/*38*.

Musgrave, James, S-4905/*214*①.

mushikui, IDC.

Mushkabad, OC/*267*①, *286*.

mushroom, CEA/*503*; OC/*278*; S-288/*14*①.

mushroom brim, C-5239/*296*.

mushroom knop, CEA/*429*①.

mushroom paperweight, LAR83/*437*①.

mushrooms and tree motif, C-5174/*228*①.

mushroom-shaped handle, LAR83/*241*①.

mushroom stopper, CEA/*447*①; LAR83/*421*①; S-4436/*63*①; EA/*stopper*.

mushroom stoppers, C-0706/*235*.

mushroom swelling, SDF.

mushroom-turned, SDF.

mushroom weight (tuft), EG/*291*.

Mushwami, OC/*139*.

Mushwami Beluch, OC/*140*①.

musical automata, CEA/*547*.

musical automaton, C-0279/*193*①.

musical box, C-1502/*180*; C-MARS/ *204*; EA.

musical bracket clock, LAR83/*184*①.

musical clock, EA.

musical glass, EA.

musical hanging clock, S-4955/*35*①.

musical imps, IDC/①.

musical instrument, IDPF/*165*; SDF.

musical reserve, C-5181/*97*.

musical stone, C-5156/*309*; S-4965/ *262*.

musical train, S-4802/*25*.

musical trophy, C-2364/*52*①; C-2437/*47*; C-2486/*63*; C-5117/ *372*①, *479*①; IDC.

musical trophy motif, C-2493/*226*.

musical ware, IDC.

musical watch, EA/①; S-4927/*41*①.

music bench, EA.

music-box, CEA/*68*①.

music box, C-0706/*139*; CEA/*549*.

music cabinet, C-0249/*312*; C-1407/ *186*; C-2402/*237*.

music canterbury, LAR83/*266*①.

music desk, SDF.

Music Lesson, the, IDC.

music plate, IDC.

music rack, SDF.

music scene, C-2486/*155*.

music stand, DADA; S-4461/*746*; SDF.

music stool, C-2403/*44*; EA; SDF/ ①.

musikoli figure, IDC.

muskabad, DADA.

musket, ACD; CEA/*28*①, *44*; DADA; S-4972/*267*.

musketoon, DADA.

Muskota, C-0225/*11*.

muslin, C-1506/*2*; C-1603/*90*; C-3011/*79*; SDF.

muslin swirl, EG/*246*①.

musquash, C-0604/*116*; C-2203/*215*.

mussette, EA/*bagpipe*.

mustache cup, IDPF/*165*①; K-802/ *22*.

Mustafa, EA.

Mustafi, S-288/*18*①.

Musta Hafiz, CEA/*92*①.

mustard barrel, EA.

mustard fork, C-5114/*76*.

mustard-jar, IDC/①.

mustard ladle, C-5114/*76*.

mustard-pot, C-2487/*77*; C-2910/*90*; C-5117/*58*①, *279*①.

mustard pot, C-0254/*15, 109*; C-0706/*36*; C-1502/*46*; DADA/①; IDPF/*166*①; LAR83/*596*①; MP/ *482*①; S-3311/*656*.

mustard silk, C-2704/*13*.

mustard spoon, C-0103/*23*; C-0406/ *29*; C-2202/*39*; C-5114/*76*; C-5117/*38*; DADA; EA.

mustard-yellow, C-5236/*1622*; IDC.

Muster, IDC.

mutchkin, CEA/*594*; DADA; EA.

muted tone, C-0405/*181*.

Muthesius, Hermann, DADA/ *Supplement*.

Mutomatic, C-2904/*22*.

Mutoscope, C-2904/*22*.

mutton-fat jade, C-2458/*315*; C-2569/*3*; DADA.

muttonfat jade, C-5156/*430*.

mutual solvent, DATT; LP.

mutule, SDF.

muzzle, S-4972/*265*.

M.v.G., EA/*van Gelder, Marinus Hendriksz*.

myall wood, DADA.

Mycenaean, DATT/①.

Mycenaean pottery, IDC.

Mycock, William S., C-2409/*71*.

My Country, S-4843/*528*①.

Myddleton Cup, EA.

Myer Myers, S-4905/*234*①.

Myers, OPGAC/*345*.

Myers, J., C-2489/*134*.

Myers, Joel, DADA/*Supplement*.

Myers, Myer, C-5153/*45*①; CEA/*673*①; EA/①.

Mylar, DATT.

Myott, Son & Co., C-2409/*291*.

Myra-Kristall, C-2409/*13*.

myrtle, DSSA.

myrtle green, DATT.

myrtle pan, IDC.

mysterious basket, the, IDC.

'mysterious setting', RTA/*194*①.

mystery clock, EA/*242*①.

mythical animal, C-5156/*419*①.

mythological figure, IDC.

mythological plaque, .C-2427/*205*①.

mythological roundel, S-3311/*413*①.

mythological scene, C-2398/*11*①.

mythological tapestry, C-5224/*217*①; S-4972/*179*①.

N

N, CEA/*184*①; EA/*Novyi factory.*
N.A., LP.
nabati Meshkin, OC/*229*①.
Nabeshima, C-5156/*808*①; S-3312/*1118*①.
Nabeshima ware, DADA/①; EA/①; IDC.
Nabi japonard, JIWA/*213.*
Nabis, JIWA/*11.*
Nabis, Les, LP.
nacarat carmine, DATT.
Nachet & Fils, CEA/*611*①.
Nadal (Nadal l'aîné), Jean Réné, EA.
naga, C-5234/*140*; IDC.
nagaban tate-e, C-5236/*1027, 1061.*
nagaban yoko-e, C-5236/*1359.*
naga-e, JIWA/*170.*
Nagamichi, LAR82/*38*①.
Nagasaki-made lacquerware, C-5170/*169*①.
Nagoya artists, S-4928/*83*①.
Nagoya School, C-5156/*688*①.
nail, CHGH/*58.*
nail buff, S-4461/*375.*
nail buffer, C-1502/*56.*
nail file, C-0254/*242*; C-0270/*273.*

nail head, SDF.
nailhead, OPGAC/*229.*
nailhead brush stroke, JIWA/*89.*
Nailsea, DADA; EA; EG/*150*①; K-802/*16*; NYTBA/*280*①; S-4461/*132.*
Nailsea factory, CEA/*449*①.
Nailsea glass, ACD.
nail-studded, C-5156/*758*①.
Nain, C-2320/*154*; OC/*15*①.
Nain part silk carpet, S-3311/*15*①.
Nain rugs, OC/*114*①.
naive, C-5114/*180*①.
naive portrait, C-5117/*458*①.
Nakashima, George, DADA/*Supplement.*
Naked Boy, the, IDC.
nakhtysh dessert service, RGS/*21.*
naksha, OC/*18*①, *58.*
namazi, CEA/*101.*
namazlik, DADA; OC/*30.*
namazlyk, CEA/*80*①, *101.*
namban, DADA; EA/*Japanese sword-guards*; C-5236/*811*①.
namban style, C-5236/*793*①.
nameboard, C-5114/*335*①; CEA/*556.*
name chest, DADA.

named view, C-2493/*262*; IDC.
Namuroise, LAR83/*315*①.
nanako, DADA.
nanako ground, S-4928/*111*①.
Nancy, S-4461/*100*.
Nancy School, DADA/*Supplement*; JIWA/*305*.
Nancy tapestry, DADA; EA.
Nanjing school, C-5156/*623*①.
Nanking, C-5127/*268*①; CEA/*111*; EC2/*22*①; S-4905/*93*①.
Nanking latticework border, NYTBA/*166*.
Nanking ware, DADA; EC2/*20*; IDC.
Nanking yellow, DADA; IDC.
Nankin (Nankeen) porcelain, EA.
Nankin yellow, EA/*café au lait glaze*.
Nan-tai kiln, EA.
Nantgarw, ACD; C-2493/*9*①; CEA/*202*①; DADA; LAR82/*159*①; LAR83/*140*①.
NANT GARW/C.W., EA/① *Nantgarw Porcelain*.
Nantgarw Porcelain, EA/①.
Nantucket carving, S-4881/*87*①.
Nantucket style, S-4881/*388*①.
nao, S-4963/*14*①.
naos, S-4973/*279*①.
Naphatali Hart, S-3311/*741*.
naphtha, DATT.
Napier, C-0254/*199*; C-5167/*176*.
Napier, John, CEA/*609*①.
Napier's Rod, CEA/*609*①.
napkin, C-2704/*146*.
napkin press, EA; SDF.
napkin-ring, C-5174/*290*.
napkin ring, C-0706/*48*; C-1502/*1*; S-4461/*290*; S-4881/*500*①.
Naples, EA; LAR82/*160*①.
Naples style, C-5189/*35*.
Naples tapestry, EA.

Naples yellow, DATT; LP.
Napoleon gray, DATT.
Napoleonic, S-4992/*44*①.
Napoleonic dial, C-5117/*458*①.
Napoleon II, S-4992/*104*①.
Napoleon III, C-5181/*94*①; S-288/*34*①; S-4461/*624*; S-4992/*21*①.
Napoleon III period, C-5189/*311*①.
Napoleon III style, CEA/*366*.
Napoleon's monogram, C-2704/*162*.
Napoleon watch, EA/*half-hunter watch, half-hunter watch*.
Napoli, EC1/*56, 59*①, *59*①.
nappies, S-4905/*307*.
nappy, IDC.
Nara, DADA.
Nara period, EA; JIWA/*181, 205*.
Narcissus, DSSA.
narcissus bowl, C-2513/*128*①; C-5156/*70*.
Nardin, J., S-4927/*94*.
Nardin, Ulysse, C-2368/*124*; S-4927/*1*.
narghile, EA/①; IDC; IDPF/*166*; DADA/①.
nargile, IDC/*narghile*.
narrative, DATT.
narrow-boat teapot, IDC/①.
narrow format, JIWA/*52*①.
n-arrow ring-turned stem, C-5114/*231*.
narrow runner, OC/*23*.
narrow-scale work, JIWA/*170*.
narwhal, S-4972/*378*.
narwhale, C-2324/*216*①; CEA/*562*.
narwhale tazza, C-2324/*216*①.
narwhal tusk, C-2421/*6*①; S-4881/*18*①.
Nasca pot, IDPF/*35*①.
Nash, Arthur J., CEA/*479*①.
Nash, Bowles, C-5117/*255*①.
Nash, Thomas, C-0706/*235*.

nashije border, C-2357/99①.

nashi-ji, DADA.

nashiji, C-1082/182; C-5156/706①; C-5236/780; CEA/575; S-3312/1039①, 1162①; S-4829/31①; S-4928/136①.

nashiji ground, C-5127/441; S-3312/1061①.

nashiji interior, C-5236/788①; S-3312/1038①.

Nashiji lacquer, C-2437/17①.

Nashville Art Pottery, Nashville, Tennessee, EC1/85.

Naskhi script, C-2503/27①; EA.

naskh script, C-5127/213.

Nasrabad, OC/217①.

Nassau-Saarbrücken, EA/Ottweiler, Ottweiler.

nassau stoneware, DADA.

Nassau ware, IDC.

nast, C-5259/120.

nasta'liq script, S-4973/187①.

NAST/A/PARIS, EA/Paris porcelain.

Nast porcelain, NYTBA/172.

natch, DATT.

National Academy of Design, DATT.

Nationalitäten, MP/72, 119.

National Trust Worcester and Malvern Centre, C-2704/77.

native-cut, C-5173/13①.

nativity, DSSA.

nativity scene, S-4955/96①.

natsume, S-4928/161.

natural, IDPF/8.

natural dyestuff, DATT.

natural form, C-2458/414; RTA/168①.

'natural' Gebbehs, OC/214.

naturalism, DATT; JIWA/8; LP.

naturalistic, C-5116/66; IDPF/125; LP; OC/270; S-4922/85①.

naturalistically, C-1082/74.

naturalistically modeled, S-4965/106①.

naturalistically molded, S-4461/504.

naturalistic base, C-0249/171; C-2555/9①.

naturalistic bulrush, C-2421/22①.

naturalistic floral ornamentation, RTA/92.

naturalistic flower, MP/131.

naturalistic illusionism, JIWA/10.

naturalistic leaf design, NYTBA/21.

naturalistic leaf form, RTA/65①.

natural pearl, S-4414/102; S-4927/297①.

natural posture, JIWA/10.

nature, LP.

nature morte, LP.

Natzler, K-711/130.

Natzler, Gertrud and Otto, DADA/Supplement.

Naudin, François-Dominique, S-4922/1①.

Naumann, Christian Gottlieb, MP/175.

nautical inkstand, C-2910/207①.

Nautical pattern, S-2882/1357.

Nautilus, C-2204/171.

nautilus cup, EA/①.

nautilus service, IDC/①.

nautilus shell, C-5146/162.

Nautilus Shell compote, S-4843/162①.

nautilus shell cup, DADA/①.

Navajo, K-710/118.

Navajo Indian bracelet, CEA/513①.

Naval pattern blunderbuss, C-2503/122.

naval stores, DATT.

naval trophy, C-5117/40①.

Navarre, Henri, C-5191/243.

naïve painter, NYTBA/190.

navette-cut, RTA/94.

navette diamond, RTA/193①.

navette-form, S-4988/*400*①.

navette form, LAR83/*645*①; S-3311/*125*.

navette-shaped, C-2332/*302*; C-2478/*94*①; LAR82/*582*①; LAR83/*569*①, *635*①; S-4436/*17*①; S-4972/*149*.

navette-shaped coral cabochon, S-4414/*156*.

naviform, DATT.

navigational instrument, S-4881/①.

Nayarit, S-4461/*59*; S-4807/*146*①.

Nazarenes, DATT.

Nazarov, C., C-5174/*232*.

nazca, S-4807/*54*.

Nazca pottery, IDC.

N.E.A.C., LP/*New English Art Club*.

Neale, James, ACD; CEA/*158*①.

Neale & Co., EA/*Palmer, Humphrey*.

Neale & Palmer, EA/*Palmer, Humphrey*.

Neale's, K-710/*118*.

NEALE & WILSON, EA/*Neale & Co.*.

Neapolitan, LAR82/*70*①; LAR83/*309*①.

Neapolitan pique, LAR83/*605*①.

Neapolitan State Archives, CEA/*171*①.

Near Eastern pottery, DADA/*Persian pottery*.

Near Eastern taste, C-2458/*220*; C-2513/*53*.

Near Eastern ware, DADA.

nebben gul, S-288/*38*①.

necessaire, C-0249/*230*.

nécessaire, C-2487/*22*; CEA/*66*①; DADA; EA.

necessaire, LAR82/*630*①; LAR83/*455*①, *628*①.

nécessaire de voyage, EA/*canteen*.

necessary stool, EA/*close stool*; SDF.

neck, C-2458/*2*; C-5005/*402*①; C-5114/*27*①, *331*; C-5156/*4*①;

CEA/*57*①, *113*①; IDC; IDPF/*166*①; S-4461/*361*; S-4992/*6*①.

necking, SDF.

necklace, C-0225/*94*; C-2458/*324*; C-5239/*98*; CEA/*515*①, *517*①.

necklet, C-2409/*204*.

neckline, C-1506/*44*.

neck mould, SDF.

neck-mount, C-2510/*31*.

neck mount, C-2510/*89*①.

necromancer's apron, C-5234/*96*①, *119*①.

Needham, Joseph, C-2503/*92*.

Needham's patent, C-2503/*92*.

needle, DATT/①.

needle box, C-0906/*84*.

needlebox, C-1603/*14*.

needle-case, C-2427/*62*; C-5220/*17*①.

needle case, C-0254/*62*; S-3311/*160*①.

needle-etched, CEA/*478*①.

needle-fire shotgun, C-2503/*92*.

needle inclusion, C-2458/*386*.

needle lace, C-2704/*179*; NYTBA/*93*.

needle made, C-1506/*170*.

needle painted, DADA.

needlepoint, C-2704/*18*①; C-5239/*259*; DADA; S-4414/*419*①; S-4436/*3*.

needlepoint carpet, S-4804/*972*.

needle-point pen, DATT.

needlepoint rug, C-0249/*308*.

needlepoint seat, S-4461/*591*.

needlerun lace, C-2203/*29*.

needlerun net, C-1304/*80*.

Needles, John, C-5153/*175*①.

needlework, C-0249/*176*; C-0982/*88B*; C-3011/*116*; C-5116/*68*①; C-5153/*135*①; DADA; NYTBA/*100*①; S-4461/*68*; SDF.

needlework carpet, C-0249/*311*;
DADA.

needlework fragment, C-5116/*23*.

needlework picture, C-5116/*40*;
C-5157/*5*; C-5189/*318*.

needlework pillow, C-5116/*24*.

Neesz, Johannes, CEA/*166*①.

nef, ACD; C-5173/*67*①; CEA/
*627*①; DADA; EA/①; EG/*67*①;
LAR83/*243*①, *597*①; S-3311/
*692*①; SDF/①.

nef clock, EA.

negative ground, JIWA/*71*.

negative mold, DATT.

negative shape, LP.

negative space, IDPF/*5*; LP/①.

negative stencil, JIWA/*199*.

negoro, C-5156/*783*; C-5236/*852*.

negoro-nuri style, C-1082/*188*.

Negretti & Zambra, C-2904/*109*, *142*,
256.

Negro-head jewel, RTA/*109*①.

Nehavend, OC/*258*①.

Nehavend/Mishin, OC/*250*①.

Nehlig, Victor, S-286/*70*.

Nehou, Louis Lucas de, CEA/*484*.

nei, S-4963/*5*①; S-4965/*119*①.

Neilson, James (Jacques), EA.

Nelme, Anthony, C-5117/*268*①,
*293*①; CEA/*645*①; EA/①;
S-3311/*801*①.

Nelme, Francis, C-5117/*91*①.

Nelson, George, DADA/*Supplement*.

Nelson, Lord, service, IDC.

Nelson, Lord, ware, IDC/①.

Nelson chair, EA; SDF.

Nelson sideboard, SDF.

Nelson vase, IDC/①.

Nemesis, DSSA.

Nemirov-Kolodkin, C-5174/*306*①.

Nenej, OC/*331*①.

nengo, IDC.

neo-, LP.

neo-Baroque, MP/*199*.

neo-classic, ACD; C-5157/*31*;
DADA.

neo-classical, C-2421/*91*①; C-5117/
*203*①; CEA/*176*①.

neoclassical, C-5181/*150*; S-4972/
*430*①.

Neo-Classical, S-4461/*73*.

Neoclassical, S-4804/*16*①.

neoclassical art, DATT.

neo-classical design, LAR83/*639*①.

Neoclassical mode, MP/*169*.

Neo-classical period, RTA/*89*①.

neo-classical shape, C-2458/*112*.

neo-classical style, EA; IDC.

Neoclassical style, S-4804/*175*①.

neo-classical taste, SDF.

neo-classicism, CEA/*307*①.

neoclassicism, NYTBA/*59*①.

Neo-Classicism, LP.

Neoclassicism, DATT/①.

neo-classic jewellery, CEA/*513*.

neo-classic profile, C-5157/*16*.

neo-Egyptian, S-2882/*788*①; S-4853/
346.

neo-expressionist, DATT.

neo-gothic, DADA; C-5116/*131*①.

neo-Gothic designs, S-3311/*387*①.

Neo-Gothick, C-5157/*83*①.

neo-Gothic style, EA/*Gothic revival*;
RTA/*129*①.

neo-Greek, C-5153/*14*①.

Neo-Humanism, LP.

Neo-Impressionism, LP.

Neo-Impressionist, JIWA/*52*, *69*.

Neo-Islamic, S-4947/*128*①.

Neolithic, C-5236/*341*.

Neolithic Moravia, IDPF/*24*①.

Neolithic period, S-4965/*152*①.

Neolithic Sussex, IDPF/*27*①.

Neo-Plasticism, DATT/①; LP.

Neopolitan, LAR82/*329*①.

neo-Renaissance, CEA/518①.

Neo-Romanticism, LP.

Nepalese brass, C-1082/113.

nepheline syenite, DATT.

nephrite, C-0282/145; C-2332/143; C-2503/5①; C-5117/347; C-5174/311①; DADA; DATT; JIWA/305①; RGS/123①, 157①, 199①; RTA/156①.

Neptune, DSSA.

Neptune mask, C-2437/75①.

Nereids, DSSA.

nero antico, DATT.

ner tamid (memorial) lamp, C-5174/135①.

Nesbitt, Lowell, S-286/67.

neskhi, IDC.

nest, C-0982/10; C-1407/100; C-2402/20.

nested tables, SDF/nest of tables.

nesting beaker, EA.

nest of drawers, ACD; DADA; EA; SDF.

nest of tables, ACD; C-2409/246①; C-5005/317; DADA; EA; S-4988/554①; SDF.

nest of trays, DADA.

nestoris, IDC/①.

nest saucer, DATT.

nest toy, CEA/697.

net curtain, C-2704/161.

Netherlandish contemporary arts and craft, DADA/Supplement.

Netherlands maiolica, IDC.

Netherlands Pottery, C-2486/①.

net insertions, C-1603/109.

net lace, C-3011/1.

Netscher, Caspar, C-2493/283.

netsuke, ACD; C-1082; C-5127/445; C-5156/①; C-5236/695; CEA/561; DADA/①; EA/①; JIWA/75; K-710/111; LAR82/530①; LAR83/511①; S-4461/422.

network, C-5005/405①.

network pattern, IDC.

Netzglas, EA.

Neuber, CEA/53①.

Neuber, Johann Christian, EA/①.

Neubrandensteinmuster, IDC.

Neuchâtel, EA.

Neuchâtel clock, EA/Neuchâtel.

Neuchâtel style clock, CEA/237①.

Neudeck (Neudeck-Nymphenburg), EA.

Neue Brandenstein style, C-5189/77.

Neuer Ausschnitt (new cut edge) pattern, MP/474.

Neue Sachlichkeit, DATT/①; LP.

Neufforge, Jean-François de, DADA.

Neuillet, Guillaume, EA.

Neumeyer, Berlin, C-0982/18.

Neuozier, MP/122.

neu-ozier-molded, S-4823/104.

Neuozierrand, IDC.

neutral background, JIWA/23.

neutral color, DATT.

neutral orange, DATT.

neutral tint, DATT.

neutral tones, LP.

Neuwelt, CEA/451.

Neuwied blue, DATT.

Neuwied workshop, C-5224/206.

Neuzierat, EA.

Nevalainen, Anders (workmaster), C-5174/307.

Nevers, ACD; CEA/145①; DADA; EA/①.

Nevers blue, CEA/145①.

New, Keith, DADA/Supplement.

New Amsterdam, CEA/459.

new 'antiques', OC/132.

New Art, SDF.

New Bedford Seal, S-4881/323①.

Newberry, Francis H., DADA/Supplement.

Newberry, Jessie R., DADA/
 Supplement.
new blue, DATT.
new brass, EA/*brass.*
New Bremen Glass Manufactory,
 CEA/*459*; EA/①.
New Bremen Glassmanufactory,
 CEA/*460*①.
New Bremen Glass Manufactory,
 Frederick, Maryland, NYTBA/*290.*
New Canton, CEA/*190*①; DADA;
 IDC.
Newcastle, C-2202/*42.*
Newcastle glass, CEA/*429*①.
Newcastle goblet, LAR83/*430*①.
Newcastle-upon-Tyne, EA.
new Caucasian, OC/*230*①.
new china, IDC.
Newcomb, LAR83/*64*①; OPGAC/
 346.
Newcomb College (mark), EC1/*84*①.
Newcomb Pottery, DADA/
 Supplement; EC1/*76*①.
Newcomb Pottery, New Orleans,
 Louisiana, EC1/*85.*
newel-post ornament, CEA/*491*①.
New England, CEA/*685.*
New England Glass Co., CEA/*489,
 489*; LAR82/*435*①.
New England Glass Company, CEA/
 *463*①; DADA/*Supplement*; EA/①;
 EC1/*58*①, *68.*
New England Glass Company,
 Cambridge, NYTBA/*294*①.
New England Glass Company,
 Cambridge, Massachusetts,
 OPGAC/*158.*
New England Industries, S-4843/
 *315*①.
New England pineapple, OPGAC/
 229.
New England Pottery Company,
 DADA/*Supplement*; EA.

New England Windsor armchair,
 DADA.
New English Art Club N.E.A.C., LP.
New Form International, C-2904/*265.*
New Geneva Glass Works, CEA/
 *461*①.
New Geneva Glassworks, EA/①.
New Hall, ACD; C-1006/*17, 106*;
 C-1582/*138*; C-2502/*6*; DADA;
 EA/①.
Newhall, C-2493/*32*; C-5189/*3*;
 LAR82/*160*①.
Newhall, A., LAR82/*206*①.
Newhall Bone china, C-2360/*11.*
Newhall bowl, C-0782/*21.*
New Hall China, CEA/*201*①.
Newham, John, CEA/*585*①.
New Hampshire, OPGAC/*230*①.
New Hampshire mirror clock, EA.
New Jersey, OPGAC/*230.*
'new Kazak', OC/*210.*
new Kazak design, OC/*229.*
new kingdom, S-4807/*460.*
Newland, William, DADA/
 Supplement.
New Land pattern pistol, C-2503/*177.*
new Marseilles pattern, MP/*482*①.
New Masters, DATT.
New Objectivism, LP.
New Objectivity, DATT/①.
New Orleans Art Pottery, New
 Orleans, Louisiana, EC1/*85.*
Newport pottery, C-2910/*102*;
 LAR83/*81*①; C-2409/*61*; C-5167/
 71.
Newport school, EA.
New Realism, LP.
Newsam, Bartholomew, EA; SDF/
 777.
newsprint, DATT.
New Standard, EA/*Britannia
 Standard, Britannia Standard.*
new stone ware, IDC.

Newton, Sir William John, EA.
Newton's cradle, CEA/608①.
Newton Son & Berry, C-5170/136①.
Newton's terrestrial table globe, C-2478/23.
New Treaty On The Use Of The Globes, C-2904/151.
new-vase shape, C-2493/166.
New Year's card, C-0405/123.
New York City Empire, LAR83/394①.
New York clock, EA.
New York school, DATT; LP.
New York style, NYTBA/68.
New Zealand red pine, SDF.
NF, EA/Nicole, François.
N.F.D., CEA/68①.
N.F.S., LP.
N. Harding & Co., S-4905/172.
nianhao, S-4965/247①.
Nian rug, C-2482/1.
nib compartment, C-2437/17①.
niche, C-0982/23; C-5157/120; S-288/7①; S-2882/47, 197①, 213①; S-3311/291①; S-4847/71; S-4972/27①; SDF.
niched door, C-2522/180①.
niche de chien, C-5259/572①.
Nicholas II period, C-2503/7.
Nicholls and Plincke, C-5117/318①; C-5174/219①.
Nichols carpet, C-5191/327; S-3311/51B.
Nichols chinese wool carpet, S-4507/23.
Nicholson, Edward, C-2503/118.
Nicholson, Michael Angelo, SDF/759.
Nicholson, Peter, SDF/759.
nickel, C-0906/360; C-5117/398①; EG/258.
nickel lever movement, S-4802/1.
nickel-plated, C-2904/5.

nickel plated, C-2368/123.
nickel silver, DADA; EA/argentine, argentine.
nicking, SDF.
Nicolas, P., C-2409/23.
Nicole, François, EA.
Nicole, Nielsen and Co., C-5117/455①.
Nicole Frères, EA/Nicole, François, Nicole, François.
Nicole Frères à Genève, EA/Nicole, François.
Nicole Nielson winding, S-4802/42①.
nicolo, C-2332/38.
nicolo (sardonyx), RTA/37①.
Niculoso, Francisco (Il Pisano), EA.
Nider or Niderviller in black, EA/Niderviller.
Niderviller, ACD; C-2486/2; CEA/147①; DADA; EA/Niderviller.
Niedermayer, J. J., CEA/175①.
Niedermayer, Johann Josef, EA.
niello, C-0270/71①; CEA/71, 622①, 625①; DADA; DATT; EA; LAR83/607①; RGS/90; RTA/13, 56; S-4972/154①.
niello case, S-4461/339.
nielloed, C-0406/90; C-1502/114; C-2202/115; C-2368/123; C-5117/300; C-5173/4①; C-5259/237; S-3311/668①.
nielloed cartouche, RGS/105.
nielloed icon, RGS/115①.
nielloing, C-0706/150.
niello-work, C-1502/85.
niello work, RGS/145①; RTA/44①.
Nielsen, Rasmus, C-2486/205.
Nielson Pottery, Zanesville, Ohio, EC1/85.
nien hao, ACD; EA; IDC.
nien hao mark, C-2458/70.
Nien hsi-yao, EA.
Nieuwenhuis, Th., DADA/Supplement.

nieuwer amstel, DADA.

nigged, DATT.

Night, DSSA.

night clock, ACD; CEA/225①; EA/①; SDF.

night commode, EA/*close stool*; SDF.

nightdress, C-2203/7.

night lamp, C-0225/299.

night-light holder, IDPF/166①.

night stand, SDF.

night stool, SDF/*night commode.*

night table, ACD; DADA; EA/①; SDF/①.

Night watchman, IDC/①.

Niglett, John, EA.

Nikolaev, Dimitri, C-5174/302.

niku-bori, DADA.

Niloak Pottery, Benton, Arkansas, EC1/85.

Nilson, Johann Esaias, EA.

nimbus, C-5173/56①; DATT; LP; RGS/124.

Nimsci, C-0782/163.

N in black, EA/*Niderviller.*

nine-lobed shell, CEA/395①.

Nine Muses, the, IDC.

Nine Patch, C-2704/73.

nine-sided gables, S-2882/187.

Nineteenth Century pattern, C-5191/476.

19th Century taste, C-5156/165.

nineteenth dynasty, S-4807/479①.

Ninghsia, S-288/14①.

Nini, Jean-Baptiste, S-4843/462①.

Ninsei, DADA.

Ninsei Studio, EA.

Ninth Century pattern, C-5005/380.

Niobe, DSSA.

niobium, RTA/146.

nioi, C-5236/1829, 1833.

nipping, EG/291.

nipple, CEA/44.

nipple key, CEA/26①.

nipple-shield, C-2503/185.

nipple spout, IDC.

nipple wrench, C-2569/68.

Nippon porcelain, LAR82/138①.

nipt diamond wai, CEA/503.

nipt diamond waie, CEA/424①; DADA; EA/①.

nipt diamond wale, EG/291.

Niris, DADA.

Niriz, OC/110①.

Nishapur ware, IDC.

Nishida, LAR83/97①.

nishiki-de, DADA/①.

Nishiki-de ware, IDC.

nitrate green, DATT.

nitrocellulose, DATT.

Niukkanen, Gabriel (workmaster), C-5174/324①.

nivernais, C-5191/219; CEA/485①.

Nixon, Harry, LAR82/120①.

NK in Cyrillic, EA/*Kudinov factory.*

Nîmes, CEA/145①.

Noah, DSSA.

Noah's ark, C-0405/160.

NOB, EA/*Outrebon, Nicolas, II.*

Noberan, OC/261①.

noble pewter, EA/*Edelzinn.*

Nock, Henry, ACD.

Nock, London, C-2503/145.

nocturnal, CEA/607①.

nocturnal dial, EA.

nodding head figure, C-5170/165①.

nodding pagoda figure, S-4947/30①.

node, C-5236/1694.

Noe, William R., & Sons, K-711/129.

Nogaret, S-4955/104①.

noggin, DADA; EA; IDPF/167.

Noguchi, Isamu, DADA/*Supplement.*

no. 612 horseshoe, OPGAC/193.

no-hsi painting, JIWA/164.

noir belge, DATT.

noir fin marble, DADA.

Noke, C-5239/40.

Nok style, C-1082/42.

nomad bag, OC/30.

nomadic furniture, SDF.

nomad rug, OC/54①.

non-crawl, DATT.

non-creep, DATT.

nondrying oil, DATT.

non-ejector gun, C-2476/63.

Nonesuch chest, NYTBA/29.

non-figurative, LP.

Nonius, CEA/612.

non-objective, LP.

nonobjective, DATT.

Nonomura, Seiemon, EA/Ninsei Studio.

non-representational, LP.

non(e)such, ACD.

nonsuch chest, DADA; SDF/①; EA/①.

noodle, LP.

Nootka, LAR82/80①.

Nordhausen alabaster, MP/502.

Nordin, Lars, CEA/318①.

Nordström, Patrick, DADA/Supplement.

Norfolk, C-0405/208.

Noritake, C-0803/140, 140.

normal butanol, DATT.

Norman, C-0225/10.

Norman, Philip, C-5117/70.

Norman, Samuel, ACD; DADA.

Normandeaux stone, DATT.

Normandy, DADA/①.

Normandy lace, DADA.

Normandy process, EA/crown glass.

Norman style in furnishing, SDF/①.

Norse Pottery, Edgerton, Wisconsin, EC1/85.

Norse Pottery, Rockford, Illinois, EC1/85.

North, Simeon, CEA/38①.

Northam, John, CEA/69①.

North American Indian mocassin, C-1506/84.

Northamptonshire lace, DADA.

North and Cheney pistol, CEA/38①.

Northcote, Thomas, C-2487/72①.

Northern and Southern Dynasties, EA/Six Dynasties.

Northern Brown ware, CEA/116①.

northern celadon, DADA; IDC; JIWA/344①.

northern celadon ware, EA.

Northern Dynasties, EA/Six Dynasties.

Northern English, C-2704/66.

Northern Song Dynasty, C-2458/21; C-5127/31; C-5156/41.

Northern Sung dynasty, CEA/115①.

Northern Tang period, JIWA/88.

Northern Wei dynasty, CEA/114①; C-2414/23; S-4965/193①.

Northern Wei style, C-5156/190①.

North European, C-1506/177①.

North Italian Mannerism, NYTBA/46①.

North Persian rug, S-288/33①.

North Scania, EA/Scandinavian glass.

Northwestern Terra Cotta, Chicago, Illinois, EC1/85.

Northwest Persian, S-4847/163.

Northwood, Harry, DADA/Supplement.

Northwood, John, CEA/417①, 450①.

Northwood, John I, EA.

Northwood Glass, CEA/480①.

Northwood Grape, CEA/480①.

Norton, Captain John, CEA/168①; DADA.

Norton, Captain John, Lyman, Julius, EA.

Norton, Eardley, S-4927/*206*.

Norton, Eardley, London, S-4927/*57*.

Norwegian flat stem spoon, C-0103/
102.

Norwegian tapestry, EA/①.

Norwich glass, EA/*Lynn glass*.

nose-fitting floats, C-2904/*83*.

Nosek, Hans and J., OPGAC/*357*.

nosepiece, C-2904/*54*.

nosepiece fine adjustment, C-0403/
125.

nosing, SDF.

Noostetangen, EA.

notch-cut arm, CEA/*446*①.

notch-cut edging, CEA/*445*①.

notched, C-0982/*226*; EG/*291*①.

notched, openwork mount, S 4414/*42*.

notched border, C-5117/*58*①.

notched corners, S-4461/*101*.

notched medallion, S-2882/*74, 212*①.

notched rim, S-4461/*36*.

notched round terminal, S-4461/*387*.

notches, S-4461/*36*.

note, DATT.

note and card case, C-0406/*115*.

note case, C-0406/*68*.

notes, C-1603/*21*.

Notsjö (Nuutajärvi), DADA/
Supplement.

Nottingham, ACD; C-0405/*3*; CEA/
*150, 155*①; DADA.

Nottingham lace, DADA; SDF.

Nottingham stoneware, IDC.

Nottingham ware, EA.

Nottingham white, DATT.

Nourin, Henrik, S-4944/*141*.

Nourrice, la, IDC/①.

nouveau, DATT.

Nove, ACD; DADA; EA/*Le Nove*.

Nove and GBA, EA/*Le Nove*.

Nove Dvory, CEA/*451*.

novelty, C-0406/*69*; CEA/*253*①;
EG/*291*①.

novelty card, C-2704/*119*.

Noverdy, C-5239/*152*.

N over JE, EA/*Niglett, John*.

Nový Bor, CEA/*451*.

Novyi factory, EA.

Nový Svět, CEA/*451*.

Nozeman, Cornelius, S-286/*65*.

nozzle, C-0249/*290*; C-0706/*250*;
C-2202/*44*; C-2421/*4*①; C-5116/
*37*①; C-5153/*13*①; EA; IDC;
S-3311/*228*①, *433*; S-4922/*5*①,
*30*①; S-4988/*408*①.

N. PETIT, EA/*Petit, Nicolas*.

NS, EA/*Ottweiler*.

nuance, LP.

nude, C-5146/*80*①; LP.

nude statue, MP/*206*.

nude study, LAR83/*32*①.

nué, CEA/*281*①.

Nuernberg violet, DATT.

NuFilm, DATT.

Nuka glaze, LAR82/*133*①.

nulling, ACD; CEA/*406*; EA/
knurling, knurling; SDF.

numbered, C-2409/*158*; C-5117/
*426*①; C-5156/*1069*; C-5239/*189*.

numeral, C-0249/*349*.

numeral 13, CEA/*678*.

nunome, CEA/*562, 575*.

nunome-zōgan, DADA.

nuphares, C-2324/*168*.

nuppen, DADA.

nuppenbecher, DADA/①; EG/*117*①.

nuptial plate, IDC.

Nuremberg, C-2427/*201*①; CEA/
451, 685; DADA; EA/①.

Nuremberg egg, ACD; DADA/①;
EA.

Nuremberg faience, ACD.

Nuremberg glass, EA/①.

Nuremberg mark, C-MARS/*104*①.

Nuremberg shape, EG/*99.*
nuri-shi, CEA/*562, 575.*
Nürnberg, S-4853/*244*①.
nursing chair, C-0982/*202;* C-2402/*142;* DADA; EA; LAR82/*307*①; LAR83/*282*①; SDF.
nursing lamp, DADA.
nut, RGS/*31*①.
nut boat, C-0254/*175.*
nut cracker, C-1502/*136.*
nut dish, C-0254/*216.*
nutgall, DATT.
nutmeg box, DADA.
nut-meg grater, C-2398/*67.*
nutmeg-grater, C-5173/*12.*
nutmeg grater, C-0254/*147;* C-0706/*56;* EA/①; LAR83/*597*①; S-4944/*52*①.

nutmeg wood, DADA.
nut pick, C-0103/*86;* C-1502/*71;* S-4804/*35.*
nut spoon, C-0270/*85;* S-4804/*28*①.
Nuttall, Thomas, S-4944/*355*①.
Nutting, H, EA/*Hennell.*
Nyestad, Christian Hansen, C-0270/*105*①.
nylon, LP, *brushes.*
nylon brush, DATT.
nymph, DSSA.
Nymphenburg, ACD; C-2409/*137;* C-2427/*39*①; DADA/①; EA/①; LAR82/*160*①; LAR83/*140*①; S-4853/*119*①.
Nymphenburg porcelain, JIWA/*120*①.
nymph stem, C-2364/*3*①.
Nyon, ACD; EA.

O

oak, ACD; C-0982/*21, 43*; C-1407/*2*; C-2402/*5*; C-5116/*59*; C-5239/*241*; DADA; DSSA; S-4461/*568*; S-4972/*12*①; SDF.

oak bedhead, C-0982/*98A*.

oak box, C-0982/*56*.

oak-cased, C-0403/*5*.

oakcoffer, C-2382/*134*①.

oak foliage, C-2421/*108*①.

oak foliage handle, C-2510/*4*.

oak framed, C-0982/*92*.

Oakland Art Pottery, Oakland, California, EC1/*85*.

oak leaf, C-2398/*68*①; C-5116/*174*①; EA/*Jacobite glass*.

oak-leaf and rosette design, OC/*266*.

oak leaf border, CEA/*163*①.

oak-leaf charger, EA/*blue-dash chargers*; IDC/①.

oak-leaf jar, CEA/*133*①; EA; IDC.

oak-leaf pattern, IDC.

oak leaf sabot, C-0279/*426*①.

oak-leaf spray, S-4436/*75*①.

oak-leaf surround, RGS/*152*①.

oak plank, C-0982/*86A*.

oak settle, S-3311/*140*①.

oak tag, DATT.

Oakwood Art Pottery, Wellsville, Ohio, EC1/*85*.

Oakwood Pottery, Dayton, Ohio, EC1/*85*.

Oakwood Pottery Company, East Liverpool, Ohio, EC1/*85*.

oar, C-5173/*20*①; DSSA.

oar tipstaff, C-5173/*20*①.

oatmeal, S-288/*1*①.

oatmeal laid paper, S-286/*499*.

OB, EA/*Obrisset, John*.

Obadiah Rich, S-4905/*179*①.

oban, C-5236/*1326*.

ōban, JIWA/*208*.

oban tate-e, C-5236/*953*.

oban yoko-e, C-5236/*935*.

obeche, DATT; SDF.

Obedience, DSSA.

obeisance, DSSA.

obelisk, C-1702/*166*; C-2421/*9*①; C-5114/*162*; C-5116/*39, 131*①; EG/*203*①; MP/*490*①.

obelisk clock, S-4955/*54A*①.

obelisk cup, EA/*steeple cup*.

obelisk-form, C-5191/*426*.

obelisk mold, IDPF/*132*①.

obelisk shape, C-5146/*107F*.

Oberdieck, Georg Gerhard, C-5174/
 *476*①.

Oberg, A., C-5189/*155*①.

Oberhauser and Nachet, CEA/*611*①.

Oberkampf, Philip, DADA/①.

Obermaler, EA.

Oberndorf, C-2476/*5*.

obeshimi mask, S-4928/*44*①.

obi, CEA/*561, 575*.

obi-hasami, CEA/*562, 575*.

objective, C-0403/*125*; C-2904/*45*;
 LP.

objective art, DATT.

objects of vertu, C-5117; EA.

Objektringe, RTA/*179*①.

objet d'art, DATT.

objet de fantaisie, RGS/*123*①.

objets d'art, ACD; JIWA/*9*.

objets de vertu, CEA/*513*; RGS/*69*.

objets de vitrine, EA/*objects of vertu*.

objet trouvé, DATT; JIWA/*302*; LP.

oblate, IDC.

oblique, DATT.

oblique angle, JIWA/*5, 242*.

oblique perspective, DATT; LP.

oblique projection, DATT.

oblong, C-0270/*113*①; C-0782/*36*;
 C-2458/*109*①; C-5117/*7*; C-5153/
 *22*①; S-4905/*427*①; S-4972/*439*.

oblong base, C-0254/*22*.

oblong box, C-2398/*32*.

oblong dial, S-4461/*326*.

oblong form, S-2882/*1006*①; S-4414/
 297.

oblong molded body, S-2882/*726*①.

oblong teapot, C-5117/*217*.

oblong vinaigrette, C-0406/*71*.

oboe, C-0906/*329*; CEA/*549*.

Obrisset, John, EA.

Obrist, Herman, DADA/*Supplement*.

Obruk, S-4847/*162*①.

obscured glass, SDF.

obsidian, IDC.

obsidian glass, EA.

obverse, C-2513/*459*; C-5114/*37*①,
 *193*①; C-5236/*330*①; DATT;
 IDC; S-4461/*496*.

ocarina, IDPF/*167*①.

occasional chair, C-0982/*55*; C-1407/
 41, 78; C-2402/*14*; LAR83/*270*①.

occasional table, C-0982/*10, 252,
 85B*; C-2402/*20*; C-2403/*52*①;
 C-2478/*94*①; DADA; S-2882/*271*;
 S-3311/*940*①; S-4436/*133*①;
 S-4461/*624*; S-4804/*803*; SDF.

Ocean Wave, C-2704/*78*.

Ocean Wave border, C-2704/*86*.

ocher, LP; S-4461/*100*.

ochre, C-0249/*258*; C-2414/*31*;
 C-5005/*244*①; C-5127/*14*①, *297*;
 C-5146/*91B*; DATT.

ochre-edged rim, S-4414/*360*①.

ochre glaze, C-5156/*19*①.

ochre inclusion, C-2458/*396*.

ochre mottling, C-5146/*148*①.

Ochsenkopf glass, EA.

Ochsenkopf Humpen, CEA/*452*①.

O'Connell, Michael, DADA/
 Supplement.

octafoil, C-0706/*130*; C-2323/*37*①;
 C-2427/*6*①, *102*①; C-2458/*215*;
 C-5127/*59*; S-4802/*200*①.

octafoil dish, LAR82/*100*①.

octafoil form, C-2458/*47*.

octafoil salver, CEA/*647*①.

octagoal polyhedron, S-4881/*89*①.

octagon, C-2388/*143*; CEA/*56*①.

octagonal, C-0982/*85B*; C-2402/*147*;
 C-5116/*8, 70*; C-5153/*69*①;
 C-5156/*55*; C-5157/*135*①;
 C-5239/*43*; EC2/*24*①; S-4922/
 *71*①; S-4972/*141*①.

octagonal baluster jar, S-4414/*401*.

octagonal barrel, C-2476/*8*.

octagonal base, C-0279/*224*; C-5117/
 *148*①; S-2882/*698*①; S-4414/*228*.

octagonal bottle, EA/*Chinese porcelain form.*

octagonal bowl, C-0225/*79A*; EA/ *Meissen style*; S-3312/*1118*①.

octagonal breakfast table, C-5116/ *78*①.

octagonal cartouche, C-5117/*47*①.

octagonal cross, C-0706/*3.*

octagonal-cut sapphire, S-291/*89*①.

octagonal dish, C-2458/*109*①; RTA/ *169*①.

octagonal domed base, S-2882/*696.*

octagonal faceting, S-4461/*476.*

octagonal flange, C-5117/*99*①.

octagonal foot, C-0254/*205, 312*①, *165B*; C-5114/*54*①; RGS/*116*①; S-4843/*94*①.

octagonal form, S-2882/*1174*; S-4436/*55.*

octagonally carved, S-4881/*414*①.

octagonal medallion, C-2403/*199*; S-4414/*540*①.

octagonal mount, S-291/*89*①.

octagonal mullion, C-5116/*128*①.

octagonal pedestal, C-0249/*443*; S-4414/*531*①.

octagonal pistol handle, S-4922/*40*①.

octagonal plate, C-0782/*19.*

octagonal plinth, C-2398/*91*①.

octagonal powder compact, S-4414/ *44.*

octagonal rim, S-4905/*32.*

octagonal sapphire, RTA/*71*①.

octagonal section, S-4461/*36.*

octagonal shade, C-5005/*397*①.

octagonal shaft, C-2403/*1.*

octagonal shield, S-2882/*905.*

octagonal spout, C-5117/*207.*

octagonal spreading base, C-5117/ *268*①.

octagonal table, S-4461/*721.*

octagonal table clock, CEA/*236*①.

octagonal top, C-0279/*282*①; C-2388/*103.*

octagonal tubular stem, C-5117/ *197*①.

octagonal watchcase, S-4414/*153*①.

octagon-and-square ground, IDC.

octagon and vine scroll border, S-2882/*151.*

octagon border, C-2388/*172.*

octahedral diamond crystal, RTA/*55.*

octangular top, C-2437/*55*①.

octant, C-0403/*108*; C-2608/*29*; CEA/*607*①; EA; LAR83/*460*①; S-4927/*220A*①.

octant style frame, C-2904/*276*①.

Octava Watch Co., S-4927/*75.*

octave, C-0982/*18.*

octofoil, C-0103/*119*; C-5236/*823*①; IDC.

ocular, C-0403/*118*; C-2904/*45.*

odalisque, DATT/①; S-4804/*477*①.

oddment, C-0706/*44.*

Odell & Booth Brothers, Tarrytown, New York, EC1/*85.*

Odelqvist-Kruse, Anna-Lisa, DADA/ *Supplement.*

Odeonesque, C-GUST/*130*①.

Odiot, NYTBA/*228*; S-3311/*654*①.

Odiot, Charles-Nicolas, C-5203/*119.*

Odiot, Jean-Baptiste-Claude, EA.

odjaklik, DADA.

odorant, DATT.

Odysseus, DSSA.

Oeben, Jean-François, C-2364/*46*①; EA.

Oeben, Jean Francois, ACD.

Oeben, Jean François, DADA.

Oeben, J. F., CEA/*379*①.

Oeder, G. C., EA/*Flora Danica service.*

oeil-de-perdrix, C-2427/*6*①; C-2493/ *10*①, *86*; DADA.

œil-de-perdrix, IDC/①.

oeil-de-perdrix, S-4804/*303A*①.

oeil de perdrix, EA/①.

oeil-de-perdrix marble, DADA.

oeil-de-perdrix wood, DADA.

oenochoe, CEA/*415*; DATT.

oenochoë, IDC/①.

oenochoe, IDPF/*167*①.

Oesterreichischer Werkbund, DADA/ *Supplement*.

Oettingen-Schrattenhofen, DADA.

Oettingen-Schrattenhofen faience factory, EA.

oeuil-de-perdrix, C-5259/*556*①.

oeuvre, C-2357/*1*①, *56*①; LP.

off-center design, NYTBA/*114*.

Offenbach, DADA.

offering dish, IDPF/*168*①.

offertory bag, C-0405/*132*.

off-hand, EG/*291*①.

offhand, CEA/*503*.

officer's dagger, S-4972/*250*.

officer's pistol, C-MARS/*132*.

official art, JIWA/*35*.

official bead, C-5156/*364*.

official salon painting, JIWA/*23*.

offprint, JIWA/*297*①.

offscape, DATT.

offset, C-0225/*411*; DATT.

offset lithograph, S-286/*1*, *1*, *266*, *436*, *542*.

offskip, DATT.

offstanding, S-4905/*227*①.

og and oog, CEA/*267*.

O gauge, CEA/*697*.

Ogboni, C-1082/*51*.

OG clock, CEA/*239*①; EA.

Ogden, John, Sunderland, C-2489/*81*.

ogechi, SDF.

ogee, ACD; C-0982/*50*; C-1407/*59*; C-2388/*3*; C-2402/*69*; C-5114/*287*, *302*①; C-5116/*6*; C-5127/*66*; C-5153/*85*; C-5156/*135*; DADA;

DATT; IDC; S-4905/*448*①; SDF/ ①.

ogee arch, C-2320/*32*.

ogee-arched, C-2320/*44*①; C-2388/ *23*; C-2421/*154*①.

ogee-arched frieze, C-2403/*136*.

ogee arched skirt, C-5114/*358*①.

ogee banding, C-0279/*453*①.

ogee bowl, ACD; CEA/*423*①; EG/ *139*①; LAR82/*429*①; LAR83/ *450*①.

ogee bracket foot, C-2320/*48*①; C-2388/*62*①, *113*; C-2421/*149*①; C-5114/*307*①, *391*①; C-5116/*5*, *140*①; DADA; K-802/*15*; LAR82/ *281*①; S-4414/*388*①, *392*, *434*①, *440*①; S-4436/*62*; S-4461/*583*; S-4812/*19*①.

ogee (OG) clock, EA.

ogee-cut frieze, LAR83/*327*①.

ogee feet, S-3311/*109*.

ogee foot, SDF.

ogee-fronted base, LAR83/*311*①.

ogee-molded base, C-5114/*396*①.

ogee molding, C-5114/*361*.

ogee moulded bowl, C-2458/*174*①.

ogee pediment, LAR83/*324*①.

ogee-shaped, IDPF/*100*①.

ogee-shaped bowl, CEA/*656*①.

OG Gothic, CEA/*246*①.

ogi (folding silk fan), JIWA/*165*.

ogival, C-2458/*50*; C-5189/*92*; CEA/ *119*①; S-3311/*189*.

ogivale, S-4972/*464*.

ogival medallion, C-2388/*166*.

ogival moulding, CEA/*300*.

ogival outline, CEA/*620*①.

ogival wing, S-4905/*393*①.

ogive, SDF/① *ogee*.

Ogurdjalis carpet, S-4948/*60*①.

O'Hara, Colonel James, CEA/*55*①.

O'Hara Glass Works, DADA/ *Supplement*.

Ohr, George, C-5191/*13*; EC1/*77*①.

Ohrenhenkel (ear handle), MP/*486*.

Ohrström, Edvin, DADA/*Supplement*.

oignon, CEA/*257*①; LAR82/*243*①.

oignon verge, C-MARS/*183*①.

oignon watch, EA/①.

oil, C-5005/*349*①; C-5146/*74*①; C-5236/*811*①, *1801*①; C-5239/ *197A*①; DATT; JIWA/*20*①; LP, *brushes*; NYTBA/*191*①.

oil and vinegar-bottle, C-5117/*242*①.

oil and vinegar stand, EA/① *cruet frame*.

oil black, DATT.

oil-bottle, IDC.

oil bottle, C-0706/*40*.

oil can, C-0254/*182*.

oil color, DATT.

oil-dropper, IDC.

oiled paper, JIWA/*196*.

oil flask, IDPF/*168*; JIWA/*346*.

oil-gilding, IDC.

oil gilding, EA/*gilding, gilding*.

oil green, DATT.

oil index, LP.

oiling out, DATT.

oil-lamp, CEA/*203*①.

oil lamp, C-1006/*18*; C-1502/*212*; C-5114/*131*; C-5239/*104*; K-802/ *16*.

oil length, DATT.

oil of cloves, DATT.

oil of lavender, DATT.

oil of turpentine, DATT.

oil on board, C-5156/*264*.

oil on canvas, C-5156/*269*①, *283*①; C-5167/*87*①; JIWA/*21*①.

oil on paper, JIWA/*22*①.

oil paint, JIWA/*403*.

oil painting, C-5114/*180*①.

oil painting, development of, DATT.

oil pan lamp, S-4905/*345*.

oil reservoir, S-4461/*499*.

oil-resin varnish, LP.

oil size, DATT.

oilskin, LAR82/*36*①.

oil-soluble dye, DATT.

oil spot, C-5236/*1720*.

oil-spot glaze, IDC/①.

oil-spot glazing, JIWA/*352*.

oil-spotted, C-5191/*273*.

oil spotted, C-0225/*193*.

oil spot temmoku, DADA.

oil spotting, C-5239/*134*.

oilstone, DATT.

oil tempera, DATT.

oil varnish, DATT.

oily ingredient, DATT.

oinochoe, DATT; S-4973/*336*①.

ointment jar, IDPF/*168*.

ointment-pot, IDC.

Oiron faience, IDC.

oiticica oil, DATT.

ojime, C-1082/*135*, *153*; C-5127/*631*; C-5156/*695*①; C-5236/*779*; CEA/ *561*, *575*; S-4928/*123*; S-3312/ *1057*.

Okawachi, ACD.

okibirame, C-5156/*717*①; S-3312/ *1063*①; S-4829/*31*①; S-4928/ *135*①.

okimona-type, C-1082/*131*.

okimono, C-5127/*635*; C-5236/*797*①; LAR83/*474*①; S-3312/*1156*①; S-4829/*106*①; S-3312/*1164*①.

okimono style, C-5127/*524*; C-5156/ *662*.

oklad, RGS/*52*, *124*①.

Okochi, DADA.

okubi-e, C-5156/*965*①, *1017*①; C-5236/*948*, *1006*, *1010*.

OL, CEA/*148*①; EA/*Olerys, Joseph*.

Olbrich, Joseph Maria, DADA/ *Supplement*.

old blue, DADA/*Supplement*.

'old brilliant' cut, RGS/*68*.

Old Caucasian, OC/*64*①.

'old Chinese', OC/*234*.

Old Chinese, OC/*315*①.

Oldenberg, Claes, S-286/*66*.

Old English, C-0982/*209*; C-1407/*93*; C-1502/*80*.

Old English and bead pattern, LAR83/*578*①.

old-English pattern (on silver), C-5174/*530*.

old English pattern, C-5117/*34*; C-0103/*26*; C-0254/*115*; C-0706/ *12*; C-2202/*59*; C-2398/*15*; C-2487/*49*; C-5114/*9*; DADA; EA/①; S-2882/*951*; S-4414/*334*; S-4905/*222*.

Old English script, CHGH/*64*.

old English tail, SDF.

old fustic, DATT.

old Japan brocade pattern, IDC.

old Japan fan pattern, IDC.

Old Kingdom, C-1582/*11*; LAR82/ *32*①.

Old Lavah Kirman, CEA/*75*①.

old master, DATT; JIWA/*23*.

old mine diamond, S-291/*27*, *69*①.

old-mine diamond, S-291/*79*①, *204*①; S-4414/*2*①, *81*; S-4927/ *135*①.

Old Moor's Head, The, EA.

old Mosaik pattern, IDC.

old mossaik pattern, C-2493/*51*.

Old Nanking, DADA/①.

Old Newbury Crafters, C-0254/*235*.

old paint, NYTBA/*191*.

old pattern, IDC.

old rail wheel back, LAR82/*301*①.

old repairs, C-5117/*44*①.

Old Russian Style, C-5117/*315*①.

Old Sheffield, C-0254/*16*; C-1502/ *94*; C-2202/*94*.

Old Sheffield plate, C-0706/*101*.

Old Sheffield style, C-0706/*106*.

'old style', OC/*123*.

'old-style' Ardebil, OC/*241*.

Old Suiyuan, OC/*316*①.

Old Testament scene as motif, C-2421/*10*①.

old wedgwood, IDC.

oleaginous style, EA/*Dutch grotesque style*.

oleander wood, DADA.

oleograph, DATT.

oleometer, S-4881/*141*①.

oleoresin, DATT; LP.

Olérys, Joseph, CEA/*148*①.

Olerys, Joseph, EA.

Olérys-Laugier factory, CEA/*148*①.

oleum white, DATT.

olio d'Abezzo, DATT.

oliphant, LAR83/*472*①.

Olitsky, Jules, S-286/*67*.

olive, DSSA.

olive green, DATT.

Olive pattern, C-0254/*176*.

Oliver: Isaac, Peter, EA/①.

Oliver No. 6 typewriter, C-0403/*4*.

olive spoon, C-0270/*248*; EA/① *strainer-spoon*.

olive wood, SDF.

olivewood, ACD; C-2364/*55*①; C-5116/*168*①; DADA; LAR82/ *78*①.

olivier wood, DADA.

olla, IDC; IDPF/*168*.

ollio-pot, IDC.

ollio pot (Ollientopf), EA/①.

Ollivants & Botsford, Manchester, C-2489/*236*①.

Ollivier, CEA/*145*①.

Ollivier: François, Jacques-Marie, François I, Jacques-Marie II, EA.

Olmec style, C-1082/*22*.

Olorenshaw, J., C-5117/*449*.

olpe, DATT; IDC/①; IDPF/*168*;
S-4807/*491*; S-4973/*122*①.

Olsen, Michel, S-4944/*144*①.

oltremontani, DATT.

Olympia blue, DATT.

Olympic, OPGAC/*345*.

ombres chinoises, JIWA/*266*.

ombre table, EA; SDF.

Ombrierte deutsche Blumen, IDC.

Omega, C-5167/*147*.

omega furniture, SDF.

Omega mark, C-5005/*218*①.

Omega Workshops, SDF/*760*.

omnium, ACD; EA/*whatnot*; SDF.

omphalos, IDPF/*169*.

Omuro, DADA.

On a Watch, C-2704/*7*.

Ondines, S-3311/*881*.

O'Neale, Jeffrey H., ACD.

O'Neale, Jeffrey Hamet, CEA/*188*①.

O'Neale, Jeffryes (Jeffrey Hammet),
EA.

'one at the hour' timepiece, LAR83/
*208*①.

one-handed dial, CEA/*224*①.

oneiric, DATT.

one-man exhibition, LP.

one-piece dial, CEA/*222*①.

one-point perspective, DATT.

one-string violin, C-5255/*32*.

one-stroke brush, DATT.

'one way' pattern, OC/*161*.

on furniture, EA/*ribband motif*.

ongarescha, IDC.

on-glaze, DATT; IDC.

on-glaze decoration, MP/*502*.

oni mask, CEA/*568*①.

onion cresting, LAR82/*42*①.

onion flower, C-2427/*114*.

onion foot, DADA; SDF.

onion pattern, CEA/*178*①; DADA;
EA/*Zwiebelmuster*; IDC; LAR82/
*151*①; MP/*104*; S-4461/*137*.

onion shape, C-5146/*89B*①; CEA/
*57*①.

onion vase, C-0225/*331*①.

oni support, LAR83/*153*①.

Onolzbach, DADA; EA/*Ansbach*,
Ansbach.

Onondaga Pottery Company, DADA/
Supplement.

onos, IDC.

Onoto pens, C-0403/*28*.

O.N.P., EA/*O'Neale, Jeffryes*.

Onslow pattern, C-5117/*63*; C-5173/
*35*①; DADA; EA/①; S-2882/
1110, 1116; S-4922/*34*①.

On the Meditation of Death, C-2704/
20.

onyx, C-0982/*238*; C-2482/*151*;
C-5005/*370*①; C-5116/*169*①;
DADA; DATT; EA/*chalcedony*;
JIWA/*321*; S-2882/*1428*①;
S-4461/*655*; S-4507/*44*①; S-4992/
*25*①.

onyx base, C-0225/*119*; S-2882/*528*;
S-4414/*167*①.

onyx marble, DADA; DATT; EA.

onyx socle, S-4414/*168*①.

OO gauge, CEA/*697*.

OOG clock, CEA/*246*①.

oölitic rock, DATT.

Oosterwijk, Joh., S-4927/*62*①.

opacified, CEA/*169*.

opacifier, DATT.

opacity, DATT.

opal, C-0225/*285*; C-5239/*134*; EA;
JIWA/*186*①; LAR82/*499*①;
RGS/*80*; S-3312/*1238*.

Opale, LAR82/*454*①.

opalene shade, C-1702/*121*.

opalescence, DATT.

opalescent, C-0225/*166*; C-5005/*240*;
C-5146/*144B*; C-5239/*121, 125*;

CEA/*111, 477*①; LAR82/*432*①;
LAR83/*422*①; NYTBA/*281*;
S-4414/*176.*

opalescent border, S-4414/*224.*

opalescent cornucopiae, S-4414/
*225*①.

opalescent dewdrop glass, DADA.

opalescent enamel bead, RGS/*145*①.

opalescent feather device, S-2882/
1321.

opalescent glass, S-2882/*1200*①;
S-4414/*201*①.

opalescent glass bowl, S-4414/*182.*

opalescent-tipped petal, CEA/*499*①.

opal glass, EA/*Clichy*; EC1/*56, 65*①;
JIWA/*310.*

opaline, ACD; C-0249/*218*; C-5189/
93; EA/①; EG/*169*; LAR82/
*438*①; NYTBA/*281*; S-4461/*15.*

opaline glass, C-0906/*135*; EG/*39*①;
LAR83/*439*①.

opaline glass lustre, S-3311/*463.*

opaline paper, DATT.

opaque, C-0225/*204*; C-5005/*256*①;
C-5117/*355*; C-5127/*17, 102*;
C-5239/*323*; CEA/*416*①; EG/*22*;
JIWA/*40*; LP; S-4972/*415.*

opaque black, DATT.

opaque china, IDC; S-4843/*170*①.

opaque colored glass, DADA/
Supplement.

opaque-enameled collet, S-291/*240*①.

opaque glass, C-2357/*4*; JIWA/
*304*①.

opaque glaze, C-2458/*183.*

opaque-opaline glass, LAR83/*412*①,
*440*①.

opaque porcelain, IDC.

opaque projector, DATT.

opaque twist, CEA/*503*; EA; EG/
*287, 292*①.

opaque-twist glass stem, ACD.

opaque-twist stem, CEA/*423*①.

opaque white, DATT; IDC.

opaque-white glass, EA/①.

opaque white glass, DADA/
Supplement.

op art, DATT/①; LP.

Opax, DATT.

open, C-2403/*203*; DATT; S-4972/
*473*①.

open-air still-life, JIWA/*87*①.

open-arm, C-0982/*20.*

open armchair, C-0279/*334*①;
C-0982/*106*; C-2478/*34*; C-5116/
58; C-5157/*53*①; S-3311/*196*①.

open-arm settee, C-0982/*107.*

open arm settee, C-0982/*36.*

open-arm sofa, C-1407/*22.*

open back, C-0249/*457*①; C-0279/
345; C-5116/*58*; OC/*32.*

open back chair, SDF.

open-backed mount, RTA/*37*①.

open boat form, S-4414/*329*①.

open-carved, S-4881/*391*①.

open composition, LP.

open exhibition, LP.

openface, C-0270/*118*; C-5117/
*419*①; S-4461/*303.*

openface lady's watch, C-5117/*478*①.

openface lever watch, C-5117/*402.*

openface wactch, S-4802/*2*①.

openface watch, S-4927/*38*①.

open foliate scroll handle, S-4414/
*293*①.

open form, LP.

opening, DATT; LP.

open key-pattern roundel, C-2403/
193.

open knot, EA/*Persian knot,* ①
Persian knot.

open landscape, JIWA/*140*①.

open library bookcase, C-5157/*170*①.

open medallian, S-4414/*262.*

open mount, RGS/*199*①.

open rectangular link, S-291/*128.*

open robe, C-1506/*40.*

open salt, DADA.

open screen, C-1407/*182*.

open scroll, C-1082/*134*.

open scrollwork, S-291/*240*①.

open shelf, C-0982/*23*; S-4972/*625*.

open-sight, C-2476/*4*.

open space, EC2/*24*.

open splat back, S-4461/*630*.

open spout, IDPF/*214*①.

open thumbpiece, EA.

open twist, SDF/①.

openware lantern, EA.

openwell, C-0249/*326*.

openwing armchair, C-5146/*121*①.

open-work, RTA/*76*①, *104*①.

openwork, C-5005/*205*①, *220*①; C-5117/*173*; C-5127/*117*①, *330*①; C-5156/*42*; C-5234/*11*①; C-5236/*332*①; DADA/①; LAR83/*539*①; S-291/*5*; S-4461/*203*; S-4905/*28*; S-4922/*6*①.

open-work arch, RTA/*48*①.

openwork base, C-5146/*47*.

openwork basket, C-2398/*96*①.

openwork border, EC2/*22*①.

openwork cap, S-291/*224*①.

openwork coil, S-4414/*133*.

openwork design, S-4414/*8*①.

openworked rosette foot, S-4414/*343*①.

openwork finial, S-4414/*257*①.

openwork flame nimbus, C-5234/*29*①.

openwork foliated design, S-291/*115*①.

openwork foliate engraving, S-4414/*44*.

openwork foliate scroll support, S-4414/*264*①.

open work foot, C-5114/*11*.

openwork foot, S-4922/*53*①.

openwork frieze, C-5146/*183*①.

open-work handle, CEA/*465*①.

openwork handle, C-5156/*107*.

openwork laurel, S-3311/*654*①.

open-work leaf, RTA/*32*①.

openwork lotus diadem, C-5234/*17*①.

openwork mount, C-0225/*348*; S-4414/*10*①.

openwork neck, NYTBA/*143*①.

openwork panel, C-0406/*123*.

openwork scroll thumbpiece, S-2882/*1133*①.

openwork shell, S-2882/*1108*①.

openwork shell and scroll foot, C-5117/*71*①.

openwork stem, C-5117/*206*; S-4414/*342*①.

openwork support, S-4922/*6*①.

openwork trefoil mandorla, C-5234/*57*①.

openwork twig, S-4414/*313*①.

opera glasses, S-3311/*553*.

opera length, S-291/*121*.

ophite, DATT.

opium box, IDPF/*169*.

opium pipe, C-2513/*57*.

Oppenheim, Meyer, EA.

Oppenord, Gilles-Marie, DADA.

Oppenord, Gilles Marie, EA.

Opportunity, DSSA.

opposed, C-5239/*39*.

opposing, C-5116/*153*①.

opposing attitude, C-2403/*5*.

opposing corner, C-2403/*205*.

opposing drawer, C-5116/*80*.

opposing sham drawer, C-5116/*133*①.

Ops, DSSA.

opthalmoscope, C-0403/*249*.

Optical Art, LP.

optical bench, C-0403/*192*.

optical glass, EG/*284*.

optical gray, LP.

optical illusion art, DATT/①.

optical mixture, DATT; LP.

optical separation, JIWA/*89*①.

optical square, C-2904/*72*.

optical structuring, JIWA/*338*①.

optic diamond pattern, C-5191/*249*.

Optician, C-2904/*123*①.

optic reactive, C-5191/*434*.

optic star pattern, C-0225/*329*.

optic swirl pattern, C-5239/*298*.

optic twist, C-5191/*460*.

opus anglicanum, DADA; CEA/*294*; C-0405/*169*; CEA/*275*.

opus araneum, DADA.

opus consutum, DADA.

opus filatorium, DADA.

opus interrasile technique, RTA/*39*①.

opus tiratum, DADA.

orange, C-0405/*142*; SDF.

orange blossom, C-1506/*77*.

orange Fitzhugh pattern, C-2513/*315*①.

orange lustre, C-2204/*82*.

orange mineral, DATT.

orange-peel effect, CEA/*137*①; DATT.

orange pigment, DATT.

orange-rind texture, NYTBA/*158*.

orange skin, IDC.

orange-sprig border, S-4843/*138*.

orange stand, MP/*108*.

orange-strainer, C-2398/*49*.

orange strainer, C-0254/*164*①; C-5117/*248*; C-5174/*552*.

orange tub, C-2486/*12*; IDC/①.

orange vermilion, DATT.

orangeware, S-4807/*281*.

orange wood, DADA.

orant, DATT.

orb, C-0279/*172*①; C-5191/*477*; C-5239/*337*; DSSA; S-2882/*656*①.

Orbea, Manuel, Madrid, C-2503/*149*①.

orb terminal, S-4414/*241*①.

orca, IDC.

orchil, DATT.

order, DADA.

ordered still-life, JIWA/*87*.

ordering, JIWA/*16*.

orders of architecture, SDF/①.

Ordinair-Ozier, IDC.

Ordinances of the Craft of Pewterers of London, CEA/*580*.

ordos, C-2458/*210*①; C-5156/*183*.

Ordos style, EA.

Orefors, C-5191/*247*.

organ, DSSA.

organdie, C-3011/*20*.

organdie trim, C-0405/*99*.

organic, C-GUST/*159*①.

organic pigments, DATT.

organistrum, EA/*hurdy-gurdy*.

organ pipe, MP/*77*.

organ pipe pleat, SDF/*cartridge pleat*.

organza, C-3011/*3, 29*.

oribe, C-5127/*385*; C-5156/*786*.

Oribe ware, DADA; EA.

Oriental, LP/① *brushes*.

oriental alabaster, DADA; EA/*onyx marble, onyx marble*; DATT.

oriental carpet, OC/*10*; CEA/*75*.

oriental carved, C-0906/*83*.

Oriental decoration, S-4461/*366*.

Oriental export porcelain, IDC/①.

orientalizing, IDPF/*8*.

Orientalizing period, DATT.

oriental Lowestoft, DADA; EA; IDC.

Oriental manner, C-5005/*338*①.

oriental pearl, S-291/*165*①, *215*①.

oriental poppy, OPGAC/*183*.

oriental rug, DADA/①; OC/*10*; C-0225/*102*.

oriental sapphire, RTA/*62*①.

oriental style, C-5153/*5*①; RGS/*52*①.

orient yellow, DATT.

original, C-0706/*219*; C-2458/*184*; DATT.

original plate, NYTBA/*200*.

original print, DATT.

original print run, JIWA/*12*.

original work, NYTBA/*9*.

Orinak rug, DADA.

Orion, DSSA.

Orivit, C-5239/*102*.

Orkney chair, C-2910/*268*.

orlean, DATT.

Orléans, CEA/*61*; DADA.

Orloff Service, EA.

orme wood, DADA.

ormolu, ACD; C-2478/*2*; C-5116/ *37*①, *43*①; C-5127/*108*①; C-5156/*106*①; CEA/*182*①, *226*①, *264*①, *303*, *355*①, *406*, *448*①; DADA/①; DATT; EA; IDC; S-4972/*152*①, *429*; SDF/①.

ormolu base, S-4461/*490*.

ormolu block sabot, C-0279/*400*①.

ormolu border, C-0279/*450*①.

ormolu-bordered, C-2437/*49*.

ormolu capital, C-0279/*452*.

ormolu cushion base, LAR83/*39*①.

ormolu foot, C-0279/*181*.

ormolu-galleried, C-2403/*123*.

ormolu leaf sabot, C-0279/*372*①.

ormolu mount, C-0982/*1*; LAR82/ *140*①.

ormolu-mounted, C-2402/*127A*; C-5157/*16*; CEA/*381*①; S-2882/ *797*①; S-3311/*395*①; S-4804/ *472*①; S-4853/*375*①.

ormolu-mounted frieze, C-5116/*104*.

ormolu star, C-0249/*456*①.

or moulu, ACD; EA/*ormolu*.

Ormskirk watch, EA.

ornament, C-1082/*38*; C-2421/*8*①; C-5114/*190*; C-5153/*47*①; EC2/ *24*; LP; NYTBA/*23*; SDF/①.

ornamental band, C-5114/*241*; C-5153/*13*①.

ornamental border, C-5114/*82*.

ornamental form, JIWA/*6*.

ornamental interpretation, JIWA/ *278*①.

ornamental iron, NYTBA/*252*.

ornamental knop, CEA/*582*①.

ornamental mirror, MP/*132*.

ornamental motif, JIWA/*75*.

ornamental naturalism, JIWA/*297*.

ornamental pattern, JIWA/*205*.

ornamental plate, JIWA/*84*.

ornamental sword guard, JIWA/*6*, *8*.

ornamental wrapper, C-0225/*385*.

ornamented shoulder, RTA/*92*.

ornamenting, IDC.

ornamentistes, NYTBA/*145*.

ornaments d'eglise, C-0405/*201*.

ornate bow-knot, S-4414/*89*.

ornate formal device, S-4881/*234*①.

ornemaniste, CEA/*375*①, *406*.

ornithoid porcelain, IDC/①.

ornithological plate, C-2427/*77*; C-2486/*71*①.

Orozco, Jose Clemente, S-286/*374*①.

Orpheus, DSSA.

Orphic Cubism, LP.

Orphism, DATT; LP.

orphrey, C-2501/*81*; CEA/*281*①, *294*; DADA; C-1304/*224*.

orpiment, DATT.

Orr, Hugh, CEA/*37*.

Orrefors, C-2324/*109*; C-2409/*12*; C-2910/*8*; DADA/*Supplement*.

orrery, ACD; CEA/*603*①; DADA; EA; SDF.

Orr's white, DATT; LP.

Orry de Fulvy, Jean-Louis-Henri, EA.

Ortaköy, OC/*240*①.

Orthodox cross, C-5117/*342*①.

orton cone, IDC.
Orvieto, C-2427/*253*; DADA; EA.
Osaka artists, S-4928/*27*.
Osaka School, C-5156/*920*.
osanyin staff, S-4807/*416*①.
oscillating outline, JIWA/*266*.
oscillating wheel, EA/*balance*.
oscillation, EC2/*96*①.
oscillum, LAR83/*163*①.
os de mouton, C-5259/*451*.
os de mouton scroll, EA/*ram's horn, ram's horn scroll*.
os de mouton stretcher, S-4972/*470*.
osier, IDC; SDF.
Oslo, C-2904/*264*.
osmolduk, OC/*30*.
ossekopp, EA.
ostensory, EA/① *monstrance*, ① *monstrance*.
Osterbro, DADA.
Osterbro factory, CEA/*149*①.
Osterlind, Allan, S-286/*375*.
Osterspey, Jakob, EA.
ostrich cup, LAR83/*571*①; DADA.
ostrich egg, LAR82/*36*①.
ostrich-egg cup, EA.
ostrich feather, C-0405/*90*; C-1304/*41*; C-1506/*52*.
ostrum, DATT.
Ostwald Color System, LP.
Ostwald system, DATT.
o-tanzaku, C-5236/*947, 1035*.
Ott & Brewer, CEA/*208*①; NYTBA/*180*.
Ott and Brewer, CEA/*205*.
Ott and Brewer Company, DADA/*Supplement*.
Otten, Mitzi, C-5167/*160*.
ottoman, ACD; C-5239/*270*①; DADA.
ottoman (ottomane), EA/①.
ottoman, SDF/①.

Ottoman-Cairene carpet, EA/*Turkish Court Manufactory*.
Ottoman (Ottoman-Cairene) carpet, EA.
Ottoman carpet, EA/*Turkish Court Manufactory*; S-4847/*295*.
ottomane, DADA/①.
ottoman footstool, SDF/①.
Ottoman inspired field, S-2882/*156*①.
ottoman stool, C-2402/*14*.
Ottonian art, DATT/①.
Ottweiler, DADA; EA.
Ouchak rug, ACD.
Oude Amstel, DADA.
Oude Loosdrecht, CEA/*181*①; DADA; EA.
Oude Moriaenshooft, 'T, EA/*Old Moor's Head, The*.
Oudenaarde tapestry, EA; S-4972/*170*①.
Oudenarde tapestry, C-2546/*140*①; DADA.
Oudin, C., C-2489/*145*.
Oudin, Ch., S-4927/*195*.
Oudin, Charles, C-5117/*476*①.
Oudin, Geneva, C-2489/*208*.
Oudry, Jean-Baptiste, EA.
Oudry, Jean Baptiste, DADA.
oushak, C-5259/*376*; C-5189/*376*; C-5323/*15*; CEA/*78*①; DADA; S-4847/*97*①; S-4948/*145*.
Oushak (Ushak) carpet, EA.
Oushak carpet, S-4796/*219*①.
Oustri-Nan, DADA.
outcrop, C-2458/*251*.
out-curved arm, C-2364/*44*①.
out-curved knee, C-5116/*161*①.
outcurving, C-5116/*78*①.
outer border, C-5114/*6*.
outer case, C-5117/*460*.
outer guard, C-5189/*360*.
outer reeding, C-5117/*174*①.
outer shaded, C-2403/*212*.

outline, C-0982/*56*; C-5236/*1055*①; JIWA/*20, 50*; LP; S-4922/*30*①.

outlined, C-1006/*3*; C-2502/*24*.

outline drawing, DATT; NYTBA/*196*.

outline form, JIWA/*127*.

outline stitch, CEA/*285*①.

out-quenchers, EA/*douters*.

outré, LP.

Outrebon, Jean-Louis, S-4944/*190*.

Outrebon, Jean-Louis-Dieudonné, EA.

Outrebon, Nicolas, II, EA.

out-scrolled, S-2882/*311*①.

outscrolled, C-0249/*367*; S-2882/*360*①; S-4507/*78*①.

out-scrolled arm, C-2388/*12*①; C-2421/*12*①; S-2882/*255*.

outscrolled arm, C-5116/*75*.

outscrolling, C-5157/*91*.

outset, S-4461/*600*; S-4972/*504*①.

outset bow-front, LAR82/*367*①.

outset bracket, S-2882/*289*.

outset corner, C-5181/*166*; S-4414/*526*①; S-4853/*333*①; S-4955/*192*①; S-4988/*446*①.

outset-rounded, C-5114/*271*①.

outset-rounded corner, C-5114/*389*①; S-4461/*600*.

outset rounded corner, S-4414/*479*①.

outset toe, S-2882/*330*.

outside count wheel, S-4955/*25*①.

outside decorator, ACD; EA; IDC.

outsplayed leg, S-4461/*685*.

outward curving handle, C-5114/*212*①.

outward flaring rim, S-4461/*216*.

outward-scrolled, S-2882/*671*①.

oval, C-5117/*81*; C-5153/*2*①, *2*①; C-5239/*95*.

oval-back Windsor, EA/*loop-back Windsor*.

oval base, S-4461/*105*.

oval basin, S-4905/*6*①.

oval bead, C-5156/*320*.

oval beaded, C-0406/*137*.

oval black opal, S-291/*44*.

oval bowl, C-5114/*18*.

oval brush, DATT.

oval bulbous form, S-4802/*333*①.

oval cartouche, C-0406/*84*; C-5117/*120*①; S-2882/*739*.

oval censer, C-1082/*154*.

oval-cut, S-291/*11*①.

oval-cut emerald, S-291/*96*①, *169*.

oval-cut sapphire, S-291/*86*①, *108*①.

oval dish, C-1006/*216*.

oval domed cover, C-5117/*140*.

oval-filbert, LP/① *brushes*.

oval floral reserve, S-2882/*1035*①.

oval foliate reserve, S-2882/*941*①.

oval foot, C-0254/*12, 109*; C-5156/*37*①.

oval glass cooler, MP/*169*.

oval grip, C-5114/*86*.

oval gulli-gul, S-4948/*69*①.

oval-inlaid top, C-2403/*73*.

oval map, C-2704/*1*.

oval medallion, C-0254/*68*; C-0279/*448*①; C-2402/*21*; S-4414/*281, 310*①, *339*①.

oval mixed-cut kunzite, S-4414/*67*①.

oval-panelled, C-2403/*88*.

oval peridot, S-291/*123*①.

oval plate, C-0982/*16*; C-2357/*24*①.

oval portrait miniature, S-4414/*419*①.

oval quatrefoil, LAR83/*104*①.

oval reserve, S-2882/*711*①.

oval ruby, S-291/*205*①.

oval sapphire, S-291/*199*①, *220*①.

oval scene, S-4922/*9*①.

oval shaft, C-2458/*224*.

oval-shaped amethyst, S-4414/*41*①, *54*.

oviform, C-0782/*25*; C-1006/*33*;
C-2427/*20*; C-2458/*9*①, *138*①;
C-5005/*236*; C-5127/*15*; C-5156/
*423*①; C-5236/*522*①; CEA/*152*①,
*641*①; IDC; IDPF/*169*; S-4802/
*427*①.

oviform vase, C-1006/*163*; C-5156/
36; LAR82/*119*①.

ovoid, C-0706/*2*; C-1502/*36*;
C-5116/*43*①; C-5127/*7*①;
FFDAB/*129*①; S-4992/*5*①.

ovoid body, S-2882/*1368*①, *1377*①.

ovoid contour, S-4414/*187*①, *188*,
*189*①, *210*①.

ovoid corner, C-5114/*344*①.

ovoid form, C-1082/*18*; S-2882/
*974*①, *975*①, *1208*①; S-4461/*7*,
41, *251*, *404*; S-4804/*34*.

ovoid knop, CEA/*426*①.

ovoid pedestal form, LAR83/*82*①.

ovoid shape, S-4972/*248*①.

ovoid-shaped, C-5117/*318*①.

ovoid vase, S-2882/*1230*.

ovoid vessel, S-2882/*1248*①, *1267*①;
S-4414/*215*, *232*.

ovoid volume, IDPF/*117*.

ovolo, ACD; C-0249/*294*; C-2498/*37*;
C 5114/*288*, *329*①; C-5116/*135*;
C-5117/*144*①; CEA/*639*①;
DADA; DATT/①; FFDAB/*57*;
IDC; S-4804/*8*; SDF/①.

ovolo-and-bead, C-0279/*364*; C-5116/
35, *124*.

ovolo-and-rosette, C-5116/*115*.

ovolo band, S-4804/*168*①.

ovolo border, C-2398/*32*; S-2882/*900*,
968, *1053*.

ovolo moulding, EA.

ovolo rim, S-2882/*1155*; S-4414/*277*.

ovolu border, C-0254/*143*①.

ovolu corner, LAR83/*361*①.

Owari seiji, EA.

Owen, George, C-2493/*206*①.

Owens machine, CEA/*50*.

Owens Pottery, EC1/*80*①.

Owlad, OC/*151*①.

Owlad Lurs, OC/*217*.

Owlad/Pashkuhi, OC/*152*①.

owl applique, S-4965/*133*①.

owl-form canister, S-2882/*1045*①.

owl-jug, IDC.

owl jug, ACD; CEA/*137*①; DADA/
①; EA; IDPF/*169*①.

ownership mark, IDC.

ox blood, DADA.

oxblood, C-5127/*131*; S-3312/*1366*.

ox-blood glaze, EA/①; IDC; JIWA/
*324*①.

oxblood glaze, C-5236/*1608*.

O-X border, IDC.

oxbow, DADA.

ox-box, LAR82/*282*①.

ox-eye cup, EA/*college cup*.

Oxford chair, EA; SDF/①.

Oxford frame, SDF/①.

Oxford hip bath, SDF.

Oxford Lavender, CEA/*59*①.

Oxford ochre, DATT.

Oxford type, IDPF/*179*①.

oxgall, DATT; LP.

ox hair, DATT; LP/*brushes*.

oxherd pattern, IDC/①.

ox-horn cup, DADA.

oxidation, CHGH/*58*.

oxide, DATT; IDC.

oxide of tin, CEA/*449*①.

oxidised, C-0403/*102*; C-2904/*73*.

oxidized, C-5236/*970*①.

oxidized brown, C-5323/*18*.

oxidized silver, IDC; RTA/*129*①.

oxidizing atmosphere, EA.

oxidizing fire, DATT.

oxidizing-kiln, CEA/*210*.

ox-nose finial, S-4965/*308*①.

oxyacetylene welding, DATT.

oxybaphon, IDC.

oxychloride cement, DATT.

oxydized ground, RGS/*61*①.

oyster, C-2388/*51*; C-5116/*101*.

Oyster, Daniel, DADA.

oyster board, SDF.

oyster bucket, S-3311/*125*.

oyster-burl, C-5116/*138*.

oyster fork, C-0254/*206*; C-5114/*16*; C-5153/*7*; C-5203/*222*; S-4804/*35, 64, 83*①.

oystering, DADA; EA/①; SDF/①.

oyster-kingwood, LAR82/*71*①.

oyster lunette, C-2403/*152*①.

oyster piece, SDF.

oystershell, EA/① *oystering*.

oystershell veneering, SDF.

oyster veneer, ACD; EA/*oystering*.

oyster-veneered, C-2421/*49*①; C-2498/*139*; C-5116/*101, 110*; C-5157/*120*; LAR82/*291*①.

oyster veneered, LAR83/*251*①, *261*①.

oyster veneer ground, S-2882/*290*①.

oyster veneering, CEA/*326*①.

oyster white, DATT.

oysterwood, SDF.

oysterwork, LAR82/*217*①.

ozen, DADA.

ozier, C-2427/*95*; SDF/*osier*; C-2427/*86*①; C-2486/*72*①; IDC/①.

Ozier border, C-2427/*45*; LAR83/*125*①.

ozier-pattern, C-2403/*9*.

Ozier pattern, DADA/①; EA.

Ozier Pattern border, MP/*122*.

Ozierrand, IDC.

Ozier rim, LAR83/*65*①.

P

pair, C-0982/*25*; IDC.

pair-case, C-2489/*249*①.

pair case, CEA/*250*; EA.

paircase, C-5117/*457*①.

pair-cased, C-2368/*191*.

pair-case watch, ACD.

pair case watch, S-4802/*134*①; S-4927/*33*①.

pair of hands in priestly (Kohanim) blessing motif, C-5174/*23*①.

pair of screens, JIWA/*157*.

pair of shoes, C-1506/*82*.

pair of tables, SDF.

pair plate, EA/*marriage plate*.

Pairpoint, C-2910/*35*; C-5005/*374*①; C-5191/*421A*①; K-711/*130*.

Pairpoint Corp., The, C-5167/*236*.

Pairpoint Corporation, DADA/ *Supplement*.

Pairpoint lamp, K-710/*118*.

Pairpoint Manufacturing Co., CEA/ *473*①.

Pairpoint puffy lamp, K-711/*126*.

pairs of socks, C-1506/*84*.

Paisley, C-1506/*1*.

Paisley design, C-2203/*15*.

Paisley motif, C-1506/*29*①.

pai ting, ACD; DADA; IDC.

paitung, C-5236/*1699*.

pai-tun-tzǔ, IDC.

pai tun tzu, ACD.

pai-tzǔ, IDC.

pai tz'u, DADA.

pai tzu, ACD.

Pajou, Augustin, EA.

PAK, EA/*Kocks, Adriaen*.

Pakistan Bokhara, C-0906/*29*; OC/ *181*①.

Pakistani Bokhara, S-4461/*787*.

Pakistan rug, C-2482/*4*.

paktong, ACD; CEA/*541*; DADA; EA; SDF.

pa ku, DADA/*hundred antiques*.

pa-kua, IDC.

Pa Kua, DADA.

Pal (Jean De Paleologue), S-286/ *4330*①.

palace bowl, CEA/*119*①; IDPF/*36*.

Palace pattern, CEA/*469*①.

palace ware, IDC/①.

Palais du Tribunat, C-0405/*203*.

Palais Royal, C-5181/*18*①.

Palais Royale, LAR83/*604*①.

Palais Royal style, C-2546/*22*.

palampore, DADA.

palanquin hook, C-5234/*146*①.

palanquin ring, C-5234/*145*①.

Pala Period, C-5156/*211*.

Palatine lion rampant, EA/ *Frankenthal*.

pale, C-5239/*251*; CEA/*594*; LP; S-4944/*20*①.

pale celadon, EA.

pale celadon stone, C-5127/*289*①.

Paleckh, C-0249/*165*.

pale family, EA.

pale flesh tint, JIWA/*24*.

pale green, C-2403/*191*; C-2704/*13*.

pale orange, C-2403/*197*.

Palermo maiolica, EA.

pale rose, C-2403/*183*.

pale sandy-yellow, C-2403/*191*.

pale silk, C-2704/*23*.

Palestine urn, IDPF/*106*①.

palette, C-5156/*149*①; DATT; IDC; LP/①; S-3312/*1107*①.

palette cup, DATT/①; LP/①.

palette knife, DATT/①; LP/①.

palette-knife painting, DATT.

palier, DADA.

palimpsest, DATT.

paling, C-2388/*106*.

paling-filled, C-2403/*41*.

palisade, C-5236/*1734*.

palisander, DATT; LAR82/*283*①; LAR83/*314*①; SDF.

palissander, CEA/*224*①; S-4972/*596*.

palissander double bed, C-5005/ *357*①.

palissander pedestal desk, C-5005/ *355*①.

palissandre, DADA.

Palissy, Bernard, ACD; CEA/*145*①, *151*①, *484*; DADA; EA/①; NYTBA/*134*①.

Palissy ware, DATT; IDC; NYTBA/ *134*.

palladian, LAR82/*337*①.

Palladian style, EA; NYTBA/*46*①.

Palladio, NYTBA/*46*①.

Palladio, Andrea, DADA.

palladium, S-291/*252*.

palladium helical spring, C-2489/*126*.

palladium leaf, DATT.

Pallas Athena, DSSA.

pallet, ACD; C-2489/*97*①; CEA/ *228*①, *267*; SDF.

pallet frame, C-5224/*53*.

palliase, SDF.

pallisander, S-4955/*110*①.

palm, DSSA/①.

palm crown, OC/*52*.

palm cup, ACD; EG/*47*.

Palmer, Humphrey, ACD; DADA; EA.

Palmer, Richard, C-5174/*419*①.

Palmer, Thomas, S-3311/*110*.

Palmer, William, Rochester, C-2503/ *182*.

palmer's shell, EA/*badge*.

palmette, C-2478/*230*; CEA/*91*①, *317*①; DATT/①; EA; IDC/①; OC/*11*①, *79*; OPGAC/*230*; S-288/*37*①; S-3311/*4*, *629*; S-4507/*17*①; S-4804/*2*; S-4847/*5*, *52*; S-4948/*88*①.

palmette and arabesque vine field, S-2882/*93*①, *155*①.

palmette and leaf scroll, S-2882/ *123*①.

palmette and leaf scroll border, S-2882/*218A*①.

palmette border, IDC; S-2882/*108*; S-4414/*543*①, *546*①; S-4847/*116*, *317*.

palmette cresting, C-5116/*167*①.

palmette design, EG/*100*.

palmette-form, S-3311/*18*.

palmette meander, S-3311/*18*.

Palmette pattern, C-0254/*262*.

palmette rug, S-4948/*58*.

palm leaf design, S-4461/*484*.

palm leaf ground, S-4922/*24*①.

Palmqvist, Sven, DADA/*Supplement*.

palm stand, SDF.

palm top motif, EA/*boteh motif*.

palm-tree thumbpiece, EA.

palmwood, S-4804/*848*; S-4972/ *503*①.

Palsjö, DADA.

pampilles setting, CEA/*521*①.

p'an, ACD; DADA; IDPF/*171*.

pan, C-2503/*148*①; CEA/*25*①.

p'an, EA.

pan, EA; IDC; IDPF/*170*; NYTBA/ *262*; S-4461/*617*; DSSA.

panagia, C-5174/*320*①.

panama, C-0405/*216*.

Pan Asian, C-5156.

Panathenaic amphora, IDC.

pan back chair, SDF.

pan bone, S-4881/*166*①.

pan bone section, S-4881/*16*①.

Pancai, Francesco Maria, C-5170/*29*.

pancake (pannekoek) plate, EA.

pancheon, IDC; IDPF/*64*, *171*①.

panchetto, DADA/①.

pan-cover, C-2569/*60*①; S-4972/ *155*①.

Panderma, C-2320/*141*; C-5189/*390*.

Panderma rug, C-1702/*37*.

Panderma Saph, LAR82/*545*①.

pandora, C-5255/*41*①; CEA/*552*①, *697*; DSSA.

panel, ACD; C-0249/*160*; C-0782/*21*; C-0906/*2*; C-2513/*78*①; C-5005/*349*①; C-5114/*136, 347*①; C-5116/*15*①; C-5117/*326*①; C-5236/*658*①; C-5239/*307*; CEA/*276*①; DADA; DATT; LP; S-3311/*86*①; S-4461/*126*; S-4922/*69*①; S-4972/*184*; SDF.

panel-back (pan), EA.

panel back chair, SDF.

panel case, C-0279/*285*①.

panel design, OC/*153*①, *217*.

paneled design, S-4461/*387*.

paneled leg, LAR82/*345*①.

paneled rail, S-2882/*767*.

paneled rim, S-4461/*227*.

paneled stem, S-4461/*110*.

paneled top-rail, S-2882/*772*.

paneled undulated border, S-4414/*293*①.

panel foot, CEA/*647*①, *657*①; LAR83/*585*①.

paneling, MP/*31*.

panelled, C-2402/*14*; C-5005/*202*①; C-5114/*308*①; C-5116/*147*①.

panelled angle, C-2437/*71*①.

panelled back, C-0249/*478*①.

panelled-back chair, DADA.

panelled body, C-2437/*34*①.

panelled border, C-0254/*312*①.

panelled cherry, OPGAC/*230*①.

panelled construction, SDF.

panelled cupboard, C-2421/*66*①.

panelled daisy, OPGAC/*230*.

panelled dewdrop, OPGAC/*231*.

panelled door, C-0982/*99A*.

panelled end, C-0249/*407*①.

panelled flute, S-4802/*169*.

panelled form, S-4804/*78*①.

panelled frame, C-0279/*416*.

panelled frieze, C-0249/*469*; C-2403/*142*.

panelled furniture, EA/*joined furniture*.

panelled neck, C-0249/*218*.

panelled pad foot, C-0279/*296*; C-5116/*63*①.

panelled pistol handle, S-4922/*38*①.

panelled plinth, C-0249/*477*; C-5116/*47*; S-4414/*385*①.

panelled slop-bowl, CEA/*676*①.

panelled support, C-5116/*154*①.

panelled thistle, OPGAC/*231*①.

panelled top rail, S-4414/*461*①.

panelling (in glass cutting), EA.

panelling, SDF/①.

panel moulding, C-2402/*29*.

panels of ho-o, C-0803/*3*.

panetière, DADA/①.

Pan Fei border, S-4843/*257*①.

Panier Mystérieux, le, IDC/①.

Pankok, Bernhard, DADA/*Supplement*.

Pannemaker: François, André, EA.

panne silk velvet, C-2203/*82*.

Pannetier's green, DATT.

pannier, C-2332/*69*.

pannikin, EA/*saucepan*, *saucepan*.

panoplie, DADA.

panorama, CEA/*697*; DATT.

panoramic coastal landscape, MP/*474*①.

Pan-Shan, CEA/*113*①.

Pan Shan Neolithic Chinese jar, IDPF/*106*.

Panshan pottery, IDC.

Pan-Slavic taste, C-5174/*217*.

pansy vase, C-0225/*274*.

pantaleon, EA/*dulcimer*.

pantheon, DATT.

'panther ring', RTA/*161*①.

pantin (dancing jack), CEA/*697.*

Pantin, Lewis, CEA/*649*①.

Pantin, Simon, CEA/*646*①; EA.

pantograph, C-0403/*196*; C-2608/ *133*; DATT/①; LP.

Paolo Veronese green, DATT.

Paolozzi, Edouard, S-286/*68.*

pao-pie, DADA.

pao-shan hai-shui, IDC.

Pao-Tu goods, OC/*123.*

pao-yueh p'ing, IDPF/*172.*

papal cross, DATT.

papal ring, RTA/*59.*

papal rose, EA.

papal sword, EA.

Papal workshop, EA.

pa-pao, IDC.

pa pao, DADA/*eight precious objects.*

pap boat, ACD; C-2202/*17*; C-5114/ *115*; DADA; EA/①; S-4944/*16*①; C-0254/*165A.*

pap-boat, C-5117/*36*; IDC/①.

pap bowl, DADA.

Pape, CEA/*550*①.

Pape, W. R., C-2476/*99.*

papelera, DADA.

paper, C-5156/*265*①; C-5236/*564*; C-5239/*198*; DATT; LP.

paperback magazine, C-0225/*411.*

paper clip, C-0254/*237*; C-5239/*91.*

paper cut-out, JIWA/*202*①.

paper cutter, C-0254/*62.*

paper dimensions, DATT.

paper holder, S-4905/*333.*

paper knife, C-1082/*151*; C-1502/*87*; C-5005/*381*; C-5236/*810*; C-5239/ *321.*

paper label, C-5114/*358*①; C-5239/ *241.*

paper micrometer, C-2608/*72.*

paper panorama, CEA/*685.*

paper rack, C-5146/*157.*

paper-scroll, C-2320/*90*; C-2522/ *151*①.

paper scroll, C-5236/*556.*

paper-scroll toprail, C-2388/*118*①.

paper stencil, JIWA/*6.*

paper-stencil method, DATT.

paper tester, C-2904/*78.*

papertone, S-286/*467.*

paper watermark, C-0249/*32.*

paper-weight, C-5117/*364.*

paper weight, S-4905/*333.*

paperweight, ACD; C-1502/*43*; C-2409/*21*; C-5191/*426*; C-5239/ *113*; CEA/*450*①, *489*; DADA; EA/*Baccarat,* ①; IDC; IDPF/ *172*①; LAR82/*448*①, *451*①; NYTBA/*284*①.

paperweight eye, C-0279/*193*①; CEA/*697.*

paperweight vase, CEA/*492*①.

paperwork casket, C-5157/*29*①.

papier-mache, C-2402/*32.*

papier-mâché, DADA.

papier-mache, LAR83/*50*①.

papier-mâché, S-3311/*253.*

papier-mâché, S-4461/*174.*

papier-mâché, SDF/①.

papier mâché, ACD.

papier mache, C-0906/*129.*

papier mâché, C-2421/*56.*

papier mache, CEA/*71.*

papier mâché, CEA/*299, 364*①, *684*; DATT; EA/①; JIWA/*342.*

papier mache, LAR82/*397*①.

papier maché, RGS/*38.*

papier mache, S-4436/*33.*

papier maché, S-4988/*537.*

papiers collés, DATT; LP.

Papillon, Jean, DADA.

Papillon border, S-4843/*280*①.

pappenheimer, DADA.

Pappenheimer type hilt, C-2569/*27.*

pap-spoon, IDC.

pap spoon, DADA.

pap-warmer, IDC.

Papworth, C-5189/*15*.

Papyrograph copying press, C-2608/ *18*.

papyrus bloom, RTA/*23*①.

Paquier, Claudius Innocentius Du, CEA/*175*①.

Pará balsam, DATT.

parabolic outline, MP/*488*①.

Paracas, S-4807/*65*①.

parachute, C-2368/*128*.

parachute (in watch), EA.

parachute suspension, S-4927/*67*①.

parade shirt, C-2503/*35*.

paraffin, C-2904/*13*; DATT.

paraison, EA/①; EG/*292*.

Parallel pattern, C-0254/*80*.

parallel perspective, DATT; LP.

parallel-plate levelling head, CEA/ *604*①.

parallel rule, DATT.

parallel ruler, CEA/*610*①.

parallel rules, C-2904/*226*.

parang ilang, C-1082/*8*.

parapet teapot, IDC.

para red, DATT.

parasol, C-2203/*6*.

parasol-form, S-3311/*160*①.

parasol handle, S-4804/*244*.

parasol pattern, IDC.

parasol table lamp, C-5005/*419*①.

parasu, C-5234/*62*①.

para wood, SDF.

Parbury, C-2489/*183*①.

Parcae, DSSA.

parcel, C-2402/*198*.

parcel-ebonized, C-5170/*136*①.

parcel-fluted colonnade, C-0249/*475*.

parcel gilded, DADA.

parcel gilding, CEA/*678*.

parcel-gilt, ACD; C-0225/*137*; C-1502/*85*; C-2398/*17*; C-2414/ *49*①; C-2421/*91*①; C-5116/*56*, *125*①; CEA/*312*①, *620*①, *639*①; DATT; RGS/*8*①; S-2882/*294*①, *526*①, *671*①; S-3311/*220*①, *393*①; S-4436/*104*①; S-4507/*8*①; S-4802/*192*; S-4922/*9*①, *12*①; S-4972/*428*.

parcel gilt, C-0982/*85*; C-5156/ *246*①; EA; LAR83/*37*①, *537*①; SDF.

parcel-gilt chalice, RGS/*17*①.

parcel-gilt footed cup, S-4804/*57*.

parcel-giltwood, S-2882/*397*.

parchemin panel, SDF/① *parchment*.

parchment, C-5174/*166*①; DATT; MP/*81*; NYTBA/*93*; SDF/①.

parchment disc, C-5005/*357*①.

parchment glue, DATT.

parchment panelling, EA/*linenfold paneling*.

parchment paper, DATT.

Pardoe, Thomas, C-2493/*12*①; EA/ ①.

parergon, DATT.

par excellence, LP.

parfait spoon, S-4804/*31*.

parget, DADA/①.

parian, CEA/*697*; K-710/*109*; LAR82/*97*①; LAR83/*85*①, *107*①; C-1006/*189*; S-4804/*269*①.

parian body, S-4992/*6*①.

parian bust, C-1006/*104*.

parian figure, C-1006/*1*.

Parian marble, DATT.

Parian porcelain (American), IDC.

Parian porcelain, IDC/①.

parian ware, EA; ACD; CEA/*210*; DADA, *supplement*; DATT; IDPF/ *32*①; NYTBA/*181*①; S-4461/*156*.

Parianware, CEA/*204*①.

Paris, ACD; DSSA.

Paris, School of, DATT; LP.

Paris black, DATT.

Paris blue, DATT; LP.

Paris cup and saucer, C-5181/*13*.

Paris green, DATT; LP.

Parisian Art Nouveau, DADA/
Supplement.

Parisian jewellery, CEA/*522*①.

Parisian style, MP/*154*.

Paris Observatory, CEA/*602*①.

parison, CEA/*70, 414*; EG/*162, 292*.

Parisot, Peter, EA.

Paris pattern, S-4804/*81*①.

Paris porcelain, DADA; EA/①;
S-3311/*358*①.

Paris tapestry, EA.

Paris touch, DADA.

Paris vase, LAR82/*162*①.

Paris white, DATT; LP.

Paris yellow, DATT.

Parker, CEA/*27*.

Parker, Isaac, CEA/*165*.

Parker, Samuel, S-286/*376*.

Parker, Theodore, S-4843/*302*①.

Parker, William, of London, CEA/*34*.

Parker and Wakelin, C-5117/*153*①.

Parker Duofold Special, C-0403/*14*.

Parker Field & Sons, London,
C-2503/*204*.

Parker propelling pencil, C-0403/*14*.

Parker & Wakelin, EA/*E. and J.*
Wakelin, Wakelin, Edward.

Parkinson & Frodsham, London,
C-2489/*125*.

park scene, MP/*63*.

park statuary, MP/*115*.

Parlante, faïence, IDC.

parliament clock, SDF; DADA.

parlor suite, C-0279/*273*; S-3311/
*220*①; S-4804/*824*①.

parlour, SDF.

parlour chair, EA; SDF/①.

parlour cupboard, SDF.

parmazo marble, DATT.

Parnassus, DSSA.

Parnassus service, EA.

Parolin, Francesco, CEA/*172*①.

parquetage, DATT.

parqueterie, SDF/*parquetry*.

parquetry, ACD; C-0279/*377*;
C-0982/*19*; C-2402/*155*; C-2409/
185; C-5116/*168*①; CEA/*300,
406*; DADA/①; EA; LAR82/
*235*①; LAR83/*257*①; S-2882/
*394*①; S-4853/*554*①; S-4988/
*545*①; SDF.

parquetry bone and ebony inlay,
S-2882/*773*.

parquetry fielded door, S-2882/*768*①.

parquetry ground, C-0279/*428*.

parquetry inlaid motif, LAR83/*366*①.

parquetry panel, S-2882/*802*①.

Parr, Thomas, LAR83/*157*①.

Parran, Beniamin, SDF/*760*.

parrot and vine, IDC.

parrot-beak, IDC.

Parrott, Alice Kawaga, DADA/
Supplement.

Parsils, A., NYTBA/*108*①.

parson and clerk, IDC.

Parsons, Edith Baretto, C-5191/*192*.

3-part, FFDAB/*69*①.

part desk set, C-5239/*91*.

part dessert-service, C-1006/*211*.

part flatware service, C-0254/*206*.

part-fluted, C-2202/*12*.

part fluted, C-0406/*47*; C-0706/*32*;
C-1502/*4*.

Parthian ware, IDC.

partial view, JIWA/*10*.

partie, CEA/*375*①, *406*.

parting compound, DATT.

parting shard, IDC.

parting tool, DATT.

partisan, C-MARS/*66*①.

partition, C-0906/*87*.

partizan, C-2503/*14*; DADA; S-4972/
*142*①.

partly draped, C-2398/*54*①.

partly fluted, C-5117/*116*①, *124*①.

partly-lobed, S-3311/*723*①.

partly lobed baluster form, S-2882/
*1152*①.

partly-lobed boat form, S-2882/*1040*.

partly lobed boat shape, S-2882/
*1151*①.

partly lobed body, S-2882/*1072*.

partly-lobed vase shape, S-2882/
*1146*①.

partly loved ovoid form, S-2882/
*1161*①.

partly matted, C-5117/*21*.

partly octagonal stem, C-5117/*241*①.

partly pierced, S-4905/*199*①.

partly reeded, C-5117/*175*①.

part marked, C-5117/*138*.

partmould, EG/*237*①.

partner's desk, C-2478/*198*①;
C-5239/*281*①; LAR83/*331*①.

partners' desk, EA; SDF.

partners desk, C-2421/*145*①;
C-5157/*127*.

partners writing desk, S-4804/*814*①.

partner's writing table, S-4988/*507*①.

Partridge, CEA/*609*①.

Partridge, Nehemiah, DADA.

partridge and scroll cresting, C-1407/
13.

partridge eye, IDC.

partridge-eye marble, DADA.

partridge-eye pattern, DADA.

partridge pattern, EA/*caille, caille*;
IDC.

partridge tureen, IDC.

partridge wood, ACD; DADA; SDF.

partridgewood, C-0982/*19*; C-5116/*7*.

part-silk kork, OC/*303*.

part-silk Qum, OC/*303*.

part-sized mold, NYTBA/*281*.

part-solitaire, S-4992/*84*①.

part spiral twist stem, C-0406/*38*.

part-tea service, S-4992/*17*①.

part tea-set, C-5117/*304*①.

parure, EA; RGS/*80, 199*①.

pasa, C-5234/*2*①, *62*①.

Paschal lamb motif, C-5174/*169*.

Pascin, Jules, S-286/*377*.

pas d'âne guard, DADA.

Pashkuhi, OC/*152*.

'Pashkuhi', OC/*217*.

Pasquale, EA/*Antonibon, Giovanni
Battista*.

passage, LP.

Passau, EA/*kaolin*.

Passau clay, EA/① *Ansbach*.

Passavant, Claude, EA.

passé, LP.

Passemant au Louvre, CEA/*264*①.

passement, DADA.

passementerie, DADA.

passementerie button, EA.

Passenger, Charles, C-2409/*140*.

passe-partout, DATT.

passglas, DADA; EA; EG/*90*.

Passion, DSSA.

Passover plate, C-5174/*43*①.

paste, C-5117/*462*; CEA/*210, 513*;
DATT; EA/①; IDC; JIWA/*310*;
S-4992/*28*①.

paste blue, DATT.

pasteboard, LP.

paste box, C-2513/*122*①.

paste brilliant, C-2437/*32*.

paste cluster, C-2332/*329*.

paste compounder, MP/*27*.

pastedown, S-4881/*44*①.

paste jewellery, EA/*259*①.

pastel, C-5005/*265*; C-5146/*76*;
DADA; DATT; JIWA/*26*①; LP;
S-286/*471A*.

pastel on monotype, JIWA/*253*.

paten, ACD; CEA/*485*①; DADA/
①; EA/①.

patent, C-2476/*64*.

Patent Arms Manufactury, CEA/
*39*①.

patent base wind, C-2368/*31*.

patent breech, C-2569/*57*.

patent chair, NYTBA/*76*①.

patent extending table, LAR83/
*377*①.

Patent Ironstone china, IDC; CEA/
*163*①.

Patent Magnetic Filter, S-4843/
*533*①.

patent metal, EA.

patent pinion, S-4802/*8*①; S-4927/
99.

Patent Specification Abridgements,
C-2904/*199*.

patent winding, C-5117/*455*①.

patent yellow, DATT.

patera, ACD; C-0982/*53*; C-5114/
*143, 332*①, *348*①; C-5116/*158*①;
CEA/*363*①, *406, 678*; DADA;
DATT/①; EA; IDC; IDPF/
*172*①; S-2882/*790*; S-4802/*6,
108*①; SDF.

patera carved, S-4436/*130*①.

paterae, C-0249/*424*; C-0270/*2*;
C-0982/*89A*; C-2402/*29, 46*;
C-5116/*16*①; C-5117/*47*①;
S-2882/*1003*①, *1071, 1144*①,
1155; S-3311/*599*.

patera heading, C-0982/*67*; C-1407/*5*.

paterai, S-4804/*115*.

Paterna, CEA/*131*①; EA.

Paterna ware, IDC.

paternoster, SDF.

pater nostreri bead, EA/*beads and
marbles*.

pâte-sur-pâte, ACD; C-0225/*45*.

pate-sur-pate, CEA/*210*.

pate-sur-pâte, DADA.

pâte-sur-pâte, EA; IDC; NYTBA/
179.

pate-sur-pate, S-4992/*6*①.

pâte-sur pâte, S-4804/*269*①.

pâte sur pâte, DATT.

pâte-sur-pâte technique, JIWA/*324*①.

pâte tendre, ACD; DADA; EA/
Porcelaine de France; IDC.

Pathier, Jean-Jacques, NYTBA/*42*①.

Patience, DSSA.

patina, ACD; C-0279/*91*①; C-1082/
1, 36, 60; C-2414/*8*①; C-5005/
*336*①; C-5114/*189*①; C-5156/*175*;
CEA/*406*; DADA; DATT; EA;
IDC; LP; OC/*214*; SDF; C-2409/
83.

patinated, C-0225/*31*; C-2323/*154*;
C-5005/*236*; C-5116/*43*①;
C-5127/*453*; C-5239/*58*; FFDAB/
*121*①; K-711/*127*; LAR82/*46*①;
S-2882/*412, 805*; S-4461/*53*;
S-4507/*40*①.

patinated bronze, C-5157/*14*;
LAR83/*40*①.

patinated-metal, K-711/*127*; S-4804/
*583*①.

patinated metal, C-2910/*223*.

patination, C-5005/*344*①; CHGH/
58; S-3311.

Patouilleau, R., C-5181/*68*①.

patriarchal cross, DATT.

patrician, OPGAC/*195*.

patriotic charger, IDC/①.

patriotic motif, EC2/*24*①.

patriotic plate, S-4823/*19*①.

patron, DADA; LP.

patron saint of gravel, C-2704/*43*.

patte, DATT.

pattern, C-5153/*5*①; DATT; LP.

pattern-book, C-5173/*68*①; RTA/*91*.

pattern book (in silver), EA/①.

1844 pattern carbine, C-2503/*100*.

patterned, C-2421/*20*.

patterned background, JIWA/*11*.

patterned block, C-2704/*61*.

patterned brocaded design, C-5156/ *35*①.

patterned figure, JIWA/*20*.

pattern glass, DADA/*Supplement*; NYTBA/*298*①.

pattern inlay, C-5114/*337*①.

pattern-making, JIWA/*52*①.

pattern-molded, EC1/*65*①.

pattern-molded glass, EC1/*56*.

pattern-moulded, EG/*181*①.

pattern plate, IDC.

patterns of graining, NYTBA/*34*①.

patterns of net, C-1506/*164*①.

pattern stringing, C-5114/*287, 315*①, *351*①.

Patterson, P., C-2489/*156*.

patty-pan, IDC.

patty pan, DADA.

Paul, DSSA.

Paul, Bruno, DADA/*Supplement*.

Paul, Nicolaus, CEA/*181*①.

Paul, Nikolaus, EA.

Paul de Lamerie, S-3311/*791*①; S-4922/*66*①.

pauldron, DADA.

Paulet, J., CEA/*253*①.

Paul Follot, C-5005/*354*①, *354*①.

Pauline Pottery, Chicago, Illinois, EC1/*85*.

Pauline Pottery, Edgerton, Wisconsin, EC1/*85*.

Pauline Pottery Company, DADA/ *Supplement*.

paulownia, C-2458/*362*; S-4461/*412*.

'Paul Revere' pattern, S-2882/*933*.

Paul Revere pattern, S-4905/*160*.

Paul Revere Pottery, Boston and Brighton, Massachusetts, EC1/*85*.

pault de soie, C-0604/*96*.

Pauzié, Jérémie, EA.

pavé, C-2398/*7*; EA/①; S-4927/*103*.

pavé diamond, RTA/*152*①.

pavement, C-5114/*148*①.

pavé-set, C-2332/*138*; CEA/*516*①; RGS/*116, 199*①; S-4414/*36*①, *92*①.

pave-setting, CEA/*524*.

pavé-setting, RTA/*95*.

pavilion, C-2403/*113*; RTA/*170*①.

pavilion decoration, C-0279/*443*.

pavilion scene, C-2513/*111*.

pavilion view, S-4823/*15*.

pavis, DADA.

pavonazzetto, DATT.

pavonazzo, DATT.

Pavonia, OPGAC/*231*.

paw and ball foot, DADA.

paw and foliage foot, C-5117/*233*①, *283*①.

paw and panel foot, S-4804/*105*.

paw caster, C-5116/*104, 123*.

paw castor, LAR83/*366*①.

paw foot, C-0782/*225*; C-1006/*56*; C-2364/*21*①; C-2398/*32*; C-2402/ *4*; C-5114/*27*①, *234*①; C-5116/*17, 84*; C-5259/*540*; DADA; EA; S-4414/*257*①; S-4804/*10*; SDF/ ①.

pawlonia kanemono, C-0282/*125*.

paw sabot, C-0279/*423*; C-2364/*58*①.

paw support, C-2427/*247*; S-2882/ *1022*.

pax, C-5234/*263*①; DADA; EA; IDC; S-4972/*308*①.

pay foot, S-4461/*225*.

Payne, John, C-5173/*33*①.

Payne & Co., LAR82/*223*①.

Payne's gray, DATT.

paysage, DATT.

Pazyryk carpet, EA; OC/*13*①, *35*①.

PC, EA/*Crespin, Paul*.

P.Dam, EA/*Rewend, Christian F.*.

PE, EA/*Mennicken family*.

Peabody, CEA/*37*.

Peace, DSSA.

Peacemaker, CEA/42①.

Peace medal, K-710/*118*.

peach, C-0405/*154*; DSSA; IDC.

peach black, DATT.

peach-bloom, EA/①.

peach bloom, CEA/*111*; DADA; DATT.

peachbloom, C-2513/*271*.

peach-bloom glaze, IDC.

peachbloom glaze, C-5156/*145*.

Peach-bloom vase, CEA/*122*①.

peach-blow, LAR83/*446*①.

peach blow, EC1/*55*①, *56, 58*①; LAR83/*432*①; OPGAC/*172*.

peachblow, DADA; DATT; K-711/*130*; LAR82/*435*①.

Peach Blow, CEA/*472*①; NYTBA/*302*.

Peach Blow pitcher, EG/*200*①.

peach dish, S-4965/*295*①.

peach-form, S-4965/*83*①.

peach glass, C-5146/*89A*①.

peach gum, DATT.

peach-shaped, IDC.

peach spray, C-2458/*283*.

peach wine-pot, IDC.

peacock, DSSA.

Peacock, The (De Paeuw), EA.

peacock blue, C-1603/*55*①; DATT.

peacock design, NYTBA/*140*①.

peacock feather, K-710/*118*; OPGAC/*231*.

peacock-feather decoration, IDC.

peacock feather motif, EA.

peacock feather ornament, NYTBA/*141*①.

Peacock Feather pattern, C-0225/*284*.

peacock-feather-type motif, JIWA/*132*.

peacock finial, C-5156/*816*①.

peacock green, S-4905/*310*①.

peacock handle, C-5156/*421*①.

peacock in its pride, S-4802/*201*①.

peacock jar, IDC.

peacock lamp, C-0225/*340*.

peacock panel, JIWA/*376*①.

peacock pattern, C-0782/*21*; C-2486/*172*; LAR82/*112*①; LAR83/*87*①.

Peacock pattern plate, S-4823/*32*①.

peacock plate, EA; NYTBA/*140*①.

peacock table lamp, C-5005/*407*①.

pea green, EA; IDC.

peak, CEA/*594*.

Peale, Charles Wilson, EA.

peapod, IDC.

pear bottle, IDPF/*173*.

Pearce, David, CEA/*60*①.

Pearce, Edmund, CEA/*645*①.

pear-drop, C-0982/*256*.

pear drop, DADA.

pear-drop handle, LAR82/*324*①; LAR83/*326*①.

peardrop handle, SDF.

pear-form, S-3311/*765*①.

pear form, S-4922/*26*①.

pear form body, S-4414/*261*.

pear-form tea-pot, CEA/*673*①.

pearl, C-2458/*39*; C-5005/*215*①; C-5117/*361*①; C-5236/*395*①; DADA.

pearl border, C-0254/*166*.

pearl choker, CEA/*520*.

pearled, RTA/*78*①.

pearled band, RTA/*75*①.

pearled border, RTA/*78*①.

pearl glass, EG/*127*①.

pearl-handled, S-4461/*386*.

pearling, CEA/*655*①.

pearls, C-5146/*70A*.

pearl satin, EC1/*56, 60*①.

pearl-tie, DADA.

pearl ware, DADA.

pearlware, C-1006/*9, 36, 89*; C-2204/*43*; C-2493/*2*; C-2502/*11*; EA;

IDC/①; LAR82/*177*①; LAR83/
*71*①, *121*①; S-4804/*479*; S-4843/
*150*①.

pearl-white, IDC.

pearl white, DATT.

pearly costume, C-2203/*47*.

pear motif, DADA; EA/*boteh*.

pear-shape, C-2458/*4, 52*.

pear shape, CEA/*635*①; S-2882/
*1024*①; S-4414/*289*①; S-4965/
*269*①.

Pear-shape, CEA/*119*①.

pear-shaped, C-0706/*161*; C-0782/*30*;
C-1502/*20, 147*; C-5114/*30*①;
C-5117/*76*①, *151*①; C-5127/*37*;
C-5156/*10*①; IDC; IDPF/*12*.

pear-shaped amethyst, S-291/*159*;
S-4414/*41*①.

pear shaped body, C-5156/*39*①.

pear-shaped bottle, EA.

pear-shaped diamond, RTA/*148*①;
S-291/*120, 215*①, *220*①, *224*①;
S-4414/*11*①, *29*.

pear-shaped diamond petal, S-291/
*54*①.

pear-shaped emerald, S-291/*101*①;
S-4414/*39*①.

pear-shaped jade, S-291/*258*.

pear-shaped knop, LAR83/*418*①.

pear-shaped milk jug, C-0782/*56*.

pear-shaped ruby, S-291/*88*.

pear-shaped top, S-4414/*37*.

pear-shaped turquoise cabochon,
S-4414/*37*.

pear-shaped vessel, C-2414/*3*①, *12*①.

Pearson, Geo., London, C-2489/*186*.

pear stalk finial, LAR82/*38*①.

pear teapot, IDC/①.

pear top, SDF/①.

pear wood, ACD; DADA; DATT.

pearwood, C-5157/*6*; C-5239/*285*;
LAR82/*313*①; SDF.

peasant-dance jug, IDC.

peasant glass, NYTBA/*273*.

peasant jewellery, RTA/*91*.

peasant pottery, IDC.

peasant ware, NYTBA/*124*.

peasant weave, OC/*21*①; SDF.

peascod form, C-2503/*45*; C-MARS/
88.

Peaston, R., C-2487/*165*; C-5174/
551.

Peaston, William, S-3311/*783*①.

Peaston, William and Robert,
C-5117/*76*①.

peat bucket, C-2403/*39*; C-5116/*26*;
C-5157/*7*; S-4436/*17*①.

peau de pêche, IDC.

pebble, C-2458/*330*; C-5156/*304*①.

pebble border, S-2882/*1322*①.

pebble-dashed, IDC.

pebble form, IDPF/*173*①.

pebble mill, DATT.

pebble-shape, C-2458/*367*①.

pebble shape, S-4810/*63*①.

pebble-shaped, C-5156/*402*.

péché-mortel, SDF/①.

péché mortel, ACD.

Pechstein, Max, S-286/*69*.

Peck, C-2904/*37*.

pecked ground, C-5174/*44*①.

Pecking Parrot, the, IDC.

Pecten Maximum, S-4843/*163*①.

pecten-shell, LAR82/*98*①.

pecten shell, IDC.

pectin-shell, C-2360/*166*①.

pectin shell, LAR83/*456*①.

pectin-shell molded, LAR83/*156*①.

pectoral, C-5236/*335B*.

pectoral bead, C-5156/*348*①.

pectorale, C-5224/*259*①.

pectoral ornament, RGS/*91*.

pedal harp, LAR83/*510*①.

pedal straw, C-3011/*62*.

pedestal, ACD; C-0782/*207*; C-1407/
128; C-2402/*14*; C-2478/*129*;

C-2486/*121*; C-5116/*115*; C-5153/
*142*①; C-5157/*51*; C-5189/*256*①;
CEA/*503*; DADA/①; EG/*292*;
IDC; MP/*33*; S-4461/*566*; S-4992/
*23*①; SDF/①.

pedestal base, C-0249/*263*; LAR82/
*433*①; S-2882/*926*①; S-4922/
*31*①; S-4992/*21*①.

pedestal book stand, SDF.

pedestal book table, C-1407/*23*.

pedestal cabinet, LAR82/*287*①;
LAR83/*352*①.

pedestal case, EA; SDF/①.

pedestal chair, SDF.

pedestal china table, S-3311/*111*①.

pedestal clock, EA/①; LAR82/
*220*①.

pedestal cross-stretcher, C-2402/*28*.

pedestal cupboard, C-0982/*38*;
C-2402/*14*; SDF.

pedestal desk, C-0982/*14, 248*;
C-2388/*108*; C-2402/*10*; C-2478/
148; C-5156/*476*①; EA/①;
LAR83/*319*①, *330*①; S-4461/
*691*①; S-4804/*940*①; SDF.

pedestal dish, C-1006/*4, 46*; IDPF/
174.

pedestal drawer, S-2882/*270*①.

pedestal end, FFDAB/*66*①.

pedestal foot, C-0254/*30*①; C-0270/
64; C-5005/*306*①; LAR83/*641*①;
S-4414/*255, 338*; S-4804/*44*①.

pedestal form, C-2398/*32*.

pedestal kneehole desk, LAR83/
*332*①.

pedestal lotus base, S-4965/*99*①.

pedestal music stand, LAR83/*352*①.

pedestal partners desk, C-5157/*124*.

pedestal-salt, C-2427/*247*.

pedestal salt, EA.

pedestal sideboard, DADA/①; EA;
S-4436/*74*①; SDF/①.

pedestal sideboard table, DADA.

pedestal stem, EG/*134*①; LAR83/
*423*①.

pedestal stereoscope, C-1609/*253*.

pedestal table, ACD; C-0249/*384*;
C-1407/*2*; C-2402/*32*; C-2403/*48*;
EA; LAR83/*381*①; S-3311/*104*①;
SDF.

pedestal urn, IDPF/*174*①.

pedestal weight, CEA/*492*①.

pedestal writing table, DADA; SDF/
pedestal desk.

pediment, ACD; C-0279/*277*;
C-0982/*87A*; C-2402/*126A*;
C-2478/*21*; C-5114/*332*①, *357*;
C-5116/*29*①; C-5153/*87, 92,
215*①; C-5156/*756*①; C-5157/*129*;
CEA/*221*①, *300, 406*; DADA;
S-4507/*55*①; S-4988/*473*①; SDF/
①.

pedimented, LAR82/*424*①.

pedometer, C-2489/*146*; LAR83/
*217*①.

pedometer watch, EA/*self-winding
watch*.

peep-hole view, JIWA/*162*.

peep pot, IDPF/*174*①.

peepshow group, IDC/①.

Peepshowman, EA/*cris de Paris*.

peep-sight, C-2476/*1*.

peep sight, S-4972/*272*.

peever, IDC.

peg, CEA/*406*; SDF.

peg and ball support, S-2882/*624*①.

peg-and-plate, SDF.

pegasus, C-0406/*64*; DSSA; IDC.

peg construction, LAR82/*421*①.

peg doll, CEA/*697*.

peg foot, C-0279/*290, 312*; C-5116/
56.

Pegg, William, CEA/*193*①.

Pegg, William 'Quaker', EA.

pegged flagon, CEA/*589*①.

pegged joint, LAR82/*395*①.

Peggy Page, C-0405/*30*.

peg-hinged, C-5236/*1639.*

Peg lamp, K-711/*130.*

peg leg, SDF.

peg-tankard, CEA/*594.*

peg tankard, ACD; C-2382/*3;* DADA; EA/①; S-4944/*144*①.

peg toe, C-5116/*78*①, *99*①.

peinte, C-5181/*115.*

peinte candlestick, C-2364/*8*①.

peinture à l'essence, LP.

peinture claire, LP.

Peippo, Michael, C-5174/*219*①.

Peking bowl, DADA.

Peking carpet, C-0279/*2.*

Peking glass, LAR83/*445*①; S-4810/ *246*①.

Peking glass bowls, C-5127/*212.*

Peking knot stitch, C-0405/*74.*

Pekin glass, C-0282/*136.*

Peking rug, LAR82/*549*①.

pelican, DSSA.

pelice, IDC/*pelike.*

pelike, IDC; IDPF/*174.*

Pellat, Apsley, CEA/*450*①.

Pellatt, Apsley, EA/①.

pellet, C-5117/*97, 294*①, *352*①; C-5173/*48*①.

pellet border, C-2332/*115;* RGS/ *52*①.

Pelletier, John, DADA.

Pelletier, John (Jean), EA.

Pelletreau, Elias, CEA/*675*①.

pellets, SDF.

Pellevé, Etienne-Dominique, EA.

pellicular, DATT.

Pellipario, Nicola, EA/①.

pelmet, C-2402/*150;* C-2501/*135;* C-5189/*260;* DADA; SDF/①.

pelmeth, LAR82/*83*①.

Peltier, Alphonse, NYTBA/*300.*

Peltzer, Johann (Hanss) Michael, C-5174/*108*①.

Pemberton, Samuel, C-5203/*202.*

pembroke, FFDAB/*51, 58*①; C-2402/*45;* C-2478/*77;* C-5114/ *275, 348*①; C-5153/*119.*

pembroke table, C-2320/*65*①; ACD; C-0982/*11, 17;* C-1407/*89;* C-2357/*72*①; C-2388/*50;* C-2403/ *104;* C-5114/*400*①; C-5116/*93*①; C-5153/*107;* CEA/*351*①, *396*①; DADA/①; EA/①; LAR82/*402*①; LAR83/*384*①; S-2882/*298;* S-3311/*151;* S-4436/*85;* S-4461/ *690;* S-4812/*160;* S-4988/*486*①; SDF.

Pembroke vase, IDC/①.

pen, C-0254/*40;* C-0706/*5, 5;* DATT; JIWA/*66*①.

pen-and-ink stand, IDC/①.

pen-and-wash drawing, DATT.

penannular, C-1082/*9.*

pen box, C-5156/*97*①.

pen case, C-0706/*3.*

pencil, C-0706/*48;* C-5117/*355;* C-5236/*1429;* C-5239/*188;* DATT; IDC/①.

pencil cedar, SDF.

pencil drawing, C-0249/*137;* S-286/ *114*①, *156*①.

pencil holder, C-0406/*115.*

pencilled, C-2458/*64;* C-5236/*488*①; S-3312/*1388*①.

pencilled decoration, IDC.

pencilled style, C-2513/*448*①.

pencil-post, C-5114/*388*①.

pencil sketch, C-5156/*278.*

pencil type, FFDAB/*82.*

pendant, C-0225/*159;* C-1082/*159;* C-2398/*20;* C-2421/*7*①; C-2458/ *115*①, *305;* C-2482/*79;* C-5005/ *201;* C-5114/*278*①, *328*①; C-5146/*73*①; C-5153/*82*①; C-5236/*335A;* CEA/*519*①; DADA; EA.

pendant (on watch case), EA.

pen mount, S-4461/*77*①.

Pennell, Joseph, S-286/*378*①.

penner, EA.

pennine glaze, IDC.

Pennington, James, EA.

Pennington, John, C-2493/*66*.

Pennington, Seth, EA.

Pennis: Johannes, Anthony, Johannes II, EA.

Pennsylvania, CEA/*685*.

Pennsylvania baby, CEA/*697*.

Pennsylvania-Dutch, EA.

Pennsylvania Dutch, DADA; NYTBA/*38*.

Pennsylvania Dutch chest, DADA/①.

Pennsylvania Dutch ware, IDC/①.

Pennsylvania German, DADA; NYTBA/*38*①.

Pennsylvania-German style, EA.

Pennsylvania tin ware, EA/*toleware*.

'pennyano' cafe barrel piano, LAR83/*520*①.

penny bank, IDC.

penny foot, C-5153/*73*①.

penny moon phase, C-2489/*89*①.

pennyweight (dwt.), EA.

penny-wooden, CEA/*697*.

pen rack, S-4461/*385*.

pen rest, C-0706/*58*.

Penrose: George, William, EA.

pentacle, DATT.

pentafoil, C-0254/*155*.

pentafoil foot, LAR83/*577*①.

pentagon, C-2458/*280*①.

pentagonal, C-0225/*325*.

pentagonal neck, C-5146/*45*.

pentagonal shape, LAR83/*634*①.

pentaptych, C-5236/*999*①.

Pentelic marble, DATT.

Penterman, Utrecht, C-2503/*196*.

pentimento, DATT; LP.

pen-tray, C-5005/*381*; IDC.

pen tray, C-5239/*91*; S-4461/*57*.

pentray, C-0225/*66*; K-710/*115*.

pen wipe, C-0706/*57*.

pen wiper, C-5146/*157*.

penwork, C-2320/*35*; C-5157/*62*.

penwork (in furniture-decorating), EA/①.

penwork, S-3311/*492*; SDF.

penwork rosette, S-2882/*357*.

peony, C-2704/*106*; DADA.

peony and fence, CEA/*190*①.

peony as motif, C-2458/*262*.

peony lamp, K-711/*127*.

peony lamp shade, C-5005/*394*①.

peony medallion, S-2882/*94*①.

peony spray, C-2414/*68*①.

peperino, DATT.

Pepersack (Peppersack), Daniel, EA.

peplos, S-4807/*511*.

peplum, C-0604/*201*; C-1506/*68*; C-2203/*65*.

pepper, C-0706/*238*.

pepper-box, CEA/*672*①.

pepper box, DADA.

pepperbox, S-4972/*231*.

pepperbox pistol, CEA/*34*.

pepperbox revolver, C-2503/*185*; C-2569/*91*.

pepper-caster, IDC.

pepper caster, C-0254/*4*; DADA.

pepperette, C-0103/*34*; C-0706/*36, 240*; C-1502/*36*; C-2202/*19*; LAR83/*596*①; S-4461/*239*; S-4804/*53*.

pepper grinder, C-0254/*92*.

pepper mill, DADA.

peppermint box, C-0406/*104*; C-1502/*143*; C-5203/*56*①.

pepper-pot, C-5173/*17*①.

pepper pot, EA.

pepperpot, C-0706/*91*.

pepper-shaker, C-5174/*309*①.

pepper ware, IDC.

Peppin, Robert, C-5117/*63*; C-5203/ *188.*

percale, SDF.

perception, LP.

perceptual painting, LP.

Perchin, Michael, C-5117/*356*①.

Perchin, Michael (workmaster), C-5174/*317*①.

perching bird, S-4948/*122*①.

perching-bird border, C-2403/*190.*

Percier, Charles, DADA; NYTBA/ *70.*

Percier, Charles and P. Fontaine, EA.

percussion, CEA/*549*; S-4972/*217.*

percussion breech-loading military rifle, C-2569/*58*①.

percussion cap, CEA/*44*; S-4972/ *160*①.

percussion duck gun, C-2569/*59*①.

percussion pocket revolver, C-2569/ *67*①.

percussion rifle, C-MARS/*122.*

perdifume, IDC/①.

Perepedil carpet, EA.

Perepedil rug, LAR82/*549*①; OC/ *46*①; S-288/*9*①; S-3311/*72*①.

perforated, C-0225/*403.*

perforated disc, CEA/*539*①.

perforated lid, IDPF/*127*①.

perforating, CEA/*528.*

perforating wheel, DATT/①.

perforation, CEA/*528.*

performing dog, CEA/*170*①.

perfume atomiser, C-2324/*170*①.

perfume atomizer, C-0254/*208.*

perfume-bottle, IDC.

perfume bottle, C-0225/*180*; C-0254/ *37*; C-2409/*47*; C-5191/*237*; LAR83/*438*①.

perfume box, C-0270/*84*; CEA/*61.*

perfume-burner, EA/①; IDC.

perfume burner, DADA; SDF.

perfume flacon, C-5239/*127.*

perfume flask, C-0225/*273*①.

perfume pan, RGS/*39.*

perfume-sprinkler, IDC.

Pergamene school, DATT.

Pergolesi, M. A., ACD.

Pergolesi, Michael Angelo, SDF/*760.*

Pergolesi, Michclangelo, EA.

Pergolesi, Michele Angelo, DADA.

Peridon, Hendrick Janzon, EA.

peridot, C-5005/*216*①; LAR83/ *480*①; S-4414/*118*; S-4927/*276.*

Perigal and Browne, CEA/*235.*

Perigal & Duterrau, London, C-2489/ *194.*

périgord, DADA.

perilla oil, DATT.

period, C-5153/*47*①.

period costume, S-4922/*11*①.

periwig back, SDF.

periwig chair, DADA.

perizonium, S-2882/*507*①; S-4972/ *73*①.

Perkins, Charles Callahan, DADA/ *Supplement.*

Perkin's violet, DATT.

Perl, Karl, C-5191/*142.*

perlai bead, EA/*beads and marbles.*

Perles, C-5239/*125.*

Perlmutter, CEA/*173*①.

perlmutter lustre, IDC.

Perlservice, IDC.

Permalba, DATT.

permanent and temporary stand, JIWA/*315*①.

permanent blue, DATT.

permanent green, DATT.

permanent palette, LP.

permanent stand, JIWA/*315*①.

permanent violet, DATT.

permanent white, DATT.

petal-formed medallion, S-4948/
*112*①.

petal-molded bowl, LAR83/*452*①.

petal-molded standard, S-4414/*233*.

petal motif, S-4965/*223*①.

petal nick, C-5236/*429*.

petal panel, C-5156/*46*①.

petal rim cup, LAR82/*434*①.

petal-shaped, C-2458/*123*; C-5116/
*37*①; S-4905/*31*①.

petal-shaped wall lip, C-5156/*150*.

petal tessera, C-5156/*434*①.

pétard, DATT.

Peter, DSSA.

Peter Chitry, S-4905/*194*.

Peterinck, F. J., CEA/*186*①.

Peterinck, François Joseph, CEA/
*186*①.

Peter Pan collar, C-0604/*208*.

Peter Rohde II, S-4922/*10*①.

Peters, Heinrich, C-5203/*101A*.

Peters and Reed Pottery, Zanesville,
Ohio, EC1/*85*.

Peters Company, H.J., K-711/*129*.

petersham, C-3011/*66*.

Peter Stretch, EC2/*89*.

Petit, C-2493/*230*①.

Petit, Jacob, C-2493/*250*; LAR82/
*163*①; NYTBA/*172*.

Petit, Nicholas, DADA.

Petit, Nicolas, EA.

petit commode, C-0225/*376*①;
C-5239/*282*.

petite commode, DADA; LAR83/
*305*①.

petite desserte, DADA.

petite nature, DATT.

petite orfèvrerie, RGS/*82*.

Petite Rue Saint-Gilles, DADA.

petite sonnerie, C-5117/*390*①.

petite sonnerie carriage clock,
LAR83/*187*①.

petit feu, CEA/*148*①; DADA; EA/
enamel; IDC.

petit feu colour, IDC.

Petit: Jacob, Mardochée, EA.

Petitot: Jean, Senior; Jean-Louis, the
Younger, EA.

petit patron, EA/*cartoon*.

petit-point, C-2704/*39*; C-3011/*114*;
S-288/*34*①.

petit point, C-2357/*12*①; C-2388/*80*;
C-2498/*85*; C-5236/*368*; CEA/
*274*①; DADA; LAR82/*306*①;
SDF.

petit-point face, C-2704/*181*.

petit point floral needlework, C-2403/
55.

petit point needlework, C-2421/*10*①.

petitpoint paisley, S-288/*31*①.

petit point panel, C-1407/*38*; S-288/
*36*①.

petit poussin, DADA.

petrified egg, CEA/*562*.

pétrin, DADA.

Petrine age, RGS/*138*.

Petri-Raben, Trude, DADA/
Supplement.

petrolatum, DATT.

petroleum ether, DATT.

petroleum solvent, DATT.

petroleum spirits, DATT.

petrological microscope, C-0403/*181*;
C-MARS/*197*.

petronel, ACD; DADA.

Pettenkofer process, DATT.

petticoat, C-1506/*5*; C-3011/*3*.

petuntse, ACD; CEA/*110, 184*①,
210; DADA; DATT; EC2/*22*;
IDC; MP/*502*.

petuntze, DATT.

Petworth marble, DATT.

Petzold, Hans, EA.

peuplier wood, DADA.

Peuron stone, DATT.

pew, SDF/①.

Pewabic, C-5191/9.

Pewabic Pottery, Detroit, Michigan, EC1/85.

pew chair, SDF.

pew-end, CEA/322①.

pew end, SDF/①.

pew group, CEA/154①; DADA/①; EA; IDC/①; IDPF/174①.

pewter, ACD; C-5005/222①; C-5114/111; C-5239/111; CEA/ 146①, 579; DADA; DATT; NYTBA/240①; S-4461/125; S-4905/311; SDF.

pewter dial, CEA/222①.

pewterer, MP/33.

Pewterers' Company, CEA/581.

pewter mark, EA; NYTBA/242①.

pewter mount, C-2427/100.

pewter stopper, C-5114/123.

pewterware, C-5005.

Peynot, Emile Edmond, C-5189/ 168①.

Peyre cup, IDC.

peyrol, C-5259/188.

Pfalz-Zweibrücken, DADA; EA.

Pfau family: Ludwig, Hans Heinrich, David, David II, Abraham, Ludwig II, David III, EA.

Pfeiffer, Max Adolf Schwarzburg Werkstätten, MP/201.

Phaethon, DSSA.

PH and PHF, EA/Frankenthal.

pharmacist's jar, C-1609/97.

pharmacy jar, ACD; EA/drug pot; IDC; LAR82/102①.

pharmacy vase, DADA.

pharmacy ware, IDC.

phase contrast apparatus, C-0403/ 189.

phenol, DATT.

phenolic resin, DATT.

phial, CEA/49.

phiale, IDC.

phiale mesompholos, S-4807/540.

Philadelphia chair, DADA; SDF.

Philadelphia Chippendale, DADA; SDF.

Philadelphia Chippendale style, EA/ ①.

Philadelphia Glass Works, CEA/ 461①.

Philadelphia style highboy, DADA/ ①.

Philadelphia style lowboy, DADA.

Philadelphia Tin Toy Manufactory, CEA/694①.

Philadelphia Windsors, SDF/①.

Philip Harris, C-2904/127.

Philippe, M., EA/259.

Philippe, Paul, C-2910/308①.

Philippine mahogany, DATT.

Philipp Jacob, EA/Drentwett family.

philips, C-2904/188.

Phillipe, Louis, S-4947/13①.

Phillips, Robert, CEA/518①.

Philosophical Instruments, C-2904/ 200.

Philosophy, DSSA.

Philpot, Toby, C-2513/179①.

Phipps, Thomas, C-5117/376; C-5174/539①.

Phipps, Thomas and James, C-0406/ 93.

Phipps, Thomas and Robinson, Edward, C-0406/110.

Phipps & Robinson, EA/250①.

Phips, James, CEA/37.

phoenix, IDC/①; OC/79; DSSA.

Phoenix Glass Company, EC1/68.

Phoenix Glass Works, CEA/462①.

Phoenix Hill, CEA/118①.

phoenix motif, S-4965/110①.

phonocello, C-2520/40.

phonograph, C-5239/274; SDF.

phosphatic porcelain, IDC.

pictorial device, JIWA/*44*.

pictorial dimension, JIWA/*162*.

pictorial dual, JIWA/*162*.

pictorial flask, EA/①; EG/*250*①.

pictorial glass, S-4881/*359*①.

pictorial mat, S-4796/*1*①.

pictorial material, JIWA/*6*.

pictorial mount, C-5114/*15*①.

pictorial panel, C-5170/*34*①.

pictorial perception, JIWA/*10*.

pictorial rug, C-2478/*259*; S-3311/*19*; S-4796/*104*①; S-4847/*155*①.

picture, C-5114/*198*①; CEA/*278*①; LP.

picture Bible, MP/*175*.

picture box, LP/①.

picture design, OC/*156*.

picture format, LP.

picture frame, C-0254/*70*; C-5116/*54*; CEA/*239*①; DATT; SDF.

picture-frame border, C-2437/*1*①; EA/*Aubusson tapestry*.

picture-frame clock, EA/①.

picture frames, American stock sizes, DATT.

picture plane, DATT; JIWA/*10, 10, 24, 44*; LP/①.

picture putty, DATT.

picture puzzle, JIWA/*102*①.

picture rug, OC/*156*.

picturesque, LP.

picture varnish, DATT; LP.

picture within a picture, JIWA/*224*①.

PID, EA/*Drentwett family*.

Pidoux, Protais, EA.

piece mold, DATT.

piece-mould, IDC.

piecework, MP/*71*.

pie crust, C-5156/*42*; CEA/*406*.

pie-crust, C-2402/*42, 106*; C-2458/*2*.

pie-crust and shell edge, LAR83/*632*①.

piecrust border, IDC.

pie-crust border, C-2323/*7*; EA.

pie-crust edge, CEA/*338*①.

piecrust-edge, LAR82/*180*①.

pie-crust table, DADA; EA.

pie crust table, ACD; SDF/①.

pie crust tip table, LAR83/*380*①.

pie-crust top, C-0249/*372*.

piecrust ware, IDC/①; IDPF/*175*.

pied de biche, ACD; DADA/①; EA/*hoof*.

pied-de-biche, CEA/*594*; EA/*hoof foot*; IDC; S-4804/*309*①.

pied-de-biche spoon, EA/*trefid*.

pied de biche spoon, DADA.

pie-dish bezel, RTA/*55*①.

piédouche, IDC.

pien hu, IDC.

pien yao, ACD; IDC.

pier, C-5117/*342*①; FFDAB/*62*; SDF.

pier cabinet, LAR82/*286*①.

Pierce and Cunningham, S-4881/*311*①.

pierce-carved apron, S-2882/*799*.

pierce-carved cresting, S-2882/*675*①.

pierced, C-0782/*71*; C-0982/*5, 75*; C-1082/*33*; C-2388/*57*; C-2402/*7, 22*; C-2403/*112*; C-2458/*150*; C-5114/*22, 254*①; C-5117/*173*; C-5156/*37*①, *301*①, *362*; CEA/*24*①, *157*①; DADA; S-4804/*6*; S-4992/*29*①.

pierced and chased gallery, C-0254/*36*①.

pierced and waved ladder-back, LAR83/*277*①.

pierced angle bracket, C-2403/*86*.

pierced anthemia, C-5114/*35*①.

pierced anthemion splat, C-2357/*10*①.

pierced apron, C-0254/*305*; C-2421/*50*①.

pierced arched cresting, S-2882/*241*①.

pierced back-plate, C-5116/*140*①.

pierced ball, C-5005/*231*①.

pierced baluster splat, S-4414/*484*①.

pierced bar splat, C-2320/*19*①.

pierced base, C-0254/*72A*.

pierced beaker splat, S-4414/*451*①.

pierced blade, C-0254/*66*; C-0406/*56*; S-4922/*34*①.

pierced bone, C-0405/*144*.

pierced border, C-0249/*178*; C-0254/*35*.

pierced boss, C-2458/*219*.

pierced bottle, C-5127/*130*.

pierced bowl, C-0254/*96*.

pierced bracket, C-5116/*94*①; S-4414/*430*①, *465*①.

pierced branch, C-0254/*57*.

pierced brass, C-5114/*232*①; S-2882/*365*①.

pierced brass grate, C-5114/*230*.

pierced brass screen, CEA/*222*①.

pierced cartouche, C-2421/*118*①; C-5116/*124*; LAR83/*491*①.

pierced carving, EA.

pierced Chinoiserie fretwork, C-5170/*150*①.

pierced circular bowl, C-0254/*88*.

pierced column, LAR83/*206*①.

pierced cover, C-0782/*45*; S-4461/*447*.

pierced C-scroll, S-4414/*407*①.

pierced decoration, C-0249/*151*; IDC; S-291/*213*①; S-4414/*50*①.

pierced disc, C-5156/*356*①.

pierced domed cover, C-1082/*91*.

pierced double shell-guard, C-2569/*37*①.

pierced double wall, RGS/*31*①.

pierced-edge foot, CEA/*620*①.

pierced engraved, C-5116/*34*.

pierced engraved mount, S-291/*185*①.

pierced everted rim, C-0254/*316*①.

pierced finial, IDC.

pierced flattened handle, S-2882/*1211*.

pierced floral blade, C-0254/*47*.

pierced floral grille, LAR83/*642*①.

pierced flowerhead-carved splat, S-4414/*452*①.

pierced foliate, C-5116/*49*①.

pierced foliate border, C-0254/*83*; S-4414/*227*①.

pierced foliate cresting, C-2388/*75*①; S-2882/*390*①.

pierced foliate foot, C-5153/*2*①.

pierced foliate knop, S-4414/*279*.

pierced foliate pillar, S-4802/*132C*.

pierced foliate side rail, S-2882/*1446*①.

pierced foot, C-0254/*38*; C-5153/*2*①.

pierced foot-mount, EA/*basket*.

pierced form, IDPF/*175*①.

pierced frame, C-5116/*117*.

pierced fret gallery, LAR83/*318*①.

pierced fretwork gallery, C-5114/*84*①; C-5116/*131*①.

pierced gallery, LAR83/*266*①; S-4414/*332*①; S-4988/*458*①.

pierced gallery side, LAR83/*569*①; S-2882/*1004*.

pierced grill, C-0706/*11*; C-5220/*11*①.

pierced hand, S-4802/*2*①.

pierced hand hold, C-5114/*10*①.

pierced handle, C-0254/*282*; C-5114/*245*; RGS/*17*①; S-4436/*11*①.

pierced interlaced splat, C-2403/*140*; C-5116/*68*①; C-5170/*90*①.

pierced knop, S-4436/*19*.

pierced lancet back, LAR83/*272*①.

pierced lancet decoration, S-4461/*486*.

pierced leaf and berry design, K-711/ *126.*

pierced link, CEA/*510.*

pierced loop handle, C-0254/*83.*

pierced lug, IDPF/*155*①.

pierced mask, C-5156/*154.*

pierced metal, K-711/*126.*

pierced mound base, C-5156/*13*①.

pierced mounting, S-291/*216*①.

pierced neck, C-2204/*13.*

pierced openwork pattern, S-4461/*89.*

pierced oval dish, C-1006/*3.*

pierced panel, C-1082/*24*; S-4414/ *243*①.

pierced pedestal foot, C-0254/*257.*

pierced pediment, SDF.

pierced pillar, S-4802/*132B.*

pierced platinum cap, S-4414/*145.*

pierced plinth, LAR83/*162*①.

pierced rail, S-4461/*11.*

pierced rectangular blade, C-5114/*24.*

pierced relief, RGS/*22*①.

pierced rête, CEA/*604*①.

pierced rim, C-0254/*7.*

pierced rockwork, C-2458/*89*①.

pierced scroll, C-5114/*191.*

pierced scroll bracket, C-5114/*347*①.

pierced scroll crossbar, LAR83/ *287*①.

pierced scrolled decoration, S-4414/ *127.*

pierced scroll foot, C-2398/*69.*

pierced scrolling cornice, S-2882/ *1444*①, *1446*①.

pierced scrolling fretted frieze, C-5116/*48.*

pierced scrolling splat, C-5116/*119.*

pierced serving fork, S-4804/*35.*

pierced shell, C-2388/*18.*

pierced sleeve, C-0254/*53*; CEA/ *641*①.

pierced spandrel, C-5116/*48*; S-2882/ *252*①.

pierced splat, C-0982/*97B*; C-5116/ *58*; LAR83/*267*①; S-2882/*263,* *265, 334.*

pierced star band, C-5174/*522*①.

pierced strapwork, S-4414/*234*①.

pierced stretcher, C-0249/*465*①; C-5116/*94*①; S-2882/*241*①; S-4414/*486.*

pierced sugar ladle, C-0254/*315.*

pierced support, RTA/*66*①.

pierced thumbpiece, C-2398/*21*①; C-5117/*232.*

pierced trellis, LAR83/*89*①.

pierced trellis horizontal splat, C-5116/*113*①.

pierced trestle support, S-4414/*492*①.

pierced vase splat, S-4436/*127.*

pierced vertical splat, C-2403/*28.*

pierced ware, ACD.

pierced waved ladder back, LAR83/ *269*①.

pierced wave-pattern, C-5116/*90.*

pierced wing, C-1407/*85A.*

pierced with foliage, C-0406/*100.*

pierced-work (ceramic decoration), EA.

pierced work, DADA; SDF.

piercing, C-5114/*89*①; C-5153/*2*①; C-5156/*825*①; CEA/*618, 678*; DATT.

piercing (in metal), EA.

piercing technique, JIWA/*181*①.

Piercy, Josiah and George, C-2487/ *84.*

pier-glass, C-2320/*62*; C-2421/*31*①; CEA/*340*①.

pier glass, ACD; EA; FFDAB/ *115*①; LAR83/*364*①, *493*①; SDF/①.

pier-glass frame, CEA/*344*①.

pier-mirror, C-5116/*125*①.

pier mirror, DADA; S-3311/*129*①, *562*①; S-4436/*7*①; S-4988/*439*①.

Pierotti, C. E., CEA/*684.*

Pierotti, Miss A. M., CEA/*684*.

Pierre, François, CEA/*497*①.

Pierre Platel, S-4922/*42*①.

pierrette, C-2409/*289*.

pierrot, C-1603/*55*①.

pierrot and pierrette, LAR82/*46*①.

pierrot box, LAR82/*67*①.

Piers, Daniel, C-2487/*143*; C-5173/*35*①.

pier-table, C-2320/*68*①; CEA/*306*①, *336*①.

pier table, ACD; C-2388/*97*; C-5114/*374*①; DADA; EA; LAR82/*404*①; LAR83/*388*①; NYTBA/*72*; S-3311/*215*①; SDF/①.

pier top, S-4905/*423*①.

pie safe, LAR82/*339*①.

pie server, C-0254/*76, 221, 241*; S-4804/*35*.

pie slice, S-4804/*81*①.

pietà, DATT.

pieta, LAR82/*32*①.

pietà, LP; DSSA.

Pietà group, MP/*79*.

Pieterson, Jan, EA.

pietra-dura, SDF.

pietra dura, C-2332/*48*; C-5116/*28*; C-5259/*225*; DADA; DATT; EA/①; OC/*52, 83*①; S-4436/*113A*①; S-4804/*758*①, *761*①; C-0906/*88*.

pietra dura obelisk, S-3311/*530*.

pietra dura top, C-2357/*2*①.

pietra serena, C-5224/*227*.

Pigalle, Jean-Baptiste, EA.

Pigatto, C-5181/*82*①.

Pigeon, G., CEA/*603*①.

Pigeon Blood, CEA/*473*①.

pigeon-gun, C-2476/*46*.

pigeon hole, C-2409/*241*; C-5114/*333*①; SDF.

pigeonhole, C-0249/*467*; C-2357/*56*①; C-2388/*67*; C-5114/*302*①,

*363*①; C-5116/*121*①; C-5153/*113*; S-4436/*183*①.

pigeon racing clock, C-5117/*388*①.

pigeon tureen, IDC.

piggin, DADA; IDC/①; IDPF/*176*①.

piggy bank, C-0906/*132*.

pig iron, CEA/*542*.

pigment, C-2414/*28*; C-5127/*8*①; C-5156/*7*; C-5236/*358*①; DATT; LP.

pigment nomenclature, DATT.

pigment properties, DATT.

pigment yellow, DATT.

pigna, a, IDC.

Piguet, Audemars, C-2489/*205*.

Piguet, Isaac-David, EA.

Pihuamo, S-4807/*161*①.

Pijnacker, Adriaen, C-2486/*173*①.

Pijnacker: Jacobus, Adriaen, EA.

pike, C-MARS/*49*; DADA.

pikeman's pot, C-2503/*65*.

pilaster, ACD; C-0982/*22, 39*; C-2402/*3, 29, 149*; C-2478/*178*; C-5114/*347*①, *352*①; C-5116/*48*; C-5224/*54*①; CEA/*312*①; DADA; EA; LAR82/*213*①; S-2882/*807*①; SDF.

pilaster angle, C-2364/*22*①.

pilastered fluted column, C-0279/*270*①.

pilaster leg, SDF/①.

pilchard pot, IDC.

pile, OC/*15, 17*①, *32*.

pile and rope, S-288/*15*①.

pile carpet, NYTBA/*111*; SDF.

pile fabric, NYTBA/*86*①; SDF.

pile figure, S-3311/*39*.

pileless flat-woven fabric, OC/*16*.

pile rug, OC/*33*.

Pilgerflaschen, MP/*38*.

pilgram flask, S-4804/*278*①.

pilgrim, DSSA.

pilgrim bottle, C-2323/*58*; C-5156/ *37*①; EA/①; IDPF/*176*①; LAR83/*219*①; DADA.

Pilgrim century, S-4905/*384*.

pilgrim-flask, C-2427/*234*; IDC/①.

pilgrim flask, EA; EG/*38*①; LAR82/ *246*①, *440*①.

pilgrim flask shape, C-0225/*268*.

pilgrim furniture, SDF; DADA; EA.

pilgrims' badge, EA/*badge*.

pilgrims' bagde, EA/*badge*.

pilgrim's flask, MP/*38*.

pilgrim shape, S-2882/*1245*①.

pilgrims' shell, EA/*badge*.

Pilgrim style, NYTBA/*29*.

Pilkington & Gibbs Ltd., C-2904/*262*.

Pilkington gourd vase, C-2502/*44*.

Pilkington's Royal Lancastrian, C-2409/*64*.

Pilkingtons Royal Lancastrian, C-2910/*170*.

Pilkington's Tile and Pottery Company, DADA/*Supplement*.

pill, IDPF/*176*.

pillar, C-1407/*2*, *180*; DSSA.

pillar (in clocks), EA.

pillar, FFDAB/*57*①; LAR82/*409*①; SDF/①.

pillar, scroll and wheat sheaf leg, S-2882/*669*①.

pillar and claw pedestal, FFDAB/*26*.

pillar-and-claw stand, C-2904/*149*.

pillar-and-claw support, FFDAB/*27*.

pillar-and-claw table, SDF.

pillar-and-claw tripod, C-2904/*256*.

pillar and pediment, CEA/*238*①.

pillar and plate frame, CEA/*607*①.

pillar-and-scroll, EC2/*89*①.

pillar and scroll, C-5114/*358*①.

pillar and scroll clock, DADA; EA.

pillar and scroll shelf clock, CEA/ *244*①.

pillar carpet, EA/①.

pillar clock, EA.

pillared case, C-5117/*390*①.

pillared frame, FFDAB/*109*.

pillar flute cutting, CEA/*445*①.

pillar leg, LAR83/*368*①.

pillar-moulded glass, EG/*188*.

pillar moulded glass, CEA/*464*①.

pillar picture, JIWA/*10*, *170*.

pillar picture hashira-kake, JIWA/ *244*①.

pillar plate (in watch), EA.

pillars, C-5236/*851*.

pillar table, SDF.

pill box, C-0254/*189*; C-0405/*142*; C-5005/*205*①; S-4461/*385*.

pillbox hat, C-2501/*4*.

Pilleau, Pezé, CEA/*648*①.

Pillement, Jean, DADA; EA.

Pillement engraving, IDC/①.

Pillischer, C-2904/*265*.

pillow, CEA/*277*①; DADA; IDC/①; S-4965/*165*①; SDF.

pillow and claw, CEA/*353*①.

pillow back, SDF.

pillow beer, SDF.

pillow-case, C-2704/*138*.

pillowed, C-5239/*268*.

pillow foot, C-5236/*557*.

pillow lace, DADA.

pillow sword, DADA.

pill-slab, IDC/①.

pill slab, EA; IDPF/*177*; LAR83/ *122*①.

Pilon, Germain, C-5224/*291*①.

piloti, C-5167/*209*①.

Pimm, John, CEA/*392*①; DADA.

pin, C-2704/*134*; C-5005/*201*; C-5117/*1*; CEA/*220*①, *541*; DATT; S-4461/*315*; S-4972/*119*①; SDF.

pina, C-2203/*133*.

pinax, IDC.

pin-barrel, C-2489/*91*①.

pin box, C-1006/*100*.

pince-nez, C-0403/*254*; C-2608/*160*; S-4804/*220*.

pincer, DSSA; EG/*237*①.

pincered handle, EG/*120*①.

pincering, JIWA/*307*.

pinchbeck, ACD; C-2332/*63*; C-2487/*20*①; CEA/*503, 524*; DADA; EA; EG/*146*①; RGS/*204*; S-4927/*208*①; SDF.

pinchbeck case, CEA/*250*.

pinched, C-5156/*37*①; C-5236/*422*①.

pinched baluster form, S-2882/*1355*.

pinched chain trail, EG/*134*①.

pinched double lotus base, C-5156/*230*①.

pinched ear, EG/*74*①.

pinched head pleat, SDF.

pinched lip, C-2486/*125*①; IDC; S-4965/*172*①.

pinched-loop handle, C-5156/*60*①.

pinched pot form, IDPF/*177*①.

pinched quarterfoil neck, S-2882/*1388*.

pinched side, C-0249/*157*.

pinched trailing, CEA/*503*; DADA; EA/*quilling, quilling*; EG/*292*.

pinch foot, LAR83/*120*①.

Pinchon, Theophile-Desire, C-2510/*9*①.

pin-cushion, CEA/*279*①.

pin cushion, C-0406/*99*.

pincushion, C-2704/*136*.

pincushion chair, SDF.

pin cushion pattern, LAR82/*454*①.

pincushion seat, EA/*compass seat*; SDF/*pincushion chair*.

pin-cushion seat, EA/*compass*.

Pinder & Bourne, S-4947/*186A*.

Pinder Bourne, JIWA/*351*.

pin dish, S-4461/*39*.

pine, C-0982/*204*; C-1407/*3*; C-2388/*63*; C-2402/*48*; C-2458/*104*; DADA; S-4461/*554*; SDF.

pineapple, CEA/*236*①.

pineapple and fan, OPGAC/*232*.

pineapple-chequered, C-2503/*209*①.

pineapple chequered butt, C-2569/*82*①.

pineapple cup, C-5174/*110*①; DADA/①; EA/①; RGS/*31*①; S-4804/*141*①.

pineapple-cut, S-4955/*46*①.

pineapple finial, C-0254/*30*①; C-2368/*77*①; LAR82/*270*①; S-3311/*112*①.

pineapple form gilt-wood foot, S-2882/*294*①.

pineapple motif, EA/*bianco sopra bianco*.

pineapple pattern, LAR82/*99*①; CEA/*471*①.

pineapple stand, IDC.

pineapple teapot, IDC.

pineapple tureen, IDC.

Pineapple ware, IDC; S-4843/*124*.

Pineau, Nicolas, DADA; EA.

pine bark, C-5236/*465*①.

pine case, C-2904/*4, 92*.

pine chest, C-0982/*6*.

pine-cone, C-2427/*2*.

pine cone, DSSA.

Pinecone and Foliage pattern, C-2493/*38*.

pinecone finial, C-5116/*43*①.

pine cone handle, MP/*472*①.

pine-cone pattern, IDC.

'Pine Cone' pattern, S-4414/*348*①.

pine motif, EA/*boteh*.

pine needle pattern, C-5005/*386*; S-4414/*237*; S-2882/*1342*.

pine oil, DATT.

pine-soot black, DATT.

pine splay, C-5114/*261*.

pine table, C-0982/3.
pine tree finial, CEA/592①.
pine-trunk motif, S-4965/305①.
pinewood, ACD; S-4972/10①.
pin-fire, C-2476/81; C-MARS/143.
pinfire, S-291/62①; S-4972/231.
Pinfold, Edward, EA/79.
p'ing, OC/123.
Pingsdorf ware, CEA/131①; IDC.
pinhead, C-5156/322①.
pin hinge, SDF.
pinhole, IDC.
pinion, C-5117/400①; CEA/218, 267.
pinion (in clock and watch), EA.
pinion gearing, CEA/252①.
pink, DATT; IDC.
pink campion, C-0405/160.
pink color, DATT.
pink coral, S-4414/160.
pink-ground, LAR83/178①.
pink ground, EA.
pinking, C-3011/106; CEA/541.
pink lustre, IDC.
pink marble, C-5127/341.
pink mauve, DATT.
pink resist, IDC.
pink tourmaline, S-4810/165①.
pinned, C-5236/1796①.
pinned barrel, CEA/555①, 556.
pinned barrel mechanism, CEA/549.
pinned cylinder, CEA/555①.
pinned foot, C-2368/91①.
pin pallet escapement, EA/escapement.
pin-point transfer technique, S-4881/231①.
pinprick picture, S-4461/66.
pin set, C-5117/455①.
pin-spread, C-5117/1.
pinte, DADA; IDPF/178.
pin tray, LAR83/632①.

pint tankard, C-0706/243.
pintucking, C-3011/16.
pinwheel, C-5153/218①; S-4847/99①; S-4948/19①.
pinwheel device, S-4905/458①.
pin wheel escapement, EA/escapement.
pinwheel medallion, S-4948/19①.
pin wheel motif, S-4461/112.
pinwork, EA/①.
pinx, DATT.
pinxit, LP.
pinxton, DADA; ACD; CEA/194①; EA/①.
Piorry-type, S-4927/223①.
pioury, DATT.
pip, EG/270.
pipe, C-2437/40①; DSSA; IDPF/178①.
pipe, tobacco, IDC/①.
pipe-backed, C-2503/12.
pipe-bowl, IDC.
pipe case, C-1082/135; C-5156/695①, 699.
pipe-clay, IDC.
pipe clay, DATT.
pipeclay, EA.
pipe-kiln, EA.
pipe kiln, SDF.
pipe-lighter, EA.
Piper, John, DADA/Supplement.
Piper, Peterboro, C-2503/185.
pipe rack, ACD; DADA; SDF/①.
pipe rest, S-4461/218.
pipe-shaped beaker, CEA/451.
pipe-sleigh, IDC/①.
pipe stand, SDF/① pipe racks.
pipe-stopper, EA/①; IDC.
pipe tamper, S-4881/296①.
pipe tomahawk, S-4807/234①.
pipe tongs, EA/smoker's tongs; SDF.
pipette, C-0403/201.

piping, C-1506/*8*; C-2437/*2*①;
C-5239/*269*①.

pipkin, EA/*saucepan, saucepan*; IDC;
IDPF/*178*①.

pique, C-1304/*169*.

piqué, C-1506/*2*.

pique, C-2203/*66*.

piqué, C-2487/*10*.

pique, CEA/*71, 524*.

piqué, EA/①.

pique, LAR82/*70*①.

piqué, S-4802/*132B*.

piqué box, CEA/*61*.

piqué d'or, DADA.

piqué lacquer, CEA/*53*①.

piqué outer case, CEA/*253*①.

piqué point, EA/① *French snuff-box,*
① *piqué.*

piqué-posé, C-2332/*52*.

pique posé, C-0254/*166*.

piqué posé, EA/① *piqué.*

piqué work, CEA/*513*.

Piranesi, Giovanni, DADA.

Pirkenhammer, C-5189/*30*.

Pisan type, LAR82/*38*①.

Pisa vase, IDC/①.

Pisces, DSSA.

pisciform, DATT.

Pissarro, Camille, S-286/*452*①.

pistachio, S-288/*1*①; S-3311/*42*①.

pistachio-green, C-2357/*148*; C-2403/
184.

pisten, C-0225/*184*.

pistol, C-2476; C-2503/*159*;
C-MARS/*128*①; CEA/*29*①;
DADA; S-4972/*162*①, *164*①.

pistol-form, C-5174/*422*.

pistol form, CEA/*452*①.

pistol-form handle, S-2882/*1089*①.

pistolgrip, C-2476/*1*.

pistol handle, C-0706/*34*; C-5117/*80*;
IDC.

pistol-handled, C-0706/*35*; C-5174/
545; S-4922/*38*①.

pistol handled, C-2202/*23*.

pistol-handle knife, DADA.

pistol-shaped, S-4804/*214*①.

pistol-sword, CEA/*25*①.

piston pendant, C-2489/*178*①.

Pistor, CEA/*611*①.

pit, EA/*money dish, money dish.*

pitched headboard, S-4507/*77*①.

pitcher, C-0225/*53*; C-0254/*107*;
C-0270/*17*; C-5114/*38*①, *228*;
C-5153/*15*①; C-5239/*14*; CEA/
*676*①; DADA; DATT; DSSA;
IDC; IDPF/*179*①; NYTBA/
*178*①.

pitcher-mould, IDC.

pitching chisel, DATT.

Pitchon, C-5167/*69*.

pitch pine, SDF.

pitchpine, C-0982/*22*.

pith, C-5127/*456*.

pithari, IDPF/*180*①.

pithos, DATT; IDC; IDPF/*180*①.

pit house, S-4807/*284*.

pith painting, C-2323/*170*.

pith paper, C-2458/*265*.

piti, RGS/*84*.

Pitkin brothers: Henry, James F.,
EA.

pitkin flask, EA/①; CEA/*56*①; EG/
183.

Pitkin Glass Works, CEA/*56*①; EA/
①.

Pitkin pocket bottle, CEA/*56*①.

Pittar, John, C-5117/*65*.

pitted, C-5156/*300*①; C-5236/*855*①.

pitting, C-2324/*48*①; CHGH/*59*.

Pitts, Richard, CEA/*670*①.

Pitts, William, C-2510/*88*①.

Pitts, William, the Elder, EA.

Pitts, William, the Younger, EA.

Pittsburgh Flint Glass Works,
DADA/*Supplement*.
Pittsburgh Glass Works, CEA/55①.
Pittsburgh Lamp, Brass & Glass
Company, K-711/*129*.
Pittura Metafisica, LP.
pi t'ung, IDPF/*180*.
piuri, DATT.
pivot, C-1603/*113*; C-2368/*159*;
CEA/*267*; RTA/*36*①.
pivot arm, C-2904/*282*①.
pivoted, S-4881/*129*①.
pivoted detent, CEA/*259*①.
pivoted detent movement, C-5174/
*405*①.
pivoted visor, CEA/*20*①.
pivoting, S-3311/*503*①.
pivoting nipple-protector, C-2503/*161*.
pivoting tool, C-0403/*222*.
pivotted prismatic sighting, C-2904/
213.
pi yü, DADA.
PK monogram, C-5167/*36*①.
placcate, DADA.
placecard holder, C-5191/*225*.
place plate, C-0249/*164*.
placet, DADA.
Plackwitz, Tobias, C-5174/*475*①.
plafond painting, DATT.
plafonnier, C-GUST/*21*.
plain, C-0706/*85*; C-5117/*93*;
C-5146/*129*①.
plain area, OC/*292*.
plain balance, C-5117/*411*①.
plain bell form, S-2882/*1084*.
plain blade, C-0406/*48*.
plain boat shape, S-2882/*1054*.
plain body, C-2414/*9*①.
plain column stem, C-5117/*99*①.
plain conical foot, CEA/*423*①.
plain cornice, S-2882/*272*.
Plaine-de-Walsch, CEA/*486*①.

plain frieze, S-2882/*268, 269*.
'plain' ground, OC/*238*.
plain ovoid form, S-2882/*1007*①.
plain pattern, C-0254/*206*.
plain pear shape, S-2882/*1050*.
plain skirt, C-5114/*298*①.
plain sleeve, C-5117/*13*①.
plain stem, CEA/*423*①; S-4461/*547*.
plain-stem shape, EG/*294*①.
plain weave, SDF.
plait, OC/*18*.
plaited, C-1506/*63*.
plaited border, MP/*106*.
plaited fringe, OC/*25*①.
plaited hair, RTA/*131*①.
plaited hair border, C-2332/*298*.
plaited hide, C-1082/*7*.
plaited lace, DADA.
plaited stitch, DADA.
plaited straw, C-0405/*216*.
planar two-dimensionalism, JIWA/*71*.
Planché, André, CEA/*192*①.
Planché, Andrew, EA.
Planchon, Paris, C-5189/*193*.
plane, DSSA; JIWA/*63*; LP/①.
planed surface, S-4461/*371*.
plane grate firing, MP/*191*.
plane-table compass, CEA/*605*①.
planet tankard, S-4972/*139*①.
plane wood, DADA; SDF.
planewood, ACD.
plangi, C-2478/*207*.
planimeter, C-2904/*203*; DATT.
planished, CEA/*618*.
planishing, EA.
planisphere, C-2608/*130*; C-2904/*188*.
planked, C-0982/*3*; C-2402/*49*.
plank lid, C-0982/*84A*.
plank seat, C-0249/*321*①, *385*;
C-0279/*316*; S-4461/*642*.
plank-seat settee, S-4905/*413*①.

plank top, C-0249/*405*; C-5236/ *563*①; LAR82/*394*①.

planographic printing, DATT.

Plantagenet pattern, LAR82/*621*①.

plantain band, C-5156/*418*①.

plantation-made furniture, SDF.

plantation worker, C-2704/*111*.

planted, SDF.

planted moulding, SDF.

planter, C-0225/*14*; C-5156/*164*①; S-4461/*700*①.

plant form, C-0225/*327*; IDPF/ *180*①.

plant holder, C-2409/*95*.

plant medallion, C-2403/*192*.

plant stand, C-2402/*22*.

plant trough, LAR83/*590*①.

plaque, ACD; C-0706/*107*; C-1603/ *120*; C-2323/*126*; C-2414/*22*; C-2458/*227*①, *275*①; C-5005/ *213*①; C-5114/*166*; C-5117/*70*; C-5156/*172*; DADA/①; EA/①; IDC/①; MP/*204*; OC/*36*①; S-2882/*1415*①; S-291/*147*; S-4843; S-4947/*75*①; S-4992/*16*①, *60*①; SDF.

plaque mount, C-0225/*101*.

plaquette, ACD; C-5173/*53*①; EA; RGS/*61*, *115*①.

plasma (chalcedony), RTA/*38*①.

plasma, RTA/*63*①.

plasteline, DATT.

plaster, C-0279/*82*; DATT; LP; S-4843/*480*①; S-4881/*196*①.

plasterboard, DATT.

plaster cast, C-2332/*314*; C-5116/ *147*①; LP.

plaster ground, NYTBA/*24*①.

plaster model, MP/*140*.

plaster mold, MP/*72*.

plaster mould, CEA/*684*.

plaster-of-Paris, CEA/*188*①.

plaster of paris, S-4461/*492*; DATT; EA; LP.

plaster-of-Paris mold, NYTBA/*149*.

plaster primer, DATT.

plaster tool, DATT/①.

plastic, DATT; IDC; IDPF/*206*①; LP; SDF.

plastic art, DATT.

Plastic Arts, LP.

plastic gesso, DATT.

plasticity, DATT; LP.

plasticity and resilience, MP/*36*.

plasticizer, LP.

plastic magnesia, DATT.

plastic ornament, MP/*121*.

plastic paint, LP.

plastic ware, IDC.

Plastische Periode, IDC.

plastron, C-1506/*74*.

plastron-de-fer, DADA.

plat, S-2882/*766*①.

platane wood, DADA.

platband, SDF.

plat de ménage, MP/*448*; EA.

plate, ACD; C-0225/*2*; C-5114/*111*; C-5116/*90*; C-5173; C-5181/*150*; CEA/*218*, *579*, *630*①, *637*; DADA; EA; IDC; IDPF/*182*①; S-4436/*7*①; S-4804/*91*①; S-4928/ *120*①; S-4972/*338*; S-4992/*17*①.

plate armor, DADA.

plateau, ACD; C-1407/*23*; C-2409/ *207*; DADA; EA; IDC; SDF/①.

plateau facet, RTA/*162*①.

plate basket, EA/①; SDF.

plate bucket, C-2478/*69*①; CEA/ *353*①.

plate carrier, EA; SDF.

plate clock, EA/①.

plate cupboard, SDF/①.

plated, C-0706; C-2398/*83*①; C-5117, , *35*①.

plated glass, EC1/*56*.

plated handle, C-2403/*11*.

plated liner, C-5153/*17*①.

plated metal, C-0906/*261, 330.*
plated mount, C-5117/*2.*
plated silver, DADA; NYTBA/*215.*
plated spoon, C-0254/*77.*
plateelbakker, CEA/*210.*
plate-finished paper, DATT.
plate frame, EA.
plate glass, SDF.
Platel, Pierre, EA.
plate mark, DATT.
platemark, C-0249/*8;* S-286/*58, 212,
260, 441, 442.*
plate-metal, CEA/*594.*
plate money, ACD.
plate-mounted, C-5117/*1.*
plate oil, DATT.
plate pail, ACD; DADA; EA;
S-4812/*75*①.
plate rack, C-5239/*252;* CEA/*363*①;
S-4461/*559.*
plateresque, DADA.
plateresque style (in furniture), EA.
plateresque style, SDF.
platero work, EA/*plateresque style (in
furniture.*
plate-shaped base, NYTBA/*217.*
plate stand, DADA/①.
platetone, S-286/*13, 54, 208, 210,
278, 279, 379, 501, 538, 321A;*
S-2882/*1401.*
plate-warmer, EA.
plate warmer, DADA.
platform base, C-2402/*24;* LAR82/
*409*①; S-4461/*171, 743*①.
platformed cross-stretcher, C-2402/
38.
platform lever escapement, C-5117/
*389*①.
platform lever movement, S-4927/*78.*
platform rocker, C-0279/*265;*
LAR82/*305*①; LAR83/*287*①;
SDF.
platform rocking chair, S-4461/*727.*

platform shelf, C-2421/*87*①; C-2437/
*50*①.
platform stretcher, C-2388/*38;*
C-2555/*48*①; S-2882/*791;* S-4414/
*471, 529*①; S-4436/*10*①; S-4955/
58.
Platignum nibs, C-0403/*20.*
platinum, C-5005/*212*①; C-5117/
*419*①; RGS/*136;* S-4461/*319;*
S-4972/*160*①.
platinum chain bezel, S-291/*202*①.
platinum lustre, IDC.
platinum resist, IDC.
platinum rhondelle separator, S-291/
*231*①.
platinum topped gold mount, S-291/
*48*①.
plat ménage, IDC.
platter, C-0254/*3;* C-0270/*4;* C-5239/
104; IDC; IDPF/*183;* S-4461/*389;*
S-4804/*50*①, *61*①; S-4905/*71*①;
SDF.
platter tilter, IDC.
plattters, S-4802/*205.*
Plaue, LAR82/*163*①; LAR83/*105*①.
Plaue-on-Havel, LAR83/*105*①.
Plaue ware, MP/*43.*
player piano, LAR83/*521*①.
Playfair, Aberdeen, C-2503/*166.*
play indicator, C-0403/*213.*
playing card case, C-5174/*264*①.
playing surface, C-5157/*89*①, *155*①.
Plé, Henri Honoré, C-5189/*150*①.
pleasure-boat pattern, IDC.
pleat and panel, OPGAC/*232.*
pleated, C-1506/*2;* C-2493/*19;*
FFDAB/*56.*
pleated flounce, C-1506/*67.*
pleated material, C-2388/*98.*
pleated rim, C-GUST/*57.*
pleated skirt, C-3011/*11.*
pleating, SDF.
plectrum, EA; SDF.

plectrum form, S-4810/*468*; S-4965/ *85*①.

plein air, DATT; LP.

Plessy's green, DATT.

plexiform, DATT.

Plexiglas, DATT.

plexiglass, C-5236/*1630*; LP.

Pleydell-Bouverie, Katherine, DADA/ *Supplement*.

Pleyel, CEA/*550*①.

pliant, CEA/*376*①; EA/*stool*.

Plicha, C-2204/*99*.

Plimer: Nathaniel, Andrew, EA.

plinth, ACD; C-0982/*66*; C-2402/*3*; C-2458/*60*; C-5114/*59*①, *231*, *345*①, *376*; C-5116/*14*; C-5153/ *47*①, *72*①; C-5203/*177*; CEA/ *659*①; DADA; DATT; EA; IDC; LAR83/*160*①; S-4414/*171*①, *463*①, *505*①, *530*①; S-4436/ *120*①; S-4461/*65*; S-4922/*58*①; SDF.

plinth base, C-0982/*13*; C-2357/*34*①; LAR83/*243*①; S-2882/*323*; S-4804/*190*①.

plinth foot, C-5116/*92*; DADA.

plinth-shaped case, C-2437/*24*①.

plique-á-jour, C-2409/*190*.

plique-a-jour, C-5005/*206*①.

plique-à-jour, DADA; DATT; EG/ *228*; IDC/①.

plique-a-jour, LAR83/*478*①.

plique-à-jour, RGS/*50*; S-4461/*373*.

plique â jour, ACD.

plique à jour, C-5156/*844*①; CEA/ *487*①; RTA/*148*①.

plique à jour bowl, S-3312/*1280*①.

plique-a-jour cup, LAR83/*243*①.

plique-à-jour enamel, C-5005/*215*①; RGS/*52*①.

plique á jour enamelling, EA.

plique-à-jour enamelware, RGS/*201*.

P.L. Krider, S-4905/*173*.

Ploessel, CEA/*611*①.

Plot, Dr., CEA/*424*①.

plotting protractor, LAR83/*462*①.

plough, DSSA.

ploughed, SDF.

plouk, DADA.

Plowhandle, CEA/*42*①.

PLR, EA/*Régnard, Pierre-Louis*.

plucking mechanism, CEA/*548*.

plug, C-5156/*385*①; S-4881/*451*①; S-4972/*160*①.

plugged, C-5117/*17*①; C-5236/*474*.

plumage motif, JIWA/*108*.

plumbago, DATT.

plumbago miniatures, EA/①.

plumbate ware, DATT.

plumbic ochre, DATT.

plumbiferous, IDC.

plum blossom, C-2458/*363*①; DADA.

plum bob level, C-2489/*24*①.

plume, C-5116/*58*, *145*①; OPGAC/ *232*①; SDF.

plume-carved, S-4905/*455*①.

plumed, C-5170/*184*①.

plume form finial, S-2882/*325*.

plume grain, DADA.

plume ground, IDC.

plume holder, S-4972/*166*①.

plume mantle, S-4922/*21*①.

plum gum, DATT.

Plummer, Michael, C-5203/*197*①.

Plummer, William, C-0406/*122*; C-5117/*235*; C-5173/*30*①.

plum mottle, SDF.

plum-pudding, DADA.

plum pudding, C-2478/*106*.

plum pudding mahagony, C-2388/ *87*①.

plum wood, DADA; DATT; SDF.

plumwood, ACD; LAR82/*329*①.

plunge pot, IDPF/*18*①, *60*, *183*①.

plush, S-4461/*725*; SDF.

plush stitch, CEA/*274*①.

plush-wood, C-2332/*294*.

plushwork, C-2704/*46*.

Pluto, DSSA.

Pluvinet, Philippe-Joseph, S-4955/ *71*①.

pluvius pencil, S-4881/*187*①.

Pl with a crown and star, EA/*Platel, Pierre.*

PlyModern, C-5191/*313*.

Plymouth, ACD; C-2493/*104*①; CEA/*200*①; DADA/①; EA/①; LAR82/*164*①.

Plymouth pattern, C-5114/*3*; C-5153/ *1*①.

plywood, DATT; LAR82/*309*①; SDF.

p. m. spoon, C-0254/*201*.

pm spoon, C-0270/*293*.

pochade, DATT; LP.

pochade box, DATT.

pochette, CEA/*551*①; EA/*kit, kit.*

pochoir, C-2409/*151*; DATT; S-286/ *463*.

pocket, CEA/*251*①.

pocket-case, CEA/*610*①.

pocket chronometer, C-5117/*484*①.

pocket dial, CEA/*606*①.

pocket globe, C-2489/*14*; CEA/ *603*①; S-4988/*411*①.

pocket-pistol, C-2476/*12*.

pocket pistol, CEA/*29*①, *40*①; S-4972/*232*.

pocket revolver, S-4972/*234*.

pocket sextant, LAR83/*461*①.

pocket sundial, S-4802/*158*.

pocket sundial and compass, S-4927/ *221*①.

pocket watch, C-0270/*118*; C-0706/ *25*; S-4461/*303*.

pocket-watch camera, C-1609/*206*.

pockmarked, C-5146/*151*①.

Podagragruppe, MP/*115*.

Podio, Joseph Felix, C-0706/*86*.

Podio, Peter, C-5174/*524*①.

Podmore, Robert, EA.

podstakannik, RGS/*137*.

poêlon, IDC.

Poertzel, Professor Otto, C-5167/*57*.

poetic, LP.

Poggini, C-5224/*272*①.

Pogorzelski, C-5174/*52*①, *115*①.

Poillon Pottery, Woodbridge, New Jersey, EC1/*85*.

poinçon, C-2324/*240*; C-5146/*63*①; C-5167/*128*①; EA.

point, DADA; DATT.

Point, Armand, S-286/*29*.

point à l'aiguille, DADA.

point appliqué, DADA.

'point' bottle, C-5236/*451*①.

point bottle, C-5156/*109*①.

point coupé, DADA.

point cut, EA.

point d'Alencon, C-1506/*172*.

point d'Alençon, C-2501/*66*.

point d'Alenọn, DADA.

point d'Angleterre, DADA.

point d'Argantan, C-2501/*65*.

point d'Argentan, C-1506/*165*; DADA.

point de Bruxelles, DADA.

point de France, DADA.

point de gaze, DADA.

point de neige, C-1506/*163*①; DADA.

point de Paris, DADA.

point de Raccroc, DADA.

point de rose, C-1506/*164*①.

point d'Espagne, DADA.

point d'esprit, DADA.

point de Tulle, DADA.

point de Venise, DADA.

point de Venise à réseau, DADA/①.

point d'hongrie, SDF.

point d'ivorie, DADA.

point double, DADA.

pointed arch, NYTBA/23.

pointed-arch opening, NYTBA/21.

pointed-base, IDPF/39.

pointed diamond (writing diamond), RTA/94.

pointed end handle, K-802/14.

pointed funnel bowl, LAR83/428①.

pointed-leaf frieze, CEA/453①.

pointed oval-shaped amethyst, RTA/149①.

pointed pad foot, C-2388/83; C-2522/173①; S-4414/448①, 449①, 466①; S-4988/456①.

pointed scalloped rim, LAR83/423①.

pointed spout, C-0270/244.

pointed terminal, C-0254/206.

pointer, C-2904/179; CEA/261①; S-4881/93①.

point-filling stitch, CEA/278①.

pointillé, CEA/594; DADA.

pointillism, DATT; LP.

pointillisme, DATT.

pointing, DATT.

pointing trowel, DATT.

point lace, DADA.

point of sight, LP.

point of station, DATT; LP.

point plat, DADA.

point plat de Venise, DADA.

point plat de Venise au fuseau, DADA.

points, C-2402/29.

Poirié, Philippe, C-2546/48.

poirier wood, DADA.

poison tankard, EA.

poisson, C-5191/223.

Poitevin, Georges, S-4947/168.

Poitou, DADA.

pokal, C-5174/429①; DADA; S-4972/414; IDC.

poke bonnet, C-1506/63.

poker, C-5114/231; S-4461/643; S-4905/326.

poker-work, C-2904/278.

poker work, C-1603/61; EA; SDF.

po ku, IDC/①.

Polaire, C-2409/165.

polar bear rug, LAR82/37①.

polarimeter, C-2608/121; C-2904/76.

polariser, C-0403/161①; C-2904/96①, 110①.

pole, C-2421/105①; S-4972/150.

pole and trailing foliage, C-2364/56.

polearm, C-MARS/46; S-4972/141①, 238A①.

poleaxe, DADA.

poled medallion, C-5189/372; C-5323/79①; S-4948/59①.

poled medallion design, S-4948/20①.

pole finial, C-2414/16①.

pole-hammer, DADA.

pole-head, EA/*Friendly Society emblem.*

pole hinge, C-5156/486①.

pole lantern, DADA.

pole lathe, SDF.

pole library steps, C-2478/71.

pole medallion, C-0906/72; C-2388/149A; C-2482/14; DADA; S-2882/51①.

pole screen, ACD; C-5157/37; C-5170/39; DADA/①; EA; FFDAB/119①; SDF.

polescreen, C-0982/88B.

pole shaft ornament, S-4965/126①.

policemans truncheon, C-0906/136.

poliment, DATT.

polish, ACD; OC/27; SDF; C-5174/15①; DADA.

Polish carpet, DADA; EA/①.

polished, C-2458/332; C-5117/371①; C-5236/342.

polished bronze, C-1082/99.

polished surround, S-4414/63.

polishing method, JIWA/*305*.
polishing rouge, DATT.
Politec, DATT.
political satire, JIWA/*35*.
Polito's Menagerie, IDC/①.
polka design, C-5156/*472*.
Pollaiuolo, Antonio, CEA/*622*①.
pollard, C-2402/*227*.
Pollard, William, C-2493/*7*①.
pollarded wood, SDF.
pollard-elm, C-2403/*109*①.
pollard elm, C-2388/*46*①; C-2478/*80*; LAR82/*278*①.
pollard oak, C-2388/*94*; C-2421/*70*①; CEA/*406*; LAR82/*341*①.
pollard panel, C-2320/*78*.
Pollock, John, C-2487/*97*.
Polonaise carpet, ACD.
Polonaise rug, DADA.
Polonceau, Henri, EA/*51*.
polos, S-4807/*514*.
polycandelum, S-4973/*316*.
polychromatic, DATT.
polychrome, C-0782/*5, 25*; C-2202/*144*; C-2357/*101*; C-2403/*158*; C-2458/*187*; C-5127/*13*①; C-5153/*217*①; C-5234/*3*①; CEA/*111, 120*①; DATT; IDC; S-2882/*238, 358*①, *735*①, *1421*①; S-3312/*1383*①; S-4812/*35*①; S-4972/*9*①; S-4843/*16*.
polychrome and gilt, S-2882/*516*①.
polychrome armorial, CEA/*620*①.
polychrome bead decoration, LAR82/*85*①.
polychrome cloisonné enamel, RGS/*133*①.
polychromed, C-0225/*60*; C-5156/*35*①; S-4414/*227*①; S-4992/*6*①.
polychrome depiction, C-5114/*242*.
polychrome diamond, C-2704/*94*.
polychromed metal, K-711/*126*.
polychrome enamel, S-4804/*221*①.

polychrome enamel decoration, C-5114/*151*.
polychrome enamel technique, RGS/*182*.
polychrome Enghalskrug, S-4853/*240*.
polychrome flower, RGS/*49*①.
polychrome geometrical pattern, RGS/*52*①.
polychrome geometric motif, S-4414/*537*①.
polychrome scene, S-291/*104*①.
polychrome swag, S-4414/*486*.
polychrome ware, EA.
polychrome woodcut, JIWA/*108*.
polychrome wood relief, LAR83/*59*①.
polychromy, RGS/*69*.
Polyclitan school, DATT.
polyester resin, DATT.
polygonal, S-288/*33*①; S-3311/*50*.
polygonal attached medallion, S-2882/*54*①.
polygonal floral medallion, S-2882/*113, 153*①.
polygonal lid, C-2388/*78*.
polygonal medallion, S-288/*40*①; S-2882/*63, 115, 123*①.
polygonal motif, OC/*175*.
polygonal rose medallion, S-2882/*181*.
polygonal stem, C-2403/*58*.
polyhorion, SDF.
Polyhymnia, DSSA.
polymer, DATT; LP.
polymer color, DATT.
polymerization, DATT.
polymerized oil, DATT.
polymer medium, DATT.
polymer primer, DATT.
Polymer Tempera, DATT.
polymethyl methacrylate, DATT.
polyphon, CEA/*549*.
polypod, IDPF/*183*.
polyptych, DATT.

polyvinyl acetate, DATT; LP.

polyvinyl chloride, DATT.

pomade jar, C-5127/*98*.

pomade pot, IDC.

pomander, C-2202/*14*; EA/①; IDC; IDPF/*184*; LAR83/*454*①; DADA/①.

pome, DADA; EA.

pomegranate, IDC; DSSA.

pomegranate finial, C-0254/*145*; S-4955/*14*①.

pomegranate foot, RGS/*17*①.

pomegranate motif, NYTBA/*86*.

pomegranate-pattern, C-2910/*118*①.

pomegranate pattern, C-2324/*15*.

pomegranate-shaped, C-5174/*236*①.

'pomegranate tree', OC/*108*①.

pommade jar, C-0254/*37, 217*; C-5203/*171*.

pommel, C-2421/*6*①; C-2458/*211*; C-2569/*37*①; C-5117/*2, 313*①; C-5156/*262*①; C-MARS/*5*; CEA/ *21*①, *44*; DADA; LAR82/*75*①; S-4972/*152*①, *248*①; SDF.

pommel fitting, C-5156/*362*.

pommel ornament, C-5156/*356*①.

pommier wood, DADA.

pomona, C-5239/*306*; EC1/*56*; NYTBA/*302*.

Pomona factory, CEA/*154*①.

pomona glass, DADA; CEA/*477*①.

Pomone, C-5005/*236*.

pompadour, C-5236/*1621*; SDF; S-4853/*28*①.

Pompadour, rose, IDC.

Pompadour, style, IDC.

Pompadour fan, EA.

Pompeian blue, DATT.

Pompeian design, C-5146/*179*①.

Pompeian painting, DATT.

Pompeian red, DATT.

Pompeian scroll, EA/*Alcora*; IDC.

Pompeian style (Etruscan), EA.

Pompeian style, SDF.

Pompeii, C-2704/*117*.

pompeiian decoration, C-1603/*5*.

pompier, DATT.

pom-pom, C-0405/*157*; CEA/*498*①.

poncif, DATT.

poniard, DADA.

Pons, C-5181/*95*①.

pontata, DATT.

Pont-aux-Choux, DADA.

Pont-aux-Choux ware, IDC.

Pont-Aven School, JIWA/*11*.

ponteuse, DADA.

Ponti, Gio, C-5167/*194*①; DADA/ *Supplement*.

Pontifex, Daniel, EA/*Fountain, William*.

pontifical ring, RTA/*60*①.

pontil, C-5114/*124, 141*①; CEA/*503*; EG/*287*; K-711/*123*.

pontil mark, ACD; DADA; S-4881/ *359*①.

pontil rod, CEA/*414, 503*.

pontil (punty) rod, EA.

Pontipool ware, EA.

pontypool, C-2478/*5*; DADA.

Pontypool japanned ware, ACD.

pontypool japanning, SDF.

Pontypool ware, EA/①.

ponyskin, C-1304/*120*.

Poole, C-2910/*138*.

Poole, Joshua, NYTBA/*181*①.

pooling, C-2323/*1, 11*①; C-2414/*33*; C-2458/*19, 29*; C-5127/*20*; C-5156/*20*.

Poor, Henry Varnum, DADA/ *Supplement*.

pop art, DATT; LP.

Pope and Devil cup, IDC.

Pope Joan, CEA/*694*①.

poplar, ACD; S-4905/*328*; SDF.

poplar kas, S-4905/*419*①.

poplar wood, DADA.

Popov, Alexei Gavrilovich, EA/①.

Popp, Walter, JIWA/*352*①.

popping, DATT.

poppy, DSSA.

poppy head, DADA/①.

poppyhead, SDF.

poppy oil, DATT.

poppyseed oil, DATT; LP.

poppy table lamp, C-5005/*374*①.

popular print, NYTBA/*193*.

pop-up tray, C-2478/*112*①.

P.O.R., LP.

porcelain (1), ACD.

porcelain (2), ACD.

porcelain, C-0782/*1*; C-1006/*102*; C-2427/*38*; CEA/*117*①, *562*; DADA/①; DATT; EA; EC1/*83*; IDC; IDPF/*6*; NYTBA/*144*; S-4992/*9*①, *60*①.

Porcelain Axe, The (De Porceleyne Bijl) Delft factory, EA.

Porcelain Bottle, The (De Porceleyne Fles Delft factory), EA.

porcelain cabinet, JIWA/*8, 323*.

porcelain cabinet plate, S-3311/*384*①.

porcelain case, EC2/*95*①.

Porcelain Claw Factory, The, EA/ *Sanderus, Lambertus*.

porcelain clock case, MP/*72*.

porcelain colors, DATT.

porcelain design, MP/*72*.

porcelain Easter egg, C-5174/*197*.

porcelaine de France, IDC; EA.

porcelaine de la Reine, IDC.

Porcelaine de Limoges in red, EA/ *Limoges*.

porcelaine de Paris, IDC.

porcelaine de santé, IDC.

Porcelaine de Saxe, MP/*190*.

porcelaine laquée burgautée, IDC.

porcelain enamel, DATT.

porcelaine royale, IDC; EA; CEA/ *184*①.

porcelain factory, EA/*Ilmenau*.

porcelain figure, JIWA/*19*.

porcelain flower, NYTBA/*170*.

porcelain Glockenspiel, MP/*99*.

porcelain house, MP/*119*.

porcelain liner, C-5117/*330*①.

porcelain mark, CHGH/*17*.

porcelain mixture, MP/*15*.

porcelain ornament, C-2364/*7*.

porcelain painting, MP/*70*.

porcelain paste, MP/*139*.

porcelain plaque, CEA/*303*.

porcelain plate, C-1006/*51*.

Porcelain Plate, The (De Porceleyne Schotel), EA.

porcelain room, EA; IDC/①.

porcelain snuff bottle, S-4810/*38*①.

porcelain table clock, C-5174/*333*①.

porceleyn, EA.

porcellana, alla, IDC.

porcellaneous ware, IDC.

Porcelleinglas, EA/① *Potsdam glasshouse*.

porosity, NYTBA/*122*.

porphyry, C-0279/*169*; C-2364/*17*①; C-2493/*245*; C-5116/*156*①; DATT; IDC; JIWA/*310*; S-2882/ *818*①, *839*①.

porphyry bowl, S-2882/*818*①.

porphyry vase, LAR83/*168*①.

porporino, DATT.

porringer, ACD; C-0254/*287*①; C-5114/*83*; C-5153/*35, 49*①; CEA/*594, 641*①; DADA/①; EA/ ①; IDC; IDPF/*184*①; LAR82/ *585*①; LAR83/*598*①; NYTBA/ *217*①; S-3311/*635*①; S-4461/*218*; S-4804/*91*①; S-4905/*225A*.

porringer-top, C-5153/*190*①.

porró, DADA; EG/*84*.

porrón, EA/①.

Portuguese ware, IDC.

Porzellanglas, EA/*Milchglas*, *opaque-white glass*.

Porzellankrankheit, MP/*95*.

Porzellanmanufaktur, Berlin, JIWA/*324*①.

Porzelliner, MP/*88*.

pose, JIWA/*11, 20*; LP; MP/*37*.

posé d'or, DADA.

Poseidon, DSSA.

Po-shan glass, EG/*214*.

po-shan-lu, IDPF/*123, 184*.

positive space, IDPF/*5*; LP.

positive stencil, JIWA/*199*.

positive volume, LP.

positure, IDC.

posnet, EA/*skillet*; NYTBA/*262*.

posset-bowl, IDC.

posset cup, EG/*133*①.

posset cup or posset pot, EA/*caudle cup*.

posset glass, EA.

posset-pot, ACD; DADA; IDC/①.

posset pot, CEA/*152*①; IDPF/*184*①; LAR82/*112*①; S-4823/*14*; S-4905/*153*①; S-4843/*46*①.

post, C-5114/*251, 289, 295*①, *341*①; C-5153/*115*①; SDF.

post-, LP.

postage-stamp copying camera, C-1609/*160*.

post-and-spear border, EC2/*22*①.

post bed, S-3311/*278*①; SDF.

post (posted) bed, EA/*fourposter*.

posted bed, SDF/*post bed*.

posted (bird cage) frame, EA.

posted frame, LAR82/*222*①.

posted-frame movement, C-MARS/*239*①.

posted iron, S-4927/*85*①.

poster, C-0225/*412*; C-0249/*62*; JIWA/*10*; NYTBA/*208*.

poster art, JIWA/*10*.

poster color, DATT.

poster effect, JIWA/*130*①.

poster lithograph, JIWA/*62*①.

post-Gupta, C-5156/*203*.

post horn, EA.

postiche, DATT.

postillion livery jacket, C-3011/*96*.

Post-Impressionism, JIWA/*13*; LP.

post-impressionist, C-5239/*197A*①.

Postimpressionist painting, DATT/①.

postman's alarm clock, EA.

post-medieval period, RTA/*89*.

post-mortem set, LAR83/*461*①.

post-Romantic painting, JIWA/*46*.

posture, JIWA/*6*.

posy-holder, IDC.

posy holder, C-0706/*64*; LAR83/*641*①; S-3311/*642*.

posy-ring, RTA/*96*.

posy ring (brooch), EA.

pot, C-0225/*21A*; DSSA; EG/*292*; IDC; IDPF/*185*.

pot-à-oille, EA.

Potarange, Jean, S-4955/*100*①.

pot arch, CEA/*503*; EG/*292*.

potash, CEA/*413*; EG/*83*.

potash glass, CEA/*503*; DADA; EA.

potash glass (Waldglas), (verre de fougère), EG/*46*.

potash-lime glass, CEA/*451*; EG/*95*①.

potassium silicate, DATT.

potassium water glass, DATT.

pot à surprise, IDC.

potato flower, EA.

potato-flower pattern, CEA/*133*①; IDC.

potato holder, C-5203/*160*.

potato-ring, DADA; IDC.

potato ring, ACD; EA/*dish-ring*.

potato-soup glaze, IDC.

pot-au-creme dish, C-5203/*242*.

potbank, IDC.
pot-bellied measure, CEA/585①; EA.
pot-board, C-2382/153; C-2498/138.
pot board, ACD; EA; LAR82/349①;
SDF.
potboard, LAR83/324①.
potboiler, DATT.
pot bracket, ACD.
pot-cheese paint, DATT.
pot crane, ACD.
pot cupboard, C-1407/97; EA;
LAR83/305①; S-4988/466①;
SDF.
pot-de-crême, C-5189/206.
pot de crème, EC2/23①.
potence, C-5174/424.
potent cross, DATT.
Poterat, Edmé, EA.
Poterat, Louis, CEA/169, 182①; EA.
poterie, IDC.
pothanger, SDF.
pothanger or hake or hook, ACD.
Pothier, Jean-Jacques, C-2555/39①.
Pothier, J-J, EA/47①.
pot-hook, EA/①.
pothook pattern, IDC.
potiche, C-5005/351①; DADA;
IDC/①; IDPF/185; LAR83/
114①.
pot-lid, EA/①; IDC/①.
pot lid, ACD; DADA/Supplement.
pot metal, EG/161.
Potonié, C-2493/246.
pot-pourri, DADA/①.
pot pourri, C-1006/120.
potpourri, CEA/195①; IDPF/185①;
S-4843/378①.
pot-pourri bowl, IDC.
potpourri bowl, EA.
pot-pourri pot, C-2910/148.
potpourri pot, C-2409/71.

pot-pourri vase, C-2364/4; IDC/①;
LAR82/150①.
pot pourri vase, C-1006/108;
LAR83/135①.
potpourri vase, C-2493/165; S-2882/
716①.
Pot-Pourri vase, C-2427/20.
pot ring, EG/292.
Potschapel, C-2493/260.
Potschapel pedestal, S-4992/79①.
potschappel, LAR82/123①, 165①;
LAR83/104①.
Potsdam, CEA/451; DADA.
Potsdam box, CEA/64①.
Potsdam glass-house, CEA/453①.
Potsdam glasshouse, EA/①.
Potsdam service, EA/Berlin Faience
factories.
pot setting, CEA/503.
pot settling, EG/292.
pot shelf, LAR82/350①.
potsherd, IDC.
pot stand, LAR83/305①.
potstone, DATT.
pottance, CEA/251①.
potted, C-2323/11①; C-2458/138;
C-5127/18; C-5236/431①.
potted meat dish, S-4905/45①.
potten kant, DADA.
potter, MP/19; C-0906/381.
Potter, Albert H., C-5174/405①.
Potter, Harry, C-5174/419①;
S-4927/37.
Potter, J. D., C-2904/68.
Potter, John, C-5153/80①.
Potter, Mary K., S-4947/75①.
potter's clay, DATT; IDC.
potter's knife, DATT.
potter's mark, C-5189/6A; IDC;
EC2/24.
potter's mould, IDC.
potter's palette, DATT/①.

Potter's patent barrel and detent, C-5174/*405*①.

potter's pink, DATT.

potter's wheel, DATT; IDC; IDPF/ *185*; MP/*73*.

pottery, ACD; C-0225/*1*; C-0782/*25*; C-1006/*144*; C-2323/*2*; C-5239/*1*; DADA; DATT; IDC.

pottery, Greek, DATT.

pottery biscuit, IDPF/*162*.

pottery drum, C-1082/*20*.

pottery figure, C-1006/*59*.

pottery form, laws of, IDPF/*146*.

pottery group, S-4461/*59*.

pottery inlay, CEA/*565*①.

pottery mark, CHGH/*17*.

pottery panel, LAR82/*292*①.

pottery slab, IDPF/*34*.

pottery vase, S-3311/*869*①.

pottery vessel, S-4461/*445*.

potting line, C-2324/*36*.

pottle size, IDPF/*185*.

p'ou, IDPF/*186*.

pou, DADA.

pouch table, EA/*work-table*; SDF/①.

poudreuse, C-5189/*292*①; DADA/①; EA/①; LAR82/*397*①; LAR83/ *371*①; S-2882/*402, 417*.

pouf, EA.

pouffe, C-5167/*216*①; EA; SDF.

poultry shears, S-4804/*35*.

pounce, ACD; CEA/*647*①; DATT; EA.

pounce (in ceramic decoration), EA.

pounce, LP.

pounce-box, CEA/*594*.

pounce box, DADA.

pounced, C-5157/*109*①; IDC.

pounced ground, C-0279/*299*; C-5116/*174*①; C-5170/*184*①.

pounced ornament, SDF.

pounced panel, C-5116/*139*①.

pounce-pot, C-2398/*51*; C-2427/*89*; IDC.

pounce pot, C-1502/*60*; C-2493/*167*.

pounce pot (box), EA.

pounce pot, IDPF/*186, 199*.

pouncet-box, CEA/*61*.

pouncet box, DADA.

pouncing, CEA/*541*; DATT.

poupard, CEA/*697*.

pouring bowl, C-2458/*19*; C-5236/ *1597*.

pourpre français, DATT.

Poussierer, EA/*Bossierer, Bossierer*.

Poussin, C-2910/*23*.

Poussinisme, DATT.

Pouyat, François, CEA/*186*①.

Pouzait-type, S-4802/*144*①.

P over R, EA/*Rewend, Christian F.*.

Poverty, DSSA.

powder-blue, EA/*Mazarin blue*; IDC.

powder blue, ACD; C-0782/*39*; C-5127/*129*; EA/*Mazarin blue*.

Powder Blue range, C-2409/*79*.

powder blue ware, DADA.

powder bowl, C-2402/*173*.

powder box, C-0225/*162*; C-5005/ *387*; C-5239/*120*; CEA/*61*; S-291/ *163*.

powder-decorated glass, JIWA/*329*①.

powder dish, S-4461/*366*.

powdered manganese, IDC.

powdered silver sulphide, RTA/*13*.

powdered wig en queue, C-2332/*265*.

powder-flask, C-2569/*57*; C-MARS/ *115*①.

powder flask, C-0279/*43*; CEA/*21*①; S-3312/*1066*①; S-4802/*323*; S-4972/*163*①.

powder folder, CEA/*535*①.

powder horn, C-5114/*172*; CHGH/ *62*; IDC; S-4461/*230*; S-4972/ *158*①.

powdering, LP.

powdering stand, SDF.

powder jar, C-0254/*242.*

powder measure, S-4881/*515*①.

powder post beetle, SDF.

powder print, JIWA/*278.*

powder stand, DADA.

powder table, SDF.

Powell, C-2476/*64.*

Powell, James & Sons, CEA/*489.*

Powell, Roger, DADA/*Supplement.*

Powell, W., C-2476/*42.*

Powell and Lealand, CEA/*611*①.

Powell and Ross, CEA/*611*①.

Powell & Lealand, C-2904/*137,
198*①.

Powell & Leland, C-2904/*110*①.

Power, Edward, S-4944/*308.*

Poyntz, Francis, EA.

Pozzolana, DATT.

Pozzuoli blue, DATT.

Pozzuoli red, DATT.

PR, EA/*Rollos, Philip the Younger,
286.*

prabha, C-5156/*219*①, *226*; C-5234/
*5*①.

practise chanter, C-0906/*284.*

Pratt, Felix, DADA; EA.

Pratt's Son, Daniel, LAR82/*214*①.

Pratt ware, ACD; EA.

Prattware, IDC/①; LAR82/*165*①;
LAR83/*144*①; S-4843/*209*①;
S-4905/*155*①.

prayer arch, C-2388/*208*; C-5189/
398.

prayer arch type, OC/*135.*

prayer designs, OC/*106.*

prayer-mihrab layout, OC/*133.*

prayer niche, S-4847/*178.*

prayer-niche layout, OC/*134.*

prayer panel, S-288/*22*①.

prayer reserve, S-4948/*32*①.

prayer rug, C-0906/*33*; C-2478/*222*;
C-2482/*8*; C-5189/*359*; CEA/
*79*①; DADA; LAR83/*528*①; OC/
*43*①, *114*; S-4796/*29*①.

prayer shawl (Eastern European),
C-5174/*10 shpanyer.*

prayer shawl clasp, C-5174/*20.*

prayer wheel, C-5234/*61.*

praying chair, SDF.

pre-blown glass, EG/*13.*

Precht, Burchard, CEA/*317*①.

Precht frame, CEA/*305*①.

précieux, DATT.

precious metal, NYTBA/*211.*

Precious Objects, C-2458/*381.*

Precious Objects motif, S-4965/
*249*①.

precious stone, C-5117/*315*①.

precipitated chalk, DATT.

Precision, C-2904/*86.*

precision balance, C-1609/*92.*

precision clock, EA/①.

precision drawing, DATT.

preColumbian, IDPF/*81.*

Pre-Columbian, IDPF/*52*①; S-4807/
172.

pre-Columbian art, CHGH/*48*;
DATT.

pre-Columbian pottery, IDC.

predella, DATT.

predominant tone, C-2704/*105.*

preDynastic Egypt, IDPF/*36.*

Predynastic redware, C-1582/*1.*

pre-hairspring, S-4927/*220*①.

pre-han, C-5236/*335B.*

prehistoric art, DATT.

prehistoric painting, LP.

prehnite, C-5005/*210*①.

Preiss, LAR83/*32*①.

Preiss, F., C-2910/*302*; C-5191/
*121*①.

Preiss, Ferdinand, C-5167/*55.*

Preiss-Kassler foundry, C-5167/*36*①.

press-moulding (ceramic technique), EA.

Pressnummer, C-2486/84.

pressure-sensitive tape, DATT.

press view, DATT.

prestige mark, C-5174/440; CEA/71.

Prestini, James, DADA/Supplement.

Preston, Benj., S-4944/260①.

pretence, C-5173/49①; S-4905/134①.

pretender glass, DADA.

Preuning brothers, CEA/136①.

Preussisch-musikalische pattern, IDC.

Preussler, CEA/454①.

Prévost, J. J., C-5174/484.

Prevost, J.J., C-5220/38①.

Prévost, Pierre, EA.

Prewitt, William, EA.

Priapus, DSSA.

pricked, C-2503/4; C-5117/184①; C-5220/1①.

pricked ground, C-2332/66.

pricked initials, C-5117/101①.

prick-engraved, C-5173/47.

prick engraved, C-5117/96①.

pricket, ACD; C-2498/9; CEA/594; DADA; S-4972/50①; SDF; S-4461/159.

pricket candlestick, C-2458/255①; C-5236/373①; EA/①; IDC/①; LAR82/253①; S-4810/308①; S-4972/50①.

pricket stick, C-5181/58.

pricking, DATT.

prick-point, S-4802/221①.

prick-work, CEA/666①.

Pride, DSSA.

prie-dieu, ACD; C-1407/107; C-2402/31; DADA; EA; S-3311/410①; S-4853/472①; SDF.

prie-dieu chair, EA/①; SDF/①.

Priest, W., C-2487/99.

Priest, William, S-4922/59①.

Priest, William and James, C-5117/240①.

priest's table, C-0982/208.

Prieur, Barthelemy, C-5224/290①.

primary border, C-5189/360; C-5323; S-3311/4, 64.

primary carnation border, S-2882/132.

primary color, DATT; LP.

primary feature, JIWA/44.

primary leaf and wine glass border, S-2882/198①.

primary movement, JIWA/36.

primary stepped medallion border, S-2882/62.

primary structure, DATT.

Primauese, P., C-2478/21.

prima vera, DATT.

primavera, DATT; S-4881/443①.

primer, DATT.

priming, LP.

primitive, DATT/①.

primitive, Italian, DATT.

primitive art, JIWA/42; LP.

primitive artist, NYTBA/190.

primitive piece, NYTBA/40.

primitive pottery, IDC.

primitivism, LP.

primrose, OPGAC/232①.

primrose leaf-moulded, C-2360/5①.

primrose yellow, C-2704/58; DATT.

prince, C-0405/165.

Prince, J., C-5174/526①.

Prince, Samuel, CEA/397①; DADA.

Prince Henri pattern, EA; IDC.

princely coronet, C-5174/323①.

Prince of Wales check, C-2501/2.

Prince-of-Wales feathers, C-0982/123A.

Prince of Wales feathers, C-0249/402①; C-2421/121①; C-5153/212①.

Prince of Wales plume, DADA; S-4414/391①; S-4988/421①.

Prince of Wales Plume pierced splat, S-4414/*444*①.

Prince of Wales plumes, C-2421/*17*①; C-5116/*13*①; EA.

Prince of Wales plumes, and thistle, EA/*Jacobite glass.*

Prince of Wales's feathers, LAR83/*286*①; SDF.

Prince of Wales splat, S-4436/*141A*①.

Prince Regent service, C-2493/*14.*

prince's metal, DADA; EA; SDF.

princess, OPGAC/*196.*

Princess Bokhara, DADA.

princess ring, S-291/*205*①.

prince's wood, SDF.

princewood, ACD; SDF.

principal motif, OC/*192.*

principle of omission, JIWA/*25.*

pring, LAR83/*143*①.

print, C-5114/*206A*; C-5156/*599*①; C-5236/*935*; DATT; NYTBA/*197*①; S-4461/*468.*

print cabinet, SDF/①.

printed, C-0782/*181*; IDC.

printed cotton, C-2704/*48A.*

printed design, NYTBA/*100.*

printed mark, C-1006/*33*; C-2409/*61*; S-4992/*9*①.

printed mug, C-0782/*24.*

printed textile, NYTBA/*87.*

printed ware, DADA/*Supplement.*

printed wool, C-5116/*63*①.

printer's ink, C-0249/*44.*

printie, EG/*293*; LAR82/*448*①.

printing-ink, JIWA/*215.*

printing ink, DATT.

print-making, JIWA/*49.*

print rack, DADA.

printy, EG/*293.*

Prior, Edward, EA/*354.*

Prior, Edward, London, C-MARS/*179.*

Prior, Edw., London, C-2489/*175.*

Priscilla, OPGAC/*233.*

prism, C-2904/*167*; C-5114/*238*①; C-5239/*339*; FFDAB/*112*; S-3311/*263.*

prism and flute, OPGAC/*233.*

prismatic, C-0403/*143*; C-2904/*143.*

prismatic color, DATT; LP.

prismatic cutting, EG/*150.*

prismatic drop, C-1702/*130.*

prism-cut, EG/*203*①.

prism drop, C-0279/*210.*

prism ring, C-5114/*238*①.

prism-shaped, C-5167/*267*①.

prisoner of war, C-0906/*84.*

prisoner-of-war ship model, C-5224/*44*①.

privateer, CEA/*443*①.

privateer glass, EA/①.

privy council ware, ACD.

privy (secret) seal, RTA/*80*①.

Prix de Rome, LP.

problem picture, DATT.

processional candlestick, CEA/*579.*

processional cross, EA/*cross.*

processional sword, C-MARS/*46.*

process oil color, DATT.

process tempera color, DATT.

Prochetto, Philipp (Prochet), C-5174/*451*①.

prochoös, IDC.

Proclamation Touching Glass, CEA/*420*①.

Proctor & Beilby, C-2904/*63.*

Prodigal Son, C-1506/*150*; DSSA.

"Prodigal Son"plate, S-4843/*136*①.

produced corner, C-5157/*89*①.

product of vitrification, MP/*15.*

profile, C-5116/*145*①; C-5156/*299*①; CEA/*503*; DATT; EA/*silhouette, silhouettes*; IDC; SDF.

profile bust, C-0254/*53.*

profiled ink process, JIWA/*391*.
profile-medallion, CEA/*371*①.
profile portrait bust, C-5114/*194*①.
profile portrait medallion, NYTBA/*28*.
Profilm, DATT.
profil perdu, DATT; LP.
progressive proofs, DATT.
projecting cupboard door, C-2403/*154*.
projection, DATT/①; SDF.
projection clock, EA/①.
projection microscope, C-2608/*120*.
projector, LP.
Proletcult, DATT.
Prometheus, DSSA.
prong, C-0706/*53*.
pronged, C-0103/*101*.
prong-like leg, C-5167/*225*①.
prong-set, S-4927/*284*①.
'Pronk', C-5236/*1790*.
Pronk, Cornelis, C-2458/*192*.
pronk plate, C-5127/*256*①; C-2458/*192*①.
proof, C-0249/*124*; DATT; S-286/*247B*.
proof after letter, DATT.
proof before letter, DATT.
proof copy, C-5236/*947*.
proof impression, S-286/*166, 451, 304A*.
propaganda chess-set, C-2332/*16*①.
propelling pencil, C-0403/*18*; C-0406/*69*.
propelling pencil set, C-2487/*1*.
propelling toothpick, C-2487/*1*.
propellor mantel clock, C-0906/*114*.
proportion, DATT/①; JIWA/*6*; LP/①.
proportional, C-2904/*71*.
proportional calipers, DATT.
Proserpine, DSSA.

Proskau, C-2486/*185*①; DADA.
prospect door, C-5114/*302*①, *333*①, *363*①.
prospect-glass, CEA/*602*①.
Prosser, John, C-5117/*40*①.
protective lid, C-5117/*385*①.
Proto-Art Nouveau, DADA/*Supplement*.
Protogeometric period, DATT.
Protogeometric style, IDC/①.
protome, S-4973/*159*①.
proto-porcelain, C-2414/*25*①; DATT; EA/①.
protoporcelain, IDC.
prototype, DATT.
protoxide of copper, MP/*196*.
protractor, C-2904/*284*①; CEA/*610*①.
protruding vertical band, S-4414/*187*①.
protrusion, C-2458/*209*①.
proud, SDF.
Prouvé, Emile Victor, DADA/*Supplement*.
provenance, C-5116/*121*①; C-5239/*70*①; CHGH/*7*; IDC; LP.
Provence, DADA.
Provence-Coigny commode, C-2555/*64*①.
Provender for the Monastery, IDC.
Providence Flint Glass Works, CEA/*465*①.
province mark, EA.
provincial, C-0782/*27*; C-5127/*62*; C-5236/*1581*; CEA/*335*①; S-4853/*419*; S-4922/*64*①; S-4972/*611*; C-5181/*138*①; S-4461/*702*.
Provincial, French, DADA.
provincial Canadian, NYTBA/*37*.
provincial French, NYTBA/*36*.
provincial furniture, NYTBA/*35*①.
Provincial Ming, LAR82/*156*①.
provincial rococo, NYTBA/*18*.

proving mark, C-2503/*38.*
provocative, LP.
Prudence, DSSA.
Pruening, Paul, NYTBA/*135*①.
prunier wood, DADA.
prunt, ACD; C-5146/*149A*①; CEA/
503; DADA; EA/*almorrata*; EG/
*73*①; NYTBA/*272*①.
prunus, C-2458/*88, 104*; CEA/*115*①;
DADA/①; IDC/①; S-288/*10*①.
prunus pattern, IDC.
prunus vase, ACD; IDC.
Prussian, C-2503/*42.*
Prussian blue, DATT; LP.
prussian blue glass, C-2324/*139.*
Prussian brown, DATT; LP.
Prussian control mark, C-5173/*67*①.
Prussian green, DATT; LP.
Prussian red, DATT.
Prussian Royal Iron Foundry, EA/
Berlin iron jewellery.
Prussian service, IDC.
PS, EA/*Storr, Paul, Syng, Philip the
Younger.*
Psalter, DSSA.
psalterium, SDF/*psaltery.*
psaltery, DSSA; SDF.
pseudo-armorial, S-4905/*142*①.
pseudo British hallmark, C-5114/
*100*①.
pseudo-Chinese seal-mark, IDC.
pseudo English hallmark, C-5114/
*99*①.
pseudo-hallmark, C-5153/*29.*
psyché, DADA.
Psyche, C-2398/*11*①; DSSA.
psychedelic art, DATT; LP.
psykter, DATT; IDC/①; IDPF/
*188*①.
Ptolemaic Period, S-4807/*466.*
Ptolemy, DSSA.
publication line, S-286/*534.*
Public Dentist group, MP/*115.*

puce, C-2427/*33*; C-2502/*108*;
C-5005/*363*; IDC; S-4905/*77*①.
puce-scale, C-2427/*64.*
puce scale, LAR83/*113*①.
pudding dish, C-5114/*92*①; C-5127/
250.
pudding pan, IDPF/*188.*
pudding plate, C-0782/*32*; S-4905/
*109*①.
puddingstone, S-4810/*105*①.
puddle, DATT.
Pueblo Indian pottery, IDC.
Puente del Arzobispo, EA.
puente stand, DADA.
puff, C-1506/*55*①.
puffy glass, C-5167/*236*①.
puffy lamp, K-710/*119.*
pug, DATT.
pug-dog, IDC/①.
pugging, IDC.
Pugi, C-5181/*83.*
Pugin, CEA/*365*①.
Pugin, Augustus Welby, CEA/*365*①.
Pugin, Augustus Welby Northmore,
DADA/*Supplement*; EA/①; SDF/
760.
Pugin, A. W., NYTBA/*22.*
Pugin, A.W.N., C-2357/*15*①.
Puiforcat, LAR83/*592*①; S-4944/
174.
Puiforcat, Jean, NYTBA/*234*①.
Puiforcat, Jean E., C-5167/*177.*
Pulcinella, S-4843/*55*①.
pull, C-0225/*300*; C-5005/*330*①;
C-5114/*274*; C-5191/*272*; C-5239/
242; C-5259/*541*①; NYTBA/*258.*
pull down front, SDF.
pulled brim, C-0225/*291.*
pulled bronze, C-0225/*195.*
pulled bulbous form, S-4461/*17.*
pulled design, C-5191/*411*; C-5239/
134.
pulled-feather design, C-5146/*146*①.

pulled glass, C-5236/*811*①.

pulled stem, C-0225/*329*①.

pulled tel decoration, C-0225/*332*①.

pulled thread, C-2409/*20*①.

pulled threadwork, C-1506/*171*.

pulley hoop, C-5236/*402*.

pulley salt, EA.

pulling, C-2458/*79*; C-5127/*35*; DATT; IDPF/*119*.

pulling pliers, DATT.

pull-off cover, EA/*caster*.

pull-on hat, C-3011/*70*.

pullout panel, S-2882/*291*.

pull-out prospect section, S-4905/*371*①.

pull-up, EA/*wax-jack*.

pull-wind alarm mechanism, C-MARS/*224*.

pulpit-chair, SDF.

pulse piece, EA/*blind man's watch*.

pulse watch, C-2489/*137*; EA.

pulvinated, SDF/①.

pulvinated frieze, DADA.

pulvino, C-5157/*164*①.

pumice, DATT.

pumice stone, DATT.

pump, C-2904/*136*.

pumping, DATT.

pumpkin head, CEA/*697*.

pumpkin pine, DADA.

punch, CEA/*528*; DATT; IDPF/*22*; CEA/*685*.

punch-accented, C-5114/*318A*①.

punch-beaded, C-1502/*177*; C-2202/*250*.

punch-bowl, IDC.

punch bowl, ACD; C-0254/*35*; C-0782/*64*; C-2458/*144*; C-5117/*262*①; C-5127/*119*; C-5236/*829*①; DADA/①; IDPF/*188*①; NYTBA/*309*; S-4905/*60*①.

punchbowl, LAR82/*433*①.

Punch-bowl, C-2360/*11*.

punch bowl-on-stand, S-4804/*668*①.

punch cup, LAR82/*435*①.

punched, NYTBA/*30*①; S-3311/*804*①; S-4972/*51*.

punched boss, S-4905/*236*①.

punched decoration, C-0279/*203*.

punched ground, C-2357/*44*①; C-5114/*393*①; S-2882/*630*①; S-4436/*8*①.

punched ornamentation, CEA/*583*①.

punched panel, C-1407/*127*.

punched stippled ground, S-2882/*943*①.

punched surface, C-5114/*107*.

punched work, EA/①; RTA/*40*①.

punch glass, ACD.

punchinello figure, C-2421/*156*.

punching, CEA/*541*.

punch ladle, C-5114/*19*; DADA/①; EA; LAR83/*580*①; S-4804/*1, 29, 35*.

punch lifter, DADA.

punch motif, C-5114/*318A*①.

punch'ong, DATT.

Punch'ŏng (mishima ware), EA.

Punch-ŏng ware, IDC.

punch-pot, IDC/①.

punch spoon, DADA.

punchwork, C-5116/*145*①; CEA/*641*①; S-2882/*310*; S-4905/*370*①.

punch-worked, C-5170/*137*.

punchwork ground, S-4461/*608*.

punchwork pattern, NYTBA/*246*.

Punct, Carl Christoph, EA.

Punic wax, DATT.

Punktzeit, MP/*502*.

punt gun, C-2503/*95*.

punt mark, CEA/*70*.

punto, DADA.

punto a groppo, DADA.

punto a maglia quadra, DADA.

punto a relievo, DADA.

punto a reticella, DADA.

punto avorio, DADA.

punto gotico, DADA.

punto in aria, DADA.

punto nevre, DADA.

punto tagliato, DADA; NYTBA/*93*.

punto tagliato a fogliami, DADA/①.

punto tirato, DADA.

punty, CEA/*495*①, *503*; EA/*pontil.*

punty mark, ACD; CEA/*503*; DADA.

Punwon, CEA/*129*①.

punzeh, CEA/*101, 101.*

Puppenhuizen, CEA/*693*①.

purchase, DADA; EA/*thumbpiece, thumpiece.*

Purdey, J., C-2476/*15*①.

Purdey, James, London, C-2503/*113.*

purdonian, SDF.

purdonium, ACD; C-1407/*74*; EA/ *coal-scuttle*; SDF/*purdonian.*

pure calligraphy, JIWA/*49.*

Pure Coin, EA/*American silver.*

pure color, DATT.

puree, DATT.

pure gum turpentine, LP.

pure scarlet, DATT.

pure silver, CEA/*637.*

purfled, SDF.

purfled trellis pattern, CEA/*551*①.

Purim plate, C-5174/*46.*

Purism, DATT; LP.

purist, CEA/*307*①.

Puritan, EA.

Puritan furniture, SDF/①.

Puritan pattern, S-4804/*53.*

Puritan period, SDF.

Puritan spoon, DADA.

Puritan style, EA/*Commonwealth style.*

Puritan tankard, EA/*Commonwealth, Commonwealth tankard.*

Puritan watch, EA/①.

purl, CEA/*294*; DADA; SDF.

Purman, Marcus, EA.

purple, IDC; LP.

purpleheart, C-0279/*387*; C-2357/ *71*①; C-2364/*55*①; C-5005/*316*①; C-5189/*301*①; DATT; LAR82/ *329*①; SDF; C-0249/*444.*

purple landskip, CEA/*188*①.

purple lustre, IDC.

purple monochrome, EA.

purple of cassius, CEA/*210*; DATT; IDC.

purple of the ancients, DATT.

purple pigment, DATT.

purple resist lustre, IDC.

purple sapphire, S-4414/*144.*

purple slag, DADA/*Supplement.*

purple Ting, EA/*Ting-chou ware.*

purple wood, NYTBA/*60.*

purplewood, S-4823/*172*; S-4972/ *550*①.

purpurin, DATT.

purpurine plinth, RGS/*123*①.

purpurino, DATT.

purpurissum, DATT.

purse, C-0406/*115*; C-5174/*249*; DSSA.

purse frame, C-0254/*189.*

purse maker, MP/*82.*

purse watch, S-4927/*141*①.

push and pull, LP.

pushbutton, C-5005/*213*①.

pusher, C-0706/*130*; C-1502/*1.*

push pendant, C-2489/*227.*

push-piece, C-5117/*354.*

push-piece (in watch), EA.

push-piece, RGS/*92*①.

pushpiece, C-2332/*125*; C-2487/*10.*

push repeat, C-5117/*436*①; S-4802/ *16*; S-4927/*170.*

pushti, CEA/*101*; OC/*30, 30.*

push-up candlestick, S-4905/*345*.

push-up mechanism, S-4905/*342*.

pustaka, C-5234/*19*①; S-4810/*278A*.

pu-tai ho-shang, DADA.

Pu-tai Ho-shang (in Chinese ceramics), EA.

Pu-tai Ho-shang, IDC/①.

putti, C-0982/*19*; C-1603/*4*; DADA; EA; S-2882/*519*①; S-4804/*108*①.

putti and scroll foot, S-4804/*235*①.

putti decoration, C-2555/*24*①.

putti finial, S-2882/*1021*①.

putti group, MP/*490*①.

putti head, C-0279/*61*①.

putti musician, C-2398/*93*①.

putting-down, or preserving, crock, NYTBA/*159*.

putto, C-2398/*54*①; CEA/*226*①, *305*①; DATT; DSSA; IDC; LP; MP/*36*; S-2882/*757, 810*; S-4507/ *6*①; S-4804/*29*; MP/*133*① *Plates*.

putto figure, RGS/*17*①.

putto finial, C-1006/*41*.

putto mask, S-2882/*926*①; S-3311/ *793*①.

putto spandrel, C-5116/*49*①.

putto stem, C-2421/*4*①.

putty, C-5236/*377*①; DATT.

putty-colored, C-5127/*79*.

putty ground, C-5156/*58*①.

putty knife, LP/*knives*.

putz, DADA.

Puxian, S-4810/*278A*.

puzzle ball, C-5127/*216*; S-3312/ *1190*①.

puzzleball mount, C-2332/*11*.

puzzle box, C-1082/*152*.

puzzle cup, EA/*wager cup*.

puzzle fan, EA.

puzzle-jug, C-2486/*203*; C-2502/*87*; IDC/①.

puzzle jug, ACD; DADA; EA/①; IDPF/*189*①; NYTBA/*143*①.

puzzle pot, MP/*30*① *Plates*.

puzzle ring, RTA/*108*①.

Puzzolan cement, DATT.

P.V.A., LP.

PVA, DATT.

PVC, DATT.

PVD in trefoil, EA/*van Dyck, Peter*.

pwree, DATT.

PY, EA/*Pyne, Benjamin*.

Pyefinch, H., CEA/*262*①.

Pygmalion, DSSA.

pygmy cup, IDPF/*127*.

pylon shape, LAR82/*424*①.

pylon-shaped, C-2437/*34*①.

Pyne, Benjamin, EA.

pyramid, RTA/*94*.

pyramidal, NYTBA/*277*; RTA/*81*①.

pyramidal-form, S-3311/*530*.

pyramidal form, S-4414/*183*.

pyramidal roof, RTA/*48*①.

pyramid base, S-4461/*69*.

pyramid hour hand, C-2489/*128*.

Pyramid pattern, S-2882/*1314*.

pyramid pediment, C-1702/*258*.

pyramid-shape, C-2414/*4*①.

Pyrex, DADA/*Supplement*.

pyrex liner, C-2202/*89*.

pyriform, C-5114/*125*①; C-5153/ *15*①, *34*①; IDPF/*190*; S-3311/ *873*①; S-4461/*26, 45, 161*; S-4807/*537*①; EA/① *cream jug*.

pyriform body, S-4804/*180*①; S-4973/*54*①.

pyriform shape, CEA/*671*①.

pyriform vase, S-4414/*202*①.

pyriform vessel, S-4414/*206*①, *214*.

pyrometer, DATT.

pyrometric cone, DATT/①; IDC.

pyroxylin, DATT.

Pythagoras, DSSA.

pythakion, IDPF/*190*.

pyx, CEA/*62*①; DADA; EA/①;
 DSSA/①.

Q

qalamdan, C-2513/*427*.

qali, CEA/*101*.

qalian, EA/*hookah, narghile*.

qama, DADA.

Qasghai, C-5189/*367*.

Qashghai, C-5323/*49*①, *82*①.

Qashghai rug, C-0279/*17*①.

Qashqai, C-2478/*219*; OC/*15*①, *104*, *121*①.

Qashqai hebatlu design, OC/*110, 264*.

Qashqai rug, C-0906/*70*; C-2403/*188*; C-2482/*68*; LAR82/*544*①; OC/*22*①.

Qazvin, OC/*287*①.

qi, S-4963/*4*①.

qianlong, S-4810/*31*; C-2323/*55*; C-2360/*88*①; C-2458/*68, 106*①; C-5127/*67*; C-5156/*107, 281*①; LAR82/*67*①; LAR83/*80*①, *145*①, *218*①; S-3312/*1265*①.

qilin, C-2323/*32*①, *140*①; C-2458/*239*; C-5156/*154*; C-5236/*1649*①.

qing, C-2323; C-5156.

qingbai, C-5127/*22*; C-5156/*85*①; C-5236/*429*.

qingbai glaze, C-5127/*33*.

Qing dynasty, LAR82/*59*①, *80*①, *106*①; LAR83/*79*①, *100*①;

C-2323/*82*; C-2414/*1*①; C-2458/*58, 129, 156*; C-5127/*47*.

Qing-yuan Studio, Nagasaki, C-5156/*637*①.

Qoltuq, OC/*256*①.

Quack Doctor, or Market Crier, group, MP/*115*.

quadra, DATT.

quadrafoliate, S-288/*3*①.

quadrangular, C-5156/*433*; S-2882/*1262*; S-4922/*58A*①; S-4927/*220*①.

quadrans vetus, CEA/*612*.

quadrant, C-2402/*149*; CEA/*612*; NYTBA/*260*.

quadrant bead, SDF.

quadrant corner, C-5114/*275*; C-5157/*22*.

quadrant drawer, EA; SDF.

quadrant hinge, SDF.

quadrant scale, C-0403/*86*.

quadrant stay, SDF.

quadrant support, C-2388/*31*.

quadrapartite, C-2478/*80*.

quadrate cross, DATT.

Quadriga, DSSA.

quadrigae, C-2482/*112*.

quadrillé (in French ceramics), EA.

quadrillé, IDC.

quadrille paper, DATT.

quadri-lobed, S-4972/404①.

quadrilobed, S-4965/104①.

quadripartite, C-2320/58.

quadripartite base, C-2388/60; C-2421/90①, 111①; LAR83/378①.

quadriptych, C-5203/111B.

quadrupal scroll foot, C-0103/195.

quadruple, C-2402/45.

quadruple arched back, C-2403/35.

quadrupled, S-4972/150.

quadruple moulded, C-0982/34.

quadruple overlay, C-GUST/82①.

quadruple scroll leg, LAR83/368①.

quadruple-strand necklace, S-4414/73.

quadruple turned pillar, LAR83/373①.

quadrupod, CEA/354①.

Quaglia, Fernando, C-5174/454①.

quaich, ACD; C-2202/206; C-2513/141①; DADA; EA/①; LAR82/605①; LAR83/598①; C-0254/95.

quaigh, CEA/594; EA/① quaich.

Quail, CEA/191①.

quail and millet pattern, IDC.

quail clock, EA.

quail or partridge (*caille) and stork (cigogne), EA/décor coréen.

quail pattern, EA/caille, caille.

quail terminal, S-3312/1162①.

quaint style, SDF/①.

Quaker chair, EA; SDF/①.

Quantock, John, S-4944/274①.

Quare, C-2368/110①; CEA/219.

Quare, Daniel, ACD; CEA/253①; DADA; EA; S-4927/88; SDF/777.

Quare, Dan, London, C-2489/124①.

quarrel, SDF.

quarrel or quarry, ACD.

quarry, SDF.

Quarrying, C-2904/199.

quarry water, DATT.

quarter column, C-5114/302①, 369①; NYTBA/56; SDF.

quarter column angle, C-2403/149.

quartered, C-2403/118; S-4972/494.

quartered fan spandrel, C-2403/68.

quartered ground, S-4955/164①.

quartered oak, SDF.

quartered top, C-2388/47A.

quartered tulipwood, C-2364/47①.

quartered tulipwood ground, C-0279/403.

quarter-face technique, JIWA/216.

quarter-fan inlay, FFDAB/62.

Quarter Girl, C-0405/139.

quartering, C-2487/120; CEA/300, 406; SDF.

quarter mirror-figured top, LAR83/387①.

quarter-repeating, C-2368/142; C-MARS/184①.

quarter repeating, C-5117/440; S-4802/16.

quarter repeating clock, LAR83/182①.

quarter-repeating timepiece, C-5189/198.

quarter round, DATT; SDF.

quarter round molding, C-5114/307①.

quarter-sawn, SDF.

quarter-size, C-0982/40.

quarter striking, S-4802/135C①.

quarter striking clock, LAR83/208①.

quarter train, CEA/220①.

quarter-veneered, C-0249/461; C-0279/380; C-0982/122; C-5116/20, 81; C-5157/98, 176①, 178①; LAR83/366①; S-4812/131.

quarter veneered, S-4414/430①.

quartet stand, S-2882/306①.

quartetto, C-2402/*266*; DADA.

quartetto table, ACD; C-2320/*80*;
C-2388/*514*; EA; LAR83/*379*①;
SDF.

quartieri, a, IDC.

quart measure, C-0403/*76*①.

quart mug, C-0706/*81*.

quarto table, SDF.

quartrefoil dish, C-2414/*49*①.

quartz, C-5117/*2*; C-5127/*317*;
DADA; DATT; MP/*15*.

quartz inversion, DATT.

quartzite, C-2482/*78*.

Quashqai carpet, C-1702/*29*.

quasi-geometrical treatment, JIWA/
127.

Quast, Johann, C-5189/*113*.

quatra-lobed, S-3311/*617*.

quatrecouleur, CEA/*71*.

quatre-couleur, CEA/*64*①, *513*.

quatre-couleur gold, EA/*four-colour
gold*.

quatre coulour gold, EA/*four-colour*.

quatrefoil, ACD; C-0254/*126*①;
C-0782/*191*; C-2323/*75*; C-2427/
*7*①; C-2458/*91*; C-2704/*98*;
C-5116/*124, 148*①; C-5127/*63*;
C-5153/*166*①; C-5157/*130*;
DADA; DATT; EA/*trefoil*; IDC;
S-2882/*280*①; SDF/①.

quatrefoil base, C-2403/*61*; S-2882/
368.

quatrefoil bowl, C-2427/*253*.

quatrefoil charka, RGS/*38*.

quatrefoil flower, CEA/*311*①.

quatrefoil marble base, S-4461/*16*.

quatrefoil neck, S-2882/*1284, 1391*.

quatrefoil neck mount, C-1502/*14*.

quatrefoil panel, C-5156/*59*①.

quatrefoil reserve, S-4461/*139*.

quatrefoil rim, C-5005/*293*①;
S-2882/*1286*①, *1292*①, *1301*.

quatrefoil roundel, C-2403/*81*.

quatrefoil shade, S-2882/*1317*①.

quatrefoil shape, LAR82/*112*①;
RTA/*49*①; S-2882/*1258*①;
S-4944/*124*①.

quatrefoil shaped, C-1502/*53*.

quatre-lobed shape, LAR82/*161*①.

quattrocento, DADA; DATT; LP;
EA.

Quchak rug, C-0906/*61*.

Quchan, OC/*68*①.

Quebec birch, SDF.

Queen Anne, C-1502/*209*; C-5116/
*46*①; C-5117/*265*①; C-5153/*90*①;
CEA/*321*; DADA/①; S-4436/
*95*①; S-4922/*42*①; S-4972/*222*①.

Queen Anne design, LAR82/*284*①.

Queen Anne period, C-5173/*47*.

Queen Anne pistol, CEA/*29*①.

Queen Anne splat-back chair, DADA.

Queen Anne style, C-0982/*92B*;
C-2402/*105*; DADA; EA/①;
S-4804/*874*①; SDF.

Queen Anne tankard, CEA/*585*①.

Queen Charlotte, whorl, EA.

Queen Charlotte's pattern, IDC.

Queen Elizabeth, C-1506/*106*①.

Queen Elizabeth I, C-2704/*36*.

Queen pattern, S-2882/*1364*.

Queen's Beasts, the, IDC.

Queen's Burmese, CEA/*474*①.

Queen's Design, NYTBA/*302*.

Queensland maple, SDF.

Queensland walnut, SDF.

Queen's pattern, C-2493/*32*; DADA;
EA/①; IDC/①.

Queens pattern, C-1502/*106*.

Queen's shape, IDC/①.

Queen's Vase, the, IDC/①.

queen's ware, K-710/*109*.

queensware, DATT.

Queen's ware, ACD; DADA; IDC.

'Queen's ware', LAR83/*170*①.

Queensware, CEA/*110, 150*; EA/①;
NYTBA/*150*.
Queille, Pierre-François, C-2510/9①.
quenching, DATT.
quenouille, DADA.
quercitron lake, DATT.
Quervelle, A. G., NYTBA/*70*①.
Quervelle, Anthony, C-5153/*164*①.
Quervelle, Anthony G., DADA/
Supplement.
quetzal, C-5146/*52*.
Quezal, C-5167/*232*; C-5191/*412*①;
C-5239/*294*; DADA/*Supplement*;
OPGAC/*156*; S-3311/*921*①;
S-4461/*43, 86*①.
Quezal Art Glass, CEA/*459*;
NYTBA/*306*.
Quezal Art Glass and Decorating
Works, CEA/*478*①.
Quezal glass, S-2882/*1381*.
qui, S-4810/*275*①.
quick-drying size, DATT.
quicklime, DATT.
quill, C-0254/*174*①; DATT.
quill and sander, C-0403/*33*.
quill-box, IDC.
quill-holder, IDC.
quilling, DADA; EA.
quillon, C-2569/*46*①; C-5117/*313*①;
C-MARS/*5*; CEA/*22*①, *44*;
S-4972/*153*①.
quillon-block, C-2569/*41*①, *46*①.
quillons, DADA.
quill pen, S-3311/*160*①.
quill work, CEA/*287*; LAR83/*49*①.
quillwork, S-4807/*237*.
quilt, C-2704; NYTBA/*107*; SDF.
quilted, C-2478/*209*.

quilted design, C-5239/*297*.
quilted overall, C-2704/*166*.
quilted tapestry, C-1407/*7*.
quilted vase, S-4461/*43*.
quilting, DADA; SDF.
quilting bee, CEA/*287*.
quilting tied, C-2704/*88, 48A*.
quilt top, C-2704/*60*.
Quimbaya, S-4807/*100*①.
quimper, DADA.
Quimper service, S-4461/*397*.
Quimper stoneware, C-2910/*109*.
quinacridone red, DATT.
quince, DSSA.
Quinqhou, S-4810/*57*①.
quinquet, EA/*Argand lamp*.
quintal flower horn, EA/*finger vase*;
IDC; S-4843/*144*.
quirk, CEA/*406*; SDF.
quirked bead, SDF/①.
quirt, S-4807/*237*.
quisshin, SDF.
quiver, C-MARS/*47*; DSSA.
quiver-leg, DADA.
quiver pattern, IDC.
quiver-shaped, C-2421/*85*①.
quizzical bird, IDC/①.
quizzing fan, EA.
quizzing glass, C-2608/*159*; EA.
Qum, C-2478/*240*; C-2546/*175*; OC/
*72*①, *303*①.
Qum rug, C-0906/*71*.
quodlibet, IDC.
quodlibetz, DADA/①.
quoin block, SDF.

R

R.A., LP.
rabbet, ACD; SDF.
rabbit, DSSA; SDF/rabbet.
rabbit border, C-0225/3.
rabbit-form decoration, S-4965/134①.
rabbit mark, C-0225/1.
rabbit's foot brush, C-5117/1.
rabbit-skin glue, LP.
rabbitskin glue, DATT.
rabbit vase, IDC/①.
Rabby, CEA/226①.
rabeschi, EA; IDC.
Race, Ernest, SDF/761.
race cup, EA/①.
raceme, OC/290①.
racinage, DADA.
rack, C-2421/148①; C-5239/35, 240;
 EA/striking mechanism; S-4461/
 745①; SDF.
rack adjustment, C-2904/47.
rack-and-pinion, CEA/345①.
rack and pinion focusing, CEA/
 610①.
rack-and-pinion rotary, C-0403/138.
rack and snail, CEA/267.
rack and snail mechanism, CEA/235.

rack and snail striking, ACD.
rack clock, EA/①.
rack lever, C-2489/224.
rack lever watch, C-5174/369.
rack strike, C-2489/85①; S-3311/
 110①.
rack striking, S-3311/107①.
rack-striking mechanism, EA/Barlow,
 Edward.
Radeloff, Nicolas, EA.
raden, C-5236/811; CEA/562, 562,
 575; DADA.
Radford, Thomas, EA.
Radford sculpsit DERBY Pot Works,
 EA/Radford, Thomas.
radial, C-2402/126.
radially ribbed pattern, MP/122.
radial panel, C-0982/130A.
radiant boss, S-4804/21.
radiating, C-2403/176; C-2458/51①.
radiating band, C-0782/145; C-2704/
 50, 62; C-5005/334①; S-4414/192,
 225①.
radiating column, C-5005/277.
radiating floral design, S-4461/345.
radiating incised line, C-5005/228①.

radiating panel, C-0279/*356*①;
 C-0782/*66*; C-5116/*79*①; C-5224/
 77.

radically everted, C-5236/*1798*①.

Radijs, Christoffel, CEA/*630*①.

radiogram, SDF/*radio set*.

radio set, SDF.

radius, C-2904/*67*.

Raeren, C-2427/*193*①; DADA/①;
 EA.

Raeren stoneware, IDC.

Raes, Jan, EA.

Raffaele ware, IDC.

Raffaelle ware, EA.

Raffaelli, Jean-Francois, S-286/*434*.

raffia, C-0405/*157, 216*; C-2522/
 *11*①; C-3011/*62*; DATT.

raffraichissoir, C-5259/*609*①.

rafraîchissoir, C-5224/*140*.

rafraîchissoir, DADA.

rafraichissoir, IDC.

rafter, IDC.

rag, S-4881/*361*①.

Ragga ware (Rakka ware), IDC.

ragged, C-5236/*1142*①.

ragged thistle, CEA/*624*①.

rag rug, SDF.

rag-wiped, DATT.

raifraichissoir, S-4823/*234*.

rail, ACD; C-2402/*118*; C-5114/
 *388*①; DADA; S-4812/*74*①; SDF.

rail and wheel back chair, LAR83/
 *292*①.

rail back, C-0982/*24, 44*; C-1407/*41*;
 C-2402/*40*; LAR82/*297*①.

railed, C-2388/*25*.

rail-end-standard, C-2402/*56*.

rail end-standard, C-0982/*10*.

railing, CEA/*532*①; NYTBA/*252*.

railroad flask, EA/①.

railway badge, RGS/*123*①.

Railway model, S-4927/*102*.

railway watch, EA.

rainbow, DSSA.

rainbow cameo decoration, S-4947/
 *86*①.

rainbow mother-of-pearl, K-802/*16*.

Raindrop pattern, K-802/*16*.

rain drop vase, CEA/*115*①.

RAINFORTH & CO., EA/*Leeds*.

rain mottle, SDF.

raised, C-0982/*83B*; C-2409/*78*;
 C-5114/*27*①; C-5117/*150*①;
 C-5157/*58*; CEA/*673*①; S-4804/
 *17*①; S-4992/*90*①.

raised anchor period, EA/*Chelsea*.

raised beaded border, S-2882/*1071*.

raised center, S-4922/*22*①.

raised central boss, C-0782/*65*.

raised central ring, RTA/*161*①.

raised chenille work, C-1506/*143*①.

raised cover, C-5114/*57*①; C-5117/
 *56*①.

raised design, C-0225/*288*.

raised dralon, C-2402/*66*.

raised enamel, C-5236/*812*.

raised foliate handle, C-0254/*136*①.

raised foliate rim, C-0254/*71*.

raised foot, RGS/*116*①; S-4461/*521*.

raised geometric design, RTA/*152*①.

raised geometric ornament, C-1082/
 23.

raised gilding, IDC.

raised gilt, C-2555/*75*①.

raised leg, C-5156/*753*①.

raised metallic pattern, CEA/*477*①.

raised molding, C-5114/*394*①.

raised mount, S-4461/*37*.

raised neck, C-0225/*7*.

raised open handle, C-5114/*42*.

raised ornament, MP/*30, 104*; RTA/
 *107*①.

raised pattern, CEA/*528*.

raised picture, C-2704/*43*.

raised point, DADA.

raised setting, C-5117/399①, 437①; RTA/83①.

raised superstructure, C-2478/99①.

raising, CEA/678.

raising (in silver), EA.

raising, NYTBA/216.

raisin ground, S-3311/247.

raising scale, C-5157/4.

raison d'être, LP.

raisonné, LP.

Rajasthan, C-5156/197; OC/200①.

Rajasthani, S-3312/1251①.

Rajbik, OC/312①.

rakan, C-0782/72; IDC.

raked, C-5224/136①; S-4972/451①.

raking, C-5114/381①; C-5153/102①.

raking leg, S-4461/595.

raking ring, S-4461/596.

raking turned leg, S-4905/361①.

Rakka ware, IDC.

Raku, C-5156/794①; C-5236/857①.

raku Japanese pottery, EA.

raku kiln, IDPF/137①.

raku ware, DATT; DADA; IDC.

ram, DSSA.

rama, RGS/124.

Ramage, John, CEA/521①; EA.

rambouillet cup, IDC.

ramee, SDF/ramie.

ramekin holder, C-0254/175.

ram-headed bowl, C-2482/113.

ram-head handle, C-2458/69.

ramie, SDF.

ramiform, DATT.

rammekin fork, S-4804/83①.

ramon, SDF.

rampant lion, C-2409/75; C-5117/350.

rampant lion mark, C-2427/47①.

ramrod, C-2503/93; C-2569/59①; C-MARS/121; S-4972/156①, 159①.

ramrod-pipe, C-2569/93①.

Ramsay, David, DADA.

Ramsden, Omar, C-2510/24①; C-5167/141; CEA/663①; DADA/ Supplement.

ram's head, SDF.

rams' head, MP/172.

ram's head motif, EA.

ram's horn, EA.

ram's horn device border, C-5323/16①.

'ram's-horn' motif, OC/200.

rams'-horn motif, C-2478/252.

ram's horn pattern, CEA/591①.

ram's horn shofar, C-5174/29.

ram's-horn stump, SDF.

ram's horn thumbpiece, EA.

ram's mask, C-2357/35①; C-2421/27①; S-3311/766①.

rams' mask, C-2398/2, 26.

rams mask, C-0406/20.

ram support, C-0279/198①.

rance, DATT.

Rance marble, S-2882/389①, 421; S-3311/453.

Rancoulet, LAR82/503①.

Randall, Theodore A., DADA/ Supplement.

Randall, Thomas Martin, EA.

Randall, T. Martin, C-2493/10①.

Randall & Stickney, C-2904/78.

Randle, William, DADA.

Randolph, Benjamin, CEA/389; DADA; EA; SDF/774.

random effect, JIWA/349.

random segment, JIWA/87.

Ranelagh figure, IDC/①.

ranftbecher, LAR82/455①; CEA/457①; EA/49①; EG/109①.

rangefinder, C-1609/259.

range of color, MP/*19*.
range of colour scheme, C-2704/*117*.
range table, SDF.
rang-i-chub, OC/*187*.
Rangyoku, CEA/*566*①.
rank badge, S-4965/*293*①.
Rannie, James, CEA/*343*①; EA/ *Chippendale, Thomas the Elder*; SDF/*761*.
ranseur, DADA.
Ransford, Dublin, C-2503/*195*.
Ranzohan ware, IDC.
Rapapport, Julius (workmaster), C-5174/*312*①.
Raphaël, EA.
Raphaelesque, DADA; S-4804/*270*.
Raphaelesque style, IDC.
Raphaelesque ware, EA/*Worcester*.
Raphaelite, LAR82/*67*①.
Rapidograph, DATT.
rapier, C-2503/*25*; C-MARS/*14*; CEA/*21*①, *44*; DADA; S-4972/ *248*①.
rapier blade, C-2569/*45*①.
Rappaport, Julius, C-5117/*301*.
rappoir, DADA.
Raqqa, C-5156/*444*; EA.
rare print, JIWA/*9*.
Rasmussen, C-0270/*103*①.
rasp, DATT/①; IDC.
raspberry, OPGAC/*183*.
raspberry finial, C-5005/*235*①.
raspberry prunt, CEA/*417*①.
raspberry-red, C-2403/*178*.
rat, DSSA.
ratafia, CEA/*435*①.
ratafia glass, ACD; EA/①.
ratchet, CEA/*251*①.
ratchet clock, DADA.
ratchet key, C-2368/*183*①; C-5117/ *469*①; S-4927/*90*.
ratchet mechanism, C-5114/*318E*①.

ratchet work, C-2368/*91*①.
Rateau, Albert, NYTBA/*81*①.
Rathbone, Richard Llewellyn Benson, DADA/*Supplement*.
ratio, C-2904/*197*.
rationale, C-5224/*259*①.
Rato, EA.
rat's claw foot, S-4905/*432*①.
rat's tail brush stroke, JIWA/*89*.
rat-tail, NYTBA/*220*①; S-4905/*220*.
rat tail bowl, C-0103/*67*.
rat-tail bowl, S-2882/*1092*①, *1107*; S-4802/*463*; S-4905/*229*; S-4922/ *43*①.
rat-tailed, C-2487/*55*; C-5117/*14*.
rattailed, C-0254/*159*.
rat-tailed bowl, C-5117/*100*.
rat-tailed stem, C-5117/*53*.
rat-tail handle, IDC.
rat-tail oval bowl, S-2882/*1074*.
rat-tail pattern, LAR82/*591*①.
rattail pattern, C-0254/*4*.
rat-tail shaped, S-2882/*951*.
rat-tail spoon, DADA; EA/①.
rattan, DADA/*Supplement*; S-4461/ *185*.
rattan handle, C-0254/*9*.
rat terminal, S-2882/*1046*①.
rattle, C-0279/*101*; C-5203/*343*①; IDPF/*190*①.
Rauch, Christian Daniel, MP/*190*.
Rauenstein, DADA.
Raulin, Victor, S-4947/*139*①.
Rauschenberg, Robert, S-286/*435*.
Raveché, Jean-Francois, C-5220/ *35*①.
raven, DSSA.
Raven, Andrew, EA/*316*.
Raven, Samuel, EA.
Ravenet, Simon-François, EA.
Ravenna glass, DADA/*Supplement*.
ravensbill, EA.

Ravenscroft, George, ACD; CEA/ *346*①, *414*; DADA; EA/①; NYTBA/*277*.

Ravenscroft/Bishopp, CEA/*424*①.

raven's head seal, DADA; EA.

ravenstone, IDC.

raw, CEA/*415*; S-4881/*1*①.

raw color, LP.

raw glaze, DATT.

Rawlings, William, EA/*Lambert & Rawlings.*

Rawlings & Sumner, LAR82/*562*①.

Rawlins & Sumner, S-4944/*265*①.

raw sienna, DATT; LP.

raw umber, DATT; LP.

ray, C-5114/*346*①.

Ray, Man, S-286/*71*.

Ray Craft kit, C-2904/*257*.

ray decoration, RTA/*75*①.

rayed center, C-5114/*141*①.

rayed embossing, CEA/*668*①.

rayed spindle, SDF.

Rayment, London, C-2489/*182*①.

Rayner, C-2904/*230*.

raynes, cloth of, SDF.

rayon, DADA/*Supplement*; OC/*16*.

rayonnant, DADA.

Rayonnant, style, IDC/①.

Rayonnism, DATT.

Rayy, C-5236/*1743*; EA.

Rayy type, NYTBA/*128*①.

Rayy ware, IDC.

R & B, EA/*Brunswick.*

RB, EA/*Brandt, Reynier.*

R.C., C-2704/*174*.

Rea, John, London, C-2503/*139*.

RE above EB, EA/*Emes, John.*

reading chair, CEA/*334*①; DADA/ ①.

reading chair (cock-fighting chair), EA/①.

reading chair, SDF.

reading desk, SDF.

reading glass, C-1502/*56*; C-5239/ *321*.

reading machine, SDF.

reading seat (Albany couch), EA.

reading seat, SDF/①.

reading stand, C-5157/*113*①; DADA; EA/①; SDF/①.

reading support, LAR82/*396*①.

reading-table, C-2388/*28*.

reading table, DADA; SDF/①.

ready-made, DATT/①; LP.

realgar, DATT; S-4810/*28*①.

realism, DATT; LP.

realist depiction, JIWA/*201*.

realistic, LP.

realistically, C-0406/*125*.

realistically carved, C-5117/*347*.

reality, LP.

realization, DATT.

reapplied, S-3311/*88*.

rear-mounted rack and snail, S-3311/ *413*①.

rear panel, C-2368/*34*.

rear sight, S-4972/*273*①.

rearsight, C-2476/*14*①.

rebate, ACD; CEA/*406*; SDF.

Rebecca at the well, C-2704/*189*.

Rebekah at the Well teapot, DADA/ *Supplement*.

Rebhuhnpaar, IDC.

re-blued, S-4972/*233*.

rebounding, C-2476/*2, 8*.

rebrowned, C-2476/*60*; C-2503/*155*.

rebus button, EA.

recamier, DADA.

récamier, EA.

Recamier model, CEA/*306*①.

recast, MP/*205*.

receding base, S-4972/*6*①.

receding shade, JIWA/*92*.

receiver, C-2476/*10*.

receptacle, C-5005/356①; S-4905/322.

recess, C-2402/140; C-2409/239; C-2458/227①; SDF.

recess cabinet, SDF.

recessed, C-0982/254; C-5114/275; C-5116/126①; C-5127/261①; C-5156/88; C-5236/380.

recessed base, C-5156/41.

recessed carving, EA/sunk carving.

recessed centre, C-2364/1①; C-2403/154.

recessed cupboard, C-5116/114.

recessed foot, C-2458/28①.

recessed front, SDF.

recessed handle, C-5156/223A.

recessed kneehole cupboard, S-4414/437①.

recessed strecher, SDF.

recession, LP.

réchaud, IDC.

rechten Schliff, MP/30.

recipe, MP/41.

reciprocal, S-3311/66.

reciprocal border, C-2403/200; C-5189/377.

reciprocal guard border, C-0279/13①; S-4847/148; S-4948/1①.

reciprocal skittle-pattern, C-2388/150; C-2478/245.

reciprocal stripe, C-2403/160.

reciprocal trefoil, C-5323/3①.

reciprocal trefoil border, C-0279/10.

reciprocal triangles, C-0279/28①.

reciprocated trefoil guard, S-288/9①; S-2882/44, 69.

recoil escapement, EA; S-3311/107①.

recoil-pad, C-2476/2.

recorder, C-2489/247; CEA/547, 553①; EA/①.

recorder knob, C-2368/1.

Recordon, London, C-2489/239①.

rectangular, C-0406/68; C-5116/2; C-5153/25①, 61①.

rectangular aperture, C-5156/2①.

rectangular back, C-0249/433.

rectangular-back chair, NYTBA/64①.

rectangular base, C-2360/111①.

rectangular bombé form, S-2882/1193.

rectangular bulbous form, S-4802/346.

rectangular cameo, S-291/116①.

rectangular cartouche, C-1502/91.

rectangular casket, S-4922/58A①.

rectangular crystal, RTA/60①.

rectangular-cut, C-5005/208①.

rectangular foot, C-0249/350; C-5153/22①.

rectangular form, C-2414/27①; C-5146/73①.

rectangular frame, JIWA/87.

rectangular seat, C-0982/61.

rectangular section, S-4461/30.

rectangular top, C-0982/1; C-2388/105①.

rectified turpentine, DATT; LP.

rectilinear, OC/11①.

rectilinear element, OC/11.

rectilinear handle, S-4955/13①.

recto, C-1603/49; C-5174/149①; LP; S-286/13.

recumbant lion, C-0906/139.

recumbent, C-2502/25; C-2555/29①; C-5127/147; S-4905/88①.

recumbent cow, C-0782/205.

Recumbent Easy Chair, C-2370/34.

recumbent spectacle, C-0403/164.

recurved, C-MARS/38①.

recurved quillon, C-2569/37①.

recusant chalice, LAR83/583①.

recut, C-5236/355①.

red, IDC.

red anchor, C-1006/72.

red-anchor period, CEA/*188*①.

red anchor period, EA/*Chelsea*.

Red and Green family, DADA.

Red Barn, the, IDC.

red beech, SDF.

red block, OPGAC/*233*.

red bull pattern, IDC.

redcar, CEA/*100*①.

red chalk, DATT.

red china, IDC.

red crossed batons mark, C-1006/*121*.

reddle, DATT.

red dragon, EA/*German ceramic decoration*.

Red Dragon motif, MP/*470*①.

red dragon pattern, IDC/①.

red earthenware, CEA/*165*.

Redeat ('may he return'), EA/*Jacobite glass*.

red edge, IDC.

red ensign, C-2704/*19*.

Redfield, C-2476/*5*.

red-figure, LAR83/*65*①.

red-figured pottery, DATT.

red-figure style, IDC/①.

red figure ware, DADA.

red glassware, EA/*Oppenheim, Meyer*.

red glost pottery, IDC.

red-gold, C-5117/*356*①.

Redgrave pattern, IDC; C-2360/*103*.

red gum, SDF.

red gum kas, C-5114/*394*①.

red indigo, DATT.

red iron oxide, DATT.

red-Japanned, C-0279/*226*.

red jasper, IDC.

red lacquer, C-1082/*173*.

red lead, DATT; LP.

Redlich & Co., S-4905/*162*.

red mark, C-1006/*216*.

red monochrome, EA.

red ochre, DATT.

red oil, DATT.

Redon, Odilon, S-286/*440*.

red orpiment, DATT.

Redoute, Pierre-Joseph, S-286/*441*①.

red oxide, DATT.

red pigment, DATT.

red pole medallion, C-0906/*6*.

red porcelain, EA; IDC; MP/*21*.

Red Rose Guild of Craftsmen, DADA/*Supplement*.

red sable, DATT.

red sandalwood, CEA/*562*.

red stamp, C-0249/*32*.

red stoneware, DADA; EA/①; IDC.

red tear drop, C-2704/*71*.

reduced, C-2403/*118*; C-2458/*102*.

reduced pigment, DATT.

reduced theme, JIWA/*150*.

reducing, DATT.

reducing atmosphere, EA; IDC.

reducing glass, DATT.

reducing machine, EA.

reduction, C-5189/*154*①.

reduction fire, DATT.

reduction fired, JIWA/*350*①.

reduction kiln, CEA/*210*.

red walnut, C-0982/*79*; C-2403/*84*; C-2478/*171*①.

red ware, ACD.

redware, C-0249/*151*; C-5114/*154*; DADA/*Supplement*; EA/①; IDC; LAR82/*97*①, *180*①; LAR83/*64*①; NYTBA/*123*; S-4807/*302*①; S-4843; S-4853/*240*①.

reed, CEA/*549, 556*; DSSA.

Reed, Edward, CEA/*154*①.

Reed, Fix, C-5239/*265*.

Reed, Peter, NYTBA/*224*.

Reed and Barton, DADA/*Supplement*.

reed and beaded border, C-5117/*173*.

reed and foliage, C-5117/*154*①, *284*①.

reed and lion's head spout, C-5117/ *148*①.

reed and paw foot, C-5117/*153*①.

reed and shell handle, C-5117/*123*.

reed and tie band, C-5117/*149*①.

reed and tie border, C-2487/*32*; IDC.

reed and tie handle, C-0254/*130*, *143*①.

reed-and-tie motif, C-5174/*257*①.

reed-and-tie moulding (in silver), EA/ ①.

reed and tie swing handle, C-5117/ *71*①.

Reed & Barton, C-0254/*183*; C-0270/*209*; NYTBA/*320*①.

reeded, C-0982/*2, 31, 64, 95*; C-2202/*3*; C-2402/*3, 31*; C-2478/ *114*①; C-5005/*354*①; C-5116/*95*; C-5117/*129, 284*①; C-5153/*25*①; C-5259/*507*; LAR82/*292*①; LAR83/*247*①; S-3311/*109*; S-4436/*139*①; S-4905/*183*.

reeded and foliate rim, S-2882/*1039*.

reeded and pierced border, C-5117/ *302*.

reeded angle, C-2403/*142*; C-2437/ *72*.

reeded arm, C-2398/*52*.

reeded bail handle, S-4461/*390*.

reeded band, C-5005/*227*; S-2882/ *1168*①.

reeded bar back, LAR83/*276*①.

reeded border, C-0254/*64*; C-2398/ *31*; C-5114/*4*; C-5117/*55*①; S-2882/*902*①, *904*①; S-4804/ *190*①; S-4922/*50*①.

reeded bracket foot, S-4414/*326*.

reeded branch, C-0254/*2*.

reeded bun, C-5157/*173*①.

reeded central stand, S-4414/*315*.

reeded chamfered angle, C-2368/ *79*①.

reeded circular leg, C-0249/*371*.

reeded column, S-3311/*109*; S-4461/ *731*.

reeded corner, EG/*250*①.

reeded cylindrical form, S-4461/*133*.

reeded cylindrical standard, S-4414/ *246*.

reeded downscrolled foot, S-2882/*262*.

reeded downscrolled leg, S-2882/*282*.

reeded edge, C-5114/*298*①; C-5116/ *123*; C-5153/*162*①; C-5156/*485*①.

reeded edge top, S-2882/*281*.

reeded flange, C-5114/*53*①.

reeded floral scroll handle, C-5117/*7*.

reeded foot, LAR83/*594*①.

reeded foot ring, C-0254/*320*.

reeded frame, C-5116/*98*①, *113*①.

reeded girdle, LAR83/*566*①, *612*①.

reeded handle, C-5117/*41*; LAR83/ *567*①; S-4922/*27*①.

reeded leg, C-5114/*329*①; C-5116/ *58, 92*; S-2882/*277*①.

reeded loop and foliage border, C-5117/*164*.

reeded looped-form, S-3311/*123*.

reeded loop handle, C-0254/*311*①; C-2427/*19*①; C-5117/*39*.

reeded molded girdle, S-2882/*1108*①.

reeded molding, C-5114/*376*; C-5153/*23*①.

reeded pilaster, LAR83/*309*①; S-4414/*428*①.

reeded rat-tail bowl, S-2882/*1093*①.

reeded rim, C-0254/*90*①, *46A*; C-1502/*5*; S-4414/*336*①.

reeded ring finial, S-2882/*911, 1151*①.

reeded scroll handle, S-4414/*257*①.

reeded skirt, C-5114/*330*①.

reeded spigot, S-2882/*910*; S-4414/ *336*①.

reeded splat, S-2882/*330*.

reeded stem, C-2388/*32*.

reeded strap handle, C-5114/*3*.

reeded swing handle, S-2882/*1142*.

reeded swirling arm, S-4414/*254*①, *311*①.

reeded tablet, FFDAB/*38*①.

reeded upright, S-2882/*330*.

reeded vase, CEA/*142*①.

reeded wirework, C-0706/*73*.

reeding, ACD; C-5114/*46*①; C-5116/*102*; C-5117/*349*①; CEA/*678*; DADA; DATT; EA; IDC/①; SDF.

reed molded, C-0225/*122*.

reed pen, DATT; JIWA/*52*①.

reed-pen drawing, JIWA/*59*.

reed top, SDF.

reef-knot, RTA/*27*①.

reel angle, C-2357/*48*①.

reel border, C-2403/*54*①.

reel-form, S-4802/*224*①.

reel-form cover, S-2882/*904*①, *909*, *975*①, *1156*①.

reel-form neck, S-2882/*916*①.

reel ornament, LAR82/*414*①.

reel-shaped, S-4802/*430*①; S-4965/*247*①.

reel-shaped foot, S-4414/*347*①.

reel-turned standard, S-4461/*588*, *711*.

re-entrant angle, C-5170/*207*①.

re-entrant corner, C-0982/*80*; C-2320/*2*①; C-2388/*4*; C-2421/*78*①; C-2498/*106*; S-2882/*271*.

Reeves, Ann Wynn, DADA/*Supplement*.

refectory dining table, C-0982/*21*.

refectory style dining table, C-0982/*81C*.

refectory table, ACD; C-0279/*333*; CEA/*327*①; DADA; EA; LAR83/*376*①; S-3311/*89*, *471*①; S-4972/*458*; SDF.

refired ware, IDC.

reflected color, DATT.

reflected light, DATT.

reflecting dressing table, SDF/① *rudd table*.

reflecting microscope, CEA/*611*①.

reflecting telescope, CEA/*612*.

reflection, C-0249/*3*.

reflection, light, LP/①.

reflex camera, C-1609/*217*.

reform flask, ACD.

Reform ware, IDC.

refracting telescope, C-1609/*84*, *119*.

refraction, DATT.

refraction, light, LP/①.

refractive index, DATT.

refractive power, NYTBA/*277*.

refractory, DATT; IDC.

Regal XXV, C-2476/*48*.

regard ring, EA/*brooch*; RTA/*97*, *125*①.

régence, DADA; ACD; C-2364/*42*①.

Regence, C-5181/*126*.

Régence, CEA/*366*.

Regence, S-2882/*357B*.

Régence, S-4972/*598*①.

Regence, commode a la, CEA/*406*.

Régence style, EA/①; IDC.

Regence style, S-2882/*793*; S-4804/*116*①.

regency, ACD; C-0982/*203*; C-1407/*51*; C-2402/*4*, *50*; C-2478/*1*; C-5116/*1*; C-5117/*4*; CEA/*224*①, *235*, *321*, *637*; DADA/①; FFDAB/*24*; LAR82/*50*①; LAR83/*49*①, *182*①; S-2882/*258*①, *275*, *287*①; S-4436/*10*①; S-4812/*32*①.

Regency dress, C-2704/*33*.

Regency painted chair, C-5157/*115*①.

Regency point, DADA.

Regency style, C-0982/*31*; EA/①; IDC; S-2882/*342*; SDF/①.

Regent body, IDC.

regilt, S-4972/*28*①.

Regimental, C-5117/*1*.
regimental badge, C-5117/*2*.
regimental device, C-2503/*42*.
regina, CEA/*549*.
regional chair type, SDF/①.
regional exhibition, LP.
regional furniture, DADA.
register, C-5117/*431*①; DATT;
S-3311/*286*①; S-4802/*35, 97*①.
register guide, DATT.
register mark, DATT.
register plate, C-5116/*46*①.
registration mark, C-0406/*69*;
C-2493/*153*; DADA/*Supplement*.
registry mark, IDC.
reglet, DATT; SDF.
Régnard, Pierre-Louis, EA.
Regnier cup, IDC.
regula, SDF/*reglet*.
regularity of form, JIWA/*28*.
regulateur, C-2364/*76*①; C-5189/
*294*①.
régulateur, EA.
regulateur, S-2882/*814*①.
régulateur de cheminée, EA/*pendule
cage, pendule cage*.
regulation, C-5117/*394*①.
regulator, ACD; CEA/*236*①; EA/
precision clocks; S-4802/*1*; S-4804/
*923*①; S-4927/*48*①.
regulator clock, CEA/*227*①; EC2/
*95*①.
regulator dial, C-5116/*47*; S-4802/
*42*①.
Rehn Pattern, EA/*Ceramic
decoration*.
Reichard, Ernst Heinrich, EA.
Reichart, E. H., C-2486/*84*①.
Reichel-Drechsler, Elfriede, MP/*496*.
Reicher gelber Löwe (rich yellow
lion) decoration, MP/*472*①.
Reichert's illuminator, C-2904/*56*.
Reich mark, DADA/*Supplement*.

Reichsadler humpen, LAR83/*412*①;
CEA/*452*①.
Reichsadlerhumpen, DADA; EA/①.
Reid, E. K., C-2487/*62*.
Reid, Katharine, S-3311/*951*①.
Reid, William, EA/①.
Reid, W. K., C-2510/*53*.
Reid & Sons, Newcastle-on-Tyne,
C-2489/*238*①.
Reiff, Hanns, C-5174/*111*.
reign-mark, IDC.
reign mark, EA/*nien hao, nien hao*.
Reilly & Storer, S-4944/*267*.
Reily, Charles, C-5174/*503*.
Reily, John, C-5117/*369*; S-4922/
*23*①.
Reily, Mary Ann and Charles,
C-5173/*17*①.
Reimers, Johannes Johannesen, EA/
262.
Reims tapestry, EA.
reindeer, C-2704/*21*①.
reindeer handle, C-6270/*7*.
Reine, a la, CEA/*406*.
reinforced concrete, DATT.
Reinicke, J. P., CEA/*174*①.
Reinicke, Peter, EA; MP/*119*.
Reinicke, P. J., C-2486/*159*.
Reinman, P., CEA/*606*①.
Reinmann, Paul, EA.
Reiss, R., Leibenwerda, C-MARS/
192.
reistafel, CEA/*142*①, *210*.
Reiterdenkmal, MP/*96*.
Reiterstandbild, MP/*137*.
rejoined, C-2437/*6*.
rekston, DADA/*Supplement*.
release agent, DATT.
release button, S-4972/*155*①.
release-latch, C-2476/*14*①.
relic, S-4461/*548*.
relic box, CEA/*71*.

relief, C-0782/*187*; C-1082/*9, 57*;
C-1603/*73*; C-2388/*107*; C-5116/
*145*①; CEA/*395*①, *660*①;
DADA/①; DATT; EA; JIWA/*98,
304*; S-2882/*422*①, *628*①; S-4507/
*6*①; S-4804/*346*①; S-4853/*379*①;
S-4972/*1*①.

relief band, C-0225/*77*.

relief block printing, DATT.

relief-carved, C-5114/*197*①;
FFDAB/*127*①.

relief carving, NYTBA/*25*①.

relief-cast, CEA/*582*①.

relief decorated, S-4972/*66*①.

relief decoration, CEA/*620*①;
DADA; IDC; MP/*32*.

relief enamel, RGS/*51*.

relief figure, C-0249/*268*.

relief flower ornament, MP/*164*①
Plates.

relief handle, C-2458/*216*.

relief medallion, CEA/*157*①.

relief molded, S-4461/*344*.

Reliefmosik, EA.

relief-moulded, C-2458/*129, 184*;
CEA/*134*①.

relief moulded, C-2323/*57*①.

relief pattern, C-2403/*157*.

relief plaque, C-2437/*24*①; C-5114/
*174*①.

relief portrait, MP/*75*.

relief printing, DATT.

relief tile, IDPF/*232*.

religieuse, C-2364/*22*①; C-5224/
*54*①; CEA/*228*①.

religieuse clock, EA/*pendule
religieuse*.

religious, CEA/*617*.

religious dress, DSSA/①.

religious group, MP/*116*.

religious statuette, MP/*474*①.

relining, DATT; LP.

reliquary, C-0279/*100*; CEA/*452*①;
DADA; DATT/①; EA/①; IDPF/
191.

reliquary base, C-5173/*68*①.

reliquary box, C-5224/*256*①.

reliquary cabinet, LAR82/*291*①.

reliquary ring, RTA/*103*①.

relish spoon, S-4461/*202*.

remarque, DATT/①.

remarque proof, DATT/①.

Rembrandt blue, DATT.

Rembrandt flagon, EA/*tankard*.

Rembrandt green, DATT.

Rembrandt's ground, DATT.

reminder ring, RTA/*97*.

Remington rolling block rifle, CEA/
*42*①.

Remington rolling block system,
CEA/*37*.

Remmey, John, EA.

remontoire, EA.

Remy, Pierre, S-4955/*180*.

Renaa, OPGAC/*15*.

Renaissance, CEA/*509, 599*; DADA;
DATT; EA; JIWA/*87*; S-3311/
*221*①; S-4972; SDF.

Renaissance, English, DADA.

Renaissance, French, DADA/①.

Renaissance, German, DADA.

Renaissance, Italian, DADA/①.

Renaissance, Netherlands, DADA/①.

Renaissance, Spanish, DADA.

Renaissance idealism, JIWA/*87*.

Renaissance painting, LP.

Renaissance pattern, C-0254/*223*;
C-0270/*205*.

Renaissance revival, LAR83/*246*①.

Renaissance revival style, LAR83/
*582*①.

Renaissance style, IDC; NYTBA/
*23*①; S-3311/*292*; S-4804/*837*①,
*846*①.

Renaissance taste, S-4804/*227*①.

rendering, DATT; LP.

Rendsburg, DADA; EA.

Rene, C., C-GUST/11①.

René Prou, S-3311/944①.

Renier, Remy-Joseph, C-5174/469.

Rennes, DADA.

Renoir, Pierre-Auguste, S-286/445①.

Rensselaer, Kiliaen Van, CEA/674①.

rent table, ACD; DADA; EA;
S-4436/136①; SDF/①.

Rentzsch, S., EA/275①.

rep, SDF.

repaint, DATT.

repainting, LP.

repair, C-5116/119.

repaired, S-4905/42①; S-4972/248①.

repairer, CEA/191①; DADA; EA;
IDC.

repatination, S-3312/1284①.

repeat, NYTBA/91①.

repeater, ACD; CEA/41①.

repeater stop watch, S-291/118①.

repeat glass, DATT.

repeating, CEA/254①; S-4927/35.

repeating clock, EA/watch; LAR83/
181①.

repeating cord, C-5157/33①.

repeating design, C-5156/471A; EA/
alafia.

repeating desk clock, C-5117/391①.

repeating diamond panel, OC/204.

repeating lattice pattern, OC/203.

repeating medallion design, OC/208.

repeating pattern, C-5156/817①.

repeating rosette border, OC/42①.

repeating watch, EA/Barlow, Edward.

repetition, LP.

repetitive, S-4948/20①.

replaced lock, C-0270/142A①.

replacement, C-2458/99①; IDC/
replacer.

replacement cover, S-4992/37①.

replacer, IDC.

replica, C-0406/88; C-2489/67;
DADA; DATT; LP.

rep-like weave, JIWA/207.

repository, SDF.

repoussage, DATT.

repoussé, ACD; C-0254/7; C-2398/
1①; C-2458/250①; C-2478/11;
C-5005/208①.

repousse, C-5114/6, 98, 173.

repoussé, C-5153/11①, 15①;
C-5156/214; C-5157/34①; CEA/
62①, 256①.

repousse, CEA/524.

repoussé, CEA/528.

repousse, CEA/541.

repoussé, CEA/618, 630①; DADA;
DATT; EA; IDC; S-2882/926①,
928①, 939①, 940, 942①, 943①,
949①, 956①, 962①, 998①, 1061.

repousse, S-3311/304.

repoussé, S-3311/460①; S-4802/
136①; S-4804/61①; S-4972/437.

repoussé brass frame, S-2882/814①.

repoussed, S-4804/46.

repoussé decoration, RTA/11①.

Repoussé pattern, C-0254/232;
S-4804/56, 89①.

repoussé petal, C-2414/52①.

repoussé portrait, RGS/31①.

repoussé relief, RTA/30①.

repoussé silver riza, S-2882/542①.

repousse tôle mirror, S-4823/136.

repousse wag-on-the-wall clock,
S-2882/832①.

repoussé work, CEA/513.

repoussoir, LP.

repp, SDF/rep.

representation, JIWA/10.

representational, LP.

representational art, DATT.

representational aspect, MP/69.

representational motif, RTA/26①.

representative exhibition, MP/*24*.

representative object, NYTBA/*9*.

reprint, C-0249/*120*.

reproduction, C-5156/*1011*; C-5236/*1527*; C-5239/*197*; CHGH/*57*; DADA; DATT; IDC; LP; NYTBA/*6*; SDF.

reproductive print, S-4881/*188*.

reproductive process, JIWA/*12*.

reptile, C-2398/*12*①.

reptile handle, LAR83/*177*①.

Republican ware, IDC.

République Française, EA/*Sèvres*.

re-railed, C-2403/*26*.

rerebrace, DADA.

reredo, ACD/*fire-back*; DATT.

reredos, EA/*fireback*.

réseau, DADA.

réseau rosacé, DADA.

reserve, C-0254/*305*; C-5114/*182*①; C-5117/*444*①; C-5156/*62*①; DADA/①; DATT; EA; EC2/*24*; IDC; S-2882/*374, 783*①, *802*①; S-4802/*369*①; S-4905/*108*①.

reserved, S-4905/*5*; S-4992/*4*①.

Reserven, MP/*61*.

reservoir, C-2437/*21*①; C-5127/*109*①; CEA/*24*①; S-4461/*547*.

resht work, DADA.

resin, DATT; LP; RTA/*23*①.

resist, ACD; DADA; DATT.

resist lustre, EA.

resist technique, JIWA/*199*.

resist ware, IDC.

resolve, LP.

responds, S-4948/*132*①.

rest, EC2/*29*①.

restauration, C-5259/*593*; S-4804/*900*①; C-5181/*190*; C-5224/*73*; DADA; S-2882/*839*①.

restoration, C-5116/*31, 112*; C-5157/*70*; DATT; LP; S-4992/*4*①; DADA; SDF.

Restoration chair, DADA.

Restoration period silver, CEA/*642*①.

Restoration style, EA/①.

restore, SDF.

restored, C-1082/*1*; S-4992/*35*①; SDF.

restorer, DATT.

restrainer, DATT.

restricted palette, DATT; LP.

restrike, C-0249/*13*; DATT.

rest-stick, DATT.

Resurrection of Christ scene, C-5174/*208*.

retable, DATT.

retailer's mark, C-5189/*30*.

retaining hook, S-4972/*168*①.

retardant, DATT.

retarder, LP.

rete, EA/*astrolabe*.

Rethondes, C-5181/*12*.

reticella, DADA/①.

Reticella lace, C-1506/*161*.

Reticella style lace, C-1304/*231*.

reticello (vetro de trina), EG/*73*.

reticello glass, EA/*vetro a reticelli*.

reticulate, C-2458/*351*.

reticulated, C-0782/*91*; C-2493/*206*①; C-5127/*248*①; C-5156/*76*①; C-5236/*345*①; C-5239/*19*; CEA/*503*; IDC/①; LAR83/*174*①; S-2882/*712A*①; S-4436/*25*; S-4905/*16*①.

reticulated base, S-2882/*688*.

reticulated cup, IDC.

reticulated glass, EG/*77*.

reticulated ground, JIWA/*201*①.

reticulated or screened effect, JIWA/*216*①.

reticulated panel, C-0782/*14*; S-2882/*715*.

reticulated plate, S-4843/*230*①.

reticulated scroll, C-2458/*318*①.

reticulated vase, S-2882/*715.*
reticulated ware, EA/*Böttgerporzellan.*
reticulation, DATT.
reticule, C-1506/*54*①.
retouch, DATT.
retouched, C-5236/*351*①.
retouching, DATT; LP.
retouch varnish, DATT; LP.
retreating color, DATT.
retrospective, LP.
retroussage, DATT.
return, SDF.
Reubens madder, DATT.
re-use, C-2555/*74*①.
Reval, DADA.
Revault, Claude, S-4955/*134*①.
Réveillon, J. B., DADA.
Revel, Joseph, C-2364/*24.*
Revere, Paul, ACD; DADA.
Revere, Paul II, CEA/*674*①.
Revere, Paul, Jr., S-4905/*235*①.
Revere, Paul the Elder, EA/①.
Revere, Paul the Younger, EA/①.
Revere bowl, C-5203/*284A.*
REVERE in a rectangle, EA/*Revere, Paul the Younger.*
Reverend, Claude and François, CEA/*182*①.
Révérend, Claude, François, EA.
Revere style, S-4461/*460.*
reverse, C-0706/*43*; C-5117/*300*;
　C-5156/*84*①; DATT; IDC;
　S-4928/*14*①; S-4992/*7*①.
reverse break front, SDF.
reverse breakfront, C-5116/*121*①.
reversed flute, CEA/*676*①.
reversed molding, FFDAB/*110.*
reversed torpedo, OPGAC/*233.*
reverse etched, S-4972/*444*①.
reverse ogee, SDF/①.
reverse-painted, C-5005/*374*①;
　K-711/*126.*

reverse painted, C-0225/*338*; C-5239/
　311; LAR82/*503*①; LAR83/
　*482*①.
reverse-painted glass, C-5167/*235*①.
reverse painting, C-0249/*299*①;
　C-5114/*175*①; C-5127/*176*;
　C-5156/*280*; S-4414/*421.*
reverse-serpentine, C-5114/*313*①;
　LAR83/*252*①.
reverse serpentine, DADA.
reversible black opal, S-291/*113*①.
reversing, C-2704/*59.*
revival, C-5153/*4*①.
revival dish, C-5127/*382.*
revivalist jewellery, RTA/*129*①.
Revived Gothic, IDC.
Revived Kutani, IDC.
revived rococo, DADA; EA; IDC.
Revivescit ('he grows strong again'), EA/*Jacobite glass.*
Revolutionary symbol, EA/*Directoire style.*
revolving, C-2546/*67*; S-4972/*556*①.
revolving bookcase, SDF/①.
revolving breakfast dish, LAR83/
　*572*①.
revolving carbine, S-4972/*259*①.
revolving chair, C-0982/*104*; SDF/①.
revolving cover, C-5203/*40.*
revolving dial, EA/*Augsburg clock.*
revolving dish, DADA.
revolving drum table, LAR83/*365*①.
revolving handle, C-0254/*171*①.
revolving scarab, RTA/*20*①.
revolving shelf, C-2421/*53*①.
revolving stand, C-1006/*218.*
revolving table book stand, C-1407/
　146.
revolving top, C-0706/*171.*
Rewend, Christian F., EA.
Reydams, Henri, EA.
Reymond, Pierre, EA/①.
Reynal, Jeanne, DADA/*Supplement.*

reynes, SDF.

Reynolds, London, C-2503/*175*.

Reynolds, Sir Joshua, pattern, IDC/ ①.

Reyntiens, Patrick, DADA/ *Supplement*.

RF, CEA/*641*①; EA/*Sèvres, Sèvres*.

RH, EA/*Hennell, Holdship, Richard*.

RH above DH, EA/*Hennell*.

RH above SH, EA/*Hennell*.

Rhages ware, DADA; IDC, *Rayy ware*.

rhea, SDF.

Rhead, OPGAC/*346*.

Rhead, Charlotte, C-2409/*124*.

Rhead, Fred, OPGAC/*355*.

Rhead, Frederick, EC1/*78*①.

Rhead Pottery, Santa Barbara, California, EC1/*85*.

Rheims tapestry, DADA.

Rheinsberg, DADA.

Rhenish, C-2427/*195*; C-2486/*192*; LAR82/*129*①.

Rhenish beaker, CEA/*417*①.

Rhenish bottle, CEA/*136*①.

Rhenish school, DATT.

Rhenish stoneware, DADA; IDC.

rhidso, C-2320/*136*; C-2357/*119*.

Rhineland (Rhenish) stoneware, EA.

Rhineland stoneware, EA/*Raeren, Siegburg*; IDC.

Rhine wine glass, NYTBA/*273*.

rhinoceros-form, S-4965/*142*①.

rhinoceros horn, C-2458/*276*; JIWA/ *306*; LAR83/*457*①; NYTBA/*226*; S-3312/*1261*①; S-4810/*327*①.

Rhinoceros Vase, EA/①.

Rhinoceros vases, IDC/①.

Rhodé, Gilbert, C-5191/*320*.

Rhode, Gilbert, C-5239/*266*.

Rhodes, C-2360/*199*.

Rhodes, Daniel, DADA/*Supplement*.

Rhodes, David, EA/①.

Rhodes carpet, EA/*Megri carpets*.

rhodeswood, DADA.

Rhodian pottery, IDC.

Rhodian ware, EA/*Isnik*.

rhodium, S-4927/*328*①.

rhodolite garnet, S-291/*1*.

rhodonite, C-2332/*90*; C-5117/*348*; C-5174/*227, 256*①.

rhombic-form, S-3311/*64*.

rhomboid, C-5323/*3*①.

rhomboidal, C-2482/*79*.

rhomboid diamond, S-291/*86*①.

rhombus, OC/*225*.

rhomic, S-3311/*12*.

Rhus vernifica, CEA/*562*.

rhythm, JIWA/*16*; LP/①.

rhythmic, LP.

rhythmical arrangement, JIWA/*20*.

rhythmic compression, JIWA/*176*①.

rhyton, C-5156/*417*; DADA; DATT; IDC; IDPF/*191*①; S-4807/*487*.

rib, C-2458/*18*; DATT.

Ribakov, Afanasii, C-5174/*229*①.

riband, C-0982/*19, 147*.

ribanded fence, C-2476/*22*①.

riband ornament, C-2398/*21*①, *28*.

riband-reeded, C-2402/*149*.

ribband, C-1407/*22*.

ribband-back, CEA/*321*; DADA; CEA/*343*①.

ribband border, C-5224/*106*①.

ribband cresting, C-0982/*64*.

ribband motif, EA.

ribband wheel-back splat, C-5170/ *141*.

ribbed, C-2403/*2*; C-5156/*9*①; C-5236/*412*; RTA/*78*①.

ribbed baluster form, C-5146/*154A*.

ribbed banding, C-0254/*100*①.

ribbed border, C-2437/*57*①.

ribbed bowl, EG/*26*①.

ribbed column, C-5146/*175*①.

ribbed cup, C-5114/*149*①.

ribbed cylindrical form, C-5005/*239*.

ribbed decoration, C-0225/*10*.

ribbed everted rim, S-2882/*996*①.

ribbed faceted side, S-2882/*1359*.

ribbed foot, DADA.

ribbed form, IDPF/*192*①.

ribbed handle, IDPF/*118*①; LAR82/*164*①.

ribbed ivy, OPGAC/*233*①.

ribbed lobe, S-4922/*24*①.

ribbed neck, C-0225/*8*.

ribbed palm, OPGAC/*233*.

ribbed pattern, MP/*484*①.

ribbed pierced standard, S-2882/*1379*①.

ribbed pinched side, S-2882/*1362*.

ribbed rim, C-5005/*234*①.

ribbed side, S-4414/*247, 251*①.

ribbing, EG/*28*; IDC; OC/*252*.

ribbon, C-1506/*2*; CEA/*483*①; OPGAC/*234*.

ribbon and flowerhead border, S-3311/*113*.

ribbon and leaf border, IDC.

ribbon and rosette, SDF.

ribbon-and-rosette border, C-2388/*47*.

ribbon-and-stick, SDF.

ribbon back chair, SDF/①.

ribbon border, C-0279/*8*①; S-4948/*188*①.

ribbon-bound, S-4414/*110*; S-4507/*69*①.

ribbon candy, OPGAC/*234*.

ribbon-carved, S-4436/*119*①.

ribbon cresting, S-2882/*407*①.

ribbon design, OC/*205*.

ribboned, C-2458/*162*; CEA/*421*①.

ribboned bow, C-2458/*340*.

ribboned edge, EG/*246*①.

ribboned tied, C-0982/*238*.

ribbon motif, EA/*ribband motif*.

ribbon ornament, MP/*172*; SDF.

ribbon puller, C-0406/*113*.

ribbon scroll, C-2427/*225*; S-2882/*219*①.

ribbon strap, S-4414/*126*.

ribbon swag, C-2202/*154*.

ribbon-tie, C-2357/*5*①.

ribbon-tied, C-0254/*90*①; S-4804/*17*①; S-4905/*187*①.

ribbon tied, C-0254/*145*.

ribbon-tied armorial, S-4414/*321, 329*①.

ribbon-tied festoon, S-4414/*281*.

ribbon tied foliage, C-0982/*195*.

ribbon-tied laurel festoon, S-2882/*1033*.

ribbon tied laurel wreath border, C-0270/*34A*①.

ribbon-tied lily, S-4804/*11*①.

ribbon-tied plumage, S-4922/*20*①.

ribbon tied wreath, C-5117/*479*①.

ribbon-twist, C-2388/*76*.

ribbon-twist border, C-2437/*71*①.

ribbon work, DADA.

ribbonwork, S-4804/*80*.

rib decoration, RTA/*75*①.

rib mould, CEA/*503*; EG/*293*①.

rib pattern, SDF.

ribs, C-0782/*120*; S-4461/*12*.

rib section, C-5127/*33*.

ricasso, C-2569/*29*; C-MARS/*13, 46*; CEA/*22*①, *44*; DADA.

rice bowl, JIWA/*346*.

rice grain decoration, EA/*Gombroon ware*.

rice grain pattern, DADA.

rice-grain piercing, IDC.

rice paper, DATT; JIWA/*391*; S-4881/*50*①.

rice-paper painting, C-2513/*423*①.

Rich, Obadiah, CEA/*677*①.

Richard, C-GUST/*56*①.

Richard Chaffer's Factory, C-2493/
132.

Richard Champion's Factory, C-2493/
136.

Richards, J., London, C-2489/*153*.

Richards, W., C-2476/*97*.

Richards, Westley, C-MARS/*147*.

Richards, Westley, London, C-2503/
97.

Richardson, NYTBA/*300*.

Richardson, Birmingham, C-2503/*131*.

Richardson, George, S-4905/*316*.

Richardson, Henry Hobson, DADA/
Supplement.

Richardson, Joseph, CEA/*673*①.

Richardson, Joseph and Nathaniel,
CEA/*675*①.

Richardson, Joseph Jr., S-4905/
*216*①.

Richardson, Richard, C-5173/*24*①.

Richardson, Tho., London, C-2489/
106.

Richardson: Joseph, Joseph Jr,
Nathaniel, EA/①.

Richardsons of Stourbridge, EA/*spun
glass*.

Riché, L., C-5181/*68*①.

Richelieu pattern, C-0254/*227*;
S-4804/*64*.

rich lime, DATT.

Richter, A. (assaymaster), C-5174/
*313*①.

Richter, Christian, EA.

Richter, Friederich, S-4922/*12*①.

Richter, Jean-Louis, CEA/*68*①.

Ricketts, Henry, CEA/*50, 58*①.

Rider, Joseph, CEA/*42*①.

ridge, DATT.

ridged, C-5156/*9*①; C-5236/*402*.

ridged-back, OC/*185*.

ridged back, OC/*182*①.

ridged-back square-knot, OC/*22*.

ridged construction, OC/*21*①.

'Ridge' enamel, RGS/*40*.

ridge tile, IDC/①.

Ridgeway's, C-2502/*57*.

Ridgway, ACD; C-5189/*18*; S-4947/
183.

Ridgway, Job, EA.

Ridgway, John, William, EA/①.

Ridgways, C-2493/*150*①.

riding crop, S-4881/*202*①; S-4905/
*163*①.

riding sword, C-MARS/*31*①.

riding whip handle, C-5117/*67*①.

Rie, Lucie, DADA/*Supplement*;
LAR83/*146*①.

Riedel, A., C-5174/*53*①.

Riedel, Gottlieb Friedrich, EA; MP/
163.

Riedel, Joseph, EA/①.

Riel, François, EA/*317*.

Riemerschmid, Richard, DADA/
Supplement; MP/*199*.

Riesener, Jean-Henri, EA; S-4955/
*86*①, *142*①.

Riesener, Jean Henri, ACD; DADA.

Riesener, J.-H., C-2364/*77*①.

Riesenpokal, EA.

Rietveld, Gerrit, DADA/*Supplement*.

riffler, DATT.

rifle, C-2476; C-MARS/*125, 126*①;
DADA; S-4972/*261*.

rifled, CEA/*26*①.

rifled barrel, S-4972/*264*.

rifled carbine, CEA/*35*.

rifle-gun, C-2476/*4*.

rifle-trigger, C-2476/*4*.

rifling, ACD; CEA/*44*.

rifling groove, S-4972/*157*①.

rigaree, DADA; EG/*293*①.

Rigby, J., C-2476/*1*.

Rigby, Wm. & Jno., Dublin, C-2503/
92.

rigger, DATT; LP/*brushes*.

Righetti, Francesco, EA/*288*①.

right-angled rule, C-2904/*226.*
right-angle rule, C-2904/*125.*
right-hand side view, CHGH/*64.*
rightward-sloping composition, JIWA/ *219*①.
rig-ribbed, C-2427/*192.*
R I H S, CEA/*142*①.
Riihimaki Glass Works, DADA/ *Supplement.*
Rika, Eliahu, DADA/*Supplement.*
rilievo schiacciato, DATT.
rilievo stiacciato, DATT.
rill droplet, JIWA/*324.*
rim, C-2202/*3;* C-2458/*1;* C-5005/ *354*①; C-5153/*2*①; C-5156/*98*①; EC2/*22*①; IDC; IDPF/*192*①; S-4922/*2*①; SDF.
Rimbault, P., C-2368/*104*①.
Rimbault, Stephen, DADA.
Rimbault, Stepn., London, C-MARS/ *229.*
rim chip, C-5127/*15.*
Rimell & Allsop, C-0405/*208.*
rim-fire, C-2476/*12;* CEA/*40*①.
rim foot, C-0254/*152;* C-1502/*30;* C-2202/*233;* C-5117/*84, 95, 139*①, *322*①; LAR82/*440*①; S-4414/ *324*①; S-4922/*14*①.
rim-footed, CEA/*639*①.
Rimini, C-2427/*254.*
rimmed, C-0982/*38;* C-2402/*57, 123.*
rimonim, CEA/*673*①.
rimonin, C-5174/*157*①.
rim pan, IDPF/*194.*
Rimpa school, C-5236/*929*①; C-5156/*902.*
rimu, SDF.
rin, C-1603/*129.*
rinceau, DADA.
rinceau border, C-0254/*318.*
ring, C-5005/*391;* DSSA.
ring alabaster handle, C-0225/*289.*
ring base, C-5174/*56*①.

ring bottle, IDPF/*194*①.
ring-cut, S-4436/*63*①.
ring disc, C-5156/*341.*
ringed, S-4928/*76*①.
ringed bead, EA/*beads and marbles: eye bead.*
ringed coat-of-mail, DADA.
ringed handle, C-1006/*45.*
ring foot, S-4965/*82.*
Ringgold, K-711/*123.*
ring grip, C-5117/*185*①.
ring ground, IDC.
ring guard, CEA/*22*①.
ring handle, C-2437/*18*①; C-5114/ *30*①, *87*①, *217*①; C-5117/*97, 129, 150*①, *154*①; C-5127/*6*①; CEA/ *655*①; FFDAB/*125;* LAR82/ *132*①; RGS/*105*①; S-3312/ *1285*①; S-4414/*306;* S-4461/*400;* S-4922/*3*①.
ring-handled vase, EA.
ring-incised, C-5114/*318*①.
ring-jug, IDC/①.
Ringler, J. J., CEA/*175*①, *181*①.
Ringler, Joseph Jakob, EA.
ring-matted, C-5236/*396*①, *811*①.
ring mold, IDPF/*40*①.
ring mould, EG/*250.*
ring-pull, C-5116/*83.*
ring pull, FFDAB/*57.*
ring-punched, S-4965/*148*①.
Ringschraubflasche, LAR82/*539*①.
ring shank, S-291/*101*①.
ring-stand, IDC.
ring trigger, C-2569/*91.*
ring-turned, C-0982/*127, 83B;* C-2320/*19*①; C-2402/*20;* C-2421/ *66*①, *96*①; C-2478/*70;* C-5114/ *295*①; S-2882/*620*①.
ring turned, C-1407/*52.*
ring-turned column, C-5114/*263*①.
ring turned columnar support, S-4414/*455.*

ring-turned foot, C-5114/*269*①;
S-4414/*279*.

ring-turned leg, C-2403/*24*; C-5116/
55; S-4812/*173*①.

ring-turned pillar, C-2402/*41*.

ring-turned shaft, C-2388/*31, 122*①.

ring-turned support, C-2421/*75*①;
C-5116/*67*.

ring turned support, S-2882/*275*.

ring-turned tapered leg, S-4414/
*461*①.

ring-turned tapering leg, C-5116/
*113*①.

ring-turned vase, C-5153/*115*①.

ring turning, S-4414/*253*①.

ring-watch, EA/*Arnold, John*; RTA/
*103*①.

ring watch, EA.

Rinman's green, DATT.

riobitsu, DADA.

Rion, Sixte-Simon, C-5174/*480*.

rior, George, S-4927/*30*.

Rioro nuri, LAR82/*63*①.

rio rosewood, SDF.

ripe pomegranate (grenade), EA/
décor coréen.

Ripolin, DATT.

Ripp, Johann Caspar (Kaspar), EA.

Ripp, Johann Kasper, CEA/*138*①.

ripple-carved, C-5224/*108*.

rippled aquamarine, C-5146/*175*①.

rippled glass, C-5146/*161A*.

ripple-flaked, C-1582/*19*.

ripple-moulded, C-1407/*146*; C-5116/
54.

ripple-moulded border, C-2403/*97*①.

ripple moulding, C-0279/*341*①;
C-0982/*198*.

ripple-pattern, C-5224/*108*①.

rippling, C-0249/*59*.

rise-and-fall, C-2368/*78*①.

Risen Burgh, Bernard van, NYTBA/
*18*①.

riser, CEA/*528, 541*; DATT.

rising, C-2202/*44*; SDF.

rising banner, C-2421/*47*.

rising-bolt, C-2476/*1*.

rising circular foot, C-1502/*6*.

rising cover, C-2202/*59*.

rising cupboard, SDF.

rising curved spout, C-0706/*2*;
C-1502/*2*.

rising dragon spout, C-5174/*277*.

rising flat handle, C-5174/*531*①.

rising foliage, C-5117/*247*.

rising mask, C-5117/*130*①.

rising mirror, C-2478/*142*.

rising plank lid, LAR83/*402*①.

rising reeded handle, C-5117/*283*①.

rising stretcher, SDF.

rising sun, DADA.

Risler & Carré,, S-4944/*177*①.

Ritchie, James & Son, Edinburgh,
C-2489/*234*.

ritoccata, DATT.

Rittenhouse, David, DADA.

Ritter, Paulus, EA/*370*①.

ritual disc, C-5236/*341, 1684*;
S-3312/*1206*.

ritual pot, IDPF/*165*.

Ritual ring, RTA/*14*.

ritual stand, IDPF/*217*①.

ritual vessel, S-3312/*1282*①.

ritual vesssel, S-3312/*1281*①.

riven wood, EA.

Riverboat, CEA/*464*①.

rivering, S-4810/*389*.

river landscape, C-0782/*2*.

river marble, DATT.

river-pearl, RGS/*124*.

riverscape, S-4955/*36*.

riverside scene, C-2704/*45*.

Rives, S-286/*34*.

Rives paper, S-286/*47*.

rivet, CEA/*541*.

riveted, C-2493/*16*; S-4905/*114*.

riveted link, CEA/*539*①.

rivetted, S-4972/*140*①.

Riviere, Henri, S-286/*72*①.

Rivington, C-5191/*305*.

riza, C-5189/*225*; C-5203/*110*; RGS/ *124*; S-3311/*341*.

R. & J. Beck, C-2904/*111*.

RN, CEA/*641*①.

RO, EA/*Rollos, Philip the Younger*.

roan, C-2427/*56*; SDF.

roast fork, S-3311/*728*①.

roasting-jack, EA/*bottle-jack*, *bottle-jack*.

Robbe, Manuel, S-286/*453*①.

Robbia, Andrea Della, CEA/*134*①.

Robbia, Della, IDPF/*245*.

Roberson's medium, DATT.

Robert, J., C-2910/*38*.

Robert, Joseph-François, CEA/*486*①.

Robert, Louis Valentin Elias, S-4947/ *101*①.

Robert Bloor & Co., C-2360/*85*.

Roberts, David, R.A., S-286/*461*①.

Roberts, E., CEA/*609*①.

Roberts, Gideon, EC2/*89*.

Roberts, J., C-2476/*32*①.

Roberts, Richard, DADA.

Roberts, Sidney, EA/*Roberts, Samuel the Younger*.

Roberts, Smith & Co, EA/*Roberts, Samuel the Younger*.

Roberts, Thomas, DADA; EA.

Roberts & Belk, C-0406/*22*.

Robertson, Andrew, EA.

Robertson, Charles, EA.

Robertson, George, EA.

Robertson Pottery, Los Angeles and Hollywood, California, EC1/*85*.

Robertsons' Chelsea Keramic Art Pottery, CEA/*165*.

Roberts: Samuel the Younger, Samuel the Elder, Samuel III, EA.

Robert Trewick, EA/*Bone, Henry*.

Robilou, Isaac, CEA/*261*①.

Robin, Louis, C-5117/*258*; C-5174/ *446*①.

Robin, Robert, C-5224/*55*①.

robina, SDF.

Robin à Paris, C-5189/*190*.

Robineau (mark), EC1/*84*①.

Robineau, Adelaide, EC1/*81*①.

Robineau, Adelaide Alsop, DADA/ *Supplement*.

Robineau Pottery, Syracuse, New York, EC1/*85*.

Robins, John, C-0406/*92*; C-5117/*49, 223*; CEA/*655*①, *657*①; S-4905/ *241*①.

Robins, Richard, EA.

Robins, Thomas, C-0406/*132*; C-2487/*151*; C-5117/*215*①.

robin's-egg glaze, IDC.

robin's-egg-glazed, C-2458/*155*.

Robins & Lawrence, S-4972/*262*①.

Robinson, Edward, C-5174/*539*①.

Robinson, Edward II, C-5117/*376*.

Robinson, Jasper, EA.

Robinson, Thomas, C-2510/*81*; CEA/*529, 532*①.

Robinson II, John, C-5117/*241*①.

Robj, C-5191/*57*.

Roblin Art Pottery, San Francisco, California, EC1/*85*.

Robson & Sons Ltd., Newcastle on Tyne, C-0982/*146*.

Robust style, RTA/*29*①.

rocaille, ACD; C-0982/*223*; C-1603/ *109*; C-2332/*346*; C-2382/*51*①; C-5114/*11*; C-5116/*170*①; C-5259/*566*; CEA/*377*①, *406*; DADA/①; DATT; EA; IDC; MP/ *136*; NYTBA/*41*.

rocaille border, RGS/*116*①.

rocaille cartouche, RGS/*92*①.

rocaille carving, CEA/*307*①.

rocaille decoration, S-2882/*542*①.

rocaille handle, RGS/*31*①.

rocaille ornament, C-5117/*187*①;
RGS/*17*①.

rocaille panel, RGS/*92*①.

rocaillerie, IDC; S-4853/*121*①;
S-4905/*49*①.

rocaille scroll, C-5117/*291*①.

Roccatagliata, C-5189/*182*①;
C-5224/*285*①.

Roccatagliata, Nicolo, S-4947/*217*①.

Rochat, Frères, EA.

Rochat, Turin, C-2503/*212*①.

Rochegrosse, Georges, S-286/*433T*.

Rochester Lamp Co, K-711/*129*.

Rochette, Claire M., S-4947/*17*①.

rock, DATT.

rock-crystal, C-5174/*318*①; JIWA/
*123*①.

rock crystal, C-1082/*158*; C-2458/
350; C-2482/*95*; C-5236/*334*;
CEA/*64*①; DADA; EG/*99*①;
JIWA/*309*①; LAR83/*420*①;
NYTBA/*226*; S-3311/*527*①;
S-4810/*143*①; S-4927/*192*①;
S-4972/*309A*.

rock crystal case, CEA/*251*①.

rock crystal shape, EG/*67*.

rock-crystal style, CEA/*451*.

rock-crystal watch, EA.

rocker, C-5114/*267*①, *318F*①;
C-5191/*288*; C-5239/*245*; DATT/
①; NYTBA/*76*; S-4461/*570*①;
S-4905/*384*; S-4947/*122*①.

rocker blotter, C-5146/*157*; C-5239/
91.

rocker stretcher, FFDAB/*39*.

rocker support, C-1407/*42*.

rockform, C-5127/*53*①.

rocking chair, C-0906/*197*; C-0982/
96A; DADA/*Supplement*, ①;
S-3311/*201*①; SDF/①.

Rockingham, ACD; C-1582/*101*;
C-2360/*5*①; C-2493/*95*①; DADA,
supplement; LAR82/*168*①;

LAR83/*147*①; EA/*Rockingham
Works*.

ROCKINGHAM BRAMELD, EA/
Rockingham Works.

Rockingham glaze, DADA; EA.

Rockingham Royal Black, DATT.

Rockingham saucer, C-2502/*172*.

Rockingham ware, EA; IDC;
NYTBA/*154*①.

Rockingham Works, CEA/*204*①; EA.

rocking horse, S-3311/*202*①.

rocking melodian, C-5255/*43*.

rock in the sea, JIWA/*6*.

rock of ages border, IDC.

rock soap, DATT.

rockwork, C-0249/*185*; C-0782/*9*;
C-2427/*44*①; C-2458/*67*; C-5116/
35; C-5156/*433*; IDC; S-4963/
*97*①.

rock work base, S-4922/*85*①.

rockwork base, S-3311/*232*; S-4461/
181.

rockwork cresting, S-4436/*73*.

rocky base, C-2357/*50*①.

rocky landscape, C-2414/*97*①.

rocky river bank, C-2414/*101*.

Rocky Road to California, CEA/*287*.

rococco, SDF/*Rococo*.

rococo, ACD; C-2427/*47*①; C-5117/
*155*①; CEA/*147*①, *169*, *175*①,
*224*①, *513*, *529*, *630*①; DATT/①;
IDC; IDPF/*8*; LP; OC/*321*;
S-2882/*366*①; S-4905/*187*①;
S-4922/*51*①; S-4972/*427*; C-5005/
*377*①; DADA; JIWA/*87*; SDF.

rococo angle, C-2421/*115*①.

rococo base, LAR83/*37*①; S-3311/
380.

rococo cartouche, C-0254/*87*;
C-2398/*82*; C-5117/*76*①; RGS/
*79*①.

Rococo carved, S-3311/*216*①.

rococo column, S-2882/*725*.

rococo engraving, CEA/*454*①.

rococo finial, RGS/*116.*

rococo floral and foliate cartouche, S-2882/*1112*①.

rococo foliate and scrollwork border, S-2882/*1021*①.

rococo form, S-2882/*740*①.

rococo frame, RGS/*92*①.

rococo medallion, S-4414/*317.*

rococo ormolu case, S-2882/*409*①.

rococo ornament, RGS/*69.*

rococo revival, C-5114/*43*①; NYTBA/*76*①; S-4972/*554*; LAR83/*317*①; C-2421/*86*; C-2478/*32.*

Rococo revival style, C-5153/*15*①.

rococo scroll, IDPF/*231*; RGS/*31*①; S-4461/*489.*

rococo scrollwork, S-2882/*775*①.

rococo shell and foliage cartouche, C-5117/*88*①.

rococo shellwork cartouche, S-2882/*925.*

rococo shield, S-4414/*346*①.

rococo stitch, CEA/*274*①.

rococo style, C-2202/*42*; EA/①; S-2882/*995*①; S-4414/*281, 294*①; S-4804/*144*①.

rococo taste, S-2882/*776*①.

rod, C-0279/*266*; CEA/*503*; DATT; EG/*293*①; NYTBA/*270.*

Rodanet, A. H., S-4927/*83.*

rod-back Windsor, EA.

Rodgers, James, Sheffield, C-2503/*157.*

rod neck, S-4414/*211*①.

Rodney, Lord, CEA/*193*①.

Rodney decanter, EA/*ship's decanter.*

Rodney jug, EA.

Rodney ware, IDC.

rod standard, S-4414/*229*①, *252*①.

rod stem, S-4905/*168*①.

roe (roey), EA.

roe, SDF.

roelle, SDF.

roemer, CEA/*417*①; DADA; LAR82/*464*①; NYTBA/*273*; CEA/*452*①.

Roentgen, Abraham, C-5157/*151*①; CEA/*313*①; S-3311/*488A*①.

Roentgen, David, ACD; C-5224/*206*; CEA/*314*①, *381*①; EA/①; NYTBA/*61*①.

Roentgen, David and Abraham, C-2555/*21*①.

Roettiers, Jacques, EA.

Roettiers, Jacques Nicholas, CEA/*633*①.

Roettiers, Jacques-Nicolas, EA.

roey, SDF/*roe.*

Roffboss, LAR82/*82*①.

Rofs, A., C-2904/*198*①.

Rogers, CEA/*158*①; EA/*Rogers, John, George.*

Rogers, Isaac, C-2368/*148*; S-4927/*173.*

Rogers, James, CEA/*196*①.

Rogers, John, George, EA.

Rogers, William, CEA/*165.*

Rogers and Mead, DADA/*Supplement.*

Rogers Brothers, DADA/*Supplement.*

Rogers group, DADA; IDC.

rogin, S-3312/*1052.*

Rohde, Gilbert, C-5167/*224.*

Rohde, Johan, C-GUST/*105*①; DADA/*Supplement.*

Rohde, Peter III, C-5117/*191.*

Rohe, Ludwig Miës van der, DADA/*Supplement.*

roioro-nuri ground, C-5127/*442.*

roiro, CEA/*573*①, *575.*

rōiro, DADA.

roiro, S-4928/*135*①.

ro-iro-nuri, C-5220/*46*①.

roiro-nuri, C-0282/*121*; C-1082/*182*; C-5236/*790.*

roiro nuri, C-5156/*715*①.

Roi Soleil mask, C-5189/*294*①.

Roker, Philip, S-4944/*408*①.

Rolex, S-4927/*28.*

roll crease, C-0249/*12.*

rolled, C-0403/*18.*

rolled arm, C-5114/*277, 323*①.

rolled arm support, C-5114/*390*①.

rolled base, IDPF/*25.*

rolled brass, CEA/*245*①.

rolled foot, C-0254/*146A*; IDPF/*195*; S-4414/*203*①.

rolled gold, C-5117/*402.*

rolled handle, C-0254/*35.*

rolled lip, C-5114/*228.*

rolled ornamental band, C-5114/*37*①.

rolled paper work (in furniture), EA/ ①.

rolled paperwork, C-5170/*11*①; LAR83/*53*①.

rolled rim, IDPF/*195.*

roller, C-2569/*82*①; C-5127/*169*; DATT; LP.

roller-beam loom, OC/*18*①.

roller mill, DATT.

roller pinion, CEA/*244*①.

roll gauge, S-4881/*58*①.

rolling, C-2904/*48.*

rolling ball clock, EA/*ball clock, ball clock.*

rolling clock, EA/*inclined-plane clock.*

rolling ornamental stone, RTA/*22*①.

rolling up, DATT.

Rollos, Philip, S-4922/*18*①.

Rollos, Philip the Younger, EA.

roll-over, S-4972/*589.*

rollover, S-4972/*519.*

rollover arm, SDF.

rollover armrest, S-4507/*53*①.

rollover top rail, S-4955/*93*①.

rolltop, S-4972/*572*①.

roll-top desk, DADA; EA/①; LAR83/*330*①; NYTBA/*61*①.

roll top desk, SDF.

rolltop desk, C-5127/*359*①; K-710/ *118.*

Rolwagen, IDC.

roly poly, K-711/*130.*

roman, DATT; CEA/*509.*

Roman art, DATT/①.

Roman cartibulum, CEA/*371*①.

roman chapter, C-5117/*389*①; C-0225/*147*①; C-0254/*180*; C-0270/*118.*

Roman Charity, CEA/*159*①.

Roman Charity, the, IDC/①.

Roman column capital, C-2409/*120.*

Roman curule, CEA/*401*①.

Romanesque, DADA/①; DATT; LP; S-4972/*2*①.

Romanesque border, IDC.

Romanesque church, MP/*204.*

Romanesque style, CEA/*367*①.

Roman furniture, DADA.

Roman glass, CEA/*415.*

Romanic shape, EG/*35*①.

Romanist, DATT.

Roman lamp form, S-4922/*81*①.

Roman linen, DATT.

Roman mortaria, IDPF/*163*①.

Roman notation clock, DADA.

Roman numeral, C-2486/*88*①.

Romano, Giulio, EA.

Romano-British, IDPF/*30.*

Romano-British pewterware, CEA/ *582*①.

Roman ochre, DATT.

Roman painting, LP.

Roman pearl, EA/*beads and marbles.*

Roman period, S-4807/*457.*

Roman pottery, IDC.

Roman rosette, OPGAC/*234.*

Roman sepia, DATT.

Roman spindle, SDF/①.

Roman spindle-back, EA.

roman striking, ACD; EA.

Roman-style, NYTBA/69.

romantic historicism, C-2478/125①.

romanticism, DATT/①; LP.

romantic manner, S-4972/106.

Romantic period, CEA/513.

romantic scene, C-2403/65.

Roman white, DATT.

Roman work, DADA.

romayne carving, SDF.

romayne work, ACD; DADA/①; EA/①.

Rombrich, J. C., CEA/176①.

Rombrich, Johann Christoph, EA.

Rome Porcelain factory, EA.

römer, ACD; EA/①; EG/97①.

Romer, Emick, C-2487/92; CEA/654①.

Rome tapestry, DADA.

Romilly, C-5117/479①.

ronas, OC/25, 286.

rondache, DADA.

Rondé, Claude-Dominique, C-5220/56①.

Rondé, Laurent, C-5220/56①.

ronde bosse, RGS/182.

rondel, DATT.

rondelle, DATT; S-4414/140①.

Rongé, J. B., Fils, Liège, C-2503/213①.

Ronson, C-5239/110.

Röntgen, David, DADA.

Rood, Mary, EA/351①.

roof, C-5117/342①; C-5236/851.

roof-shaped, C-0225/335.

roof tile, C-2458/59; C-5127/92①; C-5236/479; IDC; IDPF/195.

Rooker, Richard, London, C-2489/83.

rook rifle, C-2476/8.

Rookwood, C-2409/133; C-5239/1; CEA/165.

Rookwood (mark), EC1/84①.

Rookwood, K-711/124; K-802/22; LAR82/170①; LAR83/148①; OPGAC/16, 344; S-3311/869①.

Rookwood pottery, DADA/Supplement; IDC; CEA/168①; EC1/73①; NYTBA/153①.

Rookwood Pottery, Cincinnati, Ohio, EC1/85.

Rookwood standard glaze, S-3311/870①.

Rookwood vellum glaze, S-3311/871.

room garden, SDF.

Roosevelt, Nicholas, CEA/672①.

rooster, C-5174/263.

root amber, S-4810/69①.

root carving, C-5127/205.

root-like foot, C-5167/185①.

root pattern, C-2493/17; IDC/①.

root-pot, IDC.

root-wood, C-1082/135.

rootwood, C-2513/41; LAR82/82①.

rope-and-ring handle, S-4992/39①.

rope band, S-4461/310.

rope bed, K-802/22.

rope-carved, C-0982/118; C-2402/50.

rope-carved colonnette, S-4461/598.

rope-carving, S-4881/88①.

rope curtain pattern (in Korean ceramics), EA.

rope curtain pattern, IDC.

roped comb, S-4972/166①.

'rope' design, OC/259.

rope-form rim, S-4804/17①.

rope handle, C-0270/116①; IDC.

'rope-loop' effect, OC/45①.

rope-loop effect, OC/289.

rope-loop ribbon, OC/303.

rope molded, C-0225/358.

rope-molded edging, C-5114/344①.

rope-moulded, C-5116/64①.

rope moulding, EA.

rope-pattern, C-2403/9; C-2421/116①; C-2458/151①.

rope pattern, C-5156/362; LAR82/98①.

rope pattern chain, C-5117/472①.

rope stitch, DADA.

rope-turned, C-2402/157; S-4461/600.

rope-twist, C-2202/15; C-2357/31①; C-5116/118; CEA/362①; S-3312/1285①.

rope twist, C-0706/225; C-1502/54; LAR82/97①.

ropetwist, C-5117/269①, 341.

rope twist back, LAR82/303①.

rope twist border, S-4461/70, 186.

ropetwist border, S-2882/1385①.

rope twist design, C-5114/122.

rope-twist edge, C-5114/131; S-4972/151①.

rope-twist handle, C-2414/4①; C-5156/427; LAR83/89①.

rope twist handle, C-2458/26.

ropetwist molded border, S-2882/1252.

ropetwist pattern, C-2493/158.

ropetwist stem, C-5117/196.

ropetwist swing handle, C-5117/14.

rope-twist toprail, LAR83/290①.

rope-work, CEA/515①.

ropework, C-2904/272; C-5114/391①; CEA/641①.

ropework swag, S-4922/26①.

Rops, Felicien, S-286/70, 463.

Rörstrand, C-2409/144; CEA/149①; DADA; EA/①.

Rörstrand Factory, Sweden, JIWA/92.

rosa, C-5239/304.

rosace, S-4972/330①.

Rosalie pattern, S-3311/216①; C-5189/265①.

Rosanjin, Kitaoji, DADA/Supplement.

rosary, DSSA.

Roscoe, Robert, C-5117/450.

rose, CEA/556; DSSA.

rose (openwork ornament), EA.

Rose, Amberley, Birmingham, C-2503/93.

Rose, John, ACD; C-2493/139; CEA/199①; EA.

Rose, The (De Roos), EA.

roseaker, DATT.

rose amber, EC1/56; CEA/472①; NYTBA/302.

Rose Amberina, CEA/472①.

rose and crown, EA.

rose and nightingale, OC/120.

rose and ribbon, SDF.

rose and vegetable-form finial, S-4804/156①.

Roseberry, S-4843/259①.

Rose Bijar, OC/309.

rose border, C-0254/307.

rose bowl, C-0103/3; C-0706/175; LAR83/540①.

rosebowl, LAR82/557①.

rose-box, IDC.

rose branch, S-4881/86①.

rose campan, DADA.

Rose Canton, EC2/29①.

rose carthame, DATT.

rose-colored, EC2/20①.

rose-cut, C-5005/207①, 215①; CEA/510; RTA/94; S-291/6.

rose cut, EA; RTA/104①.

rose-cut diamond, C-5117/353①, 478①; S-291/48①, 89①, 117①, 148①; S-4414/25①, 54.

rose-cutting, CEA/524.

rose-diamond, LAR82/496①; LAR83/455①.

rose diamond, RGS/145①; S-4927/36①.

rose du barry, ACD; EA/rose Pompadour; IDC.

rose-engine, EA; RGS/*40.*

rose-engine turned, IDC/①.

rose famille, DATT.

rose finial, RGS/*31*①.

rose florette, S-4905/*72.*

rose glass, DADA; S-4414/*205*①.

rose gold, C-5117/*408*①.

rose-in-snow, OPGAC/*234*①.

Rose in Snow, CEA/*472*①.

rosejar, C-0225/*23*①.

rose madder, DATT.

rose maling, ACD.

rose marbré, IDC.

rosemary, oil of, DATT.

rose medallion, DADA/*Supplement*; EC2/*20.*

rose medallion pattern, NYTBA/*166*; S-4461/*425.*

rose medallion vase, C-5127/*118.*

Rosemont, OPGAC/*346.*

rose motif, OC/*203.*

Rosen, Yakov, C-5117/*349*①.

Rosenberg, LAR83/*149*①.

Rosenberg, Carl Christian (Charles), EA/①.

Rosenstiehl's green, DATT.

Rosenthal, C-0249/*220*; OPGAC/ *354*; S-4804/*507.*

Rosenthal china, NYTBA/*176.*

Rosenthal und Maeder, C-5167/*36*①.

'Rose of the Salores' gul, S-288/*17*①.

rose palette, EC2/*20*①.

Rose pattern, C-0254/*218.*

rose-pink, IDC.

rose pink, DATT.

rose pink tourmaline, S-4810/*161*①.

rose point de Venise, DADA.

rose pompadour, ACD; DADA.

rose Pompadour (ground colour), EA/①.

rose Pompadour, IDC; NYTBA/*172.*

rose pompadour ground, S-2882/ *759*①, *821*①.

'Rose Pompadour' ground, S-4804/ *304.*

rose quartz, C-2458/*303*; C-5127/ *316*; C-5236/*327*; DADA; K-711/ *125.*

rose-red, C-2403/*214.*

rosespray finial, S-2882/*1190.*

rose spray pattern, C-5005/*222*①.

rose sprig, OPGAC/*234.*

Roset, Fanny, C-2910/*139.*

rosetta wood, DADA.

rosette, C-0982/*230*; C-2402/*91*; C-5114/*336*①; C-5116/*27, 129*①; C-5153/*152*①; C-5239/*46*; CEA/ *91*①; DADA; FFDAB/*59*①; IDC; OPGAC/*235*; RTA/*36*①; S-4414/ *329*①; S-4461/*270*; SDF.

rosette-and-anthemion, C-2388/*24.*

rosette border, OC/*46*①.

rosette-carved, S-4972/*446.*

rosette center, S-4414/*261.*

rosette decoration, RGS/*62*①.

rosette guard border, C-0279/*28*①.

rosette tablet, FFDAB/*25*①.

Rose Valley Pottery, Rose Valley, Pennsylvania, EC1/*85.*

rose-verte, C-2513/*131*①.

Roseville, EC1/*87*①; K-711/*124*; OPGAC/*345.*

Roseville, Imperial II, C-5191/*2.*

Roseville Pottery, Zanesville, Ohio, EC1/*85.*

rosewater basin, CEA/*623*①.

rose-water bottle, IDC/*rose-water bowl.*

rose-water bowl, IDC.

rose-water ewer, IDC/*rose-water bowl.*

rosewater ewer and basin (dish), EA.

rosewater ewer and dish, DADA.

rose-water sprinkler, EA/*almorrata*; IDC.

rouge végétal, DATT.

rough, C-5156/5.

roughage, K-711/123.

roughcast, DATT.

rough-cut, IDPF/183.

roughhew, DATT.

Rouillet, CEA/685.

Rouillet and Descamps, CEA/696①.

rouleau, C-0782/227; C-5156/110①; C-5236/488①.

rouleau vase, C-5127/85①; IDC/①; IDPF/196; C-2458/90①; S-3312/1352.

rouleaux, C-2501/22.

roulette, C-0249/32; DATT/①.

Rouli, C-2409/175.

round, LP/① brushes.

Round, J., C-0706/76.

roundabout chair, ACD; DADA; EA/corner chair, corner chair; SDF/①.

roundal-pierced, C-1502/122.

round arch, NYTBA/135.

round back chair, SDF/①.

round base, S-4461/9.

round-based, IDPF/60①.

round-bellied salt, CEA/657①.

round carpet, S-4965/108①.

round cartouche, RGS/79①.

round cylinder, S-4972/234.

rounded, C-5236/342.

rounded-bar, C-2476/16.

rounded base, S-4922/13①.

rounded body, C-5156/9①.

rounded corner, C-5116/11.

rounded form, IDPF/29①.

rounded funnel bowl, LAR83/428①.

rounded lip, IDPF/151①.

rounded rectangular, C-2421/140①; C-5114/215①.

rounded rectangular box, C-1082/96.

rounded rectangular lid, C-2478/116①.

rounded rectangular top, C-0249/452①; C-2357/69①.

rounded relief, C-5156/318, 365; S-4965/137①.

rounded sleeve group, C-5156/306①.

rounded spindle, S-4965/68①.

rounded square, C-2458/335①.

rounded square back, C-5005/345.

rounded square base, S-4461/65.

rounded terminal, S-2882/945.

roundel, ACD; C-0782/91; C-1407/10; C-2202/52; C-2323/16; C-2458/18, 51①; C-5116/79①, 161①; C-5127/66, 143①; C-5156/37①; CEA/113①; DADA; EG/33; IDC; LAR83/419①; OC/270①; S-4461/226, 422; SDF/①.

roundel border, C-2388/169.

round foot, S-4461/522.

round funnel bowl, CEA/423①.

Round game, the, IDC.

Round Gothic, CEA/246①.

roundly molded, C-5156/24.

rounds, C-5146/92B①.

Rouquet, Jean, André, EA.

Rouse, James, EA.

Rouse & Turner, EA/American Pottery Company.

Rousseau, David, C-2368/212①.

Rousseau, Eugène, DADA/Supplement.

Roussel, Pierre, C-2364/48①; EA; S-4955/88①, 164.

Roussel, Theodore, S-286/82.

Roussel, Xer-Xavier, S-286/471A①.

rout chair, SDF.

rout furniture, EA.

Roux, Alexander, C-5189/260; NYTBA/74①; S-4947/111①, 243①.

rowel, C-2503/77; C-5117/92①; RTA/55①.

rowell, SDF/roelle.

Rowley, John, CEA/603①.

royal Worcester, S-2882/716①;
C-1006/1; C-2409/134; C-2493/
173①; LAR83/174①; EA/
Worcester.

Royal Worcester porcelain, S-3311/
344.

Roycrafter, NYTBA/81.

Roycroft, C-5191/286; C-5239/89;
K-710/114.

Roysher, Hudson, DADA/
Supplement.

Rozanne, OPGAC/345.

Rozenberg, NYTBA/182①.

Rozenburg, C-2910/116; C-5005/315.

Rozenburg Pottery Company,
DADA/Supplement.

Rozenburg ware, NYTBA/182.

RR, EA/Sèvres.

RS, CEA/643①.

R. Spofforth Sculp, CEA/608①.

R.S. Prussia wreath mark, K-802/23.

rubans, à, IDC.

Rubati, Pasquale, EA.

rubbed, C-0249/8; C-5117/24;
C-5127/32.

rubber, CEA/684.

rubber-backed, OC/33.

rubber cement, DATT.

rubber mold, DATT.

rubbing, C-5127/175; DATT; LP.

rubbing block, DATT.

rubbing brick, DATT.

rubbing from a stone, JIWA/71①.

rubelle, C-5259/49.

rubena verde, OPGAC/173.

Rubénisme, DATT.

Rubens, Peter Paul, EA.

Rubens brown, DATT.

Rubens madder, DATT.

Rubina Verde, CEA/474①.

rub-out, DATT.

ruby, C-2398/7; C-5005/218①; EC1/
55①; S-288/8①.

ruby-back, S-4965/297①.

ruby-back porcelain, IDC.

ruby back porcelain, DADA.

ruby-cameo portrait-bust, RTA/112①.

ruby-cut-to-clear-glass, S-4804/669①,
675.

ruby flashed, EG/102①.

ruby glass, DADA; EG/102①;
S-2882/854; S-3311/387①;
S-4972/429; S-4992/1①.

ruby ground, C-5127/424.

ruby intaglio, RTA/69①.

ruby-lustre, C-2910/115.

ruby lustre, C-2324/20; IDC.

ruby matrix, S-4810/113①.

ruby-stained, EG/109①.

ruby tinted, S-4461/28.

ruby-tinted glass, C-2403/1.

ruched corner, C-5127/357.

ruched sleeve, C-3011/4.

ruching, C-3011/8; SDF.

Ruckers family, EA.

Ruckert, Feodor, C-5174/238.

Ruckert, Feodor (workmaster),
C-5174/297①.

Rückert, Theodore, NYTBA/232①.

Rudall, Rose & Carte, CEA/554①.

Rudall Carte and Co., C-0906/380.

Rudaux, S-286/70.

Rudbar, OC/94①.

rudder, DSSA/①.

rudder (in furniture), EA.

rudder, SDF.

rudder table, DADA.

ruddle, DATT.

rudd table, SDF/①.

Rude, François, EA.

rudimentary stem, CEA/423①.

Rudolstadt, K-711/130.

Rue Amelot, DADA.

Rue de Bondy, DADA/①; EA/Paris
porcelain.

Rue de Crussol, DADA.

Rue de la Roquette, DADA.

Rue du Temple, DADA.

Rue Fontaine-au-Roy, DADA.

Ruegger, C-2489/*232*.

Ruempol, Hendrik, Laren, C-MARS/ *239*①.

Ruempolklok, C-MARS/*239*①.

Rue Popincourt, DADA; EA/*Paris porcelain*.

Ruesnen, Francisus, Toledo, C-MARS/*19*.

Rue Thiroux, DADA; EA/*Paris porcelain*.

ruffle, SDF.

ruffled border, C-5114/*39*①.

ruffled brim, C-0225/*21A*.

ruffled brim neck, C-0225/*276*.

ruffled cane, CEA/*496*①.

ruffled foot, C-5239/*172*; S-3311/ *902*①.

ruffled lower rim, S-2882/*1381*.

ruffled rim, IDPF/*196*; LAR83/ *449*①; S-2882/*1336, 1351*①, *1365, 1394*①; S-4414/*236*①; S-4461/*27*.

ruffled shell, C-5114/*364*①.

rug, C-0906/*34*; C-2478; C-5156/*472*; C-5239/*258*; OC/*29*; S-4804/*976*; SDF.

Rugendas, Nicolaus III, Augsburg, S-4927/*221*①.

Rugg, Richard, C-0406/*116*; C-5117/ *226*; C-5173/*23*①; C-5174/*548*①; S-4944/*284*.

Ruhlmann, E. J., C-5005/*330*①; NYTBA/*80*①.

Ruhlmann, Jacques, DADA/ *Supplement*.

rule, C-0706/*64*; C-2904/*48*.

rule joint, SDF.

ruler, C-5236/*398*; DSSA.

ruling pen, DATT/①.

Rumanian 'antique Turkish prayer rug', OC/*132*.

Rumanian carpet, EA.

rumbler, EA.

rumble seat, DADA.

rum flask, S-4881/*102*①.

Rumford, Count, DADA/*Supplement*.

rum kettle, IDC.

Rum label, C-0103/*72*.

rummer, ACD; DADA; EA; EG/ *145*; LAR83/*429*①.

rummer-like goblet, EG/*108*.

run, DATT.

Rundell, Bridge and Rundell, C-5173/ *18*①.

Rundell, Bridge & Rundell, EA.

Rundell, Philip, CEA/*661*①; EA; S-4922/*24*①.

Rundell, Phillip, C-5117/*124*①.

Rundell & Bridge, CEA/*660*①.

Rundell Bridge & Rundell, CEA/ *661*①.

run glaze, IDPF/*168*.

runner, ACD; C-0906/*25*; C-2478/ *237*; C-2482/*26*; C-2704/*168*; C-5156/*471A*; C-5189/*255A*; CEA/*541*; DADA; DATT.

runner (in furniture), EA.

runner, IDC; OC/*48*①; S-4796/*31*; S-4804/*960*; SDF.

runner foot, DADA/①.

running dog, JIWA/*135*; S-4948/*6*.

running-dog border, C-2388/*170*.

'running dog' border, C-5323/*105*①.

running dog border, S-4847/*31*.

running dog guard border, S-4948/*23*.

running dog motif, EA.

running dog pattern, C-5189/*403*.

running-dog stripe, C-2320/*146*; C-2478/*228*.

running feather pattern, CEA/*292*①.

running fleck, JIWA/*383*①.

running frieze, LAR83/*321*①.

running glaze, JIWA/*349*①.

running putto shaft, C-2403/*9*.

running ribbon and foliage, S-4804/ 70①.

running scroll, C-0982/230; SDF.

running scroll border, C-5117/148①.

running sideboard, SDF/①.

running stitch, DADA.

running-wolf mark, C-MARS/33①.

run slip, IDPF/224.

run work, DADA.

rural chair, SDF/①.

Rural Lovers, the, IDC.

Ruscha, Ed, S-286/472.

rush, S-4972/578.

rush-atef crown, S-4973/114①.

rush-bottom chair, FFDAB/30①.

rush-bottomed, CEA/349①.

rushed seat, S-4414/452①.

Rusher, Charles H., C-5117/452①.

rush light, S-4905/345.

rushlight, C-2498/13; CEA/532①.

rushlight holder, EA/①.

rush seat, C-0249/412; C-0279/342; C-2403/67; C-5114/280, 289, 383①; C-5153/94①; DADA; FFDAB/30; LAR82/295①; S-4461/737; S-4905/326.

rush seat dining chair, S-3311/206①.

rush seating, SDF.

Ruskin, C-2409/66; C-2910/95; LAR82/171①; LAR83/151①.

Ruskin, John, DADA/Supplement.

Russ, W., C-5191/48.

Russell, Gordon, C-2409/241.

Russell, John, S-4905/319.

Russell, Richard Drew, SDF/761.

Russell, Sir Gordon, DADA/ Supplement.

Russell, Sir (Sydney) Gordon, SDF/ 761.

russet, C-5127/20, 289①; C-5146/62; C-5236/331①.

russet board, C-5146/74①.

Russia leather, C-0279/329; SDF.

Russian Beshir, OC/192.

Russian Bokhara, OC/179①.

Russian cloisonné, RGS/40.

Russian cross, RGS/123①.

Russian eagle, LAR82/91①.

Russian glass, EA/①.

Russian gold and silver, EA.

Russian historicism, RGS/35.

Russian Imperial tapestry works, DADA.

Russian Kazak, OC/210.

Russian Kizil Ayak, OC/188①.

Russian national style, RGS/201.

Russian niello ware, RGS/184.

Russian pattern, NYTBA/307.

Russian porcelain, EA.

Russian sable, DATT.

Russian skan technique, CEA/519①.

Russian snuff-box, EA/①.

Russian tapestry, EA.

Russinger, Laurentius, CEA/175①, 186①; EA; MP/165.

rust, DATT.

rusticated angle, C-2478/85; C-2498/ 140.

rusticated plinth, S-4812/26.

rustic figure, C-2398/24①.

rustic furniture, EA/①; SDF/①.

rustic group, C-2493/291①.

rustic handle, IDC; LAR83/576①.

Rustic Seasons, the, IDC/①.

rustic setting, C-5174/504①.

rustic style, C-5114/254①.

rustic table, C-0982/7.

rustique, DADA/①.

rust red, S-288/8①, 11①.

rustred, DADA.

rutile, C-2458/386; DATT.

rutile needle, S-4810/144①.

ruyao, S-4965/263①.

ruyi, C-0279/*146*①; C-2458/*70, 75*;
C-5127/*47*; C-5156/*94*; LAR82/
*63*①; S-4461/*426.*

ruyi border, S-4461/*393.*

ruyi-head, S-4843/*47*①, *74*①;
S-4905/*10*①.

ruyi head, C-2323/*57*①.

ruyi sceptre, C-5236/*337*; S-4810/
*528*①.

ruyi-shaped, S-4810/*276*①.

R.V.L.C., CEA/*381*①; EA/
Vandercruse-Lacroix, Roger.

RW, EA/*Wood, Ralph.*

Ryan & Watson, Birmingham,
C-2503/*132.*

Rychnov, CEA/*454*①.

Rye bottle, S-4461/*165.*

Ryosai, CEA/*569*①.

ryton, LAR82/*473*①.

ryu, IDC.

Ryukyu Islands, C-2458/*283*①.

ryusa, CEA/*562, 575.*

S

S, EA/*Sèvres, Samson, Edmé, et Cie, Shorthose, John.*

SA, EΛ/*Rato.*

Saarinen, Eero, DADA/*Supplement.*

Sabatier, LAR83/*33*①.

sabaton, DADA.

Sabbatai ring, RTA/*133*①.

Sabbath lamp, C-5174/*134*①; LAR82/*50*①.

saber, DADA.

saber-bladed, S-4461/*231*.

saber leg, C-0279/*271*; DADA/①; S-4414/*443*①, *489*.

sabicu, C-2498/*157*; SDF.

sabicu wood, DADA.

sabiji, CEA/*562, 575*.

Sabino, C-2910/*21*; C-5167/*202*.

sable, LP/*brushes.*

sable brush, DATT.

sabot, C-0982/*67*; C-1407/*61*; C-2364/*46*①; C-2402/*127A*; C-5005/*330*①; C-5189/*290*①; C-5259/*558*①; DADA; S-3311/*395*①; S-4992/*108*①.

sabre, C-5174/*210*; C-5259/*513*①; CEA/*43*①.

sabre leg, C-0982/*106, 118*; C-1407/*49, 134*; C-2357/*67*①; C-2402/*40, 89*; C-2403/*79*; C-2421/*60*; C-2478/*40*; C-5114/*265*①, *284*①, *298*①, *370*①; C-5116/*64*①, *95*; C-5153/*142*①, *171*①; C-5189/*273*①; EA; LAR83/*270*①; S-2882/*356*; S-4414/*522*①; S-4436/*155*①; S-4507/*63*①; S-4812/*172*①, *183*①; SDF/①.

sabre-leg base, C-5114/*35*①.

sabreleg chair, FFDAB/*29*.

sabre-shaped, C-2513/*43*.

sabre-shaped foot, C-2414/*11*①.

Sabrina Ware, C-2409/*134*.

Sabrinian, OPGAC/*346*.

Saburdin, Igor D., C-5174/*147*① *assaymaster.*

Sabzevar, OC/*317*①.

saccharoidal, DATT.

saccharometer, C-2904/*241*.

Sachlichkeit, DADA/*Supplement.*

sack-back, C-5153/*100*.

sack back, C-3011/*87*①; SDF.

sack-backed, C-1506/*80*①.

sack-back Windsor, EA.

sack barrow, C-0406/*112*.

sack-bottle, IDC.

sackcloth, C-1082/*11*.

sack glass, DADA.

sacra conversazione, DATT/①.

sacred pearl, C-2414/*67*①; IDC/①.

sacred sculpture, MP/*77*.

sacrificial cup (in Chinese ceramics), EA.

sacrificial red, IDC.

sacring bell, DADA.

sacristy cupboard, DADA.

Sadang-ni kiln, EA.

Saddier, C-5239/*288*①.

saddle back, SDF.

saddle back jades, S-291/*90*①.

saddle bag, C-0906/*12*; DADA.

saddle cheek, SDF/①.

saddle-cheek chair, DADA.

saddle cover, C-2482/*51*; DADA.

saddle ring, S-291/*24*①, *90*①.

saddle-seat, CEA/*342*①.

saddle seat, C-0279/*339*①; C-1407/*115*; C-5114/*381*①; C-5157/*167*①; CEA/*406*; DADA; EA; S-2882/*334, 340*; S-3311/*250*; S-4461/*596*; SDF.

saddle-shaped, C-5157/*46*.

saddle stool, SDF.

saddle top rail, C-5116/*71*.

sad iron, EA/*flat-iron*.

sad-iron, EA/*flat-iron*.

sad lady, C-2704/*34*.

Sadler, John, EA.

Sadler and Green, CEA/*195*①.

Sadler & Green, ACD.

sad ware, ACD.

sadware, CEA/*594*; DADA; EA.

Safavid, LAR82/*253*①.

safe, SDF.

safe-slide, C-2476/*7*.

safety-catch, C-2569/*82*①.

safety catch, CEA/*31*①.

safety chain, C-2486/*138*.

safety pinion, S-4802/*6*.

saffer-pot, IDC.

safflor, DATT.

safflower oil, DATT; LP.

safflower pigment, DATT.

saffron, DATT; S-288/*20*①; S-4847/*3*①, *52, 189*.

saffron border, S-4847/*32*.

saffron coral, S-288/*3*①.

saffron-pot, IDC.

Saffron Waldon mazer, C-5173.

sage color, C-5156/*47*①.

sage-green, C-2502/*15*.

sage green, C-5156/*51*①.

sage green clay, LAR83/*148*①.

sagemono, C-1082; CEA/*561*.

sagemono ensemble, S-4928/*156*①.

saggar, DATT.

sagger, DATT; IDC/①; MP/*502*.

sagger clay, MP/*28*.

sagger pin, IDC.

sagging, DATT; IDC.

Sagittarius, DSSA.

Saiko Kutani, IDC.

sail, DSSA.

sailors box, S-4905/*337*.

sailor-scrimshander, CHGH/*63*.

sailor's model, S-4881/*143*①.

saint, C-2427/*238*①.

Saint, Daniel, EA.

Saint-Amand-les-Eaux, DADA.

Saint-Amand-les-Eaux faience factory, EA/*de Bettignies, Maximilien-Joseph and Henri*, .

Saint Anne marble, DADA; DATT.

Saint Anthony cow-creamer, IDC.

Saint-Clément, DADA; EA.

Saint-Cloud, CEA/*182*①; DADA/①.

Saint Cloud, ACD; CEA/*169*.

Saint-Cloud cup, IDC.

Saint-Cloud Faience, EA/①.

Saintes, EA.

Saint Francis, C-0225/*170*.

Saint George and the Dragon, IDC/ ①.

Saint-Georges, Étienne, stamp: St GEORGE, C-5224/*155*①.

Saint-Hilaire, Jaume, Paris, MP/ *488*①.

Saint-Jean-du-Désert, DADA; EA/ *Clérissy, Joseph, Marseille.*

Saint Louis, CEA/*489*.

Saint Louis fruit, CEA/*500*①.

Saint Louis glass, EA/*Cristallerie de St Louis.*

Saint Louis panelled jasper, CEA/ *495*①.

Saint Louis shotcup, CEA/*501*①.

Saint Mihiel lace, DADA.

Saintonge, DADA.

Saint Petersburg, ACD.

Saint-Porchaire, DADA.

Saint-Porchaire earthenware (Henri II ware), EA.

Saint-Porchaire ware, IDC/①.

Saint-Yrieix, EA/*Limoges.*

Saishi, CEA/*567*①.

sakazuki, C-0282/*160*.

sake-bottle, C-2427/*143*①.

sake bottle, C-5127/*379*; C-5156/ *802*; C-5236/*834*.

saké bottle, IDC.

sake cup, S-4461/*411*.

sake plate, S-4461/*410*.

saki, C-2204/*163**.

saki bottle, IDPF/*197*①.

saku, CEA/*575*.

Sala, Domin., London, C-2489/*40*.

salade, DADA.

salad fork, C-5114/*16*; C-5153/*7*; S-4804/*5, 64, 65.*

salad-plate, IDC.

salad-server, C-5117/*34*.

salad server, S-4922/*34*①.

salad set, C-0254/*206, 221*; C-5005/ *231*①; C-5203/*227*.

salad spoon, C-0706/*194*; C-1502/*81*; C-5114/*18*.

salamander, DSSA; EA; LAR82/ *298*①; SDF.

salamander back, DADA.

Salamandre, LAR83/*469*①.

Salem, Massachusetts, CEA/*459*.

Salem rocker, EA.

Salem secretary, DADA/①.

Salem secretary (desk), EA/①.

saler, CEA/*594*; EA/*salt.*

Salian art, DATT.

saliera, IDC.

salière, IDC.

S.A.L.I.R., DADA/*Supplement.*

salivarium, SDF.

sallet, CEA/*21*①; DADA.

sallibube cup, IDPF/*197*.

sallow, SDF.

sally-wood, SDF.

salmon, S-288/*34*①; S-4847/*3*①.

salmon border, S-4847/*60*.

salmon-ground, S-4905/*5, 76*①.

salmon pink, C-1506/*103*①; C-2502/ *97*.

salon chair, LAR82/*297*①; LAR83/ *278*①.

Salon d'Automne, LP.

Salon des Indépendants, DATT; LP.

Salon des Refusés, DATT; LP.

salon set, S-4804/*238*①.

salon suite, C-5167/*216*①; C-5181/ *156*; LAR83/*359*①; S-4804/*785*①.

salopian, DADA; ACD; CEA/*199*①.

Salopian sprig, CEA/*199*①.

Salopian ware, IDC.

Salor, C-2546/*146*; OC/*173*①.

Salor and chuval guls, S-4948/*67*①.

salor juval, LAR82/*544*①; S-3311/ *32*①; C-2320/*149*; S-4796/*28*.

Salor rug, EA.

Salor Turkomans, OC/*192*.

salt, C-0782/*96*; EA/①; IDC;
 NYTBA/*294*; S-4972/*309A*; SDF;
 EA/*Salt, Charles, Salt, Ralph.*

Salt, Charles, EA.

salt, cylindrical standing, DADA.

salt, hourglass standing, DADA.

Salt, Ralph, EA.

salt, standing, DADA.

salt, steeple standing, DADA/①.

salt and pepper border, S-4796/*127*.

salt and pepper shakers, C-0254/*76*.

salt and pepper weave, S-4948/*60*①.

salt box, C-0279/*176*.

salt cellar, ACD; C-5239/*324*; IDPF/
 *197*①; LAR83/*599*①; MP/*160*;
 S-3311/*656, 735*①; S-4804/*18, 39*;
 S-4905/*8*①.

salt-cellar, C-0103/*35*; C-2398/*62*;
 C-5117/*5, 147*①; C-5173/*62*①;
 DADA; EA; IDC/①.

salt celler, C-0254/*4*.

salt chair, C-5174/*245*①; DADA.

salt dish, DADA; LAR83/*575*①.

salter, IDPF/*197*①.

salt-glaze, ACD; CEA/*150*; EA/①;
 IDPF/*8*.

salt glaze, DADA; DATT.

saltglaze, C-2360/*164*①; LAR82/
 *118*①; LAR83/*156*①, *595*①;
 NYTBA/*149*①, *157*①; S-4843/
 *89*①; S-4905/*144*.

salt-glazed, C-2427/*199*①.

salt glazed, S-4461/*481*.

salt-glazed kit, IDPF/*198*①.

salt-glazed stoneware, NYTBA/
 *157*①.

saltglazed ware, IDC.

salt-glaze ware, EA.

salt-glazing, CEA/*110*.

saltier, SDF/① *saltire.*

saltire, ACD; C-2414/*10*①; DATT;
 SDF/①.

saltire cross, RTA/*82*①.

saltire stretcher, DADA.

salt-kit, IDC/①.

salts, C-5114/*26*①; C-5153/*32*①;
 S-4802/*170*; S-4905/*339*①.

salt shell, C-5114/*76*.

salt shovel, C-0254/*92*; C-1502/*216*.

salt spoon, C-0254/*115*; C-5114/*16*;
 C-5153/*32*①; C-5173/*35*①;
 DADA; S-4922/*34*①.

salt-spoon, C-2398/*14*; C-5117/*29,
 38*; EA.

saltspoon key, C-5255/*6*.

salt throne, C-5174/*258*①.

Saltuq, OC/*176*①.

Saltykov, I., C-0270/*114*.

saluting gun, S-4972/*240*.

salver, C-0254/*18*; C-0270/*1*;
 C-1502/*24, 81, 94*; C-2202/*50,
 157*; C-2398/*27*; C-5114/*41, 93*①;
 C-5117/*4*; C-5153/*37*①; C-5173/
 *23*①; CEA/*666*①; DADA.

salver (waiter), EA/①.

salver, LAR82/*632*①; LAR83/*630*①;
 S-2882/*906*; S-3311/*760, 774*①;
 S-4804/*138*; S-4905/*192*①;
 S-4922/*32*①, *49*①.

salver top, C-5116/*52*; C-5157/*58*.

Salviati and Company, DADA/
 Supplement.

sama, C-5156/*790*.

Samadet, EA.

Samakand rug, LAR82/*545*①.

Saman, OC/*149*①.

Samarkand, DADA; OC/*108*①.

Samarkand rug, ACD; C-1702/*54*.

Samarkand ware, IDC.

Samarra ware, DADA.

samba, DATT.

samban-sugi, C-5236/*1833*.

Sambin, Hugues, CEA/*372*①;
 DADA/①; EA.

Sanderson, Elijah, DADA; EA.

Sanderson, R, EA/*Hull, John.*

Sanderson, Robert, CEA/*665.*

Sandersons, The, SDF/*774.*

sanderswood, DADA.

Sanderus, Lambertus, EA.

sand finish, DATT.

sand glass, SDF.

sandglass, C-2489/*21*①.

sand-glass, EA; SDF/*hour-glass.*

sand-grain ground, DATT.

sando, S-4965/*298*①.

San Domingo mahogany, SDF.

Sandoz, Edouard Marcel, C-5191/
196.

sandpaper ground, S-286/*305.*

sand-pot, CEA/*647*①.

sandstone, C-5156/*192*; C-5236/
*351*①; DATT; LAR82/*645*①;
LAR83/*647*①.

sandstone, S-3312/*1247.*

sandstone, S-4972/*343*①.

sandstone sculpture, MP/*133.*

sand toy, CEA/*697.*

Sandus, Lambertus, NYTBA/*142*①.

Sandwich, C-5114/*125*①; CEA/
*464*①, *489*; K-711/*123*; OPGAC/
174; S-4461/*169.*

sandwich bowl, CEA/*416*①.

sandwich-box, C-5173/*17*①.

Sandwich glass, CHGH/*64*; DADA/
①; S-4905/*310*①.

Sandwich pink flower, CEA/*499*①.

sandwich server, C-5114/*24*; S-4461/
276; S-4922/*34*①.

sandwich service, IDC.

sandy, C-5156/*19*①.

sandy accretion, C-5236/*859*①.

sandy patch, C-5127/*33.*

Sang, Jacob, CEA/*429*①; EA.

sang-de-boeuf, C-0803/*121, 121*;
C-2323/*115*; C-2458/*185*; CEA/
111; EA/*ox-blood glaze.*

sang-de-bœuf, IDC.

sang-de-boeuf, LAR82/*111*①;
LAR83/*141*①.

sang de boeuf, C-5127/*131*; C-5156/
68; C-5236/*1608.*

sang de bœuf, DADA.

sang de boeuf, DATT.

sang de boeuf glaze, S-2882/*1302.*

sang-de-pigeon, IDC.

sang de pigeon, DADA.

sanggam, CEA/*128*①; DATT.

Sanggam celadon, IDC.

sanghati, C-5234/*55*①, *59*①, *137*①.

sanguine, DATT; LP; S-286/*450,
268A, 447A, 471A.*

sanitary ware, IDC.

sanmai-bachi, LAR82/*38*①.

Sanmartino, Guiseppe, C-5224/*232*①.

San Michele tapestry, DADA.

San Michele workshop (Papal
workshop), EA.

Sansho vase, C-5236/*856*①.

Sansovino, Jacopo, DADA/①.

sans serif, DATT.

sans traverse, C-0279/*356*①;
C-5189/*301*①.

Santa Barbara tapestry manufactory
(Spanish Royal Tapestry
Manufactory), EA.

santa conversazione, DATT.

santa maria, SDF.

Santo Domingo mahogany, CEA/
*395*①.

san-ts'ai, C-0782/*229*; IDC.

san ts'ai, DADA.

san tsai, ACD.

san ts'ai, CEA/*111, 122*①.

san ts'ai ware (Ming fa-hua), EA/①.

Santwijk, Ph. van, CEA/*309*①.

sapan wood, DADA.

sapele, SDF.

sap green, DATT.

Saruq Mir, OC/56.

Saruq version, OC/44①.

Saryk gul, S-4796/82.

Saryk juval, S-4948/67①; C-5323/35①.

Saryk Torba, S-3311/28.

sash, C-1082/7; C-1506/9; C-5117/345.

sash door, SDF/①.

sashi, C-5156/689①; CEA/575; LAR83/457①.

sashimono, IDPF/206.

sashi netsuke, CEA/562.

Sasiya (Japanese lacquer craftsman), C-5170/179.

Sassanian, CEA/114①.

Sassonia, alla, IDC.

Satan, DSSA.

sateen frill, C-2704/56.

satin, C-1506/11; C-2402/117; C-3011/1; CEA/473①; DADA; OPGAC/175; S-4507/60①; SDF.

satin-birch, C-1407/133.

satinbirch, C-0982/119A.

satin boot, C-1506/71.

satin cafard, DADA.

satin damask, DADA.

satin de Bruges, DADA.

satin de Hollande, DADA.

satin-finish, S-2882/1001.

satin finish, C-5236/422①; SDF.

satin finished cotton, C-1506/3.

satin-glass, DADA.

satin glass, EC1/56, 60①; NYTBA/300.

satin mother of pearl, OPGAC/175.

satin stitch, CEA/285①; DADA.

satin-walnut, CEA/406.

satin walnut, SDF.

satin-wood, C-5114/347①.

satinwood, ACD; C-0982/10, 74; C-1407/45, 69; C-2402/110; C-2478/76; C-5116/15①, 56; CEA/303, 406; DADA; DATT; FFDAB/64; LAR82/24①; S-2882/309; S-4436/104①; S-4804/867①; S-4812/13; SDF.

satinwood band, C-2402/56.

satinwood-crossbanded, C-0982/301.

satirical embellishment, CEA/168①.

Satsuma, C-0782/1, 45; C-5156/818①; C-5236/835①, 838①; LAR83/153①; S-3312/1135①; S-4461/413.

Satsuma brocaded ware, EA.

Satsuma dish, S-3312/1120①.

Satsuma mon, S-3312/1126①.

Satsuma School, JIWA/181.

Satsuma style, C-5156/802.

satsuma vase, C-5127/408①; LAR82/173①.

Satsuma ware, ACD; C-0782/194; DADA/①; IDC; JIWA/324.

saturation, DATT; LP.

Saturday Evening Girls, Paul Revere (mark), EC1/84①.

Saturn, DSSA.

saturnine red, DATT.

satyr, CEA/135①; DADA; DSSA.

'satyr and mask' settee, LAR83/344①.

satyr mask, C-2364/42①; C-2421/27①; SDF.

satyr mask spout, S-4804/111①.

satyr mug, IDC/①.

satyrs, C-1702/318.

satyr's mask, C-5224/118①; CEA/655①.

satyr's mask border, C-0254/109A①.

sauce, DATT; CEA/56①.

sauce boat, C-0254/10, 101; C-0782/35; C-1502/51, 111, 137; DADA/①; S-3311/654①; S-4922/61①, 86①.

sauceboat, C-5114/33①; C-5117/227; C-5153/46①; C-5236/1779; LAR82/607①; LAR83/602①;

MP/*106*; NYTBA/*149*; S-4804/*93*; S-4922/*56*①.

sauce-boat, C-2427/*34*①; CEA/ *190*①, *629*①; EA/①; IDC/①; JIWA/*315*; S-4461/*104*.

sauce label, C-0406/*92*.

sauce ladle, C-1502/*62*; C-5114/ *21*①; C-5153/*30*; S-4804/*28, 35, 81*①; S-4905/*200*.

sauce-ladle, C-2398/*14*; C-5117/*37, 63*.

sauce pan, C-0254/*182*; S-4461/*208*.

saucepan, C-5117/*69*①; DADA; EA/ ①; S-4905/*185*.

sauce pot, IDPF/*199*.

sauce pour, C-0254/*191*.

saucer, C-0254/*210*; C-0706/*126A*; C-0782/*7, 117*; C-2493/*259*; C-5114/*160*①; C-5156/*44*①; C-5174/*239*①; DADA; EC2/*25*①; IDC; IDPF/*68*①, *199*①; S-4461/ *101*; S-4992/*17*①.

saucer base, S-4461/*10, 51*; S-4905/ *348*.

saucer-dish, C-2458/*38, 89*①, *205*.

saucer-dish (in Chinese ceramics), EA.

saucer-dish (in silver), EA/*strawberry dish*.

saucer-dish, IDC.

saucer dish, C-2427/*15*①; C-5127/ *27*; C-5236/*434*①, *517*.

saucer edge, SDF.

saucer well, C-5157/*151*①.

sauce spoon, C-5174/*304*.

sauce-tureen, C-5117/*150*①; IDC.

sauce tureen, C-1006/*168*; C-5174/ *538*①; EA/①; LAR83/*635*①; S-3311/*763*①; S-4922/*6*①, *27*①.

sauce-tureen and cover, C-5117/*44*①, *124*①.

saucière, IDC.

saunders blue, DATT.

Saunier, Claude-Charles, C-2555/ *49*①; S-4955/*197*①.

Saunier, Claude Charles, EA.

Saunier, Claude-Charles, stamp: C C SAUNIER, C-5224/*203*①.

Saunier, Jean-Charles, C-2364/*56*.

Saunier, Jean-Jacques, DADA.

saupoudrière, IDC.

sausage shape, NYTBA/*33*①.

sausage-turned, S-4905/*442*.

sauterelle, C-0225/*188*①.

sautoir, S-4414/*9*; S-4927/*349*①.

Sauvage, Charles-Gabriel, EA.

Savage, George and Son, C-5117/ *199A*①.

Sava Islamic pottery, EA.

Savalan rug, DADA.

Savalyev, Stephan, C-5174/*231*.

save-all, SDF.

saveall, CEA/*437*①.

Saveh, OC/*287*.

Savery, Jacob (Xavery), C-5220/ *38*①.

Savery, William, CEA/*396*①; DADA; EA; SDF/*774*.

Savinkov, Victor (assaymaster), C-5174/*216, 243*.

Savoie, DADA.

Savona, C-2427/*203*; C-2486/*213*①; DADA.

Savona Maiolica, EA.

savonarola, C-0249/*474*; C-0279/*324*; NYTBA/*24*①.

Savonarola chair, DADA.

Savonarolla, C-5181/*195*.

Savona style, CEA/*135*①.

savonette, EA.

savonnerie, CEA/*96, 75, 97*①; EA/ *299*①; NYTBA/*112*①; OC/*312*.

Savonnerie carpet, ACD; DADA.

Savonnerie style carpet, C-1702/*75*; S-3311/*77*①.

savonnette, boîte à, DADA.

Savory, Adey and Joseph, S-4944/ 266.

Savoy Glass House, EA.

Savy, Honoré, CEA/147①.

saw, DSSA.

Sawankalok celadon, EA.

Sawankhalok ware, IDC.

sawbuck frame, SDF.

sawbuck table, EA/①.

sawcer, CEA/640①.

Sawcer dish, CEA/640①.

sawed, CHGH/57.

saw-edge border, C-5156/187①.

saw-edged border, IDC.

Sawin, John, EC2/94①.

saw-tooth, S-4847/141①.

sawtooth, C-0279/157; C-5236/384; OPGAC/235①; S-4905/139①.

sawtooth border, C-2704/67.

saw-tooth edge, S-4965/220.

sawtooth edged, S-4461/109.

sawtooth mark, CHGH/57.

sawtooth panel, C-5181/9.

Sawtooth pattern, CEA/468①.

saw-tooth rim, LAR82/444①.

sawtooth triangle, C-2704/80.

Sawyer, Richard, C-2510/52; S-4944/ 312.

Saxe, DADA; IDC.

Saxe au point, MP/502.

saxe ombré, EA.

Saxon, C-0906/324.

Saxon blue, DATT.

Saxon guild flagon, CEA/589①.

Saxon service, IDC/①; MP/183.

Saxony, MP/10.

say, SDF.

saye, SDF/say.

Sayre, John, S-3311/637①.

Sazikov, Ignati (Ignatius), C-5174/ 298.

Sazikov, Ignatiy, C-5117/329①.

Sazikov, P. I., C-5117/340.

sbiancheggiato, IDC.

SB in Cyrillic, EA/Batenin, Sergei.

SC, St. Clement, St Cᵗ, EA/Saint Clément.

scabbard, C-1082/120; C-2569/40①; C-5117/2, 313①; CEA/32①; S-4972/152①.

scagiola, C-2482/257.

scagliola, ACD; DADA; DATT; EA/ ①; S-4972/441①; SDF.

scagliola marble, S-3311/517①.

scagliola picture, S-4972/87①.

scaldavivande, IDC.

scale, DATT; DSSA; LP.

scale, architects', DATT/①.

scale, engineers', DATT/①.

scale and weight, CEA/535①.

scale-blue ground, EA.

scale carving, C-5116/174①.

scaled, DADA.

scale drawing, DATT.

scale-ground, IDC.

scale ground, C-1006/208.

scale magnifier, C-2904/253.

scale model, C-5157/3.

scale-moulded, IDC.

scale of design, NYTBA/4.

scale panel, C-2486/13.

scale-pattern, CEA/177①.

scale pattern, C-0279/224; DADA/ ①; EA.

scalewood, C-5174/597①.

scale work, C-1502/117.

scalework, C-0254/143①, 316①; C-5117/21, 85①, 189①; S-2882/ 1198①; S-4905/26①, 71①; S-4922/10①.

scaling, EA/scale pattern; LP; SDF/ ①.

scallop, SDF.

scallop dish, IDPF/199①.

scalloped, C-2421/27①; C-5116/
145①; C-5153/11①; C-5259/547;
IDC; S-3311/192①; S-4804/
128①; S-4972/164①.

scalloped band, S-2882/1119①.

scalloped base, CEA/437①.

scalloped border, C-0254/58; C-5117/
66; S-4414/182; S-4461/453.

scalloped bowl, C-0254/116.

scalloped circular form, S-2882/977.

scalloped collet, RTA/82①.

scalloped edge, C-0225/143①;
C-2437/75①; C-2704/153; CEA/
445①; S-2882/738; S-4461/86①.

scalloped foot, CEA/467①.

scallop-edge, EC2/31①.

scalloped legs, C-0249/342.

scalloped line, EC2/22①.

scalloped loop, S-2882/1359.

scalloped medallion, C-2403/155.

scalloped rail, S-2882/619①.

scalloped rim, C-0254/101; C-0706/
204; C-5005/300①; C-5114/90①,
122; C-5117/78①, 89, 263①;
C-5127/247①; S-2882/915, 942①,
1022; S-4414/363; S-4461/486.

scalloped scrollwork rim, S-2882/
926①.

scalloped setting, RTA/83①.

scalloped side, C-5114/318F①.

scalloped skirt, C-5114/272①, 379①;
S-4461/610.

scalloped star, C-2704/115.

scalloped top, C-5114/311①.

scalloped trefoil setting, RTA/81①.

scalloping, EA.

scallopped, S-4992/61①.

scallop rim (plain), (inverted), (fan),
EG/145.

scallop rim neck, C-0279/150①.

scallop shell, C-2421/30①; S-4461/
221.

scallop shell decoration, C-5220/34①.

scallop shell-shape, LAR83/423①.

scaly fan, C-5170/188①.

Scammell, Joseph, C-0706/223;
C-5117/220.

Scandalli, C-0906/252.

Scandinavian ceramics, EA.

Scandinavian clock (watch), EA.

Scandinavian glass, EA.

Scandinavian gold and silver, EA.

Scandinavian tankard, CEA/587①.

scannellato, IDC.

scantling, CEA/541; SDF.

scape wheel, C-2368/85①;
C-MARS/172.

scapewheel, CEA/221①, 254①, 268.

scarab, C-2482/87; C-5005/406①;
C-5146/158①; C-GUST/128;
S-4807/451.

scarab-form, S-4927/219①.

scaraboid, C-2482/82; S-4807/451.

scaraboid shape, RTA/29①, 32①.

scarab ring, RTA/19①.

scarab-set, CEA/523①.

scarfing, CEA/528, 541.

scarificator, S-4927/222①.

scarlet, C-0405/49; C-2403/2; LP.

scarlet Boulle, C-0982/63, 83A.

scarlet lake, DATT; LP.

scarlet vermilion, DATT.

scarred pontil, C-5114/150.

scatter-pattern, JIWA/162.

scatter rug, C-5239/257.

scauper, DATT.

sceau, CEA/186①.

Sceaux, ACD; C-2486/3; DADA.

Sceaux faience, CEA/147①; EA/①.

scematic landscape, C-2427/160①.

scene, C-5156/273①.

scène galante, C-2458/268; C-5156/
441; C-5234/170.

scène galante, C-5234/175①.

scene of court pastime, MP/61.

scene of homage, MP/61.

scènes galantes, C-2323/*167*.

scenic cameo, C-0225/*226*.

scenic color, DATT.

scenic paper, DADA.

scent-barrel, IDC.

scent-bottle, IDC/①.

scent bottle, C-1006/*204*; C-1502/*59*; C-2458/*344*①; C-5239/*121*; CEA/ *50*①, *59*①; EA/①; EG/*152*①; IDPF/*3, 200*①; LAR83/*438*①, *604*①; MP/*161*; S-4461/*12*; S-4804/*248*.

scented pottery, IDC.

scent-flask, C-2427/*51*①; C-5117/ *366*①; C-5220/*1*①.

scent flask, C-0406/*66*; C-2486/*83*①; LAR83/*427*①, *438*①.

scent spray bottle, C-0706/*44*.

scent-stopper type, C-MARS/*13*.

scepter mark, MP/*147*; S-4461/*121, 138*.

sceptre, DSSA.

sceptre border, IDC.

sceptre handle, C-5156/*420*①.

'sceptre' knop, LAR83/*514*①.

sceptre mark, C-1006/*37*; C-2427/*41*; C-2486/*64*①; C-2493/*259*; C-5189/*46, 119*; S-3311/*367*①.

schaddai, C-5174/*20*.

Schadow, Johann Gottfried, EA.

Schäferkapelle (Shepherd Band), MP/*480*.

Schaper, Johann, CEA/*453*①.

Schäper, Johann, DADA.

Schäpergläser, DADA/①.

Schaper (Schapper) Johann, EA.

Scharff, Johann Gottlieb, EA.

Scharffeuermalerei, MP/*492*.

scharffeurmalereifarben, MP/*502*.

Scharling, John H., CEA/*477*①.

Schaubachkunst, C-2409/*293*.

Schaube, Kalisch, C-5174/*83*.

Schaufuss, Heinrich Gotthelf, MP/ *175*.

Scheele's green, DATT.

Scheid, G. A., LAR82/*33*①.

Scheier, Edwin and May, DADA/ *Supplement*.

Scheier, Vienna, C-2503/*152*①.

Schellink, Samuel, C-2910/*116*.

schema, DATT; LP.

schematic, LP; NYTBA/*38*①.

schematic pose, JIWA/*16*.

schematic representational style, JIWA/*162*.

schematized, IDPF/*125*.

Schepers, Gaetano, Carlos, Gaetano II, EA.

Scherf, R., C-5189/*122*.

Scheurich, P., C-5189/*80*①.

Scheurich, Paul, MP/*201*.

Schey, Fidelis, stamp: F SCHEY, C-5224/*197*①.

schiavona, S-4972/*251*; C-MARS/*23*.

schiavone, DADA.

Schier, Franz, S-4947/*31A*①.

Schiffer, Hubert, IDPF/*20*.

Schilderer, MP/*20*.

Schimmel, CEA/*693*①.

Schindler, P.S., C-2486/*134*.

Schippertje clock, CEA/*215*①.

Schissler, Christoph the Elder, EA.

schist, C-5156/*193*①; S-4807/*490*.

schizzo, DATT.

Schlachtenszenen, IDC.

schlagen, nicht schlagen, CEA/*256*①.

Schlegelmilch, Erdmann and Reinhold, K-802/*23*.

Schleissner, C-5203/*95*.

Schlesicky, F., S-4927/*116*.

Schleswig, EA.

Schletta clay, MP/*182*.

Schlichtig, Jean-Georges, C-2364/*65*.

Schlick, Benjamin, EA.

schutzen rifle, S-4972/*268.*

Schwanhardt, Georg, CEA/*453*①.

Schwanhardt family: Georg the Elder, Georg the Younger, Heinrich, EA.

Schwartz, June, DADA/*Supplement.*

Schwarza-Saale, C-2409/*118.*

schwarzlot, C-2486/*67*; CEA/*210*; MP/*502*; CEA/*138*①, *454*①; DADA; EG/*161*; IDC/①; MP/*69*; S-4853/*239*①.

Schwarzlot beaker, CEA/*453*①.

Schwarzlot painting, EA/①.

Schwarzlov, EA/*Vienna Hard-paste porcelain factory.*

Schweinfurt green, DATT; LP.

Schweppe, Jacob, CEA/*56*①.

Schwerin, DADA.

Schwingkens, G., C-2364/*49.*

Sciacca, C-2427/*212*①.

scientific instrument, C-MARS/*188*; S-4927/*222A*①.

scientific ring, RTA/*110*①.

scimitar, C-1702/*148*; C-2569/*20*; DADA.

scimitar base, SDF.

scimitar blades, C-0706/*35.*

scimitar leg, CEA/*306*①, *357*①; SDF.

scimitar-shaped, C-1502/*87.*

SC in rectangle, EA/*Courtauld, Samuel.*

scissors, C-0254/*242*; C-0406/*99*; DSSA.

scissor's case, C-5117/*97.*

scissors toy (lazy tong), CEA/*697.*

SCN in loops of tangled line, EA/ *Coalport.*

scodella, IDC.

scodella da donna di parto, IDC.

Scofield, John, C-2487/*118*; C-5174/ *538*①; S-3311/*754*①; S-4922/*49*①.

scolloped hands, C-2489/*194.*

scolopendrium pattern, IDC/①.

sconce, ACD; C-0225/*89*; C-0279/ *62*; C-0982/*62*; C-2409/*169*; C-5114/*236*; C-5239/*92*; DADA; EA/①; IDC; S-4804/*53*; S-4905/ *334*; S-4922/*5*①; S-4972/*332*①; SDF/①.

scoop, IDPF/*200*①; S-4461/*220.*

scooped quatrefoil, RTA/*84*①.

scooper, DATT.

scoops, C-5114/*17.*

scorched, C-1082/*4.*

scorched band, C-2421/*127*①.

scorched border, C-2522/*89*①.

scoring, EG/*287.*

scorper, CEA/*678*; DATT; EA.

scorpion, DADA; DSSA.

Scotch stone, DATT.

Scotch tape, DATT.

scotia, DATT/①; EA; SDF/①.

Scott, Digby, CEA/*659*①.

Scott, Digby & Benjamin, S-4922/ *26*①.

Scott, James, C-5117/*26*; S-3311/ *733*①.

Scott, James, Dublin, C-2487/*45.*

Scott, William, EA/*341.*

Scottish Alphabet, C-1506/*137.*

scottish dirk, CEA/*25*①; C-5117/*2.*

Scottish glass, EA.

Scottish glasshouse, EA/*Scottish glass.*

Scottish goblet, C-5117/*59.*

Scottish gold and silver, EA.

Scottish measure, EA.

Scottish Provincial, LAR83/*626*①.

Scottish snuff-mull, EA/①.

Scottish tablespoon, C-5174/*562.*

scouring, CEA/*594.*

scraffiato, S-4972/*123*①.

Scrafiren, MP/*445.*

scrambled colors, DATT.

scrambled paperweight, LAR83/ *443*①.

scraper, DATT/①.

scraperboard, DATT.

scratch-back, DADA.

scratch beading, SDF.

scratch-blue, EA/①.

scratch blue, IDC/①; CEA/*155*①.

scratch blue ware, DADA.

scratchboard, DATT.

scratch brown, IDC.

scratch carving, EA; SDF.

scratch coat, DATT.

scratch cross group, EA.

scratched blue (Chinese ceramic decoration), EA.

scratched cross ware, IDC.

scratched mark, IDC.

scratch knife, DATT.

scratch letter, C-0249/*116*.

screen, ACD; C-0249/*426*; C-2421/*81*; C-2458/*302*; C-5156; C-5236/*535*①; CEA/*541*; DADA, ①; EA/①; JIWA/*75*; S-4461/*653*; S-4972/*99, 436*; SDF/①.

screen fan, EA/*fans*; JIWA/*168*.

screen-form clock, S-4804/*240*①.

screening effect, JIWA/*238*①.

screen panel, JIWA/*156*.

screenprint, C-0249/*147*.

screen settee, SDF/①.

screen table, SDF.

screen writing table, SDF/① *writing fire screen*.

screw, ACD; C-0254/*173*①; C-5117/*453*①; S-4972/*266*; SDF.

screw-barrel microscope, CEA/*610*①.

screw-barrel pistol, ACD.

screw driver, S-4972/*163*①.

screwed setting, S-4927/*95*①.

screw end, C-5173/*20*①.

screw frame, S-4972/*233*.

screw mechanism, C-5114/*330*①.

screw-on, S-4922/*25*①.

screw-on burner, S-4922/*26*①.

screw-on lid, IDPF/*201*①; S-4804/*2*.

screw stopper, CEA/*55*①; IDPF/*201*①.

screw-underlever, C-2476/*2*.

scribanne, DADA.

scribed, S-4881/*207*①.

scribe's eraser, C-5156/*355*①.

scribing, SDF/①.

scrim, DATT; SDF.

scrimshander, S-4881/*394*①.

scrimshaw, C-5114/*192*①; CHGH/*63*; DADA/*Supplement*; DATT/①; LAR82/*486*①; S-3311/*160*①; S-4881.

scrimshaw jewelry, S-4881/*438*①.

scrimshaw material, S-4881.

scrimshaw whale's tooth, S-3311/*159*.

script, C-2486/*68*①; JIWA/*49*; S-4796/*219*.

script initials, C-5117/*260*.

script mark, C-2409/*35*; C-2493/*68*①.

scriptoire, SDF/① *scrutoire*.

scriptor, ACD.

scroddled ware, DADA/*Supplement*; EA.

scrodled ware, IDC.

scroll, C-0406/*47*; C-1407/*3*; C-2202/*28, 44*; C-2398/*9*①; C-2402/*46*; C-5116/*39*; C-5117/*281*; CEA/*541*; DATT; DSSA; IDC; SDF/①.

scroll, C, DADA.

scroll, S, DADA/*scroll, C.*

scroll and bead border, C-5117/*21*.

scroll and foliage feet, C-5117/*160*.

scroll and foliate feet, C-0254/*117*.

scroll and pad feet, S-4804/*26*.

scroll-and-shellform, S-4804/*147A*①.

scroll and shell handle, C-5117/*158*.

scroll and star design, LAR83/*469*①.

scroll and trelliswork cartouche,
C-5117/*110, 261*①.

scroll arm, C-0982/*4*; C-1407/*134*;
S-2882/*260*①.

scroll-back, EA; FFDAB/*33*①.

scroll back, SDF/①.

scroll backed, C-0706/*43*.

scroll back sofa, FFDAB/*29*①.

scroll band, C-2458/*91*; C-5127/*38*①.

scroll base, C-5117/*76*①.

scrollboard, S-4461/*597*.

scroll border, C-2398/*3*; IDC;
S-4461/*314*.

scroll bracket, C-0254/*58*; C-5116/
88; C-5117/*305*①.

scroll cartouche, C-5114/*6*; RGS/
*17*①.

scroll-carved, C-5114/*299*①; S-4436/
*10*①, *116*①.

scroll-carved cabriole leg, S-4414/
*432*①, *512*①.

scroll-carved splat, S-4414/*489*.

scroll cresting, C-0982/*15*.

scroll-cut feet, C-0249/*317*.

scroll design, C-0249/*364*.

scroll device, C-5146/*120*①.

scroll ear, C-5114/*381*①.

scrolled, C-2402/*9*; K-710/*111*.

scrolled acanthus cartouche, C-5116/
35.

scrolled and spray-form motif,
S-4414/*46*.

scrolled angle, C-2388/*98*.

scrolled apron, CEA/*312*①.

scrolled arched leg, C-5114/*386*①.

scrolled arm, C-5116/*86*; CEA/
*531*①.

scrolled backrest, S-4812/*66*①.

scrolled bail handle, C-5114/*43*①.

scrolled band, C-2437/*18*①.

scrolled border, C-5114/*43*①.

scrolled bracket, C-5114/*277, 341*①.

scrolled branch, C-2437/*16*.

scrolled feet, C-5114/*30*①.

scrolled foot, CEA/*307*①.

scrolled handhold, C-5116/*167*①.

scrolled handle, C-5114/*227*; S-2882/
*787A*①.

scrolled leg, C-2388/*41*; S-4955/
*144*①; SDF/①.

scrolled lunette cresting, C-2403/*46*.

scrolled marquetry, SDF.

scrolled pediment, C-2388/*5*①;
C-5114/*278*①, *361*; DADA; EA;
LAR82/*215*①; SDF.

scrolled pendant, C-5114/*361*.

scrolled reserve, S-4461/*117*.

scrolled seat, C-5114/*254*①.

scrolled strap handle, C-5114/*84*①.

scrolled toe, S-2882/*794*; S-4414/
*432*①, *482, 496*①; S-4436/*160*①.

scrolled top, EC2/*90*.

scrolled top rail, S-4414/*466*①.

scrolled trestle foot, S-2882/*291*.

scroll end, C-2402/*72*; C-5236/*559*①.

scroll engraving, S-4461/*349*.

scroll feet, C-0279/*222*; C-1082/*108*;
C-5114/*39*①; C-5116/*69*; C-5153/
*2*①; C-5259/*528*.

scroll-foot, CEA/*315*①.

scroll foot, C-0254/*25*; C-5156/*466*;
DADA; SDF/①.

scroll-form, S-4804/*19*.

scroll form, LAR83/*478*①.

scroll-formed medallion, S-4414/*338*.

scroll form support, LAR83/*284*①.

scroll handle, C-0254/*10, 42*;
C-0406/*14*; C-0706/*1*; C-5114/*2*①,
*48*①; CEA/*645*①; DADA;
LAR83/*594*①; MP/*488*①;
S-2882/*834, 1152*①; S-4414/*342*①;
S-4461/*363*; S-4922/*11*①.

scrolling, C-0782/*5*; C-2402/*180*;
C-2458/*2*; C-5005/*230*①; C-5156/
*46*①; S-4414/*38*.

scrolling acanthus, C-0279/*411*;
C-5114/*393*①; C-5116/*82, 115*.

scrolling acanthus-leaf decoration, RTA/98Ⓘ.

scrolling aoi, C-1082/137.

scrolling arm, S-2882/787AⓌ; S-4507/3Ⓘ.

scrolling biforcated arm, S-4414/233.

scrolling border, S-2882/94Ⓘ; S-4992/3Ⓘ, 35Ⓘ.

scrolling cartouche, S-4461/305.

scrolling chrysanthemum, C-2458/78Ⓘ.

scrolling collar, C-2409/57.

scrolling design, S-4414/26Ⓘ.

scrolling device, S-4461/315; S-4992/90Ⓘ.

scrolling double arm, S-2882/1347Ⓘ.

scrolling floral design, C-2704/139.

scrolling foliage, C-1502/46; C-2458/108Ⓘ; RGS/17Ⓘ, 22Ⓘ, 49Ⓘ, 52Ⓘ; S-2882/400; S-4461/301; S-4922/1Ⓘ.

scrolling foliage and caducei, S-2882/1179Ⓘ.

scrolling foliage and floral foot, C-5117/16Ⓘ.

scrolling foliage and scrollwork, S-2882/233Ⓘ.

scrolling foliage and strapwork, S-2882/731.

scrolling foliate, S-4461/5.

scrolling foliate motif, S-2882/673.

scrolling foliate rim, S-2882/925.

scrolling gadroon rim, S-4414/299Ⓘ.

scrolling guard, S-2882/201.

scrolling handle, S-4414/223Ⓘ.

scrolling hook, S-4414/238, 243Ⓘ.

scrolling leafage, S-4461/303.

scrolling leaf-molded feet, S-4414/233.

scrolling leafy border, C-2704/34.

scrolling leg, S-2882/354, 1448Ⓘ.

scrolling lotus, C-2414/80; C-2458/219.

scrolling motif, S-4461/516.

scrolling mount, S-4955/198Ⓘ.

scrolling orchid, S-4965/235Ⓘ.

scrolling pattern, S-4461/96, 591.

scrolling plume, C-5157/163Ⓘ.

scrolling seat, S-4507/35Ⓘ.

scrolling stem, C-5005/233Ⓘ; S-4461/363.

scrolling stile, C-5116/64Ⓘ, 71; C-5170/186Ⓘ.

scrolling stylised border, C-2704/28.

scrolling top-rail, S-2882/327Ⓘ.

scrolling trefoil decoration, S-4461/360.

scrolling vine, C-2458/219; C-5116/150Ⓘ.

scrolling vine field, S-4948/120Ⓘ.

scrolling vine spandrel, S-2882/153Ⓘ.

scroll mantling, C-5117/294Ⓘ.

scroll medallion, RGS/17Ⓘ.

scroll-molded, C-2493/166.

scroll molded, LAR82/199Ⓘ.

scroll motif, S-4461/317Ⓘ.

scroll moulding, SDF.

scroll mount, S-4461/40, 61.

Scroll of Esther, C-5174/7Ⓘ.

scroll ornament, SDF.

scroll-over arm, SDF/Ⓘ.

scroll painting, JIWA/223; S-3312/1166Ⓘ.

scroll pattern, CEA/562; RGS/106Ⓘ.

scroll pendant, CEA/310Ⓘ.

scroll-pierced, C-1502/4; C-2202/8.

scroll rim, S-4414/266; S-4461/528.

scroll sabots, C-0279/424Ⓘ.

scroll salt, CEA/640Ⓘ; EA/spool salt; IDC.

scrolls and pendant flower, S-2882/708Ⓘ.

scroll-shaped leg, DADA.

scroll-shaped mount, S-4414/97Ⓘ, 105.

scroll spout, C-5117/56①; C-5153/4①.

scroll support, S-2882/1130①; S-4414/303①.

scroll swing handle, C-0254/58.

scroll table, C-5236/556, 563①.

scroll terminal, C-0254/190; C-5114/395①.

scroll thumbpiece, C-0254/150A; C-5117/255①; S-4804/113; S-4922/18①.

scroll toe, C-5116/146①; C-5127/332①; S-2882/357A.

scroll toggle, C-5156/340.

scroll-top, S-4461/602.

scroll top stem, C-5117/99①.

scroll weight, C-5234/245①.

scroll with flowers, OPGAC/235.

scrollwork, C-0279/80; C-5157/10; CEA/532①; RGS/49①; S-4414/242; S-4461/93; S-4507/23.

scrollwork and floral rim, S-2882/1195①

scrollwork base, S-2882/703.

scrollwork cartouche, S-2882/965, 1064, 1187.

scrollwork frieze, LAR83/407①.

scrollwork hand, C-5117/393①; S-4802/11.

scrollwork thumbpiece, S-2882/1108①.

scrollwork trim, EC2/92①.

scrucifixion group, MP/116.

scruffing, LP.

scrutoire, ACD; DADA; SDF/①.

scuffing, DATT.

Sculpstone, DATT.

sculpted, C-0225/49.

sculpted decorative element, MP/118.

sculptor, MP/33.

sculptural, S-4461/81; S-4507/2.

sculptural clock garniture, LAR83/193①.

sculptural form, RTA/164①.

sculptural gem-set ring, RTA/92①.

sculptural pendant jewel, RTA/92.

sculptural portrait, MP/157.

sculptural relief, RTA/132①.

sculptural ring, RTA/133①.

sculpture, C-0225/127; DATT; JIWA/9.

sculpture head, S-4461/195.

sculpture in the round, DATT.

sculpture painting, DATT.

sculpture-work, CEA/660①.

scumble, DATT.

scumbling, LP.

S-curved wing, C-5153/209①.

scutcheon, CEA/405; SDF/① escutcheon.

scutella, IDPF/202.

scuttle, C-0103/93.

S. C. Younge & Co., S-4944/281.

S C Younge & Co, C-0406/50.

scythe, DSSA.

sea and harbor view, MP/61.

sea blue, S-3311/16①.

sea elephant tooth, S-4881/490①.

seafood fork, C-5114/21①; S-4461/387.

sea-green, C-1506/129.

sea green, S-288/37①.

sea-green-ground, LAR83/82①.

sea-green ground, EA.

seahorse handle, C-2364/67①.

sea-horse scent bottle, EA.

seal, C-0254/40, 234; C-1502/87; CEA/70, 540①, 594; EA/①; IDC/①; S-4928/56①.

seal box, EA/skippet box; S-4922/29①.

seal cut, C-2482/82.

sealed, C-0249/84; DADA.

sealed chair, SDF.

sealed glass, DADA.

sealed script, C-5127/*351.*

sealer, DATT.

seal form netsuke, S-4829/*6*①.

sea-life motif, NYTBA/*134*①.

sealing wax, DATT.

sealing-wax-case, C-5117/*380*①.

sealing wax case, C-5174/*441*①.

sealing wax kit, C-5239/*108.*

sealing-wax red (ceramic decoration), EA/①.

sealing-wax red, IDC.

sealing-wax-red glass, EG/*110.*

seal ink box, C-5236/*1607.*

seal-mark, IDC.

seal mark, C-0782/*150;* C-2323/*83;* C-2458/*111;* C-5127/*97*①; C-5156/*70;* S-4461/*193.*

seal matrix, EA/*seal.*

seal paste box, S-4810/*494*①.

seal-ring, RTA/*121*①.

seal salver, EA/*seal cup.*

seal script, C-5156/*183, 694.*

seal shaft, EA/*seal.*

seal skin, C-0405/*5.*

sealskin, C-2203/*215.*

seal top, CEA/*594.*

seal-top spoon, C-5117/*106*①; EA; NYTBA/*219.*

seal top spoon, DADA; LAR83/ *578*①.

seal-top terminal, S-2882/*1096*①.

seam, C-5114/*242;* MP/*36;* NYTBA/ *159.*

seamcd, C-5114/*228.*

seam line, DATT.

seam mark, IDC.

sea monsters scene, C-5174/*429*①.

sear, CEA/*44.*

sear-arm, C-2476/*14*①.

sear button, C-2503/*79.*

seascape, DATT; JIWA/*150*①; RGS/ *152*①.

sea service musket, C-2503/*146.*

seashell, MP/*36.*

sea-snake spout, C-5117/*187*①.

season, DATT.

Seasons, the, IDC.

seasons as theme, C-2486/*157*①.

Seasons spandrels, C-2489/*119.*

seat, C-0982/*5;* C-5239/*245;* CEA/ *536*①; SDF.

seat back, SDF.

seatboard, C-2368/*98A.*

seat cover, C-1506/*116;* C-2478/*225;* C-5156/*474.*

seat curb, SDF.

seated, S-4905/*88*①.

seated figure, C-1006/*70;* C-1082/*26.*

seated model, C-1006/*193.*

seated sphinx, C-2403/*3.*

seat furniture, C-2555/*41*①; C-5116/ *66;* SDF.

seating, SDF.

Seatoune, John, C-5117/*266*①.

seat panel, C-2402/*31.*

seat-rail, C-2388/*18;* C-2421/*15*①.

seat rail, C-0249/*445;* C-5157/*1;* SDF.

seatrail, C-2357/*9*①; C-5116/*167*①; LAR83/*282*①.

seau, C-2486/*5*①.

seau à bouteille, IDC/①.

seau à bouteilles, C-2486/*7*①.

seau à glace, IDC/①.

seau à liqueur, IDC.

seau à verre, IDC.

seau a verre, LAR83/*154*①.

seau crenelle, LAR83/*65*①.

seaux à liqueurs, S-4853/*10*①.

seaweed, C-2388/*79;* DADA/①.

seaweed, ashes of, IDC.

seaweed marquetry, C-2368/*98A;* C-2403/*152*①; C-2421/*45;* C-2489/*113;* C-2522/*89*①; EA/

endive marquetry; LAR82/*212*①;
 LAR83/*194*①; SDF.

seaweed tablet, FFDAB/*41*①.

Sebastian and James Crespell,
 S-4922/*56*①.

seççadeh, OC/*30*.

Seccesionists' style, C-GUST/*90*.

secco, DATT; LP.

secession, DADA/*Supplement*.

secessionist candlestick, LAR83/
 *138*①.

'secondary' arts, JIWA/*13*.

secondary color, DATT; LP.

secondary colour, OC/*262*.

secondary göl, OC/*175*.

secondary motif, JIWA/*297*①.

second-course-dish, C-5117/*54*①.

second-course dish, C-2398/*80*;
 C-2487/*32*; C-5174/*576*①.

Second Empire, C-1407/*137*; DADA/
 Supplement; LAR82/*224*①;
 LAR83/*290*①.

Second Empire style, EA.

second grip, C-2476/*64*.

second ground, CEA/*477*①.

second impression, JIWA/*181*①.

second register, S-4905/*359*①.

second Rococo period, MP/*188*,
 *492*①.

seconds dial, S-4988/*407*①.

seconds hand, EA/*hands*.

seconds ring, C-0906/*200*.

Secrest, James and Philip, DADA/
 Supplement.

secretair bookcase, C-0982/*283*.

secretaire, C-2402/*27, 100*.

secrétaire, C-2478/*82*; CEA/*344*①.

secretaire, DADA.

secrétaire, EA.

secretaire, S-2882/*780*①; S-4436/
 *93*①; S-4972/*567*①; SDF/
 secretary, ① *escritoire*.

secretaire a abattant, C-0249/*439*.

secrétaire à abattant, C-2364/*51*①;
 C-2478/*131*①.

secretaire a abattant, C-5005/*340*①.

secrétaire à abattant, DADA/①.

secretaire a abattant, LAR83/*336*①;
 S-2882/*388, 399*.

secretaire à abattant, S-3311/*457*①;
 SDF.

secretaire à abbatant, C-5259/*604*①.

secrétaire à Bourgogne, EA/*secrétaire
 à capucin*.

secrétaire à capucin, EA.

secretaire bookcase, C-1407/*106*;
 LAR83/*255*①, *340*①; S-3311/
 *120*①.

secretaire breakfront, S-4988/*501*①.

secretaire-cabinet, C-0249/*461*;
 C-2437/*71*①.

secrétaire-cabinet, C-2478/*192*.

secretaire cabinet, C-2403/*141*;
 LAR83/*336*①; S-4414/*428*①.

secretaire chest, C-0982/*57*; LAR83/
 *336*①.

secretaire chest on chest, S-4812/
 *102*①.

secretaire desk, LAR83/*331*①.

secretaire drawer, C-0249/*461*;
 C-2388/*109*; C-2403/*89*; S-4414/
 *428*①.

secrétaire en armoire, EA/①.

secrétaire en dos d'âne, EA.

secretaire en pente, CEA/*406*.

secrétaire en pente, EA/*secrétaire en
 dos d'âne*.

secrétaire en tombeau, EA/*secrétaire
 en dos d'âne*.

secretaire kneehole desk, C-2320/*54*.

secretaire on chest, C-2403/*152*①.

secretaire tallboy, LAR83/*338*①.

secretaire tallboy chest, LAR83/
 *337*①.

secretary, CEA/*392*①; DADA; EA;
 SDF/① *escritoire*.

secretary-bookcase, K-802/*15*.

secretary bookcase, C-5116/*149*①;
DADA; EA/*bureau bookcase*;
S-4461/*575*①; S-4972/*560*①.

secretary-cabinet, C-5116/*128*①.

secretary cabinet, DADA; EA.

secretary-chest, C-5116/*134*①.

secretary chest-on-chest, DADA.

secretary desk, C-5157/*74*①.

secretary door, NYTBA/*23*.

secretary drawer, C-0279/*313*;
C-5116/*134*①; SDF/①.

secret colour, EA/*Yüeh ware*.

secret compartment, C-5116/*110*.

'secret' decoration, ACD.

secret decoration, IDC.

secret drawer, CEA/*323*①; NYTBA/
58; SDF.

secret signature, EA; S-4927/*67*①.

section, C-2458/*329*; IDC; S-4972/
*140*①; SDF/①.

sectional, C-5239/*272*①.

sectional bi, C-5236/*1738*.

sectional ivory carving, C-1082/*149*.

sectional ivory group, C-1082/*128*.

Section d'Or, DATT.

Section d'Or, La, LP.

sectioned, C-5236/*335*.

section line, DATT.

sector, CEA/*609*①, *610*①.

sector rule, C-2904/*146*.

sector watch, S-4927/*214*.

'secular' prayer rug, OC/*127*.

sedan chair, EA/①; LAR83/*659*①;
SDF/①.

sedan clock, C-1702/*293*; DADA;
EA; SDF.

Sedding, John Dando, DADA/
Supplement.

Seddon, George, CEA/*321, 358*①;
DADA; EA; SDF/*762*.

seder dish, C-5174/*44*①.

seder-set, C-5174/*48*.

seder stand, C-5174/*47*①.

Sedgley, C-2409/*134*.

sedimentary rock, DATT.

sedjadeh, CEA/*101*; DADA.

seed, CEA/*503*.

seed-case, C-2482/*76*.

seeded, C-2458/*257*①; C-5236/*517*.

seeded baluster motif, C-5234/*195*.

seeded ground, C-5156/*114*①; IDC.

seeded panel, C-2427/*34*①.

seeded reserve, C-2513/*218*①.

seed lac, DATT.

seed-pearl, C-2403/*193*; CEA/*513*;
RTA/*153*①.

seed pearl, C-5005/*220*①; C-5156/
*245*①; S-4414/*145*; S-4461/*300*;
S-4927/*135*①.

seed-pearl decoration, RTA/*118*①.

seed-pearl matif, C-2388/*202*.

seed pearl pendant, S-291/*116*①.

seed pearl tassel, S-4414/*145*.

seed pod, C-1082/*56*.

seed pouch, C-1082/*7*.

seeds, EG/*293*①.

seed whorl, C-5156/*356*①.

Seefried, Peter Antonius, EA.

seeing glass, SDF.

seep, C-0405/*172*.

seersucker, C-3011/*34*.

seger cone, IDC.

Seger porcelain, JIWA/*324*.

seggar, IDC.

segmental drawer, C-2421/*98*①.

segmental leaves, C-2403/*151A*.

segmented, C-0982/*280*.

segmented dish, C-2458/*51*①.

segment painting, JIWA/*165*.

Seguso Verti D'Arte, DADA/
Supplement.

Sehna carpet, EA.

sehna khilim, DADA.

Sehna knot, EA/*Persian knot*.

Sehna rug, DADA.

Seibert, W. & H., C-2904/*233*.
seicento, DATT; LP.
Seichour runner, S-288/*1*①.
Seichur carpet, EA.
Seignouret, François, DADA/
Supplement.
Seiji, DADA.
Seilitz, MP/*158*.
seillage, DADA.
Seine-Rhine glasshouse, EG/*47*.
sejant, C-5259/*191*.
séjant, S-4972/*5*①.
Sejur carpet, EA/*Seichur carpet*.
Selbing, John, DADA/*Supplement*.
Selby, Peter, Wareham, C-2489/*116*.
Selby, Prideaux John, S-286/*86*.
Selden, George, ACD.
selenium red, DATT.
selestat, C-5191/*222*.
selette, C-5167/*183*.
self base, C-0225/*111*; C-5239/*56*.
self bronze, C-5189/*164*①.
self coloured, C-1506/*1*.
self-coloured flower, C-2704/*177*.
self-frame, S-4823/*51*; S-4843/*497*.
self-hardening clay, DATT.
self-loading, C-2476/*14*①.
self-orientating, CEA/*606*①.
self-portrait, JIWA/*40*.
self-tapering column, LAR83/*74*①.
self-terracotta base, C-0279/*86*.
self-tone, OC/*309*.
self triangular base, C-5146/*88*.
self-winding, S-4802/*92*.
self-winding watch, EA/①.
self winding wristwatch, C-5117/
*428*①.
Seligmann, Jacques, C-5173.
Selina Catherine Greene Wrought,
C-2704/*4*.
Seljuk, C-5156/*445*.
Seljuq carpet, EA/*Konia carpet*.

Seljuq ware, EA.
Sellers, James Henry, SDF/*762*.
Sellon, Humphrey, CEA/*234*①.
sellore, SDF/*selour*.
selour, SDF.
selvage, EA/*edges*; S-4796/*24*;
S-4972/*179*①.
selvedge, C-2403/*159*; C-2437/*10*;
C-5323/*71*①; OC/*22, 22*①.
Selwood, William, EA/*210*①.
semainier, C-2364/*61*; C-5259/*471*;
DADA; EA/①; LAR83/*296*①;
SDF.
semanier, C-0279/*430*①; C-5189/
*298*①, *352*; S-4461/*670, 699*;
S-4804/*770*①.
Semenov, Sava, C-5174/*231*.
Semenov, V., C-5117/*323*.
Semenov, Vasiliy, C-5117/*320*.
semerlik, DADA.
semiabstract, DATT.
semi-balloon, C-0982/*24*.
semi-balloon back, C-1407/*85*.
semi-circle lug, S-4802/*72*.
semi-circular, C-0982/*201*; C-2421/
*75*①; C-5005/*333*①; S-4972/
*565*①.
semicircular band border, S-2882/
*636*①.
semi-circular fan, JIWA/*162*①.
semi-circular folding top, C-2403/*101*.
semi-circular slab top, C-5116/*87*.
semi-curvilinear, OC/*14*.
semi-cylindrical, C-5236/*479*.
semidrying oil, DATT.
semi-eggshell, C-2458/*143*; C-2513/
230.
semi-eliptical, C-2403/*92*.
semi-elliptical, C-2478/*145*; S-4436/
*125*①.
semi-fast, OC/*26*.
semi-fast synthetic dye, OC/*23*.
semi-flexible bracelet, S-4414/*148*①.

Serestik, J., C-2546/*54*.

serge, SDF.

serial number, C-2476/*10*; S-4972/*165*①.

serial production, MP/*472*.

series, C-5156/*911*; C-5236/*1333*; IDC.

serif, CHGH/*62*; DATT.

serigraph, S-286/*302*①.

serigraphy, DATT; LP.

serinette, EA/*bird organ, bird organ*.

serpent, DSSA; EA/*musical wind instrument*.

serpentform handle, S-4414/*360*①.

serpent handle, C-2502/*49*; LAR83/*532*①.

serpentine, C-2402/*7*; C-2458/*78*①; C-5116/*14*; C-5153/*85, 182*①, *154A*①; CEA/*28*①, *406*; DADA/①; DATT; FFDAB/*57*; K-710/*111*; RTA/*18*①; S-4461/*620*; SDF/①.

serpentine and shell moulding, C-0982/*30*.

serpentine arm, C-5153/*202*①.

serpentine base, C-2388/*3*.

serpentine-bodied, C-5156/*261*①.

serpentine break, CEA/*307*①.

serpentine chest, C-2388/*106*; C-2403/*106*.

serpentine cornice, LAR83/*316*①.

serpentine crest, C-0279/*273*.

serpentine crest rail, C-5114/*291*①.

serpentine cushion seat, C-0279/*409*①.

serpentined, C-0982/*75, 118A*.

serpentine display cabinet, LAR83/*264*①.

serpentine drawer, C-0279/*415*.

serpentined top-rail, C-1407/*8*.

serpentine folding top, C-5114/*271*①.

serpentine form, S-4414/*432*①.

serpentine-front, S-4972/*435*①.

serpentine front, ACD; C-5114/*351*①; DADA.

serpentine-front case, C-5114/*249*.

serpentine-fronted, CEA/*347*①; S-3311/*122*; S-4414/*444*①, *525*①; S-4812/*125*①.

serpentine-fronted seat, S-3311/*392*①; S-4812/*73*①.

serpentine hand, S-4927/*56*①.

serpentine outline, C-5114/*32*①.

serpentine padded back, C-0249/*436*.

serpentine seat, C-0982/*15*; C-1407/*22*; C-2421/*25*①; C-2478/*35*; LAR83/*272*①.

serpentine seat rail, C-5116/*66, 152*①.

serpentine-shaped, LAR83/*190*①.

serpentine shaped, S-4414/*481*①; S-4436/*47A*①.

serpentine shelf, C-0279/*360*.

serpentine side, S-4922/*58A*①.

serpentine slope, C-5170/*26*①.

serpentine splat, C-0249/*457*①.

serpentine spout, C-2458/*179*.

serpentine stretcher, CEA/*312*①; SDF/①.

serpentine tankard, S-4944/*406*①.

serpentine top, C-0249/*450*; C-2357/*57*①; C-2437/*50*①; FFDAB/*35*; LAR83/*309*①; SDF.

serpentine top-rail, S-2882/*263, 265*.

serpentine upholstered seat, C-0249/*445*.

serpent spout, C-2360/*166*①.

Serpent torchere, C-5005/*336*①.

serrated, C-2388/*141*; C-2403/*164*; C-5127/*16*; IDC; S-3311/*30, 635*①.

serrated exterior, S-4414/*356*①.

serrated-leaf, S-4847/*48*.

serrated leaf and wine glass border, S-2882/*184*①, *215*①.

serrated leaf and wineglass border, S-2882/*66*.

serrated leaf border, S-2882/*106*.

serrated leaf field, S-2882/*90*.

serrated leaf scroll, S-2882/*157*①.

serrated-leaf skirt, S-4414/*541*.

serrated medallion, S-4948/*30*①.

serrated prabha, C-5234/*7*.

serrated stripe, C-2403/*162*.

serre bijoux, EA.

serre-bijoux, DADA.

serre papier, EA/*cartonnier*.

serre-papier, EA/*cartonnier*.

serre-papiers, DADA.

Serrurier-Bovy, Gustave, DADA/ *Supplement*.

servante, DADA; EA/*serving table*, *serving table*.

servant light, C-5174/*113*.

servant plate, IDC.

server, C-5114/*22*; C-5191/*298*; C-5239/*250*; FFDAB/*65*.

service, C-2493/*4*; C-5173/*53*①; CEA/*617*; IDC.

service japonais, JIWA/*307*.

service pistol, C-2569/*71*.

service wood, DADA.

serving dish, C-0254/*1, 193*; C-5114/ *40*①; C-5239/*35*; EC2/*23*①; S-3311/*608*①; S-4461/*121*; S-4905/*29*; S-4922/*35*①, *9B*①.

serving-fork, C-5117/*34*.

serving fork, C-0254/*80, 139, 267*; C-5114/*17*; S-4804/*1, 28, 35*; S-4922/*34*①.

serving piece, C-0254/*201*; C-5114/ *16*.

serving platter, C-0254/*73, 280*; C-5236/*1782*; S-4804/*63*①.

serving pot, S-4461/*214*.

serving set, C-0254/*21*.

serving side cabinet, C-0982/*148*.

serving slice, S-4802/*183*; S-4944/ *48A*①.

serving spatula, S-4804/*35*.

serving spoon, C-0254/*80, 148*; C-5114/*9, 17*; EA; S-4804/*28*①.

serving-spoon, C-5117/*79, 323*.

serving table, DADA; EA; LAR83/ *386*①; S-4804/*866*①.

serving-table, C-2403/*76*; C-2421/ *135*①; C-2478/*163*.

serving tray, C-5114/*1*; S-4804/*30*①.

serviteur fidéle, C-5259/*552*.

servitor, CEA/*414*.

Seseman, Johan Adolf, S-4944/*149*①.

set, C-1603/*61*; C-5116/*127*①; C-5153/*102*①; DATT; IDC; S-4972/*99*.

Seth Pennington's Factory, C-2493/ *33*.

Seth Thomas, EC2/①.

set into a trellis-work ground, C-2704/*115*.

seto, CEA/*575*; ACD; C-5156/*785*; C-5236/*858*①, *865*①, *1855*; EA/ ①.

set of chair, SDF.

Seto kiln, JIWA/*348*.

Seto ware, DADA; IDC; JIWA/ *112*①.

set-squarc, DSSA.

sette, S-3311/*217*①.

settee, ACD; C-0982/*20*; C-2388/*22*; C-2402/*183*; C-2478/*55*; C-5114/ *254*①; C-5239/*256*; CEA/*343*①; DADA/①; EA/①; FFDAB/*46*; LAR82/*362*①; LAR83/*342*①; S-3311/*516*①; S-4436/*145*①; S-4461/*682*; S-4804/*832*①; S-4812/*68*①; S-4988/*448*①; SDF/ ①.

setting, CEA/*510*; JIWA/*44*.

setting up mechanism, CEA/*252*①.

settle, ACD; DADA; EA; LAR82/ *363*①; LAR83/*342*①; S-4812/ *79*①; SDF/①.

Settle, T. and J., C-2510/*73*.

settle table, EA; SDF/①.

Seyshur carpet, EA/*Seichur carpet, Seichur carpet.*

Sezession, DATT; RTA/*138.*

Sezessionists, LP.

S-faceted, C-5157/*8.*

sfahan carpet, S-3311/①.

SFMB, EA/*Batenin, Sergei.*

Sfohl, J., C-5189/*115*①.

S form guard, S-2882/*100.*

sfregazzi, DATT.

sfumato, DATT; LP.

sgabello, C-2546/*112A*; DADA/①; NYTBA/*25*①.

S. Godbehere and Co., C-2510/*78.*

sgraffiato, C-2427/*178*; C-5127/*106*; CEA/*116*①, *129*①, *130*; DADA; EA.

sgraffiato Nishapur, C-5236/*1743.*

sgraffiato or sgraffito, ACD.

sgraffito, C-2324/*56*; DATT; EA/ *sgraffiato*; EC1/*83*; IDC; LP.

sgraffito decoration, JIWA/*85*①.

shabi, JIWA/*324.*

shabti, IDC.

shackles, C-0906/*103.*

shade, C-5005/*260*①; C-5239/*152*; DATT; EA/*silhouette, silhouette*; JIWA/*6*; LP; S-4461/*495.*

shaded, C-5117/*319*①.

shaded cloisonné enamel, RGS/*61*①.

shaded enamel, C-5117/*319*①, *329*①.

shaded enamelled, C-5174/*306*①.

shaded German flower, MP/*121.*

shaded woods, C-5116/*79*①; C-5157/ *137*①.

shade mount, C-0225/*312.*

shading, C-5005/*239, 366*; DATT; LP.

shading film, DATT.

shadow, LP/①.

shadow box, C-0249/*174*; S-4881/ *103*①; S-4972/*386*①.

shadow edge, DATT.

shadowy blue ware, IDC.

shaft, C-2370/*96*; C-2388/*27*①; C-2403/*4*; C-2421/*6*①, *139*①; C-5114/*230*; C-5127/*145*; S-4461/ *9.*

shaft and globe, CEA/*57*①.

shaft plate, C-5156/*317*①.

shagreen, ACD; C-2487/*106*; C-2904/*71*; C-2910/*238*; C-5005/ *352*①; C-5116/*8*; C-5157/*13*①; DADA; EA/①; IDC/①; LAR82/ *244*①; LAR83/*629*①; S-4802/ *145*①; S-4972/*162*①; SDF.

shagreen case, C-1502/*121*; C-5117/ *197*①; LAR83/*578*①.

shagreen-covered, C-0103/*116*; C-2368/*204*①.

shagrin grip, S-4972/*250.*

Shah, S-4847/*129.*

Shah Abbas, CEA/*89*①; DADA.

Shah Abbas carpet, EA/*arabesque carpets.*

Shah Abbasi, CEA/*101*①.

'Shah Abbas' palmettes, OC/*206, 335.*

'Shah Abbas palmettes', OC/*276.*

Shahjahanpur, OC/*306.*

Shah Jahan style, OC/*117*①.

Shahn, Ben, S-286/*474*①.

Shahr Babak Afshar design, OC/*253.*

Shahr Kurd, OC/*149.*

Shah Savan, OC/*113.*

shaker, C-5005/*235*①; CEA/*592*①; S-4461/*197*; S-4905/*317*; LAR83/ *372*①.

Shaker chair, NYTBA/*39.*

Shaker furniture, ACD; DADA; EA/ ①; SDF.

Shakespeare service, IDC.

Shakrisyabz Susani, C-2403/*177.*

shakudo, C-5156/*780*; C-5236/*785*①, *1826, 1828*; CEA/*565, 574*①, *575*; DADA; S-3312/*1048*①; S-4829/ *29*①; RTA/*180*①.

shaped hexafoil, S-4922/57①.

shaped hexagonal base, S-4414/225①.

shaped hexagonal form, S-4461/509.

shaped oblong base, S-4461/342①.

shaped octagonal foot, S-2882/701.

shaped outline, C-0254/13, 281; C-5117/6, 217; C-5174/456①.

shaped oval form, S-2882/980①, 1005①.

shaped plank seat, C-5116/119.

shaped plate, C-1702/350.

shaped quarterfoil base, S-2882/1379①.

shaped rim, C-1006/41; C-2323/78; C-5114/211.

shaped scalloped rim, S-2882/1052.

shaped scrollwork terminal, S-2882/1038.

shaped shelf, S-2882/711①.

shaped shell, S-4922/3①.

shaped shoulder, C-5174/539①.

shaped skirt, C-5114/286①; S-2882/272; S-3311/190; S-4905/378.

shaped splat, C-0249/402①.

shaped spout, C-5156/150.

shaped square base, C-5117/241①.

shaped-square form, S-4461/21.

shaped square waisted plinth, S-4414/365.

shaped stem, C-0254/75①; C-5117/271①.

shaped step, C-5156/213①.

shaped stretcher, C-5157/155①.

shaped terminal, S-2882/1016, 1058①.

shaped top rail, S-4414/484①.

shaped trefid terminal, S-2882/1094①.

shaped triangular base, C-2402/13.

shaped undertier, C-0982/94B.

Sharabian, OC/266.

sharawadgi taste, SDF.

shard, DATT; IDC.

sharito, EA/*Japanese metal-work*.

shark bone, S-4881/200①, 501①.

shark-skin, C-2458/374.

sharkskin, C-5005/352①.

sharkskin surface, IDC.

'shark's teeth', OC/303.

sharon, OPGAC/196.

sharp, S-4972/165①.

Sharp, George B., S-4905/170.

Sharp, R., LAR82/626①.

Sharp, Robert, C-0270/164①; C-2487/78①; C-5117/44①; S-4922/50①; S-4944/343①.

sharpening stone, C-2904/289.

Sharp Gothic, CEA/247①.

Sharps, C-2476/12; CEA/37.

Sharps, Christian, CEA/41①.

Sharps carbine, C-2503/103; S-4972/262①.

shashqua, C-2503/7.

shaska, S-4972/154①.

shave, CEA/300.

shaving bowl, IDC.

shaving chair, EA; SDF/①.

shaving-cup, IDC.

shaving dish, DADA.

shaving-dish, C-5117/174①; EA/*barber's bowl*.

shaving glass, SDF/①.

shaving mug, C-0706/200; C-2493/161.

shaving stand, DADA.

shaving stand (table), EA.

shaving stand, LAR83/353①; SDF.

shaving table, DADA/①; SDF.

Shaw, John, C-0406/74; C-5117/373.

Shaw, Ralph, CEA/153①.

Shaw, Richard Norman, DADA/*Supplement*.

Shaw, Thomas, C-0406/72.

Shaw, W., C-2487/99.

Shaw, William, S-4922/*59*①.

shawl, C-0225/*183*; C-1506/*151*.

shawl ends, C-2704/*166*.

Shaw's Brow pottery, CEA/*200*①.

Shawsheen Pottery, Billerica, Massachusetts, EC1/*85*.

Shawsheen Pottery, Mason City, Iowa, EC1/*85*.

sheaf-back, EA.

sheafs, C-0982/*32*.

Shearer, Thomas, ACD; DADA; EA; SDF/*762*.

shearing, EG/*287*.

shear mark, EG/*184*.

shears, DSSA.

sheath, C-1082/*5*; C-5236/*1835*.

sheathing, SDF.

sheath inro, S-4829/*82*①.

shed, OC/*18, 18*①.

sheen, DATT.

sheep, DSSA.

sheep's-head clock, EA.

sheet edge, C-0249/*10*.

sheet glass, EG/*245*; SDF.

sheet gold, CEA/*510*.

sheet gold paillette, C-5234/*194*.

sheet iron, C-5114/*184*①; CHGH/ *58*.

sheet-metalwork, CEA/*528*.

sheet of designs, C-2510/*1*①.

sheet of silver, C-5156/*174*.

Sheffield, CEA/*656*①; S-2882/*900, 901*; S-4905/*171*①.

Sheffield plate, ACD; DADA; DATT; EA; LAR82/*638*①; SDF.

Sheffield-plated, C-5157/*18*.

Sheffield plated, S-3311/*591*.

Sheffield silver process, NYTBA/*228*.

Sheffield tray, C-5114/*85*①.

Sheikh Safi carpet, OC/*37*.

shekel, C-5174/*21*.

shekeri border, OC/*48*①.

Sheldon Tapestry Works, EA.

shelf, C-5116/*131*①; C-5153/*103*①, *171*①; C-5239/*241*; SDF.

shelf cabinet back, C-2402/*46*.

shelf clock, C-5114/*358*①; EC2/*89*; S-4461/*70*.

shelf cluster, SDF.

shelf-sofa end, LAR83/*347*①.

shelf stretcher, C-0249/*365*; C-5157/ *157*①.

shell, C-2388/*20*; C-2398/*18*①; C-2402/*123*; C-2458/*108*①; C-5005/*205*①; C-5114/*334*①; C-5236/*558*①; DADA/①; DSSA; SDF/①.

shellac, DATT; LP/①.

shell and bell-flower carved, S-4812/ *73*①.

shell and dentil, S-4812/*5*①.

shell and fan motif, CEA/*386*①.

shell and foliage scroll foot, C-5117/ *17*①.

shell and foliage shoulder, C-5117/ *139*①.

shell and foliate foot, C-5117/*211*.

shell and hoof foot, C-0254/*10*; C-5117/*247*.

shell and lappet-carved, S-4812/*62*①.

shell and lattice, CEA/*630*①.

shell and mask foot, C-2398/*24*①.

shell and pad foot, C-1502/*51*; C-2398/*82*.

shell and paw foot, C-2398/*3*; C-5117/*85*①.

shell and reeded scroll top, C-5117/ *33*.

shell and scroll, C-5117/*281*.

shell and scroll border, C-5114/*2*①.

shell and scroll foot, C-0254/*134, 36B*; C-5117/*70*.

shell and scroll support, S-2882/ *972*①.

shell and tassel, OPGAC/*235*.

shell-and-thread pattern, C-5153/*19*.

shell and thread pattern, C-5114/*72*.

shell-back, DADA.

shell back, C-5117/*64*; LAR83/ 273①.

shell backed, C-0706/*43*.

shell border, C-0254/*2, 22*.

shell bowl, C-0254/*125*①, *256*; C-5117/*40*①; C-5173/*34*①.

shell cameo, LAR83/*544*①.

shell cameo scene, C-5220/*51*①.

shell-capped, S-2882/*917*.

shell capped, C-5117/*80*.

shell carved, LAR83/*361*①.

shell-carved cabriole leg, S-4414/ *431*①, *479*①.

shell centrepiece, IDC.

shell chariot, C-2437/*2*①.

shell clasp, C-2357/*12*①.

shell clip, S-4905/*332*.

shell corner, C-0406/*31*.

shell cresting, C-2388/*14*.

shell decorated base, S-4461/*38*.

shell decoration, IDC.

shell-dish, IDC/①.

shell dish, C-2513/*335*.

shell drop, C-5153/*19*.

shell-edged, IDC.

Shelley, C-1006/*49*; C-2409/*75*; C-2910/*89*.

Shelley, Samuel, EA.

shell-fluted, S-2882/*1115*.

shell-fluted bowl, S-2882/*1117*, *1126*①, *1160*.

shell fluted grip, S-2882/*1124*①.

shell foot, C-0254/*119*; S-4414/ *295*①; S-4804/*207*.

shell-form, S-4461/*290*.

shell form, C-0225/*336*; IDPF/ *202*①; S-2882/*355*.

shell form foot, C-0249/*200*.

shell-form handle, S-4461/*111*.

shell form support, S-4414/*271*①.

shell frieze, C-2402/*68*.

shell gold, DATT.

shell grip, C-5114/*87*①; C-5117/ *124*①.

shell guard, CEA/*22*①; S-4972/ *257*①.

shell handle, C-5174/*604*①; S-4414/ *299*①.

shell-headed, C-5116/*71*.

shell-inlaid, S-2882/*293*.

shell inlay, LAR83/*348*①, *352*①; NYTBA/*25*①; S-2882/*267*.

shell ladle, C-5114/*76*.

shell lockplate, C-2364/*63*①; C-2437/*61*①.

shell marble, DATT.

shell mark, C-2323/*65*.

shell motif, EA; S-4461/*614*.

shell niche, C-5203/*6*①.

shell patera, LAR83/*385*①.

shell-pattern, C-2427/*119*①.

shell pattern, C-5117/*38*; LAR82/ *251*①.

shell-pattern border, C-2437/*4*①.

shell rim, C-0254/*273*.

shells, C-5116/*29*①.

shell scroll support, C-0254/*7*.

shell-shape, C-2458/*179*; EC2/*30*①.

shell-shaped, C-1006/*216*.

shell-shaped back, C-5116/*139*①.

shell-shaped box, CEA/*640*①.

shell-shaped dish, S-3311/*350*.

shell-shaped seat, C-5116/*139*①.

shell silver, DATT.

shell slab inlay, C-5156/*756*①.

shell stem, C-5117/*79*.

shell stretcher, C-2546/*75*.

shell-work, DADA; S-2882/*1038*; SDF.

shellwork, CEA/*635*①; S-2882/ *770*①, *917*; S-3311/*774*①.

shellwork ground, C-5117/*211*.

shellwork rim, S-2882/*1018*.

shelved interior, C-5146/133①;
 S-4905/430①.

shelved superstructure, LAR83/
 400①.

shelving, SDF.

Shemakha, CEA/82①.

Shemakha rug, DADA.

shena knot, DADA/①.

Shêng-erh, EA.

Shêng-i, EA/Shêng-erh.

Shenneh-Fereghan, C-2478/242.

Shensi, CEA/113①.

shepherd and shepherdess, C-1506/
 119.

shepherd scene, C-5174/452①.

shepherd's crook, C-2388/72.

shepherd's crook arm, C-2421/13①;
 SDF.

shepherd's crook arm-support,
 C-2320/27①; C-2522/95①.

shepherds' crook arm support,
 C-2403/114.

Sheraton, CEA/321; LAR82/63①,
 71①, 298①; NYTBA/17;
 OPGAC/235①.

Sheraton, Thomas, ACD; CEA/
 354①; DADA/①; EA/①; EC2/
 91①; SDF/762.

Sheraton design, CEA/314①.

Sheraton style, DADA; EA/①;
 LAR83/341①; SDF/①.

sherbert spoon, C-0254/248.

sherbet, S-4461/43.

sherbet plate, K-710/118.

Sherborne, Norman, C-2489/85①.

sherd, DATT.

sherd (shard), IDC.

sherd, S-4965/219①.

sheroot, C-0906/143.

Sherratt, Obadiah, EA/①.

Sherwood, Thos., LAR82/223①.

sheveret, SDF/①.

shi, C-5156/325①; CEA/575.

shiba buko, IDC.

shibayama, C-2402/248; LAR83/
 532①.

Shibayama manner, C-1082/144.

shibayama style, C-5127/645;
 C-5156/712, 842①; C-5236/792①.

shibori pattern, C-5156/908①.

shibuichi, C-5127/434; C-5236/1824;
 CEA/565, 574①, 575; DADA;
 S-3312/1054; S-4928/111①, 157①;
 S-3312/1048①.

shibuichi-dōshi, DADA.

shield, C-2398/91①; C-2503/38;
 C-5114/173, 332①; DADA;
 DSSA; S-4461/341; S-4905/66;
 S-4922/7①.

shield-back, CEA/399①; DADA;
 EA; LAR82/296①; S-4436/86①.

shield back, C-0279/284; C-0982/32;
 C-1407/45; LAR83/270①.

shield back chair, SDF.

shieldback chair, NYTBA/64①.

shield cartouche, C-0254/144①.

shield decoration, NYTBA/296.

shield-end spoon, EA/wavy-end
 spoon.

shield form, S-4461/530.

shield-form cartouche, S-4461/325.

shield-form reserve, S-4804/80.

Shield Kazak rug, S-4948/50①.

shield mark, C-2427/40; C-2486/
 60①; S-4992/35①.

shield medallion, S-4948/50①.

shield mirror, LAR83/370①.

Shield of Achilles, EA.

shield of David, DATT.

shield panel, C-5156/325①.

shields, C-0279/94.

shield-shaped, C-0982/126; C-1502/
 127; C-2478/45; C-5114/336①;
 FFDAB/26; S-3311/122.

shield-shaped back, C-2357/88①;
 C-2421/17①; C-5005/322①;
 C-5116/60; S-2882/266.

shield shaped back, S-2882/*712*①.

shield-shaped backrest, S-2882/*673*.

shield-shaped case, C-2437/*22*①.

shield-shaped design, S-4414/*73*.

shield-shaped diamond, S-4414/*122*①.

shield-shaped frame, S-4461/*141*.

shield terminal, C-0254/*144*①; CEA/ *584*①.

Shigaraki, C-5156/*796*; C-5236/ *856*①; DADA/*Supplement*; JIWA/ *348*①.

shigaraki-taki, IDC.

Shigaraki ware, JIWA/*357*①.

Shigu script, C-5156/*499*.

Shih Te, C-2458/*424*.

Shih Tsung, EA/*Ch'ai ware*.

shih-tzu, EA/*lion*.

Shijo School, C-5156/*958*.

shim, DATT.

shimimori technique, JIWA/*11*.

Shindand Beluch, OC/*140*①.

Shing, Cum, C-2510/*14*.

Shingen style, JIWA/*187*①.

shingen tsuba, DADA; EA/*Japanese sword-guard*.

shing yao, DATT.

shining black ware, EA/① *Jackfield ware*.

Shino, C-5236/*853*.

Shino vessel, IDPF/*18*①.

Shino ware, EA; JIWA/*348*.

Shino yaki, DADA.

Shinto, C-5236/*1825*.

ship, DSSA; IDPF/*203*.

ship bowl, IDC/①.

ship curve, DATT.

ship decanter, DADA.

Shipibo, S-4807/*88*①.

ship model, C-5116/*32*①.

shipping bowl, S-4905/*62*①.

shipping goods, ACD.

shipping scene, C-0906/*140*.

shippo pattern, JIWA/*206*.

Ship's Barometer, C-2368/*18*.

ships clock, C-0906/*200*.

ship's (Rodney) decanter, EA.

Shiraz, C-0906/*22*; C-2320/*144*; C-2478/*257*; DADA; OC/*217*①, *220*①.

Shiraz design, C-2403/*173*.

shirazi, EA/*carpet edges*.

Shiraz kelim, S-3311/*24*①.

Shiraz kilim, C-0906/*17*.

Shiraz rug, ACD; C-2482/*23*; LAR83/*527*①; S-288/*21*①; S-4461/*758*.

Shire horse, C-2204/*92*.

shiro-nuki-e, JIWA/*49*.

shiro-nuki technique, JIWA/*49, 50*.

Shirshekeri, OC/*205*.

Shirvan, C-2320/*145*; C-2388/*156*; C-2478/*247*; C-5189/*363*; C-5323/ *104*; CEA/*81*①, *83*①; DADA; OC/*142*①.

Shirvan carpet, EA/①.

Shirvan Marasali, S-4948/*15*①, *27*①.

Shirvan rug, ACD; LAR83/*528*①; OC/*234*; S-4461/*760*; S-4796/*42*①.

Shirvan rug fragment, C-2482/*7*.

Shirvan runner, C-0906/*75*.

Shirvan weave, OC/*226*①.

shisham, DADA.

shi shi, IDC/①.

shishi, C-0782/*74*; C-5156/*821*; S-4461/*433*; C-5236/*850*.

shishiaibori, C-5156/*655*; S-4928/*118*.

shishi knop, S-3312/*1143*①.

Shi sou, C-2458/*237*.

shitogi tsuba, DADA.

Shiva Acrylic, DATT.

shivering, DATT.

Shnabelkrug, DADA/①.

Shneider, OPGAC/*156*.

sho, S-4928/*165*①.

shobu, C-1082/*80*.

shochikubai, DADA/①.

shod pad foot, C-5114/*398*①; S-4905/*427*①.

shod slipper foot, C-5114/*305*①, *355*①, *384*①.

shoe, DADA; IDC; IDPF/*24*①.

shoe buckle, C-0706/*9*; C-2409/*172*; CEA/*515*①.

shoe foot, C-5170/*76*①.

shoe horn, C-0254/*140, 242*; C-0706/ *5, 64, 210.*

shoehorn, C-1502/*56.*

shoe lace, C-1506/*72.*

shoe-piece, ACD; SDF/①.

shoe piece, DADA.

shoe piece (in furniture), EA.

Shofu, C-5236/*896*①.

Shoji Hamada, LAR82/*133*①.

shokko pattern, JIWA/*206.*

S. HOLLINS, EA/*Hollins, Samuel.*

shonsui, IDC.

shonsuitei, IDC.

shonzui, DADA.

shoo-fly, CEA/*697.*

Shoo Fly, C-2704/*53.*

shop chair, SDF/①.

shop display cabinet, C-0982/*99B.*

shop-mark, IDC.

shop round, CEA/*55*①.

shop sign, CEA/*538*①.

shop stool, SDF.

short, DATT.

Short, DeGrave & Co, S-4927/*220D.*

Short, J., CEA/*602*①.

Short, Joseph, DADA.

Short and Fenner, C-2904/*38.*

short bob pendulum, S-3311/*110*①.

short bob swing, C-2368/*44.*

short dab, JIWA/*383.*

short drawers, C-5114/*303*①; C-5116/*77.*

short draws, C-1082/*181.*

short flaring neck, S-2882/*1276*①.

short foot, C-2458/*2.*

shorthand characters, JIWA/*53.*

SHORTHOSE, EA/*Shorthose, John.*

Shorthose, J., DADA.

Shorthose, John, EA.

Shorthose & Co., EA/*Shorthose, John.*

SHORTHOSE & HEATH, EA/ *Shorthose, John.*

short jacket, C-1506/*6.*

short mouth, C-5156/*62*①.

short neck, C-2414/*26*①.

short-oil varnish, DATT.

short paint, LP.

short spreading foot, C-2414/*13*①.

short-stapled, OC/*313.*

short waisted neck, S-2882/*1261.*

Shosei, LAR82/*56*①.

Shosoin, IDPF/*83.*

shot, CEA/*101*; DATT.

shot-and-ball gun, C-2476/*87*①.

'shot enamel', LAR83/*174*①.

shot-flask, C-2569/*57.*

shot glass, S-4461/*204.*

shotgun, C-2569/*57.*

shotgun-style, C-2476/*10.*

shot silk, C-1506/*55*①; C-2203/*89*; SDF.

shot vase, LAR83/*443*①.

shou, C-5127/*105*①, *129*; C-5156/ *107, 147*①; CEA/*121*①; IDC/①.

shou character, C-2323/*47*①; C-2458/*124*①, *196*①; EA.

Shou-chou ware, EA.

shoulao, S-4810/*320*①.

Shou Lao, DADA; EA/①.

Shoulao, C-2323/*119*; C-2458/*92, 142, 284.*

shoulder, C-0254/*28*; C-0782/*77*; C-2458/*1, 18, 24*①; C-5005/*227*; C-5114/*3A*; C-5117/*166*①; C-5156/*10*①; CEA/*57*①, *113*①.

shoulder (in furniture), EA.

shoulder, IDC; IDPF/*203*; S-4461/ *28*; S-4905/*192*①; S-4922/*2*①; S-4992/*5*①, *6*①; SDF.

shoulder band, C-0225/*332*①.

shouldered baluster vase, C-2324/ *131*①.

shouldered body, LAR83/*449*①.

shouldered cylindrical form, S-4461/ *18*.

shouldered ovoid, C-2409/*5*.

shouldered ovoid body, S-4461/*82*.

shouldered shade, C-5005/*416*.

shouldered stem, ACD.

shoulder knop, LAR83/*428*①.

shoulder mount, K-711/*124*.

shoulder-stock, C-2476/*14*①.

shou medallion, C-5234/*237*; S-2882/ *190*; S-4810/*294*①.

shovel, C-5153/*73*①; C-5239/*240*; S-4461/*643*; S-4905/*326*.

shovel board, SDF.

shovel-form, S-2882/*947*; S-3311/*622*.

shovel- or shuffle-board table, ACD.

show, LP.

show-card brush, DATT.

show card color, DATT.

show case, DADA.

showframe, C-2402/*176*.

showpiece, IDC.

show-wood, CEA/*299*.

show wood, CEA/*406*; SDF.

Shrapnell, James, C-5117/*481*①.

Shreve, Crump & Low, S-4905/*164*.

shrimp fork, S-4461/*237*.

shrine, C-5236/*811*①; DADA; S-3312/*1067*①.

shrinkage, CHGH/*57*; IDC.

Shri-Yantra, JIWA/*294*.

Shropshire, CEA/*187*.

Shropshire dresser, LAR83/*324*①.

shroud, DSSA.

shrub, SDF.

shrub and tree tile, S-2882/*134*.

shrub label, C-0103/*73*.

Shucco, K-710/*118*.

Shudi, Burkhardt, EA.

Shueisai Yuzan, CEA/*573*①.

shuffle board, SDF/*shovel board*.

shu-fu, IDC; CEA/*111*.

Shu fu, CEA/*118*①.

Shufu, C-2513/*245*.

shu fu porcelain, ACD.

Shufu type, C-2323/*26*①.

Shu-fu ware, EA.

Shu Fu ware, DADA.

shunga, C-5236/*734*; JIWA/*68*; C-5156/*681*.

shunga book, C-5236/*959*.

shunga oban yoko-e, S-3312/*965*①.

Shunkosai, CEA/*569*①.

shuntei, S-3312/*960*.

shunts, C-2904/*189*.

shu-nuri, DADA.

shunzan, S-3312/*960*.

shu t'ai, IDC.

shut-bed, SDF.

shutter, C-2402/*132A*; C-2555/*68*①; CEA/*230*①.

shutter-fall, C-2402/*29*.

shuttering, DATT.

shutting together, CEA/*541*.

shutting up, CEA/*541*.

shuttle, EA.

shuttle ground, IDC.

siana cup, S-4973/*130*①; LAR82/ *90*①.

siberite, RGS/*82*.

Sibeud, H., C-GUST/*95*.

Sibiu, OC/*264*.

Sibley, Richard, S-4922/*35*①.

sibyl, DSSA; RGS/*8*①.

Sicard, Jacques, C-5191/*16*; EC1/ *80*①.

Sicardi, Louis (Luc), EA.

Sicardo, EC1/80①.

Sicardo, Weller, LAR83/64①.

Siccatif de Courtrai, LP.

Siccatif de Haarlem, LP.

siccative, DATT; LP.

Sicilian brown, DATT.

Sicilian jasper, C-2421/129①.

Sicily, EA.

sickle, DSSA.

sickle leaf, S-288/37①.

sickness, EG/293.

sick-pot, IDC.

side, CEA/549; S-4972/248①.

side bed, SDF.

sideboard, ACD; C-0982/30; C-2357/95①; C-2478/101①, 152; C-2910/273; C-5114/317①, 353①; C-5116/74, 85①; C-5153/113; C-5239/244, 252; DADA/①; EA/①; FFDAB/64①; JIWA/321; LAR82/368①; LAR83/348①; NYTBA/66①; S-4812/165①; SDF/①.

sideboard berry dish, S-4804/106①.

sideboard case, EA; SDF.

sideboard-dish, C-2398/31.

sideboard dish, LAR83/572①; S-4804/108①; S-4944/129.

sideboard pedestal, DADA.

sideboard (cupboard) plate, EA.

sideboard table, DADA/①; EA; FFDAB/65①; SDF/①.

sideboy, SDF.

side cabinet, C-0982/13; C-1407/71; CEA/340①; LAR83/263①; S-3311/546①; S-4436/154①; S-4461/573; S-4804/767, 846①, 858; S-4947/124①; S-4988/544①; S-4992/104①.

side carrying handle, C-0982/6.

side chair, C-2402/40; C-5114/279①; C-5116/60; C-5153/94①; C-5156/485①; C-5157/1; C-5239/244;

DADA; EA; S-4436/94; S-4812/117; SDF.

side collet, RTA/86①.

side column, S-4461/126.

side cord, EA.

side drawers, C-0982/9.

side ejector, S-2882/699, 699, 705①.

side-hammer, C-2503/108①; C-2569/67①.

sidehammer, S-4972/259①.

side-handle, C-2402/17.

side-handled, IDPF/229①.

side-lock, S-4972/222①.

sidelock rifle, C-2476/1.

side loop, C-5239/256.

side-pivoted visor, CEA/21①.

side plate, C-1006/41, 168; CEA/31①.

side-rail, C-2476/14①.

side rail, C-5239/249; SDF.

sidereal, C-2489/103.

side-ring, C-2569/38①.

side-saddle skirt, C-3011/52.

side-set, S-4829/81①.

side spur, CEA/29①.

side table, C-1407/64; C-2364/43; C-5116/73; C-5156/484①; C-5167/4①; DADA; EA; S-4436/100①; S-4972/470①; SDF/①.

Siebenbergen, CEA/81①.

Siebenbürger, EA/Transylvanian.

Siebenlehn feldspar, MP/459.

Siegburg, DADA/①; EA/①; S-4972/137①, 393.

Siegburg ware, IDC.

siege helmet, C-2503/69.

Siegel, Gustav, K-711/121.

siege weight, C-MARS/87; LAR82/39①.

siena, S-4436/182; C-2486/236①; DADA; EA/①.

Siena marble, DADA.

Sienese school, DATT/①.

sienna, C-5005/*281*①; DATT; LP.

Sienna marble, S-3311/*506*①.

Sierra Leone copal, DATT.

sieve, DSSA; IDPF/*57*①, *203*.

Siever, G., C-2493/*179*.

Siewers, Carl, C-5117/*303*①.

sifter-spoon, IDC.

sifting spoon, C-1502/*66*.

sight, CEA/*26*①.

sighted, C-MARS/*136*①.

sighting flat, C-2569/*85*①.

sighting scope, C-2904/*256, 266*.

sight-line, JIWA/*6, 255*.

sight size, SDF.

sign, EA; JIWA/*5*; NYTBA/*191*.

signalling telescope, C-1609/*87*.

signal red, DATT.

signature, C-5189/*38*; OC/*31*.

signature laver, S-288/*19*①.

signature panel, S-288/*19*①.

signature seal, JIWA/*6*.

signature stone, S-286/*450*.

sign bracket, EA/*bracket*.

signed, C-2458/*424*; C-5117/*393*①; C-5153/*61*①; S-3311/*808*①; S-4992/*3*①.

signed furniture, DADA.

signed in plate, C-5191/*373*.

signed in rectangular reserve, C-1082/*94*.

signed in the block, C-2409/*149*.

signed in the plate, S-4881/*30*①.

signed JB,, EA/*Brouwer, Justus*.

signet bezel, RTA/*26*①.

signet-ring, RTA/*23*①, *56*.

signet ring, CEA/*520*.

significant form, DATT.

sign paper, DATT.

sign-writer's cutter, DATT/①.

Sikes, C-2904/*82*.

Sikes' hydrometer, C-2904/*194*.

sil, DATT.

Silbermalerei, C-2427/*143*①.

Silbermann, Gottfried, EA.

sileh carpet, EA.

silent butler, C-0254/*15*; S-4461/*178*.

Silenus, DSSA.

Silenus jug, IDC.

Silesia, CEA/*451*.

Silesia Hafner ware, DADA.

Silesian, CEA/*136*①, *428*①; S-4972/*414*.

Silesian glass, ACD.

Silesian stem, ACD; CEA/*423*①; EA/*moulded pedestal, moulded pedestal stem*; EG/*134*①.

silex, DATT.

silhouette, C-0225/*53*; C-2332/*148*; DADA; DATT; EA; JIWA/*5, 6, 73, 258*; LP; NYTBA/*196*①; S-3311/*116*①.

silhouette bust, S-4414/*420*①.

silhouette effect, JIWA/*239*.

silhouette portrait, RTA/*119*①.

silhouette ware, IDC.

silhouette ware bowl, S-4461/*446*.

silica, CEA/*414*; DATT.

silica gel, DATT.

silicone, DATT.

silicon ester, DATT.

silicon-ester painting, LP.

silk, C-2403/*155*; C-2414/*96*①; C-5236/*553, 658*①; DADA; EC2/*26*; S-4461/*66*; S-4507/*1*①; SDF.

silk-backed, C-2421/*114*.

silk-backed trellis mesh, C-2403/*96*.

silk bag, C-0782/*163*.

silk brocatelle, NYTBA/*87*①.

silk case, C-5156/*458*①.

silk chiffon, C-3011/*5*.

silk crepe, C-3011/*3*.

silk crêpe, JIWA/*20*①.

silk damask, C-1506/*43*; C-3011/*86*; C-5116/*75, 161*①.

silk embroidered, C-5114/*198*①.

silk embroidery, NYTBA/*100.*

silk gauze, C-3011/*25.*

silk highlight, S-4948/*65*①.

silk-lined, C-0406/*10*; C-5153/*6.*

silk-pile, OC/*16.*

Silk Qum, C-5323/*61*①.

Silk Route, OC/*108.*

silk rug, C-0906/*23*; DADA.

silk screen, DATT/①.

silkscreen, S-286/*50, 67, 67, 90, 270*①, *284, 293*①.

silk-screen transfer, IDC.

silk stockings, C-1506/*93.*

silk-suspended pendulum, C-MARS/*217.*

silk suspension, S-3311/*413*①.

silk taffetta, C-1506/*12*; C-3011/*105.*

silk thread, JIWA/*201.*

silk velvet, C-3011/*9.*

silk warp, OC/*16*; S-3311/*75A.*

silk weaving, JIWA/*205.*

silkwork, C-1506/*142*; S-4812/*12.*

silkwork picture, C-1506/*141*①; S-4414/*419*①.

silky oak, DATT.

silla, DADA.

Silla dynasty, IDC; LAR82/*142*①; S-3312/*1323*; C-5127/*15*; C-5236/*348*①, *1570.*

Silla Korean, IDPF/*244*①.

Silla period, EA; IDPF/*148.*

sille carpet, EA/*sileh carpet.*

sillon de Caderas, DADA/①.

Silvani & Co, C-2522/*9*①.

silver, C-0254/*34*; C-5239/*42*; CEA/*251*①, *617*; S-4905/*164.*

silver and iridescent glass, LAR83/*442*①.

silver attachment, C-0406/*100.*

silver basket, S-4804/*75.*

silver beaker, S-3311/*627*①.

silver bell, S-4461/*220.*

silver bronze mirror, C-5156/*187.*

silver cabinet, EA.

silver content, C-5156/*226.*

silver deposit, CEA/*477*①.

silver deposit glassware, K-710/*113.*

silvered, C-1603/*137*①; C-2402/*13*; C-2421/*71*①; C-2458/*220*; C-5116/*48*; C-5153/*79*①; S-4972/*491*; S-4992/*11*①.

silvered-bronze, C-5005/*351*①, *367*①.

silvered chapter ring, S-2882/*708*①.

silvered-copper, C-5146/*126*①.

silvered-gesso, C-2403/*113.*

silvered glass, EC1/*55*①, *56.*

silvered (reflective) glass, EG/*194*①.

silvered handle, C-5116/*4.*

silvered-metal mount, C-5005/*334*①.

silvered metal mount, C-5005/*203.*

silvered walnut, C-2522/*15*①.

silver filigree basket, RGS/*31*①.

silver flatware, S-4905/*167.*

silver flatware pattern, EA/*Queen's pattern.*

silver foil, C-5005/*300*①.

silver form, IDPF/*203.*

silver furniture, EA; SDF/①.

silver-gilt, C-0254/*61*①; C-0406/*111*; C-5005/*221*; C-5117/*13*①; CEA/*620*①; DADA; DATT.

silver-gilt (vermeil), EA.

silver-gilt, S-3311/*668*①; S-4804/*147A*①; S-4922/*14*①.

silver gilt, S-4414/*13*①, *234*①; S-4804/*83*①.

silver-gilt and enamel, S-2882/*1010*①.

silver gilt and niello, RGS/*17*①.

silver-gilt mount, CEA/*173*①.

silver-gilt nielloed charka, RGS/*92*①.

silver-gilt riza, RGS/*124*①; S-2882/*543.*

silver glass, DADA/*Supplement.*

silver grain, SDF.

silver inclusion, C-5005/*293*①.

silverine, C-5191/*384*.

silvering, DADA; EA/①; IDC; SDF.

silver knop, S-4414/*270*①.

silver leaf, DATT.

silver-lustre ware, IDC.

silver mark Sterling, EA/*American silver*.

silver mathematical instrument, CEA/*610*①.

silver mount, C-0254/*257*.

silver-mounted, C-0406/*81*; C-0706/*9*; C-1502/*14*; C-2202/*43*; C-2458/*61*; C-5005/*205*①; C-5117/*81*; C-5157/*32*; S-4905/*163*①.

silver mounted, C-0254/*53*; C-2398/*43*; S-4436/*14*.

silver-mounted cup, C-5173/*58*①.

silveroid, S-4461/*306*.

silver overlay, C-0254/*239*; C-5114/*3A*.

silver paint, C-5239/*200*.

silver pattern, IDC/①.

silver-plate, DADA/*Supplement*; S-2882/*620*①.

silver plate, DADA.

silver-plated, S-4804/*668*①.

silver plated, C-0225/*81*.

silverplated, S-4461/*17*.

silver-plated pewter, C-5167/*159*①.

silver-plated ware, DADA.

silver-plate seal, S-2882/*631*①.

silver point, DATT.

silver powder, DATT.

silver-resist, LAR83/*126*①.

silver resist, IDC.

silver riza, RGS/*124*①.

silver shape, IDC/①.

silver sheet, C-2458/*228*; RTA/*156*①.

silversmith, MP/*33*.

silversmithing, EA.

silver stain, DATT.

silver table, C-2403/*99*.

silver tablet, C-5116/*14*.

silver tankard, S-4922/*16*①.

silver tea and coffee set, S-4804/*131*①.

silver tea caddy, EC2/*26*①.

silver thread, C-1506/*20*; OC/*16*.

silver-thread braid, C-2555/*10*①.

silver-topped, C-0706/*57*.

silver toy, EA/*miniature silver*, *miniature silver*.

silver tureen, C-5005/*225*①.

silver vase, C-5005/*227*.

silver white, DATT.

silver wire decoration, LAR83/*219*①.

silverwood, SDF.

silvery iridescence, C-2414/*26*①.

silvery patina, C-2458/*213*.

silvorum, CEA/*594*.

simile Japan, S-286/*126*①.

Simms, Jno., Chipping Norton, C-2489/*162*.

Simone Mirman, C-0405/*154*.

Simon Willard, EC2/*89*①.

simple casting, CEA/*528*.

simple plane, JIWA/*58*.

Simple quadrant, CEA/*612*.

simple-solution varnish, DATT.

Simplex Special Demonstration Model, C-2904/*7*.

Simplex tinplate typewriter, C-0403/*3*.

simple yet perfect teapot, IDC.

simplified outline, JIWA/*77*.

Simpson, Edgar, CEA/*519*①.

Simpson, Ralph, EA.

simulate, S-4972/*95*①.

simulated, C-0982/*276*; C-2402/*8*; C-5117/*190*①.

simulated bamboo, C-5116/*130*①; C-5157/*70*.

simulated bronze, C-5116/*156*①.

simulated diamond bar brooch, S-4414/*7*.

simulated door front, C-1407/*68*.

simulated drawer, C-0982/*83B*; C-1407/*189*.

simulated drawer front, LAR83/ *297*①.

simulated drawer panel, C-0982/*7*.

simulated emerald, S-4414/*40*.

simulated enamel, C-2910/*191*.

simulated fluting and paterae, C-2421/*106*①.

simulated pearls, C-2704/*36*.

simulated porphyry, C-5116/*28*.

simulated rivet, S-4905/*169*.

simulated rosewood, C-0982/*299*; C-5116/*64*①.

simulated stone, C-5174/*236*①.

simulated wickerwork, C-0706/*197*.

simulated wood, C-1006/*21*.

simulating wood grain, C-5117/*342*①.

Simultaneism, DATT; LP.

simultaneity, DATT; LP.

simultaneous contrast, LP/①.

simultaneous representation, DATT/ ①.

simurgh, C-2388/*176*; IDC; OC/ *80*①.

Sinah carpet, EA/*Sehna carpet*, *Sehna carpet*.

sinah knot, EA/*Persian knot*.

Sinandaj carpet, EA/*Sehna carpet*.

Sinas kilim runner, C-1702/*36*.

Sinceny, CEA/*146*①; DADA; EA.

Sinclair Art Pottery, Chester, West Virginia, EC1/*85*.

Sinclaire, H. P., and Company, DADA/*Supplement*.

Sinclaire, H. P. & Company, CEA/ *478*①.

sind lac, DADA.

Sinehbaff, OC/*101*.

Singapore damar, DATT.

Singer, C-2904/*26*.

singerie, DADA; DATT; EA; IDC.

singing-bird box, C-5117/*375*①; EA/ *Bruguier, Charles Abraham*, ①.

singing bird box, CEA/*71*.

singing-bird watch, EA.

Singing Lesson, the, IDC.

single ball knop, CEA/*582*①.

single bead lip, C-5114/*118*①.

single camel bag, OC/*30*.

single-case inro, LAR83/*458*①.

single-centered decorative sense, JIWA/*207*.

single chair, SDF.

single-cut diamond, S-291/*15*; S-4414/*5*①.

single-draw, C-2904/*59*.

single-eared, CEA/*647*①.

single-edged, CEA/*22*①.

single-fired, DATT.

single flap, C-5116/*129*①.

single flower, CEA/*489*.

single hand, S-4927/*85*①.

single-loop pile, EA/*weft loop*.

single lotus base, C-5156/*240*.

single-manual harpsichord, C-2520/ *49*①.

single perspective, JIWA/*10*.

single piece back, C-0906/*264*.

single reed, CEA/*553*①.

single-reeded, EA.

single-ribbed neck, C-2458/*179*.

single-spouted, IDPF/*4*①.

single-strand necklace, S-4414/*70*①, *102*.

single-stroke, LP/*brushes*.

single-stroke brush, DATT/①.

single-train movement, S-4804/*923*①.

single-warp knot, EA/*Spanish knot*.

single-wefted, OC/*15, 19*①.

Sinical quadrant, CEA/*612*.

sinister profile, S-4802/*475*.

Sinkiang, OC/*108, 108*①.

sinking glaze, JIWA/*348*.

sinking in, DATT.

sinopia, DATT.

Sino-Shan, C-2513/*112A*.

Sino Shan, C-2458/*240*.

Sino-Shan drum, LAR82/*52*①.

Sino-Tibetan, C-2458/*247*①, *321*; C-5127/*154*; C-5156/*221, 473*.

Sino Tibetan, C-1082/*100*.

sinter, DATT.

sinumbra, DADA/*Supplement*.

sinumbra (French) lamp, EA.

sinuous dragon, C-0706/*195*.

Siot-Decauville, CEA/*185*①.

Sioux Jeune, C-2364/*5*.

siphon barometer, CEA/*260, 261*①, *268*.

Siqueiros, David Alfaro, S-286/*478*①.

sirènes, C-0225/*185*①.

siren vase, IDC.

Sir Hans Sloane's plants, EA/*Hans Sloane plates*.

Sirjand Afshari, OC/*247*①.

Sir Joshua Reynolds pattern, C-2493/ *27*.

Sisfon, J., C-2904/*282*①.

Sisley, S-286/*452*.

Sisson, J., CEA/*262*①.

Sissons, William, EA/*Roberts, Samuel the Younger*.

sissoo, DADA.

Sisyphus, DSSA.

sitar, C-1082/*176*.

situla, IDC; IDPF/*204*①; S-4804/ *265*①; S-4807/*478*; S-4973/*98*①.

situlate urn, IDPF/*204*①.

sitz bath, SDF.

Sitzendorf, C-2493/*258*; LAR82/ *130*①.

Sitzendorf four branched, C-2502/ *111*.

Sivas, C-2388/*164*.

Sivas rug, C-2403/*183*.

Sivas rugs, ACD.

Six, Hieronimus, S-4927/*63*①.

six-ball armorial device, CEA/*169*.

six-character mark, C-2458/*51*; IDC.

six character-mark (character-mark), IDC.

six dynasties, DADA; C-2458/*6*; C-5156/*382*①; EA; LAR82/*132*①.

Six Figurines suite, C-2409/*38*.

six inch block pattern, C-2704/*112*.

six-leaf screen, LAR83/*334*①.

six-sided pedestal stem, CEA/*428*①.

sixteen-point medallion, OC/*290*.

sixteen-sided bowl, S-4922/*69*①; S-4944/*404*①.

size, DATT; LP; SDF.

size color, DATT.

size gilding, IDC.

sizing, DATT.

Skanska Glasbrucket, EA/ *Scandinavian glass*.

Skeen, William, C-5117/*48, 227*; C-5174/*554*①.

skeleton, C-0279/*216*; C-5157/*12*; DSSA; EC2/*96*①.

skeleton chapter ring, LAR83/*466*①.

skeleton clock, C-2368/*45*; C-5189/ *190*; CEA/*235*; DADA; LAR83/ *208*①.

skeleton glass, SDF/①.

skeletonised signature, C-2489/*84*①.

skeletonized, C-5117/*397*①, *466*①.

skeletonized watch, S-4802/*13*; S-4927/*42*①.

skeleton stock, S-4881/*305*①.

skeleton timepiece, LAR82/*233*①.

skelton clock, EA/①.

sketch, C-5156/*278*; DATT; JIWA/ *45*.

sketch (bozzetto), JIWA/*385*.

sketch, LP.

sketch box, DATT.

sketch form, JIWA/*21*.

sketching, JIWA/*88*.

sketching easel, DATT; LP.

skeuomorph, IDPF/*204*.

skew chisel, DATT.

skewer, ACD; C-5114/*60*; DADA; EA.

skiing outfit, C-3011/*53*.

skillet, ACD; DADA; IDPF/*204*①.

Skillin, DADA.

skim coat, DATT.

skimmer, EA; IDC/①.

skin, DATT; DSSA.

skin glue, LP.

skippet box, EA/①.

S. Kirk & Son, S-3311/*613*.

skirt, ACD; C-0254/*46*; C-2388/*139*; C-2403/*206*; C-2478/*228*; C-5114/ *251, 269*①, *359*①; C-5189/*369*①; OC/*111*; S-288/*7*①; S-4802/*366*①.

skirted base, S-4804/*143*①.

skirt foot, EA; LAR83/*612*①.

skirting, S-4804/*26*.

skirting board, EA/*apron*.

skirting piece, SDF.

skittle, EG/*292*.

skittle-pattern, C-2320/*138, 140*; C-2388/*143*; C-2403/*170*.

skittle pattern, C-2357/*146*.

skittle-pattern border, C-2478/*213*.

skiver, SDF.

skull, DSSA; S-4972/*166*①.

skull garland, C-5234/*21*①.

skull watch, EA/①.

sky blue, DATT.

sky-door, OC/*312*.

skyphos, C-2482/*105*; DATT; IDC/ ①; IDPF/*204*; S-4807/*498, 507*①; S-4973/①; LAR82/*90*①.

SL, EA/*Cristallerie de St Louis*.

slab, C-5116/*169*①; C-5127/*385*; C-5236/*370*①; DATT; LP.

slab A-frame, C-5156/*3*①.

slab bottle, C-2324/*43*①.

slab building, IDPF/*204*①.

slab-built, C-2324/*72*.

slab-constructed, C-5156/*97*①.

slab foot, C-5236/*494*.

slab frame, SDF/①.

slab glass, EG/*245*.

slab lappet foot, C-5156/*47*①.

slab leg, SDF.

slab method, DATT.

slab molded, C-5236/*402*.

slab plate, IDPF/*207*①.

slab pot, IDPF/*206*①.

slab side, C-5156/*80*①.

slab top, C-5116/*92*; DADA.

slack lime, DATT.

slag, C-0225/*335*; CEA/*478*①.

slag, glass, LAR82/*429*①.

slag glass, C-5191/*419*; K-711/*126*; S-4461/*57*.

slag glass frame, C-5239/*307*.

slaked lime, DATT.

slaked plaster of Paris, DATT.

slant, DATT/①.

slant-bar design, C-0279/*10*.

slant-front, C-5157/*132*①; K-802/*15*; S-2882/*283, 379, 385*①; S-3311/ *192*①; S-4436/*96*①; S-4972/ *435*①; SDF.

slant front, C-5116/*108*.

slant-front bureau, C-5116/*108*; S-3311/*504*①; S-4812/*54*①; S-4988/*450*①.

slant-front desk, C-5114/*302*①; C-5153/*121*①; S-2882/*273*①; S-3311/*501*①; S-4461/*589*①; S-4804/*838*①.

slant-front opening, S-2882/*273*①.

slant-front writing desk, DADA/①.

slanting breech, S-4972/*262*①.

slant leaf, C-0279/*33*.

slant-leaf, S-4796/*104*①; S-4847/*7*.

slant-leaf and chalice border, S-4948/ *42*①.

slant-leaf border, S-4948/*15*①.

slant top, C-5114/*302*①.

slant top desk, LAR83/*250*①.

slant-topped book box, NYTBA/*31*.

slat, C-5114/*295*①; C-5239/*247*; EA; SDF.

slat back, S-4905/*384*; SDF.

slat-back, EA/*ladder-back*.

slat-back chair, DADA.

slate, C-2364/*27*; C-2458/*306*; C-2513/*69*; LAR82/*50*①.

slate bed, C-0982/*40*.

slate cameo, S-4843/*513*①.

slate dial, CEA/*605*①.

slate guard border, S-4847/*14*.

slate motif, S-4847/*78*.

slate pigment, DATT.

Slater, T. and W. B., C-2510/*20*①.

Slater, W., LAR82/*233*①.

slate top, C-0279/*375*.

slat-pierced, C-0706/*27*; C-1502/*46*.

slatted, C-2403/*40*; S-3311/*128*.

slatted back, C-0982/*5*; C-1407/*181*.

slatted backs, C-2402/*92A*.

slatted door, S-2882/*376*.

slatted tambour, C-2364/*77*①.

slat top, C-0249/*371*.

Sleath, Gabriel, C-5174/*598*①; C-5203/*194*; CEA/*645*①, *647*①; EA/①.

sleeping chair, DADA; SDF.

sleep sofa, C-5239/*256A*.

sleepy eye, K-710/*118*.

sleepy hollow, DADA.

Sleepy Hollow chair, SDF/①.

sleeve, C-1506/*15*; C-2510/*89*①; EG/*253*.

sleeved waistcoat, C-1506/*23*①.

sleeve inro, C-5156/*707*①.

sleeve vase, C-2458/*76*①; IDC; LAR82/*93*①.

sleigh-bed, C-5167/*198*①.

sleigh bed, ACD; DADA; EA; SDF/①.

slender, C-2458/*403*; C-5127/*101*①.

slender baluster, C-0782/*41*.

slender baluster vase, C-0782/*4*.

slender form, C-5146/*95*.

slender pedestal, MP/*139*.

Slevogt, Max, S-286/*484*.

slice, C-5114/*17*; C-5236/*341*; DATT.

sliced fruit painter, EA/*cut fruit painter*.

slick, LP.

slicker, DATT.

slide, C-0249/*317*; C-1407/*157*; C-2388/*17*; C-2402/*107*; C-2904/*92*; C-5116/*69*, *140*①; C-5239/*91*; S-291/*2*; S-4972/*512*, *556*①; SDF.

slide and button, CEA/*530*①.

slide-enclosed, S-4955/*75*①.

slide mounting, C-0403/*118*.

slide-on cover, S-4944/*387*①.

slider, ACD; EA/*coaster*; SDF/*slide*.

slide repeat, C-5117/*412*①, *424*①; S-4802/*4*①, *59*①; S-4927/*112*.

slide (sliding fire) screen, EA.

slide supports, C-5114/*333*①.

slide trombone, C-0906/*298*.

slide-turntable, C-0403/*191*.

sliding, C-0982/*82C*.

sliding arm support, C-0279/*266*.

sliding box camera, C-1609/*241*.

sliding cock, S-4972/*264*.

sliding cover, C-2458/*286*.

sliding cup, C-5114/*239*.

sliding door, C-1082/*181*.

sliding extending top, C-5116/*133*①.

sliding fire screen, SDF/①.

sliding frame, C-5114/*329*①.

sliding loper, CEA/*339*①.

sliding pin-hole-gnomon, CEA/*606*①.

sliding shelf, C-5116/*138*.

sliding shoulder, C-0254/*165B*.

sliding support, C-5114/*304*①.

sliding suspension ring, CEA/*606*①.

sliding tube, C-2904/*217*.

sliding well, C-1407/*121*.

slightly arcaded, C-5116/*157*①.

slightly barrelled, S-4414/*150*.

slightly domed cover, C-5117/*152*①.

slightly raised foot, JIWA/*318*.

slightly waisted funnel bowl, LAR83/*431*①.

slight wear, C-2403/*197*.

sling, C-2482/*97*; CEA/*30*①.

sling stone, IDPF/*208*.

slip, ACD; C-0782/*163*; C-2403/*37*; C-2458/*1*; C-5127/*26*; C-5156/*6*; CEA/*116*①, *210*, *330*①; DADA; DATT; EA; EC1/*83*; IDC; S-4992/*6*①.

slip-cast form, IDPF/*208*①.

slip-casting, CEA/*210*; EA.

slip casting, DATT.

slip-cast ware, IDC.

slip clay, DATT.

slip-cup, IDC.

slip cup, IDPF/*209*①.

slip-decorated, C-5114/*155*; S-4810/*58*①.

slip decoration, DATT; NYTBA/*125*①.

slip line, C-5236/*424*①.

slip-lock, CEA/*645*①.

slip mold, IDPF/*162*.

slip-on bayonet lid, S-4804/*116*①.

slip-on cap, S-4944/*387*①.

slip-on cover, C-5117/*295*; C-5174/*295*; S-4922/*58A*①.

slip-on domed lid, S-4804/*48*.

slip painting, JIWA/*112*①.

slipped edge, C-5156/*49*①.

slipped in the stalk, CEA/*594*.

slipped-in-the-stalk spoon, EA/*slip-top spoon*.

slipper, IDC/①.

slipper bath, SDF.

slipper box stool, EA; SDF.

slipper chair, C-5170/*42*; DADA/①; EA; S-3311/*400*①; S-4461/*678*; S-4804/*909A*①; SDF.

slipper feet, C-5153/*75*①.

slipper foot, DADA.

slipper rocker, SDF.

slippers, C-1506/*85*.

slipper-shaped, IDPF/*146*.

slipper side chair, C-5005/*326*.

slipper vase, LAR83/*641*①.

slips, CEA/*294*.

slip seat, C-5114/*364*①, *395*①; S-4461/*593*①; S-4905/*374*①, *403*①; SDF.

slip-stem spoon, DADA.

slip-top (slipped-top) (slipped-in-the-stalk) spoon, EA/①.

slip trailer, IDPF/*209*①.

slip trailing, DATT.

slipware, ACD; DADA; EA; IDC; IDPF/*14*; LAR82/*102*①, *180*①; LAR83/*84*①.

slit, C-5117/*17*①, *220*; C-5146/*128*①.

slit-and-window sight, CEA/*604*①.

slit-head, CEA/*697*.

slit-kilim tapestry, OC/*134*.

sliver, C-5156/*355*①.

Sloan, John, S-286/*485*.

Sloane, Hans, flowers, IDC/①.

Sloane, Sir Hans, EA.

Slodtz, Antonie-Sébastien, Paul-Ambroise, EA.

Slodtz, Réné-Michel (Michel-Ange), EA.

Slodtz,René Michel, DADA.

slop-basin, C-5117/*318*①; C-5153/*21*①; DADA.

slop basin, C-5114/*51*; EA/①.

slop-bowl, C-1006/*57*; C-2427/*4*①; IDC; LAR83/*65*①.

slop bowl, C-0782/*140*; C-1006/*211*.

slopbowl, C-2486/*68*①.

sloping, C-2402/*8, 116*.

sloping crossbanded flap, C-2403/*72*.

sloping flap, C-0982/*9, 301*.

sloping lid, C-2403/*75*.

sloping line, JIWA/*16*.

sloping lip, C-5156/*9*①, *158*.

slot, CHGH/*58*.

Sloth, DSSA.

slot screwing, SDF.

slotted, C-1506/*2*; C-1603/*105*.

slotted scoop, S-4461/*209*.

slotted spoon, S-4461/*383*.

Slovakia, CEA/*451*.

Slover and Taylor, CEA/*401*①.

slow-beating cylinder watch, C-2489/*148*.

slow-drying size, DATT.

slow-motion device, CEA/*605*①.

slow wheel, IDC.

slub, OC/*276*.

slush molding, DATT.

slut, SDF.

S machine, EG/*253*①.

small animal figure, MP/*468*①.

small bowl, C-1006/*71*.

small chair, EA/*side chair*; SDF.

Small Charger, S-4843/*13*①.

small compartment, C-5157/*29*①.

small-diameter support, JIWA/*378*①.

Small Fluted, CEA/*56*①.

small house, C-2704/*26*; CEA/*56*①.

small repeating pattern, OC/*203*.

small rim, C-2458/*102*.

small-scale pattern, NYTBA/*86*①.

small sculpture, MP/*112*.

small single bag, OC/*30*.

small sofa, C-2421/*43*.

small sword, C-2569/*40*①.

smallsword, CEA/*44*; DADA; S-4972/*251*.

small-tall clock, EA/*dwarf-tall clock, dwarf-tall clock*.

small work box, C-5116/*1*.

smalt, DATT; IDC; LP.

smaltino, DADA; IDC.

smalto, DATT.

smaragd green, DATT.

Smart, John, John II, EA.

S. Maw Sons & Sons, C-2904/*294*.

smear glaze (in ceramics), EA/①.

smear glaze, IDC; MP/*502*.

smelling bottle, CEA/*48*①.

Smillie's bath, DATT.

Smith, Anne, C-5117/*52*.

Smith, Apsley, Stephen, EA/*Smith, Benjamin the Younger*.

Smith, Beck & Beck, C-2904/*66, 107*.

Smith, Benjamin, C-2510/*51*①; C-5117/*136*①; C-5174/*500*; CEA/*659*①.

Smith, Benjamin and James, CEA/*661*①.

Smith, Benjamin II, C-2510/*74*①.

Smith, Benjamin III, S-4944/*261*①.

Smith, Benjamin Jr., C-5153/*48*.

Smith, Benjamin the Elder, Benjamin the Younger, EA.

Smith, Benjamin the Younger, EA.

Smith, D., LAR82/*626*①.

Smith, Daniel, C-0270/*164*①; C-5117/*68*①.

Smith, Donavit Guilielmus, EA/*216*.

Smith, Edward, C-5117/*22*①.

Smith, Evan, EA/*Roberts, Samuel the Younger*.

Smith, G., C-2487/*147*.

Smith, George, C-2421/*91*①; C-2487/*128*; C-5117/*248*; DADA; EA; S-4922/*34*①; SDF/*763*.

Smith, George II, C-5117/*46*①.

Smith, George Jr., C-5174/*530*.

Smith, J. H., C-2493/*156*.

Smith, London, C-2489/*153*; C-2503/
159.

Smith, Robert, C-5117/*209, 281*.

Smith, Sampson, EA/①.

Smith, Sissons & Co, EA/*Roberts,
Samuel the Younger*.

Smith, Stephen, C-5117/*203*①.

Smith, Thomas, C-2489/*64*.

Smith, Thomas C., CEA/*207*①.

Smith, William, K-710/*117*.

Smith and Wesson revolver, CEA/
*40*①.

Smith Brothers, EC1/*68*.

Smith & Chamberlain, S-4905/*167*.

Smith II, Benjamin, C-5117/*30*①.

Smith Premier No. 10 typewriter,
C-0403/*10A*.

Smith's, S-4881/*313*①.

Smiths, C-2409/*170*.

Smith's blue, CEA/*193*①; EA/
Derby, Derby blue; IDC.

Smith & Sons, C-2368/*98*.

Smith's patent carbine, C-2503/*101*.

Smith & Wesson, C-2476/*11*①.

smoke crystal, S-4810/*154*①.

smoked, C-2458/*426*.

smoked glass, LAR82/*439*①;
LAR83/*433*①.

smoke-jack, EA/*spit*.

smoker's bow, K-802/*15*; SDF/①.

smokers' bow, EA.

smoker's chair, SDF.

smoker's companion, SDF.

smoker's set, C-5239/*104*.

smokers set, C-1502/*91*.

smoker's tongs (pipe-tongs)
(ember-tongs), EA/①.

smoker's tongs, SDF.

smokey, C-5239/*132*.

smokey quartz, LAR82/*74*①.

smoking, DATT.

smoking-room chair, SDF/①.

smoking set, C-0225/*222*; C-0254/
271; C-5174/*215*.

smoking stand, C-5239/*261*.

smoking utensil, C-5156/*695*①.

smoky, NYTBA/*292*.

smoky glass, C-2409/*12*.

smoky quartz, C-5117/*342*①.

smooch, DATT.

smoothing, IDPF/*55*①.

S Mordan, C-0706/*64*.

S-motif, C-2357/*128*; C-2388/*146*;
C-2478/*221*; S-4948/*30*①.

Smyrna carpet, EA.

Smyth, J., C-0706/*232*; LAR82/
*598*①.

Smythier, Robert, CEA/*641*①.

snail, OPGAC/*236*.

snail cam regulator, C-5117/*422*①.

snail curl, S-4965/*105*①.

snail dish, IDPF/*209*.

snail foot, C-1502/*146*.

snail-form ewer, C-5174/*429*①.

snailing, EA.

snake, DSSA.

snake chain, S-4414/*147*.

snake finial, C-0254/*64*.

snake foot, ACD; C-5153/*106*;
DADA; S-2882/*316*; S-3311/
*111*①; S-4461/*609*; S-4905/*449*①.

snake handle, C-2427/*214*; CEA/
*164*①; MP/*172*; S-4461/*103*.

snake head terminal, S-4965/*119*①.

snakelike coil, IDPF/*98*.

snake-link, S-4927/*483*.

snake loop handle, C-0254/*292*①.

snake on lace, CEA/*495*①.

snake ornament, S-4927/*378*①.

snake paperweight, LAR83/*437*①.

snake-pipe, IDC/①.

snake ring handle, S-4802/*237*①.

snakeskin effect, JIWA/*349*①.

snakeskin glaze, JIWA/*324*①.

snake-skin green (Chinese glaze), EA.

snakestone, DATT.

snake terminal, S-3311/*746*①.

snake-thread glassware, EG/*156*.

snake wood, ACD.

snakewood, DATT; SDF.

snap, DATT.

snap-action Purdey bolt, C-2476/*66*.

snaphance, DADA.

snaphaunce, ACD; CEA/*23*①, *44*.

snap (tilt-top) (tip-top) table, EA.

snap table, SDF.

snap-top table, LAR82/*400*①; LAR83/*369*①.

snap-underlever, C-2476/*4*.

snare, CEA/*549, 556*.

snarling iron, EA.

Snider, CEA/*37*.

snip-spout, IDC.

Snow, Jo, CEA/*230*①.

snowball vase, IDC.

snowflake, C-2427/*253*.

snowflake motif, C-5174/*275*.

snowflake pattern, S-4414/*123*.

snowman figure, EA; IDC/①.

snuff bottle, ACD; C-2458/*334*①; C-5127/*301*; C-5236/*1735*; DADA.

snuff bottle (in Chinese ceramics), EA.

snuff bottle, EG/*214*①; JIWA/*303*①; LAR83/*646*①; S-4810/*1*①.

snuff-bottle, C-1082, *157*; C-5117/*365*①; C-5220/*10*①; IDC.

snuff box, ACD; C-0254/*68*; C-1502/*87*; C-2202/*6*; C-5114/*97*; C-5173/*4*①; DADA; IDPF/*209*①; LAR83/*605*①; S-3311/*715*①; S-4802/*135D*①; S-4804/*222*; S-4922/*23*①.

snuffbox, CEA/*527, 540*①; FFDAB/*12*①; MP/*161*; S-4905/*127*①.

snuff-box, C-5117/*45*; CEA/*50, 61*.

snuff-box (tabatière), EA.

snuff-box, IDC/①; RGS/*105*①.

snuff coloured, C-1506/*58*①.

snuff dish, S-4810/*240*①.

snuffer, ACD; C-1502/*107*; C-2202/*44*; C-2364/*6*; C-2487/*114*; C-5114/*53*①; C-5117/*99*①; CEA/*646*①; DADA/①; EA/*316*①; S-3311/*737*; S-4461/*243*; SDF.

snuffer stand, ACD; C-5117/*99*①.

snuffer's tray, S-4802/*215*.

snuffers tray, C-0406/*131*; C-0706/*188*; C-1502/*107*; C-2202/*191*; C-5203/*200*; CEA/*650*①; LAR83/*630*①; S-4922/*66*①.

snuffer-tray, C-2487/*114*; C-5117/*52*.

snuffer tray, ACD.

snuff grater, DADA.

snuff mull, LAR82/*36*①; LAR83/*591*①.

snuffmull, C-5117/*1*.

snuff pipe, IDPF/*209*①.

snuff (tobacco) rasp, EA/①.

snuff rasp, LAR83/*62*①.

snuff spoon, ACD; DADA; EA.

Snuff-taker, the, IDC.

snuff-taker's set, C-2458/*419*.

soak, DATT.

soap basin, C-0249/*357*.

soap box, DADA/①; EA/①.

soap dish, C-0254/*234*; C-0782/*159*; IDPF/*209*①.

soaprock, IDC.

soaprock or soapstone, ACD.

soaprock porcelain, EA/*Caughley*; IDC.

soapstone, C-0782/*197*; C-2458/*299*; C-2482/*87*; C-5156/*173*; CEA/*187*; DATT.

soapstone (soap-rock) (steatite), EA.

soapstone (soaprock), IDC.

soapstone (steatite), JIWA/*310*.

soapstone, LAR82/*472*①; S-4461/*4*.

soapstone cup, C-1082/*166*.

soapstone figure, C-1082/*121*.

soapstone porcelain, CEA/*195*①.

soapstone (soap-rock) porcelain, EA.

soba cup, C-5156/*815*.

sociable, EA/*confidante, confidante*; SDF/①.

Socialist Realism, DATT.

social realism, LP.

social table, EA; SDF/①.

Société des Artistes Indépendants, LP.

Société des Vingt, LP.

society mask, S-4807/*390*①.

Society-of-Arts, C-2904/*97*.

Society of Arts and Crafts, DADA/ *Supplement*.

Society-of-Arts-type microscope, C-0403/*139*.

Society-of-Arts type microscope, C-2608/*55*.

society portrait, JIWA/*247*.

sock, C-1506/*97*.

sock-boot, IDC.

sock darner, C-5191/*374*.

socket, C-0254/*165*①; C-2202/*44*; C-2421/*63*①; S-4972/*142*①.

socket bayonet, C-2503/*106*.

socle, C-0225/*366*; C-0279/*55*①; C-2409/*249*; C-2421/*3*①, *8*①; C-2437/*12*①; C-5189/*7*; C-5259/ *158*①; EA; IDC; S-2882/*508*①, *522*①, *353A*; S-3311/*287*①; S-4461/*249*; S-4972/*90*①; S-4992/ *13*①; SDF.

soda, CEA/*414*.

soda glass, CEA/*503*; DADA.

soda-glass, EA.

soda lime glass (lime glass), DADA/ *Supplement*.

soda-lime glass, DADA/*Supplement*.

soda-lime (lime-soda) glass, EA.

soda-lime glass, EG/*39*①.

soda-lime-silica glass, EG/*236*.

sodalite, C-2458/*349*.

soda syphon, C-0706/*44*.

sodium silicate, DATT.

sofa, ACD; C-2388/*21*; C-5114/ *273*①; C-5116/*112*; DADA; EA; S-4461/*608*; SDF/① *settees*.

sofa à pommier, DADA.

sofa bed, EA; SDF/①.

sofa-table, CEA/*355*①.

sofa table, ACD; C-0982/*65*; C-2357/*60*①; C-2388/*49*; C-2402/ *64*; C-2403/*95*①; C-2478/*81*; C-5116/*80*; DADA; EA/①; LAR82/*24*①, *408*①; LAR83/ *391*①; S-4812/*121*①; SDF/①.

sofa writing table, C-5116/*133*①.

soffit, ACD; SDF.

soft chün, DADA.

softener, DATT.

softground, S-286/*282*①, *283*.

soft-ground etching, C-0249/*92*; DATT; S-286/*82*, *445*①, *471A*①.

softground etching, S-286/*447*①.

softly polished, C-5156/*320*.

soft-metal, S-4928/*108*.

softmetal, C-1082/*98*.

soft modelling, C-5156/*28A*.

soft-paste, CEA/*110*; IDPF/*202*①.

soft paste, DADA; DATT.

softpaste, C-5127/*112*; C-5156/*66*; C-5236/*1611*.

soft-paste, Chinese, IDC.

soft paste plaque, C-0249/*307*.

soft-paste porcelain, ACD; CEA/ *65*①, *169*, *210*; DATT.

soft-paste (artificial) porcelain, EA.

soft-paste porcelain, IDC; MP/*15*.

soft paste porcelain, DADA/*soft paste*.

soft-paste porcelain factory, EA/ *Tournai*.

soft soap, DATT.

soft solder, DATT.

soft steel, DATT.

softwood, DADA; DATT; SDF.

Soho Arabesque, C-2522/3①.

Soho Manufactory, EA.

Soho Manufactury, CEA/516①.

Soho tapestry, C-2522/3①; CEA/ 331①; DADA; LAR83/262①.

Soho Tapestry Works, EA/①.

soi-disant, LP.

soiling, C-0249/3.

Sokolov, M. F., C-5117/320.

Solanier, Paul, S-4922/11①.

Solanier, Pierre, C-5203/100①.

solar, C-2904/196①.

solar lamp, DADA/Supplement.

solder, CHGH/59; DATT; EA.

soldered, NYTBA/216.

Soldner, Paul, DADA/Supplement.

soleil, C-5005/355①.

soleret, DADA/①.

solferino, DATT.

solid, C-2478/8; LP.

solid agate ware, EA; IDC/①.

solid ball knop, CEA/424①.

solid baluster splat, S-4414/449①.

solid casting, EA.

solid cock, S-4802/132A.

solid colour, C-2704/60.

solid cube, C-2458/3.

solid end standard, C-0982/212.

solid jasper, IDC.

solid seat, S-4972/473①.

solid splat, NYTBA/45①.

solid stage, C-2904/45.

solid trestle end, C-2357/51①.

Solis, Virgil, C-5173/68①; EA.

solitaire (in china), LAR82/153①.

solitaire, S-4853/163①.

solitaire ring, RTA/94; S-291/46.

solitaire service, IDC.

Solkets, C-5191/208.

Solnhofen stone, DATT.

Soloman, William, S-4944/374.

Soloman Marrs & Co., C-2904/67.

Solomon's seal, DATT/①.

Solon, Louis, S-4947/3①.

Solon, Louis Marc, DADA/ Supplement.

Solon, Marc, ACD.

Solon, Marc-Louis (Miles), EA.

Solon, Marc Louis, NYTBA/178①.

soluble blue, DATT.

solvent, DATT; LP.

solvent naphtha, DATT.

solvent retention, DATT.

sölvgass, RGS/84.

Solvychegodsk enamel, RGS/52.

Somada, C-5236/1648.

Somada brocade, C-5236/783.

Somada Hisamitsu and kakihan, CEA/573①.

Somada style, C-5236/783.

Somada taste, C-5127/442; C-5156/ 736①.

sometsuke, JIWA/348.

sometsuke ware, IDC.

Somme, Thomas, C-5189/156①.

Sommerfeldt, Jens Kieldsen, C-5203/ 55.

Sondag, Rudolph, EA.

Song dynasty, K-711/125; LAR83/ 477①; C-2323/4; C-2414/49①; C-2458/19; C-5236/429, 1586; S-3312/1312①.

Sŏngju Changhŭng-go, CEA/129①.

Song taste, C-5156/398.

Song ware, S-4965/214.

Song/Yuan Dynasty, C-2458/28①.

Sonnenschien, J. V., CEA/181①.

Soochow, C-2458/334①, 365①.

soot, MP/166.

soot brown, DATT.

Sophia Young Wrought, C-2704/*29*.

Soqui (Saqui) (Lequoi), EA.

Soqui, Monsieur, CEA/*200*①.

sorbet dish, C-2324/*117*.

Sorel cement, DATT.

Sorgenthal porcelain, EA/*von Sorgenthal, Konrad*.

Sormani, Paul, C-2364/*58*①; C-5181/*205*①; C-5189/*350*①.

soroimono, DADA.

Sosson, L., C-5191/*135*.

sosuke, namikawa, DADA.

Soten school, LAR83/*661*①.

sotto in sù, DATT/①.

soufflé blue, EA/*Mazarin blue*; IDC.

soufflé dish, EA; IDPF/*210*.

souffle ground, C-5127/*44*; C-5236/*488*①.

Soufflot, Jacques Germaine, NYTBA/*60*.

Souf Kashan rug, S-4796/*176*; S-4847/*255*①.

Souj-Bulak, DADA.

Souj Bulak, CEA/*91*①.

soul house, IDPF/*210*.

soumac, C-2478/*219*; LAR82/*545*①; S-4847/*24*①.

Soumac bag, S-4847/*1*①.

Soumac bagface, S-4796/*16*①, *137*.

Soumac carpet, S-4796/*140*①; S-4948/*7*①.

Soumac stitch, S-4847/*129*.

Soumac stitch carpet, S-4461/*835*.

Soumac stitch skirt, S-4847/*28*.

Soumain, Simeon, EA/①.

soumak, C-2357/*152*; C-5189/*403*; C-5323/*100*; CEA/*77*, *82*①; DADA.

Soumak bagface, C-5323/*24*①; LAR83/*529*①.

soumak carpet, EA/*sumak carpet*; C-0279/*28*①.

Soumak rug, ACD.

sound post, CEA/*556*.

sound-post, CEA/*552*①.

soup bowl, S-4461/*2*.

soup coupe, C-2409/*68*; C-2910/*106*.

soupière, IDC.

soup ladle, C-1502/*100*; C-5114/*69*; C-5153/*30*; LAR83/*580*①; S-3311/*632*; S-4905/*191*.

soup-ladle, C-2398/*14*; C-5117/*40*①, *83*①.

soup paddle, S-4881/*485*①.

soup plate, C-0782/*20*; C-1006/*125*; S-4804/*135*.

soup-plate, C-2398/*29*; C-5117/*110*, *234*.

soup spoon, C-5114/*16*; S-4804/*28*①, *35*; S-4905/*160*; S-4922/*34*①.

soup tureen, C-0254/*30*①, *84*①, *145*; C-1006/*41*; CEA/*633*①; EA/*tureen*; LAR83/*635*①; S-4804/*34*; S-4922/*48*①, *51*①.

soup-tureen, C-2398/*3*, *38*①; C-5117/*128*①; C-5153/*17*①; RGS/*179*①.

soup-tureen and cover, C-5117/*129*.

soup-tureen liner, C-5117/*180*.

Souroural, J., C-5239/*19*.

souscription watch, S-4927/*67*①.

Southall, Birmingham, C-2503/*167*.

South American gold and silver, C-5174/*478*①.

South Bohemia, CEA/*451*.

South Boston Flint Glass Works, CEA/*462*①.

South Chung-cheong, CEA/*129*①.

southern barbarian type, JIWA/*186*①.

Southern Calendar Clock Co., CEA/*248*①.

southern Kuan ware, EA.

Southern Porcelain Company, CEA/*205*.

Southern Rose pattern, C-0254/*221*.

Southern Song Dynasty, C-2458/ 24①; C-5127/17; C-5156/36.

Southern Sung dynasty, CEA/117①.

Southern Sung period, JIWA/88.

Southern Tang period, JIWA/88, 88.

South Jersey glass, EA/①.

South Jersey type glass, CEA/459①.

south Persian long rug, S-3311/9.

South Staffordshire enamel, EA/①.

Southwark delftware, EA; IDC.

souvenier spoon, C-1502/58.

souvenir, DADA/①.

souvenir box, EA/*Birmingham enamel.*

souvenir card case, C-0906/143.

souvenir lapel watch, C-5174/423①.

souvenir spoon, C-0706/141; S-4461/ 239.

souvenir watch, EA.

sou'wester, C-3011/75.

sovereign's mark, NYTBA/213.

Sovereignty, Twelve emblems of, IDC.

S over L, EA/*Schleswig.*

sow, CEA/541.

Sowerby, CEA/450①.

Sowers, Robert, DADA/*Supplement.*

soya bean oil, DATT; LP.

soy-bottle, C-5117/279①.

soy frame, C-5174/584; EA.

soy pot, IDC.

SP, EA/*Pantin, Simon.*

spa box, C-0906/108.

space, JIWA/10; LP/①.

Space Arts, LP.

spaced, S-4922/9①.

spaced concentric, CEA/489.

spaced millefiori, CEA/491①.

spaced-out fluting, IDPF/99①.

spacer, S-4881/87①.

space time, LP.

spackle, DATT.

Spackman, Thomas, S-4944/410①.

spa cup, IDC.

spade, DSSA.

spade cap, S-4905/404①.

spade device, C-5167/256.

spade foot, C-0249/373; C-0982/88A; C-1407/69; C-2402/8; C-5114/ 260①, 282①, 336①, 346①, 347①; C-5116/58; C-5153/117①; CEA/ 338①; DADA; FFDAB/75; LAR82/369①; SDF.

spade hand, S-4802/4①.

spade-shaped, C-2458/316.

spade-shaped bowl, C-5153/8.

spade-shaped vase, C-2324/48①.

spadroon, C-2569/21; CEA/32①.

Spain, CEA/581.

spall, DATT.

spallen/niet spallen, C-MARS/240.

spandrel, ACD; C-2357/71①; C-2402/175; C-2478/179; C-5116/ 18; C-5157/33①; C-5323/36①; CEA/79①, 101, 225①, 268; DADA; EA; S-288/6①; S-2882/ 85, 123①; S-3311/5, 18, 19; S-4414/539; S-4804/966; S-4948/ 180①; SDF.

spandrel piece, ACD.

spandril, SDF/*spandrel.*

spangled, CEA/473①; EG/192.

spangled-glass, DADA.

spangled glass, EC1/56, 67①.

Spanish art nouveau, DADA/ *Supplement.*

Spanish Baroque, S-3311/469①.

Spanish black, DATT.

Spanish carpet, DADA; EA.

Spanish ceramic, EA.

Spanish chair, DADA; SDF/①.

Spanish chestnut, SDF.

Spanish colonial, S-4461/515; LAR82/293①; S-4972/81①.

Spanish foot, C-2402/19; C-5114/ 397①; C-5153/99, 201①; C-5170/

89; DADA; EA; LAR83/*268*①;
S-4905/*380*; SDF/①.

Spanish-form barrel, C-2503/*206*①.

Spanish glass, EA/①.

Spanish gold and silver, EA.

Spanish (single-warp) knot, EA/①.

Spanish lace, DADA; CEA/*474*①.

Spanish leather, SDF.

Spanish mahogany, SDF/*San Domingo mahogany.*

Spanish red, DATT; LP.

Spanish series tapestry, C-5224/*217*①.

Spanish tapestry, EA.

Spanish trencher, EA.

Spanish ware, IDC.

Spanish Wheel design, C-2203/*109*.

Spanish white, DATT.

span-rail, SDF.

spare glass, C-5117/*478*①.

spare toe, SDF.

sparkguard, LAR83/*225*①.

sparking lamp, DADA.

spar oblisk, S-4988/*416*①.

sparrow, DSSA.

sparrow-beak, IDC.

sparrow-beaked jug, EA/*bird-beaked jug, bird-beaked jug.*

sparrow-beak spout, LAR83/*69*①.

sparrow pot, IDPF/*22*.

Sparta, C-0906/*63*; C-2320/*169*.

Sparta carpet, C-0906/*65*; C-2482/*13*; C-2546/*199*.

Sparta rug, DADA.

spar urn, S-4436/*15*①.

spar urns, C-5157/*17*.

spar varnish, DATT.

spar vase, C-5157/*16*.

sparver, DADA; SDF.

spat, C-1506/*30*.

spatial divider, JIWA/*5*.

spatial relativity, JIWA/*157*.

spatter, CEA/*473*①; DATT.

spatter glass, ACD; EC1/*56*; EG/*192*.

spatter pattern, JIWA/*231*.

spatter ware, EA/*sponged ware*; IDC.

spatterware, C-5114/*160*①; CHGH/*62*; DADA.

spatula, DATT.

spatulate, S-4965/*119*①.

spatulate foot, S-2882/*1344, 1347*①, *1353*.

spatulate handle, C-5114/*20, 101*.

spatulate terminal, C-5114/*94*①.

spaudler, C-MARS/*104*①.

Spaulding, C-5117/*421*.

Spaulding and Co., C-5117/*425*①.

Speakman, Edward, LAR82/*200*①.

spear, C-2458/*1*; C-MARS/*47*;
DSSA; S-4972/*275A*.

spearhead, S-4905/*16*①.

spearhead band, C-0782/*42*.

spearhead border, IDC.

spearhead decoration, C-0249/*267*.

spearhead design, C-5323/*26*.

spear-head spoon, DADA.

spear prism, C-5181/*5*.

spear tip band, C-0254/*263*.

spear tip border, C-0254/*82*.

specchiai, EA/*Venetian glass.*

special grade, C-5117/*420*.

specie jar, CEA/*54*①.

specimen flower, C-5189/*90*.

specimen flower spray, C-1006/*84*.

specimen marble, C-2546/*117*①;
C-5224/*171*①.

specimen marble top, NYTBA/*70*①.

specimen rotator, C-2608/*99*.

specimen-top, S-4804/*860*①.

specimen vase, C-0706/*96*; C-1502/*23*; C-2202/*96*.

speckled, C-5146/*151*①; C-5239/*14*.

Speckled Agate, S-4843/*351*①.

spider wheel, DATT.

spider work, DADA.

spigot, C-0254/*170*; C-0270/*117*①;
C-5114/*35*①, *121*; C-5117/*148*①,
*305*①; C-5153/*14*①; EA;
FFDAB/*67*; IDPF/*18, 210*;
S-4905/*6*①.

spigot block, IDPF/*38*.

spike, C-0249/*454*①; C-5116/*36*;
C-5157/*8*; S-4972/*141*①.

spike, oil of, LP.

spiked shoulder, C-5174/*462*.

spike foot, LAR83/*637*①.

spike lavender, DATT.

spike oil, DATT.

Spiller, Gottfried, EA.

spill holder, C-2202/*62*; LAR83/
*174*①.

spill-vase, C-1006/*107*; C-2502/*62*;
IDC.

spill vase, C-5181/*29*; C-5236/*334A*;
LAR82/*177*①.

Spilsbury, Francis II, C-5174/*547*.

Spilsbury, John, CEA/*692*①.

spinach jade, C-2458/*318*①; C-5127/
*286*①; C-5236/*329*; C-5259/*41*;
DADA.

spinach nephrite, C-5236/*1691*.

spindle, ACD; C-0249/*386*; C-2478/
18; C-5114/*289, 319*; C-5116/*119*;
DADA; DSSA/①.

spindle (in furniture), EA.

spindle, S-2882/*773*; S-4461/*596*;
SDF.

spindle-and-baluster, SDF.

spindle-and-bead, SDF.

spindle back, C-1407/*93*; S-4436/*113*;
S-4461/*642*.

spindle-back chair, SDF.

spindleback settle, K-710/*120*.

spindled, C-0982/*55, 98A*; C-1407/
146; C-2402/*72*; S-4972/*493*.

spindled backrest, S-4812/*117*.

spindled gallery, C-2402/*125*.

spindle feet, C-5174/*188*①.

spindle-filled, C-2388/*9*.

spindle-filled trestle end, LAR83/
*397*①.

spindle form superstructure, S-2882/
688.

spindle-galleried, C-2498/*71*.

spindle-galleried division, C-2403/*42*.

spindle gallery, LAR82/*294*①, *399*①;
SDF.

Spindler, J. F. and H. W., C-2555/
*52*①.

spindle splat, C-2388/*74*.

spindle support, LAR82/*274*①.

spindle whorl, IDPF/*210*.

spindle wood, DADA.

spine, C-5117/*372*①; OC/*18*.

spinel, RGS/*70, 199*①; S-4927/*320*.

spinet, ACD; C-2520/*53*; CEA/*548*;
DADA; EA/*harpsicord family*, ①
harpsichord family; SDF.

spining top, C-0406/*69*.

Spink & Son, LAR82/*592*①.

Spinner, David, EA.

spinning, CEA/*594*; DATT; EA/
metal spinning; NYTBA/*216*.

spinning mark, NYTBA/*216*.

spinning wheel, ACD; CEA/*357*①;
DADA; SDF.

spinning-wheel, the, IDC.

spiral, C-2458/*232*; C-5146/*117*.

spiral and leaf motif, C-2704/*85*.

spiral cable stem, CEA/*433*①.

spiral column, C-0982/*37*.

spiral-column back, C-1407/*107*.

spiraled triangular section, LAR83/
*445*①.

spiral filigree, RGS/*67*.

spiral-fluted, C-0249/*287*; C-0706/*3,
247*; C-1502/*14*; C-2202/*13*;
C-5114/*300*①; C-5116/*46*①, *135*;
S-4436/*75*①.

spiral fluted, C-0254/*30*①.

spiral fluted caster, C-0254/*20*.

spiral fluted design, RTA/*27*①.

spiral fluted side, C-0254/*71*.

spiral fluting, C-0254/*49, 89*;
 LAR83/*537*①; S-4804/*112*①.

spiral form, RTA/*153*①.

spiral gadrooning, RTA/*80*①.

spiral handle, S-4461/*373*.

spiraling band, S-2882/*1215*①.

spiraling metal, S-4461/*39*.

spiralled, C-0982/*28*.

spiralled panel, C-0254/*52*.

spiralling, C-2403/*186*.

spiralling comma, C-5156/*758*①.

spiralling line, C-2414/*66*①.

spiralling lobe, S-4804/*141*①.

spiralling petal, C-2414/*77*; C-2458/
 33.

spiralling rib, S-4853/*9*①.

spirally-fluted, C-1502/*109*.

spirally fluted stem, S-4436/*19*.

spirally-gadrooned, C-2421/*74*①.

spirally gadrooned, LAR83/*164*①.

spirally lobed lower body, S-4414/
 280.

spirally milled, C-2364/*2*.

spirally molded, S-4414/*359*.

spirally-moulded, C-2458/*93*.

spirally moulded, C-2427/*24*; C-2437/
 16.

spirally paneled domed base, S-4922/
 *5*①.

spirally-ribbed branch, C-2357/*5*①.

spirally-ribbed column, C-5005/*230*①.

spirally turned, S-4414/*417*①.

spirally turned columnar stem,
 S-4414/*467*①.

spirally-turned frame, C-2437/*68*①.

spirally-turned leg, S-4461/*606*.

spirally-turned shaft, C-2357/*47*①.

spirally turned top rail, S-4414/*443*①.

spirally twisted, C-1006/*27*; S-4972/
 *248*①.

spirally-twisted support, C-2421/*52*①.

spiral ornament, S-4461/*445*.

spiral pattern, IDC.

spiral purchase, CEA/*668*①.

spiral rib, LAR82/*183*①.

spiral-ribbed, S-2882/*1336*.

spirals, C-2704/*62*.

spiral scroll, RGS/*105*①.

spiral seed, C-5156/*340*.

spiral shell finial, C-5117/*187*①.

spiral threading, C-5114/*149*①.

spiral-turned, C-5116/*168*①; S-4461/
 9.

spiral-turned leg, S-2882/*785A*①.

spiral turned leg, S-2882/*256*.

spiral-turned legs, C-5116/*91*.

spiral-turned support, C-0279/*325*.

spiral turning, ACD; DADA; SDF.

spiral twist column, LAR82/*293*①.

spiral-twisted, S-2882/*1278*.

spiral twisted stem, S-2882/*1077*.

spiral twist leg, S-2882/*336*.

spiral-twist pilaster, C-5114/*276*.

spiral-twist stem, LAR83/*353*①.

spiral-twist trumpet-form body,
 S-2882/*1349*.

spiral-twist vase, C-5153/*122*①.

spire, C-1702/*162*; C-5116/*44*;
 C-5181/*121*.

spirea band, OPGAC/*236*.

spirit, DATT.

spirit-barrel and stand, IDC/①.

spirit bottle, C-2513/*454*①; IDPF/
 *210*①.

spirit-burner, S-4461/*241*①.

spirit burner, DADA.

spirit burner stand, S-4461/*296*①.

spirit case, DADA; SDF.

spirit flask, C-0254/*187*; C-0406/*6*;
C-1502/*47*; C-5173/*16*; LAR83/
*577*①.

spirit fresco, DATT.

spirit lamp, C-0254/*182*.

spirit level, C-0403/*190*; C-2368/*2*.

spirit-measure, EA.

spirit screen, C-5127/*355*.

spirit thermometer, C-2489/*32*.

spirit varnish, DATT; LP.

spit, DATT.

spit-dog, EA; SDF/①.

spit-jack, EA.

spitoon, C-5203/*65*.

spit-out, DATT.

spit-rack, SDF.

spitstick, DATT.

spittoon, EA; IDC/①; IDPF/*212*;
S-4905/*317*; SDF/①.

spit: turnspit, spit-jack, smoke-jack,
bottle-jack, hastener, EA.

splad, SDF/① *splat*.

splad or splat, ACD.

splash, C-2458/*34, 252*; C-5156/*8*.

splashback, LAR83/*408*①.

splashboard, C-5239/*243*; FFDAB/
65.

splashed, C-2414/*35*①; C-2502/*44*;
C-5236/*854*; CEA/*473*①.

splashed and spattered, EG/*27*.

splashed lustre, IDC.

splashed ware, IDC.

splashes, C-5127/*22*.

splash glaze, S-4965/*163*①.

splash-glazed, S-4963/*54*①.

splash glazed, LAR83/*162*①.

splash rail, S-4436/*151A*①; S-4988/
*523*①.

splashrail, S-4812/*165*①.

splat, C-0249/*321*①; C-0982/*32*;
C-1407/*8*; C-2402/*7, 95*; C-5114/
*265*①, *290, 364*①; C-5116/*127*①;
C-5127/*332*①; CEA/*313*①; EA;

FFDAB/*29*①; S-4905/*460*①;
SDF/①.

splat, splad, CEA/*406*.

splat-back, C-2402/*39*; DADA.

splat back, C-0279/*291*; C-0982/*30,
75*.

splay, SDF.

splayed, C-0982/*2, 49*; C-2402/*27*;
C-5114/*49*; DADA; S-4804/*12*①;
S-4972/*528*①.

splayed base, C-2388/*87*①; IDC.

splayed bracket foot, C-1407/*54*;
C-2320/*53*①; S-4414/*438*①,
*454*①, *495*①, *521*①; S-4436/*90*;
S-4812/*9*.

splayed circular foot, S-4461/*274*.

splayed downswept leg, S-4414/*531*①.

splayed flambeau, C-2364/*12*①.

splayed foot, C-2458/*236*; C-5116/
*149*①; C-5146/*160*①; FFDAB/*92*;
LAR82/*253*①; S-2882/*1374*;
S-4461/*234*; SDF.

splayed front leg, C-5127/*347*.

splayed joint, SDF.

splayed leg, C-0249/*324*; C-0279/
*356*①; C-2357/*51*①; C-2388/*32*;
C-2403/*31*; C-5114/*382*①;
C-5116/*89*; LAR82/*321*①; SDF.

splayed-out leg, CEA/*355*①.

splayed reeded leg, C-2421/*75*①.

splayed rim, IDPF/*123*.

splayed rim foot, S-4804/*21*.

splayed tail, S-3311/*295*①.

splayed terminal, CEA/*584*①.

splayed trestle end, LAR83/*400*①.

splay foot, LAR83/*362*①.

splay-fronted, SDF/①.

splay support, LAR82/*355*①.

spliced, S-4972/*606*.

spline, DATT/①.

splint seat, DADA; EA.

split, C-5117/*44*①; C-5236/*933*①;
CHGH/*57*; S-4972/*230*.

split and slashed form, IDPF/*212*①.

split baluster, S-4812/47①; SDF/①.

split bobbin, SDF.

split claw, RTA/156①.

split complementary, LP.

split-end spoon, EA/*trefid spoon*.

split-hair border, S-4847/170.

split-hair motif, S-4948/71①.

split handle, SDF.

split moulding, C-0982/44, 91.

split pearl, C-5117/472①; S-291/105①; S-4927/125.

split-pearl bezel, C-5174/328①.

split pearl border, LAR83/243①.

split pin, C-5236/392①.

split pine wood, MP/28.

split ring, C-5156/395.

split second chronograph, C-5117/432; S-4802/35, 106.

split spindle, CEA/390①; SDF.

split stitch, CEA/274①.

split tapestry technique, S-4948/87①.

split tiger decoration, S-4963/16①.

splitting, S-288/13①.

split turning, EA; SDF.

split wood dowel, S-4881/52.

Spode, ACD; C-1006/11; C-2502/18; C-5189/16; CEA/158①; DADA/①; EA/*Spode, Josiah, II, Spode, Josiah, I*; LAR82/177①; LAR83/85①.

Spode, Josiah, CEA/160①; NYTBA/180.

Spode, Josiah, I, EA/①.

Spode, Josiah, II, CEA/187; EA.

Spode and Stone China, CEA/160①.

SPODE Felspar Porcelain, EA/*Spode, Josiah, II*.

Spode transfer print, C-2458/93.

spoke, C-2370/29①.

spolvero, DATT.

sponge-box, C-2487/39.

sponge box, DADA/① *soap box*.

sponged decoration, C-5114/160①.

sponge decoration, NYTBA/143①.

sponged effect, C-2513/372①.

sponged ground, IDC.

sponged manganese, C-2486/187①.

sponged tree, C-2427/187.

sponged ware (spatter ware), EA/①.

sponged ware, IDC.

sponging, IDC.

sponsen, EA/*pounce*.

spontaneity, LP.

spontaneous combustion, LP.

spontoon, C-MARS/55; DADA.

Spook School, DADA/*Supplement*.

spool, NYTBA/40.

spool furniture, SDF.

spool (capstan) (pulley) (scroll) salt, EA/①.

spool-shaped, C-1502/161; C-2202/151.

spool-shaped base, C-2398/96①.

spool-turned, NYTBA/40.

spool turning, ACD; EA.

spoon, ACD; C-5117/14; C-5156/427; C-5174/239①; CEA/579, 582①; DADA/①.

spoon (in clock), EA.

spoon, IDC; IDPF/212①; S-4905/48①.

spoon-back, ACD; C-0982/202; C-5170/42; DADA; EA; LAR82/363①.

spoon back, LAR83/278①, 280①; SDF/①.

spoon-box, C-5117/14.

spooned, C-5114/395①.

spooner, DADA.

spoon gouge, DATT.

spoon-hand, CEA/697.

spoon rack, DADA; EA.

spoon rest, C-5127/266①.

spoon-stand, IDC/①.

spoon-tray, DADA; IDC.

spoon tray, C-1006/*97*; C-2458/*153*; EA; S-4905/*55*; S-4944/*391*①.

spoontray, C-2486/*127*.

spoon-warmer, IDC.

sporran, C-0604/*33*.

sporting gun, C-2476/①; S-4972/*160*①.

sporting lustreware, IDC.

sporting pistol, CEA/*26*①.

sporting rifle, C-2476/*5*.

sporting subject, IDC.

spotlighting, JIWA/*49*.

spotted celadon, DADA.

spotted design, C-0225/*282*.

spotted ground, C-0225/*72*; C-5239/*115*.

spotted muslin, C-2203/*100*.

spot test, IDC.

spout, C-0706/*192*; C-2202/*2*; C-2458/*13*①; C-5153/*16*①, *18*①; EC2/*30*①; IDC; IDPF/*214*①; S-4461/*361*; S-4905/*13*①.

spout and bridge, IDPF/*215*.

spout-cup (feeding cup), EA/①.

spout-cup, IDC.

spout cup, DADA/①.

spouted, S-4972/*131*①.

spouted bowl, IDPF/*200*①, *215*①.

spouted jar, C-5156/*27*.

spoutlike lip, IDPF/*70*.

spout-pot, IDC.

S. P. Q. P. (Senatus populusque Palermitani),, EA/*Palermo maiolica.*

spray, C-0782/*9*; C-1006/*15*; C-5005/*218*①; S-4905/*90*①.

spray design, S-291/*58*①.

sprayer, DATT/①.

spray form mount, S-4414/*71*.

spray gun, DATT; LP.

spray pressure can, LP.

sprays of roses, C-2704/*22*.

spray technique, JIWA/*267*①.

spreader, IDC.

spreading base, S-4461/*210*; S-4922/*15*①, *18*①.

spreading block foot, C-2320/*39*①.

spreading circular base, C-1502/*8*; S-2882/*1267*①.

spreading circular foot, C-2202/*27*; C-5117/*59*; S-2882/*902*①.

spreading domed foot, C-5117/*73*①, *189*①; S-4804/*8*.

spreading flute, C-5116/*151*①; C-5224/*132*.

spreading foot, C-0254/*44*; C-0782/*110*; C-2398/*5*; C-2458/*26*; C-5114/*50*; C-5117/*5*; C-5127/*15*; CEA/*641*①; LAR82/*440*①; S-4922/*8*①, *58*①.

spreading gadrooned central foot, C-5117/*98*①.

spreading hexafoil foot, LAR83/*583*①.

spreading leaf-tip, S-4922/*2*①.

spreading molded foot, S-4804/*53*.

spreading oval foot, C-0706/*26*; C-5117/*129*.

spreading plinth, C-5156/*5*.

spreading polygonal stem, C-2421/*79*①.

spreading reeded base, C-5117/*50*.

spreading reeded foot, C-5117/*47*①.

spreading rim, S-4905/*189*①.

spreading rim foot, C-0254/*64*; C-5117/*6*; S-4804/*11*①.

spreading shaft, C-2458/*225*.

spreading square base, S-4804/*87*.

spreading stem, C-2364/*2*.

spreading stepped base, S-4461/*205*.

spreading tripod base, C-5116/*69*.

spread-wing eagle, C-5114/*345*①.

sprezzatura, DATT.

sprig, DADA; S-4461/*398*; SDF.

sprigged, C-1006/*86*.

sprigged gauze, C-1506/*10*.

sprigged muslin, C-1506/*83*.

sprigged ware, DADA; IDC/①.

sprigging, CEA/*210*; DATT; EA; IDC.

sprig-moulded, CEA/*155*①.

sprig of daisies, C-2704/*85*.

Sprimont, Nicholas, ACD; CEA/*187, 188*①; EA.

spring (in clock and watch), EA.

spring, EC2/*89*; S-4972/*155*①.

Spring as motif, C-2364/*14*①.

spring back base, C-5239/*269*①.

spring barrel, C-0403/*118*.

spring bayonet, C-2503/*141*.

spring detent, C-5117/*484*①; S-4802/*30*①; S-4927/*89*.

spring détente escapement, RGS/*179*①.

spring detent escapement, EA.

spring detent platform escapement, C-2368/*40*①.

spring-driven, EC2/*96*①.

spring driven, CEA/*222*①.

Springfield Armory, CEA/*42*①.

spring foot-detent, C-2489/*126*.

springing point, SDF.

spring loaded, C-0906/*110*; S-4972/*269*①.

spring-loaded door, S-4927/*174*①.

'spring of Chosroes', OC/*144*.

Spring of Chosroes carpet, EA.

spring-opener, C-2476/*20, 104*①.

spring-operated drawer, C-2522/*44*①.

spring revolving chair, SDF.

spring rocker, NYTBA/*76*.

springs, ACD.

spring spindle, SDF.

springtime picture, JIWA/*68*.

spring-tongs, EA/*sugar tongs*.

spring upholstery, SDF.

sprinkler, EG/*78*①; IDPF/*215*①; JIWA/*302*.

sprinkler bottle, C-2513/*463*; S-4807/*531*.

sprocket, C-2403/*165*; CEA/*238*①.

sprout, C-5117/*6*.

spruce, SDF.

spruce ochre, DATT.

sprue, CEA/*528, 542*; DATT; RTA/*141*①.

sprung over regulator, C-5117/*400*①, *451*①.

sprung superstructure, LAR83/*318*①.

spun brass gong, C-5236/*1706*.

spun glass, CEA/*449*①; EA/①.

spur, C-2503/*77*; C-5117/*92*①; C-5156/*47*①; C-5236/*424*①; CEA/*232*①; DATT; IDC; S-4972/*240*.

spur-ground, IDC.

spur-mark, IDC.

spur mark, C-2414/*90*①; C-5127/*5*①; C-5236/*406*①; S-4965/*158*.

spur motif, EA/*alicate, alicate*.

spurred-arch, S-3311/*212*.

spurred arched, S-4905/*326*.

spurred arched support, S-4905/*321*.

spurred-arch support, C-5114/*229*.

spurred butt-cap, C-2569/*74*.

spurred pommel, C-2503/*214*①.

spur stretcher, SDF/①.

spur trigger-guard, C-2569/*96*①.

spy-glass, EA/①; LAR83/*465*①.

spy glass, C-5220/*9*①.

spy glasses, C-2904/*237*.

spy-hole, CEA/*552*①.

squab, CEA/*325*①; DADA; SDF/①.

squab cushion, C-2403/*79*; C-2421/*58*①; C-2437/*43*; C-2478/*90*; C-2498/*75*.

squab seat, LAR83/*267*①.

square, C-0982/*88A*.

square-back, FFDAB/*29, 29*①.

square back, C-5114/*346*①.

square baluster vase (Chinese ceramic form), EA.

square base, C-0254/*136*①; C-0406/
31; C-0782/*212*; C-2398/*2, 26*;
C-5117/*46*①.
square base with canted corner,
S-2882/*700*①.
square bead, C-5156/*320*.
square-carved, S-4881/*298*①.
square contour, S-4414/*190*.
square-cut emerald, RGS/*194*①;
RTA/*193*①; S-291/*67*①.
squared C-handle, C-0254/*319*.
squared edge, C-5239/*179*①.
squared feature, C-5156/*252*①.
squared frame, S-4414/*44*.
square dial, C-2368/*67*①.
square dish, C-0249/*266*; C-0782/*42*.
squared loop handle, C-5156/*80*①,
*425*①.
square drum, CEA/*549*.
squared scroll, C-5156/*107*.
squared spiral, C-2323/*57*①; C-2513/
*87*①; C-5236/*548*.
squared wire, RTA/*152*①.
square-eared, C-5116/*126*①.
square emerald-cut diamond, S-291/
*107*①.
square fluted leg, S-4414/*452*①.
square form, S-4922/*4*①.
square fruit bowl, C-1006/*41*.
square-geared, S-4927/*215*①.
square handle, C-5127/*37*.
square hood, LAR83/*194*①.
square jar, C-2458/*45*; C-5127/*29*.
square jardiniere, C-1006/*153*.
square-knot, OC/*22*.
square leg, CEA/*309*①, *396*①.
square-legged stand, C-2388/*43*;
C-2403/*120*.
square line-inlaid, C-5114/*373*①.
square mesh bag, S-4414/*44*.
square mount, C-0225/*243*.
square-mouthed bowl, IDPF/*216*①.
square-off, LP/①.

square paw foot, C-0249/*456*①.
square pedestal base, C-0225/*366*;
S-4414/*344*①.
square pedestal foot, C-0254/*108*;
S-4414/*339*①.
square piano, C-0982/*94B*; CEA/
*550*①; SDF/①.
square plaque, C-1082/*83*.
square plate, EC2/*23*①.
square plinth, C-5117/*161*①;
C-5153/*24*①; MP/*492*①.
square seal mark, C-2458/*123*.
square section, S-4461/*22*; S-4972/
*325*①.
squares edged, C-2704/*46*.
square-shaped emerald, S-4414/*76*①.
square shoulder, IDPF/*228*.
square shouldered leg, C-5236/*548*.
squares of fawn, C-2704/*56*.
square tapered leg, C-5114/*377*①;
S-4414/*436*①.
square tapering, C-0982/*174*;
C-2402/*38*.
square tapering leg, C-2421/*93*;
C-5116/*74*.
square tapering vase, C-0782/*58*.
square tiered plinth, C-5234/*192*①.
square top, C-0982/*12*.
squaring, DATT.
squaring off, DATT.
Squash Blossom pattern, C-0225/
100B.
squat, C-0782/*30*; C-1006/*103*;
C-2202/*84*; C-5156/*66*; S-4804/*14*.
squat bulbous form, S-4461/*15*.
squat domed body, LAR83/*176*①.
squat foot, S-4461/*390*.
squat form, S-4928/*164*①.
squat globular form, S-4461/*103*.
squat globular teapot, C-1006/*56*.
squat-jar, C-2910/*110*.
squat mallet shape, LAR83/*413*①.
squat melon form, LAR83/*613*①.

stagantler netsuke, S-4829/*11*①.

stage, DATT.

stage adjustment, C-0403/*126*.

stagecoach, LAR83/*659*①.

staggered panel, S-3312/*1267*.

staggered warp, OC/*21*①.

staghorn, S-4461/*297*; S-4972/*156*①.

staghorn furniture, DADA/
Supplement.

staghorn grip, C-MARS/*2*.

stagshorn, C-5127/*457*; C-5156/
*689*①; LAR83/*457*①.

stags' horns, EA/*Ludwigsburg*.

Stahly, Claude, DADA/*Supplement*.

Staigg, Richard Morell, EA.

stain, C-5239/*241*; DATT; LP.

stained, C-0982/*86*; C-1082/*134*;
C-2402/*88*; C-2458/*417*; C-2498/
162; C-5116/*33*; CEA/*484*;
S-4461/*727*; S-4972/*489*①.

stained-agate, C-5117/*344*.

stained enamel, C-5239/*128*.

stained fruitwood, S-4955/*187*①.

stained glass, C-0249/*158*; DADA/
①; DATT; EC1/*56*; EG/*50*①;
LAR82/*447*①; LAR83/*440*①;
S-4972/*4*①.

stained-glass lamp shade, NYTBA/
306.

stained glass panel, C-5224/*226*①.

stained-glass window, JIWA/*264*.

stained horn, S-4955/*31*.

stained lustre, IDC.

stained pine, C-1407/*99*.

stained star, C-0279/*421*①.

stained sycamore, CEA/*303*.

Stainer, C-0906/*275*.

staining, C-0249/*6*; DADA.

staining power, DATT.

stainless steel, DADA/*Supplement*;
RTA/*194*①; S-4922/*34*①.

stair ramp, CEA/*542*.

stake, CEA/*678*; DSSA; EA.

stalactite glass shade, C-5167/*250*①.

stalk, C-2458/*306*.

Stalker and Parker, ACD.

stalk form handle, C-5189/*20*.

stalk-like, C-5127/*73*.

stalky marquetry, C-2555/*58*①.

stall, SDF/①.

St-Amand-les-Eaux, CEA/*149*①.

stamnos, DATT; IDC/①; IDPF/*217*.

stamp, C-5174/*22*.

Stamp, James, S-3311/*767*; S-4944/
294.

stamp box, C-5146/*157*; C-5239/*91*.

stamp case, C-1502/*22*.

stamp decoration, C-1407/*94*.

stamped, C-0906/*364*; C-2476/*51*;
C-5005/*208*①; C-5114/*51*;
C-5116/*172*①; C-5117/*27*①;
C-5156/*95*; C-5236/*392*①; CEA/
*629*①; IDC; S-4804/*30*①; S-4905/
169.

stamped anthemion border, C-5153/
*21*①.

stamped beaded border, C-5117/*227*.

stamped border, C-5114/*42, 59*①.

stamped brass, C-5114/*286*①.

stamped brass rim, C-5114/*163*.

stamped brocade, LAR83/*233*①.

stamped classical decoration, S-4804/
*32*①.

stamped floral border, C-5114/*108*.

stamped furniture, CEA/*345*①.

stamped leaf border, C-5114/*47*.

stamped leather, DADA; S-4881/
*361*①.

stamped out, CHGH/*58*.

stamped scrollwork border, C-5117/
*68*①.

stamped velour, C-0982/*2*; C-1407/
63.

Stamper, Francis, CEA/*231*①.

Stampfer, Hans Jacob, EA.

stamp holder, C-0706/*58*.

stamping, CEA/*510, 540*①.

stamping (die-stamping), EA.

stamping, IDC; NYTBA/*216*; SDF.

stampino, a, IDC.

stamp moistener, S-4804/*218*①.

stamp numbered, S-286/*433*.

stamp signature, S-286/*539*.

stamp signed, S-286/*474*.

stand, C-0249/*334*; C-0279/*433*;
 C-1006/*210*; C-2458/*146*①;
 C-5114/*282*①, *318C*; C-5116/*57*;
 DADA; EA; IDPF/*217*①; S-4461/
 33, 604; S-4843/*162*①; S-4905/
 *70*①; S-4922/*24*①; S-4965/*244*①;
 SDF.

standard, ACD; C-0249/*238*; C-2402/
 13; C-5114/*184*①; C-5189/*249*;
 CEA/*542*; S-2882/*812*; S-4461/
 488; S-4507/*6*①; S-4992/*23*①;
 SDF; C-0249/*362*; EC1/*73*①.

standard Afghan ersari, OC/*186*①.

standard chair, LAR83/*276*①.

standard chest, SDF.

standard form, C-5117/*3*①, *97*.

standard glaze, C-0225/*14*; C-5239/*9*.

standard grimace, JIWA/*69*①.

standardized pose, JIWA/*27*.

standard lamp, LAR83/*486*①.

standard mark, C-5173/*9*①.

Standard trunk, C-0279/*329*.

stand-away hinge, CEA/*50*; EA.

stand bullseye, C-0403/*133*.

standing, SDF.

standing bedstead, SDF.

standing bowl, IDPF/*218*①.

standing-breech, C-2476/*64*.

standing caryatid, C-1082/*63*.

standing china shelf, C-2421/*52*①.

standing corner cabinet, LAR83/
 *310*①.

standing corner cupboard, C-2403/
 138.

standing cup, ACD; C-5173/*58*①;
 DADA/①; EA; LAR83/*571*①;
 S-4905/*168*①.

standing cup and cover, S-4802/
 *222*①.

standing cupboard, SDF.

standing lamp, C-0249/*163*.

standing model, C-1006/*194*.

standing mortar, C-5116/*53*.

standing official bead, C-5234/*221*①.

standing salt, ACD; CEA/*639*①.

standing salt: bell, hour-glass,
 pedestal, steeple, spool, EA.

standing scale, S-4927/*220D*.

standing tray, EA; SDF.

standish, ACD; CEA/*647*①, *657*①;
 DADA; EA/*inkstand*; IDC/①;
 S-4461/*174*; S-4905/*340*①; SDF;
 S-4461/*76*①.

Standish pattern, C-0254/*252*.

stand oil, DATT; LP.

St. Andrew cross, S-2882/*219*①.

St. Andrew's cross, DATT; RGS/
 *133*①.

Stangenglas, EA/①; EG/*101*①.

stangen-glass, CEA/*417*①.

Stangers, The, CEA/*460*①.

Stangl, J. Martin, C-5191/*8*.

Stanley, C-2904/*71*.

Stanley, W. F., London, S-4927/
 220E.

St. Anne, C-5189/*339*①.

St. Anne marble top, S-4823/*186*;
 S-4972/*592*.

stannic oxide, CEA/*456*①.

stanniferous, IDC.

stanniferous glaze, DATT.

stannum, CEA/*579*.

St. Anthony's cross, DATT.

Stanton, C-2476/*80*.

Stapart's ground, DATT.

staple, LP.

staple gun, DATT.

stave, C-1082/*51*; C-MARS/*52*; CEA/*21*①, *503*; EG/*293*; LAR82/*449*①; S-4881.

stave sheath, CEA/*495*①.

stavet, RGS/*160*.

stay, CEA/*542*.

staybar, CEA/*542*.

stay rail, FFDAB/*35*; S-4905/*374*①.

stay-rail, S-4905/*429*①.

stays (in furniture), EA.

stays, SDF/①.

St. Basil's Cathedral motif, C-5174/*276*.

St.-Cloud, NYTBA/*169*①.

St. Cloud, C-2427/*2*.

St. Cloud factory, MP/*15*.

St C over T, EA/*Saint-Cloud*.

steady, DATT.

steady rest, DATT.

steaked, C-5146/*157*.

steak knife, C-0254/*262*.

Steamboat, CEA/*464*①.

steamer, C-5236/*864*①.

steamer chair, SDF/①.

steamship and other boats on the sea, C-2704/*27*①.

steam-softened carved member, CEA/*345*①.

Ste. Anne marble, S-4955/*78*.

steatite, ACD; CEA/*187*; DATT; EA; IDC.

steatite scarab, C-2482/*77*.

stecca, DATT.

stecco, ACD.

stecco, a, IDC.

Stedman, OPGAC/*236*①.

steel, C-2569/*82*①; C-2904/*284*①; C-5117/*41*; C-5189/*129*①; CEA/*516*①; DATT; S-4461/*297*; S-4972/*160*①.

Steel (Steele), Thomas, EA.

steel blade, C-0706/*115*; C-5117/*137*①; S-4922/*38*①.

steel blue, DATT.

steel comb, CEA/*549, 555*①.

steel engraving, CHGH/*63*; S-4881/*374*①.

steel facing, DATT.

steel framed, C-0982/*84*.

steel furniture, EA.

Steelkraft, C-5239/*270*①.

steel-link, S-3311/*504*①.

steel pallet, C-2368/*91*①.

steel pinion, CEA/*218*.

steel rim lock, CEA/*531*①.

steelyard, NYTBA/*260*.

steeple, C-0279/*73*; C-5114/*231*.

steeple clock, EA; EC2/*91*①.

steeple cup, DADA.

steeple (obelisk) cup, EA/①.

steeple cup, LAR83/*570*①.

steeple finial, C-5114/*231*.

steeple salt, EA.

steep side, C-2414/*76*①.

stegkanne, LAR83/*514*①.

Steiff, K-710/*118*; K-711/*130*.

stein, IDPF/*218*; LAR83/*136*①; NYTBA/*182*; CEA/*550*①; IDC.

Stein, Johann Andreas, EA.

Steindorff & Co., C-2904/*224*.

steingut, CEA/*210*; DADA; EA; IDC.

Steinkabinettstabatieren, EA.

Steinlen, Theophile, S-286/*29*.

Steinlen, Theophile Alexandre, S-286/*88*.

Steinschonau, CEA/*451*.

steinzeug, CEA/*210*; DADA; EA/①, ① *stoneware*; IDC.

stele, C-5127/*149*; C-5156/*196*; C-5167/*15*①; C-5236/*1748*; S-3312/*1249*①.

Stella, C-5181/*79*①.

Stella, Frank, S-286/*508*①.

stellar, C-2388/*156*.

stellar device, S-4461/*101*.

stellar motif, C-2478/*216*.

stellate, DADA/①; DATT; S-288/*25*①; S-4905/*376*.

stellate form, S-4988/*440*①.

stellate motif, S-4955/*73*①.

Stellingwerf, Jacob Henrik, C-5117/*173*.

stem, C-2421/*111*①; C-5114/*37*①, *132*①; C-5117/*121*①; C-5153/*42*①; IDC; S-4802/*116*; S-4881/*158*①; S-4972/*311*.

stem base, IDC.

stembowl, S-3312/*1365*.

stem-bowl, C-2323/*148*①.

stem cup, C-2414/*52*①; C-2458/*165*①; C-5156/*77*.

stem cup (Chinese pottery form), EA/①.

stem cup, IDC/①; IDPF/*218*①; JIWA/*340*.

stemcup, LAR83/*117*①; S-4965/*217*①.

Stem-cup, CEA/*119*①; DADA.

stem dish, C-0782/*26*; C-2458/*113*①; C-5236/*1570*.

stem-form handle, S-4414/*352*①.

stem jar, C-5127/*15*.

stemma, C-2546/*112A*.

stem saucer base, CEA/*464*①.

stem scroll, S-2882/*111*.

stem-scroll, EA/*Baluchi carpet*.

stem stitch, CEA/*282*①.

stemware, C-5146/*90*; S-4461/*484*; S-4804/*673*①.

stemware service, S-4804/*669*①.

stem wind, C-5117/*400*①; S-4802/*57B*.

Stenberg, Marianne, DADA/*Supplement*.

stencil, C-5236/*1498*; CEA/*170*①; JIWA/*5*; LP, ① *brushes*.

stencil coloring, S-286/*527A*.

stencil cutter, DATT/①.

stenciled, C-5114/*206*; S-4905/*354*①.

stenciled decoration, C-5114/*326*①.

stenciling, DATT.

stencil knife, DATT/①.

stencilled, C-5005/*374*①; S-4461/*595*; S-4905/*428*①.

stencilled decoration, C-5239/*255*.

stencilled firm's mark, C-5005/*315*.

stencilled lustre ware, IDC.

stencilling, C-5153/*84*; IDC.

stencil mark, C-2493/*6*.

stencil method, JIWA/*199*.

step-cut, RTA/*94*.

step-cut decanter, CEA/*448*①.

step-cut design, EG/*265*①.

step cutting, CEA/*445*①.

step-domed cover, CEA/*656*①.

step down base, LAR82/*506*①.

Stephan, Pierre, C-2360/*123*; CEA/*201*①.

stephane, S-4807/*513*; S-4973/*146*①.

Stephens, Tams, & Company, CEA/*208*①.

Stephens, William, CEA/*205*.

Stephen Smith, C-0406/*137*.

stepped, C-0225/*64*; C-2403/*103*; C-5005/*330*①; C-5114/*84*①; C-5236/*542, 1586*; C-5239/*58*.

stepped and domed lid, S-4804/*44*①.

stepped and hooked medallion, C-2478/*215*.

stepped and indented motif, C-2478/*214*.

stepped base, C-0249/*279*; C-2421/*3*①; C-5156/*190*①; CEA/*643*①; LAR82/*208*①; LAR83/*203*①; S-4414/*249*.

stepped circular base, S-4461/*207*.

stepped circular foot, S-4414/*175*.

stepped circular lid, C-5114/*119*①.

stepped circular pedestal foot, S-2882/*974*①.

stepped conical finial, C-2323/*21*①.

stepped cornice, C-5005/*340*①.

stepped cover, C-5117/*291*①.

stepped curve, SDF/①.

stepped cylinder, C-5005/*211*.

stepped cylindrical plinth, S-2882/ *1027*①, *1060*.

stepped dentate motif, C-GUST/ *103*①.

stepped flowerhead, S-4948/*18*①.

stepped flowerhead border, S-4414/ *544*.

stepped fluting, C-5005/*343*.

stepped foot, C-2458/*169*; LAR83/ *429*①.

stepped handle, C-5005/*247*.

stepped interior, S-4988/*473*①.

stepped lid, EA; LAR82/*71*①; S-4461/*393*.

stepped lotus base, S-4461/*475*.

stepped marble base, C-0225/*136*.

stepped medallion, S-2882/*42*, *118*; S-3311/*11*.

stepped medallion border, S-2882/ *81*①, *207*.

stepped motif, C-2458/*2*.

stepped oblong base, C-0254/*266*.

stepped oblong foot, C-5114/*57*①.

stepped octagonal base, C-5117/*99*①; S-2882/*694*.

stepped octagonal foot, C-1082/*86*.

stepped oval foot, C-0254/*318*.

stepped oval onyx base, S-2882/ *1430*①.

stepped oval setting, RTA/*35*①.

stepped pad feet, C-5153/*46*①.

stepped platform, S-2882/*1419*①.

stepped platform base, S-4461/*156*.

stepped plinth, C-2437/*14*①; C-5116/ *50*①, *115*; C-5127/*42*①.

stepped rectangular base, S-2882/*702*; S-4414/*475*①.

stepped rectangular section, S-4461/ *45*.

stepped rim, CEA/*641*①.

stepped shoulder, C-5156/*444*.

stepped square base, C-5114/*133*①.

stepped superstructure, C-0249/*326*; C-2421/*116*①.

stepped tapering foot, C-5005/*337*①.

stepped trapezoidal base, S-2882/ *1416*.

stepped wood stand, C-5156/*6*.

steps, SDF.

stereochromy, DATT; LP.

stereometric principle, JIWA/*353*①.

stereoscope, C-1609/*134*.

stereoscopic dissecting microscope, C-2608/*64*.

sterling, ACD; C-0225/*94*; C-5239/ *98*; CEA/*678*; DADA; DATT; NYTBA/*213*.

Sterling mark, EA.

sterling silver, C-5239/*106*.

sterling standard, NYTBA/*213*; EA/ *American silver*.

Stern, EA/*rose*.

Sternschüssel, IDC.

steroscopic folding plate camera, C-1609/*138*.

stethoscope, S-4927/*223*①.

Steuben, C-2910/*63*; C-5191/*374*; C-5239/*289*; K-710/*118*; NYTBA/ *310*; S-4461/*3*.

Steuben Division of Corning Glass Works, CEA/*481*①.

Steuben Glass, DADA/*Supplement*.

Steuben Glass Company, OPGAC/ *178*.

Steuben Glass Works, CEA/*459*; LAR82/*456*①.

Steur, J. de, CEA/*604*①.

Stevengraphs, C-0249/*175*.

Stevens, Bob C., C-2458/*296*.

Stevenson, Ambrose, C-5117/*267*①.

Stevenson, Andrew, CEA/*163*①.

Stevenson, Ralph, CEA/*163*①.

Stevenson & Hancock, C-1582/*55*.

Stevens & Williams, CEA/*481*①; NYTBA/*300*.

Steward, J.H., C-2904/*97*; C-MARS/ *200*.

stew pot, IDPF/*218*①.

St. Gobain factory, EA/*de Nehou, Louis-Lucas*.

stiacciato, DADA.

stick, DSSA.

stick (in fan), EA.

stick-back, EA.

stick back, SDF.

stick barometer, C-2368/*15*; C-2489/ *33*; C-5116/*45*①.

stick clock, LAR83/*211*①.

stick form, C-5157/*4*.

stick furniture, SDF.

stick-handle, EA.

stick lac, DATT.

Stickley, Gustav, C-5191/*287*; C-5239/*250*; K-710/*115*; LAR83/ *337*①.

Stickley, Gustave, NYTBA/*78*.

Stickley, L & JG, C-5191/*290*.

Stickney, Gustav, DADA/*Supplement*.

stickpin, C-5117/*353*①; S-4927/*233*.

sticks and heart piercing, C-5189/ *270*①.

stick stand, C-0782/*75*; C-2402/*79*.

stick-stand base, C-1407/*142*.

sticky-blue, CEA/*200*①.

sticky blue, EA.

stiddy, CEA/*542*.

Stiegel, Heinrich Wilhelm, DADA/ ①.

Stiegel, Henry William, CEA/*459*; EA.

Stiegel, W.H., NYTBA/*287*①.

Stiegel, William Henry, NYTBA/ *289*①.

Stiegel glass, EA/①.

Stiegel-type, C-5114/*151*.

Stiegel-type tableware, CEA/*459*①.

Stiehl, Christian Gottlieb, EA.

stiff leaf, C-1006/*166*; C-2402/*55*; C-2458/*57, 110*.

stiff leaf decoration, RTA/*66*①.

Stijl, de, LP.

stil-de-grain, DATT.

stile, ACD; C-0249/*314*; C-0279/*428*; C-0982/*230*; C-5114/*267*①, *291*①, *310*①, *322*①, *364*①, *401*①; C-5116/*172*①; C-5157/*38*; DADA; EA; NYTBA/*32*①; S-2882/*837*; S-4461/*552*; S-4812/*81*①; S-4988/ *541*①; SDF/①.

stile bello, EA.

stile compendiario, IDC.

stile Liberty, DATT; RTA/*138*.

stile severo, EA.

stiletto, C-MARS/*5*; DADA.

stiletto-form, C-5167/*225*①.

stiletto shoe, C-2203/*91*.

still, DATT; IDC/①; IDPF/*219*.

still-life, JIWA/*87*.

still life, C-5236/*1095*; DATT; DSSA; LP.

still life marquetry, S-4955/*167*.

still life motif, S-4955/*91*①.

stilt, DATT; IDC.

stilt-mark, IDC.

stilton scoop, C-0406/*54*.

Stimmung, LP.

stimulus color, DATT.

stinkwood, LAR82/*329*①.

Stinton, H., C-2493/*183*①.

Stinton, Jas., C-2493/*182*①.

Stippeldey, Johann Carl, C-5174/ *97*①.

stipple, DATT; LP; S-3311/*159*.

stipple-chased, S-4972/*35*.

stippled, C-2704/*50*; CEA/*594*; IDC; LAR83/*135*①; S-4461/*242, 256*; S-4905/*8*①; S-4928/*92*①.

stippled background, SDF.

stippled gold link, S-4414/72.

stippled ground, C-5117/191; S-2882/ 940, 1064, 1198①.

stippled mount, S-291/137.

stippled niello ground, RGS/92①.

stippled silver ground, S-291/135.

stipple-engraved, C-2522/51①; EG/ 124①; LAR82/464①.

stipple engraving, C-0249/11; CEA/ 444①; DADA; DATT; S-286/ 441①, 442①, 443①, 444①; S-4881/25①.

stipple ground, S-2882/998①.

stipple-like matting, CEA/618.

stipple print, C-1603/112.

stipplework, C-5117/386①.

stippling, EA; EG/184; NYTBA/ 296; RGS/182; RTA/38①.

stirring-hole, C-2486/145.

stirring rod, EA.

stirrup-cup, C-5117/67①; EA/①; IDC; RGS/170①.

stirrup cup, ACD; DADA; IDPF/ 219; LAR82/584①; LAR83/ 147①; RGS/116; S-4843/201①.

stirrup handle, C-5189/62.

stirrup hilt, C-2569/21.

stirrup jar, IDPF/219.

stirrup ramrod, C-2503/159; C-2569/ 64.

stirrup-shaped, RTA/62①.

stirrup-shaped design, S-4414/18.

stirrup-shaped hoop, RTA/37①.

stirrup-shaped link, S-4414/162①.

stirrup-shaped ring, RTA/55①, 56.

stirrup spout, IDPF/219①.

stirrup spout handle, IDC.

stitch, NYTBA/100.

stitched hide, C-0403/2.

stitched muslin, S-4881/48①.

stitched-up, ACD.

stitchery, NYTBA/104①.

stithy, CEA/542.

St. Ives, C-2910/128.

St Ives Pottery, JIWA/352.

St. James pattern, C-0254/227.

St. Lambert, C-2409/7.

St. Lazarus' cross, DATT.

St. Louis, CEA/486①.

St. Luke, Guild of, CEA/210.

Stobwasser, C-2487/6.

Stobwasser, Georg Siegmund, EA.

stock, C-2476/1; CEA/23①, 44; S-4972/155①, 159①.

stock anchor, CHGH/25.

stockbook, C-2476/14①.

Stöckel, Joseph, EA.

Stockelsdorf, DADA/①.

stockinette, C-1304/194; C-2501/42.

Stocksdale, Bob, DADA/Supplement.

Stockton Art Pottery, DADA/ Supplement.

Stockton Art Pottery, Stockton, California, EC1/85.

Stockuhr, EA.

Stoddart, CEA/550①.

stoel, C-MARS/236.

stoelklok, CEA/242①; EA/① Dutch clock.

stoeltjeklok, EA/Dutch clock.

Stoke, CEA/203①.

Stoke handle, IDPF/116①.

Stoke-on-Trent, DADA.

stole, C-3011/16; DADA.

stollenschrank, LAR83/260①.

Stöltzel, Samuel, MP/41.

Stölzel, Samuel, CEA/173①; EA.

stomacher, C-2501/150; EA/①.

St. Omer, CEA/145①.

stomp, DATT, ①; LP.

stone, C-0225/94; CEA/503; DATT.

stone (in glassmaking), EG/293.

stone, RGS/37; S-4461/514.

Stone, Edmund, CEA/599.

stove grate, SDF.

stove-tile, CEA/*136*①.

stove tile, S-4972/*396*.

stoving enamel, DATT.

St. Petersburg, DADA.

St. Petersburg imperial porcelain manufactory, MP/*162*.

St. Porchaire ware, NYTBA/*135*.

Strachan, A. J., CEA/*69*①.

Strachan, A.J., EA.

Stradivari, Antonio, EA.

Stradivarius, C-0906/*268*.

stragshorn, C-5236/*698*.

Strahan, Robert, LAR82/*359*①.

straight banding, EA; SDF.

straight bracket foot, C-5114/*304*①; DADA.

straightedge, DATT; S-4881/*56*①.

straighted sided bowl, S-4972/*419*.

straight front, SDF.

straight gadroon border, S-4922/*31*①.

straight handle, C-2414/*27*①; C-5114/*38*①.

straight leg, C-0225/*376A*.

straightline, S-4414/*40*.

straight line bracelet, S-291/*82*①.

straightline bracelet, S-4414/*106*①; S-4927/*397*.

straightline design, S-4414/*138*.

straight line escapement, C-5117/*423*①.

straightline link, S-4414/*75*①.

straightline strap, S-4414/*153*①.

straight neck, S-4414/*189*①.

straight-sided, S-4905/*158*.

straight sided, IDPF/*11*.

straight-sided dump shape, CEA/*56*①.

straight-sided oval form, S-2882/*1008*①.

Straight Tipped pattern, S-4804/*162*.

straight trumpet, CEA/*549*.

strainer, C-0782/*159*; C-5114/*10*①, *44*; C-5173/*29*; DATT; EA/①; IDPF/*57*①; S-4843/*70*.

strainer insert, C-5005/*235*①.

strainer spoon, EA/①.

straining pincer, DATT.

Stralsund, DADA; EA.

strand, S-4927/*327*.

strap, S-4972/*250*.

strap-and-jewel work, SDF.

strap-handle, IDC.

strap handle, C-2458/*31*①; C-5114/*115*; DADA; EC2/*29*①; IDPF/*223*①; LAR83/*112*①; S-4965/*227*①.

strap-handled, CEA/*673*①.

strap hinge, C-0249/*406*; SDF.

strap loop handle, C-2323/*19*.

strap-metal, S-4804/*861*①.

strappo, DATT.

strap-work, C-1502/*47*; C-2202/*76*; C-2910/*205*.

strap work, C-0103/*102*; EA; S-288/*13*①, *16*①.

strapwork, ACD; C-0254/*100*①, *302*; C-0982/*223*; C-2398/*90*; C-2402/*55*; C-2421/*30*①; C-5116/*145*①; C-5153/*12*①; C-5156/*167*①; CEA/*305*①, *678*; DADA/①; IDC; S-2882/*312*; S-4507/*46*①; S-4804/*101*①, *112*①; S-4905/*168*①; S-4922/*8*①; S-4972/*67*①; SDF/①.

strapwork band, LAR83/*537*①.

strapwork border, C-0249/*477*; CEA/*635*①; S-2882/*280*①.

strapwork-carved, S-4414/*391*①; S-4436/*7*①.

strapwork-carved tripod cabriole leg, S-4414/*478*①.

strapwork design, S-4461/*605*.

strapwork feet, S-4414/*278A*.

strapwork spandrel, S-2882/*169*①, *218A*①.

strapwork splat, C-5153/*151*①;
S-4461/*614*.

Strasbourg, C-2486/*182*; CEA/
*147*①; DADA/①; EA/①.

Strasbourg flowers, EA/*deutsche
Blumen, deutsche Blumen*; IDC.

Strasbourg turpentine, DATT; LP.

Strasburg, LAR82/*181*①.

strass, CEA/*524*; EA/*Strass (Stras.*

'strass' (paste), RGS/*70*.

Strass (Stras), Georges-Frédéric, EA.

Stratford design, NYTBA/*307*.

stratified bead, EA/*beads and
marbles*.

straw, C-1506/*63*; S-4461/*384*.

strawberry, OPGAC/*184, 237*.

strawberry button, LAR83/*624*①.

strawberry cut, S-4436/*63*①.

strawberry diamond, C-5181/*9*.

strawberry diamond cutting, CEA/
*446*①.

strawberry diamond lozenge, C-0279/
157.

strawberry dish, C-5117/*263*①;
DADA; S-4802/*456*①.

strawberry-dish, C-2487/*28*①;
C-5174/*597*①; EA/① *saucer-dish*.

Strawberry Hill, C-2357/*20*①.

Strawberry Hill Gothic, SDF.

strawberry-leaf bowl, IDC/①.

strawberry-leaf dish, IDC.

strawberry moulding, IDC.

strawberry pot, IDPF/*223*①.

straw bonnet, C-1506/*64*.

straw chair, SDF.

straw colored, C-5127/*8*①.

straw-glaze, C-2458/*8*.

straw-glazed, C-2323/*1*; C-5156/*22*;
C-5236/*1571*①; LAR82/*107*①;
S-4965/*159*①.

straw glazed, C-5236/*412*; S-3312/
*1303*①.

straw marquetry (straw work), EA/
①.

straw marquetry, SDF.

straw-matting pattern, JIWA/*187*①.

straw-work, ACD; C-0906/*84*; SDF.

straw work, DADA.

strawwork, C-5157/*10*.

streaked, C-0782/*216*; C-5005/*246*①;
C-5127/*42*①.

streak glaze, S-4461/*118*.

streaky, EG/*27*.

streamer, FFDAB/*121*.

streamline, DATT.

Strengall, Marianne, DADA/
Supplement.

stress-free glass, EG/*280*.

stretcher, ACD; C-0249/*354*;
C-0982/*199*; C-5005/*353*; C-5114/
*265*①; C-5116/*55, 62*; C-5153/
*95*①; C-5157/*125*①; C-5239/*247*;
CEA/*406*; DADA; DATT/①; EA;
LP; S-3311/*187*①; S-4905/*451*①;
S-4972/*446*; SDF/①.

stretcher base, LAR82/*414*①.

stretcher mark, SDF.

stretching, DADA/*Supplement*.

stretching canvas, LP/①.

stretching frame, DATT.

stretching pliers, DATT/①.

stretching rail, SDF.

Streublumen, IDC.

stria, DATT; S-4810/*245*①.

striae, CEA/*503*.

striated, C-2202/*7*; C-5127/*644*;
C-5146/*165*①; NYTBA/*270*;
S-4414/*236*①, *244*①; S-4461/*87*①,
495; S-4972/*108*①.

striated feather device, S-2882/
*1323*①.

striated feathering, S-2882/*1340*.

striated fluorspar, LAR83/*456*①.

striated marble, S-2882/*535*.

striated wavy device, S-2882/*1372*.

striation, C-2458/*404*; C-5156/*355*①;
DATT; EG/*63*①; IDC; S-4461/*30*.

stricken or burgeoning oak, EA/
Jacobite glass.

Strickland and Jenkins, SDF/*764*.

striding stance, JIWA/*16*.

striges, SDF.

strigil, S-4973/*312*.

strike, C-0225/*307*.

strike-a-light, EA.

strike and silent, CEA/*256*①.

striker, C-5173/*10*.

strike-silent, S-4972/*430*①.

strike/silent dial, C-5157/*33*①;
CEA/*223*①.

strike silent mechanism, S-4905/
*359*①.

strike through, DATT; LP.

striking, CEA/*474*①.

striking bracket clock, LAR83/*182*①,
S-3311/*110*①.

striking carriage clock, LAR83/
*187*①.

striking dead-beat escapement,
C-5157/*35*①.

striking figure clock, C-5117/*394*①.

striking mechanism, EA.

striking movement, C-0249/*293*;
C-0279/*229*.

striking on gong, C-0906/*114*.

striking system, EA.

striking train, CEA/*221*①.

string-banded, LAR83/*49*①.

string banded, C-0279/*288*.

string-box, C-2332/*80*.

string box, C-0906/*143*.

string-cut, C-5156/*786*.

string cut, C-5156/*62*①.

stringed keyboard, CEA/*548*.

string gnomon, CEA/*606*①.

stringing, ACD; C-2409/*236*;
C-5114/*272*①, *367*①; C-5146/

*133*①; C-5153/*168*①, *168*①;
C-5170/*81*; C-5189/*314*①; DADA.

stringing (in furniture), EA.

stringing, FFDAB/*26*; S-2882/*298*,
*671*①, *1321*.

string-mark, IDC.

string rim, LAR83/*413*①.

string ring, CEA/*57*①.

strings, SDF.

string seat, C-0982/*55*.

strip, DATT.

stripe, C-2403/*155*; JIWA/*71*.

stripe border, S-2882/*101*, *157*①.

striped banding, C-5116/*6*.

striped curtain, C-2704/*7*.

stripe design, OC/*205*.

striped gauze, C-1506/*9*.

striped stringing, C-5116/*18*.

striper, DATT; LP/① *brushes*.

strip form, JIWA/*234*.

stripped base, C-5116/*39*.

stripped pine, C-5116/*115*.

stripping, LP.

strippled border, S-4461/*224*.

strippled ground, S-4823/*28*.

strip quilt, C-2704/*59*.

Stroganov school, RGS/*52*.

Strohblumenmuster, IDC.

Strohmenger, LAR82/*26*①.

stroking, IDPF/*55*.

Strömbergshyttan, DADA/
Supplement.

strong box, C-0906/*164*; C-2498/*88*;
LAR83/*405*①.

strongbox, C-5224/*261*; S-3311/
*307*①; S-4972/*338*.

strong drying oil, DATT.

strontium white, DATT.

strontium yellow, DATT; LP.

Stroud, William, C-5117/*67*①;
S-4922/*47*①.

stroviol, C-0906/*351*.

struck, S-4905/*310*; S-4972/*144*①.

Struck, Alexander, MP/*207*.

struck moulding, SDF.

structural element, JIWA/*73*.

structyre, C-5127/*359*①.

strut, C-5117/*356*①; C-5146/*124*①; S-4965/*282*①.

strut clock, C-1702/*311*; EA; LAR82/*226*①; LAR83/*203*①.

strut frame, C-2904/*69*.

strut support, C-5239/*268*.

strut timepiece, LAR83/*209*①.

Stuart, C-0249/*362*; C-0279/*285*①; C-5116/*101*; S-4812/*52*①; S-4972/*450*.

Stuart, Early, DADA.

Stuart, Late, DADA/*Stuart Early*.

Stuart crystal, C-5117/*81*.

Stuart drinking vessel, CEA/*642*①.

Stuart period, C-5170/*55*; SDF.

Stuart tankard, EA/*tankard*.

Stubbs, John, SDF/*764*.

stucco, C-5236/*409, 1745*; DATT; SDF.

stucco figure, S-4965/*90*①.

stuck moulding, SDF.

stuck-on handle, CEA/*415*.

stud, C-0279/*329*; C-2202/*135*; C-2421/*134*①; C-2458/*217*; C-5117/*199*①, *360*①; C-5156/*47*①; CEA/*251*①; LAR82/*338*①; S-3312/*1279*; S-4461/*23*; S-4927/*255*; S-4972/*238*; SDF.

studded, C-5005/*322*①, *371*①; C-5127/*14*①; JIWA/*187*.

studded frame, C-2357/*4*.

studding, C-0782/*23*.

student lamp, C-5239/*342*.

'student's' candlestick, LAR83/*224*①.

Studer, C., S-4881/*28*①.

stud foot, C-5117/*10*.

studies, C-2409/*161*.

studio, LP.

studio-craftsman, DADA/*Supplement*.

studio easel, DATT.

studio glass, EG/*155*.

studio mark, NYTBA/*211*.

studio pottery, IDC.

stud release, C-5156/*456*.

study, DATT; JIWA/*9*; LP; S-4928/*2*①.

stuffed seat, C-5116/*66*.

stuffing spoon, C-5114/*17, 75A*; S-4804/*35*.

stuff-over, SDF.

stump, C-5116/*165*①; C-5157/*106*①, *141*①; DATT/①; LP.

stump bedstead, SDF.

stump-end, CEA/*594*.

stump-end spoon, EA.

Stumpff, Jean-Chrysostome, C-2364/*51*①.

stump foot, DADA; EA; SDF/①.

stumping chalk, DATT.

stump leg, C-0982/*79*.

stump-top, CEA/*594*.

stump-top spoon, EA/*Puritan, Puritan spoon*.

stump-work, SDF.

stump work, CEA/*276*①, *294*.

stumpwork, DADA; NYTBA/*104*①.

stun, DATT.

stupa, C-5156/*225*①; C-5234/*20*①, *189*①.

Sturm, Der, LP/①.

Sturm, Ludwig Phillip Georg, MP/*198*.

sturned, S-3311/*213*.

Sturzbecher, DADA/①; IDC.

sturzebecher, IDPF/*223*.

Stutzuhr, EA/*Stockuhr*.

S-twist, DATT.

style, C-5153/*4*①; CEA/*612*; CHGH/*62*; DADA; DATT, ; JIWA/*7*; LP; NYTBA/*9*; SDF.

Style, The, LP.

style Berain, EA.

Style Egyptienne, CEA/*455*①.

style Inglese, DADA/*Supplement*.

style liberty, DADA/*Supplement*.

style mécanique, le, DATT.

style of Callot, EA/*Callot figures*.

style of furniture, DADA.

style of Horaku, S-4829/*27*①.

style rayonnant, CEA/*146*①; EA; IDC.

Styles, Alex, CEA/*663*①.

stylised, C-1502/*114*; C-2403/*184*; C-2414/*90*①.

stylised artichoke finial, C-0706/*122*.

stylised bell, C-2704/*100*.

stylised butterfly, C-2704/*5*.

stylised cicada, C-2414/*8*①.

stylised dragon motif, C-2414/*14*①.

stylised floral border, C-2704/*5*.

stylised flowers, C-2704/*3*.

stylised fruit, C-2704/*28*.

stylised glass border, C-2403/*171*.

stylised rib twist, C-2202/*234*.

stylised scrolling lotus, C-0782/*3*.

stylised tree, C-2704/*4*.

stylization, DATT; JIWA/*5*, *75*.

stylized, C-0225/*41*; C-1082/*63*; C-5005/*273*; C-5116/*156*①; C-5153/*4*①, *12*①; C-5156/*59*①, *303*①; C-5236/*842*①; IDC; IDPF/*126*①; S-4922/*24*①; S-4972/*248*①.

stylized boteh, S-2882/*205*.

stylized design, C-5146/*73*①.

stylized figure, C-1082/*8*.

stylized finial foot, S-4461/*77*①.

stylized floral mount, S-291/*60*.

stylized floral ornamentation, RTA/*162*①.

stylized flower-motif, OC/*203*.

stylized foliage, RTA/*40*①.

stylized foliate, C-5153/*13*①.

stylized foliate base, C-0225/*127*.

stylized formal pattern, C-5127/*16*.

stylized fruit pattern, C-5114/*18*.

stylized honeysuckle spray, S-2882/*813*①.

stylized indianische (Indian) flowers, MP/*61*.

stylized loop handle, C-0254/*120*①.

stylized lotus bud, C-5234/*143*.

stylized ornamentation, EC2/*20*①.

stylobate, SDF.

stylograph, DATT.

stylus, DATT; DSSA; S-4972/*70*.

stylus bead, C-5156/*312*.

styrene resin, DATT.

styrofoam board, S-286/*269*.

Subes, Raymond, C-5167/*195*.

subjective, LP.

subject matter, JIWA/*6, 10*; LP.

subjects, JIWA/*6*.

Sub-Mycenaean pottery, IDC.

subscription (souscription) watch, EA/①.

subsellum, SDF.

subsidiary dial, EA.

subsidiary guard, OC/*45*①.

subsidiary seconds, C-5117/*396*①.

subsidiary seconds dial, S-3311/*107*①.

sub-stage, C-2904/*96*①, *198*①.

substrate, DATT.

substratum, DATT.

subtlety, IDC; MP/*10*.

subtractive color, DATT.

subtractive color mixture, LP.

Suburban Alter, CEA/*118*①.

succès de scandale, LP.

succès d'estime, LP.

successive proofs, DATT.

sucket fork, DADA.

sucket spoon, EA/①.

sucrier, C-0249/*151*; C-5189/*6*;
C-5259/*229*; CEA/*157*①; EA/
*232*①; IDC; LAR83/*90*①, *539*①.

sudsidiary seconds dial, S-4802/*2*①.

suede, C-0982/*206*; C-5116/*154*①;
C-5146/*107A*①.

suede effect, DATT.

suë et mare, DADA/*Supplement*.

Sué or Iwaibe ware, EA.

Sue(ki) ware, IDC.

suffusion, S-3312/*1209*①.

sugar, C-0254/*199*.

sugar and tea vase, C-5173/*34*①.

sugar-basin, C-2398/*24*①, *36*①;
C-5117/*217*; C-5153/*21*①.

sugar basin, C-0254/*318*; C-0706/*1,
32, 245*; C-1502/*54A*; C-5114/*2*①.

sugar-basket, C-5174/*528*.

sugar basket, C-0254/*315*; S-4802/
384; S-4804/*105*.

sugar-bowl, C-5117/*86, 299*; C-5153/
*1*①, *3*①; IDC/①.

sugar bowl, C-0782/*117*; C-1006/*43*;
C-5114/*8*; C-5153/*14*①; DADA;
EA/①; IDPF/*224*①; S-3311/
*620*①; S-4804/*23*; S-4905/*175*①;
S-4992/*17*①, *84*①.

sugar-bowl and cover, C-5117/*133*①.

sugar bowl and cover, C-1006/*217*.

sugar-box, C-2486/*136*①; CEA/
*667*①; RGS/*31*①.

sugar box, C-0254/*44*; C-5117/*295*;
S-4802/*176*①; S-4922/*58A*①.

sugar-caster, C-2910/*90*; IDC/①.

sugar caster, C-0254/*94*; C-0706/*51*;
C-1502/*10, 96*; C-2409/*76*; CEA/
*643*①; LAR83/*555*①; S-4804/*53,
116*①.

sugar crusher, EA.

sugar-dredger, IDC.

sugar ladle, S-4804/*195*①.

sugar loaf mold, IDPF/*224*.

sugar-nipper, C-2487/*106*.

sugar nipper, EA.

sugar nips, C-2202/*39, 142*; C-5203/
152; S-3311/*776*; S-4802/*399*.

sugar pail, S-4944/*96*①.

sugar shell, S-4804/*1, 64*.

sugar-shovel, C-5174/*240*①.

sugar shovel, C-5114/*76*.

sugar-sifter, C-5117/*15, 270*①;
C-5174/*275*.

sugar sifter, C-0254/*113*; DADA;
EA/*shifter*; LAR82/*592*①.

sugar spade, S-4905/*167*.

sugar-spoon, IDC/①.

sugar spoon, C-5146/*62*; EA;
S-4905/*167*.

sugar tong, EA/①.

sugar-tong compensation, C-MARS/
172.

sugar-tongs, C-5117/*64*.

sugar tongs, C-0706/*227*; C-1502/*12*;
C-5114/*21*①; DADA; S-4804/*28,
35*; S-4905/*167*; S-4922/*58A*①.

sugar-twist, C-0249/*363*.

sugar urn, S-4905/*214*①.

sugar vase, LAR83/*640*①.

suggi, OC/*52*.

sugi, C-5156/*685*①.

Sui dynasty, EA; LAR83/*80*①;
C-2414/*47*①; C-5127/*8*①;
C-5156/*34*①.

Sui/early Tang Dynasty, C-2458/
*54*①.

Suisse, Gaston, C-5167/*204*.

Suisse Frères, C-0225/*129*①.

suit, C-1506/*58*①.

suite, C-2421/*112*; C-5116/*66*;
C-5189/*267*①; S-3311/*516*①;
SDF.

suite, en, IDC.

suite of carpets, EA.

suite of embroidered hangings,
C-1506/*105*①.

sujet galant, RGS/*140*.

Sukashi, LAR83/*661*①.

sukashi-bori, DADA.

Sukenobu School, C-5156/*884*①.

Sukhotai, C-5127/*161*; C-5156/*88*.

Sukhothai period, C-5236/*356*①.

Sukhothai pottery, C-2458/*49*.

Suleiman, OC/*176*①.

sulfure, EG/*171*.

Sulkowski, S-4853/*198*①.

Sulkowski Service, EA.

Sulkowsky or ordinair Ozier pattern, MP/*484*.

Sulkowsky service, IDC; MP/*33*.

sulky, C-5114/*187*①.

Sullivan, Louis, DADA/*Supplement*.

Sully, Henry, EA.

Sully, Thomas, EA.

sulphide, CEA/*503*; DADA; EA; EG/*293*; CEA/*450*①.

sulphide medallion, CEA/*487*①.

sulphide paperweight, CEA/*490*.

Sultanabad, C-5189/*373*; S-4461/*446*.

Sultanabad carpet, EA/*Mahal carpet*.

Sultanabad lid, IDPF/*138*.

Sultanabad pottery, IDC.

Sultanabad rug, DADA.

sultane, EA/*lit de repos, lit de repos*.

Sultan rug, S-4847/*239*①.

sumac wax, DATT.

sumak, S-3311/*8*.

sumak (soumak) carpet, EA.

sumakh prayer rug, OC/*141*.

sumi, C-5127/*338*; C-5156/*852*①; C-5236/*914*①; DATT.

sumi box, LAR82/*66*①.

sumi-e, C-5236/*1495*①.

sumi ink, S-286/*369*.

sumi-zōgan, DADA.

Summer, George Heywood Maunoir, DADA/*Supplement*.

summer bed, SDF.

summer chawan, C-5236/*865*①.

summer flower-spray, C-2421/*9*①.

summer flower swag, C-2403/*66*①.

Sūmmerian, CEA/*686*①.

Summerly's art manufacturers, DADA/*Supplement*.

summer tea bowl, IDPF/*227*①.

summit, C-5117/*342*①.

Sumner, William, S-4944/*279*.

sun-and-moon dial, S-4927/*88*.

sun and moon dial, EA/①.

sun-bird, OC/*54*.

sunbonnet baby design, K-710/*118*.

sunburst, C-2421/*8*①; C-2704/*7*; C-5117/*31*①, *199*①; CEA/*56*①; DADA; K-711/*123*; OPGAC/*237*; S-4905/*139*①; S-4927/*215*①; S-4972/*238*; SDF/①.

sunburst clock, C-2364/*13*①.

sunburst cresting, C-0249/*241*.

sunburst decoration, C-2487/*110*.

sunburst design border, S-4414/*541*.

sunburst flask, EA/①.

sun-burst ground, RGS/*92*①.

sunburst medallion, S-2882/*69, 135*.

sunburst-octagon, C-2388/*193*.

sunburst pendulum, C-1702/*349*; C-2437/*27*①.

sunburst-shaped cover, S-4414/*56*①.

sunburst variation border, S-4948/*73*①.

sunburst-veneered top, C-5189/*334*①.

sunburst wing, C-1407/*120*.

sun crest, C-5117/*257*.

sundae cup, C-0706/*203*.

Sunday painter, DATT.

Sunderland, DADA; LAR82/*110*①.

Sunderland lustre, IDC.

Sunderland ware, EA/①; IDC.

sundial, C-0403/*214*; C-5156/*459*; CEA/*605*①; EA/①; S-4802/*160*.

sun-dial ring, RTA/*90*.

sun disc, C-5117/*202*①.

sun disc and shell decoration, C-5174/*516*.

sun-disk, S-4973/*112*.

sunface, CEA/*182*①.

sun-face terminal, C-2493/*130*.

sun-flash, CEA/*535*①.

sunflower, DADA; DSSA.

sunflower bowl, IDPF/*224*.

sunflower dish, IDC.

sunflower-shaped, S-4955/*52*.

sunflower tureen, IDC.

sunflower-yellow, C-2403/*194*.

sunflower yellow, DATT.

Sung, C-5239/*40*; CEA/*111, 571*; DADA/①.

Sung Chinese bowl, IDPF/*28*.

Sung dynasty, CEA/*111*; EA; IDC; ACD.

Sung glaze, IDC.

Sung period, JIWA/*16, 49*.

'Sung' vase, LAR83/*94*①.

Sung vase, LAR82/*121*①.

Sung yao, IDC.

su-ni-po, IDC.

sunk (recessed) carving, EA.

sunk carving, SDF.

sunk center, C-5117/*192*.

sunken blue, IDC.

sunken panel, EA.

sunken-rib, C-2476/*38*.

sunken rosette, C-5116/*95*.

sunk moulding, SDF.

sunk panel, SDF/①.

sunk relief, DATT; JIWA/*178*①.

sunk seconds, S-4802/*53*.

sunk top, SDF.

Sunqua Studio, C-2323/*170*.

sunray clock, SDF.

sun-ray pattern, S-4927/*56*①.

sun-refined oil, DATT.

sun-thickened oil, DATT; LP.

Superba white, DATT.

superficial copy, JIWA/*8*.

superimposed, S-4905/*37*①; S-4972/*159*①.

superimposition of patterns, JIWA/*205*.

superoxol, DATT.

superrealism, DATT.

superstructure, C-2403/*134*; C-2437/*57*①; C-5157/*152*①; LAR83/*304*①; S-2882/*771*①; S-3311/*425*①.

Suppenwärmer, IDC.

supper service (set), EA.

supper-set, IDC/①.

supper set, DADA/①.

supper table, C-1407/*52*; CEA/*337*①; DADA.

supplier's card, S-4972/*163*①.

support, C-0982/*87B*; C-2202/*2*; C-2402/*101*; C-5114/*15*①, *292*①; C-5116/*86*; C-5153/*177*①; C-5181/*196*; DATT; LP; NYTBA/*25*①; S-4461/*74*.

supported, C-5157/*149*①.

supporter, C-5117/*15, 140, 213*①; SDF.

supporting plane, JIWA/*73*.

support rings, S-4461/*17*.

support sheet, S-286/*433B*.

supra porta, DATT.

Suprematism, DATT/①; LP.

surbase, SDF.

sureau wood, DADA.

surface, C-5114/*232*①; C-5239/*241*; JIWA/*10, 50*.

surface-active agent, DATT.

surface agate ware, IDC.

surface color, DATT; LP.

surface dip, CHGH/*56*.

surface polishing, MP/*28*.

surface scratch, CHGH/*59*.

surface-spatial color woodcut, JIWA/*206*.

surface structure, JIWA/*305*.

surface tension, DATT.

surface treatment, JIWA/*327*.

surfactant, DATT.

surfeit water glass, ACD.

surgeon's instrument, S-4927/*223A*①.

surgeon's tool, C-MARS/*189*.

surimono, C-5156/*958*; C-5236/*1095*; JIWA/*12*.

surmount, C-0406/*83*; C-0706/*3*; SDF/①.

surmounted, C-5116/*162*①; C-5127/ *220*①.

surprise cup, IDC/①.

surprise mug, IDC.

Surrealism, DATT; LP.

surrealistic, IDPF/*53*①.

Surrey enamel, EA.

surround, C-2437/*24*①; C-5117/*334*; C-5156/*483*①; IDC; S-2882/ *961*①; S-4928/*130*①; S-4948/*139*.

surtout, DADA.

surtout-de-table, IDC; S-4944/*177*①.

surtout de table, C-2437/*55*①; C-5224/*19*.

surtout du table, S-4461/*214*.

surveying aneroid barometer, C-2608/ *83*.

surveying compass, C-2489/*19*①.

surveying instrument, CEA/*604*①.

surveyor's compass, CEA/*605*①.

surveyor's level, C-0403/*150*; C-1609/*12*.

susani, C-2357/*101*; C-2478/*202*.

Susa ware, DADA.

sushi box, C-5127/*441*.

suspension, C-2482/*82*; EA.

suspension cartouche, S-291/*240*①.

suspension chain, C-2324/*235*; C-2487/*10*.

suspension loop, C-1082/*19*; C-5127/ *308*①.

suspension pot, IDPF/*198*①.

suspension ring, C-5117/*313*①.

suspension rod, EA.

Susse frères foundry, C-5167/*1*.

Sussex, DADA.

Sussex marble, DATT.

sussex pig, IDPF/*224*①; IDC/①.

Sussex ware, IDC.

Sutherland, C-2402/*56*.

Sutherland, Graham, DADA/ *Supplement*; S-286/*432*.

Sutherland table, ACD; C-0982/*45*; C-1407/*87*; DADA; LAR82/*392*①; LAR83/*372*①.

Sutherland Wine Cistern, EA.

sutra paper, C-5156/*598*①.

Sutton, Rob, Stratford, C-2489/*166*.

Suyk, Tijmon, NYTBA/*226*①.

Suyk, Tijomon, CEA/*630*①.

Suzani, S-4847/*9*①.

suzani embroidery, S-4804/*957*; S-4796/*146*; S-4948/*16*①, *39*①.

Suzani prayer embroidery, S-4796/*9*.

suzuri bako, DADA.

suzuribako, C-5236/*807*; EA/*193*; S-4829/*94*①; S-4928/*170*①; S-3312/*1062*①.

SVE, EA/*van Eenhoorn, Samuel*.

SW, EA/*Wood, Samuel, Wood, Samuel*.

swag, ACD; C-0254/*36*①; C-2202/ *136*; C-2398/*22*; C-2493/*219*①; C-5114/*96*①, *257*①, *368*①; C-5116/*41*; C-5127/*25A*; CEA/ *134*①, *523*①, *678*; DADA; DATT; EA/*festoon*; FFDAB/*132*①; IDC; K-710/*110*; S-2882/*380, 1065*①; S-3311/*273*①; SDF.

swag decked urn, S-4823/*123*.

swag drapery, SDF.

swage, EA.

swagged, C-0279/*198*①.

swagged arms, C-5116/*41*.

swagged drapery, C-2437/*3*①.

swagged foliate band, C-5005/*227*.

swagged urn, S-2882/*319*; S-4461/
545.

swagger stick, C-0403/*26*.

swag-hung, S-4436/*7*①.

swag-hung corbelled border, S-4812/
3.

swag inlaid cornice, C-5114/*347*①.

swag pattern, C-5114/*265*①.

swamped, C-2503/*207*; C-2569/*96*①.

swan, DSSA; OPGAC/*237*.

Swan, Abraham, EA.

Swan, Robert, C-5153/*26*①.

swan cup, IDC/①.

swan finial, CEA/*461*①.

swan-form, C-5181/*116*.

Swank halok pot, IDPF/*70*.

swan-neck, C-0982/*49, 271*; C-2402/
69, 256.

swan neck, DADA.

swan neck carrying handle, LAR83/
*251*①.

swanneck cornice, S-2882/*278*①.

swanneck crested bonnet, S-2882/
*284*①.

swan-neck cresting, LAR83/*341*①.

swan neck cresting, LAR83/*254*①.

swan-necked beam scale, LAR83/
*467*①.

swan-neck handle, MP/*490*①.

swan neck handle, DADA; LAR83/
*301*①, *324*①.

swan-neck hinge, SDF.

swan-neck pediment, ACD; C-1407/
37; CEA/*321*.

swan-neck (bonnet-scroll)
(goose-neck) (scrolled) pediment,
EA.

swan-neck pediment, SDF/①.

swan neck pediment, C-5116/*89,
125*①; LAR82/*285*①; LAR83/
*197*①.

swan-neck spout, IDC; S-2882/*902*①,
*904*①, *975*①, *1102*; S-3311/*765*;
S-4905/*214*①.

swan neck spout, C-0254/*33*.

swanneck spout, S-4802/*441*①.

Swan pens, C-0403/*23*.

Swansea (1), ACD.

Swansea (2), ACD.

Swansea, CEA/*202*①; DADA; EA/
Cambrian Pottery Works; LAR82/
*182*①; LAR83/*161*①; S-4843/
*230*①; EA/① *Nantgarw Porcelain*.

Swansea Porcelain, C-2493/*1*.

Swansea Pottery, CEA/*202*①.

swan service, IDC/①; CEA/*174*①,
*188*①; EA; MP/*70*.

swan service dish, C-2427/*119*①.

swan-shaped, S-4972/*491*.

swan skin, JIWA/*167*①.

swan's-neck, S-3311/*109*.

swan's neck cresting, S-4414/*458*;
S-4436/*46*; S-4812/*6*; S-4988/
*521*①.

swan's neck pediment, C-5114/*358*①;
S-4461/*602*.

swan's neck regulator, C-5117/*403*;
C-5174/*340*.

swash turning, SDF.

swastika, C-2323/*147*①; DADA/①;
DATT; IDC.

swastika-and-bar ground, IDC.

swastika-and-square ground, IDC.

swastika border, OC/*252*.

swastika design, C-5146/*71*①.

swastika motif, OC/*249*①.

swastika pattern, C-0782/*225*.

swatow, C-5236/*1606*; C-5156/*103*;
CEA/*111*; DADA; EA/①;
LAR83/*141*①; S-4965/*258*①.

swatow blue and white, C-5127/*52*.

Swatow dish, CEA/*122*①.

Swatow style, C-5156/*798*; C-5236/
830.

Swatow-type, C-0782/*213*.

swatow ware, IDC.

sway, CEA/*532*①.

72①, 153①, 318①; C-5173/30①; CEA/630①; RGS/49①; S-4414/ 273, 337; S-4461/79; S-4802/384; S-4922/71①.

swing-handled, C-0103/93.

swing handled, C-2202/94.

swinging carriage, C-5239/270①.

swinging handle, C-5239/100①.

swing-leg, DADA/①.

swing leg, SDF.

swing-leg support, C-5153/196①.

swing-leg table, EA.

swing mirror, C-2402/126A.

swing rocker, SDF.

swing spigot, C-0254/143①.

swing stopper, CEA/55①.

swinton, DADA; IDPF/40.

Swinton Pottery, EA/Brameld.

swirl, C-5005/401①; C-5127/72; CEA/503; EG/293.

swirl border, C-0225/354.

swirl cased, K-802/16.

swirl center, C-5239/256.

swirl decoration, S-4461/33.

swirl device, S-4461/36.

swirled, C-5005/247.

swirled lobe, S-2882/1066.

swirling, C-5117/35①.

swirling branch, C-5117/219①.

swirling flute, C-5117/90; C-5220/ 54①.

swirling foliate branch, C-5117/166①.

swirling lobe, S-2882/930.

swirling lobe and flute, S-2882/ 1090①.

swirling wave pattern, CEA/470①.

swirl lobe, S-2882/1024①.

swirl-lobed sconce, S-2882/995①.

swirl-ribbed pattern, C-5114/150.

swirl rim, LAR82/170①.

swirl-shaped design, S-4414/17, 45.

swirl weight, LAR83/437①.

Swiss armchair, SDF/①.

Swiss ceramics, EA.

Swiss embroidery, DADA.

Swiss hood, CEA/222①.

Swiss snuff-box, EA/①.

Swiss watch, EA.

swivel, C-2402/144.

swivel envelope top, C-0982/279.

swiveling, S-4905/453①.

swivel knife, DATT.

swivelling bezel, RTA/19①.

swivel mounted, S-4972/240.

swivel pendant, C-2489/241①.

swivel rest, C-0225/336.

swivel ring, C-2482/88.

swivel seal, LAR83/532①.

swollen body, C-5239/2.

swollen cylindrical form, C-5005/ 243①; S-4414/212①.

swollen form, C-5146/144C.

swollen lower section, S-2882/1254.

swollen pear shape, C-2409/8.

swollen shoulder, C-5191/432.

sword, C-1082/5; C-2398/91①; C-2458/211; CEA/20①; DADA; DSSA; S-4972/154①.

sword-carrier, C-2569/40①.

sword guard, C-5156/311; JIWA/90, 178.

sword-hilt, CEA/516①.

sword liner, DATT.

sword mount, C-5156/331①.

sword pommel, LAR83/468①.

sword-rapier, C-MARS/33①.

swords, SDF.

sword-slide, C-2513/425.

sword slide, C-5156/333.

swordsmith, CEA/537.

sword with pommel, MP/499①.

Swortfiguer, John, S-4905/178.

swung thumb-piece, RGS/105①.

sycamore, ACD; C-2357/*82*①;
C-2364/*55*①; C-5005/*320*①;
C-5146/*139*; C-5224/*119*①;
LAR82/*70*①, *78*①, *83*①, *328*①;
SDF.
sycamore, English, DATT.
sycamore wood, DADA.
Sydney Herbert, C-2904/*20*.
syllabub, DADA.
syllabub glass, EA/①.
Sylvestrie pottery, LAR83/*97*①.
symbol, C-5153/*47*①; JIWA/*5*; LP.
symbolic, JIWA/*7*.
symbolic element, JIWA/*75*.
symbolic imagery, JIWA/*14*.
symbolic realism, JIWA/*10*.
Symbolism, JIWA/*50*; LP.
Symbolist, JIWA/*6*.
symbol of Passover motif, C-5174/
*102*①.
symmetrical, OC/*17*.
symmetrical knot, EA/*Turkish knot*,
Turkish knot.
symmetrical lattice-pattern, OC/*329*.
symmetrical niche, JIWA/*321*①.
symmetrical scrolling foliage, RGS/
*157*①.
symmetry, IDPF/*5*.
Symonds, Robert Wemyss, SDF/*764*.
symphonie, EA/*hurdy-gurdy*.
symphonium, CEA/*549*; S-4804/
*949*①.
sympiesometer, C-2368/*4*①.
Sympson, SDF/*765*.

Synar, Richard, CEA/*466*①.
synchromism, LP; DATT.
Syng, Philip Jr., CEA/*668*①;
S-4905/*221*.
Syng, Philip the Younger, EA.
synthetic blue spinel, S-4414/*27*.
synthetic Cubism, LP.
synthetic drawing, JIWA/*58*.
synthetic dyes, DADA/*Supplement*.
synthetic fibers, DADA/*Supplement*.
synthetic organic pigments, DATT.
synthetic resin, DATT; LP.
synthetic resin paint, LP.
synthetic resin varnish, LP.
synthetic ruby, S-4414/*27*; S-4927/
*141*①, *319*.
synthetic sapphire, C-2324/*243*;
S-291/*144*①.
synthetic stone, RTA/*194*①.
Synthetism, LP.
Syon Cope, CEA/*275*.
syphon glass, EG/*98*①.
syphon stand, C-0103/*111*; C-1502/
81.
SYP teapot, IDC/①.
Syracuse China Corporation, DADA/
Supplement.
syringe-form, S-4927/*222*①.
syrinx, DSSA.
syrup jar, C-0254/*9*; IDC.
syrup jug, S-4905/*317*.
systematic fragmentation, JIWA/*10*.
Szoeke, Andrew, C-5167/*225*①.

T

tableau 676

tableau, C-0403/*11*; IDC.

table base, C-2513/*54*; S-4804/*346A*①.

table bedstead, EA; SDF.

table-bell, C-2427/*99*; C-5117/*210*①.

table bell, C-0254/*199*; C-0406/*89*.

table (hand) bell, EA/①.

table bell, LAR82/*556*①.

table board, SDF.

table bottle, C-2458/*348, 377*.

table cabinet, LAR83/*263*①.

table caddy, S-4461/*38*.

table candle-stand, C-2403/*12*.

table-candlestick, C-5117/*35*①; C-5173/*27*①; C-5174/*601*①.

table candlestick, S-3311/*766*①; S-4922/*5*①.

table centerpiece, MP/*74*.

table centrepiece, EA/*épergne*.

table-chair, EA/*chair-table*, *chair-table*.

table chair, DADA; SDF.

table chairewise, SDF/*table chair*.

table cigar lighter, C-1502/*50*.

table clock, CEA/*224*①, *268*; EA; S-3311/*415*①; S-4802/*151*①; SDF.

table-cloth, C-2704/*137*.

table cloth, C-1506/*106*①.

tablecloth, S-4461/*184*.

table cover, S-288/*34*①.

tablecover, C-1506/*109*.

table cupboard, SDF.

table-cut, S-4927/*323*.

table cut, EA.

table-cut diamond, S-291/*240*①.

table-cut emerald, S-291/*240*①.

table-cut ruby, S-291/*240*①.

table-cut stone, RTA/*94*.

table d'accoucher, LAR83/*379*①.

table de chevet, DADA.

table-decoration, IDC/①.

table decoration, C-5005/*360*①.

table de jeu, DADA.

table de lit, S-3311/*488A*①.

table de milieu, LAR82/*401*①.

table de nuit, C-5259/*436*.

table de toilette, S-3311/*507*①; S-4823/*221*.

table diamond, RGS/*199*①.

table dormant, SDF.

table easel, DATT/①.

table en chiffoniere, S-4804/*784*.

table en chiffonnier, S-3311/*439*①.

table en chiffonniere, C-0279/*375*.

table en chiffonnière, C-2364/*52A*①; C-5224/*65*①.

table en chiffonniere, S-4972/*541*.

table en guéridon, EA.

table-flap case, SDF/①.

table-fork, C-2398/*14*; C-5117/*43*.

table fork, S-4905/*170*.

table fountain, C-2364/*9*①; MP/*133*.

table garniture, LAR82/*175*①; S-2882/*1034*①.

table gigogne, DADA.

table glass, NYTBA/*290*.

table knife, S-4905/*160*.

table lamp, C-0225/*235*①, *337*; C-5005/*257*①; C-5239/*89, 154*.

table lamp base, C-5005/*403*.

table lighter, C-0254/*15*.

table-lustre, IDC.

table mat, C-2704/*142*.

table napkin, C-1506/*48, 106*①.

table-ornament, IDC.

table pedestal, NYTBA/*24*.

table-pétrin, DADA.

table piano, SDF/①.

table piece, NYTBA/*170*①.

table rack, S-4461/*36*.

table scarf, NYTBA/*86*.

table-screen, IDC/①.

table screen, C-2458/*149*; C-5127/
*286*①; C-5156/*424*; C-5157/*154*①;
DADA/① *screen*; LAR83/*334*①.

tables de Chevet, S-4461/*681*.

table-seal, C-5220/*7*①.

table servante, EA/*serving table,
serving table*.

table-service, C-2398/*14*; C-5117/*43*.

table service, EA.

table-silver, C-5117/*38, 64*.

table snuff-bottle, C-1082/*155*.

table snuff-box, C-5117/*374*①.

table-spoon, C-2398/*14*; C-5117/*43*.

table spoon, C-1502/*83*.

tablespoon, C-5114/*17*; C-5153/*28*①;
S-4905/*160*; S-4922/*34*①.

table stand, C-5156/*164*①; C-5236/
*346*①.

table stool, C-5156/*489*.

tablet, C-5114/*326*①, *368*①; C-5236/
1738; CEA/*244*①; DSSA;
FFDAB/*27*; IDC; S-4928/*71*①;
SDF.

tablet-centered drawer, C-2478/*101*①.

tablet centre, C-2388/*9*; C-2403/*67*;
C-2421/*15*①.

tablet-centred, C-2388/*128*; C-2421/
*85*①.

tablet chair, SDF.

tablet crest rail, C-5114/*265*①.

tablet dial, S-4802/*159*.

tablet drawer, FFDAB/*92*.

table telescope, C-2608/*58*.

tablet-form, C-5156/*402*.

tablet frieze, C-2403/*98*.

tabletier, EA/*Biennais,
Martin-Guillaume*.

table top, S-4992/*83*①.

tabletop, CHGH/*57*.

table tronchin, DADA.

Tablets of the Law motif, C-5174/
*7*①.

tablette, EA.

tablet-top (in furniture), EA.

tablet-top, SDF/①.

tablet toprail, C-2403/*66*①.

table vitrine, S-3311/*493*.

table ware, S-4905/*66*.

tableware, MP/*34*; S-4461/*2*.

taboret, DATT.

tabouret, ACD; C-0249/*447*; DADA/
①; EA; S-2882/*357A*; S-4461/*564*;
S-4507/*73*①; SDF.

tabouret de pied, C-5259/*535*.

Tabriz, C-2320/*158*; C-2388/*175,
180*; C-2478/*225, 272*; C-5181/*53*;
CEA/*89*①; OC/*300*①, *300*①.

Tabriz carpet, ACD; C-1702/*15*;
C-2403/*212*; EA/①; S-4461/*840*.

Tabriz prayer rug, S-288/*12*①;
S-4796/*200*①.

tabriz rug, DADA.

Tabriz-style medallion-all-over design,
OC/*302*.

Tacca, Pietro, C-5224/*278*①.

tacchiolo, IDC.

taces, DADA.

tachi, DADA/①.

Tachism, JIWA/*396*.

tachisme, LP; DATT.

tachiste, LP.

tachometer, C-2904/*189*.

tachymeter dial, C-5117/*431*①.

tack, C-5114/*242*.

tacker, DATT.

tacking, S-4461/*567*.

tacking iron, DATT.

tacky, DATT.

tact, EA/*montre à tact, montre à
tact*.

tactile effect, JIWA/*270*①.

tactile value, DATT; LP.

Taddel (Dattel), Heinrich, EA.

taffeta, C-1506/*74*; DADA; SDF.

taffeta glass, DADA/*Supplement*;
OPGAC/*180*; CEA/*480*①.

Tamasiro, Ota, LAR83/*218*①.

Tamayo, Rufino, S-286/*512*①.

Tamba, JIWA/*348*①.

Tamba artists, S-4928/*92*①.

Tamba ware, EA.

tambour, ACD; C-0279/*182*; C-2402/ *132A*; C-5005/*353*; C-5114/*333*①; C-5116/*29*①; C-5153/*112A*; EA; FFDAB/*88*①; K-802/*15*; LAR82/ *68*①, *414*①; S-4972/*572*①; S-4988/*533*①; SDF.

tambour case, FFDAB/*51*.

tambour desk, DADA/①.

tambour door, C-0279/*415*; C-5114/ *347*①; C-5189/*272*①; C-5259/*591*; CEA/*402*①; S-4853/*540*①.

tamboured net, C-1506/*33*; C-2203/ *140*.

tambour-front, DADA.

tambour front, CEA/*316*①; LAR83/ *305*①.

tambour front bureau, LAR83/*252*①.

tambour-fronted, S-4436/*123*①; S-4812/*167*①.

tambourine, DSSA.

tambourine pattern, IDC.

tambour lace, C-1506/*175*; DADA.

tambour-reeded side, C-5114/*370*①.

tambour shutter, C-0982/*188*; C-2364/*55*①; C-2403/*65*; C-2437/ *54*①; CEA/*359*①.

tambour stitch, DADA.

tambour table, SDF.

tambour-top, S-4804/*936*①.

tambour watch, EA.

tambour work, CEA/*294*.

tamenuri, C-5156/*714*①.

Tametaka, CEA/*561*①.

tammy, FFDAB/*110*; SDF.

tamp, DATT.

Tanagra figure, IDC; MP/*115*.

Tanagra figurine, DATT/①.

Tanagra statuette, DADA.

Tandart, CEA/*227*①.

Tandart Ainé, S-4955/*184*.

Tanegainisha, C-5156/*779*.

Tanegashima Ju, S-3312/*1097*.

tang, C-2503/*28*①; C-2569/*59*①; CEA/*44*; DADA; S-4972/*156*①, *272*.

T'ang, DADA; IDPF/*87*①.

Tang, C-2323/*151*.

T'ang dynasty, IDC; ACD.

T'ang dynasty, CEA/*111*; EA/①.

Tang dynasty, LAR82/*182*①; LAR83/*79*①, *160*①; C-2323/*1*; C-2414/*28*①; C-2458/*9*①; C-5127/*1*; C-5156/*5, 313*; C-5236/ *346*①, *1569*; S-3312/*1304*①.

tangent, C-2904/*253*; CEA/*556*.

tangent screw, C-2904/*61*①.

Tang period, JIWA/*88, 88, 133*.

Tang pottery ware, S-4963/①.

Tang-Style, S-4461/*400*.

Tang taste, C-2513/*62*.

t'ang wan, IDPF/*27*.

T'ang Ying, EA.

tankard, ACD; C-0706/*38*; C-1502/ *176*; C-2360/*130*①; C-2398/*19*①; C-2427/*184*①; C-5127/*228*①; CEA/*136*①, *624*①; DADA; EA/ ①; EC2/*23*; FFDAB/*138*①; IDC; IDPF/*225*①; LAR83/*609*①; MP/ *62*; NYTBA/*156*①; RGS/*17*①; S-4804/*97, 137*①; S-4922/*10*①; S-4972/*393*.

tankard and cover, C-5117/*198*①.

tankard form, C-0403/*76*①; LAR83/ *177*①.

tank case, S-4802/*87*.

tank melting, EG/*236*.

tank wrist watch, S-4461/*319*.

tank wristwatch, S-4802/*69*①; S-4927/*4*.

Tanner, John, C-5153/*50*①.

Tännich, Johann Samuel Friedrich, EA.

Tanning, Dorothea, S-286/*521*①.

Tanqueray, Anne, S-4922/*32*①.

Tanqueray: David, Ann, EA.

tansu, CEA/*575*.

tantalum, RTA/*146*.

tantalus, C-0254/*23*①; C-0906/*90*;
 EA; LAR82/*65*①, *71*①; LAR83/
 *424*①; SDF; DSSA.

tanto, C-1082/*120*; DADA.

T‘an-tou, EA/*Hsiao-pai-shih*.

tantric figure, S-3312/*1068*①, *1248*①.

tanzaku, C-5236/*950, 1214, 1279,
 1326*; JIWA/*170, 244*.

Tanzenmann, DADA/①.

Tao Kuang, CEA/*124*①; DADA;
 EA.

Tao Kuang period, LAR82/*107*①.

taotie, C-2414/*7*①; C-2458/*69, 211*;
 C-5236/*378*①.

t’ao t’ieh, IDC; S-4843/*68*①.

tao tieh, CEA/*113*①.

t‘ao-t‘ieh mask, EA.

taotie mask, S-3312/*1281*①; S-4810/
 *287*①.

taotie panel, C-5127/*308*①.

tap, C-5117/*305*①.

tap-action pistol, C-2503/*193*;
 C-2569/*78*.

tape, C-1506/*59*; DATT.

tape guipure, DADA.

tape hinge, S-286/*497*.

tape hinging, S-286/*18*.

tape lace, C-1506/*175*; C-2203/*105*;
 DADA.

tape measure, C-0406/*99*.

taper-bodied, C-0403/*152*.

taper box, DADA; EA/*bougie box,
 bougie box*; LAR83/*546*①.

tapered baguette-diamond, S-291/*16*.

tapered baguette diamond, S-291/
 *57*①, *75*①; S-4414/*96, 119*①.

tapered bowl, S-4905/*217*①.

tapered case, C-5114/*264*.

tapered cluster, S-4414/*109*.

tapered cylindrical form, S-4922/*7*①.

tapered diagonal link, S-4414/*75*①.

tapered faceted stem, S-4414/*276*.

tapered Florentine mesh strap, S-291/
 138.

tapered foot, C-5114/*329*①, *341*①.

tapered half-hoop, S-4414/*74*.

tapered handle, IDPF/*119*.

tapered mesh strap, S-291/*81*①.

tapered neck, C-5114/*36*①.

tapered oval form, S-2882/*1073*①.

tapered rectangular form, C-5005/
 *256*①.

tapered section, S-291/*67*①.

tapered stem, C-0254/*2, 74, 257*.

tapered trunk, SDF/①.

tapering, C-0782/*40*; C-0982/*2*;
 C-2402/*8*; C-2458/*190, 416*;
 C-5127/*103*; C-5153/*112*; C-5156/
 52; C-5239/*9*.

tapering base, CEA/*415*.

tapering case, C-2437/*30*.

tapering club shape, S-2882/*1256*①,
 1285.

tapering contour, S-4414/*243*①.

tapering cylindrical, C-0406/*119*;
 C-5117/*18, 56*①.

tapering cylindrical form, C-5005/
 *302*①; S-4461/*17*.

tapering cylindrical neck, C-0782/*13*.

tapering cylindrical vessel, S-4414/
 195.

tapering enamelled beaker, RGS/
 *62*①.

tapering foot, C-0249/*439*.

tapering form, S-4461/*237*.

tapering leg, C-0982/*4*; C-2388/*21*;
 C-2402/*1*; C-5114/*327*①; C-5116/
 34.

tapering neck, C-0782/*118*; C-1082/
 84; C-2204/*12*.

tapering octagonal beaker, RGS/*8*①,
 182.

Tassel, E., C-5189/*168*①.

tassel-carved, S-4436/*62*.

tasseled drapery, S-4955/*167*.

tasseled drapery swag, S-2882/*933*.

tasseled medallion, S-3312/*1267*.

tassel foot, EA/*paintbrush foot*; SDF.

tassel frieze, S-3311/*535*①.

tassel fringe, LAR83/*478*①.

tasselled chain, C-2364/*3*①.

tasselled cord, C-1506/*4*.

tasselled drapery, C-5116/*131*①.

tasselled end, C-0405/*214*.

tasset, C-2503/*48*; C-MARS/*104*①; DADA.

Tassie, S-4843/*514*①.

Tassie, James, DADA; EA.

Tassie medallion, IDC.

Tassie's cast-glass, CEA/*513*.

tassle, C-5117/*22*①; S-4905/*377*①; S-4972/*250*.

Taste and Sight motif, C-2493/*251*.

taster, S-4802/*229*.

tat-e, JIWA/*170*.

tate-e, JIWA/*244*.

Tatham, Charles Heathcote, EA.

Tatham, Thomas, EA.

tatted, C-0604/*251*.

tatting, C-2704/*171*; DADA.

tatting chair, SDF/①.

tatty, OC/*132*.

tau cross, DATT; RTA/*80*①.

Tau-Cross, DSSA.

taufschein, DADA.

tau handle, IDC.

Tauk Nauska, C-2388/*183*.

Tauk Nuska gul, C-2357/*157*.

taupe, S-288/*34*①.

Taurus, DSSA.

Tautenhahn, Karl Ferdinand, Augsburg, C-2487/*42*.

tavern, C-0405/*161*; CEA/*234*①.

tavern clock, EA/*Act of Parliament*, ① *Act of Parliament*; SDF.

tavern glass, DADA.

tavern mug, EA/*mug*.

tavern pot, LAR83/*516*①.

tavern table, C-5114/*296*①, *309*①, *378*①, *318B*①; DADA; S-3311/ *131*, *182*; S-4905/*442*.

Tawney, Lenore, DADA/*Supplement*.

taws, ACD; IDPF/*226*.

taws ball, IDPF/*43*①.

tax-farmer, EA.

tax mark, C-5117/*177*①.

Ta-yao kiln, EA.

Tayleur, John, C-5174/*588*①.

Taylor, Howson, DADA/*Supplement*.

Taylor, J., C-2403/*82*.

Taylor, John, C-2487/*61*; EA.

Taylor, John, London, C-2489/*75*①.

Taylor, Joseph, C-0406/*84*; C-0706/ *11*.

Taylor, Samuel, C-5117/*291*①.

Taylor, Thomas, Holborn, C-2489/*72*.

Taylor, W., C-2487/*162*.

Taylor, William, C-5117/*284*①.

Taylore & Perry, C-0706/*221*.

tazza, ACD; C-0225/*65*; C-0279/*169*; C-2427/*223*①; C-2458/*150*; C-2502/*113*; C-5005/*230*①; C-5156/*775*; C-5173/*①*, *68*①; C-5239/*137*; CEA/*419*①, *622*①, *622*①; DADA; EA/①; EG/*73*①; IDC/①; IDPF/*226*; LAR82/ *454*①; LAR83/*441*①, *608*①; S-3311/*920*; S-4802/*223*①; S-4804/*7*①, *54*; S-4853/*333*①.

tazza-form, S-4507/*61*①.

tazze, C-5117/*311*①; S-2882/*784*; S-4804/*73*①.

TB, EA/*Rato*.

TB, signed, EA/*Bogaert, Thomas*.

T Bradley, C-2204/*81*.

Tbrèche d'Alep marble, S-4955/*55Z*.

TB & S, EA/*Bradbury, Thomas*.

teakettle stand, DADA.

tea-kettle stand and lamp, C-5173/32①.

tea knife, C-1502/128.

teakwood, C-0982/207; DADA.

teakwood centre table, C-1407/14.

teal, C-5239/44; S-288/13①; S-4992/8①.

tea-measure, IDC.

Teams Glass Works, EA/Davidson & Company.

Tea Party, the, IDC/①.

teaplant beaker, C-2493/73①.

Teaplant pattern, S-4823/29.

tea-pot, C-5005/222①, 229.

teapot, ACD; C-0706/1; C-0782/2, 117; C-2398/24①; C-5114/2①; C-5153/1①, 23①; C-5236/463①; DADA/①; IDC; IDPF/228①; LAR83/624①; S-4804/23; S-4922/24①, 24①; S-4992/17①.

teapot and hanging lamp motifs, S-4948/51.

'teapot' shape, OC/43.

teapot-stand, C-5117/5, 138.

teapot stand, C-0254/150; LAR83/608①; S-4905/126①; S-4922/24①.

teapot warmer, IDC.

teapoy, ACD; C-2478/80; DADA/①; EA/①; IDC; LAR82/412①; LAR83/382①; S-3311/225①; SDF/①.

tear, DADA; DATT; EA; EG/294①.

tear bead, CEA/503.

tear drop, C-5156/258①.

teardrop, DATT; IDC; NYTBA/277.

teardrop and tassel, OPGAC/237.

teardrop body, LAR83/445①.

tear-drop form, S-4461/386.

teardrop-form, S-2882/1219; S-4461/130.

teardrop form, C-5005/280①; LAR83/439①; S-4414/203①; S-4461/168.

teardrop-form vase, S-2882/1236.

teardrop pattern, IDC.

tear-drop pull, CEA/391①.

tear drop shape, IDPF/3①.

teardrop shape, C-0225/101B.

tear-drop shaped, C-5146/87B.

tear jar, IDPF/231.

tear-shaped, NYTBA/219.

tea-saucer, IDC.

tea-service, C-2398/39; IDC.

tea service, C-0782/26, 117; C-1502/54A; C-2202/3; C-2458/134①; C-5005/222①; C-5114/7; C-5153/21①; DADA; EA/①; JIWA/348; LAR83/614①.

tea set, S-4804/23, 32①; S-4905/179①.

teaset, LAR83/615①.

teasle, C-GUST/10.

tea spoon, C-5153/7.

teaspoon, C-2398/14; C-5114/16; C-5117/53; C-5153/26①; DADA; S-4804/4, 28①, 35①; S-4922/1①.

teaster, SDF.

tea-strainer, C-1006/53; IDC.

tea strainer, C-0254/239; C-5114/76; C-5174/286①; IDPF/231①; S-4461/266; S-4804/65.

tea strainer bowl, C-1502/115.

tea-table, C-2403/45.

tea table, C-0279/450①; C-0982/27; C-1407/76A; C-2402/37; C-5005/318①; C-5114/270①; C-5153/190①; DADA/①; EA/①; S-4461/590; SDF/①.

tea-tray, C-5117/10.

tea tray, C-0254/11; DADA; EA/①; LAR83/616①, 630①; S-4804/164①; S-4922/28①.

teatray, S-4461/241①.

tea-urn, C-5117/148①; IDC.

tea urn, C-0254/25; C-0706/119; C-5114/35①; C-5146/61A①; DADA; EA/①; LAR83/639①;

Tempestà, Antonio, EA.

template, DATT/①.

temple art, JIWA/9.

Temple Bar, C-2904/152.

temple clock, EA.

temple d'amour, EA/temple clock.

temple drum, C-5156/758①; C-5236/846.

temple facade, C-5174/124①.

temple gong, C-0282/29.

temple guardian, C-5236/850.

temple hanging, C-5156/440.

temple of Venus, MP/74.

temple pattern, IDC.

temple plaque, C-2458/242.

temple rubbing, S-4461/435.

temple scene, MP/61.

temple-shaped, C-5170/150①.

Templeton, James, EA/chenille Axminster.

temple vase, C-0279/148①; C-5156/771; CEA/118①; IDC/①.

Templier, Raymond, C-GUST/124①.

Tempo period, JIWA/194.

temporary stand, JIWA/315①.

Tempyo, DADA.

tenacity, IDC.

ten-branch chandelier, C-5157/12.

tendril, C-0254/314; C-2357/84①; C-2388/209; C-2458/373; C-5116/152①; RTA/42①.

tendril-filled border, S-4847/342.

tendril-form, S-4944/270①.

tendril handle, C-2398/68①.

tendril meander, C-5156/756①.

tendril terminal, C-0103/48.

tenebrism, DATT.

Teniers, David the Younger, EA/①.

Teniers figure, C-2427/27①, 102①.

Teniers' scene, S-4944/255①.

Teniers scene, C-2364/64①.

Teniers subject, IDC/①.

Teniers tapestry, LAR82/647①.

Tenjiku Tokubei, CEA/567①.

tenmoku, C-5156/791; DATT.

tenmoku glaze, C-2324/24; C-2910/79, 113.

Tennant, Dora, C-5191/47.

Tennessee Pink, DATT.

tennis outfit, C-3011/51.

tenon, ACD; CEA/322①, 542; NYTBA/19①; SDF/①.

tenoned, FFDAB/75.

tenon joint, FFDAB/75.

tenor lute, EA/lute family.

tension, LP.

tent bag, OC/30.

tent band, S-4796/19.

tent bed, SDF/① field beds.

tent entrance curtain, OC/154.

tent-pole cover, C-2478/223.

tent-stitch, LAR82/646①.

tent stitch, C-1506/122; CEA/274①; DADA; SDF.

tent storage-bag, OC/204.

Teotihuacan, S-4807/195①.

Teplitz, C-0225/51.

'tequilla ring', RTA/167①.

Terechkovitch, Kostia, S-286/432.

tereh, DADA.

Tereszczuk, P., C-5191/181; OPGAC/14, 16.

Tereszczuk, Peter, C-5005/311①.

Terez, C-0225/51.

term, ACD; C-5157/33①; DADA/①; DATT; IDC; SDF/①.

term dial, C-5189/198.

terme, C-5189/182①.

term handle, S-4992/18①.

terminal, C-2202/74; C-2409/181; C-5114/312①; IDC; IDPF/120; S-2882/790, 794; S-4414/114①, 279A①; S-4461/209, 373; S-4507/8①; S-4804/4, 29; S-4905/220; S-4927/128①; S-4992/9①.

tête-à-tête service, IDC/①.
tête-á-tête service, S-4804/*423*.
tete-de-negre, C-5157/*112*①.
tete-de-negre ground, S-2882/*235*①.
tête de poupée, EA.
Tête-À-Tête, S-4461/*162*.
tetsubin and cover, C-1082/*113*.
Teutonia alarm clock, CEA/*240*①.
Teutonia Clock Manufactory, CEA/ *240*①.
Teutsche Bluhmen, MP/*131*.
Texas, OPGAC/*237*.
Texas limestone, DATT.
textile, C-2458/*300*; S-4972/*205*.
textile backing, OC/*15*.
textile design, JIWA/*12*.
textile painting, JIWA/*206*.
textile patterning principle, JIWA/ *213*.
textile still-life, JIWA/*215*①.
textile technique, RTA/*198*①.
texture, CHGH/*63*; DATT; JIWA/ *53*; LP/①.
textured, C-5117/*422*①.
textured bark finish, C-2409/*37*.
textured basketweave design, S-4414/ *63*.
textured decoration, S-4414/*54*.
textured effect, JIWA/*332*①.
textured laid paper, S-286/*528C*.
textured oval link, S-4414/*83*①.
textured stylized floral mount, S-291/ *44*.
TF, CEA/*195*①.
T.F. & Co, EA/*Fell, Thomas*.
T. G. Hawkes & Company, Corning, New York, NYTBA/*307*.
TH, CEA/*642*①; EA/*Heming, Thomas*.
Thai bronze, C-1082/*117*.
Thalia, DSSA.
thalo blue, LP; DATT.

Thalo green, DATT.
Thalo Red Rose, DATT.
thanka, C-5127/*364*.
TH crowned, EA/*Heming, Thomas*.
theatrical, C-1506/*47*.
theatrical figure, IDC/①.
theatrical mask, C-5116/*169*①.
theatrical poster, NYTBA/*208*.
theatrical standard, C-5236/*1706*.
theatrical sword, C-MARS/*16*.
The Double Jug factory, EA/ *Victorson, Victor*.
Theed, William, CEA/*660*①; EA.
Theed & Pickett, EA/*Rundell, Philip*.
theestoof, C-2546/*97*.
The Fortune factory, EA/*Peridon, Hendrick Janzon*.
The Golden Flowerpot, EA/ *Pijnacker, Jacobus*.
The Greek A factory, EA/*Kocks, Adriaen*.
The Greek A factory mark, EA/ *Dextra, Jan Theunis*.
The Hague Decorating workshop, EA.
The Happy Parents groups, EA/ *Acier, Michel-Victor*.
The Heart factory, EA/*van der Laarn, Jan*.
Thelot, Johann Andreas, CEA/*628*①.
thematic, JIWA/*6*.
thematic connection, JIWA/*24*.
thematic strand, JIWA/*14*.
theme, JIWA/*5*; LP.
The Metal Pot factory, EA/*Cleffius, Lambert, Peridon, Hendrick Janzon, cachemire*.
Thénard's blue, DATT; LP.
theodolite, C-0403/*226*; C-2608/*68*; C-2904/*184, 217, 279*①; CEA/ *604*①, *605*①; LAR83/*461*①; S-4927/*220E*.
The Old Pottery, EA/*Leeds*.

theorbo, CEA/552①, 556; EA/*lute.*

theorem painting, C-5114/*206.*

The Peacock factory, EA/*Cleffius, Lambert, Verhagen, Johannes.*

The Pole factory, EA/*Kocks, Adriaen.*

The Porcelain Axe factory, EA/*Hoppesteyn.*

The Porcelain Claw factory, EA/*Sanderus, Lambertus.*

The Porcelain Plate factory, EA/*Pennis, Johannes, van Duyn, Johannes.*

therm, FFDAB/*84*; SDF/①, ① *term.*

thermed foot, SDF/*therm.*

thermed leg, SDF/*therm.*

therming, SDF.

thermo-couple, C-0403/*213.*

thermocouple, DATT.

thermograph, C-0403/*188*; C-2608/*114.*

thermo-luminescence dating, IDC.

thermoluminescence test, C-5156/*21*①; S-4965/*193*①.

thermometer, C-0249/*349*; C-2368/*1*; C-2904/*43, 82, 261*; C-5116/*33, 45*①; C-5157/*11*; CEA/*249*①, *262*①; EC2/*99*①; S-4881/*57*①.

thermometer stand, IDC.

thermometer tube, CEA/*262*①.

thermoplastic, DATT.

thermos, C-0254/*15.*

thermosetting, DATT.

The Rose factory, EA/*Hofdyck, Dammas, Peridon, Hendrick Janzon, van Dijk, Abraham.*

Theseus, DSSA.

Thesmar, André Fernand, CEA/*487*①; DADA/*Supplement.*

The Three Ash-Barrels factory, EA/*Kam, Gerrit.*

The Three Golden Ash-Barrels factory, EA/*van Eenhoorn, Wouter.*

The Three Graces, EA/① *Eberlein, Johann Friedrich.*

The Two Ships, EA/*Pijnacker, Jacobus.*

The Two Ships factory, EA/*Pennis, Johannes.*

The White Star factory, EA/*Hofdyck, Dammas.*

The Young Moor's Head factory, EA/*Hoppesteyn.*

Thibaud, CEA/*191*①.

Thibault Frères Foundry, C-5189/*135.*

thickly potted, C-5156/*57.*

thicknessing-up, SDF.

thick ring foot, S-3312/*1113*①.

Thieme, Carl, C-2493/*260.*

Thienot, Ch., OPGAC/*15.*

thimble, C-0406/*99*; C-1502/*101*; C-2427/*63*①; C-2487/*7*; DATT; IDPF/*231.*

thimble and castor leg, LAR83/*401*①.

thimble case, C-5174/*443*①.

thimble foot, LAR82/*379*①.

thimble measure, C-1502/*160.*

thimble sabot, S-4955/*126*; S-4972/*523*①.

thimble surface, IDC.

thin japan, C-0249/*23.*

thinly potted, C-5156/*65.*

thinner, DATT; LP.

thin proportion, NYTBA/*18.*

thioindigo violet, DATT.

Thionville pattern, C-5167/*130.*

thio violet, LP.

thirdendale (thurndell), EA.

third eye, S-4965/*102*①.

Third Republic, C-0982/*77*; C-1407/*16.*

thirty-day, S-4988/*407*①.

thistle, C-0225/*175*; CEA/*637*; OPGAC/*238*①.

thistle and rose pattern, NYTBA/ *278.*

thistle cup, EA/①.

thistle glass, DADA.

thistle mark, EA.

thistle measure, EA.

thistle motif, S-4414/*53.*

thistle shape, IDPF/*67*①; LAR83/ *428*①.

thistle-shaped, C-0706/*138*; C-5174/ *229*①; LAR82/*441*①.

thistle vase, C-2324/*50*①.

thixotropy, DATT.

Thomas, Mahlon, C-5153/*181*①.

Thomas, Seth, DADA; EA; K-711/ *130.*

Thomas Bradbury and Sons, EA/ *Bradbury, Thomas.*

Thomas Bradbury & Sons, C-0406/ *37.*

Thomas Fell & Co., EA/*Fell, Thomas.*

Thomason, Edward, LAR82/*584*①.

Thomason, I. J., EA.

Thomason, Sir Edward, EA.

Thomas Webb & Sons, JIWA/*86*①.

Thomas Webb & Sons, Stourbridge, NYTBA/*299*①.

Thomire, CEA/*368*①.

Thomire, Pierre-Philippe, EA/①.

Thomire, Pierre Philippe, DADA.

Thomire, Pierre Philippe, stamp: THOMIRE A PARIS, C-5224/ *268*①.

Thomire-Dutherme et Cie, EA/ *Thomire, Pierre-Philippe.*

Thomire et Cie, EA/*Thomire, Pierre-Philippe.*

Thompson, Benjamin, DADA/ *Supplement.*

Thompson, George, DADA/ *Supplement.*

Thompson, John W., CEA/*166*①.

Thompson, T., Lancaster, C-2489/ *167.*

Thompson, William, S-4905/*170, 202.*

Thomson, William, S-3311/*634.*

Thonet, C-5191/*302*; C-5239/*256.*

Thonet, Michael, EA/①; K-711/*121*; NYTBA/*4.*

Thonet Bentwood Furniture, DADA/ *Supplement.*

Thorn-Prikker, Johan, DADA/ *Supplement.*

thorny prunt, CEA/*452*①.

Thos. Law & Co., EA/*Law, Thomas.*

Thos. Webb & Son, CEA/*60*①.

thousand butterfly bowl, C-5127/ *142*①.

Thousand Cranes red ground, C-5127/*136*①.

thousand eye, OPGAC/*238*; CEA/ *472*①.

Thracian kilim, S-4796/*75.*

thread, CEA/*503*; CHGH/*58.*

thread and shell, C-5117/*63*; DADA.

thread-and-shell pattern, EA.

thread circuit, DADA/①.

thread decoration, C-GUST/*40.*

thread dye, CEA/*294.*

threaded, C-2421/*27*①.

threaded arabesque decoration, C-0254/*277.*

threaded edge, DADA; EA.

threaded glass, DADA; EC1/*56.*

threaded handle, C-0254/*132.*

threaded old-English pattern, C-5174/ *537.*

Threaded Old English pattern, S-2882/*1121.*

threaded pewter rim, C-5114/*153.*

threaded type, S-4972/*234.*

threaded wavy spatulate handle, C-5114/*110.*

threading, C-5239/*306*; EA/*trailing*; EG/*34, 62.*

threading tool, DATT.

thread panel, S-2882/*236.*

thread relief, S-4965/*123*①.

thread rug, S-3311/*42*①.

threads to the inch, NYTBA/*112.*

thread tap, C-0403/*193.*

Three Abundances, the, IDC.

Three Abundances motif, S-4965/ *298*①.

three-arm balance, C-2368/*39*①; C-5174/*409*①.

three-arm balance wheel, S-4927/ *67*①.

three-barrel pistol, CEA/*31*①.

three-bladed fleam, C-0403/*255.*

three-bottle inkstand, LAR83/*585*①.

three-case inro, LAR83/*458*①.

three-chairback settee, C-5189/*278*①.

three circle, C-0403/*173.*

three-color glaze, S-4965/*165*①.

three-color ware, DADA.

three-colour decoration, IDC.

three-colour decoration san ts'ai, JIWA/*343.*

three-dimensional, LP.

three-dimensional form, CEA/*489.*

three-draw stadometer, C-0403/*152.*

Three Face, CEA/*472*①.

three-face doll, K-711/*128.*

three-face lamp, K-802/*16.*

Three-Face pattern, CEA/*472*①.

three faces, CEA/*697*; OPGAC/*238.*

Three Fates, DSSA.

three Fates and the Thread of Life, C-2704/*39.*

Three Fishermen, the, IDC.

three fleurs-de-lis and LV, EA/ *Valadier: Luigi, Giuseppe.*

Threefold Blessing, the, IDC.

Three Friends, C-2458/*368*①.

Three Friends (in Chinese ceramics), EA.

Three Friends, the, IDC/①.

three fruits, OPGAC/*184.*

Three Fruits motif, S-4965/*298*①.

three-glyph inscription, C-2414/*3*①.

Three Golden Ash-barrels, The (De 3 Vergulde Astonnekens), EA.

Three Graces, C-2398/*18*①; DSSA.

three-jar mercury pendulum, S-4804/ *923*①.

three-layered onyx, RTA/*75*①.

three-leaf diadem, S-4965/*91*①.

three leaf lotus diadem, C-5234/*41*①.

three-legged skillet, NYTBA/*262.*

three-light applique, S-3311/*398*①.

three-light candelabra, S-2882/*690*①.

three light candelabra, C-0706/*250.*

three panel, OPGAC/*238.*

three pedestal, C-5157/*146*①.

three-pedestal dining table, C-5116/ *123.*

three piece suite, C-0982/*207.*

three-ply, SDF.

three-point perspective, DATT.

Three Porcelain Bottles, The (De Drye Porceleyne Flesschen), EA.

three-pronged, C-5117/*96*①.

three-pronged table-fork, C-5117/ *96*①.

three-prong support, S-4414/*248*①.

threequarter baluster gallery, C-2403/ *142.*

three-quarter bust, C-5117/*361*①.

three-quarter galleried, C-2403/*132.*

three-quarter galleried rectangular top, S-2882/*303.*

three-quarter gallery, C-2403/*65.*

three-quarter life size, S-4972/*95*①.

three-quarter pattern, S-4414/*228*①.

three-quarter plate, C-5117/*401.*

three quarter plate movement, C-5117/*395*①; S-4802/*22.*

three quarter relief, S-4972/*8*①.

three-quarters dexter, S-4802/*492, 551*.

three-quarter waved, C-0982/*129A*.

three scroll, C-2202/*28*.

three seater, C-0982/*207*.

three-stage barrel, C-2569/*57*.

three-train clock, EA.

throne, DSSA; SDF.

throne back, S-288/*14*①.

throw, DATT.

thrower, IDPF/*6*; MP/*19, 502*.

throwing, ACD; CEA/*210*; EC1/*83*; IDC; IDPF/*55*.

throwing room, MP/*73*.

throwing spiral, IDPF/*136*.

thrown, C-2324/*57*; IDPF/*5*.

thrown chair, SDF.

throwne chair, SDF/*thrown chair*.

thrown handle, IDPF/*118*①.

thrust, LP.

thuluth script, S-4973/*248*.

thumb, SDF.

thumb and broad flute, CEA/*447*①.

thumb back, LAR83/*269*①.

thumbed boss, IDPF/*121*.

thumbed-down strip, IDPF/*68*.

thumb glass, DADA.

thumb grip, C-5114/*239*.

thumb groove, IDPF/*119*.

thumb-indented, C-5236/*1590*.

thumb-mark, IDC.

thumb-molded, C-5114/*303*①; C-5153/*137*①, *178*①.

thumb-molded door, C-5114/*266*①.

thumb-molded drawer, C-5114/*261, 389*①.

thumb-moulding, CEA/*322*①.

thumb moulding, SDF.

thumb-nail, DADA.

thumbnail sketch, DATT.

thumb-nail spring bolt, FFDAB/*75*.

thumb-piece, CEA/*64*①, *594, 636*①; IDC.

thumb piece, C-0406/*77*; C-0706/*205*.

thumbpiece, C-2202/*44*; C-2398/*65*; C-2458/*179*; C-2486/*189*①; C-5114/*115*; C-5117/*306, 199B*①; C-5153/*41*①; C-5173/*42*①; DADA/①; EA; S-291/*7, 129*①; S-3311/*705*; S-4802/*228*①; S-4922/*3*①, *21*①; S-4944/*144*①.

thumbpiece safety-catch, C-2569/*65*.

thumb pot, IDPF/*232*.

thumb-pressed marking, S-4965/*183*①.

thumbprint, OPGAC/*238*.

thumbprint cutting, EG/*117*①.

thumbprint lamp, LAR83/*484*①.

thumb-print-molded, S-4507/*16*①.

thumbprint optic pattern, C-5191/*382*.

thumbprint pattern, C-5114/*139*①; NYTBA/*298*①.

thumbprint vase, LAR82/*462*①.

thumb pruntie, CEA/*447*①.

thumb-ring, RTA/*86*①.

thumbtack, DATT.

Thumbuster, CEA/*42*①.

Thun, C-2427/*178*.

thunder and lightning, CEA/*542*.

thunderbolt, DSSA/①; FFDAB/*93*.

Thuret, I., LAR82/*230*①.

Thuret, Isaac, CEA/*226*①.

Thuret, Jacques and Isaac, C-2555/*30*①.

Thuret (Turet): Isaac, Jacques, EA.

thurible, DADA; EA/*censer*; S-4944/*167*.

Thuringia, DADA.

Thuringian, C-2486/*59*; LAR83/*430*①.

Thuringian factories, MP/*165*.

Thuringian ware, IDC.

thurming, SDF/*therming*.

thurndell, EA.

thurndendel, IDC/①.

Thurot, Gabriel, C-5203/*129*①.

thuya, NYTBA/*60*; SDF.

thuyawood, DADA; LAR82/*293*①; LAR83/*370*①; S-4804/*856*①.

thymiaterion, IDC.

Thynne, Lord Henry, service, IDC.

thyrsus, DSSA/①; S-4807/*502*.

TI, CEA/*640*①.

Tianqi, C-5127/*72*; C-5156/*803*.

Tianqi cyclical date, S-4965/*238*①.

Tianqi period, S-4965/*250*①.

tiara, C-2414/*24*; CEA/*516*①; DSSA; EA; LAR82/*501*①; RGS/*199*①.

tiara stopper, C-5239/*121*.

tiare russe, RGS/*179*①.

Tibats, H., C-2370/*62*; S-4988/*459*①.

Tibet, CEA/*561*.

Tibetan, OC/*315*①.

Tibetan Bay-lep, C-5156/*150*.

Tibetan character, S-4965/*239*①.

Tibetan knot, OC/*168*.

Tibetan mat, C-2403/*193*.

Tibetan rug, OC/*31*①.

Tibetan style, S-4810/*387*.

Tibetan white-metal, C-1082/*82*.

Tichborne trial, the, IDC.

tick, SDF.

Tickenhall, DADA.

ticket, EA/*bottle label*.

ticking, SDF/*tick*.

Tickle, William, C-5117/*457*①.

tic-tac escapement, C-5224/*53*.

tic-tac movement, C-2368/*28*.

tidy, DADA/*Supplement*.

tie, DADA.

tie-backs, C-5114/*162*.

Tiebel, Johann Gottlieb Friedrich, MP/*175*.

tie boarder, C-2398/*89*①.

tied emblem, C-5156/*141*, *811*①.

tied emblem mark, C-5127/*86*①.

tied with a blue bow, C-2704/*29*.

Tiefschnitt, EA.

T'ien Ch'i, DADA.

T'ien Ch'i, EA.

T'ien Shun, DADA.

Tientsin, OC/*32*.

tie-pin, C-5117/*360*①.

tier, C-0249/*357*; C-0982/*85B*; C-5114/*302*①; C-5116/*41*, *114*; LAR82/*294*①.

tiered, C-5127/*346*; C-5146/*57*①; S-4972/*654*①.

tiered body, C-5146/*169*①; S-2882/*364*.

tiered foot, C-0279/*456*①.

tiered oviform, C-5146/*148*①.

tiered platform base, C-0982/*60*; C-1407/*21*.

tier table, C-5153/*163*①.

Tiffany, C-2910/*22*; C-5239/*315*; OPGAC/*176*; S-2882/*1331*.

Tiffany, Charles Lewis, CEA/*520*.

Tiffany, Louis C., EC1/*78*①.

Tiffany, Louis Comfort, CEA/*479*①; DADA/*Supplement*.

Tiffany, Louis Comfort (mark), EC1/*84*①.

Tiffany, Louis Comfort, NYTBA/*236*①; OPGAC/*176*.

Tiffany & Co., C-5153/*2*①; S-4905/*160*.

Tiffany and Company, C-5167/*156*①.

Tiffany and Company, Inc., DADA/*Supplement*.

Tiffany & Co., New York, NYTBA/*230*①.

Tiffany & Company, C-5005/*221*.

Tiffany Favrile, LAR83/*414*①.

Tiffany favrile glass, S-3311.

Tiffany Furnace, CEA/*459*.

Tiffany glass, DADA.

Tiffany lamp, K-711/*126*.

tiffany pattern, C-5114/*17*; C-0254/
289.
Tiffany pottery, IDC.
Tiffany Pottery, Corona, New York,
EC1/*85*.
Tiffany setting, RTA/*198*①.
Tiffany Studios, DADA/*Supplement*.
tig, IDPF/*242*①.
tiger, DSSA; IDC.
tiger-form handle, S-4965/*115A*.
tiger grasping a snake, C-2414/*21*①.
tiger head, LAR82/*37*①.
tiger-maple, C-5114/*388*①, *318C*.
tiger maple, C-5153/*197*①; LAR82/
*280*①; LAR83/*251*①, *294*①.
tiger's eye, C-2458/*354*; S-4927/*252*.
tiger's-eye glaze, IDC.
tiger-skin decoration, IDC.
tiger skin rug, LAR82/*36*①.
tiger skin ware, DADA.
tiger table, SDF.
tiger-ware, C-5173/*55*①.
tiger ware, DADA/①; IDC/①.
tigerware, CEA/*638*①; LAR82/
*596*①; LAR83/*66*①; C-2427/
*193*①.
tiger-ware jug, ACD.
tigerware jug, EA.
tigerwood, DATT; SDF.
tight, LP.
tight-fitting glaze, CEA/*191*①.
tightly quilted, C-1506/*92*.
tightly scrolling foliage, C-1082/*179*.
tight-scroll-ground, S-4905/*17*①.
tight squared spiral, C-5156/*44*①.
Tijou, Jean, CEA/*528*; EA.
tile, C-1006/*26*; C-2513/*459*;
C-5127/*92*①; C-5239/*13, 337*;
DADA/*Supplement*, ①; DATT;
EA; IDC/①; IDPF/*232*①; JIWA/
*110*①.
tile device, C-5323/*3*①.
tiled stove, MP/*84*.

tile-effect pattern, EA/*Mudjur carpet*.
tile landscape, NYTBA/*137*①.
tile picture, C-2427/*150*①; C-2486/
*168*①; EA/①.
tile plaque, C-0249/*166*.
tilework, S-3312/*1332*①.
till, ACD; C-0403/*5*; C-5114/*259,
362*①; C-5116/*104*; S-4905/*376*;
SDF.
Tillander, Alexander (workmaster),
C-5174/*323*①.
Tillard, Jean-Baptiste, C-2364/*35*.
tiller, C-MARS/*105*.
Tillet, Leslie, S-4881/*318*①.
tilleul wood, DADA.
Tilliard, EA/*253*①.
Tilliard, Nicolas, C-2364/*35*.
Tilliard the Elder, J-B, CEA/*377*①.
Tillman, William, Borough Green,
Kent, C-0982/*34*.
tilting chest, DADA; SDF.
tilting octagonal top, S-2882/*275*.
tilting-top table, DADA.
tilt-top, C-0982/*48, 197*; C-2402/*9,
32*; C-5114/*282*①; C-5116/*28, 52*;
C-5153/*106*; FFDAB/*71*①;
S-3311/*111*①; S-4905/*447*①.
tilt top, C-0249/*401*.
tilt-top candlestand, C-5114/*260*①.
tilt-top table, EA.
tilt-top (tip-top) table, LAR83/*365*①.
tilt-top table, S-2882/*288*.
tilt-top tripod, CEA/*304*.
Timbrell, Robert, C-5173/*45*①.
time, LP.
time lamp, DADA.
Time motif, C-2493/*114*.
timepiece, C-0906/*106*; CEA/*268*;
C-2368/*28*.
timepiece carriage clock, C-2489/*51*.
Time's dividers, C-5224/*55*①.
time staining, S-286/*56*.
timing screw, C-5117/*484*①.

Timonox, DATT.

timpani, CEA/554①.

tin, C-5114/181①; DATT; S-4905/345.

tinaja, IDC.

tin and temper, EA.

tin coffeepot, C-5114/227.

tinctorial power, DATT.

tincture, DATT; SDF.

tinder-box, EA.

tinder box, C-1702/104; SDF/①.

tinder bucket, S-4461/505.

tinderlighter, C-2503/87.

tin dioxide, CEA/580.

tine, C-0254/5; C-5114/18.

tin-enamel, ACD.

tin enamel, IDC.

tin-enamel glaze, EA/tin-glaze; NYTBA/128.

tin enamel glaze, DADA/tin glaze.

tin-enamelled, CEA/150.

ting, ACD; DADA; EA/①; IDPF/235①; CEA/111; IDC

Ting-chou ware, EA.

tinge, C-5127/12; DATT.

Ting glaze, EA/①.

tin-glass, EA/bismuth, bismuth.

tin-glaze, CEA/130, 210; EA.

tin glaze, ACD/tin-enamel; DADA; IDC.

tin-glazed, CEA/110; IDPF/4①; LAR83/99①.

tin-glazed earthenware, EA/Antwerp, ①; IDC; MP/502.

ting-tang, EA/striking systems.

Ting ware, ACD.

Tingware hexagonal mortar, IDPF/163.

Ting yao, IDC/①; DADA.

Ting-yao ware, JIWA/344.

tinja, DADA.

tinning, CEA/535①; EA.

tin-oxide, CEA/169.

tin-oxide glaze, NYTBA/140.

tin-plate, C-2904/18; CEA/684.

tin-plate cover, C-2904/5.

tin-plated iron, CHGH/59; EA.

tinsel, C-1506/23①.

tinsel picture, NYTBA/193.

tint, CEA/503; DATT; LP.

tint block, DATT.

tinted, C-5005/253①; S-4992/6①.

tinting strength, DATT.

tintinnabula, S-4973/167.

tint stone, S-286/390, 461①, 462①; S-4881/28①.

tint tool, DATT.

tinware, C-5114/208①; CHGH/59; NYTBA/246①; S-4905/346①.

tinware, painted, DATT.

tin white, DATT.

tip, gilder's, DATT.

tipped, S-286/213, 235, 242.

tipsy key, EA.

tipt, C-5114/64.

tip-top, LAR83/366①.

tip-top table, EA/snap table; SDF.

tip-up, C-2478/181①.

tip-up barrel, S-4972/274.

tip-up piecrust top, C-2403/53.

tip-up top, C-2320/52; C-2388/60; C-2421/102; C-2478/95①.

tirate, IDC.

Tiron, Jean-Marie, C-5220/50①.

Tisch, Charles, CEA/404①; NYTBA/78①.

Tischchenmuster, IDC.

Tissot, S-4927/12①.

Tissot, James-Jacques, S-286/522.

tissue guard, C-0225/385.

Titanian ware, LAR83/93①.

titanium, RTA/146.

titanium green, DATT.

titanium pigment, DATT.

titanium white, DATT; LP.

Titan vase, EA/*Vechte, Antoine.*

Titcomb, S-4905/*167.*

tithe, C-2704/*37.*

Tithe Pig, S-4843/*231*①.

tithe pig group, IDC/①.

tithing box, S-4881/*488*①.

titled, S-4992/*35*①.

title-page, JIWA/*38*①.

title sheet, C-5236/*1155*①.

titre, RGS/*166.*

titre mark, RGS/*164.*

Tityus, DSSA.

Tiute, John, S-4922/*69*①.

T. J. Wheatley & Company, Cincinnati, Ohio, EC1/*85.*

Tlapacoya, S-4807/*135.*

Tlatilco, S-4807/*133*①.

TLV, C-2458/*218.*

T motif, S-4965/*82.*

to, CEA/*575.*

toad, DSSA.

toad, three-legged, IDC.

toad-back moulding, SDF/①.

toad-mug, IDC.

toadstone, RTA/*58.*

toadstool seat, SDF.

toasted, C-0706/*178.*

toasted cheese-dish, C-5117/*132*①.

toasted cheese dish, EA/①.

toaster, C-2382/*38*; EA/①; SDF.

toasting glass, ACD; DADA; LAR83/*452*①.

toast-master glass, ACD; EA.

toastmaster glass, DADA.

toastmaster's firing glass, CEA/*436*①.

toastmaster's glass, LAR83/*451*①.

toast-rack, IDC.

toast rack, C-0254/*9*; C-0706/*71, 179*; C-1502/*81, 150*; EA/①; LAR83/*628*①.

toastrack, C-2409/*141.*

toast rack-on-lampstand, S-4804/*165.*

tobacco-box, C-2398/*8*; C-5117/*16*①, *294*①.

tobacco box, C-5116/*25*; C-5153/*65*; CEA/*50, 63*①; DADA; EA/①; NYTBA/*260*①; S-4972/*335.*

tobacco cutter, EA.

tobacco grater, DADA.

tobacco-jar, C-2427/*155*①; IDC.

tobacco jar, C-0225/*75*; C-0254/*71, 271*; C-5191/*100*; EA; IDPF/*235*①.

tobacco-leaf pattern, CEA/*160*①; IDC.

tobacco leaf pattern, S-4905/*36*①.

Tobacco Leaf Pattern, The, C-2360/*84*①.

tobacco-leaf teapot, C-2513/*174*①.

tobacco pouch, C-1082/*135*; C-5156/*695*①; C-5236/*1823.*

tobacco rasp, C-0279/*44*①; EA/*snuff rasp.*

tobacco-seed oil, DATT.

tobacco-spit ware, CEA/*150, 164*①.

tobacco-stopper, EA/*pipe-stopper,* ① *pipe-stopper.*

tobacco stopper, CEA/*533*①; IDC.

tobacco tongs, SDF.

Tobe, DADA/*Supplement.*

Tobey, Marc, S-286/*525.*

tobi seiji, DADA; IDC; EA.

toby jug, C-2409/*88*; DADA/①; IDPF/*236*; S-4905/*155*①; ACD; EA; IDC/①; LAR82/*98*①; LAR83/*144*①; NYTBA/*150*; S-4461/*135*; S-4843/*179*①.

toc watch, S-4927/*187.*

Todd, John, Glasgow, C-2489/*76*①.

toddy-jug, IDC.

toddy ladle, C-0103/*4*; C-0254/*139*; C-1502/*44*; C-5203/*75*; S-4802/*375, 387*; S-4905/*230.*

toddy lifter, DADA; EA.

toddy rummer, ACD.

toddy table, SDF.

toe, CEA/*542*; S-4988/*449*①; SDF/ ①.

toe cap, C-1506/*82*; FFDAB/*54*.

toed leg, LAR82/*329*①.

toe of the frizzen, CEA/*30*①.

toe-recess, CEA/*323*①.

Toft, Charles, EA/①.

Toft, Thomas, ACD; DADA; NYTBA/*126*①.

Toft family: Thomas I, Thomas II, Ralph, EA/①.

Toft ware, EA; IDC/①.

toggle, C-0403/*34*; CEA/*561, 565*; S-2882/*1217*①.

togi-dashi, CEA/*562*.

togidashi, C-5127/*441*; C-5156/ *705*①; C-5236/*779*; CEA/*575*; DADA; EA/*193*; S-3312/*1053*; S-4928/*150*①.

togidashi-zōgan, DADA.

toile, DADA; NYTBA/*132*.

toile de Jouy, DADA.

toilet, DADA.

toilet-and-writing table, EA.

toilet bottle, C-0103/*53*; C-0254/*111*; C-0706/*5, 48*.

toilet box, C-1502/*59*; C-5157/*27*①; CEA/*61*; IDPF/*236*; LAR83/ *456*①, *546*①; RGS/*139*; S-4802/ *173*①.

toilet canister, C-0706/*116*.

toilet chair, SDF.

toilet glass, SDF.

toilet-jar, C-5173/*53*①.

toilet jar, C-0254/*237*; C-1502/*59*; C-2202/*60*; S-4922/*72*①.

toilet-mirror, C-2364/*15*①; C-2388/*3*; C-2403/*14*.

toilet mirror, ACD; C-0982/*50*; C-1407/*144*; C-2402/*153*; DADA/ ①; EA/①; S-4436/*69*.

toilet-pot, IDC.

toilet pot, S-4905/*28*.

toilet-service, C-5173/*53*①.

toilet service, EA/①.

toilet-set, C-2398/*45*; IDC.

toilet set, C-0254/*37*.

toilet stand, C-1407/*26*.

toiletta, SDF.

toilet table, DADA; EA; SDF/①.

toilet water bottle, C-0254/*239*.

token, CEA/*594*; EA; K-710/*118*.

Tokmak, DADA.

tokoname, DADA/*Supplement*.

Tokugawa, DADA; S-4928/*171*①.

tokugawa mon, C-5236/*835*①.

Tokugawa period, CEA/*565, 575*.

tokuri, LAR82/*134*①, *142*①.

Tokyemon, Toshima, EA.

Tokyo School, LAR83/*45*①.

tôle, C-2364/*13*①; DADA.

tole, DATT.

tôle, NYTBA/*246*.

tole, S-4436/*78*; S-4812/*40*; S-4972/ *453*; S-4461/*486*.

tôle bocage, C-5157/*9*.

tole compartment, S-4414/*415*.

tole decorated, LAR82/*66*①.

Toledo, Francisco, S-286/*526*.

Toledo blade, C-MARS/*28*.

Toledo ceramic ware, EA.

tôle figures, C-5157/*31*.

tôle lamp, C-5189/*221*.

tôle or tôle peinte, EA.

tole painted, LAR83/*52*①.

tole-peinte, LAR83/*46*①; S-4804/ *471*.

tôle-peinte, S-4853/*187*①.

tôle peinte, IDC.

tole peinte, S-2882/*401*①.

tôle pente shade, S-4823/*153*.

tôle shade, C-0279/*224*.

tole shade, S-4461/*10, 51*.

tole tea canister, S-3311/*261*.

tole tray, S-4972/*540*①.

toleware, CHGH/*61*; DATT.

toleware (tolerware), EA/①.

Toleware, LAR82/*78*①.

toleware tray, LAR83/*660*①.

toltec pottery, IDC.

toluene, LP.

toluidine red, DATT.

toluol, DATT.

tomato-red, C-2357/*161*; C-2403/*188*.

tomato red, EA; IDC.

tomato server, C-0254/*190, 227*; S-4804/*35*.

Tomato Vine pattern, C-0254/*268*.

tombac, EA.

tombeau, à, IDC.

tombeau, en, CEA/*406*.

tombeau form, C-2546/*85*①.

tomb-figure, IDC/①.

tomb furniture, C-5156.

tomb guardian, IDC/①.

tomb tablet, IDC.

tomb tile, S-4965/*155*①.

Tomimoto, DADA/*Supplement*.

Tomin, CEA/*566*①.

tomobako, C-5156/*823*; C-5236/*868*.

Tomotade, C-1082/*132*.

Tompion, CEA/*219*.

Tompion, Tho., London, C-2489/*196*.

Tompion, Thomas, ACD; DADA; EA; SDF/*777*.

tonal, LP.

tonal gradation, JIWA/*50, 58*.

tonal value, JIWA/*10*.

tonder lace, DADA.

tondino, IDC; IDPF/*236*; S-4972/*127*①; C-2427/*221*①.

tondo, DATT; IDC; LP; S-4807/*327*; S-4881/*32*①.

tone, C-5236/*328*; C-5239/*197A*①; DATT; LP.

toned, C-5236/*957*; S-3312/*963*①.

toned ground, DATT; LP.

tone-on-tone, S-4948/*118*①.

toner, DATT; LP.

Tong Dynasty, C-5156/*601*①.

tonged spoon, S-4461/*383*.

tongs, C-0254/*114*; C-5114/*61, 231*; C-5153/*73*①, *39A*①; DSSA; EA; S-4461/*643*; S-4905/*326*.

tongue-and-dart, C-0982/*16*; C-2402/*46*.

tongue and dart molding, S-2882/*397*.

tongue and groove, CEA/*367*①; DADA.

tongue border, IDC.

tongued slipper foot, C-5114/*395*①.

tongue lac, DATT.

Tongzhi, C-2458/*162, 204*; LAR83/*78*①.

Tongzhi period, LAR82/*125*①.

toning, DATT.

toning down, DATT.

tonkotsu, C-0282/*125*; C-5156/*697*①; CEA/*565, 574*①; S-3312/*1058*.

tonlet, DADA.

tonneau-shaped, LAR82/*500*①; LAR83/*480*①.

Tönnich, Johann, Samuel, Friedrich, EA.

tonquin porcelain, IDC.

T⁰ of Tebo, impressed, EA/*Bow Porcelain Manufactory*.

Tooker, George, S-286/*527*.

Tookey, Thomas, C-2487/*51*.

tool, C-5239/*240*; S-4881.

tooled, C-2437/*75*①; C-5116/*27*; IDC; S-3311/*384*①; S-4461/*565*; S-4972/*35*.

tooled gilt ground, S-2882/*736*.

tooled leather, C-0225/*311*; DADA; S-3311/*477*.

tooling, MP/*30*.

tool mark, CHGH/*57*.

tool stand, S-4905/*326*.

tooth, DATT; LP.

toothed flange, C-2414/*10*①.

toothed foot, RGS/*17*①.

toothed setting, RTA/*39*①.

toothed wheel, CEA/*252*①.

tooth-like leaf, OC/*323*.

tooth-pattern, OC/*321*.

tooth pattern, C-5127/*61, 253*①;
 C-5156/*120*①; C-5236/*497*.

tooth pick, C-1502/*178*.

tooth pick case, C-0406/*96*.

toothpick holder, C-0254/*57*; C-5174/
 38.

top, C-5239/*281*①.

topaz, C-5239/*153*; S-4927/*334*①.

topaz baguette, RTA/*186*①.

top bevelled glass, C-2368/*36*①

top foot, S-4414/*487*; S-4436/
 *113A*①; S-4853/*453*①.

top-grip, C-2476/*2*.

top hat, C-0604/*37*; C-1506/*46*.

topia, DATT.

Topino, Charles, EA/①.

Topino, Charles, stamp: C TOPINO,
 C-5224/*208*.

top knot, C-5116/*162*①.

toplever, C-2476/*64*.

topographical beaker, LAR83/*412*①.

topographical vase, C-2493/*262*.

topographical ware, IDC.

topographic landscape, DATT/①.

Toppan Abner, EA.

top plate, CEA/*250*.

top-rail, EA/*yoke-rail*.

top rail, C-0249/*360*; C-5116/*127*①;
 S-4436/*179*①; S-4972/*594*; SDF.

toprail, C-2388/*7*; C-2403/*25*;
 C-2421/*13*①; C-2478/*34*; C-5127/
 *332*①; C-5236/*1649*①.

top reset, C-5153/*90*①.

top-section, C-2402/*36*.

Topsy, CEA/*247*①.

top tilting, C-5114/*398*①.

top tone, DATT.

top view, CHGH/*64*.

top yoke, SDF.

toque, C-3011/*67*.

Torah binder, C-5174/*12*①.

Torah case, C-5174/*7*①.

Torah crown, C-5174/*155*①.

torah pointer, C-0254/*52*.

Torah scroll handle, C-5174/*156*.

Toranj, DADA.

torba, C-2478/*218*; CEA/*101*; OC/
 30; S-288/*17*①.

torc, RTA/*42*①.

torch, DSSA.

torchère, ACD.

torcherc, C-0249/*369, 438*, C-2357/
 *28*①.

torchére, C-2357/*35*①.

torchere, C-2388/*27*①; C-2478/
 *124*①; C-5116/*106*; C-5157/*77*①.

torchère, DADA/①; EA/*candle
 stand*.

torchere, LAR82/*255*①; LAR83/
 *61*①, *353*①; S-2882/*808*; S-3311/
 *514*①; S-4414/*482, 526*①.

torchère, S-4507/*19*①; S-4804/*683*①.

torchere, S-4812/*140*.

torchère, S-4853/*463*①.

torchere, S-4972/*453*.

torchère, S-4988/*538*①; SDF.

torch-motif, C-2478/*218*.

torchon, DADA.

torchon board, DATT.

torchon paper, DATT.

toreutics, DATT.

Toricelli, S-4972/*426*.

torii, CEA/*575*.

Torinese, C-2364/*14*①.

tormented color, DATT.

Toro, Bernard, DADA.

Torond, Francis, EA.

torpedo, OPGAC/*239*.

torque, C-2482/*116*.

Torricelli, CEA/*260*.

Torricellian vacuum, CEA/*260*.

torsade, CEA/*495*①, *503*; EG/*294*.

torso, C-5156/*198*; C-5157/*2*; C-5167/*2*①; S-4963/*72*①; S-4972/*39*①.

tortillon, DATT; LP.

tortoise, IDC.

'tortoise' border, OC/*43*.

tortoise-shell, C-5114/*191*.

tortoise shell, C-5156/*314*; CEA/*562*; DADA; S-4461/*72*.

tortoiseshell, ACD; C-1082/*187*; C-1502/*43*; C-2202/*25*; C-2458/*397*; C-2910/*232*; C-5116/*11*; C-5127/*19*; C-5157/*32*; C-5236/*782*; CEA/*303, 303, 477*①, *517*①; EA; S-4972/*437*; SDF.

tortoiseshell glaze, IDC; LAR83/*172*①.

tortoiseshell piqué, CEA/*64*①.

tortoiseshell pique, LAR83/*605*①.

tortoise shell ware, DADA.

tortoiseshell ware, EA/①; IDC.

tortoiseshell wood, SDF.

torus, DADA; EA; SDF/①.

torus foot, S-4973/*124*①.

torzella, IDC.

Tosa, DADA.

Tosa School, C-5156/*885*; C-5236/*927*①; JIWA/*100*①.

Toshiro, EA.

Toshiro, Kato, JIWA/*348*.

t'o t'ai, DADA; IDC.

tot cup, C-0706/*138*; S-4944/*141*.

totem, C-5167/*94*①; DATT.

tou, DADA; EA/①; IDPF/*236*①.

touch, ACD; CEA/*594*; DATT; EA.

touch box, DADA.

touch-hole, CEA/*21*①, *44*.

touch mark, DADA.

touchmark, C-5174/*44*①.

touch of Paris, DADA.

Touchon and Co., C-5117/*433*; C-5174/*367*.

Touchon & Co., S-4927/*145*.

touchpiece, DADA.

touch plate, DADA.

touchplate, CEA/*595*; EA.

touchstone, DADA; EA.

Toulmin, Samuel, C-5117/*464*.

Toulmin and Gale, C-2332/*1*.

Toulouse-Lautrec, Henri De, S-286/*527A*.

toupie, C-5259/*525*; FFDAB/*51*.

toupie foot, C-0279/*226*; C-5005/*358*①; C-5116/*73*; C-5157/*143*; C-5189/*42*①; C-5259/*613*①; S-2882/*399, 797*①, *807*①; S-3311/*434*①; S-4507/*53*①; S-4853/*364, 457*.

Touraine tapestry, DADA.

tourbillon, C-5117/*445*①; CEA/*255*①.

tourbillon (tourbillion), EA.

tourbillon, LAR82/*239*①; S-4802/*128*①.

tour de force, LP.

tourist head, C-1082/*74*.

tourmaline, C-2458/*352*; C-5117/*342*①; RTA/*145*; S-4927/*278*.

Tournai, ACD; C-2427/*23*①; C-2486/*13*; CEA/*186*①; EA; LAR82/*183*①; LAR83/*164*①.

Tournai tapestry, EA.

Tournay, DADA/①.

Tournay tapestry, DADA.

Tours tapestry, EA.

Tourte bow, EA/*violin family*.

Toussaint Jean-Baptiste, EA/*Baccarat*.

Toutin, Jean, EA.

tou ts'ai, EA/①; IDC.

tou ts'ai, CEA/*111*.

towel horse, C-0982/*28*; C-2402/*135*;
 DADA.

towel (clothes) horse, EA.

towel horse, SDF.

towel rail, SDF/*towel horse*.

towen linen, SDF.

tower, C-0405/*165*; DSSA; C-2503/
 177.

tower-form, C-5174/*52*①.

tower pattern, LAR82/*177*①.

tower structure, C-5146/*107D*①.

tower type, CEA/*226*①.

Tower weight, EA.

towing, IDC.

Towle Manufacturing Co, C-0270/
 170.

Towle Silversmiths, C-0254/*189*;
 DADA/*Supplement*.

town and lake scene, C-5174/*539*①.

town carpet, OC/*12*.

town landscape, C-5224/*14*①.

town mark, C-0406/*87*; C-2427/*195*;
 C-2486/*195*; C-2487/*29*①; EA/
 Russian gold and silver.

Townsend, Charles, C-5117/*75*①;
 C-5173/*26*①.

Townsend, Christopher, DADA; EA.

Townsend, Edmund, DADA; EA.

Townsend, Family, The, SDF/*775*.

Townsend, Job, DADA; EA.

Townsend, John, CEA/*394*①;
 DADA; EA.

Townsend, Stephen, EA; SDF/*774*.

Townsend, William, S-3311/*777*.

town Serabend, OC/*57*.

toxicity, LP.

toy, C-5117/*36, 95*; CEA/*466*①,
 684; DADA; EA; IDC; IDPF/
 *238*①; S-4881/*170*①.

T-pattern border, IDC.

T P E, CEA/*152*①.

trace, C-5153/*32*①.

tracery, C-0249/*478*①; C-2357/*15*①;
 C-2388/*145*; C-2398/*92*; C-5153/
 *126*①; DATT; EA/*34*; NYTBA/
 21; S-4948/*160*; S-4972/*15*①;
 SDF/①.

tracery vine, C-0279/*34*①; C-2403/
 155.

tracery work, DADA/①.

tracing, DATT.

tracing box, DATT.

tracing cloth, DATT.

tracing paper, DATT; S-286/*156*.

tracing wheel, DATT.

traction fissure, DATT.

trade piece, C-1082/*11*.

Trade Porcelain, NYTBA/*166*.

trade standard, DATT.

trade token, EA.

traditional, LP.

traditional concept, JIWA/*10*.

Trafalgar chair, SDF.

Trafalgar furniture, EA; SDF.

Trafalgar vase, EA.

tragacanth, gum, DATT.

Traherne, Margaret, DADA/
 Supplement.

trail, C-5005/*414*①; DATT/①; EG/
 22.

traile, DATT/①.

trailed, CEA/*153*①.

trailed circuit, DADA.

trailed coloured rod, EG/*22*.

trailed decoration, IDC; LAR83/
 *443*①.

trailed glass, EA/*almorrata*.

trailed ornament, CEA/*503*; DADA.

trailing, CEA/*417*①; DATT; EA;
 IDC; JIWA/*304*①.

trailing foliage, C-2421/*133*①.

trailing scroll, C-1006/*215*.

trailing vine, C-0406/*50*.

trail work, CEA/*50*①.

train, ACD; C-1506/*77*; C-5117/*413*; CEA/*268*.

train (in clock or watch), EA.

train, S-4927/*24*.

trained skirt, C-3011/*105*.

train movement, S-3311/*488*①; S-4988/*413*①.

trains back to back, C-MARS/*239*①.

train spectacles, C-2608/*176*.

traite, DADA.

trammel, EA; SDF.

tramp art, S-4905/*372*①.

Trans Caucasian rug, LAR83/*526*①.

transfer, DATT; LAR82/*70*①; S-4461/*396*.

transfer beaker, EG/*119*①.

transfer engraving, S-4414/*410*.

transfer-gilding, IDC.

transfer lithography, DATT.

transfer paper, DATT.

transfer-print, C-2403/*6*; CEA/*170*①.

transfer-print decoration, NYTBA/ *150*.

transfer-printed, C-5114/*162*; S-4414/ *348*①; S-4804/*283*; S-4823/*41*; S-4843/*140*①, *315*①; S-4905/*51*①.

transfer printed, C-0249/*184*; C-5236/*469*①; LAR83/*122*①.

transfer printed decoration, DADA.

transfer-printing, CEA/*210*; IDC/①.

transfer printing, ACD.

transfer-print on glass, C-2403/*7*.

transferring, LP.

transfer ware, K-711/*131*.

transit, S-4927/*220*C①.

Transite, DATT.

transitional, C-2323/*40*①; DATT; C-0782/*8*.

transitional cabriole leg, S-2882/*388*, *791*, *836*.

Transitional design, C-2437/*53*①.

Transitional furniture, EA/*Adam style*.

Transitional period, S-4965/*276*①.

transitional rapier, C-2569/*37*①.

Transitional Shang Dynasty, C-5156/ *341*.

transitional style, C-5189/*301*①; C-2360/*132*①.

transition clock, EA.

transition Ming, IDC.

transit theodolite, C-2608/*144*.

translucence, EC2/*22*.

translucency, DATT; LP.

translucent, C-2458/*19*; C-5005/*238*; C-5117/*330*①; C-5127/*23*, *211*; C-5146/*87A*; CEA/*160*①; EC2/ *20*; EG/*22*; IDC.

translucent glass, JIWA/*304*①.

transmitted light, DATT.

transmutation glaze, IDC.

transom bar, CEA/*542*.

transparency, Berlin, IDC.

transparent, DATT.

transparent base, DATT.

transparent bead, C-2704/*22*.

transparent bipartite, CEA/*472*①.

transparent brown, DATT.

transparent copper green, DATT.

transparentemail, C-2910/*19*.

transparentemail beaker, LAR82/ *429*①.

transparent glass, EG/*23*①.

transparent gold ochre, DATT.

transparentizer, DATT.

transparent japan paper, JIWA/*50*.

transposed triggers, C-2476/*66*.

transversal, CEA/*607*①, *612*.

transverse-bolt, C-2476/*64*.

transverse panel, S-4965/*78*①.

Transylvanian, CEA/*81*①; OC/*264*.

'Transylvanian', OC/*133*.

Transylvanian carpet, EA.

Transylvanian rug, ACD.

Tranter, G. William, CEA/*36*①.

Trapani, C-2427/*208*①.

Trapani maiolica, EA.

trap-cut, RTA/*104*①.

trap door Springfield rifle, CEA/ *42*①.

trapeze-cut, S-4414/*73*.

trapeziform seat, EA/*caquetoire*.

trapezium-shaped weight, CEA/*255*①.

trapezoid, C-5114/*301*①.

trapezoidal cabinet, C-5157/*62*.

trapezoidal reserve, MP/*488*①.

trapezoid-shaped, C-5181/*124*.

trap gun, C-MARS/*118*.

trapping, S-4965/*134*①.

Traprain Treasures, C-2202/*189*.

trapunto, CEA/*291*①.

Traquair, Phoebe Anna, DADA/ *Supplement*.

Trasuntino, Vito, CEA/*550*①.

Trauerkrug, IDC/①.

trauschein, DADA.

travailleuse, DADA.

travel case, S-4461/*23*.

traveling apple corer, LAR83/*579*①.

traveling clock, C-5146/*67A*.

Travellers' pattern, CEA/*199*①.

travelling canteen, RGS/*170*①.

travelling case, C-5117/*390*①.

travelling clock, C-0406/*81*; EA/①; SDF.

travelling fork, C-5117/*197*①.

travelling jewelry case, S-4905/*338*.

travelling knife, C-5117/*2*.

travelling mirror case, C-5236/*1705*.

travelling pen, C-0403/*32*.

travelling service, EA/①.

travelling set, EA/*canteen*.

travelling shrine, C-5156/*756*①.

travelling shrine inro, S-4829/*70*①.

travelling spoon, fork, and knife, C-2487/*38*①.

travelling trunk, C-1407/*126*.

tray, ACD; C-0254/*8*; C-2398/*23, 72*①; C-2402/*101*; C-2421/*56*; C-2458/*282*; C-5005/*222*①; C-5114/*14, 99*①*, 210*; C-5153/*3*①; C-5236/*1822*; C-5239/*91*; DADA; EC2/*29*①; IDC/①; IDPF/*239*; LAR83/*660*①; NYTBA/*246*; S-4922/*76*①; S-4992/*17*①*, 84*①; SDF.

tray-box, SDF.

tray candlestick, DADA.

trayle, DATT/①.

tray-slide, C-2437/*50*①.

tray stand, DADA.

tray table (voider stand), EA.

tray top, C-0249/*417*; C-5146/*69*①; C-5181/*162*.

tray top commode, LAR83/*305*①.

tray-top table, EA.

tray top table, SDF.

treacle glaze, IDC.

treacle moulding, SDF.

treacle ware, IDC.

Treasury inkstand, EA.

treatment, JIWA/*16*.

treble-curved, IDPF/*12*.

treble elliptic, FFDAB/*55*①.

treble-grip action, C-2476/*1*.

Treby Toilet Service, EA.

trecento, DATT.

tree, DSSA.

tree design, OC/*106*.

tree-form, C-5005/*391*.

tree form skirt, S-2882/*207*.

tree-from base, C-5005/*405*①.

treen, ACD; DADA; EA/①; S-3311/ *155*; S-4414/*414*①; SDF.

tree-nail, SDF.

treen base, S-3311/*262*①.

treen box, S-4461/*362*.

treen jar, S-4414/*411*①.

treen plate, CHGH/*57*.

treen ware, SDF/*treen*.

treenware, K-711/*130*.

tree of life, OPGAC/*239*①; CEA/ *290*①; S-4414/*534*①; S-4796/*109*; S-4847/*40*.

'tree-of-life' design, OC/*106*.

Tree of Life motif, DADA/①.

Tree of Life pattern, CEA/*468*①.

tree peony scroll, C-5156/*44*①.

tree-platter, IDC.

tree pottery, IDC.

tree-stump mound base, C-2486/*82*.

tree-trunk, IDC/①.

tree trunk base, C-0225/*343*.

tree trunk form stem, S-2882/*1031*.

tree trunk standard, S-2882/*1366*①.

tree trunk stem, C-5174/*110*①.

trefid spoon, EA/①; S-4802/*463*.

trefid terminal, S-2882/*1093*①.

trefid top, C-5117/*96*①, *100*.

trefled cross, DATT.

trefoil, C-1502/*52*; C-2202/*136*; C-2458/*205*; C-2482/*80*; DADA; DATT; EA/*Ilmenau*.

trefoil (in silver), EA.

trefoil, IDC; LAR82/*106*①; S-4948/ *6*; SDF.

trefoil arch design, C-5114/*137*①.

trefoil base, C-0279/*433*; CEA/ *338*①; S-2882/*1346*①; S-4414/*246*.

trefoil charka, RGS/*31*①.

trefoil foot, C-5117/*66*.

trefoil form, S-4804/*147*①.

trefoil handle, CEA/*668*①.

trefoiling, C-0254/*136*①.

trefoil lip, S-2882/*1395*①.

trefoil neck, C-0225/*196*.

trefoil ornament, OC/*176*①.

trefoil panel, C-5127/*155*.

trefoil prabha, C-5234/*99*①.

trefoil punch, C-5117/*187*①, *269*①.

trefoil rim, LAR83/*432*①.

trefoil shade, C-0225/*357*.

trefoil shape, LAR82/*437*①.

trefoil-shaped, C-5117/*116*①; LAR83/*223*①.

trefoil shaped, C-1603/*120*.

trefoil top, C-5005/*320*①.

trefoliate cap, S-4414/*159*.

treille, DADA.

trek, CEA/*140*①; EA; IDC.

trellis, C-0249/*423*; C-2403/*123*; C-5127/*27, 143*①; LAR82/*288*①.

trellisage, IDC.

trellis-and-dot pattern, C-2437/*75*①.

trellis and feather design, C-2704/*66*.

trellis and grille, JIWA/*5*.

trellis-and-rosette, C-5116/*164*①.

trellis-and-rosette pattern, C-2478/*44*.

trellis and rosette-pattern, C-5224/ *205*①.

trellis border, CEA/*153*①; IDC.

trellis canopy, C-2437/*3*①.

trellis chain, EG/*128*①.

trellis design, C-2704/*47A*.

trellis diaper border, S-4905/*30*①.

trellis diaper vignette, S-4414/*348*①.

trellis door, LAR83/*257*①.

trellised, DADA.

trellis field, S-2882/*59, 77*①.

trellis flowerhead skirt, S-2882/*67*.

trellis form, LAR82/*496*①.

trellis grand, C-0249/*470*.

trellis ground, IDC.

trellis medallion field, S-2882/*200*.

trellis-moulded, CEA/*435*①.

trellis paling, C-2421/*52*①.

trellis panel, C-0249/*461*; S-2882/ *280*①.

trellis parquetry, C-2437/*52*①; C-2555/*59*①.

trellis-pattern, C-2403/*128*.

trellis pattern, C-0249/*182*; C-0782/ *32, 227*; C-2414/*8*①; C-2427/*4*①; IDC; LAR82/*178*①.

trellis-pattern inlay, C-2555/*49*①.

trellis-pattern panel, C-2437/*31*①.

trellis rase field, S-2882/*81*①.

trellis-rosette, C-0279/*423*.

trellis-work, CEA/*648*①; S-4948/*185*①.

trellis work, C-1502/*49*; C-5146/*100*; SDF/①.

trelliswork, C-0249/*297*; C-2704/*89*; C-5116/*56*; C-5117/*22*①, *316*; EC2/*23*①; LAR83/*66*①; S-4414/*357*①; S-4804/*22*①; S-4905/*5*.

Trelon, EA/*Baccarat*.

trembleuse, C-2427/*79*①; CEA/*176*①; EA/①; IDC/①; LAR82/*163*①.

trembleuse saucer, LAR82/*115*①; S-4823/*72*①; C-2427/*2*.

Trembley, London, C-2489/*172*.

trembly rose painter (in English ceramics), EA/①.

Tremo, H., C-5191/*132*.

tre-nail, CEA/*322*①.

tre nail, CEA/*300*.

trencher, ACD; C-0406/*55*; DADA; EA; IDC; SDF.

trencher-salt, C-2427/*34*①, *249*.

trencher salt, ACD; C-2498/*44*; CEA/*642*①; DADA; EA/①; IDC; LAR83/*599*①.

trench periscope, C-0403/*111*.

trendal, SDF.

trendle, SDF/*trendal*.

trennel, SDF.

Trentvale Pottery, East Liverpool, Ohio, EC1/*85*.

trephine set, S-4927/*224B*①.

Tresilian, Master John, CEA/*529*.

trespolo, EA.

Tress & Co. Ltd., C-0405/*57*.

trestle, ACD; CEA/*327*①.

trestle base, C-0249/*313*; C-5114/*268*①; FFDAB/*110*; S-4461/*707*, *731*.

trestle cot, SDF.

trestle-end, C-0249/*381*, *463*; C-2409/*246*①; C-5005/*317*; C-5116/*80*, *83*, *129*①, *153*①.

trestle end, C-0249/*394*; C-0279/*272*①, *289*; C-2388/*49*, *111*; C-2421/*78*①, *110*①; C-2478/*81*; C-5005/*353*; LAR82/*272*①.

trestle end support, LAR83/*391*①.

trestle-end table, C-0249/*471*.

trestle foot (in furniture), EA.

trestle foot, S-2882/*362B*; S-4436/*10*①, *162*①; S-4905/*327*①; SDF/①.

trestle form, S-2882/*662*.

trestle-form support, S-2882/*361*.

trestle leg, C-5114/*380*①.

trestle plank table, S-4812/*55*.

trestle sabre leg, C-5259/*532*.

trestle support, S-4414/*470*, *523*①; S-4436/*118*①; S-4812/*121*①; S-4988/*480*①.

trestle-table, CEA/*371*①.

trestle table, ACD; DADA/①; EA/①; S-3311/*469*①; S-4461/*706*; S-4972/*474*①; SDF/①.

Treviso porcelain, EA/*Venetian porcelain*.

trevit, SDF.

triad, IDC.

trial firing, MP/*19*.

trial proof, DATT.

triangle, DATT; DSSA.

triangle base, C-2388/*27*①.

triangle border, IDC.

triangle-cut diamond, S-291/*236*①.

triangle-cut emerald, S-291/*103*①.

triangle diamond, S-291/*235*①.

triangle-period, CEA/*188*①.

triangle period, EA.

triangle-shaped diamond, S-4414/*49*①, *62*①.

triangle-shaped ruby, S-4927/*316*①.

triangular, C-0406/*55*; S-4922/*29A*①.

triangular band, C-5117/*58*①.

triangular base, C-2388/*93*①; S-2882/*839*①.

triangular blade, C-2414/*5*①.

triangular composition, S-4928/*25*①.

triangular cornice, S-2882/*678*①, *679*①.

triangular decorative field, RTA/*38*①.

triangular dish, C-0782/*42*.

triangular-faceted stone, RTA/*94*.

triangular foot, C-0254/*59*①.

triangular form, C-5005/*279*.

triangular icicle, CEA/*448*①.

triangular lappet, C-2414/*16*①.

triangular loop, S-4965/*124*①.

triangular motif, C-2414/*7*①; CEA/ *466*①.

triangular mount, C-5005/*226*①.

triangular pediment, C-2421/*150*①; DADA; S-4414/*384, 505*①.

triangular plinth, C-5116/*37*①, *156*①.

triangular section, S-4461/*25*.

triangular stretcher, S-4436/*116*①.

triangular support, S-4461/*73*.

triangular vessel, S-2882/*724*.

Trianon de Porcelaine, EA.

tribal art, CHGH/*46*.

tribal Herati derivative, OC/*76*①.

'tribal' rug, OC/*13*.

tribal type, OC/*12*.

tribal Veramin rug, OC/*221*.

tribhanga, C-5234/*6*①, *40*①.

Tribolo, C-5224/*295*①.

trichlorethylene, DATT.

trichterbecher, IDPF/*240*; DADA; IDC.

trick leg table, FFDAB/*51*.

trickling, DATT; LP.

Triclinium carpet, S-4847/*308*①.

tricorn, C-2427/*50*①.

tricorn hat, C-2204/*34*.

tricoteuse, C-5224/*58*; C-5259/*599*; DADA; EA; LAR82/*400*①; S-2882/*362B*; SDF.

tric-trac board, ACD; C-0279/*419*.

tric-trac table, C-2364/*50*①; DADA; S-2882/*391*; S-4972/*650*①; C-2437/*59*.

tridarn, ACD; LAR82/*334*①; LAR83/*312*①, *324*①.

tri-darn, SDF/*tri-ddarn*.

tridarn cupboard, DADA.

tri-ddarn, SDF.

trident, DSSA.

trident motif, C-2414/*17*①.

Triebischtal manufactory, MP/*193*.

Trier, CEA/*131*①.

triffet foot, S-4436/*181*①.

trifid, C-5153/*202*①; C-5157/*95*.

trifid-end spoon, DADA.

trifid end spoon, C-0103/*83*.

trifid foot, C-0249/*459*; C-5114/ *310*①; S-3311/*102*; S-4414/*431*①; S-4461/*201*; S-4988/*457*①.

trifid handle, C-5114/*161*.

trifid spoon, EA/① *trefid*.

trifle, ACD; CEA/*595*; DADA; EA.

trifle-box, IDC/①.

trifle-mug, IDC.

trifler, CEA/*595*.

triform, C-2402/*32*; S-2882/*1022*.

tri-form base, S-4922/*26*①.

Trigg, Tho., London, C-2489/*123*.

trigger, CEA/*24*①.

trigger guard, CEA/*25*①, *36*①; S-4972/*164*①, *272*.

triggerguard, S-4972/*159*①, *259*①.

trigger-lever, C-2569/*110*①.

trigger-plate action, C-2476/*4*.

triglyph, DADA; S-4972/*500*.

trigram, C-0803/*46, 46*; C-2458/ *120*①; C-5156/*65*; C-5236/*1595*.

Trigrams, Eight, IDC.

trilby, C-0604/*37*.

tri-lobed rim, C-5005/*305*①.

trimetric projection, DATT.

trimmed, C-0225/*408*; C-1506/*3*; C-5236/*938*; CHGH/*35*.

trimmed with lace, C-2704/*174*.

tring tile, IDC.

Trinidad asphalt, DATT.

trinket basket, S-4807/*353*.

trinket box, C-1502/*20, 32*; C-2202/*1*; IDC; S-4461/*365*.

trinket chest, S-4461/*38*.

trinket dish, LAR83/*575*①.

trinket drawer, C-1407/*130*.

trinket stand, IDC.

trinket tray, C-0706/*41*; C-1502/*53*.

trio table, SDF.

tripartite, C-0254/*25*; C-2202/*158*.

tripartite follate base, C-5116/*37*①.

tripartite stem, C-5116/*69*.

triple-arched, S-3311/*216*①.

triple bar pendulum, C-2364/*76*①.

triple bevelled plate, C-2357/*①*.

triple border, C-2357/*128*.

triple case watch, S-4802/*132B*; S-4927/*30*.

triple chairback settee, C-5116/*66*.

triple claw and ball foot, C-2202/*238*.

triple curve, IDPF/*116*①.

triple cylinder bead, C-5156/*313*.

triple decker, EA/① *double decker*.

triple delft rack, LAR83/*325*①.

triple divided, C-2421/*28*①.

triple-divided top, C-5116/*51*.

triple domed, SDF.

triple-extension field camera, C-1609/*135*.

triple-flap, C-5157/*139*①.

triple-flap card table, C-5157/*89*①.

triple-flap games table, C-5116/*126*①.

triple-flap top, C-5116/*126*①.

triple-function piece, CEA/*340*①.

triple-gobbing, EG/*253*.

triple-gourd, S-4853/*47*①.

triple gourd vase, C-5236/*493*; IDC.

triple harp, CEA/*548*.

triple hoof foot, C-2202/*16, 240*.

triple hoop, RTA/*26*①.

triple medallion pattern, OC/*249*.

triple mirrors, C-2402/*14*.

triple niche field, S-2882/*161*.

triple nosepiece, C-0403/*127*.

triple open twist, SDF.

triple overlay, C-0225/*247*①; C-5005/*290*①.

triple-overlay glass, C-5167/*136*①.

triple pad foot, C-0103/*35*; C-0706/*224*.

triple pilaster, CEA/*312*①.

triple plate, C-2421/*41*①.

triple reed brim, C-5114/*9*.

triple-reeded, EA.

triple ring, C-5156/*20*.

'triple ring', RTA/*154*①.

triple shell, C-0706/*2*.

triple splay support, LAR83/*378*①.

triplet objective, CEA/*602*①.

triplet opal, RTA/*144*.

triple turned, C-0982/*34*.

tripod, ACD; C-0225/*14*; C-0782/*45*; C-5239/*156*; CEA/*338*①, *604*①; DADA; LAR82/*168*①, *506*①.

tripod base, C-2388/*31*; S-4461/*599*; S-4804/*3*.

tripod bowl, C-2458/*245*; C-5127/*28*.

tripod cabriole leg, C-5116/*146*①.

tripod cauldron, C-2414/*7*①.

tripod censer, LAR83/*44*①.

Tripod Clock, C-2368/*52*①.

tripod dish, S-4965/*156*①.

tripod food vessel, C-2414/*6*①.

tripod jug, CEA/*655*①.

tripod leg, C-5116/*59*.

tripod light, SDF/*①*.

tripod narcissus bowl, C-5156/*47*①.

tripod pedestal, S-4992/4①.

tripod pot, IDPF/240①.

tripod pouring vessel, S-4461/274.

tripod scrolled leg, S-4414/460.

tripod shade, C-0225/327.

tripod stand, S-4804/309①.

tripod table, C-0249/372; C-0982/
85B; C-2388/35①; C-2402/155;
C-2403/50; C-2478/95①; C-5116/
28; DADA/①; EA/claw table;
S-4436/106; SDF.

tripod vase, C-1082/114.

Tripoli, CEA/445①.

triptych, C-5156/911; C-5203/111A;
C-5236/942; DADA; DATT/①;
JIWA/39①; LP; S-3311/286①;
S-3312/979①; SDF.

triptych form, S-4804/240①.

tristimulus value, DATT.

trisula, C-5234/15.

triton, DSSA.

Triton candlestick, IDC.

triumphal car, C-2398/92.

triumphant mie, JIWA/69.

trivet, ACD; C-0225/47; C-5114/
232①; C-5239/13; DADA; EA/①;
IDC; NYTBA/250; S-4905/325①;
SDF/①.

Troby, Mary, S-4944/322①.

trofei, DADA; IDC.

troika scene, C-5174/216.

trois-couleurs, CEA/513.

trolle kant, DADA.

trolly lace, DADA.

Trompe de l'oeil, C-0405/124.

trompe l'oeil, ACD; C-1603/120;
CEA/210, 537; DADA; DATT/①;
EA.

trompe l'œil, IDC/①.

trompe l'oeil, LP.

trompe l'oeil cap, C-0254/214.

trooper's pistol, S-4972/215.

Troost, Cornelis, CEA/304.

trophy, C-5114/15①; DADA; EA;
IDC/①; S-4922/1①; SDF.

trophy cup, C-0706/72; C-1502/157,
157; C-5203/347; DADA.

trophy of Music, C-5174/449①.

trophy of Science, C-5174/457①.

trophy plaque, C-2437/20.

trophy plate, C-0225/366.

trophy-type, IDPF/153①.

Tropical Moderne, S-3311/951①.

Trott, Benjamin, EA.

Trotter, Daniel, DADA; EA.

Trou, Henry, II, CEA/182①.

troubadour, CEA/386①.

troubadour style, SDF.

trough, NYTBA/37; S-3311/155.

trough spout, IDC; IDPF/241.

Troughton, E., CEA/607①.

Troughton, Edward, CEA/603①.

Troughton & Simms, C-2904/203,
249.

trough undertier, C-0982/81.

Trou: Henri-Charles, Henri II,
Henri-François, EA.

troumadam, SDF/①.

trousers, C-1506/30.

trousse, DADA.

Troutbeck, William, EC2/90①.

trowel, C-0103/94.

Troxel, Samuel, NYTBA/126①.

troyka, RGS/92①.

troy ounce, C-5167/141.

troy ounce bucket weight, C-0403/83.

Troy weight, EA.

trucage, DATT.

Truchet, Abel, S-286/533①.

truckle, SDF.

truckle bed, ACD; DADA; EA; SDF.

true baluster stem, CEA/423①.

true copy, MP/466.

true porcelain, EA/hard paste; IDC.

true wood, SDF.

truité, IDC.

trulla, IDPF/*241*.

trullisatio, DATT.

Trulocke, E., CEA/*28*①.

Trumbull, John, EA.

trumeau, C-0279/*411, 439*; C-5181/
157; C-5259/*484*; DADA/①;
S-2882/*381*①, *382*①; S-4955/*29*;
S-4972/*428*; MP/*132*.

trumeaux, S-4804/*809*.

Trump, IDC/①.

trumpet, C-0906/*254*; C-5127/*15*;
DSSA; IDPF/*241*.

trumpet bowl, CEA/*423*①; EG/*288*;
LAR82/*443*①; LAR83/*452*①.

trumpet brim, C-0225/*225*; C-5239/*9*.

trumpeter clock, EA.

trumpet flower, C-0225/*271*.

trumpet foot, CEA/*643*①, *672*①.

trumpet-form, S-4461/*96, 192*;
S-4804/*17*①; S-4810/*307*①.

trumpet form, C-0279/*165*; C-5236/
*823*①; LAR82/*59*①; S-4414/
*209*①.

trumpet-form vase, S-2882/*1341*.

trumpet-form vessel, S-2882/*1272*.

trumpet leg, DADA; SDF.

trumpet lip, C-2458/*164*①.

trumpet-neck, IDC.

trumpet neck, C-1082/*80*; C-2323/
*57*①; C-2414/*10*①, *48*①; C-2458/
*27*①, *65*; C-5127/*79*; C-5156/*9*①,
*54*①; LAR83/*442*①.

trumpet shape, S-2882/*1375, 1392*.

trumpet-shaped, C-0254/*302*; C-0982/
165; C-2382/*33*①; C-2437/*15*①;
C-5153/*69*①.

trumpet-shaped base, C-5005/*257*①.

trumpet-shaped foot, CEA/*419*①;
S-2882/*1076, 1086*①.

trumpet-shaped shade, C-5005/*336*①.

trumpet-turned, S-4436/*94*.

trumpet turning, EA.

trumpet vase, C-0225/*246*①; C-5239/
144; IDC; S-4843/*253*①.

truncated, JIWA/*5*; S-3311/*296*;
S-4507/*8*①.

truncated-cone shape, RTA/*48*①.

truncated cone shape, RTA/*38*①.

truncated conical form, LAR82/
*252*①.

truncated foreground shape, JIWA/
10.

truncated jar, LAR83/*141*①.

truncated meiping, C-5236/*425*①.

truncated object, JIWA/*242*.

truncation, C-5114/*174*①; C-5189/
180.

trundle bed, DADA; EA; SDF.

trunk, C-0249/*362*; C-0279/*319*;
C-5116/*50*①, *150*①; C-5236/*1641*;
CEA/*241*①.

trunk (in clock), EA.

trunk, EA/①; NYTBA/*24*; S-4461/
709; SDF.

trunk door, C-2357/*26*①; C-2368/
*110*①.

Truro, CEA/*187*.

truss, SDF.

trussel, SDF.

trussing bed, SDF.

trussing coffer, SDF.

truss leg, SDF.

Truth, DSSA.

tryblion, IDPF/*241*.

tryps, IDPF/*241*.

tryptich, S-286/*269*①.

ts'ai, IDC.

Ts'ang Ying-hsüan, EA.

tsata, RGS/*124*.

ts'a ts'ai, DADA.

tschinke, CEA/*22*①.

Tschirnhaus, Ehrenfied Walther von,
MP/*13*.

tsêng, DADA.

T'Serstevens, Michele, C-2458/*295*.

Tudor style, EA; SDF/①.

Tudor-style, NYTBA/*29*①.

Tudor ware, IDC.

Tudor Welsh, IDPF/*169*.

Tudric, C-0225/*91, 101*; C-2409/*211*; C-2910/*151*①, *251*; LAR82/*231*①; RTA/*139*.

Tudric style, C-5191/*285*.

Tudric timepiece, LAR83/*203*①.

tufa, DATT.

Tufft, Thomas, DADA; EA.

tufted, OC/*33*; S-4507/*1*①.

tufted rectangular back, C-0279/*266*.

tufted velvet, S-4461/*569*.

tufting, SDF.

tughra, C-2478/*234*.

tui, EA; IDPF/*241*; S-4965/*115A*.

Tuileries pattern, S-4804/*36*.

tuille, DADA.

Tuisarkan, OC/*259*①.

Tuite, John, C-5173/*37*①; S-4944/*404*①.

tula, DATT; EA.

Tula-ed silver, RGS/*115*.

Tula work, RGS/*115*.

tulipano, IDC.

tulip border, C-2704/*8*.

tulip charger, EA; S-4843/*14*①.

tulip-form, S-4927/*220*①.

tulip form, S-4804/*209*.

tulip-form body, S-4414/*251*①.

tulip-form cup, S-4414/*236*①.

tulip glass, LAR83/*445*①.

tulip globe, C-0279/*187*.

tulipiano, C-2486/*16*.

tulipière, IDC.

tulip Ladik carpet, EA.

tulip motif, C-2704/*100*; S-4948/*70*①.

tulip ornament, EA.

tulip pattern, CEA/*253*①.

tulip pillar, S-4802/*134*①.

tulip poplar, FFDAB/*31*.

tulip-shaded, S-4955/*50*①.

tulip-shaped, C-2421/*4*①.

tulip-shaped body, CEA/*585*①.

tulip-shaped shade, C-2357/*6*①.

tulip table lamp, C-5005/*369*①.

tulip-vase, IDC/①.

tulip ware, DADA; EA; IDC.

tulip with sawtooth, OPGAC/*239*.

tulip wood, ACD; SDF.

tulipwood, C-2357/*57*①; C-2364/*45*①; C-2403/*64*①; C-2421/*71*①; C-2478/*12*; C-5116/*15*①; CEA/*303*; DADA; LAR82/*24*①, *280*①; S-4436/*59*; S-4461/*624*; S-4992/*105*①.

tulipwood parquetry, S-3311/*395*①.

tulle, C-3011/*26*; DADA.

tulwar, C-2503/*3*; C-2569/*4*; DADA.

tumble-polished stone, RTA/*145*.

tumbler, ACD, ; C-0225/*17*; C-5114/*146, 151*; C-5239/*143*; CEA/*44*; DADA; EA/①; EG/*45*; LAR82/*455*①.

tumbler-cup, C-5117/*186*①, *256*①.

tumbler cup, DADA; LAR82/*584*①.

tumbling hour figure, CEA/*243*①.

Tumbridge, DADA.

tumi, S-4807/*11*.

Tunbridge, C-0249/*283*.

Tunbridge ware, ACD; C-0906/*126*; EA/①; S-4436/*79*①; SDF.

Tunbridgeware, LAR82/*67*①; LAR83/*49*①.

Tuner, J. A., C-0906/*287*.

tune-selection ring, C-2489/*91*①.

tung oil, DATT.

tung ware, IDC; EA/①.

tung yao, DADA.

tun-huang form, JIWA/*170*.

tunic, DSSA.

tunicle, DADA.

tuning fork device, C-0279/*28*①.

tunnel handle, IDPF/*241*①.

tunnel-kiln, IDC.

Tupling, CEA/*235*.

turban, C-0405/*138*; DSSA.

turban hat, C-3011/*61*.

turbelik carpet, EA.

turbith, DATT.

Turcman carpet, EA/*Turkoman carpet*.

Turcoman Asmalyk, S-4461/*766*.

Turcoman cape, S-4461/*820*.

Turcoman line, S-4847/*133, 98*.

Turcoman line border, S-4796/*69, 121*.

tureen, C-0782/*187*; C-1006/*111*; C-2427/*28*①; C-5127/*273*; C-5146/*63*①; CEA/*158*①, *183*①; DADA/①; EA; EC2/*23*①; FFDAB/*128*①; IDC/①; IDPF/ *241*①; MP/*106*; RGS/*105*①; S-4804/*44*①.

tureen-shaped finial, C-5005/*228*①.

tureen stand, CEA/*160*①.

Turet, Isaac, EA.

Turing, William, SDF/*765*.

Turin maiolica factories, EA.

turkbaff, CEA/*101*.

Turkbaff carpet, EA.

Türkenköpge, IDC.

Turkestan carpet, EA/*Turkoman carpet*.

turkey border, C-0225/*2*.

Turkey brown, DATT.

Turkey carpet, C-0906/*32*; C-2482/ *16*; SDF.

'Turkey carpet', OC/*232*.

Turkey design, C-0906/*30*.

Turkey leather, SDF.

turkey-pattern, C-2546/*61*①.

turkey red, C-2704/*72*; DATT.

Turkey umber, DATT.

Turkey work, ACD; DADA; EA; SDF.

Turki, OC/*40*.

Turkish, C-2388/*194*.

Turkish carpet, EA; S-4461/*853*.

Turkish corner, SDF/①.

Turkish Court Manufactory carpet, EA.

Turkish cups, MP/*123*.

Turkish-frame type, DADA/ *Supplement*.

'Turkish' geometric, OC/*13*.

Turkish kilim rug, C-0906/*73*.

Turkish knot, CEA/*76*; DADA; EA/ ①; OC/*17*①.

Turkish-knotted pile, EA/*Armenian dragon rug*.

Turkish market clock, EA/①.

Turkish market watch, EA/*Turkish market clock*.

Turkish ornament, RTA/*91*.

Turkish pottery, DADA.

Turkish rug, DADA; S-4461/*754*.

Turkish saph design, OC/*129*.

Turkish silk rug, S-4461/*783*.

Turkish style, SDF/①.

Turkish table, SDF.

Turkish village, C-5189/*359*.

Turkish village rug, S-4461/*759*.

Turkish Yastik, S-4948/*2*.

Turkman carpet, EA/*Turkoman carpet*.

Turkman rug, DADA.

Turkman Tekke Ensi, S-288/*22*①.

Turkman Tekke Mafrash, S-288/*5*①.

Turkman Tekke rug, S-3311/*26*①.

Turkoman, C-0279/*31*①; C-2357/ *130*; C-2388/*139*; C-2478/*218*; C-5189/*369*①; OC/*66*①, *141*①.

Turkoman carpet, EA.

Turkoman chuval rug, LAR83/*526*①.

Turkoman Ersari, OC/*210*.

Turkoman göl, OC/*176*①.

Turkoman juval, C-2320/*131*; C-2482/*46*.

Turkoman kilim, C-0906/*18.*
Turkoman line border, S-4948/*57*①.
Turkoman motif, OC/*224*①.
Turkoman rug, DADA.
turk's head finial, C-2569/*46*①.
turmeric, DATT.
Turnau Technical School, JIWA/
*185*①.
Turnbull's blue, DATT.
turned, C-0982/*85B*; C-1603/*6*①;
C-2478/*24*; C-5239/*255*; S-4436/
*1*①, *19*; S-4905/*361*①; S-4972/
*167*①.
'turned all over', SDF.
turned and blocked leg, S-2882/*242*.
turned and fluted leg, S-2882/*767*.
turned and incised line, C-2704/*130*.
turned and ringed spindle, LAR83/
*409*①.
turned and ringed support, LAR83/
*380*①.
turned armchair, C-5114/*267*①.
turned baluster, CEA/*308*①.
turned baluster-form leg, S-2882/*673*.
turned baluster stem, S-2882/*693*①.
turned base, S-4436/*1*①.
turned brass foot, C-0279/*178*.
turned bulbous column, C-2402/*9*.
turned chair, ACD; SDF/①.
turned column, C-2402/*4*.
turned columnar baluster, C-5114/
*250*①.
turned crest rail, C-5114/*267*①.
turned domed cistern cover, S-4414/
*389*①.
turned double C-scroll carved support,
S-4414/*496*①.
turned finial, C-5114/*25*①, *89*①;
S-2882/*350*.
turned foot, C-0249/*343*; C-0279/*440*.
turned foot caster, C-5116/*76*.
turned frame, C-2403/*52*①.
turned handle, C-0254/*84*①.

turned horn eyepiece, C-2904/*141*.
turned H-shaped stretcher, C-5116/
*65*①.
turned H-stretcher, S-4414/*466*①.
turned leg, C-0982/*300*; C-2402/*17*;
S-4461/*565*.
turned maple, S-4905/*384*.
turned necked vase, C-5157/*16*.
turned nozzle, S-2882/*697*.
turned-out lip, NYTBA/*217*.
turned-out rim, IDPF/*64*.
turned-over, C-5156/*49*①; IDPF/*231*.
turned over, C-5156/*4*①.
turned-over end, NYTBA/*248*①.
turned pillar, C-0982/*48*; C-1407/*3*.
turned scrolled support, S-4414/
*529*①.
turned shaft, C-2388/*60*.
turned spindle, S-4461/*595*.
turned spiral, S-4972/*378*.
turned spool gallery, S-2882/*619*①.
turned stand, C-5116/*31*.
turned stem, S-4461/*547*.
turned stepped foot, S-3311/*295*①.
turned stop fluted leg, S-2882/*765*①.
turned stretcher, C-0279/*295*①;
C-2402/*171*; C-5114/*397*①;
S-4414/*523*①, *524*①; S-4436/*117*;
S-4461/*595*.
turned structure, C-0906/*197*.
turned support, C-2370/*63*; C-2388/
25.
turned tapering leg, C-0982/*8*, *11*,
90A.
turned trumpet-shaped foot, NYTBA/
62.
turned upright, C-0982/*85A*; S-4414/
*524*①.
turned wood base, C-0254/*7*.
turned wooden handle, C-5114/*232*①.
turned wood finial, C-0706/*1*.
turned wood handle, C-0254/*47*;
C-5114/*207*①.

Turner, C-2360/*186*.

Turner, G., S-4944/*63*.

Turner, John, ACD; DADA; EA/①.

Turner, John & William, CEA/*157*①.

Turner, Thomas, ACD; CEA/*187*, *199*①; EA.

TURNER, TURNER & CO, EA/ *Turner, John*.

turner's chair, LAR83/*285*①.

Turner's stoneware, IDC.

turner's wheel, MP/*87*.

Turner's yellow, DATT.

turnery, SDF/①.

turning, ACD; C-5114/*231*; DADA/ ①.

turning (in furniture), EA/①.

turning, IDC/①; SDF/① *turnery*.

turning base, S-4461/*214*.

turning tool, DATT/①.

turning up (in silver), EA.

turnip foot, SDF/①.

turnip watch, EA/①.

turn-off, S-4972/*222*①.

turn-off barrel, C-2503/*180*; C-2569/ *65*, *81*①.

turn-off pistol, C-2569/*73*.

Turnpenny, William and Edward, C-5117/*22*①.

turnsole, DATT.

turntable, DATT.

turnup, C-1506/*87*.

Turn Wahliss pottery, S-3311/*862*.

turpentine, DATT; LP.

turpeth mineral, DATT.

Turquerie, ACD.

turquoise, C-5005/*248*①, *402*①; C-5127/*43*; C-5156/*35*①; CEA/ *418*①; DADA/①; LP; RGS/*80*; S-4905/*23*①.

turquoise bead, C-2482/*79*.

turquoise blue, DATT.

turquoise cabochon, S-4414/*90*①.

turquoise-enamelled, S-4905/*28*.

turquoise green, DATT.

turquoise (sea-green) ground, EA.

turquoise matrix, RTA/*145*; S-4810/ *114*①.

turquoise mineral, EA.

turquoise sofa, EA.

turret, C-5174/*161*①.

turret clock, EA/①; SDF.

turret corner, CEA/*392*①.

turreted, C-2332/*7*.

turret-form, S-4461/*77*①, *385*.

turret-shaped elevation, RTA/*173*①.

turret skirt, S-4796/*129*.

turskaya chern, RGS/*91*.

turtleback, C-0225/*334*; C-5239/*337*.

turtle-back, C-5146/*165*①; DADA.

turtleback tile, C-0225/*326*.

turtle-back tile, C-5005/*393*①; C-5167/*277*①.

turtle-back tile chandelier, S-3311/ *939*①.

turtle-palmette, C-2357/*150*; C-2388/ *150*; C-2403/*189*; C-2478/*247*.

turtle shell mask, LAR82/*36*①.

turtle shell stem, LAR82/*74*①.

turtle top table, LAR82/*406*①.

Turton, William, C-5117/*231*.

Tuscan, C-0249/*465*①; C-2486/ *223*①.

Tuscan column, LAR83/*208*①.

Tuscan order, SDF/①.

Tuscan red, DATT.

Tuscan school, CEA/*130*.

Tuscany, DADA.

Tuscany Provincial, LAR83/*313*①.

tusche, DATT.

tusche-washout method, DATT.

tusk, C-1082/*133*; C-1702/*79*; S-4461/*369*; S-4972/*378*.

tutania, EA.

tutenag, ACD.

Tuthill Cut Glass Company, DADA/ *Supplement*.

t'u ting, DADA.

t'u Ting yao, IDC.

tut pull, C-5239/*290*.

tut pull design, C-0225/*322*.

Tuttle Silversmiths, C-0254/*235*; C-0270/*291*.

Tverskoi, Dimitr Ilich (assaymaster), C-5174/*220*.

TW & Co, EA/*Bradbury, Thomas*.

tweed, C-2501/*1*.

tweed flecked, C-0405/*208*.

twelve-petaled rosette, MP/*474*①.

twelve-petalled rosette, RTA/*61*①.

Twenty, The, LP.

25th Dynasty, S-4807/*474*①.

twiffler, IDC; IDPF/*242*.

twig and vine handle, C-0254/*124*①.

twig-basket, IDC.

twig foot, LAR82/*146*①.

twig-form handle, S-2882/*1419*.

Twigg, London, C-2503/*193*.

twiggen chair, SDF.

twiggie chair, SDF/*twiggen chair*.

twig-handle, C-2493/*4*.

twig handles (Ceramic decoration), EA.

twill, C-0604/*72*; CEA/*294*; S-4507/ *16*①.

twill canvas, DATT.

twill weave, SDF.

twillye, SDF.

twin-acorn thumbpiece, EA.

twin-banding, C-5005/*347*.

twin bar splat, C-5157/*144*①.

twin bed, DADA.

twin bottle, DADA.

twin-branch, C-2421/*19*①.

twin-branch candelabrum, C-2421/ *4*①.

twin-branch candlestick, C-2403/*9*.

twin caddies, C-0906/*86*.

twin columns motif, C-5174/*148*①.

twin cup, IDPF/*242*.

twin-cusped thumbpiece, EA.

twined, C-0225/*203*; C-5239/*133*.

twined basket, S-4807/*345*①.

twined design, C-5239/*286*.

twin fish flask, S-4965/*157*①.

twin-fish vase, C-5156/*67*.

twin-flap, C-2388/*49*; C-2403/*74*.

twin flap, C-0249/*383*.

twin-flap top, C-2403/*95*①; C-2421/ *126*①; C-2478/*76*; C-5116/*80*; C-5157/*101*①.

twin flap top, C-0279/*337*.

twin-handled urn, C-2437/*32*①.

twin hinged flap, C-0249/*358*.

twining ornament, RGS/*40*.

twin ladder panel back, C-0982/*20*.

twin-lens reflex camera, C-1609/*186*.

twin love-bird motif, CEA/*584*①.

twinned ring-turned support, C-2357/ *46*.

twin-pedestal, C-2478/*154*; C-5116/ *136*.

twin pedestal dining table, C-5116/ *102*.

twin-pedestal table, C-2370/*134*.

twin piano, SDF.

twin plate, C-5116/*125*①.

twin ring, S-291/*150*①, *186*①.

twin-shield chair back, C-1407/*22*.

twin-turned pillar, C-0982/*31*.

twirl-rib, C-5191/*467*.

twist, SDF.

twist barrel, C-2569/*59*①.

twist base, C-5239/*90*.

twist direction, DATT.

twisted branch handle, C-5117/*131*①.

twisted column, NYTBA/*73*.

twisted double handle, IDPF/*117*①.

twisted gold rope design, S-4414/*98*.

twisted handle, C-0254/*122*; IDPF/ *133*①.

twisted lobed baluster form, S-4804/ *131*①.

twisted rope border, S-2882/*603*.

twisted rope handle, C-5114/*49*.

twisted rope-work, C-5117/*323*.

twisted ropework handle, S-4922/ *14*①.

twisted spiral, NYTBA/*32*.

twisted stem, CEA/*419*①.

twisted stem base, C-5146/*176*①.

twisted strap handle, EC2/*22*①.

twisted trunk stem, C-0270/*26*①.

twisted wire, CEA/*635*①.

twist firing glass, LAR82/*463*①.

twist goblet, LAR82/*441*①.

twisting, CEA/*528*; SDF/*twist*.

twisting stem, C-5005/*235*①.

twist leg, C-5116/*101*.

twist rod, C-5239/*339*.

twist-stem, EG/*246*.

twist stem, C-0103/*62*.

twist-turned, C-5189/*275*①.

twist turned stretcher, LAR82/*301*①.

twist turning, DADA.

twist whalebone, C-1502/*44*.

two arm bi-metallic balance, C-5117/ *484*①.

two-bottle inkstand, LAR83/*584*①.

two carver chair, CEA/*327*①.

two-case inro, LAR83/*458*①.

two-cell bezel, RTA/*81*①.

two-color, C-5117/*429*①.

two-color cut-glass, LAR83/*421*①.

two-colour, C-2458/*346*①.

two-dimensional, LP.

two-dimensional pattern, JIWA/*95*①.

two-dimensional patterned surface, JIWA/*24*.

two-dimensional profile, CHGH/*63*.

two-draw telescope, C-2608/*53*.

two-flap top, LAR83/*394*①.

two-fold, S-4461/*653*.

two fold binder, C-1082/*184*.

two-foot Gunter's rule, CEA/*609*①.

two-handed sword, CEA/*20*①.

two-handed tray, C-5117/*28*①.

two-handled, C-0406/*27*.

two-handled bowl, C-2458/*237*①.

two-handled cup, C-0706/*183*; C-5117/*39*, *73*①; EA.

two-handled jardiniere, C-1006/*58*.

two-handled Monteith, LAR83/*91*①.

two-handled snuffer-tray, C-5117/ *126*①.

two-handled tray, C-1082/*175*; C-5117/*131*①.

two-handled vase, C-2510/*19*①; C-5239/*5*.

two-light candelabra, S-3311/*263*.

Two Little Ships, The (De Twee Scheepjes), EA.

two panel, OPGAC/*239*.

two-part cabinet, S-4972/*462*①.

two part casting, CEA/*631*①.

two-part court cupboard, S-4972/*450*.

two-part cupboard, NYTBA/*26*①.

two-part (three-part) glass, EG/ *294*①.

two part manju, S-4829/*31*①.

two-pedal harp, CEA/*551*①.

two-pedestal, S-3311/*224*.

two piece back, C-0906/*266*.

two-point perspective, DATT.

two-pronged, C-0706/*35*.

two-pronged fork, C-5156/*427*.

two-pronged fork of Schwarzburg, EA/*Abtsbessingen*.

two relief-decorated, CEA/*579*.

two-rod arm, S-4414/*249*.

two-section bracelet, S-291/*213*①.

two-sided tray, IDPF/*9*①.

two small fish in blue, EA/*Nyon*.

two small houses, C-2704/*8.*

two-stage barrel, C-2569/*60*①;
C-MARS/*130.*

two-stage blade, C-2569/*46*①.

two suns, EA/*Boulton, Matthew,
Sheffield plate.*

two-tier, C-5127/*348.*

2-tier sellette, C-5005/*316*①.

two-tier table, C-2402/*227*; LAR83/
*401*①; S-2882/*778.*

two-toned gold, S-4802/*60*①.

two-train movement, S-4414/*385*①;
S-4812/*16*; S-4972/*430.*

two train watch, S-4802/*19, 116.*

tye and dye, DADA.

tyg, ACD; CEA/*152*①; DADA; EA/
①; IDC/①; IDPF/*242*①;
LAR82/*159*①; LAR83/*85*①.

tyger and wheatsheaf pattern, IDC.

tyglike, IDPF/*17*①.

Tyler, Geo., London, C-2489/*89*①.

tympan, DATT.

tympanum, EA/*astrolabe*; S-4807/
*508*①.

Tyneside pottery, IDC.

type-high, DATT.

type-shuttle, C-0403/*7.*

typewheel, C-2904/*16.*

typewriter, C-2904/*3.*

typical palette, S-4461/*131, 397.*

typography, DATT/①.

Tyrian, C-5146/*144*①; CEA/*481*①.

Tyrian purple, DATT.

Tyrolean, S-3311/*467*①; S-4972/
*337*①.

Tyrolean green earth, DATT.

Tyrolean peasant design, NYTBA/
*38*①.

Tyrrhenian, DATT.

Tyrrill, Robert, C-5117/*290*①.

tyuwood, S-4436/*55.*

tzitzi, DADA.

Tzǔ, IDC.

t'zu chin, EA.

tzu chin, DADA.

Tz'u-chou, K-710/*120.*

Tz'u Chou, DADA/①.

Tz'u-chou, CEA/*111, 116*①.

tzu-chou polychrome figure, C-0803/
42, 42.

Tz'u-chou stoneware, EA/①.

Tz'u-chou type ware, S-4965/*227.*

Tzu Chou ware, ACD.

Tz'ǔ Chou yao, IDC/①.

Tz'u Chou yao ware, JIWA/*346*①.

tzu-t'an, DADA.

U

ubrecht, CEA/79①, *101*.

ubrik, CEA/*101*.

ubunakago, C-5236/*1825*.

uchiwa, JIWA/*165*.

uchiwa-e, C-5236/*986, 1064*.

Udall & Ballou, C-0254/*182*.

udder wipe, K-710/*118*.

U-gouge, DATT.

U. H. Heisey Co., Newark, Ohio, OPGAC/*165*.

uintaite, DATT.

uji, CEA/*575*.

ukibori, S-4928/*83*①.

ukiyo-e, DADA/①; JIWA/*16*; C-5156/*859*.

Ule, CEA/*137*①.

Ulm, C-2476/*14*①.

ultraism, DATT.

ultramarine, EG/*110*; IDC; LP.

ultramarine ash, DATT.

ultramarine blue, DATT; MP/*187*.

ultramarine green, DATT.

ultramarine violet, DATT.

ultraviolet light, DATT.

ultra-violet radiation, IDC.

Ulysses, DSSA.

umbel, C-0225/*261*.

umber, DATT; LP.

umbo, C-2482/*120*.

umbrella-like form, CEA/*501*①.

umbrella picture, JIWA/*36*.

umbrella shade, C-0225/*334*.

umbrella stand, C-1006/*64*; C-5114/*253*; C-5170/*110*; C-5181/*14*; EA; S-4461/*712*; SDF.

umbrella stand/coatrack, C-5005/*328*①.

Umbrian ware, IDC.

umematsu netsuke, C-5127/*541*.

Umetada School, JIWA/*181*.

umimatsu, C-5236/*715*①; CEA/*575*; S-4928/*76*①.

umoregi, CEA/*575*.

unaker, ACD; EA; IDC.

unbacked and with the original papers, C-2704/*49A*.

unbacked fret, SDF/①.

uncial, DATT.

Uncle Sam hat, K-802/*22*.

Uncle Tom and Eva, C-1006/*60*.

'unclipped', OC/*214*.

uncut foot, C-2414/*26*①.

uncut looped-ended kilim strip, OC/ *318*.

uncut moquette, C-1407/*36*.

undenominated, C-2904/*39*.

under-and-over, C-2476/*4*.

underbodice, C-1506/*55*①.

under-brace, ACD.

underbrace, SDF/① *stretcher*.

undercut, C-5153/*196*①; C-5156/ *351*①; CEA/*406*; DATT; SDF.

undercut carving, RTA/*122*①.

undercut relief, C-5156/*380*①.

undercut rim, IDPF/*112*①.

underdish, C-0254/*316*①; EC2/*22*①.

underframe, C-0982/*69*; C-1407/*75*; C-2402/*97*; LAR82/*393*①.

underframing, SDF.

underglaze, ACD; C-0782/*121*; C-2458/*188*; C-5127/*25*; C-5156/ *98*①; C-5236/*468*①; DATT; EC1/ *83*; IDC/①; LAR83/*75*①; S-4461/*121*.

underglaze-blue, S-4414/*349*①; S-4804/*282*; S-4905/*5*, *11*①, *34*①, *51*①.

underglaze blue, CEA/*210*; DADA; MP/*205*.

underglaze colors, EC2/*23*.

underglaze colours, EA/ *high-temperature*; IDC.

underglaze red, DADA.

underglaze vine leaf pattern, MP/*184*.

under-hammer, C-2569/*91*.

underlever-cocking, C-2476/*66*.

underlining, JIWA/*67*.

underpainting, DATT; LP.

underpainting white, DATT.

underplate, C-5114/*3*; C-5239/*35*; S-4461/*43*; S-4804/*157*.

under-sheets, C-2704/*174*.

undershelf, C-5239/*242*.

underside, S-4905/*325*①; S-4928/ *40*①.

undersides, C-5236/*558*①.

underskirt, C-0405/*46*.

underslung bell, C-2489/*53*.

under-tier, C-1407/*73*.

undertier, C-0249/*357*, *359*; C-0982/ *35*, *82B*; C-1702/*94*; C-2402/*33*; C-2482/*87*; C-5005/*316*①, *320*①; C-5116/*67*; C-5259/*542*; LAR83/ *380*①.

undertint, DATT.

undertone, DATT.

undulating, C-1506/*76*; C-5127/*349*.

undulating leaf-molded rim, S-2882/ *1296*①.

undulating rim, C-5146/*144B*; S-2882/*954*, *1258*①.

undulating stylised flowering border, C-2704/*16*.

undulating trailings, S-3311/*921*①.

undyed wool, OC/*25*.

unencircled, C-2458/*113*.

uneven molded quality, NYTBA/ *56*①.

unfired clay, IDPF/*115*.

unfired raw glaze, CEA/*151*①.

unframed, C-5236/*580*①.

unframed fragment, C-2704/*46*.

ungen, JIWA/*16*.

Unger Bros., OPGAC/*15*.

unglazed, C-0782/*126*; C-2323/*3*; C-2458/*3*; C-5127/*1*; C-5156/*5*; IDPF/*3*; S-4972/*123*①.

unguentaria, S-4807/*555*.

unguentarium, IDC; S-4807/*533*.

unicorn, DSSA.

unified and organic form, NYTBA/ *45*.

uniforms, C-2704/*60*.

Union Electric Co. Ltd., C-2904/*257*.

Union Flint Glass Works, CEA/ *464*①.

Union Glass Company, DADA/ *Supplement*; EC1/*68*; NYTBA/ *306*.

Union Glass Works, CEA/*459*.

Union Porcelain Works, DADA/ *Supplement*; NYTBA/*179*①.

Union Porcelain Works, The, CEA/ *205*.

Unite, George, C-0706/*219*; C-5203/ *161*.

United States Pottery, DADA.

United States Pottery Company, EA.

unit furniture, DADA/*Supplement*; SDF.

unity, JIWA/*132, 213*; LP.

Universal Camera Lucida, C-2904/*79*.

universal dining table, SDF.

universal equinoctial dial, LAR83/ *461*①.

Universal Geneve, S-4927/*27*.

universal pocket sundial, LAR83/ *461*①.

universal round, JIWA/*295*.

universal table, SDF.

University City (mark), EC1/*84*①.

University City Pottery, EC1/*81*①.

University City Pottery, University City, Missouri, EC1/*85*.

Unknown Glass Species, CEA/*483*①.

unlettered proof, DATT.

unlined patchwork, C-2704/*64*.

unmarked, S-4905/*312*.

unmounted, C-1603/*87*; C-5156/ *599*①; C-5236/*564*.

unpicked, C-2203/*164*.

unpierced stem, C-5117/*206*.

unsigned, C-5005/*268*.

unspatial space, JIWA/*10*.

unusually fine, C-5157/*174*①.

unwashed handspun, OC/*313*.

unwashed millspun, OC/*313*.

'unwearable' ring, RTA/*177*①.

up-and-down dial, EA.

up-and-down hands, C-2489/*129*.

up-and-down scale, S-4927/*91*①.

up and down scale, S-4802/*104*.

upholder, ACD; SDF.

upholstered, C-0982/*2, 77*; C-5153/ *86*; C-5239/*268*; S-3311/*102, 512*①.

upholstered arcaded seat, C-5116/ *164*①.

upholstered back, C-5116/*62*.

upholstered panel, C-0982/*82C*.

upholstered seat, C-0249/*433*; C-0982/*4*; C-5116/*58*.

upholstered settee, CEA/*331*①.

upholsterer, SDF.

upholsterers' chair, SDF.

upholstery, ACD; DADA; NYTBA/ *87*; SDF.

upholstery nail, C-1082/*6*.

upper blade, C-5114/*22*.

upright, C-0982/*193*; C-1407/*1*; C-2402/*157*; C-2403/*14*.

upright (in chair), C-5170/*204*①.

upright, SDF.

upright bouquet, CEA/*503*; EG/*294*.

upright cabinet piano, EA/*266*①.

upright form, C-0406/*77*.

upright piano, C-5005/*347*; S-4461/ *736*.

upright pianoforte, C-0982/*18*.

upright secretary, S-4972/*546*.

upright support, C-0279/*338*.

upsetting, CEA/*528, 542*.

Upson board, DATT.

upspringing scroll, C-2555/*29*①.

upturned brim, C-1506/*64*.

uraeus, C-1582/*9*; S-4973/*109*①.

uragawara, DADA.

Urania, C-2409/*181*; DSSA.

uranium, EG/*258*.

uranium glass, EG/*110, 170*.

uranium yellow, DATT.

Urbino, C-2486/*245*①; CEA/*145*①; DADA/①; LAR82/*183*①; S-4461/ *176*.

Urbino Maiolica, EA/①.

Utzmemmingen, EA.

Utzschneider and Fraunhofer, CEA/ *602*①.

Uzbek, Ċ-2357/*107*; C-2478/*202*.

Uzbek chapan, C-2320/*128*.

Uzbek felt rug, OC/*39*①.

Uzbeki, OC/*141*.

V

vacant, C-0706/*148*; C-2202/*15*;
C-5117/*21*, *134*Ⓘ.
vacant baroque scrolling, C-5117/*90*
vacant cartouche, C-0254/*120*Ⓘ;
C-1502/*85*; C-2398/*38*Ⓘ; C-5117/
312Ⓘ, *442*.
vacant foliate cartouche, C-0254/*49*.
vacant foliate wreath, S-2882/*910*.
vacant oval, S-4905/*186*Ⓘ.
vacant oval cartouche, C-0254/*60*.
vacant rococo cartouche, C-0254/*71*.
vacant scroll, C-0706/*246*.
Vacheron & Constantin, C-5117/*418*.
Vacheron & Constantin, Geneva,
S-4927/*20*.
Vachette, Adrien-Joseph-Maximilien,
EA.
vacua, C-2904/*136*.
vacuum, C-2904/*136*.
vacuum pump, C-2608/*123*
vacuum syringe, S-4927/*224A*.
vagireh, OC/*62*.
Vagireh rug, DADA.
Vail, Roy, C-2476/*6*.
vaisseau à mat, C-5189/*28*.
vaisseau à mât, EA; IDC/Ⓘ.
vaisselier, C-5181/*201*Ⓘ; DADA.

vaisselier-horloge, DADA/Ⓘ.
vajra, C-5156/*365*; C-5234/*32*Ⓘ;
S-4810/*278*Ⓘ.
Valadier: Luigi, Giuseppe, EA.
Valadon, Suzanne, S-286/*535*Ⓘ.
valance, DADA; EA; SDF.
valanced, C-5153/*154A*Ⓘ.
valanced pigeonhole, S-4905/*371*Ⓘ.
valanced skirt, C-5114/*374*Ⓘ;
S-4461/*615*; S-4905/*463*Ⓘ.
valence, C-1304/*248*.
Valencia, DADA.
Valenciennes, DADA.
Valenciennes lace, C-0405/*16*;
C-2203/*135*.
valency, EG/*256*.
Valenschwerck, EA.
Valentien, Albert R., OPGAC/*344*.
Valentien, A. R., LAR82/*170*Ⓘ.
Valentien Pottery, San Diego,
California, EC1/*85*.
valentine, C-5114/*178*Ⓘ; S-4881/
195Ⓘ.
Valentine pattern, IDC; S-4905/*25*Ⓘ.
Valentine teapot, IDC.
Vale of The White Horse, C-0405/*18*.
valet, S-4507/*83*Ⓘ.

vallance, SDF/*valance*.

Vallerysthal, C-5191/*249*.

Vallet, J., C-5189/*232*.

'valleys', OC/*187*①.

Vallières, Nicolas Clément, C-5117/*183*①.

Vallin, Eugène, DADA/*Supplement*.

Vallin, Nicholas, CEA/*230*①.

Vallis, N., SDF/*777*.

Vallotton, Felix, S-286/*536*.

Val St. Lambert, C-0225/*205*.

Valsuani foundry, C-5167/*19*.

Valton, Charles, C-5191/*164*.

value, DATT; LP.

valve, C-5117/*235*; CEA/*554*①.

vambrace, DADA.

vamplate, C-2503/*18*.

van Aelst (van d'Alost), Pieter, EA.

van Blarenberghe, Louis, Henri-Joseph, EA.

Van Briggle (mark), EC1/*84*①.

Van Briggle, K-802/*22*.

Van Briggle, Artus, EC1/*79*①.

Van Briggle, Colorado Springs, C-2910/*157*.

Van Briggle Pottery, Colorado Springs, Colorado, EC1/*85*.

Vance/Avon Faience, Tiltonville, Ohio, EC1/*85*.

Vance/Avon Faience, Wheeling, West Virginia, EC1/*85*.

van Ceulen, I., Jeune, C-MARS/*166*.

Van Cleef and Arpels, CEA/*520*; OPGAC/*13*.

van Cleynhoven, Quirinus, EA.

van Dalen, Lieven, EA.

van den Bogaert, Jan, EA.

van den Chijs, Pieter, Alkmaar, C-MARS/*240*.

Vanderbank (Vanderbanque) (Vandrebanc), John, EA.

van der Biest, Hans (Jans), EA.

van der Bogaert, Martin (Desjardins), C-5224/*250*①.

van der Borght, Jacques, EA/*341*①.

van der Burgh, Cornelis, EA/①.

van der Ceel: Abraham, Maarten, Abraham II, EA.

Vandercook, M., C-5191/*159*.

Van Der Cruse, Roger (RVLC), C-2555/*49*①.

Van der Cruse, Roger (Lacroix), signed R.V.L.C., S-4955/*184*①.

Vandercruse-Lacroix, Roger, EA.

van der Goten, Jacob, EA.

van der Hecke, François (Frans), EA.

van der Hecke, Jean-François, EA.

van der Hecke, Pierre, EA.

van der Laarn, Jan, EA.

van der Lely (Lely), Gabynus, EA.

van der Lely (Lely), Johannes, EA.

VanderLey laid paper, S-286/*231*①.

van der Planken, Frans, EA/*de la Planche, François*.

van der Rohe, Ludwig Mies, C-GUST/*157*.

van der Rohe, Mïes, C-5167/*192*①.

van Dijk, Abraham, EA.

Van Doorn De Bilt, C-MARS/*201*.

van Duyn, Johannes, EA.

van Dyck, Peter, EA.

Van Dyck border, C-0782/*35*.

vandyke, CEA/*79*①.

Vandyke border, IDC.

Van Dyke brown, DATT.

Vandyke brown, LP.

Van Dyked border, C-0405/*12*.

Van Dyke edge, CEA/*447*①.

Van Dyke pattern, C-5239/*304*.

Van Dyke red, DATT.

vandyke (trefoil) rim, EG/*143*①.

Van Dyke umber, DATT.

vane, CEA/*220*①, *542*; EA.

van Eenhoorn, Lambert, EA.

van Eenhoorn, Samuel, EA.

van Eenhoorn, Wouter, EA.

Van Erp, Dirk, K-711/*127.*

van Frijtom, Frederik, EA.

van Geelen, H., S-4944/*165.*

van Geffen, Arnoldus, C-5203/*65*; S-4944/*164.*

van Gelder, Marinus Hendriksz, EA.

Van Gelder paper, S-286/*500.*

van Gumster, A. M., Utrecht, C-MARS/*125.*

van Heemskerk, Willem, EA.

vanishing point, DATT; JIWA/*10*; LP.

Vanitas, LP.

vanitas theme, S-4802/*141.*

vanitory, SDF.

vanity, C-5239/*288*①; S-4927/*441*; DSSA.

vanity box, S-4881/*318*①.

vanity case, C-1304/*714*; LAR83/ *628*①; S-291/*129*①.

vanity mirror, S-4461/*39.*

van Oiley, Bernard, EA.

van Pol, Christian, C-5220/*25*①.

van Rijsselberg, Ary, EA.

van Risenburgh, Bernard, EA.

van Roome, Jan, EA.

van Schurman, Anna Maria, EA.

Vanson, C-2493/*248.*

van Stapele, Martinas, C-2487/*35.*

Van Vianen, CEA/*644*①.

van Vianen, Adam, EA/①.

van Vianen, Christian, EA.

van Vianen, Paul, EA.

vaporization casting, DATT.

varada mudra, S-4810/*271*①.

varangian, DADA.

var-baluster form, C-5189/*182*①.

Vardy, John, C-2522/*30*①; C-5170/ *180*①; EA.

vargueno, CEA/*307*①.

vargueño, DADA/①; EA/①.

vargueno, LAR82/*290*①; LAR83/ *262*①.

vargueno on chest, S-4972/*483*①.

variable telescope, C-2476/*5.*

variagated, C-5005/*399*①.

variant, OC/*45*①.

variation, JIWA/*16.*

variations of shield, EA/① *Nymphenburg.*

vari-baluster, C-5127/*356*; C-5224/ *23*; C-5236/*373*①.

vari-color, C-5117/*319*①.

vari-colored, C-5117/*320.*

vari-colored stone, C-5156/*375*①.

varicoloured enamel band, C-2368/ *210*①.

variegated, C-0279/*139*; C-2458/*68*, *208*; C-5146/*122*①; S-4843/*349*①.

variegated marble, C-2324/*353.*

variegated pebble, C-5156/*376*①.

variegated ware, IDC; K-710/*109.*

variety, LP.

varigated inlay, C-2368/*12*①.

variously printed cotton, C-2704/*50.*

Varnier, R., C-5181/*66.*

varnish, ACD; C-0906/*255*; DADA; DATT; LP, *brushes*; SDF.

varnish dark brown, C-0906/*289.*

varnished, C-1603/*81.*

varnish gilding, IDC.

varnish golden orange, C-0906/*341.*

varnishing day, DATT.

varnish light brown, C-0906/*288.*

varnish medium brown, C-0906/*282.*

varnish orange brown, C-0906/*283.*

varnish reddish brown, C-0906/*305.*

varnish size, DATT.

Varnolene, DATT.

Varsovie, EA/*Warsaw faience factory.*

vasa diatreta, EG/*33, 265.*

vasa murrhina, DADA; EC1/*56.*

vase-turned stile, C-5114/399①.

vase-turned support, C-5153/96①.

vase vaisseau à mât, IDC.

vasiform, C-5170/67; S-4461/292,
528.

vasiform shape, FFDAB/26.

vasiform splat, S-2882/255.

vaso a calice, IDC.

vaso a colonnette, IDC.

vaso a palla, C-2486/219; C-2427/
211①.

vaso a rotelle, IDC.

vaso campana, IDC/①.

vaso di Spezieria, IDC.

vaso puerperale, IDC/①.

vaso senza bocca, IDC.

Vasse, François-Antoine, DADA.

vassoio, IDC.

Vassou, Jean-Baptiste, C-2364/
52A①; S-4955/135①.

Vassou, Jean-Baptiste, stamp: JB
VASSOU, C-5224/95①.

Vaucanson, Jacques de, CEA/685

Vaucher Freres, LAR82/238①.

vaulted, C-0279/329.

vaulted top, C-0249/362.

Vauquer P, C-2489/248①.

Vauxhall bevel, SDF.

Vauxhall glass, SDF.

'Vauxhall' paste (glass), RTA/123①.

V-carved, C-5236/543.

VDuyn, EA/van Duyn, Johannes.

VEB Staatliche Porzellan-Manufaktur
Meissen, MP/5, 211.

Vechte, Antoine, EA.

Vedar, C-2910/19.

veduta, DATT/①.

vegetable-based colour, OC/148①.

vegetable black, DATT.

vegetable-dish, C-2398/61.

vegetable dish, C-0254/11, 183; EA;
LAR83/575①; S-4804/46, 150①;
S-4905/106; S-4922/50①.

vegetable-dish and cover, C-5117/
116①.

vegetable oil, DATT.

vegetable spoon, C-0270/166.

vegetable tureen, C-1006/41, 117.

vegetable violet, DATT.

vegetable wax, DATT.

vegetal finial, C-0254/304.

vegetal oil, DATT.

vehicle, DATT; IDPF/244①; LP.

veil, C-1506/170; DATT; DSSA.

veilleuse, CEA/203①, 377①, 406.

veilleuse (porcelain warmer), EA.

veilleuse (sofa), EA.

veilleuse, IDC; LAR83/142①;
S-4905/154①.

veilleuse-théière, IDC/①.

veilleuse-tisanière, IDC.

veined, C-2388/97; C-5005/361.

veined celadon, C-5156/309.

veined hardstone, RTA/123①.

veined marble, C-5181/128; C-5191/
201①; S-4461/155; S-4992/21①.

veined marble socle, S-4461/71.

veined white marble, C-5157/16.

vein stone, DATT.

Vela, Vincenzo, C-5224/252①.

velatura, DATT.

Velde, Henry van de, DADA/
Supplement; MP/199.

Velez, Guillaume-Gaspar, C-5174/
473①.

Vélin d'Arches, S-286/474.

vellum, C-0249/33; C-2904/141;
C-5146/107B①; C-5156/460;
C-5239/3; DATT; LAR82/404①.

vellum board, S-286/396A.

vellum covered, C-0225/23①.

vellum glaze, LAR83/148①; S-4414/
215, 215.

vellum paper, DATT; JIWA/*102*.

vellum vase, LAR82/*170*①.

velocipede, LAR83/*659*①.

velvet, C-2421/*14*①; C-3011/*11*;
C-5116/*151*①; C-5157/*100*①;
C-5239/*280*; DADA/①; NYTBA/
*103*①; S-4972/*152*①; SDF.

velvet box, C-5153/*6*.

velvet brown, DATT.

velvet case, C-1082/*187*.

velvet finish, SDF; CEA/*473*①.

velvet-lined slide, C-2357/*66*①.

velvet sheath, C-5156/*448*.

velvet weave, S-4461/*66*.

velvety polish, C-5156/*372*①.

V.E.M.C., C-2704/*102*.

Venables, Stephen, S-4944/*414*①.

Vendée, DADA.

veneda, DATT.

veneer, ACD; C-2402/*212*; C-2409/
185; C-5153/*92*; CEA/*224*①, *300*;
DATT; FFDAB/*27, 77*; SDF.

veneered, C-0982/*280*; C-5114/
*179*①; C-5116/*55, 149*①; LAR82/
*42*①; S-3311/*132*; S-4436/*14*;
S-4972/*494*.

veneered in rosewood, C-2904/*297*.

veneering, C-5116/*116*; DADA; EA;
SDF.

veneer top, C-5114/*272*①.

Venetian, CEA/*484*; OPGAC/*177*.

Venetian Baroque, S-3311/*512*①.

Venetian bead, EA/*beads and
marbles*.

Venetian blind, DADA.

Venetian blue, DATT.

Venetian bobbin style, C-2203/*102*.

Venetian fair group, EA; IDC.

Venetian flat point, DADA.

Venetian frame, SDF/①.

Venetian glass, CEA/*415*; DADA/①;
EA/①; EG/*58*①; NYTBA/*268*.

Venetian Guild, CEA/*415*.

Venetian lace, C-1506/*169*.

Venetian maiolica, EA.

Venetian painted furniture, DADA.

Venetian pastels, MP/*73*.

Venetian pattern, S-2882/*1343,
1363*①.

Venetian point, DADA.

Venetian porcelain, EA.

Venetian raised ivory point, DADA.

Venetian raised point, DADA.

Venetian red, DATT; LP.

Venetian rose point, DADA.

Venetian school, DATT.

Venetian strike and alarm clock,
CEA/*248*①.

Venetian style, C-2409/*43*.

Venetian tapestry, EA.

Venetian velvet, DADA.

Venetian winged glass, JIWA/*321*.

Veneto, C-2486/*244*.

venets, RGS/*124*.

VENEZIA, CEA/*170*①.

Venice (Cozzi), C-2427/*28*①.

Venice, DADA.

Venice porcelain, ACD.

Venice turpentine, DATT; LP.

Venini, Paolo, DADA/*Supplement*.

Venini & Co., EG/*80*.

venison dish, EA.

vent, C-2503/*209*①; DATT.

ventail, DADA.

Vente, Pierre, C-2364/*20*①.

vent-hole, IDC.

ventilago, DATT.

Ventrella, C-0270/*59*.

venture furniture, SDF.

venturine, EA/*aventurine*, ①; SDF/
aventurine.

Venus, DSSA.

Venus and Adonis, C-2427/*44*①.

Venus and Mercury, C-2427/*31*.

Vera Cruz, S-4461/*466*.

verneh rug, EA.

Vernet green, DATT.

Verney Carron Frères à Lyon, C-MARS/143.

vernice liquida, DATT.

vernicle, RGS/124①.

vernier, C-0403/142; C-2368/14; C-MARS/201; CEA/612.

Vernier, Paul, CEA/268.

vernier regulator, C-5174/366.

Vernier scale, CEA/260, 268.

vernis, C-5259/236①; IDC.

vernis martin, C-2332/53①; C-5189/350①; CEA/66①; DADA/①; DATT; SDF; ACD; EA/①; C-0249/338, 356; C-2437/33①; LAR82/226①; NYTBA/18①; S-4804/779①; S-4992/107①.

vernis Martin fan, EA.

vernis mou, DATT.

vernissage, DATT; LP.

vernisseur, SDF.

Vernon, Samuel, CEA/671①.

Verona brown, DATT.

Verona green, DATT.

Verona marble, S-4955/105①.

Verona yellow, DATT.

Veronese green, DATT.

verre craquele, CEA/503.

verre craquelé, EG/289①.

verre de fougère, CEA/484; DADA; EA; EG/156; NYTBA/284.

verre de jade, JIWA/307.

verre de Nevers, EG/166①.

verre-de-soie, C-5191/376.

verre de soie, OPGAC/178.

Verre Double, CEA/487①.

verre églomise, ACD.

verre eglomise, CEA/503.

verre églomisé, EA/①.

verre églomisé, EG/175①, 295①.

verre eglomise, LAR82/398①.

verre églomisé, RTA/127①.

verre eglomise, S-4853/347A①.

verre églomisé, S-4972/444①.

verre eglomise-mounted, C-5116/172①.

verre filé, EA/① Nevers; EG/166①.

verre filé de Nevers, EA.

verre frisé, EG/166①; EA/① Nevers.

verre eglomisé, SDF.

Verreville glass house, EA/Scottish glass.

verrier, DADA.

Verrier, Max De, C-5191/146.

verrière, IDC; CEA/199①.

verroterie cloisonné, ACD.

ver sacrum, DADA/Supplement.

Versailles pattern, S-4804/35①.

verse, C-1506/128; C-1603/22; C-2704/4, 26.

verseuse, IDC.

version, JIWA/20.

verso, C-0270/118; C-1603/137①; C-5174/149①; LP; S-286/1, 13; S-2882/1398, 1402, 1403①; S-4881/186①; S-4972/64①.

Verstelle, Geertruy, EA.

vert anglais, IDC.

vert antique, DATT.

vert antique marble, DADA.

vert campan, DADA.

vertebrate bandings, S-4414/234①.

vert émeraud, LP.

vert émeraude, DATT.

Vertes, Marcel, S-286/96①.

vertical, C-2458/51①, 146①; C-5153/170①.

vertical articulation, JIWA/72.

vertical band, C-5156/9①.

vertical disc-shaped stopper, EA/stopper.

vertical flange, IDPF/231.

vertical focus, JIWA/251.

vertical format, JIWA/5, 170.

vertical grille, JIWA/72.

vertical groove, C-2458/42.

vertical lug, IDPF/155①.

vertically lobed cylindrical stem, S-2882/1378①.

vertical pale, S-2882/1071.

vertical panel, CEA/642①.

vertical principle, JIWA/87.

vertical rails, C-0982/53.

vertical ray decoration, S-4944/211.

vertical ribbing, S-4905/151①.

vertical ribbons, C-2324/151.

vertical rib border, C-5117/276①.

vertical rib moulding, CEA/428①.

vertical stacking, JIWA/87.

vert jaune, IDC.

vert Paul Véronèse, LP.

vert pomme, IDC.

vert pré, IDC.

Verzelini, Giacomo, ACD; EA/①.

Verzelini, Jacope, CEA/420①.

vesica, SDF.

vesica piscis, DATT.

Vesperbild, DATT.

vessel, C-1082/10; C-2458/1①; C-5156/52; C-5236/407①; S-4461/44; S-4992/1①.

vessel on stand, JIWA/314.

Vest, CEA/137①.

vesta case, C-0103/56; C-0406/98; C-1502/22; C-2202/138; LAR82/248①, 598①; LAR83/455①, 592①; C-0706/95.

Vestier, Antoine, EA.

vestigial handle, C-2482/78; LAR82/33①.

vestigial lug, IDPF/133①.

Vestorian blue, DATT.

vetro a reticelli (reticello glass) (Netzglas), EA.

vetro di trina, ACD; EA.

vetro di trina (reticello), EG/246.

Veuve Perrin, EA.

Vever, Henri, JIWA/12.

Veyrassat, J., S-286/70.

Vezzi, C-2486/26①; LAR83/113①.

Vezzi, Francesco, CEA/170①; EA/①.

Vezzi porcelain, IDC.

V-gouge, DATT.

VH, EA/Brunswick.

Vi, EA/Lesum.

vial, CEA/49; NYTBA/270.

Vianen, Adam Van, CEA/629①.

Viardot, Charles, C-5220/33①.

vibrant banding, S-4461/397.

vibrate, DATT.

vicar and Moses, DADA; IDC/①.

Viceroy, C-2904/173.

Vichy, H., CEA/695①.

Vickers, C-2476/100.

Vickers, John, EA.

Victoria design, NYTBA/307.

Victoria green, DATT.

Victorian, C-0706/3; C-0982/1, 9; C-1502/9; C-2402/8; C-5116/27; C-5117/159①; C-5157/61; CEA/229①, 321, 365①, 683; DADA/Supplement, ①; LAR82/36①; NYTBA/73; S-2882/711①; S-3311/259①; S-4436/18①; S-4922/85①.

Victorian design, CEA/510.

Victorian Gothic, CEA/403①; EC2/99①.

Victorian Irish, C-0706/14.

Victorian luster, NYTBA/130.

Victorian mahogany, C-0982/17.

Victorian oak chair, C-0982/37.

Victorian period, SDF.

Victorian Scottish, C-0406/36; C-0706/12.

Victorian shaped, C-0406/15.

Victorian Staffordshire Figure, IDC.

Victorian style, EA/①.

Victorian vernacular style, SDF/①.

Victorian walnut, C-0982/*89A*.
Victoria pattern, S-2882/*1335*.
Victoria red, DATT.
victorie, C-5239/*129*①.
Victorson: Victor, Louwijs, EA.
Victory, DSSA.
Vicus, S-4807/*4*.
Videau, Ayme, C-5117/*89*.
Videau, Aymé, S-4944/*382A*①.
vide-poche, C-0225/*151*; DADA/①.
vidre de Damas (Damascus-style glass), EG/*84*.
vie de Bohème, LP.
vielle, EA/*hurdy-gurdy*.
Vienna, DADA; LAR82/*184*①; S-4461/*140*.
Vienna blue, DATT.
"Vienna"-decorated, S-4992/*64*①.
'Vienna' decorated, S-4804/*434*.
Vienna-decorated, S-3311/*384*①.
Vienna ecuelle, S-4804/*437*①.
'Vienna' ewer, S-4804/*443*①.
Vienna green, DATT.
Vienna Hard-paste porcelain factory, EA/①.
Vienna lake, DATT.
Vienna manufactory, MP/*39, 160*.
Vienna plaque, C-2493/*305*.
Vienna plate, S-4947/*27*.
Vienna porcelain, ACD; S-3311/*383*.
Vienna Porcelain Factory, EA/ *Austrian snuff-box*.
Vienna red, DATT.
Vienna regulator, EA/①; CEA/ *240*①.
Vienna Regulators, CEA/*222*①.
Vienna table top, S-4947/*28*.
Vienna-type, C-5189/*82*①.
Vienna ultramarine, DATT.
'Vienna' vase, S-4804/*440*①.
Vienna vase, S-4947/*26*①.
Vienna vase and stand, C-1006/*35*.

Vienna white, DATT.
Vienna Workshops, JIWA/*378*.
Viennese, C-2364/*4*; C-2398/*7*①.
Viennese hand-tufted carpet, DADA.
Vierge de Pitié, DATT.
vieux Paris, C-5259/*112*; DADA; IDC; C-5181/*22*.
vieux Paris plate, S-4823/*97*①.
view, C-2493/*68*①.
viewpoint, JIWA/*33*.
views, NYTBA/*197*①.
Vigilance, DSSA.
vignette, C-0249/*33*; C-1603/*1*; C-2427/*141*①; DATT; IDC; JIWA/*84*; LP; S-2882/*941*①; SDF.
vignettes, S-3311/*678*①; S-4461/*273*; S-4853/*27*①; S-4905/*26*①.
Vignola, Giacomo da, DADA.
vihuela, EA/*guitar*.
vihuela da arco, EA/*viol family*.
vihuela da mano, EA/*viol family*.
Vikhlaev, Alexei (assaymaster), C-5174/*231*.
Viking, OPGAC/*239*.
Vile, William, ACD; C-5116/*170*①; C-5170/*145*①; CEA/*341*①; DADA; EA; NYTBA/*47*①; SDF/ *765*.
Vile & Cobb, CEA/*321*; EA/*Cobb, John*.
Vilkum, CEA/*451*.
villagers, C-2704/*37*.
village rug, OC/*15*.
village variant, OC/*99*.
village weave, SDF.
Villanis, E., C-2910/*297*; C-5191/*172*.
Villeroy & Boch, Mettlach, Germany, NYTBA/*182*.
Villon, Jacques, S-286/*432, 538*①.
Vinaccia, Domenico, EA/*224*.
Vinache, Jean Joseph, MP/*118*.

virgule, CEA/*258*①; S-4927/*215*①.

virgule escapement, EA.

viride aeris, DATT.

viridian, DATT; LP.

viril, CEA/*620*①.

virtù, DADA.

Virtues, the Twelve Cardinal, IDC/ ①.

virtuoso, LP.

vis-a-vis, LAR82/*366*①.

vis-à-vis, LP.

viscosity, DATT.

visible seam, NYTBA/*293*.

visiting card case, C-0706/*100*.

visor, C-2503/*75*; C-5117/*386*①; DADA; S-4972/*166*①.

Viss, OC/*236*①.

Visscher, Anna Roemers, EA.

Visscher, Maria Tesselschade, EA.

visual idiom, LP.

visual unit, JIWA/*36*.

vitarka mudra, S-4810/*265*①.

Vitrearius, EA/*Laurence Vitrearius*.

vitremanie, SDF.

vitreosity, CEA/*113*①.

vitreous, DATT; EC2/*23*; IDC.

vitreous enamel, DATT; LAR82/ *484*①; LAR83/*468*①.

vitrine, ACD; C-0249/*229, 332*; C-0279/*378*①; C-1407/*69*; C-2402/*127A*; C-5181/*169*; C-5189/*291*①; DADA; EA/①; LAR83/*320*①; S-4461/*550*; S-4804/*791*; S-4992/*105*①; SDF.

vitrine cabinet, S-4436/*124*①; S-4804/*863*①.

vitrine-stand, C-0249/*359*.

vitrine table, S-3311/*156*; S-4804/ *800*①, *864*①; S-4992/*117*.

vitro di trina, DADA.

Vitrolles à Paris, C-5224/*49*①.

vitruvian, C-0249/*300*; C-5189/*288*①; S-4436/*116*①; S-4812/*3*; C-2402/ *149*; C-2478/*111*.

vitruvian scroll, S-4436/*47*; ACD; CEA/*317*①; DADA; DATT/①; IDC; S-2882/*930*; SDF/①.

Vitruvian scroll (wave) pattern, EA/ ①.

Vitruvian scrolls, S-4802/*325*.

vivid, C-0405/*31*.

vivid blue, C-2704/*102*.

Vivien, N., S-4947/*169*.

Vizagapartam, C-5170/*23*①.

Vizagapatam, C-2421/*151*①; C-2478/ *16*; LAR82/*340*①.

Vladeviere à Paris, C-2904/*70*.

V-loop pile, EA/*weft-loop pile*.

V-neck, S-4972/*140*①.

Vodder, Niels, DADA/*Supplement*.

vodka cup, C-5117/*339*; C-5174/*244*.

vodka service, RGS/*179*①.

vodka service: ewer, tray, vodka cups, C-5174/*306*①.

Vögelesdekor (German ceramic decoration), EA.

Vögleinkrug, IDC.

Vogler, J. G., CEA/*606*①.

Vogue, C-2409/*165*.

voided checked pattern, C-1506/*117A*.

voider, CEA/*595*.

voider (voiding dish) (voyder), EA.

voider, SDF.

voider stand, EA; SDF.

Voigt, Georg, MP/*492*①.

Voigtlander & Sohn, C-2904/*172*.

volant, DADA.

volatile solvent, DATT.

Volcanic Arms Company, CEA/*41*①.

volcanic ware, EC1/*83*.

volet, DATT.

voliate, C-5116/*174*①.

Volkar, Charles, DADA/*Supplement*.

Volkmar, Charles, C-5191/*15*.

Volkmar, Leon, DADA/*Supplement*.

Volkmar Kilns, Metuchen, New Jersey, EC1/*85*.

Volkmar Pottery (mark), EC1/*84*①.

Volkmar Pottery, Tremont and Corona, New York, EC1/*85*.

Volkmer, Tobias, EA.

Volkstedt, ACD; C-5189/*25*; DADA; EA; LAR82/*185*①.

Volkstedt porcelain, S-3311/*867*①.

Vollard watermark, S-286/*384*①, *466*.

voltmeters, C-0403/*199*.

volubilis, C-5191/*218*.

volume, JIWA/*36, 71, 132, 327*; LP/①.

volume color, LP.

volumetric, LP.

volumetric form, JIWA/*344*.

volute, ACD; C-2478/*82*; DADA; EA; IDC; IDPF/*140*; RTA/*37*①, *39*①; S-2882/*676*①; S-3311/*216*①; S-4922/*22*①; SDF.

volute-carved, S-4461/*614*; S-4905/*383*①.

voluted, C-5116/*139*①; CEA/*26*①; S-4988/*478*①.

volute decoration, S-4804/*16*①.

voluted foot, MP/*486*①.

voluted frame, S-4812/*144*①.

voluted handrest, S-2882/*677*①.

voluted support, C-5116/*153*①; S-4461/*650*; S-4823/*173*①; S-4972/*498*.

volute handle, IDC.

volute krater, S-4973/*132*①.

volutes, C-0249/*466*; C-0279/*219*; C-5116/*145*①; C-5153/*182*①, *188*①.

volute-shaped, C-5189/*294*①.

volvelle, CEA/*612*.

von Brühl, Count Heinrich, EA.

von dem Busch, Ernst Augustus Otto, EA.

Vonèche glassworks, EA/*Baccarat*.

Von Hennicke service, IDC.

von Jünger, Christoph, Johann, EA.

von Löwenfinck: Adam Friedrich, Maria Schick, EA.

von Lücke, Johann Christoph Ludwig, EA.

von Münnich service, EA.

Von Rath, Peter, S-4944/*158*①.

von Sorgenthal, Konrad, EA.

von Tschirnhaus, Count, CEA/*169*.

von Tschirnhaus, Ehrenfried Walter, EA.

Vordoveh, OC/*246*①.

vorschrift, DADA.

Vorticism, DATT; LP.

VOsterbro, EA/① *Copenhagen Stoore Kongensgade*.

voting box, LAR83/*260*①.

votive, IDPF/*245*①.

votive figurine, C-1582/*4*.

votive plaque, C-5234/*68*.

voulge, DADA; S-4972/*149*.

Voulkos, Peter, DADA/*Supplement*.

voyder, ACD; DADA; EA/*voider*; SDF/*voider*.

voyeuse, DADA/①; EA; S-4461/*702*; S-4823/*208*; S-4853/*453*①; SDF.

voyeuse à genoux, EA.

Voyez, Jean, EA.

Voyez, John, ACD; CEA/*159*①.

Voysey, Charles Francis Annesley, DADA/*Supplement*; SDF/*765*.

VR, EA/① *Frankenthal*.

vrai réseau, DADA.

Vries, Jan Vredeman de, DADA.

VR stamps, C-2904/*38*.

v-sight, C-2476/*87*①.

Vüer, J. C. V., CEA/*607*①.

Vuilleumier Frères, S-4927/*60*.

Vuitton, Louis, C-2409/*166*.

Vulcan, DSSA.

Vulliamy, ACD.

W

W (Wecker), CEA/*236*①.

W, EA/*Wallendorf, Wegely's factory, Berlin, Worchester.*

wabi, JIWA/*353*.

Wa-cha-p'ing, EA.

Wachen, E.R., C-5191/*127*.

Wachovia, CEA/*166*①.

wad clay, DATT.

wadding clay, DATT.

Wadsworth, John, EA; SDF/*775*.

Wadsworth and Solon, IDPF/*8*①.

Wady, John, CEA/*233*①.

wafer barrel, LAR83/*516*①.

wafer-box, DADA.

wafer box, C-0270/*140*①; C-0706/*40*; EA.

waffle, OPGAC/*240*.

waffle and thumbprint, OPGAC/*240*.

waffle pattern, CEA/*499*①

wager cup, CEA/*628*①; DADA.

wager cup (puzzle cup), EA/①.

wager cup, LAR82/*583*①.

Wagner, C-2493/*306*; C-5189/*121*; C-5191/*185*; S-4461/*185*.

Wagner, J. G., EA.

Wagner, Johann Jacob, MP/*122*.

Wagner, Otto, DADA/*Supplement*; K-711/*121*.

wagon base, C-5174/*517*①.

wagon seat, DADA/①.

wagon-spring, EC2/*91*①.

wagon-spring clock, EA.

wagon spring clock, CEA/*245*①.

wag-on-the-wall clock, ACD; DADA.

wag-on-wall clock, EA.

Wahnes, Heinrich Christian, MP/*174*.

wainscot, ACD; DADA.

wainscot (in furniture), EA.

wainscot, SDF.

wainscot armchair, LAR83/*285*①.

wainscot bedstead, SDF.

wainscot chair, DADA; LAR82/*313*①; SDF.

wainscot oak, SDF.

waist, C-0225/*41*; C-2458/*216*; SDF.

waist clasp, C-2409/*172*; C-2910/*203*.

waistcoat, C-1506/*20*; C-2203/*46*.

waist door, S-4414/*385*①; S-4812/*16*; S-4988/*407*①.

waisted, C-0782/*48*; C-1502/*72*; C-2458/*23*; C-5156/*3*①, *317*①; IDC; LAR83/*203*①; S-4507/*6*①;

S-4804/*923*①; S-4972/*397*;
S-4992/*13*①; SDF.

waisted albarelli, C-2427/*225*.

waisted alberello, C-2204/*119*.

waisted back, C-2403/*46*.

waisted balloon back, LAR83/*272*①.

waisted baluster section, S-2882/*1290*.

waisted bowl, EG/*107*①.

waisted bucket bowl, LAR83/*450*①.

waisted bulging form, S-4414/*234*①.

waisted cylindrical neck, C-2414/
*47*①.

waisted foot, S-4905/*8*①.

waisted form, LAR83/*595*①; S-2882/
*1323*①.

waisted hexagonal beaker, LAR83/
*412*①.

waisted neck, C-0270/*111*; C-0782/
85; C-2414/*12*①; C-5005/*297*①;
C-5117/*151*①; S-2882/*1219*;
S-4414/*194*①, *217*, *219*①, *251*①;
S-4461/*7*.

waisted neck and flaring lip, S-4414/
*222*①.

waisted pedestal base, S-4461/*159*.

waisted rim, C-5127/*21*.

waisted rim foot, S-4804/*34*.

waisted shape, EG/*43*①.

waisted shoulder, S-4414/*223*①;
S-4461/*17*.

waisted side, C-5117/*111*①.

waisted socle, S-4461/*67*.

waisted spreading base, S-4461/*102*.

waisted stem, C-5117/*31*①.

waisted stuffed back, C-5116/*167*①.

waisted top, LAR83/*318*①.

waisted vessel, C-5146/*59*.

waiter, ACD; C-0254/*97*; C-5114/
*39*①; C-5117/*226*; C-5173/*23*①;
EA; LAR83/*632*①; S-3311/*783*①;
S-4802/*310*①; S-4905/*173*.

waived, C-0406/*76*.

Wakasugi, C-5127/*387*.

Wakasugi ware, IDC.

Wakefield, John, S-3311/*730*.

Wakelin, J., C-2487/*162*.

Wakelin, John, C-5117/*284*①.

Wakelin: Edward, John, EA.

Wakelin ledger, EA.

Wakelin & Taylor, EA/*Wakelin,
Edward*.

Wakely & Wheeler, LAR82/*583*①.

Wäkevä, Alexander, C-5117/*314*①.

Wäkevä, Stephan (workmaster),
C-5174/*313*①.

wakizashi, C-5236/*1833*; DADA.

Waldenburg, DADA.

waldglas, DADA; ACD; CEA/*451*,
*452*①; EA.

Waldmann, Oscar, C-5191/*193*.

Walhiss, Ernst, C-5191/*48*.

Walker, Allen, LAR82/*237*①.

Walker, Capt. Samuel, CEA/*40*①.

Walker, D. L., CEA/*30*①.

Walker, John, C-5117/*246*①.

Walker, Samuel, C-5117/*78*①; CEA/
*202*①.

Walker & Hall, C-0406/*3*, *126*;
C-0706/*70*; S-3311/*708*.

Walker Model, CEA/*40*①.

walking stick,, C-1082/*180*.

walking stick, C-2904/*154*; S-4881/
*86*①; S-4972/*378*.

walking stick camera, LAR82/*75*①.

walking-stick flute, CEA/*548*.

walking stick handle, C-0706/*25*.

walking stick telescope, C-1609/*113*.

wall, CEA/*64*①.

Wall, Dr., CEA/*187*; DADA.

Wall, Dr. John, EA.

Wallace, James & Co., Edinburgh,
C-2503/*150*.

Wallace Silversmiths, C-0270/*169*.

Wallbaum, Matthäus, EA/*Wallpaum,
M*.

wallboard, DATT.

wall-bracket, C-2421/*34*①.

wall bracket, DADA/①; MP/*194*.

wall brackets, C-5116/*35*.

wall cabinet, C-5114/*278*①.

wall-cistern, IDC.

wall cistern, S-4905/*6*①.

wall clock, C-0279/*281*; CEA/*221*①; EA/*Black Forest clock*, ①; SDF/ ①.

wallclock, S-3311/*460*①.

Wallendorf, C-0249/*180*; C-2486/ *62*①; C-2493/*259*; C-5189/*51*; DADA; EA/①; MP/*164*.

Waller & Hall, C-0706/*36*.

wallet, DSSA.

Walley Pottery, West Sterling, Massachusetts, EC1/*85*.

wall figure, C-0782/*222*.

wall fountain, C-5224/*45*①; DADA/ ①; EA; LAR82/*50*①.

wall furniture, SDF.

wall grille, CEA/*534*①.

wall hanging, NYTBA/*87*; S-4461/ *513*.

wall-hanging, LAR83/*649*①.

walling wax, DATT.

Wallis, E., CEA/*693*①.

Wallis, T., C-2487/*147*; C-2510/*65*①.

Wallis, Thomas, C-0706/*243*; C-5117/*216*.

wall light, C-2421/*19*①; C-5157/*24*; S-4436/*25*; SDF.

wall-light, C-2320/*4*; C-2357/*5*①.

wall mask, C-2409/*89*.

wall-mask, C-2910/*105*.

wall mirror, C-1407/*79*; SDF.

wall mount, C-5146/*132*①; C-5181/ *104*.

wall of Troy pattern, DATT.

Walloon-type, C-MARS/*19*.

wall painting, C-2458/*258*; DATT; LP.

wall panel, C-5146/*136*①.

wallpaper, DADA.

wallpaper motif, JIWA/*175*①.

wallpaper panel, C-2421/*112*①.

Wallpaum (Wallbaum), Matthäus, EA.

Wall-period, CEA/*195*①.

wall piece, C-5114/*236*.

wall plaque, C-2409/*90*①; IDPF/ *245*①; S-4804/*211*①.

wall-plaque, EA.

wall plate, MP/*205*.

wall pocket, C-2493/*124*; DADA; EA; IDPF/*246*①; K-711/*124*.

wall-pocket, IDC/①.

wall primer, DATT.

wall sconce, C-5239/*155*; LAR83/ *592*①; S-4461/*78*.

wall-sconce, EA/*sconce*; IDC.

wall scraper, DATT/①.

wall table, SDF.

wall tapestry, JIWA/*241*.

wall vase, C-1006/*143*; C-2458/*198*; C-5156/*101*; EA; IDPF/*246*①.

wall-vase, IDC.

walnut, ACD; C-0982/*9*; C-1407/*1*; C-2402/*14*; C-5005/*331*①; C-5116/*20*, *63*①, *101*; C-5153/ *89*①; C-5156/*682*①; C-5239/*279*; CEA/*303*; DADA; DATT; JIWA/ *323*①; S-3311/*185*①; S-4436/ *53*①; SDF.

walnut oil, DATT; LP.

Walpole Salver, EA.

Walrich Pottery, Berkeley, California, EC1/*85*.

walrus ivory, S-4810/*78*①; S-4881/ *449*①.

walrus tusk, C-5114/*197*①; CEA/ *562*; S-3311/*171*.

Walsh, Peter, C-5203/*187*.

Walter, A., C-5005/*242*①; C-GUST/ *52*①.

Walter, Almeric, C-5167/*123*①; CEA/*488*①.

Waltham Premier Maximus, S-4927/
95①.

Walther, Paul, MP/494.

WALTON, EA/Walton, John.

Walton, George, C-GUST/138①;
DADA/Supplement.

Walton, John, CEA/159①; EA.

Walton-type, C-2502/39.

Walzenkrug, IDC.

wan, IDPF/247; OC/249.

wand, DSSA.

wanded chair, SDF.

wanded flask, CEA/50.

Wanderers, The, DATT.

wandering-hour watch (chronoscope),
EA/①.

wan emblem, S-4810/393①.

Wangford, C-2493/131.

Wang Hing & Co., C-2487/27;
C-2510/14A.

Wang Yuan, C-2414/102①.

Wan-li, CEA/111, 121①.

Wan Li, C-0782/9; DADA.

Wanli, C-2323/33①, 145①; C-2458/
51; C-5156/98①; C-5236/367①;
LAR82/156①; LAR83/78①.

Wanli era, C-5156/607①.

Wanli period, C-5127/53①.

Wan-li porcelain, EA/①.

Wanli style, LAR82/112①; LAR83/
87①.

Wannopee Pottery, New Milford,
Connecticut, EC1/85.

wan shou wu chiang, CEA/123①.

wan symbol, S-4965/98①.

Wappengeschirr, IDC.

warbler pattern, IDC.

WARBURTON, EA/Warburton,
Jacob.

Warburton, Anne, EA.

Warburton, Jacob, EA.

Warburton, John, DADA.

Warburton, Peter, CEA/201①.

Ward, Joseph, CEA/646①.

Ward, Lynd, S-286/26.

Ward, William, S-4905/220.

Ward & Bartholomew, S-4905/193.

Warden, Tho., London, C-2489/92①.

warden's mark, C-2487/29①.

Wardian case, EA; SDF/①.

wardrobe, ACD; C-0982/86B;
C-2402/14; DADA; EA; FFDAB/
98①.

wardrobe (French), FFDAB/98①.

wardrobe (winged), FFDAB/100①.

wardrobe, LAR83/406①; NYTBA/
72; S-4972/500; SDF/①.

wardrobe en suite, C-2402/259.

wardrobe trunk, SDF.

Wareham, J.D., OPGAC/344.

war-hammer, DADA.

Warhol, Andy, S-286/541.

wari-kogai, DADA.

'war jewellery', RTA/162①.

war-lance, C-2503/18.

warm color, LP.

warm colors, DATT.

Wärmeglocke, IDC.

warming dish, C-0254/24; C-5127/
248①; C-5189/79.

warming dish and cover, S-3311/588.

warming-pan, EA/①.

warming pan, ACD; C-0906/105;
S-4905/326; SDF.

warming server, S-4461/456.

warming stand, C-0270/27; C-0706/
101; S-3311/587①; S-4802/291.

warming-urn, IDC.

Warmstry House factory, EA/Barr,
Martin.

warning coat, DATT.

warp, C-2388/153; CEA/76, 101;
EA/weft; OC/17①; SDF.

warping of pictures, DATT.

warp strings, OC/16.

warring states, C-2323/*128*; C-2414/
22; C-5156/*176*.

Warring States Dynasty, C-2458/*211*.

Warring States/Early Han dynasty,
C-2458/*225*.

Warring States/Eastern Han Dynasty,
C-2458/*226*.

Warring States period, C-5236/*393*①;
EA.

warrior Immortal, C-2458/*234*①.

Warsaw faience factory, EA.

Warth, C-2493/*238*.

war trophy, C-5181/*191*.

Warwick, C-5117/*242*①; OPGAC/
346.

Warwick China Company, DADA/
Supplement.

Warwick frame, DADA; EA;
LAR82/*582*①; LAR83/*569*①.

Warwickshire Hunt Club, C-0405/*17*.

Warwick vase, CEA/*660*①; EA;
IDC; C-5117/*161*①.

WA & S, EA/*Adams family*.

wash, C-5156/*455*; C-5236/*488*①,
917; CEA/*119*①; DATT; LP,
brushes; OC/*23, 27*.

wash and linear technique, S-4965/
*288*①.

washbasin, MP/*106*.

wash drawing, DATT; JIWA/*61*①.

washed, C-2493/*138*.

washed blue ground, C-0782/*114*.

washed china clay, MP/*85*.

washed millspun, OC/*313*.

washer stop, C-0403/*161*①.

wash-hand stand, SDF/①.

wash handstand, EA/*washstand*.

wash-hand table, SDF/①.

washing dolly, C-0906/*165*.

washing stand, ACD; EA/*washstand*;
SDF/① *wash stand*.

Washington, Martha, service, IDC/
①.

Washington head knob, CEA/*469*①.

Washington inaugural button, EA.

wash sprayed on paper, JIWA/*269*.

wash stand, SDF/①.

washstand, C-0982/*161*; C-1407/*166*;
C-2402/*84*; C-2403/*63*; C-5153/*91*;
EA; LAR83/*408*①; NYTBA/*29*.

wash-stand, EA/① *basin-stand*.

washstand set, IDPF/*247*.

washtand, DADA.

washy, C-5236/*496*.

washy gray, C-5127/*49*.

washy underglaze, C-5156/*125*①.

wassail bowl, C-2382/*4*①; C-2498/*3*;
DADA; EA; S-4436/*4*①; SDF.

wassail cup, IDPF/*247*.

wassail table, SDF.

was-scepter, S-4973/*115*.

wasserbehalter, LAR83/*519*①.

Wassily chair, C-5191/*326*①.

waste, C-0254/*100*①.

waste bowl, C-0254/*189*; C-5114/*2*①;
C-5153/*14*①; S-4804/*70*①.

waste mold, DATT.

waste-mould, IDC.

waste mould, EA/*investment*.

waster, ACD; CEA/*210, 542*; EA;
IDC.

Watanabe seal, S-3312/*985*①.

watch, ACD; C-2489/*236*①; CEA/
250.

watch and a chain, C-5117/*396*①.

watch and fob, CEA/*522*①.

watch bangle, S-291/*134*①.

watch case, C-5117/*482*①; EA/①;
MP/*118*; S-3311/*260*.

watchcase, S-4414/*21*①.

watch chain, C-1502/*101*; C-5117/
*406*①.

watch-chain, EA/*fob chain*.

watch cock, S-4927/*71*.

watches, S-4461/*323*.

watch glass, EA.

watch jewel, EA/*jewelling*.

watch key, C-5174/*422*; EA/*key*.

watch-lid, JIWA/*184*①.

watchmaker, C-2904/*267*.

watchmaker's lathe, C-2608/*93*.

watchmaker's turns, C-0403/*121*.

watchman's clock, EA/*tell-tale clock*, *tell-tale clock*.

watch paper, EA.

watch pocket, C-0405/*132*; IDPF/ *247*①.

watchspring gauge, C-0403/*84*.

watch-stand, IDC; SDF/①.

watch stand, LAR82/*83*①.

water bench, DADA/①; SDF/①.

water bowl, C-5236/*854*.

water buffalo, C-2414/*97*①.

waterbug, S-4796/*225*.

waterbug medallion, S-4948/*171*①.

waterbug palmette, S-4847/*202*; S-4948/*181*①.

Waterbury, K-711/*130*.

water clock clepsydra, EA/①.

water color, LP.

watercolor, C-0225/*409*; C-5114/ *178*①; C-5156/*155, 893*; DATT; NYTBA/*193*; S-4461/*66*.

water-color, LP/*brushes*.

watercolor paper, DATT.

Watercolour, JIWA/*19*①.

watercolour over black ink, JIWA/ *212*①.

water dropper, C-5236/*810*; IDPF/ *247*①.

water-dropper, C-2513/*345*; IDC/①.

watered, C-1506/*13*; C-2503/*3*.

watered blade, C-5174/*212*.

watered silk, C-3011/*8*; CEA/*473*①.

watered steel, C-5156/*448*; C-5234/ *157*; DADA.

waterfall setting, CEA/*521*①.

waterfall stem, C-2357/*6*①.

waterfall swag, C-2364/*10*①.

water filter, IDC.

Waterford, CEA/*446*①; DADA; NYTBA/*282*.

Waterford chandelier, EG/*150*.

Waterford glass, ACD.

Waterford Glass House, EG/*149*.

Waterford Glass Works, EA.

water fountain, IDPF/*247*.

water garden, IDPF/*248*①.

water-gilding, CEA/*406*.

water gilding, DATT; EA/*gilding*, *gilding*; SDF.

water glass, DATT.

water glasses, C-5146/*90*.

water-glass painting, DATT; LP.

water green jade, C-5127/*287*①.

Waterhouse, Hodson and Co., C-2510/*87*①.

watering can, IDPF/*249*①.

watering pail, IDC.

water-in-oil emulsion, DATT.

water-jug, EA/*jug*.

water kettle, S-4461/*296*①.

water leaf, DADA.

water-leaf ornament, EA.

water lily bowl, C-2910/*161*.

water-lily service, IDC/①.

water-lily table, CEA/*386*①.

waterloo leg, SDF; EA/*sabre leg*.

Waterman's Ideal No, C-0403/*15*.

Waterman's Ideal No. 12, C-0403/*13*.

watermark, C-0249/*116*; C-5236/ *1491*; CHGH/*63*; DATT; S-286/ *89*.

watermark date, S-286/*322*; S-4881/ *34*①.

watermarked metal, C-5127/*145*.

water-of-Ayr, DATT.

water paint, DATT.

water pipe, DADA; IDPF/*248*.

water pitcher, C-0254/*3*; C-5114/ *28*①; S-3311/*609*①; S-4804/*49*①, *89*①; S-4905/*165*①.

wave pattern, C-0279/*219*; C-5127/
43; C-5234/*105*①; CEA/*118*①;
EA/*Vitruvian scroll*; S-4928/*12*①.

wave pattern border, C-0254/*56*.

wave-patterned border, EA.

waves, C-5146/*89*.

wave scroll, DATT; SDF.

wave scroll medallion, S-2882/*146*.

wave theme, JIWA/*129*.

wavy band, C-2458/*2*; JIWA/*135*.

wavy device, S-2882/*1267*①.

wavy-edged plate, EA.

wavy-end, EA/① *shield-end*.

wavy-end spoon, DADA.

wavy lobe, S-4461/*216*.

wavy ray border, IDC.

wavy ribbon border, LAR83/*165*①.

wavy rim, S-4414/*278*①, *317*.

wavy toprail, LAR83/*268*①.

wa wa, IDC/①.

Wawronet-Muller, E., S-4947/*213*.

wax, C-0249/*174*; C-0279/*75*①;
DATT; S-4843/*513*①; S-4972/*70*,
*386*①.

waxen relief, S-4843/*513*①.

wax figure, MP/*36*.

wax-jack, C-5117/*55*①.

wax-jack (wax-winder) (taper-stand)
(pull-up), EA/①.

wax jack, DADA; LAR83/*590*①;
S-4802/*185*①.

wax painting, LP.

wax-pan, C-5117/*35*①.

wax pan, C-0254/*12*; C-0270/*13*;
C-2493/*177*; C-5236/*373*①.

waxpan, C-5174/*32*①.

wax polish, SDF.

wax-resist, C-5236/*1717*; LAR82/
*143*①.

wax resist, C-5236/*878*①.

wax seal, S-4881/*297*①.

wax taper box, S-4944/*28*①.

wayang mask, C-5127/*163A*.

waywiser, C-2489/*31*; C-2904/*254*;
EA/①.

waziri, OC/*190, 176*①.

W & B, Wedgwood & Bentley, EA/
black basalt or basaltes.

W Brown and Sons makers, C-0906/
277.

W & C, EA/*Caldwell, James*.

WC in wavy shield, EA/*Cripps,
William*.

W E, CEA/*136*①.

WE, EA/*Mennicken family*.

Wealden glass, EA.

Weald of Kent, CEA/*529*.

weapons, C-1082/*6*.

wear mark, EG/*295*.

Weatherby, C-2476/*5*.

weathercock, EA/*vane*.

weathercock (weather-vane), EA/*vane*.

weathered, C-5236/*844*①; S-4972/
*5*①.

weathered oak, SDF.

weather-glass, CEA/*249*①.

weathering, CEA/*70*.

Weather Ometer, DATT.

weather vane, NYTBA/*262*.

weathervane, C-5114/*184*①.

weather-vane, CHGH/*36*; EA/*vane*.

weather-worn, C-5236/*845*.

weave, OC/*10*.

weaver, MP/*82*.

Weaver, Holmes, DADA.

weaver's date, C-5189/*377*.

web, DSSA.

Webb, C-5191/*215*; C-5239/*151*;
K-711/*130*; LAR82/*458*①;
OPGAC/*156*.

Webb, Aileen Osborn (Mrs.
Vanderbilt Webb), DADA/
Supplement.

Webb, Joseph, CEA/*473*①; OPGAC/
175.

Webb, Philip, DADA/*Supplement*.

water-pot, IDC.

water pot, C-5236/*1705*; IDPF/ *250*①; JIWA/*305*①.

water purifier, C-1006/*177*.

water-ripple texture, C-5191/*488*.

Waters, Billy, IDC.

water-smoothed, IDC.

Water Spout clock, C-2368/*51*.

water stain, C-5236/*597*①.

water stained, CHGH/*35*.

water staining, C-0249/*132*.

water stoup, LAR83/*242*①.

water-tortoise, IDC.

water vessel, JIWA/*346*.

water-white, DATT.

Watkin's, C-2904/*72*.

Watkins, C-2904/*217*.

Watkins, William, S-3311/*779*.

Watkins of Charing Cross, C-2904/ *59*.

Watmough, R., Birmingham, C-2503/ *187*.

Watson, John, C-5174/*513*; C-5203/ *181*①.

Watson, Prof. W., C-2458.

Watson, Thomas, C-5117/*37*.

Watson and Bradbury, EA/*Bradbury, Thomas.*

Watson Company, C-5153/*4*①.

Watson's, C-2904/*128*.

Watt, Elizabeth Mary, C-GUST/*6*①.

Watteau, Jean-Antoine, EA.

Watteauesque, C-2546/*38*; C-5189/ *306*①.

Watteau figure, LAR82/*152*①.

Watteau figures, S-4853/*211*①.

Watteau painting, MP/*121*.

Watteau service, EA/*green Watteau service.*

Watteau subjects, IDC/①.

wattle medallion, IDC.

Waugh, Sidney, CEA/*482*①; DADA/ *Supplement.*

wave, C-2458/*43*.

wave and foliate border, C-0254/*281*.

wave and shell border, C-0254/*265*.

wave-band, RGS/*105*①.

wave border, IDC; LAR83/*109*①.

Wave Crest, LAR82/*457*①.

waved apron, C-2402/*49*; C-5116/ *121*①.

waved back, C-2364/*36*①; C-2421/ *25*①.

waved base, C-2388/*34*.

waved circular, C-2402/*32*.

waved corded rim, S-2882/*1057*①.

wave decoration, JIWA/*130*①.

waved edge, RGS/*105*①.

wave design, C-5146/*113*①.

waved everted rim, S-2882/*1308*.

waved frieze, C-0279/*312*; C-0982/ *43*; C-2403/*102*.

waved gallery, C-2421/*56*.

waved guilloché ground, RGS/*123*①.

waved lip, C-5156/*804*.

waved molded rim, S-2882/*1197*①.

waved pattern, C-2414/*72*.

waved rim, C-2202/*1*; S-2882/*972*①, *1069, 1100*①.

waved scrollwork rim, S-2882/*979*①.

waved stretcher, C-2388/*41*; C-2403/ *23*; C-5116/*91*.

waved surround, C-2320/*62*.

waved top rail, C-0279/*303*①; C-5116/*63*①, *158*①.

waved X-stretcher, C-5181/*165*.

Wave Edge pattern, C-0254/*290*; C-0270/*248*.

wave mark, C-2486/*97*.

wave molded, C-0225/*49*.

wave motif, S-4965/*107*①.

wave moulded, C-0782/*31*.

wave moulded base, C-0782/*116*.

wave moulding, SDF.

wave-pattern, C-0249/*304*; C-2458/ *62*①, *90*①; C-5116/*118*.

Webb, Philip Speakman, SDF/*766*.

Webb, T., OPGAC/*156*.

Webb, Thomas, CEA/*450*①.

Webb and Scott, DADA.

webbe, SDF.

webbed, S-4461/*16*.

webbed mount, S-4461/*23*.

webbed pattern, S-4461/*86*①.

webbed seat, C-5239/*265*.

Webber, Kem, C-5239/*268*.

webbing, SDF.

webbing scroll, S-4461/*26*.

webbing scroll mount, S-4461/*15*.

Webb's Crystal Glass Co. Ltd., EA/*Scottish glass*.

Webb & Sons, Thomas, EC1/*66*①.

Weber, C., C-2493/*307*.

Weber, David, CEA/*236*①.

Weber, Franz Joseph, EA.

Weber, Kem, C-5191/*321*.

web feet, CEA/*393*①.

web foot, DADA.

web foot (in furniture), EA.

web foot, SDF.

Webley, C-2476/*46*.

Webley revolver, ACD.

Webley & Scott, C-2476/*55*.

Webster, Moses, C-2360/*85*; EA.

Webster, William, SDF/*778*.

Webster Mfg. Co., N.Y., C-5181/*57*.

wedding basket, S-4807/*318*.

wedding belt, C-5174/*184*①.

wedding casket, EA/*marriage casket*.

wedding dress, C-1506/*77*; C-3011/*105*.

wedding ring, C-5174/*183*.

wedding trousseau, C-1506/*7*.

wedding umbrella, K-710/*118*.

wedge, DATT.

Wedge-Fast, C-2476/*89*.

wedge thumbpiece, EA.

Wedgewood, C-1006/*2*; C-1502/*88*.

Wedgewood-Greatbach, LAR82/*188*①.

wedging, IDC.

Wedgwood, ACD; C-2502/*15*; CEA/*448*①; FFDAB/*125, 128*①; IDPF/*12*; JIWA/*351*; LAR82/*186*①; OPGAC/*354, 372*; S-4461/*2, 625*; EA/*black basalt or basaltes*, ① *Queensware*.

Wedgwood, Josiah, CEA/*109, 203*①, *516*①; DADA/①; K-710/*117*; MP/*171*; NYTBA/*150*.

Wedgwood, Josiah I, EA.

Wedgwood, Josiah II, EA.

Wedgwood-Arbeit, IDC.

Wedgwoodarbeit, EA.

Wedgwood & Bentley, LAR83/*167*①.

Wedgwood & Bentley, Etruria, EA/*black basalt or basaltes*.

Wedgwood coloured body, IDC.

Wedgwood creamware, CEA/*149*①.

Wedgwood date letter, EA.

Wedgwood II, Josiah, CEA/*203*①.

Wedgwood inlay, CEA/*314*①.

Wedgwood jasper medallion, CEA/*516*①.

Wedgwood jewellery, EA.

Wedgwood lustre, IDC.

Wedgwood-pattern medallion (on furniture), C-2522/*84*①.

Wedgwood style, MP/*488*①.

Wedgwood ware, IDC.

wedjat-eye, C-2482/*84*.

Wednesbury, EA.

weed pot, IDPF/*251*.

Weeks, C-2478/*83*.

Weesp, CEA/*181*①; DADA.

Weesp porcelain factory, EA.

weet chestnut, SDF.

weft, CEA/*76, 101*.

weft (woof), EA.

weft, OC/*19*①; S-3311/*75A*; SDF.

weft-brocaded, C-2478/*216*.

weft-loop pile, EA/*Alpujarra rug.*

weft-loop (single loop) (V-loop) pile, EA/①.

weft-loop pile rug, OC/*34.*

weft-loop rug, OC/*16, 33.*

weft string, OC/*16.*

Wegely, C-2486/*84*①.

Wegely, W. K., CEA/*177*①.

Wegely factory, MP/*146.*

Wegely's factory, Berlin, EA.

Wegner, Hans, DADA/*Supplement.*

wei ch'i, IDPF/*251.*

Weidenmuster, IDC.

Wei Dunasty, C-5156/*7.*

Wei Dynasty, C-2323/*2*; C-2458/*4*; C-5127/*3*①; C-5236/*349*①, *408*①.

weighing machine, C-5116/*30*; C-5157/*4.*

weight, C-0279/*97*①; CEA/*221*①; EA/①; EC2/*89*; IDPF/*251*; LP/①; S-4436/*37*①.

weight clock, C-MARS/*230*①.

weight driven, CEA/*221*①.

weight driven movement, C-1702/*350.*

weight-driven shelf clock, CEA/*244*①.

weighted bar, EA/*balance.*

weight pan, C-5157/*4.*

Weimar School for Arts and Crafts, DADA/*Supplement.*

Weir, C-2904/*11.*

Weir, Don, DADA/*Supplement.*

Weisse Erde Zeche St. Andreas, MP/*27.*

Weissenfels, Duke of, series, IDC.

Weisweiler, Adam, DADA; EA/①; LAR82/*401*①; S-4955/*192*①.

Wei taste, C-5156/*184.*

Weitzendorfer, Franz, CEA/*241*①.

Welch, K-711/*130.*

Welch, E. N., CEA/*264*①.

welcome cup, EA/*Willkomm.*

weld, DATT.

Welder, Samuel, C-2487/*125.*

welding, CEA/*528, 542*; DATT.

Weldon, London, C-MARS/*160.*

Weldring, John, C-5170/*12*①.

well, C-2403/*91*①; C-2458/*62*①; C-5114/*401*①; C-5116/*77*; C-5236/*424*①; DSSA; IDC; IDPF/*251*①.

well-and-tree plate, DADA.

well-and-tree platter, C-0254/*22*; S-2882/*918.*

well-carved, C-5116/*146*①.

well-chiselled, S-3311/*300.*

well crane, CEA/*539*①.

Weller, C-5239/*1*; OPGAC/*345.*

Weller, David Friedrich, MP/*174.*

Weller Pottery, DADA/*Supplement*; EC1/*73*①, *80*①.

Weller Pottery, Zanesville, Ohio, EC1/*85.*

well-figured, C-2421/*88*①; C-2476/*3*; C-5116/*2, 83, 116, 129*①; C-5157/*78, 165*①.

well-figured wood, LAR83/*367*①, *390*①.

well-finished, S-3312/*1368*①.

well-fitted, C-2403/*97*①.

well form, IDPF/*252*①.

well head, IDPF/*252*①.

wellhead, C-5236/*402.*

well-hollowed, S-4810/*63*①.

Wellington, C-2402/*128A.*

Wellington, Duke of, services, IDC.

Wellington chair, SDF.

Wellington chest, C-2478/*82*; EA; LAR82/*318*①; LAR83/*298*①, *337*①; SDF.

Wellington Service, MP/*183.*

Wellington Shield, EA.

Wellington-style dressing chest, C-1407/*29.*

Wellington vase, IDC.

well-platter, IDC.

well-potted, S-3312/*1368*①.

well potted pear shape, LAR83/*92*①.

well-proportioned, JIWA/*108*.

wells, C-0254/*278*; C-5236/*531*.

Wells, Francis, S-4988/*413*①.

Wells, Reginald, DADA/*Supplement*.

Well-sinking, C-2904/*199*.

well slant, DATT.

wells metal, SDF.

Welsh, C-2704/*107*; CEA/*202*①.

Welsh dresser, ACD; C-0249/*410*①;
C-0279/*338*; C-5157/*131*①;
C-5170/*74*; DADA/①; EA; SDF/
①.

Welsh harp, CEA/*548*; EA.

Welsh quilt, C-2704/*82*.

Welsh tailor and his family, IDC.

welsh tray, IDPF/*252*.

Welsh ware, DADA.

Wem, C-2476/*80*.

Wemyss, C-1006/*28*.

Wemyss Glasshouse, EA/*Scottish
glass*.

Wemyss-ware, LAR82/*99*①, *189*①.

Wendell & Roberts, C-0270/*237*.

Wenshu, S-4810/*280*①.

Wernier, Guillaume, EA/*de Melter,
Jean*.

Werniers, G., C-2546/*142*①.

Werritzer, Peter, C-2487/*91*; C-5117/
383.

Werthers Leiden, MP/*175*.

Wesley, John, CEA/*159*①.

West, Matthew, C-5117/*51*, *73*①.

West Country measure, EA/*Bristol
measure*.

Western Han Dynasty, C-5156/*9*①,
*380*①.

western hemlock, SDF.

Western Ijo, C-1082/*71*.

western red cedar, SDF.

Western Zhou Dynasty, C-2414/*3*①;
C-5156/*298*①.

Westerwald, C-2486/*191*①; CEA/
*138*①; DADA; LAR82/*190*①;
LAR83/*171*①; S-4972/*395*①.

Westerwald stoneware, EA.

Westerwald ware, IDC/①.

Westley Richards & Co, C-2476/
*14*①.

Westminister dial, C-5189/*198*.

Westminster chimes, C-5116/*49*①;
LAR82/*214*①.

Westminster clock, EA.

West Riding, C-2904/*40*.

West Somerset, C-0249/*408*①.

Westward Ho pattern, CEA/*472*①.

wet clay, DATT.

wet-drug jar, C-2427/*214*; C-2486/
*208*①; IDC/①; LAR82/*137*①.

wet drug jar, S-4972/*131*①.

wet grinding edge runner, MP/*191*.

wet-into-wet, DATT; LP.

wet-plate camera, C-1609/*159*①.

wet-plate sliding box camera, C-1609/
*151*①.

wetting agent, DATT.

wetting down, DATT.

Wetzlar, C-2904/*233*.

Weylandt, Nicolaas, Amsterdam,
C-MARS/*241*.

WF, EA/*Fountain, William, 346 Toft
family*.

WF above DP, EA/*Fountain,
William*.

WF in script, EA/*Fountain, William*.

W. F. Stanley & Co., C-2904/*73*.

whale, DSSA.

whalebone, JIWA/*195*; S-4881.

whale-end shelf, LAR82/*274*①.

whale-form handle, S-2882/*622*①,
*634*①.

'whale hunting' plate, S-4823/*23*.

whale ivory, S-4881/*63*①.

whale ivory pipe, S-4881/*164*.

whale oil lamp, CEA/*464*①; DADA; LAR82/*502*①.

whale oil lamps, S-4461/*547*.

whale's tail decoration, EA.

whale stamp, S-4881/*361*①, *508*①.

whales teeth, C-5114/*192*①.

whales tooth, C-5114/*193*①.

whale-tooth, CHGH/*63*.

whaling goblet, S-4881/*359*①.

whaling implement, S-4881.

whaling weapons, S-4881/①.

Whaliss, Ernst, C-GUST/*11*①.

Whartenby, Thomas, S-4905/*200*.

what-not, DADA; S-4461/*622*.

whatnot, ACD; C-1407/*73*; C-2320/*38*; C-2370/*63*; C-2421/*66*①; C-5189/*268*①.

whatnot (omnium) (étagère), EA.

whatnot, LAR83/*409*①; SDF/①.

whatnot-cabinet, LAR83/*259*①.

whatnot pedestal, SDF.

wheat and barley, OPGAC/*240*.

wheat-ear, C-2398/*21*①; CEA/*347*①; DADA.

wheatear, C-0982/*32*.

wheat-ear decoration, LAR83/*289*①; MP/*56*① Plates.

wheat ears, C-5116/*105*; S-4955/*192*①.

Wheatley, T.J. (mark), EC1/*84*①.

Wheatley pottery, LAR83/*64*①.

Wheatley Pottery Company, Cincinnati, Ohio, EC1/*85*.

wheatsheaf (gerbe), EA/*décor coréen*.

wheatsheaf back, SDF/①.

wheatsheaf pattern, IDC.

wheat stalk design, C-5236/*878*①.

Wheatstone, C-0906/*263*.

Wheatstone and Lachenal, CEA/*553*①.

wheel, C-2370/*29*①; CEA/*218*; DSSA; EC2/*89*; IDC; S-4972/*155*①.

wheel arbor, CEA/*223*①.

wheel-back, DADA; EA.

wheel back, LAR83/*288*①; S-4461/*557*①.

wheelback, C-0982/*300*; C-5157/*100*①.

wheel back chair, SDF/①.

wheel-backed, LAR82/*310*①.

wheel balance, CEA/*220*①, *221*①.

wheel barometer, C-2368/*1*; C-2489/*32*; CEA/*260*, *261*①, *268*; S-3311/*153*①.

wheel-carved, C-2324/*168*; C-5005/*282*①; C-5146/*150*; C-GUST/*61*①.

wheel carved, S-4414/*204*①, *204*①.

wheel carved and etched, LAR83/*443*①.

wheel-cut, C-5156/*309*; C-5236/*335A*; EG/*36*.

wheel cut, C-0225/*181*.

wheel cutting, CEA/*417*①.

wheel cutting engine, CEA/*218*.

wheel-engraved, CEA/*435*①; IDC.

wheel engraved, CEA/*444*①.

wheel engraving, EA/*engraved glass*; EG/*124*①.

Wheeler, Candace, DADA/*Supplement*.

Wheeler & Wilson treadle sewing machine, C-0403/*10*.

wheel-form, S-4927/*80*.

wheel-hatching, C-5156/*352*①.

wheelhead, IDPF/*5*.

Wheeling Glass Factory, EA/*lime glass*.

wheeling peach blow, EC1/*56*.

Wheeling Pottery Company, DADA/*Supplement*.

wheel-lock, ACD; C-MARS/*126*①; DADA.

wheel-lock holster pistol, C-2569/*108*①.

wheel-lock pistol, C-2503/*203*①.

wheel-lock rifle, CEA/22①.

wheel-lock sporting rifle, C-2569/103①.

wheel-lock tinder-box, EA/tinder-box.

wheel-lock tschinke, C-2569/109①; S-4972/155①.

wheel mark, C-2427/50①.

wheelock gun, S-4972/157①.

Wheel of Life, JIWA/295.

wheel pattern, IDC.

wheel-polished, MP/464①.

wheels, C-0406/112.

whelk foot, C-2487/111.

whelk red, DATT.

whetstone, DATT.

whey, OC/25.

whiche, SDF.

Whieldon, LAR82/191①; LAR83/172①.

Whieldon, Thomas, ACD; CEA/154①; DADA; EA/①; NYTBA/149①.

Whieldon-type, S-4843/119.

Whieldon type, NYTBA/149①.

whieldon ware, IDC/①.

Whieldon-Wedgwood ware, IDC.

whimsey, C-0225/254; EA; NYTBA/141.

whip, C-1082/7; DSSA.

Whip, Thomas Lancaster, LAR82/238①.

whip form, C-5174/427①.

Whipham, Thomas, C-5173/32①.

Whipham, Thomas & Wright, Charles, S-4922/13①.

whip handle, C-5117/63.

whiplash line, JIWA/384①.

whiplash motif, S-2882/1447①.

whiplash mount, C-2409/7.

whiplash tendril, C-2409/2.

whipt-syllabub, DADA.

whirles, SDF.

whirligig, K-711/130.

whisky tot bottle, C-0706/206.

whistle, C-0254/135; C-0406/98; C-1082/57; IDC; IDPF/252①.

whistle (human head) (animal head), S-4965/163①.

whistle and bell, CEA/675①.

Whistler, James A. McNeill, S-286/546①.

Whistler, Laurence, DADA/Supplement.

whistle tankard, EA.

whistling vessel, S-4807/55.

Whitall Tatum & Co., CEA/489.

white, CEA/460①.

White, J., C-2904/81.

White, J., Glasgow, C-2904/44.

White, John, CEA/647①.

whitebeam wood, DADA.

white body colour, JIWA/88.

white bridal bouquet, CEA/496①.

white Bristol glass, CEA/449①.

white clouding, C-5127/289①.

white earth, DATT.

white ebony, SDF.

white enamel dial, C-5117/456.

white-firing clay, CEA/170①.

Whitefriars Glass Works, DADA/Supplement.

Whitefriars Glassworks, EA.

Whitefriars miniature scent bottle, CEA/492①.

white-glazed, S-4810/43①.

white glazed, C-1006/144.

white gold, LAR82/500①; S-4461/304; S-4927/409.

white granite, DADA, supplement.

Whitehead, Christopher Charles, CEA/158①.

Whitehead, James and Charles, CEA/158①.

Whitehead, Wm., S-4988/412①.

White House service, IDC/①.

White House Works, EA/*Atterbury & Company.*

Whitehurst, John, EA.

white iron ware, DADA.

white jade, C-5127/*297*; DADA; S-4810/*169*①.

white jasper, S-4843/*459*①.

white lawn, C-1506/*34.*

white lead, DATT; LP.

white lead in oil, DATT.

white-line cut, DATT.

white-line technique, JIWA/*5, 45.*

white loop, CEA/*449*①.

white mahogany, DATT.

white marble, C-0982/*250.*

white-metal, C-0103/*194*; C-0706/*3*; C-2202/*38*; C-2910/*201.*

white metal, C-0249/*169*; C-0706/*25*; EA/*Britannia metal*; LAR83/*559*①.

whiteness, EA.

'white-on-black' print, JIWA/*11.*

white-on-black print, JIWA/*70.*

white on white, CEA/*147*①.

white opaque spiral, CEA/*431*①.

white paste, CEA/*171*①.

white pigments, DATT.

white porcelain, JIWA/*5, 344.*

White Pottery, Denver, Colorado, EC1/*85.*

white quartz, RGS/*138.*

White: Robert, George, EA.

white silver, DADA.

white slip, S-4804/*276.*

white slip decoration, S-4461/*478.*

white spirit, DATT.

White Star, The (De Witte Star), EA.

white state, MP/*166.*

white stoneware, EA/*salt-glaze ware, salt-glaze ware.*

white Ushak carpet, EA.

white walnut, DATT.

white-ware, IDC.

white ware, C-5156/*43*; C-5236/*1589.*

white ware (granite ware), DADA/*Supplement.*

white ware, S-4965/*215*①.

Whiteware, IDPF/*111.*

whitewash, DATT.

whitewashed, JIWA/*378.*

white wax, DATT.

whitewood, FFDAB/*46*①; NYTBA/*56*; SDF.

whitework, C-1506/*68*; C-2203/*41*; C-2704/*18*①; CEA/*277*①.

white Wycombe, SDF.

Whitford, Samuel & George, C-0270/*155*①.

whiting, DATT; LP; S-4461/*178.*

Whiting Co., C-0270/*205.*

Whitmore, Jacob, NYTBA/*244*①.

Whittall, Eleanor, C-2910/*101.*

Whittle, James, C-2522/*30*①.

Whitty, Thomas, CEA/*96*; EA.

Whitworth patent rifle, C-2503/*115.*

Whitworth steel, C-2476/*15*①.

whole length, DATT.

whorl, C-2458/*1*①; C-5127/*146*①; DADA.

whorl foot (in furniture), EA.

whorl foot, SDF/①.

whorl-like finial, C-0254/*319.*

whorl motif, S-3312/*1281*①.

whorl-pattern, C-2458/*56*①, *215.*

whorl pattern, C-0782/*8*; C-2493/*123*; C-5156/*149*①; EA; IDC; S-4829/*87.*

Whyte, David, S-4944/*359.*

Whyte Thompson & Co., Glasgow & South Shields, C-2904/*90.*

WI, EA/*Willaume, David, the Elder.*

WI, or G enclosing W, EA/*Wickes, George.*

Wiburd, James, C-5170/*12*①.

Wichjajev, Ivan (assaymaster), C-5174/*84*.

Wichman, Erich, C-2910/*144*.

Wichmann, I.N., Oldenburg, C-MARS/*130*.

Wickenden & Sons, C-2904/*82*.

wicker, C-5156/*12*①; DADA/ *Supplement*; LAR82/*305*①.

wicker baby carriage, LAR83/*659*①.

wicker chair, DADA; SDF.

wicker-molded rim, S-4843/*230*①.

wickerwork, IDPF/*14*; SDF.

wickerwork basket, C-0782/*6*.

wickerwork motif, CEA/*650*①.

Wickes, George, C-5117/*83*①; C-5174/*604*①; EA.

wick holder, C-5114/*144*①; C-5153/ *11*①.

Widdicomb Furniture Company, DADA/*Supplement*.

wide-band ring, RTA/*113*①.

wide border, C-0249/*416*.

widely flared rim, C-0782/*14*.

wide-mouthed, IDPF/*60*①.

wide openwork, S-4905/*162*.

wide-rimmed, IDPF/*12, 69*①.

wide runner, OC/*23*.

widow finial, IDC.

Widow of Zarephath, IDC.

wiederkomm, DADA.

Wiener Werkstätte, C-5167/*162*①.

Wiener Werkstatte, C-GUST/*91*①.

Wiener Werkstätte, DADA/ *Supplement*; JIWA/*199*.

Wiener Werkstatte, LAR82/*88*①; LAR83/*604*①.

Wieseltier, Vally, C-5191/*58*; C-5239/ *49*.

Wigan, Edward, C-5117/*52*; S-4944/ *335*①.

wig bag, C-1506/*26*.

wig block, SDF/①.

wig drawers, S-3311/*507*①.

Wiggin, CEA/*32*①.

Wiggin & Co., C-2503/*140*.

wig glass, SDF.

Wight, Franklin, CEA/*167*①.

Wigornia, IDC.

wig-stand, ACD; IDC/①.

wig stand, DADA; EA; IDPF/*253*①; SDF/①.

Wigström, Henrik, C-5117/*363*①.

Wigstrom, Henrik (workmaster), C-5174/*311*①.

wig table, SDF/① *wig stand*.

Wilbraham, London, C-2503/*125*.

Wilcox H. C., and Company, DADA/ *Supplement*.

Wilcox & Wagoner, C-0270/*271*.

Wildenhain, Frans, DADA/ *Supplement*.

Wildenhain, Marguerite, DADA/ *Supplement*.

Wildenstein, Paul, MP/*36*.

Wilder, C., LAR82/*45*①.

Wilders, J., London, C-2489/*171*; C-MARS/*155*.

wildflower, OPGAC/*240*; CEA/ *472*①.

wild rose, EC1/*56*; CEA/*474*①; NYTBA/*302*.

Wilhelm, Georg, CEA/*138*①.

Wilhelm Sattler & Son, S-4843/ *347*①.

Wilkens, S-4944/*125*.

Wilkes, J., C-2476/*51*.

Wilkes, J. London, S-4881/*25*①.

Wilkes, Johannes, EA/*216*.

Wilkes, John, CEA/*531*①.

Wilkie, C-2704/*119*.

Wilkinson, CEA/*27*.

Wilkinson, Henry, C-2510/*45*.

Wilkinson & Co, C-0270/*140*①.

Wilkinson & Co., C-5191/*423*.

Wilkinson Ltd., C-GUST/*9*①; LAR83/*81*①.

Wilkinson pottery, C-2910/*106, 166;*
C-2409/*68.*

Will, Colonel William, CEA/*579*①,
*593*①.

Will, William, NYTBA/*242*①.

Willard, Aaron, C-5153/*168*①; EA/
①.

Willard, Simon, CEA/*243*①; DADA;
EA.

Willaume, David, S-4922/*68*①.

Willaume, David II, C-5117/*288.*

**Willaume: David the Elder, David the
Younger,** EA/①.

Willcox & Gibbs, C-2904/*4, 12.*

Willcox & Gibbs sewing machine,
C-0403/*9.*

Willebrand, Johann, Augspurg,
C-2489/*24*①.

Willems, Joseph, CEA/*186*①; EA.

Willets Manufactory Company,
DADA/*Supplement.*

Willett, Marinus, DADA.

William III, C-2487/*132;* C-5116/
110; C-5117/*268*①; CEA/*644*①;
DADA; IDC/①; S-4922/*19*①.

William III period, C-5170/*95.*

William III style, C-0249/*367;*
C-5117/*201.*

William IV, C-0706/*229;* C-0982/
82A; C-1407/*121;* C-1502/*65, 163;*
C-2357/*17*①; C-2398/*41;* C-2478/
82; C-5116/*47, 134*①; C-5117/
*109*①*, 209, 281;* S-4436/*74*①;
S-4802/*313;* S-4812/*190*①;
S-4922/*73*①; S-4988/*551*①.

William and Mary, C-0249/*345;*
C-2388/*105*①; C-5114/*309*①;
C-5116/*168*①; C-5117/*293*①;
C-5157/*172*①; CEA/*321;* DADA/
①; LAR83/*199*①; S-4436/*1*①;
S-4812/*47*①; S-4972/*457.*

William and Mary design, C-2403/
110.

William and Mary period, C-2498/*77;*
C-5173/*49*①; LAR82/*71*①.

William and Mary style, CEA/*389;*
EA/①; NYTBA/*17*①; S-3311/
265; S-4804/*876*①; SDF; S-4812/
*2*①.

William B. Durgin Co., S-3311/*617.*

William Cookworthy's Factory,
C-2493/*104*①.

William Gale & Son, C-5153/*17*①;
S-4905/*167.*

William Hutton & Sons, C-0706/*29.*

Williamite, CEA/*443*①; LAR83/
*430*①.

William I. Tenney, S-4905/*183.*

Williams, F., C-2476/*60.*

Williams, Hanbury service, IDC.

Williams, John, CEA/*29*①.

Williams, London, C-2489/*80*①.

Williams, Richard, C-5117/*74;*
S-3311/*772*①.

Williams, Sir Charles Hanbury,
CEA/*188*①.

Williams, William, C-2487/*166*①.

Williams, William I, S-3311/*789*①.

William Smith & Co., EA/*Stafford
Pottery.*

Williamson, Samuel, NYTBA/*229*①.

Williamson, Thomas, C-5174/*561*①.

Williamson, Timothy, EA/*241.*

William Whiteley Ltd., C-0405/*90.*

Willis, C-2489/*237*①.

Williston, Samuel, EA.

willkom, DADA.

Willkomm, EA.

Willkomm glass, EA.

Willmore, J., EA/*250*①.

Willmore, Joseph, C-0406/*70;*
C-5117/*25*①; C-5173/*12;* LAR82/
*591*①.

Willmore, Thomas, C-0406/*84;*
C-5117/*45.*

willow, ACD; SDF.

willow oak, OPGAC/*240.*

willow-pattern, C-2458/*93.*

willow pattern, ACD; DADA/①; EA/①; IDC.

Willson, Thomas, C-2478/*135*.

Wilme, John, C-5117/*84*.

Wilmore, Joseph, C-0706/*56*.

Wilson, Henry, CEA/*519*①; DADA/ *Supplement*.

Wilson, James, CEA/*610*①.

Wilson, Joseph, CEA/*166*①; S-3311/ *720*①.

Wilson, R. & W., S-4905/*188*①.

Wilson, Robert, C-2503/*129*; DADA; EA; S-4905/*222*.

Wilton, CEA/*96*; DADA.

Wilton carpet, ACD; EA; SDF.

Wilton Carpet Manufactory, EA/ *Axminster carpet*.

Wiltshire, CEA/*233*①.

wimple, C-5174/*12*①.

wincanton, DADA.

Wincanton delftware, EA/①.

Winchcombe, Michael Cardew, LAR82/*102*①.

Winchester, C-2476/*10*; CEA/*37*.

Winchester, Oliver F., CEA/*41*①.

Winchester measure, C-0403/*80*①; EA.

Winchester Model 1866, CEA/*41*①.

Winckelmann, IDC.

Winckelmann, Johann, DADA.

wind, DSSA.

windage-slide, C-2476/*14*①.

wind chime, IDPF/*253*.

wind compass, C-2489/*30*①.

Windham pattern, C-0254/*248*.

winding aperture, C-5117/*458*①.

winding hole, CEA/*227*①, *250*; S-4927/*207*①.

winding indicator, C-5117/*404*①, *425*①.

windlass, C-2503/*83*①.

windmill, C-2704/*4*; DSSA.

Windmill, the, IDC.

windmill cup, DADA; EA/①.

windmill medallion, OPGAC/*185*.

Windmills, Joseph, CEA/*253*①; EA/ *366*①.

Windmills, Jos., London, C-MARS/ *175*.

windmill watch, EA/①.

windmill weight, K-710/*118*.

window, C-0249/*158*; C-5239/*307*; CEA/*484*.

window (in glassmaking), EG/*260*.

window bench, DADA.

window-grille, CEA/*538*①.

window guard, NYTBA/*252*.

window-like decoration, JIWA/*157*.

window-seat, C-2478/*33*.

window seat, C-0249/*373*; C-5116/ *75*; EA/①; S-3311/*227*①; S-4436/ *138*①; S-4461/*675*; S-4988/*476*①; SDF/①.

window stool, SDF.

windsor, S-4905/*451*①; C-0279/ *339*①; C-0982/*300*; C-5114/*291*①, *381*①; C-5153/*100*; CEA/*324*①, *406*; S-4812/*135*; S-4905/*336*①.

Windsor armchair, C-5116/*119*; S-2882/*328*①.

Windsor bench, SDF.

windsor chair, C-0249/*402*①; ACD; DADA; FFDAB/*49*①; LAR82/ *302*①; LAR83/*286*①, *289*①; NYTBA/*39*; SDF/①.

Windsor cricket, SDF.

Windsor furniture, EA.

Windsor pattern, C-0254/*114*.

Windsor rocker, SDF.

Windsor settee, SDF.

windsor side chair, S-4905/*443*①; S-2882/*350*.

Windsor table, SDF.

windswept style, C-5156/*87*①.

wind toy, CEA/*697*.

wine and roses, OPGAC/*185*.

wine and water vase, IDC/①.

wine-barrel, IDC.

wine beaker, C-2414/*10*①.

wine-bottle, IDC/①.

wine bottle, CEA/*57*①.

wine bottle (in silver), EA.

wine bottle (in pottery), EA/①.

wine bottle, IDPF/*253*①.

wine bottle cart, S-4461/*38*.

wine cask, IDPF/*253*.

wine cellaret, LAR83/*410*①.

wine-cistern, CEA/*146*①; IDC.

wine cistern, ACD; CEA/*345*①; DADA; EA; S-4436/*185*①; SDF/①.

wine-coaster, C-2398/*9*①; C-5117/*127*①; C-5174/*517*①.

wine coaster, C-0254/*7*; C-0706/*179*; LAR82/*577*①; LAR83/*562*①.

wine-cooler, C-2388/*48*①; C-2398/*5*; C-2421/*65*①; C-2478/*79*; C-5117/*30*①; CEA/*135*①; IDC.

wine cooler, ACD; C-0254/*152*; C-5116/*57, 79*①; C-5157/*97*①; CEA/*344*①; DADA/①.

wine cooler (ice bucket) (ice pail), EA/①.

wine cooler, IDPF/*253*; LAR83/*410*①, *644*①; S-3311/*149*①; S-4436/*176*①; S-4461/*179*; S-4802/*294*; S-4804/*176*; S-4905/*47*①; S-4922/*31*①; SDF/① *wine cistern*.

wine-cradle, IDC.

wine cruet, LAR82/*437*①.

wine cup, C-2458/*172*; S-4461/*411*; S-4965/*167*①.

wine-ewer, IDC.

wine ewer, C-0254/*126*①; C-2458/*91*; C-2513/*131*①; C-5156/*173*.

wine field, C-0906/*1*.

wine-flagon, C-2502/*96*.

wine-flask, IDC/①.

wine fountain, DADA; EA; SDF/① *wine cistern*.

wine-funnel, C-2510/*69*.

wine funnel, C-0254/*182*; EA/①; LAR83/*645*①; S-4802/*363*.

wine funnel stand, DADA.

wine glass, C-5146/*90*; CEA/*291*①.

'wine-glass' border, OC/*45*①.

wine-glass cooler, IDC.

wine glass cooler, DADA; EA.

wine glass design, C-0279/*33*; C-5323/*5*.

wine glass stand, EA.

wine goblet, C-5005/*223*.

wine jar, C-5156/*60*①; CEA/*121*①.

wine jar (Chinese ceramic shape), EA/①.

wine jug, CEA/*49*.

wine keeper, SDF.

wine-label, IDC.

wine label, C-2487/*84*; EA/①; LAR83/*645*①.

wine lable, C-0406/*82*.

wine measure, C-5114/*115*; EA.

wine-pot, C-2513/*359*; CEA/*641*①; IDC.

wine pot, C-5236/*1593*; IDPF/*253*①.

winepot, LAR83/*591*①.

wine-pot style, CEA/*641*①.

wine press, C-0982/*87A*.

wine-red, C-2502/*107*.

wine red, S-288/*33*①.

wine table, ACD; C-0982/*135*; DADA; S-4988/*549*①; SDF.

wine-taster, C-5117/*185*①; IDC/①.

wine taster, C-0254/*43*; C-5203/*123*; CEA/*631*①; DADA; EA/①; LAR82/*642*①; S-4461/*258*; S-4802/*229, 237*①; S-4922/*3*①.

winetaster's bowl, NYTBA/*227*.

wine tasting table, LAR83/*380*①.

wine-ticket, IDC.

wine vase, EA/*wine fountain*.

wine vessel, C-2414/*5*①.

wine wagon, DADA; EA/①.

wine waiter, ACD; DADA; EA; SDF.

wing, S-4972/*574*①.

Wing, Tycho, CEA/*604*①.

wing alarm lantern clock, LAR83/*200*①.

wing and paw feet, C-0254/*82*.

wing appendage, C-0225/*374*①.

wing arm-chair, CEA/*393*①.

wing arm chair, C-5005/*345*.

wing armchair, C-0982/*265*; C-2388/*12*①; C-5157/*158*①; LAR83/*279*①; S-3311/*189*; S-4436/*102*①.

wing back, C-1407/*7*.

wing-back armchair, S-3311/*270*.

wing-backed, CEA/*345*①.

wing bookcase, ACD; SDF.

wing chair, ACD; DADA; EA/①; FFDAB/*29*; S-4812/*52*①; SDF/①.

wing clothes press, SDF.

winged, EG/*73*①; FFDAB/*104*.

winged balance, S-4802/*134*①.

winged cupid or cherub, EA/*amorini*.

winged form, IDPF/*255*①.

winged glass, EA.

winged goblet, NYTBA/*273*①.

winged griffin, C-2421/*91*①.

winged griffon, C-2482/*88*.

winged horse decoration, S-4965/*142*①.

winged lion leg, DADA.

winged mask, C-5189/*49*①.

winged mask feet, S-4461/*76*①.

winged pallet arm, C-5117/*422*①.

winged paw feet, C-0279/*196*①; C-5114/*359*①; S-4414/*312*①.

winged putto, C-2398/*4*①.

winged serpent, C-0254/*286*.

winged-sphinx support, S-4507/*59*①.

winged stem, CEA/*419*①.

winged tiger decoration, S-4965/*132*①.

winged wardrobe, DADA/*wing wardrobe*; FFDAB/*93*①; SDF/*wing wardrobe*.

wing-handle, IDC.

wing handle, IDPF/*255*①.

wing-lantern clock, EA.

wingnut type winding assembly, C-2489/*127*.

wings, C-2402/*70*; C-5114/*323*①, *365*①; C-5157/*158*①, *170*①; DSSA.

wing wardrobe, DADA; EA/*wardrobe*; SDF.

Winkel-Zeiss, Gottingen, C-MARS/*198*.

Winkworth, Tho., C-2489/*65*.

Winslow, Edward, CEA/*667*①; EA.

Winslow, Kenelm, DADA.

Winsor blue, DATT.

Winsor green, DATT.

Winter, Martin, EA.

winter berry vase, C-5005/*251*①.

winter chawan, C-5236/*857*①.

Winterhalder, CEA/*219*.

Winter motif, C-2493/*108*.

'Winterscape' cameo, LAR83/*449*①.

Winterstein, EA.

Winterthur Hafnerware, EA.

Winthrop desk, DADA.

Winthrop pattern, C-0270/*166*; S-4461/*494*.

Wintle, Jacob, S-4944/*181*.

wiped, C-5156/*145*.

wiped clean, C-5156/*47*①.

wiping, DATT.

wire, C-5153/*161*①; S-4972/*248*①.

wire character, C-2458/*221*①.

wired for electricity, C-5005/*418*①.

wire-end tool, DATT.

wire frame, C-2357/*7*①.

wire handles, C-5153/*44*①.

wire mesh, C-2388/*134*; C-2403/*66*①.

Wood, Beatrice, DADA/*Supplement.*

Wood, Ben., London, C-2489/*168.*

Wood, David, EC2/*92*①.

Wood, Enoch, CEA/*159*①; DADA; EA/①; LAR83/*173*①; S-4843/*191*①, *302*①.

Wood, Grant, S-286/*549*①.

Wood, Ralph, CEA/*159*①; DADA/①; EA/①; LAR83/*173*①; NYTBA/*150*①; S-4843/*174*①.

Wood, Ralph II, EA.

Wood, Robt., London, C-2489/*88.*

Wood, Samuel, C-2487/*98*; EA; LAR82/*582*①; S-4944/*85.*

Wood, William, EA.

wood alcohol, DATT.

Woodall, George, NYTBA/*299*①.

Woodall Brothers, CEA/*450*①.

wood ash, EG/*288.*

wood base, S-4461/*511.*

woodblock, C-5236/*1498*①; NYTBA/*87*①.

woodblock engraving, S-4881/*378*①.

woodblock print, S-4461/*414.*

wood caddies, S-3311/*225*①.

Wood & Caldwell, EA/*Wood Enoch, Caldwell, James, Wood Enoch.*

wood-carving knife, DATT.

wood-carving tool, DATT/①.

wood club, C-1082/*27.*

woodcut, C-0249/*23*; C-1603/*62*; DATT; JIWA/*5*; S-286/*16, 69, 105*①, *106*①, *368A*①.

woodcut genre, JIWA/*233.*

woodcut illustration, MP/*189.*

woodcut tools, DATT.

wooden box yatate, JIWA/*149*①.

wooden clock, CEA/*221*①.

wooden foot, CEA/*443*①.

wooden frame, C-2704/*11.*

wooden frame press, MP/*191.*

wood-engraving, S-286/*26.*

wood engraving, DADA; DATT; JIWA/*12*; S-286/*55, 124*①, *130*①, *471*①, *473, 304A, 304B.*

wooden handle, C-5153/*25*①.

wooden hang up, CEA/*243*①.

wooden lace, C-2704/*121.*

wooden ring method, CEA/*684.*

wooden shaft, C-0405/*103.*

wooden ware, SDF/*woodware.*

Wood-family ware, IDC.

Woodforde, Nancy, CEA/*275.*

wood form, IDC.

wood handle, C-5117/*56*①; S-4905/*225*①.

wood hilt, C-1082/*28.*

Wood & Hughes, C-0270/*229*; S-3311/*627.*

wood inlay, EC2/*90*①.

wood joint, C-2402/*88.*

wood mask, C-1082/*44.*

wood panel, C-5239/*197A*①; LP; NYTBA/*191.*

wood playing board box, C-1082/*177.*

wood posted, S-3311/*204*①.

wood punch, C-5114/*188*①.

wood rod pendulum, C-1702/*251.*

wood scroll handle, C-0706/*2*; C-1502/*2.*

wood sculpture, C-5156/*765*①.

Wood & Sons, C-1006/*168.*

wood stands, C-0782/*116.*

Woodstock, EA.

wood tripod, C-2904/*41.*

wood turpentine, DATT.

Woodward, J., C-2476/*37, 69.*

Woodward & Grosjean, S-4905/*187*①.

woodware, SDF.

woodwind, CEA/*548.*

woodworm, SDF.

woof, EA/*weft*; SDF.

wool, C-3011/*40*; C-5156/*472*;
 C-5157/*64*; C-5236/*552*①;
 NYTBA/*94*; S-288/*8*①.

wool carpet, C-0225/*372*.

wool embroidery, CEA/*285*①.

Wooley, Jackson and Ellamarie,
 DADA/*Supplement*.

Wooley & Co., CEA/*32*①.

woollen pile, OC/*16*.

woollen-warped, OC/*16*, *17*①.

woolly effect, EA/*Bogle, John*.

wool-winder, SDF/①.

woolwork, C-0405/*158*.

Wooten Patent Desk, DADA/
 Supplement.

Wooton desk, K-802/*15*; C-1407/*150*.

Wooton Desk Co., C-1407/*150*.

Wootton desk, LAR82/*418*①.

Wootton Patent Office desk, LAR83/
 *332*①.

Worcester, ACD; C-2493; CEA/
 *448*①; DADA; NYTBA/*176*①;
 S-4461/*458*.

Worcester Barr, Flight, Barr, C-1006/
 114.

Worcester dragon, IDC.

Worcester Dr Wall, C-1006/*208*.

Worcester porcelain, NYTBA/*176*;
 S-3311/*343*①.

Worcester Royal Porcelain Company,
 CEA/*187*.

WORCESTER ROYAL
 PORCELAIN WORKS, EA/
 Worcester.

worcester Style, C-5236/*1794*①.

Worcester Tonquin Manufacture,
 CEA/*187*.

Worchester, EA/①.

Worfel foundry, C-5189/*155*①.

workable fixative, DATT.

work bag, C-5114/*339*①.

work bag slide, C-5114/*344*①.

work-box, DADA.

Worke, Jno., London, C-MARS/*164*.

worked, C-5116/*164*①; S-288/*36*①.

worked cold, CEA/*528*.

working feature, C-5157/*3*.

working proof, S-286/*538*.

workman's mark, IDC.

works, C-5114/*266*①; C-5116/*47*;
 JIWA/*6*.

works of mercy jug, IDC.

work stand, S-4804/*862A*①; SDF/①.

work-table, C-2388/*29*; CEA/*402*①.

work table, ACD; C-0982/*120A*;
 C-2402/*15*; C-5116/*55*; DADA/①.

work (sewing) table, EA/①.

work table, LAR83/*393*①; NYTBA/
 *18*①; S-4461/*600*; S-4972/*495*;
 SDF.

worktable, C-5114/*281*; FFDAB/*51*.

'world axis', OC/*107*.

World of Art, DATT.

world time watch, S-4461/*329*.

wormage, S-3312/*960*.

worm and screw angle, C-0403/*138*.

worm and wheel regulator, S-4927/
 *210*①.

wormed, C-5236/*845*.

worm gear, CEA/*252*①.

worm gear regulator, C-5174/*342*.

wormhole, C-5236/*920*.

worming damage, S-4972/*340*①.

Wormley, Edward, DADA/
 Supplement.

worm's-eye view, DATT/①.

worn, C-5117/*383*; C-5236/*1337*①.

Wornum, CEA/*550*①.

Worshipful Company of Goldsmiths,
 EA/*Goldsmiths' Company*,
 Goldsmiths' Company.

Worshipful Company of Pewterers,
 London, EA.

worsted fabric, C-5005/*350*①.

Worswick, Tho., Lancaster, C-2489/
 168.

worth, OC/*29*; C-5239/*131*.

Wostenholme, CEA/*43*①.

wotnot, CEA/*364*①.

W. Ottway & Co., C-2904/*169*.

Wou-ki, Zao, S-286/*104*.

wove, DATT.

woven, C-1082/*139*; C-2403/*158*; C-5156/*474*; C-5236/*884*; S-288/*26*①; S-4972/*171*①.

woven form, DADA/*Supplement*.

'woven gardens', OC/*144*.

woven hairwork, RTA/*122*①.

woven in reversibly, NYTBA/*86*.

woven in the style of a quilt, C-2704/*116*.

woven rush seat, C-1407/*138*.

woven work, JIWA/*205*①.

wove paper, C-0249/*18*; C-2324/*275*; S-286/*46, 54, 94C*.

W.P. & Co., S-4927/*102*.

W. & P. Cunningham, S-3311/*759*①.

WPM, EA/*Ludwigsburg*.

wrap-around door, C-5167/*194*①.

wrath, DSSA.

wreath, C-2202/*52*; C-2437/*14*①; C-5114/*85*①; C-5117/*135*①.

wreath-and-boss decoration, C-2555/*63*①.

wreath-cast, S-4972/*502*.

wreathed column, SDF.

wreathed hoop, RTA/*78*①, *78*①.

wreathed pattern, RTA/*76*①.

wreath handle, C-2437/*71*①.

wreathing, EA; IDC.

wreath medallion, C-5005/*397*①.

wreaths, C-2421/*39*①; C-5117/*283*①.

wreath-surrounded urn, CEA/*352*①.

wreath work, SDF.

Wren, John, C-5203/*187*.

wrest pin and plank, CEA/*556*.

wriggled, CEA/*584*①, *595*.

wriggled-work, C-2382/*68*; LAR82/*537*①.

wriggled work, DADA.

wrigglework, C-0706/*6*; C-2498/*45*①; C-5117/*465*①; C-5173/*52*①; CEA/*657*①, *678*; LAR83/*515*①; S-2882/*902*①, *1118*①; S-3311/*754*①; S-4802/*359*①; S-4804/*178*①.

wriggle-work, C-1502/*48*; C-2202/*135*; EA/①.

wrigglework band, S-2882/*1145*①; S-3311/*753*①.

wrigglework border, C-5117/*62*; S-2882/*931, 1002, 1120, 1162*.

wriggle-work border, C-0254/*6*; C-5114/*86*.

wrigglework reserve, S-2882/*1086*①.

Wright, Charles, C-2487/*123*; C-5117/*232*; C-5173/*32*①.

Wright, Frank Lloyd, DADA/*Supplement*.

Wright, James, C-5174/*562*.

Wright, Russell, C-5239/*272*①; DADA/*Supplement*.

Wright and Mansfield, C-5116/*66*.

wrinkles, DATT.

wrist-chronograph, C-5174/*393*①.

wrister, SDF.

wrist rest, C-5127/*295*; S-4810/*475*①.

wrist watch, C-5117/*399*①; S-4461/*300*.

writhen, C-2487/*88*; C-MARS/*7*.

withen cover, C-0254/*136*①.

writhen-knop, CEA/*595*.

writhing, DADA.

writing and toilet chest, LAR83/*333*①.

writing arm, DADA; SDF.

writing armchair, C-5116/*161*①; SDF.

writing box, C-0279/*177*; SDF.

writing cabinet, DADA/①.

writing-case spinet, CEA/*548.*

writing-chair, C-2546/*67.*

writing chair, ACD; C-0279/*266*; C-0982/*93*; DADA/①; EA/*corner chair, corner chair*; SDF/①.

writing desk, C-0225/*374*①; C-5114/*333*①; C-5239/*276*; EA/①; S-4461/*610*; SDF/①.

writing diamond, RTA/*94.*

writing door, C-2402/*100.*

writing drawer, C-0982/*283*; C-2402/*27*; SDF.

writing equipage, DADA.

writing fire screen, SDF/①.

writing flap, C-5114/*347*①; S-4461/*583.*

writing furniture, DADA/①.

Writing Instrument, C-2904/*25.*

writing panel, S-4812/*111*①.

writing plateau, C-2402/*29.*

writing slide, C-0279/*410*; C-5005/*341*①; CEA/*400*①.

writing slider, SDF.

writing slope, C-0982/*28*; LAR82/*68*①; LAR83/*51*①.

writing surface, C-5153/*87.*

writing table, C-5116/*83*; C-5156/*753*①; DADA/①; FFDAB/*107*①; S-4436/*162*①; S-4804/*833*①; SDF/①.

writing-table, C-2478/*116*①.

writing table-cabinet, C-0249/*467.*

writing Windsor, EA.

written in an old hand, S-4881/*65*①.

W. R. jug, IDC.

Wrotham, CEA/*152*①; DADA.

Wrotham English slipware, EA/①.

Wrotham ware, IDC.

wrought iron, ACD; C-2402/*206*; C-5114/*184*①; DADA; EA; NYTBA/*250*①.

wrought-iron, C-5005/*351*①; C-5239/*92*; S-4461/*44*; S-4804/*946*①; S-4905/*325*①.

wrought iron hinge, CEA/*300.*

wrought plate, EA.

W. R. Smily, S-3311/*713.*

wrythen, CEA/*584*①.

wrythen (writhen), EA.

wrythen, LAR82/*444*①.

wrythen body, C-2360/*126*①.

wrythen finial, C-2487/*76*; S-3311/*596*①.

wrythen-knop spoon, EA/①.

wrythen moulding, CEA/*425*①; EG/*288.*

WS & CO, QUEEN'S WARE STOCKTON, EA/*Stafford Pottery.*

WS & Co STAFFORD POTTERY, EA/*Stafford Pottery.*

W Stinton, C-1006/*20.*

W. & T. Avery, C-2904/*35.*

W. Thornhill & Co., S-4947/*125*①.

wucai, C-2458/*187*; C-2323/*61*①; C-5156/*101, 800*; LAR83/*80*①.

Wucai box, LAR83/*137*①.

wucai vase, C-5127/*47.*

wu-chin, IDC.

wu chin ware, DADA.

Wu-chou ware, EA.

wufu, S-4810/*575*①; S-4965/*266*①, *295*①.

Wunderlich, Paul, S-286/*99, 432.*

Wurstkrug, IDC.

Würth, Johann Sebastian, C-5117/*180.*

Würth: Ignaz Joseph, Johann Sebastian, EA.

Würzburg, EA.

wu ts'ai, ACD.

wu ts'ai, CEA/*111, 121*①; EA/①.

wu-ts'ai, C-0782/*179*; IDC.

wu ts'ai yao, DADA.

Wyatt, James, C-2357/*10*①.

Wyburd, Leonard F., C-GUST/*139*①.

Wyche, David, London, C-2489/*83.*

wych elm, SDF; CEA/*324*①.

Wycombe chair, EA; SDF/①.
Wylde, C-0906/*334.*
Wynkoop, Benjamin, NYTBA/*217*①.

Wyon, E. W., C-5189/*7.*
wythe, SDF/*withe.*

X

xanthorrhoea, DATT.
X base, CEA/*401*①.
X-chair, SDF/①.
xestobium rufovillosum, SDF.
X-form base, S-2882/*337*.
x-form chair, CEA/*305*①; DADA.
X-formed base, C-0279/*435*.
X-form leg, S-4812/*98*①.
X-form stand, S-2882/*1008*①.
X-form stretcher, DADA/①; S-2882/
 *798*①; S-3311/*116*①.
X-frame, C-2388/*33*.
X frame (curule frame), EA/①.
X-framed, LAR82/*306*①.
X-framed stool, LAR83/*355*①.
X-frame stool, C-2437/*24*①.
Xianfeng period, S-4965/*270*①.
xiechai, S-4810/*264*①.
Xing You Heng tang, C-2458/*418*.
Xingzhou type, C-2414/*30*①.
'x'-motif, C-2320/*149*.
X-motif, C-2478/*225*.

X motif, C-2403/*187*.
X-pattern splat, C-2403/*25*; C-2478/
 156A; LAR83/*275*①.
X-shaped, C-5239/*286*; SDF/①.
X-shaped folding chair, NYTBA/*24*.
X-shaped platform stretcher, S-4414/
 476.
X-shaped stretcher, C-5114/*330*①.
X shaped stretcher, C-0982/*238*.
X-shaped support, C-2409/*240*.
X stand, C-5236/*1640*.
X-stool, SDF/①.
X-stretcher, LAR83/*280*①; S-4414/
 *459, 497*①; S-4436/*9*; SDF/①
 X-shaped.
Xuan, Xhu, C-5156/*247*①.
Xuande, C-2458/*70, 235, 252*;
 C-5156/*84*①.
Xuande period, S-4965/*239*①.
xulopyrography, SDF.
Xu Wei, C-2414/*99*①.
xylene, DATT.

Y

'Y' diaper ground, S-3312/*1135*①.

Y-diaper ground, IDC.

year clock, SDF.

yeast black, DATT.

Yedo period, IDPF/*18*.

Yefimok, RGS/*166*.

Yei style, S-4807/*272*①.

yellow, IDC.

yellow berry, DATT.

yellow birch, SDF.

yellow carmine, DATT.

yellow deal, SDF.

yellow earth, DATT.

yellow ground (German ceramic decoration), EA.

yellowing, DATT.

yellow lake, DATT.

yellow marble, C-2403/*85*.

yellow meranti, SDF.

yellow metal, EA/*patent metal, patent metal*.

yellow-ocher, EC2/*32*①.

yellow ocher, LP.

yellow ochre, DATT.

yellow oxide of iron, DATT.

yellow pigment, DATT.

yellow pine, SDF.

yellow seraya, SDF.

yellow serpentine, S-4810/*111*①.

yellow tiger (German ceramic decoration), EA.

yellow tiger pattern, IDC/①.

yellow ultramarine, DATT.

yellow varnish, DATT.

yellow vase, MP/*62*.

yellow ware, DADA/*Supplement*; IDC.

yellow weed, DATT.

yellow wood, SDF.

Yemenite, C-5174/*14*.

Yendje, CEA/*82*①.

yen-yen, IDC; IDPF/*256*.

yenyen, C-5127/*36*; S-4810/*245*①; S-4965/*238*①; C-5156/*122*①.

yen yen vase (Chinese shape), EA.

Yenyen vase, C-5127/*36*.

Yen Yu tian, C-2458/*413*.

yeoman furniture, SDF.

yeseria, DADA/①.

yesteklik, DADA.

yett, CEA/*542*.

yew, ACD; DSSA; SDF.

yew-wood, C-0982/*116*.

yew wood, DADA; S-4436/*1*①; S-4461/*642*; S-4812/*192*①.

yewwood, C-2357/*56*①; C-5116/*119*; S-3311/*158*.

Yezd, OC/*103*①, *294*①.

Yezd-Kashans, OC/*299*.

Yezd rug, DADA; S-4461/*756*.

Yezhongsan, C-2458/*356*①.

Ye Zhongsan The Younger, S-4810/*61*①.

Y:-huang-kuan, EA.

Yi, CEA/*129*①; EA.

Yi dynasty, C-0782/*149*; IDC; C-2323/*173*; C-2458/*58, 270*; C-5127/*49*; C-5236/*426*①, *1574*; DADA; JIWA/*346*.

yi form, S-4965/*292*①.

Yi-hsing, IDC/①; EA.

Yi-hsing square bell shaped teapot, C-0803/*41, 41*.

Yi-hsing stoneware, EA/*earthenware*.

Yi-hsing type, IDPF/*228*①.

Yi hsing yao, DADA.

ying-ch'ing, IDC.

Ying Ch'ing, DADA.

Ying-ch'ing ware, EA/*Ching-pai ware, Ching pai ware*.

Ying Ch'ing ware, ACD.

ying-hsuing, DADA.

ying-pau, IDC.

Z

Z, EA/*Zurich porcelain and faience factory.*

Zaandam clock, EA/*Dutch clock,* ① *Dutch clock.*

Zacatecas, S-4807/*186.*

zaccab, DATT.

Zach, Bruno, C-2910/*310*; C-5191/*123*①.

Zachammer, Sigismund, CEA/*630*①.

Zadkine, Ossip, S-286/*104.*

zaffer, DATT.

zaffer (zaffre), EA.

zaffer, IDC.

zaffre, DATT; IDC/*zaffer.*

Zagheh, OC/*98*①.

Zagros Luris, OC/*222.*

Zais, Guiseppe, C-2357/①.

Zanesville, Ohio, CEA/*462*①.

Zanesville Art Pottery, Zanesville, Ohio, EC1/*85.*

Zanesville Glass Manufacturing Company, EA/①.

Zapon, DATT.

zapotec pottery, IDC.

Zappler, LAR82/*232*①; S-4927/*202.*

Zappler clock, EA.

zar, CEA/*101.*

zara maki, DADA.

zarcherek, CEA/*101*; OC/*30.*

Zarephath, Widow of, IDC/①.

zarf, C-5117/*368.*

zaronim, CEA/*101*; OC/*30.*

zaroquart, CEA/*101.*

Z chair, C-5191/*320.*

zebrano, DATT; SDF.

zebra wood, ACD; C-0225/*373.*

zebrawood, C-5191/*308*①; DATT; LAR83/*389*①; S-4881/*503*①; SDF.

zeeuwschekast, LAR83/*314*①.

Zeichur cross, C-0279/*8*①.

Zeigler carpet, C-2482/*29.*

Zeisel, Eva, DADA/*Supplement.*

Zeiss, CEA/*611*①.

Zeiss, C., C-2476/*7.*

Zeissig, Johann Elias, MP/*155.*

Zeitgeist, LP.

Zellenmosaik, EA.

Zelli-Sultan rug, S-288/*23*①.

Zelli Sutlan rug, LAR82/*547*①.

Zenith Mk3, C-0906/*254.*

Zenjan, OC/*90*①.

Zenjan rug, DADA.

Zen painting zenga, JIWA/*391.*
Zepner, Ludwig, MP/*498.*
zeppelin-form, S-2882/*1282.*
Zerbst, DADA; EA.
zern bead, RGS/*67.*
Zeschinger, Johannes, C-2486/*79*①;
 EA.
Zeshin, CEA/*574*①, *575.*
Zeshin style, S-4928/*172*①.
Zethelius, Pehr, EA.
Zeus, DSSA.
zhalovannye, RGS/*85.*
Zhejiang, C-2513/*246*; S-4965/*188*①,
 *237*①.
Zhejiang celadon dish, S-3312/
 *1320*①.
Zhengde, C-5156/*79*①.
Zhengde period, S-4965/*254*①.
Zhengde Tang, C-2458/*140*①.
zhi, C-2414/*3*①, *12*①.
Zhiang Sheng, C-2414/*100*①.
zhilong, S-4810/*474*①.
Zhitomir, C-5203/*111.*
Zhou dynasty, LAR83/*476*①;
 C-2414/*4*①; C-2458/*209*①;
 C-5156/*174*; C-5236/*378*①, *335A*;
 S-3312/*1282*①.
Zhuen, S-4810/*59*①.
Zick, Janarius Johann Rasso, EA.
Ziegler, C-2478/*274.*
Ziegler Sultanabad carpet, S-4948/
 *146*①.
zigana, SDF.
zig-zag, S-4905/*75*; SDF.
zigzag, OPGAC/*185.*
zigzag band, C-5117/*385*①.
zigzag border, S-2882/*76.*
zig-zag decoration, C-2493/*236.*
zig-zag edging, OC/*246.*
zig-zag fence pattern, IDC.
zigzagging pattern, JIWA/*71.*
zig-zag pattern, C-2323/*47*①.

zigzag pattern, S-2882/*1218.*
Zile, LAR82/*545*①.
Zili, S-4847/*239*①.
Zil-i-Sultan bird and vase, OC/*104*①.
Zimmerman, A. & J., C-GUST/
 *107*①.
zinc chromate, DATT.
zinc chrome, DATT.
zinc green, DATT.
Zincke, Christian Friedrich, EA.
zinc-lined interior, C-2357/*95*①.
zinc lining, FFDAB/*67.*
zincograph, JIWA/*33*①.
zinc oxide, DATT.
zinc white, DATT; LP.
zinc yellow, DATT; LP.
zingana, DATT.
zinnober green, DATT.
zirat fladke, EA/*Scandinavian glass.*
Zirat Fladske, EG/*221*①.
zircon, S-4927/*312.*
zirconium drier, DATT.
zirconium oxide, DATT.
Zircopax, DATT.
Zirhaki motif, OC/*335.*
ziricote, SDF.
zischägge, C-2503/*74.*
zither, C-0906/*375*; C-1702/*143.*
zither Salzburg type; Mittenwald
 type, EA.
Z-motif, C-2478/*217.*
zo, CEA/*575.*
Zoan Maria (Giovanni Maria), EA.
Zocce, MP/*449.*
zocle, EA/*scole*; SDF.
Zodiac, DSSA.
Zodiac Bowl, CEA/*482*①.
zodiac figure, C-2458/*11*①; S-4965/
 *202*①.
Zodiac pattern, C-5005/*381*; S-2882/
 1373.
Zoffoli: Giacomo, Giovanni, EA/①.